The Arts in Latin America
1492–1820

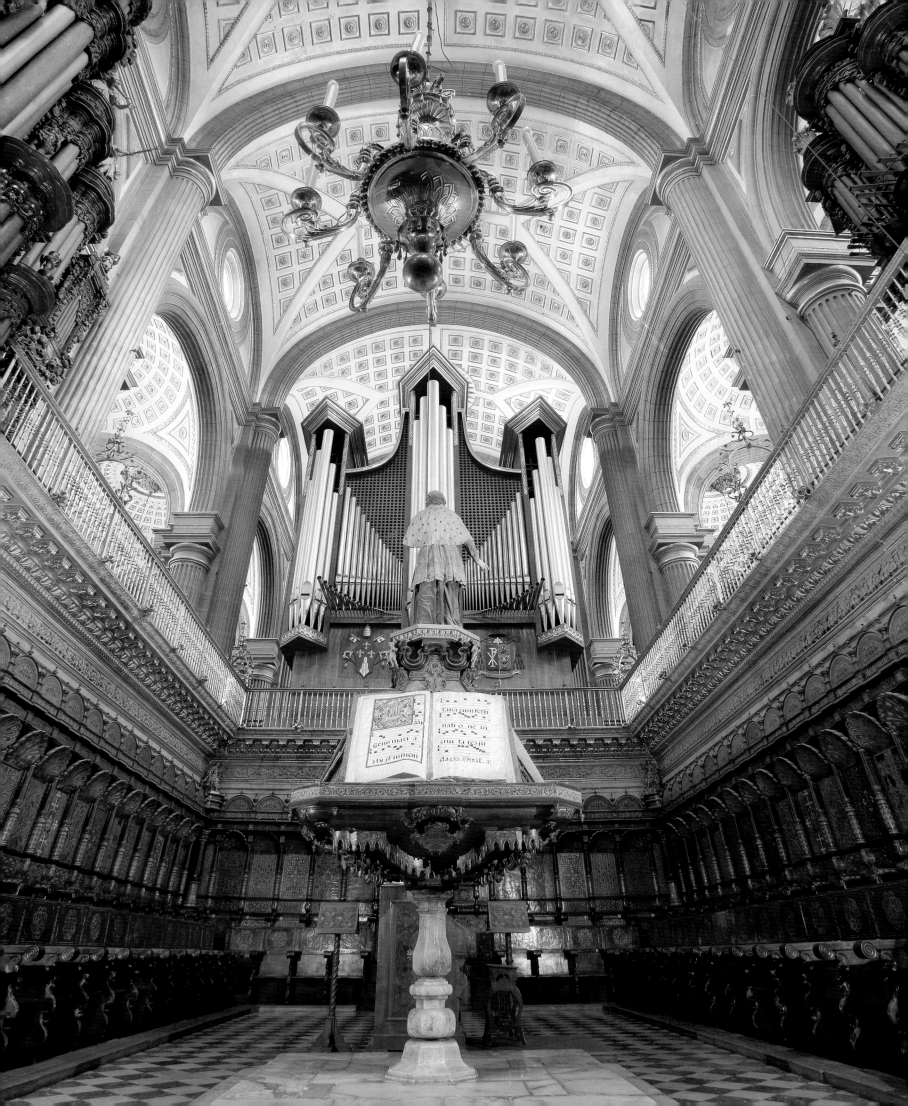

The Arts in Latin America
1492–1820

Organized by Joseph J. Rishel
with Suzanne Stratton-Pruitt

PHILADELPHIA MUSEUM OF ART
ANTIGUO COLEGIO DE SAN ILDEFONSO, MEXICO CITY
LOS ANGELES COUNTY MUSEUM OF ART

IN ASSOCIATION WITH

YALE UNIVERSITY PRESS
NEW HAVEN AND LONDON

Produced by the Publishing Department
Philadelphia Museum of Art
Sherry Babbitt, Director of Publishing
2525 Pennsylvania Avenue
Philadelphia, PA 19130 USA
www.philamuseum.org

Published in association with Yale University Press
P.O. Box 209040
302 Temple Street
New Haven, CT 06520-9040
www.yalebooks.com

Editorial coordination by Beth A. Huseman
Edited by Joseph N. Newland, Q.E.D., with Mark Castro, Kathleen
 Krattenmaker, Celia Cullen Martin, David Updike, and Jennifer Vanim
Designed by Zach Hooker
Proofread by Sharon Rose Vonasch
Translations by David Auerbach, Gregory Dechant, Susa Oñate,
 Margaret Sayers Peden, Laura A. E. Suffield, and Clare Thorbes
Maps by Anandaroop Roy
Produced by Marquand Books, Inc., Seattle, www.marquand.com
Color separations by iocolor, Seattle
Printed and bound in Belgium by Die Keure, Brugge

Jacket/cover front: Luis Niño, *The Virgin of the Rosary with Saint Dominic
and Saint Francis of Assisi* (cat. VI-98); jacket/cover back: detail of chasuble
(cat. II-9); frontispiece: Cathedral of Puebla, Mexico; pp. 96–97: detail of
ballot box (cat. I-26); pp. 144–45: Dominican Convent of Saint Rose of
Lima, detail of chasuble (cat. II-7); pp. 176–77: detail of box for sweets or
yerba maté (cat. III-35); pp. 228–29: detail of flask for holy oil (cat. IV-2);
pp. 246–47: Attributed to Miguel Mauricio, detail of *Saint James Killer of
Indians* (cat. V-4); pp. 320–21: Gaspar Miguel de Berrío, detail of *The Patron-
age of Saint Joseph* (cat. VI-93); pp. 474–75: detail of desk (cat. VII-25)

Text and compilation © 2006 Philadelphia Museum of Art
*Stars in the Sea of the Church: The Indian in Eighteenth-Century
New Spanish Painting* © 2006 Ilona Katzew

Photography credits appear on p. 568.

Library of Congress Cataloging-in-Publication Data
 The arts in Latin America, 1492–1820 / organized by Joseph J. Rishel
with Suzanne Stratton-Pruitt. — 1st ed.
 p. cm.
 Published on the occasion of exhibitions held at the Philadelphia
Museum of Art, fall 2006; Antiguo Colegio de San Ildefonso, Mexico
City, winter/spring 2007; and Los Angeles County Museum of Art,
summer 2007.
 Includes bibliographical references.
 ISBN-13: 978-0-87633-250-4 (pma paper)
 ISBN-10: 0-87633-250-5 (pma paper)
 ISBN-13: 978-0-87633-251-1 (pma cloth)
 ISBN-10: 0-87633-251-3 (pma cloth)
 ISBN-13: 978-0-300-12003-5 (Yale cloth)
 ISBN-10: 0-300-12003-6 (Yale cloth)
 1. Art, Latin American—Exhibitions. 2. Art, Colonial—Latin
America—Exhibitions. I. Rishel, Joseph J. II. Stratton, Suzanne L.
III. Philadelphia Museum of Art. IV. Antiguo Colegio de San Ildefonso
(Museum). V. Los Angeles County Museum of Art.
N6502.A79 2006
709.8074748'11—dc22 2006019264

Note to the Reader
† next to an artist's name in the catalogue section indicates that a brief
biography can be found on pp. 527–35.

Published on the occasion of the exhibition *The Arts in Latin America, 1492–1820*

Philadelphia Museum of Art	September 20–December 31, 2006
Antiguo Colegio de San Ildefonso, Mexico City	February 3–May 6, 2007
Los Angeles County Museum of Art	June 10–September 3, 2007

The international tour of the exhibition was made possible by Fundación Televisa.

The exhibition was also supported by an indemnity from the U.S. Federal Council on the Arts and the Humanities and funding from the Mexico Tourism Board. Initial scholarly research was supported by a Collaborative Research Grant from The Getty Foundation and The Andrew W. Mellon Fund for Scholarly Publications at the Philadelphia Museum of Art; funding for conservation was provided in part by the Huber Family Foundation and the Ceil and Michael E. Pulitzer Foundation.

In Philadelphia, the exhibition was also supported by The Annenberg Foundation Fund for Major Exhibitions, the Robert J. Kleberg, Jr., and Helen C. Kleberg Foundation, The Pew Charitable Trusts, Barbara B. and Theodore R. Aronson, Popular Financial Holdings, the National Endowment for the Arts, the Connelly Foundation, The Women's Committee of the Philadelphia Museum of Art, Martha Hamilton Morris and I. Wistar Morris III, Maude de Schauensee, Paul K. Kania, Marilynn and Carl Thoma, The Brook J. Lenfest Foundation, Vivian W. Piasecki, and other generous individuals. Promotional support was provided by NBC 10 WCAU and Amtrak.

In Mexico City, the exhibition was also made possible by the National Autonomous University of Mexico (UNAM), the National Council for Culture and the Arts (CONACULTA), and the Government of the Federal District of Mexico (GDF). The Antiguo Colegio de San Ildefonso is supported by a tri-partite Mandate comprising the National Autonomous University of Mexico (UNAM), the National Council for Culture and the Arts (CONACULTA), and the Government of the Federal District of Mexico (GDF).

The exhibition was organized by the Philadelphia Museum of Art in collaboration with the Antiguo Colegio de San Ildefonso, Mexico City, and the Los Angeles County Museum of Art.

The organizers are grateful for the special collaboration of the National Council for Culture and the Arts (CONACULTA), the National Institute of Anthropology and History (INAH), and the National Institute of Fine Arts (INBA), Mexico.

The catalogue was made possible by the Davenport Family Foundation.

Sponsor's Statement

Mexico and indeed all of Latin America have been producing works of cultural significance for more than three thousand years. Very few countries can boast of such a long-term and substantive contribution, and it is Televisa's belief that through our foundation, Fundación Televisa, we have an obligation to help share our culture with the world. In the past three years, we have sponsored *The Aztec Empire* in New York, *Courtly Art of the Ancient Maya* in Washington and San Francisco, and *Lords of Creation: The Origins of Sacred Maya Kingship* in Los Angeles, Dallas, and New York, all highlighting the arts of Mexico.

Now we are sponsoring *The Arts in Latin America, 1492–1820*, which is the first comprehensive exhibition to explore the convergences of indigenous American, European, African, and Asian cultures and the creation of new identities and art forms in Latin America from the years of the initial European encounters in the late fifteenth century to the formation of modern nations in the early nineteenth century. The exhibition provides insightful perspectives on many fronts, including Mexico's contributions to the masterworks created during the often-overlooked colonial period in Latin America.

To us, these exhibitions hold a significance that transcends the world of art, because they serve to broaden knowledge and expand horizons among peoples and across borders. They also lay the groundwork for a more solid friendship and a more prosperous partnership not only between the United States and Mexico, but also among all the countries whose treasures are represented in the exhibition. These relationships are critical to each of our countries and must continue to grow in breadth and importance.

In this spirit, Televisa—through its foundation—is proud to sponsor the outstanding exhibition *The Arts in Latin America, 1492–1820*, which we hope will be a source of reflection and enjoyment for all who visit it and all who benefit from the thoughtful texts in this impressive catalogue.

Claudio X. González
President
Fundación Televisa

**Fundación
Televisa**

Partners' Statements

Every so often, Latin American nations pause to examine their views on the essence, on the identity, that characterizes each of them individually as well as their perceptions of the unity that unquestionably emerges from their diverse cultures. A privileged instrument in that reflection has been history: the history of their ideas, the history of their economy and their politics, the history of their artistic expression.

The Arts in Latin America, 1492–1820—one of the most ambitious exhibitions on this subject in many years—is slated to become a cornerstone in this search for our common identity. It is characterized by an amazing breadth of study through time and geography. That the organizers have undertaken this enormous task speaks to their intellectual boldness.

The conceptual and logistical challenge of organizing such an exhibition is enormous: it embraces more than three hundred years, a long, fecund period in styles and their variations, and it includes works from Argentina, Bolivia, Brazil, Chile, Colombia, Cuba, the Dominican Republic, Ecuador, Guatemala, Mexico, Peru, Puerto Rico, and Venezuela, each with its own aesthetic expression. The level of complexity of this project is raised still higher because the works collected here range from sacred art to utilitarian objects such as textiles and cabinetry.

The meticulously controlled scope of *The Arts in Latin America* allows us to appreciate what the vital interchange that occurred following 1492 meant for both Europe and America. The Europeans, who arrived spurred by a mixture of desire for wealth and thirst for the mystic, found before them evidence that there were other civilizations and that the world, brimming with diversity, extended far beyond what they had imagined. For the native Americans, who for thousands of years had developed in isolation from other cultural influences, the encounter was cataclysmic. Soon, showing vigorous creativity, they assimilated the principles and techniques arriving from the Old World, and thus in America there were, immediately after contact, European masters and Indian artists in every range of endeavor. Both groups imprinted their particular sensibility upon the aesthetic currents flowing from the other side of the ocean.

Those dual manners of looking at the world forged a tension, a mutually enriching dynamic, that was to determine the splendor of colonial art and give it a specific character, for Latin America was never a simple reflection of what was happening in Europe. As the visitor to this exhibition will see, to the multiple influences already present in the art from Spain and Portugal, America added specific perceptions, a delicate mastery of materials, and an indigenous expression that make its arts unique.

This splendid exhibition invites us to experience personally the exhilarating adventure that signified the formation of a regional aesthetic and outlook, filled with the dark and light of chiaroscuro, that lends individuality to national traits and, at the same time, allows recognition of a shared voice from our America.

Sari Bermúdez
President
National Council for Culture and the Arts (CONACULTA), Mexico

The National Autonomous University of Mexico is proud to receive *The Arts in Latin America, 1492–1820*, at the Antiguo Colegio de San Ildefonso. On this occasion we have the unrivaled opportunity of reviewing and examining our past through an abundant selection of more than two hundred works from some twelve Latin American countries and the Commonwealth of Puerto Rico.

This exhibition is the result of an unprecedented international effort that has allowed us to gather together an ample and splendid sample of the creative talent that flourished in the various territories of Spanish and Portuguese America between the sixteenth and nineteenth centuries. Without a doubt, through its grand scope and singularity, the collection united here will capture the attention of the public and become a point of reference for the understanding of our history.

As an institution committed to the promotion of projects and programs that look toward all of Latin America, our university has a long history of cooperation and exchange based on solidarity, and related to multiple areas of knowledge and research, including the arts and humanities. Over the years, in consideration of the ties of identity that unite the different countries of the region, we have organized various academic encounters so as to reinforce the historical and cultural integration of our continent. In the past two decades, there fortunately has been considerable growth in the contacts among Latin American educational institutions and museums, which has made it possible to more fully share, deepen, and disseminate the knowledge and renewed visions of specialists.

This exhibition and the book that accompanies it are, in many ways, important contributions that result from the renewed interest in our colonial artistic legacy. Here we find projected the contemporary reflections that will permit reinterpretations of this transcendent period of our history. It was during those centuries that a network of commercial routes uniting Asia, Europe, Africa, and America was developed. The resulting interactions promoted the exchanges of ideas and the mixing of cultural traditions that are manifest in the astonishing diversity of the arts.

As members of a university community, we celebrate the realization of this ambitious project. Aware, on the other hand, of the complexities of art and of history, and of the heterogeneous realities of Latin America, we are conscious of the difficulties inherent in attempting to encase within a handful of concepts so many and such varied manifestations of the abilities of human beings to express and transfigure their experiences. We are confident, however, that the titanic effort that has resulted in this exhibition will lead to a greater appreciation of our arts and enhance and deepen our mutual understanding.

Juan Ramón de la Fuente
Rector
National Autonomous University of Mexico (UNAM)

When Napoleon's troops occupied Spain in 1808, a process was set in motion in her American colonies that would culminate in their independence and in the emergence of the countries that today constitute the map of our Latin America. On the eve of celebrating the bicentennial of the formation of the free and sovereign nations of Latin America, Mexico City—capital of the historic Viceroyalty of New Spain—takes great pride in offering a setting for the exhibition *The Arts in Latin America, 1492–1820*, in one of her most splendid venues, the Antiguo Colegio de San Ildefonso.

This exhibition affords us a closer look at the very crucible in which our identities were forged: the colonial period, without which none of our peoples could comprehend their present reality. Beyond the polemic concerning the destruction of ancient indigenous cultures, it cannot be questioned that, beginning with the era of discoveries, the encounter that led to establishing colonial systems favored the amalgamation of a variety of cultural expressions that resulted in the creation of new societies, those that over the years produced the mestizo Latin American peoples we are today.

The extraordinary selection of works of art and items of everyday use that comprise this exhibition encompasses over a dozen nations, one commonwealth, and a period of more than three

centuries. In it we discover individuals and societies nurtured by an authentic creative genius that presented us with objects of exquisite utility and worth. In it, too, we discover that we are possessors of an unequaled legacy that, in addition to the aesthetic pleasure it offers, fills us with a sense of belonging. It thus acquires a more relevant and profound significance: that of the cultural heritage that binds us together, identifies us, gives us coherence, and most of all, allows us to glimpse a bright and hopeful future, that of the just and equitable society for which we all yearn.

We celebrate the opportunity to explore this exhibition that allows us to recapture a vital part of our past, just at the moment we are preparing to commemorate the bicentenary of our nations.

Alejandro Encinas
Mayor
Government of the Federal District, Mexico

In 1492, Isabela of Castile and Fernando of Aragon, the *Reyes Católicos*, achieved the unification of Spain. That same year, the sailor-explorer Christopher Columbus stumbled upon "very many islands peopled with countless inhabitants," as he himself described the new territories that altered the geography and the history of the epoch, and stirred the mentalities of the Old as well as the New Worlds. That discovery encompassed an amazing group of civilizations, which were to be subjected to a long process of adaptation to ideologic, religious, social, economic, political, and military precepts from across the sea that would favor European expansion in America.

Once the period of military conquest was over, the Spanish crown established the visible figure of the viceroy to assure the supremacy of its political authority, to sustain its evangelizing campaign, and to execute administrative functions in the new lands. Thus in 1535, the first of four viceroyalties, New Spain, was established. It would endure for more than three hundred years.

Under the supreme control of the clergy, the fruitful cultural life of New Spain produced a lavish array of artistic expression that, although from its beginnings had evangelization as its only goal, within a very short time had acquired unique characteristics nurtured by images, symbols, and signs derived from Mesoamerican beliefs that then evolved into a splendid eclecticism revealing a search for its own language.

The present publication offers a comprehensive panorama of *The Arts in Latin America, 1492–1820*, and serves as faithful testimony of the magnificent exhibition organized by the Philadelphia Museum of Art in collaboration with the Mandato del Antiguo Colegio de San Ildefonso/ National Autonomous University of Mexico, Mexico City, and the Los Angeles County Museum of Art with the support of many individuals and institutions.

Since 1939, the National Institute of Anthropology and History has established itself as the premier Mexican organization for researching, recovering, conserving, and disseminating the memory of the Mexican past. By participating in the realization of *The Arts in Latin America*, we are pleased to reaffirm our desire to circulate relevant aspects of Latin American history among new and more widespread publics, as well as to increase knowledge of the diversity and riches of our multiple cultures.

Luciano Cedillo Álvarez, Conservator
Director General
National Institute of Anthropology and History (INAH), Mexico

Contents

Directors' Foreword

We are honored and delighted to present to a broad public in the United States and Mexico this extraordinary compendium of works of art from what are now twelve countries across Latin America and the Commonwealth of Puerto Rico. Between the great indigenous civilizations of the ancient Americas and the modern nations that came into being in the early nineteenth century are three centuries of rich artistic interaction and creativity that this book and the exhibition it accompanies seek to explore in an unprecedented geographical and cultural panorama.

We join Joseph J. Rishel in his salute to the remarkable international team of scholars and colleagues whose research has brought this panorama to life, and with him we thank the talented staff at each of our institutions who together have brought this complex project into being. It has been the breadth of vision and passionate dedication to this exhibition on the part of Joseph Rishel himself that has shown the way.

An international cultural undertaking such as this one requires the wise counsel of members of the diplomatic corps of many nations, whether in Washington, D.C., or in each collaborating country, and the exhibition has had unstinting support wherever we turned. We are profoundly grateful to all the ambassadors, the ministries of culture, and their staffs who provided timely help and encouragement. We owe a particular debt of heartfelt thanks to the embassy and consulates of Mexico in the United States for their interest in this cultural partnership between our countries. Without the splendid, sympathetic, and always resourceful support of United States Ambassador to Mexico, the Honorable Antonio O. Garza, Jr., Cultural Attaché Marjorie Coffin, and Senior Cultural Affairs Specialist Bertha Cea Echenique, from the inception of this project until opening day at each of our museums, the exhibition could not have been realized.

The intellectual and artistic breadth of this project and the compelling beauty and humanity of the works of art shown in the exhibition and discussed in this volume have attracted the passionate adherence of hundreds of individuals in many countries who have helped in a multitude of ways. They have our warmest thanks. To Barbara B. Aronson, Patricia Phelps de Cisneros, Roberta and Richard Huber, Ana María Keene, and D. Dodge Thompson go special gratitude for their advice and enthusiasm all along the way. We are also especially grateful to The Getty Foundation and its director, Deborah Marrow, for their generous and timely support through a Collaborative Research Grant that permitted the scholarly travel and international exchange of ideas so critical to the formation of the show. Research and preparation for this book were also sustained by the invaluable support of the fund for scholarly publications at the Philadelphia Museum of Art created by a grant from The Andrew W. Mellon Foundation and matched by generous donors.

The early and enlightened lead sponsorship of Fundación Televisa and the enthusiasm of its Chairman, Emilio Azcárraga Jean, have been crucial to the success of this great cultural enterprise. We thank the Televisa team of Claudio X. González, Mauricio Maillé, and Diana Mogollón González for their quick grasp of the importance of the exhibition to an international audience and their unwavering support.

Government agencies in both the United States and Mexico have been generously enthusiastic in their support. A grant from the National Endowment for the Arts, an indemnity from the U.S. Federal Council on the Arts and the Humanities, and a grant from the Mexico Tourism Board have all played important roles in our museums' ability to introduce the project and our mutual desire to deepen the understanding of shared cultural values.

In Mexico City, the Antiguo Colegio de San Ildefonso has greatly benefited from the generous and heartfelt support of its three governing entities: the National Autonomous University of Mexico (UNAM) and its Rector, Juan Ramón de la Fuente, and its Coordinator of Cultural Programming, Gerardo Estrada; the National Council for Culture and the Arts (CONACULTA) and its President, Sari Bermúdez; and the Government of the Federal District of Mexico (GDF) and its Mayor, Alejandro Encinas.

In Philadelphia, the Museum is deeply grateful for an endowment for major exhibitions created by the Annenberg Foundation, and to the Robert J. Kleberg, Jr., and Helen C. Kleberg Foundation, The Pew Charitable Trusts, Barbara B. and Theodore R. Aronson, Popular Financial Holdings, the Connelly Foundation, The Women's Committee of the Philadelphia Museum of Art, Martha Hamilton Morris and I. Wistar Morris III, Maude de Schauensee, Paul K. Kania, Marilynn and Carl Thoma, The Brook J. Lenfest Foundation, Vivian W. Piasecki, and other generous individuals. Without their faithful support, sustained throughout the length of this ambitious project, the exhibition could not have reached its splendid potential. We are also grateful to the Huber Family Foundation and the Ceil and Michael E. Pulitzer Foundation, who with other, anonymous donors assisted with the restoration of the magnificent *Crucifix* from the Monastery of São Bento de Olinda in Brazil. We are also pleased once again to have the promotional support provided by NBC 10 WCAU and Amtrak.

There are over 120 lenders, public and private, in eleven countries across Latin America and the Commonwealth of Puerto Rico as well as the United States, England, Spain, Switzerland, and Italy, without whose willingness to part with their treasures the exhibition would not have happened. To each of them go our heartfelt gratitude for their crucial role in making up the vast, composite picture that is presented in this exhibition. Suzanne F. Wells, the Philadelphia Museum of Art's Director of Special Exhibitions Planning, brought her unparalleled skills of diplomacy and artful coordination to the task of bringing together the myriad aspects of such a major international project. The Museum's Senior Registrar, Irene Taurins, and her staff worked tirelessly and creatively to organize the loans from so many locations around the globe. They, with their Philadelphia colleague Warwick (Rick) Wheeler, Director of Corporate Relations, and their partners in Mexico City and Los Angeles—Ery Cámara Thiam, Exhibitions Manager at the Antiguo Colegio de San Ildefonso; and Ilona Katzew, Curator, Latin American Art, and Irene Martín, Assistant Director, Exhibition Programs, at the Los Angeles County Museum of Art—made up a splendid international team. The English edition of this book, so handsomely produced by Marquand Books, is made possible by a generous grant from the Davenport Family Foundation. It has been edited with skill and devotion by Beth Huseman at the Philadelphia Museum of Art, and overseen by the Museum's Director of Publishing, Sherry Babbitt, who together brought to this complex project their complete attention, intelligence, and grace under pressure. And now, on behalf of the extraordinary and far-reaching collective partnership of scholars, curators, donors, lenders, and supporters, we invite you to join with us in this remarkable celebration of the arts of Latin America.

Anne d'Harnoncourt
The George D. Widener Director and Chief Executive Officer
Philadelphia Museum of Art

Paloma Porraz Fraser
Director
Antiguo Colegio de San Ildefonso, Mexico City

Michael Govan
Chief Executive Officer and Wallis Annenberg Director
Los Angeles County Museum of Art

Lenders

ARGENTINA
Catedral Metropolitana, Buenos Aires
Museo Nacional Histórico, Buenos Aires
Order of Minorite Friars, Monastery of San Francisco, Córdoba

BOLIVIA
Museo de Arte Sacra, Arzobispado de La Paz
Museo de Arte Sacra, Catedral Basílica de San Lorenzo,
 Santa Cruz de la Sierra
Museo Casa de Murillo, La Paz
Museo de la Casa Nacional de Moneda, Fundación Cultural
 BCB, Potosí
Museo Nacional de Arte, La Paz
Museo Santa Teresa, Potosí
Provincia Misionera San Antonio en Bolivia, Museo del
 Convento de la Recoleta, Sucre

BRAZIL
5ª Superintendência Regional do Instituto do Patrimônio
 Histórico e Artístico Nacional, Recife, Pernambuco
Arquidiocese de São Salvador da Bahia (Catedral Basílica)
Fundação Museu Carlos Costa Pinto, Salvador, Bahia
Monastery of São Bento, Olinda, Pernambuco
Monastery of São Bento, Salvador, Bahia
Museu Arquidiocesano de Arte Sacra, Mariana, Minas Gerais
Museu de Arte Sacra, São Paulo
Museu de Arte Sacra da Universidade Federal da Bahia,
 Salvador, Bahia
Museu do Ouro, Sabará, Minas Gerais
Museus Castro Maya/IPHAN, MINC, Rio de Janeiro
Palácio dos Bandeirantes (Acervo Artístico Cultural dos
 Palácios do Governo do Estado), São Paulo
Paroquia Nossa Senhora do Rosario/Mitro Arquidiocesana
 del Belo Horizante, Minas Gerais
Beatriz and Mário Pimenta Camargo Collection, São Paulo

CHILE
Apelles Collection
Museo de San Francisco, Santiago

COLOMBIA
Bank of the Republic of Colombia, Bogotá
Cathedral of Tunja
Museo de Arte Colonial/Ministerio de Cultura, Bogotá
Navas Collection, Bogotá

DOMINICAN REPUBLIC
Cathedral of Santo Domingo

ECUADOR
Convento Máximo de la Merced, Quito
Museo de Arte Colonial, Casa de la Cultura Ecuatoriana, Quito
Museo Franciscano (Fray Pedro Gocial), Quito
Museo Jacinto Jijón y Caamaño, Pontifica Universidad
 Católica del Ecuador, Quito
Museo Nacional del Banco Central de Ecuador, Quito
Oswaldo Viteri, Quito

GUATEMALA
Archdiocese of Guatemala, Guatemala City
Castillo Collection, Antigua
Museo Fray Francisco Vázquez, Iglesia de San Francisco,
 Guatemala City
Museo Popol Vuh, Universidad Francisco Marroquín,
 Guatemala City

ITALY
Museo degli Argenti e delle Porcellane, Palazzo Pitti,
 Polo Museale Fiorentino, Florence

MEXICO
Cathedral of Cuernavaca/CONACULTA, DGSMPC,
 Morelos
Cathedral of Puebla/CONACULTA, DGSMPC
Church of La Compañía de Jesús/CONACULTA,
 DGSMPC, Guanajuato
Church of San Bernardino/CONACULTA, DGSMPC,
 Xochimilco, Mexico City
Church of Santo Domingo/CONACULTA, DGSMPC,
 Mexico City
Fomento Cultural Banamex A.C., Mexico City
Fundación Televisa A.C., Mexico City
Daniel Liebsohn, Mexico City
Metropolitan Cathedral/CONACULTA, DGSMPC,
 Mexico City
Museo de Arte de Querétaro
Museo del Colegio de San Ignacio de Loyola Vizcaínas,
 Mexico City
Museo Franz Mayer, Mexico City
Museo José Luis Bello y González, Puebla
Museo Nacional de Antropología/CONACULTA, INAH,
 Mexico City
Museo Nacional de Arte/INBA, Mexico City
Museo Nacional de Historia/CONACULTA, INAH,
 Mexico City
Museo Nacional del Virreinato/CONACULTA, INAH,
 Tepotzotlán
Museo Regional de Querétaro/CONACULTA, INAH
Museo Soumaya, Mexico City
Pinacoteca, Church of San Felipe Nerí/CONACULTA,
 DGSMPC, Mexico City
Temple of Tlatelolco/CONACULTA, DGSMPC,
 Mexico City

PERU
Banco de Crédito del Perú (Casa Goyeneche), Lima
Cabildo Metropolitano de Arequipa
Church of the Company of Jesus, Cuzco
Church of San Pedro, Lima
Church of San Sebastián, Cuzco
Convent of Our Lady of Copacabana, Lima
Convento de la Merced, Cuzco
Convento de San Agustín, Lima
Instituto Nacional de Cultura, Museo Nacional de
 Arqueología, Antropología e Historia del Perú, Lima

Monasterio de Nuestra Señora del Prado, Lima
Museo de Arte de Lima
Museo de Arte Religioso, Palacio Arzobispal, Cuzco
Museo Histórico Regional (Instituto Nacional de Cultura),
 Cuzco
Museo Pedro de Osma, Lima

PUERTO RICO
Archbishop's Palace, San Juan

SPAIN
Alorda-Derksen Collection, Barcelona and London
Cathedral of Seville
Marqués de los Balbases, Madrid
Museo de América, Madrid
Museo de la Catedral, Palencia
Museo Fundación Lázaro Galdiano, Madrid
Museo Nacional del Prado, Madrid
Parish Church of San Juan, Telede, Canary Islands
Patrimonio Nacional, Monasterio de las Descalzas Reales,
 Madrid
Várez Fisa Collection, Madrid

SWITZERLAND
Esther Schmidt Siegfried, Zurich

UNITED KINGDOM
Fitzwilliam Museum, University of Cambridge
Victoria and Albert Museum, London

UNITED STATES
American Museum of Natural History, New York
The Brooklyn Museum of Art, New York
Denver Art Museum
Dumbarton Oaks Research Library and Collection,
 Washington, D.C.
The Hispanic Society of America, New York
Roberta and Richard Huber, New York
Los Angeles County Museum of Art
Jan and Frederick R. Mayer, Denver
Meadows Museum, Southern Methodist University, Dallas
The Metropolitan Museum of Art, New York
Philadelphia Museum of Art
San Antonio Museum of Art, Texas
Marilynn and Carl Thoma, Kenilworth, Illinois
University of Pennsylvania Museum of Archaeology and
 Anthropology, Philadelphia
Wadsworth Atheneum Museum of Art, Hartford, Connecticut
Elisabeth Waldo-Dentzel, Northridge Studios, California

VENEZUELA
Banco Mercantil, Caracas
Church of San Francisco, Caracas
Patricia Phelps de Cisneros
Fundación John Boulton, Caracas
Herrera Guevara Family, Caracas

and anonymous lenders

Contributing Authors

Luisa Elena Alcalá

Pedro Ángeles Jiménez

Gauvin Alexander Bailey

Sergio Barbieri

Clara Bargellini

Dilys E. Blum

Elizabeth Hill Boone

Michael A. Brown

Marcus Burke

Teresa Calero Martínez de Irujo

Mitchell A. Codding

Jaime Cuadriello

Thomas B. F. Cummins

Gustavo Curiel

Patricia Díaz

Pablo Escalante

Cristina Esteras Martín

Elena I. Estrada de Gerlero

Marta Fajardo de Rueda

Carmen Fernández-Salvador

M. Concepción García Sáiz

Teresa Gisbert de Mesa

Juana Gutiérrez Haces

Ilona Katzew

Paula Kornegay

Eckart Kühne

Andrea Lepage

Adrian Locke

Pilar López Pérez

Alicia Lubowski

Diana Magaloni Kerpel

Consuelo Maquivar

Gridley McKim-Smith

Margaret E. Connors McQuade

Alma Montero

Ramón Mujica Pinilla

Alfonso Ortiz Crespo

Adriana Pacheco Bustillos

Donna Pierce

Anne D. Pushkal

Myriam A. Ribeiro de Oliveira

Joseph J. Rishel

Jorge F. Rivas P.

Haroldo Rodas

Rogelio Ruiz Gomar

Alessandra Russo

Sofía Sanabrais

Nuno Senos

Suzanne Stratton-Pruitt

Carl Brandon Strehlke

Edward J. Sullivan

Marjorie Trusted

Elisa Vargaslugo

Sofía Irene Velarde Cruz

Luis Eduardo Wuffarden

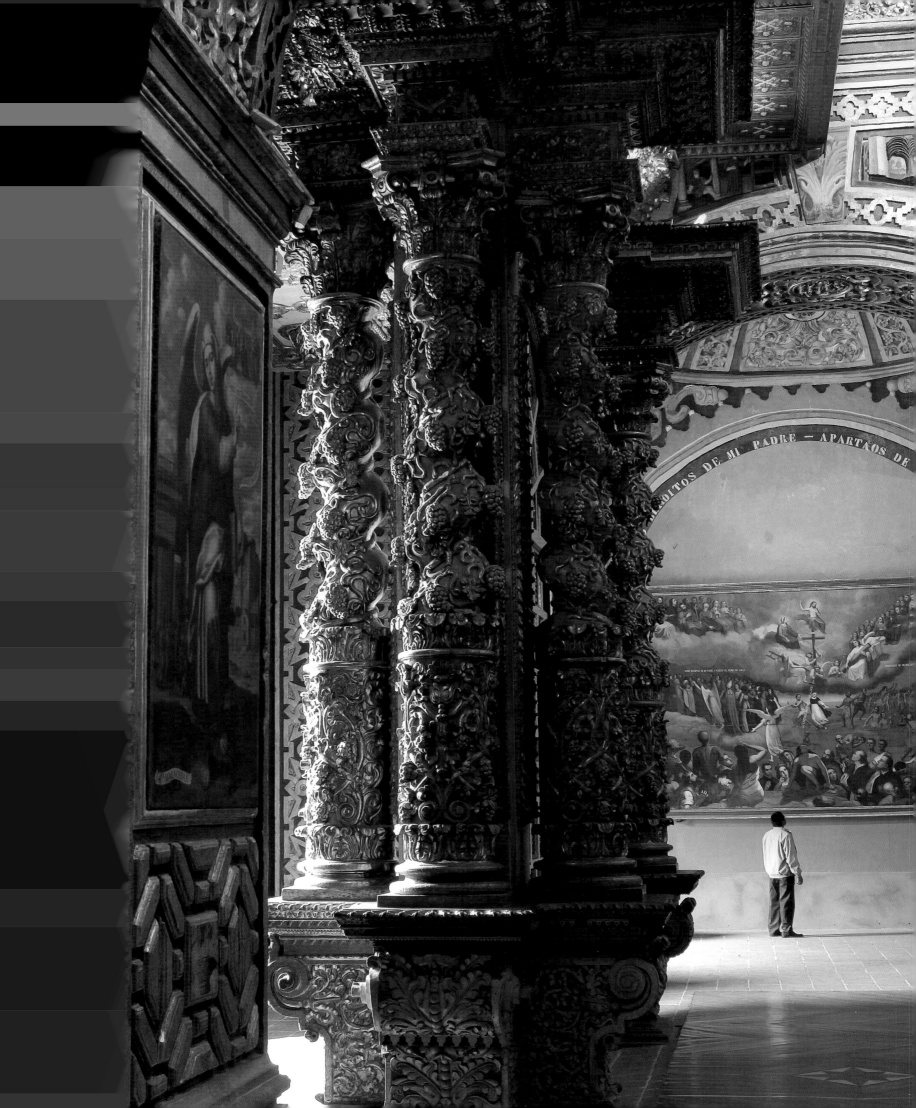

Preface

This exhibition and the accompanying catalogue are the product of a broad and, for the central organizing team, delightful collaboration with international colleagues, as diverse and complexly interlinked as the contents of the exhibition itself.

Philadelphia has of course had a long history of relationships with Latin America, with trade connections dating back to the seventeenth century. Alexander von Humboldt stopped here in 1808 following his journeys throughout northern South America and Mexico to have his portrait painted by Charles Willson Peale, who accompanied him to Washington to introduce him to Mr. Jefferson; and the widow of Augustín de Iturbide, once emperor of Mexico, retreated to Philadelphia following her husband's execution in 1824 and is buried in a local churchyard. The engineer Robert H. Lamborn left part of his extensive collection of Mexican colonial art (with a few Peruvian objects as well) to the then Pennsylvania Museum in 1903, and it was through a week-long visit with her students from the national university of Mexico in 1974 that I met (in what was really my first encounter with a serious scholar in this area) the remarkable Elisa Vargaslugo de Bosch, who gently explained to us the value and nature of our own collections. Part of this group of paintings had been shown as a temporary exhibition at the museum by Anne d'Harnoncourt in 1969, when she was a junior curator, and it was really, with the spur of Katherine (Katie) Crawford Luber, then a curator in the European Painting Department, that we were able to give a permanent home to a selection of the Lamborn collection in a reinstallation of, interestingly, the European galleries in 1992, supported by the Kleberg Foundation, who were among the first to offer financial help to the present project. And it was in conversations with Katie that the fundamental notions of this exhibition—a completely pan-American colonial survey—took form, and much of the initiative to approach the J. Paul Getty Trust in 2001 to help underwrite our own travel but still more importantly, the formation of an international team of scholar/advisors (see Acknowledgments), was her doing, the successful results of which are truly the foundation for the shape and breadth of the project as now realized.

FIG. A-I
Mampara, eighteenth century. Church of
La Compañía, Quito, Ecuador

The Lamborn pictures offer a rather small slice of the quality and range of colonial art but gave us a central base from which to act. Bigger encounters—sometimes at a level close to epiphanies—fed our ambitions. The colonial section of the 1990–91 *Mexico: Splendors of Thirty Centuries,* done by the Metropolitan Museum of Art in collaboration with the San Antonio Museum of Art and the Antiguo Colegio de San Ildefonso in Mexico City, was for many of us a major eye-opener of the levels of achievement possible in this little-explored passage in the history of world art. Many will note the all-too-obvious overlap with the Mexican selection here and of that ambitious show more than fifteen years ago, which we made without apology since it simply underscores the prescience and insights of the organizers of that project. A trip to Madrid in 1999 by Katie and myself, in the company of Roberta Huber (a major colonial painting collector), to see the brilliant *Los Siglos de Oro* organized by Jonathan Brown, Joaquín Bérchez, and Luisa Elena Alcalá, gave us the courage to follow, in a pan-national fashion, Latin colonial art, just as an early trip to Brazil sponsored by the Lampadia Foundation set our determination to extend our boundaries outside those of viceregal Spain to encompass the Portuguese colonies as well. Diana Fane's *Converging Cultures* at the Brooklyn Museum in 1996, which then traveled to Phoenix and Los Angeles, laid for us many of the essential premises of our own project, reinforcing our bias to include art in all mediums and thereby confront some of the conventional wisdoms about "high and low" or even "Old and New Worlds." *Brazil: Body and Soul,* organized by Edward J. Sullivan at the Guggenheim Museum in 2001, particularly its very thoughtful and choice colonial selection, outlined (more ambitiously than we could here) many of the essential elements of exploring this area. Most recently, the last two rooms of the *Aztecs* show at the Royal Academy of Arts in London, given over to works of art postdating the conquest, with its unprecedented gathering of codices and featherwork, was a complete revelation.

Add to this those first visits to the Plaza of San Francisco in Quito, the cathedral in Cuzco, the Aleijadinhos at Congonhas, sculptures in La Merced in Guatemala City, the dizzying (indeed from the altitude) miles of Holguín paintings in Potosí, and on and on. The pleasure and education of being a kind of New World "Grand Tourist" over the past four years have given us an overview (riddled with slights and prejudices certainly) that I hope is immediately evident in the unapologetic celebratory nature of this show.

Which is not to say that we are in any way ahead of the curve in our enterprise. Anyone who has followed, over the past two decades, the burgeoning scholarship, particularly in history, musicology, and anthropology, with art history running to keep up, on colonial Latin America, with progressively more intense research and exhibition activity, will immediately grasp the essential passivity—in the sense of the reception of increasing waves of new discoveries and insights—of our present efforts. For example, it was at a weekend symposium at the King Juan Carlos I Center at New York University that I first met Marjorie Trusted, the sculpture curator at the Victoria and Albert Museum, and Marilynn Thoma, an important collector of Andean colonial painting. And it was through our happy engagement with Nancy Farriss and her students in the History Department at the University of Pennsylvania, particularly during their periodic meetings called "Colonial Dialogues," that we have been able, along with the efforts of the Getty-supported advisory committee, to follow the direction and energies of colonial studies in general, while asking for lots of specific advice.

Ours is a completely synthetic experiment, an attempt to step back and view three hundred years of art-making over a vast geographic area from a horizontal viewpoint. This is not to diminish the wisdom and concrete importance of more vertical (i.e., national) approaches, which, in the large, have been the primary source for much of the object selection and scholarship involved here. But it seemed a time when a different perspective, even in a transient exhibition that will have the brief life of a little more than a year, could allow for reflections on the

importance of the works of art on view in relationship to one another and their implications (in this context) well beyond the immediate concerns of art history.

Our thanks to the many who have contributed substantially to this book and to the formation of the exhibition are listed elsewhere, but we would be remiss not to close here with the specific mention of our immediate colleagues who have made this adventure so pleasurable: Paloma Porraz Fraser and Ery Cámara at the Antiguo Colegio de San Ildefonso in Mexico City, Ilona Katzew and Bruce Robertson at the Los Angeles County Museum of Art, Adrian Locke at the Royal Academy of Arts in London (which unfortunately had to drop out as a participating partner near the close of the exhibition planning), and most especially Suzanne Stratton-Pruitt and Mark Castro in Philadelphia.

Joseph J. Rishel
The Gisela and Dennis Alter Senior Curator of European Painting and Sculpture before 1900
Philadelphia Museum of Art

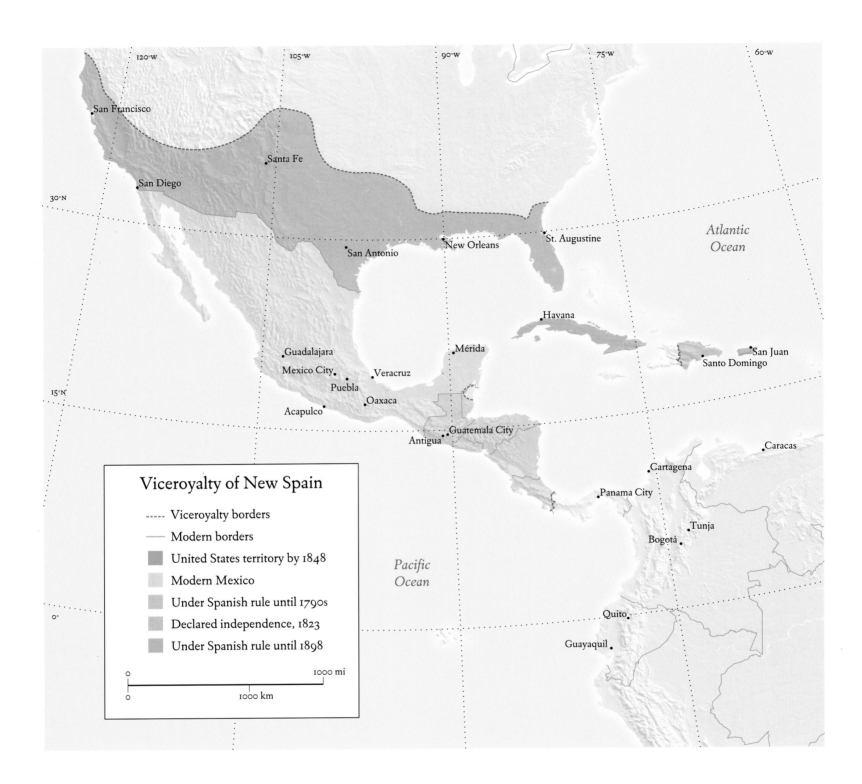

Viceroyalty of New Spain

- - - - Viceroyalty borders
——— Modern borders
United States territory by 1848
Modern Mexico
Under Spanish rule until 1790s
Declared independence, 1823
Under Spanish rule until 1898

0 ————————— 1000 mi
0 ————————— 1000 km

San Francisco
Santa Fe
San Diego
New Orleans
St. Augustine
San Antonio
Havana
Guadalajara
Mérida
San Juan
Mexico City
Veracruz
Santo Domingo
Puebla
Oaxaca
Acapulco
Guatemala City
Antigua
Caracas
Cartagena
Panama City
Tunja
Bogotá
Quito
Guayaquil

Atlantic Ocean

Pacific Ocean

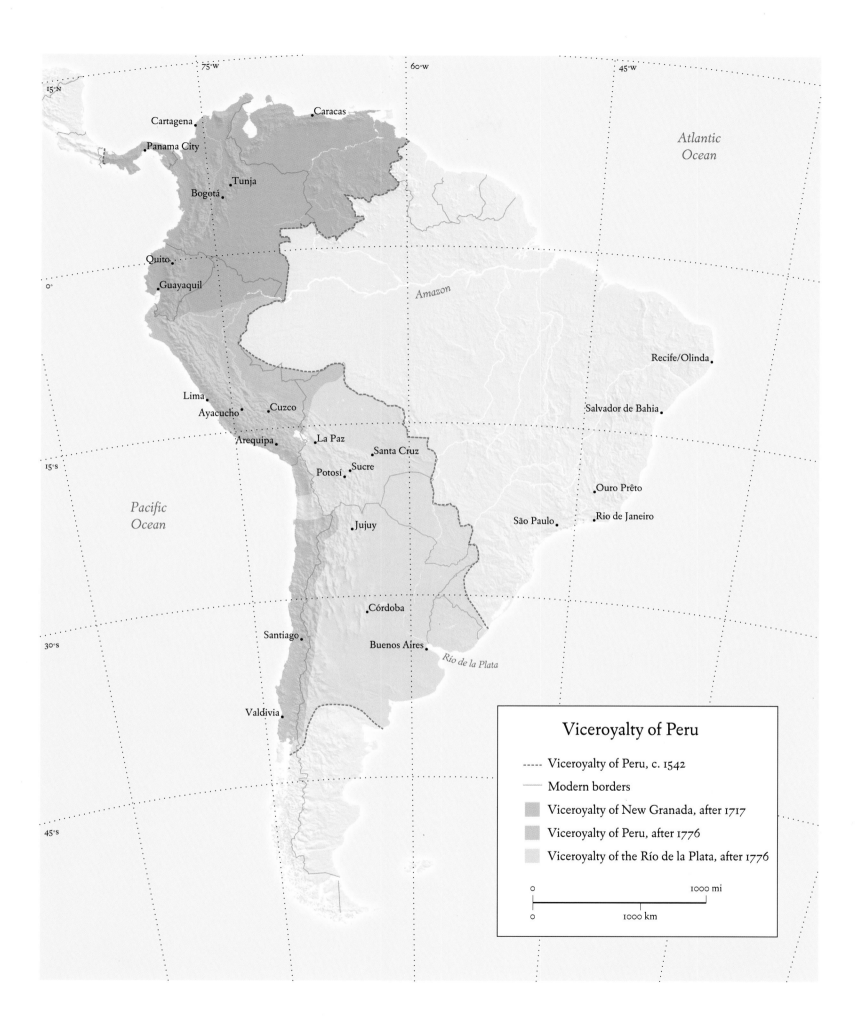

Viceroyalty of Peru

- - - - Viceroyalty of Peru, c. 1542
_____ Modern borders

Viceroyalty of New Granada, after 1717

Viceroyalty of Peru, after 1776

Viceroyalty of the Río de la Plata, after 1776

0 1000 mi

0 1000 km

Atlantic Ocean

Pacific Ocean

Amazon

Río de la Plata

Cartagena
Caracas
Panama City
Tunja
Bogotá
Quito
Guayaquil
Recife/Olinda
Lima
Ayacucho
Cuzco
Salvador de Bahia
Arequipa
La Paz
Santa Cruz
Potosí
Sucre
Ouro Prêto
São Paulo
Rio de Janeiro
Jujuy
Córdoba
Santiago
Buenos Aires
Valdivia

15°N
0°
15°S
30°S
45°S
75°W
60°W
45°W

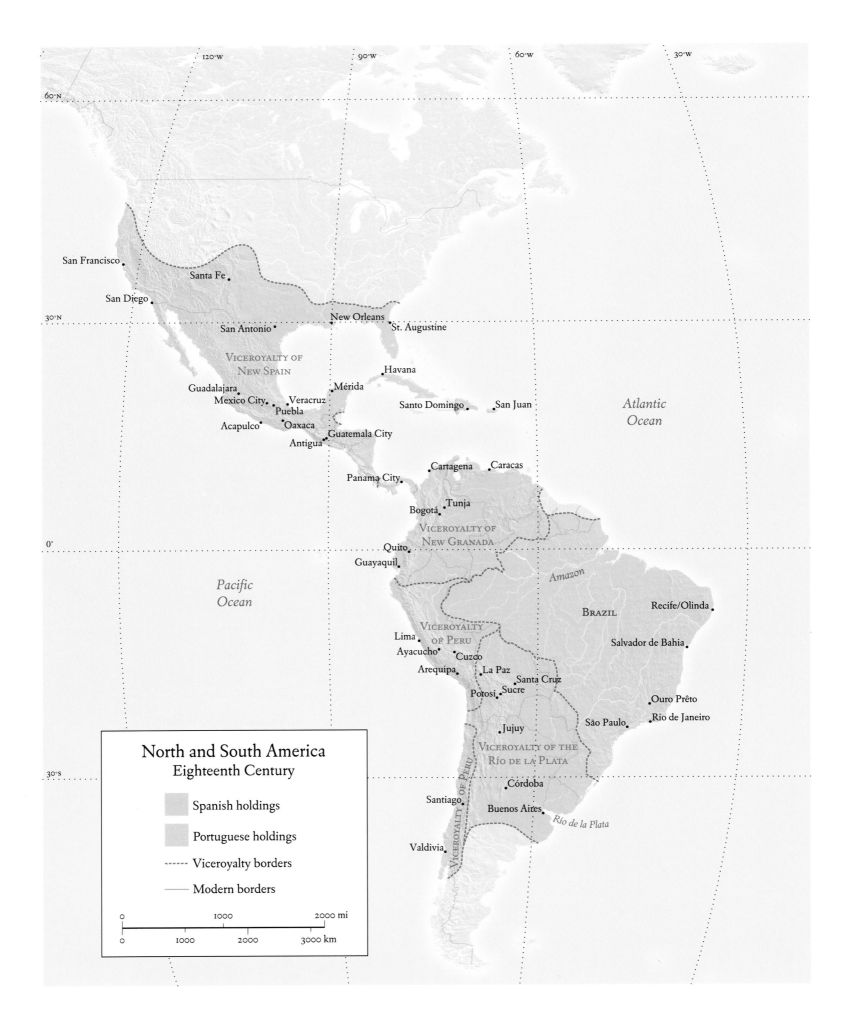

North and South America
Eighteenth Century

■ Spanish holdings

■ Portuguese holdings

--- Viceroyalty borders

— Modern borders

San Francisco

Santa Fe

San Diego

New Orleans

St. Augustine

San Antonio

VICEROYALTY OF
NEW SPAIN

Havana

Guadalajara

Mérida

Mexico City

Veracruz

Santo Domingo

San Juan

Puebla

Acapulco

Oaxaca

Guatemala City

Antigua

Panama City

Cartagena

Caracas

Bogotá

Tunja

VICEROYALTY OF
NEW GRANADA

Quito

Guayaquil

Amazon

*Atlantic
Ocean*

BRAZIL

Recife/Olinda

*Pacific
Ocean*

VICEROYALTY
OF PERU

Lima

Salvador de Bahia

Ayacucho

Cuzco

Arequipa

La Paz

Santa Cruz

Potosí

Sucre

Ouro Prêto

São Paulo

Rio de Janeiro

Jujuy

VICEROYALTY OF THE
RÍO DE LA PLATA

Córdoba

Santiago

Buenos Aires

Río de la Plata

VICEROYALTY OF PERU

Valdivia

0 1000 2000 mi

0 1000 2000 3000 km

60°N

30°N

0°

30°S

120°W

90°W

60°W

30°W

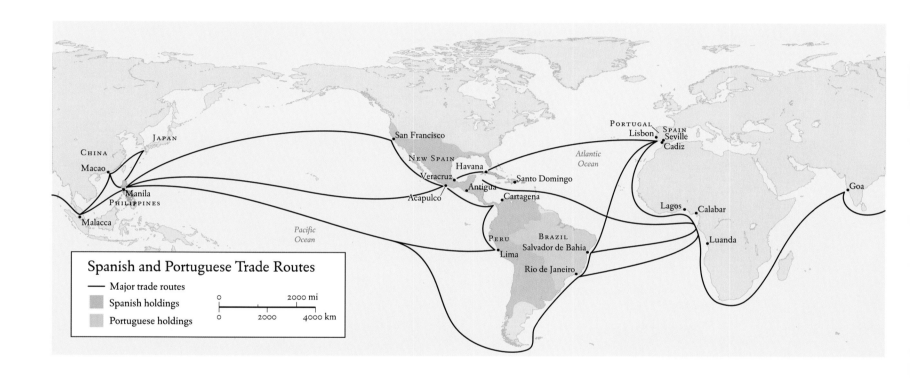

Spanish and Portuguese Trade Routes

—— Major trade routes

Spanish holdings

Portuguese holdings

0 2000 mi
0 2000 4000 km

CHINA
Macao

JAPAN

San Francisco

NEW SPAIN
Veracruz
Acapulco

Havana
Antigua
Santo Domingo
Cartagena

Manila
PHILIPPINES

Malacca

Pacific
Ocean

PERU
Lima

BRAZIL
Salvador de Bahia
Rio de Janeiro

Atlantic
Ocean

PORTUGAL
Lisbon
SPAIN
Seville
Cadiz

Lagos
Calabar

Luanda

Goa

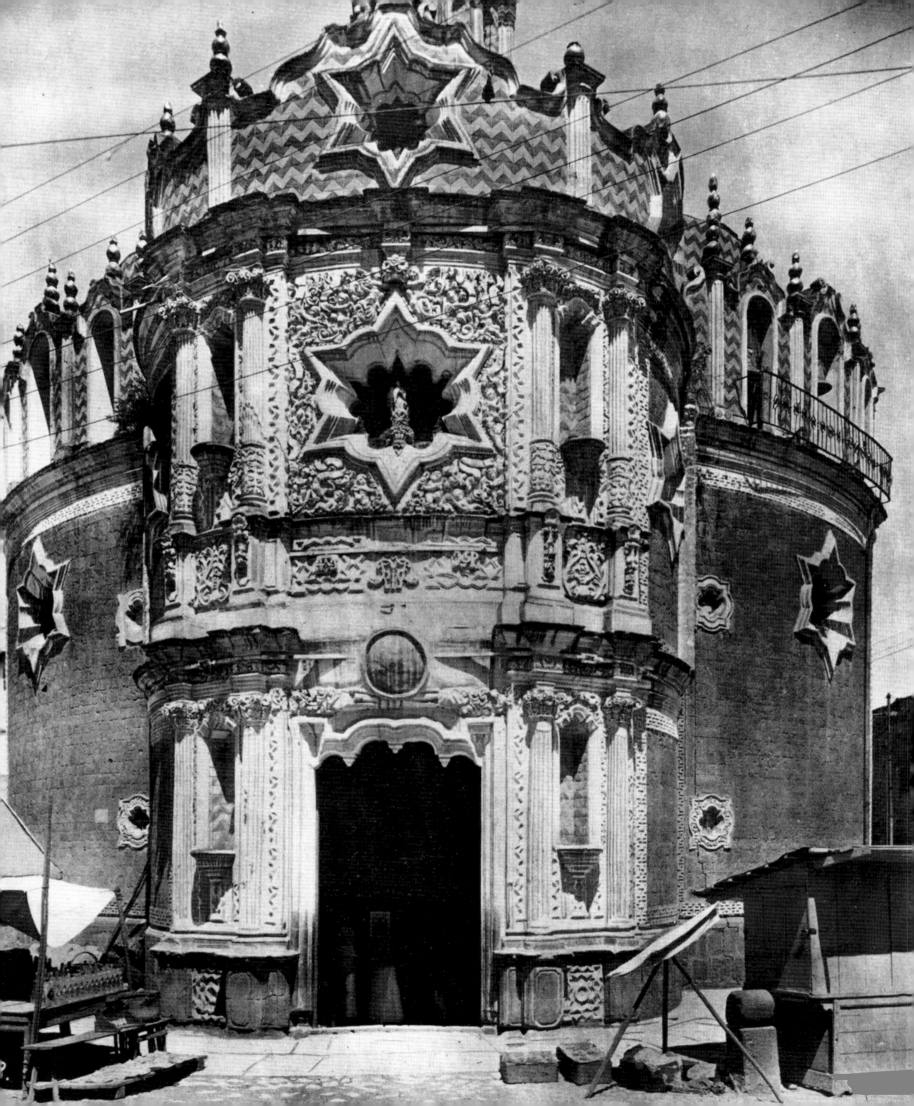

Art in Colonial Latin America:
A Brief Critical Review

Joseph J. Rishel

The critical fortunes of Latin American colonial art have been, in many ways, no more radical in their eclipse and rediscovery than, say, those of the Italian baroque. The complex artistic achievements of over three hundred years of creation in the Iberian colonial world (about a third of the earth's surface) were for all intents and purposes shelved at the beginning of the nineteenth century, only to be brought back into focus in the mid-twentieth century. Cycles of taste, pendulum swings of a world vision, and complex shifting political and social values all have had their roles in creating this situation. The dominant opinions based on northern American and European values won out against the perceived excesses and brilliance of the images themselves and the effort of the Counter-Reformation, just as—in ways still odder—the liberal values of France and the United States began to dominate the Latin American sense of self at the moment of national revolutions (from 1820 onward) in ways that often forced local creations off the central stage.

This said, the patterns of reevaluation for which this exhibition can stand as one more platform of reconstruction and evaluation are tremendously loaded in terms of sense of self and sense of nation. Latin American issues of artistic heritage are inescapably linked to political and social considerations on a scale and authority rare in any parallel European system.

Ironically, the end was the beginning. With the reimposition of an outside set of standards signaled by the creation of institutions such as the Mexican fine arts academy—the Academy of San Carlos—in 1785, whose very purpose was to raise the level of teaching to a universal (essentially European) notion of values, the pattern of local guilds and activities, for both artisans and artists, which over the past centuries had reached a very high level of independent creative energy and organization (not to mention inheritable skills and audiences), was essentially called into question. This is nowhere more touching than in Andrés López's portrait of the Mexican viceroy Don Matías de Gálvez y Gallardo (1790; cat. VI-64) pulling back the curtain on the new Academy of San Carlos, as two youths, barefoot and in ponchos, enthusiastically examine the recently arrived plaster cast of the Louvre *Gladiator*. With this

FIG. B-I
Guillermo Kahlo (Mexican, 1872–1941). *Facade of the Chapel of Pocito, Villa of Guadalupe, Mexico City.* From *Iglesias de México*, with text and design by Dr. Atl and photographs by Guillermo Kahlo, vol. I (Mexico City: Secretaría de Hacienda, 1924), p. 29

declaration of innocent awe in the face of a new emphasis of standardization and academic reformation, undermining much that had preceded it, the scales tipped in such a way that, as Octavio Paz noted with droll irony:

> The world that it reveals to us—the society of the viceroyalty of Mexico in the seventeenth and eighteenth centuries—is a world which we all knew but which no one had yet seen. Studies of the subject abound, yet none had shown us that world in all its uniqueness. . . .

> New Spain: that name describes a singular society and a no less singular destiny. It was a society that passionately denied its antecedents and its ancestors—the Indian world and the Spanish world—and at the same time formed ambiguous links with both; in its turn, that society was to be denied by modern Mexico. . . . The society of New Spain was a world which was born, grew, and then expired the moment it reached its maturity. Mexico killed it.[1]

And while Paz's reference is completely Mexican, his observation can apply to the evolution of nearly all Latin American culture from this point onward. The governing opinions, coming more and more from without, are essentially negative about local artistic creation. Alexander von Humboldt, who did more to shape a global view of the New World than any other nineteenth-century figure, could, finally, see colonial creations as wanting by comparison with Europe, of which they are secondary reflections, just as the much less sophisticated Fanny Calderón de la Barca—in her best-selling memoirs of her years in Mexico as the wife of the Spanish ambassador in the early 1840s—was very slow to find much of worth in Mexican buildings, paintings, or utensils.[2] And aside from occasional reflections by those still linked to the viceregal ancien régime that were colored by nostalgia, comments about colonial arts throughout much of the nineteenth century were left largely to outside visitors, with travel guides being one of the essential tools to track critical opinions.[3]

For example, the commissioner to Mexico for an English mining company, William Bullock, made careful notes in 1824 of many colonial monuments, including the cathedral of Mexico City, which, he wrote, "is far famed for its splendour and riches, and deserves its high reputation." But he goes on to say that "the existing state of this city exhibits only a shadow of the grandeur it had once attained. The period of its greatest splendour, wealth, and luxury, may be placed within one century of its conquest by Cortez." Of the Academy of San Carlos, Bullock observed that

> it has been extinguished by the revolution: it has neither student nor director. The building and plaster casts, etc. remain, but its revenues are lost. Baron Humboldt has given us a rather flattering picture on this subject, at the time he visited the country: if his account be correct, as indeed I have every reason to believe it to be, twenty years of internal war and insurrection have produced a deplorable change in the state of the arts. There is now not a single pupil in the Academy; and though the venerable President still lives, he is in a state of indigence, and nearly blind.[4]

FIG. B-2
Emanuel Leutze (American, born Germany, 1816–1868). *The Storming of the Teocalli by Cortés and His Troops*, 1848. Oil on canvas, 7 feet, ¾ inch × 8 feet, 2¾ inches (215.3 × 250.8 cm). Wadsworth Atheneum Museum of Art, Hartford. The Ella Gallup Sumner and Mary Catlin Sumner Collection Fund

FIG. B-3
Luis Montero (Peruvian, 1827–1869). *Funeral of Atahualpa*, 1867. Oil on canvas, 11 feet, 6 inches × 14 feet, 1½ inches (3.5 × 4.3 m). Museo de Arte, Lima, on loan from the Pinacoteca Municipal "Ignacio Merino," Lima, Peru

The Bostonian William H. Prescott's 1843 *History of the Conquest of Mexico* and his later *History of the Conquest of Peru* (1847) were best sellers from the beginning and did much to shape the formalized notions of pre-Columbian society and the drama of the conquest; they set, with a remarkably strong authority, a *terminus post quem* to serious considerations of Latin American culture after Cortés and Pizarro. Let two major examples—both based directly on Prescott—illustrate this point: Emanuel Leutze's oft-reproduced painting of the conquest of Mexico, *The Storming of the Teocalli by Cortés and His Troops* of 1848 (fig. B-2), established, for several generations, the model that was to be followed. And if his was a completely European perspective, Luis Montero, the most important nineteenth-century Peruvian academic painter, articulated a similar vision with his equally celebrated *Funeral of Atahualpa* of 1867 (fig. B-3), painted during his second stay at the academy in Florence and first seen in Lima in 1888.

There were, of course, isolated voices. In 1859, José Manuel Groot published in Bogotá his *Noticia biográfica de Gregorio Vásquez Arce y Ceballos*, perhaps the first (in "modern" terms) monograph on a Latin American artist.[5] Much admired by Humboldt, Vásquez may have had particular appeal when seen through the lens of Spanish comparisons, but these kinds of sympathies did not prevent Groot from placing him firmly in a New World context with an abundance of anecdotal biography and discussion of specific works, and Groot's contributions outweigh any such criticism.

More ambitious is José Bernardo Couto's *Diálogo sobre la história de la pintura en México* (begun in 1860 although not published until 1872 in Mexico City),[6] which he wrote in support of his friend Peregrín Clavé, director of the Academy of San Carlos following its reform/restoration in 1843.[7] While it can be seen, from a modern perspective, to be guided by a firm Creole defense of the superiority of European sources, it is nonetheless a very intelligent

walk through the principal and remarkably inclusive outline of this development of painting in New Spain, which would take another fifty years to come into full voice. Not surprisingly, the strongest and most eloquent of these new voices—and the person who really can be considered the central figure in the new and broadly effective reconsideration of the value of colonial art— Manuel Toussaint (1890–1955), published a new edition of Couto's *Diálogo* in 1947. This was done near the end of a career that began, at Toussaint's return from Europe, full of comparative notions about old Spanish and Mexican culture, and went on to be swept up in the high energy and bold spirit of the national enterprise of the new revolution—which, for all of its investment in the new and completely independent (that is, indigenous) identity of the nation, gave fair (and under the circumstances, rather brave) measure to the consideration of colonial matters.

Toussaint's first books were two volumes in the very beautifully produced six-volume set published between 1924 and 1927 by Dr. Atl,[8] a member of the new cultural elite who would essentially transform Mexican self-identity in the arts. Illustrated with watercolors and drawings by Dr. Atl himself, the volumes are still more noteworthy for the beautiful and very carefully considered photographs by Guillermo Kahlo, the father of Frida (see fig. B-1). This publication was on a new and ambitious level heretofore unknown for colonial subjects, with, for example, Toussaint's discussion of the development and history of the cathedral of Mexico City still a model of careful research and observation.

In 1948 Toussaint went on to publish *Arte colonial en México*,[9] still a fundamental text, which was the outcome of his diligent visits to (then often extremely isolated) monuments and monastic archives. His unapologetic affection for his subject was certainly as liberating to the field itself as was the depth of his scholarship. Already in 1935 he had organized the Laboratorio de Arte in the Universidad Nacional Autónoma de México, which in 1936 became the Instituto de Investigaciones Estéticas that he headed until his death in 1955. This institution continues as one of the critical centers of Latin American colonial studies on a completely international level. Several of the authors working on the present project are either faculty or students at this remarkable institution.[10]

Toussaint's new objective was soon to find many parallels to his Mexican examples throughout Latin America as well as from outside the Latin American world. Following his remarkable example of investigating undocumented, often completely unphotographed monuments is Harold Wethey's work in Peru during the Second World War.[11] A glance at Wethey's bibliography reveals his reliance on numerous publications, nearly all of a regional focus, dating back into the 1920s and 1930s, most notably those by José Uriel García on Cuzco and Guillermo Lohmann Villena on colonial Lima. Between 1951 and 1955, in the *Revista del Archivo Histórico del Cuzco*, Jorge Cornejo Bouroncle published his important discoveries of artists' records from the Cuzco archives. These provided a foundation for the fresh and pioneering work by José de Mesa and Teresa Gisbert from the 1950s onward (including her contributions to this publication), which places them at the center of the study of both stylistic schools and major individual artists in the Viceroyalty of Peru. In 1968 Carlos Abeláez Camacho and F. Gil Tovar published their important survey of the visual arts in Colombia. Thereafter, as with Mexican studies, the vigor and range of Andean colonial art history have gained steady momentum.[12]

Beginning in 1938 with an eight-page article on the colonial churches of Brazil, Robert C. Smith set in motion (with an energy and degree of influence equal to those of Toussaint) the waves of essential reevaluations of Portuguese colonial activity in the New World.[13] And whereas Smith laid much of the foundation for the now-burgeoning field of Brazilian colonial studies, it was Germain Bazin's enthusiastic declarations of the independent worth and importance of the Brazilian baroque, published in 1956–58,[14] that established (abroad and in Brazil itself) a new popular acceptance of this work, particularly for that of O Aleijadinho, whom Bazin recognized as the national hero he remains.[15]

The work of George Kubler is more polemical and drawn to abstract cultural theories (and judgments) than was that of his Mexican near-contemporary Toussaint. Kubler, with his far-ranging interests in pre-Columbian and colonial Latin American art (embracing Brazil as well as the Spanish viceroyalty), made a powerful mark on his own time and still colors, perhaps, our overall sense of critical values. The pleasure he took in looking at, and describing, colonial works of art, particularly architecture, is abundantly evident. However, in the long run, his judgments about colonial artistic achievements are highly qualified.

The oft-quoted passage from the 1959 Pelican *Art and Architecture in Spain and Portugal and Their American Dominions, 1500 to 1800*, which Kubler edited with Martin Soria, established for a time (and perhaps still does in some quarters) a formidable "glass ceiling" for the reception of Latin American colonial artistic validity:

> Even the best Colonial artists, painters and sculptors, remained far below the best European standards. In comparison with Europe, a greater proportion of painting and sculpture is to be considered folk art, which is often expressive and interesting. It would be difficult to determine the race of the artist by looking at his work. Some of the best and most "European" works in South America—the paintings by Miguel de Santiago and the carvings by Caspicara—were done by mestizos or Indians. Though in Mexico City and in some other capitals the Indian was excluded from artistic participation, both as subject and object, his spirit influenced Colonial art. The recently arrived Spaniard was energetic and arrogant. Gradually he assimilated the submissive courtesy, grave passivity, and gentleness of the Indian. Colonial art preferred decorum to violence and sweetness to passion. Tranquility, placidity, and orderly measure set the tone. Vivid movements are as rare as they were unseemly in actual life. Profiles and frontal faces are avoided in favor of three-quarter views, which are less abrupt and easier to do. Features are idealized and tend to be beautiful rather than individual or ugly.[16]

The text here is that of Soria, but not in any way foreign to Kubler, who, well into his later career, ruminated on the nature of art and specifically colonial patterns in his, for a time, hugely influential book of 1962, *The Shape of Time: Remarks on the History of Things*, in which he plainly concludes:

> The consequences of the colonial extensions from the mother country are easily charted in Latin America. Equipping a continent with cities, churches, houses, furnishings, and tools required a gigantic outlay of energy at minimum standards of performance. The native labor learned a behavior at the outset which has been perpetuated ever since by small human numbers, by the unfavorable dispersal of habitable zones, by the immense distances between towns, and by the imperfect communications among colonies as well as between the colonies and the Peninsula.

> The sluggish and careless pace of colonial events was overcome only thrice in three centuries, and only in architecture: the buildings of Cuzco and Lima from 1650 to 1710; Mexican viceregal architecture from 1730 to 1790; and the Brazilian Third Order chapels of Minas Gerais from 1760 to 1820. Of course Latin America has towns and villages of extraordinary beauty, like Antigua in Guatemala, Taxco in Mexico, and Arequipa in Peru, but their charm, favored by climate and setting, rests upon the relaxation of more rigorous standards of invention rather than upon the eager quest for excellent newness that made Florence or Paris for so long the centers of many epochal changes in the history of things. In Antigua or Arequipa or Ouro Prêto, as at picturesque towns in every province of Europe, beauty was attained by concord in simple old themes, much reduced from the difficult *pièces*

de maîtrise we see in great cities and at court. It is the beauty of oft-repeated traditional forms favored by nature, rather than the beauty of things separated from the immediate past in their makers' intense quest for new forms.[17]

This differs dramatically from Toussaint's equally pensive reflections about the essential nature of colonial creation, when he first stated in 1948: "One of the cardinal aims of this book—in which we trust we may be successful—is to show at every step this persistence of the indigenous spirits, casting a soft tinge of melancholy over the works of the proud conqueror."[18]

The leveling of the critical field, rather than the reinforcement of a kind of hierarchy of power, has perhaps been Toussaint's single greatest contribution and one that has essentially prevailed since the 1960s, even while Kubler's blunt isolation of the dilemma of social and racial conflict (and the limitations it imposes) is still a very active element in all "colonial dialogues," be they in Europe, the United States, or numerous intellectual centers throughout Latin America.

Critical research and new attitudes toward national patrimony had their concrete reflections in the creation of institutions, with Toussaint's department at the Universidad Nacional Autónoma de México being one of the most influential. In Spain, the Museo de América in Madrid was created by decree in 1941, although it did not open until 1944, and then only in temporary quarters in the archaeological museum before it was finally established in its present independent building in 1961. A compendium of many of the greatest works of art sent back from the New World, it is, far and away, the single most important general museum of Latin American colonial material anywhere. This official act of consolidation and, perhaps, new objectives regarding colonial matters are also reflected in the ambitious survey *História del arte hispanoamericano* initiated by Diego Angulo Iñiguez with E. Marco Dorta and M. J. Buschiazzo, published in Barcelona beginning in 1945 and continuing until 1967, a monumental achievement of complete evenhandedness, with few of the conventional old-new, high-low prejudices.

In Buenos Aires, a 1920s house was converted into a colonial museum in 1937 but came into its full powers in 1947 with the accession of the collection of Don Isaac Fernández Blanco, the second-most important comprehensive, pan-American collection. More nationally oriented colonial museums were created in South America. In Bogotá, the seventeenth-century Jesuit college, La Casa de las Aulas, was converted to the Museo de Arte Colonial in 1942. The Museo de Arte Colonial in Caracas was founded in the same year, and moved to its present quarters in the Hacienda San Bernardino in 1961 under the tremendously productive stewardship of Carlos F. Duarte. The huge complex of the church of the Carmo on Praça da Independància (formerly Largo do Carmo) in São Paulo, Brazil, was dedicated in 1943 as the Museu de Arte Sacra, with the greatest parts of its collection dating from the colonial period. The Museo Histórico Regional in Cuzco, which houses major colonial objects, opened in 1946.

In the two principal viceregal capitals of Lima and Mexico City, museums dedicated to colonial objects were slower to take shape. The survey *Museo de Arte in Lima*, with its large display of colonial works, was consolidated from diverse private collections in 1961 in the cast-iron exhibition building constructed for the industrial fair of 1869. In Mexico City, while some colonial objects had been on view in the galleries of the Academy of San Carlos as early as the acceptance of the Pani collection in 1921, the first institution specifically created for such works was opened in 1957 in the eighteenth-century palace of the Condes de San Bartolomé de Xala. The Pinacoteca Virreinal, in the former convent of San Diego on the city's Alameda, opened in 1964, with many of its works now incorporated into the newly restored Museo Nacional de Arte (MUNAL). Also in 1964, the Museo Nacional del Virreinato was created in the ex-Jesuit complex at nearby Tepotzotlán, to grand effect.[19]

To these accomplishments can be added the important contributions of museums in the United States. Herbert Spinden, in his long tenure (1929–50) at the Brooklyn Museum, had

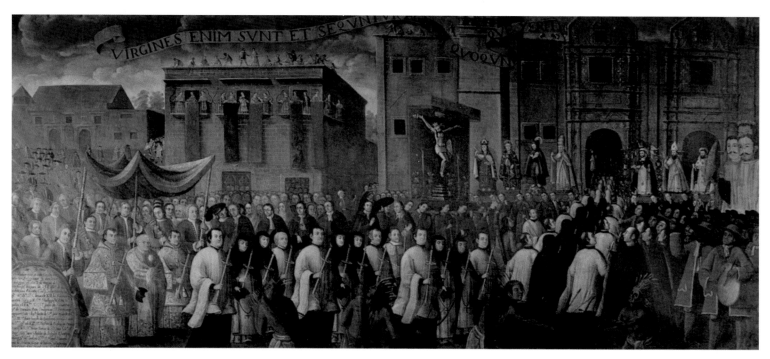

FIG. B-4

The Nuns of Saint Catherine Moving to Their New Convent, 1738. Oil on canvas. Museo Regional/ CONACULTA, INAH, Morelia, Mexico

the unprecedented effect of bringing colonial art to a degree of serious consideration equal to that given in the previous generation only to pre-Columbian objects.[20] In Davenport, Iowa, and Philadelphia, two collections, both formed by late nineteenth-century investors/capitalists involved in Mexico, found museum homes, while at the Denver Art Museum, Frederick and Jan Mayer, working on earlier systematic foundations of Mexican colonial collecting, are now rapidly creating a center of international importance.

All of this accelerating activity—a sharpening of focus through international collaboration between collectors, governments, scholars, and institution-builders—obviously moved in and out of focus in the twentieth century, even as "post-colonial" as a notion came into prominence in many areas of intellectual and moral orientation, giving distance in many cases to glances back in time at artists or objects that were previously overlooked.

However, as much as we are in debt to a handful of international scholars who fundamentally reoriented our minds and eyes, such superficially blocked stages of growing awareness as discussed here can give only a vague sense of the ponderous and deeply human circumstances that place us, today, in such a receptive state of mind to what, fifty years ago, would have been thought (in the places of the works' making as well as abroad) very outré material.

This all leads us back to another observation by Octavio Paz, with strong implications for all the diverse patterns of social and cultural life throughout Latin America since the early nineteenth century:

> Historical reconstructions are also archaeological digs in the historical subsoil.
> A society is composed of its institutions, its intellectual and artistic creations. . . .
> The metaphor which designates this hidden reality changes according to the schools, generations, and historians . . .
>
> Most historians offer us a conventional image of New Spain: an intermediate stage between Indian Mexico and modern Mexico, conceived as a stage of formation and gestation. This linear perspective distorts the historical reality; New Spain was more than a pause or a period of transition between the Aztec world and independent Mexico. The official history presents it in an even more negative light: New Spain was an interregnum, a stage of usurpation and oppression, a period of historical illegitimacy. Independence closed this particular parenthesis and reestablished

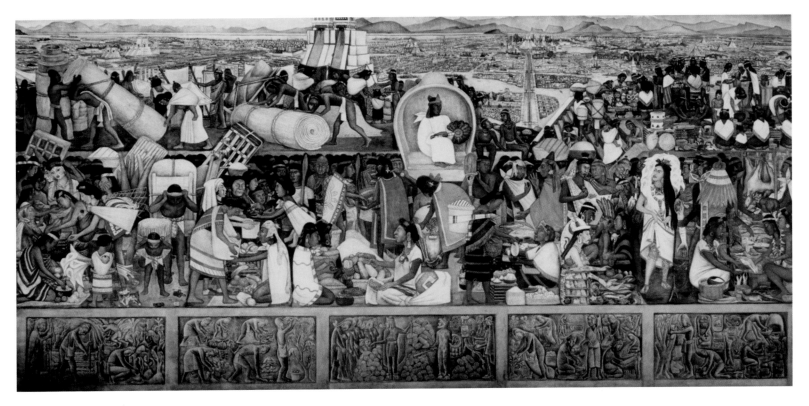

FIG. B-5
Diego Rivera (Mexican, 1886–1957). *The Great City of Tenochtitlán*, 1945. Fresco, 16 feet, 2 inches × 31 feet, 10 inches (4.9 × 9.7 m). Palacio Nacional, Mexico City

the continuity of the historical discourse, interrupted by three centuries of colonization. Independence was a *restoration*. Our defective vision of New Spain's historical reality is at last explained: not myopia but an eclipse concealed it from our view . . . the corpse which we buried in our backyard.[21]

The repressed and retarded become the advanced. New connective lines of creative energy are redirected. And, of course, the artist understands this first and best: On May 3, 1738, in Valladolid (now Morelia in Michoacán) the cloistered Dominican nuns of Santa Caterina moved with great state and ceremony to their new convent on the Camino Real (now Madero), called "Las Monjas." This colorful event, which involved, it would seem, the entire populace along with Indian dancers and liveried bands—giant floats and holy images packed onto the doorstep—was documented in a huge painting destined for the convent's sacristy and now in the regional museum (fig. B-4). It is a kind of masterpiece of colonial topography. Displayed in a case just before the hung canvas is a now very faded letter that reads like the script of a well-informed and self-consciously didactic museum lecturer:

A community of nuns moving to their new convent.

I find that this painting representing a procession on the principal street of Valladolid (today Morelia) is of great interest in the history of Mexican painting, because it brings together the following characteristics:

a) It is a rare case of realistic painting, during its time, 1738, related to a concrete social event, relating with plastic veracity the period and place in which it occurs.

b) It is of doubtless social value, for the public spectacle in the painting shows a truthful slice of the colonial society with all of its divisions into classes and castes.

c) Ethnographically, it is important because, since the painting is a truthful collection of portraits, it powerfully emphasizes the differences in the racial components of the personages.

d) Historically, it constitutes an important document with respect to clothing, customs, and the architectural character of the place painted.

e) Finally, considered solely as a painting, it is of strong character, fluidity of execution, and of a composition that is bold in its realism.

Diego Rivera[22]

The letter is without a date, and we can therefore only speculate on what effect Rivera's encounter may have had on him or his work, although we can but guess that it was a lesson not lost on the creation of his own recordings of Mexican human spectacle on a monumental and very public scale (fig. B-5).

A quick review of the bibliography at the end of this book will reveal the huge increase in the number of exhibitions and publications about Latin American colonial art since those critical years of the mid-twentieth century that have been the focus here. It will also highlight the degree to which these early explorations into a new territory have taken deep root, to the point where present-day Latin American colonial studies are a genuine growth area in university art history departments throughout North and South America, with some serious beachheads in Europe and Japan as well. All of this makes the present project, happily, more of an homage to those critical figures who helped define the original terms of the debate, as well as a declaration of how far (or sometimes not) we have come.

NOTES

1. Paz 1976, p. xi.

2. Calderón de la Barca 1843.

3. See Pratt 1992.

4. Bullock 1824, pp. 143, 133, 163. These observations on Humboldt and Bullock are the work of Alicia Lubowski. See also Ades et al. 1989.

5. Groot 1859. Groot laid the groundwork for the still more ambitious, and remarkably thorough (as witnessed by a new edition in 1985), biography of Vásquez published in Paris by the gifted Roberto Pizano Restrepo in 1926; see Pizano Restrepo 1926/1985.

6. Couto 1872/1995.

7. The critical, and unique, virtues of this book are confirmed by two new editions in the twentieth century, the first, tellingly, by Manuel Toussaint in 1947, and the second by a team of scholars for Conaculta in 1995.

8. Atl et al. 1924.

9. The Universidad Nacional Autónoma de México (UNAM) also published the second edition in 1962, the third in 1974, the fourth in 1983, and the fifth in 1990. For the English edition, see n. 10.

10. For a very fond biography of Toussaint and his achievements, see the introduction by Elizabeth Wilder Weismann to *Colonial Art in Mexico*, her English translation of his 1948 book (Toussaint 1967, pp. vii–ix).

11. Wethey 1961; and Wethey 1949.

12. For the evolution of scholarship of Andean art, see Ramón Mujica Pinilla's essay "Arte e identidad: las raíces culturales del barroco peruano," in Mujica Pinilla et al. 2002, pp. 1–57.

13. Smith's remarkable career as a scholar of both Portuguese and Brazilian art and architecture is surveyed in Smith 2000, which has a fifteen-page bibliography of his publications!

14. Bazin 1956–58.

15. Bazin 1963.

16. Kubler and Soria 1959, pp. 164–65.

17. Kubler 1962 *Art and Architecture*, p. 113.

18. Toussaint 1967, p. 4.

19. See Fernández 1988.

20. Fane 1996.

21. Paz 1976, pp. xi–xii (emphasis in original).

22. A transcription of this letter was kindly provided by Eugenio Mercado Lopez, Director of the Museo Regional Michoacano.

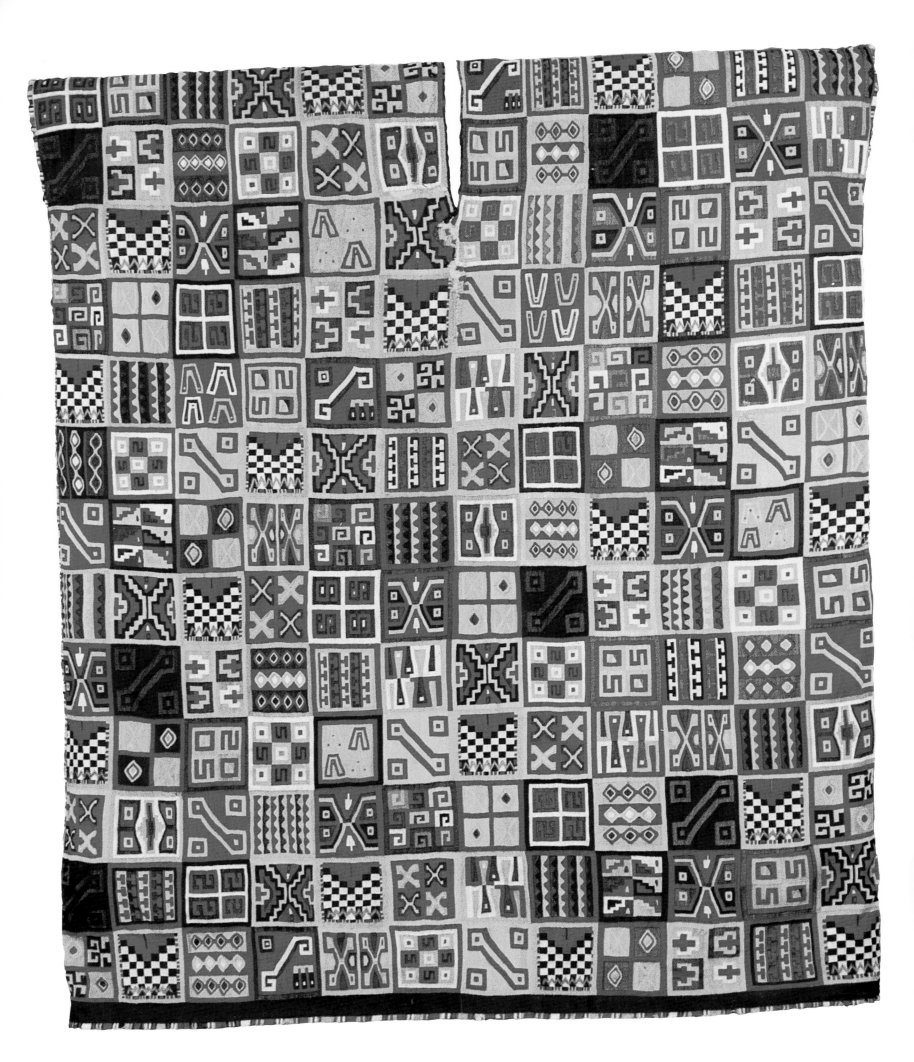

Colonial Foundations:
Points of Contact and Compatibility

Elizabeth Hill Boone and Thomas B. F. Cummins

It is notable the extraordinary devotion the Indians have for all types of paintings.

—Felipe de Guevara, *Comentarios de la pintura*, 1560 (1788)[1]

In 1535 the young Felipe de Guevara accompanied Carlos V on his successful campaign to recapture Tunis from the Turks, an event that was financed by the ransom of the Inca sovereign Atahualpa. Guevara also traveled with and observed the Flemish artist Jan de Vermeyn, who recorded visually the entire expedition so that it might be turned into the greatest tapestries of the Spanish royal collection. Upon his return Guevara traveled through Italy visiting churches and collections of paintings. His interest in painting came to him honestly as it was his father, Pedro de Guevara, a great collector, who gave Margaret of Austria, among other things, Jan van Eyck's portrait of Giovanni Arnolfini and his wife, which led to its eventual arrival in Spain (now in the National Gallery, London). Some twenty years later, Felipe de Guevara finished writing his thoughts about the history of painting in his *Comentarios de la pintura*, a manuscript that lay unpublished until 1788. What is interesting about Guevara's manuscript, besides his comments concerning the paintings of Hieronymous Bosch (paintings that probably belonged to his father), is that it traces the history of the painting of the ancients, such as Apelles and Zeuxis. In a chapter entitled "De Las Pinturas Egipcias," Guevara describes two types: pictorial compositions and hieroglyphic images. About the latter, the modern reader finds a quite surprising entry:

> This type of painting [Egyptian hieroglyphics], which by its form and style clearly expresses ideas and concepts, seems to have been imitated by the Western Indians and those of the New World, especially in New Spain: now whether this is so because by ancient tradition it came from Egyptians, which is possible, or whether it is that the natives of these two nations shared a similar imagination [is unknown]. Whatever the truth is, all that these Indians wish to show us about their ancients [their past] they show us through their paintings and among themselves they communicate their ideas by means of the same [type of] painting.[2]

Man's tunic (cat. 11-2)

Guevara then goes on to describe how such images work, writing that a *"cazique"* (native leader) commissioned an image of four hundred of his soldiers, which was represented by "a man with weapons in his hand with one foot forward to show him walking, and above his head was placed a circle with four points that signified four hundred, and thus they have depicted in figures the expeditions that the vassals of your Royal Majesty undertook in the conquest of Mexico and elsewhere."[3] It is unclear what images Guevara specifically saw and whether they formed a part of his own collection, but it is very clear that he was well acquainted with and appreciative of the native manuscripts and codices that were being brought to Spain in the first years after the conquest. In fact, he goes on to write about the contributions that the Americas had made to painting, first mentioning colors, especially cochineal, an "extremely rare carmine" (*carmin rarísimo*) that in fact changed the nature of red in Europe. Guevara then notes that it is proper to acknowledge that the Mexicans have brought something new and rare to the art of painting, which is painting with the feathers of birds.[4] Guevara, of course, is describing the feather painting of Mexico, which quickly became admired by the very first Spaniards. It is important to point out that Guevara's text is the earliest attempt to situate pre-Columbian painting within the outlines of the history of European painting, discussed and appreciated along with Apelles, Bosch, and others. Most importantly, Guevara did not denigrate the art of the Americas, old or new, but saw it as a part of painting in general. His comments are also different from those of Albrecht Dürer, who, when first confronted with the treasures of the Aztec emperor Moctezuma in Brussels in 1520, "saw among them wonderful works of art and marveled at the subtle ingenuity of people in strange lands; I do not know how to express all that I experienced there."[5] For whereas Dürer marveled at the beautiful things from a strange land, Guevara did not think of the Americas as strange, nor did he marvel; instead, he saw them as the history of art.

The point is that after the very first amazement upon seeing things of the New World, certain forms of late pre-Columbian and early colonial art circulated throughout the collections and thoughts of Spaniards and natives at a very high level of appreciation, especially in Spain. How else, for example, could a series of oil-on-canvas paintings of the Inca kings painted by native artists near Cuzco in 1570 come to hang in the royal palace in Madrid next to two of Titian's most important imperial portraits? Our attempt here, then, is to introduce some of the initial Spanish and indigenous intersections of use and appreciation of the early colonial arts of the Americas, most especially in Mexico and Peru.

NEW SPAIN

When the Spaniards first encountered the people and things of the Americas, they were struck with awe and wonder, but they also felt an assuring sense of recognition. The Spaniards found the indigenous Americans to be different from them in so many ways, but they also recognized numerous similarities as well. Columbus sailed from Palos prepared to discover in the distant lands people who were giants or other of the "monstrous races" first described by Pliny the Elder; instead he noted in 1493 that the people he encountered on his first voyage were "well-built people of handsome stature. . . . In these islands I have so far found no human monstrosities, as many expected; on the contrary."[6] In short, he found men and women much like himself.

Particularly in Mesoamerica, where the Aztec empire dominated politically and economically, the Spaniards encountered peoples, social and intellectual systems, and material culture that they easily recognized and understood. In Mesoamerica, they were reassured by such features as mortared masonry architecture organized into great ceremonial and secular complexes, a well-established tradition of figural representation, and the use of books and documents to record knowledge. One sees the pragmatism of the conqueror Bernal Díaz del Castillo when, as part of the 1517 Cordova expedition that brought the first Spaniards to Mexican

shores, he first happened upon a temple complex in the town off the coast of the Yucatán Peninsula now called Isla Mujeres. The conqueror noted that surrounding a small plaza were

> three houses built of masonry, which served as [temples] and oratories. These houses contained many pottery Idols, some with the faces of demons and other with women's faces. Within the houses were some small wooden chests, and in them were some other Idols, . . . and some necklaces and three diadems, and other small objects in the form of fish and others like the ducks of the country, all made of . . . gold. When we had seen the gold and the houses of masonry, we felt well content at having discovered such a country.[7]

By the time Hernán Cortés arrived in 1519 on the Gulf Coast of Mexico to begin his inland invasion, the Spanish conquerors had become familiar with Mesoamerican religious architecture, cult images, and use of gold; they had also acquired two of the painted screen-fold books that recorded ideology, history, and all manner of mundane matters for the indigenous people. Cortés promptly sent two such books back to Carlos V along with other treasures (objects fashioned of gold, silver, featherwork, and cloth) and his first description of the lands he intended to conquer for his emperor.[8]

As Spain and Europe came to learn more about the Americas and to incorporate the foreign lands into their intellectual world, the Spaniards also entered into Mesoamerican understanding and visual discourse. Early reports of the Spanish explorations soon filtered back to Moctezuma, carried by messengers who probably bore painted images of the foreigners and their boats.[9] Moctezuma sent his own artists to meet and record Cortés when he landed on the Gulf Coast of Mexico. As Díaz del Castillo notes, a governor of Moctezuma

> brought with him some clever painters such as they had in Mexico and ordered them to make pictures true to nature of the face and body of Cortés and all his captains, and of the soldiers, ships, sail and horses, and of Doña Marina and Aguilar [the interpreters], even of the two greyhounds, and the cannon and cannon balls, and all of the army we had brought with us, and he carried the pictures to his master.[10]

These paintings were so true to life that the men of Moctezuma's court recognized one of their own as Cortés's virtual twin, and the Aztec emperor sent this man as an ambassador to Cortés because of this likeness.[11]

In the years following the conquest, the cultural features and ideologies that Aztec Mexico shared with the Europe of the conquerors became natural points of acceptance and conflation. Equivalencies developed in the minds of Spaniards and Aztecs alike, which helped to bridge the rupture of the conquest. These points of compatibility eased the transition to a colonial world: they shaped the cultural climate and visual discourse throughout the sixteenth century, and they provided the foundation for the further development of colonial art in the centuries to follow. These arenas where indigenous and European assumptions and habits converged most closely also fostered productive relationships between the native population and the newly arrived Spaniards. A particularly powerful alliance developed between the native populations and the mendicant friars that was to last through much of the sixteenth century, and a mutual dependency arose between the native lords and the Spanish authorities and settlers that was to remain for much of the colonial period.

Points of Compatibility

Many of the factors that shaped colonial society and art production in New Spain were the indigenous cultural features that distinguished pre-conquest Mesoamerica from other parts of the Americas. The Aztecs and their neighbors had a strong tradition of graphic and sculpted

FIG. C-I

Diego Valadés, *Rhetórica christiana* (Perugia, 1579).
Benson Latin American Collection, The University
of Texas, Austin. Depiction of the evangelical process
as an idealized Franciscan monastic complex

figuration. Their craftsmen skilled in the production of luxury goods composed an esteemed segment of society. The Aztecs also recorded knowledge in books and documents. Their religion accepted multiple cult figures and was administered by an ascetic priesthood. In these areas, and a host of others, indigenous and Spanish understandings overlapped.

Mesoamerican art, and particularly Aztec art, was figural rather than geometric or abstractly symbolic. It was characterized by a relative naturalism that recommended it well to Europeans accustomed to their own traditions of figural realism and iconography. When Bernal Díaz del Castillo spotted the ceramic figures in the temple of Isla Mujeres, or later when the conquerors climbed the steps up to the Templo Mayor in the Aztec capital, they immediately recognized the figural cult images as "idols"—that is, as pagan religious objects within the realm of their own understanding. A goal of these first conquerors at each community they encountered was to remove the indigenous idols and install the cross and the image of the Virgin in their stead, the new, Christian figures replacing the old.[12]

The Spaniards also recognized that the Mesoamericans had books, books painted in images and figures to be sure, but books nonetheless. Although these books and documents were executed on long strips or broad panels of bark paper or deer hide and on great cotton sheets, the Spaniards understood them to be containers of knowledge and functionally equivalent to their own documents. Cortés was impressed by the native tribute lists he saw; in his later campaigns, he relied on native maps and battle plans.[13] The Franciscan friar Toribio de Benavente Motolinía, while decrying the many genres of religious books as works of the devil, praised the veracity of the Aztec pictorial histories, which he declared to "contain the truth."[14] For Spanish administrators trying to describe Aztec Mexico to the crown, to set tax and tribute levels, and to reapportion lands, these native books fulfilled many of their documentary needs; royal decrees specifically ordered these authorities to consult the native documents to substantiate oral testimony. The Spaniards accepted painted manuscripts on an equal basis as evidence in legal disputes and in administrative and Inquisitorial investigations.[15] They recognized that the indigenous rhetorical tradition, which stressed the art of memory, complemented the painted record; it was not altogether different from their own rhetorical traditions for developing memory.

Although most of the features of Aztec religion, particularly human sacrifice and the worship of multiple gods, naturally repelled Spanish sensibilities, points of commonality still developed. The Catholic papacy selected mendicant friars—Franciscans, Dominicans, and Augustinians—to carry the thrust of evangelization in New Spain, because of their missionary zeal and vows of poverty. The first major group to arrive was a cohort of twelve Franciscans in 1524, followed two years later by twelve Dominicans, and in 1533 by seven Augustinians.[16] The native peoples recognized these friars as similar to their own priests, who lived equally chaste and austere lives, and they seemed willing to accept the Spanish supernaturals without much argument, just as they had earlier added the patron gods of their indigenous neighbors to their own pantheons. However, the Aztecs wondered why they also had to forsake their own gods, who had served their people well for so long.

Mendicant and Native Alliance

Soon, however, a powerful alliance was forged between the indigenous population and the mendicant friars charged with their conversion. The Mexican monastery complex developed out of the traditional indigenous base of agrarian collectivism, joining native labor and mendi-

cant direction toward a single purpose. Monasteries unlike those in Spain rose throughout New Spain.[17] In the hands of native builders, the true arch and vault imported from Europe enhanced traditional masonry techniques to create single nave churches of impressive size and fortresslike aspect. The novel architectural features of these monastic complexes met the special requirements of early colonial Mexico: open chapels and large *atrios* (or patios) accommodated great numbers of worshipers who were previously accustomed to open-air religious observances. Mural programs painted almost entirely in European style on the walls of the churches, chapels, and cloisters carried Christian messages to both mendicants and natives, who equally understood the didactic power of images.

The plan and view of an ideal monastery, published by the mestizo friar Diego Valadés in his *Rhetórica christiana* (1579), presents this vision of what was conceptualized as a new Jerusalem, where mendicants and natives were joined in the collective endeavor of instruction and conversion (fig. C-1). Within the great *atrio*, Franciscans support the church on a litter while their brethren administer the sacraments and instruct the natives in church doctrine as well as the purposes of penitence, confession, and matrimony. An anonymous friar teaches about creation with the aid of a large painting to which he points for emphasis (upper right), and another friar, who is specifically identified as Pedro de Gante, instructs natives in the European trades with the aid of another such painting (upper left). Both the mendicants and their pupils shared the belief that knowledge is best conveyed and learned with the aid of pictures.

Schools founded by the Franciscans accelerated native conversion to European ways. Friar Pedro de Gante founded a school for the mechanical arts at San José de los Naturales in Mexico City, where native sons became skilled in European construction and craft techniques and learned to direct their own indigenous technologies to new Christian purposes. It was at San José and elsewhere that the indigenous art of featherwork continued, for example, but now with Christian subject matter and taking the form of bishops' miters, priests' stoles, altar cloths, and two-dimensional pictures. In sculpture, native craft and the ancient traditions of graphic figuration and relief carving were channeled into impressive facades for monastery churches, great stone *atrio* crosses with their surfaces covered by relief carvings of the symbols of the Passion (fig. C-2), and baptismal fonts that could unite Christian and ancient Aztec images in a message of salvation.

The Franciscan desire to train and develop a native clergy led to the creation of the Colegio de Santa Cruz in Tlatelolco, where the sons of the Aztec lords learned the European liberal arts as well as advanced church doctrine. At Santa Cruz the indigenous and European traditions of rhetoric, writing, and the memory arts came closest together. Its students produced plays and sermons written in Latin and alphabetically in their own native languages; they also created encyclopedias of native culture that combined images of the pre-conquest past with textual explanations of their meaning. The students at Santa Cruz became the principal scribes, informants, and assistants for the mendicants who desired to learn about the ideology, history, and lifeways of the pre-conquest peoples. The assistants of the Franciscan ethnographer Bernardino de Sahagún, for example, were trained at Santa Cruz.[18]

The destruction of pre-conquest religious books and cult figures, and the suppression of indigenous religion, virtually extinguished the native tradition of religious figuration. In the monasteries and churches, and in private houses, the early colonial Catholic imagery looked to Europe for figural sources. Under the oversight of the friars, native artists learned European formal canons and religious iconography, copying compositions directly from graphic images, especially prints that arrived from Europe, or drawing on them more indirectly for inspiration and imagery. Imported book illustrations and single-sheet prints, executed from woodcuts and engravings, became the prototypes for murals,

FIG. C-2
Atrial cross, Mexico, before 1556. Stone, height 135¹³⁄₁₆ inches (345 cm). Basilica of Guadalupe/CONACULTA, DGSMPC, Mexico City

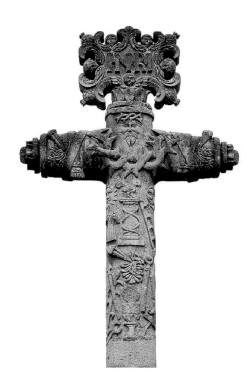

feather "paintings," and architectural relief. In the religious realm, the indigenous figural tradition may have died with the conquest, but the understanding behind it—that figural imagery was an effective communicative platform—survived, and for the rest of the colonial period, its style, content, and application developed along essentially European lines.

Secular Dependencies

The relationship of the natives to the Europeans in the secular and political realms was much less an alliance than a mutual dependency.[19] The crown officially regarded the native elites as "natural lords," who, like European nobility, were a class above the common people under their control. Conquerors and immigrants married into Aztec royal families, taking native princesses as their brides and creating an empowered group of elites. The Spanish husband of Moctezuma's daughter, for example, petitioned for return of her ancestral lands.[20] The Spanish authorities also valued the indigenous lords because of the labor and tribute they could marshal. For their part, the indigenous elites recognized that the Spaniards were key to their continued success; they soon learned how to argue their positions within the Spanish system as they strove to maintain their power, prestige, lands, and exemptions from tribute.

The documentation the native elites employed included materials written in the new alphabetic script, but pictorial documents were also created and brought forth. Spanish authorities accepted these painted manuscripts as repositories of much-sought information, and they acknowledged the painted books as the indigenous equivalent of European documents and records, according them roughly the same status. In some cases, the pictorial records were considered even more truthful than those written in alphabetic script. The ancient, and thereby "true," documents were the pictorial ones.

In this climate of acceptance, a painted tribute list, now called the Codex Huejotzingo, was entered into a lawsuit brought by Hernán Cortés against Nuño de Guzmán and other colonial bureaucrats in 1531 (fig. C-3). Cortés had been given as a grant the labor and products of the town of Huejotzingo, but while he was away in Spain for several years, Guzmán and his colleagues usurped Cortés's rights to the town and its tribute. The painted records of goods and services became an integral part of the litigation as "written evidence," which carried even more weight than oral testimony.[21]

This document is remarkable in other respects as well because it depicts a large featherwork picture of the Madonna and Child, which was the Madonna standard that Guzmán carried into battle. The document also lists the many male and female slaves who were sold to acquire the gold that enriched the standard. The Codex Huejotzingo, then, is an indigenous painting of another indigenous work of art, both of which were executed by Huejotzingo artisans working in their traditional techniques, but employed and valued by Spaniards as they themselves jockeyed for power and prestige.

Indigenous documents continued to figure in petitions and disputes brought before Spanish authorities well into the colonial period. When the three most important native rulers of Mexico complained to the authorities about excessive tribute in the 1550s and 1560s, they brought their complaints in painted form.[22] As lands were reapportioned and as inhabitants from depopulated towns congregated into new communities, the indigenous elites looked to their ancient histories, genealogies, and maps to document their holdings and rights. Although many of these secular documents predated the conquest, others—annals, histories, and map-based cartographic histories—were painted anew in the mid- and late sixteenth century,

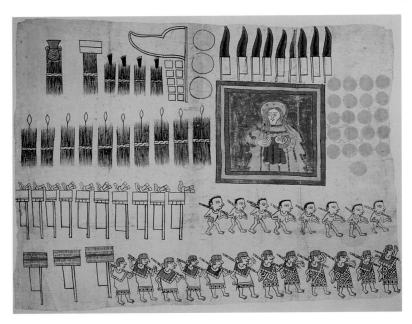

FIG. C-3
Codex Huejotzingo, painting 5, recording tribute of the town of Huejotzingo provided to Nuño de Guzmán, including a large featherwork standard of the Madonna and Child, 1531. Harkness Collection, Manuscript Division, Library of Congress, Washington, D.C.

FIG. C-4

Tira de Tepechpan, 1550s–1590s. Fonds mexicain 13–14. Bibliothèque Nationale de France, Paris. Here in this history the events of the Spanish conquest are presented: the arrival of the Christian faith (cross and dove), and Hernán Cortés in 1519 (year 1 Reed), followed by the introduction of smallpox, the burning of the Aztec Templo Mayor and the deaths of Aztec rulers, and (above them) a seated Cortés who reconfers lands and titles on an indigenous lord

FIG. C-5

Lienzo de Tequixtepec, sixteenth century. Cartographic history presenting the lands and history of this Mexican town, which still retains the *lienzo*

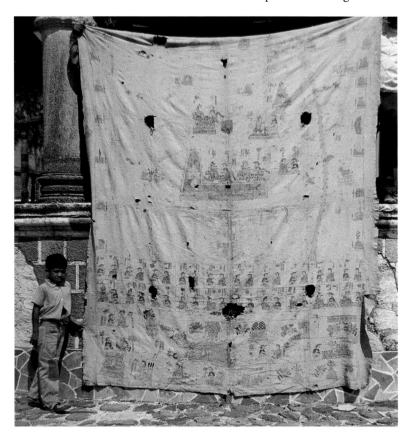

generations after the Spanish invasion (fig. c-4). Into the early seventeenth century, some native elites were still updating their painted annals.

The painted history remained a politically powerful manuscript genre that continued to carry agency through the colonial period, and still does so today. In the early eighteenth century, many towns in Mexico that no longer had any ancient documents commissioned new ones to be created in an archaizing style and submitted these new "old" paintings to the Spanish authorities.[23] Elsewhere in Mexico some pre-conquest painted histories were broken apart, inscribed with the names of town boundaries, and submitted as maps in boundary disputes in the eighteenth and nineteenth centuries.[24] Today, those towns in rural Mexico that are still fortunate enough to retain their sixteenth- and seventeenth-century pictorials value them as the community charters, maps, and ancient histories they are (fig. c-5).

Native traditions continued in the colonial period within rural and village contexts. The Spaniards and successive waves of immigrants were drawn instead to the urban centers. Even Spaniards who controlled lands and labor in rural Mexico lived and built houses in the cities, where artists from Europe came and introduced a succession of European styles. While the cities became increasingly Spanish, or Creole, the countryside of Mesoamerica remained largely native throughout most of the colonial period.

PERU

The interaction between native and Spanish art in the Viceroyalty of Peru took a different turn from that which had occurred in Mexico. One reason was the absence of an indigenous Andean tradition of manuscript painting such as had existed among the Aztec and Maya. The Inca, who controlled a vast coastal and mountainous territory from southern Colombia to the middle of Chile, recorded their historical, religious, and economic information by means of the *khipu*, a series of colored knotted strings joined to a main cord (fig. c-6). In fact, there was no pictorial

FIG. C-6

Khipu, Inca. Wool and cotton cords with a series of knots indicating decimal places suspended from main cord. American Museum of Natural History, Smithsonian Institution, Washington, D.C., 41.2/6722

FIG. C-7

Martín de Murúa (Spanish, c. 1525/35–1618), *Maita Capac Inga*, from *Historia general del Perú*, 1611–13. MS Ludwig XIII 16, fol. 28v. Handmade laid rag paper with pigments and ink. J. Paul Getty Museum, Los Angeles

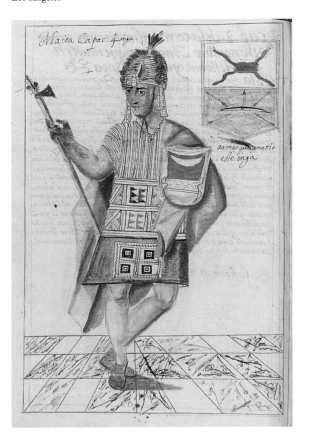

tradition in any medium that could so quickly accommodate European images in the same manner as in Mexico. It is important to remember that one of Cortés's earliest recorded interactions in Mexico City concerned an artistic interchange. He wrote that "and lest Your Highness should think all this is an invention, let me say that all the things that Monteczuma had ever heard of have been modeled very realistically in gold and silver or feathers, and with such perfection they seem almost real. He gave many of these things to your majesty, and also other things that he had made from drawings I gave him, such as holy images and crucifixes . . . and many other things."[25] What is significant about Cortés's comments is that they transpired within the context of a still very volatile and unstable situation between the "Aztec hosts" and "Spanish guests." Nonetheless, within this tense atmosphere of looming doom and destruction, there was an almost immediate and spontaneous emulation of European forms in Mexican mediums by Aztec artists, suggesting that at a very basic level there was a deep commensurability between the two artistic systems, something that Guevara recognized and that permitted him to incorporate Mexican painting within the history of European painting, as discussed above. What is important for our discussion of Peru is that such emulation did not immediately take place. And, it has sometimes been argued that the ongoing unstable situation of the Viceroyalty of Peru inhibited the kind of artistic development that occurred in Mexico. This can only be a partial explanation, however, because, as Cortés's comments demonstrate, the integration between the arts of Mexico and Spain occurred not only quickly but under the most suspenseful conditions. Hence, as we shall discuss, the development of colonial art in Peru was a bit slower in its synthesis of forms and mediums, and in some cases there was hardly any parallel with what took place in Mexico. For example, there are only three illustrated manuscripts from early colonial Peru, and they are based on European precedents and show no real Andean roots, whereas, as demonstrated, there is a myriad of Mexican colonial manuscripts that continue well into the eighteenth century. This does not mean, however, that Andean artists were not capable of both assimilating new forms and ideas to their own traditions and emulating Spanish pictorial traditions for their own purposes. As we shall discuss, they were every bit as capable as their Mexican counterparts, but they did not necessarily follow the same trajectory.

For example, whereas a pictorial document such as the Huejotzingo manuscript could find itself placed with a Spanish court case, the *khipu* was the form of record in Peru. Both the history of the Inca and their religion were transcribed into Spanish manuscripts, and statistical information was recorded by *khipus* that were used as incontrovertible evidence in colonial lawsuits. In addition, in Peru the Spanish found a rich artistic tradition of geometric abstraction that was based primarily on textile designs, called *tocapu*, that were woven into male tunics called *uncus*. Such objects of beauty were collected by the Spanish, and one was kept in the royal collection in the Escorial. It is described in an inventory of Felipe II as a "shirt [*uncu*] of the Indians, that they [the Inca] call *cumbi* [tapestry weave], [that is] woven of diverse colors and figures, of which the figures are signs [*señales*] of the coats of arms of the provinces that the Inca possessed, by which he knew them."[26] Although the term *tocapu* is not used in the document, it would seem that this is exactly what these "signs of the coats of arms of the provinces" were and that they were similar to the pattern of abstract geometric designs that compose the magnificent *uncu* in the collection of Dumbarton Oaks (cat. 11-2). Unfortunately we cannot compare the Dumbarton Oaks example with the *uncu* of the Escorial, as the latter was described in the inventory as being moth-eaten and full of holes, and thus declared as having no value.

The Inca crown, the *mascaipacha*, was also a textile—a red fringe that fell over the forehead. The crowns of the last two Inca sovereigns were also recorded as a part

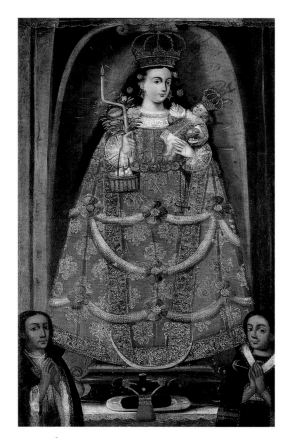

FIG. C-8
Painting of a statue of the Virgin of Candlemas.
Oil on canvas, 59⅞ × 30 inches (152 × 76.2 cm).
Private collection

of the royal collection in the Escorial in the inventory of 1600. They were inventoried, like the Inca shirt, under a special category, called *cosas extraordinarias*, or "extraordinary things," and their entry reads: "it was said that it [the *mascaipacha*] was the insignia with which the Inca were crowned and the one is that with which was crowned Huayna Capac and the other, Atahuapla [*sic*], [and that they were] placed in a basket of straw and wool, [and that] they have no value."[27] And so, as worthless things, the supposed crowns of the last two Inca kings, like the Inca tunic, were assigned to the trash heap of history, lost forever.

One can see that some of the most valued objects, those that were of paramount symbolic importance to the Inca, did not carry the same kind of importance to the Spanish as did their Mexican counterparts. However, through the instruction of European artists, Andean artists were able to quickly adjust their practices to produce works that did appeal to the new norms. Thus we find Juan Pantoja de la Cruz, court painter to Felipe II (*pintor del cámara del rey*), on July 7, 1600, recording the paintings in the fifth room of the royal palace in Madrid as a part of the same process of inventorying the possessions of the recently deceased King Felipe II in which the Inca crowns and tunic were registered. Listed among this vast collection were many of the great paintings that now form the basis of the Prado museum, including Titian's allegorical portrait of Felipe II, Justus Tiel's allegorical portrait of the education of Felipe III, and the most famous painting of all, Titian's equestrian portrait of Carlos V. Juan Pantoja de la Cruz also describes other, and perhaps even more surprising, paintings that were hanging cheek by jowl with the Titians and Tiel: "four large paintings in which is painted in one the royal family tree and in the other three the portraits of the twelve Inca kings up to and including Huayna Capac."[28] These paintings, commissioned by the viceroy of Peru Francisco de Toledo in 1571, were painted in Cuzco by native artists expressly as a gift for Felipe II. Although now lost, these paintings, or others like them, served as the source for a number of images of Inca kings, including perhaps the color washes in Martín de Murúa's two illustrated manuscripts of 1590 and 1613. What is significant about the portraits of the Inca painted by native artists is that they were hanging in the same room with Titian's portraits of Carlos V and Felipe II and that Pantoja de la Cruz saw them as being similar in kind to the other paintings; he assigned them a monetary value, much less than that of Titian's portraits, of course, but nonetheless of some substantial value. That is, the portraits of the Inca kings painted by colonial Andeans artists in Cuzco were ascribed in Madrid a categorical status equal to that of some of the greatest works by one of the greatest artists of the Renaissance. It is therefore clear that by 1571, or less than thirty years after the conquest, native painters of Peru had learned to produce works of art that, like those of their Mexican counterparts, were desired and seen by the highest members of Spanish society.

Our point is that the two categories into which the Inca objects were placed—art (the paintings of the Inca kings) and extraordinary things (the actual royal symbols of the Inca)—within the royal collection demonstrate the changes that quickly occurred in Peru as Andean artists adapted to the new situation, just as artists did in Mexico. In Peru, it seems that the portraits of the Inca commissioned by Toledo initiated a tradition of Inca portraits that had a wide appeal among Spanish, mestizo, and native Andean patrons and that once begun at the end of the sixteenth century continued almost unabated to the mid-nineteenth century.[29] For example, the only three extensively illustrated manuscripts from Peru, two by Martín de Murúa and one by Felipe Guamán Poma de Ayala, contain a series of portraits of the Inca kings and queens (fig. c-7).[30] What is interesting in these three series is that the earliest manuscript by Martín de Murúa has an iconography that is much closer to Andean concepts of sovereignty and descent than this later manuscript in which the arrangement and iconography of the Inca kings and their queens follow a European pattern.[31] Moreover, the *tocapu* and the

mascaipacha became important iconographic elements that appear in a number of different contexts in colonial paintings. For example, descendants of the Inca posed for their own portraits wearing some combination of Inca tunic with *tocapu* and often also wearing the *mascaipacha*. In a devotional painting of the statue of the Virgin of Candlemas, for example, the two indigenous patrons are depicted in profile on either side of the statue, while the *mascaipacha* is placed below her (fig. c-8). Here the symbol of Inca sovereignty is used to demonstrate the devotion of these native elite to a Christian image. At the same time traditional objects of Andean ritual use such as *keros,* or paired wooden drinking vessels, began to be decorated with figures of Incas toward the end of the sixteenth century. Borrowing from the newly introduced figural style of European painting, these images conjured up the presence of the past for individuals who lived and used these ritual vessels within the native communities, which were often very distant from the Spanish cities where the portraits of the Inca were displayed. And though the *keros* shared in the new figural representation of the Inca, the technique was very different and came from traditional knowledge. Thus while the images might appear to emulate the figural painting introduced by the Spaniards, they in fact were not painted at all but created by laying on the surface of the wood a gum-based residue that was mixed with pigments and heated until it became a viscous material that could be cut into different shapes to form various figural elements. Nonetheless, these new images share in the common colonial iconography of the Inca, which emphasized the symbolic elements of royal regalia.

One finds not only objects of Inca symbolic power converted into pictorial symbols for a new colonial context but also the most prestigious medium of the Andes, weaving, turned to new expressive purposes. Thus we find the transformation of Inca tapestry weave, with its geometric designs of *tocapu* as seen on the tunic, being used to create large-scale narrative biblical scenes such as the Creation of Eve (fig. c-9).[32] These new tapestries were, in many ways, an extension and large-scale woven copy of the didactic images pointed to by the Franciscan teacher in Valadés's 1579 engraving of an ideal Mexican monastery (see fig. c-1).[33] They

FIG. C-9
The Creation of Eve, Andes, early seventeenth century. Tapestry weave, cotton warp and camelid weft, 104 × 98⅞ inches (264 × 251 cm). Círculo de Armas, Buenos Aires

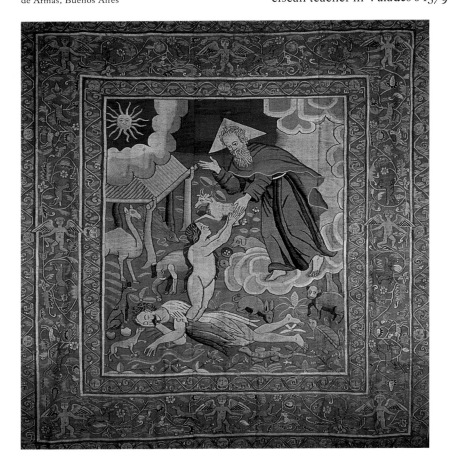

created an overpowering image within a medium that carried the highest value in Peru and therefore elevated the biblical message. This Andeanized Christianity combined Christian and Andean symbols just as the Mexican baptismal fonts discussed above combined Christian and Aztec imagery; in both cases, this synthesis was expressed within a local idiom. The most startling example of such a synthesis, perhaps, is the dressing of a sculpture of the Christ Child in Inca royal symbols. We have a description from 1610 of the celebration in Cuzco in honor of the beatification of the founder of the Jesuit order, Ignatius of Loyola. The festivities took place over a twenty-five-day period.[34] Various processions were performed by the Inca descendants of the six parishes of Cuzco as well as the two parishes just outside the ancient capital of the Inca, San Sebastián and San Jerónimo. On different days, the members of a different parish marched into the central plaza, making reference to past conquests of the Inca. For example, those from San Jerónimo were led into the plaza by their *curacas* (leaders) carrying the symbols of the Inca, including the *mascaipacha.* They sang a song of victory over the ancient enemy of the Inca, the Chanca, which was now sung in honor of Ignatius. When the native residents of the parish of Hospital entered the Plaza de Armas singing a song about Huayna Capac, the penultimate Inca sovereign, that

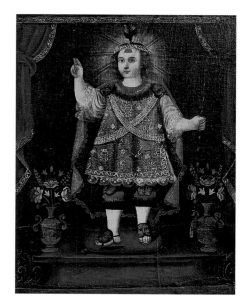

FIG. C-10
Christ Child of Huanca, eighteenth century. Oil on canvas. Formerly in Argentina (present location unknown)

was now also dedicated to Ignatius, they were greeted by a lay confraternity that displayed to the crowd a statue of the Christ Child dressed in imperial Inca dress, including the *mascaipacha*. For the Andean audience, the vestments of the Christ Child denoted with singular efficacy the reigning power in Peru to which they now dedicated their ancient songs of victory. We have an idea of what this early seventeenth-century sculpture may have looked like from eighteenth-century paintings that depict a very similar iconography to the description from 1610 (fig. C-10). What is remarkable is that the native Andean artist rendered the dressed statue more as if it were a portrait of the living Christ than a sculpture. The figure wearing a *mascaipacha* and Inca tunic is released from a static pose and appears in dynamic movement, even casting a shadow as it raises a leg as if to step. More importantly, there is a transcendent radiance as if this is a truly divine being from which emanates a celestial light. This then is not just a painting of a sculpture but an image that imagines a vivified Christ divinely dressed in Inca regalia.

The synthesis of a Christian image and Inca symbols is an early and crucial part of colonial art, as it is through the imaginative expression of plastic representation that the invisible is made manifest. The blending of forms, iconography, mediums, and techniques creates a local expression of a complex system of values and representations that melded orthodoxy to heterodoxy. It is a process that was to be found in Mexico and Peru, and is what gives each colonial culture a unique and creative body of art. At the same time, native traditions, be they manuscript painting or textiles, stone carving or decorated wooden ritual vessels, allowed native communities to maintain connections to the past through the images and techniques that came from that past. It is in these early artistic expressions that we can first glimpse the complexity and vibrancy of colonial Latin American art.

NOTES

1. Guevara 1560/1788, p. 235.

2. Ibid., pp. 235–36.

3. Ibid.

4. Ibid., pp. 236–37.

5. As cited in Jantz 1976, p. 94.

6. Morison 1963, pp. 183, 185.

7. Díaz del Castillo 1956, p. 8.

8. Cortés 1986, p. 45.

9. Dibble 1981, p. 45, pl. 3d.

10. Díaz del Castillo 1956, p. 72.

11. Ibid., pp. 73–74.

12. E.g., ibid., pp. 63–64.

13. Cortés 1986, pp. 94, 109, 192, 340, 344, 354, 365.

14. Motolinía c. 1555/1971, p. 5.

15. For the range of painted books and Spanish reaction to them, see Boone 1998; see also Robertson 1959.

16. Ricard 1966, p. 21.

17. See Kubler 1948.

18. Robertson 1959, pp. 46–48.

19. For relations between the Aztecs and Spaniards, see Gibson 1960; Gibson 1964; and Lockhart 1992.

20. Gibson 1964, p. 76.

21. Codex Huejotzingo 1531/1995; Codex Huejotzingo 1531/1974; see also discussions by Thomas Cummins: Cummins 1995 "Lies," pp. 153–58; and Cummins 1995 "Madonna," pp. 55–68; and also Boone 1998, pp. 179–81.

22. See Cortés Alonso 1565/1973.

23. These are known today as the Techialoyan Codices. See Robertson 1975; Wood 1989; and Borah 1991.

24. Smith 1963; Smith 1966; Smith and Parmenter 1991, pp. 61–71.

25. Cortés 1986, pp. 100–101.

26. Sánchez Cantón 1956–59, vol. 2, p. 334.

27. Ibid., p. 333.

28. Ibid.

29. See the various essays in Majluf 2005.

30. Murúa 1590–1600; Murúa 1613; Guamán Poma de Ayala 1615/1980 *Primer*.

31. Cummins 2002, in Mujica Pinilla et al. 2002, pp. 40–44.

32. See Phipps 2004 "Cumbi."

33. Copies of Diego Valadés's *Rhetórica christiana* circulated in Peru, and a copy is recorded in the 1648 inventory of the private library of Francisco de Avila, who died in Lima the year before; see Hampe Martínez 1996, p. 74.

34. Avila [attr.] 1923.

The Spanish American Colonial City:
Its Origins, Development, and Functions

Alfonso Ortiz Crespo

At the time of the discovery and conquest of the New World, one of the crown's maxims was that the Spanish should establish permanent settlements, a process in which cities played a fundamental strategic role.[1] According to historian Arturo A. Roig, from the start this involved a two-pronged plan of creating cities for the Spanish settlers and villages for indigenous peoples, where they could be controlled.[2] In other words, the idea was to create two republics, one for the Spanish and another for the Indians.

The Spanish had already established the practice in Spain of planning new cities using a grid system, or checkerboard design, especially in areas retaken from the Muslims or in regions of significant population growth.[3] There were practical reasons for designing cities on a grid in the New World, since it was relatively easy to implement and allowed for an equitable distribution of land among the Spanish conquerors. It also enabled planners to leave room for plazas, the public spaces that were an essential component of the Spanish city. This does not mean, however, that a perfect model for urban development in Spanish America was available from the very beginning of the conquest. The settlers had to adapt the Spanish model to the particular terrains and circumstances of the New World. The instructions that King Fernando the Catholic (r. 1479–1516) gave to Nicolás de Obando, governor of the Caribbean island of Hispaniola (present-day Haiti and Dominican Republic), in 1501 illustrate the extent to which colonial administrators determined the number and location of cities established in the territories under their charge:

> It is necessary to establish some settlements on the island of Hispaniola, which cannot clearly be envisioned from here; you shall view the sites and locations on said island and, in accordance with the quality of the land and places and people beyond the towns that exist there now, you shall establish the number of settlements that you deem appropriate.[4]

FIG. D-I
San Francisco Plaza, Quito, Ecuador

23

In 1513, the same monarch gave similar instructions to Pedro Arias Dávila, governor of Darién (present-day Panama and Colombia) from 1513 to 1526, and in 1526 Carlos V issued his Settlement Ordinances, one of which reads:

> Once the discovery by land or sea has been completed in accordance with the relevant laws and guidelines, the province and region to be populated have been chosen, and the places for new settlements selected, they shall be allowed to grow as follows: the coastal settlements shall be erected salubrious and strong, taking into account the shelter provided, the depth of the harbor, and the potential for defending the port [fig. D-2]. For coastal as well as inland settlements, the site shall be chosen without prejudice to the Indians and natives and taken over with their freely given consent. In designing the plan for the settlement, it shall be divided into squares, streets, and lots in ordered, straight lines commencing from the central square, from which shall issue the streets leading to the main roads and gates. Enough open space shall be left so that in the event of rapid population growth, the city shall be able to continue to expand in the same way.[5]

The year 1524 saw the creation of the Consejo de Indias (Council of the Indies), which advised the monarch, made recommendations for the appointment of public officials, served as the supreme court for appeals launched in Spanish America, censured the actions of senior functionaries, and controlled economic policy. From the council flowed a variety of measures to ensure the proper development of the colonies. However, "direct administration of the American territories [was] always carried out by city government [and] revolved around three main axes: government and the law—'to govern is to impose justice,' as the saying went—taxation, and the military."[6]

Under the auspices and protection of the Spanish empire, the conquerors pacified and settled the Americas, creating an extensive web of permanent urban settlements that so thoroughly organized the region that, according to the historian Rafael Manzano, "its only equals in human history are the Greek colonization of the Mediterranean, the grand Alexandrian undertaking in the Hellenistic world, and the creative efforts involved in building the cities of the Roman Empire."[7]

EXPLORATION AND CONQUEST

The Spanish installed their first platform for the conquest of the Americas on Hispaniola with Nicolás de Obando's 1502 blueprint for the city of Santo Domingo. The oldest city in Spanish America, its initial layout already featured the incipient grid associated with Spanish cities. From Hispaniola they explored and conquered the rest of the Caribbean, including Cuba, Puerto Rico (fig. D-3), and Jamaica. Around 1519, once the discoveries and conquests in this region were consolidated, settlement moved to Mexico, Florida, Tierra Firme (the northeastern part of South America, bordering the Caribbean Sea), and Panama. From Mexico, the Spanish headed south and conquered Central America, where they eventually met up with

FIG. D-3

Plan of the City and Bay of San Juan de Puerto Rico in the Eighteenth Century. Servicio Histórico Militar, Madrid, no. 5791

explorers coming north from Panama.[8] Panama in turn became the starting point for new southerly expeditions, which led to the occupation of Peru. Meanwhile, they set out from Mexico in four directions: northwest toward what is now California, northeast to present-day Texas, east toward the Yucatán, and west to the Philippines across the Pacific Ocean.

After the conquest of the Inca empire and the arrival of the Spanish at Cuzco in Peru, the explorers advanced into the interior of the continent, to Upper Peru (present-day Bolivia), Tucumán (present-day Argentina), and southern Chile. From Cajamarca in Peru, they advanced north to Quito (present-day Ecuador) and from there toward Santa Fé de Bogotá (Colombia), where they met expeditions that had advanced southward from the Atlantic coast. From Quito they also headed east, discovering the Amazon River and navigating it all the way to the Atlantic Ocean. By 1570, these explorations had been completed, from the Labrador Peninsula to the Strait of Magellan and from there all the way to Oregon. The Spanish settlers maintained their control of these vast new territories by founding cities. By 1570, some 180 cities had already been founded, among them San Juan (Puerto Rico), Havana (Cuba), Panama City, Mexico City, Guatemala City, Quito, Lima (Peru), Buenos Aires (Argentina), Santa Fé de Bogotá (Colombia), Santiago de Chile, La Paz (Bolivia), and Caracas (Venezuela), all of which are now capitals of modern Latin American republics.

The settlers adapted and improved upon the Spanish city model as they gained experience during their exploration and penetration of the American continent, so that less than a century after the arrival of Columbus, the Spanish crown had implemented standardized urban planning through the extensive body of law created for its American territories. In 1573, King Felipe II issued his Ordinances for New Settlements—legal precepts to manage the affairs of empire, dictated by the king by virtue of his authority. These were issued in order to regulate a variety of activities, and upon their issuance previous ordinances governing the same matters ceased to be in effect. The ordinances were, according to Italian historian Leonardo Benevolo, "on the one hand a compendium of the theories produced by the culture of his time and, on the other, a balance sheet of experience gained."[9] This body of legislation was assembled over seven decades, incorporating instructions, decrees, recommendations, and ordinances issued by the Spanish crown to its American subjects, as well as the reports the conquerors and governors sent back to the king describing the actions they had taken.

According to Benevolo, the settlement ordinances were the first urban development laws of the modern era. He notes that they stemmed from the medieval tradition of regular cities that were founded in the thirteenth century and the first half of the fourteenth, such as French walled cities and Spanish towns. These models, which spread throughout the European countryside, were influenced by Renaissance architectural treatises, such as those of Vitruvius and Serlius, and the principle of geometric regularity, which became widespread in practice and a primary requirement in manufacturing techniques.[10]

Jorge Enrique Hardoy, one of the most important scholars of Latin American urban history, notes that, despite the extensive regulations issued by the Spanish authorities, New World cities took shape largely in response to localized needs:

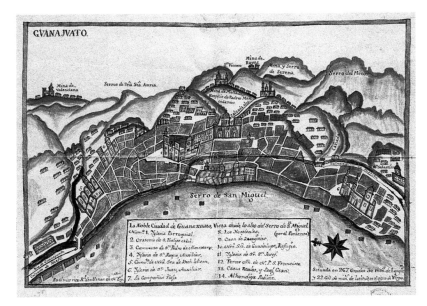

FIG. D-4
The Noble City Guanajuato (view of the mining
city Guanajuato from the hill of San Miguel),
eighteenth century. Colored manuscript, 12⅛ ×
15¾ inches (30.9 × 40 cm). Archivo General de
Indias, Seville (México, 601)

The origins and functions of urban centers, whether they were planned or developed spontaneously, were intimately connected with their locations. These were the most influential factors that caused cities to deviate from legislation meant to guide their layout and internal structure through specific principles of urban planning. However, the idea of the classical model of the Spanish American city was not created in Spain or Europe and transplanted to America. It arose from progressive improvements in disparate concepts that were first used comprehensively in Spanish America. The legislation supported this process but did not initiate it.[11]

Hardoy reminds us that although the most important and populous Spanish American cities used the checkerboard design, with its rectangular net of square city blocks, there were many more small cities in which this regularity was not achieved. Indeed, not all cities were constituted in accordance with the established model. Many of the region's urban centers had been established prior to the issuance of the settlement ordinances. And even if planners were intent on using a geometric urban structure "characterized by order, rationality and the breadth of its basic organization," not all Spanish colonial cities did so.[12]

There are many reasons why some new cities did not follow the classical model. The Ordinances for New Settlement, the body of law that established the precise model, were issued only in 1573. Many of the cities founded in the previous seven decades therefore constituted experiments in which the model that would later become the norm was gradually perfected. Other cities emerged from spontaneous settlements; some were mining camps situated on rough terrain right over the mineral deposits (fig. D-4); and still others sought a secure location with topographical features (hills or mountains) or geographical ones (rivers or ravines) that did not easily lend themselves to the grid format (fig. D-5), which worked best over flat ground. Port cities were established in places with the best anchorage and easily defensible topography (see fig. D-3). Thus, the physical environment took precedence over all other factors.

CLASSIFICATION OF SPANISH AMERICAN CITIES

The cities founded by the Spanish conquistadors formed nodes in a broad network whose purpose was to control, administer, explore, maintain, and defend territory. As Hardoy notes, the function of each city was intimately tied to its location. The function of a maritime city, for example, was different from that of an inland city. In 1973, with a view to better understanding different types of cities, a worthy effort was made to systematize certain of their characteristics. As the authors of the study note: "Faced with the temporal and spatial complexity of this phenomenon, 'class' seems to be a valid term to use in discussing and generalizing about a reality of urban planning. Within this general theory, 'class' is understood as the organized combination of various classifications that permit a de facto inventory of a great variety of elements, in this case cities, based in different sectors."[13] Thus, the study developed a classification based

FIG. D-5
View of the Rich Mountain of Potosí, eighteenth
century. Colored pencil and watercolor on paper,
13⅝ × 18¾ inches (34.5 × 47.5 cm). Museo de la
Casa Nacional de Moneda, Fundación Cultural
BCB, Potosí, Bolivia

on a city's founding date, form, fortification, location, principal activities, strategic role within the territorial system, and pattern of growth:

<div align="center">EXAMPLES OF CITIES BY CLASSIFICATION</div>

Form
Regular: Guatemala (Guatemala)
Semi-regular: Quito (Ecuador)
Irregular: Potosí (Bolivia)

Defensive Capabilities
Fortified: San Juan de Puerto Rico (Puerto Rico)
Non-fortified: Mendoza (Argentina)

Location
Maritime: Acapulco (Mexico)
Semi-maritime: Lima (Peru)
Interior: La Plata (Sucre, Bolivia)

Activities
Commercial: Portobelo (Panama)
Mining: Guanajuato (Mexico)
Defensive: San Agustín de la Florida (USA)
Administrative: Santa Fé de Bogotá (Colombia)

Strategic Role
Way station/connector: San Luis de Potosí (Mexico)
Origin/destination: Havana (Cuba)

Growth Pattern
Unidirectional: Caracas (Venezuela)
Multidirectional: Trujillo (Peru)
Mixed: Buenos Aires (Argentina)

Cities were first classified into three broad epochs according to their date of founding. During the first epoch (1492–1570), which encompassed the period of discovery, early settlement, and pacification of the continent, the city acquired its defining characteristics. During the second epoch (1570–1700), the urban model was consolidated, and the structure of colonial society and its patterns of production and commerce were put firmly in place. In the third epoch (1700–1810), colonial Spanish America advanced toward self-determination and generated its own structures. Cities were also classified into three groups according to their form: *regular,* where the checkerboard layout was used; *semi-regular,* where the layout adapted flexibly to site conditions; and *irregular,* where norms were not applied and the city generally developed spontaneously.

Because a strong defense was required in order to protect land and sea routes, cities were further classified as either *fortified* or *non-fortified.* The flow of wealth from the New World converged on the Caribbean Sea, the *Mare Nostrum* of the Spanish. This vast area was coveted by the other European powers from early on, which forced the empire to fortify its ports against corsairs and pirates. Of special interest are the fortifications developed toward the end of the sixteenth century by the military engineers Juan Bautista Antonelli and Cristóbal de Roda in the city of Cartagena de Indias (Colombia). These consisted of a comprehensive system that made maximum use of the existing features of the coast and the natural protection provided by the port as well as the placement of various forts with their bastions, ramparts, trenches, storehouses, parade grounds, and so on, in keeping with the most advanced Renaissance military engineering practices.

Cities were also classified according to their location, such as *maritime* if they were situated directly on the coast (fig. D-6); *semi-maritime* if they were closely linked to a port; and *interior* if they were located far from the coast. *Semi-maritime* cities were essentially two cities in one: a port and a city located a few kilometers from the coast, with good roads connecting the two. This was the case with Lima and El Callao, cities that have since merged owing to the explosive urban growth of the twentieth century.

FIG. D-6
Map of the castle and harbor of Acapulco, 1712.
Archivo General de Indias, Seville (México, 106)

Although cities are home to an infinite number of activities, some of these could be identified as predominant, resulting in the following classifications: *commercial,* for cities where trade was the prevalent activity; *mining,* for cities that generally arose spontaneously at mineral locations or from aboriginal mineral exploitation sites; *defensive,* for cities that were integrated into a marine or land-based military system; and *administrative,* for cities that functioned as the seat of a broad regional or territorial government. Generally speaking, trade was the main activity in port cities. A clear example of this is Guayaquil (Ecuador), a city that for two centuries after its founding was the exclusive port of entry for products going to Quito, which was located 2,800 meters above sea level in the Andes and several days' journey away. Likewise, a good deal of Quito's main source of wealth (textile production) was exported via Guayaquil. By the middle of the eighteenth century, Guayaquil had consolidated its own economic activity around its shipyards and the export of cocoa and fine wood. For its part, Quito would remain an administrative city, home to the president and the *audiencia* (royal court of justice), the bishop, treasury officials, the taxation system, and other administrative officials and functions.

Depending on the role a city played within the territorial system, it was considered a *way station/connector* city—in other words, a junction—or an *origin/destination* city, a place where people came to carry out various commercial and cultural activities. Within the complex network of cities woven by the Spanish empire in the New World, the metropolis fulfilled several roles in accordance with its location, the importance of its productive and economic activities, the number of its inhabitants, and its geographical placement.

The final classification category has to do with the way a city grew. This growth could be *unidirectional,* that is, along a specific axis following geographic, legal, or other barriers;

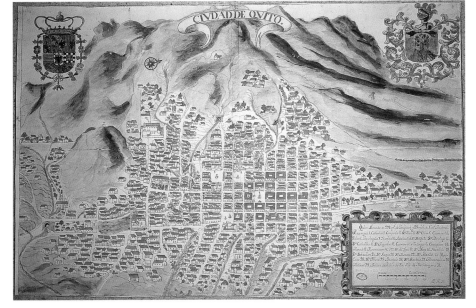

FIG. D-7
City of Quito, 1734. Archivo General de Indias, Seville
(Panamá, 134)

multidirectional, starting from a center—generally the main square—and growing along the various axes that intersected at right angles; or *mixed,* where the growth was undefined but with each part growing according to its own logic. The direction in which a city grew was not only dictated by the realities of the terrain it sat on, which might present barriers to development in a given direction, such as the presence of the sea, a wide and deep river, or a steep mountain (fig. D-7). It was also subject to legal impediments, such as a large privately held agricultural property, great tracts of religious or military land that halted urban sprawl, and limitations imposed by defensive walls around the city, among other things.

FOUNDING CITIES

Choosing a site on which to establish a city required the careful consideration of numerous factors, including the nature of the terrain, proximity to access roads, security, climate, and the availability of water, firewood, building materials, and the like. Its successful establishment often depended on the presence of indigenous inhabitants, because over time these people became a labor force vital to urban daily life. This is why many cities were founded on or near indigenous villages, although the original village layout rarely determined the design of the colonial city.

The founding of cities or towns was not only a practical act, but also a legal one that led to the formation of a municipal council or city hall. For this reason, a distinction must be made between officially *founding* a city and simply *building* a town or a mining or military camp. During the first epoch of settlement, various conditions had to be met before any population center—be it a city, town, settlement, or village—could be officially recognized and enjoy the privileges granted by the colonial government. First there had to be a founder, that is, someone to whom the Spanish crown or other legitimate authority had granted the power or privilege of founding a city and whose presence at the site was mandatory. Until the mid-sixteenth century, the power to found a city rested solely with the governor, who derived his authority from a contract with the king. Later, this power was transferred to the highest available authority: a judge, the president of the *audiencia*, or the viceroy.

The political organization of the Spanish crown's overseas territories developed in step with the process of exploration, incorporation of new territories, and founding of cities, creating an ever more complex institutional network. During the exploration of the Caribbean, administrative matters were placed directly in the hands of those who enjoyed the king's confidence. In 1503, however, the Catholic monarchs created the Casa de Contratación, or House of Commerce, whose headquarters were located in the city of Seville. The scope of this institution's authority included everything related to trade with the New World, whether in administrative or judicial matters (the latter decreed in 1511). From 1539 on, the House of Commerce presided over royal treasury (*real hacienda*) cases related to trade with Spanish America. The House of Commerce was also an important center for maritime and cartographical research. The famous navigator and explorer Amerigo Vespucci became the first chief pilot (*piloto mayor*) in 1508, in charge of compiling information from mariners in order to draw up charts, as well as testing and graduating pilots or sea captains. In 1717, the House of Commerce moved from Seville to Cádiz; it was abolished in 1790.

The Council of the Indies acted as an advisory body to the king in matters related to the administration of the colonies until 1834. The Council recommended candidates for various administrative posts, fulfilled broad legislative duties, acted as the final court of appeal in civil and penal matters in Spanish America, oversaw the financial administration of the colonies, and governed dealings with the church without interfering in spiritual matters. The viceroyalties were the head of the administrative organization of the New World and were presided over by the viceroy, who acted as the king's representative in governmental, judicial, property, and military matters. The viceroy also presided over the *audiencia*, which was composed of a number of magistrates who served as judges and as an advisory body. Two large viceroyalties were created at the beginning of the colonization period: New Spain, which covered the territories of Central and North America and the Caribbean, and Peru, which comprised the present-day republics of Colombia, Ecuador, Peru, Bolivia, and Chile.

The vast expanse of territory and the continuing increase in population spawned a complex administrative system, with other *audiencias* being created within the viceroyalties, and within those, *gobernaciones* (districts under a governor's jurisdiction) and *corregimientos* (magistracies or districts with a mayor appointed by the king). *Capitanías* (captaincies) were created in the *gobernaciones* with greater strategic military importance. Soon after the accession of the House of Bourbon to the Spanish throne early in the eighteenth century, two new viceroyalties were created: Nueva Granada in the northern region of South America, and Río de la Plata to the south, as well as various *intendencias* (areas under an intendent's authority). Within this general bureaucratic framework were the cities, which served as bases from which to occupy new territory, and as the places where civil and ecclesiastical organizations were concentrated. Cities were administered by a *cabildo*, or town council, an institution that had been transplanted from the metropolis, where it had reached a high degree of refinement. The cabildo was responsible for regulating daily life via the issuance of ordinances.

FIG. D-8

Plan and foundation record of the city of Resurrección
(Mendoza), in the province of Cuyo (Tucumán), 1562.
Archivo General de Indias, Seville (Buenos Aires, 10)

A city's founder would appoint the various municipal authorities, either personally or through a proxy: a lieutenant governor and a city council, generally with two mayors and two or three council members, who were replaced each year. The founding ceremony was recorded in an official document accompanied by the founding blueprint, which in many cases already indicated the distribution of plots of land and thus became the symbolic representation of the settlement (fig. D-8). The new community was required to have at least thirty Spanish male residents of legal age (older than twenty-five) who had gone before a notary public to declare their desire to settle in the new town. This is the process whereby the Spanish conquerors became residents.

Plots of land for the administration, the church, and residential homes were marked on the blueprint, leaving space for those who would come later. Lands were also consigned to religious communities for their monasteries and convents. Unlike Spain, Spanish America boasted enormous tracts of land, and newly founded towns and city governments moved quickly to appropriate large areas of territory from the colonial government that was being established. Because common lands were secured for pasturing the city's livestock, and land outside the city limits was set aside for agriculture and animal husbandry, the jurisdiction of most cities took in an area with a radius of some twenty thousand feet (5,573 m).

Following a town or city's establishment, other public officials were gradually appointed to carry out a variety of urban planning and municipal duties: chief and deputy bailiffs to collect taxes, carry out seizures, and run prisons; a public inspector to ensure the accuracy of weights and measures; a surveyor to measure plots of land and establish boundaries; an attorney to plead the cases of residents before the authorities; a notary public to certify documents and transactions; a trustee to hold the property of the deceased to protect their families; a majordomo to administer the tax revenues, and so on.[14]

Once the grid was laid out for a newly founded city, each resident was responsible for building a house on his lot. But in some settlements, the urgency of securing shelter led the conquistadors to use indigenous structures, adding Spanish touches to the settlement later on, once the native inhabitants had been trained to use the new tools, materials, and techniques of construction introduced by the conquistadors. Often, however, Spanish settlement concerns had an immediate effect on the original village. In the city of Quito, for example, mere weeks after its founding in 1534, the town council decided that the Indians' thatched wooden huts sitting on new settlers' lots had to be demolished as fire hazards.[15] Two years later, the council issued an order to enclose the lots with adobe or stone walls and to build residences within these enclosures, with a separate cabin for the kitchen, also of adobe or wattle and daub, to reduce the risk of fire. The use of wood was permitted only in chicken coops.[16]

A review of the early years in the life of the cities, through the examination of agreements and orders emanating from the councils, shows the constant desire to establish order in the new settlements. In order to improve the appearance of the city, residents were expected to respect the prescribed alignment of facades, and were responsible for laying out the streets in straight lines and leveling them. There was also a preoccupation with the cleanliness and

order of the streets, since there were always residents who, in the process of erecting their homes, used the thoroughfares as a place to pile up building materials or to mix lime. Particularly on the city outskirts, residents often turned entire stretches into patios and gardens until the streets disappeared, provoking a firm reaction from the authorities to reclaim public property.

From the first, the participation of indigenous people in construction was essential. With the passage of time, bricklaying and masonry work rested exclusively with the Indians, particularly in areas where indigenous people were numerous, and where they possessed a solid building tradition. To this group fell not only the tasks of construction, but also those of provisioning the market, cleaning the city, carrying water to homes from public fountains, and countless artisanal tasks and services that facilitated the daily activity of the settlements.

EVANGELISM AND CIVILIZED LIFE

The conquest of the Americas was driven by religion and by greed. It could be said that the fervor of the reconquest of Muslim lands in Spain leaped the Atlantic and, intensified by the thirst for gold, riches, and fame, overran entire continents, in the process confronting a host of natural hazards and an immense variety of peoples and cultures.

The reconquest had significantly strengthened the position of the Spanish crown, placing the church in the New World largely in the service of Madrid rather than Rome. In return for defending the interests of Pope Innocent VIII in Italy, King Fernando (whom he named "Catholic Majesty") was given the right to present his candidates for the most coveted clerical posts. In 1508, Pope Julius II broadened royal patronage rights to encompass the church in the New World, particularly as related to ecclesiastical postings.[17] Because the crown directly managed all ecclesiastical affairs—deferring to Rome only on doctrinal issues—it had total control over the Americas. As the historian Federico González Suárez observed, "all spiritual authority came to rest in the hands of the monarch and his subordinates."[18] The Christianization of subjugated nonbelievers became one of the primary motives of the conquest, especially once the Council of Trent (1545/63) acknowledged that indigenous peoples were valid subjects for salvation and that, because they possessed the free will to distinguish between good and evil, "Old Christians" (as those claiming to be free of Jewish or Islamic ancestry were called) had a duty to indoctrinate them.

Once the land was discovered, pacified, and controlled through the establishment of urban centers, the crown and the Spanish settlers immediately launched an intensive effort to "civilize" the indigenous peoples. This effort permanently clashed with the worldview and survival systems that had been developed over millennia by the people of the Americas. However, little by little, they were converted to the Christian faith and compelled to live in a "civilized manner," so that their social and economic structures could be adapted and modified for the benefit of the Spanish and the colonial system. The result was a manageable structure based on exploitation, although an endless number of elements native to the subjugated cultures survived.

In fact, the colonial system triumphed quickly in the areas where advanced indigenous cultures had developed—the Aztecs in Mexico, the Chibchas in Colombia and Panama, and the Quechuas in Peru—primarily owing to the high population density and the native people's cultural development and social organization, which were compatible, adaptable, and exploitable by the settlers. Another key factor in the success of the Spanish conquest was the quality of the land and climate, which allowed for the extensive cultivation of the most important crops of Europe (wheat, barley, and fruit trees) and the Americas (corn and potatoes), as well as the raising of cattle, sheep, horses, and pigs. The indigenous people who took care of these crops and animals were to be treated according to the model established in Spain for vassals of the monarchy. In the words of the king: "The Indians were free and as such it has been and always

will be my will that they be treated, and that they serve only in those areas and in the manner in which, in these our kingdoms, we have been served by our vassals."[19]

THE INTERNAL STRUCTURE OF THE COLONIAL CITY

In the classical model of the Spanish American city, the main square acquired exceptional importance, as it generally lay at the center and therefore became the heart of the city (fig. D-9). City life flowed toward it, and its perimeter was occupied by buildings representing civil and ecclesiastical power: the Spanish cathedral or parish church, the city hall, the episcopal palace or house of the parish priest, the office of the governor, and the Royal Court of Justice or the viceregal palace.[20]

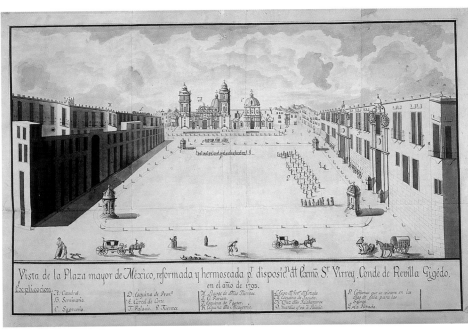

FIG. D-9

View of the Main Square of Mexico, Reformed and Embellished by Order of His Excellency, Grand Viceroy, Count of Revilla Gigedo, 1793. Archivo General de Indias, Seville (México, 446)

From the beginning, the city center was very important, because each resident received a plot of land whose size and proximity to the main square depended on his contribution to the conquest. As the city developed, the Spanish and Creole populations that settled there enjoyed greater or lesser social status in accordance with the proximity of their homes to this center. But as Ramón Gutiérrez points out: "paradoxically, the indigenous people 'lived' in the plaza more than the Spanish themselves."[21] The indigenous population, without residing in the center of the city, spent more time there, since the tasks of provisioning and maintaining the city, as well as the trade in goods that took place in the square, among many other jobs, fell to them. According to Miguel Rojas-Mix, the urban development model mirrored that of a society in which a sense of fellowship was applied in full and where, rather than being excluded, indigenous people were integrated into the social model.[22] If indeed the crown's intention was to create two separate "republics," it does not mean that this intention was fully realized. In constructing the social order, the colonizers did not exclude the indigenous population from the system by isolating them, for example, on reservations; on the contrary, they integrated them into a clearly defined and rigid caste society, that is, one in which they could not improve their station.

The city was an open space that allowed Indians and blacks to enter. And although the imposed caste system was completely impermeable, it did serve to acculturate the Indian. The indigenous population lived in peripheral districts of the cities—where there was a parish church for religious observances, a house for the curate, and a cemetery—or in nearby villages. They came into the cities each day in order to fulfill their duties or trade their goods; but there was also a large indigenous population that lived inside the houses of the Spaniards, the Creoles, or those of mixed race, working as domestic servants, wet nurses, cooks, water carriers, and so on.

The city center was encircled by residential neighborhoods that were also home to convents and monasteries, which were situated far enough apart so as not to interfere with each other. These generated a client relationship with the surrounding neighborhood. Sometimes plazas were located in front of these institutions, bringing together a variety of activities and functioning as a temporary staging ground for festivals, processions, bullfights, or specialized temporary markets (fig. D-10). The presence of monasteries not only brought order to the urban space, but also provided services to the population. In addition to spiritual activities, the churches provided medicine through their apothecaries, education through their schools,

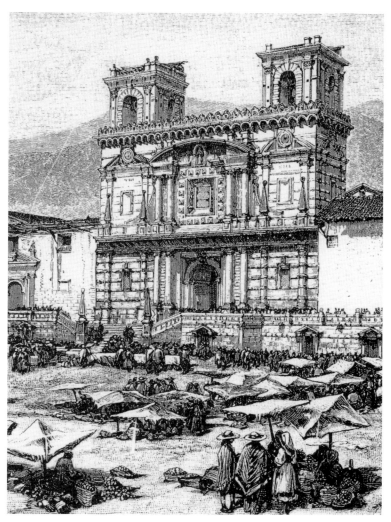

FIG. D-10
The plaza and facade of the Church of San Francisco
de Quito, mid-nineteenth century. Engraving.
Colección Frisa Ilustrativa

and surplus water via a public fountain in the plaza, since the city council generally granted religious communities the permanent right to an abundant supply of water; it was not unusual for cloistered nuns to make sweets, liqueurs, and fine handicrafts and market them to the public beyond the walls by means of a winch. The sheer size of these religious establishments often altered the flow of roads within the grid layout of the city.

Many convents and monasteries developed strategies for attracting wealthy families, offering them burial spaces, which they sold at high prices, requiring further that the buyer build the underground burial vault and often erect an altar and altarpiece, depending on the space allotted and the wealth of the title holder. In this way, the religious communities were able to capture economic resources and to artistically enrich the interiors of their temples.

The residential areas surrounding the city center also contained parishes inhabited by whites and mestizos. Their churches were generally simple, with a single nave, and beside them lay the cemetery where parishioners were buried. Indian parishes were located on the perimeter of the city and were obviously quite numerous in areas with a dense population of indigenous people, such as Upper Peru, Guatemala, and Mexico. These neighborhoods arose as a result of the displacement of the native population to the periphery, the spontaneous settlement by "foreign" indigenous people living a "free" life (see below), or the forced mobilization of laborers for the mines, as in the case of Potosí (Bolivia).

As an outgrowth of the medieval experience in Spain, the system of *encomiendas* (the granting of land and indigenous inhabitants to a settler) was established in some regions of Spanish America from the outset of colonization. Indigenous people subject to an *encomendero* paid him an annual tribute, and in exchange were supposed to receive material and spiritual protection, that is, instruction in living a *vida en policía*, or "civilized life," and indoctrination in the Christian faith. They were required to remain within their ethnically defined territories, devoted to their day-to-day activities: agriculture, animal husbandry, and some artisanal activities such as textile weaving or the production of ceramics. *Indios forasteros* (foreign Indians) was the term for those indigenous people who, for various reasons, had abandoned their communities and lived "free," or without being subject to an *encomendero;* since they did not have to pay tribute, they were free to sell their labor.

On the periphery of cities the grid tended to blur because there was less construction, and the streets became paths. This was the preferred location for what city dwellers considered nuisance activities: slaughterhouses, tanneries, textile mills, fulling mills, grain mills, and so on. Urban planning regulations also recommended that hospitals and quarantine facilities be located on the outskirts of the city "for patients with contagious diseases . . . in part so that no evil wind passing through it could harm the rest of the population" noted Article 121 of the Ordinances of Felipe II. Artisans' workshops, such as tile, brick, and pottery ovens, were also installed on the outskirts, while inns and boarding houses were built along the access roads.

Far from the bustling center, at the very edge of the city, the male religious orders maintained alternative monasteries or retreats, where they sought to attain spiritual perfection through isolation and prayer. (The Jesuits did not have such facilities, but they built houses in various cities where lay people could devote themselves to their spiritual practice.) Hermitages associated with particular saints were also established beyond the walls of the cities, and

shrines—generally great stone or wooden crosses—were erected along city access roads, thereby "Christianizing" the landscape; they were sometimes built on top of pre-Hispanic temples and other sites of cultural significance to indigenous peoples. Occasionally, a Way of the Cross, marking the stations of the Via Dolorosa (Christ's route from Pilate's judgment hall to Golgotha), was created along a processional path that ascended to the summit of a hill. Pillories and gibbets, generally made of stone and crowned by a cross, the symbol of justice and faith, were not uncommon in the settlements. These medieval symbols of jurisdiction represented the appropriation of territory and could also be found at sites where the physical execution of justice was carried out.[23] Finally, public pastures were located in the areas immediately surrounding the city, with fields for cereal grains beyond them.

In coastal communities, the ordinances recommended that the main square face the port, but otherwise, the internal structure of these towns was as described above. By their nature, port cities boasted facilities specifically designed for the movement of cargo and passengers: warehouses, shipyards, rope- and sail-making shops, and so on.

RESIDENTIAL ARCHITECTURE

Residential architecture in the Spanish American colonial city was generally subordinate to the monumental architecture of the church, although in viceregal seats such as Mexico City and Lima it was not uncommon to find small palaces belonging to the local Spanish and Creole nobility, who were generally accustomed to living in luxury. The ordinary Spanish house, derived from the Mediterranean patio house with its corresponding Muslim influences, was cleverly adapted to the diverse climatic conditions of Spanish America. The result, with the rooms of the house opening onto corridors surrounding a central patio, was a simple and practical dwelling that satisfied the family's need for shelter, security, and privacy using modest materials that were readily available in each region. The adaptation of this model was so successful that it survived across generations with few modifications, save for commonsense upgrades and decorative improvements specifically related to changing fashions. The patio house was eventually consecrated as the prototypical urban home, becoming a tradition in many parts of the Americas until the beginning of the twentieth century (fig. D-11).

In the early years most colonial townhouses were single-story dwellings, although a second floor could be added to provide additional space or to improve a family's social standing; such a two-story dwelling was known as a *casa de altos* (elevated house). The space inside the one-story house was organized in the same manner as in the two-story house: an entrance hall led to corridors with columns or pillars surrounding a central patio (fig. D-12); the rooms opened onto the corridors. If the lot was deep enough, other patios, or even stables and gardens, were built in behind. With the increasing density of the city centers, these service areas disappeared and, instead, more patios and rooms were built. The model was adapted to the circumstances of each site. In the *casa de altos*, the owners usually lived on the upper floor, while the downstairs rooms facing the street were allotted to shops, and the back rooms housed servants, slaves, and storage areas. The most exclusive spaces in these houses included the balcony, which was often enclosed with lattice windows, the great hall, and the family oratory, the last-named a common feature of the house that was used for devotional practice and that, depending on the status of the owners, could come to contain a treasure trove of art. There was a marked rural influence evident in these homes, which featured a front porch with benches along the sides designed to facilitate various artisanal or domestic tasks.

It was not unusual to find a shantytown on the peripheries of the cities, inhabited by the indigenous population. The homes of the indigenous people were generally very simple, built by the people themselves out of relatively unprocessed materials that were readily available, such as clay, adobe, wattle and daub (*bahareque*), wood, or *guadua* (a variety of bamboo); roofs were thatched with palm leaves or straw over round logs, depending on the site, the climate,

FIG. D-11
A group of dwellings in the sector of the plaza of San Francisco, Quito, Ecuador

FIG. D-12
Central patio of a house in Quito, Ecuador

and the availability of materials. These one-story dwellings consisted of a single room that served all the occupants' needs. Whenever the settlers possessed greater economic resources, they tried to emulate urban homes, using better, costlier materials such as baked clay tiles for the roofs, and improving the spatial arrangement.

As we have seen, the most desirable residential area of the city was around the main square and, to a lesser degree, around the plazas fronting the convents and monasteries. These were densely occupied areas where the original plots of land that comprised each block were completely built up. Nevertheless, in the early years of the colony, it was not unusual for the homes of the wealthy to have a courtyard, a backyard, vegetable gardens, and stables.

THE ROLE OF THE CHURCH IN COLONIAL SOCIETY

The profound piety of every stratum of colonial society meant that, through various mechanisms, a good part of the colony's profits were funneled into the church and into religious ritual. In a world where religion accompanied a human being every step of the way from cradle to grave, where all ceremonies, whether of transcendent or secondary importance, were marked by the presence of the church, it is not surprising that the cream of society devoted itself to serving God and his representatives on earth. The church was not merely an institution with formidable spiritual control; rather, it sustained its ideological and even political domination through economic power. The fundamental importance of religion was embodied in the thousands of architectural structures spread throughout Spanish America, from the humble mud-and-straw church in the bleak highlands of Upper Peru to the monumental cathedrals of Mexico City or Puebla (eastern Mexico); from the extraordinary baroque temple of Santa Prisca in Taxco (Mexico) to the expressive wooden missionary church in Chiquitos (Bolivia).

By the beginning of the eighteenth century, fully a third of the buildings in the center of cities like Quito were in the hands of the clergy. Religious personnel were equally numerous. According to a report sent by Diego Rodríguez Docampo to the bishop of Quito in 1650, there were some 300 regular clergy in the city alone, with the Franciscans being the most numerous.[24] In addition, some 260 nuns lived in the city in three convents, along with an equal number of novices, lay sisters, female children, and servants. As nearly as can be determined, the

city had 25,000 inhabitants, which means that approximately 3.5 percent of the population of Quito belonged to the ecclesiastical estate.

Because the level of illiteracy remained high throughout the colonial period, church doctrine was taught primarily through sermons and images. As a result, the birth and development of colonial or viceregal art was intimately linked with the teaching of Christian doctrine. The church also took advantage of its fundamental role by teaching singing, reading, and writing. In many cases, this instruction was expanded to include various trades, such as building construction, the fabrication of musical instruments, and the fine arts of painting and sculpture, all in the service of religious worship. These early experiences would later reveal the strength of indigenous and mestizo artists.

The opulence of the churches themselves was designed to impress the faithful and, by extension, other religious congregations, which naturally sparked the urge to emulate the Catholic example. Sculpted and painted images, polychromy, liturgical treasures such as tabernacles, chalices, and ciboria, as well as metal plaques, frontals, and tapestries dramatically transformed the interior spaces of churches and also flaunted their wealth, attesting to the huge economic power that lay behind each congregation.

Preaching was not only directed toward pedagogy; it was also a vehicle for influencing the masses. The same could be said about the practice of disseminating images rich with symbolism and messages. With the reinvigoration gained through the Council of Trent, the church strengthened its use of both word and image, and the pulpit became a substantial element in the church, not merely as a liturgical fixture with a clearly defined function, but also as a symbol of the power of God. Originally a small elevated platform, the pulpit was later endowed with a railing and a sounding board, and it eventually became the stage on which the drama of the spiritual conquest of the Americas was acted out and the faith and the power of the church consolidated. The pulpit was the focal point for sermons in Spanish or in the native languages; this was the place from which Christian doctrine was explained, the faithful were instructed and persuaded, public events were discussed, and personal morals were argued. It is important to make note of this, because the Counter-Reformation was alive and well in the Americas. Following the Protestant Reformation at the beginning of the sixteenth century, the Roman church lost its spiritual and political influence over much of Europe. It responded by undergoing profound changes that were explicitly stated in the resolutions of the Council of Trent, which, among other objectives, sought to win back the church's prestige.

The spirit of Trent spread rapidly throughout the Catholic world and was artistically associated with the baroque, which bore fantastic fruit in the fertile ground of the New World. As Ramón Gutiérrez notes, Spanish American society in the mid-seventeenth century was characterized by the gradual rise of the Creole sector and the integration of the indigenous population, particularly in urban settings. There were a number of reasons for the rise of the Creoles. One important factor was that their numbers increased more rapidly than those of the European-born Spaniards, since once illusions about the New World faded the flow of immigrants from Spain to the Americas remained low. But the Creoles also gained power and social prestige toward the end of the first third of the seventeenth century when they acceded to administrative posts by paying money for them. One could even buy the office of the viceroy, which was put up for sale at the end of the same century. Amid "this 'consolidated' reality rises the superstructure formed from the tensions of Spanish and American social psychology, the affirmation of the socioreligious axis via the Counter-Reformation and the search for the essential concepts of participation and persuasion through the baroque," as Gutiérrez stated.[25] According to Gutiérrez, "the synthesis of the sixteenth century as the buildup and culmination of diverse experiences—the Gothic, Plateresque, Mudéjar, Renaissance and pre-Hispanic— begins to evolve into a different process. Now the emphasis is on integration, not accumulation. The edges blur, that which was subordinate becomes emergent, and the capacity to

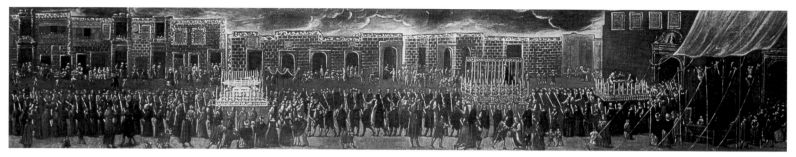

FIG. D-13
Procession in the Main Square of Lima, end of the
seventeenth century—beginning of the eighteenth.
Church of La Soledad, Convent/Monastery of
San Francisco, Lima, Peru

appropriate ideas, concepts, and forms is no longer linear, but rather enveloping and creative,
generating new responses." The church was the point of convergence in this stratified society,
not the state, which was too "remote for a real level of decision-making and too close for
repression."[26]

In its protagonist role, the church encouraged the active participation and collective
expression of indigenous peoples and mestizos through religious celebrations, masquerades,
fireworks, bullfights, and religious processions, and in the handcrafting of triumphal arches
made of reeds, palms, and pasteboard. The baroque spirit of participation and persuasion per-
mitted these social groups to commandeer the streets and plazas—public spaces from which
they were usually excluded in the rigid class structure, which had assigned them the role of
mere manual laborers and suppliers of goods and services, and not that of actors (fig. D-13).

The Spanish empire founded close to a thousand cities over its nearly three centuries
of colonial domination of the Americas. These cities functioned as grand arenas of social inter-
action among the various castes, as well as administrative and religious centers *par excellence*,
loci for the diffusion of culture and education, settings for multiple political and social events,
and junctions in a complex trade network, among many other roles. Cities were fundamental
to the continuing growth and vitality of the Spanish colonies.

NOTES

This essay draws in part on several previously
published works. See Ortiz Crespo and Terán
Najas 1993; Ortiz Crespo 2001; and Ortiz
Crespo 2004.

1. CEHOPU 1989, p. 13.

2. See Roig 1984, vol. 1, p. 30.

3. See, for example, Kubler 1962 *Art and
Architecture;* "Antecedentes" 1989; García
Fernández 1989; Torres Balbás 1968;
Zawisza 1972; and Lluberes 1975.

4. Aguilera Rojas and Moreno Rexach 1973,
p. 11.

5. CEHOPU 1989, p. 12.

6. Ibid., p. 55.

7. Rafael Manzano, prologue, in Aguilera
Rojas and Moreno Rexach 1973, p. 7.

8. It should be remembered that these names
do not necessarily designate the republics
that arose after independence from Spain;
as such, their territorial area was different.

9. See Aguilera Rojas and Moreno Rexach
1973, p. 12.

10. Benevolo 1975, pp. 112–13.

11. Hardoy 1975, p. 30.

12. Aguilera Rojas and Moreno Rexach 1973,
p. 12.

13. The study was published in Aguilera Rojas
and Moreno Rexach, pp. 19–23, and pre-
pared by the architects Javier Aguilera
Rojas, Joaquín Ibáñez Montoya, and Luis
J. Moreno Rexach. It served as the basis
for the classification of thirty-eight sites in
Spanish America, whose historical layouts
were reproduced from the depths of the
Archivo General de Indias in Seville and
the Archivo del Servicio Histórico Militar,
in the same work.

14. Salvador Lara 1992, pp. 74–75.

15. *Cabildos de Quito* 1934, vol. 1, pp. 67–68.

16. Ibid., pp. 207–8.

17. See Rodríguez García and Castilla Soto
1998, p. 108.

18. González Suárez 1971, vol. 2, p. 1376.

19. Vargas 1982, p. 247.

20. For a detailed study of the significance of
the main square, see Rojas-Mix 1978.

21. Gutiérrez 1983, p. 90.

22. Rojas-Mix 1978.

23. See Fagiolo 1975, p. 30.

24. Rodríguez Docampo (1650) 1994.

25. Gutiérrez 1983, p. 103.

26. Ibid.

The Black Hand:
Notes on the African Presence in the Visual Arts of Brazil and the Caribbean

Edward J. Sullivan

PROLOGUE: A TRI-CULTURAL *ZEMI* FROM HISPANIOLA

The Museo Nazionale Preistorico Etnografico Luigi Pigorini in Rome houses one of the most compelling and enigmatic objects of Caribbean art from the earliest years of the colonial era. The *Beaded Zemi* (fig. E-1), which scholars now believe was created on the island of Hispaniola (present-day Haiti and Dominican Republic) around 1515, has been exhibited recently as an example of the highest point reached by the artists of the Taíno nation.[1] The Taíno, whose origins may be traced to mainland South America, inhabited the Greater Antilles until their precipitous decline by the mid-sixteenth century due to the effects of their enslavement by the Spaniards and the ravages of European diseases. In addition to its significance within the history of the liminal period of American art that straddles indigenous hegemony and Iberian domination, this *zemi* (a figure embodying the spiritual forces of the Taíno pantheon) is also a powerful indicator of the early and profound presence of African material culture in the New World.

Although the sculpture is modest in size, its visual impact is commanding. This anthropomorphic figure is meant to be seen from both front and back. It is endowed with a human face on the "front" and a skeletal, demonlike visage on the reverse, probably referring to the good/evil duality in human nature, as well as the contradictory qualities of the natural and the spirit realms. The *zemi* is composed of a wooden armature encased by a crocheted cotton covering onto which Caribbean shells and a mosaic of beads have been applied. The beads, as well as the tiny mirrors that form part of the skeletal face on the reverse, are of European (most likely Venetian) origin, yet the patterns they form are reminiscent of those on some African textiles. The human face of the *zemi* was carved from the horn of an African rhinoceros.

Recent scholarship suggests that this figure was created in the second decade of the sixteenth century, after the Taíno had come into contact with West African slaves (and with European soldiers and settlers), who introduced the Taíno to their design patterns.[2] The use of rhinoceros ivory indicates that even at this early date after the initial American-European contact, African luxury items were imported to the Caribbean. This *zemi* serves as an authoritative

Detail of fig. E-8

FIG. E-I
Beaded Zemi, Dominican Republic, c. 1515.
Wood, cotton, shell, glass beads, and mirrors,
height 12⅝ inches (32.1 cm). Museo Nazionale
Preistorico Etnografico Luigi Pigorini, Rome

metaphor for the impact and integration of African materials in a New World context. It also marks the grandeur of the Taíno, an almost completely lost ancient civilization; as an adumbration of the cultural and spiritual significance of African forms in the shaping of American art; and as a virtual icon of the artistic miscegenation that lies at the heart of the material achievements of the colonial era.

THE BLACK HAND AND THE FLASH OF THE SPIRIT

The term "black hand" in the title of this essay serves both as a bibliographical reference and as a personal homage to Emanoel Araújo, an artist, art historian, critic, and museum professional whose work, in the form of documenting, explicating, and collecting art created by or depicting Afro-Brazilians from the colonial era to the present, has been critical in disseminating knowledge of one of the most significant aspects of the Brazilian aesthetic and historical experience.[3] The numerous exhibitions organized by Araújo have all presented ambitious panoramas of the visual and performing arts created by, influenced by, and representing people of African heritage in Brazil.[4] He has maintained a deep interest in the development in the colonial period of a vocabulary of images in Christian arts that bore the stamp of the *orixas* (spiritual forces) of Yoruba-based Candomblé, Umbanda, and other belief systems that migrated westward from Africa.[5] These syncretistic images arose from the necessity among slaves of concealing the visual concomitants of their transatlantic beliefs. This was also true in the Caribbean and other areas of intense black settlement and religious presence. After the abolition of slavery, Afro-Brazilian arts became increasingly direct in their references to African origins, and thus, for example, contemporary altars overtly honor the Afro-Brazilian deities and spirits and are steeped in the cosmologies of African religions.

Araújo has also been an assiduous gatherer of Afro-Brazilian material, first for his personal collection, but always with the intention of creating a museum where the public could have permanent access to a significant body of work by and depicting black Brazilians. The Museu Afro-Brasil, with Araújo's collection at its core, was formally established in 2004 in the Manoel de Nóbrega Pavilion in Ibirapuera Park, site of São Paulo's Bienal since the 1950s. The museum serves a highly important function in both highlighting the inextricably important black element within Brazilian visual arts and culture and serving as a constant reminder of the shameful circumstances in which Africans were brought to the country.

Araújo's vision parallels that of Robert Farris Thompson, another key critical voice who has served as a source of constant inspiration for scholars of African-American art worldwide.[6] Thompson received his doctorate at Yale in 1955 and has remained affiliated with the university ever since. He has written several of the most widely read studies of the diffusion of African visual culture within the Americas. His investigations encompass the colonial era and the beginnings of slavery, including its consequences for transatlantic material culture and its ramifications for modern and contemporary times. His 1983 book *Flash of the Spirit: African and Afro-American Art and Philosophy* is a broadly based investigation into the palpable and spiritual presence of Africa in the Americas.[7] It is significant that many of Thompson's most important academic achievements have been made in the realm of museum exhibitions and catalogues, as this has been a common phenomenon within the development of the history of the art of the Americas. Among his most outstanding accomplishments has been the 1993 exhibition and book *Face of the Gods: Art and Altars of the African Americas*, in which Thompson offered a precise analysis of the transcultural nature of these public and private vortices of worship.[8] That same year, Thompson's essay (accompanied by the photography of Phyllis Galembo) in the book *Divine Inspiration: From Benin to Bahia* provided a compelling source for anyone interested in the vital links between Africa and Brazil.[9]

The work of Araújo and Thompson has created entirely new ways of conceptualizing the interpenetrations of African modes of visualization into the context of New World experience.

Without the example of their scholarship the efforts of other researchers in this field would be inexorably impoverished.

AFRICA IN THE AMERICAS

The arts of the Americas during the long era of European domination, like those of any place or time, must be examined through the widest possible lens, taking into account the relevant geographical, social, political, and historical factors.[10] Contemporary scholarship on colonial Latin American art has become richer and more nuanced with every generation of researchers. Beginning approximately in the last two decades of the twentieth century, scholars in this field became disillusioned with art historical analyses that relied solely on empirical evidence as it pertained to individual works of art or to the limited and often stereotyped notions of stylistic "development" and iconographical patterns. In the most innovative writing in the field, academics and museum professionals alike continued to peel away the many layers of heretofore unanalyzed information about the place of painting, sculpture, architecture, and graphic work within the fabric of colonial society in the Spanish- and Portuguese-speaking Americas. Many of the most important examples of visual culture from the Caribbean territories, the European colonies of New Spain and Peru, and the other provinces of the South American mainland do not fall into any conventional definitions of "high art." Several of the key instances of artistic intervention that I discuss below might be described by some critics as "popular," "folk," or "anonymous" art. Yet these objects, which are sometimes utilitarian and at other times highly symbolic embodiments of spiritual power, often serve as the most potent barometers of cultural exchange and transformation.

The sections that follow will address, in the broadest possible terms, issues stemming from the complex question of African intervention within the panorama of colonial art. As in the case of the impact of Asian elements on the material and visual cultures of the Americas in the viceregal era (see Gauvin Alexander Bailey's essay in this volume), the question of the African presence and its bearing on articles of New World manufacture has been analyzed with evolving sophistication and nuance by scholars in recent decades. It is an immensely important theme, one that lies at the backbone of many cultures in the Americas. In the case of Caribbean and Brazilian colonial cultures, art produced by Africans and those of African descent from the sixteenth through the nineteenth century, as well as forms of artistic production—including domestic objects but also "official" or ecclesiastical art—rooted in categories of utilitarian or aesthetic manufacture developed in Africa, comprise some of the quintessential components of the colonial visual experience. In this essay I will concentrate on these two cultural focal points. First, I will examine art objects in a variety of media that reflect the direct impact of African ways of seeing and employ materials that recall African modes of manufacture. Second, I will examine some depictions of Africans and people of African heritage within the representational arts of the Caribbean and Brazil, as well as some key art historical monuments of the colonial era created by Afro-Caribbean and Afro-Brazilian master painters, sculptors, and architects.

Before looking at any specific works of art, it is necessary to stress a point regarding nomenclature that is as fundamental as it is overlooked. In the United States and Europe, terms such as "Latin America," "Asia," or "Africa"—phrases of convenience to define large geographical areas—often turn into catch-all axioms to signal exotic "otherness" within the context of conversations about culture. In studying the older literature on the art of the Americas, for instance, one often comes across phrases such as "African influence" or "Asian" (or even "Oriental") "inspiration" to define a vague set of characteristics associated with places outside the area under consideration. More recently, scholars have taken greater care to explicitly define such influences, pinpoint their sources of origin, and decode their meanings. There are, of course, many "Asias" and many "Africas," just as the Americas are composed of a multiplicity of (often radically diverging) cultures.

In the case of Africa, much of the material culture that reached the Americas directly (as opposed to the indirect importation of African objects via Europe) came from the western part of the continent. Unlike Asian goods such as textiles, ceramics, lacquerware, and paintings (e.g., screen paintings known as *biombos*), which were imported *as* luxury arts, principally through the trade route of the Manila Galleon,[11] relatively few African items were imported as aesthetic objects per se. While knowledge of Asia, as well as concrete objects of Asian manufacture, came to the New World during the course of trade relations, from the mid-sixteenth to the late nineteenth century "Africa" had one principal connotation in the minds of the inhabitants of the Americas: it was the source of slave labor. The slave traffic between Africa and Brazil, for example, started in the early sixteenth century and did not end until 1851, and slavery itself was not outlawed until 1888.[12] What reached the New World directly from Africa in the early phases of the development of the slave system were mostly small and ephemeral objects of wood or metal, not "works of art" in the conventional sense. But more important, in many ways, than the items themselves were the memories of how they functioned, the materials from which they were made, and the practical or spiritual purpose they served. The transmutation and accommodation to new geographical and social circumstances undergone by material objects propelled them into new realms of existence. Yet, perhaps the most transcendent transatlantic migrations were not those of the objects themselves but rather what we could call spiritual essences or ethereal presences, which continue to travel within the constantly refigured diasporas that crisscross the Americas and, with the help of contemporary forms of communication, return to Africa in new forms.

The powerful presence of African spiritual beliefs in an American context—what Thompson calls the "flash of the spirit"—is manifested in a multitude of objects that refer to the *orishas* (*orixas* in Portuguese), or forces of spiritual power that were born within a West African context and took on new dimensions, names, and additional levels of personality when

FIG. E-2
Afro-Brazilian *oratório*, Minas Gerais, Brazil, nineteenth century. Painted wood, 24¼ × 15¼ inches (61.6 × 38.7 cm). Museu do Oratório, Ouro Prêto, Brazil

coming into contact with the (sometimes nominally) Christian cultures of places such as Brazil or Cuba. Brazilian *oratórios* offer a case in point. These domestic shrines or private altars, fashioned from polychromed wood and imitating the architectural styles popular in the eighteenth and nineteenth centuries, usually contain images of Christ, the Holy Family, or the saints. Some of them are substantial in size, while others, especially those made for traveling and provided with doors that enclose the central image, are modest or even miniature. The Museu do Oratório in Ouro Prêto, Minas Gerais, is the largest single repository of Afro-Brazilian *oratórios*. Comprising the Angela Gutierrez Collection, the museum houses outstanding examples of home altars that embody the dynamic religious *métissage* (hybridization) of West African and Catholic belief systems (fig. E-2).[13] These Afro-Brazilian examples contain images of the saints (including the "black saints," on which I will comment shortly), as well as additional items such as coins, jewelry, and charms, which may be understood both as objects of everyday or popular cultural use and as embodiments of the spiritual powers or specific talismans associated with the *orixas* of Candomblé and other Afro-Brazilian religions.

Oratórios played a vital role in domestic religiosity, serving as the focal point for familial devotions such as novenas (a nine-day period of prayer practiced by Catholics), or as miniature

chapels within the recesses of the bedchamber. In the Afro-Brazilian examples, not only the specifically religious content of the diminutive altars, but also the form of the carved images included within them recall modes of African manufacture. While the overall format of the Gutierrez *oratório* may derive from Western categories of religious visual expression, the art of fashioning human and animal figures from wood was equally related to traditions imported to Brazil from West Africa. This is also evident in the widely popular carvings of saints (*santos*) and ex-voto images (called *milagres*, or "miracles") that form an integral node of intersection between Christian imagery and African-based artistic practices.[14] Many cultures throughout the world have fashioned objects that are imbued with spiritual power and carry with them specific meanings as offerings of thanks for favors received from deities. Brazilian votive sculptures have an especially visceral impact. Ex-voto images (a genre whose surviving examples are principally from the nineteenth and early twentieth centuries) play a significant part in any discussion of Afro-Brazilian imagery, and their importance for postcolonial spirituality continued to imbue them with emotional and visual vibrancy until recent times. Linked as much to the traditions of African carving as to Western (and, specifically, Mediterranean) sacred imagery, ex-voto images come in many forms, most often depicting human figures or parts of the body (fig. E-3),[15] though ex-votos in the shape of animals or inanimate objects associated with rural life, such as farm implements, are by no means uncommon. All of these small sculptures were created as offerings for the cure of a person or animal or for other miracles attributed to the divine intervention of a saint. Many of these Brazilian *milagres* would be deposited in a "house of miracles," a room devoted to them within a church. The spiritual power ascribed to these images parallels that of the fetish objects so critical to the sacred material culture of many African peoples. The links between these forms of religious commodity within the transatlantic dialogue occasioned by the institution of slavery are unavoidable facets of the circulation of objects in the colonial and post-colonial eras in the Americas.

Wood carving often provides a barometer of the inextricable melding of the African past with the American present in colonial forms of visual expression. While the Brazilian examples offer clear indications of the amalgam of transnational material cultures, others from the Caribbean are equally potent. In Puerto Rico, as in other parts of the Americas, the tradition of carving small wooden *santos* was one of the principal embodiments of popular spirituality in the colonial period (and later). The rich visual vocabulary and extensive iconographic repertory of these images have been discussed from a variety of points of view by numerous scholars, among them the critic Marta Traba.[16] Traba analyzed *santos* from the perspective of their relationship to the Spanish metropolitan traditions of polychromed *tallado* (carving) that has its roots in the Middle Ages. Its manifestations in the seventeenth and eighteenth centuries produced such universally recognized artists as Juan Martínez Montañés (1568–1649), Juan de Mesa (1583–1627), Luisa Roldán (1650–1704), and many others. The (often anonymous) Puerto Rican *santos* created by artists far removed from an academic tradition equally embody, as Traba argued, a rebellion against the canonical proportions and accepted European values of "beauty" or "quality" to exemplify a sui generis mode of creativity. As in the case of Brazilian ex-voto carvings, the Puerto Rican figures play a key role within the domestic spirituality of their creators and their owners. The saints are often considered essential components of the household and are integrated within the familial realm as protectors and guides of both devout and mundane activities. Throughout the years the *santos* acquire the physical marks of ownership, in that they are often repainted (sometimes in different colors from one generation to another) to signify the shifting nature of their owners' aesthetic personalities. Puerto Rican *santos* perform—in both the literal and the figurative sense—a highly important role in their domestic settings. If an individual or family prays for the *santo* to come to their aid in a given situation and it does not, the figure is turned against the wall, *castigado* (punished) until the desired favor is granted. While the performative nature of these saint images has been analyzed

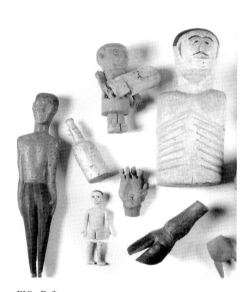

FIG. E-3
Ex-votos, Brazil, nineteenth century. Wood.
Vilma Eid Collection, São Paulo, Brazil

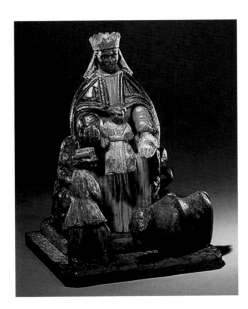

FIG. E-4
Virgin of Montserrat/Miracle of Hormigueros, Puerto Rico, nineteenth century. Painted wood. National Museum of American History, Smithsonian Institution, Washington, D.C., Teodoro Vidal Collection

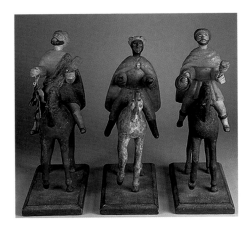

FIG. E-5
The Three Wise Men, Puerto Rico, nineteenth century. Painted wood. National Museum of American History, Smithsonian Institution, Washington, D.C., Teodoro Vidal Collection

from a sociological point of view, it is equally significant for what it indicates about some of the fundamental roots underlying the meanings *santos* have acquired within Afro-Caribbean society. *Santos* may be linked to the many wood-carving conventions brought to the Americas during the era of slavery. I do not wish to deny their relationship with European sculpture, but I would suggest that a richer, more nuanced understanding of these quintessential contributions to the colonial art of the hemisphere emerges when we recognize some of the parallels they have with the physicality and even theatricality of many works of African art (masks, fetish objects), which may be inert in themselves but are viable as objects of power once they are utilized and placed (literally and/or figuratively) in motion.

Within the history of Puerto Rican *santos* there are several iconographies that have significant local associations and, in addition, underscore the important role of black culture within visual traditions of the island. Best known among these is the image of the Virgin of Montserrat (also called the Miracle of Hormigueros; fig. E-4). In 1599 a peasant named Gerardo González from the countryside near the village of Hormigueros (in southwest Puerto Rico) was menaced by an enraged bull. Afraid for his life, he prayed to the black Virgin of Montserrat, a medieval advocation of Mary venerated at the famous shrine of the same name near Barcelona, and she appeared with the Christ Child. The bull suffered a broken leg before attacking González, who later founded a church in the Virgin's honor in Hormigueros. This black Virgin subsequently became the patroness of the island. A second extremely popular *santo* image is that of the Three Wise Men, the kings from Asia and Africa who visited the Christ Child at the place of his birth in Bethlehem (fig. E-5). The black Magus, Melchior, is much revered in Puerto Rico, a country that has special reverence for the Three Wise Men. According to folklorist and historian Teodoro Vidal, "no other country in Spanish America . . . has as many depictions of the Three Kings as the ones found [in Puerto Rico]."[17]

Blackness permeates the art historical experience in the colonial Americas, as it does the social fabric of the hemisphere, from the first instances of slavery's scourge to its final moments in the late nineteenth century. The terror of displacement made all the more poignant the presence of those material goods that managed to survive the Middle Passage. Much of the African-based visual culture of the Americas during the long colonial era (which, of course, did not end until 1898 with Spain's loss of her last two American colonies, Cuba and Puerto Rico) was born of pain itself. In public institutions in the Americas devoted to the history of slavery, such as the Kura Hulanda Museum in Willemstad, Curaçao, we may observe the material heritage of slavery in the form of shackles, manacles, yokes, and other implements of corporeal oppression and physical abuse. The horrendous circumstances in which an estimated 9 to 18 million Africans were transported to the New World, as seen in diagrams of slave ships such as that published in Thomas Clarkson's well-known anti-slavery treatise, could not be erased from the collective consciousness. Such physical torments often left indelible marks on the visual imagination, evident in the iconography of colonial art in the Americas.[18]

In a lithograph from 1834–39 Jean Baptiste Debret (1768–1848), who studied with the French neoclassical artist Jacques-Louis David (1748–1825) and was active in Brazil from 1816 to 1831, depicts the punishment for a runaway or recalcitrant slave (fig. E-6, top).[19] Flogging at a public whipping post (*pelourinho*), often located in the center of town (as in the old Pelourinho district of Salvador da Bahia, perhaps the spiritual nexus of the unbreakable umbilical cord linking Africa and Brazil), was one of several common forms of castigation for slaves who had attempted to escape or had performed some other misdeed.[20] (Another, equally humiliating method of punishment is seen on the same page [see fig. E-6, bottom], in which Debret depicts several slaves with their legs locked in wooden stocks languishing in a jail cell.) It is not surprising, therefore, that the extended and bloody episode from the

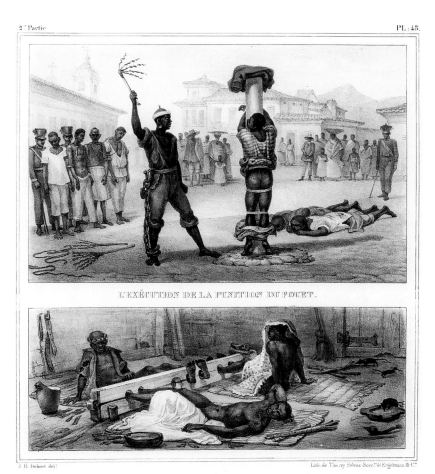

L'EXÉCUTION DE LA PUNITION DU FOUET.

NÈGRES ÀO TRONCO

FIG. E-6
Jean Baptiste Debret (French, 1768–1848),
*L'exécution de la punition du fouet; Nègres ào [au]
tronco* (Slave being whipped; Negroes in stocks)
from *Voyage pittoresque et historique au Brésil* (Paris:
Fermin Didot Frères, 1834–39), pt. 2, plate 45.
Hand-colored lithograph. Print Collection, Miriam
and Ira D. Wallach Division of Art, Prints and
Photographs, The New York Public Library, Astor,
Lenox and Tilden Foundations

Passion when Christ is tied to the column and whipped became a particularly cherished scene in the visual hierarchy of Afro-Brazilian spirituality. Numerous examples of this iconography are found in the art of colonial Brazil, especially by the hands of masters from the eighteenth- and nineteenth-century centers of northeast Brazil, where the African impact was most profoundly felt. These images stand not only as paradigms of Christ's mortification and steadfastness, but also as highly charged metaphors for the physical suffering and spiritual redemption of Afro-Brazilians. Perhaps one of the most outstanding examples is the highly dramatic work (see cat. v-48), now in the Museu de Arte Sacra of the Universidade Federal da Bahia in Salvador, Brazil, by Manoel Inácio da Costa (c. 1763–1857), who has been called the most outstanding sculptor of his generation by art historian Myriam Andrade Ribeiro de Oliveira.[21] In this work Christ's massive hands strain at the (real) ropes that bind him to the column. His bloodied, muscular body presents a combination of resignation and imminent triumph over pain and servitude.

AFRICANS AS SUBJECTS

The earliest surviving depictions of Africans in the Americas are in paintings by Europeans. Perhaps the first such representations of Africans in a New World setting were those by Albert Eckhout (c. 1610–1665), the Dutch painter who traveled to northeast Brazil in the retinue of Prince Johan Maurits van Nassau Siegen. Between 1637 and 1644 Johan Maurits served as governor of the province of Nieuw Holland, which had been established in February 1630 by the Dutch West India Company in the region comprising the present-day cities of Recife and Olinda (and the island of Antonio Vaz).[22] This cultivated ruler established two palaces there, complete with botanical and zoological gardens, and brought scholars, scientists, and several artists with him to the Dutch outpost. The two painters were Eckhout and Frans Post (1612–1680),[23] whose landscapes painted in situ represent the earliest on-site renditions of the American terrain. The National Museum in Copenhagen now houses the series of twelve large-scale still lifes by Eckhout in which New and Old World fruits and vegetables are depicted together, serving as metaphors, according to art historian Rebecca Parker Brienen, of the desired peaceful convergence of the cultures (fig. E-7).[24] Also in the Copenhagen museum are Eckhout's twelve "ethnographic portraits" representing the various racial "types" found in Brazil, including individuals indicative of the miscegenation, or blending of races, in colonial society. While it is unclear whether these pictures were executed in Brazil or in Holland after the artist's return, they were the products of his direct observations in northeast Brazil.[25] Danish historian Mogens Bencard has argued that these paintings were intended as models for tapestries, and there are indeed elements of theatricality, drama, and even exaggeration in some of them.[26] The ethnographic depictions include male and female figures and, in some instances, their children. This is the case with the two representatives of African groups in Brazil (figs. E-8, E-9). The woman holds an elegant African basket filled with New World fruits and wears an elaborate African hat, possibly of Angolan origin. In her waist is tucked a Dutch clay pipe, a common allusion to prostitution in Dutch Golden Age art.[27] The African man has an elaborate ceremonial sword in his waist and stands next to an African date palm. While the depictions of the objects they hold are realistic, and

FIG. E-7
Albert Eckhout (Dutch, c. 1610–1665), *Still Life
with Gourds, Fruit, and Cactus,* c. 1641. Oil on canvas,
38⅝ × 35⅜ inches (98 × 90 cm). National Museum
of Denmark, Copenhagen

undoubtedly are based on things seen by the artist in Brazil
or Holland, the overall impression of the African family unit
is somewhat puzzling. Africans in Brazil were there as slaves,
brought from the area between the Gulf of Guinea and the
Congo, and not as elegantly adorned individuals with fine
baskets, headdresses, and weapons, as shown by Eckhout.
Nonetheless, these images are significant as monumental
representations of African types whose presence in Brazil
would become, throughout the colonial period and beyond,
a crucial component of society and culture.

While in the bulk of this essay I deal with art and
visual culture from the Caribbean and Brazil, it is instruc-
tive, as a corollary to this material and to widen the frame of
our discussion, to consider some key examples from outside
these regions. In some of these works the subject of black-
ness is dealt with in the most negative possible way, while in
others there is a more "objective" reading of the presence of
Africans or persons of African descent within an increasingly
multiracial society. The series of six paintings executed in
Quito in 1783 by the late-eighteenth-century artist Vicente
Albán show, in a way not unrelated to Eckhout's project
of representation of the racial "types" in Brazilian society,
the various social and ethnic levels of what was then a part
of the Viceroyalty of Peru. The figures are set within landscapes that appear more ideal than
real. They include Africans, Indians, and Caucasians meant to stand for the various regions of
the territory. Curiously, there is an equal emphasis on the objects that accompany the human
figures in the paintings. Each of the "types" stands next to a large table or other support on
which there is an outsized profusion of fruits. Other fruits as well as local birds and animals
complete the scene. One of Albán's paintings, *Lady with Her Black Slave,* depicts an elabo-
rately dressed Creole woman in a heavily embroidered dress, holding a type of hat considered
fashionable by Andean women of the time. Her jewelry includes gold hair ornaments, a choker
of black pearls, and two pendants of pearls and gold. Gold and pearls also adorn her waist.
Behind her is her slave, who motions toward the piece of papaya held by her mistress. The
slave's feet are clad in black stockings, although she wears no shoes. Her elaborate garb (desig-
nating her as a city as opposed to a rural slave) indicates the high social status of her owner,
not the slave's own personal wealth.[28] The woman and slave are, collectively, labeled as exhibit
A, and the inscriptions continue with letters *B* through *F,* signaling the types of trees and fruit
present in the scene.

These Ecuadorian works are inevitably reminiscent of the now well-studied genre of
Mexican *casta* paintings.[29] Principally an eighteenth-century phenomenon, *castas* for the
most part are family scenes depicting the many racial blendings found in New Spain. The
vocabulary of the classifications (most *castas* feature texts describing the details of the *mesti-
zaje,* or racial mix, written directly on the surface of the image) is rich and complex, as many
recondite terms had been devised by the eighteenth century to describe the variety of mixed-
blood categories. The majority of *castas* were done in series of sixteen (or sometimes more)
elements painted individually or (more rarely) on a single surface. The human taxonomies
represented in these series served, in part, as tools to control and classify the collective identities
of a highly complex society that had taken on a multicultural character, far beyond anything
early-sixteenth-century Spanish settlers could have imagined.[30] Perhaps the most convincing
reason for their creation was to suggest a semblance of order to the intricate racial and social

FIG. E-8
Albert Eckhout (Dutch, c. 1610–1665), *African Man*, 1641. Oil on canvas, 104 × 63¾ inches (264 × 162 cm). National Museum of Denmark, Copenhagen

FIG. E-9
Albert Eckhout (Dutch, c. 1610–1665), *African Woman and Child*, 1641. Oil on canvas, 111 × 74⅜ inches (282 × 189 cm). National Museum of Denmark, Copenhagen

combinations found in Spain's most important colony. Sent to Iberia, these concrete almanacs of Mexico's ethnicities created a tangible way of visualizing and understanding colonial life.

While most *casta* paintings serve as harmonious metaphors for the desired amicable co-existence of the multiple levels of society under Spanish rule, certain examples reveal instances of violence. These may be construed as similes of a slowly deteriorating social structure during the waning decades of Iberian hegemony in Mexico. Racial discord is often shown in representations of the mix of Spanish and African blood. According to the codification of the *castas* within eighteenth-century Mexican society, the mixings in which black blood formed a component were the lowest on society's scale. Blackness denoted slavery, and slaves were not accorded any of the social or moral considerations given to other ethnic groups. Whiteness could be re-obtained, it was thought, after several generations of marriage between racial types in all cases except those that involved Africans or their descendants. *De Español y negra nace mulata* (From a Spaniard and a Black Woman Is Born a Mulatta) of 1774 (Museo de América, Madrid) is part of a *casta* series by the late-eighteenth-century Mexican painter Andrés de Islas. As in many similar paintings, the stereotypical hot-bloodedness of the person of African descent is graphically depicted: the black woman is about to hit her white male companion with a hammer or kitchen implement, while their mulatta daughter wails in fear and clings to her mother's skirts.

Secular images such as the ones discussed above should be looked at in conjunction with other depictions of Africans and persons of African descent in the colonial art of the Americas, in order to obtain a more nuanced view of the integral role of black subjects and artists within viceregal societies. In this regard, one of the most significant genres of colonial art is the depiction, in both two- and three-dimensional works, of black saints. Foremost among these is Martín de Porres, the first African-American to be canonized. Born in Lima in December 1597, an illegitimate son of a Spanish nobleman and a freed black slave, Martín entered a Dominican monastery at age eleven. Despite the order's stricture against allowing blacks to serve as monks, he took holy orders and soon became renowned for his devotion to the poor and sick in the Peruvian capital. Martín de Porres died in 1639, and, although he was not beatified until 1873 (and canonized in 1962), he quickly became one of the most venerated figures of sanctity throughout the Americas. Accordingly, the iconography of Martín de Porres forms a rich subchapter of the history of viceregal art. An early representative example is an anonymous eighteenth-century Peruvian painting that depicts him standing in an interior space, wearing the Dominican habit, and holding a broom, his principal attribute indicating his dedication to labor, no matter how menial (Collection of Manuel Mujica Gallo). In this straightforward, compassionate rendition, one is tempted to link Martín's broom with the sword or spike held in the hand of other triumphal saints, such as Saint Michael in depictions of his battles with Satan. Martín de Porres's broom thus becomes a potent symbol of triumph over evil and heresy—as well as social injustice and prejudice.

Such a reading of this saint's attribute may be strengthened when considered in a comparative context with the many black saints whose representations form a critical facet of the visual landscape of colonial Brazilian art. In many parts of the country, including Minas Gerais and northeast Brazil, confraternities were established by and for slaves that had saints of African origin at the core of their cults. Among the most well-known of such confraternities was that of Nossa Senhora do Rosário dos Homems Pretos (Our Lady of the Rosary of Black Men) in Recife, whose church included altars dedicated to Saints Elesbaan, Benedict of Palermo, Anthony of Catalagirona, Moses the Hermit, Iphigenia, and Melchior (the black Magus who visited the infant Christ), all of whom were of African origin.[31]

Saint Elesbaan (Elesbão in Portuguese) was a sixth-century Ethiopian Christian king. He ruled over the Axoum people and was a great adversary of a neighboring pagan monarch, Dhu-newas, the Arabian king of the Hamerites, who vigorously persecuted Christians. Elesbaan later gave up his crown to become a monk and died in about 555. Brazilian baroque images of him, such as an example from the black brotherhood of Our Lady of the Rosary in Olinda, show Elesbaan triumphant over his (white) adversary, holding a small replica of his church in his left hand (cat. v-49). While this is an overt expression of the victory of Christianity over paganism, we may read the rhetorical gesture of Elesbaan (who would originally have had a staff or spear in his right hand) as related to that of Martín de Porres in the Peruvian painting discussed previously. For the slave population of the Americas, the principal audience for whom these images were created, notions of liberation would have meant considerably more than references to the historical emancipation of the Catholic Church from the threat of oppression from other religious beliefs in its early centuries.

Given the number of prominent artists of African descent in Brazil in the colonial period, it seems likely that the creators of black saint sculptures were black or mulatto, although we cannot be certain because the pieces are not signed and there are no records attesting to their authorship. Many of the paradigmatic and well-studied examples of Brazilian baroque sculpture, architecture, and painting, however, are known to be by Afro-Brazilian artists.[32] Several remarks on the most famous of these masters, along with some notes on the Afro–Puerto Rican painter José Campeche, may serve to close this section on the theme of Africa in the Americas.

FIG. E-IO

João Francisco Muzzi, *Reconstruction of the Retreat of Nossa Senhora do Parto* (cat. VI-95, detail)

The high point of Brazil's baroque opulence in the visual arts came in the eighteenth century, coinciding with the colony's increased wealth from the gold and diamond riches of the inland region of Minas Gerais. While the cities there, principally the capital, Ouro Prêto (then known as Vila Rica), but also smaller towns like Mariana, Sabará, Diamantina, São João del Rei, and Congonhas do Campo, grew in size and architectural splendor, the country's principal metropolis, Rio de Janeiro, became even more sophisticated and endowed with impressive buildings and graceful urban design schemes. One of the artists most responsible for the elegance and modernity of Rio in the last quarter of the eighteenth century was the Afro-Brazilian sculptor and architect Valentim da Fonseca e Silva, called "Mestre Valentim" (c. 1750–1813).[33] Mestre Valentim, whose father was Portuguese and mother a black Brazilian, executed commissions from lay congregations and the government. Much of his work survives, including elements of his most ambitious project, the Passeio Público (Public Promenade) in the center of the city, an urban space akin to a courtly garden that was reminiscent of analogous aristocratic promenades at the Palace of Queluz in Portugal.[34] This venture consisted of terraces, benches, pavilions, fountains, a series of allegorical sculptures, an entrance gate, and two obelisks. The viceroy under whose direction the Passeio Público sculptures were executed, Dom Luis de Vasconcelos, was an admirer of Mestre Valentim's work. And yet, although Valentim is known to have executed the project, there are no specific documents related to it that mention him by name. Indeed, the position of the black artist within the hierarchy of Brazilian society was ambiguous. Mulattos were allowed to own workshops (as Valentim did) but could not be the directors of the works themselves. However, a painting of 1789 by the Italo-Brazilian artist João Francisco Muzzi (late eighteenth century–1802) offers powerful visual evidence of the deference with which Mestre Valentim was treated and the esteem in which his work was held (cat. VI-94).

In late August 1789 a hospital and asylum for women in the center of Rio, known as the Recolhimento de Nossa Senhora do Parto (Hospice of Our Lady of Birth), burned to the ground. Its destruction was chronicled by Muzzi in a work whose title, *Fatal e rápido incèndio do Antigo Recolhimento de Nossa Senhora do Parto* (Deadly and Rapid Fire in the Old Hospice of Our Lady of Birth), attests to the swiftness with which the flames consumed the structure. The picture itself, now in the Museu da Chácara do Céu in Rio de Janeiro, serves as an important visual document of contemporary clothing, modes of public transport, and other aspects of urban existence in the late eighteenth century.[35] For our purposes, its companion, *Feliz e Pronta Reedificação do Antigo Recolhimento de Nossa Senhora do Parto* (The Successful and Quick Reconstruction of the Old Hospice of Our Lady of Birth), offers the greatest interest. The new building, with its white facade and red tile roof, was a point of pride in the swiftly growing modern city. A detail of the foreground of the painting signals this and also indicates

the importance of its architect, Mestre Valentim (fig. E-10). Here the master, with dark skin and wearing a dark brown coat, is positioned in front of virtually all other participants in the scene, including the viceroy Dom Luis de Vasconcelos. Mestre Valentim stands before Vasconcelos in a deferential pose, holding his plans for the structure. The viceroy hails him enthusiastically, as do other members of his retinue. While this is a modest detail of a relatively small genre painting, it is a critically significant record of the contribution of this Afro-Brazilian artist to the urban fabric of Rio during one of its most optimistic epochs.

Considerations of the "black hand" in artistic creation throughout the Americas in the colonial era has led me to think beyond individual works of art by Afro-Brazilian or Afro-Caribbean artists, beyond representations of people of African descent in art, and beyond the African artisanal traditions that were transmitted to the Americas during the era of slavery. Contemplating images such as that of the hospice of Nossa Senhora do Parto, designed according to the plans of a black architect, or the elegant Passeio Público in Rio de Janeiro, as well as any of the large or small monuments (domestic, religious, and official) throughout Latin America that define the "masterpieces" of colonial construction, I am obliged to think not only of who planned them, but also who carried them out. Inevitably, we come face to face—again—with the realities of slave labor, the forced black participation in the built environment in both urban and rural settings. While we generally associate the work of slaves with rural agriculture such as sugar plantations, or with the mining regions of Brazil, it is also true that the grand churches and cathedrals, the viceregal palaces, and the opulent dwellings of the upper classes would have been impossible without the participation of African and African-American workers. The grandeur of the American baroque must be thought of not solely in terms of its "success" as a "style" or its achievements in the aesthetic rivalry with European models, but also as a product of the sweat, strength, and tenacity of the thousands of anonymous workers of African (and, of course, indigenous, in the case of other regions of the Americas) heritage who literally put the buildings together.

When discussing the multitalented mulatto artist Mestre Valentim, the work of his contemporary Antônio Francisco Lisboa (c. 1738–1814) is inevitably called to mind. Lisboa, known by his nickname "O Aleijadinho" ("The Little Cripple"), has been cited as the most outstanding representative of the Brazilian baroque in architecture and sculpture, and indeed, the best-known scholarship on the colonial art of Minas (and Brazil in general) has been dedicated to him.[36] Born in Vila Rica as the illegitimate son of an African slave mother named Izabel and the well-known Portuguese architect Manoel Francisco Lisboa, Aleijadinho was active throughout the region, leaving Minas only once to travel to Rio. He acquired the name "Aleijadinho" because he suffered from a degenerative disease that caused his arms to wither and lose strength. According to his early biographers, as an adult he was obliged to work with tools strapped to his forearms. As Oliveira has argued in her fundamental texts on the artist, Aleijadinho created a highly original style that manifests itself in his sculpture through the intensive, expressive quality and prominent, almond-shaped eyes of his figures, whose bodies are often elongated and contorted (see cat. V-40). In many examples of his work, these elements bear similarities to contemporary Central European sculpture. While original works of art by German, Swiss, or Austrian artists may not have been known in Brazil, Aleijadinho and his contemporaries had access to prints of such works, brought to Minas by the clerics who came from Bavaria and other regions of the Alps and beyond. Aleijadinho's greatest

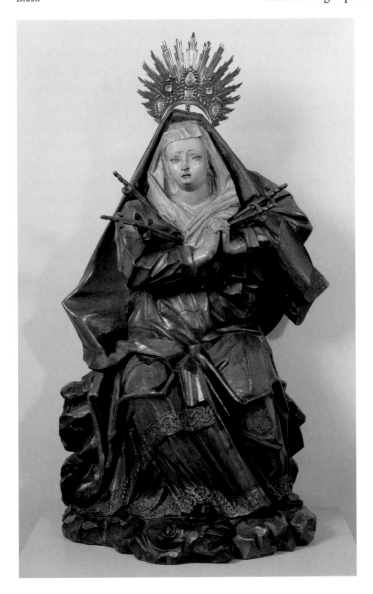

FIG. E-12

O Aleijadinho (Antônio Francisco Lisboa) (Brazilian,
c. 1738–1814), Facade of the Church of São Francisco
de Assis, 1766–94. Ouro Prêto, Brazil

large-scale masterpiece is the project realized (with many assistants) between 1796 and 1799 for the pilgrimage church of Bom Jesus de Matozinhos at Congonhas do Campo. This consisted of sixty-four wood images of Christ's Passion and Death for a series of chapels located on a hill leading up to the church, as well as a series of life-size Old Testament prophets to decorate the monumental outside staircase of the sanctuary.[37]

Many controversies surround attributions of works to Aleijadinho. Although some of these arguments have been settled by the research of Oliveira and her colleagues, only a few Aleijadinho works have been securely documented; most are attributed to him through stylistic analyses. The intimate, highly affecting *Our Lady of Sorrows* (fig. E-11), generally accepted as by his hand, embodies many of the characteristics often linked to the production of Aleijadinho, including complex angular carving, an overall triangular composition, and an elongated, dramatic face.[38] The elegant mother of Christ looks heavenward for divine sustenance in her time of greatest anguish. Her pain has been actualized by the addition of seven real swords that pierce Mary's body, referring to the seven sorrows she suffered in her adult lifetime.

Of Aleijadinho's architectural projects, one of the most celebrated is his first major commission, the Franciscan Third Order Church of São Francisco de Assis in Ouro Prêto, built in 1766–94 (fig. E-12). With its undulating facade and sensuous bell towers, São Francisco epitomizes the most theatrical phase of the Brazilian baroque. The sense of drama established by the outside of the church is amply continued inside, not only in the details of the building itself but in the extraordinary decoration of the ceiling painted by one of the artist's closest collaborators, Manoel da Costa Ataíde (also spelled Athaide or Atayde; 1762–1830).[39] The highly idiosyncratic perspective, ultimately reminiscent of the most extravagant examples of late Roman baroque paintings by Andrea Pozzo (1642–1709) and his contemporaries in both Italy and Central Europe, was executed between 1801 and 1812 on a ceiling of long wooden slats, as was customary in Brazilian colonial religious structures.[40] Ataíde's São Francisco ceiling (fig. E-13) shows the Glorification of the Virgin, a dramatic heavenly glory, painted in pastel tones, with scores of angels and the Old Testament King David playing musical instruments and singing to the Virgin Mary, whose large, imposing body breaks through the clouds in a burst of glory, and whose features clearly indicate someone of African descent.

The most highly accomplished painter in the Caribbean during the late eighteenth and early nineteenth centuries, José Campeche (1751–1809), was the son of a freed slave, Tomás Campeche y Rivafrecha, and a Spanish woman, María Josefa Jordán.[41] Campeche studied with noted Spanish artist Luis Paret y Alcázar (1746–1799) while the latter was in political exile in San Juan, Puerto Rico, and achieved widespread fame in his day as a creator of religious images in a rococo style. He was most renowned as a portrayer of the wealthy and politically well

FIG. E-13
Manoel da Costa Ataíde (Brazilian, 1762–1830),
Glorification of the Virgin, 1801–12. Paint on wood
(ceiling above the nave). Church of São Francisco
de Assis, Ouro Prêto, Brazil

connected in contemporary Puerto Rican society. I have not been able to identify any portraits by Campeche of people of color. However, in his compelling representation of a young boy from an impoverished family outside the capital who was born without arms Campeche addresses members of the economically disenfranchised classes of colonial society. The portrait of Juan Pantaleón Avilés (see cat. VI-123) of 1808, a late work by the artist, falls somewhere between several art historical categories. With its sorrowful subject, a two-year-old boy displayed on a bed with foreshortened legs and armless torso, this picture is reminiscent of the ex-votos that give thanks to God for a favor received. Its legend, written in archaizing fashion on a strip of canvas at the lowest register of the painting, reminds us of the descriptions of miracles performed by Christ, the Virgin Mary, or the saints, to whom hapless people pray for restoration of health or alleviation from a crisis. However, in this case no miracle has occurred and no favor has been granted. The text describes how the child was taken to the capital city and given the sacrament of Confirmation in April 1808.[42] Its matter-of-fact account reminds us of the Enlightenment fascination with depictions of natural aberrations. On the other hand, it also brings to mind the Spanish baroque taste for representations of physical deformities in works such as Jusepe de Ribera's *Boy with a Club Foot* of 1642 in the Louvre. While Campeche's work is unusual within his oeuvre, the artist draws upon the qualities of compassion and insight that were characteristic of his other works painted from the live model.

CODA: A BLACK MASTER'S CLASSROOM

Although the present exhibition examines works of art principally from the sixteenth to the early nineteenth centuries, the history of colonialism in the Iberian Americas did not end until 1898, with Spain's loss of Cuba and Puerto Rico (as well as the Philippines). I will conclude this essay by considering an image redolent of meaning within the context and readings of works of art associated with blackness in the colonial Americas that I have proposed here. *La escuela del maestro Rafael* (The School of Rafael Cordero), by Puerto Rican artist Francisco Oller y Cestero (1833–1917), was painted about 1890–92, a moment at the extreme end of the colonial experience (fig. E-14). An evaluation of the art and material culture produced during the later part of the nineteenth century serves to underscore the protracted agony of this form of government and the societal attitudes that accompanied it. Such an analysis may also function as something of a preamble to an encounter with reconfigured forms of colonialism that came about immediately after the end of Spanish hegemony in the Americas. At that time Cuba became a de facto economic colony of the United States, and Puerto Rico experienced U.S. annexation, eventually assuming the ambiguous denomination of "free associated state" (*estado asociado libre*), thus entering another era of colonial existence that continues to the present. As for the rest of the Americas, many of the former Spanish colonies also developed (or were obliged to develop) an economic (and, in an increasingly globalized age, cultural) dependency on the United States that, combined with the many American expansionist and protectionist campaigns throughout the twentieth century, introduced new forms of colonial governance in the hemisphere that continue to provoke acute tensions in many quarters.

FIG. E-14
Francisco Oller y Cestero (Puerto Rican, 1833–1917),
The School of Rafael Cordero, c. 1890–92. Oil on
canvas, 39 × 62⅝ inches (99 × 159 cm). Ateneo
Puertorriqueño, San Juan, Puerto Rico

Oller was Puerto Rico's distinguished late-nineteenth- and early-twentieth-century painter.[43] He was also the principal agent for opening the art scene in that country to broader, more international aesthetic currents, having studied in 1851 in Madrid at the Real Academia de Bellas Artes de San Fernando (with Federico de Madrazo) and (between 1858 and 1863) in Paris at the École Impériale et Spéciale de Dessin, the ateliers of Thomas Couture and Charles Gleyre, and the Académie Suisse. Oller's friendships and professional relationships with Camille Pissarro and Paul Cézanne were also crucial for the development of his art, which was strongly influenced by Impressionism as well as by the Realism of Gustave Courbet and the members of the Barbizon group of landscape painters. Oller was highly attuned to the social realities of Puerto Rico and could be considered a nationalist, judging by his writings and his art. He founded the Academia Gratuita de Dibujo y Pintura (Free Academy of Drawing and Painting) in 1868, and his interests in promoting literacy and art education formed an integral component of his activity.

Puerto Ricans of African descent are the protagonists of several of Oller's most important works. His most famous painting, *El velorio* (The Wake) of 1893 (Río Piedras, Museo de Arte y Antropología de la Universidad de Puerto Rico), depicts the *baquiné* (wake) for a small child in a modest house located in the mountainous central part of the island. There is an almost bacchic feeling to the picture, as many participants in the scene play music, sing, gossip, and drink, paying little attention to the baby laid out on a simple kitchen table in the center of the composition. The one exception is a tall, thin black man who peers down at the child with a mixture of sadness and compassion.[44]

Another composition in which an Afro–Puerto Rican plays a key role is *La escuela del maestro Rafael*, a painting that offers an apt summation of some of the principal observations in this essay. Rafael Cordero was a well-known educator. A former slave who had worked in the tobacco fields (tobacco leaves at the table at the extreme right suggest this occupation), Cordero had purchased his freedom and, in 1810, opened a free primary school in San German, and later in San Juan, for the instruction of indigent young boys in the rudiments of arts and letters. This institution soon attracted the sons of well-to-do citizens, a number of whom later became leaders of the country's independence movement. When observing this work, I cannot help but think of Oller's own school for the advancement of arts on the island. It is not at all outside the realm of possibility that the painter was expressing an autobiographic identification with Cordero here.

In the painting Cordero, who looks out at the viewer, is surrounded by art: four pictures (including a Madonna and Child in the manner of José Campeche) as well as a sculpted crucifix hang on the wall. The black man, a turban on his head indicating his earlier days as a slave, embodies the importance of intellectual and artistic advancement. Cordero here holds the key to the future of the country—the enlightenment of the nation's children of all racial backgrounds. He denotes, furthermore, the integral significance of the African presence and the African integration within the intellectual and artistic fabric of the hemisphere.[45] We understand his presence as a metaphor of nationalism, in its most positive aspects, and, by extension, a signifier of the inextricable links with the cultural heritages of Africa.[46]

NOTES

1. Bercht et al. 1998.

2. See Taylor et al. 1998, in Bercht et al. 1998, pp. 158–69.

3. For an overview of the historiography, see the editor's introduction to Araújo 1998, pp. 9–19. Araújo notes the pioneering work of Clarival do Prado Valladares in the study of black visual culture in Brazil, especially in his series of journal articles published in the 1960s. Araújo presented an updated overview in his essay "Exhibiting Afro-Brazilian Art," in Sullivan 2001, pp. 312–25.

4. Araújo organized the groundbreaking exhibition at the Museu de Arte Moderna de São Paulo titled A Mão afro-brasileira: significado da contribução artística e histórica (The Afro-Brazilian Hand: Significance of the Artistic and Historical Contribution) to celebrate the one-hundredth anniversary of the end of slavery in 1988. This project mined the talents of many major figures in the Brazilian art world and demonstrated that within Brazil (and, by extension, the rest of the Americas) the impact of the African presence on the visual arts is an ongoing process that cannot be categorized into inadequate historical periods. This has been made abundantly clear by Araújo's more recent curatorial and critical work. As director of the Pinacoteca do Estado de São Paulo, Araújo was responsible for many important exhibitions, including Arte e religiosidade no Brasil: heranças africanas (Art and Religiosity in Brazil: African Heritages) in 1997, which presented a wide selection of images and texts that dealt with historical and spiritual issues related to the intersection of Christianity and the principal African religions that were imported into the country and refashioned during the era of slavery. Arte e religiosidade was, in a sense, a prelude to one of his most significant museological achievements, the exhibition Negro de corpo e alma (Black in Body and Soul), held in São Paulo in 2000 as part of the series of exhibitions known collectively as Brasil 500 anos: mostra do reduscubrimento (Brazil 500 Years: Rediscovery Exhibition), which presented an in-depth analysis of virtually every possible area of the visual arts in which the black presence made itself known in Brazil from the sixteenth century to the beginning of the twenty-first. The 2001 show at the Museu Histórico Nacional, Rio de Janeiro, entitled Para nunca esquecer: negras memórias: memórias de negros (To Not Forget: Black Memories: Memories of Blacks) represented an equally transhistorical effort to showcase black achievements in all facets of Brazilian culture.

5. See Araújo 1997.

6. I use the term "African-American" in its widest, hemispheric sense.

7. Thompson 1983.

8. Thompson 1993 Face.

9. Thompson 1993 "Countenance."

10. Space prohibits extensive commentaries on the large body of recent literature in this area. Throughout the text I will simply refer to some of the most salient studies as they pertain to the images reproduced and discussed here.

11. On the Manila Galleon trade route, see Schurz 1939; and Hospicio de los Venerables et al. 2000.

12. In Puerto Rico the Proclamation of the Abolition of Slavery was issued in 1873.

13. Gutierrez and Avila 1999.

14. See Bercht 1989. On the relationship between African wood sculpture and Brazilian wood carving, see Barata 1998, in Araújo 1998, pp. 183–92.

15. Art historian Lélia Coelho Frota notes the African elements in the treatment of the human face in many milagres. See Frota 1989, in Bercht 1989, p. 29.

16. Traba 1972 Rebelión. See also Vidal 1994.

17. Vidal 1998, in Hermandad de Artistas Gráficos de Puerto Rico 1998, p. 105. See also Vidal 1979.

18. See, for example, the diagram of a slave ship published in various editions of Thomas Clarkson's Lettres nouvelles sur le commerce de la Côte de Guinée. Clarkson (1760–1846) was significant for his tracts against the slave trade, published in his native England, France, and elsewhere. For a reproduction from the 1815 edition, see Moura 1997, in Araújo 1997, unpaginated.

19. Debret was an important member of the French Artistic Mission, which had been invited to Brazil by the Portuguese government in 1816. The aim of the Mission was to "modernize" (read "Europeanize") Brazilian art. While Debret's paintings of Brazilian scenes and daily life are well known, his most important contribution to the description of the country's customs, the variety of its inhabitants, and the profusion of its natural life can be found in the lithographs for his immense three-volume publication, Voyage pittoresque et historique au Brésil, containing over 150 plates (Debret 1834–39). The scenes of punishment are found in plate 45 of the Second Part of the Voyage. Debret was also instrumental in founding the Academia Imperial de Belas Artes in Rio de Janeiro.

20. Hugh Honour calls such drawings and prints by early-nineteenth-century foreign travelers in Brazil (including the German artist Johann Moritz Rugendas) "picturesque" scenes, "one of the 'sights' of Brazil viewed by the traveler." Honour 1989, part 1, p. 141.

21. Oliveira 2000, p. 62.

22. There is a large bibliography on Dutch Brazil. See especially Boxer 1957; Boogaart et al. 1979; Whitehead and Boeseman 1989; and Herkenhoff 1999.

23. See Larsen 1962; Sousa-Leão 1973; and Parker Brienen 2001, in Sullivan 2001, pp. 62–74.

24. See Parker Brienen 2001.

25. The controversy surrounding the place where Eckhout painted his Brazilian pictures is summarized in Parker Brienen 2001; and in the texts by Barbara Berlowicz and Peter Mason, respectively, in two exhibition catalogues: Berlowicz et al. 2002; and Buvelot 2004.

26. Bencard 2002, p. 288.

27. Parker Brienen 2001, p. 66.

28. O'Phelan Godoy 2003, p. 108.

29. On casta painting, see García Sáiz 1989. For the most recent history and interpretation and for further bibliography, see Katzew 2004.

30. See Klor de Alva 1996, in Katzew et al. 1996.

31. Whistler 2001, p. 49.

32. For a discussion of the position of black and mulatto artists in Brazil at this period, see Tribe 1996.

33. On Mestre Valentim, see Carvalho 1999.

34. Carvalho 1999, p. 15.

35. There are two other paintings of the same subject by Leandro Joaquim, who collaborated on works for the Passeio Público with Mestre Valentim, in the collection of the Museu de Arte Sacra, Cathedral of Rio de Janeiro.

36. International interest in the art of Aleijadinho was inspired by the work of French art historian and curator Germain Bazin. See Bazin 1972, originally published in French as Aleijadinho et la sculpture baroque au Brésil (1963). For the state of current research, and for an up-to-date bibliography, see Oliveira et al. 2002.

37. For the best photographs of this series (especially of the soapstone sculptures of the prophets decorating the monumental staircase in front of the church at Congonhas), see Mann and Mann 2002. For history and criticism of the series, see Oliveira 2002.

38. According to Oliveira and her colleagues, this sculpture was "possivelmente feita para altar de pequena capela de fazenda, oratório particular ou mesmo para retábulo lateral de igreja mineira" [possibly made for an altar of a small chapel on a farm, a private *oratório*, or even for a side chapel of a church in Minas Gerais]. See Oliveira et al. 2002, p. 106.

39. See Frota 1982; and Menezes 1989.

40. Ataíde was very likely aware of Pozzo's widely disseminated treatise *Perspectiva pictorum et architectorum* (Rome, 1693–1700).

41. The most complete study of Campeche's work is in Taylor et al. 1988. For the most recent study of Campeche's portraits and an overview of his career, see Vidal 2004.

42. "Juan Pantaleón, hijo legítimo de Luis de Avilés y de Martina de Luna Alvarado vecinos labradores de la villa de Coamo esta isla de San Juan Baut.a de Puerto Rico. Nació el día 2 de Julio de 1806, y conducido por sus padres a esta Capital. Le confirió el Sacramento de la Confirmación el 6 de abril de 1808 el Illmo. Sr. Obispo Diocesano D.D. Juan Alexo de Arismendi por cuya orden se hizo esta copia cogida del natural. José Campeche" [Juan Pantaleón, legitimate son of Luis de Avilés and Martina de Luna Alvarado workers from the town of Coamo on this island of San Juan Bautista de Puerto Rico, was born on 2 July 1806 and brought by his parents to this capital. The sacrament of Confirmation was conferred upon him in 6 April of 1808 by His Excellency Bishop Juan Alexo e Arismendi on whose orders this copy (painting) was made from life by José Campeche.]

43. See Benítez 1983.

44. For an interpretation of Oller's *El Velorio* as a representation of "spiritual grace," see Boime 1990, pp. 120–24.

45. Art historian Osiris Delgado stresses Oller's staunch nationalist sensibility and also underscores the importance for this artist of the figure of the Afro–Puerto Rican. See Delgado 1998.

46. See the interpretation of this painting by Boime 1990, pp. 79–86. While I agree with many of the author's observations, I vigorously disagree with the following comment on the representation of Maestro Cordero: "It shows the able pedagogue looking wistfully at the spectator—seemingly overwhelmed by boisterous and mischievous children. Cordero is not shown as the austere teacher, but as a kind of comical, touching creature unable to control his pupils."

Asia in the Arts of Colonial Latin America

Gauvin Alexander Bailey

Colonial Latin America was more directly and profoundly affected by Asian culture than Europe ever was, even during the period when countries from Italy to Sweden were swept up in the art and design style known as chinoiserie (c. 1670–c. 1830). More than a century before chinoiserie took hold in Europe, colonial societies in Spanish and Portuguese America were captivated by the arts of Japan, China, and India, of which they had extensive firsthand knowledge. Even a cursory look at inventories or surviving collections reveals that much of the furniture, ceramics, and textiles that adorned colonial homes and churches—whether in Potosí, Bolivia, or Pernambuco, Brazil—either came from Asia or was inspired by Asian art. Add to this the thousands, perhaps tens of thousands of Asians who migrated to the Americas during this period and the significant role Asia played in the colonial imagination, and it becomes clear that Asia's cultural and social impact on Latin America is much more than a historical footnote.

Two thriving trade routes put Latin America in direct contact with Asia for almost the entire colonial period. Beginning regular service in 1573, the ships of the annual Manila Galleon linked the port of Acapulco in New Spain (in present-day Mexico) to the markets of the Philippines, China, and Japan, making Acapulco and Mexico City two of the largest markets for Asian goods outside Asia.[1] From Acapulco, many Asian products were shipped south to Panama, Bogotá, Quito, and Lima, and onward to the furthest outposts of the Andean world. Latin America's other direct link with Asia began even earlier. Starting with their foundations in 1549 and 1565, respectively, the Brazilian towns of Salvador and Rio de Janeiro became obligatory ports-of-call for the Portuguese East Indiamen (ships of the British East India Company) sailing between Lisbon and the Portuguese colonies of Goa (India), Malacca (Malaya), and Macao (China).[2] Precious cargoes of Chinese, Indian, Ceylonese, and Japanese arts were bartered in Brazilian ports for sugar, dried meat, and other local produce. Asian goods were available in such numbers in Brazil that they quickly satisfied the needs of the young colony and spilled over the borders into the Spanish-speaking south, to modern-day

Detail of fig. F-9

Uruguay and Argentina. In their day, the Asian markets at Salvador and Rio de Janeiro rivaled those of New Spain and Lisbon.

THE MANILA GALLEON AND PORTUGUESE EAST INDIAMEN

The Manila Galleon, known in Spanish as the *Nao de China* (China Ship) or *Nao de Acapulco* (Acapulco Ship), made regular annual crossings between 1573 and 1815, when it succumbed both to competition from the Spanish Compañía de Filipinas (1785) and to the effects of the Latin American independence movement, which put an end to Spain's control of Latin American trade.[3] The sturdy teak ships, usually built by Filipino shipwrights, sailed from Acapulco to Manila's port of Cavite laden with South American and New Spanish silver, as well as other natural products such as cochineal, a red dye for clothing from Oaxaca.[4] Chinese traders in Manila exchanged the silver for manufactured goods, primarily porcelains from Jingdezhen, China; ivory statues of saints from Fujian and Manila; folding screens from Macao and Japan; spices, pearls, and furniture, mainly from Southeast Asia; and, above all, fine silk cloth—including (before 1692) pieces of Chinese imperial court costume, sent to the Americas after the dynasty that commissioned them had fallen.[5] The cargo listed in the 1573 shipment—712 pieces of silk and 22,300 porcelain vessels—gives an idea of the prodigious scale of the trade.[6] Most ships left Cavite between June and July, made landfall in northern California after the perilous eastern crossing (the western crossing was shorter and safer), sailed down the coast of New Spain, and reached Acapulco between November and December.[7] Although at first as many as four ships sailed per year, the Spanish government soon restricted the number to one or two so they could maintain tighter control over the trade.[8]

Acapulco came to life during the two or three months the ship was docked there, and the *feria de Acapulco* (Acapulco fair)—an annual wholesale and retail trade fair replete with imperial ceremonies in which the city's population swelled to many times its normal size—satisfied merchants from across the Spanish empire. Goods intended for consumption in New Spain and Spain continued inland on an arduous mule train over the mountains past Taxco to Mexico City, where some were sold in the Parián market. Officially named in 1703 after Manila's Chinese neighborhood, the Parián in Mexico City was housed in a special building southeast of the cathedral in the present-day Zócalo, and its luxury and exoticism enthralled colonial visitors until 1843, when it was demolished. Juan de Viera, who passed through the market in 1777, exclaimed: "It is the most handsome spectacle of the many boasted by this city . . . ! What a diversity of porcelains and ceramics from China and Japan! . . . What curiosities of ivory, silver, and metal . . . ! What sets of crystal from China!"[9]

Most Asian products brought to the Americas remained there. Recent archaeology testifies to the impressive extent of this trade: Chinese porcelains, ivories, and other products have been excavated at Spanish or French colonial sites in Mexico City, Guatemala, Panama, Florida, Old Mobile (Alabama), and coastal California.[10] A smaller number of Asian goods entering Mexico City were packed on mule trains and carried via Puebla (which still has its own Parián market) to the port of Veracruz on the Gulf of Mexico, where they were shipped on to Cádiz and Seville.[11]

A significant number of Asian products made their way to the south. As the richest of the Spanish viceroyalties and the source of most of the silver that went to Manila, Peru naturally wanted a share in the spoils. Although at least two Manila Galleons are known to have traveled directly between Manila and Callao (the port of Lima), the Spanish Crown halted direct trade in 1582 to protect the Spanish silk industry, and Peruvian merchants had to buy Asian luxury goods at the Acapulco *feria* and later from the nearby Puerto del Marqués for their insatiable clients from Lima, Arequipa, and Potosí.[12] By the 1580s, trade in Asian products between the viceroyalties had become so heavy that it displaced traffic in local or Spanish goods.[13] The northern Andes region (present-day Panama, Colombia, Venezuela, and Ecuador) received

Asian goods from two directions: some shipped from Acapulco to Panama City, where they were packed onto mule trains and transported over daunting mountain passes to Bogotá, Popayán, and Quito, while others made the trip north from Lima. Bolstered by a plantation economy, the northern Andean elite could afford fine luxury goods, and their taste ran to Asian styles—as is attested by the number of Chinese porcelains, silks, and other products that are recorded in inventories of private homes, convents, or dowries.[14]

Brazil had more frequent contact with ships going to and from Asia than did Spanish America, as the traffic from ports such as Macao and Goa was heavier and less strictly regulated. Salvador and Rio de Janeiro were regular stops for East Indiamen (*Naus da Carreira da India*) as they changed crews, replenished food and drinkable water, and bartered goods.[15] As was also the case in New Spain, these ports had their own Asian merchandise warehouses or *fazendas* as early as the sixteenth century, and merchants did a brisk trade in Chinese porcelains, Indo-Portuguese and Ceylonese ivory statues (few Chinese ivories traveled via this route), Indian and Chinese textiles, and Japanese and Indo-Portuguese furniture, particularly fine furniture and boxes from Gujarat.[16] The scale of this trade even dwarfed that of the Manila Galleon: the Museu Histórico Nacional in Rio de Janeiro alone preserves 572 ivories from colonial Brazilian collections; hundreds more can be found in churches and other collections throughout the country; and by one estimate as many as ten million Chinese porcelains were sold in Brazil between the sixteenth and nineteenth centuries.[17] Chinese porcelains were allegedly so common in colonial Brazil that they were given to slaves and used as chamber pots. Many church steeples and domes, particularly in the state of Bahia, are plastered with broken crockery, including pieces of Chinese porcelain that would have been considered treasures elsewhere—even if broken.

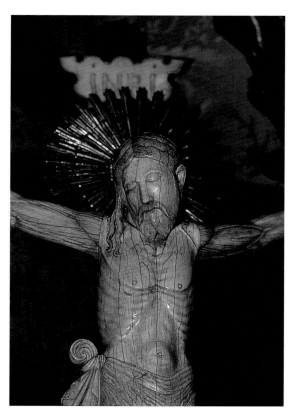

Crucified Christ, Sri Lanka or Goa, seventeenth century. Ivory, height 50⅝ inches (128.5 cm). Archicofradía del Santísimo Sacramento de la Catedral, Buenos Aires

ASIAN ART FOR A WORLD MARKET

The Asian works of art and manufactured goods that reached American shores were usually very different from those intended for domestic markets. The porcelains—whether the late Ming blue-and-white vases with Chinese opera scenes that were treasured in the palaces of Puebla and Salvador, or the chocolate-drinking sets and lavish soup tureens that were executed to order in the eighteenth and early nineteenth centuries from patterns supplied by viceregal patrons—were made to satisfy European tastes.[18] Although they were frequently carved by non-Christians, the ivories did not depict Hindu or Buddhist deities but rather Christ, the Virgin Mary, and the saints, based on European engravings and meant to satisfy a global Christian market (fig. F-1). The furniture that was sent to the Americas and Europe, whether by Hindu or Christian Indian furniture-makers in Goa, Buddhist craftsmen in Ceylon, or Muslim artisans in Gujarat, was also specially adapted to Western tastes.[19] The same was true for Asian textiles, by far the most common Asian products to reach Latin American shores in the colonial era. Many of them looked like the set of ecclesiastical vestments now in a private collection in Buenos Aires (cat. 11-10). Made in the Philippines or Macao in the eighteenth century, probably by Chinese artisans and on order for a Latin American client, these rose-colored silk garments are embroidered with bird, animal, figural, and floral motifs in lively colors, including fanciful serpents, a European hunter with a gun, and a bull chasing a man up a tree. Yet despite their exoticism, they are completely different in style from anything made for the domestic Chinese market, where costume adhered to a strict hierarchy of symbols. Only rarely, as in the case of secondhand clothing from the Chinese court (see discussion below) did materials reach the Americas that had been made for an Asian clientele.

The most extravagant special order from viceregal America for an Asian work of art was the magnificent bronze choir screen in the Mexico City Cathedral (fig. F-2).[20] Commissioned

FIG. F-2
Choir screen, Macao (after a design by Nicolás Rodríguez Juárez), completed 1724, installed 1730. Cast from *tumbaga* and *calaín* (an alloy of bronze and silver), 42½ × 32¼ feet (13 × 9.8 m). Mexico City Cathedral

FIG. F-3
Saint Anne with the Infant Mary, Goa and Brazil, eighteenth century. Wood and ivory, height 17¾ inches (45 cm). Museo de Arte Hispano-americano Isaac Fernández Blanco, Buenos Aires

in 1721 by the cabildo (municipal government) of Mexico City from the prominent New Spanish painter Nicolás Rodríguez Juárez (1667–1734), the design was shipped to Manila and onward by junk to Portuguese Macao, where Chinese smiths followed Rodríguez Juárez's instructions as translated by a Franciscan friar. Costing a staggering 46,000 pesos (30,000 over budget), the screen was shipped back to Acapulco in 125 boxes and bundles and was unveiled to great acclaim in March 1730. Asian and Latin American artisans frequently collaborated on a more modest scale. Filipino or Chinese ivory sculptors would produce heads and hands of saints in ivory, which would be shipped to Brazil or Spanish America and fitted onto bodies of polychromed wood or papier-mâché made by local artisans. In the case of the delicate Brazilian *Saint Anne with the Infant Mary* in the Museo Fernández Blanco in Buenos Aires, Goan ivory sculptors made the heads and hands, which were shipped to Brazil and fitted onto bodies made from local hardwood by Brazilian artisans (fig. F-3).

MIGRATION OF PEOPLES BETWEEN LATIN AMERICA AND ASIA

The Manila Galleon and ships of the *Carreira da India* not only brought Asian products to the Americas, they also brought Asian people. As early as the end of the sixteenth century, Filipino and Chinese immigrants settled in New Spain, and they were joined by Japanese Christian converts as early as 1611, all of them living in places such as Mexico City, Guadalajara, Cuernavaca, and Puebla.[21] One of the first recorded Japanese residents of New Spain was living in the town of Ahuacatlán (now Nayarit) in 1624. Since Asians living in the Americas would have converted to Christianity and adopted Christian names (the Japanese were escaping the persecution of Christians instituted by the Tokugawa government in 1614), it is difficult to trace them in documents. Typical is Juan Antón, "of the Japanese nation," who turns up in a document of 1631 as the godfather of the child of a freed black slave in Guadalajara—which also shows that Asians tended to interact with other non-Europeans.[22]

Asians came to the Americas both voluntarily and involuntarily (as slaves). Unfortunately, it is still very difficult to determine which was the more common motive. Once in the Americas, some Asians worked as sailors or longshoremen, domestics or indentured laborers, while others worked in the trades as merchants, craftsmen, and barbers. Evelyn Hu-DeHart has discovered that as early as 1635 a group of Chinese barbers was established in Mexico City, leading Spanish barbers to protest against the "excesses" and "inconveniences" of having to

compete with them.[23] An archival reference to a confraternity of "chinos" who commissioned a side chapel in the convent church of Santa Clara in Mexico City (1692), which they adorned with ivory statues, has convinced art historian Elisa Vargaslugo that Chinese artisans must have been working and enjoying financial success in Mexico City by that time.[24]

The same migration took place in Brazil, where Asian crews numbering in the hundreds or even thousands, including Chinese, Arabs, Indians, Malays, Ceylonese, and Javanese, passed through on Portuguese, English, French, and Dutch ships, with large numbers choosing to remain on Brazilian shores.[25] One of them, a Chinese sailor named Xie Qinggao who was a crew member on Portuguese ships between 1782 and 1796, made some of the first recorded Chinese impressions of Brazil.[26] As in New Spain, some Asians were forcibly settled in Brazil as slaves, domestics, and indentured workers, such as the Chinese slaves who were brought to the gold mines of Minas Gerais in the eighteenth century, and the Chinese agricultural workers who came in increasing numbers to places like Bahia and Pernambuco in the late eighteenth and early nineteenth centuries.[27] In 1814, for example, the Conde de Linhares brought some three hundred Chinese laborers to Rio de Janeiro to construct and cultivate the tea garden he had built in the Botanical Garden.[28] Other Asians who arrived in Brazil were artists and craftsmen, such as the Indo-Portuguese painter Jacinto Ribeiro from Goa, who was attracted by the gold rush in Minas Gerais in 1720 and may have worked in the region.[29]

Occasionally Asian nobility passed through colonial Latin America. Catarina de San Juan (1606–1688), a popular Catholic mystic who lived for many years in Puebla, astounding her visitors with reports of visions full of cloudbursts, angels, and saints, was allegedly born into an aristocratic Muslim family in Mughal India.[30] Mirra (as she was known before her conversion to Christianity) made the perilous journey to New Spain via Portuguese-held Cochin in India (where she was baptized) and Manila (where she was sold as a slave to a sea captain from Puebla) before finally being freed in Puebla.[31] Her funeral, which featured an elaborate catafalque adorned with paintings and poetry, was attended by some of the most important figures in the viceroyalty, including Antonio Núñez de Miranda, the Jesuit confessor to her contemporary Sister Juana Inés de la Cruz, baroque New Spain's most celebrated poet. Three separate versions of her story were published, one of which was the longest work ever printed in New Spain. Over the centuries Catarina's legend has been conflated with that of another figure, a popular folkloric character from Puebla who wears a distinctive brightly colored embroidered skirt and is known as the "China Poblana."

A more art historically significant aristocratic visit was that of the embassy of the Japanese samurai Hasekura Rokuemon, composed of 184 people, which stopped in New Spain in 1614 on the way to Madrid and Rome in the name of the shogun Tokugawa Ieyasu (1543–1616). The Japanese nobles were fêted from Acapulco to Veracruz and made a lasting impression, leaving a colonial society eager for exotica with a strong taste for Japanese furnishings and designs.[32] In their luggage they brought five boxes of Japanese screens and six suits of samurai armor, exotic works of craftsmanship that created an immediate vogue for Japanese styles in New Spain.[33]

An earlier visit of Japanese dignitaries accompanied by Rodrigo de Vivero y Velasco, former governor of the Philippines, gives us the first known written account of the Amerindian reaction to Asian people.[34] During a ceremonial procession in 1610, the Nahua historian Chimalpahin recorded the following impressions of these exotic representatives of "the great royal altepetl of Japan" (an *altepetl* is a traditional Nahua social organization):

> They wear something like an ornamented jacket, doublet, or long blouse, which
> they tie at their middle, their waist; there they place a *catana* [Asian cutlass] of
> metal, which counts as their sword, and they wear something like a mantilla. . . .
> They seem bold, not gentle and meek people, going about like eagles. And their

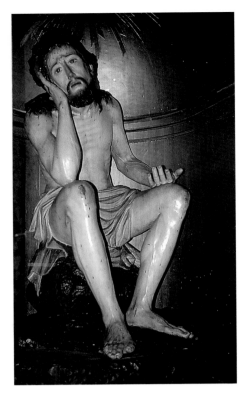

FIG. F-4
Esteban Sampzon (Sino-Filipino, active in Argentina,
fl. 1773–after 1800), *Our Lord of Humility and Patience*,
c. 1799. Polychromed orange wood, eyes of glass,
height 39 inches (99 cm). Church of La Merced,
Buenos Aires

foreheads are very bare because they closely shave their foreheads. . . . [T]hey look like girls because of the way they wear their hair. . . . And they do not have beards, and they have faces like women, and they are whitish and light, with whitish or yellow faces. All the people of Japan are like that, that is how their corporeal aspect is, and they are not very tall.[35]

Despite tantalizing suggestions in archives, only one Asian artist working in the Americas—aside from Ribeiro, who was either a mestizo or entirely of European descent—can be securely documented: the Sino-Filipino Esteban Sampzon (fl. 1773–after 1800), who became one of the most prominent sculptors in the Viceroyalty of Rio de la Plata (Argentina) in the late eighteenth century.[36] Sampzon was probably of Chinese heritage, not only because he called himself an "Indio de la China" (Indian from China) but also because the Chinese Parián in Manila was a thriving sculpture center and a logical place for him to have received his training.[37] Although we do not know how he arrived in Argentina, Sampzon divided his time between Buenos Aires and Córdoba from 1780 to about 1805, serving not only as a sculptor in both cities but as the leader of a military battalion of mestizos in the viceregal capital of Buenos Aires.[38] A number of sculptures by Sampzon survive in Córdoba and Buenos Aires, including an image of Christ as the Man of Sorrows in the church of La Merced (fig. F-4), which demonstrates an expert hand and a subtle sense of emotion and pathos that is also reflected in Filipino ivories of the era. Especially noteworthy is the realism of the facial features, with the parted lips and the intensely expressive eyes, enhanced—as was traditional in both Latin America and the Philippines—by glass inserts.[39]

Europeans who spent long periods of time in Asia also helped bring Asian culture to the Americas, especially in Brazil, where governors, viceroys, and bishops frequently did stints in Macao or Goa before settling in Olinda, Salvador, or Rio.[40] The most notable for the history of art was the French Jesuit artist Charles Belleville (1656–1730), a longtime guest of the Chinese Kangxi emperor and painter of the sacristy ceiling in the church of Nossa Senhora de Belém outside of Cachoeira (Bahia), the most purely Asian work of art produced on Brazilian soil (fig. F-5).[41] Born in Rouen in 1656, Belleville was a miniaturist, sculptor, and architect by trade and had served the Jesuits in China from 1698 to about 1708. Under the Chinese name Weijialou, Belleville served as one of a contingent of Europeans employed at court to

FIG. F-5
Charles Belleville, S.J. (French, active in China
and Brazil, 1656–1730), Sacristy ceiling, 1700–1710.
Polychromed wood with gold leaf. Church of Belém,
Cachoeira, Bahia, Brazil

introduce the emperor to Western technology and arts. Belleville paved the way for the much more famous Italian Jesuit painter Giuseppe Castiglione (1688–1768), who rose to prominence under the Qianlong emperor in the first half of the eighteenth century.

Belleville arrived in Brazil in 1708 or 1709 en route to Lisbon, having either been shipwrecked off the coast of Bahia or having left the ship voluntarily at Salvador because of bad health.[42] In Brazil, Belleville worked primarily as a painter, and although many works have been assigned to him, the Cachoeira ceiling is the only one with a secure attribution. It is executed in an entirely Asian manner, painted on wooden panels with rich seal reds, greens, and gold against a black lacquer background, and featuring delicate floral decorations with fleshy peonies, chrysanthemums, lotus flowers, and gold geometrical ornamentation. Unfortunately, this unparalleled work of colonial Portuguese art was significantly damaged by heavy rain in early 2002.

Belleville ushered in a vogue—almost unique to Brazil—for chinoiserie painting in church interiors. Altar panels, choir stalls, organ cases, vestry closets, and sacristy ceilings in places like Minas Gerais and Bahia were painted with delicate scenes inspired by Chinese lacquers, in gold on a deep blue or red background.[43] However, these works were inspired by European chinoiserie furniture and design books, and therefore have more to do with European tastes than with Latin America's link with Asia.

FIG. F-6
Chinese temple lion, Macao or Brazil, c. 1734.
Stone. Church and Monastery of Santo Antônio,
João Pessoa, Paraíba, Brazil

ASIA IN THE COLONIAL LATIN AMERICAN IMAGINATION

In Spanish America, the response to Asian culture often went beyond a mere passion for exotica. Whether intellectuals or aristocrats, criollos (native-born Latin Americans) believed in a cultural affinity between Asian civilizations and those of America's pre-Hispanic peoples—even going so far as to maintain that the ancient worlds of Asia and the Americas were related.[44] Therefore, as anti-Spanish sentiment grew in the late seventeenth and eighteenth centuries, criollos embraced Asian culture as part of their reclamation of their own continent's indigenous past. Confusion about the distinction between the East and West Indies dates from Columbus's first landfall in 1492, when he thought he had landed in Japan and called Native Americans "Indians." The first Franciscan friars to reach the Americas in the 1520s believed that the indigenous peoples they encountered belonged to the so-called Lost Tribe of Israel—the Asia of the biblical past.[45] Throughout the colonial period, missionaries in the Americas compared their congregations to those in Asia, and mission libraries in the Americas regularly included books on missionary exploits in Asia.[46] In Brazil, Jesuit and Franciscan foundations even adorned their churches with Chinese temple lions, such as the spectacular stone examples of about 1734 guarding the entrance plaza in front of the Franciscan church and monastery of Santo Antônio in João Pessoa, Paraíba (fig. F-6).

Some intellectuals made more scientific inquiries into the relationship between Asia and ancient America, beginning with the sixteenth-century Peruvian Jesuit José de Acosta (1539–1600), the first to propose that Amerindian peoples migrated from Asia over a northwest passage, which later became known as the Bering Strait Land Bridge.[47] Subsequent generations noted similarities between pre-Hispanic art and that of China and Southeast Asia, as well as the apparent affinity between Aztec picture-writing and Chinese script, a commonality cited in the 1660s by another Jesuit intellectual, Athanasius Kircher (1602–1680). Kircher attempted to link Asian and Mexican antiquity by arguing that Indian, Chinese, and Aztec culture were all derived from ancient Egypt—a theory very

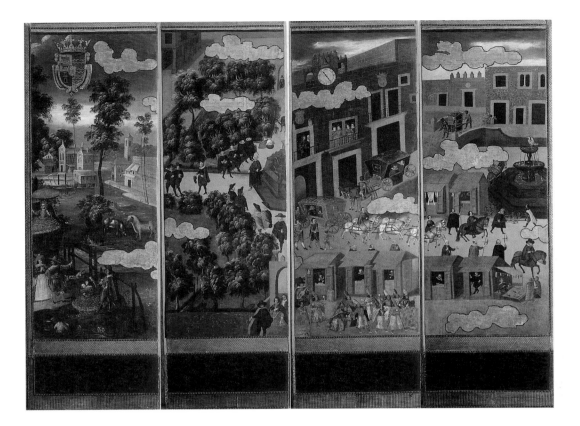

FIG. F-7
View of the Viceroy's Palace in Mexico City, Mexico
City, Mexico, c. 1660. Four-panel *biombo,* oil on
canvas, 93¾ × 118⅛ inches (238 × 300 cm). Rodrigo
Rivero Lake Antiques International, Mexico City

popular with viceregal criollos eager for a native antiquity comparable with that of the Old World.[48] Kircher's works were read avidly by prominent colonial intellectuals such as Sister Juana Inés de la Cruz and Carlos de Sigüenza y Góngora, and he kept up a lively correspondence with viceregal literati.[49]

Asian art gave colonial Spanish Americans a medium for expressing their pride in the indigenous antiquity of their land. Asian-inspired decorative arts from New Spain, such as *biombos* (folding screens), that feature depictions of Amerindians evoked this belief in a connection between Asian and pre-Hispanic cultures. Derived from the Japanese tradition of folding screens (*byôbu*), *biombos* were adorned with landscape and urban scenes and sometimes inlaid with mother-of-pearl, ivory, and gold.[50] The Japanese screens of the late sixteenth and early seventeenth centuries show scenes, in water-based pigments on paper with gold-leaf accents, of European missionaries and sailors, people considered exotic to the Japanese, set in Japanese cityscapes. Colonial Mexicans had early exposure to such works, as the shogun Ieyasu sent ten of them to New Spain as a gift to Viceroy Don Luis de Velasco (ruled 1607–1611) in exchange for gifts given by a grateful Rodrigo de Vivero after he and his shipwrecked crew were hosted in Japan.[51]

Mexican *biombos,* which were done either as oil on canvas or—in another Japanese-inspired medium—as *enconchado* (inlaid with mother-of-pearl) panel paintings, rarely depicted Asian subjects, even though some scholars believe that six of them were made by Japanese emigré artists who adopted the name González (fig. F-7).[52] Instead, whether showing a procession in front of the viceregal palace in Mexico City, with its overtones of imperial authority, or representing a series of classical allegories as a model for virtuous domestic behavior, their subjects were firmly grounded in the life of New Spain.[53] Yet, like their Japanese models, some of these screens represented "the Other," in this case pre-Hispanic Amerindians. *Biombo* screens frequently depicted scenes such as the conquest of Mexico or pre-Hispanic games. What is remarkable about the conquest series is that the Spanish and Aztecs are paid equal honor, affirming the legitimacy of both the viceregal present and the pre-Hispanic past. Not only are the troops of both sides depicted in roughly equivalent numbers,

but their leaders also possess the same regal splendor, the conquistadors with their flags unfurled and Moctezuma with his brilliant cape, headdress, throne, and canopy. It is fitting that such a series belonged to a viceroy—José Sarmiento Valladares, Conde de Moctezuma y de Tula (ruled 1696–1701)—whose wife was a descendant of that great emperor of the Aztecs.[54]

ASIAN AND AMERINDIAN ARTISTIC ENCOUNTERS

Amerindian artisans also discovered affinities with Asian arts. In the areas around San Juan de Pasto (present-day Colombia) and Michoacán (in New Spain), seventeenth- and eighteenth-century lacquer workers seized upon similarities between Japanese and pre-Hispanic lacquer traditions to create hybrid lacquer trays and furniture of great delicacy and originality.[55] Artisans in Pasto adapted pre-Hispanic materials and techniques to execute Asian patterns in a technique called *barniz de Pasto* (sometimes called *barniz chinesco*). These northern Andean lacquer workshops (there were around forty in 1801) mixed the sap of the indigenous *mopa-mopa* tree with pigments, which they then applied to gourds and, in the colonial period, wood, gold, and silver. Among other things, they adapted designs from Japanese lacquers.[56] A fine *barniz de Pasto* tray now in Quito copies not only Japanese lacquers but also Chinese porcelains, which inspired its scalloped rim and central section (called a *cavetto*), the fleshy peony in its center, and the individual floral sprays distributed around the *cavetto* (cat. 1-27).

Artisans in pre-Hispanic Michoacán also made lacquered gourds, and missionaries encouraged them to preserve their traditions after the conquest.[57] Lacquer workers applied layers of *aje* or *chia* oil, lime-based powders, and pigments onto the polished surface of a gourd, as well as onto wood, which was then burnished.[58] Other mediums, not true lacquers (i.e., without a clear, glossy coating), were painted over a thick layer of slip. Beginning in the eighteenth century, in the wake of an increasing vogue for Asian-inspired patterns, lacquer workers began to copy a kind of design that was native to Japan, which they called *maque* (after the Japanese *maki-e*, "picture lacquer"). The Michoacán pieces (from Pátzcuaro and Uruapan) most closely resemble Asian models, with patterns that included Japanese-style gold filigree work and Japanese temples and landscapes, set against a black background. These lacquers are epitomized by the work of the Purépecha master José Manuel de la Cerda from Pátzcuaro (active c. 1764; cat. 1-18).

Asian influence was manifested in the world of textiles as well—particularly in the Andes, where flourishing textile traditions had existed for centuries. Native American artisans rarely adapted pre-Hispanic techniques to Asian styles with such spectacular results as in a seventeenth- or eighteenth-century Peruvian tapestry that combines Chinese designs and motifs with indigenous fauna and uses an extremely sophisticated technique that originated on the Andean coast centuries before the Incas (fig. F-8).[59] Produced by an altiplano (highland) workshop responsible for a group of similar pieces, this textile, which was probably made as a bedspread, features a central design of two Chinese phoenixes surrounded by mythical and real animals interspersed with Chinese peony flowers against a rich red background. The animals include the *qilin*, a Chinese mythical beast that is part lion and part deer, as well as crowned lions and collared dogs taken from European engravings, and South American fauna such as the llama (or perhaps vicuña) and *vizcacha*, a kind of rodent. The red background would have appealed to both cultures, since in China it represented *yang* (that which is happy and auspicious), while in pre-Hispanic Peru it was a symbol of luxury because the dye, made from the cochineal beetle, was very difficult to work.[60]

FIG. F-8
Cover, Peru, late seventeenth–early eighteenth century or later. Cotton, wool, and silk interlocked and dovetailed tapestry, 93⅞ × 81⅝ inches (238.3 × 207.3 cm). Museum of Fine Arts, Boston, Denman Waldo Ross Collection

The model for this piece can be traced quite precisely. It was a rank badge from the late Ming dynasty (1368–1644) known in English as a "mandarin square," whose animal symbols denoted the wearer's place in court hierarchy.[61] Mandarin squares had already become obsolete after the new Qing dynasty replaced Ming court costume with its own in 1652, which was why they were traded abroad and found their way in such numbers to Latin America, one of the few instances in which works of art meant for a domestic Asian market were imported to Latin America.[62]

THREE CRIOLLO TRADITIONS IN THE ASIAN MODE

Three other Asian-inspired art traditions fall squarely in the criollo realm. The most famous was that of the Talavera kilns of Puebla, responsible for the largest volume of Chinese-inspired ceramics in the Americas.[63] Beginning in the later seventeenth century, potters from Puebla made Chinese-inspired pottery using a white to brick-red clay with underglaze blue designs over white slip. They also made Asian-style tiles—a format the Chinese almost never exported —that soon covered the palaces, convents, and churches of Puebla and Mexico City with brilliant colors, as seen in the church of San Francisco at Acatepec (c. 1730) and the famous Casa de los Azulejos (Palacio de los Condes del Valle de Orizaba), owned by the descendants of Rodrigo Vivero, in the capital (fig. F-9).[64] In fact, this taste for exterior tile revetments derives not from a Chinese prototype but from an Islamic tradition mediated through Spain, in which walls and domes of mosques and other buildings were often covered with brightly colored tiles.

Another celebrated response to Asian art is found in the sculpture of Quito (fig. F-10).[65] In the eighteenth century, the city's sculpture workshops produced unusually delicate wooden statues that were enhanced by ivory-white skin tones (the faces were often painted over a mask of lead or silver). But they are most remarkable for their brilliantly painted drapery, which featured *chinesca* (Chinese-style) floral decoration. Scholars have traced the style of these sculptures to Chinese silks, and also to Chinese or Filipino ivories, which had similar white faces and delicate features. Bernardo de Legarda (died 1773), perhaps the most famous Quito sculptor, listed four Chinese (or perhaps Filipino) sculptures in his will: "An [Immaculate] Conception from China . . . another of the same of wood and a diadem of silver . . . another of the same with her base of jasper . . . another of the same of ivory with her base of marble."[66]

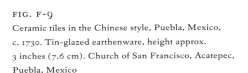

FIG. F-9
Ceramic tiles in the Chinese style, Puebla, Mexico, c. 1730. Tin-glazed earthenware, height approx. 3 inches (7.6 cm). Church of San Francisco, Acatepec, Puebla, Mexico

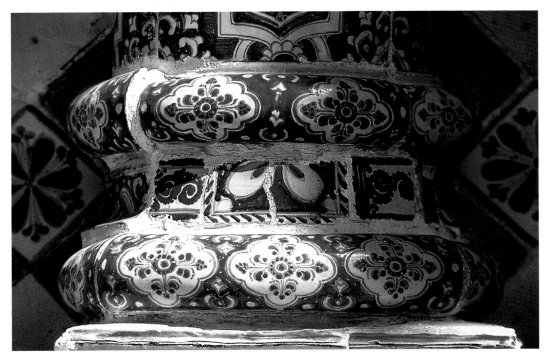

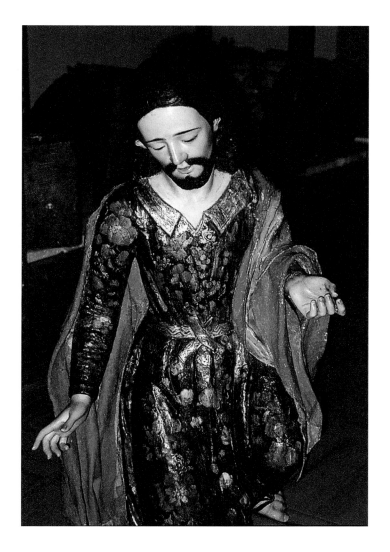

FIG. F-10
Saint Joseph, from a Nativity, Quito, Ecuador, eighteenth century. Polychromed wood with *chinesca* decoration, height approx. 13⅜ inches (34 cm). Museo Nacional del Banco Central del Ecuador, Quito, Ecuador

Lesser-known, but ubiquitous in collections of colonial Latin American furniture, are the bureaus and boxes made in impressive numbers by Peruvian workshops following Japanese and Indian models.[67] The most unusual are those inspired by Indian prototypes. One such group features dark hardwoods inlaid with mother-of-pearl and tortoiseshell, as in an extraordinary bureau in the Museo Pedro de Osma in Lima (cat. VII-10), which is based on a specific kind of sixteenth- and seventeenth-century Gujarati casket made of teak covered with black mastic and inlaid with mother-of-pearl.[68] The other group includes a series of even more delicate small boxes that are entirely covered in mother-of-pearl plaques, inspired by another kind of Gujarati casket in which the plaques are attached with silver nails.[69] Both of these forms were extremely popular in criollo households and as furnishings for churches.

Colonial Latin American culture owes a profound debt to Asia that deserves to be acknowledged alongside the better-known contributions of Amerindian, African, and European cultures. This legacy is a testament not only to the extraordinarily multicultural nature of colonial society but, more importantly, to the originality and creativity of its artists and artisans. Long before air travel and advanced communication turned the world into a "global village," the civilizations of five of the world's continents exchanged art forms and ideas across thousands of miles and vast oceans solely by means of long and perilous sea voyages. The works of art that resulted from this exchange are not "purely" Asian, Amerindian, African, or European but something new—and in many ways more exciting—resulting from a combination of them all.

NOTES

This research would not have been possible without generous funding from the National Endowment for the Humanities and the National Endowment for the Arts. The author would also like to acknowledge the support and encouragement of the Americas Society, Asia Society, and Japan Society in New York, as well as the entire *Phoenix and Hummingbird* advisory board.

1. The literature on the Manila Galleon is extensive. See Hospicio de los Venerables et al. 2000; Bonta de la Pezuela 2000; Museo de Historia Mexicana 1998; Jornadas Culturales Mexicano-Filipinas 1997; Alvarez Martínez 1993; Museo Nacional de Historia 1988; Knauth 1972; Torre 1981; Schurz 1959; Mason 1961.

2. On Brazil's trade links with Asia, see J. R. T. Leite 1999; Museo Histórico Nacional 1985; Lapa 1968; Carneiro 1942; Brancante 1950.

3. Schurz 1959, p. 27; Kuwayama 1997, p. 11. The Spanish Compañía de Filipinas, which traveled directly to Manila from Spain without passing through the Americas, already had a permanent factory in Guangzhou in 1789. See Museo Histórico de Acapulco, Fuerte de San Diego 2002, p. 29; Bonta de la Pezuela 2000, p. 80.

4. Museo de Historia Mexicana 1998, pp. 15, 43; Bonta de la Pezuela 2000, pp. 26–28.

5. Bonta de la Pezuela 2000, pp. 23–25; Camman 1964, p. 24.

6. Schurz 1959, p. 27.

7. Bonta de la Pezuela 2000, pp. 32–38.

8. Ibid., pp. 23–25.

9. Ibid., pp. 101–2; Museo de Historia Mexicana 1998, p. 109.

10. Pasinski 2002; Shulsky 2002; Shulsky 2001; Shulsky 1998; Kuwayama 1997, pp. 20–21; Desroches et al. 1996; Shulsky 1995; López Cervantes 1976.

11. Kuwayama 1997, p. 13.

12. Kuwayama 2000, p. 21; Parry 1990, pp. 131–35; Camman 1964, p. 25; Borah 1954, pp. 8, 81, 118, 123. For an intriguing look at the image of the Asian in colonial Peru and Bolivia, see Gisbert 2001, pp. 259–72.

13. Borah 1954, p. 63; Kuwayama 2000, p. 21.

14. Kennedy 1993, p. 96; López Pérez 1997–98.

15. Museo Histórico Nacional 2002, p. 2; Camargo-Moro 1995; Museo Histórico Nacional 1993, p. 14; Museo Histórico Nacional 1985; Lapa 1968.

16. J. R. T. Leite 1999, p. 22.

17. Museo Histórico Nacional 2002, p. 2; Museo Histórico Nacional 1993, p. 14; J. R. T. Leite 1999, p. 22.

18. Museo Histórico de Acapulco, Fuerte de San Diego 2002, pp. 18–22.

19. Bomchil and Carreño 1987, pp. 71–72.

20. Toussaint 1992, pp. 107–8.

21. Patiño 1993, pp. 350–90; Mathes 1973, p. 100; Calvo 1992, p. 82. One reference from 1634 is to a merchant named Francisco de Reinoso, who signed a *carta de compañía* agreement with "Luis de Encío, de nación japón, estante en la ciudad."

22. Calvo 1992, p. 82.

23. Evelyn Hu-DeHart, personal communication, summer 2004.

24. Vargaslugo 1994, p. 121; Estella Marcos 1989, p. 601.

25. J. R. T. Leite 1999, pp. 16–18.

26. Ibid., p. 19.

27. Boxer 1995, p. 175.

28. J. R. T. Leite 1999, p. 20.

29. Ibid., p. 18; Bennassar 2000; Avila 1984; Andrade 1978. Ribeiro's ties to the chinoiserie paintings in churches in this region, such as the Capela de Nossa Senhora do O in Sabará (1720), are tenuous at best.

30. Bailey 1997.

31. Ibid., pp. 47–48.

32. Bailey 1999, p. 63; Kimura 1997; Escobosa de Rangel 1993, pp. 21–27; Boxer 1993, pp. 314–15; Suntory Museum of Art 1990; Knauth 1972, pp. 167–74, 206–16.

33. Curiel 1999, pp. 16–17.

34. Knauth 1972, pp. 190–91.

35. Chimalpahin was a Nahua historian active between 1590 and 1620. For more on the fascinating character of Chimalpahin, see Schroeder 1991. The quotation is reproduced with gracious permission of Susan Schroeder from Lockhart et al., 2006, vol. 3, pp. 134–35. I am extremely grateful to David Tavárez for bringing this material to my attention.

36. Bailey 2005, p. 66, fig. 29; Academia Nacional de Bellas Artes 1982, vol. 1, pp. 336–43; Ribera and Schenone 1948, pp. 85–87.

37. Jose and Villegas 2004, pp. 98–102; Jose 1990, pp. 15–17.

38. Academia Nacional de Bellas Artes 1982, p. 336; Buenos Aires, Archivo General de la Nación (AGN), IX, *Gobierno, Tribunales*, leg. 223, Document no. 11.

39. Jose and Villegas 2004, pp. 30–32.

40. Duarte Coelho, founder of the city of Olinda, was one of the first Portuguese to set foot in Guangzhou; the first bishop of Brazil, Dom Pero Fernandes Sardinha, served as Vicar-General of Goa before arriving in Salvador in 1552; and Antonio de Noronha, Marquês de Angeja, was viceroy of India before being viceroy of Brazil in 1714–18. This relationship worked in reverse as well, as with Bahia native Dom Alexandre da Silva Pedrosa Guimarães, who served as bishop of Macao in 1772–89. See J. R. T. Leite 1999, p. 15.

41. O'Neill and Dominguez 2001, p. 405; J. R. T. Leite 1999, pp. 171–78; Beurdeley and Beurdeley 1971, p. 194; S. Leite 1953, pp. 129–30.

42. J. R. T. Leite 1999, p. 175.

43. Ibid., pp. 125–250; Fonseca 1995; Brajniko 1951.

44. Bailey 2005, pp. 349–51.

45. Edgerton 2001, pp. 13–33; Lara 2004, pp. 68–71.

46. Jesuit missions from Paraguay to Peru included books of missionary heroism in Asia. The Paraguay reductions of San Juan Bautista, Santos Apostoles, and San Ignacio Miní, as well as the Jesuit college in Arequipa, all had copies of a work entitled *Defensa de los nuevos christianos de la China*. The Jesuit reduction of San Miguel, in present-day Brazil, had a copy of *Asia Portuguesa* in three volumes, and the reduction of Santo Ángelo and the colleges at Juli and Potosí had some or all of the three-volume set of Daniele Bartoli's history of the Jesuits in Asia entitled *Dell Istoria della Compagnia di Giesu. L'Asia descritta* (Rome, 1660–67). Other works on Asia in mission libraries in Paraguay and Peru include Athanasius Kircher's *China illustrata* (Amsterdam, 1667), Leonardo de Argensola's *Conquista de las Islas Malucas* (Madrid, 1609), Luis de Guzmán's *Historia de las misiones que han hecho los jesuitas en la China* (Alcalá, 1601), Pedro Chirino's *Relación de las Islas Filipinas i de lo que en ellas an trabaiando los padres de la Compañía de Jesús* (Rome, 1604), as well as histories of Portuguese Asia and Chinese Christians. Buenos Aires, Archivo General de la Nación (AGN), IX, 22-6-3, *Temporalidades de misiones* (1768–78), No. 1, fols. 19v, 20v; No. 2, fol. 11r; No. 29, fol. 14v; No. 24, fol. 22r; No. 23, fol. 8v; IX, 22-6-4, *Temporalidades de misiones* (1768–78), No. 20, fol. 33r; Lima, Archivo General de la Nación (AGNP), *Temporalidades (Juli)*, leg. 130, 4, fol. 53v; *Temporalidades (Potosí)*, leg. 172 (1767–93), fols. 50v, 55r, 57v–58v; AGNP, C956, *Inventario de la biblioteca y aposentos del Colegio de la Ciudad de Arequipa* (1766), fols. 32v–33r, 38r, 41v.

47. Pagden 1992, pp. 146, 149–50.

48. Both Kircher's *Oedipus aegyptiacus* and *China illustrata* helped encourage viceregal interest in pre-Columbian cultures.

49. Gutiérrez Reyes and Celaya Méndez 1991, cat. nos. 16, 25, 26, 27; Osorio Romero 1993, pp. xv–xliv; Paz 1988, pp. 166, 176–77.

50. Cuadriello 1999 "Reino"; García Sáiz 1994; Vargaslugo 1994, pp. 119–23; Dujovne 1984; Dujovne 1972.

51. Museo de América 1999, p. 158.

52. Rivero Lake forthcoming, p. 98.

53. For a penetrating new study of the imperial and moralistic ideology found in *biombo* paintings, see Schreffler forthcoming. See also Bailey 2005, pp. 110, 120–21, 141–41, 159–61; Museo Soumaya 1999.

54. Dujovne 1972, p. 8.

55. Kennedy 1993, pp. 96–97.

56. Ibid.; Americas Society 1992, p. 55.

57. Pérez Carrillo and Rodríguez de Tembleque 1997, pp. 31–46; Pérez Carrillo 1990.

58. Pérez Carrillo and Rodríguez de Tembleque 1997, pp. 21–27; Castelló Yturbide 1981; Jenkins 1967.

59. Phipps et al. 2004, pp. 250–56; Stone-Miller et al. 1992, pp. 201–3; Camman 1964, pp. 21–34.

60. Stone-Miller et al. 1992, p. 203.

61. Camman 1964, p. 26; Hong Kong Museum of Art 1995, pp. 254–99.

62. Camman 1964, p. 25.

63. McQuade 1999 *Talavera*, pp. 13–47; Angulo Íñiguez 1946.

64. Escobosa de Rangel 1993, pp. 21–27.

65. Kennedy 2002 *Quito;* Museo Nacional del Banco Central del Ecuador 2001; Museo Nacional del Banco Central del Ecuador 2000; Mena 1997.

66. Kennedy 1993, p. 96.

67. Bomchil and Carreño 1987, pp. 418–20.

68. Museu de São Roque 1996, pp. 142–43; Calouste Gulbenkian Museum 2001, pp. 113–16.

69. Museu de São Roque 1996, pp. 144–45; Calouste Gulbenkian Museum 2001, pp. 111–12.

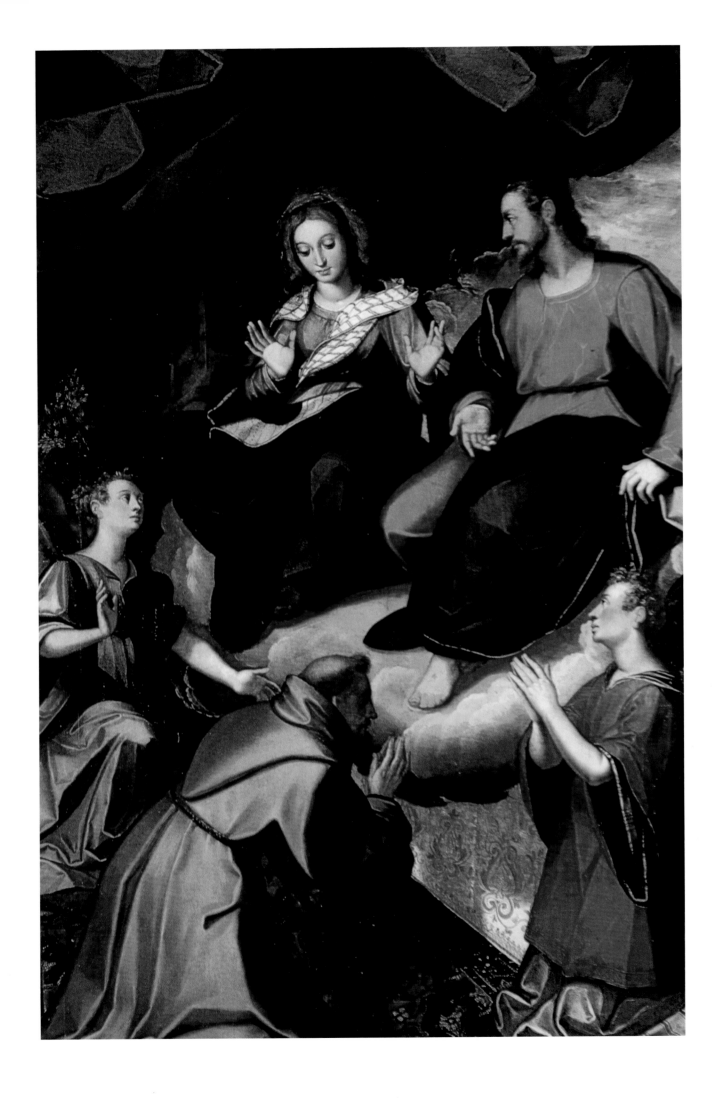

The Parallel Course of Latin American and European Art in the Viceregal Era

Marcus Burke

This essay seeks to examine Latin American art in the Spanish viceroyalties at moments of closer or more remote relationship to Spanish and European art and to offer criteria, including patronage issues, that may be used in ongoing investigations of the subject.[1] It should be acknowledged at the outset (as the present exhibition makes clear) that any discussion of viceregal artistic culture must include, along with paintings and sculpture, the various decorative arts, not to mention the glories of viceregal architecture, all of which must be considered before a complete picture may be obtained. However, only a few elements of that larger story will be addressed here, in order to sketch the broad issues involved.

It has often been assumed that the arts produced in colonial societies must be entirely subordinate to those of the colonizing country. In this typically Eurocentric view, the colonial works must either be alien, exotic phenomena tolerated by the colonizers or be provincial imitations of the arts of the colonizing country, with the strong implication that they are second-rate.[2] Indeed, variations on these assumptions have often been applied to Latin American viceregal art, obscuring the rich and dynamic history of the arts in the Spanish colonies and their relationship to the broader European cultural context. For example, one Eurocentric point of view places viceregal art exclusively within the context of Iberian culture.[3] Another point of view, also derived from Eurocentric misunderstandings, categorizes Latin American art in the colonial era as an alien, "wholly other" phenomenon vis-à-vis European art, grouping it with tribal African, Oceanic, and of course, pre-Columbian art.[4] Ironically, this attitude has opened colonial art studies to the benefits of scholarly interchange with pre-Columbian archaeology and cultural anthropology, yielding much new understanding of the importance of indigenous contributions to viceregal culture[5]—although this more "anthropological" approach runs the danger of assuming that microcultural developments in the early period may be taken to stand for colonial culture as a whole over the entire range of three centuries.

In contrast with both the Eurocentric "colonial" explications and the anthropological approach, a tradition of self-referential, descriptive art history largely focused on European-style

FIG. G-1

Baltasar de Echave Orio (Spanish/Mexican, c. 1548– after 1612), *The Vision of Saint Francis*, c. 1600–12. Oil on panel, 96¼ × 63⅝ inches (244.5 × 161.5 cm). Museo Nacional de Arte/INBA, Mexico City

works of art has been cultivated in the Latin American countries themselves.[6] A related international school of investigators, including both peninsular Spanish and Latin American scholars (as well as the present author), also takes a descriptive/chronological approach, discussing Latin American viceregal art as a separate phenomenon in itself, but doing so in terms derived from European art history.[7] This orientation also presents dangers: among the temptations in approaching Latin American viceregal art through the portals of European studies is that of assuming artistic developments at the centers of colonial power to be completely representative of viceregal culture, which of course they were not. There are also tendencies to select artists who either follow European norms or vary these in precisely understandable ways, to focus on Mexico rather than on South America before 1700, and to pay relatively little attention to the arts of design.

Many of the meta-historical problems facing viceregal studies may be resolved by admitting the existence of two cultural processes at work in the Spanish and Portuguese colonies. The first of these cultural processes is the blending of European and indigenous American cultures during the sixteenth and early seventeenth centuries, with significant consequences especially on the periphery but also occasionally at the centers of power during the subsequent centuries. (For the sake of convenience, we will call this type "hybrid" art, on the understanding that unlike a biological hybrid, this type of art had a wealth of viable offspring.[8]) The second process is the establishment, at many centers of power, of Euro-American schools of art making few direct references to the fine arts of the pre-Hispanic cultures, even when there was interaction with the hybrid art forms and their successor styles.

Although there is not sufficient space to argue the point fully, I would like to suggest that viceregal studies would benefit immensely from setting the point at which "indigenous" culture turns into "hybrid" culture earlier rather than later in the history of any locale. Indeed, given the importance of religion in pre-Hispanic cultures, it would seem impossible to maintain a sense of purely "indigenous" culture for more than a generation after the definitive establishment of Spanish military/political dominance and concomitant missionization at any center of power, since the first thing the Spanish did was to suppress the public cult of the local gods. At any point under effective Spanish control, therefore, what had been pre-Hispanic artistic culture must be understood as being quickly hybridized, although many aspects of the past culture and faith were kept alive in private contexts and resistance was widespread, even over several generations in some regions.[9] Indeed, we may in fact say that even the hybrid objects evolved rather quickly into what should be called the products of "local schools." In all of this, we must make the important proviso that the situation in central Mexico differs markedly in many ways from that in the Andes, or even from that on the far northern frontier of Mexico itself. Most importantly, in Peru, the establishment of two capitals—a Spanish viceregal capital at the new European city of Lima and a second administrative center in the former Inca capital of Cuzco—made a certain amount of cultural differentiation unavoidable.[10]

In general, and on different timetables according to location and patronage, the hybrid art forms may be said to have been progressively marginalized by social-historical events over the course of the three hundred years of colonial history. Marginalization, however, does not always cause decay, and in fact, the local popular styles into which the hybrid arts evolved often remained vital and available to spark revivals, especially in the decorative arts. It must also be remembered that, at least after the European-American urban societies (often designated by the adjective "Creole") began to reach a "critical mass" in the late sixteenth century, the hybrid cultures began to react directly with the new Creole (European-American) societies as well as indirectly with Europe itself through books and works of art.

One highly interesting aspect of many of the objects in the present exhibition is the way they show selected hybrid art forms being kept active over several generations by market forces or specialized patronage. For example, feather mosaics (cat. 11-1) and Andean textiles (cat. 11-2),

two of the most appealing of the hybrid art forms, were the sort of exotic luxury item that a mercantilist imperial system would allow to be exported back to Europe. (Andean textiles also maintained important values for social and political communication within colonial society.[11]) In this category also fall the various ceramic products, including those with scented clay, produced at Tonalá and other centers in Mexico and even in Chile, as well as a wide range of lacquerware from Peribán, Pátzcuaro, Michoacán, Pasto, and other locations. Even at the centers of power in a wholly European context, new hybrid art forms, such as paintings on mother-of-pearl, and new subjects, such as the *casta* paintings, were developed for export to Europe.

Let us now turn to the second of our two processes, the establishment of European-style artistic schools. We hope to demonstrate that, from a very early point, these must be understood as *parallel* developments within the European cultural sphere, analogous to provincial schools within Europe itself (for example, Bohemia or Poland)—neither an alien cultural phenomenon nor a merely derivative imitation of Spanish art, receiving influences from a broader European, as opposed to narrowly Spanish, spectrum of sources, if always within the limits of Counter-Reformation Roman Catholicism.

A guild of painters on the European model was established at Mexico City in 1557; guilds or confraternities were active at Quito by about 1585, Lima by the mid-1600s, and Cuzco by 1649.[12] The Mexico City guild regulations, while free from overt racial prejudice, establish firm control of artistic production at the capital in the hands of the immigrants and their professional descendants. In addition, the immigrant artists would prove exceptionally adept at manipulating post-Tridentine religious values to suit their own commercial purposes.[13] (As we shall see in the case of Cuzco in the 1600s, guild politics could be manipulated to benefit artists of indigenous and mestizo origin as well.)

What was the nature of the European styles brought to the New World in the later sixteenth century? Whatever their orientation, almost all scholars agree that the dominant artists participated in various ways in the style called mannerism, and that there was a significant influence from Italianized Flemish art, which we may call "Italo-Flemish reformed mannerism," and which was also the dominant influence on the school of Seville in the later 1500s.[14] (The "reformed" descriptor recognizes the impact of the Catholic Counter-Reformation in the century after the Council of Trent, 1545 to 1563/64.) In Mexico, the three artists who first defined the new, urban colonial school were a Netherlandish (Flemish) painter, Simón Pereyns (to Mexico 1566; died 1589); an Andalusian, Andrés de la Concha (to Mexico 1567; died after 1612); and a Basque, Baltasar de Echave Orio (born c. 1548–after 1612; in Mexico from c. 1580), all of whom may be categorized as Italo-Flemish mannerists intimately familiar with the school of Seville.

An important question must be raised at this point. Were these artists, and their contemporaries in South America, simply a branch of the school of Seville, not yet, as Jonathan Brown has put it, "emancipated from peninsular models"?[15] Or were they engaged in a parallel endeavor that, even if it came from similar origins and followed the same direction as artistic production in Spain, was essentially independent? This is more than a semantic point of the "half-full/half-empty" sort, since it affects greatly the terms of discourse and the bases for analysis affecting all subsequent viceregal art. Looking at the situation in Mexico, we see strong artistic parallels alongside the fact that all three artists spent varying amounts of time in Seville on the way to America. Yet the very biographies of the artists suggest caution: only Concha was actually formed in Seville. Furthermore, the school of Seville itself, as all scholars agree, was in the later sixteenth century in the grips of foreign influence and filled with immigrant artists, above all those from the Netherlands, a part of the Spanish empire—exactly the situation developing contemporaneously in Mexico.

For example, a comparison of works by the Sevillian master Pedro Villegas Marmolejo (1519–1596) to those of Pereyns and Concha, suggested by Brown,[16] certainly reveals a

"commonality of approach" between Pereyns, a Netherlander who worked in Seville on his way to Mexico, and Villegas, a Sevillian strongly influenced by Netherlandish art. At the same time, however, the comparison reveals Concha, the Sevillian, to be rather more Italianate than his former compatriot, perhaps suggesting why he might have emigrated in the first place. With Echave Orio (fig. G-1), we encounter a more complex situation: the majority of his works can described within the orbit of Italo-Flemish mannerism, fully consistent with work at Seville—but selected pieces might also be related to Italian art, including the works of the first group of Italian painters active at the Escorial in Spain in the 1580s.

The important point, however, is that no causal relationship is evident. While the immigrant artists in Mexico came from or passed through the school of Seville, once arrived in the New World they had relatively few, relatively unimportant concrete examples of peninsular works of art to imitate. The paintings they had seen in churches and other public collections in Seville, not to mention on the easels of fellow artists, became only fading memories, replaced by randomly imported objects, print sources, and the works of art coming out of their own brushes. In the New World, the immigrant artists would have found a completely different set of patrons, not all of them Spanish and only a few Sevillian, new problems to solve, and a different constellation of sources and influences. Of course, many of these were the same sources available in Seville, including the same Italian and Flemish prints and highly similar Italo-Flemish pictures, such as the seven or eight works that Maarten de Vos sent to Mexico, along with others sent to Peru.[17] If, in an era when European art was highly internationalized, the New World artists had direct access to many of the same models—Flemish prints, Jerome Nadal's prints,[18] de Vos's pictures—as their former colleagues in Seville, this in itself suggests that the situation was one of parallel artistic development. Therefore, as in the case of the hybrid art styles, we should set the point at which the emancipation from peninsular models begins earlier rather than later. Indeed, we may even say that it was greatly advanced simply by getting on the boat to America.

Turning to the Viceroyalty of Peru, the appeal to peninsular Spanish and Sevillian models makes only occasional sense. The first three major European artists active in the late 1500s and early 1600s were all Italians. These were the Jesuit painter Bernardo Bitti (1548–1610), born in Ancona and trained in Rome, who traveled widely in Peru and Bolivia after arriving in 1575; the Roman-born Angelino Medoro (1565–1632), who was active in what is now Colombia as well as Peru; and the Roman-born Mateo Pérez de Alesio (c. 1547–c. 1616), who appears to have been of Spanish descent and who worked in Seville as an already mature artist from 1584 to 1587, picking up many influences from the local Italo-Flemish manner.[19] In addition to Pérez de Alesio's work in Seville, the parallel with what was developing there and at Mexico City is apt in that all three would have relied on Flemish and Italian prints, seen the works of de Vos and other Flemish art, and once again, were formed in an artistic atmosphere in Italy that had long since become highly international. However, Bitti, Medoro, and Pérez de Alesio were also interacting with much stronger hybrid or even directly indigenous cultural environments as a result of their itinerant activity. In any event, the point is that European-style art began from the outset as a parallel phenomenon, aware of developments in Spain but also following its own aesthetic dictates at each center.

In the next generation, which may be described in terms of the "prosaic style" engendered by the Counter-Reformation, Mexican painting diverges and Peruvian painting remains distinct from the Spanish schools.[20] In Mexico, a large part of this may be attributed, as all scholars have observed, to the dominance of Flemish models. Here patterns of collecting may be said to intervene, since in Spain itself, Flemish pictures were imported in large numbers, increasingly removing the market and motive for imitation as the seventeenth century progressed. In Latin America, any European painting became an important source of influence, a direct model, taking its place alongside printed images. To jump ahead fifty years, we find

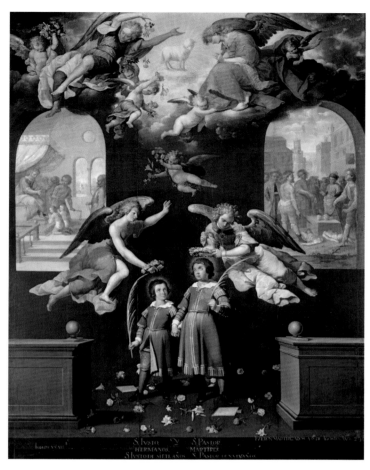

FIG. G-2

José Juárez (Mexican, c. 1615/20–1667), *Saints Justus and Pastor*, c. 1653. Oil on canvas, 148½ × 113¼ inches (377 × 288 cm). Museo Nacional de Arte/INBA, Mexico City

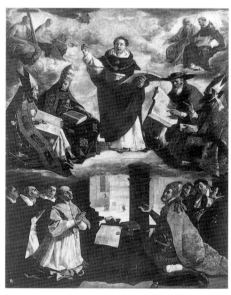

FIG. G-3

Francisco de Zurbarán (Spanish, 1598–1664), *Apotheosis of Saint Thomas Aquinas*, signed and dated 1631. Oil on canvas, 187 × 147½ inches (475 × 375 cm). Museo de Bellas Artes, Seville, Spain, 199

at Puebla, Mexico, where an important collection of Flemish pictures remains in the cathedral to this day, that artists such as Antonio Pacheco de la Serna (active c. 1680), often painting on copper, extended the school of Jan "Velvet" Breughel (1568–1625) and his generation to the end of the seventeenth century.[21] No such phenomenon exists on any significant level in Spain.

Let us now turn to one of the moments in which European-style painting in Latin America comes into close alignment with the Spanish school, particularly that of Seville: the establishment of seventeenth-century tenebrist naturalism in the 1640s, nearly forty years after its establishment in Italian art by Michelangelo Merisi da Caravaggio (c. 1571–1610), and twenty years after artists such as Diego Velázquez (1599–1660) and Francisco de Zurbarán (1598–1664), following the lead of Jusepe Ribera (1591–1652) at Naples, introduced the style into Seville. In Mexico, three interrelated developments—the coming of age of the Mexican painter José Juárez (c. 1615/20–1667), the arrival of the Sevillian master Sebastian López de Arteaga (1610–c. 1652) in 1640, and the large-scale exportation of works by Zurbarán to Latin America[22]—advanced the new style. In Peru, it was the arrival of the works by Zurbarán and his shop that played the dominant role, along with the importation of a collection of peninsular Spanish art.

The exact nature of the influence of Zurbarán's works in Latin America, which once seemed so clear and direct, is now debated.[23] There is even uncertainty over exactly which paintings by Zurbarán came to Mexico. Arteaga, who shows as much relation to other members of the school of Seville as to Zurbarán, can hardly be considered a follower of the latter but does share the common relationship with Caravaggio and the tenebrist-naturalist movement in early-seventeenth-century art (see cat. VI-12). With José Juárez, however, we are faced with an extraordinary affinity to what was practiced at Seville, particularly by Zurbarán; should his works have been discovered without context, one might well assume that he had worked in Andalusia. For example, a work such as José Juárez's *Saints Justus and Pastor* (fig. G-2) shows Juárez using such motifs as the flowers on the floor, a bipartite composition, and a darkened screen of architectural elements as a backdrop for figures highlighted in the tenebrist manner, which are highly similar to what is found in the works of Zurbarán, such as the *Apotheosis of Saint Thomas Aquinas* of 1631 (fig. G-3).[24] In Peru, the direct relationships are fewer, although a sharp-focus tenebrism informs the work of Luis de Riaño (1596–c. 1667) at Lima; the extent to which this was accomplished in imitation of Zurbarán's works remains to be elucidated. In all aspects of Zurbarán's role in Latin America, it must be kept in mind that the print sources in use by Latin American artists were often the same prints used by Zurbarán,[25] creating an affinity that would not require direct imitation.

Curiously, questions about the nature of Zurbarán's influence on Latin America underscore the point this essay seeks to make: that the Latin American schools represent parallel rather than subordinate phenomena vis-à-vis Spanish art. That so perceptive a scholar as Juan Miguel Serrera should question the nature of Zurbarán's influence and have difficulty relating the Mexican works of Alonso Vásquez (active 1582–1608, in Mexico from 1603) to those of his previous Sevillian period argues strongly for the Latin American schools having quickly developed a sense of independence and respect for local artistic traditions.[26]

A series of interactions among artists, paintings, and prints in mid-seventeenth-century Mexico demonstrates both the parallels with Sevillian painting in the 1640s and the creative way in which Latin American viceregal artists used print sources. The works involved are

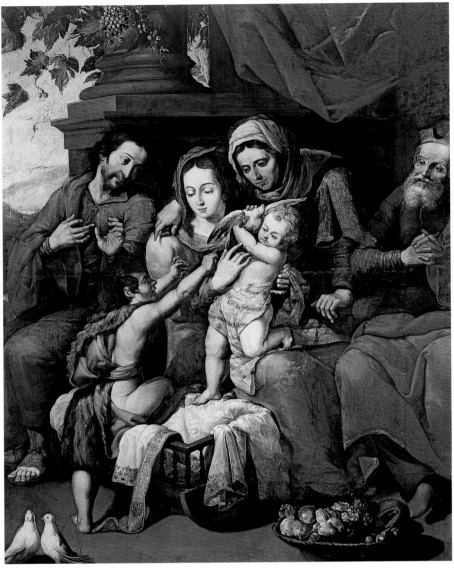

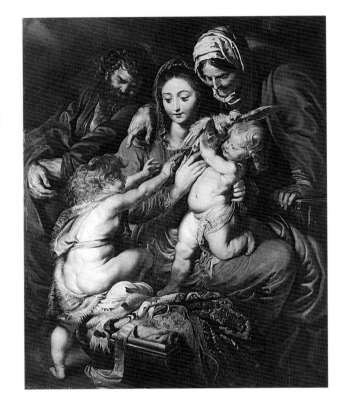

FIG. G-4
José Juárez (Mexican, c. 1615/20–1667), *Holy Family
of the Bird*, c. 1660? Oil on canvas, 76 × 59 inches
(193 × 150 cm). Museo Universitario, Puebla, Mexico

FIG. G-5
Peter Paul Rubens (Flemish, 1577–1640), *Holy Family
of the Bird*, c. 1609–10. Oil on wood, 26 × 20¼ inches
(66 × 51.4 cm). The Metropolitan Museum of Art,
New York, Bequest of Mrs. William H. Moore,
55.135.1

José Juárez's *Holy Family of the Bird* (fig. G-4); Juárez's source for the central group, a painting by Peter Paul Rubens (versions now in Los Angeles and New York [fig. G-5])[27]; José Juárez's *Adoration of the Magi* of 1655 (fig. G-6); a series of engravings after versions of *The Adoration of the Magi* by Rubens; and a work by Baltasar de Echave Rioja, *The Adoration of the Magi* of 1659 (fig. G-7). Justino Fernández was the first to note the differences between José Juárez's *Holy Family* and its source in Rubens.[28] Juárez has suppressed the three-dimensionality of the Rubens composition, especially the motif of Saint Anne leaning over the lower figures, and overall expressed the group in a more prosaic manner, arraying them before an architectural background that has expanded from the vestigial architectural elements in the Rubens source into a screen across the back of the composition, if more fully lit than is typical with Zurbarán. That is to say, José Juárez, even in adapting Rubens's composition, gravitates toward the more staid tenebrist naturalism associated with the school of Seville and the style of Zurbarán. A comparison of José Juárez's *Adoration of the Magi* with Zurbarán's 1638 version of this subject at Grenoble (fig. G-8) shows the Mexican producing a rather more three-dimensional arrangement of figures compared to Zurbarán's friezelike group and again using an ambient background light in lieu of a dark screen. Yet the figure poses, even if mediated by common print sources as well as imported pictures, the stasis of the composition, and the general tenebrist quality keep the Mexican work close to the Andalusian orbit.

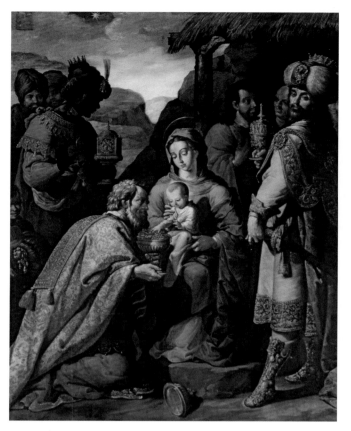

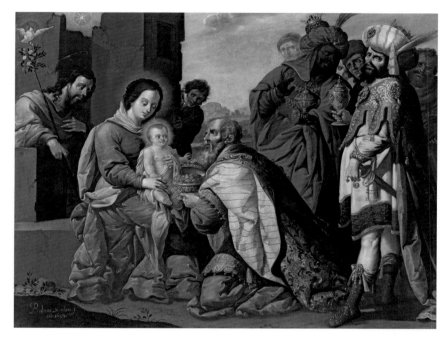

FIG. G-6

José Juárez (Mexican, c. 1615/20–1667), *The Adoration of the Magi*, signed and dated 1655; oil on canvas, 81½ × 65 inches (207 × 165 cm). Museo Nacional de Arte/INBA, Mexico City

FIG. G-7

Baltasar de Echave Rioja (Mexican, 1632–1682), *The Adoration of the Magi*, signed and dated 1659. Oil on canvas, 61 × 78¼ inches (155 × 199 cm). The Figge Art Museum, Davenport, Iowa, Gift of C.A. Ficke, 25.84

José Juárez's pupil Echave Rioja, however, inverts the stylistic function of print sources. Where his teacher had drained some of the baroque energy from the composition, Echave Rioja uses motifs from several prints after Rubens to work toward a more fully baroque composition.[29] Indeed, prints after Rubens would continue to be highly important sources for Echave Rioja as he established the high baroque style in Mexican art.

As we move to the last three decades of the seventeenth century, a period of great activity in church decoration and secular commissions, we see Mexican painting diverging once more from Spanish art along highly idiosyncratic lines, a phenomenon that has often been linked to the rise of what has been called "Creole nationalism" in the later seventeenth century.[30] Thus, the generation following Echave Rioja, such as Cristóbal de Villalpando and Juan Correa, both born around 1645, produced works, often on immense scale, that offer few stylistic parallels to Spanish painting, even when they are directly quoting motifs from Sevillian compositions.[31] The resistance of the local school to interference from Spain is remarkable, given that, in the period 1670–1700, as in the 1640s, considerable economic pressures ought to have led to the wholesale emigration of Spanish artists to the New World. This did not happen, but important works by Spanish artists, such as large-scale Immaculate Conceptions by Francisco Rizi (1614–1685) and Juan Carreño de Miranda (fig. G-9),[32] not to mention copies after Bartolomé Esteban Murillo (1618–1682) and a continued stream of Flemish works,[33] were imported into Mexico at the time. Similarly, there are works by Villalpando, such as his *Vision of Saint John* in Puebla (Museo José Luis Bello y González/INAH), that show remarkable stylistic affinities with the (equally idiosyncratic) works of Juan de Valdés Leal (1622–1690) at Seville.[34] Yet, in their most important commissions, both Villalpando and Correa reveal idiosyncrasies that can only be thought of as identifying marks of a Mexican viceregal (as opposed to Spanish colonial) school within the European tradition. Indeed, painterly freedoms, distortions of anatomy, a tendency toward certain locally engendered formulas, particularly in the rendering of angels, and an occasional touch of naïve primitivism set their works apart from those of almost any European contemporary. Even in the compositions of José Juárez, there had been a tendency

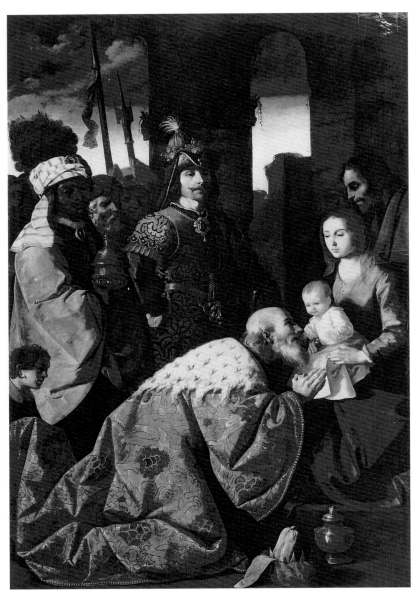

FIG. G-8

Francisco de Zurbarán (Spanish, 1598–1664), *The Adoration of the Magi*, 1638. Oil on canvas, 102¾ × 68⅞ inches (261 × 175 cm). Musée des Beaux-Arts, Grenoble, France, 561

to maintain mannerist stylistic elements, a phenomenon that Correa in particular develops into a full-blown revival.[35] This may be explained only in part by the continued use of mannerist prints as compositional sources long after their creation and by the lingering mannerist elements in Zurbarán's oeuvre. Rather, a local tradition must be invoked to explain the Mexicans' variance from the European, not to mention the Spanish, norm.

If we turn now to Peru, we find, at Cuzco, artistic developments offering remarkable analogies to the expressions of Creole nationalism in the work of Correa and Villalpando. Initially, developments in Cuzco may have been moving toward something similar to the situation in Mexico City in the 1640s. In 1673, Bishop Manuel de Mollinedo arrived in Cuzco from Lima with a collection of Spanish pictures, including works by Juan Carreño de Miranda, Sebastián de Herrea Barnuevo (1619–1671), and Eugenio Caxés (1575–1634).[36] Already at midcentury, artists such as Martín de Loaysa (active 1648–after 1663) could produce works clearly reflecting the works of Pedro Orrente (1580–1645)—presumably indicating the import of these pictures into Peru.[37] But this trend was not to dominate. José de Mesa and Teresa Gisbert have described the situation at Cuzco in 1688, in which "Spanish" painters (presumably Creoles, to judge from the names, and hispanized mestizos, but possibly also peninsular immigrants) petitioned the royal representative (*corregidor de la ciudad*) to allow them to erect the customary arch at the Corpus Christi procession without the intervention of the "Indian" guild members, who were rebelling against the Creoles' attempts to dominate the guild.[38] In the event, the *corregidor* told each of the two groups to erect an arch, certifying in effect the secession from the guild of the painters of indigenous origin. Mesa and Gisbert call this document "the birth certificate" of the Cuzco school of painting. Patronage favoring the "Indian" artists had in fact preceded the split. We thus find at Cuzco in the late seventeenth and eighteenth century a situation in which a group of artists, insisting on identifying themselves in local terms rather than subordinating themselves to peninsular or even Creole definitions of art, finds official sanction and a group of patrons willing to support them. Instead of Martín de Loaysa's reflection of peninsular models, the Cuzco school followed the more idiosyncratic production of Diego Quispe Tito (1611–c. 1680), in which the local style derived from the earlier hybrid works of art continued to react with European influences, producing something Gisbert and Mesa have called "mestizo art." That this was a cultural and artistic and not a racial process may be seen, as Damián Bayón has insisted,[39] in comparing Quispe Tito to his contemporary and rival, Basilio de Santa Cruz, who was also of indigenous origin but worked in a more fully European manner.

In effect, as I have argued elsewhere,[40] the identification of local schools of art in viceregal Latin America is a relatively simple exercise in normative aesthetics. By the 1680s, European-style painters had enjoyed well over a century of guild history in Mexico City, comprising seven artistic generations of father-son or master-pupil relationships. In the way that the Carracci emulated Raphael, Correggio, and Titian—whom they considered the "founders" of the grand tradition of Italian painting—Mexican artists could look back on

the works of Pereyns, Concha, and Echave Orio as the "founders" of the local school. In South America, Bitti, Medoro, and Pérez de Alesio fill similar roles. In all areas, certain localized aspects of style, originating both in the compositions of the sixteenth-century artists and in the parallel hybrid art styles, had long ago taken on a life of their own, so that how a patron might expect (for example) an angel to be represented would be determined by how they had been represented by previous local artists. In centers such as at Mexico City, Puebla, Querétaro, Lima, Quito, and Bogotá, both artists and patrons could develop a sense of common Creole values by reference to a body of publicly visible art. At Cuzco, and by extension in what is now Bolivia, the artists intervened proactively in this process, deciding in effect to edit the normative aesthetics to emphasize local values derived from earlier hybrid art forms, no matter how much this pushed the local style off of contemporary European norms. Beginning with the *corregidor* of Cuzco in 1688, and including church officials and wealthy patrons such as mine owners in Potosí, patronage supported these developments, yielding highly idiosyncratic (from the European point of view) local or national schools. The analogy to market forces sustaining the creation of hybrid luxury objects is significant.

In fact, we can posit that wherever the local patron class includes significant numbers of wealthy citizens of indigenous or mestizo descent, a decided sense of *patria chica* alongside the wider urgings of Creole nationalism, and a strong local artistic tradition (usually derived ultimately from hybrid art forms), then the artistic products of the local school will begin to express local norms preferentially over international European norms. We may test this hypothesis by examining the art produced at centers of power or patronage where the indigenous aspect of the population remained robust, as it did at Cuzco or Potosí. For example, in Mexico at the sanctuary of Ocotlán or at Oaxaca, many works of art show parallel affinities with the school of Cuzco, including technical details such as the use of applied gold decorations to the surface of the pictures.[41]

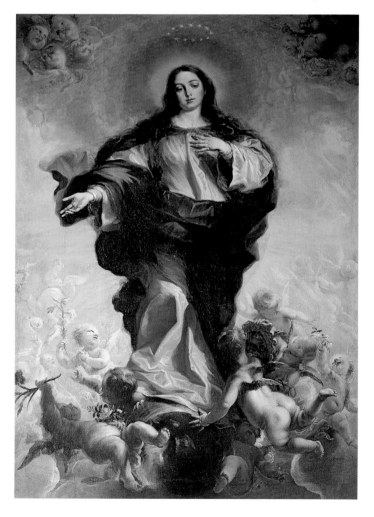

FIG. G-9
Juan Carreño de Miranda (Spanish, 1614–1685), *The Virgin of the Immaculate Conception,* signed and dated 1670–in Mexico before 1682. Oil on canvas, 83⅛ × 57⅛ inches (211 × 145 cm). The Hispanic Society of America, New York, A85

To return to Correa and, especially, Villalpando, we find artists whose styles were at once up-to-date and exuberant (that is, baroque) and sufficiently laced with references to European art to please the Spanish colonial authorities, while, at the same time, they exuded a *Mexican* feeling that was the formal parallel to the images of pre-Hispanic gods and heroes used to decorate the triumphal arches of entering viceroys as a means of impressing upon them the antiquity of local traditions.[42] The patronage that Correa and Villalpando enjoyed represented exactly the intellectual ambient in which, as Jacques Lafaye has demonstrated, the birth of the new Creole consciousness occurred.[43] Indeed, if we look at the poetry of their contemporary Sister Juana Inés de la Cruz, we see the parallels continue: the mannerist elements preserved in the large, allegorical, baroque mural paintings for the cathedral of Mexico City are analogous to the *Gongorismo*[44] and use of references taken from Renaissance mythography that lace Sister Juana's works. A similar phenomenon is found in New World ceramics, especially the blue-and-white maiolica produced at Puebla in Mexico, the designs of which derive not from peninsular ceramics but rather from Chinese export porcelains[45]—a remarkable early expression of chinoiserie.

The eighteenth century is in many ways the forgotten period of Latin American viceregal art. In contrast to almost any comprehensive exhibition, such as the present one, in which eighteenth-century works make up a sizeable percentage of the objects, histories of Latin American art tend to run out of things to say about this era at the centers of power. The variations from the European norms in the works of Juan Correa

or the Cuzco painters are noteworthy, but equally significant is what happened to Latin American art at most centers of power in the decades after 1700: it returns emphatically to European norms.

This can be related to patronage trends after the establishment of the Bourbon dynasty on the throne of Spain in 1700. Politically, the new Spanish king, Felipe V, and his supporters found themselves faced with Austrian and British hostility abroad and rebellion at home, particularly in Catalonia, all in the context of an economy that was still stagnant on the Iberian peninsula. In Latin America, however, the economy was robust, and so it became imperative to keep the colonies from leaving the empire, especially given the crown's continuing need of Mexican and Bolivian silver. Serving at the time of the War of the Spanish Succession (1701–14, to 1721 in Spain itself), Spanish leaders throughout the Americas succeeded in maintaining the loyalty of each colony to the new Bourbon dynasty. In this context, the idio-

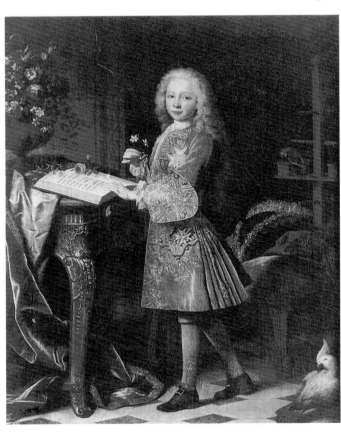

FIG. G-10
Jean Ranc (French/Spanish, 1674–1735), *Charles III as a Child*, c. 1722–23. Oil on canvas, 55⅞ × 45⅜ inches (142 × 115 cm). Museo Nacional del Prado, Madrid, 2334

syncratic expressions of a Creole nationalist spirit in the works of Correa and Villalpando from the 1680s and 1690s must have seemed almost dangerous, not to mention *démodé*, to a Bourbon Spanish official such as the Viceroy Duke of Linares. Not surprisingly, Linares's patronage was given to Juan Rodríguez Juárez, a painter who worked entirely within European norms.[46]

Juan Rodríguez Juárez (1675–1728) and his older brother Nicolás (1667–1734) were the links that connected the eighteenth century to a dynasty of Mexican painters that stretched back in direct succession to Baltasár de Echave Orio in the 1500s. Juan Rodríguez Juárez was a remarkable artist on many fronts, including the fact that he anticipated, in some cases by a decade, the developments that artists such as Jean Ranc (fig. G-10) would bring to the new Bourbon court at Madrid.[47] Indeed, from this point on, the Latin American schools at the viceregal capitals show themselves adept at remaining *au courant* with European styles in art as in fashion. But if one were to compare the Latin American artists with European counterparts, it would not be with painters in Spain, except perhaps in a general way with the followers of Murillo. Rather, Juan Rodríguez Juárez is more correctly compared with the followers of Carlo Maratta (1625–1713) in Italy or the late-seventeenth-century French school, Miguel Cabrera with Jacopo Amigoni (who worked internationally, including at Madrid), and so forth (figs. G-11, G-12). Murillo, whose influence may be said to have crushed the school of Seville for the two generations after his death in 1682, had surprisingly little direct influence in Latin America, although copies after his works came to America, Latin American artists (such as Villalpando) certainly quoted his compositions, and there is some evidence of a general awareness of his art, or at least a sharing of the international late baroque design values evident in his works.[48] For the absence of influence of the eighteenth-century school of Seville, we need only recall that Seville would lose its monopoly position as port of trade with the Indies to Cádiz by 1717.[49] Similarly, art at Madrid seems to have had a decreasing relationship to Latin America over the course of the eighteenth century, except again for common international elements, the expectations of peninsular sitters for official portraits, and the sojourn in Puerto Rico of Luis Paret y Alcázar (1746–1799), so important for the art of José Campeche (1751–1809).[50]

This lack of engagement is particularly surprising in the light of Latin American architecture and altar ensemble design in the eighteenth century, which align closely with the explosive development of late baroque forms in Spain and Portugal. The new type of design, often called *churrigueresco*, or churrigueresque, in Spain, and a variety of names, including

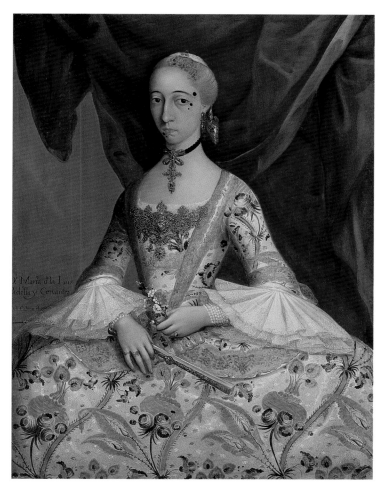

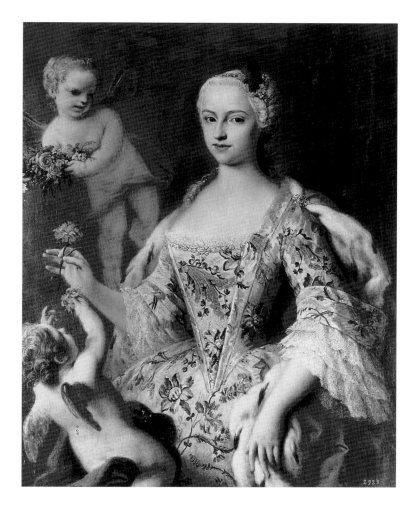

FIG. G-11

Miguel Cabrera (Mexican, 1695–1768), *Doña Maria de la Luz Padilla y Cervantes*, c. 1755–60. Oil on canvas, 43⅛ × 33⅛ inches (109.4 × 84 cm). Brooklyn Museum of Art, New York, The Dick S. Ramsay Fund, 52.166.4

FIG. G-12

Jacopo Amigoni (Italian, 1680–1752), *The Infanta Maria Antonieta Fernanda*, c. 1750. Oil on canvas, 40⅝ × 33⅛ inches (103 × 84 cm). Museo Nacional del Prado, Madrid, 2392

"ultra-baroque" in Latin America,[51] links Spain and Latin America to the late baroque phenomena in Central Europe and Italy that paralleled the development of rococo forms in France. While there is no question of the close relationship among Spain, Portugal, and Latin America in architecture, the international parallels suggest a basis for understanding the differences between the Latin American schools and Spanish painting. Like Spain itself, the Latin American viceroyalties participated in the international tendencies of the age. Yet, unlike in architecture, where Spain was a center of innovation in partnership with the viceroyalties, in painting and sculpture Spain was hardly in the forefront of innovation. The artists of viceregal Latin America had no need to defer to Madrid, except of course in political terms and as a source of news about what was fashionable in Europe generally.

One casualty of this phenomenon was the school of Cuzco. Increasingly marginalized, with much of the patronage that had driven it shifting to silver-rich Bolivia and what remained diminished by the splitting up of the Viceroyalty of Peru, Cuzqueño painting becomes generic, almost industrialized, with certain important exceptions, such as works of art related to political resistance and the neo-Inca revolt (series of portraits of the Inca kings) and a new class of folk images, often depicting Saint Isidore the Husbandman (San Isidro Labrador).[52] The Spanish authorities were not unaware of the autonomy of the local artistic schools, and the imposition of an Iberian version of late eighteenth-century style, including neoclassicism, was an important goal of the art academies that were founded throughout the colonies in the last decades of the eighteenth century.[53]

Let us end this discussion of the relationship between Spain and Latin America with a brief glance at the one area in which close connections abound: iconography.[54] Although we must be careful to separate specifically Spanish traits from the larger pool of imagery associated with the Roman Catholic Church, it is clear that the Christian imagery of the New World

stays very close to Iberian prototypes. Part of this stems from Spain's role as a leading country in the Counter-Reformation, so that the missionization of Latin America was handled by monks and priests steeped both in the energetic Spanish version of Catholicism and in the new reform values.

From the earliest moments of the missionization process, illustrated books, devotional prints, three-dimensional images, banners, and easel paintings were imported as tools for evangelization. By the late 1500s, what we may characterize as a flood of printed material was pouring into the colonies. Furthermore, these images often revealed specifically Spanish devotional concerns, such as the doctrine (subsequently dogma) of the Immaculate Conception; the roster of saints associated with Immaculist theology, such as Saints Anne and Joachim or Saint Ildefonsus of Toledo; devotions to Saint Isidore the Husbandman, the Virgin of Atocha at Madrid (and the associated image of the *Niño de Atocha*), the Virgin of the Pillar (c. 1520–1568) at Zaragoza, the Madonna of the Mercedarians (*La Merced*) from Barcelona, and the Mater Dolorosa (*Nuestra Señora de la Soledad*) made in 1564 by Gaspar Becerra for the monastery of San Francisco de Paula, Madrid. In this context we may also cite the variant images of the Madonna of the Carmelites and the Candlemas Madonnas (*Virgen de la Candelaria*), including their sumptuous garments and jewels.

Certain religious orders, such as the unshod Carmelites, Jeronymites, Conceptionists, and Mercedarians, are almost exclusively identified with Spain, so that many images of their saints are by necessity of Spanish origin.[55] These include Saints Teresa of Avila and Simon Stock of the Carmelites and Saints Peter Nolasco, Raymond of Peñafort, and Raymond Nonnatus (Ramón Nonato) of the Mercedarians. The Jesuits, whose founder, Saint Ignatius of Loyola, and many early leaders, such as Saint Francis Xavier and Francis Borja, were Spanish, also brought an iconography filled with distinctly Spanish images. Another international order heavily influenced by Spaniards was the Dominicans, whose founder, Saint Dominic, and several of whose saints, such as Vincent Ferrer and Rose of Lima, were Hispanics. (The Dominicans' management of the Inquisition gave them a powerful, indeed ominous, structural connection with the Spanish government.) Since reformed Franciscan piety underlay much Spanish Catholicism in the late 1400s and 1500s, and contributed so heavily to the initial missionization of the New World, Franciscan images, while hardly exclusive to Spain, are nevertheless a reminder of the central importance of the order and its theology—an element of a common religious culture.

At the same time, as in matters of style, Latin American viceregal imagery can also follow its own lead. Different statues of Saint Francis, for example, could take on a devotional life of their own, while even specific cult images, such as that of the *Niño de Atocha* from Madrid, could become re-identified with an American locale, as happened at Zacatecas, Mexico, with new characteristics such as a certain hat or costume. An image of Our Lady of Refuge, brought to Zacatecas in 1719 from Frascati, Italy, by a Jesuit missionary (the date is also given as 1744), became the basis of a widespread cult from the eighteenth century to the present.[56] But in Mexico, all devotional images of the Virgin pale before the image of Our Lady of Guadalupe at the hill of Tepeyac in Mexico City. So powerful was her cult, and so numerous the *guadalupanas*, or copies of the original cult image, that the distribution of devotional image types normally associated with Spain is completely replaced in Mexico. For example, the most typical peninsular devotional image is a representation of the Virgin of the Immaculate Conception dressed in blue and white with a crown of twelve stars and a crescent moon below.[57] In contrast, later-seventeenth- and eighteenth-century Mexican painters, when called upon to present an *Inmaculada*, often present her in the guise of her biblical source, Our Lady of the Apocalypse, with the addition of wings and a serpent at her feet. This image might have seemed more politically correct to Creole nationalists, eager to express their devotion to Mary Immaculate but reluctant to commission images with so direct a connection to Spain and its monarchy.

In this central aspect of Roman Catholic devotional art, Mexico differs markedly from Spain. Similar comments could be made about the local devotions that grew up around particular Marian images, often with syncretic associations, throughout the Andean region, not to mention images associated with miracles.[58]

To conclude, it seems clear that when we approach Latin American viceregal culture, we must do so with a clear sense that we are studying cultural phenomena parallel to those in Spain, although equally connected to the wider arc of European culture. Whether dealing with hybrid art forms, their indigenous precedents, and their local successor schools, or with the establishment of purely European guild-dominated painting at the centers of colonial power, any review of Latin American art in the viceregal period must be prepared for surprises and wide swings of artistic interest. All of the phenomena, whether they approach or retreat from Iberian norms, reveal deeply interesting underlying cultural developments, and in so many cases, have produced works of art of undeniable power.

NOTES

1. While almost all authors who have investigated the Latin American viceregal arts have by necessity considered their relationship to Spanish and Portuguese art, and European art in general, a number of recent investigations have focused specifically on this topic. Among these (in chronological order) are Burke 1979—expanded at greater length in Burke 1998, pp. 7–13, 29–33, 41–42, 55–61, and in Burke 1992; Sullivan 1996; Brown 1997; Brown 1999; and Brown 2004. See also the comments on the influence of Flemish and Spanish art on the school of Cuzco in Mesa and Gisbert 1982, vol. 1, pp. 99–123.

2. See, for example, Martin Soria, in Kubler and Soria 1959, p. 303: "The work of the Colonial painter is permeated with devotion, intensity, and a folk stylization—and nearly always with a disarming naiveté. Often a peculiar, inward-turned spirituality is perceptible. Though Colonial painting usually lacks originality and slavishly follows prints from Antwerp and Rome, the Colonial artist contributed colour."

3. For example, Francisco Diez Barroso stated at the outset that "art in New Spain is a branch of Spanish art"; see Diez Barroso 1921, p. 17. A generation later, Kubler and Soria's very title, *Art and Architecture in Spain and Portugal and Their American Dominions*, implied a subordinate role for Latin America (see n. 2).

 A much more sophisticated attempt to look at the Mexican viceregal school in the later sixteenth and seventeenth centuries through the lens of art at Seville is Brown 2004. Strongly implicit in Brown's arguments, as well as those of some of his Mexican colleagues, such as Rogelio Ruiz Gomar, is the idea that Mexican colonial art was subordinate to Spanish art at the outset, then slowly "emancipated" itself from peninsular models.

4. For example, even as active a center of colonial studies as the Graduate Center of the City University of New York (CUNY) required, as late as 1999, that doctoral candidates who wished to work on colonial topics elect the "non-Western" specialty. (CUNY now allows students to combine colonial studies with either pre-Columbian or Renaissance-baroque specialization.)

5. See the essay in this catalogue by Elizabeth Hill Boone and Thomas B. F. Cummins, citing bibliography.

6. For example, beginning with Bernardo Couto in the nineteenth century and Manuel Romero de Terreros in the 1920s, Mexican authors have told the story of their viceregal artistic heritage in a descriptive mode based on biographical information and the description of works of art, all arrayed in a chronological framework. Two twentieth-century benchmarks for this type of history are Manuel Toussaint's work on Mexican art and the later work of the Bolivian scholars José de Mesa and Teresa Gisbert for the Viceroyalty of Peru, especially Cuzco. See Toussaint 1982; Toussaint 1967; and Mesa and Gisbert 1982.

7. Epitomizing this approach is Enrique Marco Dorta's 1973 survey—*Arte en América y Filipinas*—based on his earlier collaboration with Diego Angulo Iñiguez and Mario Buschiazzo in *Historia del arte hispano-americano* (Angulo Iñiguez et al. 1945–56). In 1979, working with Linda Bantel, I adapted Marco Dorta's approach to a more detailed sequence of sixteenth- and seventeenth-century art historical styles, especially those generated in Italy; see Bantel and Burke 1979, pp. 16–19, citing the work of Donald Posner and Walter Friedlaender. The stylistic basis of the argument is summarized in Posner 1971, vol. 1, pp. 3–8, 35–43, and notes.

8. The term "Indocristiano" was first popularized by Constantino Reyes-Valerio; see Reyes-Valerio 1978; and Reyes-Valerio 1986. For extended discussions of these issues, see Tovar de Teresa 1992; and Tovar de Teresa et al. 1992; cf. Lara 2004. An extremely useful recent investigation of the encounter between European and indigenous American cultures is Gruzinski 1992. For the enlightening views of a scholar of Italian Renaissance art on sixteenth-century Mexico, see Edgerton 2001. For parallel developments in South America, see Majluf and Wuffarden 1998.

9. Again, see the essay by Boone and Cummins in this volume; cf. the highly useful discussion of Andean religion after the conquest by Sabine MacCormack, "Religion and Society in Inca and Spanish Peru," in Phipps et al. 2004, pp. 101–13. The fact that most of the Spanish religious inquiries in the seventeenth-century involved shamans is indicative of the private nature of resistant spirituality and the implied loss of public cult.

10. For a useful overview of the effects of this separation, see Cummins 1996.

11. See Phipps 2004 "Garments."

12. Ordinances of 1557 and 1686 are published in Toussaint 1965, pp. 220–26; cf. Toussaint 1967, p. 132, and notes. For further information on the guild of painters, see Barrio Lorenzot 1920; Carrera Stampa 1954; and especially Santiago Cruz 1960. For a more recent study documenting subsequent guild practices, see Tovar de Teresa 1984, pp. 5–40. Mesa and Gisbert (1982, vol. 1, pp. 137ff., and 310) have discussed the Cuzco documents. A highly useful discussion in both social-historical and art-historical terms of the interplay among the guilds, the prior artistic production on the mendicant missions, and the new urban contexts in the late sixteenth and early seventeenth century may be found in Alcalá 1998 "Profesión." Alcalá discusses Peru as well as Mexico.

13. See Burke 1998, p. 12; cf. Alcalá 1998 "Profesión," pp. 86–90.

14. For example, Toussaint 1965, pp. 51ff.; cf. Burke 1979, p. 20. Toussaint, as well as Tovar de Teresa (1992, p. 62) and Brown (2004, pp. 19–20), prefer to use the term "Romanists" to describe the Flemings and their Sevillian followers. This term originally applied to the sixteenth-century Netherlandish painters in the wake of Jan Gossaert Mabuse (c. 1478–1532), such as Jan van Scorel (c. 1495–1562) and Maerten van Heemskerck (1498–1574), who brought a decidedly mannerist version of the Italian Renaissance to the Low Countries from the 1520s. Brown uses the broader sense of the term, which extends to second- and even third-generation artists, such as the Antwerp masters Frans Floris (1519/20–1570) and his follower Maarten de Vos (1532–1603), who sent art to Latin America.

15. Brown 2004, p. 19.

16. Ibid., p. 20, cat. 6, fig. 65; Clara Bargellini, who catalogued the work for the 2004 Denver exhibition, also mentions that the work by Concha is "akin" to Villegas but stresses the connection to the Italian Renaissance (see Pierce et al. 2004).

17. Maza 1971 Pintor; Mesa and Gisbert 1970, pp. 36–48; cf. Rogelio Ruiz Gomar in Pierce et al. 2004, p. 55.

18. See Buser 1976.

19. For the influence of Bitti and Medoro on the school of Cuzco, see Mesa and Gisbert 1982, vol. 1, pp. 56–79; for a sensitive summary of the role of this generation of immigrant artists, see Alcalá 1998 "Profesión," pp. 95–100.

20. Bantel and Burke 1979, pp. 22–25. See the works in the present exhibition by Luis Juárez (cat. VI-11), Baltasar de Echave Ibía (cats. VI-7–VI-9), and the immigrant Alonso López de Herrera (cats. VI-6, VI-10); in Peru, these works find parallels in the paintings of Antonio Bermejo (born 1588) and Leonardo Jaramillo (active 1619–43).

21. A series of four Old Testament subjects painted on large copper sheets by Pacheco de la Serna in the Flemish style are preserved in the Pinacoteca Universitaria, Puebla; a similar series, framed in Puebla frames and presumably also by a Puebla artist, may be found in the Museo Regional de Querétaro; see Burke 1992, pp. 69–70.

22. For documentation and study of Zurbarán's exports to America, see Kinkead 1984; and Navarrete Prieto 1999 Zurbarán.

23. Junquera y Mato 1999; contrast Juan Miguel Serrera's more precisely focused skepticism, "Zurbarán y América," in Museo del Prado 1988, pp. 63–83.

24. José Juárez has been studied at length by Nelly Sigaut; see Sigaut 2002.

25. Navarrete Prieto 1999 "Mecánica"; cf. Buser 1976.

26. Serrera 1991; and Serrera 1988.

27. Los Angeles County Museum of Art, no. 53.27; and Metropolitan Museum of Art, no. 55.135.1. The work was engraved by Schelte à Bolswert (c. 1586–1659) and published by Martinus van den Enden (1605–after 1655); see Liedtke 1984, vol. 1, pp. 209–13; Liedtke (p. 211) suggests that the engraving follows the slightly larger Los Angeles version. The work by José Juárez was formerly in the Academia at Puebla, now Pinacoteca Universitaria. I am indebted to Mary Sprinson de Jesús for advice on the Metropolitan Museum picture.

28. See Fernández 1943, pp. 51–57.

29. Echave Rioja's process is analyzed at length in Burke 1998, pp. 34–37.

30. Lafaye 1976, pp. 54–75; Brown 2004, pp. 22–23, also summarizes the contributions of the Creole patrons. For an analysis of the commission, see Gutiérrez Haces et al. 1997, pp. 72–85.

31. For example, Villalpando included a complete copy of Murillo's Santiago Madonna, now in the Metropolitan Museum of Art, no. 43.13, as a symbol of charity in his The Church Militant for the sacristy of the Mexico City cathedral. This observation has been made by Soria in Kubler and Soria 1959, p. 311; Maza 1963, p. 32; Marco Dorta 1973, p. 347; and most other recent scholars.

32. The Rizi is still in the cathedral at Puebla; the Carreño is now at the Hispanic Society of America, New York, with provenance to a Mexican nineteenth-century private collection. It was in Mexico by 1682, since it was copied by Echave Rioja. I am indebted to Clara Bargellini for notice of this copy (see Gutiérrez Haces et al. 1997, repro. p. 44).

33. But cf. the discussion in the text and n. 48, below.

34. Villalpando has often been compared to Valdés Leal, especially by Spanish scholars such as Angulo Iñiguez and by Marco Dorta, who went so far as to describe Villalpando as a "disciple" of Valdés Leal, "as close in style as he is far away in distance." See Marco Dorta 1973, p. 347; cf. Angulo Iñiguez et al. 1945–56, vol. 2 (1950), p. 417. The role of Correa and Villalpando in Mexican painting is discussed at greater length in Burke 1992, pp. 105–17, from which the comments in this section have been abstracted.

35. On the subject of the durability of mannerism in Mexican art, see Angulo Iñiguez et al. 1945–56, vol. 2 (1950), pp. 393ff.; Martin Soria, in Kubler and Soria 1959, pp. 303ff., who even coins the term "Mannerist High Baroque"; Manrique 1971, pp. 21–42; Manrique 1976, pp. 107–16; and Burke 1979, pp. 20–21, 28–36 and notes. For the parallels in architecture, see Moffitt 1984; and Tovar de Teresa 1990 "Estípite."

36. Mesa and Gisbert 1982, vol. 1, pp. 118–24.

37. Ibid., p. 118; also cited by Damián Bayón, in Bayón and Marx 1989, p. 112.

38. Mesa and Gisbert 1982, vol. 1, pp. 137–38.

39. Bayón and Marx 1989, p. 112.

40. For an expansion of this argument, see Burke 1992, p. 113, summarizing previous bibliography.

41. See, for example, the works illustrated in Dalton Palomo and Loera y Chávez 1997, pp. 43–45.

42. The triumphal arches were erected by the city leaders and cathedral chapters to welcome the arrival of new viceroys and other political officials, beginning in 1528 with an arch set up to welcome the second *audiencia*. The most famous of these arches are the two erected in Mexico City in 1680 for the Viceroy Marquis of la Laguna; the iconographical programs were written by Carlos Sigüenza y Góngora (for the city) and Sister Juana Inés de la Cruz (for the cathedral). Sigüenza's arch included images of the Aztec emperors in lieu of the more traditional Greco-Roman and medieval political exemplars. For an overview of this topic, see Maza 1968. Elena Estrada de Gerlero, in *Catedral de México* 1986, pp. 395, 397, has convincingly linked Sister Juana's program for her arch to the 1684–91 redecoration campaign for the cathedral sacristy by Juan Correa and Cristóbal de Villalpando.

43. Lafaye 1976, pp. 54–75; cf. Brading 2001, especially pp. 96–145.

44. "*Gongorismo*" refers to the highly convoluted, baroque style that grew up in imitation of the works of the Spanish poet Luis de Góngora y Argote (1561–1627).

45. The most recent studies of this phenomenon are by Margaret Connors McQuade; see McQuade 1999 *Talavera*; and McQuade 2005.

46. The portrait is at the Museo Nacional de Arte, Mexico City; see cat. VI-27.

47. See Burke 1979, pp. 41–43; Rogelio Ruiz Gomar is completing a long-needed study of Rodríguez Juárez.

48. My suggestions of direct influence in *Mexico* 1990, pp. 361–63, were certainly overstated; the more cautious analysis in Burke 1992, pp. 157–58, seems closer to the mark. See Moissén 1967, pp. 11–18. Highly important new information on the passage to America of Juan Simón Gutiérrez (1643–1718), a follower and copyist of Murillo, and other aspects of Murillo's influence, has been published by Sofía Sanabrais; see Sanabrais 2005. I agree with Sanabrais's characterization of Murillo's influence as "vague."

49. The Casa de Contratación de las Indias was moved to Cádiz definitively in 1717.

50. Paret was exiled briefly to the island in 1775–76. On Campeche, see cats. VI-119– VI-123 and p. 529 below.

51. See Toussaint 1967, pp. 275–77; Toussaint clearly separates the first and second Mexican baroque eras. The transition from the high baroque of later seventeenth-century architecture, with elements such as Solomonic columns, to the new style with its idiosyncratic forms such as *estípites* and niche pilasters, was confirmed by the arrival in Mexico of the Spanish architect and designer Jerónimo de Balbás (c. 1680–

1748) in 1718, drawn to Mexican patronage.

52. Led by an upper-class descendant of the Inca, who styled himself Tupac Amaru II, the revolt began in 1780 and continued, in spite of the execution of Tupac in 1781, until 1783. In no way can Tupac Amaru II be thought of as culturally indigenous; his noble indigenous descent was balanced by his wealth, social position in colonial society, and education. The geographically widespread nature of the revolt suggests why the eighteenth-century imagery of Inca kings is so varied and robust. See cat. VI-115.

53. On the Academy of San Carlos, see Charlot 1962; Bérchez 1989; Toussaint 1965, pp. 204–7; and Toussaint 1967, pp. 441–44. Michael A. Brown is preparing a doctoral dissertation on Mexican portraiture; it contains a chapter on the rise of the Academy (Institute of Fine Arts, New York University).

54. Parts of the following discussion are repeated from my article "On the Spanish Origins of Mexican Retablos," in Zarua and Lovell 2001, pp. 39–45; used by permission. The foundation study of Counter-Reformation iconography is Mâle 1932. For the theological source of Counter-Reformation imagery, see Schroeder 1941 (reprinted 1978), pp. 216–17, 484–85.

55. On the general importance of the orders for Counter-Reformation art internationally, see Mâle 1932, pp. 384–512.

56. Tiscareño 1910.

57. See Hibbard 1969, pp. 18–32; and Stratton 1989, pp. 84–91.

58. See Alcalá 1999.

Artisans and Artists in Ibero-America from the Sixteenth to the Eighteenth Century

M. Concepción García Sáiz

Although widely dispersed, there is a wealth of information on the movement of Spaniards, Portuguese, and other Europeans to the New World between the sixteenth and eighteenth centuries.[1] There exist the names and, in some cases, the primary occupations of a large number of craftsmen who immigrated as adults to the Americas, equipped with the training received in their native places. Most of them undertook the voyage in response to a strong demand for skilled labor in the New World and in the hope of the rapid enrichment associated with the notion of making good in this new land, which offered the promise of a better life than was possible for them in Europe. Exact biographical research is hampered by the fact that some of these craftsmen made the voyage in the retinue of such grandees as viceroys or archbishops and are recorded simply as retainers, without precise indication of their actual occupations.

Apart from the private interests of those who decided to embark on an oftentimes uncertain future in the New World, it was the policies of territorial settlement implemented by the Spanish and Portuguese crowns from the early sixteenth century onward that served as the principal impetus for the movement of these artisans at particular periods and to particular destinations. As early as the end of the fifteenth century, when Christopher Columbus was preparing his second voyage in 1493, the Catholic monarchs ordered him "to embark with more than one thousand two hundred armed men, and among them to offer incentives to a large number of artificers and workers in all of the mechanical arts."[2] These skilled craftsmen, mainly carpenters, accompanied the very first voyages of discovery and were employed to meet the daily needs of the expeditions, especially the repair and construction of vessels and the erection of small provisional settlements, often for defensive purposes, which were nevertheless the germ of the later power centers of viceregal society. They were soon joined by other skilled workmen, particularly stonecutters, masons, and ironworkers, who were indispensable to the stability of these first enclaves.

These same expeditions also included soldiers who had worked as craftsmen or even artists in their places of origin but had abandoned these trades to follow the lure of the spoils

FIG. H-I
Pulpit, made in Potosí, Bolivia, early eighteenth century. Cathedral of San Salvador de Jujuy, Argentina

offered by the conquest. The chronicles that recount their lives in the New World are often confused, and include an element of self-serving fabrication designed to excite the interest and admiration of the reader: accounts such as those of two soldiers who accompanied Pedro de Alvarado on one of his expeditions occupy a position midway between fantasy and reality. According to the narration of events, these two individuals spoke with a *cacique* who wished to learn the truth about the vessels in which the Spaniards had arrived, and which his messengers had seen from afar and described to him: "When he [the *cacique*] asked if either of the two was able to paint such a vessel, one of them, named Treviño, *who had been a sculptor in wood and not a mediocre shipwright*, offered and promised to paint a vessel in a very large hall. . . . He painted a vessel of enormous girth, of the kind the Genovese call a *carraca*, with six masts and as many holds. . . . His companion painted a fierce-looking horse, much larger than those left by Phidias and Praxiteles on the Esquiline hill . . . forged in bronze; and on its back, covered in trappings, he placed a horseman clad in armor."[3]

Whether it was owing to official policy or to personal decisions, the fact is that by the middle of the sixteenth century a large number of Spanish and Portuguese artisans, as well as others in lesser number from other places in Europe, had immigrated to the New World. This migration marked the beginning of a continuous flow of artisans and artists to the Americas over the course of three centuries, reaching such a point that on various occasions limits were set to their departure from the mother country, which was in this way losing a considerable number of inhabitants necessary to its own development.

Bernal Díaz del Castillo, the soldier and chronicler who accompanied Hernán Cortés on his conquest of Mexico, recalls how, after the emperor Moctezuma had received the Spaniards in Tenochtitlán and installed them in the palaces that had belonged to his father, Axayacatl, Cortés made a request for masons "so that we could make a church in our lodgings . . . and in three days our church was made . . . and once it was finished we were daily in the church praying on our knees before the altar and images."[4] This took place in 1521, and by the following year the architect Martín de Sepúlveda was already in Mexico working for Cortés "on the construction of the church of this city, as well as the houses of this *real audiencia* and the drainage gutter, and other necessary works."[5] A mere fifteen years after the entry of the Spaniards into the Aztec capital, construction began on a basilican church that would serve as the city's first cathedral, and in 1562 the foundations of the definitive cathedral were laid according to the plans of the architect Claudio de Arciniega; already in 1551, stone had begun to be transported into the city for its eventual construction. At first the cathedral of Seville was taken as a model, "of a lavishness such as befitted a city and church that was to be the seat of an archbishopric," but it was soon realized that the marshy ground on which it was to be erected would not sustain so monumental a construction. With a change of reference, it was considered that "one like the cathedral of Segovia or Salamanca was sufficient."[6]

Fulcanelli called the Gothic cathedral a "Sanctuary of Tradition, Learning, and Art,"[7] and the cathedrals of the New World, mostly heirs to the great Spanish and European Gothic tradition, did indeed function as such. For centuries they were centers of activity for artists and artisans and had a clear influence on parish churches and religious houses, which often garnered special prestige by imitating their ornamental and iconographical characteristics. The construction and furnishing of the cathedrals presupposed the existence of a wide and varied group of specialists capable of fitting them out as places of worship and as settings for the various ceremonies celebrated in their interiors, through which a multiplicity of symbols associated with both civil and religious authority were renewed and perpetuated. The size of the buildings, the long periods required to construct and fit them out, and their special significance to political and religious life are reasons enough for them to offer a matchless compendium of artistic traditions, and to exemplify the activities of the artists and artisans who participated in their creation (cat. VI-72).

In addition to the master builders, architects, masons, and stonecutters directly responsible for the architectural structures, each one of these buildings required the collaboration of cabinetmakers, cartwrights, woodworkers, engravers, and joiners in charge of the altarpieces, stalls, pulpits, and altars—not to mention the more ordinary furnishings. At the same time as these were being created, sculptors and painters would be producing the statues, panels, and canvases that formed part of the altarpieces or decorated the walls of naves, sacristies, chapterhouses, and other internal departments of the cathedrals. Gilders and *encarnadores* ("painters of flesh tones" of sculptures) provided color for these images and for the altarpieces themselves, while ironworkers and locksmiths fashioned grilles and gates. Ceramists, fulfilling a different function than that of the potters and painters, decorated the interior and exterior surfaces of the building, working alongside the glaziers and bell founders. Indispensable to the execution of the religious offices were the labors of the embroiderers and workers in passementerie, who produced the liturgical vestments and furnishings: miters, chasubles, capes, dalmatics, stoles, maniples, humeral veils, chalice veils, frontals, corporals, standards, curtains, tapestries, and altar cloths. Special mention must be made of the goldsmiths and silversmiths who produced the tabernacles, chalices, ciboria, patens, incense burners, cruets, sacring tablets, candlesticks, sacrariums and monstrances, lecterns, reliquaries, coffers, lamps, crosses, and even altar frontals or entire altarpieces, as well as the plentiful jewelry that adorned the images or the prelates themselves, encrusted with gemstones cut by the lapidaries. Finally, there were the makers of violas, organs, and other musical instruments, and the miniaturists who illustrated the psalters.

Obviously, during the first years of the viceroyalties many of these objects came from the Iberian Peninsula, and such items continued to arrive in significant numbers for the next three centuries. In some cases, they were gifts from the monarchs themselves, intended for specific destinations, or commissions performed by workshops in Spain—especially in Seville —that supplied the American market. A busy trade was carried on, involving the Spanish and Portuguese artisans working on the Iberian Peninsula, the agents or merchants who moved the goods, and the churches and religious establishments that formed the bulk of their clients. Works were also sent to the numerous fairs in the New World, where they were sold to the highest bidder before beginning the long journey in search of a final buyer. But the greater part of these works were doubtless produced in the New World by artists and artisans trained in the European tradition who organized themselves along lines that had been laid down in the Middle Ages. This is the case whether they were originally from Spain, Portugal, or elsewhere in Europe or were born and trained in their crafts in the Americas. In the early years, when work was to be undertaken, there were repeated requests to the mother country by the viceregal authorities themselves for "some good master such as is lacking here," but colonial production soon came to constitute the principal supplier of the internal market.

The trades and crafts mentioned above were performed by a significant segment of the urban population, especially in the larger cities, where demand was strong and steady during periods of economic boom. This production soon acquired a value of its own and was one of the factors in the consolidation of viceregal society, which thereby defined itself with respect to the mother country, while at the same time, the centers of major activity in the New World began to take on individual identities vis-à-vis each other.

The work of artists and artisans became in this way the material support of a society that, as it developed, began to recognize itself in its works, that is, to identify itself with them and distinguish itself from other societies on their basis. The daily labor was done on site or in workshops often located in the craftsmen's own dwellings. Workshops dedicated to a given trade were grouped together on the same street or in the same district, a phenomenon that, in the cases of Mexico City and Cuzco, had clear pre-Hispanic antecedents. In these workshops, master, *oficiales* (craftsmen), and apprentices would live and work closely together and were often linked by family ties, as it was common for a trade to be handed down from father to son

or nephew, and for the craftsmen to marry the daughters of their masters. This was the environment in which the apprentices were trained after being entrusted by their parents or guardians to a master, who undertook to make an *oficial de provecho* (a good craftsman) of the young man within about five years. The apprentice could then, upon completing the corresponding examinations, achieve the grade of master himself and work independently.

The defense of professional interests against outsiders, the quality control of the work, and the regulation of the processes of apprenticeship and commercialization all formed part of the body of statutes of the various guilds (*gremios*) that had functioned in Europe since the Middle Ages and that continued to operate in the New World. These statutes, published under the name *Ordenanzas*, were directly linked to the city for which they were set down, and in principle were valid only there, so that an artisan who was able to ply his trade freely in one city, after having passed his examinations, might be rejected in another in which he had not earned his qualifications.[8] Toward the end of the eighteenth century this situation changed radically, as the guild system—considered obsolete and blamed for the slow progress in the mechanical arts—was replaced by one proposed by the royal academies of fine arts based on a hierarchy of the arts and an officially regulated method of teaching them. The claims of artists that their work be dignified with special consideration, made especially by painters from the seventeenth century onward, first in Italy and then in Spain,[9] reinforced the division between the major or fine arts—architecture, painting, and sculpture—and the lesser arts, which included all those known also as the mechanical arts.

The *Ordenanzas* required that an artisan exercise his own trade exclusively, in accordance with the statutes stipulated therein, but in reality this pretension was subverted time and again. Various factors contributed to the situation, but most of all the ample activity and versatility of many of the craftsmen themselves, who were perfectly capable of performing several different tasks. It is not, in fact, difficult to find cases such as those of Diego Martínez de Oviedo, who was hired in the second half of the seventeenth century in Cuzco to work as principal master in the office of architect (*maestro mayor del oficio de arquitecto*) and at the same time as master carpenter (*maestro carpintero*) or master joiner (*maestro ensamblador*);[10] of Pedro Ramírez "the Elder" in New Spain, designated architect, sculptor, engraver, and joiner in different documents;[11] or of Manuel de Samaniego of Quito, a painter, sculptor, and architect of great renown among his contemporaries and author of the only treatise on painting written in viceregal America.[12] In Portuguese America, painting and sculpture were considered liberal professions, so the practitioners of these arts enjoyed greater independence than did their colleagues in Spanish America, although in general terms they too worked within the guildlike system also employed in Portugal.[13]

The most common daily tasks that faced these artisans were the repair of already existing works that had deteriorated with the passage of time and the renovation and refurbishing of older works to bring them up to date. Evidence of successive interventions into the same work is offered by the plentiful documentation concerning a chest of drawers used to store the sacred vessels and ornaments in the sacristy of the cathedral in Lima. Designed in 1608 by the architect Juan Martínez de Arrona, the chest was considerably renovated in 1618 by the joiner and sculptor Martín Alonso de Mesa, who added a central body to it—increasing its height—and modified the features of the apostles represented in relief. These reliefs were then reworked in 1631 by the sculptor Pedro de Noguera.[14] In 1665 a master silversmith, Luis Lisama, made twenty-four large candlesticks for the Mercedarian monastery in Cuzco by recasting material—"old candlesticks, chalices, and other pieces"—that the members of the order had delivered to him, a common practice (fig. H-2).[15] Artisans might also act as contractors for larger projects, entering into business relationships with other colleagues and guild members, with payment sometimes made in kind. In Cuzco in 1618 the *oficial* of the painter Miguel de Romaní agreed to work with the master Jerónimo Gutiérrez for one year

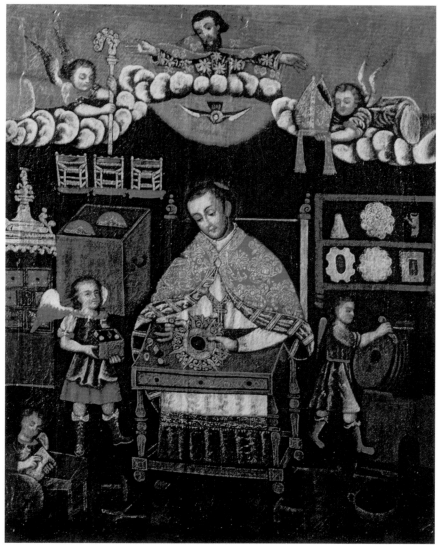

FIG. H-2
Saint Éloi in His Workshop, Cuzco school, first
half of the eighteenth century. Oil on canvas,
35⁷⁄₁₆ × 27¹⁵⁄₁₆ inches (90 × 71 cm). Private collection

in exchange for "a full suit of Quito flannel, a vest, a cloak, a doublet, a hat and a pair of silk stockings, two Rouen linen shirts, twelve pairs of cordovan leather shoes, ten silver pesos, and a full year's board."[16]

The regulations of the *Ordenanzas*, though never fully complied with where they happened to be in effect, nevertheless permeated the professional lives of artisans, even in places where they were never promulgated, which is to say, in the greater part of this cultural landscape. When artisans were not controlled by the authorities of the guilds, they worked under the sway of the church, which was ever concerned about the propriety of its images and wary of outbreaks of idolatry, or of local authorities who tried to ensure proper dealings between the artisans and their clients. The masters themselves would sometimes seek other sources of income outside of their professions, engaging in all kinds of trade and also lending money. In New Spain at the end of the seventeenth century and the beginning of the eighteenth, the joiner Mateo de Pinos comanaged a fabric shop and lent money to his fellow citizens, including to his colleagues and in exchange for his own paintings, with which he surely traded as well, all while still plying his principal trade.[17]

The relationships of these artisans with their clients took two forms. The more common was a direct commission for a particular work made for a specific purpose, established in a contract that bound both parties. The terms generally consisted of an agreement on the part of the artist to finish the work to the client's satisfaction within a given term. The client was to provide the necessary means—assistants, materials, food, and so on—and to make the corresponding payment. It was customary for the work to conform to a model submitted by one of the parties and accepted by both. The artist might submit the outline of an altarpiece, or the client might insist on a prestigious model already realized in some other place: "like that of . . ." or "in like manner to that of . . ." with minor variations. The client might also demand that the painter or sculptor imitate a composition shown in some print, or the artist himself might propose a model based on a drawing of his own or on one of the many prints he had collected to form his personal repertory of images. In any case, both the artist and the client had the right to claim noncompliance with the terms of the accord and to submit the dispute to the arbitration of experts, generally designated from among the overseers (*veedores*) of the guild (fig. H-3).

Another form of artisan-client relationship consisted of free commercial dealings in the workshops themselves, in shops, or even in the open street markets where any customer might appear. Many of these shops were installed around a city's central plaza and normally offered works produced in the popular taste for private devotions or for home or personal decoration. Artisans who had not passed their professional exams commonly worked in this way, outside of the statutes of the guild, although established professionals would inveigh against this ambulant street commerce, in which they saw an unfair competition that moreover damaged the prestige of their art by treating it as simple merchandise.

All of these circumstances clearly represent a transposition of traditional peninsular models that had originated in the Roman world and were maintained and developed in Europe

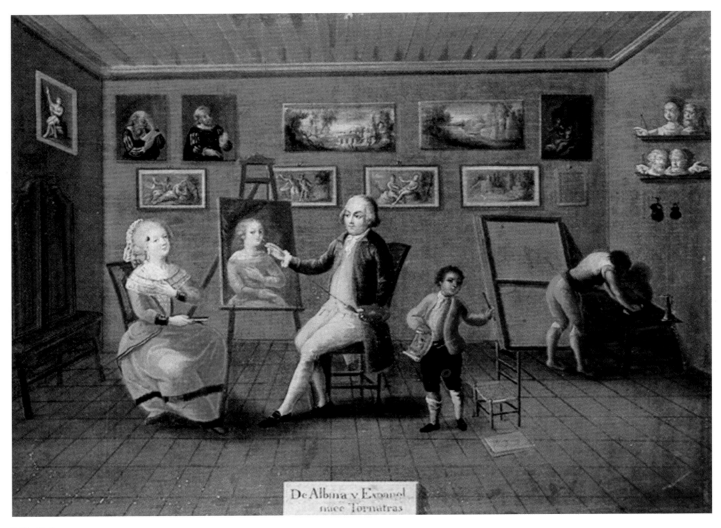

FIG. H-3

From Albino and Spaniard, a Return-Backwards Is Born, c. 1785–90. Oil on canvas, 24⅝ × 32¾ inches (62.6 × 83.2 cm). Private collection

throughout the Middle Ages, assuming decisive importance in urban centers by the time of what is known as the colonial or viceregal period. In Spain during the eighteenth century, almost half of the inhabitants of a city such as Santiago de Compostela worked as artisans, and it is likely that in times of greatest activity, Mexico City and Cuzco had similar proportions of skilled craftsmen, allowance being made for the particularities of the New World context. In general terms, these artists and artisans formed part of what in Spanish America was designated the "republic of Spaniards," comprising peninsular Spaniards, other Europeans who had arrived in the New World through Spain, criollos (or "American Spaniards"), and mestizos—everyone, in short, except the indigenous population, which for its part constituted the "republic of Indians."

This ideal structure, organized by the Spanish crown with the aim of protecting the indigenous peoples by keeping them separated from the Spanish, functioned irregularly over the course of the centuries. It was most efficient in the sixteenth century, when the indigenous population were grouped into communities from which Spaniards were prohibited, with the exception of the religious orders responsible for their conversion and catechization. In the seventeenth century, extraordinarily important new versions of this system were created, such as the Jesuit communities in the Paraguay-Argentina-Brazil area and in California. In fact, it is in these relations of the indigenes with other sectors of viceregal society—of which they formed a part, in varying ways—that we encounter the most complex and singular chapter of colonial art. The cultural traditions of the two communities, originating in clearly divergent concepts, could only enter into a dialogue after a process of reformulating the messages, which allowed a reading based on traditional codes in which the symbolism of images played a fundamental role.

The varying states of cultural development that the indigenous peoples had reached at the moment they were incorporated into Euro-American culture by the Spanish and Portuguese doubtless shaped this process, which was characterized by great diversity. Broadly speaking, it was the magnificent stonecutters trained in the pre-Hispanic architectural traditions who first participated as recognized specialists in the new constructions. Their work was endorsed by the achievements of the great ceremonial centers that the conquistadors had encountered and by the ancestral importance of architecture in many of their cultures, to which the numerous clay reproductions of buildings—in some cases thought by the chroniclers to have been small-scale models of actual constructions—bear ample witness.[18]

Where local artisanal traditions were highly developed, the encounter with the new culture gave rise to an ensemble of strongly delineated interpretations marked by the indigenous craftsmen's technical mastery of local materials. The requirements imposed by the new society, however, and the introduction of objects belonging to alien ways of life gave rise to a large number of new crafts previously unknown to the indigenous peoples. The technical skill of the native craftsmen in dealing with a variety of materials and in imitating new models was recognized and praised by chroniclers and travelers from the time of their very first contacts with the native peoples, and opened the way for their incorporation into European artistic and artisanal systems of production. Whether trained by Spanish or Portuguese masters or self-taught—through the observation and imitation of the objects and work of the peninsular craftsmen—many indigenous artisans organized their workshops along European lines and were even incorporated into the guild system, although strict limitations were sometimes imposed on their incorporation as masters within the hierarchy of master, *oficial,* and apprentice. The acceptance of the indigenous craftsmen into many different guilds depended on the labor market. Where there was strong demand, obstacles to indigenous participation disappeared, whereas in conditions of low demand, Spanish artisans exercised their privileges and kept the Indians outside of the legal structures, making it unlikely that they would participate in major official commissions. It is clear, however, that their exclusion was not the result of any general official policy.

Nevertheless, when in 1688 the indigenous painters of Cuzco decided to separate from their Spanish colleagues and organize their own guild, it was doubtless because they had a clientele that preferred their work to that of the Spaniards.[19] This clientele would have consisted of both indigenous *caciques,* who in the patronage of churches and religious establishments had found a way to consolidate the privileges of their own social position, and ecclesiastical authorities, who continued to offer commissions to such renowned indigenous artists as the painters Diego Quispe Tito, Basilio de Santa Cruz Pumacallao, and Sinchi Roca and the sculptor Tomás Tayru Tupac.

The Catholic Church was in fact maintaining in the New World a practice that had been traditional in Europe—the use of the arts as instruments of evangelization and catechization—at the same time as it utilized the teaching of the mechanical arts to the native population as an extraordinarily efficient means of acculturation. This is why the religious orders played an important role in the organization of schools and workshops, which were installed in the *conventos* (convents and monasteries) and managed by members of the orders. The Viceroyalty of New Spain had centers such as the college of San José de los Naturales, located next to the Franciscan monastery in Mexico City, and the school in Pátzcuaro under the guidance of the bishop Vasco de Quiroga. These institutions constitute points of reference in understanding this process of acculturation, which took place on a smaller scale all over the viceroyalty. In Brazil the *conventos* also housed the busiest workshops of artists, at least in the seventeenth century, but there the teaching of the mechanical arts to the indigenous people was not the principal objective. In the workshops of the Brazilian religious establishments it was the members of the orders, renowned sculptors such as Friar Agustín de la Piedad and Domingo de

FIG. H-4
Bernardino de Sahagún (Spanish, c. 1500–1590),
Official with Pen, from *Historia general de las cosas
de Nueva España (Codex Florentino)*, late sixteenth
century. Biblioteca Laurenzio-Medicea, Florence

la Concepción da Silva, who supplied liturgical furnishings for the churches.[20]

The productions of these indigenous artisans, trained within the *conventos* and laboring permanently in work programs implemented by the friars themselves, are by no means uniform, determined as they were by highly varied circumstances. The diversity of the indigenous traditions is probably the most important factor, but the differing qualifications of the various teachers and the design of the specific objectives called for doubtless also had an effect. The artists of the many mural paintings covering the walls of sixteenth-century *conventos* in New Spain were heirs to a pictorial tradition—including both mural painting and the illustration of codices—with deep roots in the pre-Hispanic world (fig. H-4). The schools in the above-mentioned Jesuit areas, however, instructed the indigenous students in a set of mechanical arts that were completely alien to their traditions.

As a result of this process, many indigenous artists and artisans were integrated into the European system of production in which commercial interchange played a role that until then was unknown to them, while others took part in the great enterprise of conversion with a symbolic and ritual sense of labor that was much closer to their traditions. As the process of evangelization waned and those responsible for carrying it out were displaced from the indigenous environment, these groups dispersed to be absorbed into the sector of artisans in general. This would have happened to the mural painters in New Spain when the secular clergy took over from the mendicant orders toward the end of the sixteenth century, and it happened to the Guaraní artisans following the expulsion of the Jesuits from their enclaves in 1767.

The complexity of this extraordinary process, so diverse beneath its apparent uniformity, is manifest in numerous works of art that reveal the relationship of the artisan or artist with his work and with the environment in which it was produced. Thus, the indigenous specialists in the production of featherwork, textiles, or *keros* (Inca libation vessels) continued to work during the viceregal period in circumstances that are difficult to define, although they remained formally and functionally within the indigenous segment of colonial society. In this way the technique of featherwork survived, especially in New Spain, thanks to the efforts of the religious orders, which offered protection to these artisans in their schools and commissioned from them Catholic liturgical and devotional works, conferring on these objects a symbolic value that, removed from the context in which they were produced, was supplanted by appreciations derived from the European vision of the exotic. The small paintings with Christian iconography, and the miters and chasubles "painted" or "embroidered" with tiny quetzal feathers, were generally viewed on the Iberian Peninsula as yet another proof of the great skill of the indigenous artists, of their "exquisite" technique. But these objects no longer expressed a union with the divine. In the viceregal context, however, they had all the characteristics required to fulfill a function of extraordinary importance: the application of pre-Hispanic symbolism following a process of Christianization of the referents.[21] The *keros* and the traditional

indigenous garments, such as the *uncu* (a type of tunic), produced for the Inca nobility continued to be made during colonial times for the same purposes as before, although the role of these elites in the structural hierarchy of the viceroyalty was no longer the powerful one it had been before the arrival of the Spaniards. The *keros* and *uncus* nevertheless remained strong signs of identity, to which the colonial authorities assumed differing attitudes, accepting or prohibiting their use in accordance with varying circumstances. In both cases the specialists who produced them preserved the traditional techniques and incorporated the required content—and its corresponding formal idiom—in order to thrive in a new context.[22]

NOTES

1. The source most commonly consulted is the *Catálogo de pasajeros a Indias durante los siglos XVI, XVII y XVIII*, in seven volumes. It can be supplemented by information from travel journals, religious and military chronicles, private correspondence, legal documents concerning the commissioning of works, and official instructions to the viceregal governments, along with many other documents.

2. Anglería 1530/1989, década primera, capítulo primero, p. 15.

3. Ibid., década octava, capítulo décimo, p. 503. The emphasis is mine.

4. Díaz del Castillo 1983, no. 209, p. 196.

5. Icaza 1969, vol. 1, p. 134.

6. Serrano 1964, p. 12.

7. Fulcanelli 1973, p. 46.

8. Carrera Stampa 1954; Heredia Moreno 1991; Heredia Moreno 1992; Ruiz Gomar 1985; Ruiz Gomar 1990; Samayoa Guevara 1962; and Torre Revello 1932.

9. Serrera 1995, pp. 277–88.

10. Cornejo Bouroncle 1960, pp. 68, 70.

11. Castro Morales 1982, p. 12.

12. Vargas 1975.

13. Flexor 1999, p. 85.

14. Ramos Sosa 2005, pp. 117–18.

15. Cornejo Bouroncle 1960, p. 69.

16. "Un vestido entero de paño de Quito, ropilla, capa, un jubón de motilla, un sombrero y un par de medias de seda, dos camisetas de ruan de cofre, doce pares de zapatos de cordobán, diez pesos en plata y comer todo el año." Ibid., p. 128.

17. Lorenzo Macías 2005.

18. Schávelzon 1982; and Schávelzon 1993.

19. Gisbert 2002, pp. 99–144.

20. Oliveira 1989.

21. García Sáiz 1998.

22. Cummins 2002; and Gisbert et al. 1987.

Sirve para
La dio la M. S
Ana de S.S. Jo

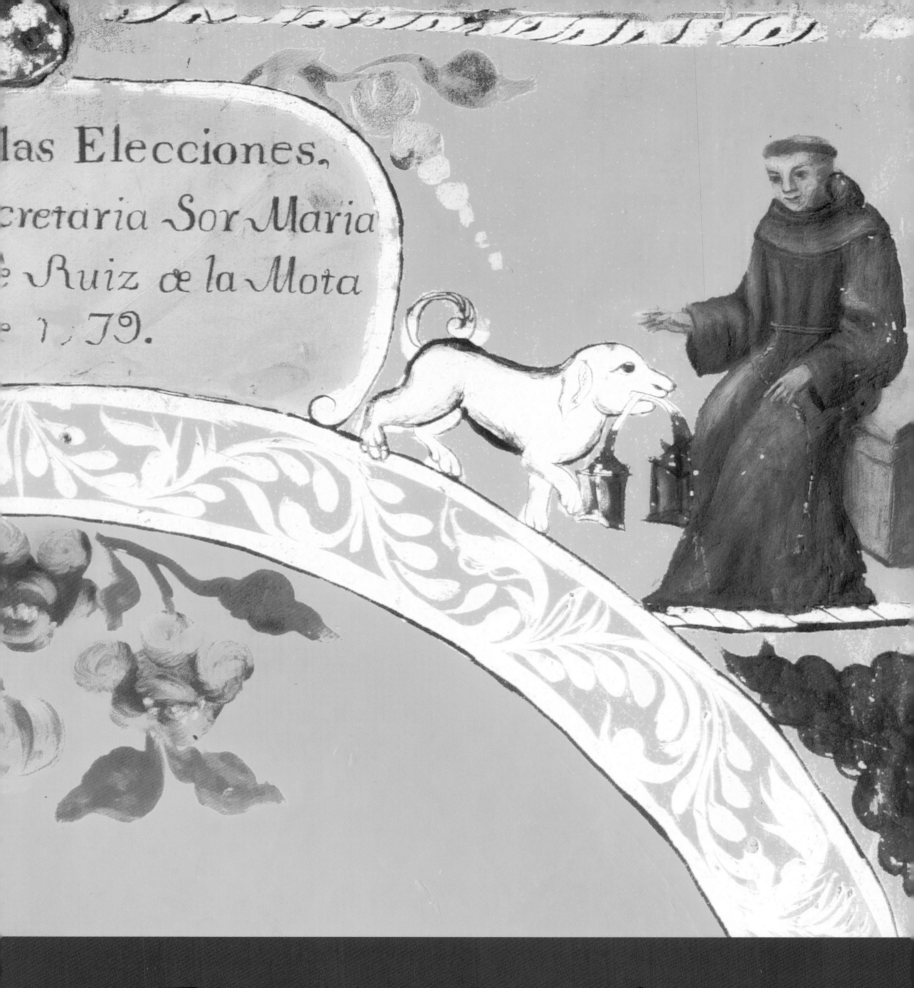

las Elecciones,
cretaria Sor Maria
Ruiz œ la Mota
1179.

Decorative Arts

The Decorative Arts in Latin America, 1492–1820

Mitchell A. Codding

The creative genius of the indigenous artisans of Latin America served as the foundation for the decorative arts of the colonial era. The luxurious objects of gold, silver, feathers, and textiles that they produced for the elite of the Aztec and Inca empires proved a source of marvel to European audiences when they first reached the courts of Europe. Albrecht Dürer, the renowned Renaissance artist, had the opportunity to view in Brussels in 1520 the first treasures of conquest sent by Hernán Cortés to Carlos V, of which he wrote in his diary: "For I have seen therein wonders of art and have marveled at the subtle *ingenia* of people in far-off lands. And I know not how to express what I have experienced thereby."[1] Toribio de Benavente, known as Motolinía, arrived in Mexico in 1523 with the first Franciscans and immediately became one of the greatest advocates for the indigenous population of Mexico. In his *History of the Indians of New Spain*, Motolinía spoke eloquently of the ingenuity of the native artisans: "In the mechanical arts the Indians have made great progress, both in those which they cultivated previously and in those which they learned from the Spaniards." To which he later added, "They never make anything without changing the style, seeking to create new models."[2]

From the sixteenth through the eighteenth centuries the indigenous, African, Asian, and European artists and artisans of colonial Latin America created some of the most extraordinary decorative arts ever produced, drawing freely upon the rich artistic traditions and techniques of their homelands. Hybrid art forms emerged as indigenous media and techniques were adapted to European forms, European designs were incorporated into the indigenous arts, and Asian motifs, techniques, and forms were reinterpreted by both European, African, and indigenous artisans. Under the tutelage of Catholic missionaries, Mexican artists painted Christian devotional images of phenomenal sophistication and beauty employing the pre-Columbian art of the feather mosaic. Taking their inspiration from Asian porcelains and lacquers, Colombian artisans perfected the indigenous *mopa mopa* lacquer technique, which they combined with gold and silver leaf to transform wooden chests and writing boxes into luxury objects destined for European nobility. Asian lacquerwares inlaid with mother-of-pearl brought by the Manila Galleons inspired artists in seventeenth-century Mexico to create a

new genre of painting, *enconchados*, by encrusting mother-of-pearl within the compositions of oil paintings on wood panels.

In general the decorative arts of colonial Latin America followed the pattern of the major European stylistic movements, from Renaissance to neoclassical, but regional preferences permitted some styles and motifs to endure long beyond their passing in Europe. For example, sixteenth-century Renaissance C-scrolls and mannerist strapwork cartouches remained popular motifs in the arts of the Andes well into the eighteenth century. The enormous wealth of the viceregal capitals of Mexico City and Lima attracted more artists and artisans, which accounts for the disproportionately large number of decorative arts produced around these centers throughout the colonial period. Fine examples from many areas of the decorative arts were manufactured in virtually every region of Latin America at one time or another during the viceregal era, but for the purposes of this survey we have limited the discussion to the most exceptional examples. The decorative arts that are unique to colonial Latin America also are described in greater detail since some remain virtually unknown outside of their regions.

CERAMICS

The ancient civilizations of the Americas possessed sophisticated ceramic technologies three thousand years before the arrival of the Europeans. They employed molds for figures, vessels, and applied ornaments. Decorative techniques included burnishing, painting with polychrome slip glazes, incising, carving, and stamping. With the arrival of Catholic missionaries and the establishment of colonial governments, the production of traditional figural and decorated ceramics virtually ceased, as these wares were perceived as potent symbols of the suppressed "idolatrous" civilizations. Indigenous potters subsequently were limited to producing common utilitarian wares and storage vessels. The ancient ceramic traditions, however, were not entirely lost. In the seventeenth and eighteenth centuries burnished and slip-glazed red- and black-wares from Mexico, Panama, and Chile found a new market in Europe, which transformed them into some of the most highly prized ceramics of their day.

With the arrival of Spanish potters in the mid-sixteenth century, the production of European-style wares was facilitated by the introduction of new ceramic technologies: the kiln, the potter's wheel, and glazes with tin or lead. While a good deal is known about the establishment and production of the pottery industry in New Spain, its history in the Viceroyalty of Peru remains largely undocumented, though there is little evidence to suggest any extensive manufacture of tin-glazed earthenware or tiles. Throughout the colonial period Mexico maintained a virtual monopoly on fine tin-glazed earthenware, or maiolica, which was exported throughout the Spanish colonies. Based on archaeological findings, the earliest examples of tin-glazed earthenware were produced at potteries in Mexico City beginning in the mid-sixteenth century and continuing through the first quarter of the seventeenth. These consisted largely of plain tin-glazed tablewares, along with decorated wares with simple designs in blue, yellow, and orange, such as the so-called San Juan polychrome, named after the district of Mexico City where the potteries are believed to have existed.[3] Mexico City was quickly superseded in the early seventeenth century as the nearby city of Puebla emerged as the major viceregal center for the fine maiolica that graced the tables of the colonial elite.

Talavera Poblana

Through the seventeenth and eighteenth centuries the famous blue-and-white Chinese-inspired ceramics of Puebla were simply referred to as *loza fina* or *loza blanca* (fine or white earthenware). The term *Talavera Poblana* by which they are known today did not come into use until the nineteenth century.[4] Puebla's rise as a center for the production of fine earthenware and tiles was due in large part to abundant local deposits of suitable clays. By midcentury

the success of Pueblan potters had provoked the need to impose production and quality standards for the industry. A guild of potters was formed and ordinances were adopted in 1653 to govern all facets of the trade.[5] The ordinances required all potters to pass examinations administered by guild masters before practicing their craft, and specified additional exams for the manufacture of *loza fina*. They also established production standards for the quality of clay bodies and glazes, as well as for the uniformity of plate sizes for tableware. To avoid fraud, each master was instructed to place his sign or mark on all of his wares, and these marks were to be registered in a book kept by guild officials. Unfortunately this rule seems to have escaped rigorous enforcement since relatively few extant pieces bear marks. Additional ordinances were adopted in 1682 to regulate the decorative styles imitating Chinese porcelains and maiolica of Talavera de la Reina in Spain.[6]

The earliest fine maiolica produced in Puebla in the first half of the seventeenth century shows pronounced Spanish and Hispano-Islamic influences in its decoration, yet these pieces are by no means mere copies. Pueblan maiolica consistently shows a richer and bolder decorative style than that found on analogous Spanish wares. Two unique *lebrillos* (large flat-bottomed basins) formerly in the Pérez Salazar collection are painted solely in manganese brown. Both display exuberant borders in a bobbin-lace pattern that frames, on one, a portrait bust of a woman reminiscent of the portraits found on tricolor Spanish Talavera ceramics from the early seventeenth century, and, on the other, an American tom turkey, a motif with clearly no European precedent.[7] Two other exceptional *lebrillos* of Hispano-Islamic influence combine bobbin-lace patterns in black with Mudejar-inspired interlacery in a rich cobalt blue (cat. 1-29).

FIG. I-I
Jar with iron lid (*chocolatero*), Puebla, Mexico, c. 1700. Tin-glazed earthenware, height 13⅜ inches (34 cm). The Hispanic Society of America, New York, E994

The Chinese-inspired blue-and-white maiolica for which Puebla is best known made its appearance in the second quarter of the seventeenth century, as confirmed by the observations of the Jesuit historian Bernabé Cobo around 1630.[8] Substantial quantities of pottery and tiles also were painted with glazes of yellow, orange, brown, green, and blue, the five-color palette of Spanish Talavera polychrome ware, but it was blue-and-white that dominated production through the mid-eighteenth century. During this period, which marked the golden age of Talavera Poblana, new Chinese forms were introduced that were decorated in an eclectic mix of styles inspired by Chinese porcelains of the late Ming and early Qing dynasties, as well as earlier Islamic, Italian, and Spanish ceramics. One classic Chinese form, a shouldered, straight-necked jar or vase (*tibor*), to which a locking iron lid for storing chocolate or valuable spices was frequently affixed, gained immediate and enduring popularity (fig. 1-1). In Puebla, the Chinese style frequently combined the symmetrical design of the Asian models with the *horror vacui* inherited from the Hispano-Islamic tradition, a trait that permeated viceregal decorative arts. Chinese-inspired motifs favored by the Pueblan potters included garden or rocky landscapes, pagodas, figures of queued Chinese servants, phoenixes, cranes, chrysanthemums, and flowering prunus, with which they integrated the Mexican quetzal and nopal cactus.

An exceptional pair of *tibores* signed "he"—attributed to Damián Hernández, a master potter and a founder of the guild in 1653—are superb examples of how Pueblan potters creatively blended Chinese and Islamic decorative styles with European and colonial motifs to create a unique Mexican style (cats. 1-30, 1-31). These vases combine the form and designs of late Ming porcelains with *aborronado* decoration (dots used to fill outlined figures), a technique of Islamic origin mentioned in the 1682 amendments to the ordinances. Chinese and European figures set in scenes of triumphal chariots and bullfights serve as the focal points

FIG. 1-2
Tile panel (*tablero*) of the Virgin of the Immaculate Conception, Puebla, Mexico, last quarter of eighteenth century. Tin-glazed earthenware, 51¼ × 39½ inches (130.2 × 100.3 cm). The Hispanic Society of America, New York, LE1799

FIG. 1-3
Tile panel (*tablero*) of Saint Christopher, Puebla, Mexico, eighteenth century. Tin-glazed earthenware, 86⅝ × 77³⁄₁₆ inches (220 × 196 cm). Museo Franz Mayer, Mexico City

of the decorative program. Although triumphal chariots are commonly associated with Renaissance Europe, these ephemeral creations were not unfamiliar during important public festivities and religious celebrations in the major cities of seventeenth-century New Spain.

The production of architectural tiles represented a major segment of the pottery industry in Puebla from the beginning, as evidenced by a contract given in 1602 to the potter and tilemaker Gaspar de Encinas for 1,800 tiles for the main altar of Mexico City's cathedral.[9] Virtually all of the decorative styles—bobbin-lace pattern, *aborronado*, Chinese, Talavera polychrome—were employed on tiles used in all types of religious and secular settings. Tiles embellished the interiors and exteriors of structures throughout the viceroyalty, but it was in the churches and convents of Puebla that they became the predominant ornamentation for facades, domes, cupolas, chapels, altars, fountains, and kitchens. In the second half of the eighteenth century tilemakers began producing large figural tile panels (*tableros*), mostly of religious subjects, which provided them with the perfect medium to display their artistic skills (figs. 1-2, 1-3). By the end of the eighteenth century *tableros* could be found ornamenting the brick facades of many of Puebla's churches, including San Marcos (1797), where the confraternity of potters held their religious celebrations.[10]

Búcaros de Indias

In the seventeenth and eighteenth centuries *búcaros de Indias* were among the most highly prized and valuable ceramics in many of the greatest noble collections of Europe. These rare potteries were coveted not so much for their exotic forms, which were in some cases extravagant even for the baroque era, but for their aromatic, evaporative, gastronomic, and medicinal qualities. They were the preferred storage and drinking vessels for water since their porosity accelerated evaporation and lightly chilled the liquid, while the flavor and aroma of damp clay that they imparted to water, arguably an acquired and cultivated taste, turned the humble beverage into a sybaritic experience. The consumption of small pieces of the ceramic delicacy, known as geophagia, or by the more elegant Spanish term *bucarofagia*, was not just fashionable

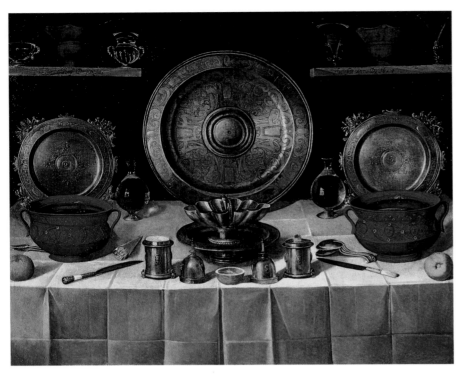

FIG. I-4
Juan Bautista de Espinosa (Spanish, c. 1590–1641),
Still Life with Metalwork Objects, 1624. Oil on canvas,
38⁹⁄₁₆ × 46⁷⁄₁₆ inches (98 × 118 cm). Collection of
Masaveu, Oviedo, Spain

but a true obsession among the women of Spain's aristocracy in the seventeenth century.[11] As a result of ingesting the clay, those privileged enough to afford this luxury on a regular basis experienced yellowing of the skin, distention and hardening of the stomach, intestinal blockages, and reduced menstruation.[12] Queen María Luisa de Orleáns, the unhappy wife of Carlos II, reportedly had a fondness for *búcaros*, and had consumed some of this clay on the day before her death in 1689.

Búcaros de Indias comprised a diverse group of burnished red-, white-, or black-slipped earthenware produced in Mexico, Panama, and Chile from the sixteenth through the eighteenth centuries. As a ceramic type they were far from unknown in Europe, with antecedents dating back to the *buccheri* of the Etruscans of the eighth to fifth centuries B.C.; the *terra sigilata* found throughout the Roman Empire, including the Iberian Peninsula; and the medieval Portuguese *púcaros* of Estremoz and Lisbon.[13] Numerous contemporary Spanish and other European writers, ranging from the great Spanish dramatist Lope de Vega (1562–1635) to the French countess Madame d'Aulnoy (1650/51–1705), commented upon the fashion and vice of *búcaros*. Their presence in Spanish still-life paintings of the seventeenth and eighteenth centuries offers further proof of their popularity and luxury status.[14] An early, if not the earliest, visual record of *búcaros* is found in *Still Life with Metalwork Objects* (1624) by Juan Bautista de Espinosa (fig. 1-4), where Mexican ceramics take pride of place alongside fine crystal and gilded silver chargers on a table fit for a king. Spain's greatest painter, Diego Velázquez, even recorded their presence at the court of Felipe IV in his masterpiece *Las Meninas* (1656; Museo del Prado, Madrid), in which the Infanta Margarita is offered the perfumed water of a *búcaro* served on a small golden tray.[15]

Much of what we know today about *búcaros de Indias* derives from two sources: the writings of the seventeenth-century Florentine scholar, scientist, and hedonist Lorenzo Magalotti (1637–1712); and the extensive collection of these wares formed over the course of two centuries by the counts of Oñate, now held by the Museo de América in Madrid. Magalotti documented all facets of the esoteric cult of *búcaros* in passionate detail in a series of letters written in 1695 to the marchesa Ottavia Strozzi in Rome.[16] In these letters Magalotti described the three distinct types of New World *búcaros* favored by the cognoscenti: those from Guadalajara in New Spain, Natán (today Nata) in Panama, and Chile. He noted how those from Chile, produced solely by nuns in a convent in Santiago, were the most esteemed for their bright red color, form, and decoration. While drinking glasses were the most common forms, they also manufactured all sorts of ceramic tableware, including spoons and forks, as well as the liturgical objects found on church altars, such as lamps, candleholders, and cups.[17] Two almost identical incense burners, one from the Oñate collection in the Museo de América, and another from the Lebrija palace in Seville, both of which are gilt-decorated with applied figures of sirens, kings, and flowers, illustrate why the Chilean wares were so highly regarded for their exotic forms and ornamentation by seventeenth-century audiences.

Turning to the *búcaros* from Guadalajara, or specifically the neighboring village of Tonalá, Magalotti noted that they were superior to those of Chile in the aromatic qualities of their clay, but notably inferior in their forms.[18] His aesthetic assessment of Tonalá wares was admittedly limited by the pieces that he had encountered. In contrast, the pinched forms of deceptively

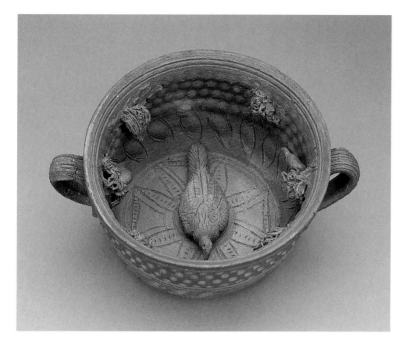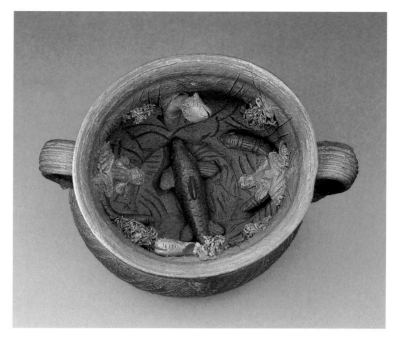

Cups with handles and interior applied decoration,
Tonalá, Mexico, or Natán, Panama (cats. 1-8, 1-9)

modern design of the burnished, red-slipped *búcaros* from Tonalá seem to hold greater appeal for present-day audiences than the quintessentially baroque Chilean pottery (cats. 1-1, 1-2, 1-10). Though unknown to Magalotti, Tonalá also produced blackwares that were documented in the 1685 inventories of the estate of the countess of Oñate.[19] The Florentine scholar would have been fascinated by the bizarre, Palissy-inspired black drinking vessels from Tonalá that display a veritable swamp in their interiors—applied figures of frogs, snakes, lizards, fish, and plants—thus providing the added benefit of twice the normal clay surface for infusing water with their earthy fragrance (figs. 1-5a, b). Magalotti also reported that several white-slipped *arcibuccheri* (giant jars, or *tibores*), decorated with red-slip arabesques, recently had arrived in Florence for the Grand Duke Cosimo III. A surprisingly large number of these oversized yet fragile ornamental water jars, often measuring over three-feet tall, have survived, scattered throughout the aristocratic collections of Europe (cat. 1-5).

In Magalotti's estimation the burnished black *búcaros* from Natán were the most precious and delicate of all. The town of Natán was a significant early settlement on the Pacific coast of Panama. Although this province is not readily associated with a ceramics industry in modern times, Panama provided most of the tin-glazed earthenware consumed in the Viceroyalty of Peru up to the middle of the eighteenth century. According to Magalotti, all of the people of Natán were involved in the production and trade of massive quantities of the coveted black pottery, which supplied Cartagena, Colombia, all of the Caribbean, and Spain. Prized foremost for the exquisite aroma of their clay, the *búcaros* from Natán frequently were fitted in mounts of gold or silver, which, as Magalotti observed, contrasted nicely with their shiny black surface and simple forms.[20] Unfortunately, no examples from Natán have been identified in modern collections, making Magalotti's commentaries all the more valuable.

Before concluding his eight letters on *búcaros* to the marchesa Strozzi, Magalotti informed her how the natural scents of the clays were restored and preserved by the experienced nuns of the convent of the Descalzas Reales in Madrid.[21] Since *búcaros* lost some of their aromatic properties on the long ocean voyage from the Indies, which Magalotti compared to seasickness, on their arrival in Spain they were soaked several times in clean water and then allowed to dry in closed, ventilated cabinets. After moistening with amber-scented water and once again dried, they were perfumed with burning incense in a special chamber. To preserve their enhanced scent they were stored in small coffers made of cypress, cedar, or aloe. Not to be outdone, Magalotti recommended his personal ritual for preserving their treasured essence,

which included perfuming the wooden coffers in which they were stored with flower-scented waters before filling the bottoms with cotton balls infused with the smoke of balsam and perfume tablets boiled in floral waters. The final step was to ensure that the coffers were airtight so that their precious aroma was retained when they were not in use.

NANBAN ART IN THE AMERICAS

The Nanban period in Japan (c. 1549–c. 1639) refers to the era when Portuguese and Spanish missionaries introduced Christianity into the island country, and when Portuguese merchants monopolized its trade for nearly fifty years until the arrival of the Spanish in 1596 and the Dutch in 1600. Upon reaching Japan, the Portuguese encountered a phenomenal array of decorative arts, with the exceptional works of lacquer and painted folding screens of particular interest. In little time Japanese master artisans were producing these wares for the Portuguese and their European trade partners. Works made for the export market were referred to in Japanese with the term *Nanban*, meaning "southern barbarian," in reference to the fact that the Portuguese and Spanish had come from Macao and Manila, both south of Japan. Although Spain and New Spain enjoyed only a very brief period of favorable relations with Japan, highly significant diplomatic and trade missions were sent from Japan to New Spain in 1610 and 1614. These missions brought with them numerous Japanese merchants and artisans, some of whom remained in New Spain to carry out their trades.

Biombos

The Spanish word *biombo*, used for decorative folding screens, was derived from the Japanese term for screens, *byæbu*. Nanban screens typically depict the arrival in Japan of the Portuguese ships carrying merchants and missionaries. The first Japanese folding screens arrived in New Spain with the 1614 Japanese mission, and their popularity with the cultural elite of the viceroyalty must have been immediate, since Mexican artists and artisans had begun to recreate them in their own style by the 1630s. Unlike the Japanese screens, which utilized gold and silver leaf, inks, and paints on paper, the Mexican screens were essentially treated like traditional oil-on-canvas paintings. The earliest datable *biombo* bears the coat of arms of the Marqués de Cadereyta, sixteenth viceroy of New Spain (1635–40), and shows scenes of the main plaza of Mexico City, with the viceregal palace in the background and the merchant stands of the famous Parián market (named after its Manila counterpart) in the foreground (see Bailey fig. F-7). Nanban prototypes clearly served as the source for this screen, given the similarity of subject and the addition of the golden Japanese-type clouds, a detail omitted in

FIG. 1-6
Folding screen (*biombo*), with a view of Mexico City (reverse shows the conquest of Mexico), Mexico, eighteenth century. Oil on canvas, 7 × 18 feet (2.13 × 5.5 m). Museo Franz Mayer, Mexico City

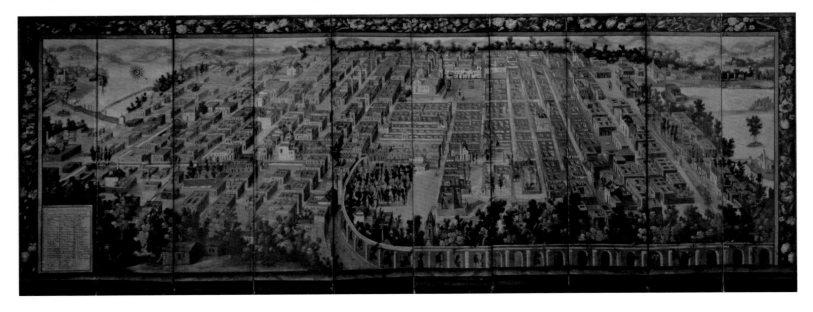

most subsequent Mexican screens. Later in the century the influence was less noticeable but still present, as demonstrated by an important screen that pairs, on one side, scenes of the conquest of Mexico, framed at the top with gold embossed arches executed in a technique reminiscent of Japanese cloud forms, and, on the other, an elevated view of Mexico City (fig. 1-6). A few *biombos*, like a screen in the Museo del Virreinato, Tepotzotlán, with scenes of the defense of Vienna against the Turks, have frames that imitate Nanban-type lacquer encrusted with mother-of-pearl in a technique known as *enconchado*, which was developed by Mexican artists in the seventeenth century.

Through the seventeenth and eighteenth centuries, *biombos* explored various subjects—classical, allegorical, mythological, religious, historical, the hunt, the four continents—as well as lighter themes with scenes of daily life, entertainments, and festivities set in idealized and real landscapes. Several screens have been attributed to important artists such as Juan Correa (c. 1646–1716), the most prominent member of a family of mulatto painters, and Miguel Cabrera (1713/1718–1768), the most celebrated Mexican painter of the eighteenth century; however, most of the painters were anonymous, and *biombos* were rarely, if ever, signed by the artist. Many screens have survived because of their treasured status, for they were counted among the most important decorative objects in the palaces of Mexico and Spain. Since they were largely commissioned by viceroys and other members of the aristocracy, many Mexican *biombos* returned to Spain with their owners once their viceregal terms had expired. This explains in part the large number of *biombos* found today outside of Mexico. The popularity of the Mexican screens also spread to other Spanish colonies, such as Nueva Granada, where a more limited number of *biombos* were produced in the eighteenth century.

Enconchados

In simplest terms, *enconchados* are oil paintings encrusted with mother-of-pearl. The art also known as *pinturas enconchadas* was unique to the Viceroyalty of New Spain, where it developed in the last half of the seventeenth century and flourished for a relatively brief period into the early decades of the eighteenth century. Combining lacquer techniques, both Mexican and Nanban, with the fine art of oil painting, *enconchados* represent a true synthesis of the arts and culture of Europe, Mexico, and Japan.

The *enconchado* technique required the skills of both an artisan and an artist. First a preparatory sketch was placed on a canvas attached to a wood panel, over which pieces of mother-of-pearl of varying sizes were laid on selected areas of the composition. A plasterlike compound was used to fill the spaces between the shells, and a transparent organic oil or resin was applied to seal this layer. Next, powdered gold was sprinkled over the surface to enhance the luminosity of the mother-of-pearl. The artist then painted the work, usually principally in tempera, for its translucent properties, with oils reserved solely for flesh tones. When complete the entire work was varnished to seal the delicate tempera and to give a lacquerlike appearance.[22]

The invention of this uniquely Mexican art has been attributed to three artists, Tomás González de Villaverde and his sons Juan and Miguel.[23] Documents from the late 1680s describe Tomás González, a resident of Mexico City, as a painter of *maque* (lacquer), an intriguing detail given the similarity of the *enconchado* technique with Nanban lacquer. Whether or not they invented the new art form, Juan and Miguel González unquestionably were the most prolific artists in the genre, producing dozens of signed works around the turn of the century. Their most famous compositions are two twenty-four-panel series on the conquest of Mexico, one in the Museo Nacional de Bellas Artes, Buenos Aires, and the other, dated 1698, in the Museo de América, Madrid. As evidenced by the works of the González brothers, *enconchado* paintings were customarily produced as a series on a single theme, often religious, such as the life of Christ or of the Virgin. Other notable painters worked in this

genre, including Nicolás Correa, Agustín del Pino, Antonio de Santander, and Pedro López Calderón. Perhaps the finest extant *enconchado* is the *Wedding at Cana* (1696) by Nicolás Correa (cat. 1-13), in which the artist exploited mother-of-pearl to its fullest potential. Unlike other *enconchado* artists, who indiscriminately employed relatively large pieces of nacre, Correa matched pieces of varying size and color to the composition to brilliant effect.

LACQUERWARES

The lacquerwares of Latin America are among the most original and exceptional decorative arts produced during the viceregal era, yet they are notably absent from the international histories of lacquer, which do include other non-Asian imitative techniques, such as japanned furniture produced in Europe and the United States. This can be explained in part by the scant examples to be found in museum collections, though the general lack of information available outside of Spanish-language sources is the more probable cause.

Two separate lacquer traditions developed during the colonial period: one in the Viceroyalty of New Spain, centered in west-central Mexico in the present-day states of Michoacán and Guerrero; the other in the Viceroyalty of Peru, encompassing the Andean region from the city of Pasto in southwest Colombia to Quito, Ecuador, and beyond into the highlands of Peru. Within each tradition, variant styles and techniques developed over the course of three centuries. Most importantly, both traditions developed from pre-Columbian lacquer techniques that utilized organic materials endemic to the regions of production, distinct from East Asian lacquers that employed a resin obtained from the lacquer tree (*Rhus verniciflua*). These uniquely American lacquer traditions, which combine indigenous techniques and European forms with designs borrowed from Europe, Asia, and pre-Hispanic America, serve as the ultimate expression of the transculturation that defines the arts of colonial Latin America.

Barniz de Pasto

Mopa mopa, a translucent pale green natural resin, is the principal medium for the lacquerwares generally referred to as *barniz de Pasto* (Pasto varnish) that have been produced in Colombia, Ecuador, and Peru from the viceregal period to the present day. Even though *mopa mopa* had been known to naturalists for several centuries, the true botanical source of the resin was not identified until 1977 by the Colombian botanist Luis Eduardo Mora-Osejo.[24] The sticky elastic resin is obtained from the garbanzo-sized leaf buds of the *mopa mopa* tree (*Elaeagia pastoensis* Mora), native to the tropical rain forests of the mountains of southwest Colombia near Mocoa, the capital of the department of Putumayo. Its use by the pre-Hispanic peoples of Colombia has been confirmed by the discovery of beads made of *mopa mopa* in tombs of ancestors of the Pasto Indians that date back more than a thousand years. Further confirmation is provided by Spanish reports of indigenous artisans in Mocoa and Timaná who were producing tobacco boxes and staffs decorated with colored lacquers in the sixteenth century.[25] During the colonial period the indigenous peoples of the Sibundoy Valley of Colombia supplied the resin-covered leaf buds, pressed into blocks, to the lacquer artisans who processed and colored the resin for application on a variety of decorative wooden objects.

The transformation of raw *mopa mopa* into a decorative lacquer was largely a manual process, beginning with the removal of impurities such as leaves, bark, or other organic matter. Small amounts of the gummy resin were then chewed and/or boiled in water to make it sufficiently elastic to stretch into thin sheets, which also facilitated the removal of additional impurities. This process was repeated numerous times in order to achieve the most transparent lacquer. Once the desired level of purity was achieved, organic and mineral colorants were added through kneading or chewing. After being boiled in water again, two artisans would stretch the highly elastic *mopa mopa* into extremely thin sheets by pulling it in opposing

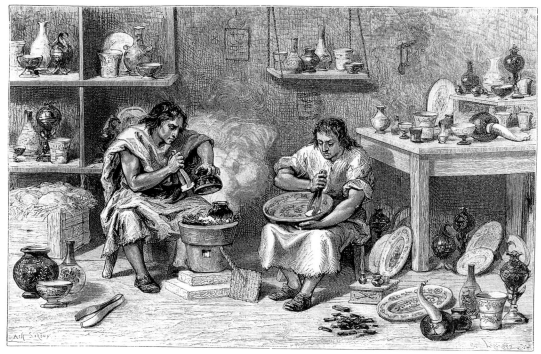

FIG. 1-7
Fabrication of Objects of Barniz de Pasto, after a drawing by Achille Sirouy, in Édouard François André, "L'Amérique equinoxiale," in *Le Tour du monde,* 2nd semester (Paris: Librarie Hachette, 1879), p. 325. The Hispanic Society of America, New York

directions with their hands and teeth. The varied shapes needed for the decorative design then were cut from the center of the sheet and applied with heat to the wooden object (fig. 1-7). Once cooled the bond was permanent. The resulting lacquer provided an exceptionally durable and waterproof surface impervious to most organic solvents.

Two independent *mopa mopa* lacquer traditions developed during the colonial period: one in the Andean region of Peru, Ecuador, and Bolivia, associated primarily with the Inca *keros,* paired wooden beakers used for the ritual consumption of maize beer, or *chicha;* the other tradition centered in Pasto and to a lesser extent in Quito, characterized by European forms and motifs exhibiting a pronounced Asian influence. Early in the colonial era *keros* with colored *mopa mopa* inlays of traditional Inca animal and floral motifs began to supplant those with incised linear designs typical of the Inca period. The pictorial style of later colonial examples, distinguished by their elaborate figural designs based on Inca mythological and historical themes, shows greater Spanish influence more in keeping with the traditional European aesthetic. Although *mopa mopa* had been suspected as the medium employed in the painted decoration of the colonial *keros,* it was not until recently that its use was confirmed through analytical sampling.[26] The sixteenth-century Bolivian lacquer chest included in the present exhibition (cat. 1-20), decorated with dragons (*amaru*) and scenes of Inca conquest, represents one of the few decorative objects, other than *keros,* known from this tradition.

Mopa mopa achieved its fullest artistic expression as a lacquer medium in the seventeenth and eighteenth centuries in the hands of the *barnizadores,* the indigenous or mestizo lacquer artisans of Pasto and Quito. Both cities were closely aligned throughout most of the colonial period since Pasto fell under the jurisdiction of the diocese and Audiencia of Quito, rather than the Audiencia of Nueva Granada centered in Bogotá. The earliest reference to the production of lacquer objects in Pasto dates from around 1666, yet by this time it reportedly had already enjoyed considerable fame in Europe.[27] Throughout the eighteenth century various travelers made their way to Pasto, where they studied, described, and extolled the virtues of the prized lacquer. The naturalist explorers Jorge Juan and Antonio de Ulloa, who visited in 1740, remarked that *barniz de Pasto* rivaled the best Asian lacquers in the beauty, shine, and durability of its colors.[28] Miguel de Santisteban, who arrived at Pasto in December of 1740 on his journey from Lima to Caracas, observed the *barnizadores* firsthand and provided the earliest detailed account of their techniques.[29] Friar Juan de Santa Gertrudis, who stayed in Pasto four times in 1761–62, also described the process, but added that the lacquered plates, chargers, bowls, basins, and cups made by the artisans were as lustrous as the Chinese porcelain for which they were easily mistaken.[30]

The famous German naturalist Alexander von Humboldt visited Pasto in 1801, recording in his diary a wealth of detail on the history, manufacture, and commerce of *barniz de Pasto.*[31] Of particular interest is his report that the *barnizadores* credited Catalina Petronila de Mora,

who held an *encomienda* in Timaná at the turn of the seventeenth century, for having established the industry in Pasto. Though not corroborated by other colonial sources, this account merits further investigation, since Timaná was one of the earliest centers of lacquer production. Other lacquer artisans told Humboldt that Catalina Petronila de Mora had learned the art from her Indian laborers and then perfected it in Pasto. He goes on to observe that there were 80 *barnizadores* in 1801, including several masters with 4 or 5 laborers, who used 600 to 800 pounds of *mopa mopa* annually in the manufacture of lacquerwares valued at 10,000 to 15,000 pesos. Like other early travelers, Humboldt described the source of the resin and the lacquer process, but was the first to identify the colorants: indigo dissolved in water for blue; pure indigo for black; annatto for red; diluted blue mixed with the powdered root of *Escobedia scabrifolia* (a saffron-like colorant) for green; *Escobedia scabrifolia* over silver leaf for gold; and lead oxide for white.

What distinguished the lacquerwork of Pasto from the indigenous tradition was the technique that came to be known as *barniz brillante*, so-called because of its glowing metallic luster, achieved by combining silver or gold leaf with the lacquer. This required stretching highly refined *mopa mopa* resin, natural or tinted, into sheets as thin as onion skin. The varied shapes of the design were cut from the center of the sheet, where it was the thinnest, and laminated over silver or gold leaf. These pieces were then applied to the object as independent design elements; as smaller pieces of a larger design, as with marquetry; or stacked to create designs in relief. Additional details were incised in the lacquer, such as the veins of a leaf or flower. In some of the most complex early treatments, minute threads of black or white *barniz* were used to outline figures, to add fine details, or to create cross-hatching for shading effects.

During the colonial period *barniz de Pasto* was employed in the decoration of a wide variety of secular and religious wooden objects, including larger case pieces such as drop-front writing cabinets, or *vargueños*, as well as portable writing desks, chests, domed coffers, book stands, picture frames, trays, bowls, plates, nesting beakers, and cups. The designs found on the earliest seventeenth-century examples incorporate floral, foliate, and hunting motifs that include both realistic and mythological beasts. All of these early designs clearly derive from sixteenth-century European sources, such as prints, drawings, and illuminated manuscripts. Pieces produced from the last half of the seventeenth century through the eighteenth century exhibit an eclectic mix of motifs drawn from European, American, and Asian antecedents, including the squirrel-and-grapevine motif common to sixteenth-century Chinese and Japanese decorative painting as well as seventeenth-century lacquers from the Ryukyu Islands (Okinawa); peonies and carnations from Chinese porcelains and textiles; tropical flora and fauna of the tropics; the double-headed Habsburg eagle; and images from European heraldry, mythology, and still-life paintings.

All of these influences can be found on a circa 1685 portable writing desk commissioned by the bishop of Popayán, Colombia, Cristóbal Bernardo de Quirós, as a gift for his brother Gabriel Bernardo de Quirós, secretary to Carlos II (cat. 1-15). The exterior exemplifies the fusion of Asian and indigenous motifs, where the squirrel-and-grapevine design has been reinterpreted as a monkey-and-grapevine. Even the form of the writing desk, with its subtly curved edges and slightly elevated drop-front, more closely resembles sixteenth-century Nanban lacquer cabinets from Japan than traditional Spanish models. The synthesis of these diverse artistic and cultural traditions is most notable on the interior of the lid, which displays the coat of arms of the Quirós family over a basket filled with tropical fruits and flanked by parrots, all set against a rich background of grapes, vines, leaves, and carnations (fig. 1-8).

There is reference to the production of *mopa mopa* lacquer in Quito as early as 1625,[32] though extant pieces and other documents seem to limit the activity of *barnizadores* to the eighteenth century. The presence of workshops of *barniz de Pasto* in the city is confirmed by a *vargueño* inscribed "*facto in Quito en 1709*," in the Museo Franciscano Fray Pedro Gocial

in the Convent of San Francisco in Quito. The similarities in design and motifs of the *barniz* created in Pasto with those on this dated *vargueño*, as well as on other pieces in the Museo Franciscano and the Museo Jacinto Jijón y Caamaño in Quito (cat. 1-27), suggest that *barnizadores* from Pasto were responsible for establishing workshops in Quito in the late seventeenth century that produced wares until the nineteenth century.

Mexican Lacquer

Early historical accounts refer to Mexican lacquerwares as *pinturas* (paintings) or *barnices* (varnishes). The terms *laca* (lacquer) and *maque* (from *maki-e*, the Japanese word for lacquers incorporating gold or silver) do not come into use until the eighteenth century with the introduction of the chinoiserie style, which emphasized gold in the decoration. The essential ingredients for all of the colonial Mexican lacquers were *aje* and *chia* or *chicalote* oils, which were combined with powdered dolomite or other mineral clays to produce a thick liquid or soft paste. Organic and mineral colorants were added to the mixture, and this served as the lacquer medium that was applied to a variety of wooden objects and gourds. *Aje* oil was obtained from the females of a scale insect (*Llaveia axin* or *Coccus axin*), cultivated since pre-Hispanic times on acacias, piñon pines, and hog plum trees, among others.[33] The live insects were gathered during the rainy season of May and June, and boiled in water until the waxy *aje* fat floated to the surface for collection. The boiled insects were then squeezed in a fine cloth to extract any remaining fat. The *aje* fat was purified by additional boiling and straining. Solid when cooled, the malodorous fat was wrapped in corn husks for storage.[34]

Chia oil was extracted from the seeds of a sage plant native to Mexico (*Salvia chian*), which the Aztecs cultivated as a major food crop as well as for its oil and medicinal uses. Oil from the seeds of the *chicalote*, or Mexican poppy (*Argemone mexicana*), which is toxic and possesses narcotic properties, was used interchangeably with *chia* oil in the preparation of the lacquer. To extract the oil, the seeds first were toasted and ground, then mixed with hot water to form a paste that was kneaded until drops of oil began to appear. The paste was wrapped in a fine cloth and squeezed to extrude the oil, which was strained for impurities and boiled to preserve it for storage.[35] When combined with *aje* oil, the *chia* or *chicalote* oil acted as a thinner and as a drying agent that formed a hard lacquer surface that was impermeable to most liquids.

The discovery of gourd vessels with well-preserved polychromy at archaeological sites in Chiapas, Coahuila, the Yucatán, Morelos, and Puebla has firmly established the existence of a pre-Hispanic lacquer tradition in Mexico dating back more than two thousand years. Indigenous codices and histories, along with early Spanish chronicles, further detail the large-scale production of these "painted" gourd cups among the Mexica, Purépecha, and Maya.[36] In the famous *Florentine Codex* of the 1540s, the Franciscan missionary Bernardino de Sahagún documented the use of *aje* in the decoration of gourds. Drawing upon the accounts of native informants, he described the trade of the gourd seller in the great Aztec market of Tlatelolco: "He sells gourds with raised [designs], with stripes, with lines, scraped, rubbed with *axin* [*aje* oil], rubbed with [the powdered] fruit pits [of the yellow sapote], smoked, treated with oils."[37]

The production of painted and lacquered gourd cups and other containers continued in central and southern Mexico throughout the colonial period, but it was not until the seventeenth century that the indigenous Mexican lacquer technique was adapted to the decorative

arts intended for the Spanish market. In the seventeenth and eighteenth centuries the cities of Peribán, Uruapan, and Pátzcuaro in the modern state of Michoacán, and Olinalá in the state of Guerrero, became the principal centers of production. Each of these centers developed distinct styles and techniques that were employed in the making of a diverse array of decorative utilitarian objects.

Peribán, situated in western Michoacán near the border with Jalisco, was home to the earliest artist workshops for lacquerware in Mexico. The Franciscan chronicler Alonso de la Rea, writing in 1639, credited the indigenous lacquer artisans with having invented in Michoacán the art that he called "Peribán painting."[38] He praised this lacquer not only for its beauty but for its durability and resistance to hot liquids. De la Rea went on to describe the technique, observing that a coating of the lacquer was first applied to the object and allowed to dry completely. "Figures, mysteries, or landscapes" were incised on the surface, and the interior of the designs then was removed down to the wood with a steel point or burin. The excised areas were filled with colored lacquers, applied one color at a time. De la Rea reported that Peribán lacquer was used to decorate a variety of fine writing desks, boxes, chests, trays (*bateas*), gourd bowls (*tecomates*) and cups (*jícaras*), and other curious objects.

The pre-Hispanic inlay or *embutido* technique first described by De la Rea characterized the lacquers of Peribán from the seventeenth into the early eighteenth century, and those of Uruapan in the eighteenth. Judging by the complexity of the designs on early Peribán lacquers, the technique was labor intensive and time-consuming. Each application of lacquer had to be burnished with a soft cloth before completely drying, a process that took several days. The exuberant, but limited, color palette of Peribán lacquers consisted of red, yellow, orange, blue, green, black, and white. Mineral clays were sources for reds and yellows, while organic pigments yielded additional colors, such as brazilwood or cochineal for red, saffron root for yellow, mangrove bark for blue, and charred corncobs or charred guava tree branches for black.[39]

The earliest and finest examples of Peribán lacquerwork roughly date to the first half of the seventeenth century. Barely a dozen pieces from this period survive, limited to a few *bateas*, chests, portable writing desks, and a *vargueño*. Most are preserved in Spanish collections, prized in their day for the colorful decoration and exotic medium. The *bateas* in fact gained such fame that any large lacquered bowl often was referred to as a *peribana* into the nineteenth century. Truly objects fit for a king, the two Peribán domed writing desks in the collection of the convent of the Descalzas Reales in Madrid almost certainly were a gift from the Spanish monarch to the Carmelite nuns. The same applies to a *batea*, of similar style and decoration, in the Conceptionist convent at Ágreda in Soria, Spain, home to the mystic Sister María de Ágreda (1602–1665), a longtime correspondent and advisor to Felipe IV. A contemporaneous painting by Antonio de Pereda, *Still Life with an Ebony Chest* (1652), gives further proof of the prized status of Peribán lacquers (fig. 1-9). Atop the ebony chest at the right sits a Peribán *jícara*, or gourd cup, accompanied by equally valuable *búcaros de Indias* from Tonalá. This unique visual record of a Peribán gourd cup, of which none are known today, provides a means for dating other extant pieces based on the stylistic comparison of the decorative motifs. The figure of a siren and the accompanying designs on the gourd cup, for example, are virtually identical to those on the reverse of a *batea* in the Hispanic Society of America (fig. 1-10).

FIG. 1-9
Antonio de Pereda (Spanish, 1611–1670), *Still Life with an Ebony Chest*, 1652. Oil on canvas, 31½ × 37 inches (80 × 94 cm). State Hermitage Museum, Saint Petersburg

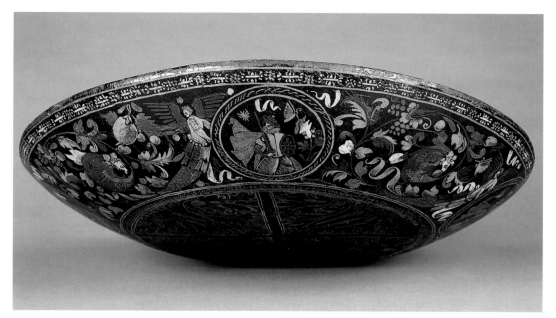

FIG. I-IO

Detail of the reverse of a tray (*batea*), Peribán,
Mexico, seventeenth century. Lacquer on wood,
height 3⅛ inches (8 cm), diameter 22¼ inches
(56.5 cm). The Hispanic Society of America,
New York, LS1808

Typical motifs on early Peribán lacquers include central strapwork cartouches of a marked mannerist influence containing allegorical or mythological figures. The cartouches are surrounded by imaginary landscapes populated with courtly figures in late sixteenth-century European dress engaged in all manner of outdoor activities. A fantastic menagerie of domestic animals, wildlife, and mythical creatures inhabit the scenes, and include the occasional New World species, like the armadillo. The compulsion to leave no space undecorated, or *horror vacui*, so characteristic of the colonial decorative arts, is epitomized by the Peribán lacquers. Dutch and Flemish prints served as the primary source for these images, yet the creative genius of the indigenous artisan remains omnipresent.

One notable exception to the largely European-derived design on Peribán lacquers is a large domed chest in the Lebrija palace in Seville that incorporates a geometric pattern of eight-pointed stars, typical of sixteenth-century Islamic-inspired Mudejar woodwork. The interior of the lid displays a flower-filled vase within a circular bobbin-lace border, which contrasts sharply with the geometrical design of the exterior. A similar lace border is found on the interior of the drop-front of a *vargueño* in the Hispanic Society of America (cat. 1-15), as well as on Talavera Poblana ceramics of the early seventeenth century.

Pátzcuaro, located in the center of Michoacán, gained renown in the eighteenth century for its Asian-inspired lacquerwares. The composition of its lacquer differed little from that in Peribán—*aje* oil, *chia* or *chicalote* oil, mineral clays, and organic pigments—yet the technique more closely approximated japanning. Objects were decorated by applying a single color lacquer ground, predominantly black or red, upon which the scenes and designs were painted with a brush using natural pigments and gold, either leaf or powdered. Local artisans produced a wide array of forms, from small coffers to large pieces of case furniture, but they are best known for large *bateas*, some exceeding three feet in diameter, and for sewing boxes (*almohadillas*).

It remains unknown when lacquer production began in Pátzcuaro; however, the art already was thriving in 1766 when the Spanish friar Francisco de Ajofrín visited. Of particular significance, Ajofrín noted in his diary that a celebrated lacquer painter of indigenous noble lineage, José Manuel de la Cerda, flourished at that time and that his wares surpassed the lacquers of China. He also reported seeing a dozen *bateas* made of ash that Cerda was preparing for the vicereine Marquesa de Cruillas.[40] Considered the finest of all of the Pátzcuaro lacquer artisans, Cerda was the only one ever to sign his work, of which a few pieces survive (cats. 1-17, 1-18).

Pátzcuaro lacquerwares exhibit a variety of motifs adapted from European and Asian sources. Many of the *bateas* maintain the decorative program established at Peribán with a central cartouche or rondel containing figures, surrounded by four smaller rondels with separate scenes or figures. Since a number of pieces display similar themes or motifs, they are believed to originate from the same workshop.[41] A group of five *bateas* exhibit an Asian-inspired floral border with four large peonies that frames scenes of daily life and recreation with figures in contemporary European dress. Another small cluster of works displays scenes from classical

mythology. Yet another group of large *bateas* dating from the late eighteenth century, decorated with concentric bands of Asian-inspired floral motifs usually done in gold on a reddish ground, always include figures of greyhounds in one of the borders (cat. 1-16).

Although the exact dates for José Manuel de la Cerda are not known, he clearly influenced the style of Pátzcuaro lacquerwork through the close of the colonial era. Pieces from his workshop show the most pronounced Asian influence, with landscapes of weeping willows, flowering plums, cranes, pagodas and other structures of a general Asian style, set against a ground of black lacquer. The eighteenth-century fashion for chinoiserie decoration, and in particular European japanned furniture, served as the inspiration for these designs. Despite the fact that Asian lacquers were in abundant supply for comparison, Cerda may have borrowed his designs directly from European examples or from pattern books, such as *A Treatise of Japaning and Varnishing* (Oxford, 1688) by John Stalker and George Parker. A militaristic theme runs through many of the *bateas* and case pieces, as European soldiers and cavalry prepare for combat, battle turbaned soldiers (Indians or Turks), and besiege cities with cannons. Sewing boxes and other small pieces from the workshop are generally rococo in style and of a more pastoral theme, exhibiting narrative scenes of daily life, courtship, and recreation framed within rocaille and floral borders.

Olinalá, in the eastern part of the modern Mexican state of Guerrero, also emerged as a major lacquer center in the eighteenth century. Unlike the artisans of Peribán or Pátzcuaro, those in Olinalá relied solely on *chia* oil mixed with mineral clays and organic colorants for their lacquer. According to Joaquín Alejo de Meave, the village priest in 1791, the lacquerers of Olinalá excelled in the "painting" of gourd cups and larger gourd vessels, but also manufactured lacquered chests, writing boxes, trays, sewing boxes, candle screens, and bookstands.[42]

Meave dedicated most of his invaluable essay to the composition of the colorants for the lacquer, giving recipes for red, blue, yellow, green, crimson, purple, black, and white. He also described the two techniques used in the decoration of the lacquers. The first, known as *rayado*, or "scored," required the application of two layers of lacquer of contrasting colors. While the second layer of lacquer was still soft, the designs were scored in outline into the lacquer with a maguey or cactus spine, and the surrounding areas were excised. This exposed the contrasting first layer of lacquer, leaving the outlined designs of the second layer in relief. In the second technique, called *plateada* or *dorada a pincel*, silver or gold leaf was adhered to a base coat of lacquer, upon which the designs were painted in lacquer with a fine brush. Meave observed that only men practiced the gilded technique, while women were involved in all facets of lacquer production, including the laborious task of grinding the mineral clays. One exceptional survival from this period that superbly illustrates both decorative techniques is a convent voting box dated circa 1779 in the Museo Franz Mayer in Mexico City (cat. 1-26).

CONCLUSION

All of the decorative arts unique to colonial Latin America were very much the product of their age, their creation made possible only through the confluence of diverse peoples, cultures, and traditions at a propitious moment in time. As is typically the case with autochthonous traditions in the decorative arts, the most complex, creative, and truly exceptional works tend to date from the early years or decades of production. Since only the finest works have been preserved through the centuries, we often have no sense of their formative stages or antecedents. They frequently seem to have simply sprung forth developed to their maximum potential. In many instances, they did develop quickly because highly skilled indigenous artisans continued to practice their ancient crafts. Rapid development also was stimulated by novel external influences, the arrival and rapid popularization of Nanban decorative arts in Mexico serving as a prime example.

As the products of their era, many of these remarkable traditions flourished for a lamentably brief time, such as the *búcaros* of Natán and Santiago, Peribán lacquerware, *biombos*, and *enconchados*, none of which lasted beyond the eighteenth century. Those that survived the colonial era saw sharp declines in production, quality, and originality, as were the cases with Talavera Poblana, Tonalá ceramics, and the lacquers of Pátzcuaro and Olinalá. Most underwent "revivals" in the twentieth century in an attempt to resurrect these lost arts by returning to the original materials, techniques, and styles of their golden age in the seventeenth and eighteenth centuries. The decorative arts of Latin America will continue to evolve, bringing forth new traditions and golden ages, yet their moment of brilliance, when the arts and cultures of Europe, Africa, Asia, and America converged for the first time, will never be surpassed.

NOTES

1. Panofsky 1943, vol. 1, p. 209.

2. Motolinía 1541/1951, pp. 299–300.

3. Lister and Lister 1982, pp. 13–24.

4. McQuade 1999 *Talavera Poblana*, pp. 13–16.

5. Cervantes 1939, vol. 1, pp. 22–25.

6. Ibid., pp. 27–29.

7. *Talavera poblana* 1979, cat. nos. 2, 3, unpaginated.

8. Cobo 1890, vol. 1, p. 243.

9. Cervantes 1939, vol. 2, pp. 15–18.

10. Ibid., pp. 114–15.

11. To eat the clay they used broken vessels or intentionally broke small cups. Broken pieces were sold by weight in Mexican ports. Presumably those that arrived broken in Seville, apparently many, were also sold by weight.

12. Aulnoy 1892, pp. 110–12.

13. Michaelis de Vasconcelos 1905, pp. 140–96.

14. García Sáiz 2003, pp. 194–96.

15. Seseña 1991, p. 39.

16. Magalotti 1943, pp. 1–176.

17. Ibid., pp. 124–30.

18. Ibid., pp. 130–36.

19. García Sáiz and Barrio Moya 1987, pp. 108–10.

20. Magalotti 1943, pp. 138–44.

21. Ibid., pp. 147–54.

22. Huerta Carrillo 1991, pp. 53–57.

23. Tovar de Teresa 1990 "Concha," pp. 106–34.

24. Mora-Osejo 1977, pp. 5–31.

25. Friedemann 1985, pp. 15–18.

26. Newman and Derrick 2002, pp. 291–302.

27. Fernández de Piedrahita 1688, p. 360.

28. Juan and Ulloa 1826/1918, vol. 2, p. 252.

29. Santisteban 1992, pp. 123–24.

30. Santa Gertrudis 1956, vol. 2, pp. 76–77.

31. Humboldt 1994, vol. 2, pp. 152–55.

32. Simón 1953, vol. 6, p. 47.

33. Castelló Yturbide 1972, pp. 34–35.

34. Sepúlveda y Herrera 1978, p. 43.

35. Ibid., p. 62.

36. Medina González 1997, pp. 22–27.

37. Sahagún 1961, p. 78.

38. Rea 1643/1882, p. 40.

39. Pérez Carrillo 1990, pp. 66–68.

40. Ajofrín 1958, vol. 1, p. 220.

41. Pérez Carrillo 1990, pp. 123–90.

42. Meave 1791, pp. 173–78.

I-I *Two-handled jar*

Tonalá, Jalisco, Mexico
Seventeenth century
Red-slipped earthenware
Height 17¹¹⁄₁₆ inches (45 cm)
Museo de América, Madrid

PROVENANCE: Catalina Vélez de Guevara, Countess of Oñate; Museo
Arqueológico Nacional, Madrid, 1884; Museo de América, 1941

I-2 *Bottle*

Tonalá, Jalisco, Mexico
Seventeenth century
Red-slipped earthenware
Height 14³⁄₁₆ inches (36 cm)
Museo de América, Madrid

PROVENANCE: Catalina Vélez de Guevara, Countess of Oñate; Museo
Arqueológico Nacional, Madrid, 1884; Museo de América, 1941

I-3 *Beaker*

Tonalá, Jalisco, Mexico
Seventeenth century
Red-slipped earthenware
Height 4 inches (10.3 cm); diameter 2⅞ inches (7.2 cm)
The Hispanic Society of America, New York, LE1975

PROVENANCE: Private collection

I-4 *Double-handled bowls*

Tonalá, Jalisco, Mexico
Last quarter of the seventeenth century–early eighteenth century
White-slipped earthenware
Height 1¹⁵⁄₁₆ inches (4.9 cm); diameter 4¹⁄₁₆ inches (10.3 cm)
Height 2⅜ inches (6 cm); diameter 4⁵⁄₁₆ inches (11 cm)
The Hispanic Society of America, New York, LE1972, LE1973

PROVENANCE: Private collection

I-5 *Amphora*

Tonalá, Jalisco, Mexico
Late seventeenth–early eighteenth century
White-slipped earthenware with polychromy
Height 41⁵⁄₁₆ inches (105 cm)
Museo de América, Madrid, 4914

PROVENANCE: Catalina Vélez de Guevara, Countess of Oñate; Museo
Arqueológico Nacional, Madrid, 1884; Museo de América, 1941

PUBLISHED: García Sáiz and Albert de Leon 1991, pp. 86–87; *México en el
mundo* 1994, p. 201; Martínez de la Torre and Cabello Carro 1997, p. 131,
fig. 129; García Sáiz and Albert de Leon 1998, p. 45; García Sáiz 2003,
p. 200, fig. 8.4

I-6 *Sculpture of a turkey*

Tonalá, Jalisco, Mexico
Seventeenth century
Black micaceous earthenware
7⁵⁄₁₆ × 9⁵⁄₁₆ × 4¼ inches (18.5 × 23.6 × 10.8 cm)
The Hispanic Society of America, New York, LE1969

PROVENANCE: Private collection

PUBLISHED: *Hispanic Society* 2004, p. 21

I-7 *Sculpture of a fish*

Tonalá, Jalisco, Mexico
Seventeenth century
Black micaceous earthenware
5⁹⁄₁₆ × 11⁹⁄₁₆ × 3¾ inches (14.2 × 29.4 × 9.6 cm)
The Hispanic Society of America, New York, LE1970

PROVENANCE: Private collection

PUBLISHED: *Hispanic Society* 2004, p. 21

I-8 *Double-handled cup with bird*

Tonalá, Jalisco, Mexico
Seventeenth century
Black micaceous earthenware
Height 2¾ inches (7 cm); diameter 5¹³⁄₁₆ inches (14.8 cm)
The Hispanic Society of America, New York, LE1966

PROVENANCE: Private collection

I-9 *Double-handled cup with fish*

Tonalá, Jalisco, Mexico
Seventeenth century
Black micaceous earthenware
Height 3¹⁵⁄₁₆ inches (10 cm); diameter 5⅛ inches (13 cm)
The Hispanic Society of America, New York, LE1967

PROVENANCE: Private collection

I-10 *Spouted jar with handle* (botijo)

Chile
Seventeenth century
Red-slipped earthenware with polychromy
Height 9¹³⁄₁₆ inches (25 cm)
Museo de América, Madrid

PROVENANCE: Catalina Vélez de Guevara, Countess of Oñate; Museo Arqueológico Nacional, Madrid, 1884; Museo de América, 1941

I-11 *Footed dish*

Chile
Seventeenth century
Red-slipped earthenware
Height 4½ inches (11.5 cm); diameter 7½ inches (19 cm)
Museo de América, Madrid

PROVENANCE: Catalina Vélez de Guevara, Countess of Oñate; Museo Arqueológico Nacional, Madrid, 1884; Museo de América, 1941

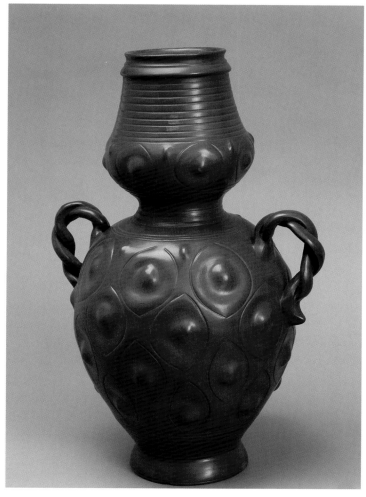

I-1 Two-handled jar

LONG BEFORE THE SPANISH ARRIVED in the New World, nearly every region of the Americas enjoyed important ceramic traditions of its own, and indeed ceramic production continued to thrive into the colonial period. Ceramics were needed for everyday use, and the tin-glaze ware introduced by the Spanish was initially too expensive and not readily available to all economic levels. At the same time that a number of indigenous ceramic traditions remained largely unaffected by the conquest, many took advantage of some of the tools and new decorative motifs introduced by European potters.

The low-fired, unglazed ceramic vessels from Tonalá (also called "Guadalajara" in some early manuscripts, after the nearby city) in New Spain, Natán (or Natá) in Panama, and Santiago in Chile were known in Spain as *búcaros de Indias* (fragrant earthenware from Latin America), linking them to a ceramic tradition in Spain and Portugal that dates back to the Etruscans of the eighth century B.C. *Búcaros*, from the Portuguese *púcaros*, were celebrated for their fine and fragrant clay bodies as well as for the flavors they imparted to the water stored within them (see Codding in this book). These became the preferred vessels for storing and drinking water, as they were believed also to purify water, which was often polluted. So pleasing was the aroma of the porous clay bodies that it became fashionable for people, particularly women, to consume small fragments of the

pottery and rub pieces directly onto their bare skin. The clay was considered to have gastronomic and medicinal qualities, and to improve one's complexion.

The popularity of *búcaros de Indias* is well documented in literature and still-life paintings of the seventeenth and eighteenth centuries, reflecting the widespread fashion for collecting New World pottery in Europe as early as the first quarter of the seventeenth century. Among the most important collections of these wares were those formed by the Florentine grand duke Cosimo III (a member of the Medici family), the Florentine Aldobrandini family, the Florentine marquise Ottavia Strozzi, and the Sevillian Duchess of Alba. The largest and best-known collection was assembled by the Spanish noblewoman Doña Catalina Vélez de Guevara, the niece and wife of Don Iñigo Vélez de Guevara, count of Oñate and viceroy in Naples from 1648 to 1653 under the rein of Felipe III. Of the five thousand pieces in her collection at the time of her death in 1684 were hundreds of pieces from "Guadalajara" and "Chile" (or Tonalá and Santiago). Three of her cabinets alone contained 161 pieces from Guadalajara valued at six *reales* each. This collection was subsequently enlarged by the countess's descendants, who donated it to the Museo Arqueológico Nacional of Madrid in 1884; it was later relinquished to the Museo de América in Madrid after its founding in 1941. It is from this collection that many of the pieces shown here originate.

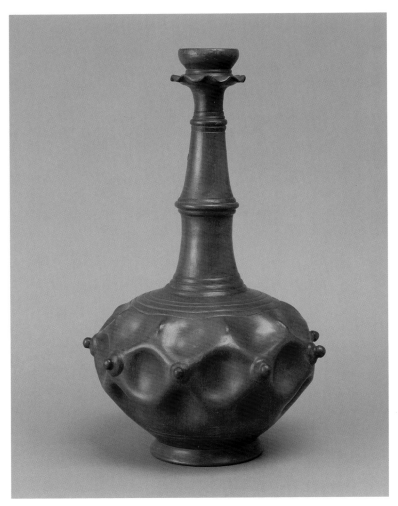

1-2 Bottle

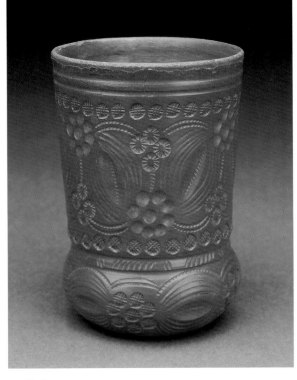

1-3 Beaker

The fascination for *búcaros de Indias* was not limited to Europe alone; the vessels gained popularity in the New World as well. According to eighteenth-century Mexican historian Matías de la Mota Padilla in his *Historia de la conquista de la provincia de la Nueva-Galicia* (1742), Tonalá pottery was valued more than crystal, Chinese porcelain, and *búcaros* made from refined sugar paste (known as *alcorza*). Mota Padilla further reports that even the dust of broken vessels from Tonalá was collected and sold in Jalapa, Veracruz, and Acapulco.

The letters of the Florentine scholar and scientist Lorenzo Magalotti (1637–1712), who had a particular affinity for *búcaros*, provide the most important source of information on the various traditions. Although he did not travel to the New World, he familiarized himself with a number of important collections and inquired about the traditions from those who knew the most. In his letters, he describes the three general types of *búcaros* in the following manner: those from Chile as the most charming (*gracioso*), those from Guadalajara as the most delicious (*ricos*), and those from Natán as the most majestic (*majestuosos*).

Of the three types of *búcaros de Indias*, the burnished ware of Guadalajara was without doubt the most popular, appearing most frequently in still-life paintings and in literature of the period. In seventeenth-century European texts, the ware was typically referred to as *barro de Guadalajara*; colonial workshops, however, were located in the town of Tonalá (as

Mota Padilla specifies) on the outskirts of the city of Guadalajara in the Mexican state of Jalisco. While these workshops were influenced by European forms and designs, and the potters may have had some instruction from Spaniards, ceramic production in this area preserved traditions that were in place centuries before the conquest.

Little research has been conducted on the workshops of Tonalá from the colonial period, and much of what has been written is based on the assumption that workshops have continued production in the same manner as centuries ago. The Mexican historian José Antonio de Alzate y Ramírez (1737–1799) offers the earliest known technical description of Tonalá ware in his 1792 article published in the *Gazete de literatura*. He describes the potters as *Indios*, or Indians, which suggests that the trade was dominated by artists of indigenous descent. Apparently, the city took pride in the fact that practically every household of Tonalá had its own workshops (*fábricas*), and that men, women, and children alike were involved in production. In his account he reveals that the clay and minerals were acquired locally but that the slip used to coat the vessels came from Sayula (south of Guadalajara) and was acquired through merchants. While he does not specify how the clay was prepared, he does point out that potters followed the same preparation as "they always had." A wheel-thrown piece in the collection of the Hispanic Society in New York that is attributed to Tonalá may suggest that at least one workshop used the wheel, but

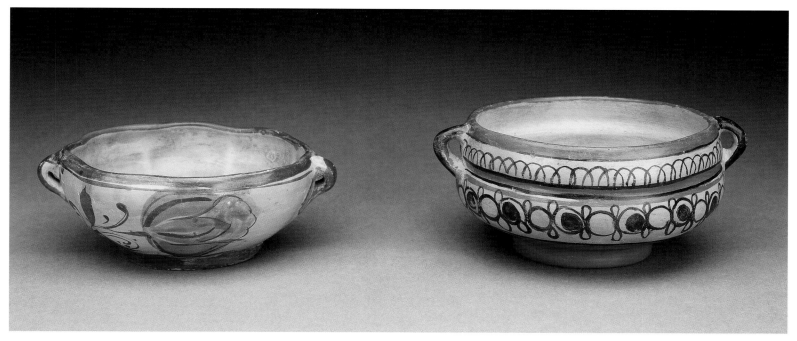

1-4 Double-handled bowls

this still needs to be clarified. According to Alzate, however, forms were hand built or mold-made. The molds used for larger pieces were made in two vertical parts and joined together. A fine powder was used to keep the clay from sticking to the mold. Additional ornamentation was applied before the clay dried. Vessels were dried in the sun, bathed in a slip mixture (clay mixed with water until semi-liquid), and then painted or decorated with punched, stamped and/or incised designs. The minerals used to add color to the slips were found locally: the dark red came from earth rich in iron containing a mineral called *azafrán de marte;* the blue contained iron as well but appeared black when applied; the blue also was combined with white to make a grayish blue; and black and brown were made from manganese. Potters painted decoration freehand with a feather instead of a brush and did not use stencils as was common among potters in Puebla. To achieve the shine for which Tonalá has been celebrated, the exteriors of vessels were burnished (or rubbed) with the tooth of a dog or a wolf and then fired. It is unclear what type of kiln the potters in Tonalá used, but it was probably above ground and circular. Alzate explains that vessels were fired under a blanket of ceramic fragments to help resist the flame, a practice passed down from pre-Hispanic times. Once the pieces had been fired, additional polychromy with gilding or silver plate could be added. Instead of using concentrated oils to apply the gold (or what is called *cisa*), sap from the fig or black mulberry tree was used. An explanation of Magalotti's assessment of Tonalá ware as the most aromatic and appetizing may be provided by Alzate, who reveals that potters may have used Mexican sapodilla plums, known as *texocotes* (haws), or pieces of pine or *ocote* to extract the pleasing aroma of the clay.

Tonalá pottery can be grouped into three general categories: red, polychrome, and black. Red-burnished pottery appears to be the earliest of the three, as examples can be found in Spanish still-life paintings as early as 1624. Such paintings reveal the variety of forms and decorations that were produced and shipped to Spain at this time. The forms ranged from cups, bowls, jars, and bottles to elaborate multitiered fountains with ring forms and other whimsical and extravagant shapes. Their decorations are characterized by fluted walls, concentric rings, and dimpled and embossed decoration. The two-handled jar with dimpled decoration in the collection of the Museo de América (cat. 1-1) is one type found repeatedly in a number of still-life paintings from the early seventeenth century. Juan Bautista de Espinosa's *Still Life with Grapes and Ceramic Jar* of 1646 (private collection) illustrates a similar piece from Tonalá. The double gourd form with dimpled impressions and concentric bands at the foot, waist, and neck must have been made from a mold in two parts. The handles were made by twisting two coils of clay and applying them to the vessel while still wet. The double-gourd shape and tall neck are reminiscent of the Spanish *cántaro*, which traditionally was used for holding liquid, and more specifically for cooling water. The decoration of a bottle in the collection of the Museo de América (cat. 1-2) presents a variation of this style of decoration. The surface of the bottle was made in honeycomb-like concave forms with applied nipple-like protrusions that resemble brass or iron bosses typically used to decorate furniture. Like other examples of this type, three groups of concentric rings draw attention to the tall neck that is topped by a small wavy horizontal projection and a flaring lip.

Another early type of red-burnished ware is characterized by punched, stamped, and incised decoration. The sophistication of these vessels is manifest in the delicate, thin walls and the complex forms and decorations. A beaker in the collection of the Hispanic Society of America is one such example (cat. 1-3). Surrounding the punched dots and stamped crosshatched motif on the exterior are a series of simple and striated lines that form a distinct repeated design. Similar motifs are found on the pair of double-handled bowls represented in Juan Bautista de Espinosa's painting *Still Life with Metalwork Objects* of 1624 (see fig. 1-4). As noted by Alzate, only the exteriors of such pieces

were burnished, including the bottom. Nonetheless, the thin walls allow the punched floral motif on the outside to show through in relief on the inside.

By the end of the seventeenth century, potters at Tonalá began to coat vessels with a white as well as a red slip and to paint floral and abstract motifs freehand in red, orange, blue, and manganese. American archaeologists have variously labeled this ceramic type as Guadalajara ware, Tonalá ware, Tonalá *bruñida* ware, and Aztec ware (the last relating it to the last phase of Aztec production), and have identified examples of the ware at sites in the southwestern United States, Florida, and the Caribbean dating from the mid- to late eighteenth century. This type of pottery is briefly mentioned in the Countess of Oñate's inventory of 1685 as *coloradas*, as well as in Magalotti's letters dated before 1695, and began to appear in Spanish and Mexican still-life paintings at the beginning of the eighteenth century. These dates suggest that this ware probably began to be produced by the last quarter of the seventeenth century.

The most popular polychrome form was undoubtedly the double-handled bowl, which according to Magalotti was used for drinking water. The bowls in the Hispanic Society illustrated here (cat. 1-4) exemplify two variations of the form. One is painted with a simple flower on each side framed by a thick red band with a thin black line. This particular form recalls a *bernegal*, defined as a wide tumbler, which was made in ceramic, silver, and glass in Spain and New Spain. Like the silver-gilt *bernegal* featured in Juan Bautista de Espinosa's still-life painting (see fig. 1-4), the Hispanic Society bowl is molded to form gadroons extending from the center. The gadroons form an eight-petaled flower on the inside painted orange and red with a circle of manganese at the center and washed blue above. The other polychrome bowl in the Hispanic Society's collection is slightly larger and is painted with two bands of abstract motifs in manganese separated by a subtle waist at the center painted red with a black line; the diameter of the foot is significantly smaller than the body, giving it a dramatic shape. The small handles are purposefully set at an angle, which must have helped the user to grasp them; this seems to have been characteristic of most bowls made by Tonalá potters.

If the small bowl was the most common form with painted decoration, the large amphora was undoubtedly the most striking. Magalotti's letters reveal that people in Europe were particularly impressed by this large ornate vessel, known as an *archibúcaro*, which appears to have been made primarily for export to Europe. The distinct amphora form, characterized by an ovoid shape and rounded bottom, is among the longest existing European forms, in use since at least the Greco-Roman period. Traditionally used to transport foods and liquids throughout the Mediterranean world, the amphora was designed with a rounded and tapered bottom for easy placement in a rack or soft dirt bed. Glazed and unglazed amphorae—known as *tinajas* in Spain and *tibores* in Mexico—were particularly important for the transport of food, oil, and wine from Spain to the New World during the colonial period, and must have had an impact on Tonalá potters. Unlike the traditional undecorated European types, however, Tonalá amphorae often were fitted with lids and displayed as prized possessions on gilded or painted wooden bases. As luxury objects they served little purpose other than to hold water and give off the aroma for which they were famed. Such amphorae are known to have been

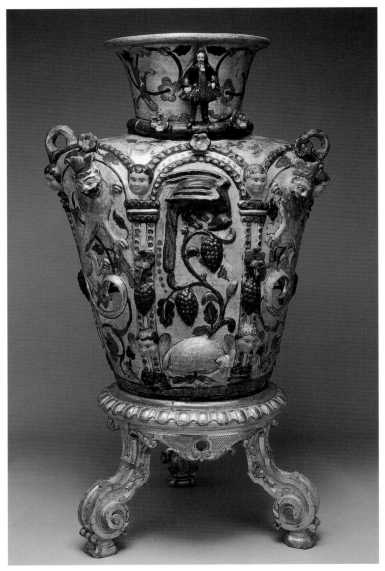

1-5 Amphora

displayed at a number of places in Italy, including the Royal Palace at Turin, the Quirinal Palace at Rome, and the Ginori Palace in Florence. Magalotti himself mentions the arrival of two such amphorae in Florence, possibly the ones acquired for Cosimo III in February of 1693.

The amphora included here (cat. 1-5) is one of the more than twenty examples belonging to the Museo de América. As noted by Alzate, such large forms were made with vertical molds in two parts and then joined together. The handles as well as the relief decoration—made from separate molds—were most likely added once the two sides were joined and while the clay was still wet. The vertical projections on the shoulders probably were intended to support additional ornamentation, such as the figure heads that appear on another amphora with similar decoration in the Museo de América.

Two entirely different decorative programs are painted on the two sides of the amphora. The more heavily decorated side features a proliferation of Spanish heraldic imagery: the crowned double-headed eagle associated with the Habsburgs (which continued after the close of the Habsburg reign in 1700); rampant lions linked to the Spanish region of

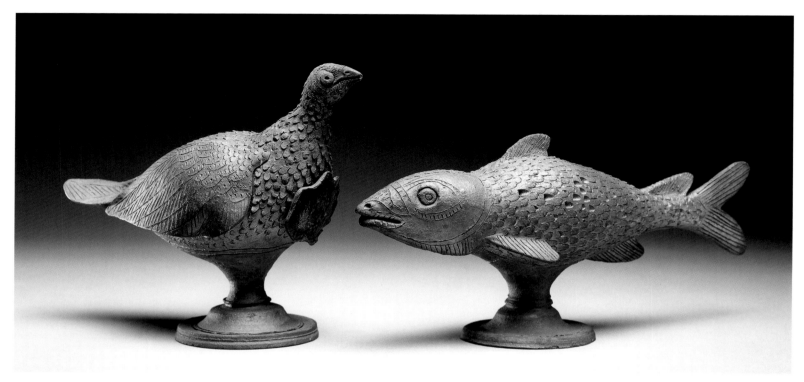

1-6 Sculpture of a turkey

1-7 Sculpture of a fish

León; a recumbent animal that appears to be a sheep possibly originating in the symbol of the Order of the Golden Fleece; and sections of fruit resembling pomegranates representing the symbol of the city of Granada. All of these symbols typically appeared on the Spanish royal coat of arms. At the center of the neck of the amphora is a male figure in high relief wearing European garb and a wig consistent with fashion from about 1695 to 1730. The space around the various figures is filled with an abundance of flowering plants and butterflies painted in red, orange, manganese, and bluish gray on cream ground. The reverse side is dedicated to an image of a bird with outspread wings and turned head that is reminiscent of the phoenix favored by Chinese porcelain potters.

Also included in the present exhibition are four pieces of black micaceous biscuit pottery with floral and animal forms, among other decoration. These pieces have been attributed to the region of Tonalá. Magalotti was unfamiliar with the black wares of Tonalá, but he did have knowledge of the black ware from Natán (or Natá) on the Pacific coast of Panama. A number of objects of this type had been given to him in 1773 by an inspector (*veedor*) named Pedro de Oritia from Brussels who had spent several years in either Peru or Mexico (he does not recall which). Compared to other types of *búcaros* with which Magalotti was familiar, the black pottery (*barro negro*) of Natán was the most beautiful and delicate. These vessels often were set in gold and silver mounts. Regrettably, little is known about these vessels, including their exact forms and decoration.

The black ware of Tonalá, on the other hand, is mentioned by other noted authors of the seventeenth and eighteenth centuries. The Italian adventurer and traveler Giovanni Francesco Gemelli Careri (1651–1725) recorded in his travel account *Viaje a la Nueva España* (printed in 1700) that one was able to purchase fine ceramic vessels called *buccari,* includ-

ing purple or black examples made in Guadalajara. Black jars from Guadalajara also are included in the 1685 inventory of the Countess of Oñate's collection. While these documents do not provide much information about this ceramic type, they reveal that the black ware was being made by the end of the seventeenth century, when Gemelli Careri traveled to New Spain.

Although no other examples of this type are known, the group of black-ware cups and sculptures included here (see also fig. 1-5), now in the collection of the Hispanic Society, possesses certain characteristics that point to production in Tonalá. While the clay is coarser than the red and polychrome types and does not appear to have been burnished, the incised, applied, and punched decoration is remarkably similar to other works of Tonalá. Like the beaker in the Hispanic Society's collection, the punched work on the upper register of the cup (cat. 1-8) is expressed on the interior, here as a series of hemispheres rather than in a floral pattern. The bowl form, the handle shape, and the applied grotesques—found on the center of the body and on the lower part of the handles—of another cup (cat. 1-9) are also found on Tonalá red ware, such as the examples illustrated in Juan Bautista de Espinosa's *Still Life with Metalwork Objects* mentioned above. Moreover, the handles of the two black-ware cups are placed at angles in the same fashion as on other examples of red ware from Tonalá. Micaceous clay is found in Guerero, and this attribution is further supported by Mota Padilla's discussion of Tonalá pottery in which he mentions "diverse animal figures" as one of the forms produced. The figures of a fish (cat. 1-7) and a *pipián,* or young turkey (cat. 1-6)— indigenous to the Americas—which form part of the same group of vessels as the two cups, may in fact exemplify such objects.

The most unusual aspect of this group is the relationship between the two figural forms built onto pedestals with incised and applied decoration

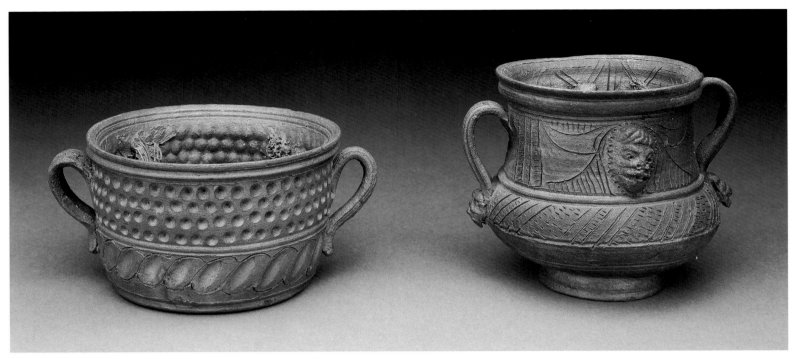

1-8 Double-handled cup with bird

1-9 Double-handled cup with fish

and the interior decoration of the two cups, one with a fish at the center and the other with a bird. The bird in the latter cup sits on an incised rendering of an eight-petaled flower surrounded by applications of moss and worms. The shape of the cup with the fish is slightly more sophisticated, with a rounded body and banded waist, and provides less room for the plethora of applied decoration, which includes worms, frogs, an eel, and moss. Of all the *búcaros* known, these cups probably best met the desire of the upper class to consume water as part of a ritual of sorts, so that while one drank the "flavored" water of Guadalajara, one would also have the visual experience of seeing all the flora and fauna found inside the vessels. One wonders if these in fact represent an "earthly paradise." Whatever the idea behind them, the exceptional condition of these vessels, with no visible signs of use, suggests that they were curiosities and simply displayed as works of art.

The French Renaissance potter Bernard Palissy (1510–1590) had a similar desire to reproduce scenes from nature in his glaze pottery, with molds taken directly from snakes, lizards, and other creatures. Interestingly, this concept was later reinvigorated by potters in Caldas da Rainha in central Portugal in the nineteenth century (their work is today called Portuguese Palissy ware). Is it possible that this French tradition was continued in Portugal earlier than the nineteenth century and that it indirectly inspired the Tonalá tradition? Or that the Mexican pieces were directly inspired by potters familiar with Palissy's ceramic work? It should be noted that black ware has been made in Portugal, although the image of a *pipián* could only be Mexican.

The *búcaros* from Chile were, according to Magalotti, appreciated less for their aroma and more for their majestic forms, bright red color, and decoration. He attributes their refined quality to the fact that they were made by nuns at a convent in Santiago. Unfortunately, the exact convent has not been identified, but Magalotti points out that there were only a few

in Santiago at that time. Apparently the non-religious Spanish and native women who assisted in the production were also known to make vessels outside the convent, but these were made as gifts and presumably not sold. Magalotti learned from a Jesuit Catalan priest who was a procurator in Chile that the nuns worked from morning to night, with the exception of the hours reserved for prayer. The priest further reported to him that during the *cuaresma* (the forty days of Lent) the nuns produced enough vessels to fill two hundred chests, of which he was paid six or eight for his services.

Although Magalotti never visited any of the workshops where *búcaros de Indias* were made, he gathered sufficient information to gain an understanding of how vessels were produced. He was particularly interested in the production of Chilean *búcaros* and thus provides detailed information on the process. He reports that, unlike the potters from Tonalá, the nuns made every vessel by hand, never using a mold. Once the vessels were made, they were left to dry in the shade. The vessels must have been bathed in a slip glaze, and painted before burnishing, though Magalotti omitted these important steps. Nonetheless, he explains that vessels were burnished with a stick or with the sharp end of a bone, which was also used to carve low relief decoration. The burnished vessels were then fired in small kilns. After firing, vessels were burnished a second time, which allowed the nuns to apply additional polychromy of gold, silver, and other colors. While the decoration applied before firing actually fused to the clay body, the colors added after firing often peeled off (and so are lost to us).

Despite their unique features, the vessels are quite similar to those from Estremoz in Portugal, as Magalotti acknowledged. This suggests that Portuguese potters had some influence on early production, that Portuguese vessels had infiltrated Chile from Brazil, or that South American forms had been imitated in Portugal (the parallel also may have been accidental).

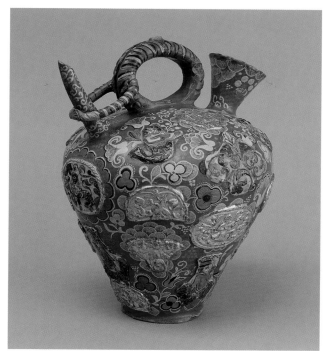

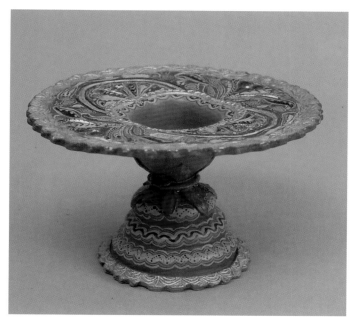

1-10 Spouted jar with handle (*botijo*)

1-11 Footed dish

Among the diverse utilitarian pieces were jars, *cantimploras* (canteens or pilgrim bottles for cooling water), fountains, plates, bowls, and even the handles of spoons and knives. While the forms were utilitarian, the ceramics were luxury objects and were used only on special occasions. The most popular form was the drinking cup. The shape of these cups is similar to a smaller European vase with rounded body, flaring walls, and a handle, all carefully decorated. The cups were easy to ship and as a result appeared frequently in Europe. Another important form was the water jug (*cántaro* in Spain and *tinaja* in the New World); it was made in small, medium, and large sizes and used to serve or even heat water. A *botijo* (cat. 1-10) in the collection of the Museo de América is one such example. The unusual closed, bulbous form, with a loop handle at the top, a spout (or *pitón*) from which to drink on one side, and a "mouth" (*boca*) into which to pour liquid on the other, is European and was made by Spanish potters in the fifteenth and sixteenth centuries for shipment to the New World. Characteristic of this ware are the bright red slip ground and the whimsical decoration in white, blue, dark red, brown, and ocher. Painted on the surface are rampant lions, flowers, and foliage inspired in part by Asian textile design. Rendered in low relief are mermaids playing string instruments, women holding baskets of fruit on their heads, and other figures wearing crowns (or, again, fruit baskets). The decoration is further enhanced by the application of low-relief gilded cloud forms typically associated with Japanese lacquer screens in the *Namban* style suited for European tastes.

A striking footed dish (cat. 1-11) represents another intriguing Chilean form in the collection of the Museo de América. It is decorated with abstract designs and stylized floral motifs painted on the surface and molded in relief. The rim and the foot are adorned with a fluted gilt rim stamped with repeated lace decoration, and applied to the waist is a rope-like coil from which extend six leaves. The wide rim of the piece suggests that it may have been a serving dish, salver, compote dish, or cup stand,

but the recess at the center indicates that it was intended to receive another object and might well have been inspired by a metal form. Alternatively, the form may have served as an incense burner, or *sahumador.* The incense would have been burned in a small cup or a dish inserted in the depression and covered by a lid with holes from which smoke would escape. The Chilean nuns are known to have made incense burners in unusual forms, although this particular piece shows no evidence of such use. Another Chilean piece in the collection of the Museo de América—a unique hatlike form with a removable lid—undoubtedly was made as an incense burner. Slits and holes throughout the piece allowed the smoke of the incense to escape, and plugs were used to stopper the holes and control the direction of the smoke. Since these incense burners were made by nuns, one would assume a Christian context for their use, although the depiction of native Andean women on the hatlike incense burner suggests that the nuns also were interested in native culture. It is not known how long the Chilean nuns continued to produce their elaborate ceramic wares. The custom of using and eating fragments of *búcaros* continued into the nineteenth century.

Margaret E. Connors McQuade

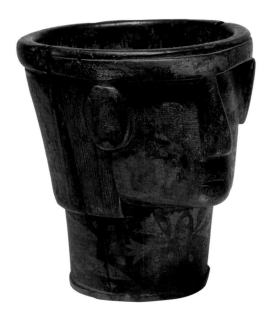
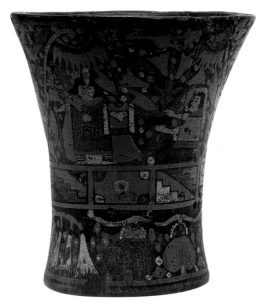
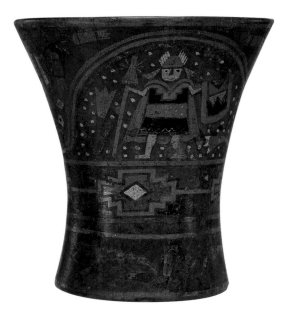

I-12 *Three* keros

Peru
Late seventeenth–eighteenth century
Wood (*escallonia*?) with pigmented resin inlay
Height 7⅝ inches (19.3 cm); diameter 7⁵⁄₁₆ inches (18.6 cm);
height (2) 7⅞ inches (20 cm); diameter 6⅞ (17.5 cm)
University of Pennsylvania Museum of Archaeology and Anthropology,
Philadelphia

THESE THREE PAINTED WOODEN VESSELS are all *keros*. Each is one
of a pair, and all were made in the Viceroyalty of Peru, carved from hard
jungle wood. The word *kero* means wood and is also the name for *cup* in
Quechua, the language of the Inca. The vessel in the shape of a human
head is from the eighteenth century, whereas the other two *keros* in the
more common hourglass shape date to the late seventeenth century.

The *kero* was an extremely important ceremonial vessel used by the
Inca to drink *aqha* (corn beer), and before the arrival of the Spanish they
were made in a variety of materials, including gold and silver. The cups
were always produced in nearly identical pairs so as to express, through
ritual drinking, the critical social, political, and religious relationships of
an Andean community.

The major difference between Inca and colonial *keros* is that colo-
nial examples were decorated with polychrome figural images. The color-
ing technique involves the inlaying of a gumlike substance that is heated
and placed into the carved-out areas that form the outline of the figures.
All details are created by cutting the colored substance into the desired

shapes and laying them over the initial solid colors. The substance, known
as *mopa-mopa* or *barniz de Pasto*, comes from the leaves of plants that
grow only in the eastern jungle, as does the wood from which the *keros*
are carved. It is therefore no surprise that many colonial *keros* depict
jungle motifs. For example, the *kero* carved in the form of a human head
represents an inhabitant of the jungle, as identified by the face paint and
long hair.

By the mid-seventeenth century *keros* were produced in a standard-
ized, almost mechanical fashion. Most *kero* painting is organized into two
or three horizontal registers. The upper register normally carries the figural
compositions; the bottom register usually has a floral motif; and when
there is a middle register, it contains a series of repeated or individual
abstract geometric designs called *tocapu*, as seen in the two hourglass-
shaped *keros*. Most figural scenes are composed from a limited stock of
figures: the Inca king, his queen (*coya*), the Inca army, and jungle inhab-
itants predominate.

This is the case with the scenes depicted on the three *keros* in
this exhibition. One shows the most common iconographic motif of all:
figures—usually an Inca king and a *coya*—placed under a rainbow. The
rainbow often springs from a feline head, as seen in this example. What
is equally important, however, is that the paintings nearly always refer to
the Inca before the arrival of the Spaniards; these ritual vessels through
their use and iconography kept the memory of the past present in Andean
culture. Even today, when *keros* are brought out in Andean communities
for special celebrations, it is understood that they came from their ances-
tors, the Inca.

Thomas B. F. Cummins

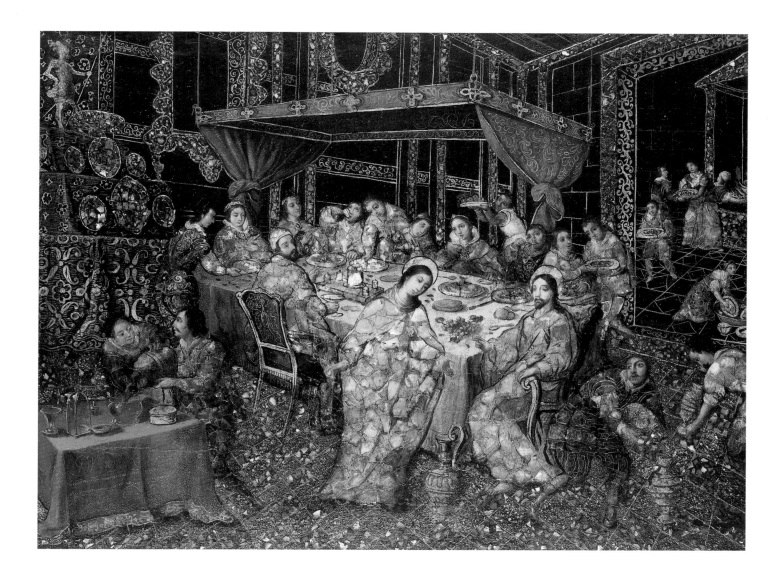

I-13 Nicolás Correa[†]

(Mexican, c. 1670/75–?)

The Wedding at Cana

1693
Oil on canvas, encrusted with mother-of-pearl
22⅞ × 29¾ inches (58 × 75.5 cm)
The Hispanic Society of America, New York, LA2158

PUBLISHED: Kubler and Soria 1959, p. 313; Dujovne 1984, p. 71

THE NEW TESTAMENT EPISODE REPRESENTED in this painting is described in the Gospels as the celebration of the Wedding at Cana (John 2:1–11), where Christ performed his first public miracle, the changing of water into wine. This occurred through the intervention of Mary, Christ's mother, who thereby assumed the role of earthly mediator on behalf of the weaknesses of humankind. Here, the scene is situated in the interior of a sumptuous room, where the celebrants converse around a table while being attended by servants who enter and leave the room through an open door on the right side of the composition. The figures of Christ and Mary, represented in the foreground, are seen at the exact moment when the Virgin informs her Son that the wedding guests have no wine. Pictured by their side, in the lower left corner, a scullery boy is seen measuring out the jugs.

In this work, Nicolás Correa deftly displays his mastery of the *enconchado* technique, and of all the possibilities the medium has to offer. He has used inlay not only in the subjects' apparel, which allows him to accentuate the effects of transparency, but also in the decoration of the floor in the main hall, which is achieved with tiny, irregular fragments of mother-of-pearl. Correa also employs the same decorative formulas on the details of wall surfaces, doors, and windows.

An interesting point is the painter's apparent tendency to include figures dressed in the style of the sixteenth century, in this case particularly the young boys and women who attend the guests, while the holy figures in the scene are attired in biblical cloaks and tunics.

The three known works by this artist to employ the technique of *enconchado*—*The Holy Family, Christ on the Road to Calvary,* and *The Wedding at Cana*—all share certain formal similarities with the works created by other artists using this specialized technique. However, it is Correa's paintings that evidence far greater attention to detail in the treatment of interior spaces.

M. Concepción García Sáiz

1-14 *Tray (batea)*

Michoacán, Mexico
Seventeenth century
Lacquered wood with inlaid lacquer decoration
Diameter 22¼ inches (56.5 cm)
The Hispanic Society of America, New York, LS1808

PROVENANCE: Cardinal Francisco Antonio Lorenza

1-15 *Portable writing desk*

Michoacán, Mexico
Seventeenth century
Lacquered wood with inlaid lacquer decoration
21¼ × 37¹⁵⁄₁₆ × 17½ inches (54 × 96.3 × 44.4 cm)
The Hispanic Society of America, New York, LS2071

1-16 *Tray (batea)*

Pátzcuaro, Mexico
Eighteenth century
Lacquered wood, painted
Height 4 inches (11.5 cm); diameter 34 inches (86 cm)
The Hispanic Society of America, New York, LS2135

1-17 José Manuel de la Cerda (Zerda)

(active eighteenth century, Pátzcuaro, Michoacán, Mexico)

Tray (batea)

c. 1760
Wood and painted lacquer
Diameter 42⅛ inches (107 cm)
Inscribed: *Mal dla Zerda Paztqo*
Museo de América, Madrid, inv. no. 6917

PROVENANCE: Cardinal Francisco Antonio Lorenza

PUBLISHED: *Mexico* 1990, cat. no. 213, p. 452; *México en el mundo* 1994

EXHIBITED: New York, San Antonio, and Los Angeles 1990, cat. no. 213

1-18 José Manuel de la Cerda (Zerda)

Cabinet on stand

Eighteenth century
Lacquered and polychromed wood with painted decoration
61 × 40³⁄₁₆ × 24 inches (155 × 102 × 61 cm)
Inscribed: *Mal dla Zerda Paztqo*
The Hispanic Society of America, New York, LS1642

PROVENANCE: Private collection, England

PUBLISHED: *México en el mundo* 1994, vol. 2, p. 294

1-19 *Sewing box*

Pátzcuaro, Mexico
c. 1785
Lacquered wood with painted decoration
5⁵⁄₁₆ × 16⁹⁄₁₆ × 5³⁄₁₆ inches (13.5 × 42.1 × 13.2 cm)
The Hispanic Society of America, New York, LE2072

IN MEXICO'S COLONIAL ERA, the modern-day state of Michoacán was an important manufacturing center of polychrome lacquered wood furniture. The scenic region, with beautiful lakes and abundant forests, is the homeland of the Purépecha, an indigenous population also known as the Tarascan Indians. In the pre-Hispanic era, the Purépecha covered gourd vessels of all shapes and sizes with multiple layers of a paste made from *aje*, a fatty insect secretion; *chia* seed oil; and a mineral compound of dolomite. After polishing, the receptacles acquired a lustrous, smooth surface that was impervious to moisture. Objects intended for the indigenous elite or for religious purposes were decorated with multiple colors. Initially, the piece received several coats of lacquer; the artist then engraved a design into this lacquer base. The sections that were to receive new color were cut out, and powdered pigments mixed with the same ingredients used in the paste were inlaid into the excised sections. During the decorating process the object was polished several times. When the image was complete, the piece was given one final polish. This pre-Hispanic decorating technique is referred to as *embutido*, the Spanish word for "inlay."

Early Spanish settlers' appreciation for the lacquered gourds is documented in early sixteenth-century literature. Writers noted the vessels' durability, moisture resistance, and, especially, their shiny surfaces. Europeans had little knowledge of Asian lacquers during this time, and it would be many decades before the development of varnish in the West. There are no whole extant examples of pre-Hispanic lacquer gourds; only fragments have been found. Moreover, there is no evidence that wood objects were lacquered and decorated. Yet, shortly after the arrival of the Spanish, the Purépecha were lacquering and decorating European wooden articles suitable for consumption by the newly arrived colonists. Coincidentally, furniture with polychrome decoration was the height of fashion in sixteenth-century Europe. In their homeland,

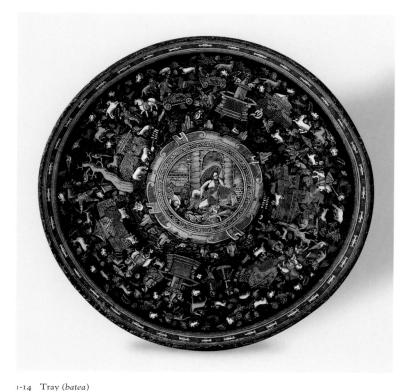

1-14 Tray (batea)

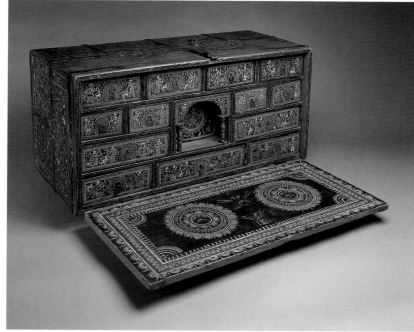

1-15 Portable writing desk

few Spaniards could afford the furnishings that were available to them in the Spanish Americas. Consequently, Michoacán's colorful pictorial furniture quickly found a thriving market in Mexico and throughout the Spanish empire.

The earliest known literary evidence of Michoacán's lacquerware furniture industry is found in the *Relación de Tiripetío*, an official report written in 1580 for the Spanish government. Writing about the town of Tiripetío, the site of an influential Augustinian monastery, the author observed the Indians' fine carpentry skills and the excellent quality of the decoration applied to chests, writing desks, tables, and trays (*artesas*). He states: "To all of these things they apply paint to make pictures and they are the best made and most unusual style that there is in New Spain." In conclusion he writes: "the writing desks (*escritorios*) are suitable gifts for a prince." In the left margin alongside the list of decorated objects he wrote: "They are very fine painters." (In this era the word "painting" was used as a general term to describe the making of images, regardless of media or subject.)

The Augustinian monastery at Tiripetío served as a training center for Purépecha craftsman. The friars brought Spanish-trained artisans to teach carpentry, metalworking, stonecutting, and other skills necessary to decorate the churches and supply colonists with European-style furnishings. After completing their training, the Purépecha workers often returned to their hometowns to practice their new skills. Pátzcuaro and Peribán are two other towns where lacquer artists applied inlaid decoration to furniture and gourds. The lacquerware workshop in Pátzcuaro is cited in the mid-seventeenth-century chronicle of an Augustinian friar, and in a contemporaneous chronicle, a Franciscan friar describes lacquerware artisans working in Peribán. Indigenous lacquer artists may have been practicing their craft in other towns of Michoacán for which docu-

mentation does not exist, and so identifying the town of origin for an individual lacquerware object is not possible.

Compressed overall surface ornament with every space embellished characterizes the design of Michoacán's sixteenth- and seventeenth-century inlaid lacquer work. It is a visual quality reminiscent of European decoration produced during the late medieval and Renaissance eras. The subjects portrayed on Michoacán's lacquerwares—hunting, courtship, domestic and wild animals, and mythological themes—reflect European taste. A portable writing desk (cat. 1-15) and a deep round wooden tray (cats. 1-14, 1-16, 1-17) are examples of Michoacán's early colonial inlaid lacquer products.

Ownership of a variety of household furniture did not become commonplace in the Euro-American world until the eighteenth century. Portable writing desks, fitted with drawers and a drop-front writing surface, are a Spanish invention (cat. 1-15). They were produced from the late fifteenth through early eighteenth centuries and were called *escritorios*. Today they are commonly referred to as *vargueños*, a modern term originating in the nineteenth century. Ownership of such portable writing desks, which implies literacy, was limited to members of the upper class, as only members of the elite society and religious orders were literate. Portability and security of the desk's contents were essential features of their construction. The writing surface, which closes over the drawers, was fitted with a substantial metal lock. Handles were attached to either side, and iron mountings wrapping around the case protected the decorative surface and contributed to overall construction integrity. At home, *vargueños* were often placed on a collapsible trestle table.

On the *vargueño* shown here, a male and a female figure are depicted in two decoratively framed roundels. There are numerous figures in profile dressed in European clothing and interacting with their dogs

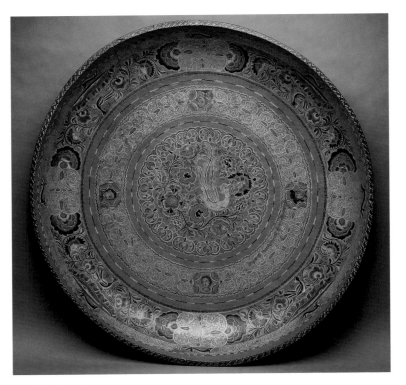

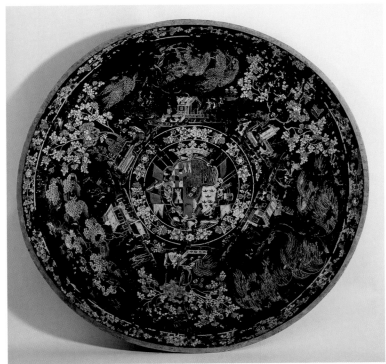

1-16 Tray (*batea*)

1-17 Tray (*batea*)

and one another. Various wild animals, such as lions, jaguars, wolves, and deer, are portrayed on all sides of the exterior case. Flowers, plants, abstract designs, and butterflies fill any remaining space. The decorative frieze, placed along each of the exterior edges of the desk, represents a typical compositional pattern found on European American furniture of this period. However, this border design was not copied from a European prototype; it is a creative combination of abstracted botanical motifs and indigenous-influenced designs. The fan-shaped elements on the corners of the border are repeated on the surface of the writing desk. Visible only when the desk is open, the writing surface features geometric designs reflecting a visual vocabulary inspired by Native Mexican arts.

The figural imagery depicted on one of the trays, or *bateas*, in the Hispanic Society (cat. 1-14) is much more diverse. The large open surface of the *batea* provided artists with a support similar to a canvas, and subjects are often more specific and complex than those shown on furniture. For example, in the center medallion of this example a female mythological subject is depicted, possibly Diana or Cybele, but more likely an Amazon; the legendary tribe of fierce women warriors worshipped Diana, goddess of the hunt. The ancient Greek and Roman myth of the Amazons became a popular literary subject during the fourteenth through sixteenth centuries, when male explorers were eager to discover the fabled clan. The female figure with a weapon at her feet who is represented here appears to have only one breast. Amazons were described as having only one breast, the other having been removed at adolescence in order to improve their aim with the bow and arrow. Allegorical female images were often used to symbolize the abundance and fertility of the Americas, and, pictured as an Amazon, also reference Europeans' perceptions of the exotic and untamed nature of these new lands. Surrounding the central image is a landscape containing a body of blue water with swimming waterfowl and animals

drinking at its edges. Finely dressed aristocratic couples stroll hand in hand around brick structures, fountains, and horse-drawn farm wagons piled high with agricultural goods. The scene evokes a prosperous rural lifestyle. Huntsmen on foot and horseback carry bows and arrows or spears and ride through the countryside amid a congeries of wildlife, including deer, lions, large birds, monkeys, and one unicorn. (The mythological unicorn, a symbol of Christ, was often represented in European hunting scenes.) The artist shows little concern with hierarchy of scale: people, wagons, lions, birds, horses, and butterflies are all drawn the same size, which is a characteristic of Spanish colonial decorative arts.

Images of aristocrats hunting in the countryside and at their leisure were popular themes on European and Asian decorative arts and textiles for many centuries. The illustrations that inspired the indigenous artist came from a variety of sources, including European prints, illustrated books, embroideries, tapestries, and metal or ceramic objects. Members of monastic orders provided Purépecha artists with these models in the early colonial period. Michoacán's lacquerwares and murals in monasteries often feature bucolic settings inhabited by exotic wildlife, fabulous flowering plants, and giant butterflies living in a perpetual spring. Such images testify to the idea that the Spanish colonies were an earthly paradise—a conviction held by many Europeans, who viewed the New World as a terrestrial Garden of Eden. Michoacán's scenic beauty, mild weather, and forests filled with deer, rabbits, and other wild game made it a well-known vacation destination for city dwellers and foreign tourists, and Michoacán's lacquerware images can be seen as portraying the region's reputation and attributes. The ubiquitous butterfly in Michoacán lacquerware may also hold local significance. For hundreds of years and to the present day, millions of North American monarch butterflies have migrated annually to the Michoacán forests to reproduce.

The round wooden *batea* does not have a European counterpart; it is a form that originated in Michoacán during the sixteenth century. Intended primarily for display, the *batea* was a renowned luxury product of the Spanish Americas. They are frequently listed in the estate inventories of New Spain's wealthiest residents. *Bateas* with European designs were frequently taken home to Spain by visiting dignitaries and high-ranking ecclesiastical authorities, establishing their role as prized New World souvenirs. Despite the popularity of Michoacán's inlaid lacquer furniture, *bateas* are the most numerous lacquer product represented in collections today.

By the eighteenth century, many colonial families had amassed great wealth from silver mining, ranching, and mercantile endeavors. They filled their palatial homes with imported French and English furnishings, and Michoacán's lacquered furniture industry suffered. The lacquerware artists began to diversify the style of their work in the eighteenth century to attract new buyers. Lacquer artists catering to consumers following European fashion trends began the practice of brush-painting colored pigments and applying gold and silver leaf directly over the lacquer base. Lacquer artists continuing the traditional *embutido* method of decoration revived ancient indigenous motifs, such as step-fret patterns so common in ancient Mesoamerican pottery. Their figurative elements are reminiscent of the stylized images observed in codices drawn by a *tlacuilo*, a native artist and scribe. They also incorporate invented new designs inspired by contemporaneous Native Mexican culture. It is believed that the eighteenth-century lacquer workshops in the town of Uruapán produced the majority of native-inspired works decorated in the *embutido* technique. The *batea* was their primary product, although chests with flat tops also exist. Extant *bateas* indicate that most were commissioned by residents to commemorate local celebrations and festivals. The finest examples have remained in Mexican collections or were exported only in the twentieth century. It is remarkable that by the eighteenth century the descendants of the Purépecha had succeeded in reclaiming their ancient indigenous art form for their own domestic decor and expression.

Lacquerware artists working in the town of Pátzcuaro eventually abandoned the time-consuming inlay technique. Beginning in the eighteenth century, they painted and also applied gold and silver leaf with a brush on lacquered ladies' dresser boxes, sewing boxes, small chests, *bateas*, and other objects. The most common subjects feature European mythological and literary themes, armorial shields, rococo ornament, and Asian motifs. The shiny lacquered surface provided the perfect base to represent Europe's most fashionable images of the day, the romantic depictions of exotic East Asia called chinoiserie. These illusory images reflecting the West's imaginary views of the gardens, people, animals, and architecture of Asia were produced in prodigious numbers on every class of decorative object and apparel.

Many European consumers of these European- or American-made materials had not yet seen authentic Asian luxury products. In contrast, the residents of New Spain had a long history of Asian trade, since Mexico City merchants organized trade via the Philippines on the Manila Galleons, which brought enormous quantities of Asian luxury goods to New Spain between 1545 and 1845. Michoacán's lacquerware artists were fortunate to have firsthand knowledge of Asian porcelain, silk, and lacquer, as well

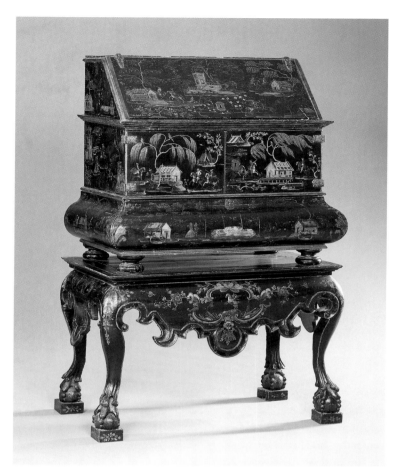

1-18 Cabinet on stand

as examples of French and English chinoiserie and rococo textiles and furnishings. English stylebooks of up-to-date designs were available in New Spain. The most influential of these was the mid-eighteenth-century book of furniture designs by the furniture maker Thomas Chippendale. His book of primarily rococo designs illustrated every type of domestic furniture.

The finest eighteenth-century painted lacquerwares were produced in Pátzcuaro by a native nobleman, José Manuel de la Cerda (Zerda), who is the only lacquer artist known to have signed his work. His abbreviated signature, "Mal dla Zerda Paztqo," noting his surname and workshop location, is inscribed under the coat of arms of the *batea* (cat. 1-17) and on the *papelera* (cat. 1-18). Both works feature his unique vision of Asian-inspired landscapes full of flowing willows and flowering trees, with depictions of aristocratic couples attired in European fashions. Unlike European chinoiserie images that represent upper-class Asians, Manuel de la Cerda depicts New Spain's residents enjoying a carefree life.

Manuel de la Cerda's impressive work is acknowledged in the travel journal of Friar Francisco de Ajofrín, who visited Pátzcuaro in 1765. In a diary entry the friar enthusiastically describes the dozen large *bateas* the artist is making for the Marquesa de Cruillas, wife of the viceroy of New Spain. He notes that "in fineness and luster they exceed Chinese lacquer and are possessions suitable for persons of very high status." Scholars speculate that the *batea* exhibited here, originally from the collection of Cardinal Francisco Antonio Lorenza, is one of the twelve *bateas* Ajofrín

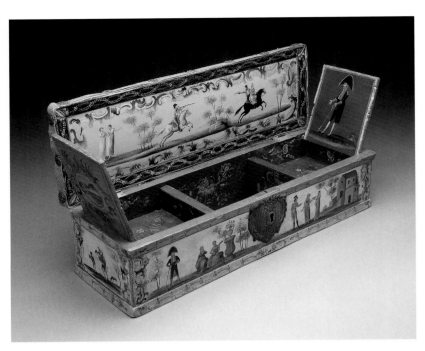

1-19 Sewing box

were often decorated according to a lady's specific instructions. In this example, the real or imaginary romantic circumstances of a woman's courtship are illustrated. The scene painted on the interior of the lid shows the woman's suitor trying to rescue her from a villainous abductor. The military officer, presumably the woman's father, is pictured on the left side of the front panel and on the underside of the interior door. The miniature portraits painted on the doors of the interior compartments are probably the lady's husband and young son. The women in the scenes wear straight Empire-waist dresses, a Neo-Classical fashion, popular in the late eighteenth century.

The selection of Michoacán's colonial lacquer work featured here evidences the rapid westernization of material culture in the Spanish Americas. Native Mexicans and Spaniards alike were challenged to adapt to the changing circumstances of daily life in the early colonial era. Pre-Hispanic art forms such as feather art and corn-paste sculpture were encouraged and respected until the native art was superseded by Spanish-trained artists working with European materials. The lacquerware art of Michoacán represents a distinct exception to this pattern. The best Michoacán lacquerware artists maintained high standards of craftsmanship and adapted to contemporary styles. They exemplify an instance in which wealthy native Mexicans and American-born Spaniards found artistic means to express a sense of pride in their New World identity. For Spanish travelers, Michoacán lacquerware served as representative displays of a precious and exotic place when brought back to the mother country.

Pre-Hispanic art forms such as feather art and corn paste sculpture were encouraged and respected until Spanish-trained artists working with European materials superseded the native art. The lacquerware art of Michoacán represents a distinct exception to this pattern. The best Michoacán lacquerware artists maintained high standards of craftsmanship and adapted to contemporary styles. They exemplify an instance in which wealthy Native Mexicans and American born Spaniards found artistic means to express a sense of pride in their New World identity. While for Spanish travelers, Michoacán lacquerware served as representative displays of a precious and exotic colony when brought back to the mother country.

Paula Kornegay

saw during his trip. It is believed that the viceregal couple presented it to Lorenza upon his arrival in New Spain in 1766 to fulfill his appointment as the new archbishop. Marqués de Cruillas's term as viceroy ended that year, and he and his wife returned to Spain.

A distinctive trait of Manuel de la Cerda's painting style is the lush foliage trimmed in gold. Bright red flowers trimmed in gold and gold leaves on the shiny black lacquer create a jewel-like surface that makes his work distinctive. Manuel de la Cerda's repertoire of subjects includes Native Mexicans, Spaniards, flowering peony trees, wispy willow trees, exotic birds, butterflies, and horses.

The exuberance of the cabinet on a stand (cat. 1-18), also decorated by Manuel de la Cerda, epitomizes the gaiety of chinoiserie imagery and a curvaceous rococo furniture form. Rococo cabinets with curved bottom drawers like this one are a shape often referred to as *bombé*, a form made popular in France and also by the furniture of Thomas Chippendale. The console table's carved ball-and-claw foot is most commonly associated with the Chippendale style. The table's massive and exaggerated lines are a common trait in Mexican-made Chippendale furniture, whose styling tends toward boldness rather than elegance. The upper cabinet door is hinged at the top, so it lifts up and folds back over the top of the cabinet, revealing seven small drawers painted in pastel colors. Behind the two doors below are three similarly painted drawers: a long one on the bottom, and two smaller ones above. This cabinet is of an unusual form and does not readily fit into a prescribed definition. The drawers are not visible, so it does not fit the usual description of a *papelera*, and as there is no writing surface, it is not a *vargueño* either. An elaborately carved shape resembling the high headboard of a bed, with painted rococo-style abstract motifs, bows, and flowers, was originally attached to the back. The cabinet and stand, now in the collection of the Hispanic Society of America in New York, came from a collection in England.

Feminine rococo decoration was perfectly suited to dresser and sewing boxes, or *almohadillas* (cat. 1-19). These treasured possessions

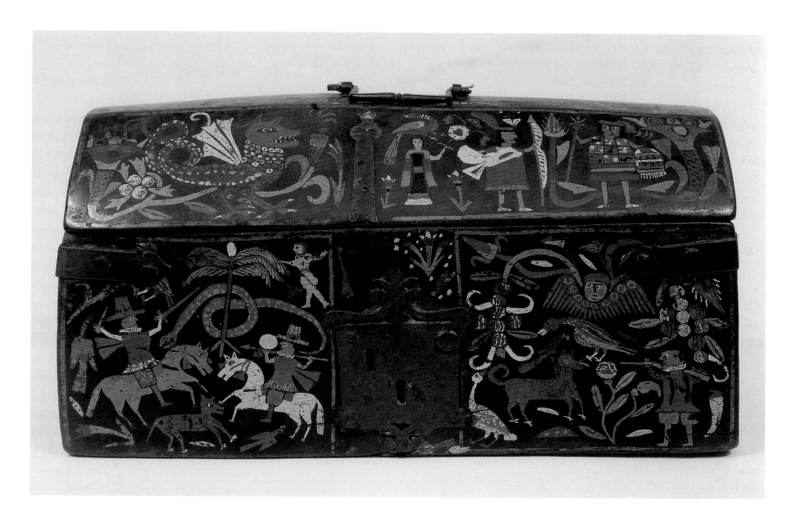

I-20 *Chest*

Charazani, La Paz, Bolivia
Sixteenth century
Polychromed wood with metal lock and mounts
9⁷⁄₁₆ × 18½ × 8¹⁄₁₆ inches (24 × 47 × 20.5 cm)
Museo Casa de Murillo, La Paz, Bolivia

PROVENANCE: Edgar Oblitas Collection, Charazani, La Paz, Bolivia

PUBLISHED: *America, Bride of the Sun* 1991, p. 442; Flores Ochoa et al. 1998, pp. 94–95; Gisbert 1999, pp. 85–98; Cummins 2002, pp. 17ff.; Phipps et al. 2004, ill. 34

EXHIBITED: Antwerp 1992, p. 442; New York 2004 *Andes*, ill. 34

THE STUDY OF VICEREGAL PAINTING in the Andes region reveals the limited extent of indigenous participation, which consisted of a few paintings of tribal leaders depicted as donors in religious compositions and various portraits of Inca rulers. Authentically Indian painting is to be found on *keros*, ceremonial wooden drinking vessels used by tribal leaders in rituals. These were studied and classified by J. H. Rowe, who pointed out that during the Inca period these vessels were decorated with incisions, and that polychromy only appeared during the colonial period.

Keros were made in Cuzco and the Isla del Sol (Lake Titicaca), as well as in Chuquisaca (Bolivia). An inscription on a canvas in the Museo Soumaya in Mexico depicting the different peoples of eighteenth-century Bolivia states that the indigenous people of the Callahuaya region (La Paz) made *mates*. It seems that these *mates* derived from *keros*, as in some documents the latter are referred to as *mates de palo* (wooden *mates*)

This chest from Charazani in the Callahuaya region was made using the *keros* technique. It is decorated with a scene of the conquest of the Antisuyo, the eastern province of the Inca empire. Its approximate date can be deduced from the clothing of the Spaniards depicted on it, which is in the sixteenth-century style. The lid has a scene with the Inca ruler—shown next to a dragon—receiving a local Indian. The Inca, who wears a tunic decorated with *tocapu* (small designs characteristic of Inca textiles), is not the heir, as he wears the *mascaipacha* (crown) to one side. The same scene is represented on the back of the chest, where we see that the Indian has handed over his spear to the Inca ruler and has received the Inca tunic. These two scenes represent the moment when the Inca enters the Antisuyo and delegates his power to the native ruler. The dragon represents the serpent Amaru.

The conquest of the Antisuyo took place during the reigns of Pachacuti and his son Tupac Inca Yupanqui. Also involved was the Inca Amaro, who was not a ruler but collaborated in the conquest of the Antisuyo. Amaru is also depicted on this chest in the museum in La Paz, where he is accompanied by a chief of the Callahuaya, a people who maintained contact with the Incas. The chest, with its designs similar to drawings by Felipe Guamán Poma de Ayala, provides a rare record of Inca history.

Teresa Gisbert de Mesa

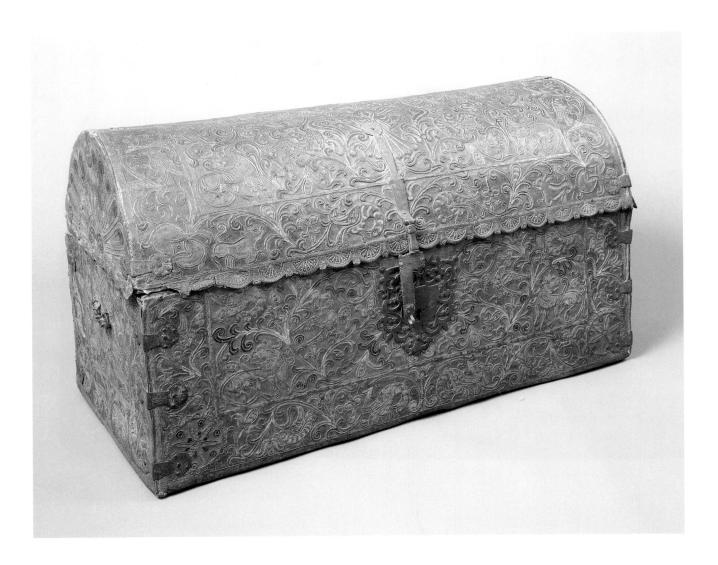

I-21 *Trunk*

Peru
Late seventeenth century
Tooled and painted leather over wood
24⁷⁄₁₆ × 42⅛ × 20⅞ inches (62 × 107 × 53 cm)
Collection of Patricia Phelps de Cisneros

A RICH TRADITION OF DECORATIVE LEATHERWORK flourished throughout Latin America during the viceregal era. The most typical and necessary domestic objects with leather-covered surfaces were chests, trunks, valises, and coffers intended either for the transport of fragile objects and fine clothing or for their storage in the bedroom. While the majority of these forms were derived from European models, one common form was of pre-Hispanic origin, the Mexican *petaca*, based on the Aztec *petlacalli*, a chest made of woven cane. By the mid-sixteenth century the word *petaca* had become a common term all over Spanish America for any leather trunk used for general transport. In New Spain *petacas* often retained the cane frames of the indigenous prototype, but they were also covered with leather that was embroidered with maguey fibers in elaborate interlacery, vegetal, and figural motifs.

The considerable number of surviving examples of such work found in collections in Spain and South America indicates that the Viceroyalty of Peru was the largest producer of quality tooled leather containers. This trunk is a superb example of the fine leatherwork produced by Peruvian artisans in the seventeenth and eighteenth centuries. Tooled designs in high relief represent one of the most characteristic traits of colonial Peruvian leatherwork. These designs typically combine indigenous and European motifs of flowers, vines, birds, monkeys, lions, Habsburg double-head eagles, and dragonlike *amaru* from Inca mythology. Other common stylistic elements include the use of foliate C-scroll borders and lids with scalloped edges. Virtually all trunks, chests, and coffers were constructed with locks. The present example retains its iron hardware and reticulated lock plate with strapwork designs, indicative of the high quality of ironwork found on larger trunks and chests of the colonial period, whether of leather or wood. Finer examples of Peruvian leatherwork were frequently painted, though only a limited number of these pieces preserve the bold coloration of the originals, such as is seen here. The indigenous Colombian lacquer, *barniz de Pasto*, was also applied to decorative leatherwork as an alternative means of adding color to the surface.

Mitchell A. Codding

1-22 *Portable writing desk*

Pasto, Colombia
Seventeenth century–eighteenth century
Wood, *barniz de Pasto*, and silver fittings
7⅞ × 12¼ × 14¼ inches (20 × 31 × 36 cm)
Inscribed on coat of arms inside lid: *DESPUES DE DIOS LAS CASA DE QUIROS*
The Hispanic Society of America, New York, LS2000

PROVENANCE: Cristóbal Bernardo de Quirós, bishop of Popayán

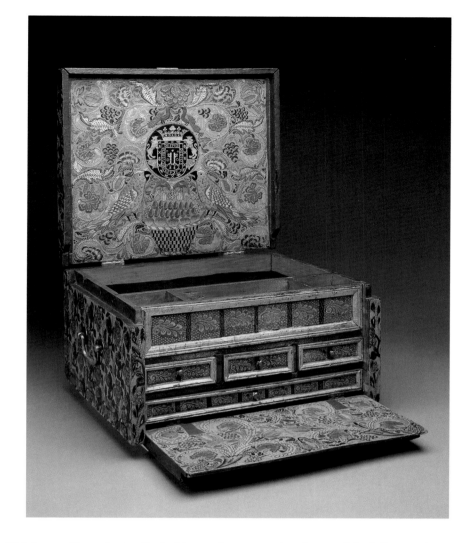

OF SPANISH DESIGN, this escritoire has a silver-hinged front and lid that can be secured by a clasp and lock plate, also of silver. All of the fittings, including the knobs on the drawers and the handles on either side, are of contemporary design, the result of a recent restoration. The interior is divided on the front into one long lower drawer and a row of three smaller ones above it, with a further cavity accessed from above whose front is given the same decorative treatment as the drawers. The coat of arms inside the lid indicates that the escritoire belonged to the twelfth bishop of Popayán, Don Cristóbal Bernardo de Quirós, a Spaniard who had also been bishop of Chiapa in the archbishopric of Guatemala. Appointed by Pope Clement X, Quirós took possession of the diocese of Popayán in November 1672. He died in May 1684 and was buried in the altar of Our Lady of the Conception in the cathedral of the city. During the ten years of his ecclesiastical administration he made improvements to the cathedral, constructed the clock tower, and promoted a range of cultural and artistic projects, not without provoking conflicts and quarrels. His coat of arms includes the phrase "After God, the house of Quirós" framing two upturned keys placed side by side as the principal element in the center of the coat of arms. This may be interpreted as a symbol of fidelity but also of power and authority. The coat of arms is surrounded by a border of crosses and stoats, the latter an animal associated with the Asturian surname Quirós. With its marquis's crown, the shield is sustained by a pair of crowned lions rampant and framed in a circle with a green background above an

Easter basket flanked in turn by two species of parrot. The foliage work, coloring, and perfect geometric organization attest to a high level of artistry and a fine sense of composition.

The exterior finish of *barniz de Pasto* corresponds to a series of works produced at the end of the seventeenth century that feature green and cream-colored backgrounds and decoration covering the total surface area of the object. In this type of work, figures are arranged without framing of any kind. It is as though the foliage were advancing on different planes like highly organized creeper vines, covering the entire surface. Plants and animals—mostly birds and monkeys—share the same formal patterns. Objects in this style can be found in Bogotá, Popayán, and Pasto.

Pilar López Pérez

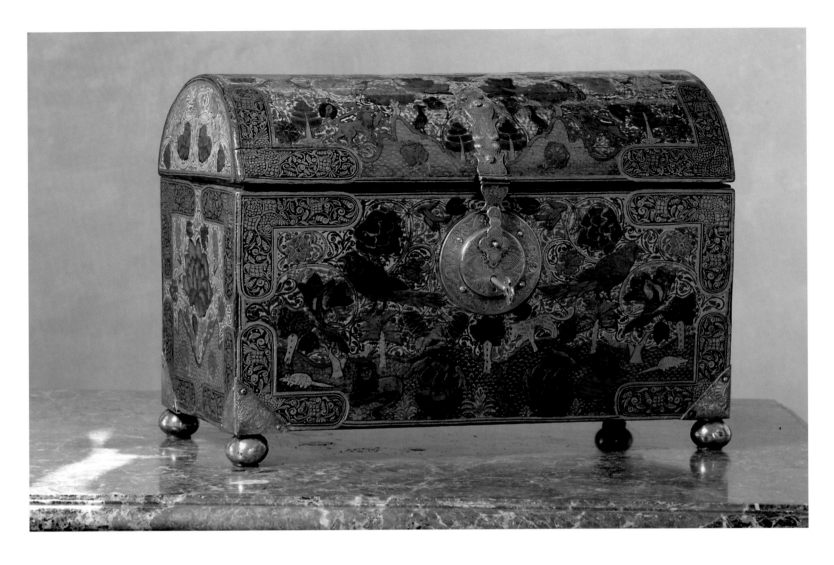

I-23 *Chest*

Pasto, Colombia
Late seventeenth–early eighteenth century
Wood, silver, and *barniz de Pasto*
18⅛ × 24⁷⁄₁₆ × 11 inches (46 × 62 × 28 cm)
Punch mark at bottom of silver lock clasp: unidentified hallmark
Private collection

THIS CHEST HAS BEEN ASSEMBLED from wooden boards nailed together with small wooden tacks. The curved lid is attached to the body by two hinges and can be locked by means of a clasp closing over a circular silver plate. The chest stands on spherical feet soldered to the silver plating at each of the four bottom corners. The hinges, lock, and corner pieces are of repoussé silver delicately worked in vine-leaf and palmette decoration. At the bottom of the lock clasp there is a mark left by an unidentified silversmith's punch, which probably refers to a geographical locality. The lid fits onto two wooden semicircles at either end of the chest, which probably also served as dust protectors.

The surface of the chest has been richly decorated in colorful *barniz de Pasto*. The subject matter of the decoration seems to involve the New World represented as an earthly paradise, with trees forming the dominant element, followed by a primordial fauna native to both the New and Old Worlds: birds, foxes, lions, armadillos, monkeys, horses, and jaguars. The lid is decorated with a crowned two-headed eagle, a symbol of royalty and a token of the importance of the object. The landscapes are framed by decorative panels in which green and gilt predominate on a dark brown background. These panels strongly recall the treatment of surfaces in Islamic art.

Pilar López Pérez

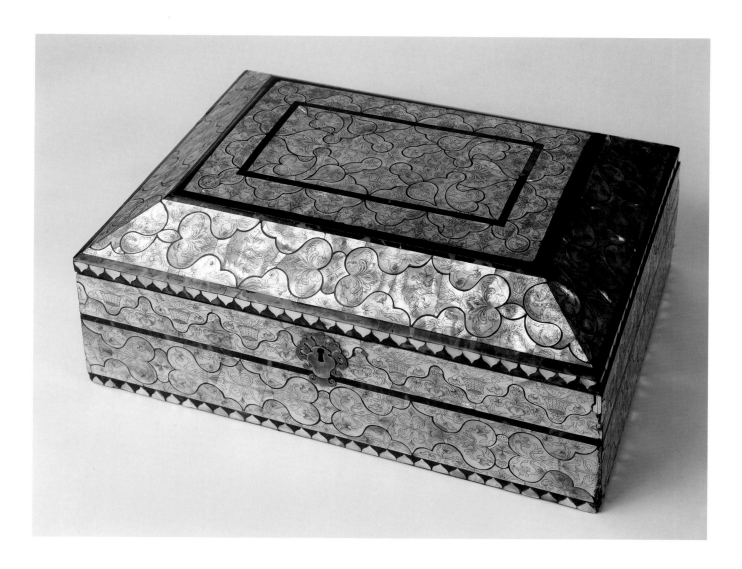

I-24 Sewing box

Peru or Philippines
Late seventeenth–early eighteenth century
Incised mother-of-pearl, tortoiseshell, and painted wood
7½ × 18⅛ × 13⅜ inches (19 × 46 × 34 cm)
Collection of Patricia Phelps de Cisneros

DECORATIVE BOXES AND FURNITURE inlaid with mother-of-pearl and tortoiseshell were among the most coveted luxury goods brought to the Americas aboard the Manila Galleons. These exotic objects were inspired by the opulent furniture, boxes, trays, and other vessels encrusted with mother-of-pearl that were produced for the European market in the Gujarat province of Portuguese India from the early sixteenth through the seventeenth centuries. Lustrous Gujarati caskets covered with mother-of-pearl plaques, fastened with silver nails in a fish-scale pattern, were considered so precious in sixteenth-century Europe that they were classified as jewelry in the inventories of royal collections. Toward the end of the sixteenth century Portuguese merchants introduced these wares into Japan, where they were copied for the Namban trade with Portugal and Spain.

Asian artisans in Manila soon were creating their own versions of these wares for export to the viceroyalties, where they enjoyed enormous

popularity, particularly in Peru, in the seventeenth and eighteenth centuries. Bold designs of flowers, petals, and leaves in marquetry of tortoiseshell and mother-of-pearl enriched the exterior and interior surfaces of the finest specimens (cat. VII-10). Because of their value and luxury status, these pieces often were treated as art objects despite their utilitarian design. Cabinetmakers in Mexico and Peru produced fine furniture and decorative objects inlaid with mother-of-pearl and tortoiseshell in a variety of styles, but the colonial pieces that exhibit a pronounced Asian influence almost certainly originated in the Philippines, particularly those with striated Chinese-style moldings.

This sewing box is truly exceptional in its design, craftsmanship, and materials. Although the decorative surface at first glance appears to be composed solely of mother-of-pearl, each piece is outlined with a thin strip of tortoiseshell. The wider borders of tortoiseshell are backed with gold leaf to enhance their color. Intricate incised decorations of flower-filled vases, flowers, and leaves cover the unusual burgundy-tinged mother-of-pearl. The interior, fitted as a sewing box with small drawers and compartments, displays flowers, plants, birds, and a garden landscape with fountain, all freely painted in gold and black on a red ground in imitation of Chinese lacquer.

Mitchell A. Codding

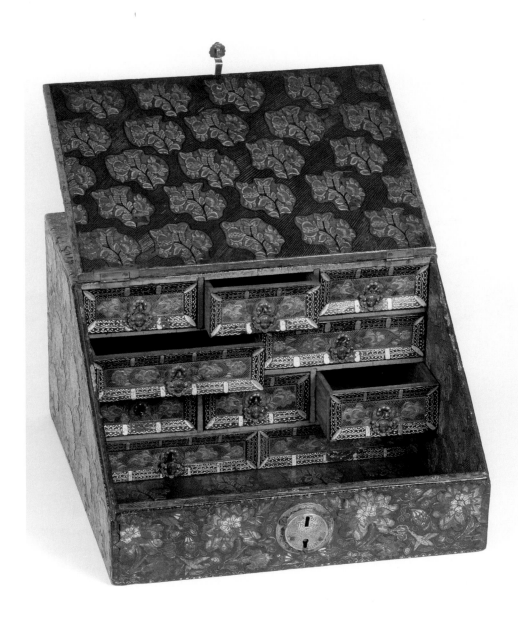

I-25 *Writing desk*

Pasto, Colombia
Eighteenth century
Wood, silver, and *barniz de Pasto*
16 × 10⁹⁄₁₆ × 17½ inches (40.7 × 26.8 × 44.5 cm)
Museo de Arte Colonial/Ministerio de Cultura,
Bogotá, Colombia

THIS TRAPEZOIDAL ESCRITOIRE, or writing desk, has a front lid that slants down and is attached by silver hinges ending in floral decorations. The lid can be secured by means of a wrought silver clasp and circular lock. The exterior of the escritoire is covered with a virtuoso display of *barniz de Pasto* decoration: vivid red and yellow flowers amid green foliage and delicate lianas, with birds of different colors, all against a reddish brown background. These ordered, geometric designs may have been based on European prints, or on the decoration of other objects or even textile designs. The execution reveals a skilled hand and a perfect control of composition, not lacking in spontaneity, with various gradations of color achieved by as many as eight different layers of varnish.

There is a clear contrast between the outside and the inside decoration of the escritoire, in terms of both motifs and finish. The figures on the interior are much simpler, tending toward rigid cutouts, rendered in direct colors. The interior is divided into four levels, with three drawers

at the top level, two in the next one down, then three again, and with a single drawer at the bottom level. The knobs are silver cherub figures. Each drawer has a decorative border of undulating gold lines that create the effect of a curled molding; in the center of the drawer, framing the knob, two flowers face each other against an aquamarine background. The rest of the interior surface is decorated in floral motifs delicately set off against a light green background. The figures are lightly silhouetted to give the effect of a bas-relief. Pomegranate flowers are delineated by a ribbon of dark green varnish. The presence of the pomegranate flower—often employed as a Christian symbol—suggests that the escritoire was a luxury object conferring some social distinction on its owner.

Pilar López Pérez

1-26 *Ballot box*

Olinalá, Guerrero, Mexico
c. 1779
Lacquered wood
7⅞ × 15¾ × 15¾ inches (20 × 40 × 40 cm)
Inscribed inside lid: *Sirve para las Elecciones, / La dio la M. Secretaria Sor Maria / Ana de S.S. Josè Ruiz de la Mota / [ano] de 1779.*
Museo Franz Mayer, Mexico City

PUBLISHED: *El Maque* 1972, pp. 72–73; Pérez Carillo 1990, pp. 94–96; Pérez Carillo and Rodríguez de Tembleque 1997, pp. 48–52

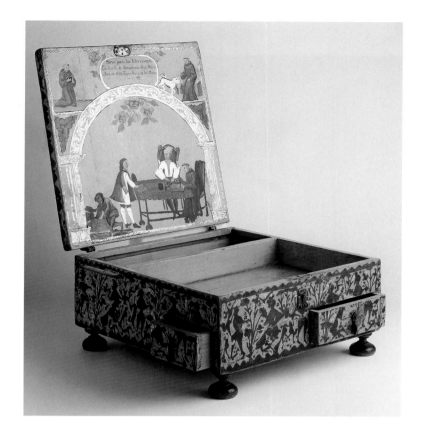

THIS ORNATE BALLOT BOX (*caja de votaciones*) exemplifies the distinctive lacquerware made since the eighteenth century in the modern-day Mexican state of Guerrero. The village of Olinalá is Guerrero's best-known lacquer center, although the craft was also practiced by artisans in nearby towns.

The box's exterior is decorated in the time-consuming *rayado*, or "cut out," technique. In this method the lacquer surface is made by combining the powders of at least two different types of pulverized stones with botanically derived *chia* oil to form a thick paste that is applied to a wooden base (scholars do not agree if the insect fat *aje* was originally included in the recipe). After the coating dries, it is sanded and polished. Pigment in powdered form is then rubbed into the lacquer coating. After the application of the base color, the process is repeated two or more times with different colored pigments in each layer. Between each coating the surface is finely burnished. Here, the orange layer was applied first, followed by one or two red-lacquer coatings. Double coating the final color provides a greater difference between the orange background and the higher red image. To produce the design, the artist drew the outline of the picture by scoring through the lacquer layers with a sharp tool or thorn. The red layer around the drawing was then cut away to reveal the orange layer beneath. The figure's facial features and wardrobe, the flower petals, and other details of the scene are incised. Sharp bird quills or the thorns of an acacia tree were often used in the decorating process. The green and white shapes were made from thick applications of pigment and paste applied on top of the orange background. Stylized figures of men and women illustrated in profile, intertwining plants forming elaborate patterns, and rabbits, deer, birds, and other wildlife intermingled among the vines are typical of the motifs portrayed on lacquerwork from Guerrero using the *rayado* design technique.

The interior of the box's lid was painted with a fine brush in a technique called *dorado*, which refers to the customary use of gold paint or gilding in this class of lacquer products. The inscription at the top, dated 1779, states that Sister María Ana, a secretary, has given this box to be used in elections. It was common for convents and friaries to hold elections for their leaders. The painting portrays Franciscan friars dressed in the order's habit; a rope, the symbol of the Franciscan order, frames the picture. A Franciscan friar and Spanish magistrate are represented presiding over an unidentifiable business transaction, while the indigenous Mexican in the lower corner is shown drawing what may be a map, indicating the possibility of a real estate dispute or transaction.

In the pre-Hispanic era Guerrero was home to several indigenous groups, each with its own language and customs. The practice of applying lacquer to gourds in the region during the pre-Hispanic era is documented in two sixteenth-century codices, the *Codex Mendoza* and the *Codex Ixtlilxochitl*. These two texts include lists of tribute (payments) rendered to the Aztec empire. The *Codex Mendoza* cites the province of Tlacozauhtitlan (place of yellow earth) with the payment of 1,200 lacquered yellow gourds. The same town is attributed in the *Codex Ixtlilxochitl* with the payment of lacquered gourds of various shapes, including 16 trays (*bateas*) of color and 268 fine gourd drinking vessels (*jicaras*) and bowls (*tecomates*). There are no known descriptions by early Spanish colonists of the ornately decorated lacquerware objects for which the region is now known. During the colonial era, the products of Guerrero's lacquerware industry were not as well known as those from Michoacán. However, today the region's artists continue to produce lacquerware of high quality, which are among the most prized examples of Mexican popular art forms.

Paula Kornegay

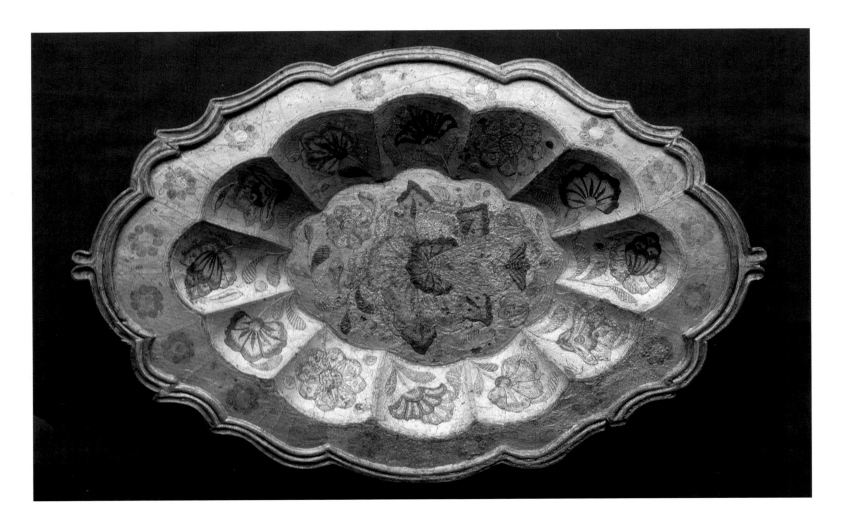

I-27 *Tray*

Quito, Ecuador
Eighteenth century
Wood with *barniz de Pasto*
11⁷⁄₁₆ × 17½ × 1⁹⁄₁₆ inches (29 × 44.5 × 4 cm)
Museo Jacinto Jijón y Caamaño, Pontifica Universidad Católica del Ecuador, Quito, Ecuador

THIS WOODEN TRAY is entirely covered in *barniz de Pasto*, a varnish that mimics Oriental lacquer decoration and that was appreciated not only for its aesthetic qualities but also for its practicality as a waterproofing agent. The tray is richly decorated in symmetrical floral motifs. Three distinct concentric fields of decoration can be distinguished. The broad outer rim, surrounded by an undulating molded border characteristic of rococo ornamentation, is decorated with synthetic flowers. Set within this area is a series of concave gadroons, each one beautifully adorned with an individual flower. The innermost field, which constitutes the base of the object, is skillfully decorated with foliage and floral motifs. The tray employs some of the decorative patterns used in silverwork.

Pilar López Pérez

1-28 Attributed to the workshop of Diego Salvador Carreto

(documented 1649, died 1670–71; Puebla de los Angeles, Mexico)

Basin with landscape in Chinese style

Second half of the seventeenth century
Tin-glazed earthenware
Height 6¼ inches (15.9 cm); diameter 21 inches (53.3 cm)
Marked on bottom of basin: C.S.
Philadelphia Museum of Art, Purchased with the Joseph E. Temple Fund, 1908-247

PUBLISHED: Barber 1908, fig. 23; Kuwayama 1997; McQuade 1999 *Talavera*, cat. no. 10

EXHIBITED: New York 1999, cat. no. 10

1-29 Attributed to the workshop of Master Potter A

(active seventeenth century, Puebla de los Angeles, Mexico)

Basin with strapwork and bobbin lace decoration

Mid-seventeenth century
Tin-glazed earthenware
Height 5½ inches (14 cm); diameter 21½ inches (54.6 cm)
Philadelphia Museum of Art, Purchased with the Special Museum Funds, 1907-310

PROVENANCE: Former Convento de San Francisco, Atlixco, Puebla, Mexico

PUBLISHED: Barber 1908, fig. 7; McQuade 1999 *Talavera*, cat. no. 2, fig. 8

EXHIBITED: New York 1999, cat. no. 2

1-30 Attributed to Damián Hernández

(documented 1607–53; Puebla de los Angeles, Mexico)

Jar with handles

Mid-seventeenth century
Tin-glazed earthenware
Height 18½ inches (47 cm)
Marked on lower register: he
Philadelphia Museum of Art, Purchased with Funds contributed by Mrs. John Harrison, 1907-295

PROVENANCE: Private collection (possibly Albert Pepper), Mexico City

PUBLISHED: Barber 1908, fig. 20; Cervantes 1939, p. 113; *Mexico* 1990, cat. no. 220

EXHIBITED: New York 1990, cat. no. 220

1-31 Attributed to Damián Hernández

Jar with handles

Mid-seventeenth century
Tin-glazed earthenware
Height 18½ inches (47 cm); diameter at mouth 6¼ inches (15.9 cm)
Marked on lower register: he
The Hispanic Society of America, New York, E991

PROVENANCE: Manuel L. Riveroll, Mexico City (acquired in 1911)

PUBLISHED: Barber 1915, pl. 7; *Hispanic Society* 1938, p. 135; Caiger-Smith 1973, fig. 152; *México en el mundo* 1994, vol. 3, p. 208; McQuade 1999 *Talavera*, cat. no. 3, figs. 17–18; McQuade 1999 "Renaissance," p. 825, pl. III; Lenaghan 2000, fig. 305

EXHIBITED: New York 1999, cat. no. 3

1-32 *Basin with the figure of Saint Michael Archangel*

Puebla de los Angeles, Mexico
Second half of the seventeenth century
Tin-glazed earthenware
Height 6¾ inches (17 cm); diameter 25½ inches (64.8 cm)
Philadelphia Museum of Art, Purchased with the Joseph E. Temple Fund, 1910-240

PUBLISHED: McQuade 1999 *Talavera*, cat. no. 7, fig. 10

EXHIBITED: New York 1999, cat. no. 7

1-33 *Jar with chrysanthemum blossoms*

Puebla de los Angeles, Mexico
Second quarter of the eighteenth century
Tin-glazed earthenware
Height 19¾ inches (49 cm); diameter 13¾ inches (35 cm)
Museo Franz Mayer, Mexico City

PROVENANCE: Franz Mayer, Mexico City

PUBLISHED: Cervantes 1939, p. 197; Cortina 1989, p. 63; *Viceregal Mexico* 2002, cat. no. 69

EXHIBITED: Houston, Delaware, and San Diego 2002, cat. no. 69

1-34 *Bowl with landscape*

Puebla de los Angeles, Mexico
Late seventeenth century
Tin-glazed earthenware
Height 4¾ inches (12 cm); diameter 15⅜ inches (39 cm)
Philadelphia Museum of Art, Purchased with the Joseph E. Temple Fund, 1906-165

PUBLISHED: Barber 1908, fig. 8; McQuade 1999 *Talavera*, cat. no. 9, figs. 14–15; McQuade 1999 "Renaissance," p. 830, pl. XII

EXHIBITED: New York 1999, cat. no. 9

FOR MORE THAN FOUR CENTURIES, the city of Puebla de los Angeles (known as Puebla) has been recognized as one of the most important centers for the production of maiolica (tin- and lead-glazed earthenware) in the Americas. Sophisticated ceramic vessels were produced for millennia prior to the conquest of Mexico in 1521, although it was the Spanish who introduced maiolica and the tools necessary for its production: the potter's wheel, a tin-and-lead-based glaze, and an up-draft kiln. The first colonial maiolica vessels were produced in Mexico City before the mid-sixteenth century. By the close of that century, however, many Spanish potters had begun to migrate to Puebla, which was founded as an industrial center for the manufacture of European-style products, including maiolica. Puebla was an ideal location for the maiolica industry; the climate was mild, the soil was rich, and there were extensive clay beds and raw sodium essential for glaze preparation. The nearby city of Cholula was celebrated for its pottery prior to the conquest and undoubtedly supplied native potters to the Puebla workshops. Moreover, Puebla's strategic location along the Acapulco-Veracruz trade route allowed potters direct access to Chinese porcelain shipped from Manila aboard the so-called Manila Galleons beginning in 1565, after the Spanish colonization of the Philippines and the discovery of a feasible route across the Pacific. With Chinese porcelain arriving in Mexico as early as the sixteenth century, Mexico was one of the earliest producers of Chinese-style pottery in the western hemisphere.

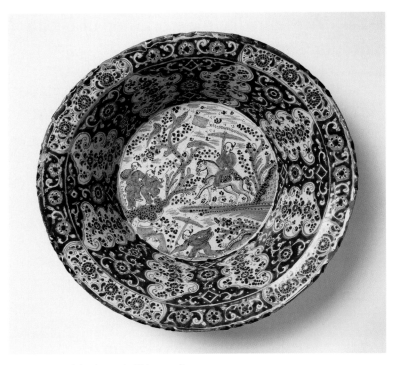

1-28 Basin with landscape in Chinese style

The first output of fine-grade vessels was largely decorated in the style of Spanish prototypes from Seville and Talavera de la Reina, as well as other ceramic centers in Spain. One of the most refined types is characterized by a weblike design finely painted in manganese in imitation of bobbin lace. Archaeologists in the United States and Mexico call this type of decoration Puebla polychrome; however, "bobbin lace" (or *encaje de bolillos*) better identifies the origin of the design. Metallic and cotton bobbin lace was made in several areas of Spain during the seventeenth century, including the ceramic center of Talavera de la Reina, where potters incorporated the design into one style of their pottery.

The basin in the collection of the Philadelphia Museum of Art (cat. 1-29) is one of the largest and most important extant examples with bobbin-lace decoration. The semicircular lace pattern is painted along the rim of the basin just as it was frequently painted on works from Talavera de la Reina. At Talavera de la Reina, the lace pattern is generally used to frame figural scenes. In Puebla, however, the design was dissected into abstract patterns and only rarely contains representational elements. An exception to this is a rare group painted in manganese on cream ground surrounding figurative images, such as a female bust, a rabbit, or a turkey. On the Philadelphia Museum basin, the pattern is used to fill the shapes created by the cobalt-blue strapwork. Strapwork of this kind is reminiscent of early Valencian lusterware of the late fourteenth and early fifteenth centuries, when potters similarly covered the entire surface with light and bold colors with intersecting lines consistent with the *horror vacui* (fear of empty spaces) that characterizes Islamic pottery.

As ceramic workshops in Puebla increased their productivity, they also expanded the types of forms they made. The large, deep, flat-bottomed basin with its steep, slightly flared walls was among the most common forms to be introduced to Puebla pottery in the seventeenth century. The form had been introduced to Spain by Muslim potters in the ninth century, and it was made in Puebla in a variety of sizes throughout the golden

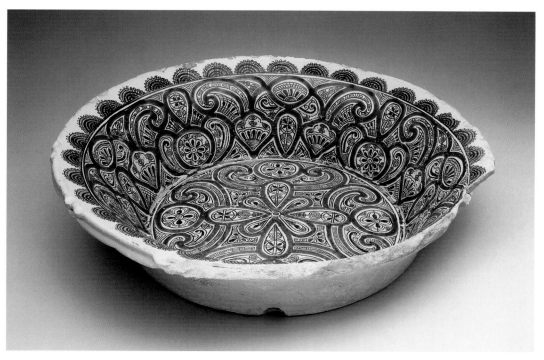

1-29 Basin with strapwork and bobbin lace decoration

age of the industry (1650–1750). Edwin Atlee Barber, former director of the Philadelphia Museum of Art (then the Pennsylvania Museum and School of Industrial Art), indicated that the Philadelphia Museum basin with lace decoration previously belonged to the former Convento de San Francisco in Atlixco (Puebla), which was founded in the early seventeenth century. At the monastery, the basin probably was used as either a simple washbasin or a baptismal font (presumably as a more affordable alternative to the silver basins commonly used). The hole on the bottom was undoubtedly for the drainage of water.

A similar basin is held by the Metropolitan Museum of Art, New York. In place of the semicircular lace patterns, the rim of the Metropolitan Museum's basin is inscribed "Soy para lavar los purificadores y no mas" (I am for washing the purificators and nothing else), suggesting that it was used only to wash the altar napkin that purified the chalice following communion. The mark "A" on the exterior wall of the Metropolitan Museum's basin may be associated with the workshop of one of the three documented master potters of the seventeenth century: Domingo de Aguilar, José Anaya, or Antonio de Arteaga. The closeness of the basins in the Metropolitan Museum and the Philadelphia Museum collections suggests that the two came out of the same workshop. The Philadelphia Museum basin, however, has a more fanciful and elaborate design and is painted with greater refinement, which would suggest that it was made earlier by a different painter. Since it was not until 1653 that the potter's guild issued its ordinances and required its master potters to mark their work, the Metropolitan Museum's basin probably dates no earlier than 1653. The appearance of small vessels with bobbin-lace decoration at the site of Saint Catherine's Island off the coast of Georgia establishes its production prior to 1680, when the site was abandoned.

The dense application of cobalt blue in small dots was one of the most important and longest lived techniques used to decorate vessels in the seventeenth century. The basin with the image of Saint Michael Archangel (cat. 1-32) in the collection of the Philadelphia Museum of Art is one of the most impressive examples of this type. The affinity for decorating entire surfaces with small dots is typical of Islamic designs introduced to Spain by Muslim potters in the twelfth century and popularized by potters at Manises (Valencia) in the fifteenth century. The technique also was employed in the seventeenth century by potters in Talavera de la Reina for a decorative type known as *punteada*. Edwin Atlee Barber first described this style at Puebla as "tattooed." However, the first clause of the 1682 amendment to the 1653 issuance of the potters' ordinances articulates the use of "blurred dots," or *aborronado*, in blue as one style of decoration, production of which must have already begun prior to this issuance. On the Philadelphia Museum example, small dots are used to create a variety of forms and figures outlined in light blue. The most prominent is the figure of the archangel Michael, who is depicted with an elaborate free-flowing cloak, feathered headdress, expanding wings, and holding a baton in his left hand and a banner in his right. He stands above three winged angel heads, which was a standard image in illustrations of saints and virgins. Surrounding the archangel on the basin's inner walls are flowers, architectural structures, and a variety of birds, including parrots and a quetzal, the latter famed for its long, beautifully colored tail feathers but here painted in fine, light blue lines with dense cobalt dots and dashes.

The lavish use of cobalt identifies this and other such works as "refined ware" (*loza refina*), which, according to the third clause of the 1682 amendment to the potters' ordinances, should imitate China porcelain patterned with "very intense" blue. The *aborronado* technique was almost exclusively painted in cobalt blue and continued to be used throughout the eighteenth century in combination with other styles. Unlike the extravagant use of cobalt on the interior of the basin, the exterior walls are decorated with simple loosely painted stylized floral and plant motifs similar to those found on Valencia lusterware of the

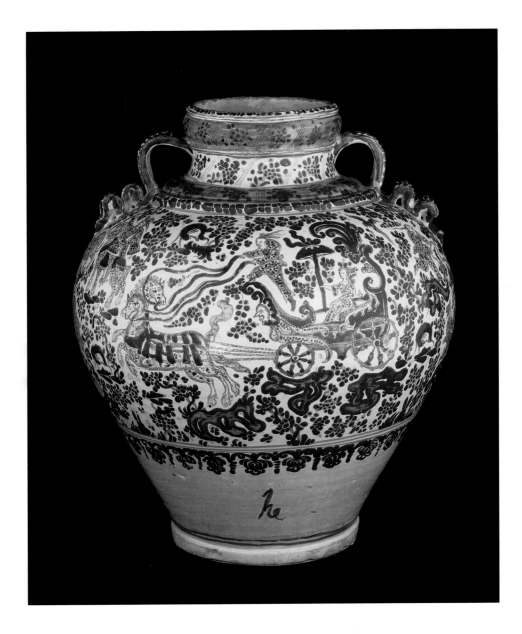

1-30 Jar with handles

fifteenth century. Chinese potters also painted similar motifs on the reverse sides of some of their vessels, but the practice probably originates with Muslim potters.

A pair of seventeenth-century jars marked "he," one each in the collection of the Philadelphia Museum of Art (cat. 1-30) and the Hispanic Society of America (cat. 1-31), comprises two of the most outstanding examples of Puebla pottery. The decoration incorporates a more refined and controlled usage of the *aborronado* technique within a distinctive style that characterizes works marked "he." On these jars, dots become more refined leaves, flowers, and clusters of grapes growing from vines that extend from cloud forms and run through the various scenes to fill the empty areas of the central register. Unlike the basin with Saint Michael Archangel, the overall decoration is clearly articulated and not crowded beyond recognition. The main figures are still formed of small dots and light blue outlines, and the smaller animal figures (deer, birds, and rabbits) are rendered in solid dense cobalt.

The decoration of the two jars is drawn from various traditions, most notably Islamic, Spanish, Italian, and Chinese. As previously mentioned,

the use of small leaves or dots to fill space in the central and upper registers is typical of Islamic design. The narrative style with the horse-drawn chariot circling the jars, however, reflects Italian Renaissance *historiato* (narrative) painting, which had a profound impact on seventeenth-century maiolica workshops in Seville and Talavera de la Reina. While most European examples are based on Renaissance engravings, Puebla vessels such as these are composed of distinct individual scenes that typically do not convey any particular story; exceptions are those vessels with religious scenes such as the Baptism of Christ. Like those of other similar Puebla works, the painter of these jars emphasized the movement and action of the figures. For example, on the Hispanic Society's jar, lines are sketched beneath the chariot driver's foot to emphasize his thrust forward. Moreover, three-dimensionality is not carefully articulated. While an attempt is made to portray two galloping horses side by side, the wheels of only one side of the chariot are depicted.

The chariot holding the woman with a parasol is repeated on the front and back of the two jars, yet the figures on each side differ slightly. One side depicts a grotesque figure holding a rabbit, a Chinese male figure

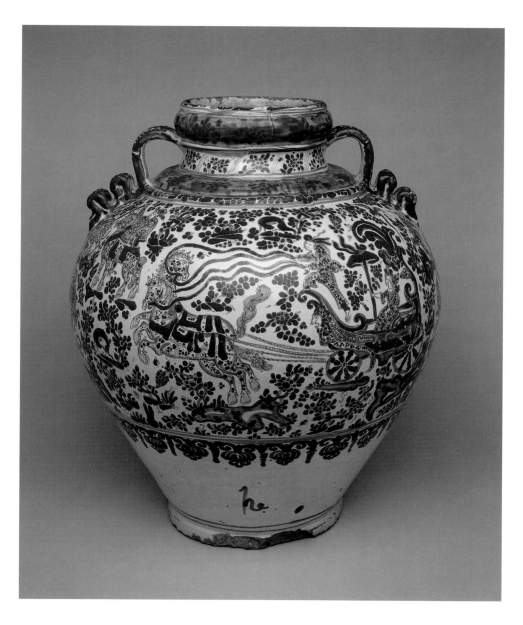

1-31 Jar with handles

walking two dogs on leashes, a Chinese man facing a cannon, and a Chinese female holding a parasol with a deer and a quetzal bird above her. The other side depicts a passive European bullfighter on horseback facing the bull with sword in hand, a European man seated next to a tree holding the leash of a cat or dog, and the same Chinese figure with dogs and grotesque figure with a rabbit that appear on the opposite side (except that on this side the rabbit is about to leap from the man's lap).

The influence of Chinese porcelain is less pronounced on these two jars than on other works marked "he." Most notable are the Chinese figures identified by their loose clothing, queues (hair braids), and mustaches; the floating baselines, which may have been inspired by Chinese cloud scrolls; and the band running along the base of the jars, which recalls the use of pendants and tendrils so popular in Chinese porcelain design. The jars' inverted pear-shape with tapered base recalls Chinese *guan* storage jars, although Spanish oil jars also take a similar form.

The mark "he"—painted on the lower registers of the jars—has been attributed to the master potter Damián Hernández, who was one of three of the founding members of the potter's guild, and one of its first inspectors. Born in Spain, Hernández settled in Puebla at a young age and learned the art of tin-glazed earthenware in Mexico from Antonio de Vega y Córdoba. While the mark may refer to another potter, Hernández's contributions to the potter's guild strongly imply that he was one of the most successful potters of the seventeenth century, and was therefore likely to have made such refined works as this pair of jars. Regardless of the attribution, the range in quality and painting styles of the other works marked "he" suggests that they were not all painted by the same hand. Nonetheless, it is logical to assume that the best pieces are those of the master, who typically owned and operated the workshop.

By the end of the seventeenth century, some of the Spanish and Italianate styles gave way to more direct interpretations of Chinese porcelain designs. Some workshops—such as the one that employed the mark "C.S."—focused on the Chinese style, evidenced by the number of Chinese-style works painted with the mark. In his 1908 monograph on Puebla pottery, Barber attributed the mark "C.S." to the master potter Diego Salvador Carreto (active in 1649; died 1670–71), who was one of the founders of the potter's guild. It is also possible that the mark points

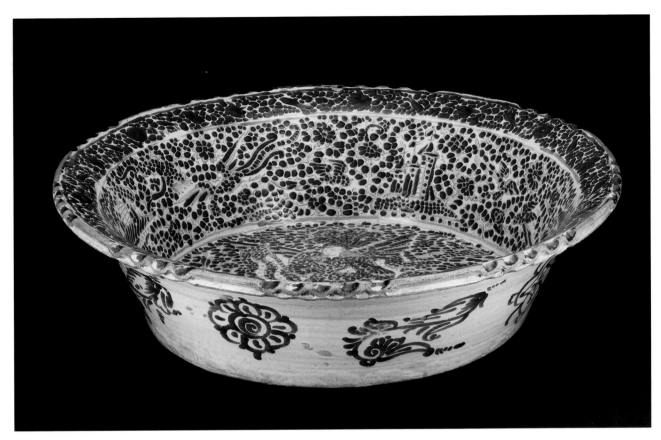

1-32 Basin with the figure of Saint Michael Archangel

to the workshop of Cristóbal Sánchez de Hinojosa the elder, who was active in 1627, or that of his son of the same name, who was active in 1668.

The basin marked "C.S." in the collection of the Philadelphia Museum of Art (cat. 1-28) demonstrates one interpretation of Chinese porcelain design, particularly of the Wanli era (1572–1620). Eight irregular lobed panels in white reserve on blue ground decorate the interior walls, and four reduced panels in white reserve on blue ground decorate the "pie-crust" rim. The decoration in blue ground was achieved by sketching the floral, abstract, and curvilinear motifs in light blue and carefully filling the surrounding area with dense cobalt. The central roundel of the basin reflects Chinese landscape decoration of the early sixteenth century and later. In the present landscape scene, two single figures and a pair of Chinese people frolic amid flowering trees, shrubs, and small mounds: to the right, a man holds a parasol while riding a horse; to the left, two boys prance together as they fly a kite; and below, a man with a parasol crouches down low as if in dance. In the Puebla tradition, light blue vines with small cobalt leaves fill the remaining space around the figures. Clearly, this landscape scene was not drawn directly from a specific Chinese type. However, it reflects a Puebla interpretation rather than a European one. A similar basin marked "C.S." is held by the Museo José Luis Bello y González (INAH) in Puebla. The center of that basin is dominated by two women, one playing a banjolike instrument while sitting down, the other standing carrying a rifle from which a dead rabbit is suspended. While the same irregular panels in white reserve on blue ground decorate the interior walls, the panels in white reserve on the exterior wall contain figures wearing only a scarf around their bodies.

More typical of Chinese landscape painting is a bowl in the Philadelphia Museum collection (cat. 1-34). On this example, a deer frolics through a field with a tall, unusual plant situated between two mosque-shaped structures. A third mosque-shaped structure appears upside down below; the dark blue area under the landscape may represent water and the building a reflection. Deer were common decoration on porcelain of the type known as kraak, after the Dutch name for the Portuguese galleons they frequently captured. Kraak porcelain was first produced around 1500 by workshops in Jingdezhen, Jiangxi, in central China, and was shipped in quantity to the New World. The ware's popularity is made evident by the number of examples recovered from sites in central Mexico and areas of the Pacific Ocean where galleons have sunk. On this bowl, only a double line of blue frames the landscape, and little attention is paid to scale and perspective (for example, the deer is almost as tall as the buildings). Like other works of the period, the reserve of the bowl is painted with free-flowing brushwork characteristic of Spanish lusterware of the fifteenth century.

By the early eighteenth century, the Chinese style was fully developed. Eighteenth-century examples are marked by restraint, symmetry, and a balance between decorated and undecorated areas, a sharp contrast to the crowded decoration that characterized the second half of the seventeenth century. A mid-eighteenth century jar in the Museo Franz Mayer (cat. 1-33) stands out as one of the more refined Chinese-style examples of this period. While Puebla decorators were rarely slavish in copying Chinese prototypes, the form and decoration of this jar were directly modeled after a blue-and-white porcelain jar from the Kangxi reign (1661–1722) of

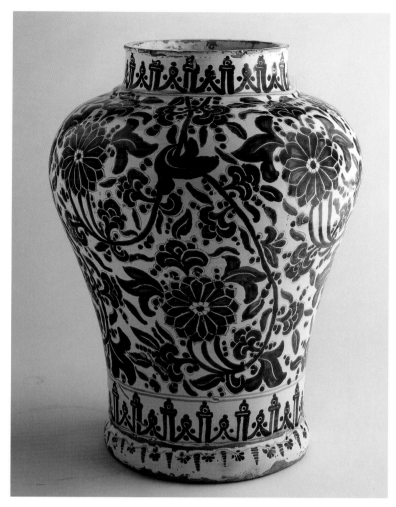

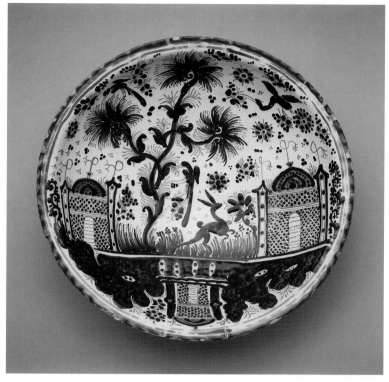

1-33 Jar with chrysanthemum blossoms

1-34 Bowl with landscape

the Qing dynasty. Nearly identical to its prototype, the jar is covered by stems of chrysanthemum blossoms that weave through petals and leaves. George Kuwayama indicates that this design also appears on Chinese silk damask, fashionable in Mexico at the time; however, since a Chinese ceramic prototype exists, it is more likely that the potter was inspired by a specific porcelain jar he had seen.

Documents from the mid-eighteenth century identify the workshop of Diego de Santa Cruz de Oyanguren y Espíndola as having "invented" the Chinese style in Puebla. Don Diego was appointed *alcalde* (mayor) of the guild numerous times between 1734 and 1761. The workshop was located on calle de Espíndola—present-day Avenida 2 Poniente 900— which was named after the artist's family. One particular document prepared by the master potter himself states that most experts would not even be able to distinguish his work from that of China or Japan, as his ware is "not only the most polished, but also the most durable." While it is unlikely that he "invented" Chinese-style pottery in Puebla, since seventeenth century examples are known, he apparently specialized in reproducing Chinese porcelain, and such refined works from the period may even have come out of his workshop.

Unlike the main panel of the Museo Franz Mayer jar, the pattern above and below does not derive directly from a Chinese prototype. The pattern is made up of alternating stylized architectural structures that must

have evolved from the calligraphic *alafia* motif found on Spanish lusterware. The *alafia* (which means health and happiness in Arabic) motif consists of a circumflex accent over an alpha on its side. It was a common border motif for Puebla decorators during the first half of the eighteenth century.

Margaret E. Connors McQuade

Textiles

Textiles in Colonial Latin America

Dilys E. Blum

Much of the contemporaneous information on Latin American textiles at the time of European contact comes from detailed descriptions and illustrations contained in Spanish administrative reports, royal documents, travel accounts, and pictorial codices. These sources vividly document a rich textile heritage that ranged geographically from the Maya and Aztec empires in Mexico and Central America to that in the Andean mountains of the Incas, which ran from northern Ecuador through Peru to southern Chile. The early Spanish chroniclers remarked on the beauty and technical sophistication of native weavings, frequently equating them with the finest of European silks. Throughout the indigenous empires, the most elaborate textiles were reserved for royalty and elites. Cloth served many functions, such as clothing that marked the identity and social position of the wearer, as sacrificial offerings, as a medium of exchange, and as ceremonial gifts. The enormous quantities of luxury clothing and textiles levied as head tax from their subjects by the Aztec and Inca rulers are documented in the lists of tribute in illustrated manuscripts such as the Aztec *Codex Mendoza* and in Spanish chronicles of Inca history, including Felipe Guamán Poma de Ayala's *El primer nueva corónica y buen gobierno*, completed in 1615.[1] Official reports and notarized documents such as wills and inventories provide valuable information on the variety of textiles used during this period and often indicate where they were produced.[2] However, while pre-Hispanic textiles have been extensively studied by historians and archaeologists, it is only since the late 1970s that there has been a surge of interest in textiles produced in and exported to Latin America between the conquest and independence, with articles focusing for the most part on the economic history and geography of basic cloth production and dyes.[3] Scholars are only now beginning to intensively study and publish research on surviving textiles from this period, seen most recently in Elena J. Phipps's work on colonial Andean tapestries.[4] This essay presents a broad overview of textiles from European contact to independence, organized by fibers and techniques. Each has its own complex history, which can only be touched on here.

The cotton plant was indigenous to Latin America and was grown primarily in the fertile lowland coastal areas and river valleys, and it came naturally in a range of shades from light to dark. Under the Maya and Aztecs, cotton garments were worn only by the nobility,[5] and raw cotton, cotton cloth, and cotton clothing—cloaks, loincloths, tunics, and skirts—were paid as state-imposed tribute to the rulers, while commoners used textiles woven from the coarser *maguey* or yucca fibers.[6] Apart from fragments and weaving implements such as spindle whorls, unfavorable climatic conditions have left little physical evidence of cotton textile production before and just after the Europeans' arrival. With few extant examples to document the elaborate clothing and textiles used by the indigenous ruling classes at the time of the conquest, one must rely on visual depictions in codices, mural paintings, figural sculptures, and early written descriptions, such as those by Hernán Cortés. Writing in 1520 to Carlos V of Spain, Cortés described the elaborate cotton textiles he received as a gift from the Aztec emperor Moctezuma, who "gave me many garments of his own, which even considering that they were cotton and not silk were such that in all the world there could be none like them, nor any such varied and natural colors or such workmanship. Amongst them were very marvelous clothes for men and women, and there were bedspreads which could not have compared even with silk ones. There were also other materials, like tapestries which would serve for hallways and churches, and counterpanes for beds, of feathers and cotton, in various colors and also very wonderful."[7]

Cortés's letters also reveal some details of indigenous weaving techniques. One, dated 1519, mentioning a "piece woven in patterns of red, black and white, and on the back these patterns do not show"[8] describes a textile that would have been woven on the traditional back-strap loom with a supplementary weft, thereby producing a pattern visible only on the front. The quality of cotton weaving in Latin America declined rapidly (under the *encomienda* system) from its pre-contact heights, and by the late seventeenth century cotton cloth production was largely a cottage industry, with indigenous women carding, spinning, and weaving basic cloths, i.e., coarse plain white cotton, for household use and limited local trade. The Spanish and Portuguese prohibited the production of all but the coarsest cotton cloth in order to protect their home industries. Although the first cotton *obraje*, or large workshop, in New Spain had been established in Puebla in 1686, it was not until 1757 that one was established in Oaxaca and 1765 in Mexico City.

For the later colonial period visual sources such as paintings offer clues to the types of cotton textiles, both indigenous and imported, that were available in Latin America, and these are especially useful for identifying the ordinary cloths used by non-elites. Mexican *casta* paintings in particular provide a valuable record of the range of fabrics in New Spain during the second half of the eighteenth century and their use by different racial, social, and economic groups. Some of the textiles shown in these paintings can be identified by linking the pictorial images to descriptions in contemporaneous documents and travel accounts. For example, the distinctively patterned textiles labeled *xilotepec* in Miguel Cabrera's painting, dated 1763 (cat. VI-49), that shows a Spanish man, his indigenous wife, and their mestiza daughter in front of a market stall were described by the Italian traveler Gemelli Carreri in the late seventeenth century as a fabric decorated with figures and birds, among other designs, and also ornamented with duck feathers.[9] Both the mother and daughter wear underskirts of the fabric, which is shown being worn by Amerindian women in other *casta* paintings by artists such as José de Ibarra and Juan Patricio Morlete Ruiz.

Casta paintings are also a rich source of information on the range of printed cotton and linen textiles found in New Spain during the second half of the eighteenth century. Clues to

their possible origins lie in the history of textile printing and the relationship of the pictorial images to surviving printed textiles, such as fabric swatches included in official documents and in merchants' letters. During the eighteenth century a significant amount of printed cotton was imported or smuggled into New Spain from Europe and the West Indies, including re-exports from the East Indian trade. Mexico is known to have produced some prints copying European designs. Four samples of *indianillas*, or Mexican stamped cotton named after East Indian printed cottons, are included in a manuscript prepared by the royal inspector (*visitador*) José de Galvez in 1783 for the viceroy.[10] According to the accompanying reports, the printers of cotton textiles in New Spain had difficulty achieving the desired quality with the red and blue pigments available and worked only when Chinese and European imports could not meet demand. From inventories it appears that *indianillas* were used primarily for petticoats or underskirts.

Small repetitive designs such as the blue prints on white ground used for men's dressing gowns and children's clothing pictured in *casta* paintings by José de Alcíbar (cat. VI-48) and José de Páez may have been printed with adaptations of the kind of clay stamps known to have been used by the Aztecs. Or, these garments could also have been imported ready-made from Europe; in Spain they were the common stock of drapers and tailors. However, it is more likely that the sophisticated blue-on-white printed textiles seen in these paintings were of English, American, or Spanish origin because of the technical difficulty of directly applying blue to a white ground at this time. The method known as "penciled blue" allowed indigo mixed with chemicals and thickeners to be painted onto fabric using a brush, but it was not until the English developed the "china blue" process that indigo could be printed directly. English china-blue printed textiles were available in the North American colonies by 1742 and possibly were marketed or printed in Spain as early as 1732.[11] By the 1760s the technique was used by North American printers for small designs similar to those seen in the paintings. At least one American textile printer, Archibald Hamilton Rowan of Delaware, printed cottons for the South American market, from 1797 to 1799, which were sold by the Quaker merchant James Lea.[12] Much of the printed cotton cloth in late colonial Latin America was re-exported from Spain and Portugal or was contraband, such as the British cottons smuggled into New Spain via the West Indies from North America. In addition, there was a substantial trade in Dutch textiles printed in Holland and India for the Dutch market and exported by way of Marseilles for the West Indian plantations and for the Spanish market; the brightly colored prints seen in *casta* paintings dating from 1760 to 1780 are closer in color and design to the block-printed chintzes made in India for the Dutch market than those produced for the English, and they may in fact have been textiles from India or Dutch copies re-exported from Spain or Portugal. After 1778, the introduction of free trade between Spain and her American dominions helped the Spanish textile industry develop its printed cotton industry. By 1783 the Compañía de Hilados de Algodón in Catalonia, founded in 1772, had sixty factories and an annual production of a quarter-million pieces of *indianas* (printed cottons) for export to Spanish America.[13] After the liberalization of foreign trade, much of the printed cotton and linen cloth consisted of *pintados*, printed on imported linen rather than domestically produced cotton.

CAMELID AND WOOL

The introduction of new fibers, weaving technologies, and production methods by the Spanish transformed cloth making throughout colonial Latin America. By the end of the sixteenth century European sheep including the merino, a breed known for its fine wool, had spread throughout New Spain and the Viceroyalty of Peru.[14] The weavers of the Andean highlands, however, continued to work with the native camelid fibers—llama, vicuña, and alpaca—as they had traditionally. Under the Incas they produced finely woven tapestry cloth called *cumbi* for royalty

and the elite; under Spanish rule *cumbi* was adapted to meet new needs with pictorial and armorial tapestries replacing Inca royal garments. Colonial Andean tapestry weaving developed a unique aesthetic that integrated native traditions with European and Asian influences, such as designs adapted from European lace, Spanish carpets, and Chinese silk tapestry (*kesi*) and embroideries imported via the Manila Galleon. Colonial Andean tapestry-woven textiles were used for religious furnishings such as altar covers, carpets, and church hangings, and in religious and civil processions. They also served the colonial elite as wall hangings and table and bed covers, and were sent to Europe as royal and diplomatic gifts and as souvenirs.[15]

Andean tapestry workshops were likely the specialization of particular villages, and by the eighteenth century may have been organized more formally. There is at least one instance of tapestry weavers being brought from Europe to establish a workshop at the Jesuit arts and crafts academy at the Calera de Tango estate outside Santiago, Chile.[16] Large tapestries were woven on upright tapestry looms by men, while women spun and wove small tapestries and garments such as wedding mantles and tunics for religious statues, for example, those of the Christ Child (cat. VI-III).

Despite the Spanish prohibition in 1575 of wearing Inca-style garments, tunics and mantles continued to be worn, and during the eighteenth century these were officially sanctioned as festival dress. As before the Europeans' arrival, indigenous clothing throughout Latin America—whether Andean tunics and mantles or Mexican *huipils*, wraparound skirts, and loincloths—was woven to shape, or sewn together from lengths of uncut finished cloth rather than cut from yardage and tailored in the European fashion.

The manufacture of wool cloth in Latin America after the conquest took several forms. Non-elite women adapted the indigenous tradition of weaving for the household (*telares sueltos*[17]) using the backstrap loom, while artisan production using the horizontal treadle loom introduced by the Spanish developed in small workshops (*trapiches* or *obradores*) and in large, complex workshops (*obrajes*).[18] The first wool *obrajes* opened in Puebla during the 1530s and were owned and operated by immigrants from the wool-producing areas of Spain. They were organized throughout colonial Latin America for the integrated production of wool cloth and followed the manufacturing process through all its phases, including carding, spinning, dyeing, weaving, finishing, inventory, and sales. They produced basic cloth, primarily wool textiles and coarse unbleached cotton cloth, or *manta*, that were used for tents, sacks, horse blankets, packing materials, bags, floor coverings, religious habits, military uniforms, and clothing for the poor and African slaves. Contemporaneous reports describe the textiles produced in these workshops as mostly coarsely woven and of poor quality, although Puebla and Quito were said to produce a finer wool fabric. The English cleric Thomas Gage, writing in the mid-seventeenth century, described the wool cloth of Puebla as "judged now to be as good as the cloth of Segovia, which is the best that is made in Spain, but now is not so much esteemed of nor sent so much from Spain to America by reason of the abundance of fine cloth which is made in this city of Puebla de los Angeles."[19] By the mid-eighteenth century Puebla was producing primarily heavy coarse wool cloth deemed suitable only for servants and the poor and was now competing with other wool-producing centers such as Cholula and Querétaro in Mexico and Castille in Spain.[20] Rural estates and religious institutions managed their own workshops and produced basic cloth for their own use or sold it locally. The *obrajes* were frequently criticized for taking advantage of the native workers—men, women, and children—through forced labor, initially through tributes under the *encomienda* system, and then through *repartimiento*. The native Andean Felipe Guamán Poma de Ayala wrote of the church's abuses in 1615: "These fathers and pastors are occupied in demanding that clothing from ordinary cloth, sacks, canopies, bedspreads, tablecloths, sashes for the waist, belts, cords, and other things be made for them for trade and commerce without pay."[21]

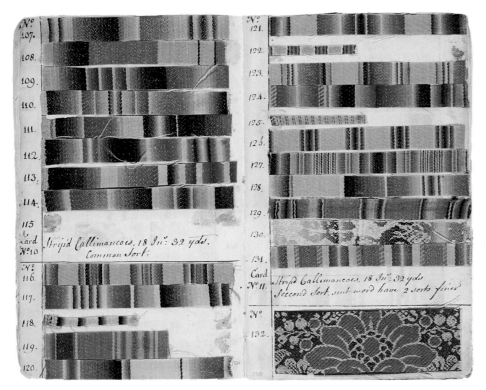

FIG. 11-1
Pattern book with samples woven for textile manu-
facturer John Kelly (sent to Spain and Portugal),
Norwich, England, 1763. Worsted wool mounted on
paper, 10⅝ × 13 inches (27 × 33 cm). Victoria and
Albert Museum, London, Gift of Mrs. Bland, 67-1885

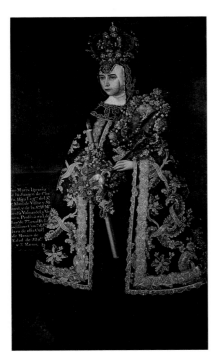

FIG. 11-2
José de Alcíbar (Mexican, active 1751–1803),
Sister Maria Ignacia de la Sangre de Cristo, c. 1777.
Oil on canvas, 70⅞ × 43 inches (180 × 109.2 cm).
Museo Nacional de Historia/CONACULTA,
INAH, Mexico City

Neither Spain nor Portugal was able to meet the Latin American elites' demand for finely woven wool cloth. The textiles they produced were similar to those made in the native *obrajes*—dark, heavily textured, and poorly made. Between 1723 and 1744 the royal manufactory at Guadalajara, Spain, unable to sell all of its output at home, sold the remainder in the colonial market for much less than its transportation costs.[22] The textiles compared poorly to the lighter woolen and worsted cloth made in England, such as the brilliantly colored striped and patterned Norwich Stuffs (fig. 11-1) that were exported to Iberian ports and then re-exported to Latin America. English woolen goods were exchanged for Portuguese port wines and entered the Portuguese-controlled harbors duty free before being shipped to the Spanish colonies as contraband. Other English textiles—including the fine-textured, lightweight wool called "Spanish" cloth that was manufactured in Wiltshire from imported Spanish dyed wool—were exported to the West Indies and indirectly to Spanish America. A French report from 1686 noted that the Dutch shipped camlets, Leiden wool *lakens* and *says*, and Indian cotton cloth via Curaçao to Spanish South America and sent the same cloths (though lighter-weight Dutch brocades and silks were substituted for the heavier camlets) to Mexico via Cádiz.[23]

SILK

The demand for luxury fabrics in colonial Latin America placed a heavy burden on the Spanish silk industry despite it being second in size to that of Italy until the middle of the seventeenth century. In an attempt to offset the inflated price of silk in Spain, the crown introduced sericulture into Hispaniola at the beginning of the sixteenth century.[24] By 1526 a silk workers' guild had been established in New Spain, and a domestic silk industry developed between 1531 and 1580. The arrival of the first shipment of Chinese silks via the Philippines in November 1573, however, signaled its decline and eventual demise as a viable industry. A major component of the Manila Galleon trade through Acapulco was based on the exchange of Chinese silks for Mexican silver, and by 1592 China was the major source of silk in New Spain. Periodically throughout the seventeenth and eighteenth centuries restrictions were placed on the shipment of silk from Mexico to Peru to protect the Spanish silk industry, which had struggled since the end of the sixteenth century to maintain its ascendancy in the face of an economic depression and French competition. During the mid-eighteenth century the Spanish silk industry underwent a revival under the guidance of French weavers and began to produce textiles modeled on those of Lyon, the center of French silk weaving, which meant Spanish silks could replace the French in Latin America. A likely example of Spanish manufacture during this period is the silver brocaded silk worn by the crowned nun Maria Ignacia de la Sangre de Cristo in the painting by José de Alcíbar from about 1777 (fig. 11-2). It is nearly identical to a silk with a Spanish provenance in the collection of the Centre de Documentació i Museu Tèxtil, Terrassa. The heavy gold- and silver-brocaded silks shown in portraits of the Latin American elite were likely the products of Spanish factories such as the Toledo manufactory of Molero, established in 1714, that specialized in such silks, including those used for vestments originally in the cathedral of Mexico City (cat. 11-7). A small amount of silk continued to be woven in Mexico City

during the eighteenth century, and samples are included in the previously mentioned manuscript report by the *visitador* José de Gálvez (fig. 11-3), which probably was prepared in response to a directive from the crown forbidding the manufacture of any goods that would compete with Spanish production, including textiles. The report indicated that there were just a few looms operating in Mexico City, producing only limited amounts of silk fabric, most commonly *rengues* that included strands of metallic or colored threads and ribbons (*listones*). Amerindians kept raising small amounts of silk for their own use or for small-scale trade. Toward the end of the eighteenth century wild silk and forest silk were woven into articles of native dress such as handkerchiefs, shawls, and sashes in southern Oaxaca.

DYES

The cultivation of and trade in the native dyestuffs of cochineal, indigo, brazilwood, and logwood (*campeche*) provided the Spanish and Portuguese with profitable exports. Cochineal was the most valuable export commodity in New Spain after silver.[25] Obtained from a type of female beetle found on different varieties of cacti, the extraction of cochineal was extremely labor intensive. The dye was first exported to Europe in 1518 from Mexico, where it had been used since antiquity. Shortly thereafter cochineal supplanted kermes, obtained from the dried bodies of female insects living on the Mediterranean kermes oak, as the preferred red dye. Cochineal was highly prized by the European luxury textile industry for its rich color and fastness, and cochineal-dyed cloth was used by the nobility, the church, and for military uniforms.

Although a wild indigo, called *xiquilite* by the Mayas, had been used in Central America since antiquity, the Spanish introduced plantation production in the Yucatan, El Salvador, Nicaragua, and Guatemala. By the early seventeenth century indigo had replaced cacao as Central America's leading export, and it was the Kingdom of Guatemala's most important commodity through the eighteenth century, destined principally for the Peruvian and Spanish markets, whence it went mostly to England and Holland.[26]

The dyewoods—logwood and brazilwood—were also important exports. A black to blue dyestuff extracted from the former, the heartwood of a tree native to Central America and West Indies, was used to dye inexpensive textiles. The right to cut and export logwood was a source of conflict between the Spanish and British during the seventeenth and eighteenth centuries.

FIG. 11-3
Page from manuscript on Mexico City's silk weaving and textile stamping industries, Mexico City, 1783. Paper, silk weaving, textile samples sewn onto pages, 12 × 8½ inches (30.5 × 21.6 cm). Brooklyn Museum, Carll H. de Silver Fund, 44.188

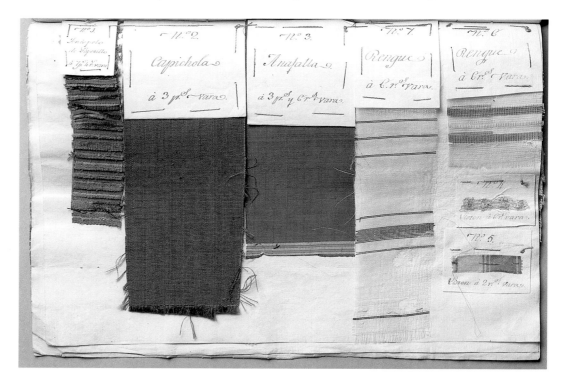

Brazilwood, as its name implies native to Brazil, contains the coloring matter brazilin, which was used to dye red, although it is not a stable dyestuff.

FEATHERWORK, EMBROIDERY, AND NEEDLEWORK

The native peoples of Latin America had long decorated cloth with pigments, dyes, a variety of weaving techniques, featherwork, and simple embroidery stitches, likely a type of running stitch. The most valued art form in pre-conquest Mexico was featherwork, in which feathers were employed in elaborate decorations for the clothing and the textiles of the ruling classes. The skills were preserved under the Spanish and taught in convent schools such as San José de los Naturales, run by the Franciscans. Instead of producing such items as headdresses, shields, and cloaks, the skills of indigenous artisans were redirected to the service of Christianity, and feather mosaic work was combined with other materials for religious pictures, portable altars (cat. III-3), chalices (cat. III-4), and bishop's miters (cat. II-1).

According to the Franciscan missionary Toribio de Benavente Motolinía, writing in 1528, European embroidery techniques were taught to the Mexicans by a brother Daniel, a lay Italian from Santiago, Spain, and a master embroiderer. Other embroiderers from Europe soon followed, and in 1546 an embroiderers guild was founded in Mexico City; like its Spanish model it regulated the organization of the workshops and embroidery materials and techniques. The examination for master embroiderer was open to both Spanish and Amerindian men, although the latter were not permitted to work with gold. It included embroidering an image using shaded gold for the hands, feet, and face, and another image done in silk. Those taking the exams paid the inspectors for the privilege, as they had in Spain, with the indigenous people paying half the amount. The most expensive and elaborate embroideries from colonial Latin America that survive are church vestments, some of which were paid for with tithes and alms or donated by wealthy individuals. Many of the sets of ecclesiastical vestments and furnishings are as resplendent as the churches and cathedrals in which they were used. Those supplied to the cathedral of Mexico City are well documented and include sets made in New Spain as well as ones commissioned in Spain, often as gifts to the church. The most magnificent group to survive was executed in Spain for the cathedral by the Sevillian master embroiderer Marcus Maestre between 1623 and 1627 (cat. II-6).[27] Male convents included among their members master embroiderers who made new vestments and repaired the old.

Female convents also instructed their members in embroidery and needlework and provided much of the plain sewing and white-work (see cat. VI-114) for the church, such as embroidered albs and altar cloths. Several female convents were particularly known for their embroideries. The novices from the convent of La Concepción in Mexico City embroidered large silk medallions (*escudos de monjas*) that they wore on the day they took the veil. The famous Dominican convent of Las Rosas in Puebla, founded in 1602, was known for sets of vestments embroidered with musical angels by its members. In Quito, sets of vestments were also commissioned from China and from the Philippines, from Sangley embroiderers of mixed Chinese and Filipino ancestry

FIG. II-4
Shawl (cat. II-12, detail)

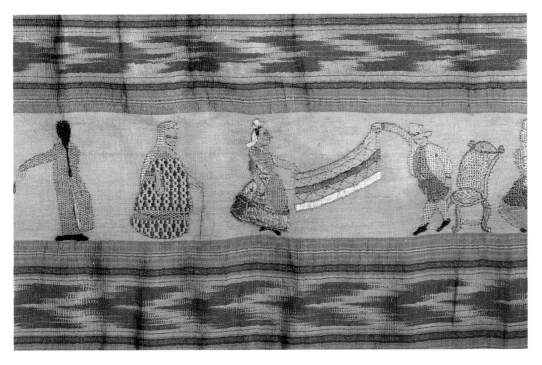

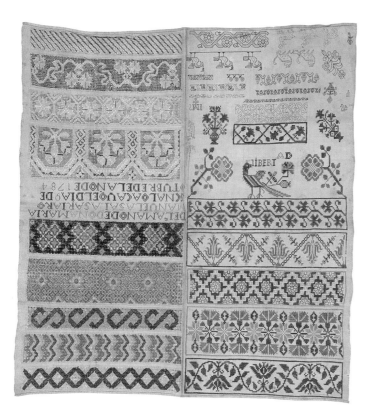

FIG. II-5
María Manuela Salasar (Mexican), Sampler, 1784.
Silk embroidery on linen with cut work. Philadelphia
Museum of Art, Gift of Beatrice B. Garvan, 2000-8-3

(cat. II-10). In Chile, a part of the Viceroyalty of Peru, vestments for the cathedral in Santiago of about 1750 attributed to the Munich-born embroiderer Benito Gainer, of the Calera de Tango workshops founded by the Bavarian Jesuits, are modeled on Bavarian rococo-style embroideries.

Proficiency in embroidery and needlework (fig. II-4) was part of a young woman's training in the domestic arts, and in the colonial Americas, as in Europe, these skills were taught from a very young age.[28] In New Spain the most affluent girls were tutored at home, while girls from middle-income families attended *escuelas de amigas*, where instruction ended at age 10 and was limited to teaching the recitation of prayers, catechism, and needlework exercises. Orphan girls attended academies, the first of which was established in 1543, where they were taught embroidery, sewing, and spinning flax and wool among other skills. It was only in the mid-eighteenth century with the establishment of an academy by the Society of Mary that reading and writing became part of a girl's education. In 1755 the first free public girls' school was established in Mexico City by the nuns of the Enseñanza (Colegio del Pilar), and it instructed its students in reading, writing, and needlework. Extant samplers (fig. II-5) show the extensive range of decorative stitches taught to the girls. Similar educational establishments existed throughout colonial Latin America, primarily for orphan and mixed-race girls, who were taught sewing, mending, design, cutting, white-work, silk-work, knitting, and other needlework. Needlework was taught to girls who entered convents, where they also learned skills such as making artificial flowers that could be marketed outside of the cloister.

LACE

Commenting on the economic impact of the lace trade in his *Theory and Practice of Commerce and Maritime Affairs*, Don Gerónimo de Uztáriz observed that "many families [have] been ruined by the great quantities of fine lace and gold stuffs they purchased of foreign manufacture, by which means Spanish America is drained of many millions of dollars."[29] More detail is provided in *A Voyage to South America*, in which Jorge Juan and Antonio de Ulloa describe their travels between 1735 and 1744 to Cartagena, Porto Bello, Panama, Guayaquil, Quito, Lima, and Concepción, and include intriguing observations on the dress worn by the inhabitants. One of the distinguishing features was the profusion of lace that trimmed women's garments, edging sleeves, the necklines of shifts, and the bottoms of petticoats. On the clothing of the inhabitants of Lima, the travelers commented: "In the choice of laces, the women carry their taste to a prodigious excess, nor is this an emulation confined to persons of quality, but has spread through all ranks, except to lowest class of Negroes. The laces are sewed to their linen, which is the finest sort, though very little of it is seen, the greatest part of it, especially in some dresses, being always covered with lace; so that the little which appears seems rather for ornament than use. These laces too must be all of Flanders manufacture, no women of rank condescending to look on any other."[30] In Spain and other European countries, lace motifs were appropriated as decorative elements for textiles and other decorative art forms. In Latin America, with European influences, lacelike patterns were woven into Andean tapestry borders and women's mantles and appear in Mexico in Talavera ceramics (cat. I-29). The colonial market was a major outlet for the Flemish lace trade conducted primarily through Cádiz. The Antwerp firm Van Lidth de Jeude, for example, exported lace via Cádiz with a final destination of Veracruz, Mexico.[31] Flemish lace was also exported through Cádiz by foreign merchants, including English and French trading houses. Different styles of lace were designed for specific

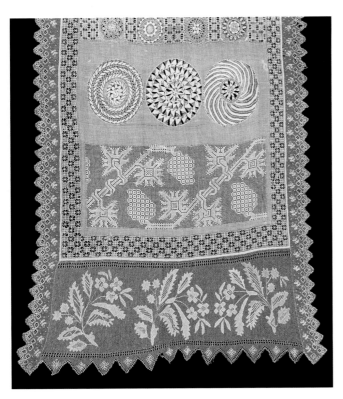

FIG. II-6

Cloth (detail), Argentina, late eighteenth to early
nineteenth century. Linen needle-lace; filet and
drawn thread work, 88 × 29 inches (223.5 × 73.7 cm).
Philadelphia Museum of Art, Purchased with the
Offertory Fund, 1923-69-1

markets; Spain and its colonies particularly favored narrow edgings and
boldly figured guipure. The colonies were also used as an outlet for lace
designs no longer in fashion and otherwise unsalable on the Continent.

Latin America also carried on an extensive lace trade with France.[32]
Great quantities of mignonette, an inexpensive linen thread lace edging,
were exported in the early eighteenth century from Saint-Malo and Mar-
seilles, by way of Spain. Later in the 1750s and 1760s Italy exported similar
lace edgings made on the Ligurian coast as well as black lace and guipure.[33]
A French lace (similar in style to Valenciennes) made in Le Havre was
exported to Peru in large quantities. The Le Puy lace trade with the Spanish
colonies developed as a means of recovering from the economic recession
of the early eighteenth century. Densely figured, Le Puy lace was similar in
design to the seventeenth-century-style Antwerp lace for the Spanish market.
A sample book dated July 1752 in the archives of a Haarlem firm contains
sixty-two examples of single mesh ground straight lace samples for Mexico.[34]
Gold and silver metallic laces that feature prominently in late seventeenth–
eighteenth-century Latin American paintings (cat. vi-99) were made in
France and exported in enormous quantities through Saint-Malo. During
the second half of the eighteenth century, Spanish silk and thread lace from
Barcelona and Seville copying styles of Flemish lace but inferior in quality
and design were exported to Spanish America. Lace making was also taught
to young women in schools and lace was also produced in convents. Several examples of altar
cloths (fig. II-6) from Argentina made in convents testify to the sophistication and fineness
of needle-lace and embroidery.

Independence brought dramatic change to Latin American textile production, and
industrialization replaced artisanal work as the countries entered the global market.

NOTES

1. *Codex Mendoza*, Bodleian Library, Oxford
 University; *El primer nueva corónica y
 buen gobierno*, Det Kongelige Bibliotek,
 Copenhagen.

2. Jameson 2004.

3. One of the early studies is Boyd-Bowman
 1973.

4. See Phipps 1996; and Phipps's contributions
 to Phipps et al. 2004.

5. Sayer 1985 is an excellent overview of pre-
 conquest costume and textiles.

6. Berdan 1987.

7. Cortés 1986, p. 101.

8. Ibid., p. 45.

9. Gemelli Carreri 1699/1927, pp. 74–75.

10. Manuscript now in the Brooklyn Museum;
 see Fane 1996, cat. no. 20, pp. 100–101.

11. Thomson 1992, p. 66.

12. Montgomery 1970, p. 102.

13. Fisher 1981, p. 36.

14. Dusenberry 1947.

15. Phipps 2004 "Cumbi."

16. Ibid., p. 80.

17. For discussion of cotton textile production
 by women, see Villanueva 1985; and Bochart
 de Moreno 1995.

18. The classic studies are: Salvucci 1987; and
 Miño Grijalva 1993.

19. Gage 1648/1958, p. 50.

20. Bazant 1964, p. 64.

21. Guamán Poma de Ayala 1615/1980.

22. La Force 1964, p. 355.

23. Israel 1989, p. 316.

24. Borah 1943.

25. Donkin 1977; Lee 1948; and Lee 1951.

26. Smith 1959.

27. Litto Lecanda 1999.

28. Gonzalbo Aizpuru 1990.

29. Uztáriz 1751.

30. Juan and Ulloa 1748/1964, p. 196.

31. Levey 1983, p. 48.

32. Ibid., p. 56.

33. Ibid., p. 62.

34. The Haarlem firm is of Wilhelm Philip
 Kops. Ibid., p. 55.

154 DILYS E. BLUM

Dressing Colonial, Dressing Diaspora

Gridley McKim-Smith

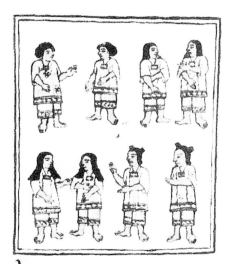

*V[...] las [...] de poner [...]
c[...] [...] colorado, [...]
[...] [...] [...] [...]
[...] [...] [...] [...]
[...] los pies, [...] mismo [...]*

FIG. 11-7

Bernardino de Sahagún (Spanish, c. 1500–1590), *cueitl* and *huipil*, from *Historia general de las cosas de Nueva España (Codex Florentino)*, late sixteenth century. Biblioteca Laurenzio-Medicea, Florence; reproduction from facsimile (Mexico City: Editorial Aldus, 2001)

It is said that clothes express power. Images from Mexico and the Andes, called the Viceroyalties of New Spain and Peru, however, demand more sensitive description. Clothing in Latin America voiced power with many inflections, including politics, race, wealth, gender, and, especially among the Creoles, or Spaniards born in the New World, the experience of living in a diaspora. The Spaniards who moved to the colonies exhibited a sense of displacement from their homeland in the way they dressed even after they became landed gentry in a new world. A nuanced reading of the images—for this essay deals with images of clothing, not with real garments—shows that what is at stake is often not so much power as differentiation, the desire to establish an identity that is recognized as separate, apart, or different, although power may also flow from such difference.

Clothing figures prominently in the history of Latin America. Moctezuma's gifts to Hernán Cortés during their first official exchange in 1519 included garments.[1] In Peru clothes were so important they could get you killed: during the indigenous uprising in 1781–82, a mule driver was hanged because he wore an Inca tunic, which publicly proclaimed his allegiance to the rebel chieftain Tupac Amaru II.[2] Clothing was a means of picturing the world, and as a metaphor it extended to animals and furniture. In the eyes of a Spaniard visiting Tlaxcala, Mexico, in 1640, "dressing" animals vivified them and endowed them with charisma. Describing the entry of the viceroy, he wrote: "They had a richly dressed horse for him, with trappings embroidered in the same gold and amber as the viceroy's dress."[3] Similarly, the *huacas* (sacred objects) in the Andes that the Spanish denounced as idols wore fine garments, which were made especially for them,[4] and clothing formed a part of most sacrifices to the pre-conquest gods.[5]

The conquistadors believed that clothing in the Americas, as in Spain, was crucial, as Patricia Rieff Anawalt points out in her survey of Mesoamerican clothing.[6] As early as 1579–85, a questionnaire for Spanish officials in New Spain, circulated by order of Felipe II, specifically asked "with whom they fought wars, and their manner of fighting; their former and present manner of dressing."[7] The most informative records in this regard come from missionaries, and especially from the Franciscan Bernardino de Sahagún's *Historia general de las cosas de Nueva España*, written from 1547 to 1579, which represents what an anthropologist might

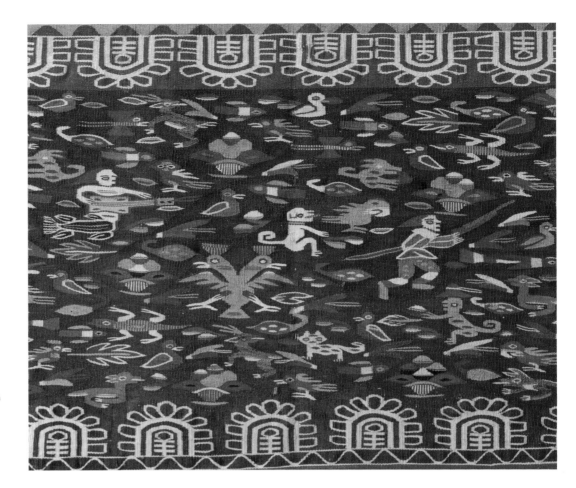

FIG. 11-8
Tapestry mantle (detail of mermaid, imperial eagle, and lace), Lake Titicaca Region, Bolivia, late sixteenth or early seventeenth century. Tapestry weave, cotton warp and camelid, metallic, and possibly *vizcacha* hair weft, 43½ × 47½ inches (110.5 × 120.7 cm). National Museum of the American Indian, Smithsonian Institution, Washington, D.C.; 05/3773

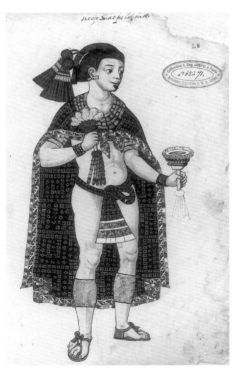

FIG. 11-9
Nezahualpilli wearing *maxtlatl* and *tilmatli*, from *Codex Ixtlilxochitl*, Mexico, sixteenth century. Pigment and ink on paper, 12¼ × 8¼ inches (31 × 21 cm). Bibliothèque Nationale de France, Paris

call fieldwork on Aztec culture. According to Sahagún, women in the Valley of Mexico wore a skirt, or *cueitl*, and a sleeveless blouse, or *huipil* (fig. 11-7).[8] The Dominican Diego Durán reported in 1579–81 that these blouses were elegant (*galanas*) and "embroidered in different colors and designs, with featherwork on the front; insignia done in colored thread; and on the back some of them bore embroidered flowers; others, imperial eagles."[9] Durán's account shows that already European motifs like the imperial Habsburg eagle had found their way into the native design vocabulary. In the Andes, examples of indigenous appropriation of European designs in the late sixteenth and early seventeenth centuries appear in a wedding mantle depicting Adam and Eve in the Staatliches Museum für Völkerkunde, Munich, and in a wedding mantle with mermaids, lace, and an imperial eagle from Lake Titicaca (fig. 11-8).

Clothing for Mexican males often expressed profession and social standing. For the Aztecs, as well as for other groups, there were elaborate warrior suits made of feathers and a *tilmatli*, or cloak, which Nezahualpilli, the ruler of Texcoco, wears in an illustration from the *Codex Ixtlilxochitl* (fig. 11-9).[10] Nezahualpilli's *tilmatli* is long, as befits a monarch. The Aztec loincloth, or *maxtlatl*, was the primary and indispensable masculine garment, worn by men of all ranks; the loincloth was also worn by the Tlascalans, Tarascans, Mixtecs, and Maya. While the number of early drawings of garments from Peru is tiny compared with what was produced in New Spain, in view of the extraordinary attention given to textiles in the Andes, it is nonetheless clear that cloth and clothing were important in that region as well. Felipe Guamán Poma de Ayala's drawing *Manco Capac Inca* (fig. 11-10) shows the fundamental Andean male garment: the *uncu*, a tunic described by the Spaniards as a kind of shirt that reached to the knees or a little higher.[11] It was often decorated with woven *tocapu*, the abstract square and rectangular designs that appear here around the waist. Over the *uncu* men wore a *yacolla*, or large rectangular mantle.[12] This untailored cloth was fastened with a *tupu*, or metal pin, at the shoulder, and a wide belt, or *chumpi*, could be tied around the waist.

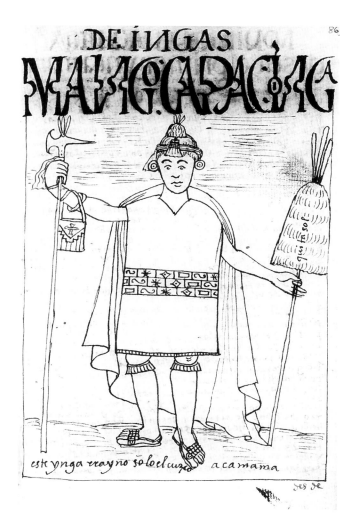

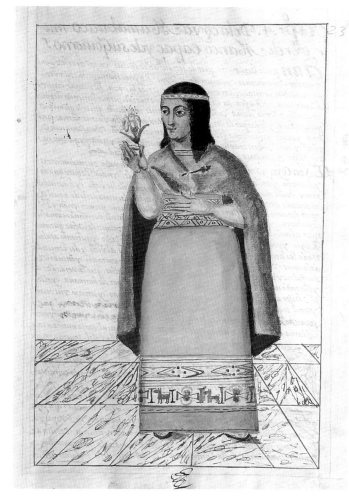

FIG. II-IO

Felipe Guamán Poma de Ayala (Andean, 1534–1615),
Manco Capac Inca (The first Inca), from *El primer
nueva corónica y buen gobierno*, 1615. Ink on paper,
book: 5¾ × 8 inches (14.5 × 20.5 cm). Det Kongelige
Bibliotek, Copenhagen

FIG. II-II

Martín de Murúa (Spanish, c. 1525/35–1618), *Coya
Mamahuaco*, from *Historia general del Perú*, 1611–13.
Handmade laid rag paper with pigments and ink,
12 × 8 inches (30.5 × 20.3 cm). J. Paul Getty Museum,
Los Angeles

In high-status garments, fineness of weave was crucial, and the tapestry-woven fabrics, or *cumbi*, of the Andes are famous for their complexity. Hundreds of finely spun yarns were tightly packed together, surfaces were perfect, and the finishing meticulous. The high quality of *cumbi* also depended on the superiority of Andean yarns and dyes. Spaniards introduced European sheep's wool to the region, but its shorter, curlier fibers made a fuzzy yarn unlike the silky, long-fibered alpaca. Weavers left the warp loops intact when they took the fabric from the loom, chaining the loops together to form the two finished edges; this required calculating dimensions and design before weaving and allowed for no margin of error. Whether used in mantles, *uncus*, or even as a ceremonial coca bag, *cumbi* were finished on both sides, and embroidery stitching was double-sided, too, producing a garment that was identical inside and out. Such craftsmanship and attention to quality—deeply held values, both—expressed notions of completeness and complementarity, as if indicating a gift to the gods or to an important individual. Men's mantles were generally not as finely woven as women's, although the meaning of that difference is unclear. A woman's mantle, or *lliclla*, was worn over an *anacu*, or long tunic, such as that seen in Martín de Murúa's painting *Coya Mamahuaco* (fig. II-II), and was fastened with a *tupu*. The woven pattern toward the bottom of Mamahuaco's *anacu* is horizontal, an orientation unique to women's garments. A woman's *lliclla* specified her place of origin, region, clan, and marital status.[13] An example of how a textile communicated such biographical information is the Inca *anacu* in the Museum of Pachacamac, which displays broad fields of bright color, intricate patterning, and high-quality weaving, suggesting that it is a ceremonial garment worn by one of the "chosen women" who spun, wove, and made *chicha*, the ritual drink; these women were categorized according to status, age, and beauty, and each category was associated with specific colors.

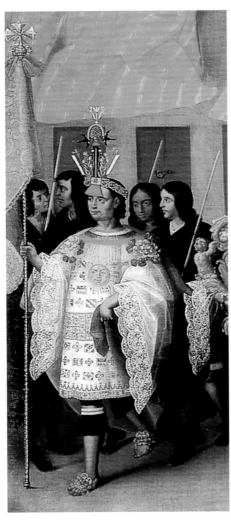

FIG. II-12

Circle of Basilio de Santa Cruz Pumacallao, *The Parish of Saint Sebastian* (cat. VI-73, detail)

Although eroticism can be present in clothing, in the Spanish empire female sexuality was equated with promiscuity, and Spanish women were instructed to cover themselves. There is a profound difference between the original dress of Inca women as reported by an early observer and the dress they wear in colonial images, as pictures of Inca clothing were self-censored. Martín de Murúa, for example, drew the portrait of the mythologized queen as if her *anacu* were a prim skirt that completely covered her genitals and legs. But as the scandalized priest Bernabé Cobo noted, in real life this wraparound skirt was left open from the waist: "although one edge [of the skirt] overlaps a little, when they walk they come apart from the *chumpi* or sash on down, revealing part of the leg and thigh."[14] This opening could show more or less as a woman moved, and it might have revealed even more than Cobo reported. None of the published observers of dress in the Americas were women; while a male author could, and did, comment that Andean men wore loincloths beneath their *uncus*, he did not say whether Andean women wore underwear. In any event, Friar Cobo was relieved to point out that by his own time, "because they are Christian they display more decency" and the women "sew and close the side [of the skirt]."[15]

Friar Cobo betrays a different but equally telling prejudice in his description of Andean dress: "They use simple clothes, without putting one on top of another, and they are made with so little design, that they are not cut to order, nor do they have need of scissors."[16] His dismissive judgment is not surprising, given the history of Western clothing. Since the Renaissance, there has been a bias in the West in favor of tailored clothing or *couture* (literally, "cutting") as a manifestation of higher civilization. This relegates most non-Western clothing to the category of "primitive." As Elena J. Phipps has pointed out, however, beginning with the Spaniards there has been a history of overlooking the highly developed cultural meanings incorporated into Andean weaving, which included a respect for the integrity of the textile that led Inca artists to weave garments that were perfectly finished on all sides, so that not even the threads were cut.[17] Andeans did not rely on cartoons but rather used memory techniques to produce a pattern, thread by thread, preserving particular color combinations and design templates to indicate, for example, administrative rank. Women's *llicllas* showed regional affiliation in technical details such as the treatment of the center versus the outer edges, the spin of the yarn, and the color, design, and striping sequence. The size and position of the color fields also varied to show whether a garment was intended for festival wear or for mourning.

As Durán's description of a *huipil* decorated with a Habsburg double eagle makes clear, the Spanish conquest had an immediate effect on indigenous dress. Although our view of native dress in the colonial period is inevitably clouded by the agendas of the early viewers who described and depicted it, so there is no ready access to what people wore, a few patterns are discernable. Some indigenous garments, like the *huipil* in New Spain, seem to have survived colonization, and they appear in inventories or paintings from the time of the conquest onward. Those who required inventories, however, had attained a certain level of wealth, and a painted portrait also implies prosperity. Many Native Americans did not achieve the material riches enjoyed by the Creoles, so their indigenous clothing may not always be recorded. Equally important, a portrait is a calculated representation of a sitter, not a snapshot of his or her appearance in everyday life. The images in this or in any exhibition therefore present a highly selective picture of a society. Based on surviving representations, however, we can draw some general conclusions about the fate of indigenous clothing in the colonies.

In the colonial world, changes of dress traveled almost exclusively in one direction. Judging from portraits and records, the garments of the dominant Spanish were appropriated by natives in the Americas, but Spaniards rarely flaunted native clothing, at least not initially. Instead, the Creoles, who were concerned to demonstrate their Spanishness, often exaggerated the Iberian elements in their dress.

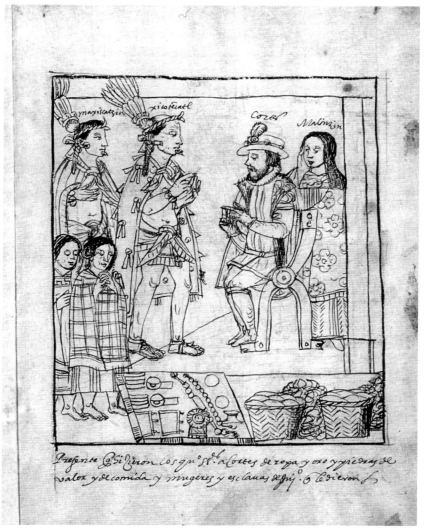

FIG. 11-13
Cortés and Marina with Tlaxcalan Lords and Ladies,
c. 1584/85. Pen and ink on paper, bound with Diego
Muñoz Camargo (Mexican, sixteenth century),
*Descripción de la ciudad y provincia de Tlaxcala de
las Indias y del Mar Océano para el buen gobierno y
ennoblecimiento dellas*, 1581–84. Special Collections
Department, Glasgow University Library, Scotland

There seem to be survivals of ancient Inca dress on display in the clothing worn by participants in the feast of Corpus Christi at Cuzco, recorded in a painting of 1675–80 (fig. 11-12), but these are visible only in the garments worn by Andeans, which are composites of pre-conquest and colonial elements, as Carolyn Dean has suggested.[18] The *mascapaycha*, or scarlet fringe, on the forehead of the standard-bearer (*alférez real*) at the far left may have kept its correct form of threads of dyed red wool, but its meaning has expanded from signifying legitimate descent from the ruler to a more general claim of political authority.[19] Teresa Gisbert has pointed out that the *uncu*, pectoral, knee fringe, and headdress are based on pre-conquest dress, while the medallion in the shape of the sun and the masks worn on the shoulders and feet are colonial inventions.[20] As Isabel Iriarte has noted, the *tocapu* motifs that decorated the *uncus* in pre-conquest times have proliferated to cover formerly blank areas, and their emphasis signifies elite Inca membership.[21] Obviously, the sleeves with Flemish lace are a Spanish status indicator. Whether because of the appealingly abstract design of European lace or because of its prestige value, isolated fragments of lace appear in other indigenous creations, specifically in native tapestry mantles (see fig. 11-8). In these mantles the motif is so graphic that it looks Andean, and full lengths of lace also appear on the sleeves of the costume of the standard-bearer from the parish of San Sebastián (see fig. 11-12). When the Frenchman Amédée Frézier made his voyage to the New World in 1712–14, he spoke of women in Lima who adorned their silks "with a prodigious Quantity of Lace" and reported that "even their very Smocks . . . are full of Lace; and their Prodigality extends to put it upon Socks and Sheets."[22]

What did Iberian dress look like in the sixteenth and seventeenth centuries? The garments of the invading Spaniards were absolutely different from the clothing of the Native Americans. This is particularly visible in the late sixteenth-century work *Cortés and Marina with Tlaxcalan Lords and Ladies*, which shows Cortés seated with his translator Marina standing behind him (fig. 11-13).[23] Cortés's white linen shirt, or *camiseta*, shows at his wrists, and the *jubón*, the standard garment that covers his torso, is drawn somewhat loosely here. Cortés wears a ruff and a short cape or *bohemio*, and his thighs are covered by *calzones* or *valones*, ancestors of modern trousers. His boots resemble leather *borceguíes*.

Iberian dress for women appears in *The Annunciation of the Birth of Saint Francis*, a late seventeenth-century painting by Juan Zapoca Inga (fig. 11-14).[24] An outer corset, or *cuerpo*, was worn over a *camisa*, a linen shirt with a high neckline that did not reveal cleavage. The desired silhouette for the torso was smooth and hard, and in Spain a leather undergarment stiffened with splints or cardboard produced it.[25] The sheer volume of fabric in the detachable sleeves and enormous skirts demonstrated financial power, and since the skirts insulated the body from contact with the world, they further emblematized sexual chastity. The skirts were supported by a notorious substructure, called a *verdugado* or *guardainfante*, made of willows, wood, bone, or metal. These farthingales were sometimes worn in Latin America into the eighteenth century,[26] beyond their fashion life in Europe, revealing an antiquarian tendency that is characteristic of Creole dress and that also occurs in other diaspora groups worldwide.[27]

Portraiture operates in a different realm from everyday
life. A woman in New Spain could own and wear a *huipil*, but
to wear a *huipil* in a painting, as Sebastiana Inés Josefa de San
Agustín did for her portrait of 1757, was to make an open claim
of indigenous ancestry (fig. II-15).[28] The cartouche on Sebastiana's
huipil refers by name to her Native Mexican parents, including
her father, who was a *cacique* governor of Santiago de Tlatelolco.
Yet the *huipil* has been so thoroughly Hispanicized here that the
Aztecs depicted in early missionary drawings might not have rec-
ognized it. Originally an open, easily sliding shift, Sebastiana's
huipil has become closed and static, anchored by an undergarment
that shows at the neckline as European lace, with sleeves trimmed
with more lace and then decorated with pearls and jewels, all in
response to Spanish styles.

The painting's date corresponds to Sebastiana's admission
to a convent for native nobility in Mexico City, making this an
indigenous version of a crowned nun (*monja coronada*) portrait
(see cat. VI-65). Beautiful examples of Creole subjectivity, paint-
ings of crowned nuns in Mexico reflect a Spanish ritual of religious
profession that has been carried a step further through the develop-
ment of especially elaborate clothing and the institution of a new
genre of painting to mark the occasion. The Creoles took a very
Spanish tradition and inflated it, and their hyperbole is another
colonial marker. In what seems an unconscious appropriation of
indigenous custom, their portraits feature quantities of flowers,
whether real or artificial; according to Durán, flowers had played
an important role at the Aztec court.[29] The prominence of flowers
in traditional local life combined easily with European tradition,
resulting in abundant flowers in sixteenth-century Christian reli-
gious processions throughout Latin America.[30]

By the last decade of the seventeenth century, the majority of well-known artists around
Cuzco were natives rather than transplanted Europeans, as had been the case earlier.[31] Never-
theless, paintings of the Virgin from this time show European, not Andean, garments (see
cat. VI-98). Yet these paintings assertively reinterpret Spanish court dress. In the example
mentioned, the luxury of the mantle is extreme: ropes of pearls encircle it not in single strands
but in swags; fine Flanders lace hangs from the wrists in spendthrift abundance; and lace also
forms the bottom edge of the petticoat beneath the mantle. The source of this clothing can no
longer truly be called peninsular Spain because in reality it is largely, if somewhat exaggerat-
edly, Creole. The Creoles, despite their grievances, had by now become powerful members
of Peruvian society. Knowledge of peninsular dress styles was filtered through them, and their
traditions were both hyperbolic and conservative. These paintings do not show eighteenth-
century fashion in either Cuzco or Madrid; the wide skirt derives from the farthingale. The
Virgin was the Queen of Heaven, and her clothing resembles the wardrobes of European
queens and nobles—but from the past.[32] These paintings, furthermore, often depict *statues*
of the Virgin. In Europe a painting of Mary was more likely to depict the divine lady as a
miraculous apparition, as palpable reality despite her divinity. Although cheap Spanish prints
of popular statues did travel to the New World and may have strengthened the developing
tradition of statue painting in Latin America, that tradition took on an independent life. In
the example cited above, the artist has made sure we understand that we are seeing a sculpture
rather than a deity: the pedestal at the bottom of the image casts a shadow.

The statues in these paintings are fictive, but real sculptures wearing real clothes also existed. In a statue by Caspicara, one of South America's greatest artists (cat. v-25), the Virgin's clothing is not contemporaneous, or even permanent, because *imágenes vestidas* were constantly re-dressed. Only the head and hands, the areas not covered by clothing, were finished. Beneath the gorgeous garments was an undeveloped form instead of a sculptured body with breasts, buttocks, and legs. This makes it very clear that identity could be transmitted perfectly adequately by clothing, rather than by the body, which could be abbreviated and thereby elided.[33]

Throughout the colonial period the Creoles and peninsulars in the Viceroyalties of New Spain and Peru were careful to set themselves apart from the natives by wearing clothing that was Spanish rather than indigenous. Imports from elsewhere might be adopted—silks from Asia, lace from Flanders—but the basic structure of Spanish costume was usually preserved, especially on public occasions. When the town council, or cabildo, of Mexico City organized a "serious parade" in 1711 at the birth of a new *infante*, the prince in Spain, they required a group called the Gentlemen of the Republic to wear "el sombrero con penacho de pluma á la española y borseguis [*sic*]" (the hat with a bunch of feathers, Spanish style, and antique-type boots).[34] *Borceguíes*, or boots like those worn by Cortés in *Cortés and Marina with Tlaxcalan Lords and Ladies* (see fig. 11-13), were an archaism in 1711 and had not been worn in Spain for generations. These gentlemen had also to wear a hat with a bunch of feathers *a la española*, so they were Hispanized literally from head to toe.

Members of the cabildos in the capital cities of both Mexico and Peru were mostly Creoles. While their wives might wear indigenous blouses at home, when on view in a portrait,

FIG. 11-15
Portrait of Sebastiana Inés Josefa de San Agustín, 1757.
Oil on canvas, 22⅞ × 18¾ inches (58.1 × 47.6 cm).
Museo Franz Mayer, Mexico City

such as the Countess of Monteblanco's (cat. vi-104), they would divorce themselves from Peruvian dress. In this display-conscious hemisphere, clothing was important in creating the public version of the self. Unlike Sebastiana in her portrait (see fig. 11-15), a Creole woman would insist on posing as a noble Iberian—except that only a colonial would display a coat of arms, an antiquarian detail that clearly places the countess in a diaspora. Creoles had developed a transnational identity, a sense of themselves as Mexicans or Peruvians as well as subjects of the Spanish empire, and that double identity was sometimes communicated through their dress.[35] This behavior was complex and could seem contradictory. Colonials could dress hyperbolically to show New World identity, as the Countess of Monteblanco did in her obsessive lace, or they could revive a discarded Spanish dress code, as the cabildo did with their hats and boots from the glory days of empire. Joe Cleary and Claire Connolly have noted that "there are broadly two approaches to defining diaspora: a traditional paradigm which sees diaspora as produced by some form of . . . uprooting and resettlement outside the boundaries of the homeland . . . ; and a post-modern reading of diaspora by anthropologists and cultural critics, which sees it as expressing modes of 'hybrid' consciousness and identity."[36] The present author sees some aspects of Latin American dress and artworks as displaying a consciousness similar to what is seen in a diaspora. Comparable

FIG. 11-16
The Hernándezes Honoring Their Devotion to Saint Michael Archangel (detail of Sra. Hernández), 1818. Oil on canvas, 35⅞ × 29 inches (91 × 73.5 cm). Museo Soumaya, Mexico City

expressions of complex identity appear in North America, as in Saint Patrick's Day parades in New York and Chicago in which people wear green clothes, drink green beer, play archaic music, and exaggerate their Irish identity in ways that resemble nothing that takes place in Ireland.

Did the Creoles ever embrace a garment that was genuinely hybrid, merging the peninsular and the indigenous into a blended whole? Isabel Cruz de Amenábar suggests that in Chile and the Andes the poncho developed in the seventeenth and eighteenth centuries as such an invention, and Virginia Armella de Aspe claims a comparable place for the sarape in Mexico.[37] Combining the cape from Spain with indigenous mantles, these garments met the needs of the new climate, both physically and politically. Ponchos and sarapes begin to appear in travelers' notes and published engravings in the eighteenth century, often in connection to outdoor life or riding horses, or as an expression of rootedness in the land. These garments seem to be rare examples that crossed classes and were used by both Native Americans and Creoles; as such they are special cases in Latin American clothing.

In our contemporary world it is fashionable to wear exotica. Similarly, in the sixteenth and seventeenth centuries it was briefly modish to appear in court masques wearing clothing that claimed to refer to Inca or Aztec or Brazilian traditions.[38] Yet this took place more in London and Paris than in Madrid. The Spanish court apparently did not share in this public celebration of heathen dress, although they did adopt other items, such as pearls, that came from the Americas. The emperor Carlos V took jackets lined with *plumas de Indias* with him to Yuste when he retired there at the end of his life, but he did not make a point of wearing feather jackets at court.[39]

Fashion in the colonies was set by the peninsulars and by Creoles, and Creoles did not present themselves in portraits wearing American clothing until that became a vogue validated in Europe. Although the hot temperatures of the Caribbean made thin cotton dresses a necessity from the beginning, high-ranking Creoles were not portrayed wearing them. Not until 1797 did the daughters of the governor of Puerto Rico model the frocks that had been very much the rage in London and Paris for more than a decade (see, for example, the portrait by José Campeche in the Museo de Arte de Puerto Rico),[40] and one has to wait until about 1818 to see the routine use of the simple muslin chemise in the Americas (fig. 11-16). Simplicity had its own appeal at the end of the eighteenth century, when revolution was in the air, but the fact that such an unpretentious cotton dress, reportedly from the French Caribbean, had been worn by Queen Marie-Antoinette and by the Duchess of Devonshire established it as desirable in the colonies.[41] Ironically, in France and England it was known as a *robe à la créole*.

NOTES

1. See Cortés 1993, pp. 105–58, for an inventory of the gifts he sent to Fernando and Isabela from Veracruz.

2. O'Phelan 1988.

3. Gutiérrez de Medina 1947, p. 58: "[L]e tuvieron caballo ricamente aderezado, con aderezos del mismo bordado que su vestido de oro y ámbar" (all the translations used herein are the author's).

4. Phipps 2004 "Garments," pp. 16–39.

5. Ibid., pp. 33–34.

6. Anawalt 1981, p. 3.

7. Cline 1972–75, vol. 3, p. 235.

8. Sahagún 2001, *uipilli* in vol. 3, fol. 30v and 31r; Sahagún 1979, vol. 2, fol. 30v and 31r. For *cueitl*, see fol. 31r.

9. Durán 1967, vol. 2, p. 207: "[L]abradas de diversas colores y pinturas y plumerías en los pechos, anchas armas pintadas, con hilo de colores, y, a las espaldas, en otras, ponían rosas labradas; en otras, águilas imperiales."

10. For the *maxtlatl*, see Anawalt 1981, pp. 21–24; for the *tilmatli*, pp. 27–33. For the *Codex Ixtlilxochitl*, see Elizabeth H. Boone's catalogue entry in *Mexico* 1990, cat. no. 124, pp. 274–79.

11. See Cobo 1653/1890–95, vol. 4, pp. 159–61. Cobo was writing around 1610.

12. Phipps 2004 "Garments," pp. 20–21.

13. Ibid., p. 21.

14. Cobo 1653/1890–95, vol. 4, p. 162: "aunque dobla un poco un canto sobre otro, cuando andan se desvían y abren las orillas desde el *chumpi* o fajadura para abajo, descubriendo parte de la pierna y muslo."

15. Ibid., vol. 4, p. 162: ". . . por ser cristianas profesan más honestidad, acostumbran coser y cerrar el lado."

16. Ibid., vol. 3, p. 33: "Usan de ropas sencillas, sin ponerse unas sobre otras, y son hechas con tan poca traza, que no se cortan á su medida y talle, ni tienen necesidad de tijeras."

17. Phipps 1996, p. 156.

18. Dean 1999, pp. 123–24.

19. Ibid., pp. 104–9.

20. Gisbert 1980, pp. 120–24.

21. Iriarte 1993, pp. 54, 71; Dean 1999, pp. 131–40.

22. Frézier 1717, pp. 219, 258–59.

23. See the discussion of this version of the *Lienzo de Tlaxcala* in Berger 1998, pp. 62–66.

24. Cruz de Amenábar 2000, pp. 111–26; Cruz de Amenábar 1996, pp. 45–53.

25. Bernis 2001, p. 214.

26. Their continuation is cited by Cruz de Amenábar 1996, p. 49. Armella de Aspe, Castelló Yturbide, and Borja Martínez 1988, p. 68, report that Viceroy Revillagigedo "hizo que los verdugos salieran vestidos" (commanded that farthingales be worn).

27. Ethnic groups in North America similarly cling to outdated fashions from the homeland, as when Polish-Americans in Philadelphia retain obsolete dances. See Goode and Schneider 1994, p. 93.

28. In their catalogue notes describing the portrait of an Indian noblewoman, Ilona Katzew and Ana Paulina Gómez Martínez mention a 1696 inventory; see Pierce et al. 2004, cat. no. 39, p. 299 n. 7.

29. Durán 1967, p. 333. I am grateful to Sara Morasch for sharing her research with me.

30. As reported by Mendieta 1596/1971, pp. 429–30.

31. Gisbert 2002, pp. 98–143.

32. Webster 2004, pp. 249–71; Duncan 1986, pp. 32–57.

33. Welles and McKim-Smith 2004.

34. *Actas Antiguas* 1911, December 16, 1712, p. 178.

35. See Pagden 1987.

36. Cleary and Connolly 2005, pp. 118–19.

37. Cruz de Amenábar 1996, p. 147; Armella de Aspe et al. 1988, p. 154.

38. See Honour 1975, pp. 84–117.

39. Cadenas y Vicent 1985, p. 38. I thank María Judith Feliciano for sharing this reference with me.

40. For a detail of this painting, see *Los Tesoros* 2000, p. 39.

41. Ashelford 1996, pp. 174–75; the author has generously shared unpublished information on the transmission of the style to Europe.

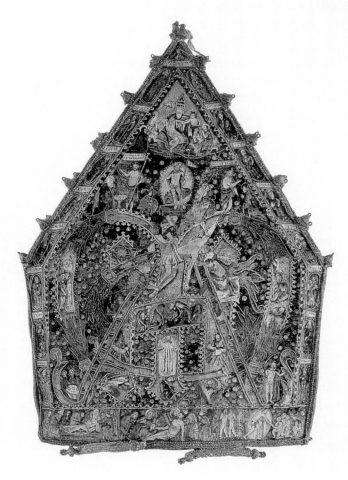

II-I *Feather miter with infulae*

Mexico

Sixteenth century

Feathers glued on parchment and textile, with embroidery

Miter 16 × 11⅜ inches (40.5 × 29 cm); infulae 16½ × 3¹⁵⁄₁₆ inches (42 × 10 cm)

Inscribed on miter, in the center: *IHS* and *MA* (fusion of the monograms of Christ and Mary); following the frame of the object: names of the Apostles, of the Doctors, and of the Prophets; on lower end of infulae: *TU ES GLORIA MEA / TU EXALTAS CAPUT MEUM* [Psalm III, 4l]; *IHS*

Museo degli Argenti, Palazzo Pitti, Polo Museale Fiorentino, Florence

PROVENANCE: Ferdinando I de Medici Collection (inventory of 1571)

PUBLISHED: *Mostra medicea* 1939, p. 114; Anders et al. 1971, p. 39, ill.; Heikamp 1972, p. 15ff., figs. 18, 20, 21; Castelló Yturbide 1993, p. 168; pp. 161, 162, ill.; Estrada de Gerlero 1994 "Plumaria," pp. 88–90, ill.

EXHIBITED: Florence 1939, p. 114

EXPERT IN A UNIQUE MESOAMERICAN TRADITION, feather artists (usually named by the Nahuatl term *amanteca*, though the Purépecha *uzquarécucha* is also attested) were extremely renowned in New Spain's society. The aesthetic effects obtained by the natural composition of their magnificent creations—compared by Western eyes to mosaics or miniatures and often called treasures—had already seduced Cortés, who sent Mesoamerican feather goods to Europe in 1519. From the first decade of colonization, the production of these objects became a powerful tool of Christianization: the high meticulousness required by the technique was considered a guarantee of the concentration, rationality, and will of the newly converted. Feather artists had to recreate European models, copied from engravings that condensed the most powerful theological principles and programs. The extraordinary artistry of colonial feather creations resides in their ability to transfer Western iconographies to the visual world of New Spain through Mesoamerican techniques.

This miter with the infulae appears in an inventory of 1571 as part of the "guardaroba romano" of Ferdinando I de Medici (1549–1609) along with another miter representing the Trinity, now lost. The future Grand

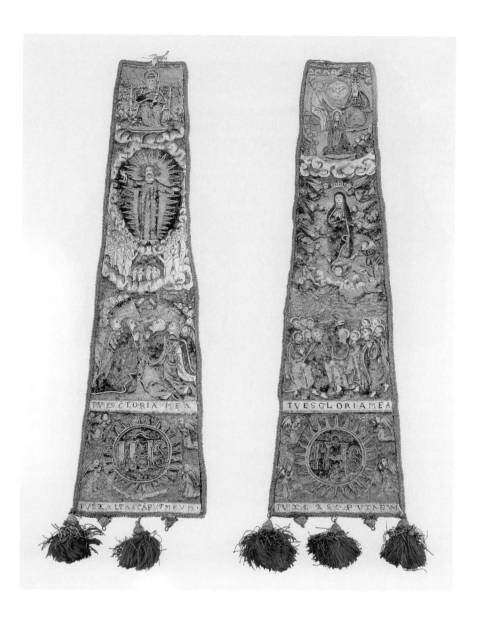

Duke of Tuscany had received these *mirabilia* when he was a young cardinal in Rome. They had arrived in Europe with several other miters (today there are six others still preserved), probably brought by the Mexican bishop of Michoacán, Vasco de Quiroga, to be presented at the Council of Trent. According to another hypothesis, it might have been just after his travel to Europe and when he returned to New Spain that Quiroga would have asked Purépecha feather artists to create miters inspired by the hats made of peacock feathers he had seen in Rome. Whatever the case, the extreme interest the feather miters created in New Spain stems from the fact that once they reached Europe they were not stored with the hundreds of other overseas *exotica*, but were actually used during the Christian ceremonies in the Old World; traces of wear are clearly visible and documented.

This miter and the infulae from Florence offer a visual synthesis of Christian Redemption in a concentrated iconographical program that encompasses the key moments of the Passion cycle within the intertwining initials of the names of Christ and Mary (IHS and MA). Particularly remarkable is the rendering of the letters of the inscription, noted by

several sources, together with the chromatic potentialities of the material, which give evidence of the supreme level of the feather artist's excellence and ability to renew traditional repertories.

Alessandra Russo

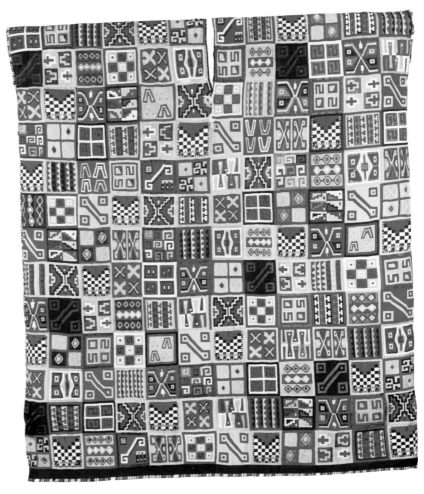

11-2 Man's tunic

11-2 Man's tunic

Inca

Early to mid-sixteenth century

Tapestry weave, cotton warp and camelid weft

36 × 30 inches (91.4 × 76.2 cm)

Dumbarton Oaks Research Library and Collection, Washington, D.C., B-518

PROVENANCE: Acquired by Robert Bliss prior to 1954

PUBLISHED: Lothrop et al. 1957, no. 373; Disselhoff and Linné 1961, p. 181; Horkheimer and Doig 1965, p. 141; Barthel 1971; Rowe 1979, pp. 257–59; *Circa 1492* 1991, cat. no. 451, p. 394; Rowe and Rowe 1996, no. 133, pp. 457–65; Phipps et al. 2004, cat. no. 18, pp. 153–56

EXHIBITED: Washington 1961; Washington 1991, cat. no. 451; New York 2004 *Andes*, cat. no. 18

11-3 Man's tunic (front and back)

Lake Titicaca

Mid- to late sixteenth century

Tapestry weave, cotton warp and camelid, silk, and silver weft

38½ × 30¾ inches (97.8 × 78.1 cm)

American Museum of Natural History, New York, B1500

PROVENANCE: Said to have been found on Island of Titicaca; Adolph Bandelier, 1895

PUBLISHED: Bandelier 1910; Crawford 1916, fig. 8; Lothrop 1979, p. 223; López-Baralt 1992, pl. 1; Cummins 2002, figs. 10.10a, 10.10b; Pillsbury 2002, p. 84, fig. 18; Phipps et al. 2004, cat. no. 19, pp. 156–59

EXHIBITED: New York 2004 *Andes*, cat. no. 19

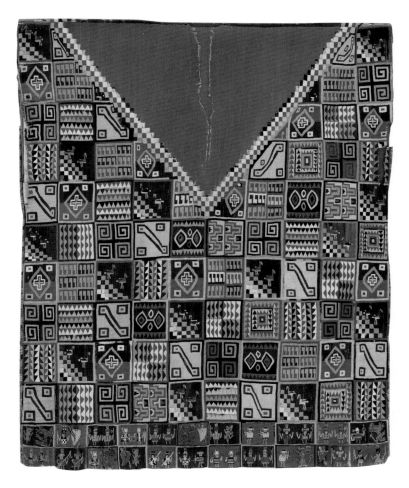

11-3　Man's tunic (front)

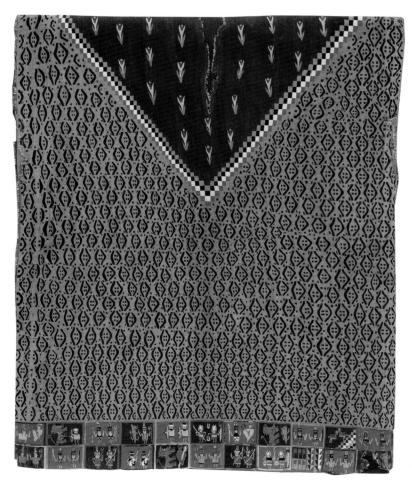

11-3　Man's tunic (back)

THE TUNIC, OR *UNCU*, was the basic Andean man's garment and reached to the knees or just above. It was constructed from one or more uncut lengths of tapestry-woven cloth sewn together at the sides, and the neck opening was completed on the loom. A rectangular mantle, usually not tapestry woven, was worn over the *uncu* and often knotted at the shoulder. Tunics worn by royalty were woven with geometric designs, known as *tocapu*, arranged in a square grid; the finest and the only extant one with an allover design on the front and the back is in the Dumbarton Oaks Collection, Washington, D.C. (cat. 11-2). The meaning of the approximately twenty-four unique designs laid out in a random sequence has yet to be deciphered by scholars but may represent heraldic or lineage symbols. One square can be identified as a miniature black-and-white checkerboard tunic with a red stepped yoke, a form that was distributed to elite soldiers from royal storehouses by the Inca kings and worn in miniature by small figurines used in sacred ritual ceremonies. The tunic was likely made in the Bolivian Altiplano, possibly in Capachica near Lake Titicaca, and according to Andean weaving scholar Elena Phipps may represent a self-conscious expression of Inca power and authority symbolized by the Inca term *capac uncu*, "rich and powerful shirt."

A tunic in the collection of the American Museum of Natural History, New York (cat. 11-3), has the *tocapu* design on the front but a stylized jaguar pelt on the back, which would have added a dramatic presence to the tunic when it was worn in processions or for other festivities. Jaguar and puma pelts were traditionally used in Inca ceremonies and rituals as symbols of power and strength. The lower border of the tunic, in striking contrast to the traditional Inca composition of geometric designs, includes two rows of animated figures representing eighteen distinct groups of Andean warriors interspersed with European-style rampant lions, Andean jaguars, and the Christian symbol of pierced hearts. The presence of silver weft threads around a silk core in the border indicates that the tunic was woven after the conquest. The tunic was found at Chucaripupata on the northwest end of the Island of Titicaca.

Dilys E. Blum

II-4 *Tapestry*

Peru
Seventeenth century
Tapestry weave, cotton warp and camelid weft
89½ × 70½ inches (227.3 × 177.8 cm)
The Metropolitan Museum of Art, New York, Purchase,
Morris Loeb Bequest, 1956, 56.163

PROVENANCE: With American Art Galleries 1924, lot 629
(described as "Kelim cover, Goan, XVII century);
purchased by the Museum from Guillermo Schmidt
y Pizarro, 1956

PUBLISHED: Weibel 1939, pp. 197–206; Zimmern 1943,
pp. 33–34, pls. 1A, B, 2; Wadsworth Atheneum 1951,
cat. no. 179; *MMA Bulletin* 1957, p. 61, ill.; Phipps et al.
2004, pp. 243–46; Phipps et al. 2004 "Conservation,"
pp. 1–4, 6

EXHIBITED: On loan to the Brooklyn Museum; Hartford
and Baltimore 1951, cat. no. 179; New York 2004 *Andes*,
pp. 243–46

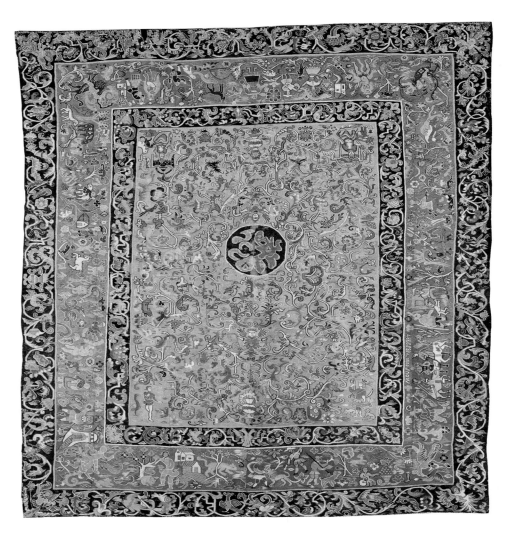

ANDEAN WEAVERS ADAPTED the tradition of tapestry weaving to meet the Spanish need for textiles that were similar to those they had known in Spain. These included armorial tapestries with coats of arms granted by the Spanish crown and other decorative hangings for interiors. This tapestry combines ornamental designs from European printed sources, Chinese and Indian trade influences, and Andean imagery, creating a hybrid that Adele Weibel proposed calling "Creolerie." The central field contains a motif that according to several scholars is an adaptation of a Chinese motif, possibly the cloud form or a paired phoenix symbol, and contains the heads of two angels. The four corners of the central field feature figures representing a crowned figure with scepter seated beneath a canopy with a panther, dog, and small elephant; a similar figure with a cow and calf; a Spanish page; and an Inca hunter with stag and hounds. The wide border contains narrative scenes adapted from the Bible, mythology, and Andean everyday life, including dancers, hunters, shepherds, and a young couple with their new baby in front of a church. The left side border shows three Spaniards on mules and is inscribed with the words MOUSSOM [N] ESSƎPT. It has been suggested that this is a phonetic misspelling of the French phrase *nous sommes sept*, referring to the insurgents

in the Tupac Amaru II rebellion, which would date the tapestry to the late eighteenth century rather than the seventeenth. The overall layout of the tapestry is similar in design to Indo-Portuguese coverlets and contains many of the same animal and figural motifs from various print sources found on seventeenth-century Portuguese bedcovers and Mexican lacquer work *bateas*. This masterwork of tapestry weaving incorporates traditional Andean *cumbi* techniques using native cotton and camelid fibers with metallic and silk threads introduced by the Spanish, and, unlike European tapestries, is finished on both sides. The tapestry was woven with fibers dyed with cochineal for red, indigo for blue, and rutin for yellow.

Dilys E. Blum

II-5 Attributed to the Workshop of Sancho García Larraval

Gremial of Archbishop Juan de Zumárraga

Spain or Mexico
1528–37
Embroidered velvet with gold, silver, and silk threads
39⅜ × 39¾ inches (100 × 101 cm)
Museo Nacional del Virreinato/CONACULTA, INAH, Tepotzotlán, Mexico, 10-1257

PUBLISHED: Toussaint 1948 *Catedral*, pp. 235, 260, ill.; Toussaint 1967, pp. 70–71, fig. 62; *Mexico* 1990, cat. no. 118, pp. 256–57; *Tepotzotlán* 2003, pp. 38–39

EXHIBITED: New York, San Antonio, and Los Angeles 1990, cat. no. 118; Mexico City 2006, p. 351

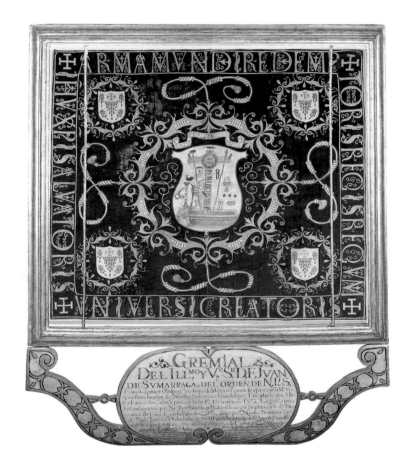

THE OLDEST KNOWN EMBROIDERY in colonial Latin America is the gremial of Archbishop Juan de Zumárraga. The gremial, originally in the treasury of the Mexico City cathedral, was used as a lap cloth and placed on the knees of a bishop seated at Mass or other services. Bishop Zumárraga, a Basque, was a Franciscan who in 1527 emigrated to Castile, where he was appointed Protector of the Indians by Carlos V. He arrived in Mexico in 1528 and returned to Spain in 1532. He remained there until 1534, when he returned to Mexico as its first bishop; he died there in 1548. The gremial's design is similar to that of earlier Spanish ceremonial cloths. It is embroidered on blue velvet with gold and silver metallic and red silk threads and white silk appliqués. The text around the border reads *ARMA MUNDI REDEM / TORIS REGIS REGUM / UNIVERSI CREATORIS / IHVXPI SALVATORUS* (The arms of the Redeemer of the World, King of Kings, Creator of the Universe, Jesus Christ the Savior). The shield in the center contains the cross and instruments of the Passion surrounded by a decorative foliate design and knotted Franciscan cords representing the order's vows. In the four corners are shields with the five bloody wounds of Christ, part of the Franciscan coat of arms, surrounded by decorative borders. The gremial is said to have been embroidered by Zumárraga's

nephew Sancho García Larraval, from Durango. Larraval was originally a tailor; he went to Mexico, where his uncle secured for him the monopoly of making ornaments for the church. It is possible that Larraval was in charge of a large workshop, and since he was a tailor, it is unlikely that he would have embroidered the gremial himself. The gremial was made prior to the establishment of the embroiderer's guild, which was officially established in New Spain in 1546. A letter written in Basque from Zumárraga to Kattalin Ruiz Muntsaratz and dated 1537 informs her that his nephew was now a rich and honorable man and thus able to marry her daughter. Larraval, he writes, will be returning to Spain with gifts to complete her daughter's dowry (they had been married by proxy) as well as a pair of chasubles and antependia for the church, possibly from the bridegroom's workshop. Another possible source for the gremial is Spain. Zumárraga is known to have brought with him from Castile in 1528 a rich set of vestments, which included "the most impressive gremial."

Dilys E. Blum

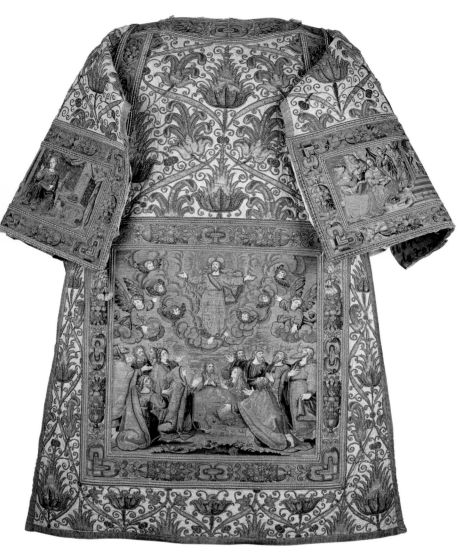

11-6 Dalmatic

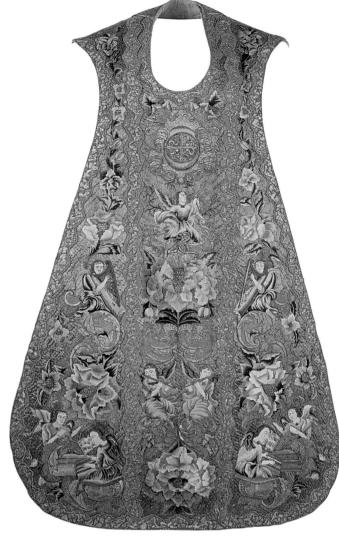

11-7 Chasuble

11-6 Marcus Maestre

Dalmatic

Seville, Spain
1625–27(?)
Silk and gilt thread embroidery
59⅛ × 39¾ inches (150 × 101 cm)
Museo Nacional del Virreinato/CONACULTA, INAH, Tepotzotlán, Mexico

PUBLISHED: Turmo 1955, pp. 63–72; Litto Lecanda 1999

11-7 Dominican Convent of Saint Rose of Lima, Puebla, Mexico

Chasuble and dalmatic

c. 1750
Silk and gilt thread embroidery
Chasuble 45⅜ × 30 inches (115 × 76 cm); dalmatic height 45¾ inches (116 cm)
Museo Nacional del Virreinato/CONACULTA, INAH, Tepotzotlán, Mexico

PROVENANCE: Cathedral of Mexico, Mexico City

PUBLISHED: Toussaint 1948 *Arte*, pp. 195–96; Toussaint 1948 *Catedral*, pp. 236–37; INAH 1967, p. 57, photo 25; Wardwell 1973, p. 188, fig. 10; Thurman 1975, cat. no. 131, pp. 260–61; Lutteroth 1988, pp. 171–73; *Mexico* 1990, cat. no. 162, pp. 383–86

EXHIBITED: Chicago 1975, cat. no. 131; New York, San Antonio, and Los Angeles 1990, cat. no. 162

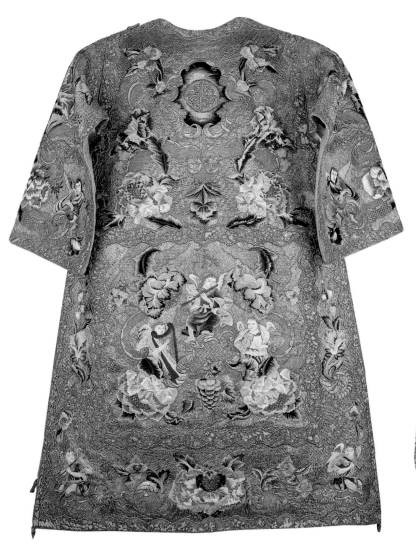

11-7 Dalmatic

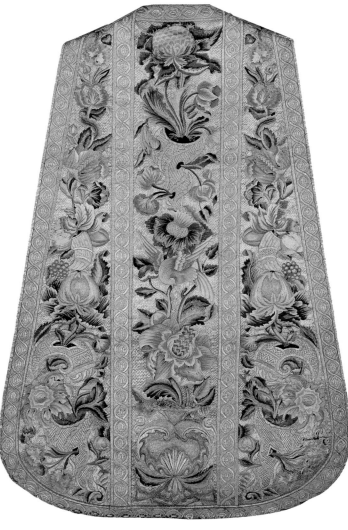

11-8 Chasuble

11-8 *Chasuble*

Mexico
1725–30
Silk and gilt thread embroidery on linen
43⅜ × 46⅛ inches (110 × 117 cm)
Los Angeles County Museum of Art, Costume Council Fund, M.85.96

11-9 *Chasuble and cope*

Quito, Ecuador
Eighteenth century
Silk and gilt thread embroidery
42½ × 32⅜ inches (108 × 82 cm)
Convento Máximo de la Merced, Quito, Ecuador

11-10 *Chasuble and chalice cover*

Philippines
1750(?)
Silk and gilt thread embroidery
Chasuble: 42¼ × 46⅛ inches (107 × 117.2 cm); chalice cover: 9 × 9 inches (23 × 23 cm)
Private collection

PROVENANCE: Concepción Unzue de Cesares

PUBLISHED: *Arte religioso* 1992; *Inventario de bienes muebles* 1998, cat. no. 276, p. 136

EXHIBITED: Buenos Aires 1948; Buenos Aires 1992

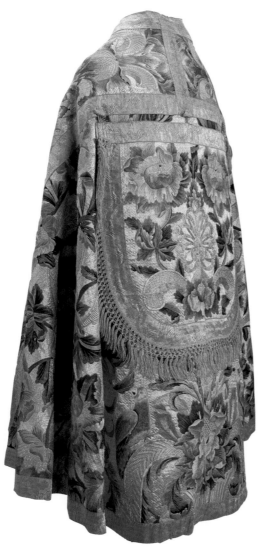

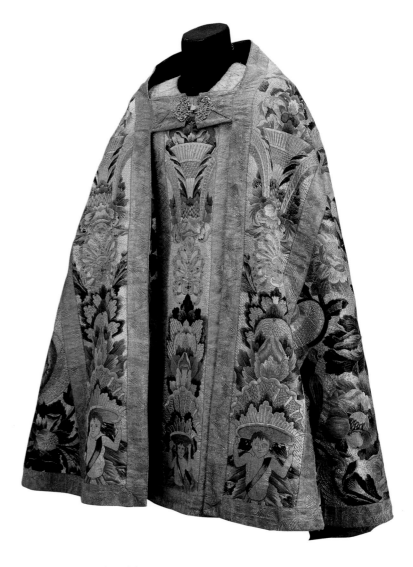

11-9 Cope (back)

11-9 Cope over chasuble

THE POWER AND WEALTH of the Spanish monarchy and the Catholic Church was embodied in the resplendent vestments and furnishings used by the churches and monasteries of colonial Latin America. Some were excess vestments sent from Spanish churches, while others were special commissions financed by the colonial bishoprics or paid for by the alms and tithes from wealthy parishioners. The earliest set of vestments to survive in New Spain was commissioned between 1623–32 for the cathedral of Mexico City (cat. 11-6) from the master embroiderer Marcus Maestre, considered the most outstanding of his trade in seventeenth century Seville. Maestre was the official embroiderer for the archbishopric of Seville and produced vestments and altar frontals for churches throughout Castile. The surviving set includes a cape with hood, chasuble, stole, maniple, chalice veil, burse, and altar frontal. It is embroidered with exquisitely drawn scenes from the Bible in the prevailing style of Sevillian painting, dominated at the time by Francisco Pacheco and Juan de Roelas. It is conceivable that many of the images were drawn by the embroiderer Pablo Legot, a member of Maestre's workshop, who in 1630 took the guild examination in painting and went on to become one of Seville's leading artists. Legot's drawings for embroidery in various artists' styles would

have helped the young artisan attain his goal of becoming a painter, for it was a common practice for aspiring painters to copy the work of established masters in order to develop their drawing skills. Legot was born in Luxembourg in 1598, emigrated to Seville in 1610, and according to archival records, was an embroiderer at the time of his marriage in 1619. Maestre acted as a reference for Legot for several commissions as the painter established his career beginning in 1628, and the artist later worked on a number of altarpieces in churches for which Maestre embroidered the vestments.

Among the most renowned sets of embroidered vestments are those with musical angels and the emblem of the Dominican Order of Saint Rose of Lima originally owned by the cathedral of Mexico City (cat. 11-7). The convent was founded in Mexico City in 1602 under the nuns of Santa Catalina de Sena, and by 1614 it was established in Puebla, first as a *beaterio* and then as a convent. The vestments are heavily embroidered in gold, silver, and silk with a variety of flowers, fruit, and foliage including pomegranate flowers, carnations, and acanthus leaves, as well as angels playing musical instruments, including the harpsichord, viola da braccio, drums, horn flute, and harp. The hood of the cape contains a roundel with the figures of Christ wearing a crown of thorns and

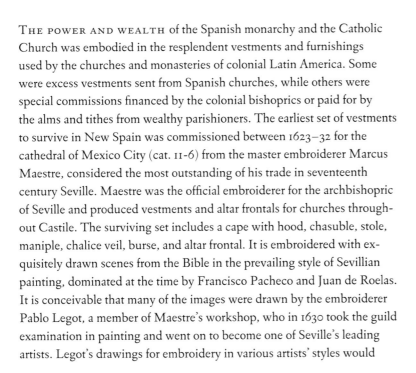

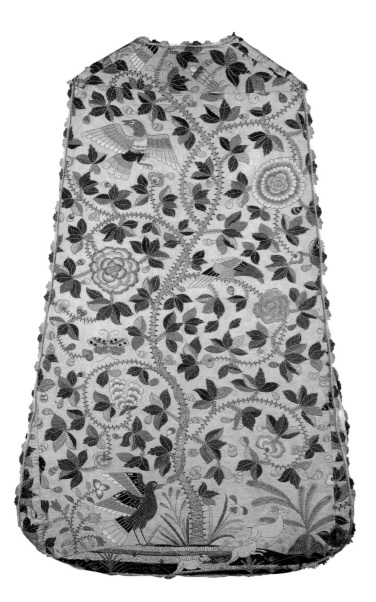

11-10 Chasuble

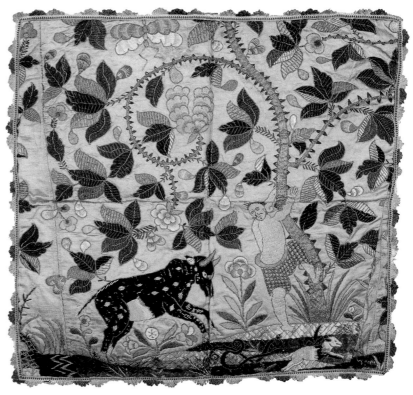

11-10 Chalice cover

Saint Rose of Lima dressed as a Dominican and wearing a wreath of roses. Saint Rose, who was of mixed Spanish and Inca ancestry, was said to have supported her family doing embroidery and needlework. The dalmatic, chasuble, and burse are embroidered with the rose emblem of the convent. The set of vestments is related to two partial sets, a chasuble in the Cleveland Museum of Art and dalmatic and humeral veil in the Art Institute of Chicago. The workmanship on the three sets differs although they were designed on the same model, which may indicate that the Mexican set was a copy worked at the convent, which was known for its embroidery, or the three were executed in one workshop at different times for different occasions. The Cleveland and Chicago vestments are dated to the late seventeenth century and are attributed to Bavaria and Southern Europe respectively. It is possible that the Mexican set, which others have dated to the mid-eighteenth century, also dates from this period and was made to commemorate the canonization of Saint Rose of Lima in 1671. Anne Wardwell noted in an article on the Cleveland chasuble that the connection between Bavaria, Mexico, and Spain is reinforced by the gift of Mexican embroidered vestments to the Kapuzinerklosters of Klausen by its founder Maria Anna of Pfalz-Neuburg, the second wife of Carlos II of Spain. A

set of vestments in the Los Angeles County Museum of Art (cat. 11-8) possibly embroidered in Puebla at the Saint Rose of Lima convent features floral decoration as well as angels and birds. Embroidery workshops existed throughout Latin America. A chasuble from the Convento Máximo de la Merced in Quito, Ecuador, is embroidered with flowers, fruit, and parrots (cat. 11-9); it is said to have been worked by members of the embroiderers' guild in Quito.

Vestments were often constructed from textiles that were originally used for other purposes, such as women's dresses, which were given as gifts to the church. The chasuble and burse in a private collection in Buenos Aires (cat. 11-10) is likely to have been remade from a larger textile, possibly a bedcover or hanging that was probably embroidered in the Philippines by Sangley artisans of Filipino and Chinese ancestry. The chasuble has been pieced together so that the original border continues up the sides while other sections have been made into the maniples and a burse. The design includes the tree of life surrounded by flowers, animals, butterflies, and birds, and on the burse, a native wears a plaid sarong. The chasuble is inscribed with the initial S and the name ARCHICOFRADIA DEL SANTISIMO SACRAMENTO.

Dilys E. Blum

11-11 Antonia Sánchez

(Guatemalan, possibly born 1728)

Sampler

1738
Linen with silk embroidery, silk ribbon, and bobbin lace
40³⁄₁₆ × 14¹⁵⁄₁₆ inches (102 × 38 cm)
Fitzwilliam Museum, University of Cambridge, T.121-1938

PUBLISHED: Humphrey 1997, pp. 100–101

INDIGENOUS GIRLS AND ORPHANS in New Spain were instructed
in the art of embroidery as part of their education at the *escuelas amigas*
and *beaterías* first established in 1525 at the convent of San Francisco in
Texcoco by Catalina de Bustamante. Many Mexican samplers from the
eighteenth and nineteenth centuries that were worked in educational insti-
tutions survive in museum collections; they were avidly collected during
the first half of the twentieth century by English and American collectors,
including the archaeologist and scholar Zelia Nuttall. This unusual example
from Guatemala, part of New Spain, is notable because of its large format
and early date, 1738. According to the embroidered inscription, it was
worked by Antonia Sánchez, who likely was of Indian or mixed-race heri-
tage. She would have attended a *beatería* until a suitable marriage partner
was found, usually at puberty. According to church records, Antonia was
born in 1728 in Quezaltenango and married in 1742 at age 14. Unlike
Mexican samplers of the period that are a virtual dictionary of embroidery
stitches, this example is purely decorative and would have represented
the culmination of a young girl's needlework education and proof of her
skill as an embroiderer. The design includes the monogram of Our Lady
and an armorial with the Order of Carmelite nuns, an indication that the
sampler was produced under convent instruction. The crowned double-
headed eagle is a reference to the Spanish empire, and images native to
Guatemala include the quetzal bird and a parrot, as well as sheep; figures
with feathered headdresses represent indigenous people, including one
with a sword slaying a dragonlike animal. The sampler is embroidered in
three sections and is edged with bobbin lace and ribbon bows, a decora-
tive element also found in samplers made in Spain.

Dilys E. Blum

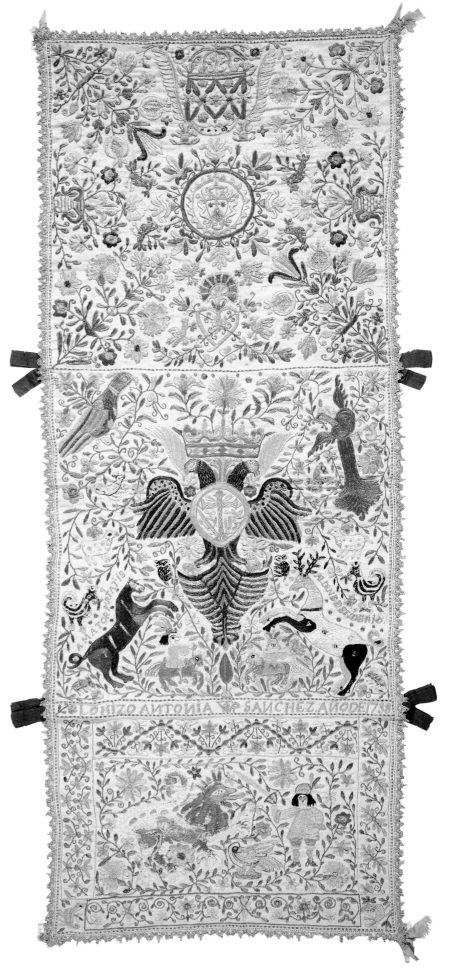

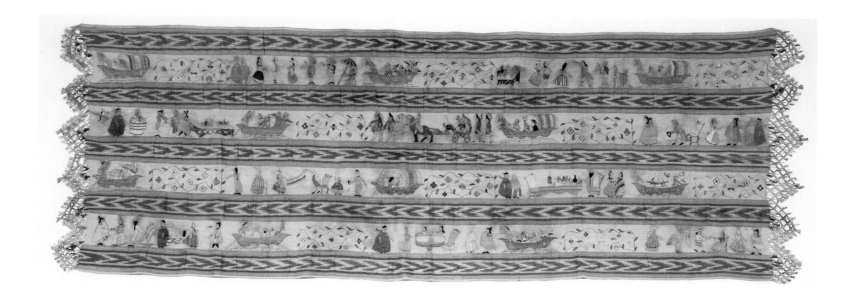

11-12 *Rebozo*

Mexico
c. 1790
Silk, with silk and silver thread embroidery
30½ × 93¾ inches (77.5 × 238.1 cm)
Philadelphia Museum of Art, Gift of Mrs. George W. Childs Drexel,
1939-1-19

PUBLISHED: Blum 1997, cat. no. 103, p. 59; *PMA Handbook* 1997, p. 87

THE QUINTESSENTIAL MEXICAN GARMENT during the colonial period was the *rebozo* or shawl, which crossed all class and ethnic lines. *Rebozos* were used both as a wrap and a carrier. They were not only utilitarian but were presented to young women to mark special occasions. During the seventeenth century, for example, a *rebozo* was presented to a young woman to mark her entrance into a convent. Although craft guilds were established in New Spain as early as 1524 (blacksmiths), the cotton weavers who wove *rebozos* were the last guild established. In 1757 the weaving of *rebozos* was regulated by an ordinance stipulating the size, weave, type of yarn, and designs, and in 1796 the twist of cotton and silk was designated. The *rebozos* from Temascaltepec and Sultepec were especially fine and included a high silk content and a great deal of needlework, as well as knotted silk fringe. The *rebozo* seen here was woven with warp-resist dyed stripe; in a similar shawl in the collection of Parham Park, West Sussex, United Kingdom, the stripes are embroidered to imitate dyed stripes. The shawl is embroidered with silk and metallic threads and is reversible, i.e., the back is as finished as the front, a technique typical of colonial Mexican embroidery. The ends of the shawl are knotted with silk fringe. Destined for an elite clientele, such shawls were likely embroidered both in urban workshops and by skilled elite needlewomen in their parlors at home. The *rebozo* seen here dates from about 1790 and is embroidered with figures engaged in leisure activities in Mexico City, including dancing, boating, and dining outdoors. As in Mexican *casta* paintings, the figures can be identified by their dress and include the clergy, Indian women, and Creole and Spanish elites.

Dilys E. Blum

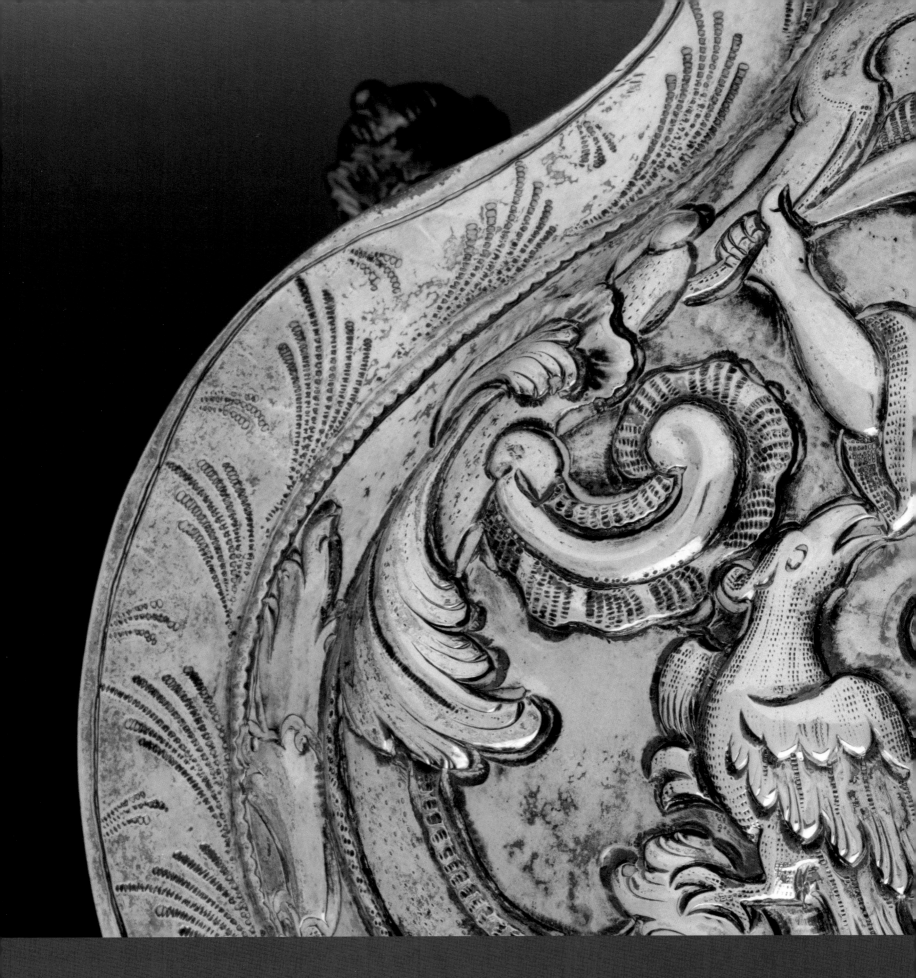

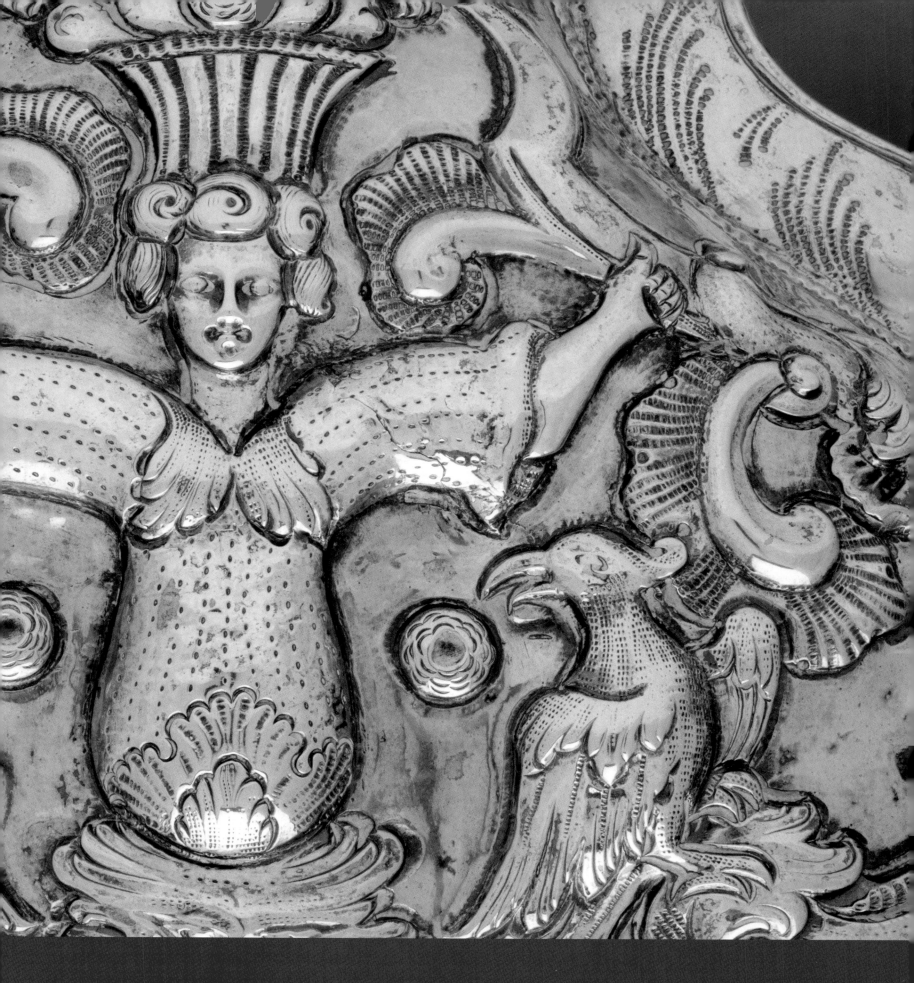

Hispanic Silver

Silver and Silverwork, Wealth and Art in Viceregal America

Cristina Esteras Martín

From 1492 onward, the meeting of the Old and the New Worlds (Europe and the Americas respectively) implied among other things an inevitable situation of cultural confrontation and interaction. The key protagonist in this process—which would change the face of European history—was Spain. In its process of imperial projection, Spain aimed to impose its own cultural experiences on Hispanic America, and thus transmit to the New World the aesthetic concepts and customs that had gradually arisen in Spain over centuries. However, it was not always possible to bring this about in a linear manner, as the course of this projection was determined by a series of circumstances in which a direct process of cultural transference was subjected to strong pressures from the receiving continent. What arrived from Spain might be accepted, but it might also be reworked or even totally rejected, given that it was being presented to a new and different society, made up of Spaniards and native peoples. Given that it was, we might say, lord and master of the continent in question, this society determined the degree and manner of this cultural transference.

The New World that the Spaniards encountered was as plural as Spain itself, and that cultural pluralism was directly related to its great regional and geographical variety, the differing levels of development of its own cultures, and its wealth of traditions. For this reason, the new culture generated in Hispanic America would be characterized by diversity: the way in which it came into being, however, was extremely laborious. Although obviously not uniform, it began in the early decades of the sixteenth century, and depended on the process of discovery and conquest of different areas.

The prevailing aesthetic currents of the day arrived from Spain, and we might describe Hispanic America as a huge melting pot in which these currents were gradually fused with indigenous ones. Silverwork is a result of this process of synthesis between the experiences of the dominant culture (Spain) and the subjected ones (the indigenous cultures), although the former clearly prevailed. The result was the birth of an art that could in no way be considered a simple continuation of what was produced in Spain, as it was by nature different and can thus be considered an authentic mode with its own distinct personality. Colonial silver would not

simply respond to the requirements of the Spanish, but rather to very specific needs of the complex cultural development of a new, mixed society: that of Hispanic America.

Given the plural nature of colonial society resulting from the wealth of different cultures that constituted it (distributed overall into three distinct areas: urban, rural, and marginal, which have independent processes of development), modes of artistic expression were not uniform and homogenous. Thus, along with the other art forms, viceregal silver manifested an enormous plurality of traits and characteristics over its long period of existence. A monstrance made in Mexico in the mid-eighteenth century, for example, is different from one made at the same time in Guatemala, Bogotá, Lima, or La Paz. Originality was inherent in each different artistic center, and it would be incorrect to generically apply the concept of a homogenous art form. Similarly, it is not acceptable to consider viceregal silver as anachronistic, as this reflects a Eurocentric viewpoint according to which New World silver should be judged by the time-frames established in Europe, whereas it is in fact dependent on the different society that brought it into being. In the same way, it is totally unacceptable to assess the quality of this silver by its approximation to European work, judging its importance by its capacity to cease to be Hispanic American. A paradox indeed.

We now know that Hispanic American silver came into being along with the birth of cities and as a clear response to the strong and early demand for both secular and religious silver by this young society from about the mid-sixteenth century. However, its rapid appearance and long and remarkable development can be explained by, among other reasons, two factors crucial for this process: on the one hand, the solid indigenous experience in working in precious metals, and on the other, the abundance of local supplies of these metals.

There are numerous testimonies to the mastery of pre-Hispanic indigenous silversmiths. Among the most expressive is undoubtedly that of the Franciscan chronicler Friar Toribio de Benavente, known as Motolinía. In his *Historia de los indios de la Nueva España* (1541) he writes: "To be fine silversmiths they need only tools which they do not have, but with one stone on top of another they make a tazza and a plate; furthermore, to cast a piece and make it in a mold, they are better than the Spanish silversmiths, as they can make a bird which moves its tongue, head, and wings; and they can cast a monkey or other monster whose head, tongue, legs, and hands move; and they put little instruments in its hands so that it seems to dance with them; and what's more, they make a piece half in gold and half in silver, and cast a fish with all its scales, one of gold and the next of silver."[1] With regard to the skills of Inca silversmiths, Pedro Cieza de León in his *Crónica del Perú* (1553) states that "the natives of this kingdom were great masters as silversmiths and in other trades."[2]

Further accounts of the marvels that arrived from Hispanic America have come down to us from the other side of the Atlantic. One such is that of the humanist scholar from Milan Pedro Mártir de Anglería, who lived in Spain and worked in the service of Ferdinand and Isabella, the "Catholic kings." He was fascinated by unique pre-Hispanic pieces such as those from Moctezuma's treasure that Cortés sent to Carlos V, and wrote in his book *Décadas del Nuevo Mundo* (1530): "In truth I do not admire the gold and stones: what really astonishes me is the skill and effort with which the work makes use of the material. I have seen infinite designs which I cannot describe, it seems to me I have never seen anything like it in the way their beauty so attracts the gaze of men."[3] Albrecht Dürer himself, who cannot be accused of lack of aesthetic judgement, expressed his emotion and astonishment on seeing the same treasure in Brussels. The artist wrote in his diary (1520): "These things are more beautiful than all the wonders . . . in my life I have never seen anything that delighted my heart more than these objects. . . . I wonder at the subtle ingeniousness of the men from these strange lands; I do not know how to explain what I felt there. It seems to me that I have never seen anything comparable in the way their beauty attracts men's gaze to such a degree."[4]

There were, thus, large numbers of native silversmiths with a profound knowledge of the techniques of this art, working to the same high levels of technical mastery in soldering and alloying, relief work, engraving, and casting from molds. As soon as they had the right tools, they were able to produce any type of object requested from them. Once the Spanish crown allowed them to work in gold and silver, following an initial ban, these silversmiths joined the labor market, some working for themselves, others under the protection of Spanish silversmiths. While in most cases they followed guidelines imposed by the prevailing (Spanish) aesthetic, in others, particularly in areas where cultural traditions were notably deep-rooted, indigenous silversmiths clung to their own forms and working methods. For this reason in the Peruvian mountains and Altiplano they still today make clasps (*tupus* and *ttipquis*) to fasten their blankets (*lliclla*), ceremonial vessels (*keros* and *aquillas*) for drinking *chica*, staffs for dancing in popular celebrations, and batons of office (*varayoc*) to indicate the power and status of mayors and chiefs. The production of such objects was so entrenched that not even the arrival of the Spaniards could bring it to an end.

So abundant were precious metals in Hispanic America that "el Inca" Garcilaso de la Vega (1539–1616) wrote with astonishment in the *Comentarios reales de los Incas* (1609) that "the mines offer such riches that after a few years of working, iron will be worth more than silver. This proved to be the case in 1554 and 1555."[5] Deep within the earth of Hispanic America lay vast mineral wealth, and while it is true that in the pre-Hispanic period the mining and refining of precious metals—mainly for religious and ceremonial purposes—were already

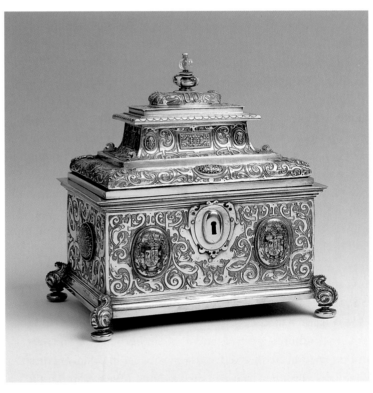

FIG. III-I
Coffer, Mexico City, c. 1650. Silver, rock crystal, and enamel; 12⅝ × 11 × 8¼ inches (32 × 28 × 21 cm). Várez Fisa Collection, Madrid

taking place, mining as an economic activity per se came into being during the period of Spanish rule. Across the whole huge geographical area in question, silver and gold deposits were being discovered underground. Thus in the Viceroyalty of New Spain, the silver mines at Zacatecas, Guanajuato, Taxco, Pachuca, Real del Monte, and San Luis Potosí (all in present-day Mexico) became famous; in Central America there was gold and silver in Comayagua and Tegucigalpa (Honduras) and in Darién (Panama); in Colombia there were rich deposits of gold and silver located in the basins of the rivers Cauca and Magdalena, on the Pacific Coast, and on the slopes of the Andes. In Ecuador, gold was mined in Zaruma, Loja, and Jaén, as well as silver in Cuenca. However, it was in Alto Peru (Peru-Bolivia) that most material was to be found, with gold mines in Asillo, Azangaro, Carabaya, Oruro, and the Chuquiavo Valley (La Paz), as well as silver at Porco, San Antonio del Esquilache, Laicacota, Lampa, Paucarcolla, Tiahuanaco, and Pasco. Without doubt, the most sizeable and splendid deposit in all of Hispanic America was Mount Potosí. This mountain had such voluminous deposits that it received the nickname of *el Cerro Rico* (Rich Mountain), as well as many other names indicative of its status as a world-renowned symbol of wealth. The phrase "worth a Potosí" (*vale un Potosí*) became well known in numerous languages, although the most effusive adjectives were written by the local chronicler Bartolomé de Arzáns de Orsúa y Vela. In his *Historia de la Villa Imperial de Potosí* (1736) his descriptions of it include "body of land and soul of silver," "a trumpet that resounds throughout the globe," "magnet of all desires," and "money enough to buy the heavens."[6]

Hispanic America did not just possess an abundance of precious metals, however (fig. III-I). It also had rich deposits of emeralds in Colombia in the regions of Muzos and Somondoco. South American silverwork could thus reinforce its intrinsic value through the use of decoration with these stones.

Base silver was to be found in abundance, but it had to be worked in order to refine it as well and as quickly as possible. From an early date, Spanish techniques for refining were introduced into native practices, but two inventions in particular were to be revolutionary. One was invented by the Sevillian Bartolomé Medina in 1555 in Pachuca (Mexico). This was a method of amalgamation of the base minerals and involved a cold process (known as *método de patio*) in which the base silver was ground and mixed with mercury, then the mercury extracted from the resulting paste, *pella*. The other method was invented by Álvaro Alonso Barba, an Andalusian-born priest in Potosí. In 1590 he invented the famous *beneficio de cazo y patio*, based on a hot process that he published in his treatise *Arte de los metales*, written in 1637 and published in Madrid in 1640. Barba's text is considered the greatest work of South American metallurgy.[7] Both methods required mercury as the mixing agent in the amalgamation, which had to be brought from Almadén in Spain until about 1566, when this element was discovered at the Huancavelica mines in Peru. Silver production notably increased in volume and speed as a result. The viceroy Don Pedro de Toledo y Leiva, marquis of Mancera, was indeed correct when he referred to the Potosí-Huancavelica combination as "the two axes on which run the wheels of this entire Kingdom [of Peru] and the wealth which your Majesty possesses."[8]

Demand for silver grew in light of the extensive production of the raw material. As a result, and in order for the crown to control silversmithing, it was decided at an early date to regulate work in this field (as had been the case in Spain since the days of Juan II [1435], and particularly under the Catholic kings[9]). As a result, a system of compulsory marking for each piece was introduced: four marks in the case of viceregal America rather than three as in Spain. The first was the personal mark of the maker, which guaranteed authorship of the object before it was taken to the royal treasury, where the assayer analyzed the metal by removing a tiny amount with a burin and leaving a symbol (known as the *burilada*). If the quality of the metal was satisfactory, he could then add his own mark (previously chosen and registered) to testify to its quality (which gave it the status of *plata de ley*, or legal silver), in addition to two other marks that he was authorized to add: one corresponding to the place where the marking had taken place (which was usually where the piece had been made), and the other the tax mark. The last-named did not exist in Spain, but it was considered extremely important in Hispanic America as it signified that a fifth part of the object's value was destined for the royal treasury. For this reason, the mark was popularly known as the *quinto* and is the most commonly found mark on Hispanic American silver. Its presence is due to the fact that, for the viceregal authorities, the most important element of the process was to collect funds for the royal purse through this method of taxation. They were less interested in ensuring that the silver reached legal standards and thus did not defraud the purchaser, or whether the maker had omitted his mark and thus his responsibility for the silver content of the alloy that he had used. All marks had to be identifiable in order for the maker or marker to be theoretically held responsible, so they usually consisted of the maker's name and/or surname (sometimes abbreviated), while the place mark usually featured the city's coat of arms or other symbols, which generally included at least the initial of the city's name. The tax mark was most often a royal or imperial crown, the features of which vary over time and depending on the place.

The abundance and durability of precious metals meant that throughout Hispanic America silver was commonly used (as well as gold, although less frequently) for ecclesiastical and secular purposes and was more often chosen than more fragile materials such as ceramic or the costly porcelain brought from China. Liturgical and domestic vessels made in this hard-wearing and simultaneously precious material were practical and luxurious (fig. III-2). Therefore both secular institutions and private homes amassed "treasuries" of silver and gold objects expressive of ostentation and luxury with all their implications of rank and social status. However, by being transformed into luxury items, these objects lost their official value as means of

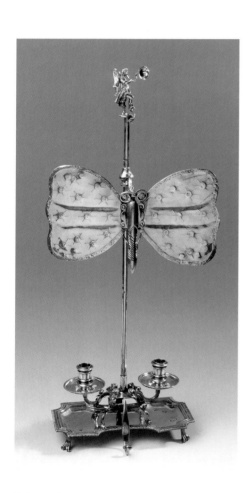

FIG. III-2
Adrián Ximénez del Almendral (1728–1779).
Two-wicked oil lamp, Mexico City, c. 1750. Silver,
cast, molded, chased, engraved, and repoussé, with
burnished punchwork. Apelles Collection, Chile

payment due to the "phenomenon of metal stagnation." In other words, while they retained their intrinsic value, they lost it as a potential circulating currency owing to an overabundance. This piling-up of silver was recorded by the world traveler Francesco Carletti in 1595, who noted in his book *Ragionamenti del mio viaggio intorno al mondo* that when traders in Lima had "accumulated 300 or 400 silver ingots, they would pile them up and spread a mattress over them, using it as a bed."[10]

As noted, viceregal silver came into being at almost the same time as the foundation of the new cities, and given that the most important of these dates from around the mid-sixteenth century, this is also the period when the history of this type of silver-making begins, while its decline corresponds to the period of independence. Numerous artistic centers were located over a wide area, but the most important were undoubtedly those in the wealthiest and most powerful centers in the mining districts. As capitals of the two great viceroyalties of New Spain and Peru, Mexico City and Lima were thus the seats of official power and centers for the spread of cultural models; comparable functions were served by the capitals Guatemala City in that kingdom, and Santafé de Bogotá and Quito in their respective *audiencias* (administrative units). Many other important artistic centers could also be singled out, for example, in New Spain those of Pueblo de los Ángeles, Zacatecas, San Luis Potosí, Guanajuato, Taxco, Oaxaca, and Mérida de Yucatán. In the Viceroyalty of Peru (a very large geopolitical area), notable centers for silver in the Andes were Popayán (Colombia), Cuzco, and Arequipa, in addition to Trujillo, Huamanga, and Huánuco (all Peru), and those on the Peru-Bolivian Altiplano around Lake Titicaca with the center at Puno. Also important were La Paz, as well as Santa Cruz de la Sierra and the Jesuit missions of Moxos and Chiquitos to the east in present-day Bolivia. Above all there was Potosí, which although it was not a viceregal capital, saw a level of luxury and consumption much higher than any of the previously mentioned cities due to its exceptional status as the leading mining center. Such was this level of ostentation that Potosí was considered the "Babylon of Peru," and the lifestyle of the city enabled silversmiths to create an exceptionally active center of production where artistic standards reached unprecedented levels of excellence.

During its first hundred years, in the sixteenth century, the art of silversmithing saw a period of accumulation and synthesis of Spanish and indigenous practices. Simultaneously, internal organization progressed following the establishment of the guild of silversmiths and the rules and regulations governing the practice of this craft in all of Hispanic America. Overall, both ecclesiastical and secular silver followed European dictates with regard to models and decoration, although this does not mean that indigenous artistic modes and symbolism disappeared, particularly in Mexico and Alto Peru.

FIG. III-3
Pair of salvers, Mexico City, c. 1673–76. Silver, gilt; each 3⅝ × 18½ × 14³⁄₁₆ inches (9.2 × 47 × 36 cm). Private collection

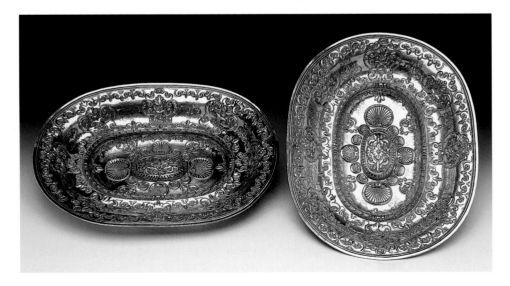

Numerous examples of religious silver have survived, and it is thus not difficult to trace the evolution of ecclesiastical silver or to study the similarities and differences with Spanish silver. Within these differences and parallels we can also analyze the common language used by Spanish ecclesiastics and native peoples to make their dialogue more comprehensible and fluid (fig. III-3). In this regard, it should be noted that the indigenous contribution to silvermaking during the sixteenth century was not limited to a unique way of interpreting ornament, with a *horror vacui*, or to playing with scale and proportion in the chosen motifs, but that it also contributed a decorative idiom comprising pre-Hispanic

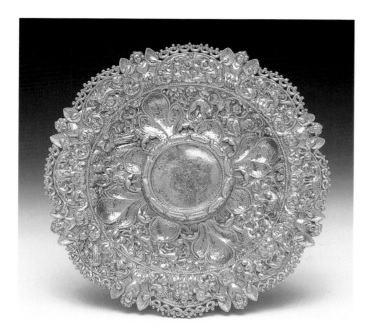

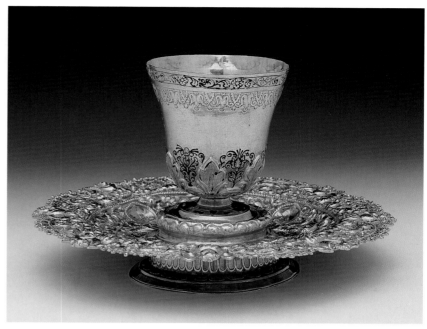

FIGS. III-4a, b
Salver and cup, Alto Perú (Bolivia), c. 1730. Gold;
cup height 7¹⁵⁄₁₆ inches (19.5 cm), salver diameter
3⅜ inches (8.5 cm). Private collection

signs and symbols capable of expressing messages comprehensible to both groups (monks and natives). The more complex and hermetic the message, the more necessary these signs and symbols were. One splendid example is the altar cross in the cathedral in Palencia (cat. III-8). Such an object explains the use in Mexico of materials such as rock crystal and exotic bird feathers, for example, which seem at first sight to have no more function than the attractiveness of their texture and color, but in fact have a symbolic presence. Indigenous people identified rock crystal with the sacred, and for that reason it was "hoarded, esteemed, appreciated, and venerated"; feathers were also sacred objects (known as the art of the *amantecas*) and had a strong symbolic value as their use was associated with the idea of divinity. Whoever used birds' feathers was associated with the sacred as well, and the iridescent colors of the feathers were seen as a symbol of divine illumination. Thus it is not surprising that important objects made for the purposes of worship, such as the Palencia altar cross, the pax in a private collection (cat. III-3), or the chalice in the Los Angeles County Museum of Art (cat. III-4), were created using these materials. Through their use, they became objects based on an art of religious syncretism, although we can also see them as the product of a process of synthesis or cultural convergence and a testimony to the positive and rapid results of cultural cross-fertilization.

In Peru, there was a similar survival of pre-Hispanic codes used to communicate through signs and symbols (particularly with regard to silverwork and textiles). This explains the use of *tocapu*, symbols of the Inca script in the form of geometric abstract designs with a mnemonic function, which helped to keep alive historical memory. However, such symbols are not found (or at least, have not been to date) on religious objects, but rather on ceremonial ones such as *keros* and *aquillas*, wooden and ceramic or silver drinking vessels, respectively. We might then conclude that religious syncretism was clearer and stronger in Mexico than in Peru. There are, however, secular objects that manifest this cultural cross-fertilization between the Spanish and the indigenous. One particularly expressive example is the basin of Prince Johann Moritz of Nassau, now in the church of Saint Nicholas, Siegen. In its form and ornamental composition (including some of the motifs) it follows the Spanish Renaissance tradition, while other motifs make reference to the world of the Andes by using ornamental language specific to that region (figs. III-4a, b). These include figures of peasants in local costume as well as depictions of local fauna such as llamas, *vizcachas* (rodents), and *tarucas* (deer).

While secular silver is less common than religious work, as it is more subject to changes in fashion, it is possible to find outstanding examples that tell us much about life in Hispanic

America during the sixteenth century. Among them are incense burners (*sahumadores*) or table braziers from Mexico; lipped ewers, drinking vessels, and footed salvers from Guatemala; as well as chargers, plates, cups, candlesticks, and other domestic and personal items from the Viceroyalty of Peru. Some of these pieces are known to us following their recovery from sunken ships off the coasts of Cuba, Hispaniola, and Florida.

Silver saw a major period of growth and development in the seventeenth century, made possible through the flourishing production of the raw material and reinforced by two further circumstances. These were the birth of an awareness of a new culture, resulting in the use of a new ornamental language, and the arrival of the baroque style around the midcentury, which gave rise to a change in the aesthetic of forms and uses. Prior to the appearance of this new style, much of the century was marked by the survival of mannerism, a style that had taken firm root in the last decades of the sixteenth century and that survived and continued to flourish in the first half of the seventeenth century, particularly in the most peripheral artistic centers. It was characterized by a taste for geometric forms and rigid outlines inherited from the early Renaissance, while its approach to decoration was plain and with a preference for abstract geometric motifs (mirrors, the letters C and S, gadroons, and cartouches) (cat. iii-6), while the opaque or semi-opaque cabochons of enamel are worked in champlevé with geometric motifs (cat. iii-7) or sometimes naturalistic ones (flowers and birds). The use of enamel was much more common in religious silver from the Andes than in the rest of Hispanic America, and its use increased over the course of the century with the arrival and consolidation of the baroque style.

Hispanic America was marked by a continual effort to imitate Spain in regard to uses and customs. For this reason, a number of typically seventeenth-century Spanish forms in silver, such as the so-called sunburst monstrance, the lipped ewer, and the *bernegal* (a broad, low vessel with a double handle, low foot, and lobed body) were sent out from the Old World and triumphed in the New. There are numerous examples of Hispanic American versions of sunburst monstrances owing to the importance given to the cult of the Eucharist by the church after the Council of Trent (1545/63), although designs varied according to the preferences of the various artistic centers. The variety of solutions and their originality are evident if we compare three almost contemporaneous pieces: a monstrance from Mexico, now in the Victoria and Albert Museum, London (cat. iii-5); one from Bogotá, now in the Museo Soumaya, Mexico City (cat. iii-20); and another from Lima, now in the Metropolitan Museum of Art, New York (cat. iii-21).

The design of Hispanic American lipped ewers can always be distinguished from Spanish models in the type of decoration (at times using indigenous fauna) or in some part of the structure, be it the lip or the handle. A good example is the splendid ewer in the Museo Fundación Lázaro Galdiano in Madrid (cat. iii-32), while other telling examples were recovered from the galleon *Nuestra Señora de Atocha* which sank off the Florida coast in 1622. Made to accompany these ewers were circular chargers whose central element was designed to accommodate the ewer (cat. iii-7). This model survived in Hispanic America until well after the mid-eighteenth century, when it was replaced by the deep, oval shape (known as a *palangana*) derived from French work (cat. iii-30).

Among the most significant forms created in the seventeenth century, within either the mannerist or baroque idiom, were the *bernegales*, broad cups with undulating rims that were very common in Spain from the sixteenth century until their disappearance in the eighteenth century (fig. iii-5). They were used for serving sparkling wine and were usually presented on a companion dish. Inside, the base was often inset with a bezoar stone,[11] which was intended to detect any poison that might have been mixed with the wine. The most splendid and ornate *bernegales* extant are from Hispanic America. Without doubt the best and most interesting of its period with regard to its structure, enamels, and the impressive size of the bezoar stone

FIG. III-5
Drinking cup, Mexico City, c. 1660. Silver; height
5⅛ inches (13 cm). Victoria and Albert Museum,
London, M.292-1956

mounted in a frog, is the example by the Mexican silversmith Miguel de Urbiola[12] in the Art Institute of Chicago. This cup, along with numerous other objects now found in private collections and museums around the world, allows us to understand and come close to the complex colonial world as well as appreciate the taste for luxury and extravagant expenditure of its society, which gradually increased as the baroque mode increasingly took hold. This luxury was equally evident in churches and on the street, in the palace and the typical home, but extravagant expenditure was most evident at such major events as the arrival of the viceroys in their American domains. These occasions saw celebrations of the most elaborate and excessive nature, such as the one offered to the Duke of la Palata when he arrived in Lima in 1682 and which included "paving the streets [of his route] with 400 silver ingots."[13] This extravagance was not, however, limited to governors and leading dignitaries: it was emulated by the mine owners, as in the case of the exceptionally wealthy Antonio López de Quiroga who, on the occasion of his daughter's marriage in Potosí (in the late seventeenth century), had the route from his house to the church covered in silver bars.

The rise of the baroque saw changes in the most commonly used techniques of silversmithing. Filigree work became more common in Cuba, Mexico (Oaxaca), Guatemala, and Peru (particularly Lima, Ayacucho, Cuzco, and Arequipa). Embossed relief decoration and the planes and outlines of objects now became more flexible, with a greater sense of movement. In the case of New Spain (Mexico), this became evident in the use of the polygon, while in Peru the bases continued to be circular or cruciform but the shafts became heavier through superimposed elements and small handles that gave the outlines a greater sense of movement (cat. III-24). With the arrival of the baroque style, the decorative idiom used underwent a radical change of direction, and a fully naturalistic vocabulary was introduced (cat. III-9). It incorporated elements from native flora and fauna and arose from a new self-awareness on the part of the Hispanic American peoples, and in particular the Peruvians, resulting in a new appreciation and esteem for the autochthonous. This change coincided with the development of a New World baroque culture, which was also inspired by a profoundly Christian sentiment. This sentiment in fact encouraged the use of plant and animal motifs in the decoration, a use that goes beyond a merely naturalistic type of ornament. It is also at this period that we first see the depiction of clearly indigenous features on the figures, as well as the presence of feather headdresses, the result of cultural cross-pollination.

The church always intended—although it was particularly evident from the second half of the seventeenth century throughout the eighteenth century—to emphasize the majesty of the religious building and the grandeur of the mass through architecture, decoration, and objects. Therefore the interiors of churches were decorated with enormous opulence: silver covered the altars from the frontals (cat. III-23) to the steps, in the form of the sacrament houses, tabernacles (cat. III-15), candlesticks (cat. III-33), missal stands (cat. III-19), votive lamps (cat. III-22), and much more. Some of these objects were purely decorative, such as the flower branches (*ramilletes*) and the plaques known as *mayas* in Peru, while others were

intended to exalt and dignify the cult of the Eucharist, at the same time creating an effect intended to arouse and deepen the religious sentiments of the faithful. There are examples of such dazzling and ornate settings in Mexico (Sanctuary of Ocotlán, Tlaxcala), as well as in Guatemala City (the parish chapel in the cathedral), and Peru, particularly in the Sierra (for example, the high altar of the church of the Belén in Cuzco) and the Altiplano (the high altar of the church of the Carmelite convent at La Paz).

In line with Counter Reformation policy, the church at this time encouraged the celebration of Corpus Christi. For the processions that accompanied this religious celebration, impressive portable bases were built for bearing the tempietto-like structures[14] that covered and protected the ornate and precious portable monstrances of the sunburst type, many of them reflecting the taste of the time (fig. III-6; cats. III-17, III-18, III-20, III-24). Arches and altars embellished with hundreds of pieces of silver were also constructed to make the street an appropriately rich setting for the procession of the Holy Eucharist.

In the viceregal secular world, gold and above all silver were to be seen in all areas of life, so that the house and city became the ideal settings to exhibit these precious metals, transformed into works of art in the form of silver objects and jewelry. Silver was present in the palace and home on the table in the form of a wide range of vessels and utensils (plates, trays, saltcellars, cutlery, compote dishes [cat. III-14], etc.) as well as other receptacles intended to serve sparkling wine (flutes, *bernegales*, coolers, etc.), different forms of lighting (candlesticks, small candle-holders, snuffers), objects of interior decoration (frames for mirrors and pictures [cat. III-9]), objects of personal hygiene (ewers and basins [cats. III-30, III-31], shaving bowls, toothpicks, earpicks, etc.), and more intimate implements (purges and syringes). Among the wealthiest ranks of society, furniture made of silver also became common.[15] These included sideboards, special tables on which to rest the implements for making maté, writing desks, caskets for keeping possessions, incense burners or tabletop braziers[16] and large braziers[17] used to heat dining rooms, bedrooms, and other spaces (both at home and also in churches),[18] as well as a whole range of items too numerous to name here. In addition we should mention horse trappings made in silver (girth, bridle, pommel, reigns, stirrups, spurs, etc).

In this general context, it is possible to distinguish several significant developments in viceregal silver. It is only in some areas of the Viceroyalty of New Spain, such as the city of México in Guanajuato, that the reverse pyramid motif was used in silverware. This element was derived from architecture (both wood and stone) and played an important role in the repertoire of baroque decorative motifs used from the middle of the eighteenth century onward. It is not, however, found in silverworks in any other areas of Hispanic America. Cups and saucers (*mancerinas*) and chocolate pots (*jícaras*), the former used to present the contents of the latter, were commonly produced throughout New Spain and the Kingdom of Guatemala for drinking this beverage, which became widespread in Central America. While drinking chocolate was also common in the south (particularly in the area of the Andes and the Altiplano), very few *mancerinas* were made (or have not survived to the present day), although a wide variety of *jícaras* were produced in silver and coconut shell with silver mounts.

The most distinctive and important feature of baroque silverware in Guatemala is the use of cockleshells, gadroons, and canopies as decorative motifs (fig. III-7), in addition to curved metal strips forming "lanterns," which also played a structural role. The influence of French and English silver on types and styles in the second half of the eighteenth century is more evident in this region than anywhere else, seen particularly in dinner services. Here, a wide range of superb examples confirm a preference for emulating the silver from those European countries. Typical decorative motifs include vine tendrils, leaves, and bunches of grapes (cat. III-14).

The eighteenth century saw the appearance in the Viceroyalty of Peru of new models in secular silver that were not to be found in other regions of Hispanic America (the Caribbean,

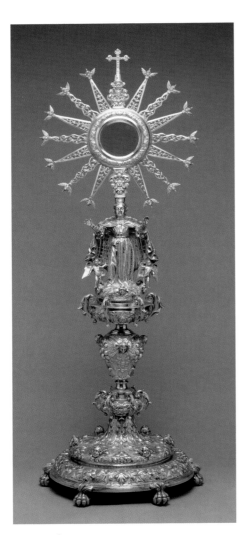

FIG. III-6
Monstrance, Puebla, Mexico, 1742. Silver, gilt, repoussé, chased, and cast. Parish Church of Salvatierra de los Barros, Badajoz, Spain

New Spain, and Guatemala, and the other provinces forming this region). This phenomenon can be explained by the appearance of new social customs that did not take hold in other areas. Above all, these new models respond to the widespread habit of drinking an infusion of the Paraguayan herb yerba maté, which resulted in the invention of a series of beautiful items. These include *mates* (recipients for the water and the herb), with their separators and pumps for sucking up the infusion, and water heaters (*pavas con hornillo*). The last-named were small vessels with feet, spout, lid, handle, and interior heater used to keep the water hot for brewing the maté. These had different forms: globe-shaped with an octagonal body or with animals, most frequently turkeys (cat. III-27), lions (cat. III-29), and bulls, generally with a notable influence of Chinese bronzeware and ceramics in the latter two. The French engineer and traveler Amédée Frézier, who visited Lima at the outset of the eighteenth century, included an interesting engraved illustration in his book *Relation du voyage de la mer du Sud . . .* (Amsterdam, 1717, plate XX). This depicts the ceremony of "taking maté," in which three ladies from Lima prepare for the ritual with its exquisite implements. Another similar print is included in *Relación histórica del viaje que hizo a los Reinos de Perú y Chile en el año 1777 hasta él 1788* by the Spanish botanist Hipólito Ruiz y Pavón, this time showing a single Creole woman from Lima.[19] To complete the ceremony, silver boxes (or occasionally wooden ones with silver mounts) were made to store the herb. These had different designs, although the most ornate and luxurious were of scallop-shell shape (cat. III-35), while the globular ones were also very attractive (cat. III-34).

While the repertoire of motifs used in Central America generally adhered to those traditionally found in Spanish baroque ornament, albeit with some local variations, in the Viceroyalty of Peru the situation was notably different, particularly in the Andean region and the Altiplano. Here there was a marked taste for strange and monstrous hybrid forms (fig. III-8). Vegetable and animal motifs were combined in a continuous metamorphosis (cat. III-23), and "fantasy" played a key role. For this reason these representations conform to an idealizing type of culture that took pleasure in taking flight from reality, not just through the use of ambiguous forms (cat. III-35) associated with mannerism, but also by looking to the jungle and hot regions for motifs remote from daily life (wild birds, monkeys, pineapples, papayas, etc.), using them to create a dream of abundance and well-being identifiable with paradise. The result was a way of escaping from the harsh conditions and deprivations of everyday reality. In addition to these motifs, others that had first appeared in the previous century were used, such as *vizcachas*,[20] *tarucas*, armadillos, and llamas. Other indigenous animal motifs that reappeared were the puma and the mythical serpent *amaru*.[21]

The neoclassical style made its appearance in the final years of the eighteenth century. In the case of Mexico this was transmitted by the recently founded Academy of San Carlos (1785), while in other parts of Hispanic America, it arrived via bodies such as the Sociedad Económica de Guatemala through the founding of their Escuela de Dibujo (drawing school), which opened in 1797. Other channels for the introduction of the style included artists themselves or religious figures, who arrived imbued with the ideas of the Enlightenment and with it the doctrinaire aesthetic of neoclassicism. This was the case with the architect Matías Maestro (1776–1835), who applied this new "good taste" in Lima, or his pupil, the priest of the cathedral in Arequipa, Antonio Pereira y Ruiz,[22] who did the same in that city between 1811 and 1816, designing various projects. The style termed the "neoclassical" took notably different forms

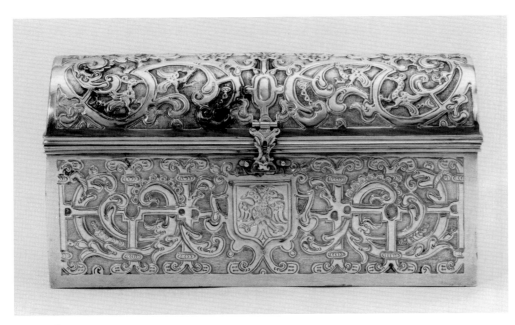

FIG. III-8
Coffer, Alto Perú (Bolivia), seventeenth century.
Silver. Victoria and Albert Museum, London,
M.190-1881

in Hispanic America at this time, but in general it did not give rise to any particularly important works. It would seem that the creativity of the previous century was almost extinguished except in a few leading centers, such as Mexico City (cat. III-10). In Peru, where the art of silversmithing had reached such marvelous heights, only Arequipa was able to maintain its quality. In previously unrivalled Potosí scarcely any works of artistic merit were produced, and the famed pieces of this period (cat. III-37) are rather celebrated for their historical or symbolic aspect.

While gold is associated for ritual and decorative reasons with the pre-Hispanic past, silver represents the apogee of this art during the more than three centuries of viceregal rule, a lengthy period that can be considered the Age of Silver, as it totally sustained life in Hispanic America and Spain. The wealth of the Americas was without doubt their silver, and thanks to it, the art of silversmithing could fully develop. It was, furthermore, a particularly brilliant art form as its roots lay primarily in the indigenous world and in its remarkable history prior to the arrival of the Spaniards. Sadly, with the dawn of the nineteenth century and the political innovations subsequently implemented by the Cortes of Cádiz (1813), which decreed industrial freedom and the abolition of the guilds, silversmithing ceased to exist as an artistic trade and thus went into decline in Latin America. This was exacerbated by a decline in silver production and the turmoil arising from the events surrounding independence. The splendor of the past had come to an end, and silversmithing of the republican period was unable to maintain its prestige. Since then it has remained submerged in a profound lethargy from which we can only hope it will one day emerge to enjoy a renascence of its former glories.

NOTES

1. Motolinía 1541/1969, p. 148.

2. Cieza de León 1553/1986.

3. Anglería 1530/1989.

4. Dürer 1520/1937.

5. Vega 1609.

6. Arzáns de Orsuá y Vela 1736/1965, book 1, chap. 1.

7. Barba 1640; on which see Bargalló 1955; Prieto 1968.

8. From *Memorias de los virreyes del Perú: marqués de Mancera y conde de Salvatierra* (1648; 1896 Lima ed.), p. 10, as cited in Lohmann 1997, p. 29.

9. Marking is a highly complex subject. For a better understanding, see Esteras Martín 1992 *Marcas*.

10. Carletti 1594/1976, p. 48.

11. Bezoars were formed in the stomach of ruminants (Persian goats and dromedaries, and llamas in South America). Various medicinal and even magical properties were attributed to them, for example, as antidotes against poison, as narcotics and stimulants, and as a remedy against epilepsy and melancholia.

12. I have identified and written on this piece in Esteras Martín 2004 "Bernegales," pp. 150–53.

13. Cited by Lohmann 1997, p. 35.

14. One of the most impressive is the example that Bishop Bernardo Serrada had made in 1731 for the cathedral at Cuzco; illustrated in Esteras Martín 1997 *Perú*, p. 67.

15. In Mexico, for example, the Marchioness of San Jorge had various pieces of silver furniture in 1695 in her reception room, while in Cuzco in 1702, the wife of the Count of La Laguna had two silver tables and writing desks or sideboards of the same material.

16. This was an essential element of domestic furniture in the Hispanic world. They came in all shapes and forms, with a single handle or with two, and were used at the table both for keeping the dishes of food hot as well as to warm hands or perfume rooms.

17. In addition, they also acted as perfume burners, as it was customary to throw olive stones onto them, which produced an agreeable scent. These large braziers either rested on a platform on the floor and took the form of a large studded, wooden wheel, or were cup-shaped, supported on legs in the form of harpies or lions or other motifs.

18. One example appears in the painting *View of the High Altar* of Cuzco Cathedral, an anonymous painting in a private collection; illustrated in Esteras Martín 2004 "Acculturation," fig. 64.

19. See Steele 1982, p. 68.

20. This is a rodent, slightly larger than a rabbit, that lives at high altitudes, around 4,100 meters (13,400 feet). In Andean mythology it is believed that these animals are in the service of the *Apus*, divinities of the high peaks; the *vizcachas* act as intermediaries between the gods and men. For this reason in a religious context—in paintings, murals, silverwork, etc.—they are seen as entrusted with putting man in touch with God.

21. This is iconographically identified with the winged dragon or basilisk, and among indigenous peoples it is thought to cause the death of whoever looks at it. It lived in Antisuyo, one of the four regions that form the Tahuantinsuyo or Inca Empire.

22. Aided by his gifts as a calligrapher and draftsman, Pereira y Ruiz illustrated his manuscript *Noticia de la muy noble y leal ciudad de Arequipa en el Reyno del Perú* (1816) with designs for architecture, furniture, jewelry, etc. On this, see Esteras Martín 1993 *Arequipa*.

III-1 *Incense burner*

Mexico City

c. 1550

Silver, molded, cast, repoussé, chased, and pierced

Height 6 inches (15.5 cm); diameter 3⅞ inches (10 cm)

Victoria and Albert Museum, London, M.62-1980

PROVENANCE: Acquired from S. J. Phillips, London, 1980

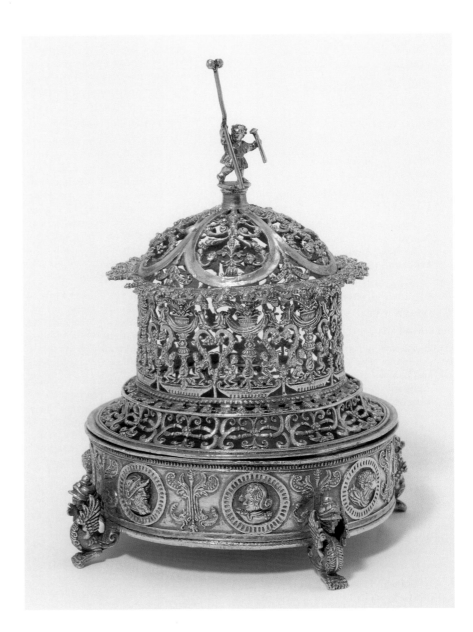

IN SPAIN THE CUSTOM OF PERFUMING rooms with aromatic substances was of long standing, and pieces of various shapes and materials were produced to serve this end. The custom was carried to Spanish America, where the new Hispano-American society preserved many peninsular traditions. As was to be expected, pieces were produced in Mexico for the purpose, and those extant are works of high quality and original design. All those known to us—one in the Instituto Valencia de Don Juan, in Madrid, another in a private collection, and a third in the cathedral in Seville, transformed into a reliquary of Saint Michael of La Cogolla—conform to the same model: the fragrances are burned in a cylindrical box that rests on fantastical legs (each one representing a being with the body of a bird and a warrior's helmeted head), while the upper part is a cylinder with a gadrooned dome, perforated to allow the smoke to escape. A cast figure usually crowns the whole.

By its resemblance in form and decoration to the pieces cited, this incense burner must have been made in Mexico City, though it is not marked with the punches pertaining to the silver workers of the city, whose imprints do however appear on two of the above-mentioned examples: the one in the private collection—with the mark of Mexico City and that of

Gabriel de Villasana—and the one at the Instituto Valencia de Don Juan, which bears the Mexico City mark alone.

The decoration draws on elements belonging to the Renaissance repertory of the second quarter of the sixteenth century, such as *candelieri*, tondi with Roman busts, urns, gadrooning, *putti*, and festoons, but since the work is Mexican it might be dated approximately to the decade of 1550–60. Its close resemblance, however, to the incense burner in the private collection makes it likely that its date is closer to the years proposed for that piece on the basis of its marks: around 1544–45. Since a certain fluctuation in dating can be expected, it might be fixed it in broad terms around 1550.

The rarity of such pieces gives this incense burner a special and important place in the panorama of Hispanic—both Mexican and Spanish—silverwork. The precise origin of the formal model remains in doubt, for although nothing with its characteristics can thus far be traced with certainty to a Spanish prototype, there is an incense burner of a similar structure in a *Still Life with Table Setting*, c. 1622, by the Madrid painter Juan van der Hamen (private collection).

Cristina Esteras Martín

III-2 Domingo de Orona

(Spanish, born 1520; active Mexico City, 1547–89)

Chalice

1566–72
Silver, gilt, cast, repoussé, and chased
Height 10⅞ inches (27.5 cm); diameter at base 6¼ inches (16 cm)
Four marks on edge of base: ORONA, right profile of male head over o/M between crowned columns, OÑA/TE, and lacustrine tower; marked with the assayer's burin
Inscribed on inside of base: *Diciembre 8 del año 1675*
Victoria and Albert Museum, London, Hildburgh Bequest, M.65-1959

PROVENANCE: Acquired under the W. L. Hildburgh Bequest, 1959

PUBLISHED: Oman 1968, no. 104, fig. 196; Esteras Martín 1989, pp. 82, 144–45 and 392; *Mexico* 1990, cat. no. 168; Esteras Martín 1992 *Marcas*, p. 8, no. 9

EXHIBITED: Mexico City 1989, no. 12; New York, San Antonio, and Los Angeles 1990, cat. no. 168

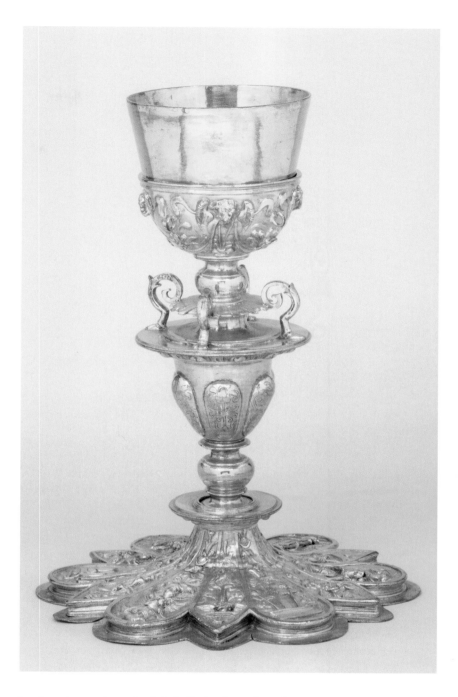

THIS CHALICE FORMED PART of the generous bequest of Dr. William Leo Hildburgh of New York City to the Victoria and Albert Museum, although it was acquired in 1959, four years after his death. Charles Oman established its Mexican origin, but was unable to interpret the rest of the marks, so the piece was classified as an anonymous work. Fortunately, the two nominal marks have now been assigned to their true owners: the assayer Oñate (who occupied his post around the years 1566–72) and the silversmith Domingo de Orona.

Domingo de Orona was a native of Zaragoza in Spain, where he was born in 1520 into an important family of silversmiths. It is not known when he arrived in Mexico, but by 1547 he had established himself in the capital of the viceroyalty and had been named head of the silversmiths' guild. He remained in Mexico City until at least 1589. He must have worked only in silver, because he had to request permission in 1563 to gild a three-piece saltcellar (of the *torrecilla* type) for the infamous Don Jerónimo de Valderrama, *visitador*, or royal inspector, of New Spain. He requested permission on another occasion to gild a "basin and a pewter tankard" for the cathedral in Mexico City.

As this is the only piece known by its marks to be the work of Domingo de Orona, therefore it can help us to recognize the rest of his production. Judging from the breadth of the base and the size of the cup, the piece must originally have been a chalice-monstrance. Unfortunately, the part that fitted into the cup to display the Eucharist (the monstrance)

has been lost, as have the little bells that hung from the rings of the cup holder, a characteristic element of this kind of piece.

Domingo de Orona employed here a design very different from the models he would have seen in Zaragoza before his departure for Mexico. It is more like certain chalices fabricated in Seville, so he may have been asked to copy one of these as a model. It would not be the first time an artist was commissioned to copy a work, and this would explain the late date of the piece, which by its style fits better into the decade of the 1550s than the period around 1566–72 indicated by Oñate's marks.

Curiously enough, another chalice of very similar characteristics is in a private collection in Guadalajara, Mexico, suggesting that the type enjoyed some success among Mexican silversmiths. It is so similar, in fact, that it might well have been attributed to Orona if its hallmarks did not show the author to have been a certain Mendía.

Cristina Esteras Martín

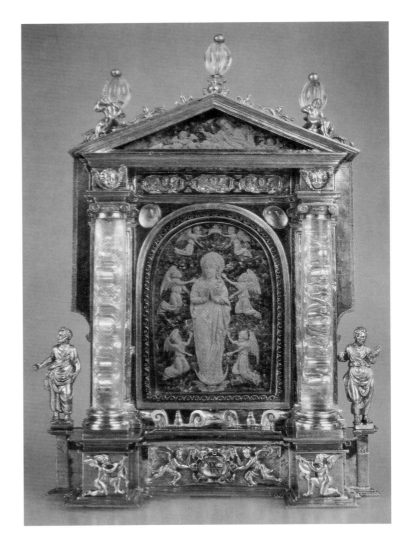

III-3 *Pax*

Mexico City

c. 1575–78

Silver, gilt, cast, and chased, with burnished punchwork, rock crystal, boxwood, feathers, and nielloed enamel

10⅞ × 7¾ × 4¾ inches (27.5 × 20 × 12 cm) (including handle)

Faint Mexico City mark repeated three times on base: o/M between columns

Inscribed: *PAXTE/CVM*

Private collection

PUBLISHED: Esteras Martín 1992 *Marcas*, p. xix, fig. 8; Esteras Martín 1994 "Plata," pp. 54–55; *Oro y plata* 1999, cat. no. 213, p. 399; Esteras Martín 2000 "Platería," p. 121

EXHIBITED: Madrid 1999 *Oro y plata*, cat. no. 213

PAXES (ALSO CALLED OSCULATORIES) were tablets used by the congregation to exchange the "kiss of peace" before the Communion. They came into general use after the Council of Trent, although the custom dates from earlier times. Sometimes they were made in pairs, in order to save time during the ceremony and so that a certain decorum could be maintained by offering one to the men to kiss and another to the women.

This extraordinary Mexican pax is unique in its use of four materials—silver gilt, rock crystal, boxwood, and feathers—that were commonly combined in Mexican silverwork, at least during the third quarter of the sixteenth century.

The pax is designed architecturally, as is usual with these pieces, and dedicated to the Coronation of the Virgin Mary. The coronation scene occupies the central niche, with its figures carved in boxwood placed against a background of feathers. In the tympanum of the pediment there is a depiction of God the Father in the act of blessing, executed with the same materials. The shafts of the Ionic columns are of rock crystal, as are the almond-shaped moldings of the spandrels and the oval finials of the attic. The work is complemented by four sculptural figures: two unidentified images, rising on either side of the base, and, on the cornice of the pediment, two putti reclining in the manner of figures by Michelangelo. There are also four angels depicted in relief: two playing musical instruments—one on either end of the base—and two

in the center sustaining a cartouche that contains the Latin words for "Peace [be] with you" in enamel lettering against the silver background.

It might be asked whether this combination of materials in a religious work came about by chance, or simply in obedience to the aesthetic tastes of whoever produced or commissioned the work. The answer is to be found in the religious sincretism of colonial Mexico and the understanding that featherwork (the art of the *amantecas*) possessed a symbolic value, being associated with the ideas of divinity, uniqueness, and sacredness. This was because bird feathers were sacred objects, images of nobility, fertility, abundance, riches, and power; those who used them were associated with the divinity, and the iridescence of feathers corresponded symbolically to the transfiguration of the divine illumination. Nor would the friars have considered it strange to see featherwork used in a cult object, knowing as they did the words in the Vulgate version of Exodus (39.1–3 and 27–29), which describe the garments of the Old Testament priests, including the ephod of Aaron, made "opere polymitario . . . cingulum vero . . . *arte plumaria*" (as Yahweh had commanded Moses).

The whole constitutes an extraordinary piece that might well confound a European, for in spite of the apparent prevalence of Renaissance form and aesthetics, it nevertheless embodies the profound religious symbolism of indigenous art. It is a product of that art which Reyes Valerio has called "Indian-Christian."

Cristina Esteras Martín

III-4 *Chalice*

Mexico City

c. 1575

Silver, gilt, cast, repoussé, chased, and engraved, with burnished punchwork, and boxwood, rock crystal, and hummingbird feathers

Height 13 inches (33 cm); diameter at base 9¼ inches (23.5 cm)

Faint marks repeated four times and hidden inside stem and cup: male head over o/M between crowned columns; on edge of cup: an angel with outstretched wings

Los Angeles County Museum of Art, Museum Associates, William Randolph Hearst Collection, 48.24.20

PROVENANCE: William Randolph Hearst Collection

PUBLISHED: *Platería mexicana* 1989, cat. no. 15; *Mexico* 1990, cat. no. 170; Esteras Martín 1992 *Marcas*, pp. xx–xxi, figs. 9, 10, no. 22; Esteras Martín 1994 "Plata," p. 54; *Oro y plata* 1999, cat. no. 208, pp. 394–95; *Aztecs* 2002, cat. no. 327

EXHIBITED: Mexico City 1989, cat. no. 15; New York, San Antonio, and Los Angeles 1990, cat. no. 170; Madrid 1999 *Oro y plata*, cat. no. 208; London 2002, cat. no. 327

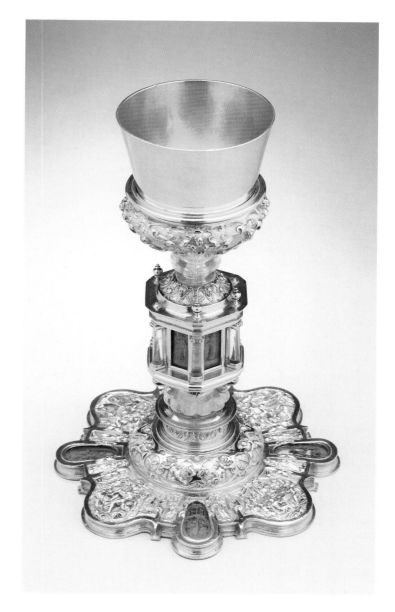

IT IS AN ESTABLISHED FACT that Mexican silversmiths of the sixteenth century worked with consummate skill and that many of their pieces are deserving of the highest praise. This is true of this impressive chalice produced by an anonymous artist around 1575, a date indicated both by the style of the work and the mark of Mexico City with which it has been imprinted.

It is a large, heavy piece in which the artist once again made use of the four materials in vogue in Mexican silverwork during the third quarter of the sixteenth century: silver gilt, boxwood, rock crystal, and feathers. The parts that give real solidity to the work, the foot and the cup, are made entirely of silver, while the stem makes partial use of it. The semicircular surfaces of the foot display four scenes worked in relief, skillfully composed and finished, which were doubtless modeled after an engraving. They depict various events from the Passion of Christ: the Last Supper, the Arrest, Christ Carrying the Cross, and the Lowering of Christ from the Cross. Between these reliefs there are oval spaces covered by glass to protect medals with boxwood reliefs that are inserted underneath and that bear other depictions of the same Passion iconography: the Agony in the Garden of Gethsemane, the Scourging, the Veil of Saint Veronica, and the Holy Sepulcher. All of these once had a background of featherwork, since lost except in the case of the last scene. The ornamentation is completed by delicate renderings of the four Latin doctors of the church (Saint Ambrose, Saint Jerome, Saint Gregory the Great, and Saint Augustine) and the Tetramorph (the four Evangelists). On the convex surfaces there are medallions containing Passion symbols: nails, the veil of Veronica, spear and sponge, and the column with two scourges.

The central knop of the stem forms an important part of the whole owing to its volume, striking presence, and architectural composition. Ionic columns with smooth shafts worked in rock crystal alternate with six niches containing depictions of the Twelve Apostles, grouped in pairs

and crafted in wood over a featherwork background. The cupholder is also striking for the figurative ornamentation covering its surface: four shields with violently foreshortened images of the Evangelists flanked by mannerist herms, all crafted in pronounced relief against a contrasting stippled background.

This is one of the two known cases (the other is the "rich chalice" of the collegiate church of Zafra, in Badajoz, Spain) of the singular presence of a male head in left profile, with beard and helmet in the manner of the Spanish conquistadors, engraved on the surface of the base, but hidden from view by the cylindrical piece of the stem. No sure explanation can be given for its presence in this place, although it may correspond in both cases to the iconography of the donor.

This chalice constitutes a unique and exceptional example for its artistic quality and the wealth of techniques masterfully handled. This doubtless moved the American magnate William Randolph Hearst to acquire it for his valuable collection. It has, moreover, the added value of being a syncretistic example of a formula of symbolic communication with the divine.

Cristina Esteras Martín

III-5 *Monstrance*

Mexico City

c. 1632–34

Silver gilt, cast, repoussé, and chased, with burnished punchwork, and enamel

Height 20½ inches (52 cm); diameter at base 7⅞ inches (20 cm)

Mark on foot: male head in left profile over o/M between crowned columns

Victoria and Albert Museum, London, Hildburgh Bequest, M.252-1956

PROVENANCE: W. L. Hildburgh, acquired in Paris, 1921, by way of Zamora (Spain); bequeathed to the museum in 1956

PUBLISHED: Oman 1968, p. 47, fig. 234; Esteras Martín 1988, p. 70; *Platería mexicana* 1989, cat. no. 31

EXHIBITED: Mexico City 1989, cat. no. 31

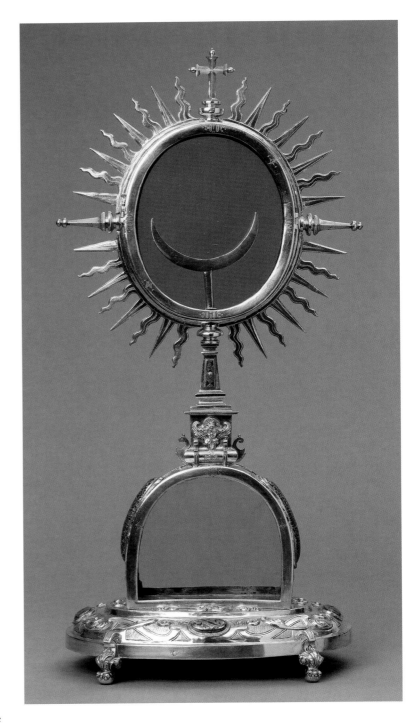

MONSTRANCES WERE USED BOTH INSIDE and outside the church to display the Eucharist for the devotion of the faithful. The most authentic manifestation of this worship was during the Corpus Christi celebrations, when the Eucharist was carried in procession by a priest attired in his pontifical garments, and under a canopy. Owing to the enormous size and weight of some monstrances from the sixteenth century on, it was also permitted in Spain for them to be carried on litters. They were produced in many shapes and styles at different periods, but the most common ones were portable, and of these the most numerous by the end of the sixteenth century were the "sunburst" variety, so called because the casing within which the Host is displayed (the *sol*) evokes by its rays the radiant solar star, symbolizing Christ.

This monstrance from the Victoria and Albert Museum is of the portable, sunburst type but differs from the prototype by the ovate form of the casing (commonly circular) and the innovative arch-shaped piece on which the stem rests. The function of this element, which was originally enclosed front and back by two panes of glass, is not known, since it is the only one of its kind. Perhaps it served as a reliquary.

The imprint of the punch of Mexico City dates the piece with certainty to the years 1632–34, although other features would lead to the same conclusion. For example, the distribution of the rays into four groups is identical to that of the Mexican monstrances in Castromocho and Becerril de Campos (both towns in the province of Palencia in Spain), as are the legs, in the shape of vegetal claws grasping balls, and the facial features and hairstyles of the cherubs.

The piece is no less attractive for the originality of its design and the instability of its mannerist structure in the form of the stem and pedestal than it is for the richness and detail of its ornament, especially the champlevé enamelwork—in ultramarine, emerald green, and ocher—of the cabochons. Those on the stem have geometric designs, whereas the four bosses that adorn the base bear naturalistic depictions of birds among branches, a motif disseminated by the German engraver Corvinian Saur between 1591 and 1597.

Although his identity is unknown, there is reason to suspect that the artist may have been connected with the silversmith Juan de Padilla (born in Castromocho in 1592 and active in his profession in Mexico City from 1622 until his death in 1672). This conjecture is based on the aforementioned formal details, as well as similarities in the design and color of the naturalist cabochons (by no means common) to those of a Eucharistic coffer attributed to Padilla in the parish church of Becerril de Campos. Still more support for this hypothesis comes from the fact that this monstrance proceeded from Zamora, a city very near the villages of Becerril and Castromocho. In Mexico, Padilla might well have performed commissions from clients who had emigrated to New Spain from the province of Palencia. Nevertheless, as all of this remains hypothetical, the piece must be classified as anonymous work.

Cristina Esteras Martín

III-6 Juan del Río

Votive lamp

Mexico

1720

Silver, molded, repoussé, chased, and cast, with burnished punchwork

Height 43³⁄₁₆ inches (110 cm); diameter of bowl 21¹¹⁄₁₆ inches (55 cm)

Inscribed under rim of bowl: *ESTA LAMPARA LA DEDICO AL SSmo. XPTO. DE LA CARIDAD EL CVIDADO DEVOZION DE SV PRIMER CAPn. EL Ldo. DIEGO DE ROXAS PRESBo. ANNO DE 1720. Juan del Rio fecit*

Museo Franz Mayer, Mexico City, 01317/GLA-0005

PUBLISHED: Esteras Martín 1992 *Mayer*, pp. 157–58; *Mexicaans Zilver* 1993, cat. no. 124

EXHIBITED: Ghent 1993, cat. no. 124

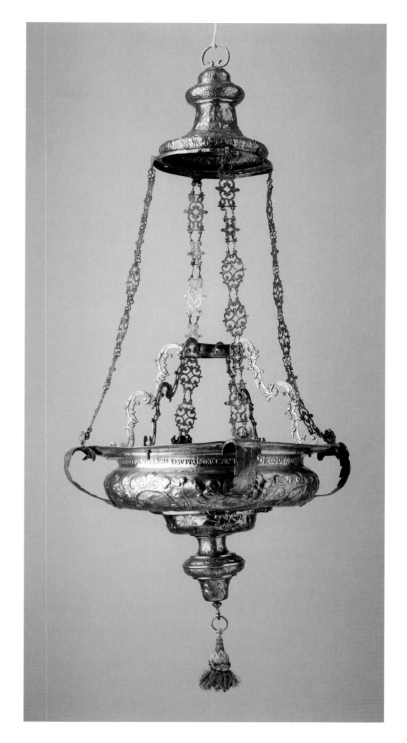

IT WAS CUSTOMARY IN SPAIN and, later, Spanish America for people to have silver votive lamps made, the better to fulfill their vows and promises to God, the Virgin Mary, or the saints. These lamps would burn continually in the place where an image of the object of the vow was kept. They usually bore an inscription, which might include the donor's name, the details of the donation, or other relevant information. The lamps were made in different styles and designs at different periods. Although some were equipped with wax candles, the most common variety had a single wick that burned in a glass receptacle containing oil located at the very center of the lamp.

The example in the Museo Franz Mayer belongs to this latter type. An engraved inscription tells us who dedicated the lamp (the priest and chaplain Don Diego de Rojas), the date of the offering (1720), the image to which it was dedicated (the Holy Christ of Charity), and even the name of the craftsman who fashioned it (Juan del Río). Although the date guides us in establishing the chronology of the piece, we know nothing more about the donor or the image to which the lamp was dedicated (for example, the church and village where it was located). Knowledge of the artistic center that produced the lamp, and of the place where the silversmith worked, would have contributed to a more exact classification of the piece.

The lamp was probably not made in Mexico City, since it was common after the beginning of the eighteenth century for any silverwork produced in the capital to bear the customary hallmarks (or at least one of the four required). Since the name Juan del Río does not appear on any known list of Mexico City silver workers, it is likely that he was active in some other city or town in the Viceroyalty of New Spain.

The undulating profile of the lamp and the naturalist decoration of the surface areas, the latter based on repoussé designs of flowers and stems, are typical of the baroque. The four cartouches contain symbols of the Passion of Christ, an iconography connected with the Christ of Charity.

The lamp's excellent state of preservation (even the chains are original) and the fact that we know who made it make this a piece of great interest among the silverwork of the Viceroyalty of New Spain.

Cristina Esteras Martín

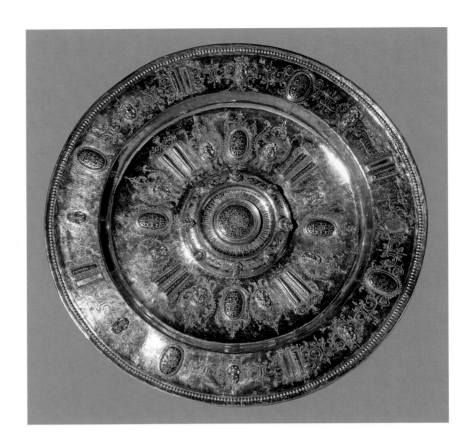

III-7 *Basin*

Mexico City

c. 1670

Silver, gilt, cast, molded, repoussé, chased, and engraved, with burnished
punchwork, and enamel

Diameter 20⅝ inches (52.5 cm)

Mark of Mexico City repeated twice on outer rim: male head in left profile
over o/M between columns timbred by a vegetal crown with three points

Cathedral of Seville, Spain, 427

PUBLISHED: Angulo Iñiguez 1925, pp. 31 and 32; Esteras Martín 1991,
pp. 178–179; Esteras Martín 1992 *Marcas*, p. 23, no. 59; Esteras Martín
1993 "Platería mexicana," pp. 42 and 44; *Oro y plata* 1999, cat. no. 218,
p. 405; *Orfebrería* 1995, cat. no. 3, pp. 28–29; *España* 2003, cat. no. 240

EXHIBITED: Madrid 1999 *Oro y plata*, cat. no. 218; Seville 1995, cat. no. 3;
Seville 2003, cat. no. 240

THESE BASINS (*FUENTES*) WERE DEFINED by Sebastián Covarrubias
in his *Tesoro de la Lengua Española* (*Treasury of the Spanish Language*)
(1611) as "large silver plates, because formerly water for hand washing was
offered to kings and princes." It is therefore a secular utensil for the wash-
ing of hands, to be filled with water from a ewer (*aguamanil*). Its presence
in the cathedral in Seville can be explained, as in many other cases, as the
result of a donation, in this case that of Doña Ana Paiva in 1688. Thus,
the piece passed from secular furnishings to religious ones.

This basin is both larger and heavier than was common, and the
richness of its decoration is also unusual, making it a truly unique and
superb example of its kind. Its singularity resides not in its form, which
merely reproduces the circular design widespread in Castile through the
sixteenth and seventeenth centuries, but rather in the magnificence of its
ornamentation.

An analysis of the ornamentation on both rim and body reveals a
perfect balance between the engraved and chased decoration based on
cartouches and vegetal Cs on the one hand, and the enameled "caissons"
and ovals that articulate the composition symmetrically, in conjunction
with the isolated superposition of small, cast cherub heads. A matchless
effect is produced by the elegance of the chasing and engraving on the
smooth, brilliant surfaces in contrast to the shading generated by the
bosses and figures in relief.

The enamel plays a fundamental role in lending color to the basin,
not so much by its varied palette—of only two colors, ultramarine and
amber—as by the fact that the colors invade every part of the composition,
including the central space that was generally reserved for an engraving
of the owner's coat of arms. In this case, it is occupied by a floral boss,
onto which the enamel has been applied, as with the rest of the ovals and
caissons, by the champlevé technique, the fillets forming geometric designs
with vegetal solutions. The silver color of the fillets underlines a further
contrast with the gilt of the rest of the surface.

Though formerly considered to have been produced in Castile, this
basin was crafted in Mexico City around 1670, as the mark of the locality—
imprinted on it twice—unequivocally confirms. A careful iconographic
analysis of the cherubic figures leads to the same conclusion, as their puffed-
out cheeks, large, almond-shaped eyes, and lock of hair falling over the
brow are all typical of these figures in seventeenth-century Mexican art.

Cristina Esteras Martín

III-8 *Altar cross*

Mexico City

c. 1560

Silver, gilt, cast, repoussé, chased, and pierced, with rock crystal

Height 18⅞ inches (48 cm); base 9½ × 9½ inches (24 × 24 cm)

Very faint Mexico City mark repeated three times between arches on base: upside-down vegetal crown with three points

Museo de la Catedral, Palencia, Spain

PUBLISHED: *Orfebrería* 1986, cat. no. 3; *Platería mexicana* 1989, cat. no. 5; Esteras Martín 1992 *Marcas*, p. 6, no. 10; Esteras Martín 1993 "Platería mexicana," pp. 41 and 43; Esteras Martín 1994 "Plata," pp. 46 and 50; Esteras Martín 2000, "Platería," p. 122

EXHIBITED: Madrid 1986, cat. no. 3; Mexico City 1989, cat. no. 5

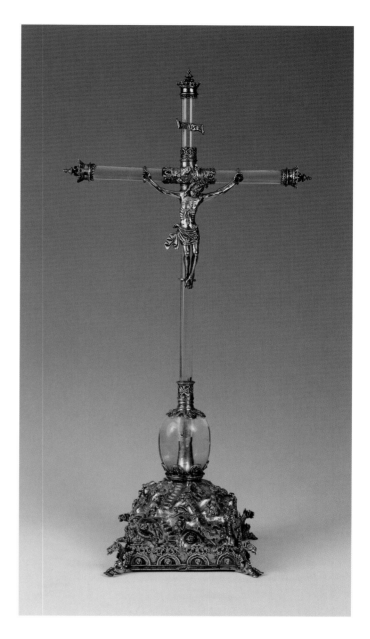

IT BECAME OBLIGATORY IN THE sixteenth century to place a cross equipped with a base onto the altar before the officiating priest. It was to be accompanied, before the Council of Trent, by two candlesticks, and later (in the seventeenth century), by as many as six, which were lighted during Sunday Mass. The crosses might be made of various materials, but silver was most commonly used. This Mexican altar cross was crafted in silver (later gilded) and rock crystal. Although these materials were not exclusive to the Viceroyalty of New Spain, the latter was used from early on—as of the middle years of the sixteenth century—in Hispano-Mexican silverwork. The presence of rock crystal is not due to chance, nor would it seem to be due to the visual or tactile properties of the material, but rather to its *sacred* quality, as can be observed in the text of the *Codex Florentino* (1575–77), in which rock crystal is said to have been "treasured, esteemed, prized, and venerated." Made of rock crystal are the cylindrical upright and transverse beams of the cross, as well as the knot from which it emerges, whereas the remainder—the tips of the arms and the crossing, as well as the base—is of silver.

The most singular aspect of this piece is not the cross itself, on which the figure of the crucified Christ is in line with Christian iconography, but rather the various elements covering the surface of the base. It is in the shape of a hill in allusion to Golgotha, but the extreme naturalism reflected in the presence of animals, plants, burrows, cascades, and other motifs comes not only of the desire to depict the life and topography of a mountainside but corresponds to a much more complex discourse, which is difficult to interpret without knowing the original context of the piece, or who had it made and for where. The artist remains anonymous, though he would seem to have been an indigenous silversmith who in his method of working left traces of his aesthetics and his language, a hermetic language including pre-Hispanic symbols that embodied messages capable of being assimilated by two groups (the Native Americans as well as the friars), and which became all the more necessary in proportion as the messages were more complex.

On this mountain (also identified with the Earth) the four elements or forces of nature seem to be represented: fire (mammals), air (birds and insects), water (amphibians and cascades), and earth (caverns and reptiles), the concrete sense of which would seem to allude to a Christological icon-ographic program referring to the dogma of the death and resurrection of Christ, and also to the redemption of humanity. The meaning of some of the motifs is quite clear: the frogs or toads are symbols of immortality; the lions, lizards, and butterflies (these last because of their phases as caterpillar, chrysalis, and butterfly) are associated with resurrection; and the cascades or springs also allude to resurrection and life.

As might be expected, the local environment makes itself felt through autochthonous flora and fauna, present in the rattlesnakes (Nahuatl *coatl*), the flowering branches and flowers (Nahuatl *xochitl*), the cactuses (*nopales*), and the grasshoppers (*chapulines*). Behind certain depictions and motifs there are also pre-Hispanic iconographic sources, as can be seen in the two cascades sweeping away the insects, designed exactly like the skirts of the water goddess Chalchiuhtlicue as illustrated on page 4 (*tonalámatl*) of the *Codex Borbonicus*, or the river accompanying the illustration of the fire god Xiuhtecuhtli and the god of the dawn Tlahuizcalpantecuhtli on page 8 of the same codex.

In short, this altar cross is a matchless example of Mexican art of the sixteenth century, and an exceptional instance of religious syncretism.

Cristina Esteras Martín

III-9 Antonio Fernández

(Mexican, active Puebla de Los Ángeles, 1730–60)

Frame

1752
Silver, partly gilt, repoussé and chased, with a wooden frame
92⅛ × 53⅝ inches (234 × 136 cm)
Maker's mark in the oval medal: FERN/ANDES
Inscription in the oval medal: *SEISO ADEVOSI/ON DEL Sr. Dr. JU/AN PERES SALGO/DIGNIDAD DE MAES/TRE ESCVELA DE LA/ STa. YGLESIA CATED/DRAL DE LA PVEBLA DE LOS ANGs. AÑO/ DE 1752*
Museo Franz Mayer, Mexico City, 18093/00333/CEE-0001

PROVENANCE: Acquired at Antiquália, Lisbon, December 12, 1966

PUBLISHED: Esteras Martín 1989, pp. 100, 276–77 and 400, fig. 114; Esteras Martín 1992, *Mayer*, pp. 188–90; Esteras Martín 1992 *Marcas*, p. 65, no. 167

EXHIBITED: Mexico City 1989, cat. no. 75; Mexico City 1991, p. 6

THIS LARGE FRAME is made of sheets of silver nailed onto a wooden structure. Conceived pseudo-architecturally, it has a central space—prepared for a painting or a mirror—in the form of a round arch with generous spandrels, and a rectilinear entablature marking off the attic, which takes the form of an undulating pediment cut out in C-shapes. Both this and the rest of the surface area are covered in symmetrical foliate relief.

In the oval above the keystone of the arch a detailed inscription explains that the piece was made in 1752 through the devotion of Don Juan Pérez de Zalgo, a canon with teaching duties (*maestrescuela*) at the cathedral in Puebla de los Ángeles who is known to have held the post from at least 1719. The inscription fails to mention the destination of the work, but it was probably dedicated to the cathedral.

The clearly imprinted maker's mark—FERNANDES—led long ago to an identification with the silversmith Antonio Fernández, whose birthplace is unknown, but who is known to have resided and worked in Puebla de los Ángeles between at least 1730 (when he was already a certified master craftsman) and 1760. He must have been a respected master in the city, judging by the importance of the commissions he received and the places where his work was displayed, as well as by the trust placed in him by the silversmiths' guild, which elected him inspector (*veedor*) in 1760. He was the author of the monstrance and the altar frontal in the famous sanctuary of Ocotlán (Tlaxcala), pieces fortunately still in existence, as well as of a monstrance with a gold casing garnished with precious stones, commissioned in 1756 for the convento of San Jerónimo in Puebla.

This frame is unique for both its size and the quality and refinement of its workmanship. It is a worthy example of the baroque silverwork of Puebla de los Ángeles, second in importance only to that of Mexico City within the Viceroyalty of New Spain.

Cristina Esteras Martín

III-10 José Luis Rodríguez Alconedo

(Mexican, born 1761, Puebla de los Ángeles; active Mexico City, 1791–1815)

Plaque of Carlos IV

1794
Silver, cast and chased, with burnished punchwork
11⅞ × 9¾ inches (30 × 25 cm)
Inscribed: *José Luis Rodríguez Alconedo, natural de la ciudad de* [Puebla de]
los Angeles, a 1° de Junio de 1794, a 32 años de edad
Museo Nacional de Historia/CONACULTA, INAH, Mexico City,
10-130732

PUBLISHED: Valle-Arizpe 1941, fig. 81; Toussaint 1974, p. 247, fig. 440;
Maza 1940, pp. 39–56; Obregón 1967, pp. 82–87; *Platería mexicana* 1989,
cat. no. 103; *Mexico* 1990, cat. no. 237

EXHIBITED: Mexico City 1989, cat. no. 103; New York, San Antonio, and
Los Angeles 1990, cat. no. 237

ON THE STRENGTH OF THIS FINE allegorical plaque bearing the likeness of the king of Spain Carlos IV, José Luis Rodríguez Alconedo was made an honorary fellow of the Royal Academy of the Three Noble Arts of San Carlos in Mexico City. This renowned silversmith, born in Puebla de los Ángeles (Mexico) in 1761, settled thirty years later in Mexico City, where he led an intense professional life, although the only works of his to have survived are this plaque and another one made as a cover for a Bible. Also an engraver and a painter, Rodríguez Alconedo was imprisoned in Mexico because of his revolutionary, pro-independence ideas, and exiled to Spain (1811–12), where he learned the technique of painting with pastels. On his return to Mexico, he joined the army of José María Morelos and fought for the cause of Mexican independence. He was captured and imprisoned again in 1814 and finally executed by firing squad in Apam, Hidalgo, on March 1, 1815.

With this piece, which he signed and dated 1794 on the back, Rodríguez Alconedo earns a place as a magnificent engraver, evident above all in the rendering of the monarch's hair and the folds of his garments. The plaque is conceived as a large oval medallion showing a bust of Carlos IV, in profile, wearing a toga and crowned with laurel, like a Roman emperor. The king is accompanied by various allegorical elements symbolizing military attributes (drums, flags, and a cannon) and by the emblem of the "heraldic lion of Spain," which clasps a sword in its paw and holds two spheres—the Old and New Worlds—in its embrace. The eye of Providence looks out from a burst of sun rays at the top of the com-

position, under which two branches of flowering laurel (symbol of immortality and attribute of victory) are tied together by a bountiful ribbon.

It is highly paradoxical that an artist such as Rodríguez Alconedo, who died defending the ideals of Mexican liberty and independence from Spain, should be remembered in the history of Mexican silverwork for a work that pays homage to the Spanish king. In any case, this worthy professor of the Academy of San Carlos is fully deserving of his fame as an excellent silversmith and engraver.

Cristina Esteras Martín

III-II Attributed to Juan Ruiz del Vandalino

(Spanish, late fifteenth century–1550)

Processional monstrance

Seville, Spain

Before 1542

Silver, gilt, cast, chased, and engraved

Height 32¼ inches (82 cm)

Mark: letter A in circle beneath patriarchal cross, with octagonal outer border with matted corners

Inscribed on three-story bell tower and on base: *SEVILLA* (in Latin characters)

Cathedral of Santo Domingo, Dominican Republic

PUBLISHED: *Exposición Histórico-Americana* 1893, cat. no. 2; Cipriano 1927, vol. 2, pp. 48–49; Alcocer 1942, pp. 231ff.; Angulo Iñiguez 1947, pp. 49ff.; Palm 1950 *Arte*, cat. no. 37; Palm 1950 "Treasure," p. 120; *Catedral de Santo Domingo* 1984, p. 14; Cruz Valdovinos 1992, cat. no. 18, pp. 28–35; Cruz Valdovinos and Escalera Ureña 1993, pp. 67–76; Sanz 1999, p. 50

EXHIBITED: Madrid 1892, cat. no. 2; Santo Domingo 1950, cat. no. 37; Seville 1992 *Platería*, cat. no. 18

LARGE PROCESSIONAL MONSTRANCES, referred to as *Custodias de Asiento*, or "seated" monstrances, began to be used throughout Spain after the arrival of the German silversmith Enrique de Arfe (Heinrich von Arff; late 1500s), who introduced this type with the Gothic monstrances of the Cathedral of León (commissioned in 1501) and at the Monastery of San Benito, Sahagún (León). The intent was to reproduce architectural structures in miniature to exhibit the holy sacrament in public processions commemorating the feast of Corpus Christi, which gained prominence across Europe after the Council of Vienna in 1311.

The tradition of exhibiting the body of Christ in public was in turn transplanted to the Americas. And thus it was in the first city founded by the Spaniards, Santo Domingo (1502), that such monstrances initially appeared. In this case, however, the work was not the result of any ecclesiastical commission, but rather the gift of one of the cathedral's clerics, Friar Diego del Río, who is represented etched onto the interior of the lower section of the piece as a figure praying before a monstrance.

As is customary in such works, the formal structure is primarily architectural: three tapering superimposed stories that serve as a support for the iconographic representation of the Eucharist, which appears in the reliefs along the hexagonal base as well as in the sculptural elements distributed throughout. The relief work includes seven scenes from the Old Testament: Abraham and Melchizedek, the Vocations of Elijah and Elisha, the Benediction of Jacob, David and His Companions Take the Hallowed Bread, Abraham and the Three Angels, Habakkuk and the Angel, and David in the Lions' Den. The statuettes on the lower section include various Apostles—Peter, Paul, John, Bartholomew, Philip, and James—while the second "story" includes images of several prophets (only David has been identified) in addition to figures of saints with palms and

angels bearing the symbols of the Passion. The third level is devoted to depictions of warriors and cherubs with lances and shields. The piece is crowned by a statue of the Resurrected Christ.

The work itself was not created in Santo Domingo, but was both commissioned and made in Seville. This is unequivocally confirmed by a mark of provenance, which bears the image of the city's symbol, the cathedral's Giralda tower, as well as the inscription *SEVILLA* on the monstrance base. The other inscription is apparently that of the silversmith charged with marking the piece. Identification of this mark, still a point of contention, would give us an exact date of manufacture. Despite these uncertainties, and in large part owing to the documentation provided by Friar Vicente Rubio, we know that the monstrance was first exhibited on Corpus Christi day in June 1542, and that it presumably would have been created between 1541 and 1542.

As to the artist of the piece, a comparative study of the relief and decorative work of the monstrance that once graced the Cathedral of Jaén (completed in 1540) and the monstrance of the Church of Fuenteovejuna (Córdoba)—the former a documented work by Juan Ruiz del Vandalino, and the latter attributed to this artist—has enabled us to attribute this Dominican work to the same artist. Ruiz del Vandalino, an important silversmith from Seville, is considered one of the main artistic forces behind the development of the Renaissance in that city. Juan de Arfe described him in his *Varia Commensuración* (1587; book IV, chapter I) as "the first one to produce fine silver carving in Spain, to bring form to silverware, and to thus instruct all of Andalusia in this art." This exceptional work reveals absolute mastery of Renaissance forms as well as exuberantly executed ornamental imagery that reflects the influence of grotesque motifs.

Cristina Esteras Martín

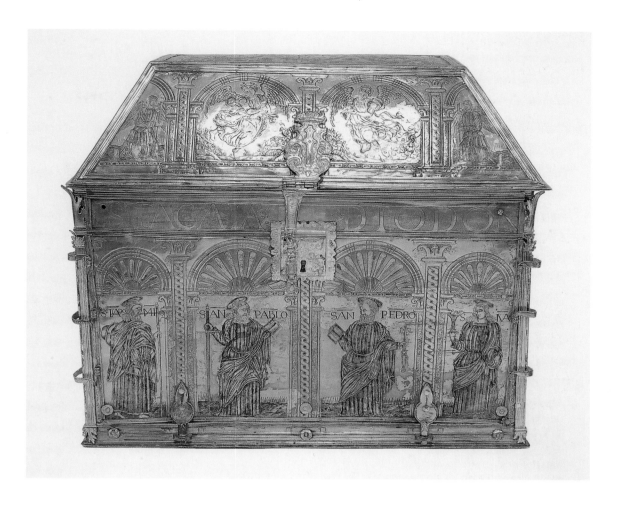

III-12 *Eucharistic coffer*

Probably Santo Domingo (Dominican Republic)

1579

Silver, chased and engraved

18⅜ × 20½ × 13¼ inches (46.5 × 52 × 33.5 cm)

Inscription along edge of coffer and on top of lid: *ESTA CAIA DIO DON/A IOANA DE ME/SA MUVGER DE IVAN DE/BERIO A 1579; ERMANA DE PERO LO/PES DE/MESA ASISTENTE Q FOE/DE SEVILLA*

Cathedral of Santo Domingo, Dominican Republic

PUBLISHED: Cruz Valdovinos and Escalera Ureña 1993, pp. 79–82; Esteras Martín 1999, p. 397; *Oro y plata* 1999, cat. no. 210

EXHIBITED: Madrid 1999 *Oro y plata*, cat. no. 210

THIS RECTANGULAR CHEST, with a lid in the form of truncated pyramid, was used to hold the Eucharist in the monument erected during the Holy Thursday festivities. The piece reproduces the form of a "sepulchral coffer" in symbolic allusion to the tomb in which the body of Christ was laid. Both the body and lid of the coffer are adorned with engraved figures. The body shows the twelve apostles (Matthew, Andrew, James the Less, Thomas, Thaddeus, Philip, James the Greater, Paul, Peter, John, Simon, and Barnabas) in niches crowned by scallop shells. The flat top of the lid shows an image of the risen Christ (eucharistic iconography once again) in a central tondo, flanked by two others containing worshipping angels,

while cherubim bearing candles or chalices are inserted between arch-bearing half-columns along the four slanting sides. Equipped with handles on its sides, the coffer can be opened by lifting the lid, which locks to the front, or by removing the corner bolts and lowering the front panel.

The engraved inscription dates the piece to 1579, almost immediately after the Council of Trent (1545/63), following which this type of work began to come into general use. The inscription also reveals the name of the donor, Doña Juana de Mesa, as well as other details regarding her family relations, such as the name of her husband, Juan de Berrio (who was constable [*alguacil*] and accountant of Santo Domingo in 1566 and 1579), and that of her brother, Pedro López de Mesa.

It is not known for certain where the coffer was fabricated, as it bears no marks, nor has any relevant documentation so far come to light, but all the evidence suggests that it was made in Santo Domingo by one of the Spanish silversmiths—perhaps from Seville—who had settled in the island in search of new opportunities for their profession. Though of anonymous workmanship, the piece is outstanding for its excellent technique and skillful handling of the graver, whereby the artist was able to create striking contrasts in the shadowing of the folds of the images. Its age and provenance give it added attraction. It was one of the few pieces that survived the plundering of the cathedral following Francis Drake's siege of the city in 1586, just seven years after it had been made.

Cristina Esteras Martín

III-13 Pedro Xuárez de Mayorga

(Spanish [?], active Santiago de Guatemala, c. 1550–68)

Chalice

c. 1550
Silver, gilt, cast, repoussé, and chased, with burnished punchwork,
and enamel
Height 11⅝ inches (29.5 cm); diameter at base 7¾ inches (18.5 cm)
Three marks on rim of base: -A/--R/-A, a conch and a crown (the last
two very faint)
Várez Fisa Collection, Madrid

PUBLISHED: Esteras Martín 2000 *Fisa*, pp. 54–58; *Quetzal* 2002, cat. no. 275

EXHIBITED: Madrid 2002 Centro, cat. no. 275

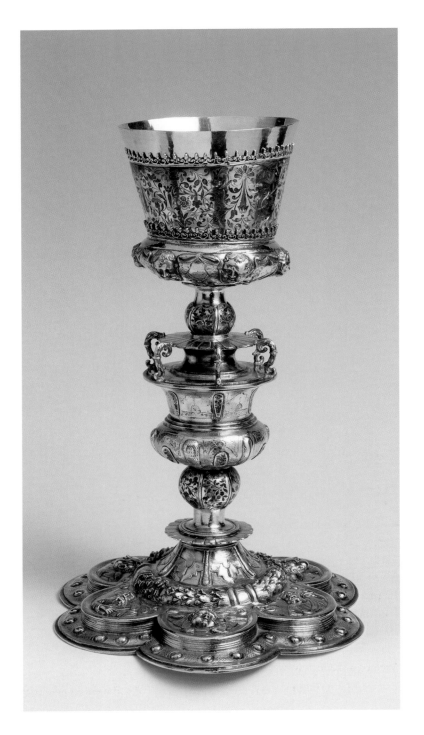

THE IMPORTANCE OF THE CHALICE in the celebration of the Mass
made these pieces extremely abundant in both Spain and Hispano-
America in all periods, though they naturally become scarcer the further
one goes back in time. There are several very well-crafted examples from
sixteenth-century Guatemala, but this one from the Várez Fisa collection
surpasses them all. The exquisite decorative enameling makes it unique
in the Hispanic world.

The enameling appears on various parts of the stem and on the
cup, where it forms a broad swath of imposing vegetal volutes. It has been
applied by the champlevé technique with painted enamel on a base of
white silver with degradation, combining various colors for the flowers,
leaves, and volutes, and an opaque reddish-chestnut tone for the stems.
An extremely rich palette was used: grayish blue, light blue, carmine grad-
ing into white (russet), muted pink turning toward rust, mother-of-pearl,
bluish green, yellow-green, and a highly transparent turquoise-green.
The decoration and composition is in line with the painted enamel work
done in the sixteenth century in various centers in Italy (Milan, Florence,
Venice) and Central Europe (Augsburg, Prague), where Renaissance
ornamentation and design survived until the seventeenth century. The
exquisite enameling technique of this chalice stands up fully to compari-
son with those illustrious forebears, as its excellent state of preservation
clearly shows.

Structurally the chalice follows models to be found in mid-sixteenth-
century Old Castile (the foot) and Seville (the balustraded stem), but the
fact is that, as is usual in Hispano-American silverwork, the piece is not
dependent on specific Spanish forebears but rather represents a synthesis
of the Spanish plurality projected toward the New World.

Among the three hallmarks on the chalice there are incomplete
but recognizable traces of the maker's mark of Pedro Xuárez de Mayorga
(MAIORGA). The marks suggest a date around 1550, or in any case

before 1553, when Cosmé Román assumed the post of assayer, since the
chalice does not bear the imprint of his punch (an R).

All that is known for certain of Xuárez de Mayorga is that he lived in
Santiago de Guatemala (Antigua) in 1568. His birthplace is unknown, but
he is likely to have been Spanish and to have arrived in Guatemala with a
certain artistic and professional standing. The catalogue of his works can
be fixed with more certainty, and there is an especially noteworthy proces-
sional cross in the National Museum of History in Mexico City (Castillo
de Chapultepec). Of all his surviving work, however, this chalice is what
gives him an undisputed place among the great Hispanic silversmiths.

Cristina Esteras Martín

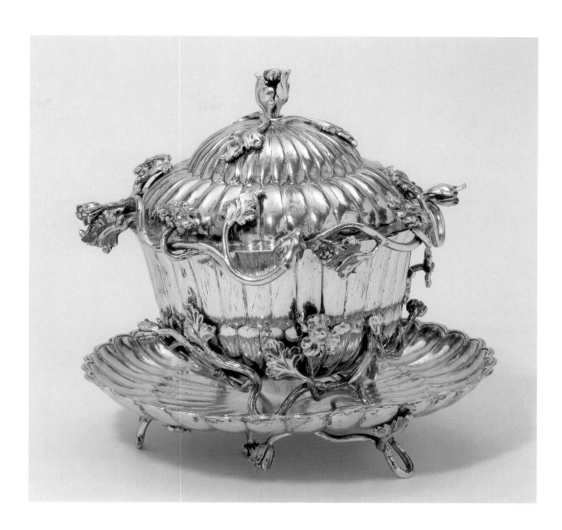

III-14 *Compote dish with salver*

Santiago de Guatemala

c. 1770

Silver, molded, cast, repoussé, and chased

Height 7¼ inches (18.5 cm); diameter 7⅝ inches (19.5 cm)

Two marks on outside base of salver: the apostle James the Greater (Santiago) mounted on horseback between two volcanoes, and an open, royal, vegetal crown

Victoria and Albert Museum, London, M.68-1953

PROVENANCE: W. L. Hildburgh, London; bequeathed to the museum in 1953

PUBLISHED: Angulo Iñiguez 1950, pp. 351–53; Esteras Martín 1992 "Miguel," p. 19; Esteras Martín 1994 "Platería," p. 176

THIS COMPOTE OR SWEETS DISH is an example of the beautiful tableware produced in the second half of the eighteenth century in Santiago de Guatemala (known as Antigua Guatemala). The design seems to have been exclusive to the city's silver workshops, as it has not so far been traced to any other place in Spain or Hispano-America.

Both the recipient and its cover, as well as the salver on which it is displayed, is decorated with gadroons adapted to the convex and concave surfaces, creating beautiful effects of movement and contrasts of light and shade. The other cast decorations applied to the piece, such as the rosettes and the leafy stems, belong to the typical Guatemalan repertoire. This ornamentation also has a functional role, as the twisting stems form the feet of both dish and salver, and those along the rim of the cover serve as handles.

When Diego Angulo found this piece in the storerooms of the Victoria and Albert Museum, he did not hesitate to attribute it to the silver workshops of Santiago de Guatemala, observing that one of its two marks depicted "two triangular hills, one higher than the other, and a figure . . . of a horseman." This was in effect the mark of the locality used in the second half of the eighteenth century, and even before that. The other mark is the royal crown, which certified payment of the *quinto real*, or "royal fifth." The specific characteristics of these two hallmarks fix the date of the piece around 1770.

Another compote dish very similar to the present one came to light in a private collection in 1992. On the basis of their decoration, both of them might be ascribed to the circle of the renowned silversmith Miguel Guerra, but this cannot be confirmed, since other silversmiths of the Guatemalan rococo, such as Patricio Xirón and Pedro Valenzuela, made similar use of gadroons, rosettes, and leafy stems. Curiously enough, these naturalistic motifs are due not to influences from Spain—where they are unknown—but rather to the silversmiths of London, where the use of such cast ornamentation, applied to the piece by soldering, persisted well into the nineteenth century.

Cristina Esteras Martín

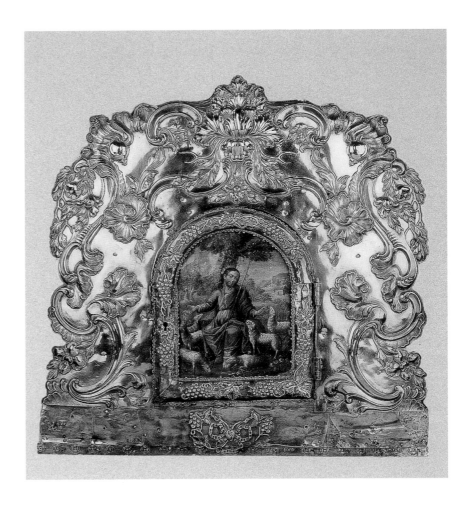

III-15 *Tabernacle*

Santiago de Guatemala (?) or Nueva Guatemala de la Asunción (?),
Guatemala

c. 1780

Silver, repoussé and chased, with wooden support

25½ × 25 inches (64 × 63.5 cm)

Marks repeated in various places: Saint James riding between two mountains,
and the imperial crown with five bands gathered at the top

Museo Popol Vuh, Universidad Francisco Marroquín, Guatemala, 1339

PUBLISHED: Alonso de Rodríguez 1980, vol. 1, p. 149, fig. 4; Esteras Martín
1994, *Platería*, pp. 210–11; *Quetzal* 2002, cat. no. 272

EXHIBITED: Madrid 2002 Centro, cat. no. 272

THE ROCOCO TABERNACLES designed in the silver workshops of
Guatemala move away from traditional architectural structures toward
compositions in which the entire surface area is decorated in C-shapes,
stems, leaves, and flowers, which generates a lively sense of movement
with no loss of symmetry. The designs were worked on sheets of silver
that were then nailed onto a cubic wooden structure, and since this was
set into the steps (*gradillas*) on the altar, it was not necessary for the entire
structure to be plated in silver, but only the front. This placement of the
tabernacle on the altar, rather than beside a pillar somewhere else in the
church, as formerly, was in accordance with the norms established by
the Council of Trent (1545/63).

Of interest in this tabernacle now in the collection of the Museo
Popol Vuh (of unknown provenance) are both the ornamentation and
the baroque iconography symbolizing the Eucharist and the triumph of
the Sacrament: the Good Shepherd painted on the door in a frame of vine
tendrils and grape clusters, the IHS monogram with the cross and nails
on the back of the door, and the "sunburst" monstrance with its pedestal
of clouds on the back wall of the box.

Two marks repeated several times indicate that the piece was crafted
in Guatemala. The mark of the locality shows the Apostle James (Santiago)
mounted on horseback between two volcanoes, and that of the treasury an
imperial crown of five bands gathered together at the top and crowned by
a cross above a globe, both symbols generally used in Guatemalan silver
workshops.

Santiago de Guatemala (the capital of the Captaincy General of
Guatemala) was destroyed by a severe earthquake in 1773, and the civil
authorities, obliged to move the city to a safer location, founded Nueva
Guatemala de la Asunción. But many of the inhabitants, among them
several silversmiths, refused to leave the ruined city, so it is impossible
to say in which of the two cities this tabernacle, dated around 1780 by its
style and marks, was fabricated.

Wherever it was made, it is an excellent piece of workmanship, as
Guatemalan silverwork has proved itself continually to be since its begin-
nings in the middle of the sixteenth century.

Cristina Esteras Martín

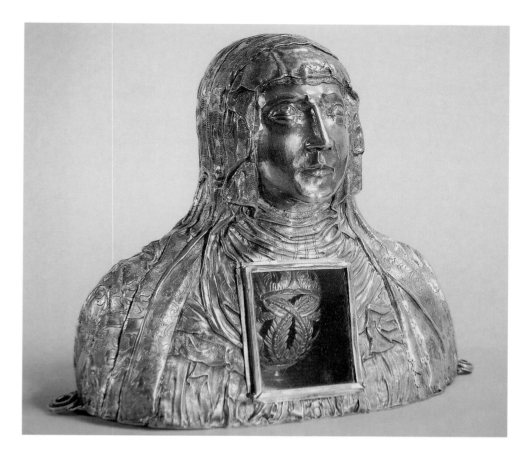

III-16 Reliquary bust of Saint Elizabeth of Hungary

Possibly Santa Fé de Bogotá, Colombia
After 1619
Silver, cast, chased, and engraved, with burnished punchwork, and gilt relics
12¼ × 14⅜ × 6¾ inches (31 × 36.5 × 17.3 cm)
Cathedral of Santa Fé de Bogotá, Colombia, 05.1.149

PUBLISHED: *Oribes* 1990, p. 54; Huertas 1995, pp. 124–25; *Oro y plata* 1999, cat. no. 215, p. 402

EXHIBITED: Bogotá 1990; Madrid 1999 *Oro y plata*, cat. no. 215

THE VENERATION OF RELICS goes back to the time of the first Christian martyrs, but it was only during the first session of the Council of Trent (1545/63) that the worship of the saints by means of painted or sculpted images was defended and made obligatory. At the same time the veneration of relics was regulated and specifications for making reliquaries laid down. As a result of this policy of the Counter-Reformation (in opposition to the Lutheran iconoclasts), the production of these cult objects multiplied.

The cathedrals, as well as other churches, understood that their prestige would be in direct proportion to the number and qualities of the relics they possessed, so benefactors of all kinds undertook to make gifts of relics and to fabricate the reliquaries in which they would be kept. Such was the case of the cathedral in Bogotá with this bust of Saint Elizabeth of Hungary, made to display for veneration, behind the glazed front window, several fragments of bone from the saint's head.

These relics were brought to the cathedral from Spain in 1573 by the Franciscan friar Don Luis Zapata de Cárdenas, who had been appointed archbishop of Santa Fé de Bogotá, a position he held until his death in 1590. He had received the relics from the hands of Doña Ana de Austria, the fourth wife of Felipe II. They were therefore of considerable value and importance, associated as they were on the one hand with the Duchess of Thuringia, daughter of the king of Hungary, and on the other, indirectly, with the queen consort of the Spanish monarch. As a result, Saint Elizabeth became patroness of the archdiocese of Bogotá.

The bones of the saint were not, however, originally kept in this reliquary in the form of a bust, but are known rather to have been in an urn, which was stolen in 1619. It is likely therefore that this reliquary was made after that date, almost certainly in Santa Fé de Bogotá, where there were plenty of skilled silversmiths capable of undertaking the work. Also

in support of this date are certain features of the piece itself, such as the realism of the saint's knitted brow (typical of the early years of the seventeenth century) and the movement of the folds of her garments. Cut off at midtorso, the sculpture shows Saint Elizabeth with her head draped in the "honest headwear" of a woman who should dress with sobriety, in keeping with her station of widow (she became one at the age of 20). In contrast, however, to this discreet and modest bearing, the ornamentation of the mantle, tunic, and headwear is patterned on the richly brocaded fabrics of a noblewoman's attire.

The importance of this reliquary resides both in the provenance of its relics and its having been fabricated in the form of a bust. Although reliquaries of this kind were common in Spain, and especially in Aragon, relatively few of Hispano-American origin have survived. It is this circumstance, in addition to its fine craftsmanship and technique, that makes it such a rare and exceptional piece.

Cristina Esteras Martín

III-17 José de Galaz

(Colombian, active Santa Fé de Bogotá, 1700–1707)

Monstrance

1707
Gold, cast, pierced, repoussé, and chased, with enamel, emeralds, diamonds, rubies, amethysts, a sapphire, a topaz, and pearls
Height 31½ inches (80 cm)
Collection of the Bank of the Republic of Colombia, Bogotá, Colombia

PROVENANCE: Church of San Ignacio, Santa Fé de Bogotá; Central Bank of the Republic of Colombia, 1985

PUBLISHED: Ortega Ricaurte 1965; Gil Tovar 1986, vol. 4, pp. 1032–33; Duque Gómez 1990, pp. 38; *Oribes* 1990, p. 68; Esteras Martín 1997 "Orfebrería (Río)," p. 157

EXHIBITED: Bogotá 1990

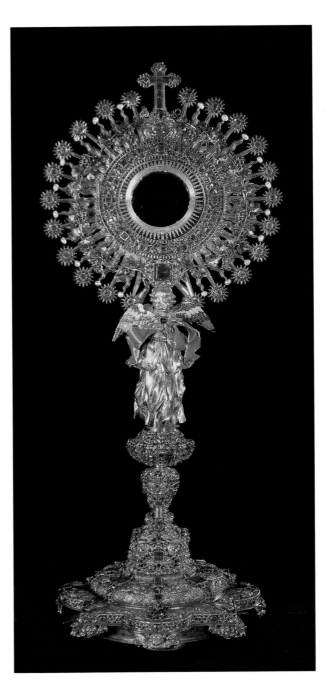

THIS MONSTRANCE FROM THE Church of San Ignacio in Bogotá, doubtless the most famous of all South American monstrances for its lavishness and beauty, is nicknamed "The Lettuce" (*La Lechuga*) because of the intense green of the 1,485 emeralds that adorn it. The piece is a genuine treasure, not only for its precious stones but because of its exquisite craftsmanship and formal design, exemplified in the sculpture of the Atlantean angel on the stem holding up the sunburst with its head and hands. This solution was very common in the high baroque silverwork of the Viceroyalty of New Spain (Mexico), but less so in that of Colombia and other parts of the Viceroyalty of Peru, although the Jesuits must have had a special predilection for the symbolism of monstrances with so-called angel-figure stems. The fine monstrance attributed to the Jesuit silversmiths of Calera de Tango Juan Köhler and Francisco Pollands (conserved in the cathedral in Santiago, Chile, after the expulsion of the Jesuits in 1767) has the same structural characteristics and the lavish decoration as the present one.

This piece, purchased from the Company of Jesus in 1985 by the Central Bank of Colombia, was crafted in Bogotá by the silversmith José de Galaz between 1700 and 1707. The terms of the contract for the work reveal that, in addition to the emeralds already mentioned, the decoration includes 28 diamonds, 62 baroque pearls, 168 amethysts (though only four of them faceted), 13 rubies, a sapphire, and a topaz. The weight of the fine gold was calculated to be 4,902.6 grams (equal to 157.62 troy ounces), and the silversmith was paid 1,100 pesos for his labor.

The intense green tonality of the emeralds is echoed by the blues, yellows, and reds of the other precious stones distributed about various parts of the piece and by the white of the pearls on the shorter sun rays and lining the inner circle of the sunburst, making for an extremely lively and intense spectrum of colors when combined with the varied palette of the enameling. The great bow on the angel's back is painted entirely in sky-blue enamel, and the feathers of its wings in strips of yellow, emerald green, ocher, and ultramarine, while the tunic and cloak are touched with intermittent strokes of green and sky-blue. There is also ultramarine enameling on the angel's cothurni footwear, and the border of vine leaves encircling the sun rays on either side is enameled with a true-to-nature emerald green.

Apart from this decoration, the basic iconographic motifs are the bunches of grapes and tendrils of vine leaf (embossed on the base and applied around the sunburst, in clear allusion to the sacrament of the Eucharist, the theme to which the piece is dedicated). For the same reason, the "angel-figure" on the stem transmits an iconographic message of the triumph and exaltation of the Eucharist, in accordance with the notions of the Counter-Reformation.

This extraordinary portable monstrance is a fine example of the exquisite work of the gold-silversmith José de Galaz and a testimony to the rich abundance in Colombia of gold and silver mines, emerald deposits (such as Muzo and Somondoco), and banks of pearls.

Cristina Esteras Martín

III-18 Nicolás de Burgos y Aguilera

(Colombian, active Santa Fé de Bogotá, 1734–37)

Monstrance

1736–37

Gold, cast, pierced, and chased, with enamel, pearls, and precious stones

Height 32¾ inches (83 cm); diameter at base 11⅞ inches (30 cm)

Inscribed on rim of foot: *ESTA CVSTODIA SE HIZO A DEVOCION Y ESPENSAS DEL ILMO SR DON ANTONIO CLAVDIO ALBARES DE QVIÑONES ARZOBISPO PRIMADO DE STA. FEE EL AÑO DE 1736 EN CVYO AÑO FALLECIO SU ILMA. PESA DE ORO 18 LIBRAS*

Cathedral of Bogotá, Colombia

PUBLISHED: Restrepo Posada 1952, unpaginated; Duque Gómez 1990, pp. 38–39; *Oribes* 1990, p. 69; Huertas 1995, pp. 26–27

EXHIBITED: Bogotá 1990

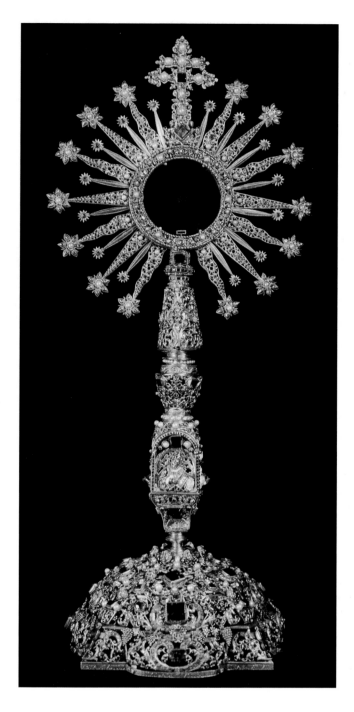

MANY FINE MONSTRANCES WERE PRODUCED in Colombia during the colonial period, but this one from the cathedral of Bogotá has earned the nickname *La Preciosa* for the excellence of its craftsmanship and the opulence of its materials. Its gold weighs 18 pounds, and 3,223 precious stones were used in its decoration, not to mention the enameling that adorns various parts of it.

This lavish monstrance was donated to the cathedral by Don Antonio Álvarez y Quiñones when he was archbishop of Santa Fé de Bogotá (1727–36), in the aim of heightening the solemnity of the Corpus Christi festivities. The commission fell to the renowned Bogotá master Nicolás de Burgos y Aguilera, who finished the piece in 1736 according to the inscription, although a certificate signed by the artist on February 14, 1737, is usually taken to indicate the definitive termination date. The certificate reads: "I, Nicolás de Burgos, gold-silversmith, certify that the monstrance which I have made for the cathedral of this city of Santa Fé has one thousand nine hundred and eighty-eight diamonds, as well as one thousand two hundred and ninety-five emeralds, and fifty-nine amethysts, a topaz, a hyacinth and a fine garnet, that all of the stones make up three thousand three hundred and fifteen stones, as well as three hundred and seventy-two pearls, and [that] its gold weighs one thousand eight hundred gold *castellanos* which makes eighteen pounds."

The monstrance has a singular design, although it maintains the cruciform base and the stem with a central node in the form of a blind shrine that are usual in these pieces. Its originality resides in the working of the material. The repoussé technique was abandoned, and the gold pierced to create openwork decoration, some of it geometrical (Cs, Ss, and cartouches) and some of it directly related to Eucharistic iconography (bunches of grapes). The same technique is used on the stem, on the sunburst with its rays of alternating lengths, and on the patriarchal cross that crowns the whole.

The nodal shrine is exceptional not only because of the four figures it contains, worked in high relief (almost in the round), but also because of the enameling used to depict their attire, in white, sky-blue, light yellow, and lemon-yellow tones, alongside the gold of the faces and hands. These figures represent the four doctors of the Church (Saints Ambrose, Jerome, Gregory the Great, and Augustine), and each one holds as his attribute a book bearing one of the words *VERVUM, CARO, PANEM,* and *VERUM.*

Around 1734–37 Nicolás de Burgos made another monstrance for the service of the convent of Santa Clara la Real in Tunja (Colombia). Although less lavish and not so finely crafted, it is quite similar in its formal characteristics to this exhibit, suggesting that this silversmith from Santa Fé de Bogotá was the disseminator (or even the creator) of this typology.

Cristina Esteras Martín

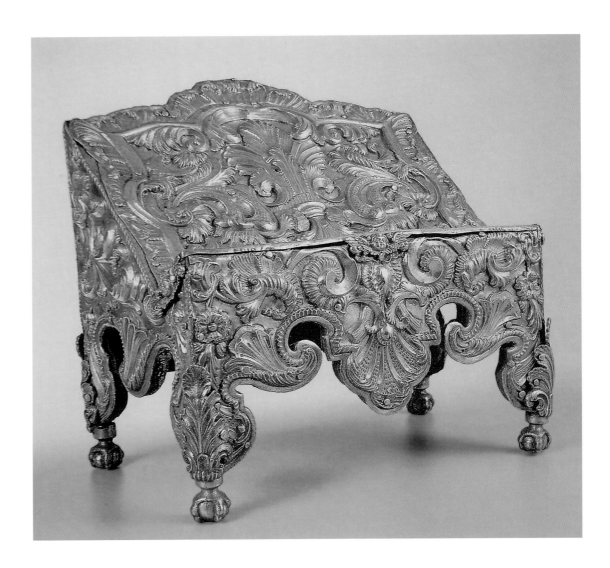

III-19 *Missal stand*

Probably Santa Fé de Bogotá, Colombia
c. 1770
Silver, repoussé, cast, and chased, with wooden support
15 × 15⅞ × 8⅞ inches (38 × 40.5 × 22.5 cm)
Cathedral of Bogotá, Colombia, 05.1.153

PUBLISHED: *Oribes* 1990, p. 84; Huertas 1995, pp. 114–15

EXHIBITED: Bogotá 1990

THIS MISSAL STAND IS ONE OF A PAIR, in line with the tradition in important cathedrals of making such stands in pairs to facilitate the placement of liturgical books on the altar. This example was made by nailing sheets of silver onto a wooden support that provides the necessary sturdiness. Cast silver was used for the feet and some of the applied decoration.

The formal design is fairly typical of Andean baroque silverwork, with the inclined planes of the rectangular front and the socle meeting to form a V, while the frontal apron and the sides show a sharply cut silhouette of segmented C- and S-shapes, with a lobate element left hanging down in the center of the apron.

The ornamentation of the silver plates is naturalistic, with palmettes and vegetal motifs treated very much in the manner of rocaille, although sporadic rosettes also appear. This decoration is worked in pronounced relief, of a sensual and highly dynamic appearance, with the symmetry and *horror vacui* characteristic of the high baroque. The rocaille tendency of the leafwork, however, betrays the triumph of the rococo and suggests a date of around 1770, although this must remain tentative in the absence of supporting documentation and without certain knowledge of where the piece was made or by whom.

Even more than the repoussé decoration, what defines the piece as Andean is the iconography of the winged cherubim, whose faces and hairstyles are typical of the baroque tastes of this region. The form of the feet—small balls in the grip of claws—and the palmettes at each corner also recall the solutions turned to account with such success on South American monstrances.

In light of the foregoing, and of an analytical comparison with other missal stands from the Viceroyalty of New Granada (present-day Ecuador, Panama, Venezuela, and Colombia) and even from other places in the Viceroyalty of Peru (for allowance must always be made for movement from one region to another), this stand would seem to have come from the silver workshops of Santa Fé de Bogotá. In the Church of Las Nieves in Bogotá there is another pair of missal stands, simpler but with similar decoration (although not yet manifestly rococo), executed by Cayetano de Esguerra in 1753.

Cristina Esteras Martín

III-20 *Monstrance*

Probably Colombia

c. 1650–1700

Silver, gilt, cast, and chased, and emeralds, diamonds, amethysts, pearls, and glass

Height 20⅜ inches (51.6 cm); diameter at base 7¾ inches (19.8 cm)

Museo Soumaya, Mexico City

PROVENANCE: Sotheby's, New York, November 25, 1986, lot 66; Christie's, New York, October 21, 1993, lot 367

PUBLISHED: Grabski 1990, cat. no. 70

EXHIBITED: Warsaw 1990, cat. no. 70

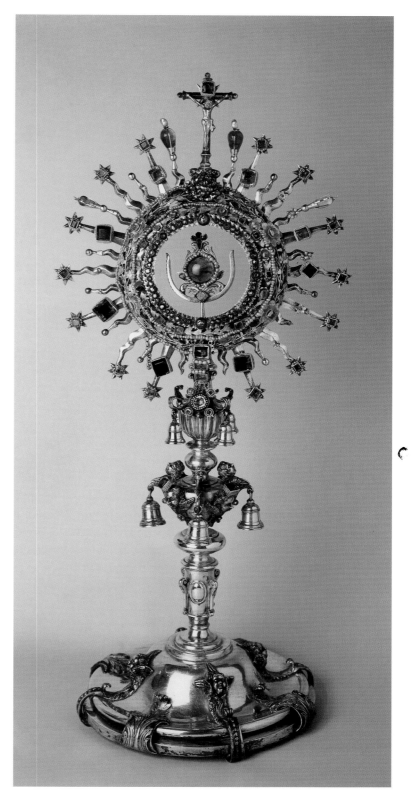

THIS TYPE OF PORTABLE MONSTRANCE became common during the Counter-Reformation as a result of the measures taken at the Council of Trent (1545/63) to encourage the veneration and worship of the Eucharist inside the churches. There arose a demand for monstrances of a size and weight that would make it possible for the priest to handle them during the celebration of the mass. In this model the glazed casing in which the consecrated Host was displayed evokes a sunburst, a symbolic transposition of the notion of Christ as the light and sun of justice.

Removed from its place of origin, this monstrance comes with neither documentation nor hallmarks to guide us in classifying it. An analysis of the work itself can provide only approximations, since different treatments of the foot and the stem have not been codified to permit identification of a specific artistic center, and still less of a specific artist. The piece is likely to be Colombian, or at least Andean, owing to the type of precious stones used in decorating it, among which emeralds predominate over other kinds (amethysts and diamonds), it being well known that there are rich deposits of emeralds in Colombia—particularly those at Muzo. Emeralds had not only material but symbolic value, and were considered sacred by the Muisca Indians of Cundinamarca and Boyacá, which is one of the reasons why they were used to give splendor and dignity to cult objects. The pear-shaped cut of the emeralds and amethysts that terminate four of the solar rays also points to an Andean origin.

A structural analysis of the work reveals that the style of the *sol* (circular, with straight rays alternating with undulating ones), of the foot (circular, with a sinuous contour), and of the stem (various independent bodies superposed one upon another, with two nodes in the form of urns) situates the monstrance in the second half of the seventeenth century, but greater exactitude is not possible. The decoration would normally be of help here, but in this case it tells us nothing explicit, as the palmettes following the contours of the base, the small bells, and the little angel heads all belong to the usual repertoire of the period, as does the placement of a cross at the top, with rhomboidal arms terminating in pear-shaped knops. It is worthy of note, however, that the body of Christ appears on the cross—an uncommon feature.

We have here, in short, an original monstrance of non-standard design, solid in its structure owing to its weight and the material used, and lavish in its decoration of precious stones. The amethyst placed in the lunette where the consecrated Host is displayed is particularly striking for its size and design. It is only the incomplete preservation of the stones that diminishes the value of the piece, for eleven of the pear-shaped jewels that once crowned the undulating rays have been lost, as well as several of the square stones, which were replaced by simple pieces of glass.

Cristina Esteras Martín

III-21 *Monstrance*

Lima, Peru

1649

Silver, gilt, cast, chased, and engraved, and enamel

Height 22½ inches (57.2 cm)

Inscribed on rim of base: *EL PADRE FR, Pº. DE VRREA NATVRAL DESTA VILLA DE XADARQVE DIO ESTE SAGRARIO AESTA IGLESIAMAIOR DONDE FVE BAVTICADº. RVEGEN A DIOS POR EL AIO 1649*

The Metropolitan Museum of Art, New York, Friedsam Collection, Bequest of Michel Friedsam, 1931, 32.100.231a,b

PROVENANCE: Friedsam Collection

PUBLISHED: Esteras Martín 1994 "Peruvian," pp. 71–76; Hecht 1994, pp. 77–88; Esteras Martín 1987, p. 383, fig. 372; Esteras Martín 1997 *Perú*, cat. no. 11, pp. 100–101; Phipps et al. 2004, cat. no. 113

EXHIBITED: Madrid and Lima 1997, cat. no. 11; New York 2004 *Andes*, cat. no. 113

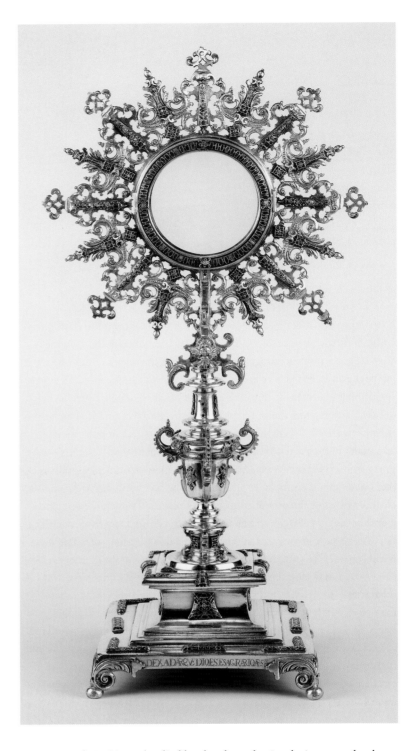

MANY OPULENT PORTABLE MONSTRANCES were fabricated in colonial Peru, and although this one donated by Pedro de Urraca is not as lavish as some, it is of particular importance owing to its donor, and because it constitutes the dated prototype (1649) of a certain model. Like so many other works, it found its way to Spain as the gift of a Spaniard who, having gone off to the New World and settled there, wished to remember his birthplace and forge a sentimental link with the village and church where he had been baptized. It was this which moved the friar Pedro de Urraca to make a gift of the monstrance to the principal church of his village in 1649, although the piece is now in New York. Urraca was born in Jadraque (Guadalajara, Spain) in 1583, and was sent as a child to Quito, where his brother was a Franciscan friar, and he himself entered the Mercedarian Order there in 1603. Five years later, in 1608, he moved to Lima, where he remained until his death in 1657. He was buried in the Mercedarian monastery there. The donor might seem to be just another *indiano* (as those Spaniards who made their careers in the New World were called), but anyone familiar with the history of Lima will know how important the figure of Urraca is and the veneration in which he is still held even today. This monstrance is therefore of considerable significance both for what it represents on an artistic level in the context of Lima silverwork, and for the historical importance of the person behind the commission.

In formal terms, the piece constitutes the prototype of a model that, with minor variations, would continue to be used in Lima through the second half of the seventeenth century. It was precisely its structure that led it to be classified as work from Lima, although it bears no markings and the inscription is silent as to its origin. Its style, however, could not possibly be confused with work from other silver centers in the Viceroyalty of Peru. Telltale features of this style include the configuration of the rays of the sunburst as an elaborate meshwork and the choice of a square base resting on foliate feet ending in small spheres.

The lavishness and rich palette of the enamelwork, and even its distribution—extremely dense on the casing of the *sol* and its rays, more intermittent on the stem and base—are invariable conventions of mon-

strances made in Lima. Applied by the champlevé technique to cabochons of various shapes, the enameling employs a palette of ultramarine, honey gold, and green, between silver fillets.

The maker of the monstrance is unknown, although a silversmith by the name of Diego de Atienza has been proposed as a possibility. Atienza is a village near Jadraque, and if this silversmith lived in Lima in the middle years of the seventeenth century, his countryman Urraca might well have commissioned the work from him. In the absence, however, of any kind of documentary evidence, this attribution cannot be considered more than just a hypothesis. What is more certain is that the monstrance is so similar to one preserved in the parish church of Embid de la Ribera, Zaragoza, Spain, that they can be considered the work of the same artist.

Cristina Esteras Martín

III-22 *Votive lamp*

Lima, Peru
Between 1687 and 1697
Silver, molded, cast, chased, and pierced
Parish Church of San Juan, Telde (Canary Islands, Spain)

PUBLISHED: Pérez Morera 2003, pp. 4–6

IMMIGRATION TO SPANISH AMERICA from the Canary Islands was intense from the time of the discovery of the New World, so it is not surprising that the churches there possess works sent back by natives of the islands to forge links with their villages of origin. It was thus that this votive lamp found its way to the Canaries as a bequest by the merchant Francisco López Zambrana to the chapel of the Virgen del Rosario in the parish church of his birthplace, San Juan de Telde.

The piece was crafted in Lima sometime after October 12, 1687, the date of the testamentary bequest, and before February of 1697, when the lamp arrived in the city of Portobelo in Panama as part of the cargo of the fleet of the *Tierra Firme*, bound for Cadiz. From the Spanish port it continued its journey to Orotava in the Canary Islands, where it finally arrived in the last days of July 1697.

Like many of the objects sent back to Spain from the Indies, the lamp suffered the vicissitudes of a hazardous ocean crossing, in the present case sinking to the bottom of the sea when the ship on which it was being carried sprang a leak. Luckily it was salvaged by divers who in that period charged thirty pesos and seven reales to "pull it out of the sea."

The fixed itinerary of this piece furnishes an approximate date and place of origin, namely Lima, the capital of the Viceroyalty of Peru, for other works of the same type, characterized by the sinuous contours of the long platter, dominated by six large S-shaped shields filled with prominently projecting C-shaped branches. Other handlelike elements are attached to the body of the upper section, generating that sensation of restless movement so typical of the Peruvian baroque toward the end of the seventeenth century. Six chains with delicately pierced links hang from the cap, which is identical in structure and decoration to the platter. The chains that originally held the recipient for the oil are missing and had perhaps already been lost when the piece was repaired in 1829.

The church of Santa María de Guía (Gran Canaria) conserves a lamp with an identical structure (dated before 1662) that is likely also to have come from Lima, although a Panamanian origin has been suggested owing to the fact that its donor was married in Panama. Given the mobility of people in Spanish America, however, it could easily have been bought in Panama after arriving on one of the galleons from Lima or even Cartagena de las Indias, where important annual fairs were held, and where its donor seems once to have lived. Two other lamps from Lima with similar features (now lost) reached the island of La Palma (one arriving in Puntagorda around 1667 and the other in the Sanctuary of Our Lady of the Snows in 1679), which suggests that the model was popular in the silver workshops of Lima in the last third of the seventeenth century.

Yet another lamp with similar characteristics is found in the parish church of Santo Cristo in Azuaga (Bajadoz, Spain). Although it has not been classified as Peruvian work, it would not be unreasonable, given its structure, to attribute it to a Lima silversmith.

Today this lamp adorns the principal chapel in the parish church of Telde, instead of burning before the Virgen del Rosario, as its donor had wished.

Cristina Esteras Martín

III-23 *Altar frontal*

Cuzco, Peru

c. 1735

Silver on wood armature, partially gilt, repoussé and chased,
with burnished punchwork

41⅜ × 110¼ inches (105 × 280 cm)

Church of the Sagrada Familia, Archbishopric of Cuzco, Peru

PUBLISHED: Tord 1977, p. 38; Esquivel y Navia 1980, vol. 2, p. 257;
Esteras Martín 1997, p. 123; Esteras Martín 2004, cat. no. 92,
pp. 280–81

EXHIBITED: New York 2004, cat. no. 92

GIVEN THE RICH DEPOSITS OF SILVER that abounded in Peru, it is
understandable that this semi-precious metal would be used so often in
ecclesiastical furnishings, particularly after the Council of Trent (1545/63),
which sought liturgical renewal and greater worship of the Eucharist and
the altar, the latter a focal point for the celebration of the Mass.

This frontal was created to adorn the altar at the Church of the
Sagrada Familia, an annex to the cathedral of Cuzco. The structure of
the piece follows the typical Cuzco model of an inverted U; its exterior
and interior borders are marked by convex molding, customary on all
baroque frontals along the Royal Road from Cuzco to La Paz, Bolivia.

The center of the main panel is dominated by a crowned, heart-
shaped cartouche, which serves as a frame for the images of Jesus, Mary,
and Joseph and the Virgin's parents, Saint Joachim and Saint Anne; the
Holy Spirit presides over the scene. The image confirms that the piece
was specifically created to adorn the Church of the Sagrada Familia, which
was consecrated as a place of prayer and devotion to the Holy Family.

Profusely decorated with dense baroque ornamentation, largely
adapted from mannerist engravings from Europe, the piece seems to high-
light certain very earthly motifs, which are intermeshed without losing
any symmetry. The repertoire of images includes horns of plenty, pome-
granates, green masks, monstrous heads, flowers, foliage, herons, angels
or sirens, and sinuous plantlike scrolls of fabric or rectilinear forms that
serve to envelope and link the various elements of the composition. Two
cherub faces with pairs of outstretched wings are set at the opposite cor-
ners of the upper panel, also in keeping with Andean frontals created in
the region of Cuzco. The treatment of these cherubs reflects indigenous
iconography, both in terms of facial details (large, almond-shaped eyes
and chubby features) and the singular coif, with its unique, circular
segmentation.

Nothing is known about the creator of this piece, although it is
likely that it was executed by one of the silversmiths commissioned to
work on the cathedral during this time, possibly the same artist who cre-
ated the frontal for the chapel dedicated to the Virgin of Choqonchaka,
also in the cathedral, which bears a similar central cartouche. The piece
could not have been created after late 1735, since the cathedral was com-
pleted and consecrated by that date, and records show that the silver
frontal was then already in place.

Cristina Esteras Martín

III-24 *Monstrance*

Cuzco, Peru
Before 1699
Silver, gilt, cast, and chased, with enamel and emeralds
Height 29¹⁵⁄₁₆ inches (76 cm)
Cathedral of Cuzco, Peru

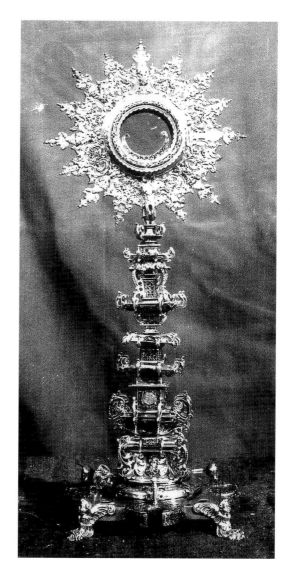

THIS SPLENDID MONSTRANCE from the cathedral in Cuzco is one of the many silver pieces commissioned for the city's churches by the bishop Don Manuel de Mollinedo y Angulo, whose coat of arms appears on the lowest section of the stem as a reminder to history of the donor's identity. This eminent figure arrived in Cuzco from Madrid (where he had been a priest at the parish church of Almudena) in November 1673, and remained in the city as bishop until his death in September 1699. The quarter-century he administered the diocese was without doubt the most brilliant period of colonial art in Cuzco. Mollinedo's energy and personal generosity caused churches to be built and rebuilt in that unfortunate city, which had almost been destroyed by an earthquake in 1650, and to be equipped with new ecclesiastical furnishings, in many cases financed from the bishop's own resources. This impressive activity resulted in the construction in Cuzco and the surrounding region of fifty churches (some of brick, some of adobe) and fourteen pulpits (including the famous examples in the churches of San Blas and Belén), in addition to an abundant silverwork production, which includes eighty-two monstrances, twenty altar frontals, and twenty-one lamps.

In spite of the absence of marks, an inscription, or documentation indicating the date and smith of the monstrance, its structural and decorative characteristics leave no doubt that it was made in Cuzco. The cruciform design of the base and the cherubim feet, with vegetal bodies and outstretched wings, are distinguishing features. Also typical of monstrances crafted in Cuzco are the superposition of various independent bodies to form the stem and the configuration of the sunburst based on pairs of facing C-shapes, with rays ending in pear-shaped finials.

A peculiar feature of the decoration is the series of handlelike vegetal adornments in C- and S-shapes (some embellished with bead molding) that run along the stem and serve to link the vertical sections one to another. Other typical decorative elements are the palmettes, the superposed cherub heads, and the four winged sirens with foliate tails occupying the central points of the base. Polychrome semiopaque enameling has been applied by the champlevé technique, with a predominance of emerald green, white, and red.

The most striking part of the monstrance is clearly the "sunburst," owing to the concentrated richness of its elements. Enameling originally covered both faces, though it is now practically all lost, and emeralds were set into the reserve side. The delicate treatment of the lunette that holds the consecrated Host is very much in the style of other Cuzco work, with its enameled vegetal designs and five emeralds set into rhomboidal cabochons to indicate the principal face of the monstrance.

The grooved openings of the semicircular projections on each side of the base constitute a decisive indication that the piece was made toward the end of the seventeenth century. This particular way of conferring movement on the design is typical of the evolving baroque style, and is to be found in other pieces such as the monstrance from the village of Yaurisque and the one from the seminary of San Antonio Abad (now deposited in the cathedral). This latter piece and the present monstrance also share important similarities in the design of the stem and the *sol.*

It is possible that either one of the bishop's favorite silversmiths—Luis Francisco Portillo (1661–1713) or Antonio de Solórzano (1670–1712)—crafted this piece, but in the absence of firm evidence it must be classified as anonymous work for the moment.

Cristina Esteras Martín

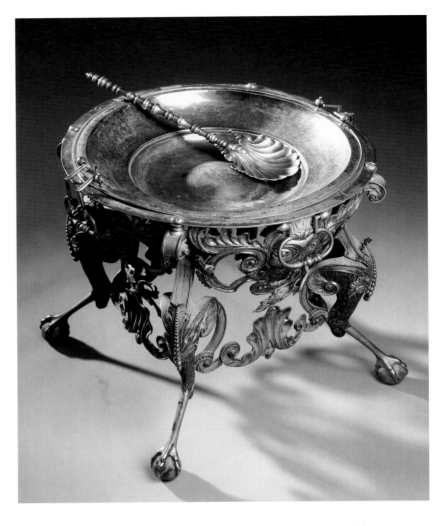

III-25 *Brazier and fire shovel*

Altiplano (Bolivia)
1759
Silver, cast, repoussé, and chased
Brazier: height 17½ inches (44.5 cm); diameter 19⅞ inches (50.5 cm)
Shovel: length 16⅜ inches (41.5 cm)
Inscribed on edge of brazier: *SE ACAVO. A. 31 DE DICI/ENVrE.*
AÑO DE/1759; PSEA: 63: MARCOS: 4 ONSAS
Private collection

LARGE CHARCOAL BRAZIERS, generally made of metal, were widely used in both Spain and Spanish America to heat houses and even churches. Braziers made of silver were more expensive and therefore less common, but inventories of goods suggest that many more of them were made for well-to-do families in the Spanish colonies than in Spain, thanks to the relative abundance of silver in the New World.

The present example is of course exceptional, not only for its imposing size and weight but also for the highly original design of the base that supports it. Generally the brazier proper rests on a wooden stand, or at best one plated in silver, whereas this base has been worked in solid silver, with a fantastical design unmatched in either Spain or the rest of Spanish America. Even the famous brazier made in Majorca in the mid-seventeenth century, property of the marquesses de la Romana (according to the *Spanish Civil Gold and Silver Work* exhibition of 1925), rested on a wooden framework covered with sheets of silver, although there is no denying the opulence of its decoration and formal design.

The origin of this example is not known for certain, but the decoration of the base strongly suggests the Altiplano region of Bolivia. The green masks with their distinctive facial features (almond-shaped eyes and puffed-out cheeks), the pair of herons facing a sensuous cluster of flowers, and the feet in the shape of monstrous birds whose heads turn into beaded palmettes and volutes: all these elements point to that part of the Viceroyalty of Peru where a sense of the fantastic in decoration was de rigueur.

The brazier proper, in contrast, is simple in design and without ornamentation. As is usual, the basin has a central concave section and is equipped with two sturdy handles, angled down in this case and terminating in ovals. The original fire shovel, with its scallop-shaped pallet and balustraded handle, has fortunately been preserved, showing the style of these objects.

The brazier is likely to have once had a covering of metal mesh (or perhaps also of silver, given the quality of the piece) to prevent direct contact with the coals.

Two engraved inscriptions indicate that the work was finished on precisely the last day of December of 1759, and weighed 63 marks and 4 ounces, or approximately 33 pounds (approx. 15 kg). The date accords perfectly with the high baroque style. Although the piece has no hallmarks, the assayer's burin has left three notches made to test the purity of the silver.

This fine brazier demonstrates once again that the Altiplano region was rich in magnificent silverwork, designed by artists endowed with imagination for formal and decorative innovations.

Cristina Esteras Martín

III-26 *Eucharistic urn in the form of a pelican*

Probably Lima, Peru

c. 1750–60

Silver, partially gilt, and gold, molded, cast, repoussé, and chased, with burnished punchwork, and precious stones

Height 32⅝ inches (83 cm); width 35⅞ inches (91 cm); base 11⅞ × 11⅞ inches (30 × 30 cm)

Monasterio de Nuestra Señora del Prado, Lima, Peru

PUBLISHED: Esteras Martín 1997 *Perú*, cat. no. 49, pp. 181–82; Phipps et al. 2004, cat. no. 120

EXHIBITED: Madrid and Lima 1997, cat. no. 49; New York 2004 *Andes*, cat. no. 120

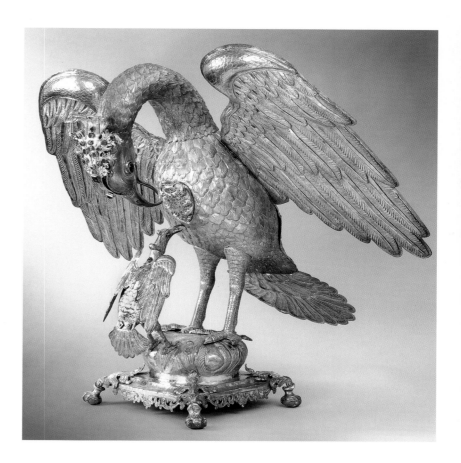

IN 1746 LIMA WAS STRUCK BY A VIOLENT earthquake that seriously damaged the city and with it the Del Prado convent of Augustinian nuns. Restoration work on the convent began two years later, in 1748, and this piece was likely fabricated after that date, for if it had existed earlier it would probably have been sold to raise money for the rebuilding of the convent. The high baroque style also dates it to the middle years of the eighteenth century and, given its high cost, it was probably a donation to the ecclesiastical furnishings of the convent. The workmanship suggests it was made in Lima, particularly the style of the pedestal and the four claw-and-ball supports at each rounded corner, with their ample palmettes ending in cherub heads.

This large-scale pelican served as an urn for the Eucharist, displayed as part of the monument erected in the church during the Holy Thursday celebrations. It was common in eighteenth-century Peru for such pieces to be made in the form of pelicans—rather than coffers, in allusion to the sepulcher of Christ—because of the bird's associations with Christ's charity and sacrifice, that is, with the Eucharist. The pelican is generally depicted—as in this case—in the company of one or more of its young, who feed on the blood it is drawing from its breast with its beak. Thus, the pelican with its chick is a clear symbol of the divine love also embodied in the consecrated host.

As such pieces tended to be large, they were usually made of sheets of silver nailed onto a wooden frame, but this one, made entirely of silver, is work of an especially high quality. Cast silver is used for the parts requiring more solidity, such as the pedestal and the body of the bird, while sheets of embossed and chased silver were employed for the lighter sections such as wings and tail. At the back of the bird's body there is a small door on hinges, with lock and key, that opens onto the depository where the Eucharist is kept.

The refinement of the present piece can be appreciated in the delicate rendering of the bird's plumage and the finish of certain details, particularly the decoration of the head, with its red and blue jewel-encrusted palmette and three gold tassels, and the gilt heart visible on the pelican's breast. These solutions lend not only opulence but also chromatic contrast and effects of light to the work. The sense of realism is heightened by the movable tongues and colored-glass eyes of both birds, brown for the mother and red for her chick.

This is definitely the best example known of such a piece, followed in importance by a work in the cathedral of Arequipa long attributed to the silversmith Marcos del Carpio of that locality. Unfortunately the author of this pelican from the Del Prado convent has not been identified, for he was a worthy exemplar of the still too little known silverwork of colonial Lima.

Cristina Esteras Martín

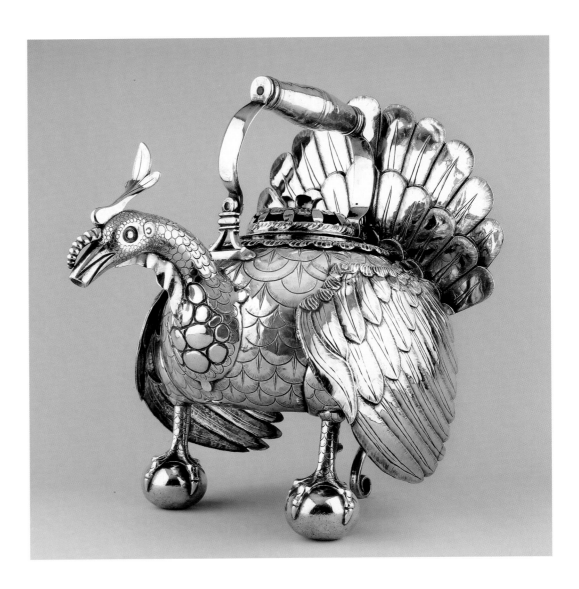

III-27 *Water heater with internal brazier*

Possibly Lima, Peru
c. 1750–1800
Silver, cast, repoussé, and chased
12¼ × 8¼ × 9⅝ inches (31 × 21 × 24.5 cm)
Private collection

PUBLISHED: Esteras Martín 1997 *Perú*, p. 58; Phipps et al. 2004, cat. no. 143

EXHIBITED: New York 2004 *Andes*, cat. no. 143

THIS WATER HEATER IN THE SHAPE of a turkey has a small brazier built into its interior to keep its container of water hot. The turkey's feet (which grasp spheres) serve as supports, along with a third appendage rolled up at the end, which is placed under the animal's tail feathers to ensure greater steadiness.

It is well known that many objects, with many different uses, were produced in the form of animals in the silver workshops of viceregal Peru. Not only were there water heaters with braziers incorporated (*pavas con hornillo*), but also incense burners and other objects, crafted in cast and molded silver, or worked in filigree. Of the animals most commonly seen, some were native to the region, such as llamas, *tarucas* (a kind of deer), and *quirquinchos* (armadillos), and others imported, such as bulls, lions, and turkeys (native to Mexico, but soon widespread throughout Europe and the rest of the Americas).

It is likely that many water heaters were fabricated in the shape of turkeys, since many filigreed incense burners are, but the present example is the only one known to us, giving it extraordinary importance.

The craftsmanship of this piece is exceptional in terms of both technique and the realistic rendering of its subject. The turkey is depicted with its tail feathers fanned out in a gesture of arrogance and its head projecting forward, the crest standing erect on its beak (now transformed into the spout of the vessel). The feathers and the wattles on the neck are magnificently captured: the bird seems to live.

Perhaps the scarcity of decoration is due to this heightened realism, but the leafwork surrounding the upper orifice recalls that used in other pieces from the second half of the eighteenth century. This may serve to date the piece approximately. The work's singularity and the lack of references and analogous pieces for comparison make it impossible to determine where it was made and by whom. In view of the fine craftsmanship, Lima might be tentatively proposed.

Cristina Esteras Martín

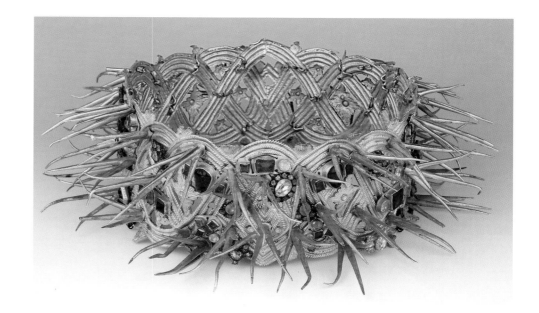

III-28 Attributed to Marcos del Carpio

(Peruvian, active Arequipa, 1741–57)

Crown of thorns

c. 1760

Gold, repoussé, cast, and chased, with emeralds, a topaz, and other precious stones

Height 3⁷⁄₁₆ inches (8.7 cm); diameter 10³⁄₁₆ inches (25.9 cm)

Cabildo Metropolitano de Arequipa, Peru

PUBLISHED: Esteras Martín 1992 *Arequipa*, pp. 132–33 and 252–53; Esteras Martín 1997 *Perú*, cat. no. 54, pp. 192–93; Phipps et al. 2004, cat. no. 91

EXHIBITED: Madrid and Lima 1997, cat. no. 54; New York 2004 *Andes*, cat. no. 91

THE TASTE FOR EMPHASIZING the dramatic elements of blood and suffering in Ecce Homo sculptures and crucifixes led Peruvian artists, especially those of the Sierra and Altiplano regions, to place upon the head of the afflicted Jesus a martyr's crown of long, sharp thorns (generally crafted in silver or even gold, depending on the importance of the image and the devotion to which it was dedicated).

In structural terms, the crowns of thorns attempt to imitate the one worn by Jesus during his Passion, but certain formal and decorative liberties reflect the different styles and periods of the silver workshops.

The one actually worn by Jesus of Nazareth was probably no more than a piece of cord serving to hold together the thorny twigs, but both this one from the cathedral of Arequipa and others that are known (for example, the one in the Mercedarian monastery in the same city, or the pair belonging to the Lord of the Earthquakes in Cuzco—one given by the Viceroy Príncipe de Esquilache and the other crafted in gold and diamonds by the silversmith Gregorio Gallegos in 1745) are much more lavish and sophisticated, both in the materials employed and in their decoration, often enhanced with precious stones.

The present crown has a cylindrical structure in which four parallel cords describe ample volutes to form a sort of basketwork from which conical thorns forcefully project. The design is enriched (though its dramatic force is somewhat attenuated) by foliage and by square, rectangular, and pear-shaped emerald cabochons, as well as small blossoms with diamonds—and later, other stones—set into them.

This crown was made for the image of the Lord of Charity (Señor de la Caridad), highly venerated in the cathedral. The artist is likely to have been the local silversmith Marcos del Carpio (documented from 1741 to 1757), who executed many works for the cathedral, including a votive lamp precisely for the Lord of Charity. He also made various pieces for the Mercedarian monastery, which conserves a crown of thorns very similar to this one, though crafted in silver rather than gold. The style suggests a date of around 1760, but it may well be earlier, as the last documentary trace of Carpio is his testament dated 1757.

Cristina Esteras Martín

III-29 *Water heater*

Possibly Lima, Peru, or Santiago de Chile
c. 1775
Silver, cast, chased, and engraved
Height 12⅝ inches (32 cm); length 10¼ inches (26 cm)
Apelles Collection, Chile

PROVENANCE: Goldeberg de Ursúa Collection, Santiago de Chile

PUBLISHED: Esteras Martín 1997 "Orfebrería (Peru)," fig. 58c;
Esteras Martín 1997 *Perú*, p. 59 and cat. no. 70, pp. 224–25;
Esteras Martín 2000 "Platería," pp. 136, 137; Esteras Martín
2004, pp. 67; Phipps et al. 2004, cat. no. 140, pp. 345–46

EXHIBITED: Madrid and Lima 1997, cat. no. 70; New York 2004
Andes, cat. no. 140

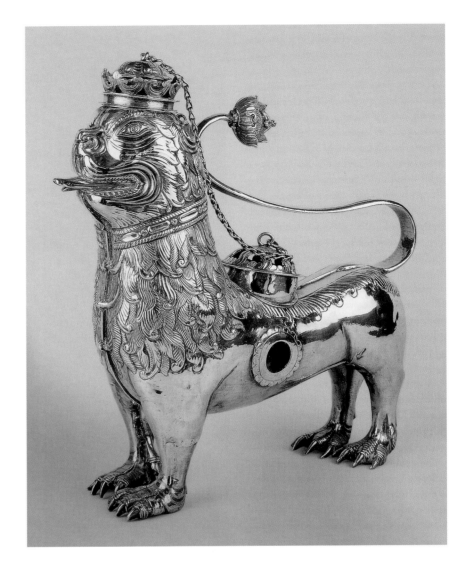

THIS VESSEL IN THE SHAPE OF A LION was used to hold the hot water required for the social custom of brewing and drinking "Paraguay tea," or yerba maté. In written documents from the Viceroyalty of Peru these pieces are referred to as "water heaters for yerba maté," or simply "heaters" or "kettles for heating water," and are occasionally described. Nowadays, however, such a piece is generally called a "brazier-kettle" (*pava-hornillo*), probably because its heating function resembles that of the *horno de pava* (the *pava* being a large bellows used in certain metallurgical ovens).

Made in the shape of spheres, parallelepipeds, or certain animals (bulls, llamas, stags, turkeys, and lions), these pieces became very common in the Viceroyalty of Peru, where the widespread custom of drinking maté created a demand for utensils such as maté cups with their *bombillas* (the hollow tube through which the drink is imbibed), boxes (*hierberas*) to hold yerba maté leaves, and water heaters.

Obviously the idea of making a vessel to serve as a ewer was not exclusive to the Viceroyalty of Peru, but the present typology was conceived there rather than in other parts of Spanish America or in Spain itself. It had existed in Lower Saxony, however, from the twelfth to at least the sixteenth century, the iconography originating in the heraldic tradition. The Peruvian "invention" was to combine the receptacle (in this case the belly of the lion) with a small brazier to heat the water. This lion has a lidded orifice on its back through which the brazier can be supplied with

coals, and a second aperture on its side to provide ventilation and permit better burning. The smoke issues through the perforations of the upper lid. The crown on the lion's head covers the opening through which water can be introduced into the deposit in the animal's belly, and the tongue serves as a spout. The piece is thus perfectly equipped to keep the water hot in low circumambient temperatures and to meet all the requirements of the maté drinking ceremony.

The use of the lion shape is not anything exceptional. Other examples, of various styles, are known to exist, but the svelteness, hieratic dignity, sobriety, and Chinese influence of the present piece suggest it was crafted in an important artistic center: Lima perhaps, or Santiago de Chile, where unpublished inventories dating from the late eighteenth century have been found that contain constant references to heaters in the shape of lions. In support of this latter attribution is the fact that the piece once belonged to the Chilean priest Don Luis de Roa Ursúa, but since he was in Lima in 1881 during the War of the Pacific, he may also have acquired it there. The origin of the piece remains uncertain.

The weight (2,925 grams, almost 6½ lbs.), fine craftsmanship, and excellent condition of this water heater make it a matchless example of its type. The rocaille decoration of the lion's hair and similar treatment of the leafwork on the brazier suggest a date around 1775.

Cristina Esteras Martín

III-30 *Ewer and washbasin*

Probably Santiago de Chile
c. 1760
Silver, cast, molded, repoussé, and chased
Ewer: height 11⅝ inches (29.5 cm); width 6¾ inches (17 cm)
Washbasin: 21⅝ × 15¾ × 11¾ inches (55 × 40 × 30 cm)
Mark repeated three times, twice on bottom of ewer and once on bottom
of washbasin: royal crown with ring
Inscribed next to spout of ewer and on bottom of washbasin: M.R.
Apelles Collection, Chile

PROVENANCE: Dominican convent, Santiago de Chile

PUBLISHED: Esteras Martín 1997 "Orfebrería (Río)," p. 157; Esteras Martín
2000 "Platería," p. 140

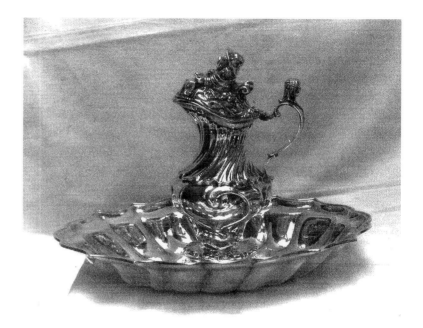

WITH THE END OF THE HABSBURG DYNASTY and the coming of the
Bourbons to Spain (1700), aesthetic tastes underwent a transformation.
French fashions began to make themselves felt in secular matters, and
as time went by, in religious ones as well. Silverwork was not immune to
these developments, and among the first pieces affected were the *aguamanil*
sets of ewer and washbasin. At the beginning of the eighteenth century
the beaked ewers and the round basins that accompanied them—typical
of the sixteenth and seventeenth centuries in Spain—gave way to another
model, which with the arrival of rococo would transform the ewer into a
pear-shaped receptacle with a tapering mouth, equipped with handles in
the form of feminine figures and a hinged cover. The washbasin (its name
having changed from *fuente* to *palangana*) became a deep-sunken oval
receptacle with a dynamic contour of concave and convex segments.

This is the structure of the present example, with certain original
variations in decoration, as might be expected, to distinguish it from
French rococo work. Nevertheless, this set follows the guidelines estab-
lished by the renowned silversmith François-Thomas Germain (1726–91)
in the *aguamanil* he made for Joseph I of Portugal. It differs, however,
in that it is oval, rather than round, in shape; that the rocaille gadrooning
covers only the neck, rather than all, of the ewer; and that the cover is deco-
rated with figures of an indigenous character rather than with "organic"
motifs such as bird forms and rocaille foliage. This cover shows a seated
Indian woman weaving, with a spindle in her left hand and her infant son
strapped to her back by means of a *lliclla*, in the company of a little dog.
The scene could not be more true to life: the woman's clothing (including

her hat), the way she is holding her child, and even the presence of the
dog reflect faithfully the everyday life of an indigenous woman of the
Andean region.

The washbasin and ewer are imprinted only with the mark showing
payment of the corresponding tax (a royal crown). The other marks have
disappeared, so neither the author of the piece is known, nor where it was
made. But as it came from the Dominican convent (the Convento de las
Rosas, hence the engraved initials M.R.) in Santiago de Chile, and since
there is another very similar *aguamanil* (bearing the mark of the silversmith
Daza) from the same convent also in the Apelles Collection, it is reason-
able to assume that this one was crafted in Santiago around 1760.

The singular rococo style of both these sets can be explained by the
influence of the silver workshops established by the Jesuits in Calera de
Tango (near Santiago). The early triumph of rococo in the silverwork of
this locality was due to the graphic repertoire brought over from Europe
by the Jesuit priest Carlos Haymbhausen in 1745.

Cristina Esteras Martín

III-31 *Basin*

Viceroyalty of Peru, probably Potosí, Bolivia, or Santa Fé de Bogotá, Colombia
c. 1640–65
Silver, molded and cast
18½ × 13¼ × 2⅜ inches (47 × 33.5 × 6 cm)
Mark, repeated four times on reverse side: crowned escutcheon with lion and
castle (1st and 2nd quarters) in orle of pearls, AN+P with orle and bordure of
pearls, PPVS with bordure of pearls and IIIRE with orle of pearls around
escutcheon with castle and lion (3rd and 4th quarters)
Alorda-Derksen Collection, Barcelona and London

PROVENANCE: Condes de Casa-Palma and Marqueses de Casa-Xara, Elorrio
(Vizcaya, Spain); "Alcalá Subastas," Madrid, until 2004

PUBLISHED: *Alcalá* 2004, lot no. 126; Esteras Martín 2005, pp. 190–93

BASINS WITH THIS STRUCTURE OF broken mixtilinear contours were
produced in both metal and ceramic in Spain, Portugal, and the Spanish
colonies overseas (found especially in Mexico). They were for personal use,
and the central groove (with its space for the neck) causes them sometimes
to be referred to incorrectly as barbers' shaving basins. Pictorial evidence,
however, shows that in the seventeenth century they formed part of *agua-
manil* sets of basin and ewer. The present example is a "Flemish" model.

This particular basin is of enormous interest because it is very rare
for such a piece from the Viceroyalty of Peru to have marks, especially one
repeated four times, as here. The imprint of all four marks is fragmentary,
but by collating them the variant can be partially reconstructed. It is a
monetary mark of the *macuquino* type, showing the crowned and quartered
coat of arms of Castile and Leon, with two lions and two castles in an orle
of pearls, a circular Latin inscription, and a bordure identical to the orle.

The Latin inscription can be reconstructed as [HISPANI]AN
+P[HILI]PPUS?IIIRE[X], with the letters rendered illegible by the
defective imprint shown in square brackets. This reconstruction involves
certain problems, because the genitive plural *hispaniarum* is generally
employed, rather than the accusative singular *hispanian*, as here, but it
would not be the first time this type of error was committed on coins, any
less than the hierarchical inversion of castles and lions on the escutcheon,
which does in fact happen here, where the 1st and 4th quarters should
properly contain the castles, and the 2nd and 3rd quarters the lions.

The numeral of the inscription—III, but possibly incomplete—
and the style of the piece suggest it was fabricated not during the reign
of Felipe III, but rather during that of Felipe IV, who broke down his
number into four units (IIII), one of which would thus be missing from
the imprint. If this is the case, the date of the work has to be fixed within
the years of his reign (1621–65), but the style would seem to place it in the
middle years of the century, with 1665 as an outside limit. Since the only
mints functioning in South America in those years were the ones in Potosí
and Santa Fé de Bogotá, either one of these cities might have been the
place where this fascinating object was crafted.

Cristina Esteras Martín

III-32 *Ewer*

Alto Perú (Bolivia)

c. 1625–50

Silver, gilt, turned, cast, repoussé, and engraved, with burnished punchwork

7 × 8⅞ inches (17.7 × 22.5 cm); diameter of base 3½ inches (8.8 cm)

Marks, repeated twice on rim of mouth: B------/---6; and YZ/QVERD°

(with a dot over the second stroke of the V)

Museo Fundación Lázaro Galdiano, Madrid, 2471

PUBLISHED: Sanz Serrano 1975, pp. 153–54, no. 4; Cruz Valdovinos 2000, pp. 194–97; *Galdiano* 2002, pp. 208–9; Esteras Martín 2004, p. 67, fig. 72; Phipps et. al 2004, cat. no. 61

EXHIBITED: Madrid 2002 Fundación; New York 2004 *Andes*, cat. no. 61

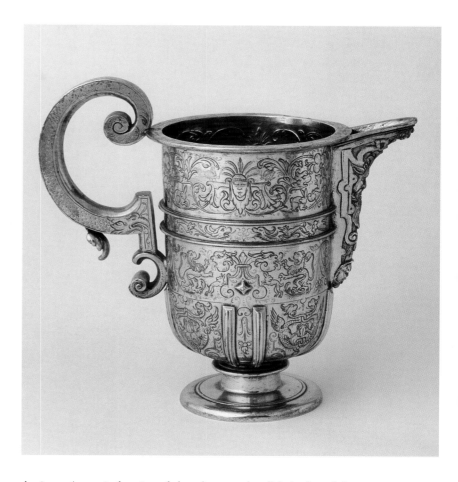

IN THE SPANISH TRADITION, Hispano-American families of a certain socioeconomic level followed the custom of using silver ewers at table, either to serve drinking water or for the ceremony of hand-washing. This ewer is of the so-called beaked type, very similar in structure to those common at the court in Madrid during the reign of Felipe III (1598–1621), though there are naturally some small differences, such as the flat, protruding rim of the mouth and the separation between the straight section of the handle and the body of the receptacle.

What defines the Hispano-American origin of the piece is its decoration, since neither its almost cylindrical form, nor the spout—decorated with the grotesque of an old bearded man and rising slightly above the mouth—nor the G-shaped solution of the handle would distinguish it from ewers crafted in the silver workshops of Madrid. The difference, then, is in the handling of the decoration, and above all in the *horror vacui* which led the artist to cover the entire surface with ornamental motifs, distributed in horizontal strips. European fauna (dogs, rabbits, foxes, birds, and butterflies) provides matter for some of the decoration, but among these animals we discover that some are not in fact rabbits, but rather *vizcachas* (rodents native to the highlands, which in Andean mythology were considered messengers of the *Apus*, divinities who lived on the mountaintops), and that the winged dragons are not griffins, but rather depictions of the Andean *amaru*, a mythical serpent that inhabited

Antisuyo (a tropical region of abundance and well-being), and that even the iconography of the lion with its protruding tongue is commonly to be found on the painted *keros* and silver *aquillas* (ceremonial vessels used to drink *chicha*, which possessed great symbolic value in the Andean world). The masks in feather headdresses do not, however, constitute a direct allusion to the indigenous world, for this type of decoration had existed in Europe since Frans Floris made use of plumage ornamentation in his engravings in 1548, a motif adopted by Cornelis Bos in 1554 in some of his grotesques.

It is this decorative vocabulary, therefore, and certain other factors, such as the great weight of the ewer (1,300 grams, more than 2⅞ lbs.) and the fact that it has been gilded inside and out, that suggest that it came from one of the silver workshops in Alto Peru (which included a large part of modern-day Bolivia) around the second quarter of the seventeenth century. It is not possible to say whether the silversmith was a peninsular Spaniard or a Creole, a mestizo, or an Andean. Whoever the author was, the work is certainly one of the most beautiful in existence, and its lavish decoration gives it a matchless presence and opulence among other Hispano-American ewers.

Unfortunately the piece has no hallmarks from the time it was made. The ones it bears are remarkings imprinted in Valladolid (Spain) in 1806, possibly the result of some modification or local inventory.

Cristina Esteras Martín

III-33 *Candlesticks*

Probably La Paz, Bolivia

1753

Silver, cast, repoussé, and chased

Each, height 57 inches (145 cm);
base 26⅝ × 26⅝ inches (67.5 × 67.5 cm)

Inscribed on base: *1753 ans*

Museo de Arte Sacro, Arzobispado de
La Paz, Bolivia

PUBLISHED: Mesa 1981, p. 22; Querejazu
and Ferrer 1997, cat. no. 37

EXHIBITED: New York 1997, cat. no. 37

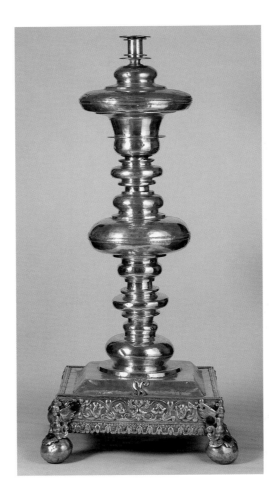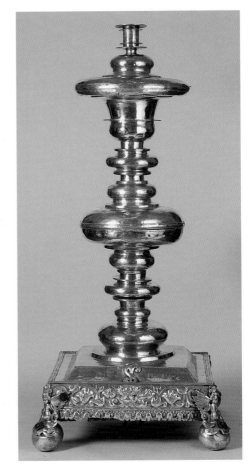

THESE LARGE, HEAVY CANDLESTICKS (*blandones*) are only known to
be used in cathedrals. They are usually placed at the foot of the principal
altar or on the steps leading up to it, almost always in sets of six, although
this set from the cathedral in La Paz, Bolivia, consists of only four, like
the set in the cathedral in Seville, Spain, made by Hernando Ballesteros
between 1759 and 1781. With candles placed in the sockets they provide
plentiful illumination.

Blandones are generally built on a human scale, measuring more
than two *varas* (just over 1.67 meters or 67 inches) in height. These mea-
sure a little less than that (1.45 meters or 57 inches), but are heavier than
usual, judging from the formidable set of Mexican *blandones* donated
by the archbishop and viceroy of Mexico Vizarrón y Erguiarreta to the
cathedral in Seville in 1741. Those candlesticks weighed around 100 marks,
whereas the present ones weigh 160 marks (36,800 grams).

These examples of the Bolivian baroque are characterized by the
smooth, squat spheroid bodies superposed on the stem, with a central
node of greater volume. The stem rests on a square and all of the decora-
tion is concentrated on it, including a border of winding stems and lush
foliage spreading out from the vegetal body of an angel placed at the middle
of each side, with a fringe of down-turned blossoms running below. The
feet are large spheres attached at each corner to grotesque angelic figures
typical of the Sierra and Altiplano regions, half-human, half-vegetal, with

their torsos ending in a skirt of enveloping leaves at the waist. The feather
headdresses of these icons add an indigenous note.

These candlesticks were crafted in 1753, as the inscription attests,
presumably in a workshop in La Paz, where there were many fine silver-
smiths at the time, although an origin elsewhere in Bolivia cannot be ruled
out. The baroque style is clearly typical of Altiplano silverwork (from the
region of the Collao).

The sign for "slave," represented by the letter S winding about a nail
(a rebus for *es-clavo* in Spanish), suggests that these imposing candlesticks
were the property of some brotherhood, dedicated perhaps to the Blessed
Sacrament.

Cristina Esteras Martín

III-34 *Box for yerba maté (?)*

Alto Perú (Bolivia)
c. 1770–80
Silver and gold, molded, cast, repoussé, and chased
Height 15⅜ inches (39 cm); diameter at mouth 7 inches (18 cm)
Private collection

THE DEBATE ON THE USE OF THIS TYPE of container continues, but the latest research seems to indicate that, given the widespread consumption in the Viceroyalty of Peru of yerba maté from Paraguay, these receptacles served as *hierberas* (to hold yerba maté leaves), rather than *coqueras* (to hold coca leaves), or containers for sweets or other costly substances (for which, however, there is documentary evidence that boxes with lock and key were also used). The present piece is therefore likely to have served to keep "Paraguay tea," for there is an inner compartment fitted to the circular shape of the receptacle for the sugar used to sweeten the drink after the maté leaves had been brewed in hot water. Other uses cannot however be discounted, since the documents that refer to *hierberas* never specify their form, so that any box or recipient—whatever its typology— might have served various uses and not just one in particular. The identification of the article must therefore remain tentative.

This particular piece, on public display for the first time, belongs to a model believed to originate in Alto Perú (Bolivia). Features such as the globular body resting on S-shaped feet that end in claws grasping small spheres, the crest that marks the front of the lid, and even the heraldic lion crowning the whole are found on other pieces—water heaters, maté cups, and also boxes—that have been classified as belonging to this region. The decoration, which recalls rocaille, would seem to suggest a date between 1770 and 1780, although the possibility of an earlier or later one must be allowed for, so long as the maker remains unidentified. Of great interest are both the treatment of the two extremes of the globe, which project in tapering concave-convex bodies adorned with undulating gadroons, and the upturned convex rim of the lid running from the lateral base of the hinge. The gleaming surface of the body contrasts with the ornate decoration of the large palmette unfolding above each of the feet. The lion that crowns the cover holds a cartouche between its front paws, certainly the most curious and striking element of the work, in terms of both iconography and function, although it was never engraved with a coat of arms or any distinctive symbol that might identify the owner of the piece.

The delicacy of the craftsmanship is also evident in the clasp of the lock and the circular escutcheon around the keyhole, with its double border of pearls, and leafwork in the middle.

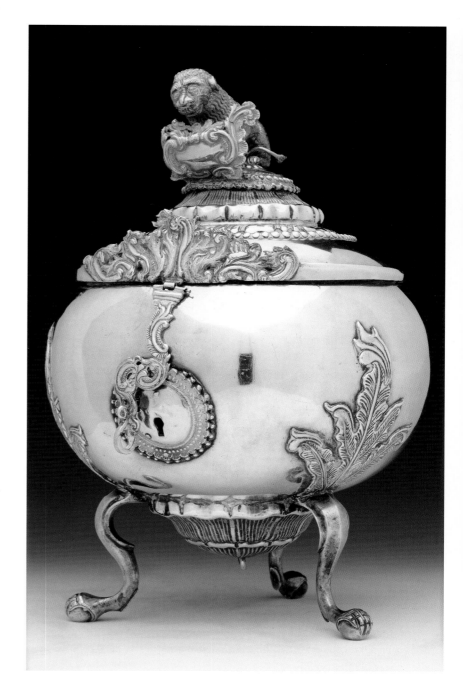

The piece is exceptional for its use of gold (on the lock and its latch, the crest, the cartouche, and the mane and tail of the lion), which gives it greater distinction, and would also have made it more expensive, so its owner is likely to have been a person of some means. The gold also lends color and contrast alongside the silver. Its many singularities give this unique piece an important place in the known sequence of this kind of object.

Cristina Esteras Martín

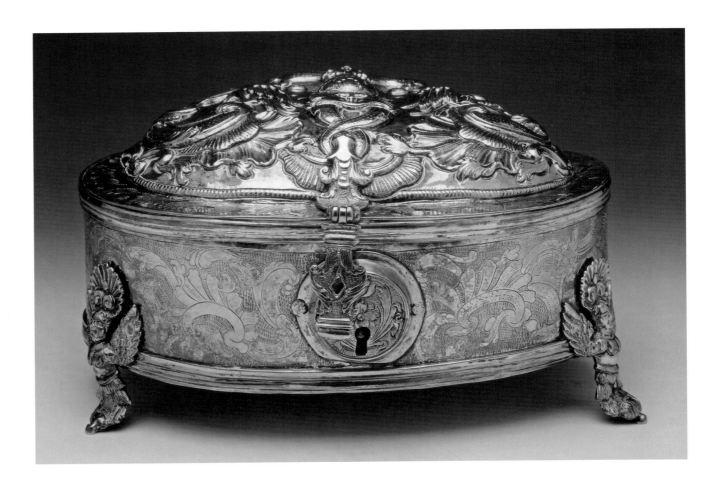

III-35 *Box for sweets or yerba maté*

Probably Potosí, Bolivia
c. 1775
Silver, molded, cast, repoussé, chased, and engraved, with burnished
punchwork
5⅛ × 8⅝ × 7⅞ inches (13 × 22 × 20 cm)
Private collection

PUBLISHED: Esteras Martín 1997 *Perú*, cat. no. 75, pp. 234–35; Phipps et al.
2004, cat. no. 137

EXHIBITED: Madrid and Lima 1997, cat. no. 75; New York 2004 *Andes*,
cat. no. 137

THE USE OF THIS TYPE OF LOCKED BOX remains subject to debate. The
most common view is that it was used to keep yerba maté leaves, but it may
well have served a variety of functions. The typology need not have been
restricted to a single purpose, but can rather be considered a box or coffer
(like this one or in other formal variants) that could be put to various uses.
One such use was to store sweets, as is demonstrated by an unpublished
document according to which the bishop of Quito Don Diego Ladrón de
Guevara made a gift to his niece María Garzón (on November 26, 1705) of
a "round box with four compartments in which to keep anises," or other
documents from Buenos Aires (dated 1787, 1790, 1796, and 1803) with ref-
erences to the invention of sweets boxes "with partitions, lock, and key."

This box is designed in the form of a scallop (*Pecten jacobeus*)—
associated with pilgrims—and has a convex lid decorated not by gadroons

in imitation of the contours of a shell, but by a monstrous canephora sur-
rounded by rocaille foliage and accompanied by two eagles and two
rosettes. The lid is attached to the body of the box by a hinge and is locked
by means of a clasp with vegetal ornamentation that fits over a circular
escutcheon. The front and sides of the box are decorated with rocaille
engraved against a stippled background, while the back displays a verdant
bucolic scene of a man playing the flute and a woman the guitar in the
presence of a delicate hummingbird. These boxes sometimes rest directly
on their bases, but this one is supported on four feet in the shape of
winged angels with vegetal bodies and scallop-shell crowns.

The interior of the box has no divisions, making it difficult to say
what it was used for. It could have held sweets, or yerba maté, or many
other things. What is important is that it is a work of exceptional technique
and very original decoration that follows the general lines of the Peruvian
model of boxes of granadilla wood fabricated in the workshops of the
Jesuit missions at Moxos and Chiquitos, in the east of present-day Bolivia.

Various ornamental details suggest the present example was made
in Potosí. The birds of prey and the rosettes flanking the canephora, as
well as the trees in the bucolic scene, recall the "free-style" decoration of
the *keros* and *aquillas* produced in this city during the colonial Inca period.
The figuration of the feet also has parallels in other work from Potosí. The
rocaille decoration fixes the date of the work around 1775, but additional
evidence could require this to be corrected.

Cristina Esteras Martín

III-36 *Portable altarpiece*

Alto Perú (Bolivia)
End of the seventeenth century
Silver, molded, repoussé, and chased, with burnished punchwork, and stucco
and polychromed maguey
8⅝ × 5 × 2⅜ inches (22 × 12.7 × 6 cm)
Private collection

PUBLISHED: *Orfebrería* 1986, cat. no. 20; *Iglesia* 1992, cat. no. 189; Esteras
Martín 1997 "Platería barroca," pl. 61; Esteras Martín 1997 *Perú*, cat.
no. 19, pp. 116–17

EXHIBITED: Madrid 1986, cat. no. 20; Seville 1992, cat. no. 189; Madrid
and Lima 1997, cat. no. 19

THESE SMALL, PORTABLE ALTARPIECES (also called *urnas*) seem to come
from the Altiplano region around Lake Titicaca, on the shores of which
there is an imposing sanctuary devoted to the Virgin of Copacabana (or
the Virgin of the Lake), devotion to whom was widespread in Peru and
Bolivia and which gave rise to a multitude of iconographic representations,
including this type of small portable shrine. Since they were intended to be
moved from one place to another, they never surpassed one meter in height,
and many known examples measure between 8 and 16 inches (20 to
40 cm). The largest known, and the most impressive, are one formerly
belonging to the Viceroy Count of Superunda (1745–61) (still in the posses-
sion of the heirs to the family title) and another commissioned by his sister
in 1749 to be donated to the convent of the Poor Clares in Nájera (La Rioja,
Spain), of which she was abbess (it is still preserved in the convent).

In fact, this Virgin is a variant of the Virgen de la Candelaria (Our
Lady of Candlemas), with whom it shares certain iconographic elements:
the richly embroidered mantle and petticoat, and the placement of the
Christ Child in the Virgin's left hand, and a candle in her right. This image
always dominates the center of the composition, and both this frontal sec-
tion and the lateral doors are made of a paste of stucco mixed with maguey
fibers to give it body and durability. This material takes both color and
gilding well, so these small altarpieces can imitate the larger polychrome
painted ones.

A silver triptych, worked on one side only, serves as a backing for
the stucco, and includes a section of tracery crownwork over the central
panel. This backing is decorated with a crown above the letter S winding
around a nail (a rebus in Spanish [*es-clavo*], signifying "slave"), indicating
that the piece served a devotional purpose and belonged to a brotherhood
placed under the patronage of the Virgin of Copacabana. The monograms
on the doors (the letters M A R intertwined) underline the theme of the
Virgin Mary, to whom all of the emblematic motifs in fact refer.

The floral ornamentation of the silver backing and the crownwork
allows the piece to be dated to the end of the seventeenth century, or per-
haps a little earlier, but definitely not after the turn of the century, when
this type of decoration became very sensual and dynamic, unlike the com-
partmentalized composition of the present piece. The rhomboids with
curved sides that occupy the interiors of the door panels also belong to the
ornamental repertoire of the end of the sixteenth century and a large part
of the following one.

Cristina Esteras Martín

III-37 *Shield of Potosí*

Probably Potosí, Bolivia
1813
Silver, cast, chased, engraved, and pierced, with gold applications
Height 67 inches (170 cm); width 40½ inches (103 cm)
Inscribed on central medallion: *De las entrañas de América/ Dos raudales se desatan:/ El Paraná, faz de perlas/ Y el Uruguay, faz de nácar./ Luego, en el Guazú se encuentran/ Y, reuniendo sus aguas,/ Mezclando nácar y perlas,/ Se derraman en el Plata.;* on the lower cartouche: *Hoy, la América de Sud/ Te ofrece con toda el alma/ En esta guirnalda y palma/ Los tributos del amor;* on the four shields of the allegorical figures: *Viva la Patria;* on cartouche held by bird at top: *La América del Sur*
Museo Nacional Histórico, Buenos Aires

PUBLISHED: Dellepiane 1917; Taullard 1941, pp. 45–46, fig. 234; Chacón Torres 1973, p. 304; Ribera 1985, vol. 4, pp. 299–300; Mesa and Gisbert 1991, p. 4

THIS "GARLAND" OR "PALM," known as the Shield of Potosí (*Tarja de Potosí*), is in fact a shield of great historical and symbolic interest, albeit of limited artistic value. Inserted within a strip of silver outlining the contours of South America (including Panama), an oval cartouche bears a poetic dedication to the Paraná and Uruguay Rivers, whose winding courses and wavy currents are represented along the exterior limit of the entire composition. At the foot of the continent there is a smaller shield flanked by two fishes marked with the emblems of commerce and navigation, all in allusion to the Río de la Plata. Two golden vessels symbolize the Atlantic and Pacific Oceans, and crowning the continent is an image of the city and the Cerro Rico of Potosí. Four arms extend from the outer border holding allegorical figures, crafted in the round, with small shields that bear the words "Long live the Fatherland," and two palm leaves outline the upper heart-shaped contour of the composition and culminate in a bouquet of leaves and fruit that serves as a pedestal for the figure of an Indian who, with his lance and Phrygian cap, exalts the ideals of emancipation.

The piece was a gift from a group of ladies in Potosí to the general of the Western Army Don Manuel Belgrano upon his entry into the city following his victories at Tucumán and Salta. The shield was presented to him before September 6, 1813, which is the date of the communication he sent expressing his intention to offer it to the Town Council (*cabildo*) of Buenos Aires, an event officially recorded in a document dated December 14 of the same year.

The shield must therefore have been finished by September of 1813, and it is reasonable to suppose it was a commission to one of the silversmiths resident in Potosí around that date. José de Mesa and Teresa Gisbert mistakenly attribute the piece to Juan de Dios Rivera Conchatupa, a silversmith from Cuzco who lived in Potosí until after the uprising of Tupac Amaru II, then moved to Córdova (Argentina) in 1780, and later on to Luján (Argentina), before finally settling in Buenos Aires, where he married in 1787 and died in 1824. This erroneous attribution is possibly due to the fact that the town council of Buenos Aires hired Juan de Dios in 1813 to "assemble" the shield, which must have arrived from Potosí in several pieces, but this does not mean he was its maker. It would in any case have been strange for the ladies of Potosí, with so many silversmiths on hand in their city, to seek out one who had been settled in Buenos Aires since 1787.

A complex work of high commemorative and allegorical value, the Shield of Potosí has come to form a part of South American history by its expression of those ideals of liberty that would bring about independence just a few years later.

Cristina Esteras Martín

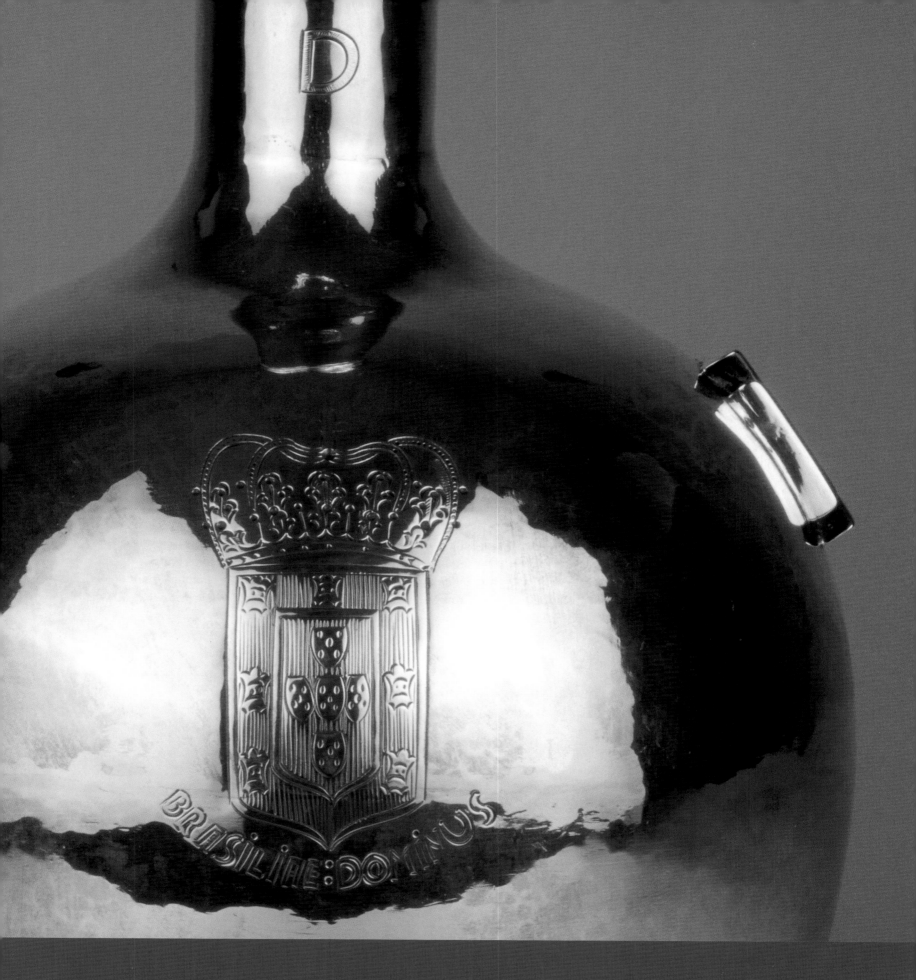

Brazilian Silver

The Art of Silver in Colonial Brazil

Nuno Senos

In ecclesiastical as well as affluent domestic contexts, silver was part of everyday life in Brazil from the early days of colonization. In her testament dated 1586, for example, Catarina Paraguassú left all her silver objects to the Benedictine monastery of Salvador. It is likely that, at this early date, a good part of Catarina's silver was made in Portugal. The importation of silver objects from Europe was commonplace and remained important throughout the colonial period. A lively trade provided the colony with examples of the latest trends in European arts not only in paintings, prints, and sculptures but also in silverworks that were displayed and used in Brazil's churches and homes (fig. IV-I).

The fact that some of the bequeathed objects were designated to be recast into a lamp and a reliquary indicates that there were local silversmiths capable of undertaking such an endeavor. In fact, it soon became apparent that the demand for silverworks, especially for religious usage, needed to be met at a local level. Letters written by Jesuit priests often mention such need and, from the 1560s onward, there is evidence of silversmiths working in Brazil.[1] Eventually, immigrants who came from Portugal to try their luck in the colony began recruiting and training apprentices, thus establishing the roots of a local tradition that would prosper.

Brazil lacked silver as a natural resource and consequently had to rely on imports. Hence the colony benefited from the formidable wealth of its neighbor, Peru, whose vast resources of silver were shipped to Spain down the Plata River. Control over the northern bank of the Plata was a contentious issue, mostly because Portugal hoped to profit from the Peruvian silver trade if it could install a trading post to serve the fleets sailing the river. The Colónia de Sacramento (in present-day Uruguay) was founded, and it remained a point of contention between the two colonial powers.

While the Spanish and Portuguese crowns fought each other, private initiative created a regular commercial flow of ships connecting Bahia, Recife, and Rio to Buenos Aires. Sailing south, the fleets would carry sugar and other commodities, but primarily they would trade in African slaves, important for the provision of labor to the mines of Potosí. On their way back, they would carry silver, which was in high demand in Brazil. A good part of this trade was smuggled, and contraband between Brazil and Peru was so common that a term was coined

FIG. IV-I
Monstrance, Bahia, Brazil, 1774. Silver, cast, chased,
engraved, and gilt, precious and semi-precious stones,
40¼ × 13⅞ inches (103 × 35 cm). Museu de Arte Sacra
da Universidade Federal da Bahia

to designate those involved in it: *peruleiros*.[2] In 1605, a very preoccupied Felipe III of Spain, then also king of Portugal, wrote to his viceroy in Lisbon saying that, according to the information provided to him, the silver from Potosí that was traded to Brazil was worth over half a million *cruzados*.[3]

Cities such as Salvador, Rio, and São Paulo, as well as those of the Minas Gerais region were the colony's liveliest commercial centers. They were also the seat of the most important institutions and home to the wealthy, and they absorbed the better part of the Brazilian silver trade; in these areas the art of silversmithing developed most. In the main urban centers silversmiths were organized in confraternities, frequently under Saint Elói, the patron saint of silversmiths. All those who wanted to become masters had to be examined by the city council (from 1625 in Salvador[4]). Once the examination was passed, the new master would be given a copy of the set of laws that ruled the mechanical trades (*Regimento dos oficiais mecânicos*), which had been approved for Lisbon in 1572, and was used in Brazil. It was the confraternities' prerogative to elect the municipal officers who controlled their trade.

Pure silver is too soft to be used and needs therefore to be alloyed, usually with copper. The proportion of silver in the alloy was established by law. In Portugal and its colonies, the standard was set in 1689 at .854 fine (i.e., 854 parts of silver to 146 of copper).[5] A finished object was taken to the *contraste*, who tested a small portion of the silver to assess its quality.[6] Works that did not meet the standard were broken and had to be remade. The *ensaiador* marked those that passed the test.

All pieces should bear two marks, one certifying the quality of the metal (usually a town mark), and another one for the silversmith. Both marks had to be registered by the city council and are therefore crucial for the identification of an object. The town mark (a "B" for Bahia, "R" for Rio, and later "SP" for São Paulo and "M" for Minas, all of them surmounted by a crown) is important to determine the place of origin while dating can be facilitated by the silversmith's mark whenever registration records have survived.

By law, from 1688 onward, all Portuguese silverworks had to be certified and marked; however, the first position of *ensaiador* was not created in Brazil until thirty years later.[7] In such a vast colony, it was impossible to establish *ensaiadores* and *contrastes* in every town and city, and they were found only in the main urban centers. Because there was a fee for having a silverwork certified, not all customers demanded certification. Complicating matters even further, many silversmiths did not register their marks, or even use one. Thus, one of the main problems in the study of Brazilian silver is the lack of marks on pieces, which makes it difficult (and often impossible) to date a work or determine its origin (fig. IV-2).

There were several legal obstacles to the production of silverworks. First, all silver entering Brazil was subject to taxes, which were difficult to collect when a considerable amount of the precious metal was smuggled into the country. Although currency was scarce, the habit of melting coins in order to cast religious and utilitarian artifacts was commonplace and, naturally, it was also troublesome. Conversely, there are several documented cases of silversmiths arrested for counterfeiting coinage. Finally, and most important, once an object was cast it was virtually impossible to determine whether or not the taxes on the silver involved in its making had been paid. These problems became even more acute once gold was found in the region of

FIG. IV-2

Naveta, Bahia, Brazil, eighteenth century. Silver, cast, chased, and engraved, 6¼ × 8¼ × 3⅛ inches (16 × 21 × 8 cm). Museu de Arte Sacra da Universidade Federal da Bahia

Minas Gerais, in the final years of the seventeenth century, because of the difficulties involved in taxing all the gold extracted.

For all these reasons, the crown tried to keep silversmiths under especially strict surveillance. In 1698, for example, King Pedro II signed a law that limited the number of silversmiths active in Rio to two. The city council protested this law, claming that it was impossible for two silversmiths to cope with the demand, but its claim was turned down. In fact, a 1703 law that forbade gold and silversmiths to settle in Minas reiterated the same limitation, as did many other laws issued throughout the century, apparently to no great effect.[8] Another form of enforcing control over the trade of precious metals was to force silversmiths to maintain their workshops in pre-assigned areas of the city. Circumscribed zones were enforced in Salvador (1735) and Rio (1742). Then, silversmiths were ordered to gather in a single street in both cities (1752 for Salvador, 1753 for Rio).[9]

Toward the middle of the eighteenth century, Portugal's revenues proceeding from Brazil steadily decreased as a result of the decline in the extraction of gold from Minas. Among the various measures designed to face this situation was a particularly radical law enacted in 1766 that ordered the suppression of all silversmithing workshops in the states of Rio, Bahia, Pernambuco, and Minas.[10] All the workshops that had forges where metal could be melted were to be destroyed, and their tools were to be confiscated by municipal officers and subsequently destroyed. In Rio, 142 workshops were closed down;[11] and in Salvador 158 workshops met the same fate.[12]

The viceroy Count of Cunha called the king's attention to the fact that the enforcement of such a measure would harm not only masters, apprentices, and officials but also their families. It would also put an end to the prosperous commerce of silver with Buenos Aires. Lisbon was not moved by these arguments and considered fighting contraband and tax evasion more

FIG. IV-3
Ciborium, Bahia, Brazil, seventeenth century. Silver,
cast, chased, engraved, and gilt, 13¾ × 7⅛ inches
(35 × 18 cm). Museu de Arte Sacra da Universidade
Federal da Bahia

important. As compensation, it offered silversmiths who were single or freed mulattos the possibility of being incorporated in the ranks of the crown's army.[13] Nevertheless, when the following viceroy, the Count of Resende, arrived in Rio, he found many workshops still open and operating. The inventory that he ordered counted 375 master silversmiths working in Rio and no fewer than 1500 officials. Like his predecessor, he wrote to the king about problems raised by this situation, but in vain. Despite the prohibition many silversmiths continued to work, and this law was not abolished until 1815.[14]

The earliest surviving silver objects in Brazil date to the seventeenth century (fig. IV-3). The monastery of São Bento in Rio, for example, has a remarkable collection, which includes a *naveta* (a container for incense in the shape of a ship) acquired sometime between 1608 and 1613, one of the oldest datable pieces in the country.[15] It also includes an elaborate monstrance dated 1635–37. Beyond its intrinsic artistic interest, this monstrance is also of particular historical value because it is inscribed with the name of its donor, André Dias Homem, a man involved in sugar trading. This piece is a testimony of a growing local aristocracy whose prominence derived from the colony's prime product, and of its use of works of silver as a means to assert its position in the social structure.[16]

From a stylistic point of view, Brazil's silver followed the patterns that came from Europe. Objects made of silver, especially for ecclesiastical use, were imported from Portugal throughout the entire colonial period, constantly providing Brazil's silversmiths with prestigious models to copy or from which to draw inspiration. Nevertheless, some regional variations deserve mention. Many nonreligious objects from Minas, for example, incorporate decorative elements inspired by the local fauna and flora. Cane handles sculpted as armadillos, or coconut shells set in silver mounts used as cups, are characteristic of this region.

In the late eighteenth century, conflicts on the southern frontier caused the military contingent of that region to be reinforced, and many silversmiths moved there. The arrival of this specialized labor force in the proximity of the Argentinean *pampa* and its developing gaucho lifestyle combined to produce a number of silverworks related to horseback riding (spurs, whip handles, stirrups) and to cattle raising (especially a series of elaborate knifes), which are characteristic of this part of the country. *Cuias de chimarrão*, vessels used to drink maté, belong to this context as well.

Farinheiras (bowls used to mix flour) made of silver, with more or less elaborate decoration, can be found all over Brazil. But perhaps the most distinctive of all Brazilian objects made of precious metals are the *pencas de balangandã*, composed of a larger piece from which hang many others (coins, amulets, crucifixes), an object of mixed religious and superstitious connotations.

Silverworks made for church usage undoubtedly constitute the most spectacular examples of the art of silver in Brazil. Throughout the Iberian world, church decoration called for a profusion of objects designed to invest religious celebrations with unparalleled sumptuousness: incense burners, monstrances, ornamental plaques (fig. IV-4), candleholders, crucifixes, lanterns, among others, all of which can be seen in this exhibition. Of the many examples, the large set of silver objects made for the decoration of the chapel of the brotherhood of the Santíssimo Sacramento in the old cathedral of Salvador is particularly remarkable. It is composed of a set of six gigantic candle bases (see cat. IV-4), a *banqueta* upon which sat six candleholders, four

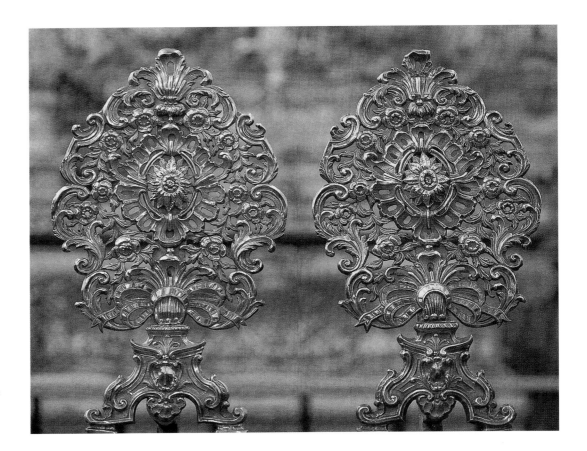

FIG. IV-4
Pair of ornamental plaques, Olinda, Brazil, eighteenth century. Silver, cast, chased, and engraved, 24⅜ × 13¾ × 7⅛ inches (62 × 35 × 18 cm). Monastery of São Bento, Olinda

ornamental plaques, an altar frontal, and a sacrarium, all to be displayed in the company of two paintings by José Teófilo de Jesus. All of these objects have been preserved, and although the chapel has been demolished, its general appearance can be seen in a set of paintings by Presciliano Silva (Museu de Arte da Bahia and Museu Carlos Costa Pinto).

One final aspect should be considered here: the ethnic composition of the silversmiths' profession. There is evidence that some of the first silversmiths to set up shop in Brazil were of Jewish origin. The agents of the Inquisition who visited Bahia and Pernambuco in 1591–95 questioned more than one silversmith accused of maintaining secret Jewish practices.[17] Some of the silversmiths were New Christians (Jews that converted to Catholicism) who had come to the colony to try to escape the persecution of the Inquisition, which was stricter in Portugal. In time, they were joined, and eventually supplanted, by African slaves and freedmen, especially those from cultures with long and sophisticated traditions of metalworking.

Following the principle of racial exclusion upon which the empire was built, in 1621 the crown passed the first law to forbid blacks, mulattos, and Amerindians from practicing silversmithing in Brazil (fig. IV-5). Like so many other regulations for the trade, however, this law was not respected and, a century later, the city council of Salvador passed new legislation that tried to put the same exclusion in force. In 1732, a judge from Pernambuco asserted that there were too many blacks and mulattos involved in silversmithing. Published accounts by many nineteenth-century travelers noted that blacks and mulattos were the best in the trade. These later testimonies make it clear that the African contingent involved was considerable and that recurrent laws to exclude it were not effective.[18] In fact, the community of freed mulatto silversmiths from Rio was able to buy a chapel in the Benedictine monastery and dedicate it to its patron, Saint Brás. The mulatto Martinho Pereira de Brito was Rio's greatest silversmith of the mid-eighteenth century. Among others, he was responsible for the sumptuous lamps of the same monastery (1781), designed by Valentim da Fonseca e Silva, better known as Mestre Valentim, one of Brazil's more famous mulatto artists.

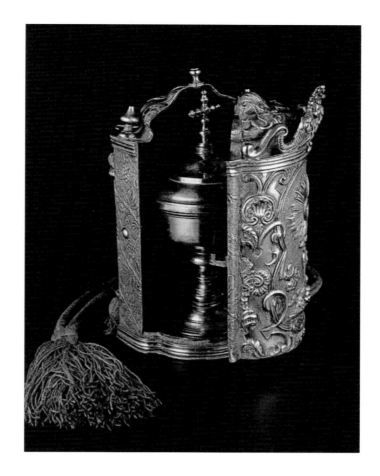

FIG. IV-5
Ciborium and case, Minas Gerais, Brazil, eighteenth century. Silver, cast, chased, engraved, and gilt, 6¼ × 3⅝ × 3⅛ inches (16 × 9.2 × 7.8 cm). Museu de Arte Sacra de São Paulo

In 1807, King João VI fled Portugal to escape Napoleon's army. Having established his court in Rio de Janeiro, he commissioned a new crown from the city's most famous silversmith, Ignácio Luiz da Costa, a mulatto. Years later, the same silversmith was commissioned to create the piece that constitutes the symbolic apex of mulatto Brazilian silversmithing, the crown of Pedro I, the first emperor of independent Brazil.[19] The very groups that the empire tried to exclude from silversmithing kept the art alive and well.

NOTES

1. Valladares 1952, pp. 203–63.

2. Canabrava 1944.

3. Marino 1998, p. 273.

4. Valladares 1952, p. 82; Alves 1962, p. 14.

5. Almeida 1993, p. 12.

6. The sample was taken with a sharp knife, in the form of a zigzagging line, which is visible in the objects that were submitted to legal inspection.

7. Marques dos Santos 1940, pp. 635–36.

8. Ibid., p. 626.

9. Ibid., p. 627; Alves 1962, pp. 8–9.

10. Transcribed in Franceschi 1988, pp. 169–70.

11. Santos 1940, pp. 627–29.

12. Valladares 1940, p. 62.

13. Alves 1962, p. 9.

14. Santos 1940, pp. 627–29; Valladares 1952, pp. 134–40.

15. Silva-Nigra 1942, p. 248.

16. The collection of silver in the Benedictine monastery in Rio was studied by Silva-Nigra; see Silva-Nigra 1942, pp. 241–75.

17. Silva-Nigra was the first to gather early references to silver; see ibid. The list has been growing ever since through the additions by subsequent scholars.

18. Valladares 1952, pp. 55–57.

19. Franceschi 1988, p. 12.

IV-I Attributed to Friar Agostinho da Piedade[†]

(Brazilian, born Portugal, c. 1580–1661)

With an unknown silversmith

Reliquary bust of Saint Lucy

Salvador, Bahia, Brazil
c. 1630
Polychromed cast lead; silver, repoussé, chased, engraved, and partially gilt; and semiprecious stones
Height 19⁵⁄₁₆ inches (49 cm)
Monastery of São Bento, Salvador, Bahia, Brazil

PUBLISHED: Silva-Nigra 1971, p. 25; Bardi 1979, p. 9; Moacir Maia 1987, p. 149; Barbosa and Machado 1988, p. 37

EXHIBITED: Salvador 1961

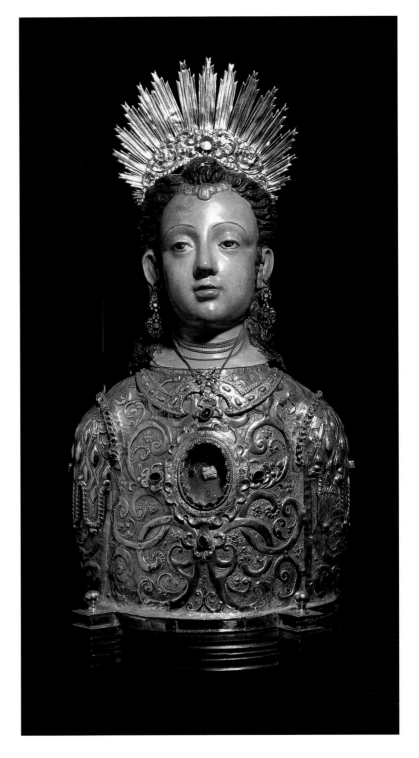

OUR KNOWLEDGE ABOUT Friar Agostinho da Piedade is based on the research done by the Benedictine friar Clemente da Silva-Nigra. In 1936, Silva-Nigra examined a terracotta sculpture of the Virgin of Monserrate in the Instituto Geográfico e Histórico da Bahia, in Salvador, Bahia. To his surprise, the piece had a long inscription that dated the work to 1636 and assigned it to the Benedictine sculptor-monk Friar Agostinho da Piedade. The archives of the Benedictine monastery in Salvador provided more information: Friar Agostinho was born in Portugal and, at a fairly young age, traveled to Salvador, where he is recorded in 1620. It was in Salvador that he became a friar and a sculptor. He died in the same city, in April 1661.

There are four sculptures signed by him (the Virgin of Monserrate, a Saint Anne Teaching the Virgin, a Saint Catherine, and a Baby Jesus), two of which are dated (the aforementioned Virgin and the Saint Anne, dated 1642). On the basis of these pieces, Silva-Nigra attributed a total of twenty-eight sculptures to Friar Agostinho, all made of terracotta except this one, whose head is made of cast lead. The reliquary bust of Saint Lucy belongs to a series of works with similar formal characteristics and dimensions. On the basis of style, they are considered to have been made around 1630. It is believed that Friar Agostinho cast the head of the saint, but the silversmith who worked on the piece remains unknown.

The cult of relics was a central part of the Catholic Church's beliefs. It was one of the points of contention between Catholics and Protestants, but the Council of Trent (1545/63) reaffirmed its validity and reinforced its practice. Religious institutions placed high value on the acquisition of relics, consisting of objects used by holy persons as well as parts of their bodies. They were kept in special containers, often made of precious woods or metals, and sometimes incorporating precious stones. A bust such as this one would provide a normally hard-to-identify relic with a human-looking container, thus mediating and facilitating the identification of the worshiper with the relic. The carefully chased, engraved, and even gilded silver of the saint's dress, as well as her silver jewelry and halo, invests the whole with the exceptional quality a relic-holder requires.

Nuno Senos

IV-2 *Flasks for holy oils*

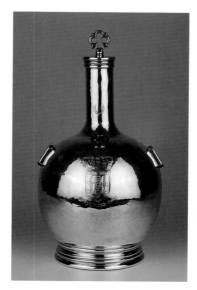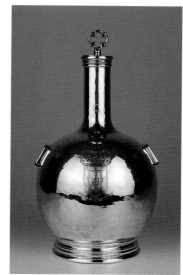

Maranhão, Brazil

1683

Silver, cast, chiseled, and engraved

Nos. 1–3: height 14⁹⁄₁₆ inches (37 cm); diameter 9¹³⁄₁₆ inches (25 cm)

No. 4: 24¹³⁄₁₆ inches (63 cm); diameter 13⅜ inches (34 cm)

Inscribed on body of bigger flask, between two crosses: *IN*HOC*SIGNO* VINCES*BRAZILIAE*DOMINUM;* middle of neck: *S.O.;* top of neck: *ANNO*DOMINII*1683*;* the bodies of the smaller flasks contain two similar crosses, a royal coat of arms, and *BRASILIAE : DOMINUS* underneath; on necks of flasks: the letters *C, D,* and *U,* respectively

Collection of Beatriz and Mário Pimenta Camargo, São Paulo, Brazil

PROVENANCE: Probably from the cathedral of São Luís do Maranhão

PUBLISHED: Bardi 1979, pp. 13 and 19; *Colecção Camargo* 1991, cat. nos. 317–20; *Universo mágico* 1998, cat. nos. 284–85; *Brésil baroque* 1999, cat. nos. 301, 303–5; Sullivan 2001 cat. nos. 173–76; *Arte in Brasile* 2004, cat. no. 113

EXHIBITED: Lisbon 1991, cat. nos. 317–20; São Paulo 1998, cat. nos. 284–85; Paris 1999, cat. nos. 301, 303–5; New York 2001, cat. nos. 173–76; Milan 2004, cat. no. 113

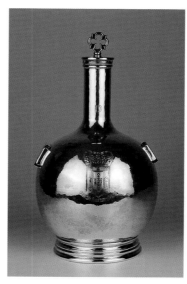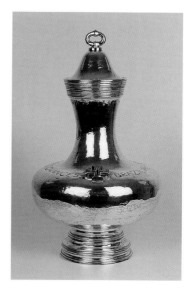

SOME OF THE MOST IMPORTANT CATHOLIC ceremonies take place during Easter. On Holy Thursday morning there is no regular mass. In the cathedral, the bishop celebrates the Chrism Mass (*Missa Chrismalis*), which is an especially solemn ceremony. During this mass the bishop consecrates the oils that are to be used throughout the year in his diocese. Only a bishop has the authority to consecrate oils. During the celebration of this special mass, the bishop is attended by a large retinue of clergymen, twenty-six of whom are invested with special ranks.

There are three kinds of sacred oils: the oil of catechumens, that of holy chrism, and that of the sick. The first one, which is pure olive oil, is used to anoint those who are about to be baptized. The oil of chrism is composed of a mixture of olive oil and balm and is used immediately after baptism. The oil of the sick is again pure olive oil and is used, as its name indicates, to anoint sick people. Once consecrated, the holy oils are kept in metal flasks marked—usually in Latin—according to their contents: the flask for the oil of the catechumens is marked OC (*oleum catechumenorum*) or OS (*oleum sanctum*); that for the holy chrism is marked SC (*sanctum chrisma*); and the flask for the oil of the sick is marked OI (*oleum infirmorum*).

The set shown in this exhibition is composed of four flasks, all with similar decoration. Three were marked in Portuguese: SO for *santo óleo,* C for *catecúmenos* or *crisma,* and D for *doentes,* the sick. The fourth flask, however, is marked with a U (sometimes read as a V), which probably refers to the word *unção,* a generic term for anointment. The unusually large size of the flasks is probably explained by the fact that in 1683, when these flasks were made, there was only one bishopric in the whole of Maranhão, which had just been created in 1677. The bishop of Maranhão

had, therefore, to consecrate a great quantity of oil as it had to last the whole year.

At the time of the Council of Trent, Carlo Borromeo insisted that every cathedral should have two sets of flasks for holy oils. The similar formal characteristics of all of these four flasks as well as their similar inscriptions suggest that they were part of the same commission and that the three matching flasks form a complete set whereas only one of the flasks of the second set survived.

Nuno Senos

IV-3 *Arm reliquaries of Saint Sebastian and Saint Benedict; foot reliquary of Saint Maur*

Bahia(?), Brazil
Seventeenth century
Silver, cast, chased, engraved, and gilded
Foot of Saint Maur: height 20⅞ inches (53 cm); diameter 5⅞ inches (15 cm)
Arm of Saint Sebastian: height 24¾ inches (63 cm)
Arm of Saint Benedict: height 24¾ inches (63 cm)
Monastery of São Bento, Salvador, Bahia, Brazil

PUBLISHED: Rocha et al. 1982; Foot of Saint Maur: Valladares 1990, vol. 4, ill. 285; *Universo mágico* 1998, p. 291; arm of Saint Benedict: Valladares 1990, vol. 4, ill. 284

EXHIBITED: Foot of Saint Maur: São Paulo 1998, p. 291

RELIGIOUS ORDERS WERE NATURALLY INVESTED in the promotion of saints who stemmed from their own ranks. Two of these reliquaries, those of Saint Benedict and Saint Maur (called Amaro in Portuguese), belong to this category. Benedict was the founder of the order for which the reliquaries were made. Most of the churches of this order are dedicated to its founder, and his image is invariably found in the main altar. Having a relic of the founding saint would add considerable prestige to the church, where it would be offered to the cult of the worshippers.

Saint Maur was one of the earlier companions of Benedict. Shortly before his death, Benedict sent him to France with a copy of the order's rule written by Benedict himself. Maur is thus credited with the introduction of this major medieval order into that country, where his cult became particularly strong. Once in France, one of Maur's servants fell from his horse and severely damaged his left foot, but Maur blessed it and the foot was miraculously cured. This miracle became crucial to Maur's imagery, and his reliquaries are often shaped in the form of a foot.

Saint Sebastian was one of the early Christian martyrs. He was pursued for being a Christian and consequently tied to a tree and shot with arrows. Sebastian survived this punishment and returned to preaching. The emperor Diocletian eventually condemned him to being beaten to death. Sebastian, however, is always represented as being shot with arrows, and the presence of an arrow piercing a left hand identifies this reliquary with him. During the Middle Ages, Sebastian became associated with protecting villages from the plague, and his cult became widespread throughout the whole of Christendom. Imagery associated with him can frequently be found in Brazil.

All three were important saints for the Benedictine order and for Christianity in general. Their relics therefore commanded displays of precious materials. These reliquaries were carefully engraved in great detail and with decorative flair. They all show similar formal characteristics and were probably made around the same time, in the seventeenth century.

Nuno Senos

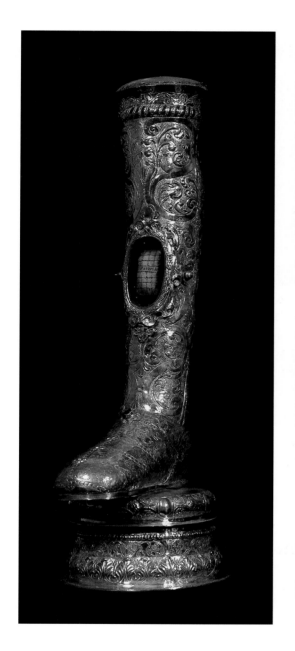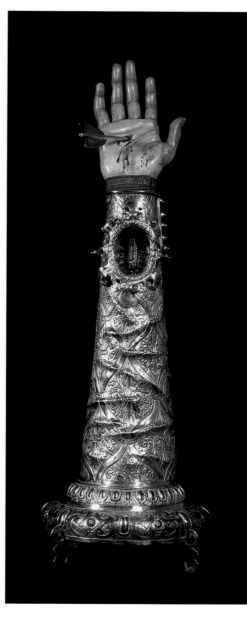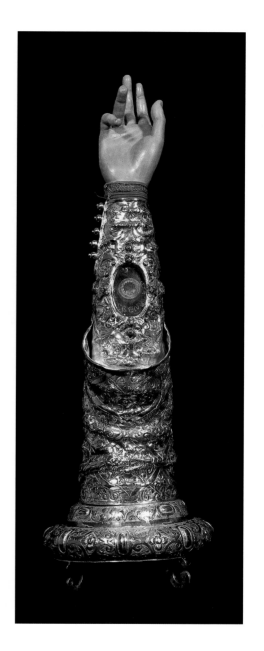

IV-4 Manuel Álvares

(Possibly active Salvador, Brazil)

Candle base

Possibly Salvador, Brazil
1696
Silver, cast, repoussé, chased, and engraved
Height 28⅜ inches (72 cm)
Inscribed on both the feet and the base: *L* at the bottom
and the mark *MED* (unidentified)
Arquidiocese de São Salvador da Bahia (Catedral Basílica)

PROVENANCE: Chapel of the Santíssimo Sacramento in
the old cathedral of Salvador (demolished in 1933)

PUBLISHED: Alves 1962, pp. 49–52; Silva-Nigra 1972,
pp. 19–21; Moacir Maia 1987, pp. 13, 172, 174

ACCORDING TO ARCHIVAL SOURCES published by Marieta Alves and Silva-Nigra, this impressive candle base was part of a set of six commissioned in 1695 and delivered a year later, destined to adorn the chapel of the wealthy Santíssimo Sacramento brotherhood in the old cathedral of Salvador. The commission was given to a man called Manuel Álvares, although the silversmith's initials in the mark do not match. The town mark of Lisbon is also problematic because it would have been virtually impossible for a commission of this nature to be met in the short span of a single year. Not only would it involve gathering a considerable amount of silver, which always took some time, but it would also require the trip from Salvador to Lisbon in the yearly fleet, the making of the objects, and the trip back to Salvador, again with a fleet that only traveled once a year. Exceptional efficiency and timeliness would have been required to make this possible. It is reasonable therefore to hypothesize that these candleholders were made in Salvador and given a pseudomark in the shape of that used in Lisbon. There are several known examples of Lisbon pseudomarks applied in Brazil during later periods. Also, the law requiring all silverworks made in the Portuguese domains to be marked was issued in 1688, but no one was appointed for the job in Salvador until 1718. The

objects under consideration were made precisely during that interval, further making plausible the pseudomark hypothesis.

In any event, this magnificent piece and its mates have come to us somewhat changed from their original appearance. In 1780, the brotherhood decided to embark on a complete redecoration of their chapel. Six new candleholders were commissioned from Domingos de Sousa Marques, who was to melt another set of old candleholders and use the resulting silver for the new ones. A *banqueta* (a low platform that sits behind the altar table and upon which rest the candleholders), an obligatory piece in prosperous Brazilian altars, was commissioned four years later. And then in 1791, the brotherhood had the upper part of this set of gigantic candle bases cut off in order to use the resulting silver for new liturgical objects commissioned from João da Costa Campos. The same silversmith made the impressive altar frontal (176 lbs or 80 kg of silver), while Joaquim Alberto da Conceição Matos made the sacrarium. Finally, the new decorative program also included two paintings commissioned from the most important painter in the city, José Teófilo de Jesús.

Nuno Senos

IV-5 *Basin*

Bahia, Brazil
Seventeenth century
Silver, repoussé and engraved
Height 2⅜ inches (6 cm); diameter 10⁷⁄₁₆ inches (26.5 cm)
Inscribed on the side: *Br B*
Collection of Beatriz and Mário Pimenta Camargo, São Paulo, Brazil

PUBLISHED: Bardi 1979, p. 87; *Colecção Camargo* 1991, cat. no. 331; *Universo mágico* 1998, cat. no. 286; *Brésil baroque* 1999, cat. no. 292; *Arte in Brasile* 2004, cat. no. 71

EXHIBITED: Lisbon 1991, cat. no. 331; São Paulo 1998, cat. no. 286; Paris 1999, cat. no. 292; Milan 2004, cat. no. 71

BASINS SIMILAR TO THIS ONE WERE USUALLY used in a ritual washing of the feet. This ceremony, based on that performed by Christ after the Last Supper, eventually became part of regular Maundy Thursday rituals. It is performed to this day by several ranks of priests, including the pope, and it also used to be performed by most sovereigns in Europe.

This rare basin, however, fulfilled a different function. After the celebration of the Mass, the liturgical objects used in it (the chalice and the ciborium, called *âmbula* in the Portuguese world) were cleaned with small pieces of linen cloth called *sanguinhos*. The small proportions of this basin indicate that it was used to wash these *sanguinhos*. The lack of decorative elements on the basin also indicates that it was not used in public ceremonies, where more sophisticated objects would have been preferred, but rather in a private setting, removed from the sight of a large audience.

It has been suggested that this is the earliest silverwork made in Bahia, but its inscription remains to be deciphered and such assertion requires further substantiation. The simplicity of the basin's form and treatment do, however, suggest a very early date.

Nunos Senos

IV-6 *Baptismal shell*

Pernambuco, Brazil

Eighteenth century

Silver, cast, repoussé, chased, and engraved

3¾ × 12⅝ inches (9.5 × 37 × 32.5 cm)

Collection of Beatriz and Mário Pimenta Camargo, São Paulo, Brazil

PUBLISHED: *Colecção Camargo* 1991, no. 91; *Brésil baroque* 1999, cat. no. 306

EXHIBITED: Lisbon 1991, cat. no. 197; Paris 1999, cat. no. 306

THROUGH BAPTISM, THE NON-INITIATED (usually, but not necessarily, a child) is introduced into the Church of Christ: "Unless a man be born again of water and the Holy Ghost, he cannot enter into the kingdom of God" (John 3:5). According to official doctrine, it was Christ—himself initiated by John the Baptist—who instituted the sacrament of baptism, and he subsequently sent out his disciples to baptize. While evoking the formula officially recognized ("I baptize thee in the name of the Father and of the Son and of the Holy Ghost") during the ceremony of baptism, the officiating priest pours water over the head of the baptized. The holy oils, the evocation of the Holy Trinity, and water are the prerequisites for a valid baptism. This baptismal shell was used to pour the water over the head of the baptized. Similar objects are still in use.

Like many other Brazilian silverworks of the colonial period, this shell is not marked, which makes dating and the determination of a geographic origin difficult. It is, however, thought to be an eighteenth-century piece from the region of Pernambuco. Regardless of the lack of data, the piece is an exceptionally interesting example of its type. The wealth of the person or institution that commissioned it is indicated by its high-quality carving as well as its unusually large size. The anonymous silversmith responsible for it also distinguished it from similar vessels by ending its rim in two symmetrical volutes rather than imitating a real shell. Moreover, it sits on three shell-like, cast feet, another distinctive feature.

Nuno Senos

IV-7 Crown for a statue of the Virgin

Brazil
Eighteenth century
Silver, cast, repoussé, chased, and engraved
22⁷⁄₁₆ × 13⅜ × 13⅜ inches (57 × 34 × 34 cm)
Private collection

PUBLISHED: Sullivan 2001, cat. no. 165

EXHIBITED: New York 2001, cat. no. 165

THE HABIT OF ADORNING STATUES OF SAINTS with jewelry and precious garments was commonplace throughout Latin America. Not only were such statues regarded as precious objects, they were also depictions of holy persons and therefore worthy of the greatest splendor. Representations of female saints were often the object of especially heavy adornment since one could attach to them earrings, necklaces, and rings. Precious metals and stones would be used in these pieces of jewelry.

The halos of holy figures were often made of silver or gold. Over the late seventeenth century and the eighteenth century, halos evolved from a simple luminous ring surrounding the head into a complex set of rays of light, which was called a *resplendor* in Portuguese. Any saint could have a halo, but only the Virgin could wear a crown, signifying her role as Queen of Heaven. As was often the case, for this crown the silversmith chose the shape of an imperial crown, composed of a profusely carved

lower part (a ring organized in three sections) linked to the cross at the top by four decorated vertical bands. The embellishment of the lower section, composed of cherubs, shells, and openwork vegetal motifs, is particularly remarkable. The size of this piece is also noteworthy because it hints at the size of the statue it was destined to adorn, which must have been close to life-size.

Nuno Senos

IV-8 Processional cross and two sets of lanterns

Probably Bahia, Brazil

Eighteenth century

Silver, cast, repoussé, chased, and engraved

Cross: 100 × 24½ inches (254 × 62.2 cm); lanterns: 76¾ × 9⅞ inches (195 × 25 cm)

Fundação Museu Carlos Costa Pinto, Salvador, Bahia, Brazil

PUBLISHED: Rosa 1980, fig. 3

CHRISTIAN RITUALS INVOLVE VARIOUS sorts of processions, from those enacted only by priests (for example, when those celebrating Mass go from the sacristy to the altar), to much bigger and more complex rituals. Perhaps the most important of all processions in colonial Latin America was that of Corpus Christi, always celebrated with great festivities in the Iberian world. A procession of the dimensions of the Corpus Christi engaged the population of a whole region, bringing out great audiences on the streets and balconies, and participating through the organization of guilds, brotherhoods, religious orders, or parishes. On such occasions, the city's windows would be decorated with rich fabrics while each institution would display its finest religious objects and create a carriage in honor of its patron saint (more common in Spanish America) or a triumphal arch (more common in Portuguese America). In the Iberian world, processions were occasions of unparalleled splendor.

A processional cross always opens a procession. It is a simple crucifix mounted upon a long staff so that it may be easily seen. The figure of Christ on the cross faces the direction in which the procession is moving unless an archbishop takes part in the procession, in which case the figure of Christ is turned toward the prelate.

All the parishes, brotherhoods, and religious orders taking part in the procession march behind the ecclesiastical figure that heads it. They carry crosses of their own, but these do not have the figure of Christ on them. The staff of these crosses is usually made of silver (as is the case here), except for those of the mendicant orders, which have wooden staffs.

In addition to the crosses, candles are present in all processions. They can be carried in candleholders or in lanterns, which protect them from the wind. The processional cross is flanked by two candleholders (called *ciriais*), which differ from lanterns in that they do not have a perforated container that protects the candle. Lanterns can be held by hand or, like the crosses, set on a staff made of wood or silver. In the nineteenth century, panes of glass replaced the perforated metal parts of the lantern. Unlike the cross, which is very simple in its decoration, the lanterns shown here are profusely decorated, evidencing the level of investment made to ensure that a procession was always a major event.

Nuno Senos

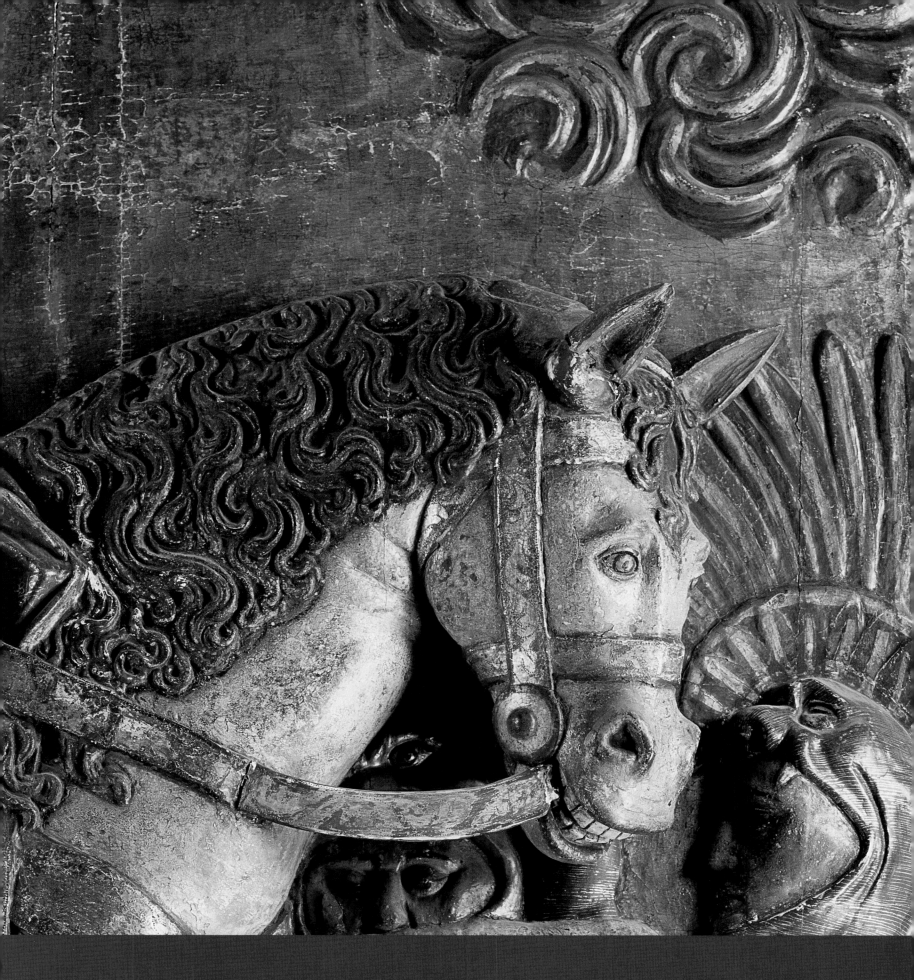

Sculpture

Exotic Devotion: Sculpture in Viceregal America and Brazil, 1520–1820

Marjorie Trusted

The Christ Child hangs from the cross, his eyes closed, a prefiguration of Christ crucified as a man (cat. v-10). This small Guatemalan sculpture, dating from the eighteenth century, epitomizes many distinctive characteristics of viceregal American sculpture. The subject elicits a human and a devout response from the viewer as well as an aesthetic one, and the materials used enhance the emotive and naturalistic representation. The figure is carved in wood and crowned with a silver halo.[1] The polychromy complements the carving, emphasizing the pathos of the subject: the flesh is pale, and the drops of blood on the face and body are bright red. This figure is one of a group of three depicting the Christ Child enacting different scenes from the Passion, a subject derived from seventeenth-century Netherlandish engravings.[2] Unlike most representations of the Passion, the sculpture shows Christ not as a man, but as a doll-like child, and thus reinforces the doctrine that Christ accepted his sacrifice from the moment he was conceived.[3]

This figure is typical of Guatemalan wood sculpture, which was particularly renowned during this period and was much exported within Mexico and South America.[4] Like many other works of art from colonial Latin America, it derives from European sources but intensifies their emotional and spiritual resonance to meet local demands. Because sculptures exert such a strong presence, they offered an important means of converting the indigenous population, as well as acting as devotional items for Spaniards and Creoles in churches, private houses, and convents. The Christ Child discussed above may well have originally been made for a convent. Like their Spanish and Portuguese counterparts, viceregal sculptures can be simultaneously compelling and unsettling. Often, as here, they combine a strikingly unusual iconography with a highly naturalistic style. Affecting sculptures such as this were less commonly made in Spain by the eighteenth century, but they continued to be produced in the New World and were sometimes sent to Europe, where they had great popular appeal. As early as the sixteenth century crucifixes made in Mexico were shipped to Spain,[5] and between 1779 and 1787, 254 cases of sculpture were exported from Ecuador to Europe.[6]

Like many works of its type, the Christ Child sculpture is anonymous. Indeed, only a few artists in viceregal America and Brazil are known by name, such as the Italian-born painter

and sculptor Bernardo Bitti (1548–1610), a Jesuit who was active in Peru (cats. v-31–v-35); the sculptor Bernardo de Legarda, active in Quito in the eighteenth century (cats. v-22, v-24, v-29); or Antônio Francisco Lisboa, known as O Aleijadinho (c. 1738–1814), who worked in Brazil (cats. v-40–v-45). The authorship of many other works is unknown, perhaps because the devotional force of the image was considered more crucial than the name of the artist. Conversely, some artists' names are recorded in documents but their works can no longer be identified. Certain deductions can be made from such written records—for example, the numerous artists who were members of religious orders, or the existence of indigenous sculptors, such as the sixteenth-century Mexican sculptor Miguel Mauricio, whose works were said by Friar Juan de Torquemada (c. 1557/64–died after 1602) to be superior to those of some well-regarded Spanish artists, though few if any of Mauricio's sculptures are known to have survived.[7] For these reasons, studying sculpture in viceregal America solely through the prism of individual artists would omit many major pieces and would perhaps fail to describe broader issues. This essay aims instead to discuss the work in terms of its contexts and functions, as well as the materials and techniques employed in making it. In this way we can begin to understand what makes these pieces so distinctive, even though they were produced across an enormous geographical area over the course of almost three centuries.

TYPES AND USES OF SCULPTURE IN THE NEW WORLD

With a small number of exceptions (funerary monuments,[8] heraldic carvings, decorative architectural sculpture on secular buildings, and genre figurines), all sculpture made during the viceregal period in the New World was religious.[9] The Spaniards and Portuguese determined the Christian subject matter, but nevertheless some sculpture can be directly linked with pre-Hispanic traditions.

Five types of religious sculpture can be distinguished: architectural and monumental stone carvings, small devotional pieces, processional figures, large-scale devotional figures in churches, and altarpieces.[10] The functions of some of these types might overlap; for example, a figure on an altarpiece could also serve as an object of devotion, albeit in the relatively public setting of a church. Similarly, some sculptures on altarpieces might be taken out in procession, although many processional figures were made for that purpose. Nevertheless, these categories can help differentiate the types of sculpture made and illuminate the diverse materials and styles.

Architectural and Monumental Sculpture

FIG. V-I
Atrial cross, sixteenth century, outside Augustinian
Monastery of San Agustín/CONACULTA,
DGSMPC, Acolman, Mexico

Stone sculptures that adorn the exterior of churches and cathedrals and large outdoor stone crosses in Mexico are among the earliest colonial works of art to survive, and they form a tradition that was partly fused with indigenous forms and styles.[11] One of the most famous of the crosses, the sixteenth-century atrial cross outside the Monastery of San Agustín in Acolman, Mexico, has at its center Christ's head crowned with thorns, carved integrally with the cross itself (fig. v-1). Densely carved floral and vegetal motifs adorn the arms and central trunk of the cross.[12] The crucified figure of Christ is embedded in the very structure, a form of the crucifix unique to Mexico. Sometimes an obsidian disc, an Aztec religious symbol, was set in the center of such crosses, merging pre-Hispanic and Christian imagery.[13] Often such crosses, as well as early churches, were built on the sites of former Aztec temples, both because the Spanish wanted to rid the country of paganism and, paradoxically, because they recognized the spiritual significance of such places.[14] By erecting Christian sanctuaries in places already deemed holy by the indigenous population, such as at Huejotzingo, or Guadalupe, Mexico, the Spaniards hoped to eradicate non-Christian traditions,[15] although ironically this may have encouraged the indigenous people to marry their own beliefs to those of the invaders. This was also true in Peru, where the sanctity of ancient Inca sites was in some ways preserved through, or

despite, the new Christian cults.[16] Sometimes stones from pagan temples were reused for Christian edifices as a practical solution to the costs and labor of transporting heavy and expensive materials.[17] In 1537 Carlos V advised the bishops of Mexico to demolish the Aztec temples "without scandal and with appropriate prudence," and to reuse the stones to build churches and monasteries, while burning the idols.[18] One such surviving stone was used as a column base for a church (cat. v-1).[19]

The weighty and powerful appearance of the massive early Hispanic stone sculptures in Mexico, with their densely patterned surfaces, recalls that of sacred pre-Columbian figures. This style was dubbed *tequitqui* by José Moreno Villa in 1942, a term he derived from the indigenous word meaning "tributary," or one who pays tribute, signifying the conjunction of local and Spanish styles, and analogous to the term *mudéjar*, used for the conjunction of Muslim and Christian styles in Spain.[20] Prior to the arrival of the Europeans, the Indians of Central and South America did not have metal tools and could carve stone only by using obsidian or other hard stones. Their sculptures often had elaborate surfaces but little detailed work, and the figurative aspects were only summarily indicated. This style continued even after the sculptors could employ sharper, finer metal tools.

One of the earliest surviving buildings in Mexico is the church at Huejotzingo, built by the Franciscans in the sixteenth century (1529–70). The carving on the exterior north portal (the *porciúncula*) indicates its Franciscan origins: Christ's wounds and drops of blood (symbols closely associated with the order) are sculpted in stone; the capitals are idiosyncratically carved in the form of baskets, probably inspired by European engravings (fig. v-2).[21] Large-winged angels in high relief adorn exterior walls of the church's four *posas;* these are small outdoor chapels, a form of building seemingly unique to the New World, which stand in the four corners of the atrium or forecourt outside the church (figs. v-3a, b).[22] The sculpted angels were almost certainly produced by native craftsmen working under the auspices of the Franciscans, possibly with the help of engraved sources.

So-called altarpiece-facades (*retablos-fachadas*) adorned the main portals on the exterior of many churches and cathedrals built in Mexico, Guatemala, and Peru up until the eighteenth century, though the most celebrated of these date from the sixteenth century. These were profusions of carvings in the overall form of an altarpiece, with niches and clearly demarcated stories. They were richly carved with foliate and vegetal decoration and peopled by slightly awkward, stumpy figures. The facade in the Jesuit church and monastery at Tepotzotlán, Mexico, dating from 1760–62, exemplifies this type of sculpture, where the surface is encrusted with dense patterning. The Virgin of the Immaculate Conception crowns the piece, and figures of Jesuit saints stand on elaborate stone plinths in the niches below.[23] The facade at the monastery of Guadalupe in Zacatecas, Mexico, similarly shows a complex patterned surface; the columns have Corinthian capitals but are decorated with a variety of contrasting and highly unclassical geometric designs with figures carved at the bases of the columns. The Virgin is flanked by monumental figures of saints standing stiffly in their niches.[24] Similar facades can be seen in Guatemala, though the figures on these are often constructed of brick and modeled plaster, rather than carved stone.[25]

On Andean churches the main and side portals could also be highly decorative. For example, the side portal dedicated to Saint Paul on the Church of Santo Domingo in Arequipa, Peru, dating from 1677–80, depicts the enthroned figure of the saint in high relief beneath the Dominican symbol of a dog, surrounded by foliage, flowers, and fruit, including bunches of grapes, no doubt a reference to the Eucharist. The rich

FIG. V-2
Exterior north portal, Church of San Miguel Arcángel (1529–70), Huejotzingo, Mexico

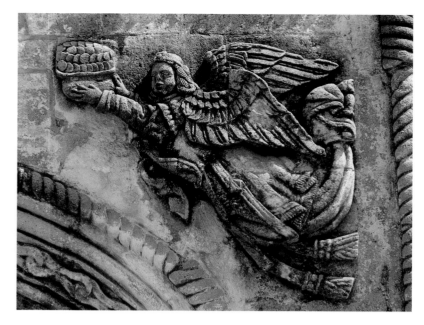

FIGS. V-3a, b
Angels in high relief on the exterior walls of the
posas, Church of San Miguel Arcángel (1529–70),
Huejotzingo, Mexico

patterning and heavy carving are unmistakably local in style, but the classicizing structure of the whole is undoubtedly based on a European design, probably derived from an imported engraving.[26] These imposing facades presented public manifestations of the piety of the community, as well as grand statements of Christian dogma.

Small-Scale Devotional Sculpture

Small devotional sculptures, such as the Christ Child described at the beginning of this essay, were prevalent not only in Guatemala,[27] but also in the Audiencia of Charcas (present-day Bolivia)[28] and New Granada (in present-day Ecuador and Colombia).[29] Those in Guatemala were probably produced locally, but a number of pieces in Charcas and New Granada may have been imported from Quito. These sculptures are generally anonymous, and some, such as the Nativity groups, approximate folk art. Such pieces were often displayed in glass cases in private houses or convents. Because many surviving devotional sculptures are found in convents, it has plausibly been proposed that they were made by nuns.[30]

Quito workshops of the seventeenth and eighteenth centuries also produced domestic altarpieces, usually in the form of polychromed and gilt wood triptychs. Their hinged wings served as doors, which opened to reveal the images within and closed to protect them in transit. The central image was often the Virgin, who would be flanked by saints. In addition to being in demand for private houses, these portable altarpieces were also used by missionaries.[31] A number of such small altarpieces were exported to New Granada and elsewhere in South America. Similar small altarpieces, or *oratórios*, were made in eighteenth-century Brazil, and these too could be taken to more distant parts for evangelizing purposes, as well as being displayed in private houses; some were even worn around the neck by beggars, who promised to pray for the souls of those who gave alms.[32] Small altarpieces, often containing myriads of tiny figures, continue to be made in the region of Ayacucho (formerly Huamanga), Peru, up to the present day.[33]

Quito sculptors specialized in small-scale polychromed wood figures, producing works of exceptional quality, including Crucifixion groups such as those by the eighteenth-century sculptor Manuel Chili, called Caspicara (cat. v-26).[34] The gilding and polychromy of the draperies and the highly polished flesh tones give these small sculptures a distinctive quality reminiscent of porcelain figurines. The techniques used for the surface finishes and colors of these groups depended on skills practiced in Spain and Portugal, which were developed and adapted to the small size of the South American pieces. These finely worked Quito sculptures were

easily transportable and relatively inexpensive compared to full-size figures for altarpieces, and many were exported to population centers around the continent, where their detailed workmanship was highly prized.

The drapery on many small-scale and life-size sculptures produced in Quito and elsewhere in Hispanic America is polychromed and gilded in a technique known as *estofado*, which ultimately derived from fifteenth-century Netherlandish practices but is now primarily associated with Iberian and viceregal sculpture. The word *estofado* comes from *estofa*, meaning "textile" or "stuff," and is used to describe this technique because the painted surface imitates a fine fabric, such as brocade or embroidered silk. Gold leaf was applied to the prepared wood surface of the sculpture, and pigment was then painted on top of the gold. The paint would then be scratched away in patterns to reveal the gold beneath. Where the gold was not actually revealed, the gilding would shine through the translucent color (see cat. v-17). The *estofado* on eighteenth-century Guatemalan sculptures is often a pattern of rhomboid shapes interspersed with stylized foliate and floral decorations. Sometimes silver leaf was combined in a similar way with polychromy, and on occasion, especially in Quito, a dilute, colored varnish of red, blue, or green was painted over silver leaf. The latter technique was known as *barniz chinesco* (Chinese varnish) and may have been inspired by Asian techniques.[35] The flesh colors (*encarnaciones*) for faces, hands, and feet were usually painted in oil or tempera and could have a polished (if oil) or matte (if tempera)

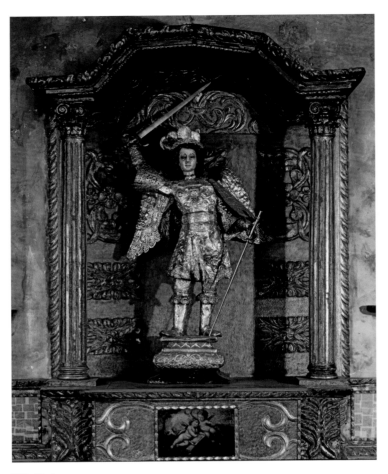

FIG. V-4

Saint Michael Archangel, eighteenth century. Silver and polychromed wood, height 4 feet (122 cm). Casa Santo Domingo, Antigua, Guatemala

finish. The techniques used were those described by the Spanish artist and theorist Francisco Pacheco (1564–1644) and could have been relayed by immigrant Spanish artists or through Pacheco's own treatise on art, which was published in Spain in 1649.[36] As in Spain and Portugal, eyelashes, real hair, and glass eyes were often added, giving the figures a strikingly realistic presence. Such naturalistic additions continued to be favored in the New World well into the eighteenth and nineteenth centuries, long after they had fallen out of favor in the Iberian Peninsula.

Many small-scale New World sculptures were made of valuable materials and were so finely produced that they could almost be classified as luxury goods. They must have been intended primarily for the Spanish and Creole market, since their purpose was not so much to convert as to encourage and maintain devotion, as well as to draw attention to the wealth and power of their owners. An eighteenth-century four-foot-high (122 cm) polychromed wood figure of Saint Michael Archangel, for example, is clad in silver armor and sports silver wings (fig. v-4). Other valuable materials, such as ivory and huamanga alabaster, were particularly appropriate for small-scale sculpture because they were available primarily in smaller pieces. Specialist workshops were often established in particular towns near where the raw material was found or imported, such as Huamanga (present-day Ayacucho), Peru, named for the nearby quarries of this particularly pure form of alabaster.[37] The innumerable statuettes and reliefs made there from the seventeenth century onward were used for devotional purposes.[38] A similar alabaster was quarried near La Paz, and some alabaster carvings, sometimes partly gilt or polychromed, were produced in Bolivia.[39] Alabaster could also be used to adorn wood figures, such as a small eighteenth-century Guatemalan figure of the Sorrowing Virgin, carved in polychromed and gilt wood, that has a face and clasped hands made of alabaster.[40] This figure is in the Museo Popol Vuh, Guatemala City.[41] The stone must have been imported from Peru or Bolivia but was likely carved in Guatemala. Eyes of glass are set within the face,

FIG. V-5

Virgin of the Dormition, eighteenth century. Wood with ivory face, hands, and feet. Cathedral, Antigua, Guatemala

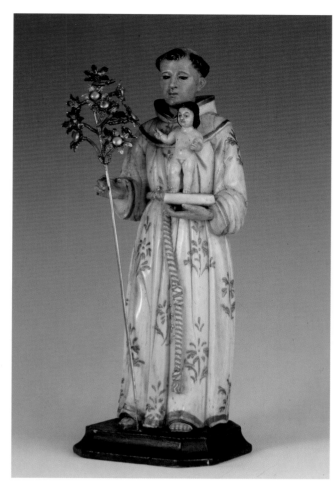

and glass tears run down the cheeks. The intimate scale of this piece enables the viewer to see the intricate surface decoration of the draperies and to appreciate the translucent stone in contrast to the richly gilt and colored wood.

Both raw and worked ivory was imported to Guatemala by way of the East Indies, China, and the Philippines (most of the raw ivory came from Africa but was imported to America from Asia).[42] Like alabaster, ivory was used as a decorative addition for wood sculpture. The eighteenth-century recumbent dressed wood figure of the Virgin of the Dormition, slightly under life-size, in the cathedral in Antigua, Guatemala, has a face, hands, and feet of ivory (fig. v-5). Like the alabaster used for the face and hands of the Sorrowing Virgin mentioned above, the ivory was probably imported unworked and carved in Guatemala. The sculpture is displayed in a glass case beneath a side altar and, although it is in a cathedral, functions as a devotional piece. Most ivory sculptures are on a much smaller scale. The Bible in the hands of Saint Anthony of Padua in a seventeenth-century polychromed Guatemalan wood statuette supports an even smaller statuette of the Christ Child, which is evidently a Hispano-Filipino ivory, carved in China or the Philippines for the Spanish market (fig. v-6). Ivory reliefs were carved in Quito: an eighteenth-century reliquary made in Quito, for instance, consists of a double-sided carved polychromed and gilt ivory medallion depicting the Virgin and two saints on the obverse and Saint Peter on the reverse. The ivory is set in silver mounts, forming a pendant. This piece is in the Museo Nacional Colonial de la Casa de la Cultura Ecuatoriana, Quito, Ecuador.[43] Another ivory from Quito shows the Holy Family with the Holy Spirit hovering above (fig. v-7).

FIG. V-6
Saint Anthony of Padua with the Christ Child, Guatemala, seventeenth century. Polychromed wood with Hispano-Filipino ivory. Private collection

Processional Figures: Indigenous Techniques

Processional figures were a vibrant part of the celebration of feast days in viceregal America and were often linked to pre-Hispanic traditions of imagery and ceremony. In some senses they continued traditions practiced by pre-Hispanic communities, now within a Christian culture. They were also vital to the process of evangelizing: the first missionaries in Mexico in particular used and indeed exploited the earlier traditions.[44]

In 1538, less than twenty years after the conquest of Mexico, Friar Toribio de Benavente, known as Motolinia (c. 1490–1569), a Franciscan friar who had arrived in Mexico in 1524, described the celebrations for the festival of Corpus Christi at Tlaxcala: "The blessed sacrament was taken in procession with many crosses and saints on floats; the arms of the crosses and the spokes of the wheels were decorated with gold and feathers, and on them were many images likewise of gold and feathers, so well-worked that they would be more highly prized in Spain than brocade."[45] Motolinia's description evokes the color and richness of the celebration and, interestingly, speaks of the use of feathers and gold, both of which were employed in Mexico for pre-Hispanic pieces. This passage also implies the Spaniards' admiration for the workmanship of these creations and suggests that indigenous artists made them. The diary of a Spanish soldier resident in Peru over a century later, Josephe de Mugaburu (d. 1686), gives vivid insights into the frequency and splendor of religious processions in Lima in the mid-seventeenth century. He speaks of Our Lady of the Rosary being taken from Santo Domingo to the cathedral in 1644, accompanied by a great number of other images of saints and decked with "more than two million jewels and pearls."[46]

Processional sculptures could be mounted on wheeled floats but were often carried, and for this reason they were frequently made of lightweight materials, including light woods such

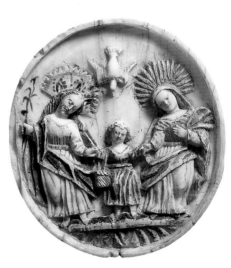

FIG. V-7
Holy Family. Ivory. Museo de Arte Colonial, Casa de la Cultura Ecuatoriana, Quito, Ecuador

as *colorín* and the stalks of plants such as maguey (a member of the amaryllis family resembling a cactus), found in Peru and Bolivia. A paste made from the pith of cornstalks, *pasta de caña de maiz*, as well as a paste made from the sap of orchids growing in Michoacán region of Mexico, *pasta de Michoacán*, might also be used. Motolinia noted that a boy could lift the life-size crucifixes single-handedly.[47] These crucifixes exemplify a popular type of sculpture, which must have been made primarily by the indigenous people, who were familiar with the techniques. Such images were made of a mixture of materials, including corn paste, paper, *colorín*, maguey, feathers, and glue. The paper and wet glue (papier-mâché) could be shaped and modeled, and the corn paste might be stiffened by the addition of feathers. The soft *colorín* was both light and easily carved. One large Mexican crucifix (78¾ inches [200 cm] high) made of such materials weighs only about fifteen and a half pounds (7 kg) (Museo de las Intervenciones, Churubusco, Mexico City; see also the Ecce Homo, cat. v-3).[48]

The so-called Lord of the Earthquakes in Cuzco, Peru, dating from the sixteenth century, is made from a mixture of materials, including maguey, corn paste, twine, wood, and fabric soaked in glue (*tela encolada*).[49] These materials were initially applied to a straw core—shaped in the form of the head, trunk, and legs of the Christ figure—that would have provided a temporary armature. Once the layers of paste and fabric were dry, the straw core was removed, leaving the hollow part-figure of Christ. Arms and hands of wood were then added and the whole was painted. Except for the wood limbs, such materials and techniques echo Inca practices: both maguey and textiles (as well as metals) were used for small images in Peru in pre-Hispanic times.[50]

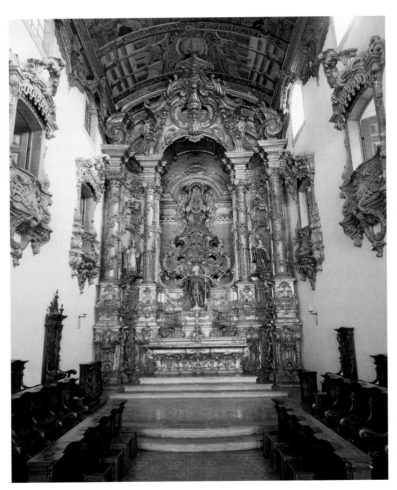

FIG. V-8
Main altar, 1783–86, Monastery of São Bento, Olinda, Pernambuco, Brazil

Altarpieces and Life-Size Sculptures: European Influences

The high altarpiece was the overwhelming central element in churches of viceregal America and Brazil. Although many baroque altarpieces have been lost through earthquakes, fires, or simply changes in taste,[51] survivors can still be seen, magnificently filling the apses of churches and cathedrals, such as the *Retablo de los Reyes* (Altarpiece of the Kings), the high altar in the cathedral in Mexico City, probably completed in 1725,[52] or the main altarpiece in the Monastery of São Bento in Olinda, Brazil (fig. v-8).[53] As in Spain and Portugal, the altarpieces usually displayed a combination of sculpture and paintings, though they sometimes showed just sculpture or (more rarely) paintings. Often life-size or larger, and usually brightly polychromed and gilt, the sculptures on altarpieces testify to the power of images to convert. Different craftsmen would collaborate in creating these structures, including architects, carpenters, painters, sculptors, and gilders. The costs were enormous and could be the equivalent of building a small church.[54] The wood used for sculptures on altarpieces was generally West Indian cedar (*Cedrela odorata*), as it was easy to work and resistant to insect attack.[55] The carvings were commissioned by church authorities, guilds, and confraternities and by private individuals motivated by devout feelings, as well as no doubt an ostentatious desire to exhibit their piety.

Altarpieces were fundamental to the didactic role of the church, and the images on them had to conform to Catholic doctrines. An engraving first published in Perugia, Italy, in 1579 by the Mexican mestizo Franciscan friar Diego de Valadés (b. 1533),[56] shows a Franciscan preaching from a pulpit, using a long stick to point at scenes of the Passion before a seated audience comprising indigenous and Spanish people (fig. v-9).[57] The ecclesiastical provincial councils

FIG. V-9
Diego Valadés (Mexican, b. 1533), *Friar Teaching*,
published in Perugia, Italy, 1579. Engraving. British
Library, London

of New Spain, held in Mexico City in 1555 and 1585, discussed the different forms and functions of images.[58] The first council ran parallel with the Council of Trent, which took place from 1545 to 1563, but which no clerics from the New World attended. One of the aims of the Council of Trent, like its Mexican counterpart, was to guide artists and their patrons in the representation of sacred subjects, emphasizing clarity and emotional directness.[59] The 1585 council in Mexico City, following the recommendations of the Council of Trent, decreed that sculpted images should not be adorned with fabric dresses, a prohibition that may have come about because such costumes could be gaudy and distracting, or perhaps because on occasion native textiles that were considered to have pagan associations were used to adorn Christian images.[60]

The prohibition of dressed sculptures evidently was not enforced, and indeed some sculptures that were originally carved and polychromed were later shaved down so that they could be dressed in actual garments.[61] Other figures, called *imágenes de candelero* (literally, "candlestick images"), had fully carved wood heads and hands but were set on simple wood frames that were then draped in a textile robe. Sometimes the supporting framework would be articulated to allow movement under the draperies so that the figure could be more easily dressed. For feast-days and processions, the costume would often be changed. Partially carved wood figures dressed in stiffened fabric (*tela encolada*) also remained ubiquitous throughout Central and South America. The wood hands and faces for such figures were often specially made in Peru or Ecuador and shipped elsewhere in Central and South America.[62] Lead faces were also commonly replicated for sacred images in Ecuador, New Granada, and Brazil.[63] Glass eyes were often set into these masks, and wigs might be added. Such faces and hands, whether of wood or lead, could be reproduced in great numbers; variety or originality of representation in religious images was not considered especially desirable, since it was more important to emphasize, and indeed not to depart from, orthodox ideas.

More than the other types of sculpture discussed so far, the figures and reliefs on altarpieces directly or indirectly recall Spanish, and especially Andalusian, sculpture. This may be because the sculptors or designers of the altarpieces were immigrant Spaniards, or because on occasion the altarpieces incorporate imported Spanish works. Additionally, the overall architectonic forms were dictated by European prototypes. Indigenous artists also designed and executed some altarpieces, although this was comparatively rare until the eighteenth century. Earlier examples include the high altarpiece at the shrine of Copacabana in present-day Bolivia, completed in 1618 by Sebastián Acosta Tupac Inca, and altarpieces created by the sculptor and gilder Tomás Tuiro (or Tairu) Tupac Inca (active 1667–died 1717/18), who was patronized above all by Manuel de Mollinedo y Angulo, bishop of Cuzco from 1673 to 1699.[64]

From the sixteenth century onward, European sculptors traveled to find work in the New World: the Flemish *ensamblador* (assembler of altarpieces) Adrián Suster went to Mexico in 1573; Bernardo Bitti worked in Peru and present-day Bolivia; and the Sevillian sculptor and architect Martín de Oviedo (c. 1565–after 1612) was active in Mexico, Peru, and Bolivia.[65] Many of these immigrant artists, such as the Sevillian sculptor Diego Ortiz, trained local artists and laid the foundations for the continuation of essentially Iberian sculptural styles.

High-quality sculpture was also exported from the Iberian Peninsula to the New World. In the sixteenth and early seventeenth centuries, life-size polychrome wood figures were sent to Lima by sculptors active in Seville, such as Roque de Balduque (active mid-sixteenth century), himself an immigrant to Spain from Flanders; Juan Bautista Vázquez the Elder (c. 1510–1588); and Juan de Mesa (1583–1627).[66] Usually these sculptures were commissioned in Peru; Roque de Balduque's *Virgin*, for example, now in the cathedral at Lima, was ordered in 1551 by the daughter of the *conquistador* Francisco Pizarro, founder of the city.[67] It served as a source for the indigenous artist Francisco Tito Yupanqui (c. 1540–1608), who sculpted the initial image of the Virgin of Copacabana, which was installed in the sanctuary of Copacabana on Lake

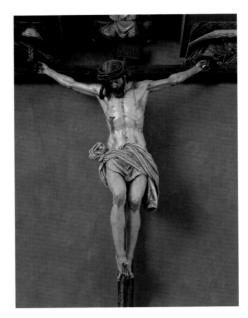

FIG. V-10
Juan Martínez Montañés (Spanish, 1568–1649),
Christ Crucified, Lima Cathedral, Peru

Titicaca in 1582–83 and soon acquired the reputation of being miraculous.[68] Tito Yupanqui had trained with the Spanish-born sculptor Diego Ortiz, who would have been familiar with the stylistic vocabulary of sixteenth-century Seville. Tito Yupanqui's workshop subsequently made replicas of the Copacabana image, which were widely distributed across the region.[69] Similarly, the form and style of many of the crucifixes in Lima must have been inspired by Juan de Mesa's crucifix of 1625 in the Church of San Pedro.[70] In the early seventeenth century the Sevillian sculptor Juan Martínez Montañés (1568–1649) sent a plethora of works to Lima, including a major altarpiece for the Monastery of the Concepción, elements of which are now in the cathedral (fig. v-10).[71] Martínez Montañés was also the author of a signed statue of the Virgin in Oruro, Bolivia, which undoubtedly influenced the development of sculptural traditions in the region,[72] and locally made variants of his standing Christ Child can still be seen in Peru and Bolivia.[73]

Other sculptures imported to America from Andalusia include works by Pedro de Mena (1628–1688), such as his two pairs of busts of the *Sorrowing Virgin* and *Ecce Homo*, one pair in the Church of San Pedro in Lima, and another in La Profesa in Mexico City; both churches are Jesuit foundations, and perhaps one Jesuit based in Spain was responsible for both commissions.[74] In Quito the work of the Granadan sculptor Alonso Cano (1601–1667), as well as other sculptures by Martínez Montañés and Juan de Mesa, certainly influenced local sculptors, although few works by these Andalusian artists survive in Ecuador today.[75] Castilian and Sevillian sculptures were additionally exported to New Granada, where the naturalistic qualities of such pieces helped form local styles.[76]

Although the stylistic roots and Christian imagery of sculpture made in Latin America derive from Europe, the styles that evolved there established a new tradition that continued up until the early nineteenth century. The inimitable expressive qualities of such pieces as O Aleijadinho's *Saint Anne Teaching the Virgin* from Minas Gerais (Sabará), Brazil, dating from c. 1775–90 (cat. v-45), have no direct parallels in the art of Spain or Portugal. Like Mexican sculptures, which were for the Spanish "por cosa muy de ver" (something definitely to be seen),[77] such figures arrest the viewer, and whether they convert, shock, or inspire admiration, their drama and power cannot be ignored.

NOTES

Acknowledgments: I am grateful to the following people for their help in the preparation of this essay: Pedro Angeles, Clara Bargellini, Patricia Diaz Cayeros, Marta Fajardo de Rueda, Concepción García Sáiz, Michael Griffin, Antonieta Guerra, Beth Huseman, Monica Katz, María del Pilar López, Carmen Morales, Ramón Mujica Pinilla, Luis Nieri, Isabel Paiz, Olga Pizano, Haroldo Rodas, Suzanne Stratton-Pruitt, Fanny Unikel, David Updike, and Luis Eduardo Wuffarden.

1. The halo is a later addition, but it undoubtedly reflects earlier versions.

2. Cf. Mauquoy-Hendrickx 1978, pp. 62 and 86–87, nos. 481–85 (I am grateful to Suzanne Stratton-Pruitt for this reference); an Antwerp engraving of 1635 by Benedictus van Haeften of the Christ Child carrying the Cross, illustrated in Fajardo de Rueda 1999, pl. 59. See also Rodríguez G. de Ceballos 1999, p. 103.

3. *Quetzal* 2002, pp. 408–9.

4. Alvarez Arévalo, p. 53; Gutiérrez 1995 "Escultura," p. 230; Luján Muñoz 1997, pp. 27–31; Luján Muñoz and Alvarez Arévalo 2002, pp. 95–109.

5. Mendieta 1870, book IV, chap. XII, p. 404.

6. Palmer 1987, p. 68.

7. "[D]e bulto hay muy buenos escultores, y tengo en este pueblo de Santiago indio natural de él, que se llama Miguel Mauricio, que entre otros buenos que hay es aventadísimo, y son sus obras mucho más estimadas que las de algunos españoles" [There are very good sculptors here, and there is an Indian who is a native of this town of Santiago, called Miguel Mauricio, who is the most talented among many good sculptors; his works are much more highly prized than those by some Spanish artists]. Torquemada 1615/1975, vol. 5, p. 314 (book XVII, chap. I).

8. The first ecclesiastical council of Mexico in 1555 prohibited interior tombs, but this proscription was not always obeyed; Berlin 1952, p. 67. Two funerary portraits are to be seen in Lima Cathedral, including a

wood bust of archbishop Bartolomé Lobo Guerrero made in the 1630s by Tomás de Aguilar; Bernales Ballesteros 1999, pp. 116–17.

9. The sixteenth-century stone portal of the Casa de Montejo in Mérida, Mexico, is decorated with fine figural sculpture, for example; see Tovar de Teresa 1979, p. 49. Figurines that appear to be secular might in fact have been made for Nativity groups, and so could be classified as having a religious purpose. See the two genre figures, both significantly in convents in Quito, of a man with wooden shoes and a seated young woman; Palmer 1987, p. 106, pls. 21 and 22.

10. Choir stalls and pulpits also have strong sculptural elements, but space does not permit a discussion of them here.

11. For examples of Aztec stone carvings, see Matos Moctezuma and Solís Olguín 2002, pp. 131–37, cat. nos. 42–49, and passim.

12. For such crosses, see also *Mexico* 1990, pp. 250–52; Toussaint 1983, p. 27.

13. Weismann 1950, p. 13.

14. Ibid., p. 7; Ricard 1947, pp. 113–14; Locke 2001, pp. 41–43.

15. Ricard 1947, pp. 113–14.

16. Locke 2001, pp. 41–43.

17. Sebastián López et al. 1992, vol. 28, p. 94.

18. "En cuanto a los *cues* o adoratorios, encarga S.M. que se derriben sin escándolo y con la prudencia que convenía, y que la piedra de ellos se tome para edificar iglesias y monasterios, que los ídolos se quemasen" [His Majesty commanded that indigenous monuments and temples should be destroyed without scandal and with appropriate prudence, and that the stones from them should be used to build churches and monasteries, and the idols be burnt]. Quoted in Ricard 1947, p. 116.

19. *Mexico* 1990, p. 255.

20. Moreno Villa 1986, pp. 10, 16. See also *Mexico* 1990, p. 248; Mullen 1995, p. xxviii.

21. Sebastián López et al. 1992, vol. 28, p. 117, fig. 130.

22. Moreno Villa 1986, p. 25 and fig. 15; Weismann 1950, p. 57; Gisbert 2004 *Iconografía*, pp. 11–12.

23. Sebastián López et al. 1992, vol. 29, p. 231.

24. Moreno Villa 1986, p. 67 and fig. 100.

25. Berlin 1952, p. 13.

26. Tord 2003, pp. 175–77.

27. Lujan Muñoz 1997, p. 31, cat. no. 15; Alcalá 2002, pp. 116–17.

28. Querejazu 1997, p. 144.

29. Fajardo de Rueda 1999, pp. 153–55.

30. Cf. the Nativity group in the Monasterio del Carmen Bajo, Quito, illustrated in Kennedy 2002 "Mujeres," p. 111, fig. 74.

31. Vargas Murcia 2003, pp. 13–23. See also López 2003.

32. Whistler 2001, p. 52 and cat. nos. 1–10.

33. Gutiérrez 1995 "Utilitarias," pp. 355–57.

34. Kennedy 1995, p. 242.

35. Mesa and Gisbert 1972, p. 25; Powell 1992, pp. 116–18.

36. Pacheco 2001.

37. Majluf and Wuffarden 1998.

38. Ibid.

39. Gutiérrez 1995 "Utilitarias," p. 355.

40. A similar eighteenth-century Guatemalan figure of the Sorrowing Virgin with an alabaster face is in a private collection in Guatemala City; see Anchisi de Rodríguez 1997, p. 23, cat. 48.

41. Luján Muñoz and Alvarez Arévalo 2002, p. 117.

42. Berlin 1952, p. 49.

43. Kennedy 2002 "Mujeres," p. 113, figs. 76, 77.

44. *Mexico* 1990, p. 376.

45. "Iba en procesión el Santísimo Sacramento y muchos aderezos de las andas hechas todas de oro y pluma, y en ellas muchas imágenes de la misma obra de oro y pluma, que las bien labradas se preciarían en España más que de brocado." Motolinía 1541/1985, p. 192.

46. Mugaburu 1975, p. 13.

47. "[A]unque el crucifijo sea tamaño como un hombre, le levantara un niño del suelo con una mano" [Even if the crucifix was as large as a man, a child could lift it with one hand]. Motolinía 1541/1985, p. 266.

48. Araujo Suárez et al. 1989, unpaginated. See also Alarcón Cedillo and Alonso Lutteroth 1993, pp. 66–74.

49. Gisbert 2001, pp. 224–25.

50. Ibid., p. 226.

51. Berlin 1952, p. 45; Bargellini 1986, p. 1137.

52. The altarpiece was executed by the Andalusian artist Jerónimo de Balbás (d. 1748), who went to Mexico in 1717 in order to carry out this work. Bargellini 1986, pp. 1140–42.

53. Sullivan 2001, pp. 156–63.

54. Bargellini 1986, p. 1137; Tovar de Teresa 1979, p. 272; Alarcón Cedillo and Alonso Lutteroth 1993, pp. 84–88.

55. Mesa and Gisbert 1972, pp. 21–22.

56. Valadés was born in Tlaxcala, Mexico, the son of a conquistador. Sebastián López et al. 1992, vol. 28, p. 144.

57. Didacus de Valadés, *Rhetorica christiana . . .* (Perugia, Italy, 1579), engraving opposite p. 110. A version of the engraving was reproduced in Friar Juan de Torquemada's *Ventiún libros rituales y monarquía indiana* (Madrid, 1723), illustrated in McAndrew 1965, fig. 11 on p. 72; Sebastián López et al. 1992, vol. 28, fig. 125 on p. 112. See also Mujica Pinilla 2002 "Arte," p. 239.

58. Rodríguez G. de Ceballos 1999, p. 90.

59. See Canons and Decrees 1990; see also *Mexico* 1990, p. 283.

60. "[L]as imágenes que en lo sucesivo se hagan de escultura sean de tal forma que no necesiten vestidos de tela, es decir sus vestidos estén hechos de la propia materia de la escultura" [Sculpted images henceforth should be made in such a way that they do not require clothes of fabric, that is to say, the clothes should be made of the same material as the sculpture]. Quoted in Berlin 1952, p. 45.

61. Weismann 1950, p. 178, citing a document of 1690 in which a Mexican cleric ordered a carved image to be cut away so that it could be dressed.

62. Ramón Gutiérrez 1995 "Circuitos," p. 67; Kennedy 1995, pp. 243–44.

63. Angel Casas 2000.

64. Benavente and Martínez 1964; Querejazu 1995, p. 267.

65. For Suster, see Querejazu 1997, p. 138; see also Tovar de Teresa 1979, p. 248. For Oviedo, see Bernales Ballesteros 1999, pp. 47–49.

66. Estella Marcos 1990; Bernales Ballesteros 1974, pp. 95–120; Querejazu 1995; Bernales Ballesteros 1999; Mesa and Gisbert 1972, p. 30.

67. Bernales Ballesteros 1999, p. 24.

68. Gisbert 2002, pp. 135, 227.

69. Sebastián López et al. 1992, vol. 28, pp. 400–401; Dean 1996, pp. 175–76; see also Querejazu 1997, p. 141; Gisbert 2001, pp. 138–39.

70. Cf. the images illustrated in Ramos Sosa 2004, pp. 7, 9, 11, 13.

71. Hernández Díaz 1965; Wuffarden and Guivobich Pérez 1992; Ramos Sosa 2004.

72. Mesa and Gisbert 1972, pp. 113–14.

73. Mesa and Gisbert 1995, unpaginated. Three mid-seventeenth-century figures of the Christ Child in the style of Martínez Montañés are illustrated.

74. Angulo Iñiguez 1935, pp. 132–33; García Sáiz 1992, p. 253; Querejazu 1995, p. 268; Bernales Ballesteros 1999, p. 88.

75. Kennedy 1995, pp. 238–39.

76. Museo de Arte Colonial 2000, pp. 9–17.

77. Weismann 1950, p. 167.

Changing Faces: The Re-Emergence of a Sacred Landscape in Colonial Mexico and Peru

Adrian Locke

Are you guarding in your home "turquoise children" and "turquoise toads"? Do you bring them out into the sun to warm them? Do you wrap them up in cotton, honoring them?[1]

These questions posed by Bartolomé de Alva in 1634 reveal the many unforeseen challenges confronting those closely involved in the dissemination of the imported state religion of Catholicism across the newly established viceregal dominions of Mexico and Peru more than a century after the arrival of the Spanish.[2] Arguably the most difficult test they faced was not the evangelization of the, to their European eyes, "pagan" population but the process of trying to comprehend the complex nature of the multitude of religious beliefs and practices that confronted them. The apparent ease of supplanting one religious belief system with another in well-organized states such as those established by the Aztec and Inca may have initially appeared relatively trouble-free. After all, the most obvious solution was to literally build a Christian church on top of a pagan temple, mirroring Hernán Cortés's direct approach when he had an altar to the Virgin Mary placed alongside those dedicated to Huitzilopotchli and Tlaloc in the Templo Mayor (Great Temple) of Tenochtitlan (Mexico City).[3]

During the initial phase of church building from the 1540s to the 1580s, spearheaded by the mendicant orders, the colonists utilized any available building material in the process.[4] Thus, for example, the Templo Mayor, the religious center of the Aztec world, effectively served as a quarry for the construction of the new metropolitan cathedral of Mexico City. In a similar vein the Coricancha, religious heart of the Inca state in Cuzco, metamorphosed into the church and convent of Santo Domingo. As one place of worship was displaced, another rose in its stead. Through this process, referred to as "topping," the spiritual (and military) conquest of the victors was reinforced while, at the same time, continuity of religious worship was secured.

The general replacement of one religion with another (and one specific sanctuary with another) was only part of a process that, some would argue, still continues today, more than five hundred years later. Michael J. Sallnow is just one of many scholars who have demonstrated

how ostensibly Catholic shrines, such as that of the Lord of the Snow Star (El Señor del Qoyllur Riti) in highland Peru, have developed multiple levels of intermixed religious worship (figs. V-11, V-12).[5] The veneration that takes place at these shrines is often extremely complex. Constructed over several generations, it reflects differing proportions of forms of worship, both indigenous and Catholic, which come together to form a new popular Catholicism that is both accepted and promoted by the church hierarchy. What is apparent, however, is the complex, multifaceted nature of religious worship that has developed (and continues to develop) over the past five centuries in Mexico and Peru. Ultimately, out of the discovery of the Americas, entirely new, hybrid forms of religious worship have emerged.

The Jesuit priest Pablo José de Arriaga (1564–1622), whose *Extirpación de la idolatría del Pirú* (Extirpation of Idolatry in Peru) was published in 1621, soon discovered the extent of the challenge that lay ahead. The physical destruction of a non-Catholic object of worship did not automatically produce the anticipated result, since it rarely put an end to its adoration. People would, for example, still venerate the location where it was originally placed, where it was removed to, or even the point at which it had been taken and buried, burned, or otherwise destroyed.[6] What made an indigenous shrine sacred was a much harder concept to grasp since it manifested itself in unpredictable ways. As Tom Cummins has argued, Juan Polo de Ondegardo (d. 1575), governor of Cuzco, went to the trouble of removing sacred sand from the ceremonial plaza of Inca Cuzco only to unwittingly reuse it during the construction of the city's Catholic cathedral.[7] The inherent religiosity of the material remained, albeit transferred to a new location.

During the founding of new towns in early colonial Mexico and Peru, a pillory and a cross were ceremonially erected in the area demarcated as the new central square. These twin symbols represented good governance and religion.[8] The cross, therefore, also came to represent Christian religious authority. Thus the replacement of an idol with a cross by the Catholic religious establishment—the established practice to root out idolatry—was an act of considerable significance. Through this simple act the church believed that it had found a straightforward solution to the problem of "idolatrous" worship, in much the same pragmatic manner that churches had replaced temples. People still returned to the same place of worship and, in all likelihood, offered the same prayers and entreaties that they had before. Essentially what the planting of the cross achieved was continuity of worship. That is, it "officially" sanctified a place that was already established as a place of worship. What was perhaps harder for the church to comprehend was that it was the place that was being venerated rather than the object. People came to a particular locus to offer their prayers; whether the object was a stone "idol" or a cross was not the point, since it was the place itself that commanded worship. As Eleanor J.

Wake has argued, Christianity was not rejected by the indigenous population in sixteenth-century Mexico because they did not see it as different but rather accepted it as a different expression of an ancient cult.[9]

Such a changing face of religious worship is not, however, unique to either colonial Mexico or Peru. The inhabitants of the Aztec and Inca states had themselves experienced the imposition of a state religion. Although the worship of local cults was allowed to continue, it was on the understanding that they were subservient to the imposed state religion. Shifting patterns of religious worship have taken place throughout world history, including during the rise of Christianity across Europe. Sabine MacCormack and William A. Christian Jr. have shown that patterns similar to those of the Christianization experienced in Mexico and Peru had previously occurred in Europe in, for example, sixth-century Britain and early medieval Spain.[10] In both, pagan shrines were reconsecrated as Christian shrines, and worship, which had gone on for generations, continued at the same locations as before. These shrines were reconsecrated through miraculous apparitions or miraculous events that, once ratified by the Catholic Church, secured the religiosity of the site. In most cases chapels or churches were built to mark the spot and celebrate the miracle.

In other words, throughout the period when parts of Europe were converting to Christianity the name and physical object of worship changed but the essential religiosity of the place itself remained unaltered. In this way sites still attracted worshippers both local and regional. This process was further consolidated by a series of miraculous events in which the sacred nature of the landscape, so important to rural agricultural economies, was preserved. A body of legends referred to as the "shepherd's cycle" emerged across ninth- to thirteenth-century Europe, recording the way in which images of the Virgin Mary were discovered by farmers and livestock herders across the landscape.[11] The population of Europe at this time was predominantly rural, and agriculture was the mainstay of the economy. The local knowledge of the immediate landscape, especially in harsh environments, and boundaries between communities were essential to the well-being of not only the local population but also the means of production. These conditions were essentially the same in the Americas, although the well-established states of the Aztec and Inca, with their large urban populations, exerted greater pressure on production through systems of tribute or taxation. In both Europe and the Americas it was the intercession of divine beings that ensured the continuity of life. Ultimately religious belief was at the center of the political, social, and economic worlds and served to safeguard entire communities.

The arrival of the Spanish in the Americas had a similar effect on the established communities of Mexico and Peru. The spiritual conquest of the Americas continued in the wake of the military conquest and served to consolidate the process of colonization, often in a more planned and comprehensible manner than that of the conquistadors. Accustomed to a state apparatus in which religion played a major role, the average person, in simplified terms, witnessed a process in which the political and religious elite were replaced by a new regime. Although this was nothing especially new, the profundity of the change was underscored by a calamitous population loss in which European disease ravaged the native populations across the Americas. Coupled with the experiences of new forms of warfare, the local population was devastated, and genuine hardship and suffering ensued. Arguably the only source of continuity and stability that people had at this time was the network of religious shrines. These were, as in Europe, preserved through a process of religious reconsecration, ostensibly turning them from pagan to Catholic, from illegitimate to legitimate places of worship.

It was during this period of great change and instability that a number of important Christian shrines appeared in both Mexico and Peru. Ultimately these miraculous shrines would overshadow the emergence and veneration of American-born saints.[12] The reasons for this are complex, but it is possible to argue that the needs of a settled urban environment based

FIG. V-13
Felipe Guamán Poma de Ayala (Andean, 1534–1615), *Saint James the Great, Apostle of Christ, Intervenes in the War in Cuzco*, from *El primer nueva corónica y buen gobierno*, 1615. Ink on paper, book: 5¾ × 8 inches (14.5 × 20.5 cm). Det Kongelige Bibliotek, Copenhagen

on European conventions, with a church hierarchy, were different from those of the rural population.

The first miraculous Christian apparitions in the Americas appeared to the Spanish conquistadors during the conquests of Mexico and Peru. On July 8, 1520, the *Noche triste* (sad night) when the Spanish and their allies were driven out of Tenochtitlan, Bernal Díaz del Castillo recalls how the Virgin Mary appeared to them, giving them courage and blinding the pursuing Aztecs by throwing dust into their eyes.[13] In similar circumstances both Felipe Guamán Poma de Ayala (c. 1534–1615) and Garcilaso de la Vega, El Inca (1539–1616), record the Virgin Mary throwing dust into the eyes of the Inca forces from the top of the Suntur-wasi tower and extinguishing the burning roofs of the city during the siege of Cuzco in 1536.[14] Saint James is also said to have appeared during the siege, transformed from Santiago Matamoros, Saint James Killer of Moors, of the reconquest of Spain (cat. v-54), into Santiago Mataindios, Saint James Killer of Indians, of the conquest of Peru (fig. v-13; cat. v-4).[15] What is interesting is that these miraculous appearances in which the Virgin Mary and Saint James the Great (the patron saint of Spain) favor the Spanish over the indigenous population did not go on to engender the most important Catholic shrines in either Mexico or Peru. Their power, based on their ability to attract worshippers and become sites of pilgrimage, waned. In fact, by the 1650s these shrines had been replaced in popularity by miraculous shrines that had much greater associations with the indigenous populations. Indeed arguably the most important national miraculous images of both countries, that is, Our Lady of Guadalupe (Nuestra Señora de Guadalupe) in Mexico and the Lord of the Earthquakes (El Señor de los Temblores) in Peru, date from this period and have continued to broaden their appeal ever since.

In much the same way as Christianity emerged across Europe, fueled by the needs of the rural population, a process of reconsecration began in Mexico and Peru. Previously "pagan" shrines became Christianized, ensuring that religious worship could continue during a time of great change. Sites of pre-Catholic religious significance were reconsecrated as Catholic shrines and, what is more, in many instances became sites of local, regional, and national pilgrimage. By establishing themselves as Catholic pilgrimage sites their appeal was spread further, and by attracting pilgrims they became important economic centers, thereby also increasing their political power.

In both Mexico and Peru it was not eponymous images of the Virgin Mary or Jesus Christ that attracted substantial followings but images that were specific to their locations, for instance the Lord of Chalma (El Señor de Chalma) in Mexico and Our Lady of Pomata (Nuestra Señora de Pomata) in Peru (cat. vi-99). Often produced in great numbers, these paintings were essentially portraits of specific images usually in situ on the altar or in the side chapel in which they were positioned. Painted versions of the Virgin of Guadalupe (cat. vi-41), in part due to her broad appeal to Mexican nationalists to whom she became a potent symbol, and the Lord of the Earthquakes spread quickly (cat. vi-114), widening their appeal in the process. The continuing power of these images is perhaps best illustrated by the fact that Juan Diego Cuauhtla-toatzin (1474–1548), an indigenous Mexican who witnessed the apparition of the Virgin of Guadalupe and was thus her chosen recipient, was canonized by Pope John Paul II on July 31, 2002, at a special ceremony held at the Basilica of Guadalupe in Mexico City.

As with all miraculous apparitions, the truth is never formally recorded at the time but is usually preserved orally until such a time as a written account is produced. Thus although the

appearance of the Virgin of Guadalupe is thought to date from 1531, no account was written until 1648, when that of Miguel Sánchez was published.[16] This was followed in 1649 by Luis Lasso de la Vega's Nahuatl *Huei tlamahuiçoltica*. Full of rich descriptive prose, Lasso de la Vega's language deliberately evokes materials prized in pre-Columbian times to appeal to a native population.

> Her clothes were like the sun in the way they gleamed and shone. Her resplendence struck the stones and boulders by which she stood so that they seemed like precious emeralds and jeweled bracelets. The ground sparkled like a rainbow, and the mesquite, the prickly pear cactus, and other various kinds of weeds that grow there seemed like green obsidian, and their foliage like fine turquoise. Their stalks, their thorns and spines gleamed like gold.[17]

Sallnow has demonstrated how in the Andes miraculous shrines linked centers of important economic activity, thereby re-establishing pre-Hispanic networks of shrines and centers of trade. In this way the long-established Andean tradition of reciprocity in which communities work together for their greater good and survival—the mainstay of social, political, and economic life—was maintained. The consecration of religious shrines allowed for the established intercommunal partnerships to continue. The emerging shrines can be seen to radiate out of Cuzco as if imitating the Incaic system of *ceques*, lines that literally linked places of religious significance.[18] In many instances miraculous images were seen as related, which further emphasized links to pre-Hispanic patterns of religious worship. The Huarochirí manuscript of 1608 compiled by Francisco de Avila (c. 1573–1647), for example, relates how the huge coastal shrine of Pachacamac was not only personified but also had a family.[19] During the colonial period the Lord of the Earthquakes was considered one of three brothers, with the Lord of Mollepata and the Lord of Inkillpata. Likewise a copy of the celebrated Virgin of Copacabana came to be the Virgin of Cocharcas (cat. VI-116), and was seen as her daughter. The Virgin of Characato in Arequipa in southern Peru, another copy of the Virgin of Copacabana, has two sisters, the Virgin of Chapi and the Virgin of Cayma.[20] The concept of religious icons being part of a family not only binds places and people together but also reflects the Andean concept of extended communities, the *ayullu*, in which kinship plays a prominent role.

The role Christian shrines played in viceregal Mexico and Peru is an extraordinarily important one. Miraculous shrines provided a significant link between the indigenous pre-Hispanic world and the establishment of a new Spanish colonial society. Through the creation of miraculous shrines, which legitimized worship at sites of great religious importance, the indigenous population was able to bridge, in part, the overwhelming change that had been forced upon them. The fact that these shrines have increased their popularity and broadened their appeal since the colonial period attests to their importance. Furthermore, miraculous images became important sources of identity from small communities to national causes.

The combination of pre-Columbian forms of religious belief with Catholicism was unplanned and not without its problems. However, the overwhelming desire of the indigenous population of Mexico and Peru for the kind of stability provided by religious worship ensured that it functioned. Essentially miraculous images became a meeting point that served the needs of the initially European and then largely Creole community as well as the indigenous community. Where once indigenous aspects of these miraculous shrines were hidden or disguised, now they have become justly embraced and celebrated. It is through these images, and the inherent power they retain, that the two very different worlds, Old and New, were to meet most successfully.

NOTES

1. Alva 1634/1999, p. 75.

2. *Confessionario mayor y menor en lengua mexicana y platicas contra las supersticiones de idolatria que el dia hoy an quedado a los naturals dela Nueva Espana, è instruccion de los santos sacramentos* was published in Mexico in 1634. Bartolomé de Alva (b. c. 1597) was the younger brother of the celebrated mestizo historian Fernando de Alva Ixtlilxochitl (1570–1648).

3. Díaz del Castillo 1963, pp. 276–77.

4. By this time it was the religious orders that were primarily responsible for furthering the conquest because the conquistadors were preoccupied with cementing their own political positions and securing financial rewards for their endeavors.

5. Sallnow 1987; and Locke 1999.

6. See, for example, Griffiths 1996; and Mills 1997.

7. Cummins 1996.

8. See Kagan 2000 for further discussions on the subject.

9. Wake 1995, p. 27.

10. MacCormack 1984; and Christian 1981 *Local.* See also MacCormack 1990, which addresses the manner in which the same issue affected late Roman Mediterranean Europe.

11. The term *el ciclo de los pastores* derives from Vicente de la Fuente's 1879 two-volume study *Vida de la Virgen María con la historia de su culto en España,* which can be found summarized in Sharborough 1975.

12. The first such individual was Isabel Flores de Oliva (1586–1617), who was canonized Santa Rosa de Santa María in Lima (then called Ciudad de los Reyes) as early as 1671 by Pope Clement X. Until recently there were only five such saints born in Spanish America. Of these, most were not canonized until the nineteenth and twentieth centuries: the Franciscan San Felipe de Jesús (Felipe de las Casas, 1575–1597, born in Mexico, canonized 1862), martyred in Nagasaki, Japan; Santa Mariana de Jesús (Mariana Paredes y Flores, 1618–1645, Ecuador, canonized 1950); the Jesuit San Roque González (Roque González de Santa Cruz, 1576–1628, Paraguay, canonized 1988), martyred in Caaro, Brazil; the Dominican San Martín de Porres (1579–1639, Peru, canonized 1962). The most recent individual to be canonized is the Mexican San Juan Diego Cuauhtlatoatzin (1474–1548), canonized in 2002.

13. Taylor 1996, p. 279.

14. Guamán Poma de Ayala 1615/1993; and Vega 1609/1966, part 2.

15. Dean 1996.

16. Sánchez 1648. For further discussions on the subject, see Poole 1995.

17. Lasso de la Vega 1649/1998, pp. 63–65.

18. See Bauer 1998.

19. See Salomon and Urioste 1991.

20. See Locke 2001.

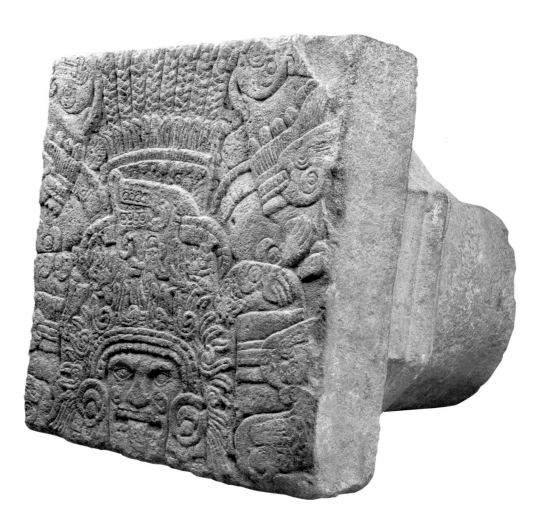

V-I *Column base depicting the "Lord of the Earth"*

Mexico

Carving, Mexica period, 1325–1521; column base, c. 1537–1650

Stone

33 × 29⅞ × 29⅞ inches (84 × 76 × 76 cm)

Museo Nacional de Antropología/CONACULTA, INAH, Mexico City, 10-46679

PROVENANCE: Main Square of the old Central Mercantile Building, today the Hotel de la Ciudad de México, Mexico City

PUBLISHED: Klein 1976; Gutiérrez Solana 1983, pp. 17–76, fig. 175; Baquedano 1993; Matos Moctezuma 1999, pp. 3–55, fig. 12; *Aztecs* 2002, cat. no. 339, p. 357; *Aztec Empire* 2004, cat. no. 361, p. 77

EXHIBITED: London 2002, cat. no. 339; New York 2004 *Aztec*, cat. no. 361

THE BAS-RELIEF on the base of this colonial column depicts Tlaltecuhtli, "Lord of the Earth," a Mexica monster-god with feminine and masculine attributes. It was conceived not as an object to be viewed, but as a ritual bridge for communication between the monument it adorned and the Earth itself. It should be viewed with its face pointing upward, since its open throat is the gateway to the underworld, the locus of birth and death.

In this piece, Tlaltecuhtli is on its belly, its arms and legs folded underneath it, the saurian embodiment of the primal Earth. Its extremities form an "X" that divides it into a central part and four sides, a map of the cosmos. According to the Mexica creation myth, the gods made Earth emerge from the water. Tezcatlipoca and Quetzalcoatl pulled it apart by its extremities, then turned themselves into serpents and entered Earth's body from opposite ends. They met in the middle, where they turned into a great cosmic tree, which raised the sky. Thus, time began and space was divided into four cardinal regions for the sun to pass through. At night, the Earth would cry out in pain, which only the blood and hearts of humans could alleviate. Thereafter, Tlaltecuhtli devoured sacrificial blood so that its body could remain alive.

Its shape, therefore, embodies the myth of the creation of Earth and time, as well as the blood pact between gods and humans. Its position on the base of a column shows the link between such monuments and events in the creation mythology. The famous statue of Coatlicue, mother goddess of the Mexica people, bears a bas-relief of Tlaltecuhtli on its pedestal, symbolizing the ancient Toltec earth out of which the Mexica era arose. Similarly, this Spanish Colonial column rises out of a Mexica Tlaltecuhtli. Significantly, in the religious iconography of the sixteenth century, the column symbolized the foundation and support of the church. This juxtaposition of elements shows how conquered indigenous peoples, using elements of their mythology, incorporated Christian forms and concepts into their own vision of the cosmos.

Diana Magaloni Kerpel

v-2 Saint Sebastian

Mexico
1577–80
Polychromed wood
59⅛ × 34¾ × 19¾ inches (150 × 88 × 50 cm)
Church of San Bernardino/CONACULTA, DGSMPC, Xochimilco,
Mexico City

PUBLISHED: Moyssén 1966; Bargellini 2005

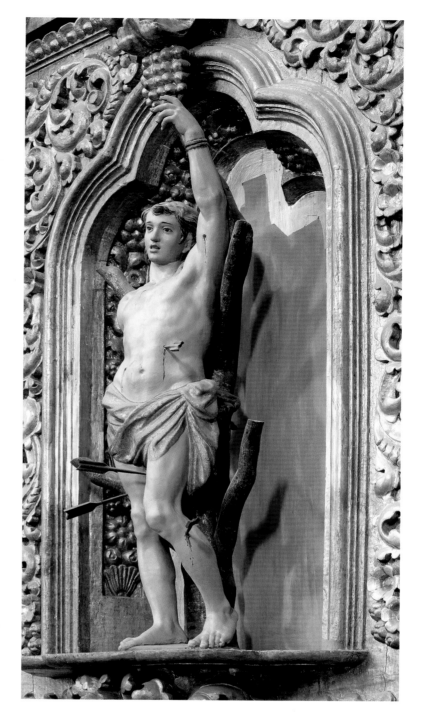

THIS FIGURE IS ALMOST CERTAINLY the Saint Sebastian referred to in the *Historia eclesiástica indiana* by the Franciscan Gerónimo de Mendieta (1525–1604). The friar recalls how in 1576 there was a great pestilence in Xochimilco, just south of the capital, where he was pastor at the church of San Bernardino, a post he held until 1580. Mendieta suggested that the population should take a saint as advocate and promise to erect him an altar. The choice fell on the apostle Saint James (Santiago). Although matters improved, it was decided in 1577 to take the martyr Saint Sebastian as a second advocate, because of his universal fame as protector against plagues, and make him the same promise. The sickness ceased, and Mendieta then built two altars, one to each saint, on either side of the steps that led up to the main altar.

Although Xavier Moyssen recognized the quality of this sculpture and its possible connection to Mendieta's text, the truth and full import of the relationship has only recently become clear, following the discovery of Mendieta's two altarpieces. One is a gilded wooden niche now in the church of the Virgin of Sorrows Xaltocán, ten blocks away from San Bernardino. Its location and the longstanding identification of its central sculpture as Saint Paul had prevented its association with the main church at Xochimilco. However, the saint's short cape, pilgrim hat, and physiognomy leave no room to doubt his identity as Santiago. Saint Sebastian, meanwhile, had been removed from his niche long ago and placed in an eighteenth-century altarpiece to the right of the main altar in San Bernardino. When the pastor of Xochimilco recently refurbished an empty niche and placed it in front of the main altarpiece of San Bernardino, it was easy to identify it as the twin of the one at Xaltocán, and the original home of

Saint Sebastian. Furthermore, the columns framing both niches resemble exactly those of the third level of the San Bernardino altarpiece, and the sculptures of all three are in the same Spanish Renaissance idiom, but could well have been made by native masters. Thus, we now have a firm chronology for the niches and their two saints, as well as a probable *terminus ante quem* for the main San Bernardino altarpiece, which must have existed in 1577, when Xochimilco was a flourishing Indian city, capable of commissioning the best for its main church.

Clara Bargellini

v-3 *Ecce Homo*

Mexico
Late sixteenth century
Corn paste, painted
21⁷⁄₁₆ × 8⁷⁄₈ × 8¹¹⁄₁₆ inches (54.5 × 22.5 × 22 cm)
Patrimonio Nacional, Monasterio de las Descalzas Reales, Madrid

PUBLISHED: Moreno Villa 1942, pp. 31–32; Bonavit 1944;
Mendieta 1870/1945, p. 404; Tormo y Monzó 1917–47, vol. 4
[1947], p. 139; Carrillo y Gariel 1949, pp. 14–19; Tudela
1967, pp. 137–41; Luft 1972, p. 18; Pérez Carrillo 1989, p. 38;
Moyssén 1990, pp. 21–24; *México en el mundo* 1994, pp. 310–
11; García Sanz y Sánchez Hernández 1999, p. 43; *Siglos de
oro* 1999, cat. no. 170, pp. 404–5

EXHIBITED: Madrid 1999 *Siglos de oro*, cat. no. 170

THIS ECCE HOMO SCULPTURE, made in Mexico toward the end of
the sixteenth century and now in the Monasterio de las Descalzas Reales
in Madrid, is unique among its kind. It is made using the pre-Hispanic
technique of working with the pith of the cornstalk, which the indigenous
peoples of the area of Michoacán employed to create images of their
various deities. The Spanish turned to account the advantages of this
technique—its lightness, perfect finish, and inexpensive materials—to
produce sculptures for Catholic worship. The present piece is remarkable
for being a bust placed on a pedestal, since most works in corn pith are
images of the crucified Christ.

The figure inclines its head gently to the right, eyes lowered, and dis-
plays a number of the iconographical features of Christ traditionally employed
since the Middle Ages: wavy hair and a cleft beard with moustache, both
modeled in corn pith. The eyes are skillfully rendered by brush, the artist
having captured with great realism the melancholy expression of Jesus at one
of the most dramatic moments of the Passion.

The whiteness of the skin contrasts with the drops of blood streaming
down the figure's torso, which is naked to below the waist, where the artist
has modeled a gilt, polychrome loincloth. The figure holds a cane and wears
a crown of thorns, the royal attributes conferred on Christ in mockery by
the Roman soldiers, according to Catholic tradition.

The harmonious beauty of this sculpture is ample evidence of the
skill of the artist, who unfortunately remains anonymous, like most of
the workers in corn pith whose images have survived, whether in Mexico
or Europe.

Sofía Irene Velarde Cruz

V-4 Attributed to Miguel Mauricio

(Mexican, active c. 1603–1610)

Saint James Killer of Indians (Santiago Mataindios)

c. 1610

Carved, *estofado*, and polychromed wood relief

98⁷⁄₁₆ × 74¹³⁄₁₆ × 15¾ inches (250 × 190 × 40 cm)

Temple of Tlatelolco/CONACULTA, DGSMPC, Mexico City

PUBLISHED: Maza 1971 "Santiago," pp. 120–22; Tovar de Teresa 1991, vol. 2, p. 39; Gutiérrez Haces 1995, p. 210; Maquívar 1999, p. 32; *Siglos de oro* 1999, p. 105; Reyes-Valerio 2000, pp. 193–94; Vargas Lugo 2005, p. 96

EXHIBITED: Mexico City 2006

IN 1603, THE MONASTERY OF Santiago Tlatelolco received Friar Juan de Torquemada as its new guardian. By then, the famous indigenous college of Santa Cruz was already in decline. Nevertheless, over the course of the next seven years, the Franciscan monk took on the task of rebuilding the church and furnishing it with a magnificent altarpiece. The only element that apparently survived the destruction of the altarpiece is this relief of Santiago Mataindios, Saint James Killer of Indians. During the centuries in which Moorish domination of Spain was resisted by Christian kings, Saint James Major was often credited with participating in the reconquest as Saint James Killer of Moors (Santiago Matamoros), appearing miraculously in battles to put the infidels to rout. In the Americas, he appeared again, siding with the Christian conquerors against the indigenous insurgents, newly minted as Saint James Killer of Indians. A lithograph published in 1861 shows what the altarpiece looked like and the original location of the relief. In this nineteenth-century source, the figure of a rider in the center row of the second section of the altarpiece is barely discernible and the technique cannot be determined but altarpieces in New Spain customarily represented the titular saint in a central narrative relief within an ensemble of paintings and freestanding sculptures.

Based on the section of his Monarquía indiana that Torquemada dedicated to the teaching of services, the carving was attributed to an indigenous resident of the village of Santiago, Miguel Mauricio, whom the cleric described as a superior sculptor.

The sculpture depicts the saint as a horseman of huge dimensions attired in a tunic and a jabot adorned with a cross. Saint James is astride a white horse, brandishing a sword, and fighting alongside a group of armed Spaniards. On the right, a warrior in plumed headgear can be seen, perhaps a Tlaxcaltec ally, while in the foreground, their adversaries lie seminude on the ground near their obsidian swords, their limbs severed. This composition, based on the legend of Saint James Killer of Moors, contains an iconography peculiar to New Spain that originated in the sixteenth century, during which certain pre-Columbian pictorial conventions were combined with Spanish ones to create a profound ideological discourse. Pre-Hispanic pictography did not use dismembered bodies in its paintings of battles, only in scenes of ritual or cosmogonic sacrifice, which symbolized the start of a new life cycle. Thus the incorporation of dismemberment in battle scenes in various postconquest codexes and in this relief does not merely represent the survival of some formal element, nor halting attempts to resolve technical problems. Instead, it is evidence of the interpretations produced by the complex process of conquest and the longevity of pictorial responses to that process.

Patricia Díaz

v-5 Manuel de Velasco

(Mexican, active late seventeenth century)

Archangel

1685

Gilded and polychromed wood

72⁷⁄₁₆ × 41 inches (184 × 104 cm)

Metropolitan Cathedral/CONACULTA, DGSMPC, Mexico City

PUBLISHED: Maza 1964, pp. 66–67; Estrada de Gerlero 1986, pp. 377–409, ill.; *Mexico* 1990, cat. no. 142, p. 331; "Jerarquía celeste" 1990

EXHIBITED: New York, San Antonio, and Los Angeles 1990, cat. no. 142

THIS MAGNIFICENT FREESTANDING polychromed archangel, one of four, and the monumental frame in which they are set within the sacristy of the cathedral of Mexico City, are the work of Manuel de Velasco, a sculptor and gilder of New Spain. Velasco was commissioned to create this work in 1684 by the cleric Pedro de Valverde. For a period of seven years, the decorative priorities of the cathedral were focused on adornment of the church's sacristy. This work in particular was to form part of the backdrop for one of the greatest paintings by Cristóbal de Villalpando, *The Church Militant and Triumphant*. Velasco's sculptures cost the church 4,000 pesos, a sum that was ironically far greater than the 400 pesos paid for Villalpando's renowned canvas.

A brief account of the symbolic importance of angels may offer a more complete idea of what these angelic images represented within the framework of baroque religious art. The writings attributed to the Pseudo-Dionysius the Areopagite, who was a fifth-century neo-Platonic monk versed in the philosophy of Plato, Plotinus, and Proclus, are considered by modern Spanish theologians as a touchstone for the mystical theology that marked the religious history of Spain, particularly during the sixteenth century. According to Dionysius's *Celestial Hierarchy*, the ecclesiastical hierarchy on earth is seen as a symbolic reflection of the harmonious hierarchy of the Kingdom of God in the heavens. Thus theology employs poetic images in order to study celestial intelligence, which is without form.

According to the Pseudo-Dionysius, anthropomorphic forms are more suited to representing divine realities than are other more profane or mundane symbolic formulations, such as beings with numerous feet or heads or composite images with eagles' beaks and plumage, and so angels are pictured in art as human. The Scriptures have given the celestial beings nine interpretive names, which are ranked into three hierarchies with three orders each. The first includes the holy thrones and the orders set aside for the cherubim and seraphim. These are the "incandescent ones," who are "full of knowledge" and are guided by the First Light of the Godhead. According to the Scriptures, these are placed immediately about God and nearest to him above all others, since it is they who directly receive divine illumination. The second group is made up of the powers, virtues, and dominions, and the third group is the order of the angels, archangels, and principalities.

In the sacristy of the cathedral of Mexico City, four archangels of the third celestial order, of which one is exhibited here, preside from the four corners of the structure, thus representing the power of the ecclesiastical hierarchy to found, build, edify, and bring about spiritual elevation and providential conversion of all subjects. These abstract, intangible intelligences are given radiant human form, swathed in sumptuous attire.

It is within the sacristy that the priests receive their vestments, thus indicating that they are spiritually disposed to the mysterious vision to which they will devote their lives. In the sacristy of the cathedral in Mexico City, two of these archangels, dressed in Roman attire and placed on pedestals, have been schematically joined with a magnificent frame adorned with ten relief cherubs—belonging to the first angelic hierarchy—in a broad semicircular molding. It is clear that the canvas and the frame were intended to form part of the same thematic plan, since the painting itself depicts several angels on approximately the same scale as the sculptures. The plethora of imagery illuminated from within is also lit by an arched rectangular window that casts light upon a series of angelic musicians flanking the work. The beginning of the first chapter of the *Celestial Hierarchy* reflects a neo-Platonic concept that every good gift and every perfect gift is from above and comes down from the Father of Lights, and that Jesus corresponds to the Light of the Father, who is the origin of all light. The baroque synthesis of mystical and theological elements in the sacristy harmoniously fuses natural light with the carefully conceived arrangement of sculptures and paintings that fill the space.

Elena I. Estrada de Gerlero

v-6　Sebastián Ramírez

(Mexican, active late seventeenth century)

Christ on the Cross

1692

Figure: carved and polychromed ivory; cross: carved ebony inlaid with ivory, tortoiseshell, and silver

37⅜ × 17¹¹⁄₁₆ × 19¹¹⁄₁₆ inches (95 × 45 × 50 cm)

Sacristy, Metropolitan Cathedral/CONACULTA, DGSMPC, Mexico City

PUBLISHED: *Mexico* 1990, cat. no. 161, pp. 381–82

EXHIBITED: New York, San Antonio, and Los Angeles 1990, cat. no. 161

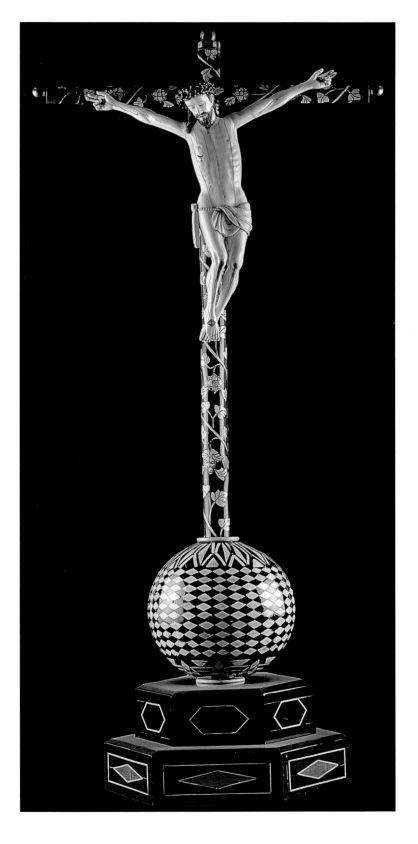

IMAGES OF CHRIST are among the most widely produced in the world of art. Whether in the form of painting or sculpture, the seminude body has always posed a tremendous challenge for artists. The sculptors of the viceregal period considered ivory one of the more appropriate materials for rendering Christ, for reasons of texture and color. During the early years of Spanish dominion, this material arrived via Europe. However, the establishment of an alternate commercial route between Acapulco and the Philippines was highly favorable for Asian merchandise. Ivory was shipped and traded in raw form or already carved, generally in the form of religious imagery.

In addition to the *sangleyes*, or Asian artists who settled in the Spanish colonies, European and Mexican artists also worked in this material. Evidence of this can be seen in this baroque sculpture of Christ kept in the sacristy of the cathedral of Mexico City, which is signed by Sebastián Ramírez.

This beautiful image of Christ Crucified exhibits painstaking treatment of anatomical details and the soft, signature curved outlines of the seventeenth-century baroque. The figure's head inclines slightly over his right shoulder; his parted lips seem to be uttering his last words to God before death. The finely executed hair, crown of thorns, and the minute details of the feet and hands all clearly demonstrate the singular workmanship of this piece. The masterful use of polychromy on areas of the face and hair, as well on the blood flowing from the wounds, brings added dignity to this image of Christ.

The striking carved ebony cross, inlaid with ivory and tortoiseshell, simulates a grape vine, a clear allusion to the blood of Christ, which is drawn from this "tree of life." The metaphor is underscored by the grape clusters and leaves that climb sinuously up the cross, which is set on a great sphere, symbol of a world that will reap the benefits of Redemption. The sculpture rests on a polygonal base, also heavily inlaid.

Consuelo Maquivar

v-7 Saint Christopher and the Christ Child

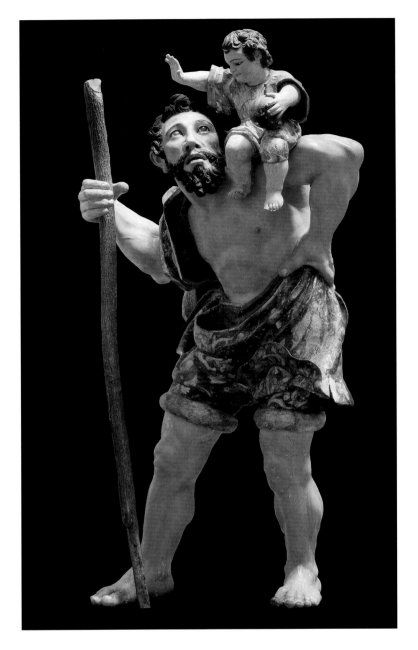

Mexico

Seventeenth century

Polychromed wood with painted reliefs on gilding

Height 94½ inches (240 cm)

Cathedral of Cuernavaca/CONACULTA, DGSMPC, Morelos, Mexico

PROVENANCE: Franciscan convent in Cuernavaca, Mexico

PUBLISHED: *Mexico* 1990, cat. no. 126, pp. 291–92

EXHIBITED: New York, San Antonio, and Los Angeles 1990, cat. no. 126

THIS REMARKABLE WORK DEPICTS Saint Christopher, whose name is derived from the Greek *Christophoros*, meaning "Christ bearing." Although this saint has been widely venerated since the thirteenth century, the Council of Trent cast doubts about his historical authenticity, and as a result many images were destroyed. According to Jacopo da Voragine's *Golden Legend*, Christopher was a man of tremendous physical stature who wished to serve the most powerful king in the world. He found a righteous monarch who greatly feared the devil and decided to stay and serve him, but when he discovered that the devil trembled before the sign of the cross, he left the monarch and chose to serve Christ alone.

Christopher was instructed in Christianity by a hermit who lived in the desert, and he devoted himself to helping pilgrims cross a dangerous river. One evening a child called out to him, asking to be borne across to the other shore. In the midst of this task, and although Christopher supported himself with a staff fashioned from the trunk of a palm tree, the weight of the child became intolerable. With great effort he at last deposited the child on dry land. The child then identified himself as "Jesus Christ, the King." As proof of his claim, he asked the giant to plant his staff in the ground. The next day, the dried piece of wood had come to life, sprouting leaves and dates. Christopher understood that he had finally found the one he was to serve forever.

A custom developed of placing monumental images of Saint Christopher at the entrance of churches and towns. In this way, those entering would invoke the protection of this saintly defender of all travelers.

Christopher is generally depicted as a man of great size, as in this image from the former Franciscan convent in Cuernavaca, the site of the city's present-day cathedral. The sculptor rendered the figure half naked in an obvious attempt to expose and exaggerate the musculature, and thus accentuate the saint's gigantic stature. The statue seems to be in motion; his head is turned slightly, and his gaze is set on the rather plump Christ Child he bears on his shoulder. The faces of both figures are very expressive, especially that of Christopher, who seems to converse with the child. His look of astonishment is a response to the child's extraordinary weight, and to the revelation that he is Jesus Christ.

The artist has clad the seminude figure of the saint in breeches held in place by a rope; an elaborately devised cloak is wrapped around his right shoulder. The Christ Child holds the celestial orb, and is given a simple tunic.

Consuelo Maquivar

v-8 *San Felipe de Jesús*

Mexico
Seventeenth century
Polychromed wood with painted reliefs on gilding
Height 53⅛ inches (135 cm)
Chapel of San Felipe de Jesús, Metropolitan Cathedral/CONACULTA, DGSMPC, Mexico City

PUBLISHED: *Mexico* 1990, cat. no. 140, pp. 323–26

EXHIBITED: New York, San Antonio, and Los Angeles 1990, cat. no. 140

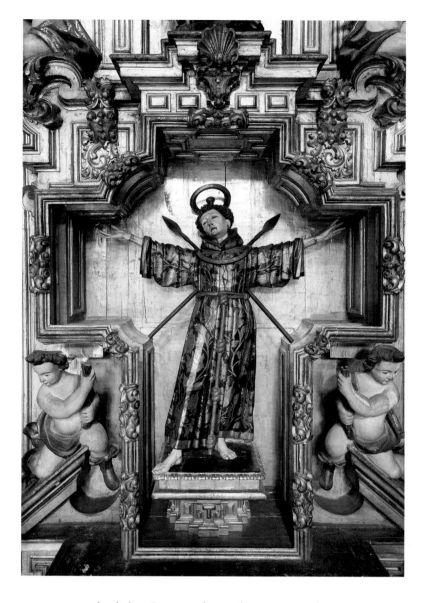

THE EARLY MEXICAN MARTYR Felipe de las Casas (1572–1597) was elevated to the altars of New Spain before he was actually canonized. Evidence of this early veneration can be seen in the chapel dedicated to San Felipe at the cathedral of Mexico City, as well as in the countless altarpieces that have borne painted or sculpted images of the saint since the second half of the seventeenth century.

Born to Spanish parents in the viceregal capital, Felipe showed from the time of his childhood, according to his biographers, a marked instability and restlessness, traits that would become more pronounced as he grew older. In order to provide the young man with greater discipline, his father sent him to the Philippines to work in the family's trading enterprises. Felipe continued to lead a dissolute life, but one day he felt the call of God, and after repenting he entered the Franciscan monastery of Santa María de los Ángeles in Manila. This event marked a radical turning point in the young man's life. He worked at the monastery's infirmary treating the sick, and adopted a rigorous and ascetic lifestyle.

When the father superior at the monastery felt that Felipe was ready for ordination, he sent him to Mexico so that his family and friends could attend the ceremony. The young man never reached his native land, however. The galleon that carried him, after sustaining heavy damage from storms at sea, landed on Japanese shores, during a time when persecution of Christians had recently been decreed. Felipe was imprisoned with the other surviving Franciscans and three newly converted Jesuits.

The Christian prisoners were forced to walk through villages and towns in an act of public humiliation. On February 5, 1597, the prisoners were taken to the hills above Nagasaki for execution. Here they were bound with iron shackles to a crucifix formed by two crossbeams nailed to a tree, and their hanging bodies were run through with lances. In 1627 these twenty-six martyrs were beatified, and in 1862 they were canonized by Pope Pius IX.

In this magnificent sculpture, the extended arms of San Felipe evoke his martyrdom. The ample sleeves of his Franciscan habit fall naturally, revealing his withered arms and lacerated body, and the habit is cut in finely wrought angular draping. The martyr's head is inclined slightly to the right, and his pallid face, with half-open eyes and mouth, elicits a sense of relinquishment and contained agony. The saint's suffering is accentuated by the use of pale polychromy. The martyr's wounds are rendered with discrete streams of blood, and the painted relievos follow a gilt floral motif covering the draped vestments.

Consuelo Maquivar

v-9 Attributed to Alonso de la Paz

(Guatemalan, c. 1630–c. 1690)

Saint Joseph and the Christ Child

Late seventeenth century
Polychromed wood with gilding
62³⁄₁₆ × 29½ × 21¼ inches (158 × 75 × 54 cm)
Church of Santo Domingo de Guzmán, Archdiocese of Guatemala,
Guatemala City

PUBLISHED: *Quetzal* 2002, cat. no. 226, pp. 383–84

EXHIBITED: Madrid 2002 Centro, cat. no. 226

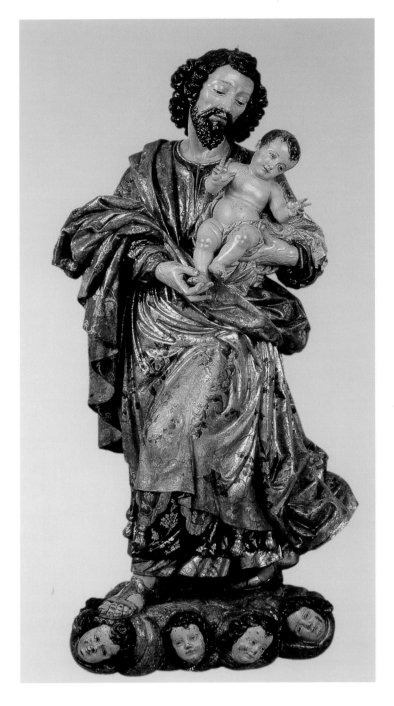

THE DEVOTION TO JESUS'S EARTHLY FATHER is deeply rooted in Guatemala, possibly owing to the strong influence of New Spain, but there was also a contribution from the region itself that left a large quantity of sculptures and paintings, in both churches and private residences.

The question of the authorship of this piece has been treated in detail by others; suffice it to say that it may or may not be the work of Alonso de la Paz, a Guatemalan sculptor active at the end of the seventeenth century. No documentation exists to confirm this attribution, however, and other works possibly executed by this artist are hardly comparable to this piece, which, in the context of other versions from the same period, constitutes a particularly original representation of Saint Joseph.

Saint Joseph is generally represented in one of three aspects: as a father, with his child in his arms, or leading him by the hand; asleep, in allusion to the revelations he received from God through an angel; or at the moment of his death, when, according to the theological notions of the Catholic Church, he ascended—as the earthly father of Christ—body and soul into heaven.

Here the earthly father of Jesus Christ is represented as a strong and vigorous man of 33 years of age, cradling his infant child in his arms almost in the posture of a dancer. The composition is disposed in a spiral motion. The left foot projects forward and the right one is drawn back, and the spiral is continued by the bend in the hips and the inclination of the head.

This sculpture may have been created for an altarpiece, but it offers more than just a frontal image of its subject, with a volume that can be fully appreciated in the round. The work is also significant in combining several techniques and mediums in a manner characteristic of late seventeenth-century Guatemalan sculpture.

A head of curly hair frames Saint Joseph's slightly oval face with its thin eyebrows and almond-shaped eyes. The nose is perfectly straight, and the thin lips and slightly open mouth are surrounded by a moustache and a beard divided in two. The saint's body is covered entirely in a tunic with fringes on its lower hem and a surplice with a high neckline. The mantle is dark green, with gilt floral designs and a sgraffito gadroon along

its border. The surplice is gilded and slightly open at the neck, where it reveals a red background. The entire figure is covered in a gilt mantle with punchwork and scales, on which roses and leaf-work have been painted. The lining of the mantle is decorated with red enamel and gilt floral motifs.

The Christ Child is characterized by sharply molded hair, oval face, almond-shaped eyes, well-proportioned nose, and small mouth with thin lips. The kicking legs and belly are rendered with the folds of flesh characteristic of a chubby infant. The infant's garment is painted white over a base layer of silver, with small sgraffito details, a stylistic feature that would later characterize many of the representations of the Christ Child in the arms of Saint Joseph.

This singular style has been called seventeenth-century *"antigueño" estofado* work by some scholars. The present piece is certainly one of the best examples of the technique.

Haroldo Rodas

v-10 *Christt Child Crucified*

Guatemala
Eighteenth century
Polychromed wood with metal halo
Height 40³⁄₁₆ inches (102 cm)
Castillo Collection, Antigua, Guatemala

PUBLISHED: Luján Muñoz and Alvarez Arévalo 1993, p. 155

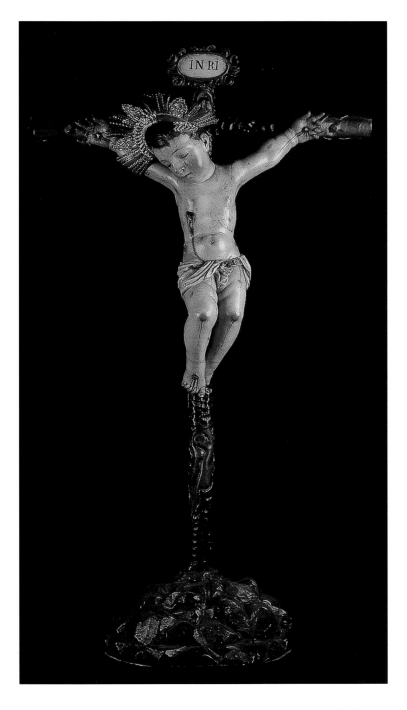

THIS STRIKING WORK IS ONE OF A GROUP based on the premonitory dreams of the Virgin Mary as narrated in the apocryphal Gospels. The influence of this iconography was widespread in Spanish America, but assumed different forms depending on the region. In Guatemala it took the form of infant Christ figures in depictions that recall the sufferings of the mature Jesus. These images may be based on engravings from the Flemish Wierix workshop, which express the notion that "from the moment of his conception, Christ spontaneously accepted the death and bitter Passion imposed upon him by the Eternal Father, and lived in preparation for them."

Be that as it may, these images of the infant Jesus create a painful visual impact. Some of them, such as the present example, show the Christ Child wounded and bleeding on the cross. Others depict the child being declared King of the Jews, in the form of an Ecce Homo; tied to the column after the Flagellation; or carrying the cross.

Here the Christ Child hangs from the cross, nails piercing his hands and feet. His head is inclined to the right, and blood-soaked hair hangs over his brow. The child's round and rosy-cheeked face evokes the vigor of infancy, curiously attached to the inert body of a child dying on the cross. The body belongs to a child under the age of two, and the youthful plumpness of the belly is all the more striking because of the wound above it. The child's loincloth is held up by a cord, lightly covering the groin area but leaving the left leg almost entirely exposed. Blood streams from the wounds on each knee, and bruised ankles show the traces of fetters or rope. From the crossed feet, pierced by a nail, blood flows down dramatically over the toes. The arms are outstretched and the hands contracted around the nails that pierce them. Completing the harshness of the scene is the gaping wound in the child's side, with its stream of blood staining the loincloth below.

What most strikes the viewer about the image is the desire to move the consciences of the faithful by means of a vision in the heart and mind of the Virgin Mary of a moment in the life of Christ when he was still but an infant. By exaggerating the drama of the Virgin's dream, the artist made an impression on colonial society and encouraged the indigenous people to serve and surrender themselves to God. The God that had come from across the ocean was associated with suffering, as were certain Andean deities. The indigenous peoples accepted that in order to surrender oneself to God, pain and suffering were necessary, and that in this way redemption and purity could be achieved.

These cruel manifestations of infant suffering are the result of a desire to move the spectator through the combination of the sublime and the terrible.

Haroldo Rodas

V-II *Our Lady of Patronage (called "La Colocha")*

Guatemala
Eighteenth century
Polychromed and gilded wood
9¼ × 3 9/16 × 2 15/16 inches (23.5 × 9 × 7.5 cm)
Private collection

PUBLISHED: *Quetzal* 2002, p. 415; Luján Muñoz and Alvarez Arévalo 1993, p. 129

THE ORIGINAL SCULPTURE OF THE Virgin of Patronage belonged to the oratory of the Espinosa de los Monteros family in the city of Santiago de Guatemala, now Antigua. The devotion was widespread in Guatemala toward the end of the seventeenth century, and in 1670 a confraternity was created with the same name and established in the private chapel of the Espinosa family. This private chapel was later opened to the public, with the authorization of the city's bishop, Juan de Ortega y Montañés. The devotion never took root among the common people, however, and when the capital was moved to Nueva Guatemala after the earthquakes of 1773, the image was refurbished and in 1778 placed in the church of Saint Joseph, where it remains today. This one, called "La Colocha" on account of the masses of curly hair, is one of the small-scale copies of the original.

Works intended for private homes form a special chapter in Guatemalan art, and they reveal the same details as sculptures of large dimensions in carving and in decoration, displaying *estofado* work of high quality and extraordinary variety, entering into a visual dialogue with the art of painting. The masters of *estofado* work produced diminutive flowers and the details of their varied miniature designs with great skill, and the gilding, sgraffito, and other aspects bear witness to the painstaking work of master gilders and painters.

There are many images of this kind in Guatemala, some of them in the possession of persons who have maintained a devotion for works handed down within their families and preserved in small niches where they can be protected and displayed. Their function can be explained from a devotional perspective, originating out of the desire to possess an image at home or even on one's own night table.

Since the *estofado* work of the original Guatemalan *Our Lady of Patronage* is older than that of the example included in this exhibition, the latter is probably a copy, but it is possible that others of the same kind were preliminary studies for larger pieces. The two "La Colocha" sculptures, large and small, are similar in their treatment of the head, which is

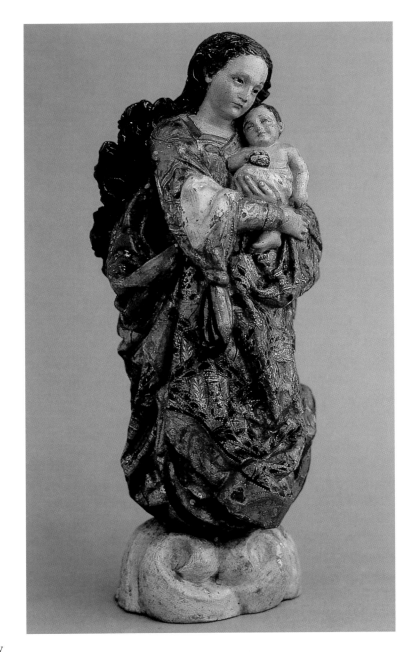

inclined, and in both, the child in the Virgin Mary's arms holds a globe symbolizing the world.

In the present example, the Virgin's mantle is covered in a grid pattern of blue-painted *estofado* decoration, with a sgraffito gadroon, against a background of gilt. The tunic—which also has gilt details on its upper part and sleeve, and ends at the top with an sgraffito gadroon—entirely covers the body, leaving the neck and face visible.

The Christ Child is wrapped in a white garment with *estofado* decoration. He holds a globe symbolizing the world in his right hand, while his other hangs down to touch the hand of the Virgin. The sculpture differs here from its model, in which the child bends an arm back toward his forehead.

This image of the Virgin Mary with the Christ Child is set on a base in the shape of a cloud, covered in gilt and white paint with sgraffito. This delicate *estofado* work provides a celestial setting for the sculpture.

Haroldo Rodas

v-12 *Saint Sebastian*

Guatemala
Eighteenth century
Polychromed wood with gilding
75⁹⁄₁₆ × 37⅜ × 33⁷⁄₁₆ inches (192 × 95 × 85 cm)
Catedral Metropolitana de Guatemala, Guatemala City

PUBLISHED: *Quetzal* 2002, cat. no. 236

EXHIBITED: Madrid 2002 Centro, cat. no. 236

IN LATIN AMERICA, WHERE MANY WORKS have never been catalogued and others are still in the process of being studied, it is often impossible to identify the artist with certainty. This sculpture of Saint Sebastian became an emblematic work and strongly influenced the iconography of Guatemalan sculpture.

Certain authorities attribute the piece to the workshop of Juan de Chávez, whose name is associated with it in the writings of Archbishop Francisco de Paula García Peláez. It is not known, however, where this information came from, or on what basis the archbishop so emphasized it. Juan de Chávez was active in the first half of the eighteenth century, but this sculpture is in a more detailed style, in which anatomical features are given full expression.

Saint Sebastian, the first Christian martyr, had a deep effect on the population. He had been considered the protector of the city against earthquakes since the middle of the sixteenth century, and one of the four parishes in the city of Santiago (now Antigua) was dedicated to him. A number of sculptures in churches of the region are based on this version, and it was also replicated in a more romantic fashion for private collectors in the nineteenth century.

There is no doubt that the master carver who executed this sculpture must have made a close study of the human body, but its perfection was also achieved thanks to the progress made in this aspect of art in the workshops of that time.

Saint Sebastian is represented here at the moment of his martyrdom. An undulating movement starts at the tip of the left hand, continues along the left arm, which is fastened to a tree, moves through the body, which is in full motion, and creates a balance by means of the right arm, which hangs downward, and the right leg, the front of which is entirely visible. Of the left leg, bent at the knee with the foot withdrawn, only part of the femur is visible.

Gazing upward with a plaintive expression, the saint has a perfectly straight nose, and his mouth is slightly open as if in supplication. The musculature around his neck bears witness to a youth and vigor overcome by the pain of the arrows that have pierced his left arm, torso, and right leg. Blood streams from the wounds in a dramatic but subtle depiction of his martyrdom.

The sculptural work is complemented by its polychromy. The clear flesh tones are perfectly achieved, with certain areas of the body rendered

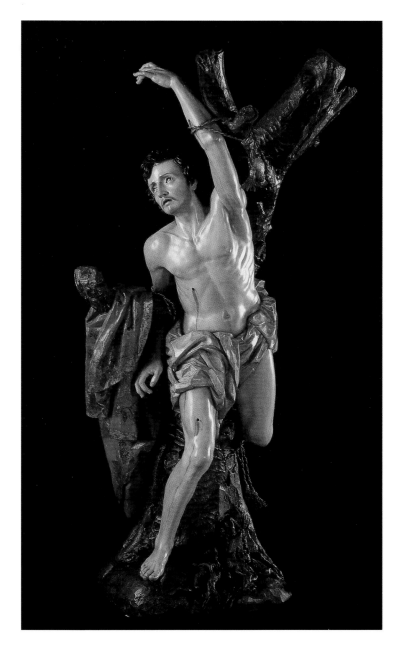

in darker colors to convey a sense of movement and muscularity. He appears naked but for the loincloth around his hips and covering his groin area. The loincloth is covered with white paint over a gilt background, the paint removed in smooth filaments by the *estofado* technique of scratching and piercing, to create an interplay of light and shadow. The saint's mantle, which hangs over one of the branches of the tree, is painted red against a gilt background, with delicate sgraffito work bringing out light touches of gold. Above these, floral designs are painted onto the black and gold paint, with a gilt border decorated in floral and rocaille motifs. The tree is painted in dark colors with gilt details to bring out the light and the striking sculptural elements of a bright but woody texture.

What is certain is that this work was a collaboration of master carvers, gilders, and painters who created a monument in the history of Guatemalan art. This sculpture served as a romantic inspiration through the nineteenth century, when it was copied by other master craftsmen to create new works intended especially for private residences.

Haroldo Rodas

V-13 *Saint Iphigenia*

Guatemala
Eighteenth century
Polychromed wood with gilding
53⁹⁄₁₆ × 24⁷⁄₁₆ × 19¹¹⁄₁₆ inches (136 × 62 × 50 cm)
Church of La Merced, Guatemala City

PUBLISHED: *Quetzal* 2002, cat. no. 231, p. 389

EXHIBITED: Madrid 2002 Centro, cat. no. 231

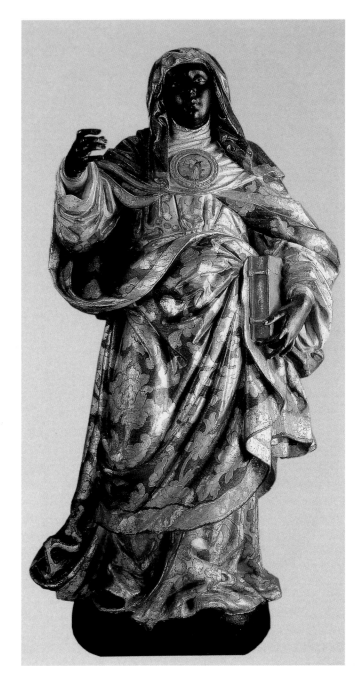

THIS SCULPTURE OF SAINT IPHIGENIA represents the daughter of
a king of Ethiopia, converted to Christianity by Saint Matthew, who
preached the gospel in that region of Africa. Iphigenia decided to dedicate
herself to the religious life and was later martyred.

The sculpture was carved originally for an altarpiece dedicated to
Saint Iphigenia in the Mercedarian church. This altarpiece contains vari-
ous paintings that narrate significant events in the saint's life and includes
a sculpture of her father, the king of Ethiopia. The work is in the style
of the eighteenth century, full of baroque expressiveness, but showing a
certain incipient balance more characteristic of neoclassicism. The artist
has given Iphigenia an oval face and delicate hands. The prominent,
rounded chin, which is slightly raised, is characteristic of images belong-
ing to the second half of the eighteenth century.

The sculpture evidences how prevailing Christian ideas permitted
the presence of saints connected to the Spanish tradition alongside others
belonging to another racial group that had arrived with the conquest,
namely the black Africans, but marginalized the indigenous peoples who
had been the object of the conquest. These could follow in the footsteps
of those who had achieved the halo of sainthood, but were never given a
place on the altars. Although Saint Rose of Lima, the first American saint,
had been canonized by this time, she was not depicted with a mestizo face.
She was increasingly Hispanicized in representations. Similarly, Saint
Iphigenia was transformed into a saint in the Spanish pattern. Only her
dark skin was retained.

All of this lends an emblematic quality to the present representation.
The form of the sculpture itself is fluid and expressive, full of movement
and grace, and with extraordinarily fine *estofado* decoration based on
branching leaves and flowers drawn in black that lend volume and greater
movement to the work as a whole. The *estofado* is of uniquely high quality.
No other images either in the church of La Merced or in others approach
this model. Because of its similarity to other production from Spain, it may
be attributed to a Spanish master—Juan de Astorga, according to Luis
Luján Muñoz—who had settled in Guatemala.

Although there is no doubt that it was completed in Guatemala, it
must be borne in mind that during the entire colonial period artists from
Spain settled in the region permanently or temporarily. This piece may
have been the creation of an artist who remained in Guatemala for a short

time and left a work of great value, one that would revitalize the aesthetic
models of *estofado* work produced there.

Although Concepción García Sáiz has described in detail the qual-
ity and execution of the work, she did not solve the question of the origin
of the eighteenth-century foliate decoration. The Guatemalan workers
in *estofado*, however, had developed a particular style by that time, and
it is thought that this sculpture was decorated in *estofado* after it arrived
in Guatemala, from Spain.

The *estofado* decoration was probably done in Nueva Guatemala
toward the end of the century, judging from the almost rococo style
of the floral details worked against the black background of the saint's
mantle. Also typical of the eighteenth century are the delicate sgraffiti
on the headwear, which reveal the gold leaf underneath the black, and
the gilt gadroons.

Haroldo Rodas

v-14 *Saint Bartholomew*

Guatemala
Eighteenth century
Polychromed wood
Height 57½ inches (146 cm)
Museo Fray Francisco Vázquez, Iglesia de San Francisco, Guatemala City

PUBLISHED: *Quetzal* 2002, cat. no. 239, pp. 396–97

EXHIBITED: Madrid 2002 Centro, cat. no. 239

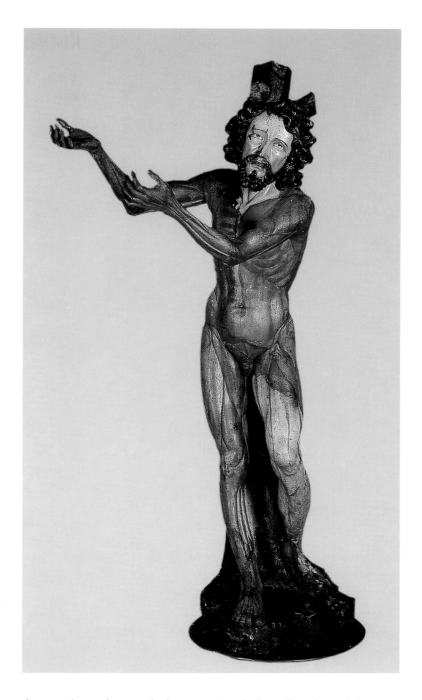

THIS REPRESENTATION OF THE MARTYRDOM of the apostle Saint Bartholomew is another example of a Guatemalan sculpture that reproduces a European painting or engraving in three dimensions. Although it cannot be fully identified with any one European work, the composition reflects the contribution of such creations.

The work is peculiar in the treatment of its subject. This work and the Saint Sebastian in the same cathedral are the only examples of anatomically complete nudes in Guatemalan sculpture.

This image was attributed by art historian Luisa Elena Alcalá to the influence of a depiction of Saint Bartholomew flayed by José de Ribera (1591–1652), whose paintings and engravings were widely known in Spanish America. Alcalá states that illustrated anatomical treatises, which had been published since the sixteenth century, also made a contribution, and she adds that this work owes much to an engraving in a treatise by Juan Valverde on the history of the composition of the human body published in Rome in 1556. This engraving became the model for isolated representations of Saint Bartholomew in Europe and America. Works such as the painting in the church of San Laureano in Tunja, Colombia, show strong similarities to it.

Dramatically rendered, the scene depicts the flaying of the apostle ordered by King Astiages in Albanopolis (now Derbend, on the west coast of the Caspian Sea) because of his preaching of the gospel. Clearly influenced by the European Renaissance, the scene is transformed into an epic of the Guatemalan baroque. The anonymous sculptor has rendered the apostle with lacerating drama.

The saint's hair is curled and frames an oval face, with glass eyes that gaze upward and a straight nose. A beard and moustache surround a slightly open mouth that offers a glimpse of teeth and a bleeding tongue. The curly beard is divided in two, and the neck is of skin tones until the beginning of the torso.

Then comes the most dramatic element of the composition: the flayed body of the saint, who raises his wounded arms in supplication to display his garroted hands and musculature, visible down to his groin area and wounded sexual organs. Only the face, neck, and part of the left leg are flesh-colored. The rest of the body is covered in a red that resembles the color of blood or the color of flesh whose skin has been stripped away. This sculpture may originally have had pieces of removable skin, in the form of a porous fabric or leather, that covered the genitals and part of the arms, but unfortunately there remain only the nails and metal clasps that held them in place.

The muscles of the right leg reveal the sculptor's knowledge of anatomy. The entire figure rests on the trunk of a tree, which like the body has sections of dark and light to create the interplay of light and shadow typical of Guatemalan painted sculpture.

The bloody impact of this piece can only be understood in the context of a society committed to the doctrine that suffering purifies. These dramatic scenes fit in with the sense of self-sacrifice of pre-Hispanic societies, transformed by Christianity into scenes of martyrdom that made a strong impression by offering hope of a spiritual renovation, following the example of those who had been martyred in God's name.

Haroldo Rodas

v-15 *Saint Michael Archangel*

Guatemala
Eighteenth century
Polychromed and gilded wood, with silver
10¹³⁄₁₆ × 6¹¹⁄₁₆ × 6¹¹⁄₁₆ inches (27.5 × 17 × 17 cm); base height 3¾ inches (9.5 cm)
Church of La Merced, Guatemala City

PUBLISHED: Urruela de Quezada 1997, p. 121

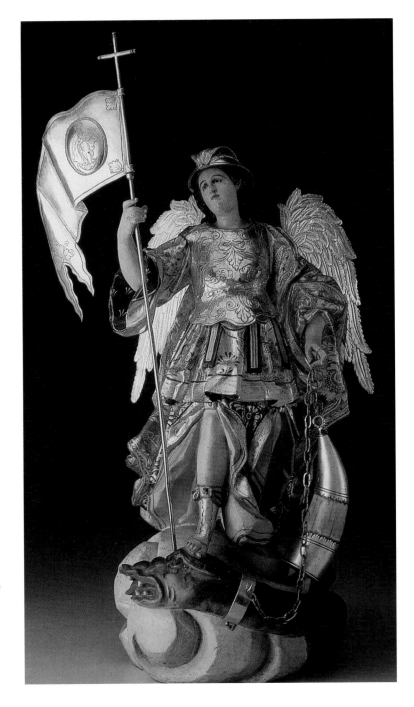

THE ARCHANGEL MICHAEL was an extremely popular subject in Latin
American colonial art. This small jewel of a sculpture is joined in this
exhibition by several other versions: a painting from Bolivia (cat. VI-86),
a painting from Mexico (cat. VI-11), and a Brazilian sculpture (cat. V-51).

It has in common with another sculpture in the exhibition, the
Virgin of Quito from the Brooklyn Museum (cat. V-30), the use of mixed
mediums to create an object of great luxury. The delicate flesh tones
(*encarnaciones*) are framed by the generous use of brilliant gold in the
polychromy of the angel's garments. The sculpture is further enhanced
by a helmet, wings, and a banner bearing the image of the Virgin of
the Immaculate Conception, all in repoussé silver. Saint Michael trods
upon Satan, who is shown as a serpent, and the whole composition rests
on a cloud. The horn the angel dangles from his right hand represents,
in unusual form, the trumpets that would sound at the Last Judgment.

The generous use of silver to embellish works of art and craft is
characteristic of the viceregal period throughout Latin America, where
the precious metal was so widely available. It was used to enhance sculp-
tures, as in this example, and was often employed in the decorative arts
as hinges for little boxes and the like. In Ecuador, silver was also used in
the polychromy of sculpture, laminated over the prepared surface of the
object and then glazed with translucent color, the technique and effect
called *chinesca*.

Although this sculpture is today in a church, and may always have
been, it is representative of a large number of small sculptures made in
two Latin American centers in particular for the secular market. The sculp-
tors of eighteenth-century Ecuador shipped crate loads of such objects
throughout Latin America, which accounts for their large numbers today
in Santiago, Chile, and Lima, Peru. Similarly, the sculpture workshops
in Guatemala provided many small sculptures, such as this Saint Michael,
for collectors in Mexico.

Suzanne Stratton-Pruitt

v-16 *Saint Anne and the Virgin Mary*

Guatemala
Second half of the eighteenth century
Polychromed wood with gilding and silver gilt
55⅛ × 30¹¹/₁₆ × 27⁹/₁₆ inches (140 × 78 × 70 cm)
Church of La Merced, Guatemala City

PUBLISHED: Urruela de Quezada 1997, p. 109; illus. pp. 80, 82, 83

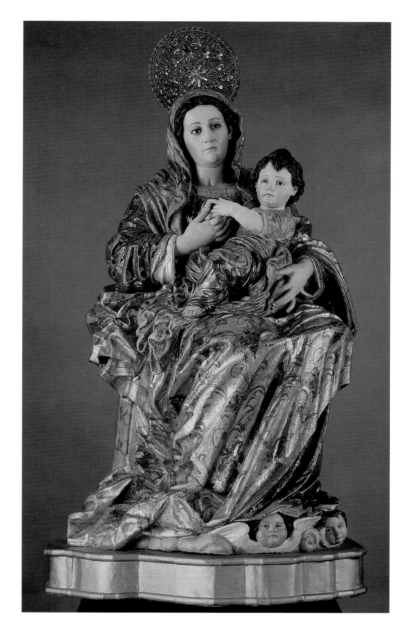

SAINT ANNE—WHOSE NAME MEANS "Gracious" in Hebrew—is
the mother of the Virgin Mary, who gave birth to Jesus Christ. The
historical account of Saint Anne comes from the Proto-Gospel of Saint
James (c. A.D. 150), published in 1552, later popularized through Jacopo
da Voragine's *Golden Legend.*

The devotion to Saint Anne developed late in the European
Middle Ages, and although it subsequently weakened, it persisted in
certain regions of the world. She is accepted as the patron saint of carpen-
ters, woodworkers, and lathe workers, possibly because she was the
mother-in-law of Saint Joseph, Jesus's earthly father. Her devotion is also
associated with childbirth, and she is the patron saint of midwives, who
request her favor when they help a woman to give birth, especially in
areas where there is no medical assistance. In Guatemala, where there
are villages named after her, the devotion of Saint Anne was widespread.

There are several ways to represent Saint Anne in art: she might
be shown alone, or teaching the Virgin Mary to read, or with the Virgin
Mary and Jesus (*Santa Ana Triple*).

There are various representations of Saint Anne in Guatemala, but
this carving for an altarpiece dedicated to the Holy Family in the church
of La Merced in Guatemala City is outstanding among them. Saint Anne
is depicted with her daughter sitting on her knee, and holding the child's
hands in her right hand. The group is well-proportioned and skillfully
carved in a baroque style. The saint's head is covered by a mantilla that
leaves visible part of the hair over her forehead, above an oval face with
rounded eyes and a perfectly straight nose. Her round chin is slightly
prominent, and her thin lips are closed around a small mouth. Her neck
is barely visible behind the ample tunic, which leaves only her hands
visible, gently cradling the infant Virgin Mary. The child has curly hair,
chubby hands, and facial features very similar to those of her mother.

Curiously, given the desire to integrate the two figures, they both
gaze straight out at the viewer, as if wishing to capture the attention of
the devout, in a posture that separates them. Their clasped hands connect
them but their gazes remain directed outward, seeming to say "listen to
me with your eyes."

The technique of the sculpture is excellent. It has been executed
in wood joined to form a single block to which the sculptor gave shape
and style. The figures are supported by cherubs' faces and clouds, which
lend a certain spirituality. Eight different *estofado* designs are distributed
over Saint Anne's mantle, shawl, gown, pleated sleeves, and the fringes
of her tunic and mantle, and the garment of the infant Virgin Mary. The
abundant folds of the garments are typical of the sculpture of the period.
Only the relaxed faces and hands of the figures are visible.

This sculpture can be compared with another of the same saint in
the church of Our Lady of El Carmen in Guatemala City, which differs
only in its *estofado* decoration with its smaller floral motifs.

Haroldo Rodas

v-17 Saint Rose of Lima

Guatemala
c. 1800
Polychromed and gilded wood
Height 66⅞ inches (170 cm)
Church of Saint John the Baptist, Amatitlán, Guatemala

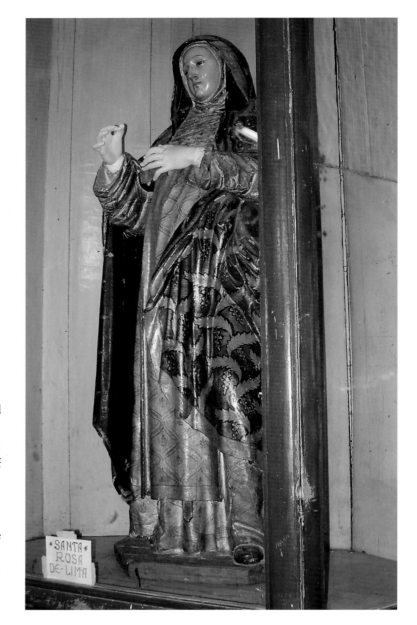

THIS IS A SINGULAR REPRESENTATION of the first saint of the New
World, attired in the habit of a Dominican nun decorated with gilding and
estofado, as a Guatemalan tribute to her memory. The life of Saint Rose of
Lima made a strong impression on Spanish America, not only because she
was the first saint canonized in the western hemisphere but also because of
her innate nobility and imposing personality, in addition to her contribu-
tions as a woman in the colonial period.

Saint Rose was born in the capital of Peru in 1586 to poor Spanish
parents. She was christened Isabel, but commonly called Rose, a name she
received officially on being confirmed by the city's bishop. Although very
beautiful as a girl and young woman, she firmly rejected all worldly vanity.
On one occasion, when she was a young girl, her mother placed a garland
of roses on her head in the presence of visitors, and Rose cut her forehead
with one of the thorns in order to diminish the effect. Whenever anyone
complimented her on her beauty, she would castigate the part of her body
that had been praised.

Her parents wanted her to marry, but she asked to be permitted
to maintain her chastity. Wishing to live a life consecrated to God, she
joined the Third Order of Saint Dominic. For meditation and penitence
she placed a skein of silver fitted out with spikes on her head, in imitation
of the crown of thorns worn by Jesus during the Passion. Saint Rose lived
a life of constant suffering, which led her to retire to the orchard of her
family home, where she built a modest dwelling.

She died on August 24, 1617, at the age of 31. Members of the colo-
nial government and that of the city of Lima followed her funeral proces-
sion in recognition of her virtues. She was canonized by Pope Clement X
in 1671. Her canonization made people of the New World realize that their
region could produce saints, and countless portraits of her were painted.
Sculptures in wood were also executed, especially in Guatemala, where
there are several in existence.

The present work is one from the church of the village of Amatitlán,
near Guatemala City. It shows the saint around the age of her death,
dressed in the Dominican habit. The saint's head is framed in a wimple
covered by a dark mantle, with the white habit visible below. The sense
of measured movement and the gentle tenderness in the expression of
the subject reflect the power of Guatemalan sculpture at the end of the
eighteenth century and beginning of the nineteenth.

The saint has an oval face, almond-shaped glass eyes, a straight
nose, and a small, closed mouth. The rounded chin is typical of figures
sculpted in Guatemala in the second half of the eighteenth century. Her
face is imbued with an idealized beauty, while the saint's habit is a simple
fabric decorated with *estofado* work that imitates the embroideries of the
period, very similar to that of the sculpture of San Vincent Ferrer in the
Dominican church in Guatemala City.

Curiously enough, these images are framed in spaces dedicated to
the Dominican order, like those of Saint Gertrude and Saint Nicholas of
Tolentino in the case of the Franciscan order. These latter images were
possibly made for Franciscan churches, and recall the decoration applied
to the image of the lay brother Sebastián de Aparicio in the Franciscan
church in Guatemala City.

Haroldo Rodas

v-18 *Descent from the Cross*

Guatemala
Second half of the nineteenth century
Polychromed wood
31⅞ × 31 × 17⅜ inches (81 × 79 × 44 cm)
Church of La Merced, Guatemala City

PUBLISHED: Urruela de Quezada 1997, p. 119

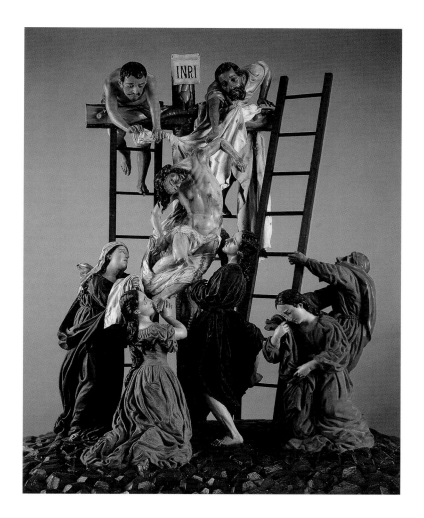

A SINGLE GLANCE AT THIS SCULPTURAL GROUP reveals its compositional source: Peter Paul Rubens's painting of the *Descent from the Cross* in the cathedral of Amiens, which deeply affected the art of Spanish America through the eighteenth century and into the nineteenth. Inspired by a copy of Reubens's painting in the sacristy of La Merced, this object takes on volume as a sculptural composition and is imbued with the romanticism prevailing at the time of its creation.

The subject had been treated previously by painters in Guatemala. There is a painting of the same subject attributed to Thomás de Merlo, a painter from Santiago de Guatemala (1694–1739), in the Capuchin church of San Miguel in Guatemala City, and another in a private collection. The sculptures of this subject form a powerful group of work persisting until late in the colonial period and demonstrate the influence on Guatemalan sculptors of European paintings and engravings.

Certain scholars have dated this piece to the end of the eighteenth century, pointing out the sculptor's desire to move away from the saturation which the *estofado* tradition had attained. This affirmation cannot be sustained, however, since the best examples of Guatemalan *estofado* work were achieved precisely toward the end of the eighteenth century and at the beginning of the nineteenth. These include the Saint Joseph in the Franciscan church and the Saint Anne in the church of El Carmen, to mention only two of the most splendid examples from this period.

Although this work can be approached as an apparent example of the baroque, it lacks the brilliant *estofado* work typical of that period. It belongs to another age, the romantic nineteenth century, during which artists recreated works of the colonial period, but with striking variations.

This sculptural group was inspired by paintings of the colonial period, but the breadth and gentleness of the carving reflect a desire to soften the impact of baroque intensity with a more balanced composition. In sculptural terms, everything is aimed at imitating the painting by Rubens, but with greater measure in the movement of the garments. The body of Jesus is broken and wounded, represented in the bloody

detail of Rubens's painting, and influenced to some extent by the works of Merlo as well.

A nineteenth-century date for the piece is indicated by the stonework of the hill of Calvary, whose orderliness is characteristic of that period. Of even more significance is the polychromy, which does not consist of *estofado* decoration, but incorporates an innovative material of the period, referred to in popular usage as *fom*, a sort of chamois of fixed colors that impedes the light and shadow effects in the sculptural details that were achieved with both *estofado* and oil pigments.

In the second half of the nineteenth century, when this technique of decorating sculpture was adopted in Guatemala, some early pieces originally decorated with *estofado* were even scraped clean and redecorated with this medium. There are many sculptures of this period to which this material has been applied, making it possible to bring out the details of the hands and faces (such as the rounded chins) with a more measured, whitish coloring of the type referred to as "snowy" (*nívea*) in certain documents.

Works such as this reflect the long life of certain quintessential art forms of the viceregal period well into and through the nineteenth century, as do the "colonial" sculptures of Gaspar Sangurima, the indigenous artist who continued the excellent tradition of Ecuadorian sculpture well past the colonial period, garnering the admiration of "the liberator" Simón Bolívar.

Haroldo Rodas

v-19 Pedro Laboria[†]

(Spanish, c. 1700–after 1764; active Bogotá from 1738)

Saint Joachim and the Virgin as a Child

1746
Carved, painted, and polychromed wood
63 × 31½ × 24 inches (160 × 80 × 61 cm)
Signed: *Petrus Laboria 1746*
Museo de Arte Colonial/Ministerio de Cultura, Bogotá, Colombia

PROVENANCE: Monasterio de San José de las Carmelitas Descalzas, Santa Fé de Bogotá, 1746; sold to the Museo de Arte Colonial de Bogotá in 1970

PUBLISHED: Fernández Jaramillo 1968; Zea de Uribe et al. 1976

EXHIBITED: Bogotá 1968; Paris, Madrid, and Barcelona 1975; Bogotá 1981

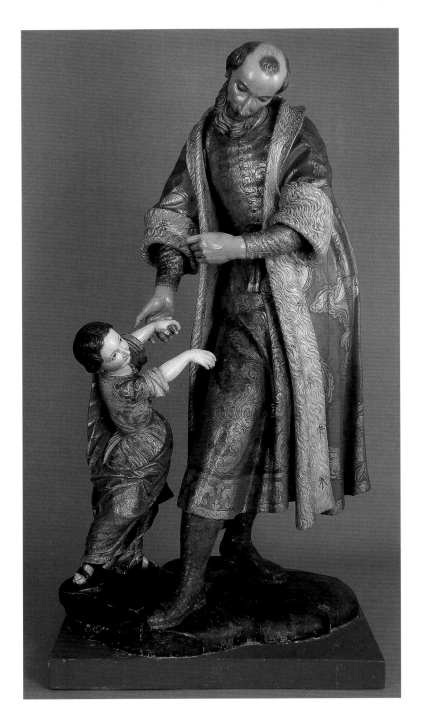

THE EDUCATION OF THE VIRGIN is among the most common themes of the Counter-Reformation. Like that of many artists of the period, Pedro Laboria's conception of the Virgin relied more heavily on the Marian legends than on any accounts presented by theologians. While the New Testament informs us that the Virgin entered the Temple of Jerusalem at a very young age, popular religious beliefs preferred to maintain that her early education was conducted by her parents, and it is more common to see Saint Anne assuming this task. Representations following this scheme have been produced by such masters as Francisco de Zurbarán, Bartolomé Esteban Murillo, and Peter Paul Rubens, and in turn by innumerable artists in the Spanish colonies of Latin America as well as Brazil. The model of the Virgin's parents serving as educators was viewed as a preferred paradigm, since "the human condition is thus fused with the divine."

This sculpture was part of the collection of the Carmelite Monastery of Saint Joseph in Bogotá. It is quite striking how baroque piety managed firmly to resuscitate the cult of the "family," which became inexorably linked to the veneration of the Virgin.

This work depicts Saint Joachim teaching the young Virgin to read. An old photograph of the sculpture shows an open book resting on Joachim's knees. This detail has since been lost, and as a result, many historians have erroneously interpreted the figures to be dancing, which would have been anathema in Catholic iconography. Laboria's highly expressive work follows the baroque tendency toward elegant movement, which is reflected here in the billowing draping of the figures' attire. The faces are sweetly expressive, and radiant polychromy, intensified by gilding, is employed on the surfaces of the clothing. The graceful sense of movement, the apparent gleam in the figures' eyes, and the way the two forms interrelate all work to create an extraordinarily realistic representation of father and daughter.

Marta Fajardo de Rueda

V-20 Pedro Laboria[†]

(Spanish, c. 1700–after 1764; active Bogotá from 1738)

Saint Barbara

Eighteenth century
Carved, painted, and polychromed wood
93¾ × 26 × 27⅛ inches (238 × 66 × 69 cm)
Signed: *Petrus Laboria fecit Sta. Fidei Anno 1740*
Archbishop's Palace, Bogotá, Colombia

PROVENANCE: Church of Santa Bárbara, Bogotá

PUBLISHED: Ibáñez 1913–23, vol. I, pp. 78–79; Santiago de la Vorágine 1982, pp. 896–903; Fajardo de Rueda 1992; Trusted 1996, pp. 10–11

EXHIBITED: Bogotá 1992 *Santa Barbara*

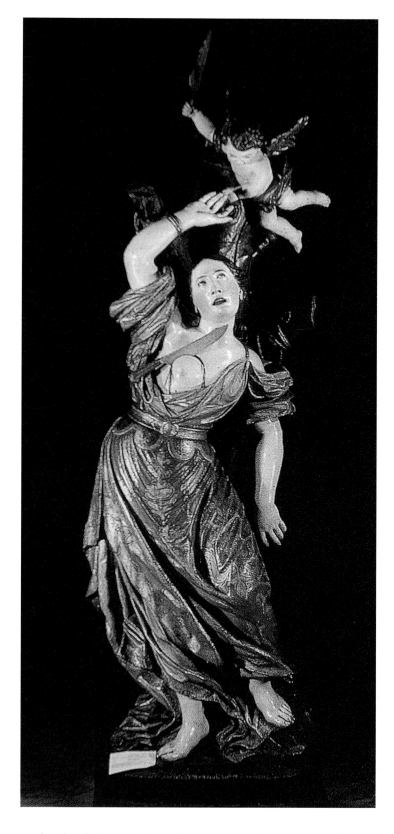

THIS SCULPTURE, A HIGHLY EVOCATIVE expression of baroque sentiment, depicts Saint Barbara in one of the culminating moments of her martyrdom. Pedro Laboria was commissioned to create the piece in the mid-eighteenth century for the main altar of the church devoted to this saint in Bogotá. Despite the cruel torture and the obvious agony of the saint, her placid gaze is directed to the heavens, here symbolized by the small angel that hovers above the tree trunk to which she is bound. The heavy folds of her drapery have been skillfully painted using a technique of applying color to gilding, which was later subjected to *sgraffito*. The resulting surface, illuminated by the gilt undercoat, is intended to echo the effects of gold embroidery and border work.

The church of Santa Bárbara was constructed in the sixteenth century by the conquistador Lope de Céspedes, who lived on the outskirts of Bogotá with his wife, Ana de Vásquez. On August 27, 1565, the city was beset by a tremendous rainstorm. A great bolt of lightening, felt throughout the city, entered a house, reaching every room in the structure until it fatally struck a young slave named Cornelia, the only victim of this natural calamity. The shock triggered by Cornelia's death led to informally organized public prayer sessions, which filled the streets of the capital. Lope de Céspedes ordered a church to be built on the site of the home destroyed in the fire. It was dedicated to Saint Barbara, the protector from storms, the patron saint of a good death and of hunters and soldiers.

Saint Barbara, whose life is a mixture of legend and history, is one of the earliest martyrs of Christendom. It is said that when she converted to Christianity, she had three windows put in her tower or bathhouse to honor the Holy Trinity. Her father, Dioscorus, tried to convince her to renounce her newfound faith. When she refused, he had her tortured. Moments after he beheaded her, Dioscorus was fatally struck by lightning. Artistic representations of the saint often depict Barbara as a princess accompanied by her various emblems, or, as is the case with this sculpture, during the act of her cruel martyrdom. She is sometimes confused with Saint Agatha, a Roman martyr who was tortured by having her breasts lopped off. Representations of both these martyrdoms are quite common in Latin America, where the cult of Saint Barbara has been particularly strong. In Colombia, images of the saint abound in both painting and sculpture. Many towns bear the saint's name as well.

Marta Fajardo de Rueda

V-21 Pedro Laboria[†]

(Spanish, c. 1700–after 1764; active Bogotá from 1738)

Saint Anthony of Padua

Eighteenth century
Carved, painted, and polychromed wood
76¾ × 28⅜ × 26¾ inches (195 × 72 × 68 cm)
Signed: *Petrus Laboria faciebat*
Cathedral of Tunja, Colombia

PUBLISHED: Arbeláez Camacho and Gil Tovar 1968, pp. 127–34;
Mateus Cortés 1989, p. 116; Schenone 1992, vol. 1, pp. 156–59

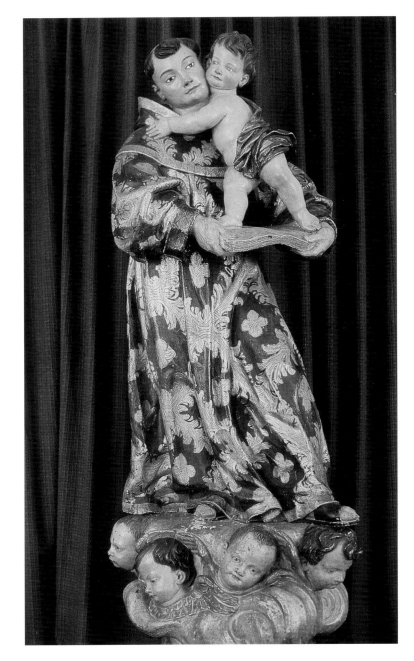

THIS MONUMENTAL SCULPTURE probably formed part of an altarpiece.
Saint Anthony of Padua is depicted with the Christ Child, who is seen
standing on an open book. The two figures are supported by a pedestal
of clouds decorated with cherubs.

The sculpture seems rough hewn and technically somewhat primi-
tive, and is either an earlier work by Pedro Laboria or a copy of a Portu-
guese version of the saint, given the tendency in that country to represent
him as somewhat overweight and of small stature. The faces are given a
stern expression, which is unusual in the works produced by Laboria.
However, the cherubs are quite masterfully rendered and exude a sense
of gracious individuality. The saint's attire is carved as softly folding drap-
ery, with skillfully applied polychromy over the traditional dark chestnut
of the habit.

Saint Anthony did not in fact hail from Padua. He was born in
Lisbon, Portugal, sometime around 1188, although some scholars argue
for a later date of 1195. His early religious life was spent as an Augustinian
monk until he came into contact with the first Franciscans at the church
of Santa Cruz in Coimbra. He withdrew from the Augustinian order and
donned the habit of the Franciscans. His renown spread from the fervent
sermons he preached in Italy and southern France. He died in Padua at
the age of 35.

Saint Anthony is the patron saint of orphans, prisoners, and sick
children. Perhaps because of his extraordinary goodness, it is said that the
Christ Child appeared to him. Thus he is often represented in both paint-
ings and sculpture accompanied by the image of Christ. Veneration of this
saint quickly spread throughout Latin America, in part because of the
doctrinal changes that occurred after the Council of Trent (1545/63).

Marta Fajardo de Rueda

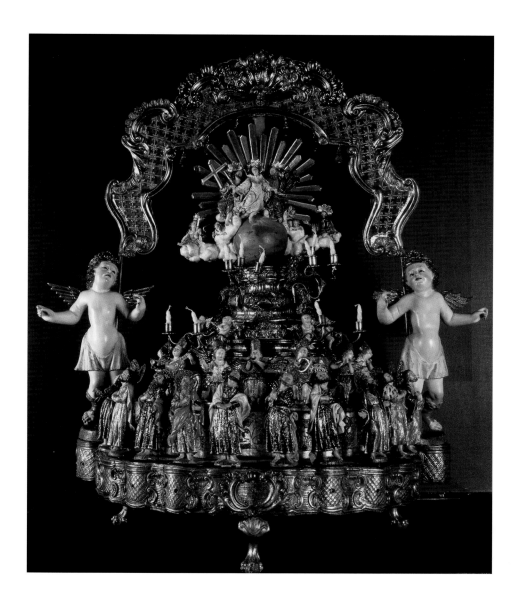

V-22 Attributed to Bernardo de Legarda[†]

(Ecuadorian, end of the seventeenth century–1773)

Allegory of the Triumph of the Virgin

Second half of the eighteenth century
Carved, gilded, and polychromed wood, and repoussé silver
31⅛ × 22¹³⁄₁₆ × 13¾ inches (79 × 58 × 35 cm)
Collection of the Bank of the Republic of Colombia, Bogotá

THIS SMALL CARVED SCULPTURE has a base in the form of a pyramidal staircase, at the very top of which is placed the image of the Immaculate Virgin, surrounded by a luminous mandorla and attributes that may allude to the apocalypse. In Spanish images of the Assumption from the sixteenth and seventeenth centuries, it was quite common to find such elements, which were also adapted in Marian representations in Latin America, even if these images were not specifically Immaculist.

Here the Virgin, accompanied by the emblems of the Holy Trinity, stands atop a globe positioned above the highest step of the staircase, which is adorned with small candelabras. To either side are angels with silver wings and crowns holding a silver filigree phylactery that encircles the entire group. Images of haloed apostles in polychrome tunics are arranged on the lower steps. Their beatific gaze is fixed toward the heavens, in admiration of the glory of the Virgin. At the base of the staircase is a band of undulating vegetal motifs and geometric designs.

A religious custom was established in eighteenth-century Quito venerating the final moments of the life of the Virgin. Thus during the highpoint of the Audiencia of Quito, many artworks were commissioned commemorating the death of the Virgin, although a far greater number of images were dedicated to her triumphal Ascension, as is the case here. In addition to these types of images, the studios and workshops of Quito produced a large quantity of other religious works catering to local sensibilities, or those of cities in the region, such as Lima, Bogotá, or Santiago, where many pieces were regularly shipped. Thus it is quite possible that the shrine at the museum in Colombia was indeed created in Quito, probably at the workshop of Bernardo de Legarda, which was one of the most productive during this period.

Adriana Pacheco Bustillos

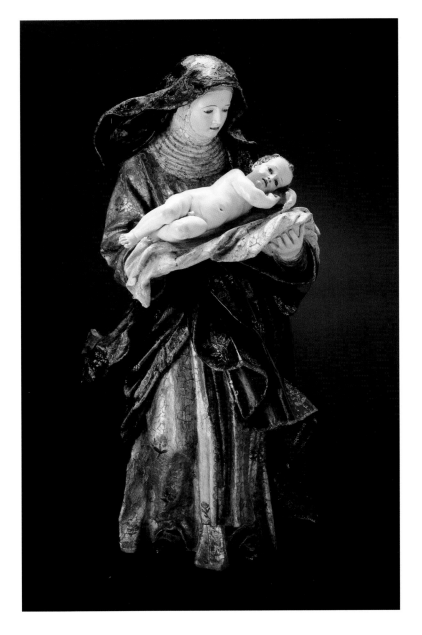

V-23 Workshop of Bernardo de Legarda[†]

(Ecuadorian, eighteenth century)

Saint Rose of Lima

Eighteenth century
Gilded and painted wood
27⅛ × 11 × 13 inches (69 × 30 × 33 cm)
Museo de Arte Colonial, Casa de la Cultura Ecuatoriana, Quito, Ecuador

PUBLISHED: Escudero de Terán 1992, fig. 93; *Breve catálogo* 1997, p. 25; *Grâce baroque* 1999, cat. no. 19, p. 165

EXHIBITED: Nantes and Paris 1999, cat. no. 19

BORN IN LIMA, PERU, in the late sixteenth century, Saint Rose (Santa Rosa) was the first native of the Americas to rise to sainthood. She was canonized by Clement X in 1671, only fifty-four years after her death, the speed of the process revealing the influence exerted on it by both the Catholic Church and political authorities in Lima. As a Creole descendant of Spaniards born in the colonies, she became a symbol of the triumph of Christianity in the New World, while her saintly life served to sustain an image of the Viceroyalty of Peru, and of her native town, as a New Jerusalem. Although she did not formally join any female religious order—in 1606 she took the habit of Saint Dominic as a tertiary, or layperson—she devoted her life to mystic knowledge and love of God. She claimed to have taken Saint Catherine of Siena as her spiritual model, but the story of her life also served as an exemplar of female virtuosity and devotional zeal for other women of her period.

Saint Rose is most commonly depicted wearing a white tunic and black cloak, the habit of the Dominican order, and is often shown crowned with roses. This particular sculpture recalls her mystic marriage to Christ, one of the salient episodes in the saint's life. While praying before an image of the Virgin Mary in the chapel of the Rosary, the Christ Child had asked her to become his bride. The sculpture shows her holding the child Jesus in her arms, her body gently inclined, her gaze lowered in sustained contemplation of the child's body. As is typical of eighteenth-century sculpture from Quito, emphasis is placed on dynamic movement and theatricality, achieved here by the spiraling rhythm of Rose's body. The saint's garments, painted with gold and polychromatic floral motifs, effectively simulate costly textiles and in turn endow the representation with a sense of realism.

Carmen Fernández-Salvador

V-24 Attributed to Bernardo de Legarda[†]

(Ecuadorian, end of the seventeenth century–1773)

Saint John of God

Eighteenth century
Polychromed wood
36⅝ × 19⁵⁄₁₆ × 12⅝ inches (93 × 49 × 32 cm)
Convento de Santo Domingo y Museo Fray Pedro Bedón, Quito, Ecuador

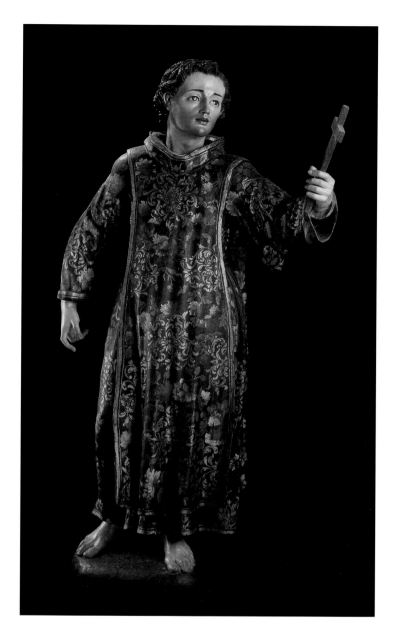

COLONIAL ARTWORKS WERE OFTEN EMPLOYED to celebrate the lives of pious individuals raised to sainthood. Such is the case in this sculpture of Saint John of God, the Portuguese founder of the Brothers Hospitallers of Saint John of God canonized by Pope Alexander VIII in 1690. Through a series of visions of both Christ and the Virgin—to which his upraised eyes in this work refer—the saint was awarded his appellation as well as his vocation. During the last decade of his life Saint John of God devoted himself to charitable works and the foundation of hospitals, founding his first hospital in Granada, Spain.

Attributed to Bernardo de Legarda, this eighteenth-century sculpture highlights the mastery of the polychrome wood technique in Quito. While the technique originated in Spain, the richness of color and broadening of the palette in works related to the *Escuela Quiteña* (School of Quito) find no European precedent.

Beginning in the late seventeenth century, Quiteño artists worked within the guild system, in which artists undertook training in order to master the highly specialized skills of various artistic trades. This sculpture is probably a product of Legarda's workshop, and the polychrome wood technique is itself the result of a refined division of workshop labor. A variety of artists were responsible for carving the sculpture (with experts assigned to various details from roughing out the form to completing the most difficult features, such as the hands and face), painting the sculpture (from flesh painting to textile painting), and ultimately assembling the finished piece. Saint John of God's habit reveals the *estofado* process, in which carved and treated wood was covered with a layer of gold leaf that was in turn covered by a subsequent layer of oil paint. Very fine lines (*sgraffito*) incised into the paint reveal the gold leaf below. The resulting effect, visible in the ornate floral decoration of Saint John of God's habit,

relates closely to textile patterns and highlights the emphasis on textile work throughout Quito. The face of Saint John of God is layered with pink tones and achieves a highly polished yet realistic patina.

While colonial sculptures often maintained rigidly frontal postures, in this example the slight tilt of Saint John of God's head, the subtle rotation of his torso in space, the upraised arm grasping a cross, and the weight balanced on one foot produce a dynamic composition.

Andrea Lepage

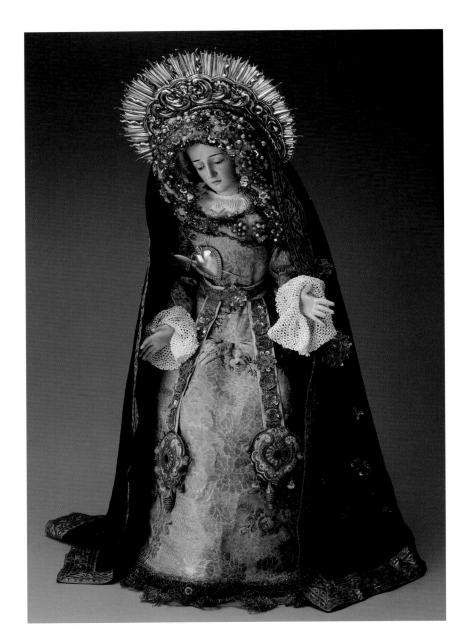

V-25 Caspicara (Manuel Chili)[†]

(Ecuadorian, 1723–1796)

Our Lady of Sorrows

Eighteenth century
Polychromed wood (*encarnada*); dress of brocade with gold
thread and semiprecious stones
37⅜ × 17½ inches (95 × 44.5 cm)
Museo de Arte Colonial, Casa de la Cultura Ecuatoriana,
Quito, Ecuador

PUBLISHED: *Breve catálogo* 1997, pp. 1, 33

THIS DRESSED POLYCHROME WOOD SCULPTURE of Our Lady of
Sorrows (*La Dolorosa*)—a subject inspired by the Virgin of Macarena
of Seville, Spain—was made by the *Escuela quiteña* (School of Quito)
master Manuel Chili, also called Caspicara. Throughout the eighteenth
century, artists active in Quito relied on European prints as artistic models,
although this practice did not prevent them from achieving original and
distinctly local compositions. Here, the artist's mastery of the medium is
apparent. Depicted without her dead son, the Virgin of Sorrows mourns
the suffering of Christ leading to his crucifixion. Caspicara conveys the
Virgin's sorrow with the sophisticated *encarnación*, or coloration, of her
skin and through her downward gaze. The subtle differences in pink tones
around the eyes reveal that the Virgin has been crying. As is characteristic
of Caspicara's sculptures, the hands set the tone of the work, and their
positioning creates a dramatic gesture of supplication. A silver broach
in the form of a sword-pierced heart reiterates the Virgin's suffering.

Colonial artworks were often employed as persuasive devices to
transmit Christian doctrine or Christian behavior. Visual aids were key
to arousing the emotions necessary to achieve spiritual enlightenment. In
this case, the intensely emotional and theatrical rendering of the sculpture
was meant to evoke feelings of empathy from the viewer. Through the
treatment of the psychological aspects of personality in both the face and
posture of the Virgin, the artist provided the viewer with a mirror for his
or her own sorrow for Christ's suffering.

The Catholic Church and religious confraternities were the main
patrons of the arts throughout the colonies, although images were also an
essential part of private devotion. Dressed Virgins were frequently com-
missioned by wealthy confraternities, and the high prestige of this particu-
lar sculpture is evident in the gold-threaded brocade and semiprecious
stones of her dress. In addition, her rich taffeta cloak is edged with gold
and silver threads and her veil ornamented with pearls. Each of these
elements, along with the lace at the sleeves and collar—which also serves
to draw additional attention to the sculpted hands and face—is part of
a particularly *quiteño* emphasis on realism in sculptural production.

Andrea Lepage

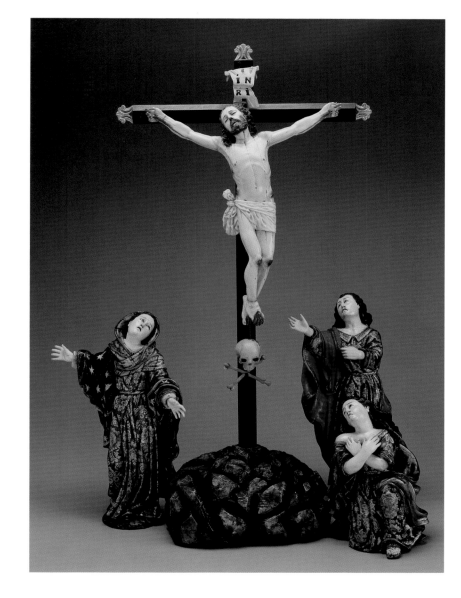

V-26 Caspicara (Manuel Chili)[†]

(Ecuadorian, 1723–1796)

Christ Crucified with the Three Maries

Eighteenth century
Carved and polychromed wood
Height: 33¹⁄₁₆ inches (84 cm)
Museo de Arte Colonial, Casa de la Cultura Ecuatoriana,
Quito, Ecuador

PUBLISHED: *Breve catálogo* 1997, p. 27

OF THE EPISODES COMPRISING the Passion of Christ, the Crucifixion is undoubtedly one of those most represented among the sculptural works produced in colonial Quito. Images of Calvary created for the altarpieces and chapels of Quito generally show Christ accompanied by the Virgin, Mary Magdalene, and Saint John. This work, however, presents a somewhat different composition, which alludes to the Gospel of Saint John.

The central element in this composition is the cross. Christ is depicted with his gaze turned toward the heavens. Realism and restraint are used in the depiction of his pallid body—there are few traces of blood or wounds, aside from on the hands, knees, and feet. Set above Christ's head is the inscription INRI (Jesus of Nazareth King of the Jews), and below the cross are the traditional skull and bones, alluding to Adam. The base, intended as an evocation of Golgotha, is composed of a structure simulating stone. Positioned at the foot of the cross are the three Marys: the Mother of Christ, shown with open hands; Mary Magdalene, kneeling with hands clenched to her chest; and Mary the wife of Cleophas, with arms outstretched.

This sculpture was probably part of a *locus orandi*, or devotional chapel, where one would retire to pray in private, and where it was quite common to find nothing more than a single image of the crucifix. What is unusual in this piece is the presence of the three Maries, which would have served to intensify the moment of meditation and invite imitation, particularly among women, of the observant figure of the Virgin.

Adriana Pacheco Bustillos

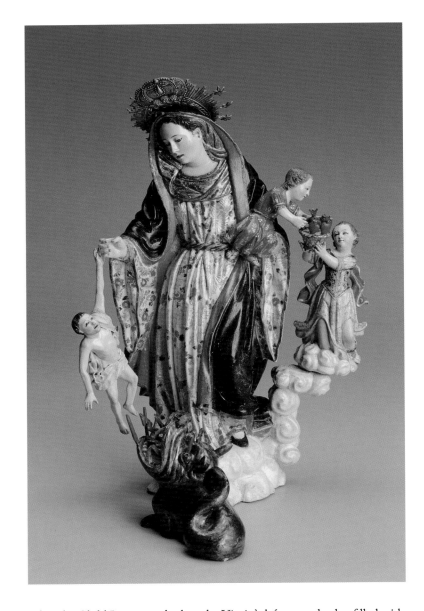

V-27 Caspicara (Manuel Chili)[†]

(Ecuadorian, 1723–1796)

Madonna of the Light

Eighteenth century
Polychromed wood
13 × 7½ × 3⁹⁄₁₆ inches (33 × 19 × 9 cm)
Museo Nacional del Banco Central del Ecuador, Quito, 270-13-69

DEVOTION TO THE *Virgen de la Luz*, or the Madonna of the Light, derived from the belief that the Virgin Mary had the power to save the souls of men condemned to eternal suffering in hell. This was a popular advocation in Spain and Spanish America during the eighteenth century, as evidenced by the large number of contemporary works devoted to the theme. Prints by the royal engraver Juan Bernabé Palomino (d. 1753), as well as a number of paintings by the eighteenth-century Mexican artist Miguel Cabrera and by the Venezuelan Juan Pablo López, are proof of the subject's importance during this period. Promoted by the Jesuit order, the cult of the *Virgen de la Luz* was nevertheless forbidden in 1770, reflecting the order's loss of power after its expulsion from Spanish territories in 1767.

The iconography of the Madonna of the Light is obviously indebted to that of Our Lady of Mount Carmel, who is often represented rescuing souls from Purgatory. In this group sculpture, just as in Palomino's engravings and in paintings by Cabrera, the Virgin pulls a man by his left arm, rescuing him from the jaws of a dragon, a symbol of Satan and a clear reference to the mouth of hell. To the right, an angel standing on clouds offers the Child Jesus, perched on the Virgin's left arm, a basket filled with hearts. In contrast to prints and paintings, the use of individual figures that can be moved around and observed from different angles, along with the natural three-dimensionality of sculpture and this work's colorful ornamentation, endows the scene with additional drama and realism. The spectator's gaze is immediately drawn to the spiral formed by the turning bodies of Jesus and Mary. The soul hangs from a thread tied to the Virgin's hand and seems to float and twist in space. In the precise, detailed rendering of the dragon, his bulging eyes and open nostrils compete for attention with the piercing tongues and arrows issuing from his mouth.

Carmen Fernández-Salvador

v-28 *Christ at the Column*

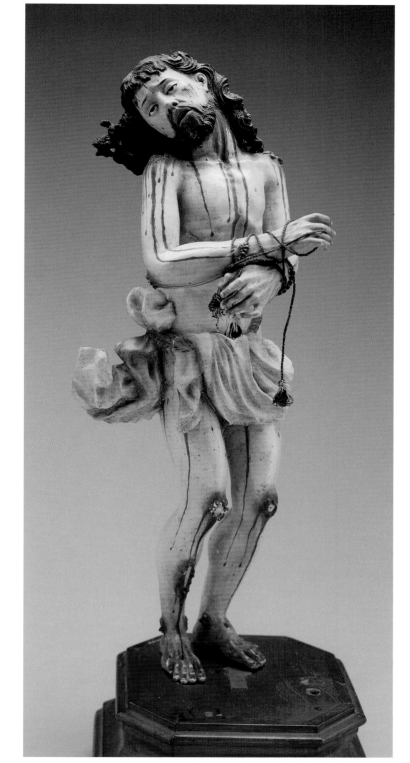

Quito, Ecuador
Eighteenth century
Painted and polychromed wood
20½ × 7¹⁄₁₆ × 8¹¹⁄₁₆ inches (52 × 18 × 22 cm)
Collection of Osvaldo Viteri, Quito, Ecuador

PUBLISHED: Kennedy 2002, p. 54

THIS HIGHLY EXPRESSIVE, Franciscan-inspired image of Christ exudes the physical torment of the Scourging. Both the column to which Christ was bound and the soldier assailing him have been lost from the sculptural group. Christ's hair is given a particularly forceful and agitated treatment, and the half-open eyes and grimacing mouth express intense pain. Blood trickles from the figure's sparse beard down his neck and body, further accentuating the extreme pallor of his skin, which is marked with wounds. In large and angular hands, the figure holds the rope that binds him; the draping of his loincloth billows from the waist, and his lacerated feet rest upon a wooden base, which is not original to the work.

From the earliest times of colonization, the Spanish evangelizers in Quito promoted ceremonial customs that were brought from Seville, where the Passion of Christ was the most important of the processional representations of Holy Week. Dramatic sermons and evocative images were used to stir compassion among the faithful, who would pray before images of the Passion in their private chapels. Prayers devoted to the Stations of the Cross, or the reading of other liturgical passages, needed visual reinforcement in order to achieve the appropriate spiritual frame of mind, as suggested by Ignatius of Loyola. In order to move followers to imitation, the depiction of such characteristics as emotion and turbulence were often preferred over charity when commissioning works.

Adriana Pacheco Bustillos

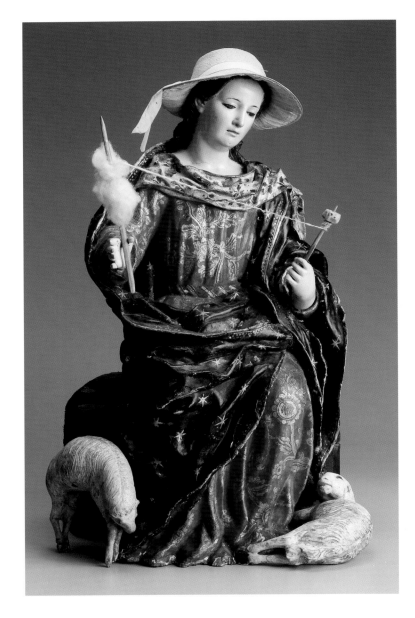

V-29 Bernardo de Legarda[†]

(Ecuadorian, end of the seventeenth century–1773)

Divine Shepherdess

Mid-eighteenth century
Polychromed wood, gold leaf, cloth stiffened with gesso and glue,
Panama straw hat, wood and wool spindle
21⅝ × 10⅝ × 9⅟₁₆ inches (55 × 27 × 23 cm)
Museo Nacional del Banco Central de Ecuador, Quito, Ecuador

QUITEÑO ARTISTS SUCH AS BERNARDO DE LEGARDA often included references to the artistic trades in their works. For example, the carpentry workshop of Saint Joseph—complete with realistic representations of the tools of his trade—was a common theme in works produced in Quito during the seventeenth and eighteenth centuries. Similarly, the Virgin was frequently shown seated and sewing, a pious activity often associated with women. In his representation of the Divine Shepherdess, Bernardo de Legarda highlights the industrious activity of the Virgin as she spins wool into yarn while at the same time celebrating trade production itself.

This commemoration of trade production was by no means contradictory to the sanctioned goals of art in the colonies. Indeed, art had a clear didactic function—it was used to convey religious doctrine, but also to teach proper behavior. Because individuals worshipped and meditated in front of sculptures and paintings, these works could provide ideal models of Christian behavior. In sculptures such as this one, the pious woman is shown resisting idleness and working industriously at her trade. In their treatment of these subjects, artists elevated their own trades by asserting their positive contributions to colonial society through the production of artworks.

Yet the construction of an artistic identity apparent in such works did not erase their religious associations. The Divine Shepherdess is the feminine counterpart of Christ as the Divine Shepherd and refers to the parable in which Christ brings a lost lamb back into the fold (cat. VI-96). Thus the docile lambs at the feet of the Virgin represent both Christ, as the Lamb of God, and the faithful.

The common emphasis on textile production in Quiteño sculpture is evident in both the Virgin's activity and her elaborately detailed dress, which was achieved using the *estofado* process (gold leaf covered by a layer of paint). Despite her seated position, the flowing drapery and the rotation of the figure in space suggest a dynamism of movement rarely employed to the same degree in Europe. The porcelain-like hands and face produce an idealized version of the Divine Shepherdess, while added details such as the hat and the spindle contribute to the sculpture's realism.

Andrea Lepage

v-30 Caspicara (Manuel Chili)[†]
(Ecuadorian, 1723–1796)

Woman of the Apocalypse
(called "The Virgin of Quito")

Second half of the eighteenth century
Carved, gilded, and polychromed wood, with silver wings and halo
25½ × 13 × 6¾ inches (64.8 × 33 × 17.1 cm)
The Brooklyn Museum of Art, New York, Gift of Mrs. Giles Whiting, 58.37

PUBLISHED: Fane 1996, cat. no. 89, pp. 232–33

EXHIBITED: Brooklyn, Phoenix, and Los Angeles 1996, cat. no. 89

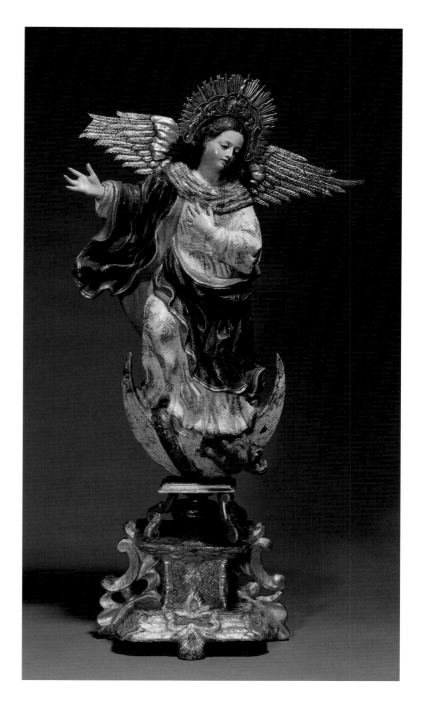

THIS IMAGE OF THE VIRGIN MARY is based on Apocalypse 12:1, in which is described "A woman clothed with the sun, and the moon under her feet, and on her head a crown of twelve stars." There follows a battle in which Saint Michael casts the devil from the heavens, and the woman is given "two wings of a great eagle" (12:14). This woman of the Apocalypse was interpreted by biblical exegetes as a symbol of the church of God and also as the Virgin Mary.

This sculpture is a variant of the image of the woman of the Apocalypse that the Franciscans in Quito commissioned Bernardo Legarda to create for the main altarpiece of their church on December 7, 1734. It is such an iconic image that it is called "The Virgin of Quito." Legarda's original creation, which is still in situ, inspired many replicas in various sizes and mediums. Numerous versions are known, including one in the Museo de Arte Religioso, Popayán (Colombia), compelling evidence of the export of such sculptures from Quito to other parts of South America.

The Virgin's pose never varies, nor do the blue, white, and rose of her garments or the crescent moon beneath her foot that tramples on the dragon/serpent that is Satan. Typical of Quiteño polychromy is the use of raised gilt designs over a background of solid color.

The iconography was particularly favored by the Franciscan order, though the many small versions extant suggest that the Virgin of Quito also had a considerable following among the laity. The iconography was long interpreted as an allegory of the Virgin's triumph over original sin; hence she is also the "Virgin of the Immaculate Conception." She is often shown holding a spear in her raised right hand, a combative pose that suggests her power to come to the aid of her devotees following natural disasters, abuse, and suffering.

Adriana Pacheco Bustillos and Suzanne Stratton-Pruitt

Bernardo Bitti[†]

(Italian, active Peru and Bolivia, 1548–1610)

Pedro de Vargas[†]

(Spanish, active Peru, 1553–after 1597)

Sculpture from the High Altar of the Jesuit Collegiate Church (La Compañía),
Cuzco, Peru
Polychromed and gilded relief of wood, maguey paste, and glued cloth
(*tela encolada*)
1583–86
Instituto Nacional de Cultura (Museo Histórico Regional), Cuzco, Peru

v-31 *Saint James Major*

55⅛ × 27³⁄₁₆ × 6¹¹⁄₁₆ inches (140 × 69 × 17 cm)

EXHIBITED: Cuzco 1972

v-32 *Saint Ignatius of Antioch*

52⅜ × 41¾ × 6¹¹⁄₁₆ inches (132 × 106 × 17 cm)

PUBLISHED: *Perú indígena* 2004, cat. no. 160

EXHIBITED: Cuzco 1972; Barcelona, Madrid, and Washington 2004,
cat. no. 160

v-33 *Saint Sebastian*

55⅛ × 27³⁄₁₆ × 6¹¹⁄₁₆ inches (140 × 69 × 17 cm)

PUBLISHED: *Siglos de oro* 1999, cat. no. 80

EXHIBITED: Cuzco 1972; Madrid 1999 *Siglos de oro*, cat. no. 80

v-34 *Saint Margaret*

55⅛ × 27³⁄₁₆ × 6¹¹⁄₁₆ inches (140 × 69 × 17 cm)

EXHIBITED: Cuzco 1972

v-35 *Saint Gregory the Great*

51⅛ × 34¾ × 6¾ inches (130 × 88 × 17 cm)

EXHIBITED: Cuzco 1972

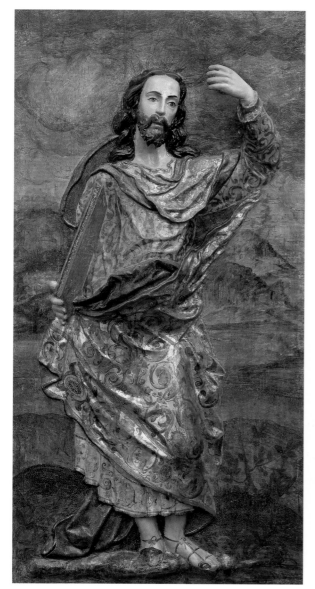

v-31 Saint James Major

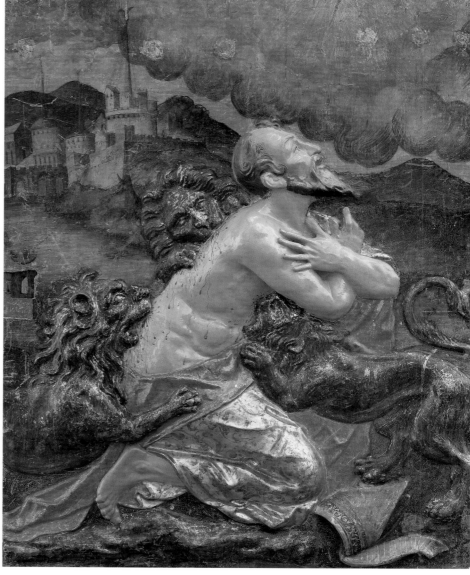

v-32 Saint Ignatius of Antioch

THESE SCULPTURES PROBABLY COME FROM the high altarpiece of the Jesuit church (La Compañía) in Cuzco (see Mujica Pinilla et al. 2002). Dedicated to the feast of the Transfiguration (August 6), the altarpiece was commissioned around 1583 by the rector José Teruel as construction of the church—under the direction of the Andalusian architect Juan Ruiz— was coming to an end. The Jesuits had come to Cuzco in 1571 and began building on the present site eight years later. The altarpiece was largely destroyed in the earthquake of 1650. Several elements, including the statues of the Trinity, were reemployed for the present structure, but these reliefs were lost until their discovery in the 1960s by Teófilo Benavente Velarde in the town of Jesús del Monte. While the building's architect could have had some responsibility for the overall design of the structure, which had architectural elements—described in a seventeenth-century chronicle as consisting of pyramidal columns with capitals, gilt and polychromed with enamel tones—the Jesuit painter Bernardo Bitti specifically came

to Cuzco from Lima to direct the execution of the altarpiece's paintings and sculptures. The central element was the artist's painting of the Trans-figuration, which is lost. He also designed the reliefs, but their execution seems largely to have been the work of his collaborator, the Andalusian artist Pedro de Vargas.

Describing his role as an assistant to Bitti, on January 18, 1585, Vargas stated (as translated by Gauvin Alexander Bailey), "It is necessary for us to be more than just painters, since we are responsible for making the whole structure and figures for them, and after all of that I have to do the gilding and tooling of the altarpieces." Vargas also noted that Bitti had worked on the altarpiece for one and a half years before being called away by Diego de Torres Bollo to start a new project at the Jesuit foundation at Juli on Lake Titicaca as well as Chuquiabo (present-day La Paz). Vargas estimated that it would take two and a half years to finish the statues and reliefs. He professed that it would be better than the team's altarpiece in

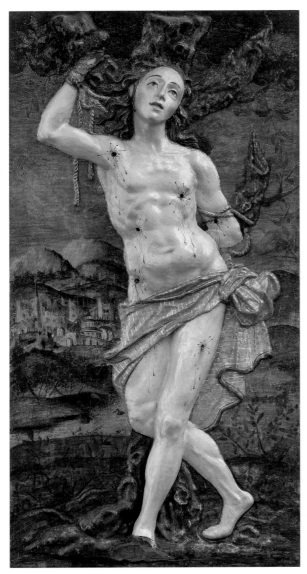

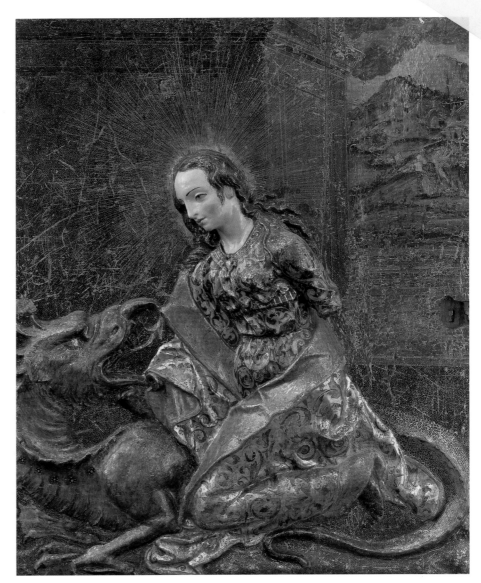

v-33 Saint Sebastian

v-34 Saint Margaret

the Jesuit church in Lima (cat. 000). Shortly after Vargas's report, on January 27, the patron at Cuzco, José Teruel, wrote to Claudio Aquaviva, the General of the Jesuit Order in Rome, saying that two tiers had been completed, and that the whole structure would be worth five thousand ducats.

To mold the reliefs, the artists used a combination of the paste of the maguey plant, native to Peru, and *tela encolada,* or canvas dipped in glue in a technique similar to that of papier-mâché. This working method, adapted in part from native practices, was less time-consuming than wood-carving and considerably facilitated production of a large altarpiece—though, if we are to believe Vargas, it still took over four years to complete the structure. *Estofado,* or patterns scratched in the paint revealing the gilt underlayer, considerably enrich the surfaces. The technique is such an essential part of the process of the gilding and tooling, which Vargas stated that he executed, that it would suggest most of the final stages of the work on the sculptures are by him. It would also seem from Vargas's testimony

that Bitti only painted the designs on the panels and that Vargas did the rest of the work.

Teruel, the rector of the church, would have dictated the subject matter, though from letters that both he and Torres Bollo sent to the Jesuit General in Rome about Bitti's activities, it is clear that there was much interest at the order's headquarters in what was happening artistically in the Peruvian outposts where decoration of the churches preceded even that of the Gesu and Sant'Ignazio, the Jesuit churches in Rome. Although the exact provenance of Bitti's and Vargas's reliefs is not known, the Jesuit monogram appears on the *Saint Margaret* and the *Saint Gregory the Great.* The saints in the reliefs reflect a number of the Jesuits' concerns. Saint Ignatius of Antioch is the namesake of the founder of the Jesuit order, Ignatius Loyola, who was not canonized until 1622. Ignatius of Antioch was thrown to the lions and martyred in the Colosseum in Rome. Saints Sebastian and Margaret, early converts to Christianity, also endured

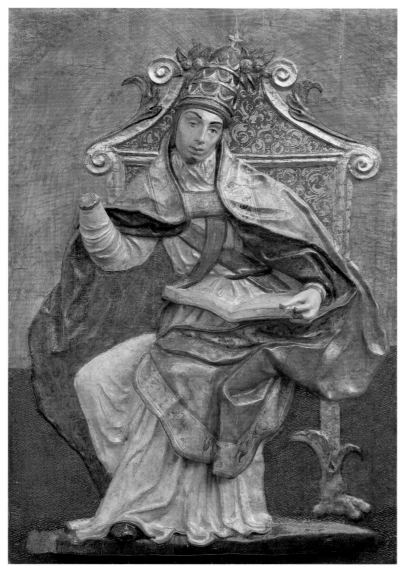

v-35 Saint Gregory the Great

ordeals for the new faith. Sebastian, a Roman soldier, survived numerous arrow wounds, and Margaret the fangs of a dragon. Saint James Major, the patron of Spain, is shown, appropriately for a work in the church of missionaries, as a pilgrim. The Jesuits were singularly devoted to the papacy, and Pope Gregory the Great was the most prominent early leader of the church.

In 1600 the church's chronicler, Antonio Vargas, described the completed altarpiece, saying that "according to all the sculptors, painters, and good craftsmen of the whole kingdom, it was the largest, the most beautiful and the foremost that can be found in it, for its statues, images, prospect, presence, painting, and dimensions" (translation my own).

Carl Brandon Strehlke

v-36 *Christ Child of Huanca*

Peru
c. 1600–1610
Polychromed wood with gilding
32⁵⁄₁₆ × 16¾ × 8¹¹⁄₁₆ inches (82 × 42.5 × 22 cm)
Church of San Pedro, Lima, Peru

PROVENANCE: Templo de la Compañía de Jesús du Lima

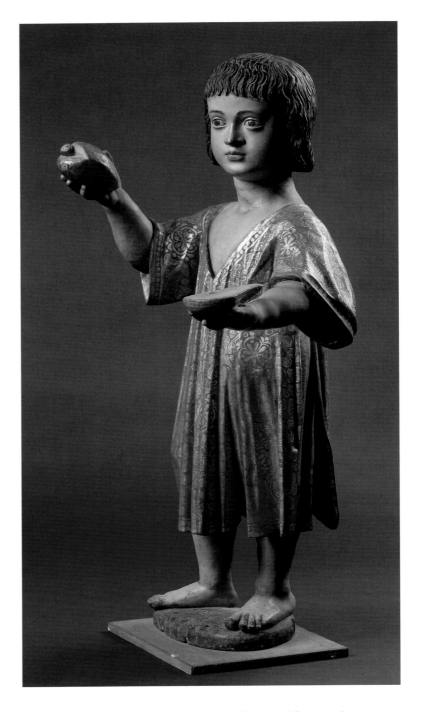

THIS IMPORTANT PIECE is one of the oldest sculptures preserved in the church of San Pedro in Lima. Style and iconography alike indicate that it is a Christ Child of Huanca, belonging to a devotion encouraged in Cuzco and Lima by the first Jesuits. The figure is dressed in a reddish "indigenous" tunic and has its hair cut in the manner of Indian converts at the end of the sixteenth century and the beginning of the seventeenth, as can be seen in the drawings of the indigenous chronicler Felipe Guamán Poma de Ayala (c. 1550–c. 1620). Transformed into a sublimated Eros or a Jesuit emblem of Divine Love among the Indians of Peru, the Christ Child of Huanca holds a heart in each hand by way of attributes: one raised and bearing the monogram of Mary Queen of Heaven, and the other half cut away.

The sculpture was not originally located in the sacristy of the church of San Pedro, but must have occupied the main lower niche of the altarpiece dedicated to the Christ Child of Huanca that was erected in 1663 in the second chapel. The cult of the Christ Child of Huanca in the church of San Pedro was the responsibility of the *Congregación de los Naturales* (Congregation of Natives) and gained such prestige among the Indians of Lima that the religious paintings adorning the chapel gave prominence to portraits of noble Indian donors as eminent promoters and champions of the devotion. According to the *Cartas Annuas* of 1660–62, the altarpiece of the Christ Child was constructed with material from the former principal altarpiece of the Jesuit church, which had been demolished at the beginning of 1624. Still more significant is the fact that this original altarpiece had been painted and carved by the Italian mannerist artist Bernardo Bitti, who arrived in Lima in 1575.

It is still not known who executed this sculpture. Although little of Bitti's sculptural work in the round is known, this piece is rather too iconic and static to be by the Italian master. Much of Bitti's work in Lima, however, was done in collaboration with the Spanish Jesuit painter and sculptor Pedro de Vargas. The sculpture may also have been produced in their workshop by some indigenous craftsman, since it is unlikely, as Teresa Gisbert has pointed out, that the Jesuits would turn to someone else when they had two artists on hand. What is certain is that Bitti traveled for the first time to Cuzco around 1583, where it was proposed to him—as Pedro de Vargas himself attests—that he manufacture altarpieces with paintings, sculpture, and relief carvings superior to those he had executed for the Colegio de Lima. In fact, one of his most famous documented works— now lost—was the sculpture of the Christ Child of Huanca made for the Indian chapel annexed to the Jesuit church in Cuzco, where the indigenous confraternity dedicated to the devotion operated. According to an anonymous Jesuit chronicler of 1600, this figure of the Christ Child "was without its equal in this city, in its kind" and was attired as an Inca and

carried on a silver litter during the Corpus Christi celebrations (a practice prohibited by Manuel de Mollinedo y Angulo during his term as bishop of Cuzco from 1673 to 1699). Since the cult of the Christ Child of Huanca originated toward the end of the sixteenth century in Cuzco and not in Lima, this sculpture would be associated with the workshop of Bitti during his third and last residence in Lima (c. 1600–1610), when various works were produced for the church of San Pedro and the celebration of the beatification of Saint Ignatius of Loyola in 1610. On that occasion the Jesuits became the great promoters of a Catholic religious syncretism, using Inca religious symbols to articulate a triumphant rhetoric celebrating the successful integration, acculturation, and evangelization of the Indians of the New World.

Ramón Mujica Pinilla

V-37 Baltasar Gavilán

(Peruvian, active c. 1734–53)

Death the Archer

1753
Polychromed wood
83⅞ × 35⁷⁄₁₆ × 51³⁄₁₆ inches (213 × 90 × 130 cm)
Convento de San Agustín, Lima, Peru

PUBLISHED: Anonymous 1873, pp. 197–99; Gisbert 1999, pp. 205–20; Estabridis Cárdenas 2004, pp. 122–23; *Perú indígena* 2004, cat. no. 342

EXHIBITED: Barcelona, Madrid, and Washington 2004, cat. no. 342

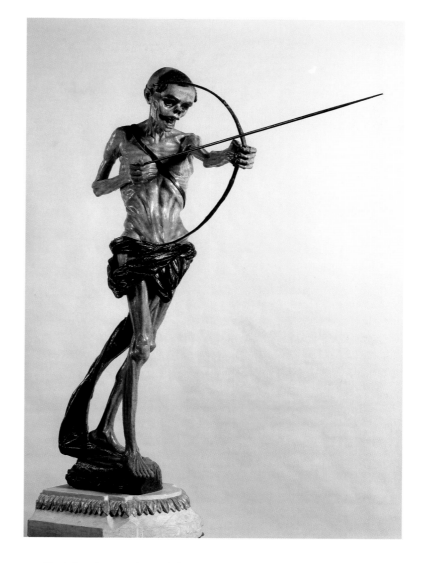

ACCORDING TO THE *TRADICIONES PERUANAS* of Ricardo Palma (1833–1919), *Death the Archer* was the last work executed by the mestizo sculptor Baltasar Gavilán, in 1753. After successfully bringing to a close his contract with the Augustinian monastery in Lima, which had commissioned the work, Gavilán returned home and was overcome by sleep. At midnight he awoke, and when he opened his eyes he saw the figure of Death standing menacingly at the foot of his bed. So extraordinarily realistic was the piece that the sculptor forgot that it was a work of his own hands, and crying out in terror he died "in a fit of madness the very day he finished the skeleton."

In fact, the sculpture was one of the *pasos de misterio*, or stations (that is, elaborate processional ensembles with symbolic constructions or evangelical scenes), that were paraded on Holy Thursday by the Confraternity of the Christ of Burgos, venerated in the church of San Agustín in Lima since 1593. According to an anonymous eighteenth-century chronicler, the first or second litter at the beginning of the procession displayed a "human skeleton, a most exquisite work of art, with an apple tree at its back, a bow, arrow, and scythe in its hand; and at its feet, crowns, tiaras, and miters." A painting from the early nineteenth century, preserved by the Hispanic Society of America in New York, shows that in the Holy Thursday procession in Lima, Death was followed by no fewer than nine stations, including the Entry of Jesus into Jerusalem, the Last Supper, the Agony in the Garden, the Arrest, the Crucifixion, and the holy relic of the *Sanctum Lignum Crucis*, carried by the Confraternity of the True Cross founded by Francisco Pizarro in 1540. Escorted by processional

candlesticks, the members of the confraternity of the Christ of Burgos marched with six black flags: three displaying the emblems of the enemies of the soul—the world, the devil, and the flesh—and three displaying Death with its triumphs: its religious trophies (tiaras, birettas, and miters) and its royal trophies (crowns and scepters).

The crowns, tiaras, and miters at the feet of Death were a baroque hieroglyph of *vanitas*, or disillusion with the world and its riches and ephemeral knowledge. This iconography was widespread in allegorical compositions of the Peruvian baroque: Death raises its scythe to cut down the Tree of Vanity, or prepares to let fly an arrow from its bow and capture a king, a pope, a cleric, or an Inca. On more than one occasion, Gavilán's figure of *Death the Archer* decorated the catafalques erected in the cathedral of Lima, as, for example, the one constructed in 1789 for the royal funerary rites of King Carlos III.

Owing to lack of funds, the confraternity of the Christ of Burgos suspended its Holy Thursday processions between 1782 and 1797, but they continued thereafter until a little past 1824, into the period of Peru's independence, at which point the feared and famous sculpture of Gavilán fell into disuse, in part because it embodied a somewhat medieval aesthetic out of tune with the new enlightened currents of thought.

Ramón Mujica Pinilla

v-38 Altarpiece of the Virgin of Copacabana

Alto Perú (Bolivia)
c. 1740/70
Polychromed gesso and maguey, gold leaf, and mirrors
22⅞ × 25⅝ × 4¾ inches (58 × 65 × 12 cm)
Museo Pedro de Osma, Lima, Peru

PUBLISHED: Gjurinovic Canevaro 2004, pp. 146–47

THE SOMEWHAT UNGAINLY IMAGE of the *Virgen de la Candelaria* (Our Lady of Candlemas), which adorned the famous sanctuary of Copacabana in Alto Perú (present-day Bolivia) from the first third of the seventeenth century, quickly became one of the most important religious icons in the viceroyalty. The sculpture, created in 1584 by an enterprising indigenous convert, Francisco Tito Yupanqui, was a replacement for the image of Copacabana, a pre-Hispanic idol venerated since ancient times on the Collao meseta, by the shores of Lake Titicaca. The substitution of images led to the rapid development of a cult among local Spanish and indigenous peoples, who would visit the site in mass pilgrimages. By the second half of the century a tremendous following had developed for the Virgin of the Lake, as she was also known. This phenomenon is reflected in the large number of portable altarpieces such as this one, which were often transported to Spain by colonial functionaries or wealthy Indians, providing testimony of the Marian fervor that had spread to the New World. Even the viceroy, José Antonio Manso de Velasco, Conde de Superunda, had

one shipped as a gift to the nuns of the Order of Saint Clare in La Rioja, Spain, in 1749. The renowned dramatist Pedro Calderón de la Barca also owned such a piece, which undoubtedly contributed to his sacramental work *La Aurora de Copacabana,* in which he tells of the origins of the famous sanctuary.

These *retablos,* or altarpieces, were generally made of wood, covered with sheets of embossed silver and topped by tracery crownwork. The interior consisted of a series of reliefs in gilt and polychromed gesso and maguey. Created in the form of a triptych with the image of the Virgin presiding at the center, the pieces show a strong influence from popular indigenous tastes. While this example has lost its silver casing, its fragile interior has been preserved intact. The center represents the Churrigueresque altar of Copacabana, reproduced in painstaking detail. Unlike other such *retablos,* the artist has succeeded in maintaining lifelike proportions between the central image and the altar, making it possible to identify the saints occupying secondary niches and even the portraits of bishops that crown the lateral niches of the main section and the heads of martyrs and popes in the upper section. On the side panels are two penitent saints, Mary Magdalene and Saint Mary of Egypt; two martyrs, Saint Catherine of Alexandria and Saint Barbara; and two apostles, probably Saint James and Saint Bartholomew. The presence of these images suggests that the work was executed after the late seventeenth century, for the earlier tendency was to include representations of angels. The Copacabana altarpieces offered a votive remembrance of the highland sanctuary, transporting the aura and tremendous religious importance of that chapel to the intimacy of the home.

Luis Eduardo Wuffarden

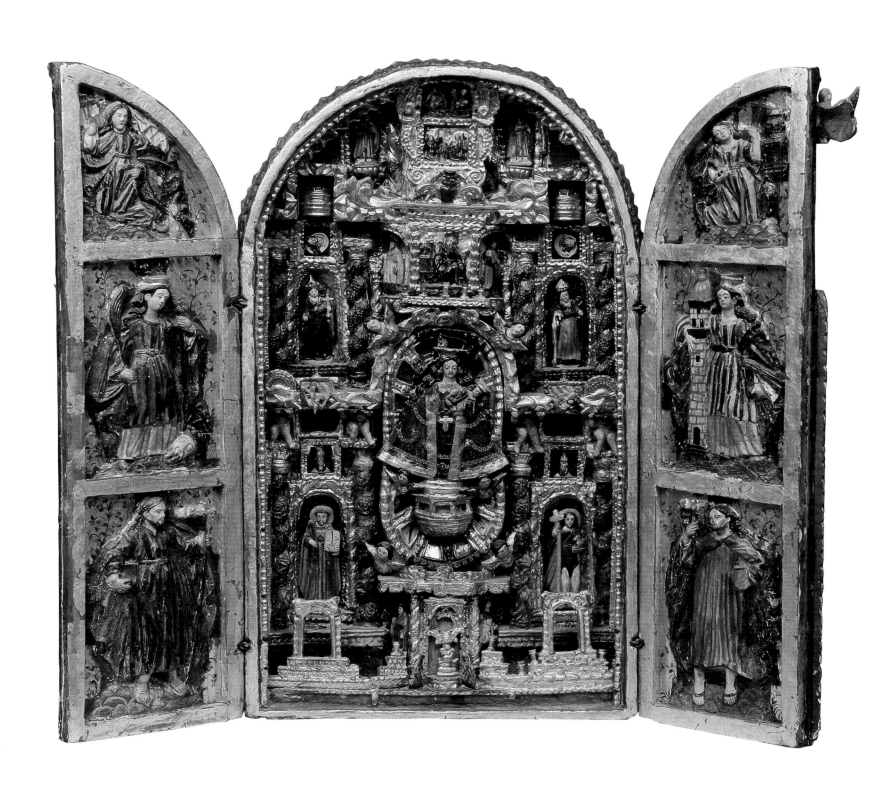

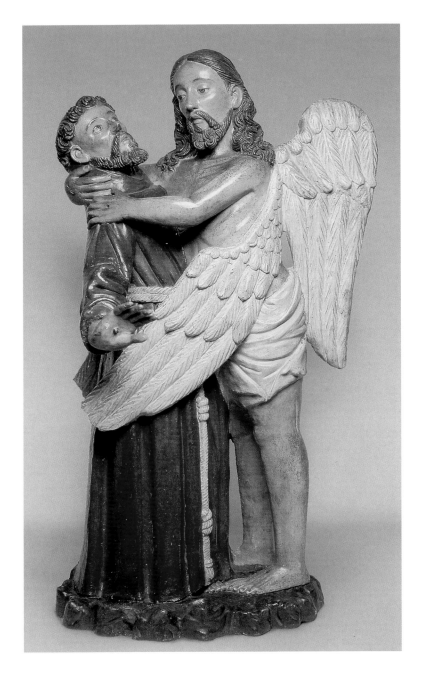

v-39 *Saint Francis Receiving the Stigmata*

Franciscan workshop, Brazil
Seventeenth century
Polychromed terracotta
66⅞ × 30¾ × 11 inches (170 × 78 × 28 cm)
Museu de Arte Sacra, São Paulo, Brazil

PUBLISHED: Lemos et al. 1983, pp. 28–29; *Brésil baroque* 1999, fig. 117;
Lemos 1999, p. 76

EXHIBITED: Paris 1999

THIS IMAGE OF SAINT FRANCIS receiving the stigmata recreates the
famous miracle at Mount Alvernia when the praying saint, during a vision
of the Crucifixion, sees Christ with three pairs of seraphic wings (one
pair is missing on this sculpture) and then receives the five stigmata of the
Passion of Christ (on his feet, hands, and left side of the thorax). Here, the
seraphic Christ is seen affectionately embracing Saint Francis, a Counter-
Reformational adaptation to the episode, which relates that Christ freed
one of his arms from the Cross in order to embrace the praying saint.

The fusion of two thematic elements seems strained, which shows
the difficulty this colonial artist had in adequately harmonizing the distinct
gestures of both figures. Saint Francis fixes his gaze on the cross above,
evidently unaware of the seraphic Christ's proximity.

This work was most likely executed by a Franciscan monk at one
of the monastic workshops that dotted the coast of the present-day states
of Rio de Janeiro and São Paulo. The beautiful sculpture exudes some of
the warmth that characterized the popular Franciscan order, members of
which were in constant contact with the people during the colonial period,
from birth to burial.

Myriam A. Ribeiro de Oliveira

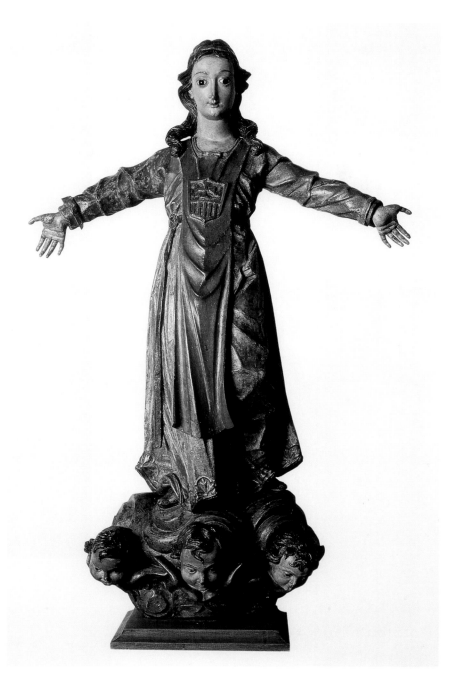

v-40 O Aleijadinho (Antônio Francisco Lisboa)[†]

(Brazilian, c. 1738–1814)

Our Lady of Mercy

c. 1760–74
Polychromed wood
39 × 24¾ × 10⅝ inches (99 × 63 × 27 cm)
Private collection

PROVENANCE: Confraternity of Our Lady of Mercy, church of Saint Joseph, Ouro Prêto; collection of Antônio Carlos Kifuri, São Paulo; Museu de Arte Sacra, São Paulo

PUBLISHED: *Arte barroca* 2000, p. 67; Oliveira et al. 2002, pp. 44–45

THIS IMAGE OF OUR LADY OF MERCY, which is presently in the collection of the Museu do Pilar in Ouro Prêto, is a small masterwork bursting with life and almost childlike ebullience. These characteristics, along with an unfettered sense of ingenuousness, reflect an extremely privileged period in O Aleijadinho's professional career, prior to the onset of the debilitating condition that gave him his nickname. The vibrant spirit of this young Virgin is echoed in an image of an adolescent angel bearing flowers that dates from 1772–74 and which seems to dance above the chancel at the church of Saint Francis of Assisi in Ouro Prêto. Both works were conceived with a sense of life-affirming optimism, the product of a young, more jovial Antônio Francisco Lisboa, who was an extroverted lover of life's pleasures.

The glass eyes of this image are intentionally fixed on the praying devotees below, while cherubs on the base mirror this rapt gaze. The piece was most likely created for the altarpiece of the Confraternity of

Saint Joseph in Ouro Prêto, but it was later transferred to the main altar at the church of Mercês.

The subject is dressed in the habit of the Mercedarian Order, which is identified by the monastic belt dangling to her right, and by the scapular bearing the order's insignia. This heraldic shield is divided into two horizontal fields—the first features a silver Cross of Malta, and the second is dominated by four red bars, from the royal shield of Aragon. Traditional representations of Our Lady of Mercy sometimes include two images of kneeling slaves on the Virgin's cape or robe, which are not seen here, owing in part to the sculpture's narrow base, which is formed by clouds and putti. We can see that a cape of real cloth once adorned this image, as suggested by the figure's open arms and the empty space left along the sides, between the Virgin's tunic and her hair.

Myriam A. Ribeiro de Oliveira

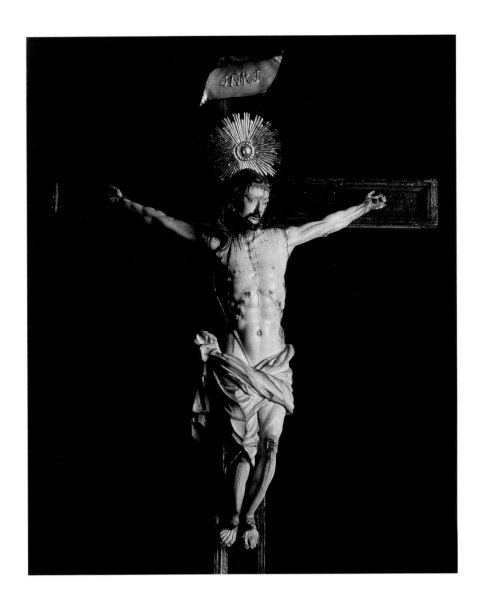

V-41 O Aleijadinho
(Antônio Francisco Lisboa)[†]

(Brazilian, c. 1738–1814)

Crucifix—Bom Jesus de Matosinhos

c. 1775–90
Polychromed wood
Christ: 22½ × 16½ × 4⅜ inches (57 × 42 × 11 cm)
Cross: 51⅝ × 23⅝ × 10¼ inches (131 × 60 × 26 cm)
Museu Aleijadinho, Ouro Prêto, Minas Gerais, Brazil

PROVENANCE: Church of Our Lady of Mercy and Pardons, Ouro Prêto

PUBLISHED: Bazin 1963, p. 368; Oliveira et al. 2002, pp. 92–93

THIS IMAGE OF CHRIST ON THE CROSS represents one of the better-known themes in Luso-Brazilian Christian iconography, the "Bom Jesus de Matosinhos," which was venerated in Matosinhos, on the outskirts of Porto, in the north of Portugal. The elements that link the piece to this tradition include the positioning of the feet, which are nailed to the cross separately, instead of one over the other; a loincloth that partially conceals the right leg; and, perhaps more significantly, the figure's eyes, which look out in different directions: one above, and the other below. This unusual conceit is theologically symbolic—in his moment of agony, Christ is seen as tied both to the heavens (the Heavenly Father) and to the earth (the Virgin, the disciple John, and Mary Magdalene are generally situated at the foot of the cross).

This excellent sculpture also exhibits other formal characteristics of O Aleijadinho's style, such as the athletic, well-defined muscles and bones, firm countenance, sinuous locks of hair, arched eyebrows, and typically pinched lips. The angular draping of the loincloth forms a pattern of crossed diagonals.

Since this piece was intended for devotional purposes, either to be included on the main altarpiece or in the sacristy of the Church of Our Lady of Mercy and Pardons in Ouro Prêto, the artist accentuated the expressive elements of the face to convey a sense of profound sadness. The work is currently in the collection of the Museu Aleijadinho, which is part of the parish church of Our Lady of the Conception.

Myriam A. Ribeiro de Oliveira

v-42 O Aleijadinho
(Antônio Francisco Lisboa)[†]

(Brazilian, c. 1738–1814)

Bishop

c. 1791–1812

Polychromed wood

17 × 7½ × 6 inches (43 × 19 × 15 cm)

Collection of Beatriz and Mário Pimenta Camargo, São Paulo, Brazil

PUBLISHED: *Brésil baroque* 1999, fig. 112; Whistler 2001, p. 70; Oliveira et al. 2002, pp. 254–55

EXHIBITED: Paris 1999; Oxford 2001

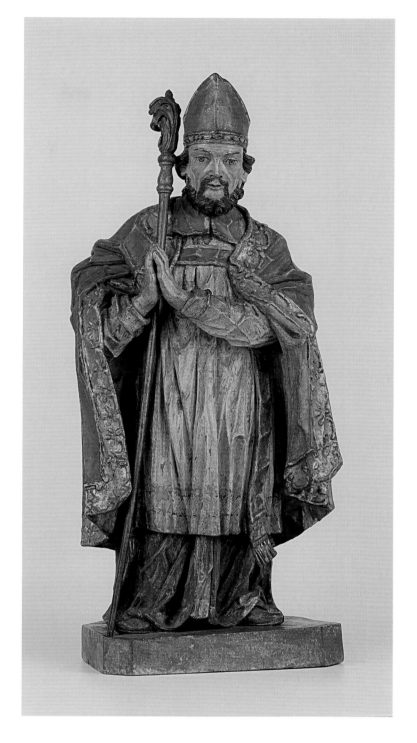

THIS SCULPTURE OF A BISHOP is one of the finest works attributed to O Aleijadinho in a private Brazilian collection. Some of his typical stylistic characteristics include the eyebrows, which form a continuous line with the nose; the large, almond-shaped eyes; the moustache emerging from the subject's nostrils; the position of the feet; and the bold "Gothicizing" drapery, which is particularly accentuated on the left sleeve of the subject's short tunic (an ecclesiastical rochet).

The contributions of O Aleijadinho's workshop are evident in some of the sculptural details, such as the awkward position of the arms and the disproportions between the torso and legs, which are clearly too short for an image of this size. Nevertheless, it is quite probable that these elements would be visually corrected when viewed from below, since the piece was originally intended for one of the side niches of an altarpiece.

The work was sculpted from a single block of wood with the exception of the hands, which were added. The polychromy is simple and employs bold colors and gilding; border patterns in *pastiglio* can also be discerned.

Based on the iconographical features of the sculpture and the saint's popularity in Minas Gerais, where it was made, the most likely identification of the subject is Saint Blaise, the Bishop of Sebaste.

Myriam A. Ribeiro de Oliveira

v-43 O Aleijadinho (Antônio Francisco Lisboa)[†]

(Brazilian, c. 1738–1814)

Saint Joachim

c. 1760–74
Polychromed wood
30⅜ × 15⅜ × 8¼ inches (77 × 40 × 21 cm)
Museu Arquidiocesano de Arte Sacra de Mariana, Minas Gerais, Brazil

PUBLISHED: Bazin 1972, pp. 201–2; *Brésil baroque* 1999, fig. 34; Oliveira et al. 2002, pp. 40–41

EXHIBITED: Paris 1999

THIS IMAGE OF SAINT JOACHIM is one of the most expressive works from the first phase of Lisboa's, or O Aleijadinho's, career, which spans from about 1760 to 1774. According to Germain Bazin, this sculpture represents the moment immediately after the Annunciation to Anne, when the angelic messenger Gabriel informs her that she is pregnant. An ecstatic Joachim, who until then had been excluded from the circle of the Just, rushes to meet his wife Anne. This encounter, at the Golden Gate of Jerusalem, has been depicted by Giotto as well as other artists.

An image of Saint Anne, of Portuguese origin, inserted in the altarpiece of Our Lady of Carmo da Matriz in Congonhas do Campo, forms an iconographical pair with this sculpture of Saint Joachim, which once occupied a parallel place in this church, until it was moved to the Museu Arquidioceseno de Arte Sacra de Mariana, where it is presently exhibited.

The sculpture, which is executed in wood, exhibits polychromy and gilding with sgrafitto, and features raised border patterns executed in *pastiglio*. The face is given a spiritual expression, despite the trace of a smile. The figure's hands and legs are clearly muscular. The defined pleating of the long tunic suggests bodily forms. The robes and cloak, which extend floating to the right of the sculpture, were technically devised to provide additional support for the legs, which almost seem to be dancing. O Aleijadinho's style is clearly evidenced in the bony treatment of the face, the pinched lips, eyebrows that form a continuous line with the nose, and a long, cascading beard.

The disproportionate dimensions of the head and legs were no doubt an intentional device aimed at reinforcing the sense of movement, especially when viewed from below, an angle at which the piece would generally be seen, since it was destined for inclusion in one of the altarpiece's niches.

Myriam A. Ribeiro de Oliveira

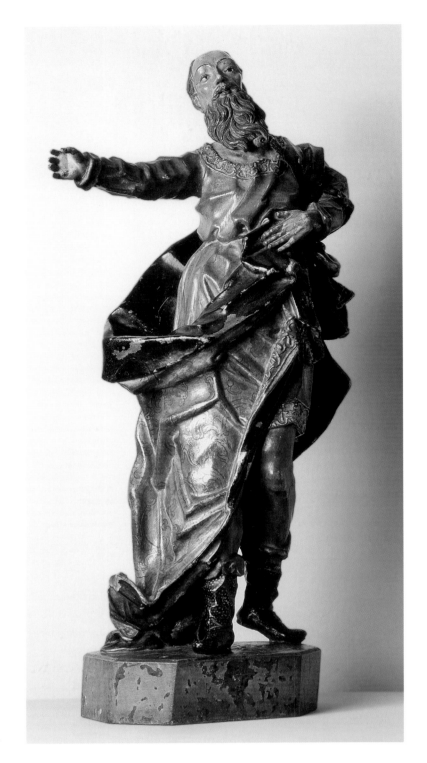

V-44 O Aleijadinho (Antônio Francisco Lisboa)†

(Brazilian, c. 1738–1814)

Decorative element (escutcheon with cherub)

c. 1775–1800
Wood
30¾ × 66⅞ × 11 inches (78 × 170 × 28 cm)
Inscribed on scroll: *Feito a custa de Antônio de Abreu Guimarães*
Collection of Beatriz and Mário Pimenta Camargo, São Paulo, Brazil

PUBLISHED: Bazin 1963, pp. 280–81; *Colecção Camargo* 1991, p. 78, fig. 117; *Brésil baroque* 1999, fig. 196; Santos Filho 2003, pp. 67–80

EXHIBITED: Lisbon 1991; Paris 1999

THIS SCULPTURAL RELIEF was originally one of the carved decorative works executed by O Aleijadinho and his workshop for the chapel at the Fazenda do Jaguara, in Minas Gerais, during the last quarter of the eighteenth century. The inscription, translated as "commissioned by Antônio de Abreu Guimarães," identifies the piece as belonging to the owner of the plantation estate that commissioned the work, but it does not identify the artist who created it.

The series of carved works at the Jaguara chapel included four altarpieces, two pulpits, choir and nave balustrades, a crossing arch escutcheon, and this relief, which was probably placed beneath the choir, near the main chapel door. In 1910, when the estate was acquired by an Englishman, the Catholic chapel was dismantled and its furnishings were donated to the main church at Nova Lima, where they are located to this day. However, some of the pieces, including this relief, found their way into private collections.

O Aleijadinho's imprint is evident in the cherub's face, with its almond-shaped eyes and well-designed lips, as well as in the fluid and elegant treatment of rocaille.

Myriam A. Ribeiro de Oliveira

V-45 O Aleijadinho
(Antônio Francisco Lisboa)[†]

(Brazilian, c. 1738–1814)

Saint Anne Teaching the Virgin

c. 1775–90
Polychromed wood
37 × 23⅝ × 17⅜ inches (94 × 60 × 44 cm)
Paroquia Nossa Senhora do Rosario/Mitro Arquidiocesana de
Belo Horizante, Minas Gerais, Brazil

PUBLISHED: *Brésil baroque* 1999, fig. 22; *Arte barroca* 2000, p. 67;
Oliveira et al. 2002, pp. 70–71

EXHIBITED: Paris 1999

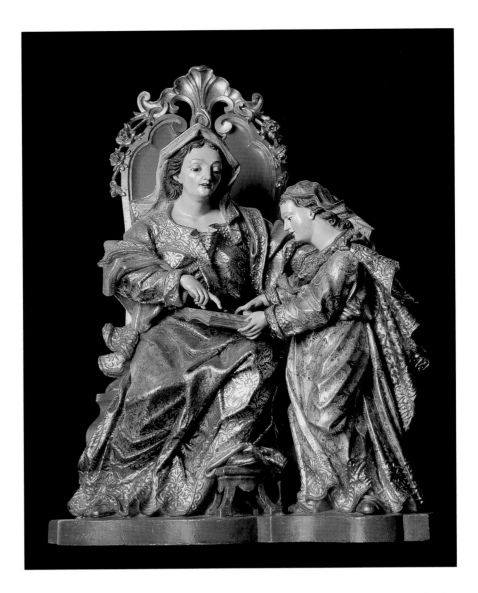

THIS WORK DEPICTS SAINT ANNE IN MIDDLE AGE, comfortably ensconced in an elaborate, high-backed chair, her left foot supported by a small footrest, and her left arm embracing the young Virgin, who here appears to be about 8 to 10 years of age. Seemingly immersed in their reading, both figures point to the book that sits opened in Anne's lap. The two figures are perfectly harmonized. This masterpiece shows Antônio Francisco Lisboa, or O Aleijadinho, at the height of his mature style, which is marked by heightened realism without the hesitancy of earlier works or the famous "stylizations" that would later be employed, when the physical limitations of the sculptor's illness would force him to use greater economy in details.

The draped garments fall naturally, tracing bodily contours and revealing a sense of movement, which is particularly apparent in Saint Anne's right leg and along the left side of the young Virgin's body. Despite the somewhat idealized depiction of these two figures, the natural rendering of faces suggests real, flesh-and-blood models. The focus of this composition is centered on the book, in which, despite some textual lacunae, one can discern the three opening verses of the Magníficat of Mary (Luke 1:46–48).

The ornate details of the chair, with its sinuous legs, scooped shell motif, and delicate garlands of roses (symbol of the Virgin), indicate that it was executed after 1770, since it is a clear example of the José I style of Portuguese rococo, which was prevalent during the last third of the eighteenth century. The sumptuous polychromy employs gilding and raised border patterns in *pastiglio*.

Saint Anne—the protector of all mothers, widows, and childless women—served as an essential icon in church altarpieces throughout Brazil from the earliest colonial times. This work may originally have been destined for the central altarpiece at the church of Our Lady of Carmo in Sabará, but was later relocated to the chapel of Our Lady of Pilar, where it was rediscovered in 1973 and moved to the Museu do Ouro, where it is presently exhibited.

Myriam A. Ribeiro de Oliveira

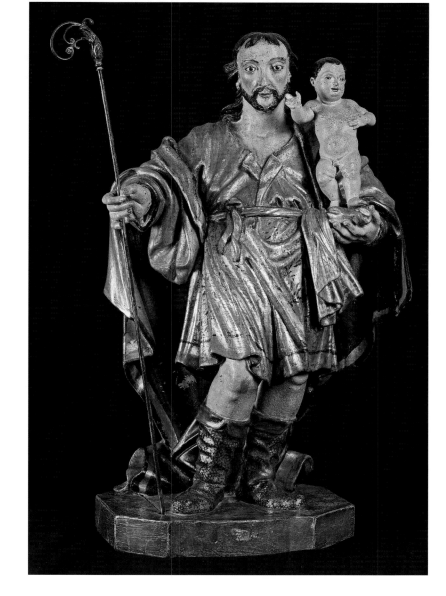

v-46 Workshop of O Aleijadinho (Antônio Francisco Lisboa)[†]

(Brazilian, c. 1738–1814)

Saint Joseph in Boots

c. 1791–1812
Polychromed wood
22½ × 13¾ × 7½ inches (57 × 35 × 19 cm)
Palácio dos Bandeirantes (Acervo Artístico Cultural dos Palácios do Governo do Estado), São Paulo, Brazil

PUBLISHED: Whistler 2001, p. 79; Oliveira et al. 2002, pp. 272–73

EXHIBITED: Oxford 2001

THIS IMAGE, which was sculpted from several blocks of wood, exhibits intact gilding but only traces of painting in *sgraffito*. The origin of the piece is unknown; however, it was purchased in São Paulo State in 1975 and is currently in the collection of the Palácio dos Bandeirantes. The modest dimensions would indicate that it might have been created for a side niche of an altarpiece, or for a household chapel.

This is one of the most common iconographic representations of Saint Joseph, the husband of the Virgin Mary, and earthly father of Jesus. Despite his importance as a descendant of the family of King David, little is known about his life aside from the fact that he was a carpenter. The figure is clearly dressed in traveling clothes, related to the Flight into Egypt, and wears a belted tunic, cape, and boots, the last of which gives this type its name. Common features include the placement of the Child Jesus on Joseph's arm and the presence of a shepherd's staff with floral motif, which here has been substituted with a crook not originally part of this piece.

While this work exhibits some of O Aleijadinho's formal hallmarks, the sculpture as a whole lacks grace and proportion. The broad and stocky figure is in stark contrast with the artist's lithe and elegant creations. The

work may be attributed to one of the assistants who worked with O Aleijadinho in his later years, or to one of his followers, who continued to imitate his style after his death in 1814.

Myriam A. Ribeiro de Oliveira

V-47 Probably José Gomes de Figueiredo

(Brazilian, active Recife, 1780s–early 1790s)

With an unknown sculptor (perhaps Gregório) and unknown painter (perhaps Francisco Xavier)

Crucifix and rood screen

c. 1783–92
Polychromed and gilded wood
Baldachin: 20 feet 8 inches × 11 feet 11¹¹⁄₁₆ inches × 3 feet 2⁹⁄₁₆ inches
(629.9 × 365 × 97.9 cm); Crucifix: 14 feet 7³⁄₁₆ inches × 11 feet 11¹¹⁄₁₆ inches ×
2 feet 2 inches (445 × 365 × 66 cm)
Monastery of São Bento, Olinda, Pernambuco, Brazil

PUBLISHED: Jansen 1955, pp. 233–385; Bazin 1956–58, vol. 1, pp. 318–19;
Smith 1972, vol. 2, pp. 406–16; Bardi et al. 1986, pp. 6, 92–93

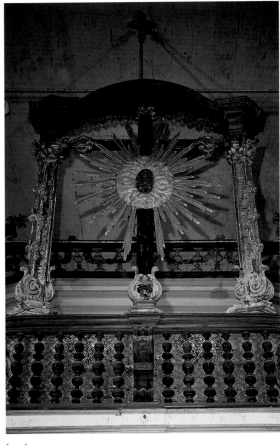

back

FRIAR MIGUEL ARCANJO DA ANUNCIAÇÃO was born to an affluent family from São Paulo that had many connections to the Benedictine Order. He became a friar himself and eventually was made abbot of the monastery of Olinda on three occasions (1769–72, 1778–80, and 1783–86). During his second mandate he decided to have major construction works commissioned for the monastery. The main chapel was replaced with a bigger, more magnificent one, and the sacristy that is located immediately behind it was also rebuilt. The decoration of both spaces was executed subsequently, and although records are not complete and do not mention the rood screen, there is no doubt that it was made at the same time.

This construction took place from 1778 to 1783, and the concomitant decoration was finished in 1793. These campaigns were one of the most ambitious artistic enterprises of colonial Brazil and produced an unquestionable masterpiece of colonial art.

The name of the architect is not known, but the best available masters were called upon for the decoration. The magnificent main altarpiece, carved between 1780 and 1786, has been attributed to José Gomes de Figueiredo, the most important wood-carver in Pernambuco in the eighteenth century. He might have worked from drawings by the Portuguese Benedictine sculptor Friar José Ferreira Vilaça. In any event, the rood screen undoubtedly came from the same campaign and workshop as the altarpiece, as well as the tribunes and the double set of stalls that furnished the main chapel. A prominent local painter, José Elói, was paid for painting the ceiling of the sacristy in 1786 and, three years later, the panel of the main altar in the sacristy.

Primary sources also mention other masters about whom we have very little information. Two still-unidentified African slaves who had worked in the Benedictine monastery in Rio were responsible for the painted ceiling of the main chapel. A sculptor by the name of Gregório carved images of Saint Gregory and Saint Scholastica for the main altar, which were paid for in 1785. The latter statue and that of Saint Benedict were painted by a man called Francisco Xavier, who was paid the following year.

The *Livro do gasto* does not mention the name of the sculptor and painter responsible for the crucifix in the rood screen, which was paid for in 1791 (sculptor) and 1792 (painter). However, given that Gregório and Francisco Xavier were responsible for all the other images in the church, it seems likely that they were responsible for this one as well.

In 1793 the crucifix was set in place. A celebration was organized to commemorate the event, and the choirmaster composed special music for the occasion. Friar Miguel, whose mandate as provincial abbot for the Brazilian branch of the order had finished in 1786, retired afterward to Olinda, where he was still able to see his work completed. When he died in 1804, he was appropriately buried in a niche in the sacristy he had dreamed of and had built.

Nuno Senos

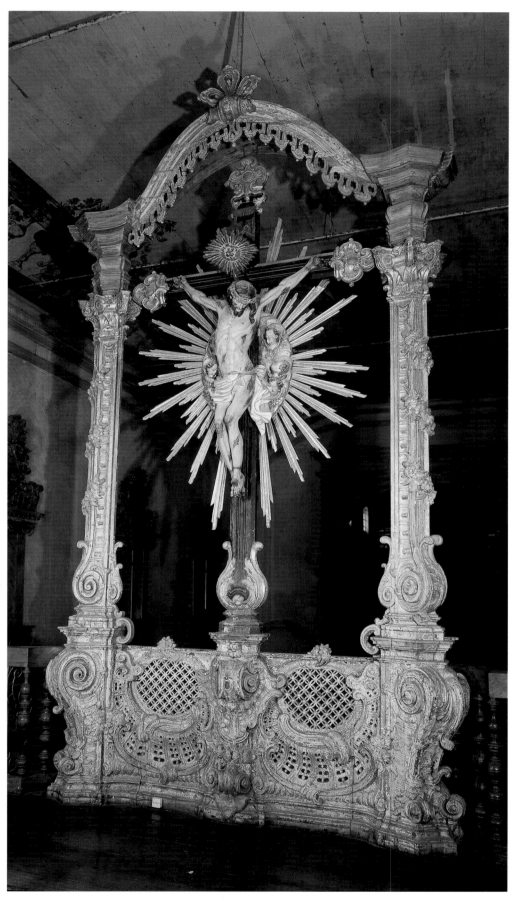

front

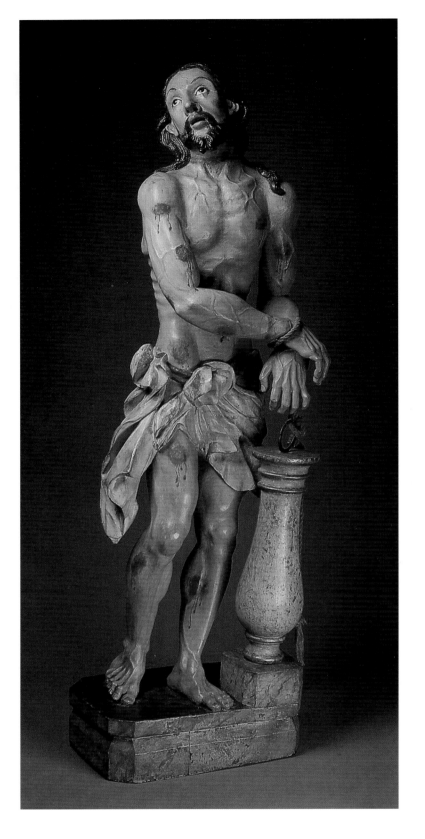

v-48 Manoel Inácio da Costa

(Portuguese, c. 1763–1857)

Christ at the Column

Second half of the eighteenth century
Polychromed wood
Height 45¼ inches (115 cm)
Museu de Arte Sacra da Universidade Federal da Bahia, Salvador, Bahia, Brazil

PROVENANCE: Monastery of São Raimundo, Salvador, Brazil

PUBLISHED: Silva-Nigra 1972, p. 72; Moacir Maia 1987, p. 91; Aguilar et al. 2000, p. 63, fig. 125

THIS WORK ILLUSTRATES one of the most popular scenes from the Passion of Christ, the Scourging—present in all the roadside scenes depicting the Passion and Death of Christ, which reached their apogee during the baroque period in Luso-Brazilian art. In an iconographic tradition that took hold during the Counter-Reformation, Christ is depicted as bound to a short column. Here, his gaze is raised skyward in an expression of apparent calm that contrasts with the tense muscles and bulging veins of his torso, which is covered with lacerations from the flogging.

Originally from the convent of São Raimundo, this piece is now exhibited at the Museum of Religious Art in Salvador, along with another sculpture of the same provenance that also represents one of the Stations of the Cross, the Christ of the Cold Stone.

Clemente da Silva-Nigra, the former director of the Salvador museum, attributed this sculpture to Manoel Inácio da Costa on the basis of certain trademark characteristics. The most evident of these are the vigorous treatment of anatomical details—which are somewhat schematic in the figure's excessively broad shoulders—the angular facial features, and the abundant draping of the loincloth, with its sinuous and almost nervous pleating.

Myriam A. Ribeiro de Oliveira

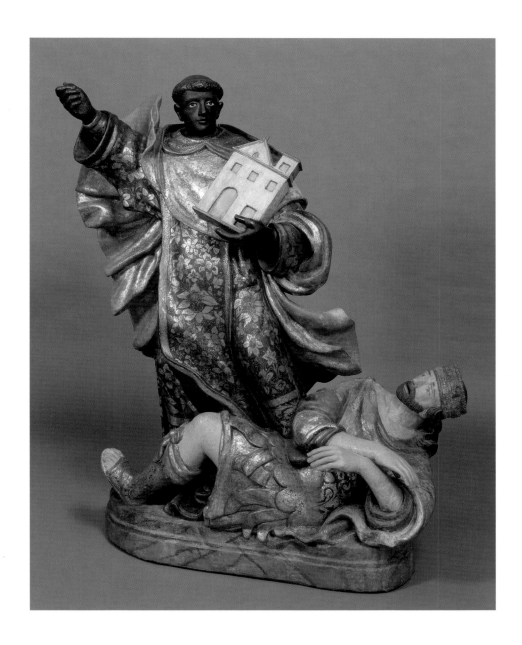

V-49 *Saint Elesbão*

Brazil
Second half of the eighteenth century
Polychromed wood
47¼ × 41⅜ × 19⅝ inches (120 × 105 × 50 cm)
5° Superintendência Regional do Instituto do Patrimônio Histórico e Artístico Nacional, Recife, Pernambuco, Brazil

PROVENANCE: Church of Rosário, Recife, Pernambuco, Brazil

PUBLISHED: Coelho 1998, pp. 1–2

ELESBÃO, A SAINT OF THE CARMELITE ORDER who was the source for the order's traditional habit with scapular, was a king of Abyssinia who lived during the fourth century. Given his African origins, images of this holy personage were often found in the churches of Afro-Brazilian confraternities.

In this sculpture the saint appears to be subjugating a white king, who is traditionally identified as Dunnam, chief of the Hamenite tribe, which was hostile to the Christians. The fact that Elesbão is depicted holding a replica of a Catholic church reinforces his association as a defender of the faith.

Originally from the Church of the Virgen del Rosário, the center for black confraternities in Recife during colonial times, the image was incorporated into the collection of the Museum of the Brazilian National Institute of Historic and Artistic Heritage with other eighteenth-century works from the same church. This sculpture—with its rhetorical symbolism, dynamically executed draping, and gilding on *sgraffito* with floral motifs—is a beautiful example of the elaborate works produced in Pernambuco during the baroque period.

Myriam A. Ribeiro de Oliveira

v-50 Saint Anne and the Young Virgin

Bahia, Brazil
Eighteenth century
Polychromed wood
33⅞ × 19¾ × 11 inches (87 × 50 × 28 cm)
Museu de Arte Sacra da Universidade Federal da Bahia, Salvador, Bahia, Brazil

PROVENANCE: Mercedarian Convent, Salvador, Brazil

PUBLISHED: Silva-Nigra 1972, p. 75; Moacir Maia 1987, pp. 70–71; *Brésil baroque* 1999, fig. 29; Oliveira 2001

EXHIBITED: Paris 1999

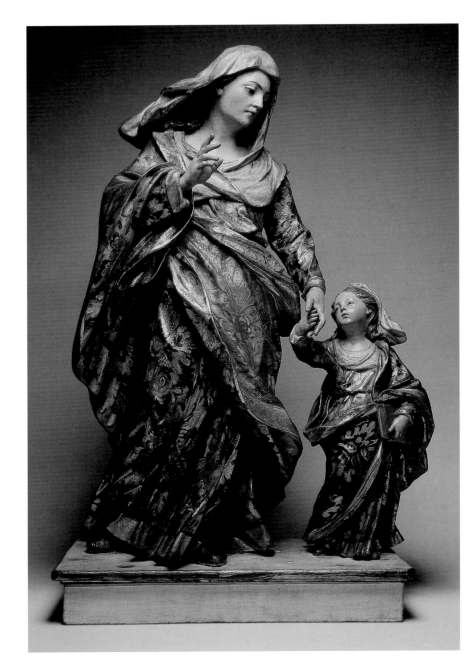

THE MOST WIDELY PRODUCED IMAGE of Saint Anne in colonial Brazil was undoubtedly that of Saint Anne Teaching the Virgin, which was revered as a source of protection for the family and thus considered an obligatory presence both in official places of prayer, such as churches, as well in household chapels or altarpieces. Such images generally depict Saint Anne in a seated position, a standing or kneeling young Virgin by her side, with both figures absorbed in reading an open book. This sculpture, which represents Anne in a striding gait, holding the hand of the Virgin, who is seen clutching a closed book, is a variation on the theme quite typical for the region of Bahia, where it was referred to as "Saint Anne the Guide."

The dimensions of this work attest to its original use on an altar at the Mercedarian convent in Salvador. It may have been paired with an image of Saint Joachim. The piece shows exceptional technical proficiency and artistic quality. The polychromy and solid gilding with *sgrafitto* in a colorful floral motif are typical of the region. There is no documentation justifying its attribution to Machado de Castro, and it is more likely that it was produced sometime around 1730 by one of the Jesuit artists of the School of Bahia, as has been suggested by Don Clemente da Silva-Nigra.

Myriam A. Ribeiro de Oliveira

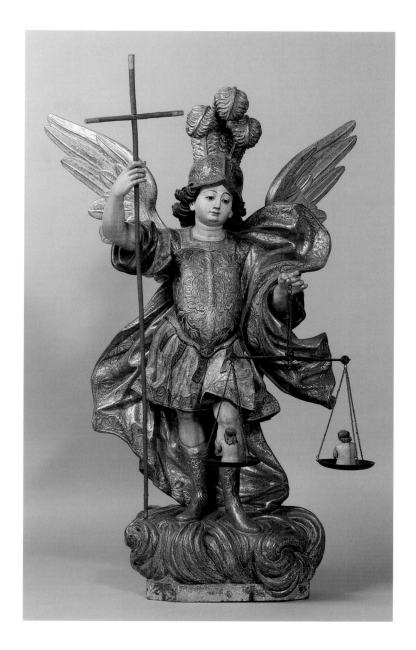

v-51 *Saint Michael Archangel*

Brazil
Eighteenth century
Polychromed wood
47⅝ × 30¹¹⁄₁₆ × 19¹¹⁄₁₆ inches (121 × 78 × 50 cm)
Private collection

THE ARCHANGEL SAINT MICHAEL is shown here as he was commonly represented in the Portuguese and Brazilian tradition. Attired as a Roman centurion, he holds a scale containing two souls in his left hand and a cruciform staff in his right. The use of the scale as one of the attributes of Saint Michael is possibly a legacy of ancient Egypt, with its notion of good and evil acts being weighed at the judgment of the dead.

In Christian iconography, the scale with souls was introduced into representations of Saint Michael at the beginning of the Middle Ages and was often to be found in scenes of the Last Judgment on the tympanums of Romanesque and Gothic cathedrals.

The saint's body is elegantly rendered, with the turn of the hip emphasized by the protruding belly and a sense of movement accentuated by the extended left leg. Refined facial features contrast with the disproportionate size of the saint's helmet. The polychromy is of excellent quality, with complete gilding, sgraffito, and pastiglio. The sculpture clearly reveals characteristics of the workshops of the Lisbon region in Portugal, and is likely to date from the middle of the eighteenth century or later.

Myriam A. Ribeiro de Oliveira

v-52 *Arm reliquaries*

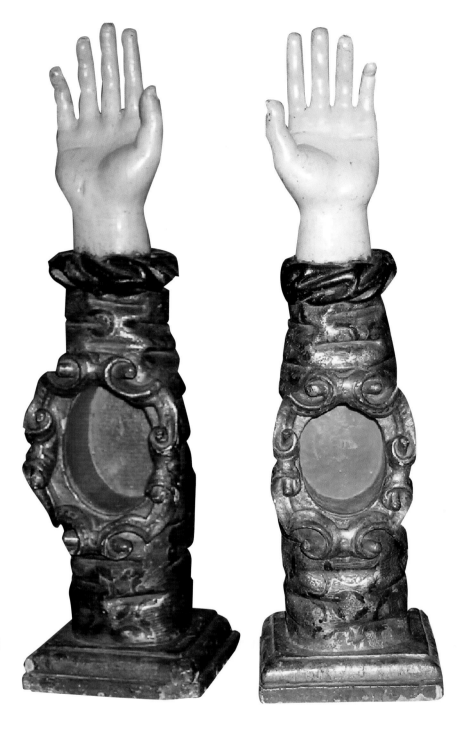

Minas Gerais, Brazil
Eighteenth century
Polychromed and gilded wood
Height 18⅛ inches (46 cm); diameter 6⅛ inches (15.5 cm)
Museu do Ouro, Sabará, Minas Gerais, Brazil

As is so often the case with Brazilian religious art, the origin of these reliquaries is unknown, nor can we identify the saints to whom the relics belonged. When silver was not available or could not be procured, other solutions were found. In this case, the anonymous artist used carved wood, which he painted and gilded. It is primarily the gilding that invests these objects with the precious character reliquaries required. In Minas Gerais, the area where these reliquaries were made, access to silver was difficult, but not to gold, which helps explain the use of gilding.

Apart from the materials, the formal conventions for all reliquaries were the same. As with the examples made of silver shown in this exhibition (e.g., cats. IV-1, IV-3), the reliquaries are made in the form of a part of the human body that reflects the relic inside, in this case, a forearm and a hand. In the middle of the forearm there is an opening framed with small scrolls, in which a pane of glass shows and protects the relic. The surface of the gilding is patterned with vegetal and geometric motifs, adding to the reliquary's decorative qualities.

Both examples have the same formal characteristics, and were certainly made in the eighteenth century, in the heyday of mining when urban settlements were forming all over Minas and their churches were being built and furnished.

Nuno Senos

v-53 Diego Quispe Curo

(Bolivian, active Potosí, 1667)

Christ at the Column

1667
Polychromed cedar
Height 54⅜ inches (138 cm); base 6 × 28¾ × 24½ inches
(15 × 73 × 62 cm)
Inscribed on pedestal: *DIDACUS QUISPE CURO ME FECIT-
ANNO 1667/ET PRIMU PERFECTUS A MARIANNO OSORIO
I BALCERA ANNO DMI. FEBRUARI 1841 . . .*
Provincia Misionera San Antonio en Bolivia, Museo del Convento
de la Recoleta, Sucre, Bolivia

PROVENANCE: La Recoleta, Sucre, Bolivia

PUBLISHED: Mesa and Gisbert 1972, pp. 123–26, 129–33, 153;
Mesa and Gisbert 1992, pp. 97, 99–100

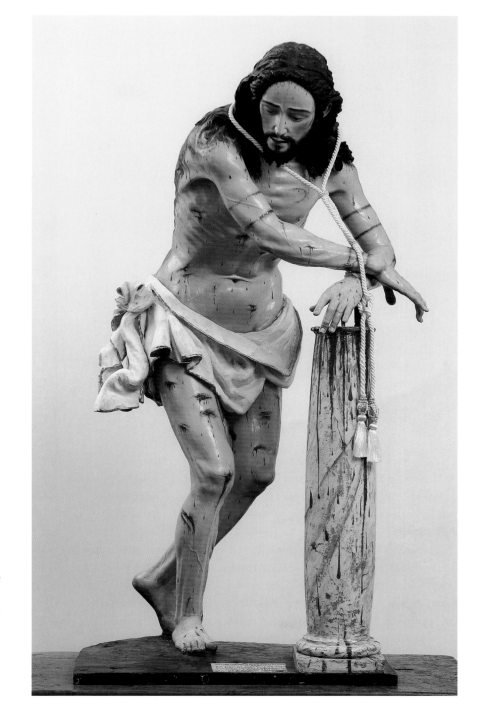

THE MOST IMPORTANT SCULPTURE WORKSHOP in the *Audiencia* of Charcas (present-day Bolivia) was at Potosí. It flourished in the first third of the seventeenth century, following the arrival of an important group of Sevillian sculptors who had left Lima because of a scarcity of work in that city. Among them was Gaspar de la Cueva, who remained in Potosí from 1631 until his death in the 1650s. Like many of his contemporaries, he had native pupils, one of whom may have been Diego Quispe Curo, who worked in the Spanish style and produced this important work now in the Museo del Convento de la Recoleta in Sucre. *Christ at the Column* is carved of cedar wood and polychromed. The inscription on the base refers to the year in which the sculpture was created (1667) and its restoration in 1841 by the painter Mariano Balcera from Potosí. Various paintings by his

hand are known in Potosí and other cities, and he was very probably a sculptor as well as a painter.

The figure of Christ is typical of the style of Cueva and of the Sevillian sculptors who came to the Andes. The anatomy, the perfection of the features, and the treatment of the hair all indicate the work of a skilled master to whom we can also attribute the *Christ at the Column* in the cathedral at Cochabamba, Bolivia. The fact that the sculptor used cedar indicates that he was taught by a Spanish master, as the Andean sculptors worked in maguey and gessoed wood, as seen, for example, in the work of Francisco Tito Yupanqui, creator of the famous *Virgin of Copacabana.*

Teresa Gisbert de Mesa

v-54 *Saint James the Moor-Killer*

Bolivia

Eighteenth century

Polychromed cedar wood

91 × 63 × 1⁹⁄₁₆ inches (231 × 160 × 4 cm)

Museo de Arte Sacra, Catedral Basílica de San Lorenzo, Santa Cruz de la Sierra, Bolivia

PROVENANCE: Llanos de Mojos, Department of Beni, Bolivia, perhaps the church of San Javier de Mojos

PUBLISHED: Plattner 1960; Mesa and Gisbert 1992 *Monumentos*; *Santiago y América* 1993, p. 395, cat. no. 113; Calmotti 2003, pp. 29–52

EXHIBITED: Santiago de Compestia 1993

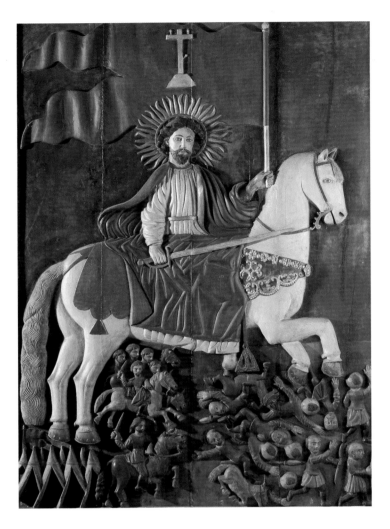

THE JESUITS (SOCIETY OF JESUS) developed a series of missions in what are now Argentina, Brazil, Bolivia, Uruguay, and Paraguay during the seventeenth and eighteenth centuries. In exchange for an exemption from the *encomienda* system, in which native tribes had to labor for their subsistence, the Jesuits created settlements called *reducciones* (in Spanish) or *reduçãos* (in Portuguese) where the indigenous people could be catechized, educated, and trained in arts and crafts. The *reducciones* functioned as businesses and engaged in trade, with a portion of the profits going to the Spanish crown. For a long while the system enabled the Jesuits to protect their charges from the more punitive *encomienda*. However, as these mission cities grew in size and economic vitality, the Spanish and Portuguese monarchs began to fear that the Jesuits were becoming too powerful. The missions came under attack, the natives fled, and the Jesuits were expelled from South America in 1767. The first Jesuit reduction was founded in Paraguay in 1610 at San Ignacio Guazú. The Moxos and Chiquitos missions in eastern Bolivia were established considerably later, with their apogee in the mid-eighteenth century.

The Jesuit artist Adalberto Marterer (1690–1753), born in Falkenau-Sokolov, Bohemia, decorated many churches of the region with "altarpieces, pulpits, confessionals, and other magnificent works." Marterer entered the Jesuit order in 1718 at the age of 27 and possibly arrived in America in 1724. He lived in San Pedro de Moxos, where he died in 1753, but he worked throughout the region. Although this bas-relief has been attributed to him, there is no documentary evidence that it was by his hand. The "art of the missions" is generally considered work produced by the indigenous people themselves, under the tutelage of the Jesuits. The simplicity of this rather flat composition suggests that it was made by indigenous artists, possibly under Marterer's supervision, but probably not by his hand. It is even possible that the relief postdates the expulsion of the Jesuits.

This representation of *Santiago Matamoros*, or Saint James the Moor-Killer (see also cat. v-4), is one of five relief sculptures that once comprised a large altarpiece. In the cathedral museum in Santa Cruz are other panels representing the Appearance of the Virgin to Saint Francis Xavier, Saint Francis Xavier Preaching in India, and the Christ Child with Symbols of the Passion. Another related panel is in Trinidad (Archbishopric of Beni) in the Church of Jesús en Getsemaní.

According to legend, Saint James Major lent his aid to the Christian forces in Spain in their crusade against the Moors in the ninth century. The Christian forces were at one point camped at Monte Clavijo, demoralized and dejected, when the saint appeared to King Ramiro I in a dream, urging him to have confidence. The next day Ramiro and his men bravely entered battle; the saint appeared as promised, riding a magnificent white horse and bearing a white standard, and the Moors were routed. This battle at Clavijo, representing the triumph of the Catholic faith, is pictured here in the simplest of terms, with the Christian forces, mounted and bearing swords, on the left near their barracks; on the right are the hapless Moors, flipped and foundering. The face of the saint is delicately modeled, and his garments are carved in rhythmic, shallow folds. The surface is enlivened by the detailed treatment of the horse's tail and the accouterments decorating its tack.

Eckart Kühne and Suzanne Stratton-Pruitt

V-55 *Christ at the Column*

Peru
Seventeenth century (figure); pedestal and column: Córdoba, Argentina, 1881
Carved wood with later polychromy
Figure 41⅜ inches (105 cm); pedestal 9 × 26 × 17½ inches (23 × 66 × 44.5 cm)
Order of Minorite Friars, monastery of San Francisco, Córdoba, Argentina

PUBLISHED: Barbieri and Gori 2000, p. 122

EXHIBITED: Córdoba 1994

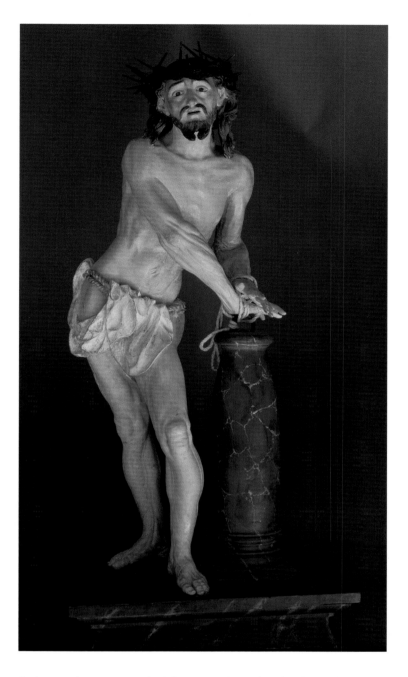

THIS EXPRESSIVE CARVING shows Christ tied to the pillar after the Flagellation. The body is in marked *contrapposto*, due to the unnatural position of the left elbow. The placement and orientation of the legs suggest that the full weight of the figure is borne by the hands clutching the pillar, accentuating the musculature of the arms. The body's zigzag twist continues in the rightward tilt of the head which, in contrast to the prototypical Spanish version of this scene, is lifted up and faces forward. There is tremendous pent-up suffering in the thin face, which is accentuated by the sharply defined cheekbones, the eyebrows, and the expression of the mouth.

The small loincloth, unknotted, drapes over and is held in place by two turns of a thick cord. The cloth covers the body in front and back, but reveals the curve of the buttocks. From the fifteenth century on, depictions of the Flagellation began to show Christ's body nude except for a loincloth, owing to the impact during the previous century of *Revelaciones*, a book by Saint Bridget, in which the Virgin says: "And while he was there, tied to the pillar, he wore no garments. Instead, he was as nude as the day he came into the world, and he suffered the shame of this disgrace."

The nudity and the simplicity of the loincloth in this *Christ at the Column* emphasize and unite the human and the divine in the body of Christ. It is the man who receives the blows of the *flagelum*. The enameled flesh tones (*encarnaciones*) of this image downplay the physical effects of the flagellation. The focus is on inner suffering, while physical pain is expressed through the torque of the body, as if Christ had just received the thirty-ninth stroke of the lash (Deuteronomy 25:2).

The convent's register of expenses states that the sculpture's Tuscan column with its pronounced *entasis* and its rectangular molded pedestal, both marbled, were replaced in 1881. Five missing fingers were added at the same time.

According to Emile Mâle, the short pillar results from the dissemination of the image of the reliquary later found in the church of Santa Prassede in Rome, taken to that city by Cardinal Colonna in 1223. The iconography of this Flagellation obeys the precise directives of the Council of Trent (1545/63), which set the standards that would mark religious works of art for centuries to come, works whose figures, pulsing with life and animated flesh, were intended to have a powerful emotional impact.

Sergio Barbieri

ET DECORAVIT ME CORONA

...OMVS SVÆ ET

Painting

Painting in Colonial Latin America

Clara Bargellini

As he advanced toward Tenochtitlan (today's Mexico City) in 1519, Hernán Cortés replaced native "idols" with crosses and images of the Virgin Mary.[1] His actions demonstrate that Cortés conceived the relationship between images and power to be fundamental, and that they were to be understood within the context of religious belief. Images were essential for Roman Catholic practice at the time of Cortés, and this one fact goes a long way to explain the countless paintings and sculptures made for and throughout the enormous geographical area that is now called Latin America between the sixteenth and early nineteenth centuries. Since conversion was the justification for conquest, indigenous peoples had to be initiated into the Christian religion, and the European colonists had to be able to continue their ancestral religious practices. Both circumstances, tied as they were to vast ambitions of expansion, demanded great quantities of images. With time, the ambitions were fulfilled, and the need for pictures as well as sculptures grew in number and in kind as New World societies became more complex.

The mere thought of attempting to comprehend in some sort of unified way all of the art, or even only the painting of colonial[2] Latin America provokes a sense of exhaustion. Furthermore, the number of studies is small in contrast to the visual richness confronting even the casual observer. The sheer challenge of so much to look at, and so much to think about, provides the exhilaration necessary to plunge in, however. In this paradoxical frame of mind, I offer the considerations that follow, beginning with thoughts on the historiography, moving on to a chronological account of salient artistic events and tendencies, anchored in observations of some specific works, and ending with a few comments.

HISTORIOGRAPHY

More than half a century ago, when studies were far fewer than they are today, Robert Smith and Elizabeth Wilder found it to be "a startling fact that no single work deals comprehensively with the history of art in the Latin American countries."[3] They seem to have thought that such a work, which would have had to include far more than just painting and cover five centuries, was desirable and possible. The main problem they envisioned was allegedly simple: "Whether

this art is interpreted as a consistent whole, or as a group of related but independent cultures, depends largely upon whether one approaches it from the diversified present or from the common heritage of the past."[4] In other words, with political history as a guide, all would fall into place. To their credit, however, they acknowledged that "on the whole it is fortunate that we have not been flooded by immature surveys of a field where so much spade-work remains to be done."[5]

In Latin America itself, the approaches to art were national, probably more for practical reasons than anything else; to this day there are far fewer art historians in Latin America than its wealth of art deserves. National studies, however, often slid onto nationalistic ground. Within the discipline of art history, nationalistic formulations found support in the pervasiveness of the Renaissance paradigm. By this I simply refer to the presuppositions that to a great extent have defined what the modern and contemporary Western world means by "art," which were put into writing in sixteenth century Italy by Giorgio Vasari, and by many others since. For scholars in Latin America, the imperative was clear: to define "schools" that developed in an orderly way, and to identify the colonial works closest to the great European achievements in order to prove the worth of the art of their respective countries.

Despite the predominance of national studies, however, there has long existed among Latin American intellectuals a persistent search for identity and unity in culture that often drew on the visual arts. "It is in its arts that Latin America's essence is to be found," as Leopoldo Castedo would put it.[6] On the one hand, Latin Americans sought a place of their own with respect to Europe and its standards. On the other, the power and influence of the United States in the nineteenth and twentieth centuries also demanded definitions and differentiation. The very formulation of "Latin America," which had had its origin in an earlier center of empire, nineteenth-century France, was accepted to distinguish the area from the Anglo north.[7]

In this light, the dependence on comparisons to European works is self-defeating. Thus, it is not surprising that a survey of Latin American art history texts reveals constant attempts to somehow contrast or at least complement the entrenched story, in which colonial artists were always at the receiving, lower end, with everything European valued as of higher quality. One way out was to define Latin American culture in general as predominantly "baroque," that is, in stylistic terms, as anti-Renaissance, therefore anticlassical, and thus in rebellion from Europe.[8] However, the main counterweight has not been in the realm of stylistic definitions, but rather in the focus on native artistic traditions. In the particular case of painting, the sixteenth-century murals (fig. VI-I) and manuscripts of New Spain[9] and the painting of Cuzco (cat. VI-99)[10] were two areas signaled out for attention since the early twentieth century.

By the 1960s, scholarship on colonial painting in Latin America had achieved a degree of consistency in factual information. It had received significant international attention as well, particularly in Diego Angulo's survey.[11] It was around this time, too, that a spate of monographs appeared. Before then, the only colonial painter celebrated in a

FIG. VI-I

Annunciation, sixteenth century, wall painting, Cuauhtinchan, Mexico

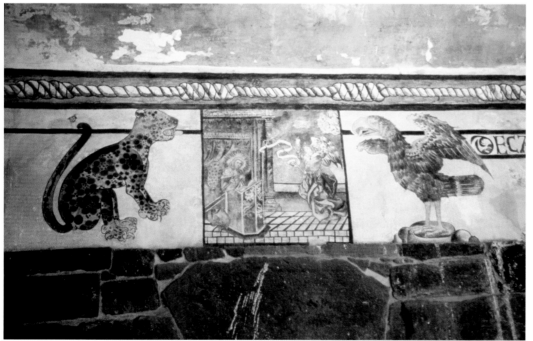

book-length study had been Gregorio Vásquez of Bogotá.[12] José de Mesa and Teresa Gisbert of Bolivia were the most prolific authors of this genre, and their first choice was Melchor Pérez Holguín.[13] In Mexico, meanwhile, the singularity of Cristóbal de Villalpando[14] and Miguel Cabrera was recognized.[15]

In the last three decades, new comprehensive treatments, though mostly organized according to current borders and not dedicated exclusively to painting,[16] and a growing density of art historical studies, including monographs on painters, have been accompanied by renewed international interest, and a willingness on the part of younger Latin American scholars to look outward. Careful examinations of specific circumstances have largely replaced the center-periphery paradigm. Racial categories as such no longer hold as much interest as in the past, although individual racial identities do, since they concern the circumstances that made creation possible. Considerations of iconography and iconology have flourished.

THE FOUNDATIONS

At the beginning, the enormous need for images that was the basic condition within which New World painting originated and developed was met in three different, coexisting ways: through imports, through formal training programs for natives, and through the immigration of European artists. The emphasis was on fulfilling the immediate need for cult images, but also on providing the conditions for the production of paintings in the new contexts that were sure to need them for many years to come.

The very earliest reception of European works that looked decidedly to the future occurred within the schools set up by Franciscan friars to train indigenous converts as artists for the *Nueva Cristianidad* that they envisaged. Educated in the arts and armed with European prints, the Fleming Pieter van der Moere, better known as Pedro de Gante (in New Spain 1523–72), established the first such school at San José de los Naturales in Mexico City in 1524; the Augustinians also had similar schools in New Spain.[17] In Quito, too, the Franciscans initiated training in the arts at their monastery in 1535, practically when the city was founded. As in Mexico City, the friars were Flemish: Joost de Rijcke, known as Jodoco de Rique (1498–1575), and the painter Pieter Gosseal (Pedro Gocial).[18] Although information is scant, there is evidence for the existence of Franciscan and Augustinian schools for natives in Peru as well.[19]

It is tempting to think that there may have been a specific plan behind the fact that all the programs in artistic training for indigenous people known to us in the first half of the sixteenth century were established by Flemish friars, but beyond testifying to the pioneering role of the Franciscan order in evangelization and to the fundamental role of images, not much more has been proved. The differences in results, however, suggest how much the context of reception must have influenced the outcome. What remains of the first Christian indigenous painting is to be seen chiefly on the walls of the monasteries built by all the mendicant orders in central Mexico (see fig. VI-I), as well as in feather mosaics, manuscripts, and maps of New Spain. In contrast, the only painting that can surely be related to the Franciscan school of Quito is the 1599 *Portrait of Don Francisco de la Robe and His Sons Pedro and Domingo* by Andrés Sánchez Gallque (cat. VI-70), who had studied there after 1553. We should remember that in central New Spain, wall painting had been expertly practiced before the Spaniards arrived, so it is not surprising that pre-Columbian elements appear on Christian monastery walls, especially given the willingness of the first generations of friars, steeped as they were in the Renaissance humanism of Erasmus, to engage with their converts.[20] When serious technical studies are eventually carried out in sufficient quantity, it is likely that evidence of pre-Columbian materials and processes will be found as well. Furthermore, utopian ideals could be given freer rein in the indigenous, rural towns of New Spain, where in the sixteenth century the friars controlled how life was organized. In contrast, the pre-Columbian cultures of Ecuador did not have a tradition of figurative wall painting, and Quito was a city of European colonists, where natives

FIG. VI-2
Simón Pereyns (in New Spain 1566–89), *Saint Christopher*, late sixteenth century. Oil on canvas. Metropolitan Cathedral/CONACULTA, DGSMPC, Mexico City

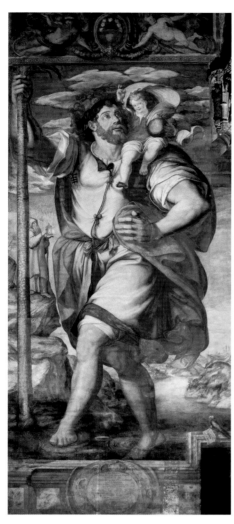

FIG. VI-3
Mateo Pérez de Alesio (Italian, 1540–c. 1632),
Saint Christopher, late sixteenth century. Fresco.
Cathedral of Seville, Spain

were clearly subordinate. Moreover, the fact that colonization in the Andes began later than in New Spain, and under more conflictive conditions, must also be taken into account.

Whatever the complexities and differences, in both the Andean and Mesoamerican contexts the friars did establish foundations for future painting. The introduction of new tools, techniques, and materials, and the use of prints as models as well as stimuli for invention were their instruments. The typological image content can be summarized in two basic categories: iconic human figures for cult, devotional, and commemorative purposes, associated with notions of the "true" portrait and hierarchical categories; and narrative in the form of representations of figures within specific spaces, taking part in particular events in sequential episodes. In conventional art historical stylistic terms, the works made in the Americas in the earliest period, and the ornamental vocabulary that accompanied them, corresponded to what was to be seen in Spain at the time: a mix of late medieval and Renaissance traditions. The early success of the friars is clear from the praise accorded to named native artists,[21] as well as in the quality of the work that survives, but also in the courses taken by subsequent developments.

IMMIGRANT MASTERS AND IMPORTED WORKS

By the middle of the sixteenth century, the importation of paintings seems to have increased. Spanish and Flemish works arrived from Seville, the Habsburg gateway to the Americas. Statistics indicate that Spain was the principal market for paintings from Flanders between 1543 and 1545,[22] and certainly many ended up in the New World. In 1553, for example, Cuzco cathedral had "an altarpiece showing the image of Our Lady with the Child Jesus in her arms and Saint Joseph, from Flanders."[23] By then, too, European artists, seeking their fortunes, had made their way to the New World, and another phase in the history of Latin American painting was under way.

The majority of the artists who crossed the Atlantic Ocean were not very famous. For that matter, neither were most of the artists who traveled from Flanders and Italy to work in Spain. As in the case of the Christian indigenous artists, we have more names than works that can be attributed to them, but we do know that there were enough painters in Mexico City in 1556 to establish a guild.[24] We also know that there were a few painters from Europe whose talents were more than ordinary, and who had a clear sense of themselves as artists in the Renaissance mold. I shall examine briefly here only three, and mention some others, in order to suggest the variety of artistic practices in this early period, which would set the scene for all that followed.

The first European painter of importance to arrive in the New World was Simón Pereyns (in New Spain 1566–89). From Antwerp, he had sought his fortune in Lisbon and Madrid, whence he went to New Spain in 1566 with the viceroy Gastón de Peralta. His presence attests to the appreciation for Flemish art in a Romanist mode in the Spanish world (fig. VI-2).[25] However, Pereyn's problems with the church in 1568 (he was under suspicion of, among other things, preferring secular to religious themes), even if probably brought on by an envious colleague, point to the vigilance that artists had to exercise, especially after the Council of Trent (1545/63). Pereyns overcame his difficulties and lived to take on important commissions, many of them in indigenous towns, such as the main altarpiece of Huejotzingo, on which he worked in the 1580s with the Sevillian, and also Romanist, Andrés de Concha (in New Spain 1568–1612).[26] It is very possible that the two artists also painted sculptures, as stipulated by guild ordinances, but this genre of painterly activity has barely been studied in Latin America.

Mateo Pérez de Alesio (1540–c. 1632), now identified as Matteo Godi da Leccia, born near Volterra in Tuscany,[27] also accompanied a viceroy to the New World, García Hurtado de Mendoza, who took him to Lima in 1590. Matteo Godi had begun his career with Michelangelo in the 1560s, was an engraver as well as a painter, and had worked in and around Rome: he painted *Saint Michael Driving the Devils Away from the Body of Moses* in the

Sistine Chapel, and participated in the frescos of the Oratory of the Gonfalone. In 1577 he worked in Malta, before going to Seville (fig. VI-3) and thence to Peru. There, he had a shop, entered mining ventures, and even took an interest in Inca antiquities. He married, and his son, who followed his father's profession, entered the monastery of Santo Domingo, where his miniatures can be seen in some of the choir books. The details that have been unearthed on the painter's life indicate that all along Matteo had been an agent of the Medici, which facilitated his return to Italy sometime between 1609 and 1613, and guaranteed his reaching old age in comfort in his native land. Matteo's early work was, of course, strongly marked by Michelangelo, but in Malta his compositions turned much quieter and his figures less muscular and contorted. This more Raphaelesque style is thought to be closer to what he painted in Peru, which is confirmed in a small painting of the Virgin and Child (private collection, Lima).[28]

The presence in Peru around the same time as two other Italians, the Jesuit lay brother Bernardino Bitti (1548–1610), who arrived in 1575, and Angelino Medoro (in Peru 1599–1629?),[29] was fundamental for the development of art in South America, since all these painters had followers.[30] Though all three produced clear and grave depictions of religious subjects, akin to the Romanism of Pereyns and Concha in New Spain, their individual styles are dissimilar, and the activities and motivations of Pérez de Alesio and Medoro, who made their careers in metropolitan contexts, were different from those of Bitti. Bitti was the first Jesuit painter to be sent to the missions, and his religiosity has led one critic to call him a sixteenth-century Fra Angelico.[31] His presence in native communities in the southern Andes, particularly in Juli, can be detected in the figures, scenes, and framing devices of wall paintings in churches of the area.[32] His activities there must have been analogous to those of the founders of the earlier Franciscan schools in New Spain and in Quito. Later, Bitti would be emulated by his fellow Jesuits—some of them also Italian, and others from France and central Europe—at the South American missions.[33] Although we do not know any works by them, we must note that there were Jesuit artists in late sixteenth-century Brazil as well.[34]

Baltasar de Echave Orio (1558–c. 1623) is the last painter I shall cite for this early period. He was in Mexico City by 1582, where he established a practice that would be continued by his descendants for several generations.[35] His work is based on the then-current Spanish amalgam of Flemish coloring and brushwork with Italian drawing and gravity. Author of a defense of his native Basque language published in 1607, he "writes and paints so well, that with style and color he honors the brush and the pen."[36] Clearly an example of the intellectual painter, Echave had at that time just signed and dated the first known replica of the Mexican Virgin of Guadalupe (fig. VI-4), a work in which he demonstrated his complex understanding of the miracle story surrounding the original image, which is both a relic and a portrait.[37] His were many of the major commissions in Mexico City at the time, including some of the paintings for the altarpiece at Xochimilco (fig. VI-5).

The activities of these and of other European artists testify to the extensive establishment of painting in European modes in colonial Latin America by the early seventeenth century. However, the differences among these painters and the heterogeneity of their styles, introduced at various times and places, could not but lead to the creation of distinct local traditions, which would be developed in the work of native artists. By "native," I mean not only Native American, but also the artists and artisans of European descent (*criollos*), as well as the many of mixed racial ancestries, all born in the New World. Imports and immigration from Europe by no means ceased, but they diminished, and with time there was a settling down and looking inward, as an ever growing number of locally trained artists were engaged in processing what had come from Europe in order to provide pictures for local audiences, in religious as well as secular contexts.

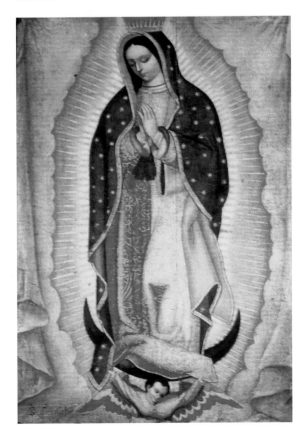

FIG. VI-5
Main altarpiece of the Church of San Bernardino/
CONACULTA, DGSMPC, Xochimilco, Mexico

The production of painting came to be centered in cities where there was enough work to support a number of shops: certainly Mexico City and Puebla in New Spain; and Lima, Cuzco, Bogotá, Quito, and Potosí in the Andes. In Brazil, there were painters in Rio de Janeiro, Salvador, and later, Ouro Prêto. There were also painters established in Caracas, Sucre, Havana, and many other places, no doubt, at different times. The concentration of work in urban centers was related to the dominance of church patronage for art, and ecclesiastical authority had by the seventeenth century passed definitively into the hands of bishops, who necessarily resided in cities. A few of them would stand out prominently as significant patrons, such as Juan de Palafox y Mendoza (1640–1648) in Puebla, and Manuel de Mollinedo y Angulo (1673–1699) in Cuzco. However, studies are still lacking everywhere that will make more comprehensible the functioning of the urban shops and their relationships to other types of production, such as that of a good number of New World painters who were clerics or belonged to religious orders, or that of the connections between the large cities and the smaller settlements, native towns, and mission centers that continued to be established until the end of the colonial period.

THE CONSOLIDATION OF TRADITIONS

The naturalism and marked *chiaroscuro* of the early seventeenth century, as it was practiced in both Seville and Rome, soon somehow worked its way into the painting of the viceroyalties. Much has been made of the impact of Francisco de Zurbarán (1598–1664), and the importation of his works is documented especially for South America.[38] In New Spain, at least, I want to note the presence of a number of Caravaggio copies, notably a *Crucifixion of Saint Peter* (fig. VI-6). In any case, painters throughout the viceroyalties were working, in the first half of the seventeenth century, in styles reminiscent, on the one hand, of the earlier linear Italianate traditions, and on the other, in ways that demonstrated baroque concerns for the depiction of emotional expression and visible reality. In Peru, for example, the exquisite idealizations of Bitti (cat. VI-68) and Medoro (cat. VI-69) gave way to such works as Lázaro Pardo Lagos's *Martyrs in Japan* (cat. VI-71). In Mexico City, Luis Juárez's gentle figures, clothed in ample plays of angular, highlighted drapery (cat. VI-11), were succeeded by the more solid, naturalistically clothed and expressive figures of his son, José (cat. VI-14).

Perhaps the single most important seventeenth-century event for the history of painting in Latin America was the arrival of compositions by Peter Paul Rubens (1577–1640), an artist who was to continue to have a presence well into the eighteenth century. It began as early as the 1630s. A 1632 *Assumption of the Virgin* in Cuzco by Lazaro Pardo Lagos (active 1630–1669) recalls the 1626 Rubens composition engraved by Pontius.[39] No paintings actually by Rubens crossed the Atlantic, as far as we know, but copies of his compositions did, as did

paintings by Spaniards who had had direct experience of works by the Flemish master.[40] Rubens's own shop organization was set up to handle not only the production, but also the reproduction of his work in paintings and prints. The scheme was commercially successful, and it also facilitated the diffusion of his images to all parts of the Christian world. Rubens's religiosity and closeness to the Jesuits may well have encouraged him to make some of his compositions available for export because of the appropriateness of their content.

The Assumption was, indeed, one of the most repeated images of the Antwerp master in Latin America. Others were the Raising of the Cross, The Lance, and the Deposition; the Triumph of the Eucharist and the Triumph of the Church from the Descalzas Reales tapestries; the Stigmatization of Saint Francis, the Education of the Virgin, various Adorations of the Shepherds and of the Magi, Holy Family compositions, the Woman of the Apocalypse, the Conversion of Saint Paul, the Apostles, and the Franciscan Allegory in Honor of the Immaculate Conception (fig. VI-7), an especially important composition for Latin America, since its iconography centers on the Spanish Habsburg support of Franciscan missions. These were not the only Rubens compositions known in the New World, of course, but they were the most frequently repeated, judging from what is preserved.[41] The selection abounds in works whose iconography is of particular relevance for evangelization in the New World, and one

FIG. VI-7
Peter Paul Rubens (Flemish, 1577–1640), *Franciscan Allegory in Honor of the Immaculate Conception*, 1631–32. Oil on panel, 21⅛ × 30⅞ inches (53.7 × 78.4 cm). Philadelphia Museum of Art, John G. Johnson Collection, 1917

wonders about the mechanisms by which certain models were sent across the Atlantic, while others were not, or why some Rubens compositions were more popular in some places than others, for example, the Education of the Virgin in Brazil. In any case, it was not only Rubens's iconography that was assimilated in Latin America but also something of the movement and vivacity of his figures and compositions, as well as the freedom of his brushwork. It must be said, however, that most painters in the New World were consistently more conservative in their handling of space.

In order to better understand the impact of Rubens, we must remember that Spanish trade with Flanders picked up again after 1585, when Spain reestablished its control there, and it continued until the middle of the seventeenth century.[42] Paintings arrived in Spain in great numbers along with books, prints, textiles, leather goods, musical instruments, and other furnishings and luxury goods, and much went on to the New World. Among all the objects that eventually reached Mexico City were *láminas de mil colores* (paintings on copper of a thousand colors) from Antwerp, according to the poet Bernardo de Balbuena.[43] The emphasis on color in paintings on copper from Flanders is precisely to the point, since it was only through actual paintings that the quality and handling of color could be studied by New World artists.

The generalized knowledge of Rubens's iconographic inventions did not, of course, result in artistic homogeneity throughout Spain and its kingdoms and viceroyalties, because the consolidation of local processes continued. The attempt by thirty-two painters in Lima in 1649 to found a guild,[44] though unsuccessful, testifies to the existence of shops there and a situation of stability, just as the establishment of a guild in Mexico City in 1556 had signified that a group of painters was working there, and meant to continue to do so. Indeed, from the seventeenth century onward the importance and stability of Mexico City production is evidenced in the shipping of paintings thence to other places in New Spain, and later to South America and

Europe as well.[45] The statutes of both the Mexico City and the proposed Lima guilds were based on those of Seville, but one wonders if the Lima painters may not have had Mexico City in mind as well in their wish for institutional status. In any case, we know that artists were organized in religious confraternities, at least. That a conflict and break occurred in Cuzco in 1688 between the indigenous painters and those of European origins is evidence of the organization of both groups.[46] The subsequent success in commercializing the huge production of Cuzco paintings covered with gold ornamentation testifies to the strength of that local tradition.

The accumulated experience of artists in various centers resulted in extraordinary works throughout colonial Latin America in the last decades of the seventeenth century. For example, in 1671 the Franciscans of Lima chose the four best painters of the city to represent the life of their founder in a series of large canvases.[47] Some of these have survived, full of fascinating details, including a self-portrait of Francisco de Escobar (active 1649–1676) in front of his easel. This is only one of several self-portraits from the late seventeenth and early eighteenth centuries, significant, of course, in terms of how painters valued their individuality and profession. Cristóbal de Villalpando (c. 1645–1714) in Mexico City also portrayed himself around 1685, in one of the six huge canvases that cover the walls of the cathedral sacristy (fig. VI-8). The painter placed himself among the bishop and clerics of the cathedral chapter in the *Apparition of Saint Michael on Monte Gargano*, represented as an allegory of the church in New Spain. He thus claimed religious learning and identified himself with his city, as did Melchor Pérez Holguín in his 1712 *Entry of the Viceroy Morcillo in Potosí*.

Some of the best paintings of the second half of the seventeenth century are very large, and fortunately, still in place. Unlike the architectural decoration of earlier periods, these are complex figure compositions that take over walls and vaults, breaking through them by the use of perspective and foreshortening, as in the aforementioned work by Villalpando in the sacristy of the cathedral of Mexico City. The same artist went on to paint in 1688–89 the dome of the apse chapel of the cathedral of Puebla with an illusionistic composition that is a vision of Mary, bearing a monstrance, with the Trinity, angels, and saints among clouds (fig. VI-9).

FIG. VI-8
Sacristy, Metropolitan Cathedral, Mexico City

FIG. VI-9
Cristóbal de Villalpando (Mexican, c. 1645–1714), *Glorification of the Virgin*, 1688–89. Oil on canvas mounted on wall, dome of the Cathedral of Puebla, Mexico

The theme combines two fundamental Hispanic cults—of the Immaculate Conception and of the Eucharist—with concerns about the role of light in religion and art.[48] The only dome decoration of its kind in Latin America, Villalpando's painting is probably related to nearly contemporaneous works in Madrid, while at the same time achieving formal and iconographic integration with the rest of the chapel. Though very different from Villalpando's work in their linear definition, the huge compositions in the cathedral of Cuzco by Basilio de Santa Cruz Pumacallao (active 1661–1700) make analogous claims on the attention of viewers. Their carefully rendered perspective views of monumental architectural spaces are at the same time playful in their details and fairytale vistas—reminiscent of Flemish and Italian works of earlier times—but also disconcerting in the contrasts of scale and illumination. The sacred personages, small in comparison to their surroundings, act out their roles in the Bible narratives

in a conventional way, but often belied by dramatic diagonal placements, lighting, and intense facial expressions, which remind us that we are in front of late seventeenth-century compositions (fig. VI-10).

The painters of the second half of the seventeenth century produced energetic and visually compelling work, and theirs was a time of the creation of memorable images grounded in specific New World experiences.[49] Besides portraits, depictions of religious and civic ceremonies (cats. VI-19, VI-73), and the city views already alluded to, they elaborated compositions that integrated pre-Columbian with colonial history, such as the stories of the conquest in New Spain (cat. VI-82) and the genealogies that began with Inca or Aztec rulers and continued with the kings of Spain from Carlos I onward (cat. VI-115). Sacred images whose origins were in the New World and their narratives were especially important. Just as the sanctuaries of these cult figures were often situated at the margins of cities, between urban and openly rural spaces, in places where people of all classes and conditions would come together, so the legends and the stories were inclusive, combining native elements with others of European origin. Prominent among these were images of the Virgin (cat. VI-116) and of the crucified Christ (cat. VI-114). The canonization of the first New World saint, Saint Rose of Lima, also resulted in the creation of iconographies throughout Latin America.[50] In all of these cases, we can follow the processes by which images signified in different contexts, how they remained local or were made inclusive, and even international, over time.[51]

Of particular interest is the relationship between the production of pictures and the concern with orthodoxy. The learning that would guarantee correct representation was generally a clerical prerogative, although some painters could be trusted to understand and interpret complex issues. Indeed, a few of them insisted on their role as "inventors" of images.[52] Nevertheless, the peculiar insistence on the written word within many colonial paintings (cat. VI-92 and others), and its integration with representation, suggests the close participation of intellectuals in the making of paintings. We have an explicit confirmation of this in an elaborately illuminated choir book belonging to the cathedral of Guadalajara, Mexico (fig. VI-11). The complex pages, full of figures and inscriptions, are signed with two names: "Don Sebastián Carlos de Castro, Inventor y Escritor," and "Juan de Dios Rodríguez Leonardo faciebat." Obviously, Castro was the learned cleric who "invented" the compositions, and his intervention was considered inseparable from writing. Rodríguez Leonardo, without the title of "don," executed the paintings. The frequent presence, furthermore, of the concept of "invention" in the inscriptions on engravings, recalls how the accurate copying of prescribed visual models had been associated with good painting in the New World from its very beginnings in the monastery schools. It is not surprising, therefore, that painters would include not only texts in their paintings but engravings as well (fig. VI-12), and that the topic of the creation and reproduction of images should have been the subject of representation throughout the seventeenth and eighteenth centuries, as well as the stimulus for thinking about images both in New Spain and South America.[53]

FIG. VI-10

Basilio de Santa Cruz Pumacallao (active 1661–1700), *Presentation in the Temple*, c. 1680–90. Oil on canvas. Cathedral of Cuzco, Peru

FIG. VI-11

Choir book, Cathedral of Guadalajara, Mexico

NEW PAINTING FOR A NEW CENTURY

The dynastic change in Spain in 1700, from Habsburgs to Bourbons, and the consequent attention to French fashion, did not create an alteration in painting at once. All of the iconographies and topics just discussed continued to be subjects for colonial art in the eighteenth century.

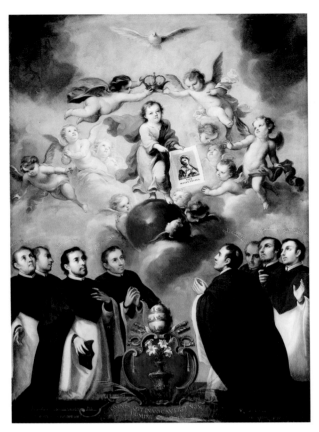

FIG. VI-12
José de Ibarra (Mexican, 1685–1756), *Baby Jesus with Canons of Puebla Cathedral*, first half of the eighteenth century. Oil on canvas. Cathedral of Puebla/CONACULTA, DGSMPC, Mexico

Baroque tendencies of realism and drama persisted, but an awareness of neoclassical artistic concerns is evident as the century progressed. Rococo vocabulary, with its associated lighter palette and open spaces, became pervasive. The assimilation of these international trends did not require by this time more than the continued importation of prints, books, a few paintings, and luxury goods that might serve as models and stimuli, and the demands of patrons and the market, exactly as was the case in Europe. The larger artistic centers, each with its own tradition, were by then well established, and could respond quickly and with ability to the new demands for nonreligious pictures and display, while continuing to fulfill older needs as well.

A case in point are *casta* paintings, a secular genre appararently unique to the New World.[54] The first known canvases dedicated exclusively to the depiction of anonymous individuals representing different New World racial mixtures date from the second decade of the eighteenth century. These early *castas* show individuals (cat. vi-47) and family groups realistically interacting with one another (cat. vi-48) against dark, neutral grounds. Viewers in New Spain could easily have comprehended these paintings as sympathetic depictions of everyday reality in their own land. Some may also have sensed that they might be attempts at domesticating troubling realities that could erupt in violence. Europeans would have been both fascinated and disconcerted—even disgusted—by the confusion. The tone of later *casta* paintings, like the 1763 series by Miguel Cabrera (1695?–1768), is remarkably different (cats. vi-49–vi-62). They are situated in specific places and the colors are lighter, but most importantly, the figures are posing.

They look out at the viewer self-consciously, and the series as a whole is a systematic presentation of a New World curiosity. The architecture included by Cabrera is spare and in accordance with neoclassical tastes; other painters of *castas* insert rococo details. The unique *castas* painted in Lima by Cristóbal Lozano (1705?–1776) for Viceroy Manuel Amat y Junyent, to be sent to the natural history cabinet of King Carlos III in Madrid, is even more systematic (Museo de América, Madrid). Whatever the complexities of the readings of all these paintings, their production is proof of the professional status and capabilities of painters in Mexico City and Lima. Cabrera, painter to the archbishop of Mexico City, was the historically conscious product of an uninterrupted tradition that dated back more than two centuries; and Lozano, equally self-aware, was the talented beneficiary of cosmopolitan, enlightened patronage in Lima, after the ruin of the 1748 earthquake.

In portraiture, too, eighteenth-century painters throughout Latin America were able to integrate the traditional conventions, established as far back as the sixteenth century, with fresh coloring and expression for new individual and group needs (cats. vi-39, vi-64).[55] Local demands for portraits of many kinds, often commemorative of the intersections of private and public life, provided the opportunity for precise observation of character, as well as commentary and documentation of domestic, social, civic, and religious details and events.

In newly built or decorated churches of the eighteenth century, painting continued to fulfill its religious role on walls and altarpieces. However, by mid-century altarpieces had become almost entirely sculptural, and large paintings served as counterpoints and complements, or they filled subsidiary spaces such as sacristies and cloisters where narrative series continued to be required (fig. vi-13). Occasionally, large canvases were also painted as illusionistic, as well as cheaper, substitutes for entire sculpted altarpieces. As for vaults and ceilings, although Villalpando had some following in New Spain, the most numerous and notable illusionistic ceiling paintings of Latin America were created in Brazil, beginning around 1730 in Rio de Janeiro, with the work of Caetano da Costa Coelho.[56] These ceilings go beyond the illusionism of the seventeenth and eighteenth centuries, and adopt the *quadratura* tradition, as propagated

FIG. VI-13
Interior of church, Taxco, Guerrero, Mexico

FIG. VI-14
José Joaquim da Rocha (in Brazil 1764–1807), ceiling,
Church of Nossa Senhora da Conceição da Praia,
Salvador, Bahia, Brazil

by Andrea Pozzo, and also practiced in Spain and especially Portugal. In fact, José Joaquim de Rocha (in Brazil 1764–1807) seems to have immigrated to Brazil from the mother country. His 1772–74 ceiling of the church of Nossa Senhora da Conceição da Praia in Salvador, Bahia (fig. VI-14), is an expert rendering of a complex architectural space in perspective, one that opens up and out to a vision of Mary in heaven. The adoption of the rococo is clearly to be seen on the ceiling of the church of Saint Francis in Ouro Prêto, painted between 1801 and 1812 by the local artist Manoel da Costa Ataíde (1762–1830) (see Sullivan fig. E-13).

The huge paintings in the public spaces inside churches had their counterparts in the plethora of small works made for private devotion. The outlines of this genre are fairly clear for New Spain, where it was the continuation of a production with antecedents at least as far back as the early seventeenth century, centered especially in the local making of paintings on copper (cats. VI-33, VI-43). By the eighteenth century, every major Mexico City artist was producing these small works for close inspection and meditation.[57] This type of painting existed elsewhere, for example in the work of Manuel Samaniego (1767–1823) in Quito.

The final phase in the history of Latin American colonial painting must be framed within the history of academic neoclassicism. For local painters, the establishment in 1785 of the Royal Academy of San Carlos in Mexico City represented the fulfillment of longstanding ambitions for professional standing and freedom from the guild. Ironically, however, they soon found themselves marginalized by the largest influx of Spanish immigrant artists since the sixteenth century. Formal academies were not founded elsewhere in Latin America, but the new purism was introduced both by immigrant painters, such as Matías Maestro (1766–1835) in Lima, or by local painters looking at foreign models, as they had done for generations.

IN CLOSING

Latin American colonial painting encompasses a huge number of disparate and imperfectly known objects; some are still practically unknown even today, and many of them are in danger of disappearing through destruction, mistreatment, and theft. There certainly is a great need to continue to map works and artists,[58] and there is no dearth of challenges in all the other areas of research already explored. Two recent approaches, however, seem to offer fresh promise. One is a growing tendency to break out of national boundaries and look for comparisons horizontally, that is, among artistic traditions within Latin America, and in analogous situations elsewhere.[59] The resulting juxtapositions often suggest new questions. The second is the attention to material and technical studies joined to art historical analysis.[60] The discoveries of how native and imported materials were combined for particular effects throughout the colonial period, while suggestive of redefinitions of painting, are also beginning to put a new face on the old notion that native traditions are the locus of creativity in colonial Latin American art. In any case, with so many inviting problems and questions, whether we will ever make sense of it all as a whole is cause for celebration rather than concern.

NOTES

1. Toussaint 1965, p. 14.

2. I use this word because of the difficulties with other general terms in parts of Latin America and elsewhere. The problems with terminology are symptomatic of the complexity of the art and of its study.

3. Smith and Wilder 1948, p. 1.

4. Ibid., p. 2.

5. Ibid., p. 5.

6. Castedo 1969, p. 11.

7. Phelan 1969.

8. A telling instance, which resulted in the term "Ultrabaroque," is Murillo 1925: *Iglesias de México*, vol. 3, *Tipos Ultra-Barrocos, Valle de Mexico.*

9. Toussaint 1965, pp. 1–32. Though published posthumously in 1965, this text was essentially finished in 1934.

10. Cossío del Pomar 1928.

11. Angulo Iñiguez et al. 1945–56.

12. Pizano Restrepo 1926.

13. Mesa and Gisbert 1956.

14. Maza 1964.

15. Carrillo y Gariel 1966.

16. Bayón et al. 1989, in which the chapter on "Brazilian Colonial Painting" was written by Myriam Ribeiro de Oliveira and Aurea Pereira da Silva; Sebastián López et al. 1992.

17. Toussaint 1965, pp. 20–22; Kubler 1948, chap. 8.

18. Navarro 1991, pp. 26–31. This book, like Toussaint's, was left unpublished at the author's death in 1965.

19. Gisbert 1992, p. 79.

20. Peterson 1993; Escalante 1997.

21. A particularly important native painter in New Spain was Marcos Griego: see Ángeles Jiménez 2004.

22. Vermeylen 1999, pp. 16–19.

23. Mesa 1992, p. 179.

24. Toussaint 1965, p. 37.

25. Ibid., pp. 54–62; Ruiz Gomar 2004 "Expressions"; and see Brown 2004, pp. 19–20, for a clear exposition of the stylistic situation in which Pereyns moved.

26. Berlin 1958.

27. Palesati and Lepri 1999; Bernardini 2002, pp. 95–98.

28. Francisco Stastny, in *Copper* 1999, pp. 247–50.

29. It seems that his name was actually Medoro Angelini: Palesati and Lepri 1999, pp. 166–67.

30. Sebastián López et al. 1992, part 1, 28:408–20; and the synthetic treatment of this problem by Wuffarden 2004 "Escuelas," p. 81.

31. Sebastián López et al. 1992, part 2, 28:408.

32. Flores Ochoa et al. 1993.

33. Plá 1999; Bailey 1999, pp. 155–164.

34. Bardi et al. 1982, p. 46.

35. Victoria 1994; Ruiz Gomar 1994.

36. Villalobos 1607.

37. Bargellini 2004, pp. 85–86.

38. Serrera 1988; Navarrete Prieto 1999 *Zurbarán.*

39. Wuffarden 2004 "Escuelas," p. 83.

40. Gutiérrez Haces et al. 1997, pp. 40–43.

41. See Ruiz Gomar 1998; and Vergara 1999, pp. 41–45, 80–87, for the Eucharist series and the Prado *Adoration of the Magi*, respectively. I am grateful to Helga von Kügelgen for sharing with me her soon to be published work on this topic.

42. Marchi and Van Miegroet.

43. Balbuena 1963.

44. Wuffarden 2004 "Catedral," p. 274.

45. For example, Silva Santisteban 1989; and Duarte 1998.

46. Sebastián López et al. 1992, part 2, 29: 550–553.

47. Wuffarden 2004 "Catedral," pp. 275–76.

48. Bargellini 1999 "Villalpando."

49. See the essay by Ilona Katzew in this volume.

50. Vargaslugo 1976; and Mujica Pinilla 2001.

51. See Cummins 1996 for a comparison of Cuzco and Lima and their images.

52. My thanks to Karin Hellwig and Helga von Kügelgen for having discussed this question with me.

53. Mues Orts et al. 2001; Bargellini 2004.

54. Katzew 2004; and Wuffarden 1999.

55. Despite all the problems resulting from poor information, Martín Soria seems to have been a pioneer in his notice of the outstanding portraiture of New Spain: Kubler and Soria 1959.

56. Oliveira 1995, pp. 294–96. My thanks to Jens Baumgarten for discussing these works with me.

57. Bargellini 1999.

58. See the considerations of Kaufmann 2004, especially part 3.

59. Two recent collections of essays explicitly point in this direction: Gutiérrez 1995; and García Sáiz and Gutiérrez Haces 2004.

60. Siracusano 2005.

Stars in the Sea of the Church: The Indian in Eighteenth-Century New Spanish Painting

Ilona Katzew

In the eighteenth century Mexican painting came into its own, its artistic splendor largely due to the consolidation of a local school of painting and the invention of new iconographies—both religious and secular. Ties with European art persisted throughout the colonial period, with painted and printed compositions circulating widely in Europe and the colonies; they were part of what may be termed a "transoceanic economy of images." This is not to say that Spanish colonial art simply copied European models—a notion that has long been dispelled—but rather that it was part of a more global context in which the exchange of images gave rise to new representations that had both local and universal resonance. The vast proliferation of images created in a colonial context points to an obvious yet often overlooked fact: their power to authenticate reality. Images were vested with the unique ability to shape memory and create history. When the Franciscan friar Juan de Torquemada (1562–1624) stated that an "image . . . is a semblance of something else which it represents in its absence," he fully understood the capacity of images to generate devotion and create memory.[1] This belief, which went back to ancient times, was also a direct result of the Counter-Reformation that held sway in Europe during the sixteenth century. During this pivotal time in the history of the church, the Spanish monarchy proclaimed itself the defender of Roman Catholicism against the Protestant enemy, and images were deemed an essential weapon in the battle to spread Catholicism.

From the beginning of colonization, images played an integral role in the colonial enterprise of disseminating information and ideas. As Serge Gruzinski has noted, visual representations, along with writing, were one of the main tools for the transmission of European culture, and partly the reason why the colonization of the Americas took the form of a veritable "war of images."[2] By the eighteenth century representations that incorporated images of the indigenous population of New Spain were widespread and an accepted pictorial and allegorical genre.[3] An examination of these works provides insight into how images were deployed to serve the interests of specific groups, the multiplicity of meanings they acquired, and how new iconographies developed from a society's constant need to assert its own identity—within the colony itself and in relation to Europe. The selection of subjects presented here is largely based

on an unpublished manuscript by the Franciscan friar José Mariano Díaz de la Vega titled "Memorias piadosas de la nación yndiana recogidas de varios autores" (1782).[4] The decision to focus on Díaz de la Vega's manuscript as a blueprint of sorts delimits the discussion, but also sheds light on some of the themes that were gaining currency during the eighteenth century in representations of the Amerindian. The analysis of this manuscript demonstrates how text and images were often inseparable genres, and a rich source for understanding how historical memory was constructed in the eighteenth century.

When Díaz de la Vega wrote his apologetic text about Christian Indians, he was responding to the increasing hostility toward this group. Debates about the nature of the Indians had a long history that harks back to the beginning of colonization. The discussion between Friar Bartolomé de las Casas and the humanist Juan Ginés de Sepúlveda about the humanity of the Indians, set in Valladolid in 1550–51, is legendary. While Las Casas set out to prove that the Indians were fully rational, Sepúlveda argued that they were no more than slaves by nature.[5] Even though in the sixteenth century the Spanish crown determined that the Indians were Christian neophytes who deserved their protection, discussions about their rational capabilities extended over the next three centuries. The seventeenth-century Creole intellectual Carlos de Sigüenza y Góngora, for example, praised the grandeur of the Indians' pre-Hispanic past but was less sympathetic to the indigenous population of his time, which he described as utterly degraded.[6]

The Spanish visitor-general and bishop of Puebla Juan de Palafox y Mendoza (1650–1654) offered a more positive view of the Indians in his "De la naturaleza del indio" (c. 1642). This short text, which had a wide readership among colonial authorities, emphasized that the Indians were good Christians and loyal vassals who enriched the crown. Palafox, however, was fully aware that the virtues he listed could also be deployed by others to stress the opposite: "Whoever was to read this discourse . . . and did not know the nature of these poor Indians, would think that their patience, tolerance, obedience, poverty, and other heroic virtues, derive from a diminishing and great baseness of spirit, of a slowness of understanding, quite the contrary being the truth."[7] In his discussion of priests' conflicting views of Indians in the eighteenth century, the historian William B. Taylor has stated that the terms used to describe the Indians centered "around two inconsistent notions: Indians as simple, timid, obedient, perhaps stupid, innocents; and Indians as deceitful, malicious, and cunningly disobedient subjects—children of the Seven Cardinal Sins." According to Taylor, many of these terms were rooted in sixteenth-century "encounter" vocabulary. In explaining the recurrence of another word often used to describe the Indians, *miserable*, Taylor has perceptively noted: "In this lexicon, one term led to another, but not in endless variations or particular complex ways. *Miserable* and its elaborations and extensions toward fear, shamelessness, ignorance, rusticity, laziness, and the rest led back to the idea that Indians were incomplete humans, lacking in willpower and reason."[8]

The origin of the Indians was also amply debated. Theories included those claiming that they derived from the people of the lost continent of Atlantis; from Asia—based on a purported physical resemblance and a common language source in East Asia; and from the Ten Lost Tribes of Israel—a theory that gave them a biblical ancestry but was also used to associate them with the "impure" Jews and thus limit their rights, such as being ordained as priests. The repository of many of the theories and myths regarding the origin of the Indians was the Spanish Dominican Gregorio García's *Origen de los indios del Nuevo Mundo* (1607).[9] García's compilation shows that sixteenth-century discussions about the origin of the Indians were not only widespread but frequently bordered on the mythical.[10] Writing in the later eighteenth century, Díaz de la Vega went to great lengths to defend the Indians and their accomplishments, noting indignantly: "Despite the fact that many authors have spilled a great deal of ink in describing the native inhabitants of the Americas, they have all treated them as a single

group, assigning them different origins according to their own conjectures, or based on what they have read, claiming indistinctly that they descend from the Hebrews, Jews, Ham . . . and even Judas. . . . Oh, wretched nation! How far can your misery extend, when all that remains is that they make your ancestors and progenitors into satyrs, minotaurs, lions, and tigers!"[11]

Even though the nature and origin of Amerindians were hotly debated, they became indispensable in the construction of a local mythology that placed New Spain at the center of a select Christian cosmography. A strong sense of Creole pride developed in Mexico in the late sixteenth and early seventeenth centuries. The eradication of the *encomienda* system (a grant of Indian labor given to the conquerors and early settlers at first in perpetuity) resulted in the loss of social standing of Creoles. Unhappy with the crown's failure to create a class of grandees in the New World, the American-born descendants of Spanish peninsulars took other measures to sustain their power and prestige. Many went on to occupy positions in the church (which they eventually dominated) and the university—two major platforms from which they were able to voice a strong sense of belonging to the land and their desire to be part of the Spanish monarchy but in their own right.[12] Motivated by the insults and arrogance that Europeans continued to exhibit toward them, Creoles sought to establish an identity for themselves by extolling their country and its inhabitants. New Spain (like Peru), however, was a hierarchical society comprising various castes and ridden with its own internal conflicts. That the Indians made up the majority of the population of New Spain was indisputable. In addition, the Indians' juridical status as new Christians, and their *limpieza de sangre* (that is, the absence of Jewish, Muslim, or black blood), made this group an appropriate symbol of the providential destiny of Mexico and its grandeur.[13] In fact, many Creole intellectuals descended from the Mesoamerican Indian nobility, with whom they sometimes shared cultural codes and values.[14]

The strong sense of *criollismo,* which was cemented in the second half of the seventeenth century, was trotted out by several authors in the second half of the eighteenth century. The attack of the dean of Alicante, Spain, Manuel Martí (1663–1737), on the population of the Americas is well known. When he responded to a student inquiring about the advantages of studying in the New World, he suggested that he move to Rome instead, arguing that the lack of significant writers and libraries in Mexico was notorious. Reactions among the intellectual elite of New Spain were vehement. One of the best-known responses is that of Juan José de Eguiara y Eguren, professor and rector of the University of Mexico, who published a vast bio-bibliography of all known Mexican writers titled *Biblioteca mexicana* (1755). In the preface to this massive compilation, Eguiara y Eguren boasts of the many accomplishments of the Indians: "If [Martí] had paid careful attention to the works of our predecessors and only leafed through the chronicles written by foreigners, surely he would not have concluded that the Indians of Mexico are ignorant."[15] In his work *Tardes americanas* (1778), the Mexican writer José Joaquín Granados y Gálvez also set out to defend the Creoles from European attacks. Resorting to an alleged dialogue between a Spaniard and an Indian, Granados y Gálvez clearly expressed that Creoles were heirs—racially and culturally—to the indigenous Mexican nobility. The relationship of Creoles to the indigenous population of New Spain was contradictory at best, but several families boasted of their mestizo origin when the union was among equals (that is, among the Mesoamerican ruling class and noble Spanish conquistadors).[16] In art, the *macehuales,* or common Indians, would also occupy an important place.

Images, often combining political and theological messages, played a key role in the development of Creole consciousness. New Spain was represented as the chosen land where the Virgin Mary and a host of saints appeared. To prove that the native population had been successfully converted, several images of the late seventeenth and early eighteenth centuries depict Amerindians as partaking of the most important Christian sacraments. Juan Rodríguez Juárez (1675–1728), one of New Spain's most accomplished artists, can be credited with inventing new iconographies that showed the population of the New Spain in its best light.[17]

In his work of Saint Francis Xavier (1506–1552), for instance, the artist depicts the famous Jesuit missionary in Asia baptizing a heathen Indian—a representation of the universal mission of Christianity and the willingness of Amerindians to embrace the faith (fig. VI-15).[18] In Rodríguez Juárez's depiction of an Indian wedding, the Indian couple is flanked by their Spanish godparents to show the social pact between the two republics comprised by the colony—the *república de indios* and the *república de españoles*. In front of the group is a *matachín* (masked dancer) playing a tambourine and a *chirimía* (flageolet) player (fig. VI-16). The extraordinarily detailed depiction of the town's festivities includes musicians, bearers of *pulque* (the intoxicating drink extracted from the maguey plant), and the release of doves from lavishly decorated *globos* (paper balloons) from the roofs of the church and the village houses. Representations of Indian weddings date back to the late seventeenth century (cat. VI-46). Commissioned to illustrate a native festivity with all its "exotic" details, they also showed that Indians were fully civilized, as they adhered to Christian mores.[19] In light of the debates about the rational capabilities of the Indians, this kind of representation conveyed a powerful political message. It is not surprising that Díaz de la Vega would frequently remark that "the Indians were never irrational, and were always capable of all the sacraments."[20] For Creoles, proving that the Indians were Christian was tantamount to proving the success of the Spanish enterprise, but also, and perhaps more importantly, their own right to a status equal to that of Spain; their land, after all, was far from pagan.

Accounts of the ability of Amerindians to become true Christians began to be codified in earnest in the seventeenth century. Díaz de la Vega culled many examples from Torquemada's *Monarquía indiana* (1615), Sigüenza y Góngora's *Parayso occidental* (1684), and Agustín de Vetancurt's *Teatro mexicano* (1698), to compose his own apologetic text.[21] The examples mostly refer to miracles that occurred to the Indians soon after the "encounter" and their "natural" susceptibility to partake of the sacraments; others describe the mysterious origin of devotional images namely as sculptures of Christ that were allegedly delivered to various sanctuaries by angels dressed as Indians.[22] Interestingly the author also transcribes two short accounts describing the lives of two virtuous Indian women—one hispanicized and the other heathen.

The first book narrates the life of the Otomí Indian Salvadora de los Santos, derived from a text by the Jesuit Antonio de Paredes of 1758.[23] Written as an edifying letter (*carta edificante*),

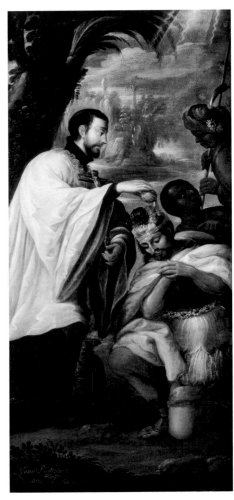

FIG. VI-15
Juan Rodríguez Juárez (Mexican, 1675–1728). *Saint Francis Xavier*, 1693. Oil on canvas, 55½ × 25¾ inches (141 × 65.5 cm). Museo Franz Mayer, Mexico City

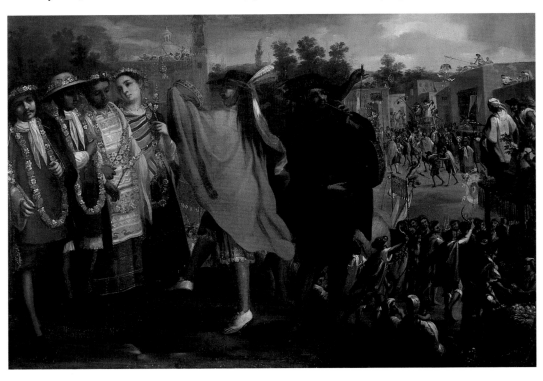

FIG. VI-16
Juan Rodríguez Juárez (Mexican, 1675–1728). *Indian Wedding*, c. 1715. Oil on canvas, 39⅜ × 57⅛ inches (100 × 145 cm). Private collection

Paredes's text conforms closely to established hagiographic models. The term *Otomí* referred to the various indigenous groups that had inhabited areas west and north of the Valley of Mexico since pre-Hispanic times. Although they aided the Spaniards in the conquest, they were often described as downtrodden and uncultured by colonial authorities. Salvadora's life was meant to tell a different story and prove that even the most rustic Indians could be redeemed and attain glory. The "saint," as she is often referred to in the text (though she was never canonized), was a simple Indian born in 1701 in the mining town of Fresnillo to noble Indians. When she turned twelve the family moved to San Juan del Río (her mother's hometown), where they lived poorly cultivating the land, taking care of a few sheep, and serving the Spaniards. From an early age Salvadora proved to be very obedient; she helped her parents in the ranch and opted for a life of utmost austerity, solitude, and penance. She also prayed constantly and devoted herself to weaving. Animals (especially birds) gravitated to her, and members of the important Spanish families of the region sought her company. Her innate piety led her to learn to read and write on her own to study the life of the saints. While visiting Querétaro one Christmas Eve, she saw a nativity scene that the Carmelite nuns had lovingly set up; enraptured by the figure of Christ, she asked to be admitted to the convent, where she made vows of celibacy. For twenty-six years she served the Carmelite nuns with utmost diligence and patience, and collected alms for their subsistence. Her kindness, hard work, and healing abilities made her famous in the region. In 1762 she fell sick during an epidemic that killed many Indians and died at the age of sixty-one. She was buried with great solemnity, and her portrait was immediately commissioned to be placed in the convent's parlor (*locutorio*).[24]

The second hagiographic text that Díaz de la Vega cites is that of Catherine Tekakwitha, an Iroquois of the Mohawk nation born in 1656 in what is today northern New York. Composed by the Jesuit missionary in Montreal Pierre Cholenec in 1717, the life of Tekakwitha became known to Spanish audiences through a translation by the Jesuit Juan de Urtassumm titled *La gracia triunfante en la vida de Catharina Tegakovita: india iroquesa* (1724).[25] The Iroquois were known for their fierceness and unwillingness to be pacified, but in the 1670s the Jesuits succeeded in converting several Mohawks and moving them into mission settlements near Montreal. The book describes Tekakwitha's natural inclination to follow the path of God, and the vicissitudes she endured until arriving at a mission where she renounced sex and followed a life of religious perfection. Her penances (fasting, self-flagellation, sleep deprivation, and so forth) were particularly severe. She died in 1680 at the age of twenty-four, and almost immediately after her death she became the object of a cult among native and French Canadian Catholics. The book describes the lengths to which Tekakwitha went to abandon her tribe and live among Christians, her enormous piety, virtues, and early death; it also dramatizes the case of several other Iroquois who embraced the faith, and their persecution and horrid martyrdoms at the hands of their own tribesmen who saw their conversion as betrayal.

The issue about the spiritual potential of the natives was very much at the fore in the capital of New Spain. It is not surprising that Tekakwitha's text was translated precisely when the city's elite and clergy were debating the establishment of Corpus Christi in 1724, the convent for Indian nuns; opposition stemmed from the conviction that Indian women were unsuitable material for the nun's vocation. As Allan Greer has stated, the debate was as much about race as gender. White consecrated virgins were charged with the role of safeguarding the city through their purity; Indian women were deemed not only racially inferior but incapable of being chaste.[26] The tale of Tekakwitha, an "exotic" Indian from a remote land was sure to grab the attention of readers, and convey the idea that even the most heathen of nations could become good Christians. In the case of Salvadora, her biographer went as far as emphasizing that poor, uneducated Indian women could be more pious than many Spanish noble women who preferred worldly pleasures to following the path of God.[27] Interestingly, Paredes's book about the life of Salvadora was reprinted in 1784 at the behest of the indigenous *parcialidades*

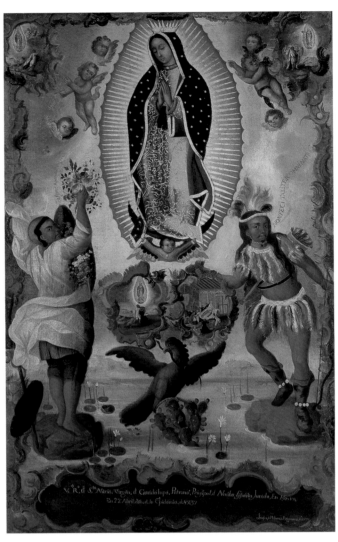

FIG. VI-17

José Ribera y Argomanis (Mexican, active second half
of the eighteenth century). *The Virgin of Guadalupe*,
1778. Oil on canvas, 64 × 68 inches (162.6 × 172.7 cm).
Museo de la Basílica de Guadalupe, Mexico City

(large sections of a town) of San Juan and Santiago in Mexico City. Dedi-
cated by the Indian governors Miguel de la Mota and Juan Ignacio de
S. Roque Martínez to the viceroy of Mexico Matías Gálvez (1783–84),
the book was designed to instill a sense of pride in their community and
prove their loyalty to the king. "The reprint of this edifying letter has the
advisable goal of providing the schools and groups where our children are
educated a type of certificate of ordination, so as they learn to read they also
learn to imitate Christian virtues by seeing them practiced in such a sweet,
powerful, and naturally appealing way by a person of their own condi-
tion."[28] The stories of Salvadora and Tekakwitha, as Díaz de la Vega knew
well, were potent examples that proved the power of God's grace to effect
perfection even within this portion of humanity. Several paintings of the
eighteenth century illustrate precisely the different categories of Indians
united by their acceptance of the faith, as a work by José Ribera y Argoma-
nis of the Virgin of Guadalupe flanked by a *macehual* and a heathen Indian
dressed in the stereotypical attire associated with this group (fig. VI-17).

A fascinating chapter of Díaz de la Vega's text is his description of
a series of portraits of illustrious Indian men, a number of them priests.[29]
The ordination of Indians as priests was contested throughout the colonial
period.[30] In keeping with the hyperbolic tone of his manuscript, Díaz de
la Vega states that many Indians attained important ecclesiastic positions
in the viceroyalty and "that to attempt to count them would be like trying to
count the stars of the firmament."[31] What is so compelling for art historians
about this section of his text is the way that Díaz de la Vega relies directly
on images to construct his argument. He describes four portraits that he
claims to have seen many times at the Colegio de Indias, a school for Indian
girls in Mexico City. Known also as the Colegio de Guadalupe, the school
was established in 1753 by the Jesuit father Antonio de Herdoñas.[32] Accord-
ing to Díaz de la Vega, the full-length portraits were placed in the *cuarto
chocolatero*, a room next to the church's sacristy where hot chocolate was served. Each por-
trait bore a detailed inscription that described the figure's name, place of origin, major literary
works, and posts. The portraits represented distinguished ecclesiastic figures identified as
Indian, including Francisco de Siles, Don Juan Merlo de la Fuente, Nicolás del Puerto, and
Don Juan Espinoza y Medrano (El Lunarejo).

Díaz de la Vega tells that the four paintings were commissioned by a priest from the ora-
tory of San Felipe Neri in Mexico City—whom he knew—from an indigenous artist.[33] He also
mentions a portrait of Antonio Valeriano at the entrance hall of the school. A native of Azcapo-
zalco, Valeriano was an Indian governor and Latinist, said to be related to Moctezuma II. In
the sixteenth century he had been one of the first students of the Franciscan college of Santa
Cruz de Tlatelolco, where he later taught. A governor of the Nahua *parcialidades* of Santiago
and San Juan, he instructed some of the early missionaries in Nahuatl, including Bernardino de
Sahagún, Juan Bautista, and Torquemada. He was also reputed to be the author of an account
of the apparitions of the Virgin of Guadalupe written in Nahuatl sometime in the mid- to late
sixteenth century.[34] The first four canvases were commissioned in the second half of the eigh-
teenth century, but there is no telling whether Valeriano's could have been earlier.

The cases of Francisco de Siles and Juan Espinoza y Medrano (El Lunarejo) also deserve
some consideration. Siles was a member of the cathedral chapter, professor of theology at the
university, and enthusiastic champion of the cult of the Virgin of Guadalupe. He wrote a lauda-
tory letter that accompanied Miguel Sánchez's *Imagen de la Virgen María* (the first published
account of Guadalupe, 1648), and fought tirelessly to secure a feast day and proper mass for the

Virgin. As part of the necessary canonical investigations ordered by Rome, Siles instigated the 1666 examination of the image by a group of prominent painters and clerics who corroborated her miraculous origin.[35]

Born in Cuzco, El Lunarejo (1632–1688) was most often described as Indian or mestizo. His fame as one of Peru's most talented literary figures extended well beyond the Andes. He became canon preacher at the cathedral chapter in Cuzco in 1683 after a long dispute following his rejection for being an Indian. Including his portrait in the colegio was a way of establishing a bridge—all the way from the north to the very southern tip of the hemisphere—between the natives of the Americas, and of stressing the talent of the original inhabitants. Memory was thus created through a careful orchestration of images. The Colegio de Indias hosted a veritable gallery of indigenous portraits meant to instill pride in the indigenous community. However, the school was visited by a much broader spectrum of people. From the time of its establishment, it had served as a refuge for single men, students, clergymen, widows, and foreigners of all social backgrounds who stopped by to grab an inexpensive bite to eat or purchase sweets and other foods. Its portrait gallery must have been well known; it is no wonder that Díaz de la Vega would single it out to praise the Indian nation.[36]

The bulk of Díaz de la Vega's manuscript addresses the significance of the natives in the apparition stories of some of New Spain's most celebrated religious icons: the Virgins of Guadalupe, Remedios, Octolán, and San Miguel del Milagro. In each case the holy figure appeared to or was found by a *ladino*, or hispanicized Indian.[37] The Virgins of Guadalupe and Remedios appeared in Mexico City, while San Miguel and the Virgin of Ocotlán are associated with Tlaxcala, a city granted special status for aiding the Spaniards during the conquest and being the first to embrace the faith. These devotions became intertwined with a sense of local pride. The Virgins of Guadalupe and Remedios were the divine bastions of the viceroyalty's capital who protected the city during floods and droughts, respectively; the Virgin of Ocotlán and San Miguel became a symbol of Tlaxcalan identity. Although Díaz de la Vega's manuscript is a compilation of excerpts from the most widely read texts about the images, its value lies precisely in the way the friar links their devotions. More significantly, the text proves that some ideas spread by earlier writers were absorbed by different groups within the colony and became encoded in eighteenth-century visual representations.

The section devoted to the Virgin of Guadalupe draws on the work of the Jesuit Francisco de Florencia, as well as the short treatise by the Nahuatl expert and priest Luis Becerra Tanco, titled *Felicidad de México* (1675). Moved by a strong patriotic sentiment, in the late seventeenth century Florencia penned a sequence of books about miraculous images in Mexico. The enormous popularity of his works stemmed from the way he synthesized the stories found in several earlier sources and from his clear and accessible prose. Florencia has been largely credited with fixing the tradition of these images and creating a coherent narrative of local devotions.[38] It not surprising that Díaz de la Vega would rely on the Jesuit's work for his own compilation. But while Florencia's impetus for writing his accounts was to create a pantheon of local images that could rival Europe's, Díaz de la Vega's intent was to underscore how "heaven wished to honor the Indian nation."[39]

The cult of the Virgin of Guadalupe appears to go back to the second half of the sixteenth century, although efforts to codify her origins only occurred in the mid-seventeenth, when a strong sense of Creole identity crystallized in New Spain.[40] The story of her four apparitions to the pious Indian Juan Diego in 1531 are well known, as is the stubborn disbelief of Bishop Juan de Zumárraga until proof was brought in the form of Juan Diego's mantle filled with extraordinary flowers that, once emptied out, revealed the image of the Virgin imprinted in the mantle. The apparition and dramatic unfolding of the cloak captured the attention of devotees, and also became the element of the story most often represented (fig. VI-18). Although the visual tradition of the Virgin of Guadalupe was fixed in the mid-seventeenth century, her images

FIG. VI-18
Miguel Cabrera (Mexican, 1695–1768). *Juan Diego*, c. 1755. Oil on canvas, 42⅛ × 32¼ inches (107 × 82 cm). Museo Regional de Querétaro/CONACULTA, INAH, Mexico

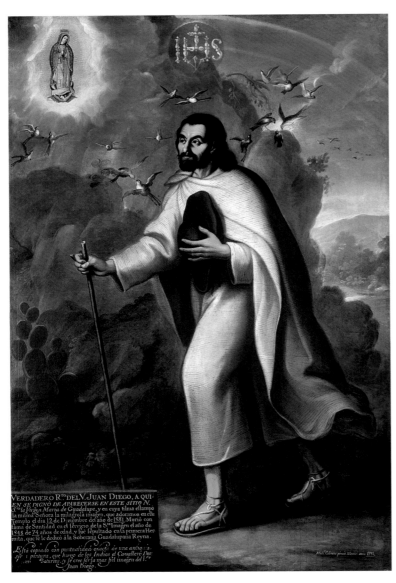

proliferated in an unprecedented way in the eighteenth. This
came about in part through her proclamation as Mexico City's
patroness in 1737; a second inspection of the original image
in 1751 by a group of prominent painters led by Miguel Cabrera
(1713/1718–1768), who declared that it was not painted by a
human hand; and Pope Benedict XIV's 1754 confirmation of the
Virgin of Guadalupe's patronage (*patronato*) and his concession
of a proper mass and office in her name. Miguel Cabrera became
the most acclaimed painter of Guadalupe after 1750 (cat. VI-39).
His early portrait of Juan Diego created for the chapter house
(*colegiata*) of the Basílica de Guadalupe, shows a key moment in
the tradition of the Virgin's apparitions, when Juan Diego, lured
by the singing of birds and a beautiful rainbow, is called by the
Virgin to the hill of Tepeyac, where her sanctuary was eventually
erected (fig. VI-19).[41]

The story of the Virgin of Remedios was documented in
1621 by the Mercedarian Luis de Cisneros and later added to
Florencia's corpus; Díaz de la Vega cites both sources.[42] Like
Guadalupe's, the tale of Our Lady of Remedios originated after
the conquest but was preserved mostly in oral form. In 1595 the
vicar José López commissioned a series of paintings, most likely
frescoes, of Remedios from the painter Alonso de Villasaña for her
sanctuary, which are now lost. As was typical of sixteenth-century
erudite decorative programs, it alternated biblical scenes with the
central events of the story of the image, alongside emblems and
Latin inscriptions.[43] Cisneros laments the lack of written docu-
ments attesting to the origin of the image (as does Florencia),
but explains that this was also the case with some of Spain's most
prominent images: "The lack of information about her origin is
unimportant, and I believe, furthermore, that this obscurity is
one of the reasons she has such a large following."[44] To write his
account, Cisneros relied on both oral tradition and the 1595 paintings, equating visual repre-
sentations with writing. "If paintings are old," he stated, "they have the power of writing."[45]
He also noted that images had long been considered the books of the ignorant—visual texts
through which they could learn the mysteries of the faith—and that their semblance to reality
had the power to move the viewer. The consubstantiation of painting and writing became a
powerful tool in the colonial era to validate history.[46]

According to tradition, the Virgin of Remedios was a sculpture brought to the New
World by Juan Rodríguez de Villafuente, one of Hernán Cortés's soldiers. After razing the
idols of the Aztecs' main altar, Cortés had the image placed at the top of the shrine. The Virgin
is said to have produced many miracles and to have aided the Spaniards during the *Noche triste*
(the bitter night when they were forced to retreat to the hill of Otoncalpulco) by casting dust
in the eyes of the Indians. That evening Cortés's soldier hid the tiny sculpture under a maguey
plant. It was found some twenty years later by the *cacique* (noble) Indian Juan Ceteulti, who
had witnessed her apparition during the *Noche triste* and several times thereafter. Juan first
took the image to his house, where he lovingly cared for it, but in seeing that the Virgin would
constantly return to the place where he originally found her at the hill of Totolotepec, he even-
tually erected a small sanctuary at the site. From that point on, Remedios became one of the
most important devotions in New Spain, especially after she was backed by the cabildo (city
council) in 1564 and a more spacious sanctuary was built in 1575.[47] She was often brought out

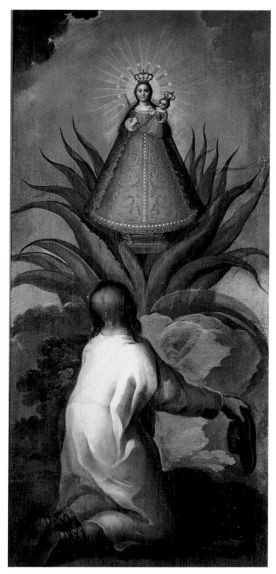

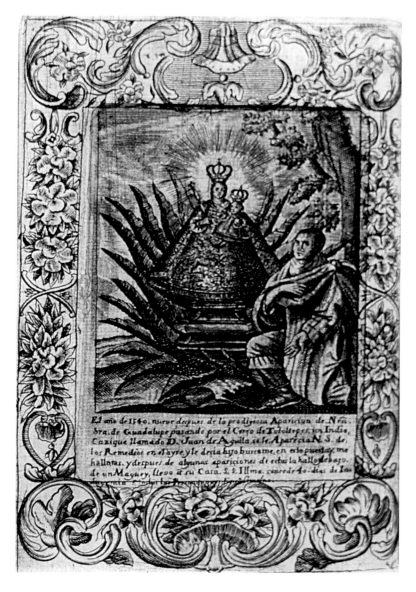

FIG. VI-20

The Discovery of the Sculpture of the Virgin of Remedios, c. 1750. Oil on canvas, 55½ × 25¼ inches (141 × 64 cm). Pinacoteca del Templo de la Profesa/CONACULTA, DGSMPC, Mexico City

FIG. VI-21

Francisco Sylverio (Mexican, 1721–1761). *The Discovery of the Sculpture of the Virgin of Remedios*, c. 1760. Engraving. Real Academia de la Historia, Madrid

in procession to Mexico City during droughts, plagues, and other calamities and had a wide following among all sectors of society (natives, Spaniards, and blacks).[48] As Díaz de la Vega reports, she remained closely associated with the Otomí communities of Tacuba until the late eighteenth century: the descendants of Juan Ceteulti continued to care for the house where Juan originally took in the image, which was well known in the region as *la casita de la Virgen* (the Virgin's little house).[49] By the eighteenth century the visual representation of Remedios began to be codified; surviving images frequently show the tiny sculpture hidden in a maguey plant at the moment when Juan Ceteulti discovers her, an apt way of dramatizing the story and highlighting the Indian as protagonist (figs. VI-20, VI-21).[50]

The significance of devotional images in Tlaxcala should be considered in relation to those of Mexico City. As the city that first swore obedience to the Spaniards, Tlaxcala claimed a glory unlike any other region of the viceroyalty.[51] Its pride in its past entailed a need for magnificent icons that could compete with those of Mexico City. The cults of San Miguel del Milagro and the Virgin of Ocotlán were late occurrences that can be linked in part to the fame attained by Guadalupe and Remedios in the capital as the two cities vied for icons. The archangel Saint Michael is said to have appeared in Tlaxcala in 1631, but the cult was only documented by Florencia in 1690.[52] Tradition here affirmed that the archangel appeared to the Indian Diego Lázaro in a religious procession in the town of San Bernabé in the jurisdiction of Nativitas. He informed Diego Lázaro of a well with healing waters and asked that he

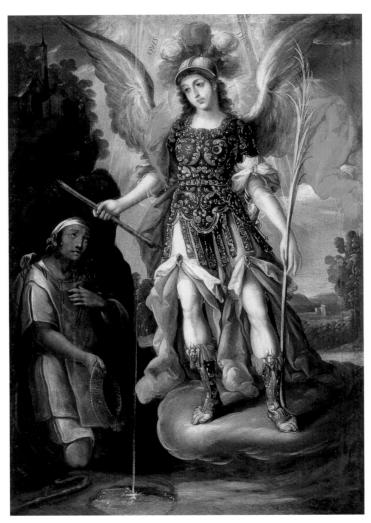

El día 7. de Mayo de 1631, se apareció el Principe Sr. San
Miguel, à Diego Lázaro de Sn Franco Indio de el Pueblo de San
Bernabe, Cercano al de Nativitas, de el Obispado de la Puebla, y
le manifesto en el Cerro Tzopiloatl, el Manantial de Agua Saludable
que oy Sevenera.

Sylverio. Sc à 1731. en las Escalerillª

FIG. VI-22
*The Apparition of San Miguel del Milagro to Diego
Lázaro*, first half of the eighteenth century. Oil on
canvas, 67⅛ × 46⁷⁄₁₆ inches (170.5 × 118 cm). Museo
Universitario de la Benemérita Universidad Autónoma
de Puebla, Mexico

FIG. VI-23
Francisco Sylverio (Mexican, 1721–1761). *The Apparition of San Miguel del Milagro to Diego Lázaro*, c. 1760.
Engraving. Real Academia de la Historia, Madrid

publicize the miracle, but afraid that he would be met with disbelief, the Indian ignored the command. Saint Michael punished him with a grave illness and appeared to him a second time, when he miraculously transported him to the site of the well. A brilliant ray of heavenly light illuminated the spring, and Saint Michael demanded again that Diego Lázaro publicize the event or risk punishment. Eventually Diego Lárzaro visited the bishop of Puebla, Gutierre Bernardo de Quirós, who upon seeing the healing effects of the water, and aware that Guadalupe and Remedios had also appeared to Indians, conducted a formal investigation (1631).[53]

Meanwhile devotion to the well and to San Miguel del Milagro grew. The bishop sanctioned the apparition, and a tiny sanctuary was erected around the well. A few years later (1643) the bishop Juan de Palafox y Mendoza of Puebla visited the site, and, after fully embracing the cult, ordered another investigation and the building of a larger sanctuary (a third investigation took place in 1675). Following the erection of the small shrine in the 1630s, narrative paintings commemorating the apparitions were placed inside, probably inspired by the painting commissioned by Diego Lázaro to remember the event.[54] By the eighteenth century the scene of the archangel revealing the spring of healing water to Diego Lázaro had become canonical in paintings and prints in Mexico (figs. VI-22, VI-23). The print collected by the Spanish Capuchin friar Francisco de Ajofrín during his 1763–65 visit to Mexico is an eloquent example of the popular following of the image in the second half of the eighteenth century well beyond the confines of Tlaxcala: it was signed by the renowned engraver Francisco Sylverio (1721–1761) in Mexico City.[55]

The history of the Virgin of Ocotlán, the most venerated image of Tlaxcala, was only recorded in 1745 by the sanctuary's third chaplain (*capellán*), Manuel Loayzaga.[56] According

to tradition, soon after the conquest there was a terrible epidemic. One evening an Indian (also named Juan Diego) went to the river Sahuapan in the outskirts of Tlaxcala to fetch water to heal the sick and saw an apparition of the Virgin at the hill of Ocotlán. She led him to a mountain stream nearby filled with *ocotes* (local pine tress), where she showed him a spring of healing waters, and explained that an image in her likeness could be found there and that he should alert the Franciscans. Seeing the healing effects of the water, the friars set out to look for the image and found a small sculpture inside a burning *ocote*. The image was then taken in a great procession to the Franciscan convent and placed in the center of the main altarpiece, where it replaced an image of Saint Lawrence. At night, the displeased sacristan removed the image of the Virgin and returned Saint Lawrence's, but the next morning he found that the statue of the Virgin had reappeared on the altarpiece. He attempted to remove the Virgin's image several more times, even taking the statue to his house and later to the sacristy, where he locked it inside a trunk and slept over it to prevent it from escaping. His attempts met with no success, as the Virgin continued to return to the altarpiece. From this point on the Virgin of Ocotlán attained great fame, and a sanctuary was erected for her. Backed by Bishop Pantaleón Álvarez Abreu of Puebla (1743–65), she was sworn a patroness of Tlaxcala in 1755, just a year after Guadalupe's official feast day was approved by the pope.

Loayzaga was the key figure in the promotion of the cult of Ocotlán; in addition to publishing the account, he devoted his life to caring for the sanctuary, which he embellished with a lavish *camarín* (the image's octagonal chamber behind the altar) and elaborate paintings by the Puebla artists Juan de Villalobos (1687–1724) and Manuel Caro (1781–1820).[57] Loayzaga drew on oral tradition to write his narrative, noting: "What is the need to reduce to paper what so mightily is imprinted, and with gold letters, in the canvases of the soul?"[58] In his account he mentions that the fame of the Virgin attracted people from all over the viceroyalty and that many copies after her were made. His chapter on the Virgin's miracles and thaumaturgic powers describes how paintings and prints of her image were often placed on the bodies of the sick to heal them. In the second half of the eighteenth century, Ocotlán's cult spread and her images proliferated. The scene of the encounter of Juan Diego and the Virgin became paradigmatic—Tlaxcala could boast of its own religious bastions (fig. VI-24).

Significantly, the first two chapters of Loayzaga's book are devoted to the martyrdom of three recent converts in Tlaxcala following the conquest: Cristobalito, Antonio, and Juan. The story of these boys was legendary from the sixteenth century and also represented in art and performed in plays.[59] Cristobalito, a pious Tlaxcalan Indian who studied with the Franciscans, begged his father to embrace the Christian faith, but was brutally killed by him when he destroyed his idols and smashed his *pulque*-filled jars. Led by the Franciscan friars, Antonio and Juan set out on a mission to find and destroy all pagan idols in the region, but were caught by the owners and viciously murdered. The story of these three martyrs was more than appropriate to frame the account of the Virgin of Ocotlán; it proved their willingness to die in the name of the faith and the special status conferred to the city of Tlaxcala. There was no higher honor than to die defending the faith, as the many portraits of martyrdoms at the hands of heathen Indians demonstrate. Probably following Loayzaga's cue, Díaz de la Vega also devotes two chapters to the three martyred boys. He also tells the story of Querétaro's prodigious stone cross (*cruz de piedra*), much publicized in the eighteenth century by the Franciscans.[60] After the conquest, the Spaniards and Otomí Indians—led by the *cacique* Nicolás de San Luis Montañez—joined forces against the Chichimecs, considered the most indomitable Indians of New Spain. Suddenly, during the battle, a resplendent light appeared in the sky, giving way to an image of a cross and Santiago, Saint James, Apostle. The vision prompted some heathens to flee in terror and the rest to convert to the faith. A great cult of the cross ensued connected to the founding of the city, and portraits of the knighted Indian leader set against the prodigious scene were painted (fig. VI-25). As the historian Antonio Rubial has argued, the tradition was

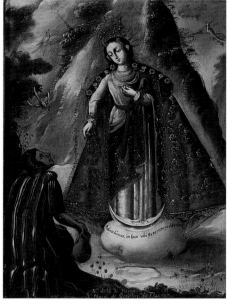

FIG. VI-24
The Apparition of the Virgin of Ocotlán to the Indian Juan Diego, second half of the eighteenth century. Oil and beads on canvas, 11⅝ × 9⁷⁄₁₆ inches (29.5 × 24 cm). Museo Soumaya, Mexico City

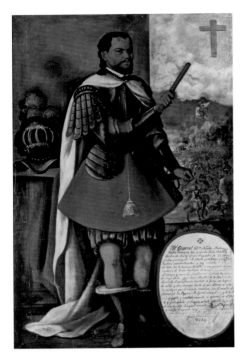

FIG. VI-25
Portrait of Nicolás de San Luis Montañez, c. 1750. Oil on canvas, 73⅝ × 46⅛ inches (187 × 117 cm). Museo de la Ciudad de Querétaro/CONACULTA, INAH, Mexico

a Franciscan invention, but it was widely accepted, particularly by the indigenous nobility, as it allowed them to broadcast their role in the establishment of the city and claim privileges and land.[61] Because of the Indians' alleged participation in the foundation of Querétaro, for Díaz de la Vega the cross was a further mark of their honor.

The significance of Díaz de la Vega's compilation lies in his choice of subjects and the way he interrelates them. In a real tour de force of apologia, the friar states:

> Of what importance is that the Indian nation should be generally derided by men, when it is extolled by Heaven and favored and exalted by God and his most Holy Mother? The incredulous should come to Mexico and inquire to whom the most Holy Empress Mary appeared so many times, to whom she spoke in a soft voice, and on whose mantle she impressed her miraculous image of Guadalupe. And he will learn that no other was elected by the Holy Virgin for such glorious enterprise than a poor, humble, and miserable Indian. Go to Tlaxcala and find out who was the subject to whom the Queen of Angels visibly appeared on the hill on the way to the river? Whom she led to that forest? To whom she offered the healing waters that she miraculously produced there? And to whom she promised her sacred image that today is known as Ocotlán? And they will be told to another Indian of the same class as the previous one. Go back to Mexico and approach the hill of Otoncalpulco to learn about the invention of the extraordinary image of Our Lady of Remedios, and you will find out that the inventor was an Otomí Indian. Go a second time to the province of Tlaxcala, and ask who the archangel Saint Michael favored with various apparitions? Who was miraculously healed with the spring of healing waters that is today venerated in the archangel's sanctuary known as San Miguel del Milagro? And you will be told an Indian like those mentioned above . . . Continue to the city of Querétaro and find out about the miraculous stone cross that is venerated there . . . and you will realize . . . that it was all in favor of the Chichimec Indians who inhabit that land. And after you have been fully informed of all this, then you can tell me if the Indians have made no happy progresses in Christendom, if they have not been favored by God and his most Holy Mother, and finally if this nation deserves to be abandoned, disparaged, and deemed irrational.[62]

This is clearly apology at its best, and creating a catalogue of the benefits brought to the Indians served many purposes beyond extolling the viceroyalty. In connecting the devotions of Guadalupe, Remedios, and San Miguel del Milagro, Florencia noted in passing that the Indians were the recipients of the apparitions despite being the most downtrodden nation in the colony.[63] But Florencia's fundamental aim, like that of many leading patriotic intellectuals of the seventeenth century was to place New Spain at the center of a unique Christian cosmography—not to redeem the Indians. Since the natives composed the majority of the population, Florencia's impetus was to prove their status as Christians rather than catalogue their accomplishments. The Jesuit's association of these devotions, however, had an impact among the clergy and on the visual arts, particularly in the eighteenth century. The main altarpiece of the church of the Merced de las Huertas in Mexico City, for instance, comprises a set of canvases by Miguel Cabrera of the Virgins of Guadalupe and Remedios and San Miguel del Milagro.[64] It is no coincidence that this altarpiece that brings together these three devotions was in the jurisdiction of Tacuba, a native town near the sanctuary of Remedios. The ensemble must have instilled a great sense of pride in the local parishioners, for the association of these devotions extolled the Indian nation and their role in the sanctity of the viceroyalty, and fostered an indigenous consciousness. Although Creole clerics were often responsible for documenting certain devotions, these in turn were based (at least in part) on

native oral traditions, and later reclaimed by the indigenous communities themselves, who had an equal stake in the promotion of their culture and place within colonial society.

The significance of Díaz de la Vega's compilation lies in his direct reinterpretation of a classic Creole agenda and his exaltation of the Indian side of things. If Luis de Cisneros referred to the Virgin Mary as the "Star in the Sea of the Church," Díaz de la Vega emphasized the Indians' unique place in that divine constellation.[65] There is little doubt that the stories that Díaz de la Vega so carefully culled were preached in Indian towns to instill a sense of ethnic pride and promote devotion, and that this narrative resulted in the commission of significant artistic programs.[66] Díaz de la Vega's manuscript exemplifies how text, images, and memory lie at the heart of the construction of history in eighteenth-century Mexico. The theme that he sounded was in the air among those who looked to counter ill-founded notions about the natives. And images (like writing) were an indissoluble part of the process. As one eighteenth-century author put it: "brushes and burins are silent chroniclers who, with light and shadow, forever render visible the treasures of history in their canvases."[67]

NOTES

© Ilona Katzew, 2006

This is an abridged version of a larger essay for *Race and Classification: The Case of Mexican America,* ed. Ilona Katzew and Susan Deans-Smith (in preparation for Stanford University Press). I wish to thank my friend and colleague María Elena Martínez for her insightful comments.

1. Torquemada 1615/1975, vol. 3, pp. 104–7. On this subject, see Brading 2001, chap. 1. All the translations are my own.

2. Gruzinski 1995, p. 12.

3. Cuadriello 2004 *Glorias*, p. 37.

4. Friar José Mariano Díaz de la Vega, "Memorias piadosas de la nación yndiana recogidas de varios Autores por el P. F. Joseph Díaz de la Vega Predicador grãl è Hijo de la Prov.ª del Santo Evangelio de Mexico" (1782), Real Academia de la Historia, Madrid, Col. Boturini, MS 9/4886. Another copy of the manuscript is at the Bancroft Library, University of California at Berkeley, MSS M-M 240. The citations are from the Madrid copy, hereafter "Díaz de la Vega 1782." The biographical information on Díaz de la Vega derives from the manuscript where the author mentions being a Franciscan priest in Mexico City and studying theology at the convent of Tlaxcala in 1740 (fol. 44v).

5. See Pagden 1986. See also Seed 1993, pp. 629–52.

6. Brading 1993, p. 371. Iván Escamilla questions Sigüenza's intention of vilifying the Indians, arguing that his description was politically motivated to sustain the favor of the viceroy Conde de Galve (1688–96). González 2002, pp. 179–203.

7. Juan de Palafox y Mendoza, "De la naturaleza del indio" (c. 1642), in Palafox y Mendoza 1762, p. 479. For an example of how eighteenth-century authors referenced Palafox, see Katzew 2006, intro.

8. Taylor 1996, pp. 173–75.

9. A summary of many of these theories is in Brading 1993, chap. 9. See also Poole 1981, pp. 637–50; and Popkin 1989.

10. For theories about the origin and nature of the natives of the New World spread during the so-called Enlightenment, see Gerbi 1993.

11. Díaz de la Vega 1782, fols. 1r–4v, 8r–9r, 62v–63r.

12. Brading 1993; and Cañizares-Esguerra 2001, p. 204.

13. On the juridical status of the Indians as new Christians, see Borah 1982.

14. Cañizares-Esguerra 2001, p. 217.

15. Eguiara y Eguren 1986, vol. 1, p. 55.

16. Ladd 1976, pp. 21, 235 n. 28. See also Cañizares-Esguerra 2001, p. 233.

17. See my discussion in Katzew 2004, pp. 67–94.

18. See Rubial and Suárez Molina 1999.

19. See my discussion in Katzew 2004, pp. 81, 172–79.

20. Díaz de la Vega 1782, fols. 7v–8r.

21. Ibid., chap. 10.

22. Díaz de la Vega mentions several crucifixions and images of Christ in Mexico City at the church of Santo Domingo, Balvanera, San Agustín, Regina Coeli, and the convent of Jesús María, as well as the sanctuary of Chalma outside of Mexico City.

23. Ibid., chap. 12. Paredes 1784.

24. Ibid., pp. 111–12.

25. Díaz de la Vega 1782, chaps. 15–18. In Urtassumm 1724. For the polemical history of this text and its unusual circulation from the northern empire of France to New Spain, see the excellent study in Greer 2003.

26. Greer 2003, pp. 238–39.

27. Paredes 1784, pp. 110–11.

28. Ibid., n.p.

29. Díaz de la Vega 1782, chap. 13.

30. Poole 1981.

31. Díaz de la Vega 1782, fol. 128r.

32. The history of the Colegio de Indias is documented in Marroquí 1969, vol. 3, pp. 11–19.

33. Apparently a fifth canvas was commissioned, but upon the death of the painter the work was effaced "without any consideration" and the canvas was placed in public auction; no information was therefore known of the sitter. Juan de Merlo is described as born in Tlaxcala; he received his doctorate in canon law from the University of Mexico, and was canon of the cathedral of Puebla and bishop of Honduras. Nicolás del Puerto is described as a Zapotec Indian born in Chichicapa (Oaxaca), who studied at the Colegio Mayor de Todos Santos in Mexico City, and occupied important posts at the university, the cathedral, and the Holy Tribunal of the Inquisition. For the paintings' inscriptions, see Díaz de la Vega 1782, fols. 128v–133v.

34. Poole 1995, pp. 83–84.

35. Ibid., pp. 104, 128–29, 142.

36. The Colegio de Indias was eventually turned into a convent. According to Marroqui the portraits were still in the possession of the nuns following the secularization of the church in the nineteenth century. See Marroqui 1969, vol. 3, p. 13. A seventeenth-century portrait of Juan de Merlo is in the collection of the Museo Nacional de Historia, Mexico City. Ciancas and Meyer 1994, p. 107.

37. The stories of these images were closely modeled on European hagiographies, where the patron saint usually appears to a shepherd. For the context of the apparition of miraculous images in Spain, see Christian 1981 *Apparitions*.

38. Gruzinski 1995, pp. 139–41. For Florencia's role in spreading the history of these images, see Antonio Rubial García's introduction to Florencia and Oviedo 1995, p. 18; and Alcalá 1998 "Jesuits," chaps. 1–2.

39. Díaz de la Vega 1782, fol. 38r.

40. The literature on the Virgin of Guadalupe is very extensive. A few useful sources include Poole 1995; Taylor 1987, pp. 9–33; Maza 1981; and Brading 2001. For the development of Guadalupe's iconography, see *Imágenes guadalupanas* 1987; and *Divino pintor* 2002.

41. Some of New Spain's most prominent Marian images were also catalogued by Florencia and Oviedo in their *Zodíaco Mariano* (1755); this work was begun by Florencia and completed by Oviedo in the eighteenth century. See *Zodíaco Mariano* 2004.

42. Cisneros 1999; Florencia 1685/1745.

43. Cisneros 1999, pp. 73–103.

44. Ibid., p. 31.

45. Ibid., pp. 46, 73. Cisneros also mentions consulting the city council's archives. On this subject, see also Alcalá 1997, pp. 43–56.

46. Luis Becerra Tanco also seems to have relied on two major seventeenth-century paintings in writing his famous *Felicidad de México* (1675): the first represents the procession of the Virgin to her new sanctuary in 1531 and the performance of her first miracle; the second a Franciscan procession from Tlalelolco to Tepeyac during the devastating 1544 plague that killed many Indians. Both works are now at the Museo de la Basílica de Guadalupe, Mexico City. See Cuadriello 1999 "Tierra," pp. 195–97.

47. On the Virgin of Remedios, see Curcio-Nagy 1996, pp. 367–91. On the relationship of the Virgins of Remedios and Guadalupe, see Alberro 1997. The Archivo Histórico del Ayuntamiento de México (Mexico City) is a rich repository of documents about the sanctuary and the devotion of Remedios, which still awaits careful study.

48. On the Virgin as a unifying element of society, see Cisneros 1999, p. 153.

49. Díaz de la Vega offers useful information for assessing the popular following of the Virgin of Remedios in the eighteenth century and the sense of pride the image continued to instill in Juan Ceteulti's family. He mentions visiting Juan Ceteulti's house where the image was originally housed, which remained in the family for generations. When Díaz de la Vega saw it in 1745 (he was in contact with Juan Ceteulti's grandchildren Guillermo, between 1745 and 1753, and Pascuala de Tovar, between 1745 and 1747), the small room of the Virgin was still preserved. Pascuala de Tovar also began building a beautiful chapel where the image was once kept, but upon her death the project was left unfinished. According to Díaz de la Vega, the house had a sculpted tablet with an eagle with extended wings—the coat of arms of the Ceteulti family; by the 1780s the house was in a state of complete disarray. Díaz de la Vega 1782, fols. 54r, 58r–59v.

50. The engraving was inserted in the travel diary of Francisco de Ajofrín, *Diario del viaje que por orden de la sagrada congregación de propaganda fide hizo a la América septentrional en el siglo XVIII* (1763). See Ajofrín 1763/1958. The manuscript is in the collection of the Real Academia de la Historia, Madrid, MS 9-17-1.

51. See the excellent study of Cuadriello 2004 *Glorias*.

52. Florencia 1692. Florencia mentions deriving part of his information from an earlier text by Father Pedro Salmerón.

53. The great flurry of miraculous images in the Catholic world led Pope Urban VIII (1623–44) to impose strict restrictions regarding their acceptance. For the context in New Spain, see Rubial García 1997, p. 56.

54. See Báez-Macías 1979; Cuadriello 1999 "Tierra," pp. 199–204; and Alcalá 1998 "Jesuits," pp. 85–95.

55. Ajofrín 1763/1958. These are the dates traditionally assigned to Francisco Sylverio. The print could conceivably be by Francisco's son, Juan Manuel Sylverio. For a revision of Sylverio's career, see Sobrino Figueroa 1998, pp. 108–16.

56. Loayzaga 1750. The book was first printed in 1745. Ocotlán's devotion was integrated to Florencia and Oviedo's *Zodíaco mariano* (1755); see Florencia and Oviedo 1995, pp. 256–71.

57. On the painted cycles, see Cuadriello 2004 *Glorias*, pp. 269–87.

58. Loayzaga 1750, intro., unpaginated.

59. Cuadriello 2004 *Glorias*, pp. 303–15.

60. Díaz de la Vega 1782, chap. 8. The source cited by Díaz de la Vega is Santa Gertrudis 1722. For the history of the cross and its diffusion in the eighteenth century by the Franciscans based on indigenous sources, see Rubial García 2004, pp. 25–58.

61. Ibid., p. 56.

62. Díaz de la Vega 1782, fols. 47r–48v.

63. Florencia 1692, p. 80.

64. Tovar de Teresa 1995, pp. 102–6, 122–23.

65. Cisneros 1999, p. 139.

66. Jaime Cuadriello offers a compelling case of the artistic patronage of a noble indigenous family in Tlaxcala in the late eighteenth century. The elaborate decorative program commissioned by Don Ignacio Faustinos Mazihcatzin Calmecahua Escobar, priest of San Simón Yehualtepec from 1785 to 1803, included paintings of the Virgin of Ocotlán, San Miguel del Milagro, Catherine Tekakwitha, and the martyrdoms of Cristobalito, Juan, and Antonio, among others. As Cuadriello has noted, this was a veritable indigenous ensemble of ethnic, familial, and regional pride. Cuadriello 2004 *Glorias*.

67. Santa Gertrudis 1722, pp. 11, 45; cited in Rubial García 2004, p. 32.

VI-1 Luis Lagarto†

(Spanish, 1556–after 1619; active Mexico from 1586)

Choir Book (details)

1600–1611
Gold leaf and gouache on vellum
35⅜ × 23⅝ inches (90 × 60 cm)
Cathedral of Puebla/CONACULTA, DGSMPC, Mexico

PUBLISHED: Toussaint 1982, pp. 116–17, fig. 193; *Catálogo Nacional* 1988, vol. 2, pp. 496–511; Tovar de Teresa 1988, pp. 79–115; *Mexico* 1990, cat. no. 134, pp. 305–6; Merlo Juárez et al. 1991, p. 134, ills. passim

EXHIBITED: New York, San Antonio, and Los Angeles 1990, cat. no. 134

VI-2 Attributed to Andrés Lagarto†

(Mexican, 1589–1666/67)

or Luis de la Vega Lagarto†

(Mexican, 1586–after 1631)

Nun's Badge: Virgin and Child with Saints John the Baptist and Catherine of Alexandria (?)

c. 1640
Watercolor on vellum in tortoiseshell frame
Diameter 5⅞ inches (15 cm)
Philadelphia Museum of Art, The Dr. Robert H. Lamborn Collection, 1903-900

PROVENANCE: Robert H. Lamborn

PUBLISHED: Bantel and Burke 1979, no. 37, p. 114; Tovar de Teresa 1988, no. 16, pp. 159–77, 218; *Mexico* 1990, cat. no. 135

EXHIBITED: New York, San Antonio, and Los Angeles 1990, cat. no. 135

VI-3 Luis Lagarto†

Adoration of the Shepherds

1610
Gouache on vellum
10 × 8 inches (25.4 × 20.3 cm)
Inscribed at lower right: *LVIS LAGARTO F. 1610*
Denver Art Museum, Collection of Jan and Frederick R. Mayer

PROVENANCE: Mariano Bello Collection, Puebla, Mexico

PUBLISHED: Toussaint 1982, p. 117, fig. 191; Tovar de Teresa 1988, pp. 128–29; Pierce et al. 2004, cat. no. 8, pp. 123–26

EXHIBITED: Denver 2004, cat. no. 8

VI-4 Luis Lagarto†

Annunciation

1610
Gouache on vellum
9¹³⁄₁₆ × 8¼ inches (25 × 21 cm)
Inscribed at upper right: *LVIS LAGARTO F. 1610*
Museo Nacional de Arte/INBA, Mexico City

PROVENANCE: Ruiz Olavarrieta Collection; Pinacoteca Virreinal de San Diego

PUBLISHED: Tovar de Teresa 1988, pp. 130–31; *Mexico* 1990, cat. no. 133, pp. 303–5; Tovar de Teresa 1992, p. 170; Ruiz Gomar et al. 2004, pp. 349–52

EXHIBITED: New York, San Antonio, and Los Angeles 1990, cat. no. 133

VI-5 Luis Lagarto†

Annunciation

1611
Gouache on vellum
12 × 10 inches (30.5 × 25.4 cm)
Inscribed at lower left: *1611*; at lower right: *LVIS LAGARTO*
Denver Art Museum, Collection of Jan and Frederick R. Mayer

PUBLISHED: Tovar de Teresa 1988, pp. 132–33; Pierce et al. 2004, cat. no. 8, pp. 123–26

EXHIBITED: Denver 2004, cat. no. 8

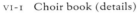

VI-1 Choir book (details)

THE GROUP OF PAINTINGS in various small-scale formats gathered here is the work of an artist from Andalusia, Luis Lagarto, and of his sons, Luis de la Vega Lagarto and Andrés Lagarto, born in Mexico City and trained by their father. As Luis illuminated the pages of one choir book after another for the cathedral of Puebla, fulfilling what seems to have been the principal artistic commission of his life between 1600 and 1611, his young sons learned the trade, along with letters and mathematics. Indeed, the multifaceted Luis was not only a skilled painter, but also a teacher, scholar, poet, and organizer of festivals. Juan Lagarto, probably Luis's father, had himself been a teacher of letters and mathematics, and whether Luis was trained under Lázaro de Velasco in the Italianate ambience of the cathedral of Granada, or had spent time in Seville, or both, certainly his education had prepared him for establishing in New Spain a family enterprise of painters of miniatures for books, documents, reliquaries, and nuns' badges, and of small devotional paintings.

Luis Lagarto was in New Spain in 1586 but may well have arrived somewhat earlier. A fully trained master before leaving Spain, he no doubt came because there was a particular interest in having someone of his talents in Mexico City. Although he might have arrived with the viceroy Villamanrique, he could also have accompanied Diego Romano y Govea, who had been in Granada and was to become bishop of Puebla. The decisive circumstance that led to Lagarto's presence in Mexico City seems to have been the remodeling of the cathedral in preparation for the Third Provincial Mexican Council, which opened there in 1585. Lagarto's earliest identified works are, in fact, some of the miniatures in a Mexico City cathedral choir book. There must have been more.

The book from the cathedral of Puebla (frontispiece and cat. VI-1) is one of a number of choir books illuminated there by Lagarto. The contract between the painter and the cathedral chapter, first published by Pérez de Salazar, stipulates that the large initials would be paid at twenty, and the

small ones at seven, pesos. Lagarto agreed to make them according to the samples that had been presented as models, and to follow the instructions of the bishop and of the cathedral clergy. All the initials are painted on a gold ground within a simple illusionistic frame that casts a painted shadow on the upper and left-hand sides of the field of gold. The letters themselves are combinations of strap-work and acanthus, all in brilliant mineral colors, with painted jewels and metal ornaments set into them at strategic points. Both elements, but most often the acanthus, metamorphose into masks and grotesque figures, both animal and human. More naturalistic flowers, fruits, insects, and birds emerge from the letters, or rest on and near them. There also are independent figures of humans, angels, putti, animals, and monsters. In the larger letters especially, saints or religious scenes, often framed in some way, occupy the central spaces. Sometimes the frames or pedestals are architectural. Occasionally, monochromatic figures and scenes appear. These are invariably naturalistic and framed, reminding one of ancient gemstones with reliefs. All these elements intermingle with the initials, and the figures react to one another through postures, gestures, and glances. Not only are all the forms shaded and highlighted; they also cast brown shadows onto the gold ground, especially at the lower and right-hand side of each shape. These complement and are consistent with the shadows of the frames, above and at left, thus increasing the illusion of relief and volume of the painted forms.

The grotesques within these miniatures, though relatively limited, and mitigated by naturalistic elements and clearly identifiable religious figures and scenes, must have been appreciated by the original patrons of these books, as is clear from the contract. Yet, their presence is surprising in the early seventeenth century, when painting in church contexts was supposed to be more instructive than amusing. The exclusively clerical use of the books, which were usually out of sight of ignorant eyes and minds, probably explains the indulgence allowed to fantasy in their production.

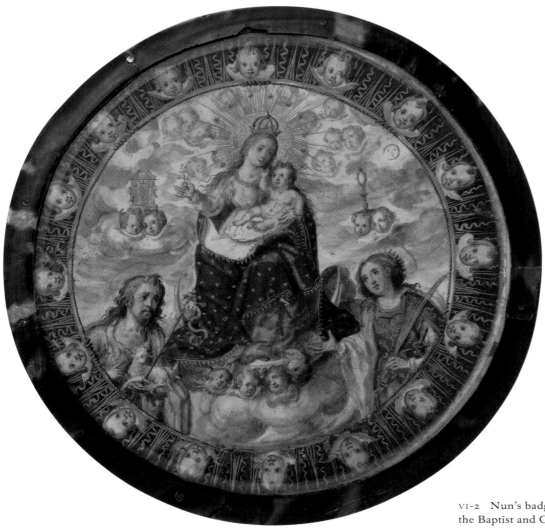

VI-2 Nun's badge: Virgin and Child with Saints John the Baptist and Catherine of Alexandria (?)

However, some of the miniatures have been selectively mutilated, possibly by censors. How and when these "corrections" took place would no doubt make an interesting story. In any case, changes in taste, and the dwindling demand for expensive choir books with elaborately ornamented initials in the ecclesiastical circles that provided the most important artistic commissions in New Spain, may be among the reasons that led Luis Lagarto to take up the production of independent religious paintings (cats. VI-3– VI-5). The small size and the exquisite detail of these works suggest that they were made for cultivated individuals, since their use would have combined devotion, close observation, and aesthetic enjoyment. It would not seem, therefore, that Lagarto was reaching out toward different patrons, but rather responding to many of the same ones who esteemed the miniatures he had created for collective use in cathedral choirs. It is unfortunate that we have no documentation on the original owners of any of Lagarto's independent paintings, but the clues present within the paintings themselves, such as the repeated presence of Dominican saints in some works, might provide information if investigated more closely.

For Lagarto, these paintings, though not on a much larger scale than his miniatures, represented major challenges on various fronts. Some of the compositions do include painted frames, but the gold grounds are gone; architecture and landscape thus play major roles. Colors are gener-

ally lighter, and there is a great deal of white. Most importantly, the severe diminution of ornament in favor of narrative and devotional content means that compositions have to integrate various figures in complex ways while communicating iconography clearly. Lagarto's solutions depend heavily on architecture in his narrative scenes. In all of them, a major architectural element defines the plane closest to the observer. In *Adoration of the Shepherds* and the Mayer *Annunciation* (cats. VI-3, VI-5), it is architecture that also takes us into the background. Nevertheless, although we know that Lagarto owned architectural treatises, and his rendering of individual classical elements is careful, he does not seem to have integrated knowledge of perspective; or, if he did, he did not use it. The generally correct perspective renderings of the floors are not consistent with the spaces defined by the entablatures and vaults. Rather, architectural elements are used to frame and emphasize events and figures. This is a significant observation for comprehending what Lagarto's training may have been, and further studies will have to clarify just what he might have known of the Italian artistic traditions that have often been cited to explain his work. As for landscape, the paintings' high mountains and suggestions of wilderness are a contrasting background to the classical architecture and peopled narratives. In some representations of the Immaculate Conception (Collection of Manuel Reyero, Mexico City), landscape seen as

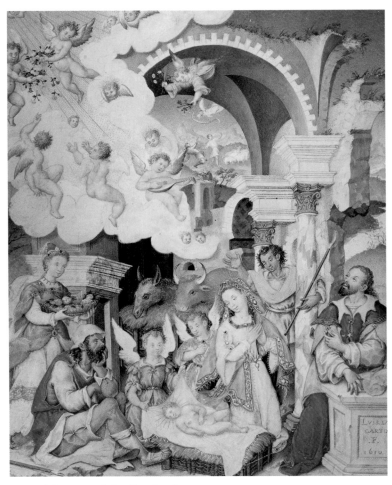

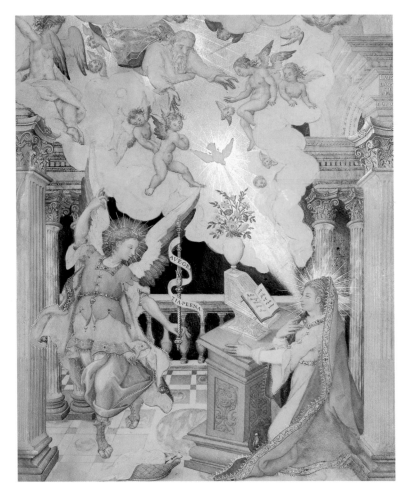

VI-3　Adoration of the Shepherds

VI-4　Annunciation

in a bird's-eye view, reminiscent of Flemish conventions, represents the world over which the Virgin reigns, and within which are set some of the symbols of her titles in the litanies.

　　The iconography of Lagarto's paintings confirms their devotional character, as well as their appeal to the high clergy and upper classes. The range of subject matter is not large: a few fundamental Gospel narratives, a Virgin of the Rosary with Saints Catherine of Alexandria and Catherine of Siena in the Museo Nacional de Arte (the subject a clue to its original owner?), and various renderings of the Immaculate Conception, which was a central image in the Catholic, and especially the Spanish, world, where the cult was promoted by the monarchy before becoming popular. The beautiful details of the paintings, however, their subtle coloring with touches of gold, and the erudite references in the iconography were for a cultivated audience. The enclosed garden with the peacock associated with eternal life, and Adam and Eve on the base of the lectern of the Virgin, the "new Eve," in the Mayer *Annunciation* (cat. VI-5) are examples. The complexity of Lagarto's *Virgin of the Rosary* (Museo Nacional de Arte, Mexico City) is another. Here Mary, holding the Child and displaying the fifteen mysteries of the Rosary in virtuoso miniatures on the borders of her mantle and tunic, is also an Immaculate Conception, clothed with the sun, standing on the moon in victory over the dragon, and crowned not only by twelve stars but also by the imperial crown of the Queen of Heaven, all under the approving gaze of God the Father

and the Holy Spirit, who complete the Trinity. The array of Mary's symbols, held by angels on clouds all around her, augment even further the surfeit of riches of this painting. Given his knowledge of letters, we may assume that Lagarto himself would have been familiar with most of this vocabulary, but his learning would have been reinforced by his patrons, who might also have provided specific models for some of the compositions. Such may have been the case of a *Burial of Christ* (location unknown), which undoubtedly was modeled on an engraving by Jan Sadeler I (1550–1600), based in turn on a composition by the Amsterdam painter Dirck Barendsz (1534–1592).

　　Besides the application of his skill as a painter of miniatures, Lagarto's comprehension of his task in these works is evidenced in their inscriptions, particularly in the ways they are signed. He uses Roman capitals, often placing his name sagaciously not just on the paintings, but within them, integrated to specific elements that suggest intriguing readings. An example is his signature on the plinth at the lower right of the Mayer *Adoration of the Shepherds* (cat. VI-3). Lagarto not only associates his name with one of the solid architectural elements that define the space of the composition, he also identifies himself with Saint Joseph, whose right hand calls attention to the signature, while the saint looks toward the heavenly vision at the upper left. Joseph is the only figure in the painting who sees the sky opening over Mary and the Child. By association, Lagarto's representation of the vision, and of the entire event, is analogous

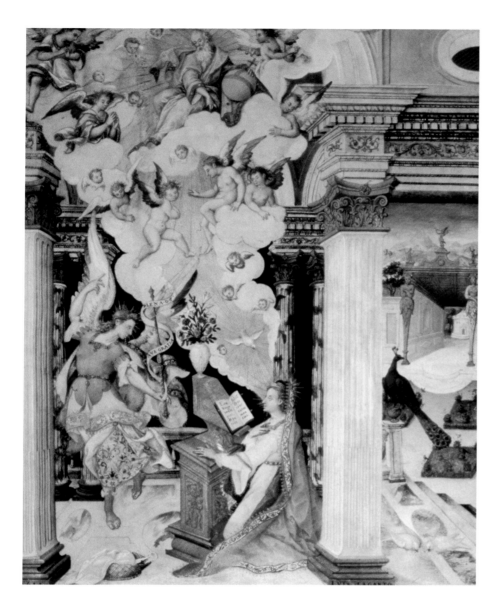

VI-5 Annunciation

to the comprehension of Saint Joseph. Other signatures seem to have been placed in homage, such as his name at the Virgin's feet in the Mayer *Annunciation* (cat. VI-5); or in devotion, as on Saint Catherine's wheel in the *Virgin of the Rosary*. It is remarkable, of course, that Lagarto signed these paintings at all, since this is a total departure from his unsigned work on the initials in the choir books, where only an occasional lizard (*lagarto*) may be a reference to himself. The signatures make clear that he considered the paintings a different kind of project from the initials. Indeed, these works can be understood as Lagarto's response to the demands for correctness and piety that were made on painters after the Third Provincial Mexican Council, which had probably brought him to New Spain in the first place.

Luis Lagarto's legacy is yet to be fully assessed. He has been studied in isolation with respect to other painters outside his immediate environment. For example, one wonders about his possible impact on Luis Juárez (cat. VI-14). In any case, he certainly was key in the training of three of his sons. An *Immaculate Conception* (Collection of Manuel Reyero, Mexico City) is signed by the eldest son, Luis de la Vega Lagarto. It is close to the father's style in the handling of the brush, but there is greater spontaneity

in Mary's gestures and expression, and more movement and fullness in her figure. The quality and quantity of the blue pigment in this work, which has been identified as lapis lazuli, is remarkable in the art of New Spain.

Andrés Lagarto, like his father and brother, produced exquisite small paintings, such as an *Immaculate Conception* signed in 1622 (Museo Nacional de Historia). His name has also been associated with the earliest known nuns' badges in New Spain (cat. VI-2). Although there is still uncertainty about these attributions, since some consider them works of his older brother Luis, there is nothing surprising in a Lagarto turning to the production of the small paintings of the badges. It was yet another genre for which their training and talents were invaluable.

Clara Bargellini

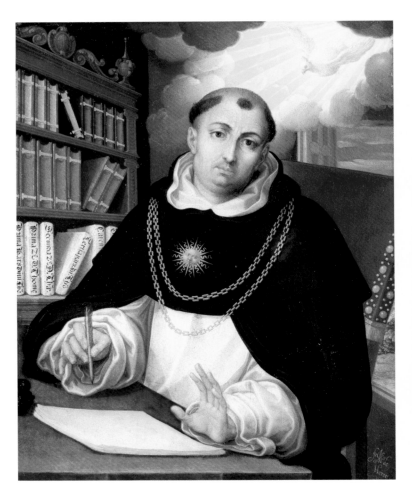
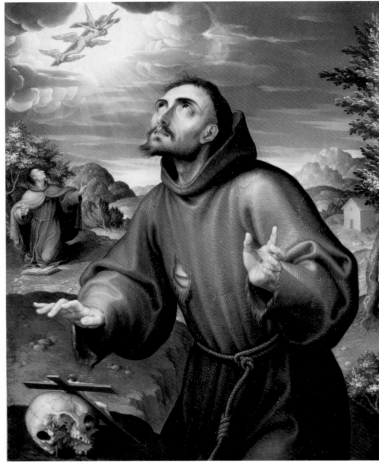

VI-6 Alonso López de Herrera[†]

(Mexican, born Spain, c. 1580–1675)

Saint Thomas Aquinas (obverse)
Saint Francis of Assisi Receiving the Stigmata (reverse)

1639
Oil on copper
14⅜ × 11³⁄₁₆ inches (36.5 × 28.5 cm)
Meadows Museum, Southern Methodist University, Dallas, Texas, Museum Purchase, Meadows Museum Acquisitions Fund

PUBLISHED: *Mexico* 1990, cat. no. 136, pp. 307–9; *Copper* 1999, cat. no. 35, pp. 226–30

EXHIBITED: New York, San Antonio, and Los Angeles 1990, cat. no. 136; Phoenix, Kansas City, and The Hague 1999, cat. no. 35

THE USE OF COPPER PLATE as a pictorial support was widespread in New Spain, undoubtedly as a result of the influence of Flemish painting. Its use in Mexico possibly began before the end of the sixteenth century, but the oldest surviving examples date from the first decades of the seventeenth century. The two artists who used this support most were Alonso López and Baltasar de Echave Ibía. Only López, however, painted on both sides of the plate, although for what reason is unclear. Two such examples are known: the present work and another with *Saint Augustine* on one side and *Saint Dominic* on the other (Museo José Bello y Zetina, Puebla, Mexico).

The four figures in these two works are represented half-length: two of them, Saint Augustine and Saint Thomas Aquinas, are in interiors, seated at a desk writing, as befits Doctors of the Church, while the other two, Saint Francis and Saint Dominick, are outside, looking upward. It also should be noted that the artist painted another version of the Saint Thomas Aquinas figure with a practically identical composition, which is now in a private collection in Mexico City.

One of the characteristics of López's visual idiom is his precise and correct drawing, particularly in the depiction of the hands, as well as in his taste for detail. This is evident in the picture of Saint Thomas Aquinas in the gilded studs on the back of the chair, in the metal clasps on the books seen with their edges showing, and in the bookcase. In the depiction of Saint Francis it is evident in the patches on the saint's habit and the skull in the foreground.

Rogelio Ruiz Gomar

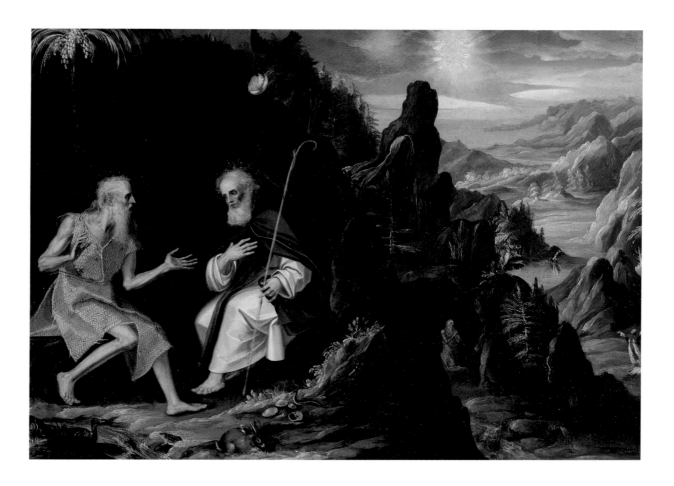

VI-7 Baltasar de Echave Ibía[†]

(Mexican, c. 1585/c. 1604–1644)

The Hermit Saints Paul and Anthony

c. 1625
Oil on copper
14¾ × 20¼ inches (37.5 × 51.5 cm)
Museo Nacional de Arte/INBA, Mexico City

PUBLISHED: Danes 1942, pp. 22–26; Toussaint 1965, pp. 94–95, fig. 131; Martínez del Río de Redo and Castelló Yturbide 1978, ill. 106, p. 34, cat. no. 106, p. 120; *Mexico* 1990, cat. no. 131, pp. 300–301; Ruiz Gomar 2004 "San Pablo," pp. 235–42

EXHIBITED: Washington, New York, Los Angeles, and Monterrey 1978, cat. no. 106; New York, San Antonio, and Los Angeles 1990, cat. no. 131

THIS DELIGHTFUL PAINTING ILLUSTRATES the visit that Saint Anthony made to Saint Paul the Hermit. Anthony, who had spent his life as a hermit, set out in order to learn about his spiritual predecessor, who had lived even more years than he had in isolation from humankind, surviving in a cave in the desert on the half loaf of bread that was brought to him each day by a raven and clothing himself in the fronds from the palm trees that grew near his cave.

This work is particularly striking for the large portion of canvas taken up by landscape. By means of a diagonal axis, the artist has divided the surface of the composition into almost equal halves, with the foreground, occupying the lower left of the canvas, reserved for the conversation between the two saintly figures, which takes place in front of the entrance to the cave. The rest of the canvas is devoted to a beautiful if conventional rendering of landscape, where the artist represents some of the key episodes in this encounter, following the narrative of Paul from Jacopo da Voragine's *Golden Legend*. Small, abbreviated representations sketch the moment in which a satyr appears to lead Saint Anthony to the hermit's cave; the vision of Saint Paul's heart ascending to heaven; the discovery of Paul's lifeless body, kneeling by the entrance of his cave; and the lions that are said to have helped dig the grave for the saint's body. Various animals are placed at the feet of the two figures: a rabbit, a duck, a lizard, a serpent, a frog, and some oysters. Given the traditionally negative associations that some of these might elicit, it is quite possible that they were meant to symbolize such sins as lust and sloth, which all those who devote themselves to God must overcome.

The fact that Echave Ibía, the second in an important dynasty of painters, had a tendency to incorporate blue-toned landscapes as a background for his paintings led to his being called *El Echave de los azules* (The Echave of the Blue Tones). However, it is almost certain that this penchant developed from having seen paintings by Flemish artists, whose landscapes, filled with silence and lyricism, began to arrive in New Spain and throughout Latin America by the end of the sixteenth century.

Rogelio Ruiz Gomar

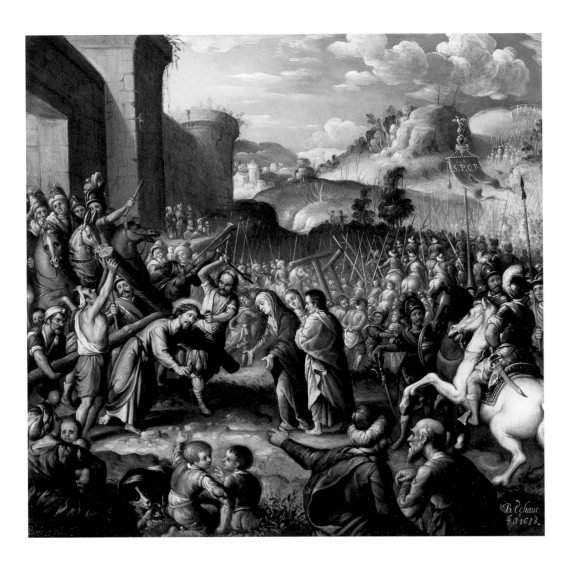

VI-8 Baltasar de Echave Ibía[†]

(Mexican, c. 1585/c. 1604–1643)

Christ on the Road to Calvary

1638
Oil on copper
16¾ × 16⅞ inches (42.6 × 42.9 cm)
Denver Art Museum, Collection of Jan and Frederick R. Mayer

PUBLISHED: Danes 1942, pp. 20–21, ills. 3, 4; Ruiz Gomar 1976, pp. 331–32; *Copper* 1999, cat. no. 19

EXHIBITED: Phoenix, Kansas City, and The Hague 1999, cat. no. 19

THIS PAINTING REPRESENTS CHRIST on the way to Calvary. He has just left behind him the great walls of Jerusalem and encounters the group comprising his mother Mary, Saint John the Evangelist, and Mary Magdalene. A large group of followers makes their way to Mount Golgotha, which is seen on an elevated horizon in the upper right part of the composition.

An intense and silent dialogue is established between the figures of Christ and Mary, resulting in a highly dramatic mood. Christ, crowned with thorns and bent by the weight of the cross, raises his suffering head, while Mary spreads her arms in a gesture of affliction. As in *The Cruci-fixion*, which is also on copper and with which this work forms a pair (cat. VI-9), the artist has included many figures in the composition, using a number of them to give life to the scene. This is the case with the woman carrying her young child, as well as the children and the two half-figures of men talking and seen from behind in the foreground. Another figure that adds life is the soldier slightly further into the composition on the far right who mounts his spirited, beautifully painted, white horse. Other notable figures are the two men who help Christ to bear the cross, although the Bible only refers to one: Simon of Cyrene. Similarly dynamic, although different in tone, is the gesture of the torturer who furiously pulls Christ's hair as he prepares to whip him with a branch. Further into the composi-tion, in the center, we see the two thieves also sentenced to die, almost lost among the crowd of priests, onlookers, and soldiers who move toward the background and have begun to climb the hill. These are compact groups made up of figures, horses, trumpets, standards, and lances. They add dynamism to the scene but also make it rather dense and heavy.

This work and its pendant were signed a year apart. Curiously, the first painting to be executed corresponds to the later scene in the order of the biblical narration. Both were recorded in the collection of Salvador Ugarte in Mexico City at the beginning of the twentieth century.

Rogelio Ruiz Gomar

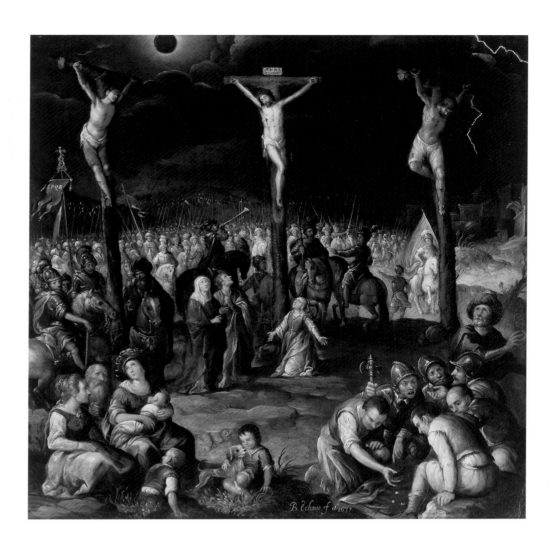

VI-9 Baltasar de Echave Ibía[†]

(Mexican, c. 1585/c. 1604–1643)

The Crucifixion

1637

Oil on copper

16¾ × 16⅞ inches (42.6 × 42.9 cm)

Denver Art Museum, Collection of Jan and Frederick R. Mayer

PROVENANCE: Salvador Ugarte, Mexico City

PUBLISHED: Danes 1942, pp. 20–21, ills. 3, 4; Ruiz Gomar 1976, pp. 332–33; *Copper* 1999, cat. no. 19, pp. 184–87; *José Juárez* 2002, cat. no. 17

EXHIBITED: Phoenix, Kansas City, and The Hague 1999, cat. no. 19; Mexico City 2002, cat. no. 17

THE SUBJECT OF CHRIST ON THE CROSS was widely represented in painting in New Spain. Generally, Christ was depicted alone or, at the most, with the Virgin, Saint John the Evangelist, and Mary Magdalene. For this reason, the present composition by Baltasar de Echave Ibía is extremely innovative, as not only do we see the two thieves on either side of Christ, but also a large crowd on Mount Golgotha. In the foreground to one side are a man; two women, one of whom gives her breast to her small child; and two children, one with a dog. On the other side are vari-

ous soldiers tossing the dice for Christ's clothing. Toward the center is a group with the Virgin, Saint John, and the Magdalene. Finally, in the middle ground and background we see numerous soldiers and other figures wearing turbans, on horseback, and carrying spears and banners.

Christ is already dead. According to the gospel narrative, at the moment of his death the sky darkened even though it was afternoon. The artist has thus depicted a dark sky with zigzagging lightning bolts and an eclipse of the sun. Echave Ibía was also able to convey a sense of life and variety in the figures. He differentiated Dismas, the Good Thief, who looks toward Christ with a serene and resigned expression, and Gestas, the Bad Thief, who turns his head away in rebellion. In the same way, the artist contrasts the restrained, dignified suffering of the Virgin with the gesticulating drama of the Magdalene. One of the soldiers clearly expresses annoyance, while the child with the dog is gleeful and an old man on the far right flees in terror.

Ibía created a beautiful figure in the woman in profile at the lower right corner, and another in the woman in a large hat breastfeeding her child. The latter figure is derived from Flemish art and may symbolize Charity. The composition is almost identical to that found in a very large canvas of some years later by José Juárez, as well as a work on copper by the obscure artist Jerónimo de la Portilla, active in Puebla, except that the composition is inverted as a result of having been copied from the same model or another similar one.

Rogelio Ruiz Gomar

VI-10 Alonso López de Herrera[†]

(Mexican, born Spain, c. 1580–1675)

The Virgin of the Immaculate Conception

1640
Oil on copper plate
20¾ × 15¼ inches (52.7 × 38.7 cm)
Signed and dated at lower left: *fr. Al° de Herrera [flourish] 1640*
Inscribed on banderole at top: *Tota Pvl/chra es Amica Mea/et/Macvla/ Originalis no/n est int*
Engraved on the reverse with fifty-five images of saints and theological symbols
The Hispanic Society of America, New York, LA2176

PROVENANCE: Forrester family, Los Angeles, acquired in Mexico c. 1890; Fred Forrester, Sr. (1878–1941), Los Angeles, to 1941; Fred Forrester, Jr. (1910–2004), Los Angeles, to 2004; heirs of Fred Forrester, Jr. (offered at auction, Sotheby's, New York, May 2005); acquired by The Hispanic Society of America, May 24, 2005

PUBLISHED: Sotheby's 2005, lot 31, pp. 68–69

EXHIBITED: New York 2005 sale, lot 31

THE DOCTRINE OF THE IMMACULATE CONCEPTION states that the Virgin Mary was herself conceived without taint of original sin by her parents, Saint Anne and Saint Joachim. This belief was widely held among Catholics from the fifteenth century but not declared dogma until the First Vatican Council (1869–70). Immaculist devotion was particularly strong in Spain, where, as Suzanne Stratton-Pruitt has demonstrated, the Spanish kings and queens actively promoted devotion to the *Inmaculada*, an unusual example of a religious movement being fomented in society "from the top down." In sixteenth- and seventeenth-century Spain, images of the Immaculate Virgin were ubiquitous, representing both an expression of popular piety and a form of religious propaganda, urging universal adoption of the doctrine by the Church. Much of this fervor was passed on to the colonies in Latin America, where the Franciscans were the most enthusiastic Immaculists.

One impediment to papal acceptance of the doctrine was the hostility of the Order of Preachers, or Dominicans, on the basis of its rejection by the prime theologian of their order, Saint Thomas Aquinas. Nevertheless, as Stratton-Pruitt has shown, Hispanic Dominicans are known to have put aside their order's objections and embraced (or have been forced to embrace) the Immaculist position. As a future Dominican leader with the special responsibilities of a creator of holy images, López de Herrera could hardly have painted the present image without the approval of his fellow friars, and we may therefore consider the picture a vivid piece of evidence for the acceptance of the doctrine among the Dominicans in Mexico.

Friar Alonso's image depicts the Virgin underneath God the Father and the dove of the Holy Spirit, surrounded by symbols taken from a variety of biblical and liturgical texts that had come to be the norm for Marian devotions since the 1400s—although the first papally approved Marian litanies were not issued until 1576, after the Council of Trent (1545/63). The primary source was the Book of the Apocalypse (chapter 12), in which a woman appears "clothed with the sun" (*amicta sole*). Menaced by a dragon, she is said to have "the moon under her feet, and on her head a crown of twelve stars."

López de Herrera adds, at bottom right, a group of black irises, sword-shaped flowers representing the sorrows of the Virgin, which pierced her heart, swordlike, at the Passion of Christ. The irises are contrasted with the roses at the left. Since there are clearly seven roses, and possibly, if one counts buds, seven irises, López de Herrera may have intended a reference to Catholic devotions of the Seven Joys and Seven Sorrows of the Virgin. The inscription at the top of the composition is a rewording of Canticle of Canticles 4:7 and reads, "thou art all fair, O my love, and there is not a spot in thee." Oddly, the most common symbol of the purity of the Virgin Mary, a "lily among thorns" (Canticle of Canticles 2:2), does not seem to have been included, in spite of the fact that lilies figure prominently in Friar Alonso's images of Saint Dominic and the Annunciation.

Marcus Burke

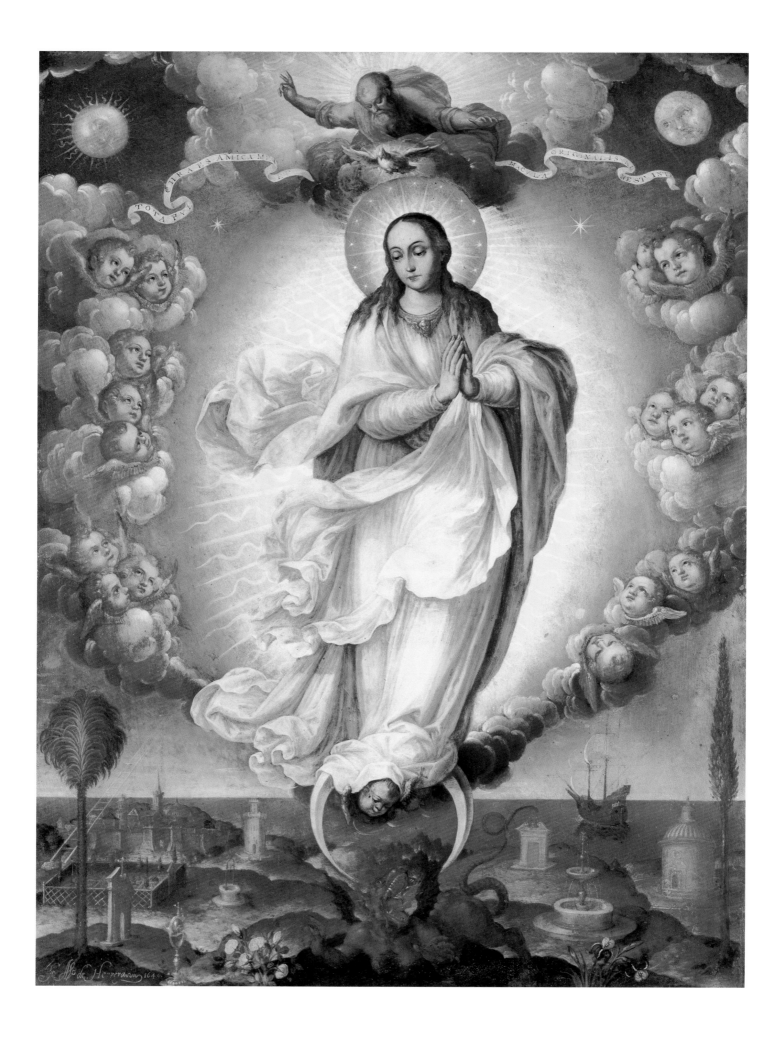

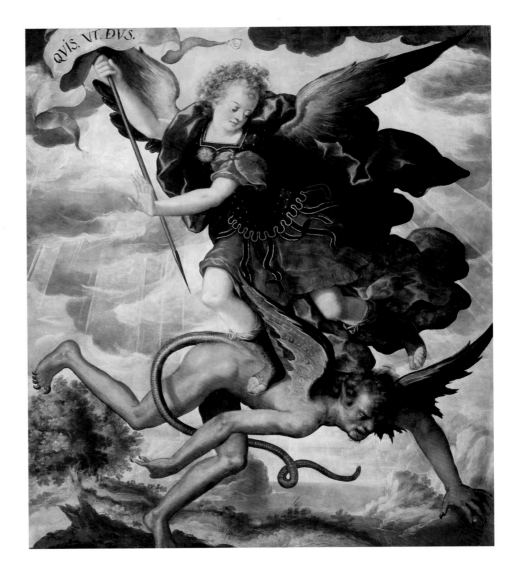

VI-11 Luis Juárez

(Mexican, c. 1585–1639)

Saint Michael Archangel

c. 1615

Oil on wood

67¾ × 60¼ inches (171.9 × 153 cm)

Museo Nacional de Arte/INBA, Mexico City

PUBLISHED: Ruiz Gomar 1987, pp. 172–77; *Mexico* 1990,
cat. no. 132, pp. 301–3; *Siglos de oro* 1999, cat. no. 82,
pp. 300–301

EXHIBITED: New York, San Antonio, and Los Angeles
1990, cat. no. 132; Madrid 1999 *Siglos de oro*, cat. no. 82

THE DEVOTION FOR ANGELS widely expressed in New Spain is
reflected in the large number of works in which they appear, in paintings,
sculptures, reliefs, embroidery, and silverwork. Archangels, cherubim,
and seraphim were all represented, the latter depicted as young children.
Among the seven archangels, the most popular and venerated was Saint
Michael because of his role in defending the Woman of the Apocalypse
and in defeating the seven-headed monster (Apocalypse [Revelation] 12).
For this reason he is considered the defender of the Catholic Church,
and his name was invoked against disasters (earthquakes and epidemics).
Saint Michael Archangel was also associated with numerous villages,
districts, rivers, and mountains that were placed under his protection,
as were churches, chapels, and altarpieces.

Among the numerous depictions of the saint to be found in art
produced in New Spain, this painting by Luis Juárez is one of the earliest
and most beautiful. The painter has represented the archangel in the con-
ventional manner with milky skin and blond curly hair. He is depicted
in a victorious pose with his wings open and brandishing a spear, which
also acts as a pole for the banner with the motto *Quis ut Deus* (Who is
as God). He has defeated Evil, who is depicted as a naked, dark-skinned
man. In comparison with this figure, the saint seems rather weak, although
there is no doubt that he has just dispatched this demon with his slim but
muscular and realistically depicted body. Following convention, the artist

has represented the Devil as ugly, with his scraggly beard, claws on his
feet and hands, batlike wings, and a long and horrible serpent's tail. The
delicate landscape in the lower part indicates that Juárez was producing
finely painted landscape backgrounds at the same time as Baltasar de
Echave Ibía, or even before him.

It is almost certain that this painting formed a pair with the work
known as *The Guardian Angel* (also in the Museo Nacional de Arte), as
both have the same almost-square format and are of similar dimensions.
For some time both were attributed to the Andalusian painter Alonso
Vázquez, active in Mexico between 1603 and 1607, but they are now
unanimously given to Luis Juárez.

Rogelio Ruiz Gomar

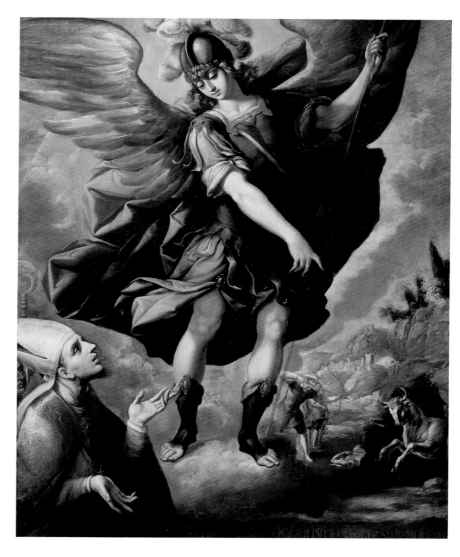

VI-12 Sebastián López de Arteaga[†]

(Spanish, 1610–1652; active Mexico from 1642)

Apparition of Saint Michael on Mount Gargano

c. 1648–52
Oil on canvas
75 × 50 inches (190.5 × 127 cm)
Signed at bottom center: *Sev.an D Arteaga fat;* illegible inscription
at bottom center and right
Denver Art Museum, Gift of Frank Barrows Freyer II for Frank
Barrows Freyer Collection by exchange and lent by Jan and
Frederick R. Mayer, 1994.27

PUBLISHED: Bargellini 1994 "Coleccionismo," vol. 4, p. 271;
Pierce et al. 2004, cat. no. 14, pp. 140–43

EXHIBITED: Denver 2004, cat. no. 14

ALTHOUGH THIS PAINTING seems originally to have been somewhat larger, its focus has no doubt always been the magnificent figure of the Archangel Michael explaining to the bishop of Siponto the strange events pictured at the lower right. In anger, a man had shot an arrow at a bull that had run away to a cave on Mount Gargano (near the Adriatic coast of Italy), but the arrow left the bull unscathed and returned to wound the man. On learning of this, the bishop and townspeople went in procession to the mountain. There the archangel, in the first of his legendary apparitions in Europe (around the year 400), declared that the cave was sacred and demanded that a sanctuary be built on the site, at the same time promising protection. Soon afterward, Saint Michael aided Siponto in vanquishing enemy infidels by causing an earthquake.

These remarkable legends would certainly have resonated in New Spain, a land of earthquakes and where "infidels" were still being converted in the seventeenth century. Moreover, Michael was head of the army of angels that conquered demons, as well as protector of the Woman of the Apocalypse, who represented both the Virgin Mary and the church, a frequent theme in all of Latin American colonial art.

As Rogelio Ruiz Gomar has pointed out, it is very possible that this painting, the first known New World representation of the Gargano miracles, was made to commemorate an apparition of Saint Michael in New Spain. The archangel presented himself in 1631 to an Indian named Diego Lázaro, at a place that would become known as San Miguel del Milagro in today's state of Tlaxcala. He caused a spring of healing waters to appear there. Bishop Juan de Palafox, of Puebla, went to the site in 1643 to investigate and verify the miracle, and Arteaga himself was in Puebla in 1646–47. His *Stigmatization of Saint Francis*, dated 1650, which may have been part of an altarpiece for the church of Santa Clara in that city, recalls the painting of hands, faces, and landscape in this composition. The helmet worn by the archangel appears here for the first time in New Spain. The Gargano apparition would later be painted for the sanctuary at San Miguel del Milagro, as well as in the sacristy of the cathedral of Mexico City, where Cristóbal de Villalpando transformed it into an allegory of the church in New Spain.

Clara Bargellini

VI-13 Basilio de Salazar

(Mexican, active 1613–45)

Franciscan Exaltation of the Virgin of the Immaculate Conception

1637

Oil on canvas

47¼ × 39¾ inches (120 × 101 cm)

Inscribed on the phylacteries: *Ego Quassi Vitis Fructificaui Suauitatem Odoris & Flores mei Fructus Honoris & Honestatus/ In Populo Honorificato & in Parte Dei mei*

Museo Regional de Querétaro/CONACULTA, INAH, Mexico

PROVENANCE: Franciscan monastery of Santiago de Querétaro, Mexico

PUBLISHED: Reta 2005, cat. no. 13, pp. 117–19, 328

EXHIBITED: Mexico City and Zacatecas 2005, cat. no. 13

THE DOCTRINE OF THE Immaculate Conception of Mary, which asserts that Jesus's mother was born without the stain of Original Sin, was not raised to dogma in the Catholic Church until the mid-nineteenth century, but it had been a subject of discussion among theologians for centuries. The doctrine was especially dear to the hearts of the Spanish Habsburgs, and Kings Felipe II, III, and IV all lent their considerable power to the effort to have the papacy declare it a dogma of the Church during their reigns in the sixteenth and seventeenth centuries. Naturally, this dispute over whether Mary had been granted the "sacred privilege" of immaculacy (which necessarily implied that her conception was miraculous and did not occur as a result of the concupiscence of her parents Saints Anne and Joachim) was also argued in the Americas.

The Franciscan order was traditionally a strong supporter of the Immaculate Conception, as reflected in this painting, originally placed in the Franciscan monastery in Santiago de Querétaro, Mexico. The Virgin Mary is shown posed in a manner traditional to the iconography of the subject, with her hands modestly joined in prayer, "clothed with the sun," and resting on a crescent moon. The symbols of her immaculacy surround her: the grapevines and roses mentioned in Ecclesiasticus are interwoven with other symbols, such as the spotless mirror, the tower of David, and the heavenly portal, that are also drawn from Scripture. Below her the City of God is populated with the Franciscans—male and female, popes and

kings—who had defended the doctrine of the Immaculate Conception: a Franciscan Jerusalem.

The inscription on the banderole above the city gate suggests in its wording that as the Franciscans had long exalted and defended the mystery of the Immaculate Conception, so they are rewarded as meriting the special protection of the Virgin Mary.

Suzanne Stratton-Pruitt

VI-I4 José Juárez[†]

(Mexican, 1617–1661)

Saint Francis Receiving the Sacred Flask

1658
Oil on canvas
78¾ × 56⁵⁄₁₆ inches (200 × 143 cm)
Signed at lower left: *Joseph xuarez ft. Año 1658*
Private collection

PROVENANCE: Monastery of San Francisco, Mexico City;
private collection, Spain

PUBLISHED: Méndez Casal 1926, pp. 118–20; *José Juárez* 2002,
cat. no. 38, pp. 215–19

EXHIBITED: Mexico City 2002, cat. no. 38

THIS SUBJECT WAS SELDOM REPRESENTED in the art of New Spain. It depicts Saint Francis doubting whether he should become a priest, as he felt unworthy of pronouncing the words that consecrate the bread and wine to become the body and blood of Christ and of touching the consecrated hosts at the moment of communion. At this point an angel appeared and showed him a glass flask, indicating that all those who aspired to the priesthood should be as pure and clear as that vessel. Saint Francis was so moved by this message from heaven that he felt himself unworthy of taking the higher orders and remained a deacon.

José Juárez has depicted the scene outdoors in a landscape. Saint Francis is seen kneeling before a beautiful adolescent angel who shows him the glass vessel. By depicting the angel's clothes as adorned with gold brooches and precious stones at the neck, shoulders, and on the top of the boots, Juárez would appear to be the first to introduce a tradition into painting in New Spain that reached its highest expression in the work of the artists of the next generation, in particular Juan Sánchez Salmerón and Cristóbal de Villalpando.

For the representation of the natural world in which the figures are set, Juárez relies on the pre-existing tradition of a leafy scene with plants,

trees, and a stream beneath a broad sky. He also, however, adds a new element of the rocky cliff behind the saint. This is conventional in form but realistic in depiction, with its irregular lines and fissures. Another highly realistic detail is the skull, depicted next to the book with foreshortening from below. All these elements, combined with the excellent draftsmanship, the outstanding depiction of hands and faces, and the competent handling of draperies and harmonious coloring, make this a remarkable work. The painting, which is among the latest in Juárez's oeuvre, was formerly in the monastery of San Francisco in Mexico City. How it left Mexico is unknown, but it was in a private collection in Spain in the early years of the twentieth century. It was recently acquired by a private collector and has returned to Mexico.

Rogelio Ruiz Gomar

VI-15 *Altarpiece of the Virgin of Sorrows*

Mexico
c. 1690
Gilt and polychromed wood, oil on panel, oil on canvas, silver, cloth
20 feet 2⁵⁄₁₆ inches × 13 feet 11⁷⁄₁₆ × 29⅛ inches (615.5 × 425.3 × 74 cm)
Fundación Televisa A.C., Mexico City

PROVENANCE: Church of the Jesuit Hacienda of Santa Lucía, now Mexican Air Force Base, Estado de México, Mexico; Hotel Fundición, Zimapan, Hidalgo, Mexico, c. 1950; Collection Borbolla, Cuernavaca, Morelos, México; Fundación Televisa, Mexico City, 1992

PUBLISHED: *Mexico* 1990, cat. no. 146, pp. 339–42; Bargellini 1993

EXHIBITED: New York, San Antonio, and Los Angeles 1990, cat. no. 146

THIS SOLOMONIC ALTARPIECE (*retablo*), so named because of its columns, inspired by those in Rome thought to have come from the Temple of Solomon, was made for the chapel of the hacienda of Santa Lucía, whose revenue supported the Jesuit College of Saints Peter and Paul in Mexico City. The design, with its arched frame and angels bearing symbols of the Passion of Christ, is based on the lost altarpiece of the Virgin of Sorrows in the church of the college, built by Tomás Juárez. The paintings are in a style reminiscent of Juan Correa, the painter of the Mexico City altarpiece.

The main cult figures in altarpieces of this period appealed directly to the emotions of the viewer. Here, the sculpted head and hands of the Virgin are mounted on an armature covered by real clothing. The lifelike quality is further enhanced by glass eyes and tears, and an eighteenth-century document says that the figure came "from Naples." In contrast, the other sculptures were carved in wood and have painted eyes; the clothing of the Four Evangelists, who fittingly sustain the columns, is in the *estofado* technique, in which a gold base is painted over with colors that are removed or tooled to selectively reveal the brightness beneath. They are thus integrated with the gilded architecture of the whole, while impressing on the viewer their otherworldly status.

This altarpiece, like most of its kind and time, combines emblematic elements with a chronological narrative in order to provide the viewer with much to look at and meditate upon. The heart at the top, pierced by seven swords, summarizes the message of the whole, while the paintings present sorrowful episodes in the life of Mary, to be read from left to right and from bottom to top: the Circumcision, the Flight into Egypt, Christ bidding farewell to his mother and meeting her on the way to Calvary, his being nailed to the cross, and his burial. The sequence is interrupted at the top center by the figure of Saint Lucy, patroness of the hacienda, in an Italian painting that replaces a Crucifixion, which is the episode that is obviously missing from the narrative. We know it was there originally, in sculpture. The altarpiece combines architecture with sculpture and painting of various origins, materials, and techniques, in a devotional whole.

Clara Bargellini

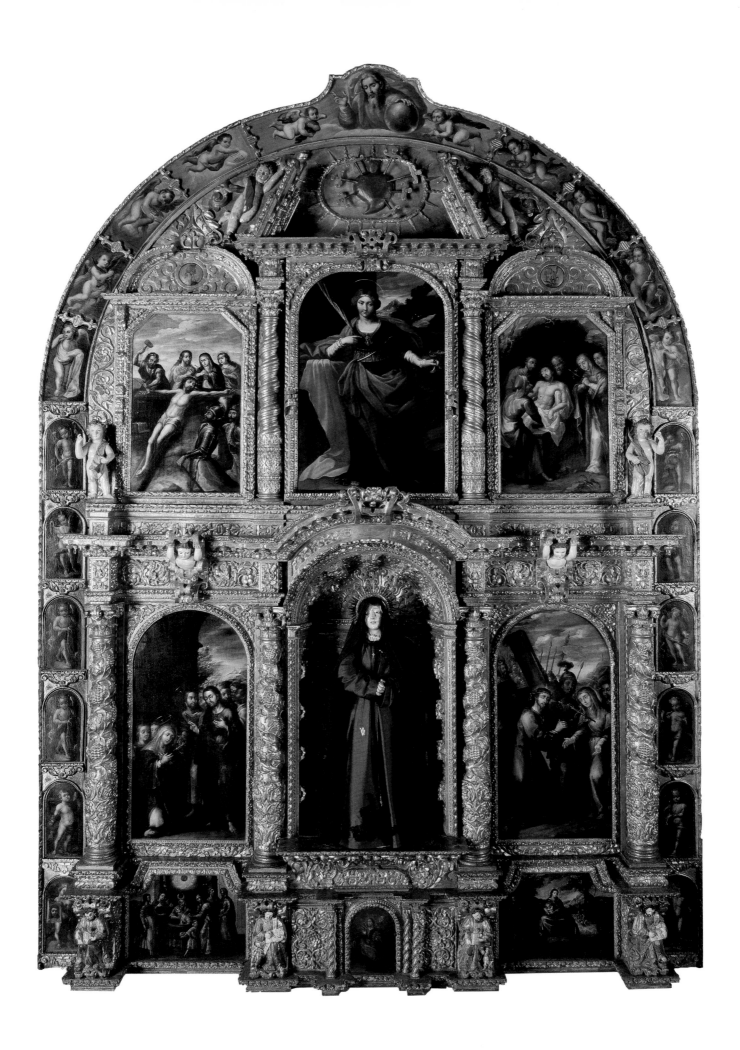

VI-16 Juan Correa[†]

(Mexican, c. 1646–1716)

The Four Elements and the Liberal Arts

c. 1670s

Oil on canvases supported on wooden frames with a gold-leaf and
gesso-embossed border
95¼ × 127⁹⁄₁₆ × 1³⁄₁₆ inches (242 × 324 × 3 cm)
Signed in the lower right corner of the side illustrating the Liberal Arts:
Juan Correa
Museo Franz Mayer, Mexico City

PROVENANCE: Possibly commissioned by Friar Payo de Ribera (New Span-
ish bishop-viceroy, 1673–79) as a gift to his half-brother, the Marquis of
Tarifa, c. 1670s; Duke of Tarifa, brother of the Duke of Medinaceli and
descendant of the Marquis of Tarifa; Jaime de Medina of Spain, inherited
from the widow of the Duke of Tarifa; acquired by the Museo Franz
Mayer in 1983

PUBLISHED: Martínez del Río de Redo 1987, pp. 127–38; Rico Cervantes
1987; Sebastián 1992, pp. 113–15, 130–32; Martínez del Río de Redo 1994
"Dos biombos," pp. 393–408; Martínez del Río de Redo 1994 "Tema
profano," pp. 453–67; Martínez del Río de Redo 1994 "Temas," pp. 133–
49, 150–62; *Artes de México: Guía Museo Franz Mayer* (Mexico City: n.d.)

EXHIBITED: Mexico City 1987; Mexico City 1994 *Juegos,* cat. no. 46

THIS SPLENDID TWO-SIDED, SIX-PANEL *BIOMBO* by Juan Correa,
The Four Elements and the Liberal Arts, is one of the rare pictorial records
that survive of New Spanish mythological painting. Moreover, the *biombo*
is unique in that it is the only one of its kind to bear the signature of the
artist. Unfortunately, it is incomplete; in its original state, it likely followed
the standard ten-panel format of the period. Illustrated from left to right on
the obverse side of the *biombo* are five of the seven liberal arts represented
by their female personifications and corresponding attributes—Grammar,
Astronomy, Rhetoric, Geometry, and Arithmetic—identified by the titles
on the phylactery above. On the sixth panel, four women who carry musi-
cal instruments most likely allude to the missing personification of Music,
Minerva, whose name appears above. Completely absent is the female
personification of the Liberal Art of Dialectic. These two missing repre-
sentations undoubtedly form part of the lost panels.

Illustrated from right to left on the reverse side of the *biombo* are
two of the four elements: Earth and Air. In the far right carriage symbol-
izing Earth, the goddess Cybele, a traditional deification of the Earth
Mother, rides in triumphant procession with Ceres, the goddess of grain
and harvests. Seated at the front is a male figure, possibly Apollo or
Phaeton, who prods the two oxen pulling the carriage, on which are illus-
trated three signs of the zodiac—Scorpio, Leo, and Virgo—that allude
to the periods of the harvest, which is further evoked by the abundance
of fruits and vegetables strewn about the ground. The presence of the
mythological figures has led Martínez del Río de Redo to identify Ovid's
Metamorphoses as Correa's source of inspiration.

The second illustrated element, Air, is depicted as a triumphal
carriage in flight, pulled along the lush Arcadian landscape by two large
birds, symbols of its corresponding element. Seated at the head of the
carriage guiding the birds is Chloris (or Flora), the goddess of flowers
and spring; the carriage is illustrated with the signs of the zodiac asso-
ciated with spring: Taurus, Gemini, and Capricorn. At the back of the
carriage, the wind god Favonius summons the winds surrounded by a
multitude of birds and a male child blowing bubbles.

While this rare example of a *biombo* depicting mythological sub-
ject matter is unique in New Spain, its provenance gives some insight
into its complex iconographical program. The *biombo* was commissioned
by the bishop-viceroy Friar Payo de Rivera as a gift to his half-brother,
the Marquis of Tarifa. The father of both men, the Duke of Alcalá de los
Gazules, a renowned patron of the arts, resided in the Casa de Pilatos in
Seville, whose ceiling was decorated with mythological scenes by Spanish
artist Francisco Pacheco (1564–1644). The choice of subject matter for
Rivera should therefore come as no surprise. Like many colonial *biombos,*
this example was sent to Spain, where it descended in the family of the
Duke of Alcalá until its acquisition by the Museo Franz Mayer.

Sofía Sanabrais

VI-17 Juan Correa[†]

(Mexican, c. 1646–1716)

Saint Michael Archangel

Seventeenth century
Oil on canvas
64⁹⁄₁₆ × 55½ inches (164 × 141 cm)
Inscribed at lower right: *Juan Correa F.*
Museo Franz Mayer, Mexico City

PROVENANCE: Acquired from the University of Michigan, United States

PUBLISHED: Vargas Lugo and Guadalupe Victoria 1985–94, vol. 2, p. 52; *Tiempos de Correa* 1994, p. 22

EXHIBITED: Mexico City 1992

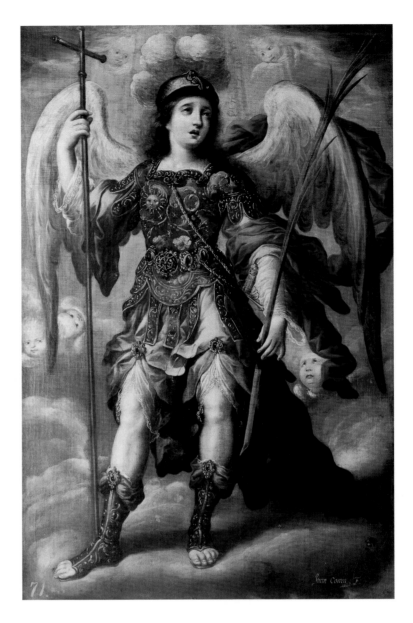

THE ARCHANGEL MICHAEL'S name means "Like unto God" (*Quién como Dios*), and he is the warrior *par excellence*, locked in eternal battle against Evil, as the protector of the Church. He is referred to as the *princeps militiae coelestis* (Prince of the Heavenly Army) and acknowledged as the guide of the departed, who will weigh the actions of souls and sound the trumpet on Judgment Day. The cult of Saint Michael dates back to ancient Byzantium and was popularized in the Middle Ages, but it received its greatest impetus toward the end of the sixteenth century when in Europe, due to the Counter-Reformation and the Council of Trent, Saint Michael became the symbol of the triumph of the Catholic Church over heresy. Later, when Spain conquered Mexico, his presence signified triumph over idolatry.

The archangel's garments are inspired by Roman attire, a later addition that had been introduced by the Romanists during the mannerist period of the sixteenth century, but was fully accepted in the baroque art of the seventeenth and eighteenth centuries. In most representations of Saint Michael, he appears wearing a plumed helmet and a heavily ornamented cuirass, carrying a shield and a sword. In this instance, the saint is depicted as much more than a warrior: he is a triumphal figure illuminated by the powers that God has vested in him. The sun and the moon, representing Christ and Mary, adorn his cuirass. The figure wears a great cape that billows up to his shoulders and between his huge, magnificent wings, which symbolize the vital, divine mission with which God has entrusted him. He is shod in elaborately decorated sandals. Ample sleeves drape in folds over his arms, and his raiment is enriched with clasps of semiprecious stones on his sandals and at the points where the tunic is gathered at his thighs. Saint Michael is represented with a variety of attributes, depending on his role, whether battling the dragon or weighing souls on a balance

scale. In this instance, he carries only the patriarchal cross and the palm of paradise, thus embodying the triumph of the church.

Saint Michael is always depicted as young and handsome. In this painting, the extreme pallor of the archangel's face stands out, as does his rapturous gaze, which gives the work a spiritual character that is different from other representations of the same subject by this artist. The bright colors are characteristic of the baroque fashion of the period, and the fine treatment of the fall of the fabric and the built-up brushstrokes are typical of Correa, as are the proportions of the features on the oval face of the archangel.

Representations of Saint Michael abounded in the baroque painting of New Spain, and Juan Correa is credited with an important number of images of this nature. This archangel, although very similar to three other works by the artist's hand, is considered, for the moment, his most successful in spirit and artistic achievement, due to the fineness of the facial features and the excellent composition, as well as the baroque movement of the ensemble of fabric and wings.

Elisa Vargaslugo

VI-18　José Rodríguez Carnero

(Mexican, 1649–1725)

Saint Christopher

Late seventeenth–early eighteenth century
Oil on canvas
75³⁄₁₆ × 47¼ inches (191 × 120 cm)
Signed: *Carnero*
Collection of Fomento Cultural Banamex A.C., Mexico City

PUBLISHED: Manrique et al. 1992, p. 65

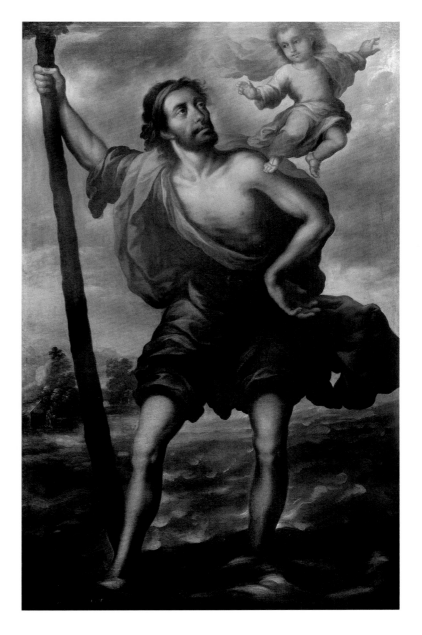

THE POPULAR VENERATION OF Saint Christopher that grew from medieval origins in the Old World rapidly took hold in the Spanish colonies of Latin America. From the sixteenth century onward, it was common to find images of this saint, bearing the Christ Child on his shoulder, placed near the doors of Mexican churches. The saint was revered by the faithful for the protection he offered to all travelers.

This painting bears the signature "Carnero," which has allowed us to attribute the work to José Rodríguez Carnero, a renowned painter active in Mexico City and Puebla from the late seventeenth to the early eighteenth century. Here, Carnero uses a traditional composition that was often repeated by artists in colonial Mexico. The saint, depicted as a man of tremendous physical proportions, is seen with a half-exposed torso, supporting himself with the trunk of a palm tree as he transports the Christ Child across a river. An unusual detail is that Jesus does not rest directly on the saint's shoulder, but instead seems to float in midair. The pictorial language of this piece—most notably the use of soft yet animated colors, an accurate sense of line that nevertheless lacks some strength, skillful treatment of light and shadow, a dramatic use of draping, and so on—evokes many of the important painters of the period, particularly Juan Correa, Cristóbal de Villalpando, and Arellano.

Despite the conventional execution, the somewhat abbreviated landscape in the background, which offers a glimpse of the hermit mentioned in the legend of the saint, brings added freshness to this painting. The effective treatment of waves in the river, achieved with bold, staggered brushstrokes, represents the most stylistically innovative element in the work.

Rogelio Ruiz Gomar

VI-19 Attributed to José de Arellano†

(Mexican, active first half of the eighteenth century)

Conveyance of the Image and Inauguration of the Sanctuary of Guadalupe

1709
Oil on canvas
69⅜ × 102½ inches (176 × 260 cm)
Inscribed: *Verdadero mapa del sitio en que se benera la milagrosa imagen de Nuestra Señora de Guadalupe de la ciudad de México Conforme se Zelebró la translación a su nuevo Santuario, el día 30 de abril de 1709 . . .*
Collection of the Marqués de los Balbases, Madrid

PUBLISHED: López Sarrelangue 1957; González Moreno 1959, vol. 1, pp. 75–76; Toussaint 1965; Ortiz Vaquero 1987, pp. 32–36, ill. 15; *Maravilla Americana* 1989, p. 114; *México en el mundo* 1994, pp. 236–37; Tovar de Teresa et al. 1995, vol. 1, p. 94; Kagan 1998, p. 260, fig. 6.13; Pérez Sánchez 1998, pp. 76–78; *Siglos de oro* 1999, cat. no. 3, pp. 149–52; Bernd 1999, pp. 92–103, ill. 24; Pierce et al. 2004, cat. no. 29, pp. 24, 190–92, ill.

EXHIBITED: Madrid 1999 *Siglos de oro*, cat. no. 3; Denver 2004, cat. no. 29

DURING THE VICEREGAL PERIOD Mexico City had four sanctuaries dedicated to different devotions of the Virgin Mary, strategically oriented as spiritual bulwarks to defend the city. The Virgins of Guadalupe, of Los Remedios, of La Bala, and of La Piedad all had feast days and pilgrimages in their honor, and in cases of need their images would come out of their sanctuaries to alleviate the tribulations of the population. The image of the Virgin of Guadalupe, identified with the indigenous population and, later on—during the eighteenth century—with the *criollos,* or Mexican-born Spaniards, was long deposited in a hermitage while a proper sanctuary was being built to house it. There were two famous occasions on which the image was removed from this hermitage: once in 1629, when it was carried to the city center to bring about the withdrawal of the waters that had flooded the city; and a second, definitive occasion, on April 30, 1709, when it was conveyed to the new church. The celebration organized for this extraordinary event was depicted in a painting by Arellano.

In the midst of a vast mountain landscape we see the hill of Tepeyac, where the miraculous apparitions of the Virgin Mary occurred, and in front of the hill a village and the new baroque sanctuary. To the right of the new church is the little hermitage that had housed the image until then. A crowd eager to witness the event fills every available space, including the rooftops of the buildings. People making their way to the celebration are depicted in every corner of the canvas. The procession to enthrone the Virgin is led by the viceroy, the Duke of Albuquerque, with representatives of the entire society of New Spain congregated around him. The door of the church remains closed as it awaits its new mistress, who appears toward the middle of the procession, preceded by members of the clergy and the aristocracy. A short distance ahead, an image of Saint Felipe de Jesús, the patron of the celebration and the first Mexican saint, is being carried on a litter. To the left of the sanctuary, dancers and allegorical figures attract a large crowd: we see a triumphal chariot and eight giants representing the different parts of the world, including one in Mexican attire who symbolizes America in the kingdom of New Spain. On the right side of the picture, several smaller processions, coming perhaps from nearby villages with litters bearing images of various saints, make their way to join the principal procession.

Juana Gutiérrez Haces

VI-20 Cristóbal de Villalpando[†]

(Mexican, c. 1649–1714)

Adam and Eve in Paradise

c. 1688
Oil on copper
23⅝ × 34⅝ inches (60 × 88 cm)
Puebla Cathedral/CONACULTA, DGSMPC, Mexico

PUBLISHED: Maza 1964, pp. 108–9, 111, ill.; Andrade 1974, pp. 84–85; Juárez Burgos and Luyando Lares 1986, p. 28; *Catálogo nacional* 1988, vol. 1, pp. xiii, 335, 363, ill., diagram no. 604; Sebastián 1990, p. 109; Merlo Juárez et al. 1991, p. 336, ill.; González Pozo 1994, p. 76; Gutiérrez Haces et al. 1997, cat. no. 65, pp. 85, 238–39, ill.; Bargellini 2002, pp. 130–31

EXHIBITED: Mexico City and Madrid 1997, cat. no. 65

PAINTING ON COPPER PLATE was popular in New Spain, not only to serve the private market of personal devotions with small-format works but also because of the technique's enamel-like textural effects and the possibility it offered of giving meticulous attention to detail in the manner of a miniaturist. It is astonishing that Villalpando produced this small plate around the same time (1680–90) that he was working on his monumental compositions in Puebla, including the cathedral dome.

This depiction of Paradise probably is associated with the scene of the Flood (cat. VI-21), also painted by Villalpando on copper plate, in the chapel known as *El Ochavo* (the Octagon) in the Puebla cathedral. The chapel constitutes a treasure-house of pictures painted for its fine altarpieces, most of them donated by the canon José de Salazar Baraona in 1688. The two paintings on copper plate probably form a pair, dealing as they both do with passages from the Book of Genesis about human disregard of the divine law and resulting punishment.

In a wooded landscape of flowers and birds an entire day passes by in Paradise, from the left side, where the sun is peeping through the trees as the Trinity molds clay to give life to Adam, to the growing darkness on the right side, where God rebukes Adam and Eve for their sin and then an angel expels them from Eden. The light is employed not only to represent a day in eternity, but to indicate symbolically the beginning and the fall of mankind. Of the eight scenes distributed around different parts of the landscape, Villalpando emphasized three by placing them in the foreground and depicting them at a larger scale: the creation of Eve, the admonition by God the Father to refrain from eating the fruit of the tree, and the moment when God reproves the couple for their pride and disobedience. The selection of scenes reveals the moralizing intention of the work but also suggests a rejection of solitude and a celebration of the beginning of life in common, of community life. Villalpando opened up a series of arches within the wooded landscape to provide a clear framework for the different scenes and, as on other occasions, used light and color to set off the most important ones.

Juana Gutiérrez Haces

VI-21 Cristóbal de Villalpando[†]

(Mexican, c. 1649–1714)

The Flood

1689
Oil on copper
23¼ × 35⁷⁄₁₆ inches (59 × 90 cm)
Inscribed near center: *Villalpando, 1689*
Puebla Cathedral/CONACULTA, DGSMPC, Mexico

PUBLISHED: Maza 1964, pp. 108–10, 112, ill.; Andrade 1974, pp. 84–85; Luyando Lares and Juárez Burgos 1986, p. 28; *Catálogo nacional* 1988, vol. 1, pp. xiii, 335, 340, ill., diagram no. 561; Sebastián 1990, p. 110; Merlo Juárez et al. 1991, p. 336. ill.; Vargas Lugo and Guadalupe Victoria 1985–94, vol. 3, p. 146; González Pozo 1994, p. 76; Gutiérrez Haces et al. 1997, cat. no. 64, pp. 85–87, 236–38, ill.; *Siglos de oro* 1999, cat. no. 91, pp. 321–23, ill.; Gutiérrez and Gutiérrez Viñuelas 2000, pp. 100, 102, ill.; Bargellini 2002, p. 130

EXHIBITED: Mexico City and Madrid 1997, cat. no. 64; Madrid 1999 *Siglos de oro*, cat. no. 91

IN 1689 CRISTÓBAL DE VILLALPANDO signed this painting on copper plate which, in spite of its relatively small size, gives monumental form to the description of the Flood contained in the Book of Genesis. The multiple meanings of this event—punishment, purification, and salvation—offered him an opportunity, as it has to many painters, to put into practice all the expressive means at his command: convulsed bodies, floating corpses, panic-stricken faces, and men in flight. Although the composition must have been based on engraved sources, Villalpando's originality is patent in his distribution of space and light. At the center of the composition, Noah's Ark, a symbol of the church and of salvation, appears to float imperturbably in the midst of the calamity. Hermetically sealed and without contact of any kind with the exterior, it is bathed in a gentle, even luminosity. In contrast, a brilliant and intense light illuminates the principal scene, in the foreground, of a man attempting to pull along an ox carrying his wife and child, who represent abandoned humanity. (The scene recalls tangentially the classical Rape of Europa.) The people portrayed on all sides in attitudes of desperation are submerged in ocher- and green-tinged shadows that presage their deaths, and their robust and dynamic bodies remind us of Villalpando's interest in Flemish painting at the time. The steely gray sky is disturbed only by the silvery lightning bolts that cleave it. Parallel to these heavenly zigzags, the watery disaster is organized dynamically by diagonal lines that emphasize intercrossing areas of light and shadow. The dynamic composition starts on the left side, moves along a building that recalls the Spanish architecture of the time, and pauses on a second red-roofed building, before moving swiftly to the right where barely outlined men and animals, like phantasmal visions, attempt to flee death. From this point yet another diagonal ascends over the landscape, behind the Ark. By his skillful handling of light and the dynamic composition of diagonals, Villalpando has strikingly captured on this little copper plate both the human drama of the Flood and its religious significance.

Juana Gutiérrez Haces

VI-22 Cristóbal de Villalpando[†]

(Mexican, c. 1649–1714)

Saint Michael Archangel

c. 1680

Oil on canvas

73¼ × 48⅛ inches (186 × 107 cm)

Inscribed around right hand of Saint Michael: *QVIS VT DEVS*

Wadsworth Atheneum Museum of Art, Hartford, Connecticut, The Ella Gallup Sumner and Mary Catlin Sumner Collection Fund, 1939.583

PUBLISHED: Maza 1964, pp. 209–11, 240; Gutiérrez Haces et al. 1997, cat. no. 49, pp. 376–77 (with additional references)

EXHIBITED: New York 1940; Mexico City and Madrid 1997, cat. no. 49

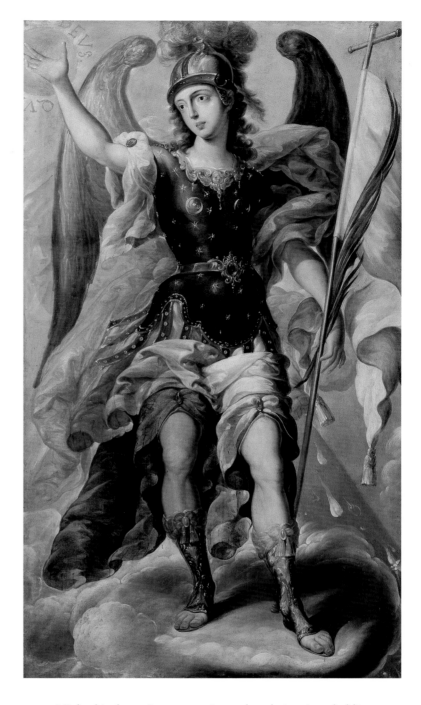

THIS ARCHANGEL WAS PROBABLY PAINTED by Villalpando in his early maturity, somewhat before he was commissioned to make the grand canvases for the cathedrals of Puebla and Mexico City in the 1680s. There is a related work, a signed painting of Saint Barachiel, which is now in the small church of the Magdalene in Coacalco north of Mexico City. Both paintings show the angels standing on a platform of similarly rendered clouds, their bodies bathed in bright light, emphasized by contrasting darker shadows as in Michael's left wing and arm. The draperies display agitated movement combined with precise drawing, while the faces, hands, and legs of the figures are clearly outlined. Especially in the treatment of the legs, Michael and Barachiel resemble one another closely. Later in his career, Villalpando's treatment of forms would become more painterly. The discrepancy in the measurements of the two canvases (Barachiel is slightly larger) is probably a result of a cutting down of the Saint Michael, which is evident in the upper and side borders. There are many representations of Michael alone, and of Michael with Gabriel and Raphael, but Barachiel alone or the four lesser archangels by themselves would be extremely unusual. This, combined with the fact that there is no reason to believe that the Barachiel was originally made for the church where it is now located, suggests that these two paintings belonged to a set of seven that was long ago dispersed.

Michael is shown in armor, as is usual, and victorious, holding a palm branch and a white standard with a red cross that is attached to a staff crowned by a cross. Around his right hand is the inscription that identifies him as godlike, as it had been represented in the sixteenth century by Marten de Vos at Cuautitlan. Michael's victory is described in the Apocalypse of Saint John, chapter 12, where he leads the army of angels that defeat the beast bent on destroying the woman who has just given birth. The proof is in the shower of stars that the beast has dragged downward, depicted at the lower right. The victory of the archangel can be understood to be analogous to that of Spain in the New World, which protected the woman, who was identified as Mary and at the same time as the church.

Clara Bargellini

VI-23 Cristóbal de Villalpando[†]

(Mexican, c. 1649–1714)

Virgin of Aránzazu

Late seventeenth century

Oil on canvas

72⁹⁄₁₆ × 42½ inches (184.3 × 108 cm)

Signed at lower right: *Villalpando f*

Museo del Colegio de San Ignacio de Loyola Vizcaínas, Mexico City

PROVENANCE: Colegio de la Paz, Vizcaínas, Mexico City

PUBLISHED: Muriel et al. 1987, p. 244; *Leal* 1993, pp. 142–43; Gutiérrez Haces et al. 1997, cat. no. 68, pp. 246–47, 383

EXHIBITED: Mexico City 1993, pp. 142–43; Mexico City and Madrid 1997, cat. no. 68

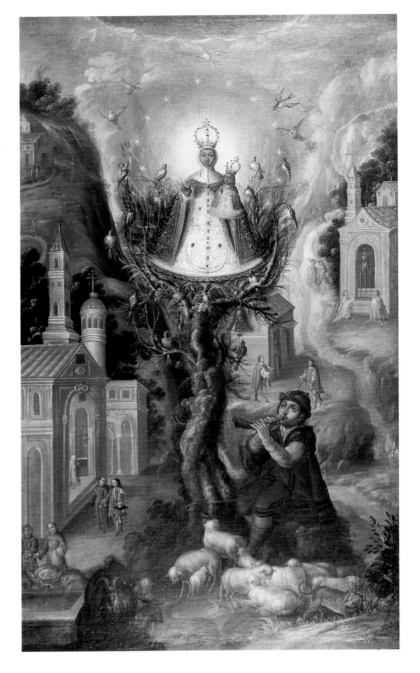

LEGEND HAS IT THAT ON SEPTEMBER 9, 1469, the shepherd Rodrigo Balzátegui heard a bell ringing in a ravine near Oñate in the Basque country of Spain. On following the sound, he found himself by a thorn tree. Looking up, he saw Mary with her Child among the branches, and exclaimed: *"Arantzan zu!"* (In the thorns—you!). The image, whose original is a stone statue, is said to have brought peace to the area, and a sanctuary was established on the site by the Franciscans. In New Spain the cult is associated with Basque families, and chapels were built near the principal Franciscan churches of Mexico City, Guadalajara, and San Luis Potosí.

This painting has been thought to have been made for the chapel in Mexico City, built between 1681 and 1688, but the existing documents do not confirm this hypothesis. There is no denying the importance of the cult in Mexico City in those years, since a major publication by Friar Juan de Luzuriaga on the apparition was printed there in 1686. Villalpando's representation has also been linked stylistically to his work in the Ochavo Chapel of Puebla cathedral around 1690. In any case, this seems to be the oldest painting of the Virgin of Aránzazu in Mexico.

The canvas shows the bejeweled and doll-like apparition among thorny branches and surrounded by twelve stars and many birds. Rodrigo is comfortably seated, accompanied by his flock. With his horn, he joins in the sounds of the bell and the singing birds in order, according to some accounts, to console the crying child. Villalpando included pilgrims and friars at the sanctuary in the composition. Two elegantly dressed men behind the shepherd are greeting each other in friendship, and two are praying to a crucifix in a chapel farther up the hill. The crossed arms of Christ and Francis over the entrance to the main church on the left identify it as a Franciscan building.

No doubt the artist was familiar with prints of the image, but the disarming ingenuousness of the whole, with its many details, expertly communicates the fairy tale quality of the legend. In contrast to other renderings of the theme, the painter gave a great deal of space precisely to the anecdotal surroundings and figures and comparatively little to the Virgin. Nevertheless, while emphasizing her small scale, he managed to give her due importance by lighting and implied sound, as well as by integrating her figure into the opening of the ravine.

Clara Bargellini

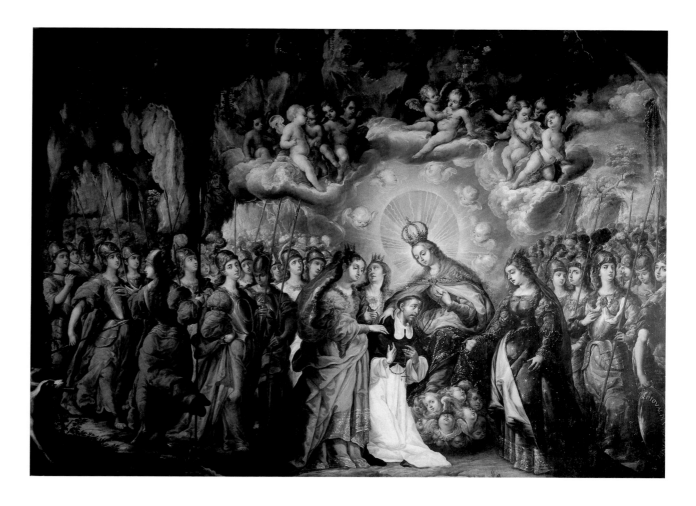

VI-24 Cristóbal de Villalpando[†]

(Mexican, c. 1649–1714)

Lactation of Saint Dominic

Late seventeenth–early eighteenth century

Oil on canvas

142⅛ × 189⅜ inches (361 × 481 cm)

Signed: *Xptoval DE VILLALPANDO F*

Church of Santo Domingo/CONACULTA, DGSMPC, Mexico City

PUBLISHED: Maza 1963, p. 29; Maza 1964, pp. 23, 125–27, 244, pp. 129–32, ill.; Berlin-Neubart 1974, p. 56; Rodríguez 1980, pp. 3–19, ill.; Sebastián 1990, p. 319; Tovar de Teresa 1990 "Convento," pp. 46–48; González Leyva 1992, p. 166; Vargas Lugo 1993, pp. 125–27, ills. 52 and 52a; Tovar de Teresa et al. 1995, p. 388; Gutiérrez Haces et al. 1997, cat. no. 31, pp. 56–57, 170–72, pp. 8–9, 171, ills.; Gutiérrez Haces 2005, pp. 111–12, ill.

EXHIBITED: Mexico City 1991; Mexico City and Madrid 1997, cat. no. 31

ONE OF THE MENDICANT ORDERS with the greatest influence in New Spain was the Dominican order, whose church in Mexico City formed part of an immense group of conventual buildings and properties. The plaza located in front of this church is still the second-most important in the center of the city, and inside the church itself hangs this remarkable painting of the *Lactation of Saint Dominic* by Cristóbal de Villalpando. The subject matter is Saint Dominic's withdrawal to do penance in a cave near Segovia, for which he was rewarded by the presence of the Virgin Mary, who nourished and comforted him with milk from her breast, transforming him into a "milk brother" of Christ. The scene unfolds in front of the cave, formed by various galleries and a small parcel of landscape that allow Villalpando to organize his composition radially. In each of the three compositional radii surrounding the Virgin there is a different group of richly attired warrior women, distinguished by the red, white, and green colors of their garments. The Virgin is identified as the spiritual center of the work by the great halo of light that surrounds her head and the group of clouds and putti that form an undulating roof over the mouth of the cavern. The geometric center of the painting, however, is the woman dressed in red who acts as the axis of this circular composition. Accounts of Saint Dominic's life mention only his encounter with the Virgin Mary, so the presence of these other female figures has given rise to various interpretations. Perhaps the most likely explanation is that they are to be understood as the armies of the theological virtues, represented by the color red for Charity, white for Faith, and green for Hope, with new significance conferred by the fact that Charity acts as the dynamic motor of the composition. The richness of the attire of these amazons, the human types employed in the work, and the handling of the folds of the garments remind us that Villalpando was studying Rubens at the time and had learned how to interpret him correctly without copying him. This scene must have gained a certain popularity in the eighteenth century, as it was also painted—albeit in different ways—by Juan Simón Gutiérrez in Seville and by an anonymous artist for the Santuario del Puig outside of Valencia.

Juana Gutiérrez Haces

VI-25 Attributed to Antonio Rodríguez

(Mexican, 1636–c. 1691)

Moctezuma

1680–91
Oil on canvas
71⅝ × 41¾ inches (182 × 106.5 cm)
Museo degli Argenti, Palazzo Pitti, Polo Museale Fiorentino, Florence

PUBLISHED: Heikamp 1972, pp. 23–24, ills. 44–47; *Pinceles* 1999,
pp. 59–61; Pierce et al. 2004, pp. 171–77

EXHIBITED: Mexico City 1999 *Pinceles;* Denver 2004

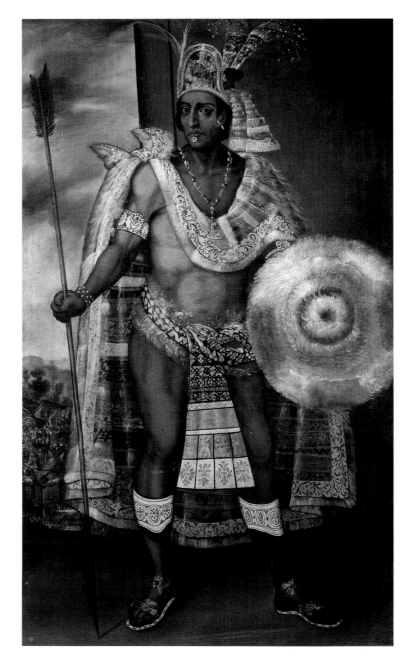

THE PORTRAIT OF MOCTEZUMA (Moctezuma II, or Moctezuma
Xocoyotzin) is unusual in that although it is a work of the last quarter of
the seventeenth century, it contains an exact depiction of pre-Hispanic
attire. This ethnographic detail can only be explained if the artist drew
on previous works. The search for these sources has allowed some light
to be shed on the circumstances in which this portrait was painted.

The pose of the sovereign, his body structure, clothing, and orna-
ments indicate the use of an image of Nezahualpilli of Tetzcoco from the
Codex Ixtlilxochitl (c. 1582). The half-mitred headdress, the javelin, and
the position of the arm point to the *Tovar Manuscript* or a copy thereof.
These are the same sources used for the engravings of kings that illustrate
the book by the Italian traveler Gemelli Careri. Carlos de Sigüenza y
Góngora, who was the custodian of both manuscripts, presented copies
of them to Gemelli, who visited him in 1697.

Sigüenza initiated the practice of creating portraits of the governors
of Mexico in 1680, when he was entrusted with the adornment of the
triumphal arch for the reception of the viceroy, the Count of Paredes.
On that occasion, Sigüenza engaged the artist José Rodríguez Carnero
to paint the portraits. Did Sigüenza, then, who had possession of the
codices and authored the idea of the "neo-portraits," have anything to
do with the painting now in Florence?

A 1703 engraving reproduces this Moctezuma portrait, and its
legend indicates that the painting was sent from Mexico to His Most
Serene Highness, the Grand Duke of Tuscany. The title of "Most Serene"
doubtless refers to Cosimo the Third. Thanks to his librarian, Antonio
Magliabechi, the Medici duke heard about the work and about Carlos

de Sigüenza's superb library, and established contact with Sigüenza
through the Duke of Jovenazzo, a mutual acquaintance.

There is sufficient evidence to suggest that Sigüenza presented
the portrait of Moctezuma to Cosimo the Third, and that Gemelli Careri
was the courier. This would explain Gemelli's sojourn of several days in
Florence prior to his arrival in Naples, where he was anxiously awaited.

Judging by its style, the artist was Antonio Rodríguez, a close friend
of José Rodríguez Carnero, who had already completed the gallery of
governors on the triumphal arch for Sigüenza.

Pablo Escalante

VI-26 *Moctezuma*

Mexico
Last quarter of the seventeenth century
Oil on canvas
72¹³⁄₁₆ × 38⅜ inches (185 × 100 cm)
Private collection

PUBLISHED: *Siglos de oro* 1999, pp. 85–87

EXHIBITED: Madrid 1999 *Siglos de oro*, pp. 85–87

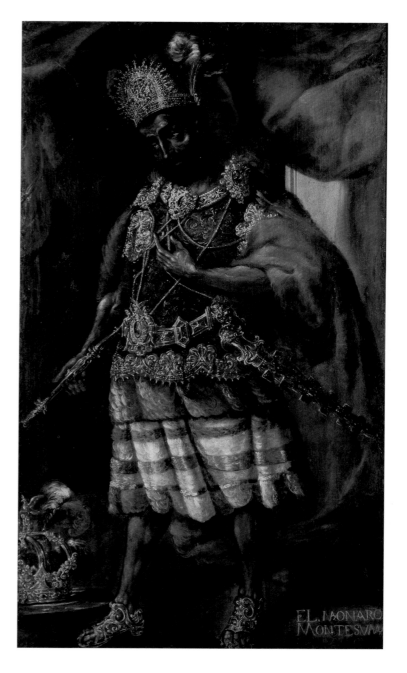

THIS ALLEGORICAL PORTRAIT of the emperor Moctezuma II can
be dated to the last quarter of the seventeenth century and is known
to have belonged to the *tecpan*, or indigenous government, of Santiago
Tlatelolco. It is not, strictly speaking, a "true" portrait of this enigmatic
historical figure, and still less does it adhere to the genre's normal docu-
mentary purpose. Rather, it is a dramatized image of the Mexica, or
Aztec, monarch as he would have been seen at the festive dances known
as *mitotes* or at the other occasional displays of pomp and ceremony
connected with the political rites of New Spain. Moctezuma is depicted
as an ancient king or illustrious notable, in keeping with the historical
and legal discourse that the indigenous nobility wished to establish
as the foundation of their privileges.

In contrast to the traditional aspects of dominance and self-
possession expressed in portraits of kings, noblemen, or courtiers,
Moctezuma is shown as downcast and dejected, on the verge of tears
or at the point of a conversion as a result of an epiphany from on high.
More striking still is the fact that he is captured in the act of stripping
himself of his insignia of rule—his imperial crown and scepter—as he
raises his left hand to his heart in a gesture of *iure in pectore* that confers
added gravity on this important decision. His crown already rests on
the silver platter at his feet, making it clear that these objects will be deliv-
ered to the Christian emperor as symbols of submission and vassalage.
This cession of arms underlines the legal principles of *translatio imperii*
and the so-called *pactio subiectionis*, whereby the imperial demands of
Carlos V are accepted so that he can assume his position as legitimate
ruler of Mexico. However, the former king of the Mexica preserves his

copilli or *xihuitzolli* (royal diadem), on which the two-headed eagle of
the House of Austria is embossed, indicating that in spite of his political
surrender he does not renounce his lineage or his nobility. There are dis-
tant echoes of his original pre-Hispanic attire in the multicolored feather
skirt, the filigree sandals, and the *macquahuitl*, or toothed macana, that
he wears. This visual representation of a "European prince" is in line
with the images of Moctezuma fabricated by the royal chroniclers, based
on the ancient premonitions and the idea of a monarch paralyzed by the
predictions of his soothsayers. It should not surprise us that the indig-
enous nobility of Mexico preferred this image of a visionary king to a
combative, recalcitrant one, in order to better negotiate its privileges and
interests in viceregal society, a culture that placed the virtue of loyalty
above all others.

Jaime Cuadriello

VI-27 Juan Rodríguez Juárez

(Mexican, 1675–1728)

Fernando de Alencastre Noroña y Silva, Duke of Linares, Viceroy of Mexico

c. 1711–16

Oil on canvas

81⅞ × 50⅜ inches (208 × 128 cm)

Inscribed in cartouche at right: *Dn. Fernando de Len-/castre Norona y Silba, Duque de Linares, Marques/de Valdefuentes, Porta Ale-/gre y Gobea: Comen-dador ma-/ior de la orden de Santiago/en Portugal. Gentilhombre/de la Cámara de su Mages-/tad, Theniente General de sus/Exercitos, Gobernador/General de sus Reales Armas/en el Reyno de Nápoles,/electo virrey del Reyno/de Serdeña. Vicario General/de la Toscana; electo Vi-/rrey del Peru. Virrey y Cap./Genl de esta nueba Espa[ña]./Murió en 3 de Junio y se enter[r]ó el/dia 6 del dicho en la peaña de este Al-/tar, año de 1717*; signed at lower right: *Ioannes Rodriguez Xuarez, fecit*

Museo Nacional de Arte/INBA, Mexico City

PUBLISHED: Burke 1979, pp. 42–43; *Mexico* 1990, cat. no. 195

EXHIBITED: New York, San Antonio, and Los Angeles 1990, cat. no. 195

IT IS WIDELY RECOGNIZED that the brothers Nicolás and Juan Rodríguez Juárez were outstanding portraitists. Juan's ability to convey the personality of his sitters and his skill at depicting their clothes and other accessories are evident in this portrait of Fernando de Alencastre, viceroy of New Spain between 1711 and 1716. In addition to providing us with the sitter's appearance, this work perfectly conveys the power and prestige inherent in his office.

The Duke of Linares was the second viceroy of Mexico to be appointed after the Bourbon dynasty's ascent to the throne in Spain. It is therefore interesting to note that he was the first of the viceroys to be portrayed in Mexico dressed totally in the French style, a taste that, although increasingly seen in Spain from the late seventeenth century, became fully dominant at the Spanish court with the reign of Felipe V (r. 1700–1746).

Rodríguez Juárez depicts the viceroy wearing a costly velvet frock coat with turned-up cuffs, in blue with gold thread embroidery. He wears a large powdered wig and holds a tricorn hat adorned with feathers under

his arm. His shoes are of leather with heels. With an air of assumed naturalness, in his aristocratic hands he holds a piece of paper and a glove. His appearance, rich clothing, and the baton of command on the table by his side, combined with the coat of arms on the curtain hanging in broad folds behind him, all reaffirm his elevated status and the importance of his role within the political and social structure of colonial Mexico.

On the subject's breast is an elaborate gold jewel with a red cross against a white background, representing the Cross of the Order of Santiago. This was one of the most important of the Spanish knightly orders, and the viceroy was its prefect, as the inscription states.

Rogelio Ruiz Gomar

VI-28 Juan Rodríguez Juárez

(Mexican, 1675–1728)

The Flight into Egypt

c. 1720

Oil on canvas

43 × 84 inches (109.2 × 213.4 cm)

Museo de Arte de Querétaro/CONACULTA, Mexico

PUBLISHED: *Museo Querétaro* 1986, pp. 168–69; Pierce et al. 2004, cat. no. 45

EXHIBITED: Denver 2004, cat. no. 45

THE PAINTING DEPICTS the flight of the Holy Family into Egypt, briefly described in the Bible. Mary and Joseph were obliged to flee with the Christ Child in order to save his life following Herod's decree that all male children under the age of two should be slaughtered (Matthew 2:13).

This is a beautiful example of Rodríguez Juárez's style, softly harmonious in line and color and with an expressive poetic sentiment. Within its overall tranquil mood, the principal figures are linked in a lively and agreeable manner. Mary, seated on a donkey, is depicted as a young woman who gives her breast to the Infant Christ and looks at him with an expression of great tenderness. Joseph walks in a protective manner by their side, looking contentedly at the touching relationship between mother and child. On the far right, two plump and seminaked little angels make efforts to lead the Holy Family, pulling the donkey's reins. In a curious touch, the animal turns its head and looks out to the viewer, as if wanting acknowledgment for the important and noble task assigned to him.

The landscape also plays an important role in the overall effect. This is, of course, not a real landscape relating to the Middle East or to the Mexican American landscape known to the artist, but rather a conventional representation. It is, however, relatively convincing and realized in an accomplished manner. Were this not a religious subject depicting biblical figures, the painting could almost be considered a rococo work, as it comes close to the spirit of those delicate scenes with nymphs, shepherds, and children at play familiar from French *fête galante* paintings. As such, it should be remembered that this is a work by a painter from New Spain executed in the early years of the eighteenth century. The painting seems to have been in the church of La Congregación, dedicated to the Virgin of Guadalupe in the city of Querétaro.

Rogelio Ruiz Gomar

VI-29 Juan Patricio Morlete Ruiz[†]

(Mexican, 1713–c. 1772)

Christ Consoled by the Angels

Mid-eighteenth century
Oil on copper
25⅜ × 33¹¹⁄₁₆ inches (64.5 × 85.5 cm)
Museo Nacional de Arte/INBA, Mexico City

PUBLISHED: Sodi Pallares 1969, p. 147; Andrade 1974, pp. 128–30, p. 129, ill.; Armella de Aspe and Meade de Angulo 1989, p. 166; Toussaint 1990, p. 168; Armella de Aspe and Meade de Angulo 1993, p. 193, ill.; Bargellini 1994 "Jesús," pp. 64–65, ill.; Vargas Lugo et al. 2000

EXHIBITED: Mexico City 1994; Mexico City 2000

SCENES OF THE PASSION OF CHRIST painted on sheets of copper, usually on a small scale, belong to a genre that evokes the intimacy of a monastic cell or a private space dedicated to prayer, with a subject matter that inspires penitential meditations and sorrowful repentance. In the baroque era, the scourging of Christ was often depicted with an emphasis on its dramatic aspects: the shedding of blood and the suffering transmitted by the expressions of Jesus. Various religious authors lingered in their writings over the moments when Christ, after being loosed from the column where he has been scourged, tries to take up his garments, the symbol of his annihilated dignity, and with his little remaining energy

attempts to gather up the blood that would be his last gift to mankind. This scene was interpreted in various ways, with Christ lying faint and breathless on the ground, or, as in the famous composition by Murillo, wiping up his blood in utter solitude. In the case of this copper plate, Juan Patricio Morlete Ruiz has managed to combine drama and suffering with tenderness. The center of the picture shows a wounded and faint Christ supported by an archangel with wings outspread as though they were another pair of arms. Several angels on either side gather up the blood and deposit it in chalices to be taken up to the heavens, where other angels weep at the sufferings inflicted on the savior. The weeping faces of the angels and the sufferings of Jesus—endured with a certain docility—do not, however, provoke a reaction of alarm and sudden repentance, as do other dramatic depictions of the same scene, but rather incite the viewer to join the angels in comforting the victim of the unjust sacrifice. Certain details belong to the traditional iconography of the scene, such as the column and the rope with which Jesus was bound, but others, such as the checkered pavement stained with blood and the submissive postures of the angels, evoke a context of everyday life with which the viewer could identify in his or her devotions. The coloring consists basically of reddish ochers and blues. The ochers create a highly charged atmosphere that culminates in the red of Christ's wounds, whereas the blues are intermingled with the garments of the angels. The lighter blue of the archangel's garments helps to set off the red of Christ's blood with greater intensity.

Juana Gutiérrez Haces

VI-30 José de Ibarra

(Mexican, 1685–1756)

The Woman of the Apocalypse

c. 1750

Oil on canvas

81⅛ × 55⅞ inches (206 × 142 cm)

Pinacoteca, Church of San Felipe Nerí/CONACULTA, DGSMPC,
Mexico City

PUBLISHED: *Obras maestras* 1990, cat. no. 24; *Privilegio sagrado*
2005, cat. no. 44, p. 276

EXHIBITED: Mexico City 1990, cat. no. 24; Mexico City and
Zacatecas 2005, cat. no. 44

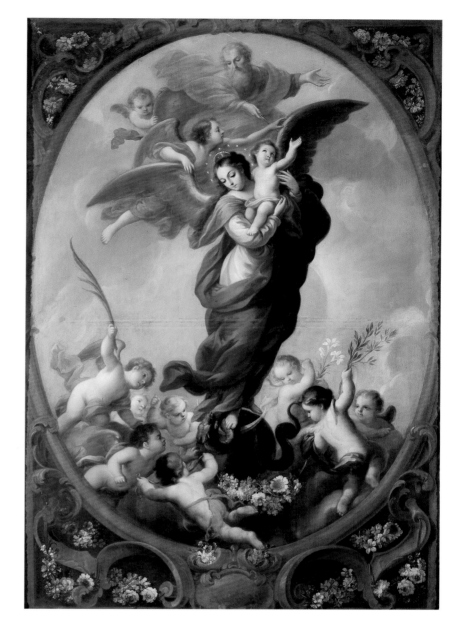

THIS FINE PAINTING REPRESENTS the Woman of the Apocalypse described in the vision of Saint John the Evangelist in Apocalypse, chapter 12. With God the Father blessing above and surrounded by angels, the woman holds the Christ Child in her arms. She is depicted with the eagle's wings by which she fled from the seven-headed monster, here replaced by the serpent usually represented at the feet of Mary in depictions of the Immaculate Conception.

It was normal practice during the Counter Reformation to fuse the concept of the Woman of the Apocalypse with that of the Immaculate Virgin, so that representations combined elements from both. Thus, the Woman was depicted dressed in blue and white, accompanied by small angels with symbols emphasizing the purity of the Immaculate Virgin, who herself was often depicted as clothed in the sun (with a glowing halo of light around her or a sunlike disk behind her back), standing on the moon and crowned with stars, corresponding to the iconography of the Woman of the Apocalypse.

The iconographic model used by José de Ibarra for the present work derives from a composition by Rubens for the altar of the Church of the Virgin in Freising, Germany. Through the medium of prints it became widely known and used by Hispano-American artists in the eighteenth century. Ibarra, however, set the figure within an elaborate trompe l'oeil oval frame of graceful rococo style. This is in turn decorated with multicolored branches of flowers in the pierced zones. This frame relates to another by Ibarra, to be seen in a painting of *The Virgin of the Immaculate Conception* now in the Museo de América, Madrid.

Ibarra successfully softened the central line corresponding to the Virgin through the use of a diagonal axis resulting from the elegant turn of the body and the accomplished handling of shadow on the clothing and wings. Ibarra repeated this composition on other occasions, thus providing a compositional model some years later (1760) for the famous work by Miguel Cabrera of the same subject. As a result, Cabrera was no longer obliged to look to Rubens's famous example, but rather had models closer at hand.

Rogelio Ruiz Gomar

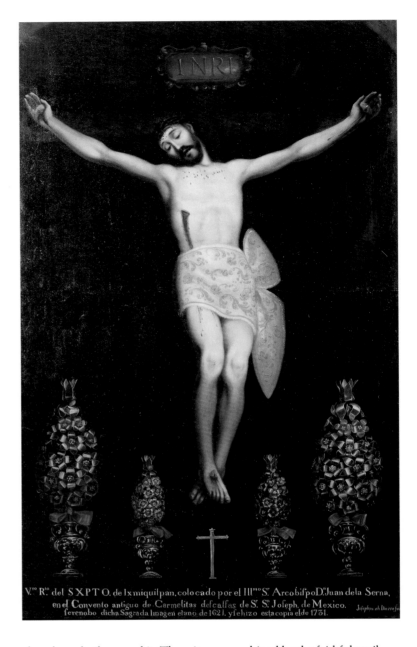

VI-31 José de Ibarra

(Mexican, 1685–1756)

Christ of Ixmiquilpan

1731
Oil on canvas
90½ × 56¼ inches (229.9 × 142.9 cm)
Inscribed across bottom: *V[erdade]ro R[etra]to del S[anto] XPTO de Ixmiquilpan, colocado por el Illmo. Sr. Arcobispo Dn. Juan de la Serna/en el Convento antiguo de Carmelitas descalsas de Sr. Sn. Joseph de Mexico./Se renobó dicha Sagrada Imagen en el año de 1621, y se hizo esta copia el de 1731;* signed at lower right: *Josephus ab Ibarra facie . . .* [cut off at right margin]
Denver Art Museum, Collection of Jan and Frederick R. Mayer

PUBLISHED: Pierce et al. 2004, cat. no. 33, pp. 200–202

EXHIBITED: Denver 2004, cat. no. 33

AMONG THE NUMEROUS SCULPTURES of Christ on the Cross created in colonial Mexico for altars in chapels, churches, and shrines, those of the so-called Christ of Chalma and the Lord of Ixmilquilpan, also known as the Lord of Saint Teresa, were the most venerated.

The latter began to be venerated in 1545 in the church at Mapethé near the town of Ixmilquilpan in the modern-day state of Hidalgo, Mexico. However, due to the fact that it became damaged over time, in the sixteenth century it was placed in a storeroom with the expectation that it would be buried with one of the villagers. However, as no one died, the sculpture was forgotten for years until one day it was miraculously restored during the course of some other equally remarkable events. These events came to the notice of Archbishop Juan Pérez de la Serna, who decided to visit the village to verify them. He was so impressed by the sculpture that he had it transferred to Mexico City in 1621. Some time later, the archbishop handed over the image to the Carmelite community at the Convent of Santa Teresa la Antigua. Its fame grew to the point where an elaborate

chapel was built around it. There it was worshiped by the faithful until 1845, when an earthquake caused the chapel dome to collapse. The sculpture was thought to have been lost, but today it is once again a cult image in the Carmelite convent at Mixcoac in the south of Mexico City.

As evidence of the widespread devotion to this image of Christ— an almost life-size sculpture made of *pasta de caña*—in New Spain, there are numerous copies of it by various painters created throughout the eighteenth century. The sculpture is easily recognizable in all of them by its accessories, including the vases with branches of silver flowers and other adornments. Among the artists who were commissioned to produce "true portraits" of the image, José de Ibarra was the most in demand. Of the three versions known by him, the present work is the earliest, as it was painted in 1731, barely three years after Ibarra had begun to work as an independent painter.

Rogelio Ruiz Gomar

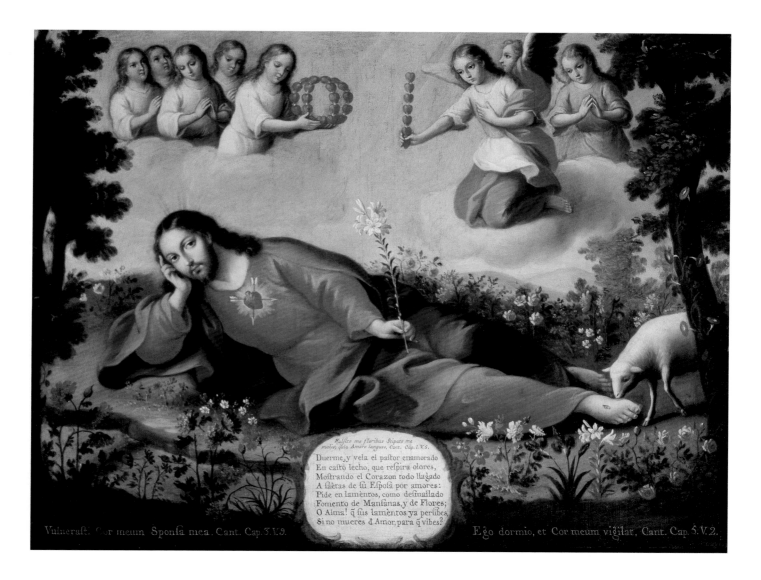

Duerme, y vela el paftor enamorado
En cafto lecho, que refpira olores,
Moftrando el Corazon todo llagado
A faetas de fu Efpofa por amores:
Pide en lamèntos, como definallado
Fomento de Manfànas, y de Flores;
O Alma! q̃ fus lamèntos ya perfibes,
Si no mueres d̃ Amor, para q̃ vibes?

Vulnerafti Cor meum Sponfa mea. Cant. Cap. 5. V. 9. Ego dormio, et Cor meum vigilat, Cant. Cap. 5. V. 2.

VI-32 Andrés López†

(Mexican, c. 1740–1811)

The Good Shepherd

Late eighteenth century
Oil on canvas
18¼ × 23⅝ inches (46.4 × 60 cm)
Denver Art Museum, Collection of Jan and Frederick R. Mayer

THIS INTERESTING WORK DEPICTS Christ reclining in a tranquil garden among flowers, his head resting on his right hand. A sheep licks one of his feet while above groups of little angels and purified souls offer him the crown and scepter of love made up of small hearts. To the modern believer, this image may seem quite strange, if not slightly unpleasant, as both the pose and the setting seem somewhat kitsch, and it shows a very feminine type of Christ. The painting is, in fact, unlikely to have been the object of devotion in any cathedral, chapel, or parish church, but it was clearly appropriate for a convent in the late eighteenth century, as it closely conforms to the heightened spirituality typical of female religious culture of the day.

If the garden was an image of paradise in the minds of such nuns, then the cloistered life of the convent could be understood as an extension of the *hortus conclusus*, the enclosed garden that symbolized the purity of the Virgin Mary. Thus every nun living there could see herself as a flower in the garden of the Divine Spouse to whom she had consecrated her life and whom she had "married" on the day she entered the religious order.

The painting is signed by Andrés López, a relatively accomplished painter active in Mexico at the end of the eighteenth and the beginning of the nineteenth centuries. López simply repeated an iconography already used by other painters, such as José de Ibarra (who produced the first version of this composition in 1738, now in the Museo Nacional del Virreinato in Tepotzotlán, Mexico) and Miguel Cabrera. Two examples by the latter are known (in a church in San Luis Potosí and another in a Mexican private collection). Also worth noting is that in the present version we can make out various inscriptions among the flowers and alongside the small symbols of Christ's Passion. These include the words *Amor, Paciencia, Oración, Caridad, Contemplación,* and *Padecer* (Love, Patience, Prayer, Charity, Contemplation, and Suffering) and refer to the suffering that each nun must accept in imitation of the Beloved and to the virtues that must motivate all her actions in life.

Rogelio Ruiz Gomar

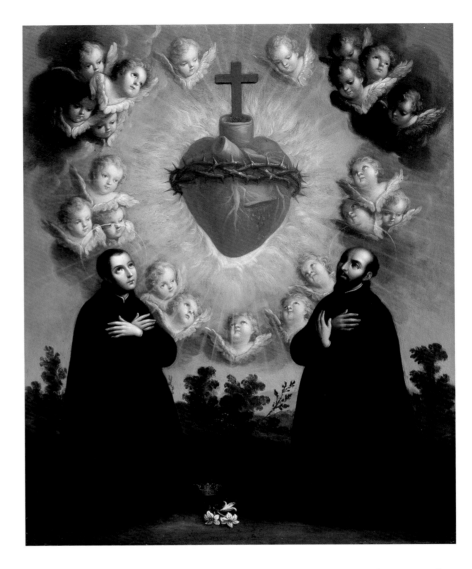

VI-33 José de Páez[†]

(Mexican, 1727–1790)

Sacred Heart of Jesus with Saint Ignatius of Loyola and Saint Louis Gonzaga

c. 1770
Oil on copper
16⅛ × 12⅞ inches (41 × 32.7 cm)
Denver Art Museum, Collection of Jan and Frederick R. Mayer

PUBLISHED: *Copper* 1999, pp. 245–47, ill.

EXHIBITED: Phoenix, Kansas City, and The Hague 1999

LIKE MANY OTHER PAINTERS in New Spain in the second half of the eighteenth century, José de Páez devoted a part of his production to various versions of the Sacred Heart of Jesus, representing it first in isolation, detailed with a naturalist precision that surprised more than one Enlightenment philosopher, and later set within the breast of Jesus. In the present version we also find two Jesuit saints, Saint Ignatius of Loyola and probably Saint Louis Gonzaga (with lily and crown in allusion to his renunciation of the marquisate of Castiglione), rapt in contemplation. The heart is encompassed by a crown of thorns, and a cross emerges from the principal artery, making the heart not only a representation of Christ's love, but also of his Passion and death. The ring of cherubs circling the heart creates the atmosphere of a miraculous, celestial vision. The scene is set in the countryside, an element that, along with the naturalistic rendering of the heart itself, would be appreciated in the world of the Enlightenment. The vision is granted to two Jesuit saints because the devotion of the Sacred Heart of Jesus was fostered by the order.

In the eighteenth century the Jesuits discovered in science a new reason for marveling at creation, and proposed an optimistic and trusting religiosity that contrasted with the ascetic rigor of Jansenists and Augustinians, who tended to emphasize the humiliation of mankind before the mystery of salvation. A clear sign of this concern on the part of the Jesuits can be observed in their sermons, which are addressed to both the reason and the heart, in an attempt to reconcile the two spheres. There is an effort not only to move the listener in order to persuade, but also to transform personal experience into a source of spirituality, establishing an emotional communication with the divinity that can lead to states of utter sublimity. This surrender to the emotions and propensity to listen to the voice of the heart was channeled particularly into two devotions that appeared suspect to many: the practice of the Via Crucis and the devotion of the Sacred Heart. The latter had many antecedents, but it was only with Saint Margaret Mary Alacoque (1647–1698) that it became openly a part of Catholic devotional life. The devotion was introduced silently into New Spain through contact with Asia, where it was in existence by 1709, and later through the book of a Jesuit from Puebla, Juan Antonio Mora, published in 1732 and based in turn on a book by Father Gallifet entitled *Of the Cult of the Most Sacred Heart of Jesus*, published in 1726.

Juana Gutiérrez Haces

VI-34 *Sister Elvira de San José*

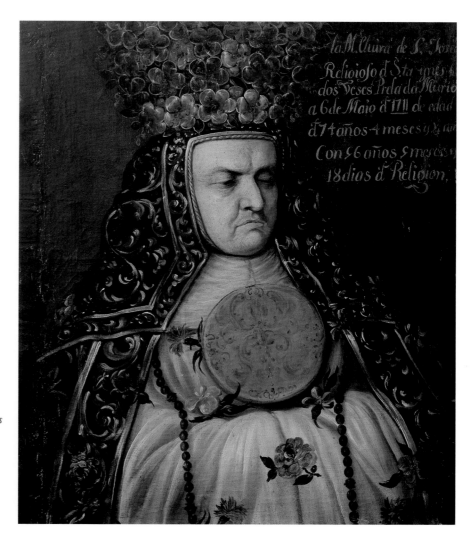

Mexico
Eighteenth century
Oil on canvas
30¹¹⁄₁₆ × 21⅝ inches (78 × 55 cm)
Inscribed at upper right corner: *La M[adre] Elvira de S. Jose/
Religiosa d[e] Sta. Inés/dos veces prelada, murió/a 6 de mayo d[e]
1711 de edad/de 74 años 4 meses y 4 días/con 56 años 5 meses y/18 días
de religiosa*
Museo Nacional del Virreinato, Tepotzotlán/CONACULTA,
INAH, Mexico

PUBLISHED: Montero Alarcón 1999, pp. 31–32

EXHIBITED: Mexico City 2003

SECOND IN QUANTITY AND IMPORTANCE to the large body of religious paintings produced in New Spain are the portraits produced there. Within this group is the attractive subsection of portraits of "crowned nuns." These depict women on their entry into a convent, dressed in rich clothing and adorned with such accessories as embroidered cloaks, floral crowns, candles, and multicolored branches of flowers. Floral crowns, a symbol of the virtuous soul, were also used in portraits of dead nuns, with the implication that at her death, the nun should be even more richly clothed for her final meeting with her divine spouse than on her entry into the convent and her spiritual marriage to Christ.

Depictions of "crowned nuns," both living and dead, are a characteristic manifestation of baroque painting in New Spain. Through their forms and colors they reveal the splendor, artifice, and complexity of the society in which they were produced, as well as the profound and highly spiritual religious culture that inspired them.

The present work is undoubtedly one of the most impressive examples known today. It clearly depicts a woman who is physically aged and worn, but rather than being depicted lying down, as if on her deathbed, she is presented vertically, as though asleep. Viewers of this painting have been known to lower their voices in order not to disturb or annoy this elderly sleeping nun.

The sitter, who was mother superior of the Convent of Santa Inés on two occasions, and who died at the age of 74, wears the blue-and-white habit of the Concepcionistas. In addition to her rosary of black beads, she has a blue emblem on her breast and is depicted with a number of carnations, which symbolize pure love. Established for poor young girls and orphans in the late sixteenth century, the convent of Santo Inés opened its doors on September 17, 1600, when its four founding nuns moved there from the convent of La Concepción. Around 1740 the painters' guild established itself in the convent's church, and as a consequence both José de Ibarra and Miguel Cabrera were buried there, among other artists.

Rogelio Ruiz Gomar

VI-35 Brother Juan Díaz and Brother José Moreno

Mexico
Last quarter of the eighteenth century
Oil on canvas
75⅝ × 50¾ inches (192 × 129 cm)
Inscribed on tablet at lower left: FRAY JUAN DIAZ, *natural de Villa de Alajas, hijo de la Santa Provincia de San Miguel, vino en misión a este apostólico Colegio el año de 1773. fue uno de los primeros religiosos que entraban en las misiones de Sonora . . .* ; on tablet at lower right: FRAY JOSE MORENO, *natural de la ciudad de Logroño, hijo de la Santa Provincia de Burgos vino en misión a este apostólico colegio el año de 1769 . . .*
Museo Regional de Querétaro/CONACULTA, INAH, Mexico

PROVENANCE: Colegio de Propaganda Fide, Santa Cruz de Querétaro

PUBLISHED: Arricivita 1792; Ángeles Jiménez 1994, pp. 5–33; Villagran 1996; Monterrosa Prado 1997, pp. 130–49; Rubial García and Suárez Molina 2000, pp. 50–71

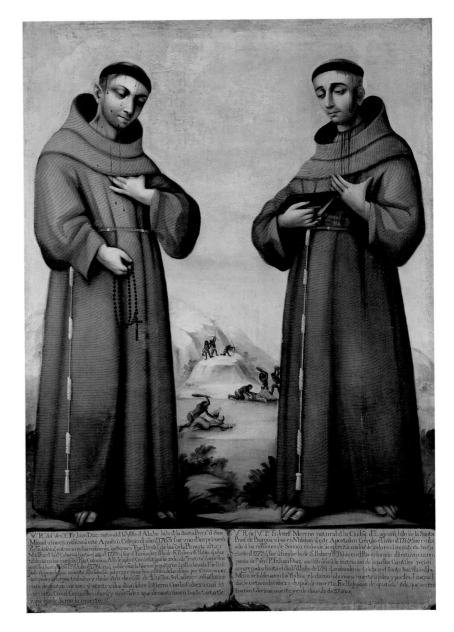

AMONG THE VARIOUS PORTRAIT GALLERIES that remain from the colleges of the Dissemination of the Faith founded in New Spain, the works that stand out owing to their number and plastic quality are those that reflect the multitude of situations that arose during the spiritual conquest of the northern territories, which often resulted in the martyrdom of the missionaries at the hands of the indomitable northern tribes. Such is the case in the scene depicted in this portrait of Brother Juan Díaz and Brother José Moreno, whose composition recalls the great painting *The Destruction of the Mission of San Sabá and the Martyrdom of Brother Alonso Giraldo de Terreros and Brother José de Santiesteban.* In both works, the figures are placed at the edges of the pictorial surface, and, rather than stressing the physiognomy or expressions of the monks, as in a typical portrait, the pieces function as true allegories of martyrdom.

In the present painting, Brother Díaz is at the left, identified by the inscription on the tablet below. He carries a rosary in his right hand, while his left hand rests on his heart, at the place where blood has dripped from his forehead. Brother José Moreno carries a book, his left hand also placed over his heart. In both figures, the Franciscan habit is almost a sculptural

construction that contains and gives shape to his body. Although mortally wounded, the brothers seem resigned, passive, and removed from the narrative being played out in the landscape they frame, where we see the manner in which the northern Indians took their lives.

Complementing the images, the tablets provide some biographical detail, including the date of their martyrdom, July 17, 1781, when both monks were working in the jurisdiction of the Sonora missions. Their deaths occurred in the context of the missionary efforts of the college of Querétaro, where between March 1773 and July 1781 their four colleagues at the institute were also martyred. Portraits of these four also exist in the Museo Regional de Querétaro. Given their characteristics, they form a series with this painting of the priests Díaz and Moreno.

Pedro Ángeles Jiménez

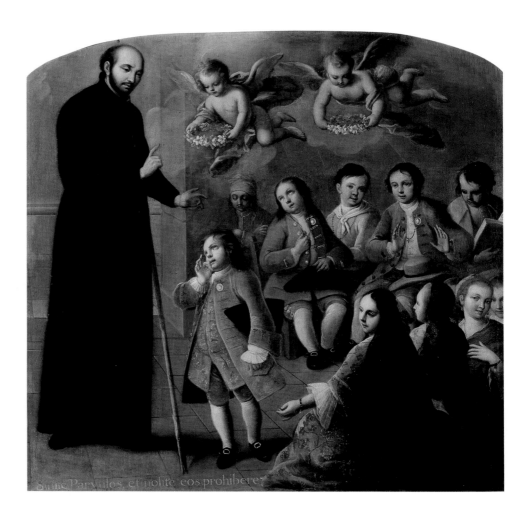

VI-36 *Saint Ignatius of Loyola Teaching the Children of New Spain*

Mexico

Second half of the eighteenth century

Oil on canvas

63 × 60³⁄₁₆ inches (160 × 163 cm)

Inscribed at lower left: *Sinite Parvulos, et nolite eos prohibere*

Church of La Compañía de Jesús/CONACULTA, DGSMPC, Guanajuato, Mexico

PUBLISHED: *Oratorio Filipense* 1995, p. 131, ill.; Jiménez Codinach 1997, p. 93, ill.

EXHIBITED: Mexico City 1997 *México*

THIS PAINTING IS KNOWN BY THE TITLE *Saint Ignatius of Loyola Teaching the Children of New Spain*, owing perhaps to the attire of the children and—still more—of the women, which so closely resembles the clothing worn in Mexico in the eighteenth century. This was only a means, however, by which the artist brought the subject matter closer to the viewer and made it possible for the devout to identify with the scene depicted—one of the fundamental objectives of the Jesuits in commissioning works of art, conscious as they were of their great educational value. In order to underline this identification of the public with the subject of the painting, one of the women seated in the foreground turns toward the viewer and gestures as if she were sharing what is taking place before her. The scene depicted is one of the many instances of Saint Ignatius's contact with children, possibly when, on his return from the Holy Land, he recommenced his education by studying Latin with children, or, more likely, when he established instruction for children in Rome through explanations of Christian doctrine in the churches and plazas. This would explain why the mothers of the children are present, and why the architecture so little resembles that of a school. An important aspect of this painting is that Saint Ignatius is represented as an educator rather than as the founder of an order or as a missionary. In order to emphasize this educational vocation the artist has added various original elements, such as the rod propped against the soutane of the saint, rather than wielded with force, as might have been more usual at the time. Here, the saint instructs the children in doctrine with gentle gestures. Another original element, which adds a touch of great tenderness, is the child who stands before Saint Ignatius and kisses his crossed fingers after having made the sign of the cross. The relaxed atmosphere prevailing among the rest of the children bespeaks a form of education based not on fear but on trust. The method is seen to bear fruit, as the children who have learned their doctrine are crowned with flower wreaths by two small angels, in recognition of their wisdom as well as their virtue. The painter of this canvas, who remains anonymous, probably belonged to the circle of Miguel Cabrera.

Juana Gutiérrez Haces

VI-37 *Plan of the Archbishopric of Mexico*

Mexico
Eighteenth century
Oil on canvas
47½ × 67⅜ inches (120.5 × 171 cm)
Museo Nacional del Virreinato/CONACULTA, INAH, Tepotzotlán,
Mexico, 10-9384

THE ARCHBISHOPRIC OF MEXICO, which comprises the large and
populous territory of Mexico City and its surrounds was established on
February 12, 1546. There are two extant maps of the churches and other
religious houses in the Archbishopric of Mexico created at some point
during the eighteenth century. They originally took the form of a vertical
scroll painting with a wooden rod at the bottom onto which the painting
would roll up and be stored in a wooden cylinder at the top of the canvas.
Both works were thus portable maps, created for ecclesiastical use.

At the center of the map is a circle representing *La Imperial Ciudad
de México* with the cathedral at its center and a number of parish churches
and monasteries identified: Santa Catarina Mártir, Santiago Tlaltelolco,
Santa María la Redonda, Veracruz, San Francisco, San Pablo, Santa Cruz,
San Sebastián, Piedad, and Tetepilco. Radiating from this center are vil-
lages and parishes. Lines drawn between them are marked with a number
denoting the distance one from the other. Each church is identified in a
circle with its name and whether it is ministered to by a religious order or
by a *doctrinero*, a parish priest dedicated to the religious instruction of the
Indians, as are different tribes and their distinguishing languages.

Although this was not intended as a topographical map, the rela-
tively higher and lower regions can be discerned, and the artist included
the largest of the lagoons: Xochimilco, Chalco, Texcoco, Atenco, and
Zumpango. Other important centers such as Guadalajara and Michoacán
are also generally indicated.

The legend on a banderole at the "top" (north is to the right of the
map, south to the left) refers to a fabulous region of great cities that the early
Spanish conquistadors believed could be found in North America ("Aquí
comienza la gentilidad hacia la gran Quivira" or "Here begins the pagan
world that reaches La Gran Quivira"). When this map was created, of
course, the north was no longer mysterious, but well explored and settled.

Suzanne Stratton-Pruitt

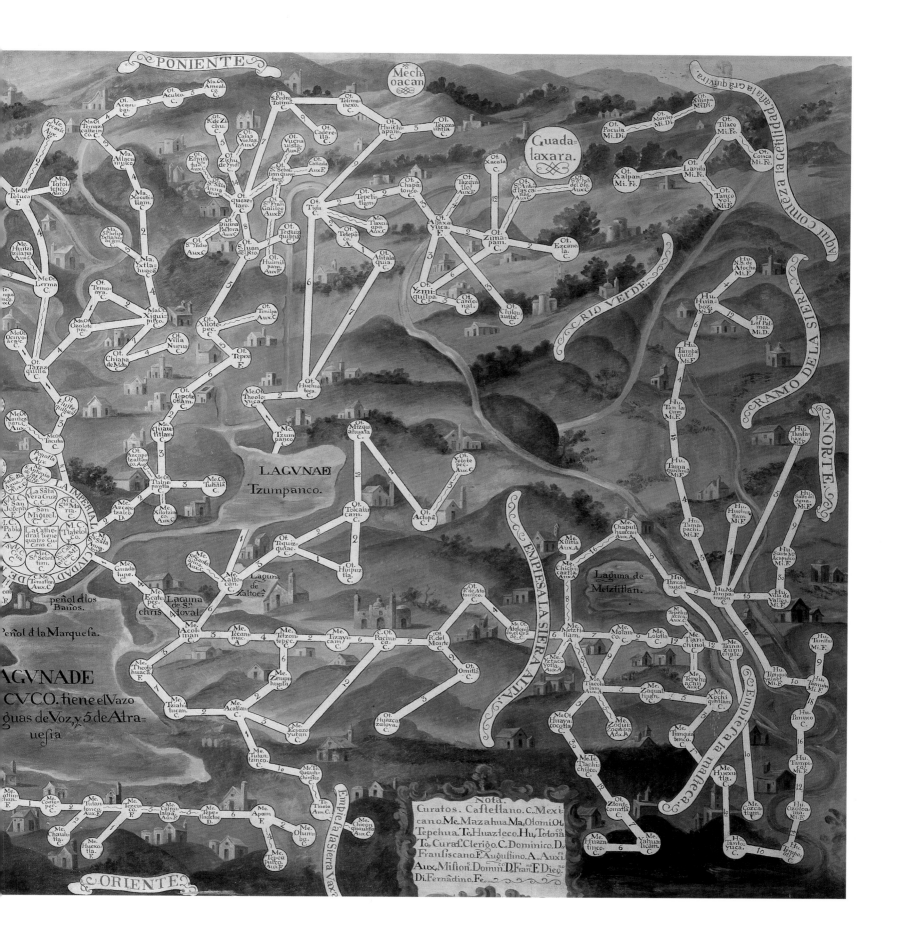

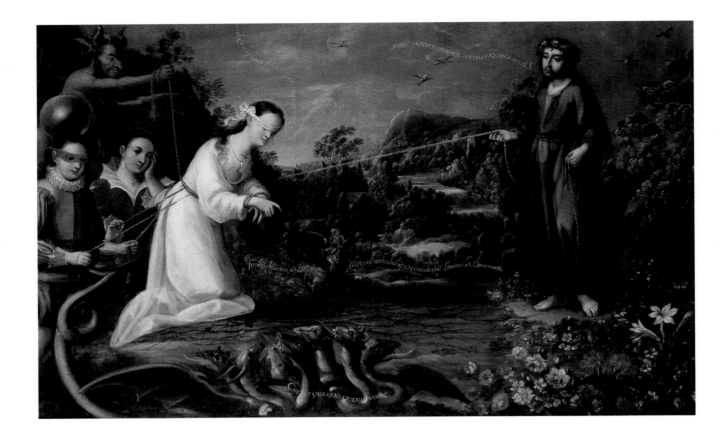

VI-38 Francisco Martínez

(Spanish, active Mexico, 1723–1757)

The Soul Guided by Christ

1732
Oil on canvas
39 × 61⅜ inches (99 × 156 cm)
Inscribed, issuing from the mouth of the soul: *Vivo autem Iam non ego: Vivit vero In me Xptus;* and, *Cupio disolvi et esse cum Xpto;* on the kerchief over the soul's eyes: *Fee y Obediencia Siega;* on the heart of the soul: MICHI ENIN VIVERE XPTUS EST; from the soul toward Christ, over the rope: *Nom mea Voluntas; sed tua Voluntas Fiat;* issuing from Christ's mouth: *Discite a me: quia mitis sum, et humilis corde;* between the soul and Christ, over the brambles: *Super Aspidem, et Basiliscum ambulabis: et conculcabis Leonem et Draconem;* labeling the seven-headed beast: CIRCUIT QUAERENS QUEN DEVORET; at lower left: *Martinez fecit, 1732 a*
Collection of Daniel Liebsohn, Mexico City

PUBLISHED: Velásquez Chávez 1986, pp. 388, 578

UNTIL NOW THIS ALLEGORICAL COMPOSITION has been identified as a narrative concerning an otherwise unknown "Saint Leonor." Probably the confusion stemmed from a misreading of one of the inscriptions on the canvas (*Leonem*, or "lions"), whose cumulative sense makes clear that the subject is the wish and need of the religious soul to be guided by Christ. The soul (the feminine *alma* in Spanish and *anima* in Latin) is held back by the World, the Flesh, and the Devil, who pull at her with ropes of various colors. The first two are in the guise of an elegantly dressed young couple, although the man's mask and the woman's melancholic gesture belie their attraction. The soul, a kneeling captive with hands bound before her, is dressed in white, blindfolded in Faith and Obedience, with a Crucifix firmly implanted in her dedicated heart. She utters appropriate biblical phrases that indicate her willingness to be led by Christ—"And I live, now not I; but Christ liveth in me" (Galatians 2:20), and "[I] desire to be dissolved and to be with Christ" (Philippians 1:23).

The way toward Christ is a barren path full of thorns and vermin, guarded by a basilisk and the seven-headed beast of the Apocalypse. Beyond is a wilderness landscape with a river broken by falls, which invariably in the paintings of New Spain represents "the desert," that is, uninhabited and therefore dangerous territory. Christ, standing on a solid, flat rock surrounded by flowers, firmly holds a rope that goes from his waist to that of the soul, as he urges that she learn from him. His crown of thorns and roses allude to the pain and joys of religious life, while the flowers at his feet can be associated with its graces and virtues; among them are the white lilies of purity and chastity and the red carnations that are pledges of love.

Although the provenance of the canvas is unknown, it must have been made for a convent or a monastery. The ropes that bind the soul and attach her to Christ, as well as the fact that several of the biblical texts in the painting are used in the proper of the mass for the day of Saint Francis, suggest the possibility that it was a Franciscan house. Until a cleaning in the 1990s revealed the signature, this work had been attributed to the Augustinian artist Friar Miguel de Herrera, one of a number of clerical painters known to have worked in New Spain. Indeed, Francisco Martínez was himself a priest.

Clara Bargellini

VI-39 Attributed to Miguel Cabrera[†]

(Mexican, 1695–1768)

The Papal Proclamation of the Patronage of the Virgin of Guadalupe in New Spain

c. 1756
Oil on copper
22¹³⁄₁₆ × 16¾ inches (58 × 42.5 cm)
Museo Soumaya, Mexico City

PUBLISHED: *Zodiaco Mariano* 2004

EXHIBITED: Mexico City 2004

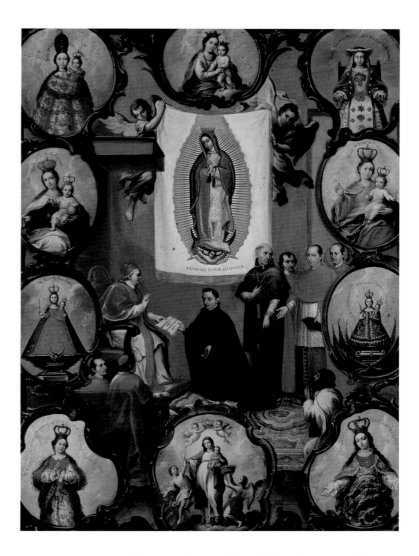

THE CENTRAL SCENE OF THIS PAINTING on copper depicts a highly significant episode in the history of religious life and identity in New Spain: the audience granted by Pope Benedict XIV in Rome in 1754 to the Jesuit proctor Juan Francisco López, who was seeking Papal approval for the universal patronage of Our Lady of Guadalupe over the territory of New Spain. This audience would lead to the Papal bull *Non est equidem*, which recognized the oaths whereby the cities and villas of New Spain had proclaimed the image of Tepeyac, or Guadalupe, to be their special protectress, in the wake of a terrible epidemic and a time of exalted patriotic fervor. Certain thinkers, both at the time and in the nineteenth century, went so far as to affirm that it was thanks to this event, at once rhetorical and juridical in nature, that "the territory was unified and the nation called into being," in spite of its status as a colony.

Alongside the throne of Saint Peter are four figures standing in the guise of aids to the Pope: Friar Juan de Zumárraga (a witness to the apparitions) and three of the prelates who did the most to bring about the process, Juan Antonio de Vizarrón, Manuel Rubio y Salinas, and Juan Gómez de Parada. In the foreground, seated on a bench, are two intellectual figures of the period, Cayetano and Antonio de Torres, canons of the Mexico City cathedral who also contributed to the promotion of Guadalupe. It was doubtless they who commissioned the painting. Finally, Juan Diego is seen kneeling to one side and observing the moment at which the Jesuit receives the bull. Hanging above is his

ayate, or mantle, on which, according to the tradition, the image of the Virgin had been impressed.

In fact, Miguel Cabrera, to whom this painting has been attributed, was commissioned to execute a faithful copy of the sacred image so that the Pope might be convinced of the ineffability of the miracle. Torres himself added to Cabrera's fame and prestige by speaking in one of his sermons of the profound impression the work had made on the Pope, as described to him by López on his return. The scene—equivalent to a beatification—took on such importance in the *criollo* imagination that Cabrera produced a large-scale mural painting similar to this small copper plate for the Colegiata de Guadalupe.

Jaime Cuadriello

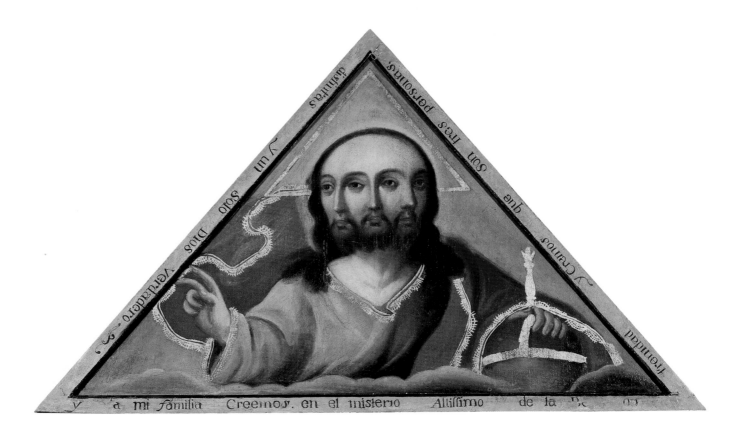

VI-40 *Three-Faced Trinity*

Peru

c. 1750–70

Oil on canvas

17½ × 29 inches (44.5 × 73.7 cm)

Wadsworth Atheneum Museum of Art, Hartford, Connecticut

PUBLISHED: *Siglos de oro* 1999, cat. no. 113

EXHIBITED: Madrid 1999 *Siglos de oro*, cat. no. 113

REPRESENTATIONS OF THE TRICEPHALOUS, or three-faced, Trinity, which appeared in Europe in the fourteenth century, were formally condemned in 1626 in Rome by Pope Urban VIII, who prohibited a Venetian woodcut in a missal preserved in the Vatican Library (1506–7; incunabulum IV, 192, fol. 233v) that depicts the Trinity with a head having three faces and two eyes, under a triangular nimbus, blessing with its right hand the orb of the world it holds in its left. That would have been the oldest graphic source of this painting from eighteenth-century viceregal Peru. Proof of the continuing prevalence of the iconography in Italy and Spain is provided by the fact that representations of the Trinity continued to be persecuted and prohibited—by Pope Benedict XIV in Rome in 1745, and by the Holy Office of the Inquisition in Madrid between 1786 and 1787. Catholic treatises on the art of painting forbid this type of image. Even before these Christian variations on the tricephalous Trinity, there existed in medieval Europe an iconography of the devil as a three-faced or three-headed monster. He is depicted thus on the facade of Saint Peter's in Tuscany and in the Camposanto in Pisa (fourteenth century). In his *Divine Comedy*, Dante Alighieri describes the "Emperor of the kingdom dolorous" as a being with three faces, six eyes, three chins, and three mouths that chew up and swallow sinners.

It was doubtless the three-headed and three-faced pagan gods of the ancient Greek, Roman, Persian, and Indo-European solar cults that led to the devil being thus represented in Christian art. The utter incompatibility of biblical monotheism with the polytheism of these cultures relegated these barbarian gods to the inferno as demonic effigies of idolatrous cults. At the end of the Middle Ages, however, and especially in the wake of the humanism of the Italian Renaissance, a new syncretistic theological current undertook to reappraise the "rudimentary pagan trinities" and to retransform Orpheus, Plato, Zoroaster, and Hermes Trismegistus into prophets of the *mysterium trinitatis*. On the tomb of Pope Sixtus IV (1484) in Saint Peter's in Rome, Antonio Pollaliuolo depicted Theology in rapt contemplation of a three-headed sun as the greatest symbol of the Christian Trinity.

Following the conquest of Peru, the Augustinian and Jesuit missionaries undertook to seek out three-headed and three-faced pre-Hispanic gods in the Andes, in order to be able to claim that the Indians of the New World had been granted glimpses of the true God even before the arrival of the Spaniards. In distinct cultural contexts, however, the same symbol can assume radically different meanings. When Vasco da Gama first arrived in India in 1498, he entered a Hindu temple and encountered a tricephalous deity being worshipped upon an altar. He knelt down before it and took part in the ceremony, ordering his soldiers to worship it as if it were God one and trine. Without realizing it, Vasco da Gama had committed the mortal sin of idolatry. In spite of iconographical similarities, it was a question of different gods.

Ramón Mujica Pinilla

VI-41 Juan Patricio Morlete Ruiz[†]

(Mexican, 1713–c. 1772)

Virgin of Guadalupe

Mid-eighteenth century
Oil on canvas
82¹¹⁄₁₆ × 53¹⁵⁄₁₆ inches (210 × 137 cm)
Inscribed: *Non fecit taliter omni nationi*
Private collection

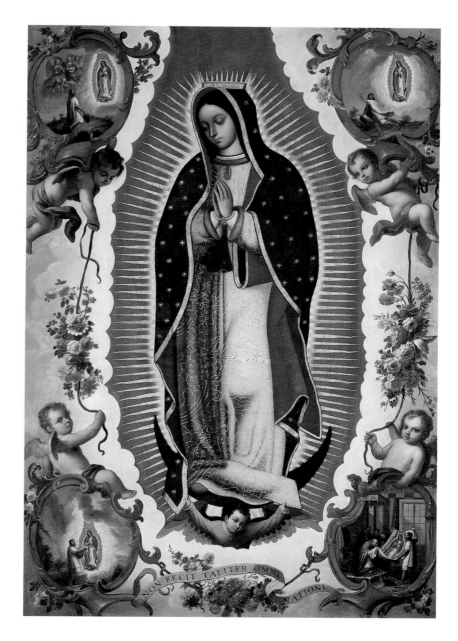

DEVOTION TO THE VIRGIN OF GUADALUPE originated with the image miraculously impressed onto one of the garments of the Indian Juan Diego. The holiness of this image obliged all those painters who wished to copy it to reproduce it as exactly as possible, in many cases even respecting its original dimensions. Many painters used tracing techniques to ensure precision in details, and no painter felt capable of reproducing pictorially what the hand of God had made. When the new version was finished, it was "touched" to the original to transmit its miraculous properties to the copy. Starting in the seventeenth century, but especially throughout the eighteenth, cartouches were added to the corners of the image to narrate the apparition story. Among the many copies, the image of the Virgin of Guadalupe painted by Juan Patricio Morlete Ruiz is of special interest. Morlete was one of the painters chosen, along with Miguel Cabrera, by the abbot of the basilica to perform an inspection of the image on April 30, 1751. Cabrera's book *Maravilla americana (American Marvel)*, which includes Morlete's "opinion" on the question as defined by Cabrera, was published as a result of this inspection. The copies executed by Morlete therefore possess the added value of being the work of a painter who had had direct contact with the sacred image. The cartouches that contain the various scenes of the apparition story are in rococo style, which was brought to New Spain along with other French influences by the Bourbons. In addition to the cartouches, a scroll has also been added at the bottom of the image bearing the words from Psalm 147:20: "He hath not done in like manner to every nation." Although this phrase had already been applied to the image of the Virgin by writers in New Spain, at the time this work was produced this usage was attributed to Pope Benedict XIV, who in 1754 had named the Virgin of Guadalupe patron of New Spain and had established her feast day on December 12. Pronounced by a pope, the words became a powerful and influential weapon in support of the Guadalupan devotion. The garland of flowers, held by putti and uniting the cartouches and the scroll, is very much in the taste of Mexican painting of the vice-regal period.

Juana Gutiérrez Haces

Mariano. Fran.^{co} de, Carrdona; muri. de dies. meses. el añ.de.1768.

VI-42 *Don Mariano Francisco de Cardona*

Mexico
c. 1768
Oil on canvas
24¼ × 32¾ inches (61.6 × 83.2 cm)
Inscribed at top right: *Mariano. Fran.^{co} de, Carrdona, murt. de dies. meses, el año. de 1768.*
San Antonio Museum of Art, Texas

PROVENANCE: Acquired by the Museum in 1991

PUBLISHED: San Antonio Museum of Art website: http://www.samuseum
.org/laac/laac_cd/COLREPB/OBJECTS/4D2.HTM

THE COMMISSION OF FUNERARY PORTRAITURE became increasingly common in eighteenth-century Mexico. While this type of portrait had an established tradition in Spain and elsewhere in Europe, the practice of commemorating deceased family members and important personalities gained a prevalence in Spain's American colonies far beyond that seen on the Continent. The genre took on a character of its own in its depiction of young subjects as members of the clergy or as archangels. This type of portraiture quickly evolved into an enduring tradition throughout Latin America, and enjoyed a massive proliferation following the advent of photography in the mid-nineteenth century. The pictures, especially the photographs, are often referred to as *angelitos* because church doctrine stipulated that baptized infants who died before developing basic intellectual capacity were innocent of sin and thereby gained unconditional entry to heaven. Indeed, despite their somber, even morbid, appearance to modern viewers, these portraits—however poignant—do not depict moments of abject sadness. Rather, they commemorate an important ritual that expressed a family's joy and pride in their child's passage into divine, everlasting life.

Mariano Francisco de Cardona, who was only ten months old (according to the painting's inscription) at the time of his death, is dressed in traditional Dominican vestments—a black, hooded coat and a white scapular—suggesting that his family had a particular devotion to this monastic order or perhaps even that the boy was destined to take the vows himself once he had reached a suitable age. The child is garlanded with lilies and wildflowers and wears a floral crown, echoing the well-known tradition in colonial Mexico of depicting young nuns upon their entry into the convent wearing similar floral headgear (see cat. VI-65). The small funeral bier on which Mariano Francisco lies in state is adorned with silk ribbons and lace, while his hands have been arranged in a gesture of eternal prayer. His eyes, likewise, have been left open slightly so as to gaze heavenward. As in the depictions of crowned nuns, portraits such as that of Mariano Francisco de Cardona reflect the purity and piety of the sitter as well as the social and religious status of his or her family.

Michael A. Brown

VI-43 Miguel Cabrera[†]

(Mexican, 1695–1768)

Virgin of Valvanera

1762

Oil on copper

16⁹⁄₁₆ × 12½ inches (42.1 × 31.7 cm)

Signed at lower center: *Mich Cabrera, pinxit 1762*

Inscribed on book held by Christ Child: *Volvio/Christo/el Ros-/
tro por/no ver/vn sacri-/legio.*

Philadelphia Museum of Art, The Dr. Robert H. Lamborn
Collection, 1903-897

PROVENANCE: Collection of Robert H. Lamborn

PUBLISHED: Philadelphia Museum of Art 1994, p. 306.8;
Bargellini 1997, pp. 576, 581; *Copper* 1999, cat. no. 10,
pp. 161–63

EXHIBITED: Columbus 1957; Tucson 1966; Philadelphia 1968;
Philadelphia 1980; Phoenix, Kansas City, and The Hague
1998, cat. no. 10

THE ORIGINAL VIRGIN OF VALVANERA, patroness of the Rioja region of Spain, is a Romanesque sculpture that legend attributes to Saint Luke. As in other cases of Spanish images, it was miraculously discovered after the reconquest. An angel directed a certain Nuño, who had retired to the area to do penance for his previously dissolute life, to look for the Virgin in the valley. There, inside a large oak, with a spring at its roots and a beehive in its trunk, he found the image. The associations with material plenty, in the water and honey, are amplified by the miracles attributed to the Virgin. They also can be understood as parallel to the promise of spiritual grace, possibly signaled by the unusual position of the Christ Child, and indicated in the book with inscription that he holds: he will ignore sin, though his direct gaze at those who approach, reinforced by that of his mother, suggests that he will not neglect the sinner.

Mary is richly clothed and crowned, and seated on a throne protected by eagles, set upon a polygonal base. Cabrera would have known the image mainly through numerous seventeenth-century prints. Among the earliest painted versions in New Spain is one by Juan Correa (Museo Franz Mayer, Mexico City). In 1725, an altar with a sculpted image was dedicated to the Valvanera within the church of San Francisco in Mexico City. A close precedent for Cabrera's painting is a canvas by José de Ibarra

(Colegio de Vizcaínas, Mexico City). Unlike Correa, who clothed his Valvanera in rich brocades, Ibarra and Cabrera have her in relatively simple red and blue. Cabrera's painting can be associated with the solid popularity of the Virgin in the 1760s, when she was honored with her own chapel; its elaborate 1766 facade still stands next to San Francisco.

Made for private devotion, this is one of many compositions on copper by Cabrera. Since in 1765 he also painted a version on canvas (collection of Jan and Frederick R. Mayer), this work is an excellent object lesson in how he understood the technique and function of paintings on copper. Obviously, he was aware that the close contemplation given these paintings provided an opportunity to demonstrate his skill in rendering details. This tiny copper has many more elements than the relatively huge canvas. The background figures and landscape, including the presence and illumination of the sun, are totally absent in the large painting, as is the book held by the child. The jeweled crowns are also rendered with much greater variety and particularity in the smaller work.

Clara Bargellini

VI-44 Miguel Cabrera[†]

(Mexican, 1695–1768)

Birth of Saint Ignatius and the Prophecies That Preceded It

1756

Oil on canvas

111 7/16 × 134 1/4 inches (283.1 × 341 cm)

Inscribed at left: *la Ve. Angela Panigarola;* and further down: *El Ve. Abad Joachin;* at lower left: *Se comenzaron estos lienzos de la vida de san Ignacio de Loyola el 7 de junio de 1756 en que se celebró su prodigiosa conversión prosiguiéndose a devoción de un hijo del Santísimo patriarca;* at bottom right: *Nacimiento de Sn. Ignacio y profecías que precedieron*

Museo Nacional del Virreinato/CONACULTA, INAH, Tepotzotlán, Mexico

PUBLISHED: Tovar de Teresa 1995, pp. 174–75, 176–77, ill.; *Pintura novohispana* 1992–96, vol. 3, pt. 2, cat. no. PI/0626, p. 119, ill.; Cazenave-Tapie 2003, p. 82

THE CASA PROFESA OF THE JESUITS in Mexico City had a large church, first dedicated in 1610 and rebuilt in the early years of the eighteenth century. Beside the church was the cloister where the provincial father resided along with the members of the order, who were distinguished by their intellectual achievements and for having sworn the "fourth vow" of their order. In addition to taking their vows of poverty, obedience, and chastity, they had bound themselves to unconditional obedience to the pope, prepared to go as missionaries to wherever he ordered. Thus, the Casa Profesa served as a temporary residence for the many Jesuits who set out to establish missions in remote regions.

In 1756 the painter Miguel Cabrera was commissioned to execute a series of thirty-two scenes from the life of Saint Ignatius of Loyola. This depiction of his birth was probably the first of the series. Almost fifty years before, Cristóbal de Villalpando had done a similar series for the Jesuit college at Tepozotlán, following closely the world-famous engravings of Peter Paul Rubens and Jean-Baptiste Barbé, which were copied in many places. Even where he took these predecessors into account, Cabrera chose to break with the tradition and to innovate in many of his compositions, moving completely away from the Rubensian model. Calling upon an ancient tradition according to which the birth of the saints repeats the form of the birth of the Virgin Mary, Cabrera depicted the mother of Saint Ignatius reclining, with her baby in her arms, on a large bed with a canopy. The saint's father stands to one side, dressed in the eighteenth-century manner, and the four women who assisted at the birth remain nearby, two of them next to a small cauldron. In the background, a parallel scene—common in this type of series—shows two figures who prophesied the life of Saint Ignatius, the venerable Abbot Joachim and the venerable Angela Panigarola. In the center of the principal room a clock is prominently visible, probably to indicate that the prophesies have been punctually fulfilled. The clock and other elements of the furnishings lend an everyday quality to the scene, but the presence of the timepiece also indicates the importance of such objects in the lives of cultivated people of the age.

Juana Gutiérrez Haces

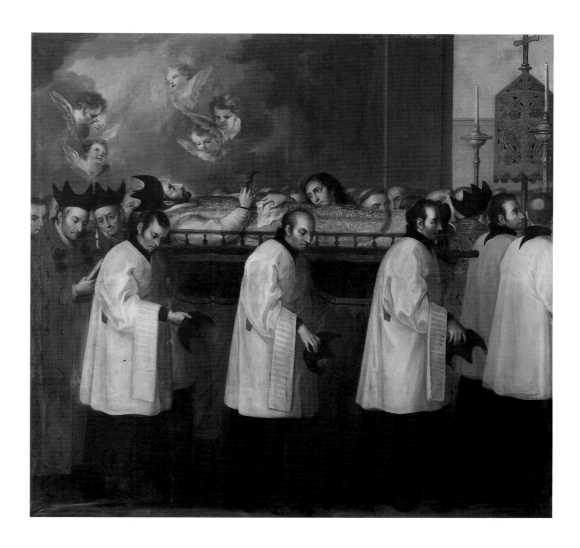

VI-45 Miguel Cabrera[†]

(Mexican, 1695–1768)

God Confirms the Sanctity of Saint Ignatius by Granting Health to a Sick Person / The Death of Saint Ignatius

1756

Oil on canvas

111 × 115¾ inches (283 × 295 cm)

Museo Nacional del Virreinato/CONACULTA, INAH, Tepotzotlán, Mexico

PUBLISHED: Tovar de Teresa 1995, pp. 176–78; *Pintura novohispana* 1992–96, vol. 3, part 2, cat. no. PI/0651, p. 134, ill.; Cazenave-Tapie 2003, p. 84; *Zodiaco Mariano* 2004, p. 122, fig. 81

IN 1756 THE PAINTER MIGUEL CABRERA was commissioned to execute a series of paintings dedicated to the life of Saint Ignatius of Loyola for the cloister of the Casa Profesa of the Jesuits in Mexico City. One of the last of the thirty-two scenes, which represents the confirmation of the sanctity of Ignatius, was converted by Cabrera into a depiction of the conveyance of the saint's body after his death. Other contemporaneous painters, such as Miguel Jerónimo Zendejas, depicted the scene in the same way as Cabrera, but this had not been the usual practice in previous series dedicated to the life of Saint Ignatius. The scene normally showed a group of devout followers approaching the coffin containing the body of Saint Ignatius in order to gather flowers and a piece of his clothing as a token of good health, including in particular a woman stricken with mumps, who is instantly healed. This woman can be seen behind the bier in the present painting, dressed in a blue cloak. The act of healing was particularly important as the sign from God that the dead man being carried to his rest was a saint. The importance of the scene probably excited a desire on the part of certain Jesuits contemporary with Cabrera to have their portraits appear among the figures carrying the bier. Although not all of them have been identified, the care lavished on the features and the individual character of each person leaves no doubt that they are portraits. This combination of a miraculous event with the conveyance of the body of Saint Ignatius was an especially original stroke on the part of Cabrera, and if the Mexican Jesuits wanted to honor their patron saint, there was no better way than to uncover their heads in a sign of humility and to carry the saint's body in procession. The paintings hung in cloisters always possessed a processional character, reflecting one after another on the mysteries of life. What better than for this painting to set the mobile, processional tone, combining a present wish for veneration with the story of the saint's life?

Juana Gutiérrez Haces

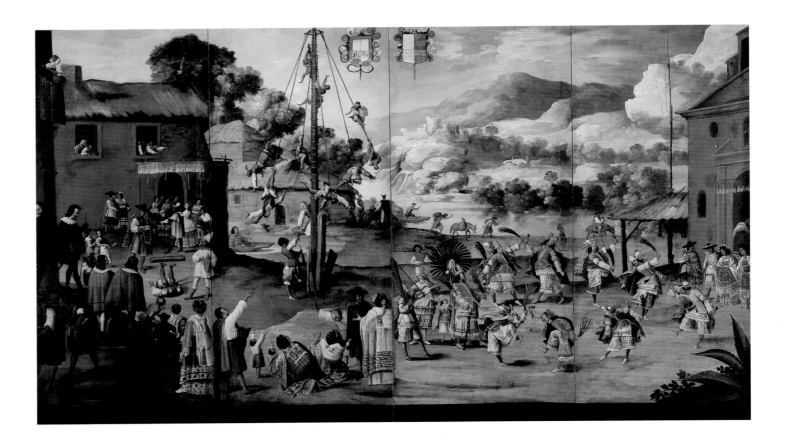

VI-46 *Indian Wedding and Flying Pole*

Mexico City

c. 1690

Oil on canvas

66 × 120 inches (167.64 × 304.8 cm)

Los Angeles County Museum of Art, M.2005.54

PROVENANCE: Rodrigo Rivero Lake Antiques International, Mexico City

PUBLISHED: Katzew 2004 *Race*, pp. 176–77; *Imágenes de los naturales* 2005, pp. 482–87

EXHIBITED: Los Angeles 2004, pp. 176–77

THE SPANISH AND PORTUGUESE WORD *BIOMBO* comes from the Japanese *byóbu* (windbreak). The first *biombos*, or screens, were introduced to New Spain (Mexico) from Japan through the legendary Manila Galleons at the end of the sixteenth century. In 1614 the Japanese shogun Iesayu Tokugawa sent a number of screens as gifts to the viceroy Luis de Velasco (1607–11). Subsequently, *biombos* were created in Mexico City and Puebla, and by the seventeenth century they had become a standard and fashionable decoration in elite households—some painted by the best artists. In fact, colonial artists displayed a great deal of freedom in creating *biombos*, decorating them with mythological, allegorical, and historical themes as well as city views, emblems, *fêtes galantes*, and so on.

This extraordinary screen depicts an Indian wedding and a *palo volador* (flying pole), one of only two screens known to represent this subject (the other is in the Museo de América, Madrid). The festivity takes place in a village situated near canals—probably Santa Anita Ixtacalco,

a famous destination in Mexico City. On the right side, a newly wed Indian couple is shown leaving the church, flanked by their native *padrinos* (godparents). A number of nearby figures take part in various pre-Columbian games that continued in colonial times, including a *mitote*, or Dance of Moctezuma. In this game, which includes a sumptuously dressed figure who plays the part of Moctezuma, eight richly attired dancers imitate the dance performed by the Aztec king, accompanied by a harpist and guitarist. In the center, several figures are climbing up or dangling from a flying pole, while the dazzled crowd points at the spectacle. On the left side of the screen, an Indian juggles a log with his feet, lying on the ground in the middle of the crowd, which includes Spaniards distinguished by their seventeenth-century capes, some of whom gesture toward the various performances. For all its attention to ethnographic detail, the scene is set against an imaginary landscape of the type usually seen in Flemish paintings.

The historical significance of the screen is double: on the one hand, the subject satisfied Europeans' curiosity about the customs and rituals of the far-flung peoples of the New World; on the other, it proved that the native population of New Spain fully partook of an important Christian sacrament—marriage—thereby conveying the notion of a "civilized" land. While the screen is unsigned, the exquisite detail (seen, for example, in the attire of the dancers and spectators), coupled with masterful, loose brushstrokes (seen in the figures dangling from the pole), reveals the hand of an accomplished and confident artist, probably Manuel de Arellano, who was active in Mexico City during the late seventeenth and early eighteenth centuries. Additionally, the screen may have been the prototype for the development of new iconographies in eighteenth-century New Spain, including the famous *casta* paintings and depictions of Indian weddings.

Ilona Katzew

VI-47 Attributed to Manuel de Arellano[†]

(Mexican, active c. 1691–1722)

Rendering of a Mulatto

1711
Oil on canvas
40 × 29¼ inches (101.6 × 74.3 cm)
Inscribed at upper right: *Diceño de mulata [h]yja de negra y español en la Ciudad de Mexico, Cabesa de la America a 22 del mes de Agosto de 17011 Años;* at lower left: *Arellano*
Denver Art Museum, Collection of Jan and Frederick R. Mayer

PUBLISHED: Katzew et al. 1996, cat. no. 1, pp. 17, 31–33; Katzew 2004, pp. 10–15, fig. 7; Pierce et al. 2004, cat. no. 30, p. 194

EXHIBITED: New York 1996, cat. no. 1; Denver 2004, cat. no. 30

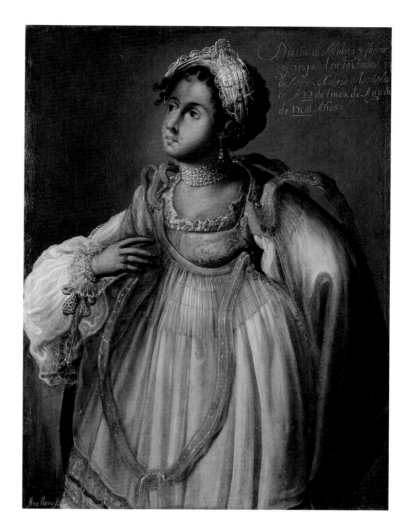

ONE OF ONLY FOUR PAINTINGS that have been identified from the earliest known set of *casta* paintings, this depiction of the daughter of a Spanish man and an African woman is signed by a member of the Arellano family and dated 1711. The four paintings were exhibited in Madrid in 1893 along with three others from the same series that have since disappeared. The canvas depicting the mulatto mate and child of the woman portrayed here is now known only from a black and white photograph. The other two paintings identified as part of the set depict a "Chichimec" (heathen) Indian male and his mate with their child and are now in the collection of the Museo de América, Madrid. Unlike later *casta* sets, Arellano's series shows individuals of the same racial background in separate, but paired, canvases. Nevertheless, the series is considered the prototype of the genre, with most subsequent sets derived from Arellano's models but differing thematically by depicting families of different racial backgrounds and compositionally by placing the family members together in a single canvas.

Like later *castas*, Arellano's renderings of the mulatto woman and of her spouse and child reveal details of daily life, clothing, and habits of the various racial mixtures in eighteenth-century Mexico. The woman's clothing is a combination of garments from different cultures. She wears a European-style bodice over a white chemise with lace ruffles at the neckline and cuffs, but also an over-blouse distinctive to women of African descent in Mexico. Known as a *manga* and worn at the neck, it was usually made of silk and was constructed much like a full, gathered skirt with frog fasteners and ribbon ties at the sides. Over her right shoulder she wears a long scarf of orange-red fabric similar to the distinctive Mexican *rebozo* (shawl). Her white headscarf has designs in dark blue and is trimmed with lace.

In the painting of her mate and child, the mulatto man wears a European suit with jacket and tricorn hat. He is shown taking a pinch of snuff from a small snuffbox, an allusion to the fact that tobacco was native

to the Americas. Their young son rides a stick horse and holds a toy lance with a small banner.

The woman's jewelry consists of a wide pearl choker, pendant pearl earrings, and four rings, probably of coral. Such rich jewelry may seem extravagant, but the abundance of pearls and coral reefs along the Mexican coasts made their use in jewelry common among women of all classes during the viceregal period. Foreign visitors to Mexico commented that both men and women of all classes sported luxurious jewelry for everyday wear. The emphasis on ostentation and public display of wealth and abundance can be associated with the growing nationalism of the late colonial period.

The exact and prominent dating of the paintings of the mulatto family, along with the proud assertion that they were set in the city of Mexico, "Capital of America," indicates that the set of *casta* paintings may have been made for a specific event. It is interesting to hypothesize that the occasion may have been associated with the assumption of power a few months earlier by the new viceroy, Fernando de Alencastre Noroña y Silva, the Duke of Linares (1711–16), appointed by Felipe V, the first king of the Spanish Monarchy from the French Bourbon dynasty. As such, these paintings would have served both to welcome the new viceroy—and through him the new king—and to educate him about the people, products, and customs he would meet in his new post. It is also surprising to note that the paintings are dated August 22, 1711, only a matter of days after a major and devastating earthquake rocked Mexico City on the sixteenth of the month.

Donna Pierce

VI-48 Attributed to José de Alcíbar[†]

(Mexican, 1725/30–1803)

From Spaniard and Black, Mulatto

c. 1760
Oil on canvas
31 × 38¼ inches (78.8 × 97.2 cm)
Inscribed at upper left: *6. De español y negra, mulatto*
Denver Art Museum, Collection of Jan and Frederick R. Mayer

PUBLISHED: Katzew et al. 1996, cat. no. 12; Katzew 2004, pp. 106–7, fig. 125; Pierce et al. 2004 cat. no. 48, p. 244

EXHIBITED: New York 1996, cat. no. 12; Denver 2004, cat. no. 48

A NUMBER OF CASTA PAINTINGS (sets of fourteen to sixteen canvases representing racial mixtures) portray families in domestic settings, providing a rare glimpse into the daily life of eighteenth-century Mexicans. This painting, which depicts a family engaged in private domestic activities in their kitchen, is one of the most beautifully executed and intimate of this type. The African mother stands at the stove and stirs hot chocolate for her family in a copper pot specifically developed in Mexico for its preparation. The young son holds a silver brazier for his father to light a cigarette. Both chocolate and tobacco were American products, unknown in Europe before contact and quite popular on the Continent by this time.

The domesticity of the scene is emphasized by the Spanish father's clothes: he is dressed in a *banyan*, a distinctive man's dressing coat, and a white cap lined with lace, both worn exclusively in the home. Reflecting the extensive Asian trade with Mexico, the *banyan* is made of chintz, a printed cotton produced in India, influenced by Chinese textiles and European chinoiserie, and exported in tremendous quantities to the Americas via the Manila Galleons. Known as *indianilla* in Mexico, chintz was used extensively by the lower and middle classes and reflects their consciousness of fashion at a time when upper classes wore Chinese silks with similar floral patterns. *Indianilla* fabrics can be seen in many *casta* paintings, particularly in skirts worn by women and girls. The boy wears a simple European-inspired brown coat and white shirt.

Both parents wear garments distinctive to Mexico at this time. The father wears the Mexican *pañuelo,* or triangular scarf, at his neck; the mother wears the Mexican striped *rebozo,* or rectangular shawl—ubiquitous among women of the middle and lower classes of the era—over her European-style full skirt and fitted white blouse.

The clothes, the family's activities, and the utensils reveal the hybridity of Mexican culture of the eighteenth century in their mix of European, Asian, and Mexican material culture. The painting also exemplifies a shift in the *castas* tradition after mid-century that was prompted by a desire to use the paintings to record socioeconomic status and to glorify the wealth and abundance of Mexico. Apparently influenced by the example of the artists José Luis Morlete Ruiz and Miguel Cabrera, *castas* increasingly incorporated American products and employed clothing and utensils to indicate occupation and status. In addition, the paintings increasingly attempted to reinforce upper-class conceptions of social stratification by privileging family groups that included a Spanish male—showing them early in the series (usually in numbers one to six) and furnishing them with details that suggested a more affluent lifestyle than that of other racial mixtures.

Ilona Katzew considers this painting—one of eight known canvases from a full series of sixteen—to be the work of the master painter José de Alcíbar, although those of lesser quality in the series were probably executed by assistants in his workshop. Other identified paintings in this series are currently in a private collection in Monterrey, Mexico, and in the Philadelphia Museum of Art.

Donna Pierce

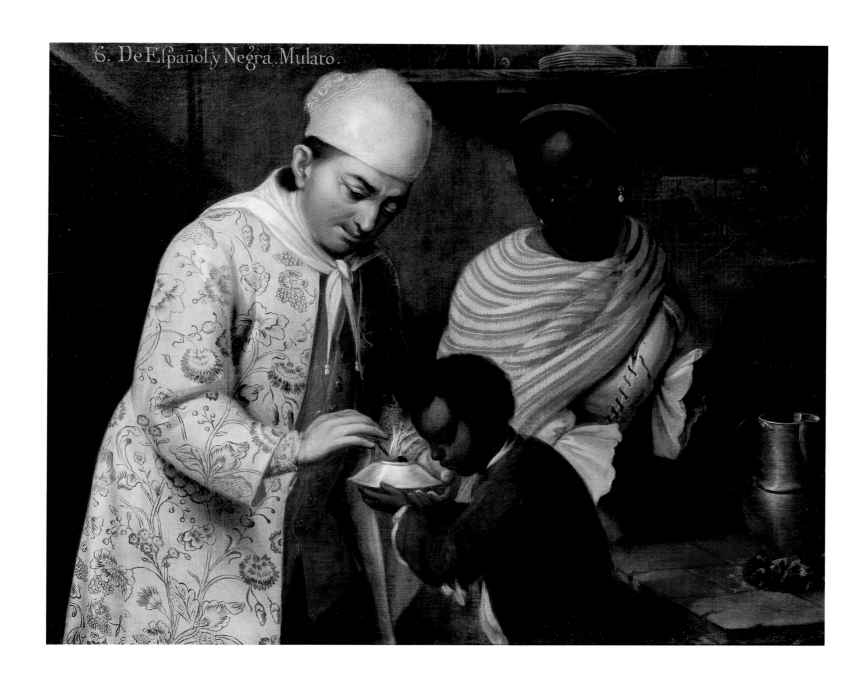
6. De Eſpañol, y Negra. Mulato.

Miguel Cabrera[†]

(Mexican, 1695–1768)

1763

Oil on canvas

Each, 51¹⁵⁄₁₆ × 39¾ inches (132 × 101 cm)

PUBLISHED: García Sáiz 1978, no. 142, pp. 186–93; Castello Yturbide 1980 "Cuadros," pp. 30–45; García Sáiz 1980; García Sáiz 1985, pp. 45–55; García Sáiz 1989; Castello Yturbide 1990, pp. 73–78; Mexico 1990, cat. nos. 197a–c, pp. 432–33; García Sáiz 1991, pp. 171–78; Estrada de Gerlero 1994 "Castas," vol. 2, pp. 79–85; Estrada de Gerlero 1995, pp. 217–52; García Sáiz 1996, pp. 30–41; Katzew et al. 1996, pp. 8–29; Carrera 2003; Katzew 2004, pp. 100–111, figs. 110–23

EXHIBITED: Berlín 1982; Cádiz 1982; Seville 1982; Cáceres 1984; Madrid 1984; Santillana del Mar 1984; Madrid 1985; Vienna, Budapest, and Cologne 1986; Alicante and Murcia 1989; Monterrey, San Antonio, and Mexico City 1989; New York, San Antonio, and Los Angeles 1990, cat. nos. 197a–c; Santa Barbara 1992; Palos de la Frontera 1995; New York 1996; Madrid 1998; Madrid 2000; Bogotá 2004; Los Angeles 2004

VI-49 *1. From Spaniard and Indian, Mestiza*

Private collection

VI-50 *2. From Spaniard and Mestiza, Castiza*

Museo de América, Madrid

VI-51 *4. From Spaniard and Black, Mulatto*

Private collection

VI-52 *5. From Spaniard and Mulatto, Morisca*

Private collection

VI-53 *7. From Spaniard and Albino, Return Backwards*

Private collection

VI-54 *8. From Spaniard and Return Backwards, Hold Yourself in Midair*

Private collection

VI-55 *9. From Black and Indian, China Cambuja*

Museo de América, Madrid

VI-56 *10. From China Cambujo and Indian, Wolf*

Museo de América, Madrid

VI-57 *11. From Wolf and Indian, Albarazado*

Museo de América, Madrid

VI-58 *12. From Albarazado and Mestiza, Barcino*

Museo de América, Madrid

CASTA PAINTINGS CONSTITUTE A NOVEL and unique genre of painting invented in early eighteenth-century New Spain. About race, rather than the social hierarchies that the English word "caste" defines, these paintings addressed the complex racial mixing that occurred in viceregal society. From the moment of the Spanish conquest, miscegenation among the Spaniards, Africans, and Indians created a variety of racial types, beginning with familiar ones such as *mestizo* (Spaniard and Indian) and *mulato* (Spaniard and African). The families depicted in *casta* paintings are shown in both indoor and outdoor settings, so that the genre provides a multitude of information about daily life in New Spain, including food, clothing, and entertainment. In their abundant details, these paintings sent a message to the mother country (for most of the series seem to have been intended for export to Spain) of the material wealth and natural abundance of the viceroyalty. In doing so, they reflect the growing consciousness of what it meant to be Mexican, and the emergence of a nationalism that would one day lead to independence. At the same time, *casta* paintings also reflect a desire to codify a social hierarchy based on what were, by the early eighteenth century, much more complex mixes of the races than simply *mestizo* and *mulato*. This effort to categorize mixed racial types resulted in some inventive nomenclature, as we will see.

This series of *casta* paintings signed by Miguel Cabrera in 1763 adheres to the models established decades earlier (around 1715–18), when, after some initial experiments, the genre was codified in formulas that would remain unchanged for the rest of the century. Cabrera's series comprises the customary sixteen canvases—of which two have not been located—depicting family groups of father, mother, and one or two children, accompanied by inscriptions that identify the *castas* to which each of the figures belongs. The painter executed the present set in the last few years of his life, when he was also engaged in producing important portraits of viceroys and other members of the elite of New Spain, paintings in which a taste for the meticulous rendering of clothing and personal ornament can be clearly appreciated. This inclination would lead him to present the figures in these *casta* paintings in an extraordinary variety of both European and indigenous attire, with a special emphasis on the clothing particular to the viceregal society of New Spain, which reinforced its identity through the use of models from a range of sources.

Cabrera clearly took delight in the textures of the materials represented, displaying a technical mastery difficult to appreciate in other kinds of compositions. What is more, in these works he abandons the stiffness still to be perceived in his portraits (in which inexpressiveness is associated with dignity) and sets out to capture gestures and body language, elements that were present in his previous work but that he took up with special attention here. Cabrera explores distinctions of social class and questions of ethnic identity within the *casta* system through his depictions of clothing, and he also represents his subjects' social environment. At the same time, by the interaction of the figures through exchanged gazes, caresses, and expressions of conversation, Cabrera succeeds in conveying a realistic picture of everyday life, yet one fully in keeping with the image of a harmonious society demanded by his clients.

Cabrera makes use of a number of elements to reinforce what constituted—fundamentally in the eyes of Europeans—the "American"

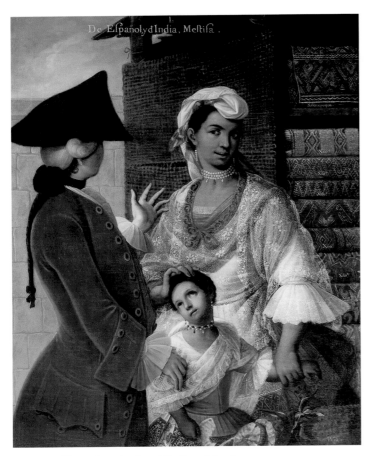

VI-49 1. From Spaniard and Indian, Mestiza

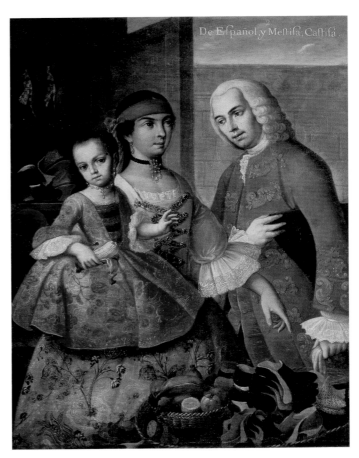

VI-50 2. From Spaniard and Mestiza, Castiza

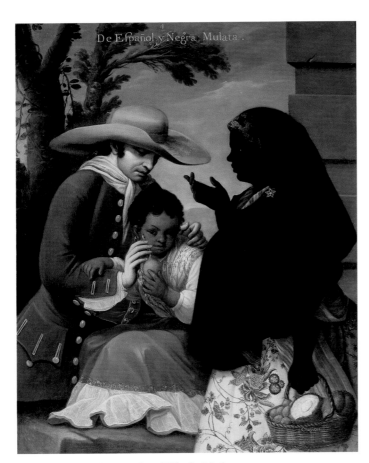

VI-51 4. From Spaniard and Black, Mulatto

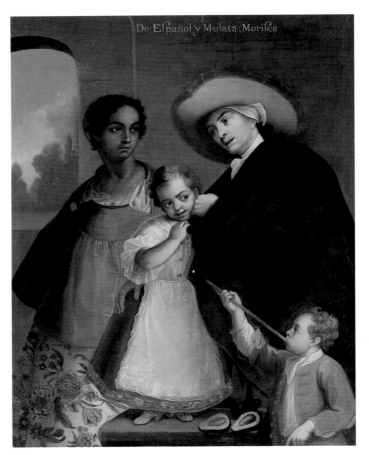

VI-52 5. From Spaniard and Mulatto, Morisca

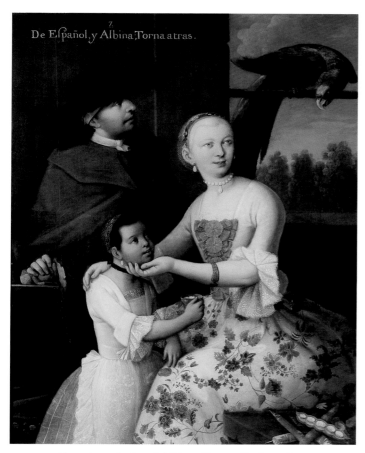

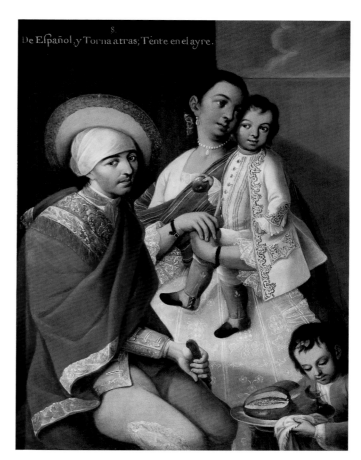

VI-53 7. From Spaniard and Albino, Return Backwards

VI-54 8. From Spaniard and Return Backwards, Hold Yourself in Midair

nature of the genre. In addition to including representations of an arma-
dillo and a macaw, two animals that had served as symbolic figurations
of the New World since the sixteenth century, he also depicts various
fruits—set out for sale on stalls or in still-life arrangements—that reinforce
this identification, by means of both the images themselves and the written
names that accompany them.

The scene that opens the series, *From Spaniard and Indian, Mestiza*,
is set in the open air, probably in front of one of the stalls of the Parián
market in Mexico City; the wall that surrounded the stalls of this market
can be made out in the background. Of the family group depicted in the
near foreground, it is the Indian mother—the central figure in the process
of *mestizaje*, or mixing of races—that forms the axis of the composition.
Looking out toward the viewer, she caresses the head of her daughter,
the *mestiza*, and holds her gently by the forearm as she apparently listens
to the words of her Spanish husband. The Spaniard is nothing more than
a silhouette, observed from the side, with his face turned toward his wife
and concealed from the viewer. This compositional tactic is unusual in
a genre whose fundamental purpose is to identify the ethnic origin of the
subjects through their facial features, something that is rendered impos-
sible in this case.

In fact, Cabrera prefers to define the identity of his subjects through
their clothing, with references to social class taking precedence over racial
or ethnic characteristics. Thus, the Spaniard, or *criollo* (that is, Spanish
"American"), is clearly a man belonging to the economic elite of viceregal
society. His status is revealed by his magnificent blue velvet frock coat,

under which a red tunic and—judging by the pleated cuffs—fine linen
shirt can be glimpsed. His powdered wig, with its long pigtail intertwined
with black velvet ribbons and bows, is covered by a black three-cornered
hat that emphasizes his stylized appearance.

The woman's attire also reveals her social status, which was prob-
ably achieved through marriage to the Spaniard, although she may also
have belonged to a noble Indian family. Of extraordinarily fine quality,
her clothing alludes to both her indigenous background and her inte-
gration into viceregal society. As the central figure in the process of
mestizaje, she is dressed in a clearly mestizo manner. She wears a folded
headkerchief, a transparent *quexquemitl* of embroidered tulle that ter-
minates in a galloon embroidered at the neck, and a skirt of Xilotepec
weave, under which can be observed a second skirt of printed calico, a
fabric originally imported from India but by this time produced in French
and English factories. Under the *quexquemitl* is a striped, fringed *rebozo*
covering part of her blouse, which is adorned with lace at the neck and
cuffs. When Cabrera depicts Indian women of a lower social class, he
is careful to avoid this mixture of garments, preferring a simple *huipil*
(a native garment, a type of sleeveless blouse) and petticoat without
European additions. Finally, the young girl—the *mestiza*—also wears
a *quexquemitl*, drawn back over her left shoulder to reveal a blouse with
frilled lace cuffs, and a skirt opened to reveal a second one of calico. The
use of two skirts, the topmost opened to reveal a second one underneath
and so accentuate the richness of the fabrics, was a feature of European
fashion at the time.

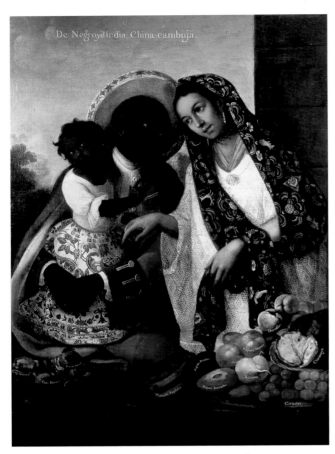

VI-55 9. From Black and Indian, China Cambuja

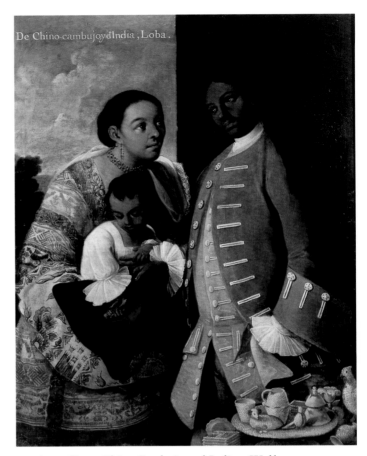

VI-56 10. From China Cambujo and Indian, Wolf

In the second painting of the series, *From Spaniard and Mestiza, Castiza*, the woman, this time a *mestiza*, is again the central figure. Here she is dressed entirely in European style, although the color of her skin clearly reveals her indigenous background, also alluded to by the head-band tied across her forehead. Her gown has a brocaded silk skirt and a galloon of passementerie on the bodice, revealing the low-cut silk blouse with frilled lace cuffs beneath. With one arm she supports her *castiza* daughter, who wears a red silk gown from under which the frilled lace cuffs of her blouse can be seen. This time it is the girl who directs her gaze at the viewer, while her parents turn their attention to choosing from among the offerings of footwear displayed before them on the market stall. The father, again a Spaniard, wears a frock coat of embroidered flannel, a red velvet tunic, a linen shirt with frilled lace cuffs, and a tie. He holds his three-cornered hat under his arm, revealing a long powdered wig.

The third painting, which would have depicted the family group of Spaniard and Castiza with their Spanish offspring (*From Spaniard and Castiza, Spaniard*), has not been located. The fourth in the series, *From Spaniard and Black, Mulatto*, shows the parents conversing in the presence of their mulatto daughter, who is seated on a stone bench in an urban landscape. The girl is dressed as a European and, although she does not belong to the same social group as the subjects of the first two paintings, Cabrera has lavished particular care on her clothing. She wears a silk blouse, a blue silk skirt ending in a flounce (covered by another lace flounce, attached with a gold braid), and a headkerchief.

Her mother is wearing a piece of clothing associated with black and mulatto women, the *saya de embrocar*, a sort of wraparound garment that covered the torso and could even reach the head. Under it she wears a printed cotton headkerchief and a striped *rebozo;* a calico skirt completes her outfit. The father wears a flannel frock coat, a red vest of the same weave, a cotton shirt with handkerchief, and a wide-brimmed felt hat adorned with a ribbon.

The fifth painting in the series, *From Spaniard and Mulatto, Morisca*, again makes use of the daughter as the central axis around which the other figures are arranged. In an interior setting this time, the little girl, the *morisca*, is depicted standing atop a wooden table beside two avocados, one of them cut in half. Her brother, clearly a *morisco*, stands beside the table playing with a peashooter. The girl is dressed in a green velvet skirt with an embroidered galloon, a cotton blouse with frilled lace cuffs, and a lace-fringed pinafore. The boy wears red short pants, a red frock coat, and a cotton shirt. The father, a Spaniard, draws his daughter toward him; his great flannel cape, lined with velvet, conceals the rest of his clothing, except for his cotton headkerchief and rimmed felt hat. The mulatto mother is wrapped in a *saya de embrocar* that offers a glimpse of her calico skirt and the neckline of her blouse, fringed with a thin line of lace, peeking out alongside a striped *rebozo*. Adorning her hair are a crescent-shaped hair-pin and a red silk bow at her right temple.

The whereabouts of the sixth painting, which would have been called *From Spaniard and Morisca, Albino*, is also unknown. The setting

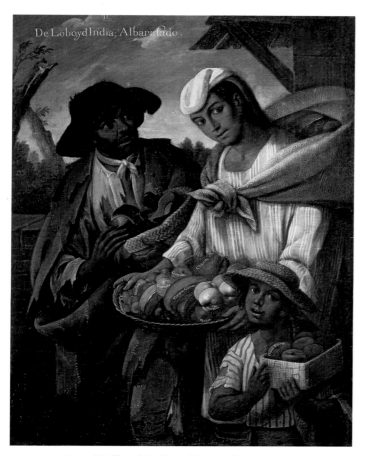

VI-57 11. From Wolf and Indian, Albarazado

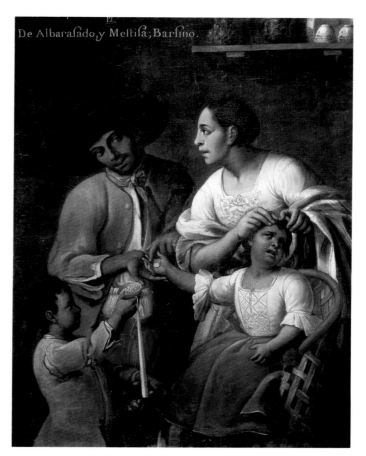

VI-58 12. From Albarazado and Mestiza, Barcino

of the seventh canvas, *From Spaniard and Albino, Return Backward*, is the interior of a home of some distinction, as evidenced by the armchair, upholstered in velvet or sheepskin, on which the Spanish father supports himself in an attitude of authority traditionally expressed in the portrait genre. He is draped in a large flannel cape that allows only a glimpse of the collar and cuffs of his shirt, and his head is wrapped in a white kerchief almost entirely covered by a black felt hat. Beside him the albino mother is caressing the face of her daughter, who offers her a small cup of pumpkin seeds. The mother wears a magnificent calico skirt, like the ones worn by the black and mulatto women in the previous paintings but with a different floral design, and a cotton or linen blouse with frilled lace cuffs and a bodice of red silk ribbons and bows. Her hairnet is decorated with an embroidered and beaded fringe. The little girl has the same hairnet and wears a checked cotton skirt, of a fabric very common in Guatemala, which is almost entirely covered by a pinafore with lace frills.

In the eighth painting, *From Spaniard and Return Backwards, Hold Yourself in Midair*, the family is shown in an unidentifiable setting, perhaps in the Parián again, presumably next to a fruit stall (not pictured) from which a serving boy offers them pieces of fruit on a tray. The Spanish father is seated, holding in his right hand a small machete with which he has probably just opened the melon offered to him. His clothing is both showy and peculiar: a short jacket and flannel breeches trimmed with a galloon of silver thread of the same type as the trim of the bright red cape or mantle draped over his shoulders, his head covered in the customary

white cotton kerchief under a round felt hat worn with a rakish tilt. The mother, a *torna atrás*, or throwback (literally, "return backwards"), is attired entirely in white, in contrast to her husband. Her blouse has frilled lace cuffs, and an ample pinafore conceals her skirt. A touch of color is supplied by the striped *rebozo* crossing her torso and falling across her back. In her arms she holds her little boy, the *tente en el aire* (another highly specific racial identifier), who is dressed in great splendor, with frock coat, vest, white embroidered breeches (probably of silk), and red gaiters.

In the ninth painting in the series, *From Black and Indian, China Cambuja*, the family is again depicted in the open air, beside tables laden with boxes and platters of fruit, each variety identified by an inscription. The Indian woman is dressed in a white gauze *huipil* from under which a striped neckerchief can be glimpsed; a silk *rebozo* or shawl of marked Oriental influence is draped over her head. Her black husband holds their daughter, the *china cambuja*, in his arms. She is wearing the customary white cotton blouse with frilled lace cuffs and calico skirt. The father's clothing, partly concealed by his flannel cape and his little girl's body, consists of a red flannel frock coat with blue lining and a white vest. The stiff-looking hat, perhaps of straw, is rimmed with a decorative ribbon.

The scene of the tenth painting, *From Chino Cambujo and Indian, Wolf*, is once again set outdoors, next to a stall selling miniature toys, one of which—a little bird—the father has hidden inside his three-cornered hat in order to present it later to his daughter. As in most of the paintings in the series, the woman, here an Indian, is dressed in great finery: a long

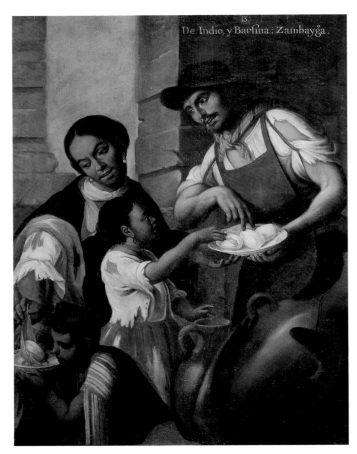

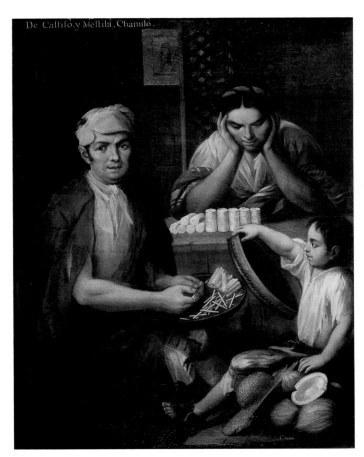

VI-59 13. From Indian and Barcina, Zambaiga

VI-60 14. From Castizo and Mestiza, Chamizo

embroidered *huipil* almost entirely covers her petticoat, and a lace-fringed linen or cotton neckerchief is placed over her left shoulder. The little girl, the "wolf," on the other hand, is dressed completely in the European style, with a linen blouse and calico skirt. The father, a *chino cambujo*, wears a blue frockcoat open over a linen shirt and a red tunic buttoned up to the neck. Hatless, he displays a mane of long, straight hair.

In the eleventh painting, *From Wolf and Indian, Albarazado*, the family, rather than shopping among the market stalls as in previous paintings, are shown as street vendors; both mother and son seem by their gazes and gestures to be offering their goods to the viewer. The father, a "wolf," is wearing what is left of a brown flannel cape that barely covers his ragged tunic, breeches, and shirt. A cotton kerchief is knotted around his neck and a tattered hat covers his head. His Indian wife has covered her head in the traditional piece of folded flannel and wears a striped *huipil* that completely conceals the skirt or petticoat beneath. Knotted around her torso is a length of *ayate*, a mantle woven of maguey fibers (*ixtle*), in which she is carrying some of the fruit that makes up her merchandise. Beside her, her son, the *albarazado*, wears a short, striped cotton shirt and a straw hat.

For the twelfth scene, *From Albarazado and Mestiza, Barcino*, Cabrera has placed his figures indoors, in the sitting room of a home where one can see a shelf of ceramic and porcelain objects and a chair of the kind crafted in Michoacán. The family group consists of the *albarazado* father, the *mestiza* mother, and two children—the *barcinos*

(meaning "ruddy")—a boy and a girl, captured at the moment of a small domestic incident. The girl, who is wearing a green flannel skirt and a cotton blouse cross-stitched down the front, has bumped her head and is being attended to by her mother, who wears a similar blouse along with a striped *rebozo* and a blue flannel skirt. The father and the little boy are contributing other remedies: the father offers a coin to the girl, and the boy, a small gourd containing seeds. Both of these figures are dressed in frayed flannel jackets and cotton shirts, to which the father has added red breeches, a neckerchief, a tattered cape thrown over his left shoulder, and a dark felt hat.

In the thirteenth painting, *From Indian and Barcina, Zambaiga*, Cabrera has captured a moment of repose in the day of a water carrier and his family, as they lunch on tamales. All wear frayed, ragged clothing, including tattered white or striped cotton shirts and even a *saya de embrocar*. Especially remarkable is the father's leather apron. This piece of clothing, along with the large receptacles in the foreground, indicate the man's trade. All the members of the family—the Indian father, the *barcina* mother, and the children (*zambaigas*)—belong to ethnic groups formed by the union of blacks and Indians.

The fourteenth painting, *From Castizo and Mestiza, Chamizo*, is set in the shop of a cigarette maker and his family. The *castizo* father, clad in rags half hidden under an old brown flannel cape, is busy rolling cigarettes that he piles on a platter in his lap as he glances out at the spectator. Seated in front of him, next to a few coconuts and a straw hat, his

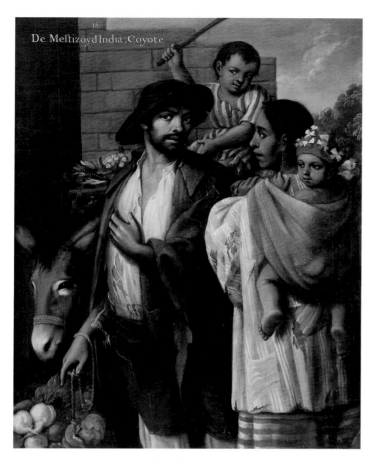

VI-61 15. From Mestizo and Indian, Coyote

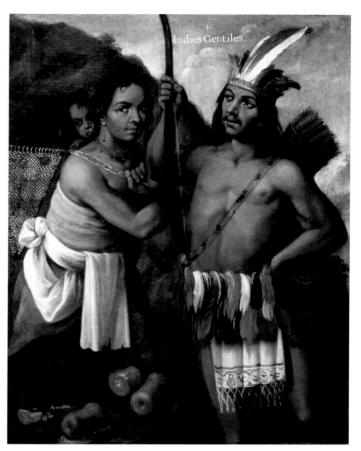

VI-62 16. Gentile Indians

son holds a lid or a second platter at the ready. In the background, on the other side of the table where the packets of cigarettes are piled, the mother leans pensively on her elbows, half-clothed in a ragged shirt and striped *rebozo*. The room is partitioned at the back by a latticed screen. To the left, in the shadows, a new platter can be seen hanging beside an engraving by the Flemish artist Adriaen Brouwer, nailed directly onto the back wall.

In the fifteenth painting, *From Mestizo and Indian, Coyote,* the street again forms the setting for the family group, whose trade is the sale of fruit and vegetables. The father is a *mestizo,* dressed in ragged European style. The Indian mother wears a striped *huipil* and a petticoat, rather than the skirt seen in Cabrera's other depictions of Indian women in the series. She carries one of her children—naked but for his little hat of colored paper cutouts—on her back in a length of *ayate.* The other child, mounted on the burro that carries the merchandise, wears a striped cotton shirt.

Miguel Cabrera's series of the *castas* ends with the customary reminder of the existence of unconverted Indians, of those who lived outside the structures of viceregal society: *Gentile Indians.* By referring to them as Gentiles the painter makes it clear that they are idolaters. The figure of the "heathen" father is a visual summing-up of the allegorical imagery of the New World, conceived by European artists and therefore limited to representations of half-naked figures, here attired in the inevitable headdress and skirt of gaudy feathers, a piece of printed cotton fringed with pomegranate motifs added to the latter. A bow and a quiver of arrows complete the image of this figure, who is accompanied by his

wife and the two small children she carries on her back in a wicker basket. In his depiction of the Indian woman, Cabrera has moved away from the formula employed for the man, preferring to show her clothed in a formless garment that adheres to her body but leaves a large part of her torso uncovered; she also wears a flowing skirt and a sort of *rebozo* or length of white flannel wrapped around her waist. The armadillo and the tropical gourds placed on the rock in the foreground complete the New World allusions.

M. Concepción García Sáiz

VI-63 *Albina and Spaniard Produce a Black Return Backwards*

Mexico
c. 1775
Oil on copper
18⅛ × 21⅝ inches (46 × 55 cm)
Collection of Fomento Cultural Banamex A.C., Mexico City

PUBLISHED: Moyssén 1979, pp. 47–56; García Sáiz 1989, pp. 250–51; Manrique 1992, pp. 49, 59; Katzew et al. 1996, p. 23; Ospina 2000, pp. 214–15; Katzew 2004, pp. 180–81

THIS EXQUISITE COPPERPLATE is part of an incomplete set of *casta* paintings, a pictorial genre that developed in New Spain in the eighteenth century. Generally comprised of sixteen scenes, early *casta* paintings from the first half of the eighteenth century represent an attempt to understand and systematize the complex process of racial mixing among New Spain's different groups—Amerindians, Spaniards, and blacks—thereby creating order from what was perceived as an increasingly confusing society. The production of *casta* paintings reached its height between 1760 and 1790, coinciding with the implementation of the Bourbon reforms of Carlos III (r. 1759–88) and Carlos IV (r. 1788–1808). During this time the Spanish government looked to strengthen its authority and regain power of its American domains, which had become largely self-sufficient. This era of renewed imperialism was tied to the larger philosophical movement of the Enlightenment, which extolled the power of human reason and the idea of progress.

This delicate painting depicts a Spanish male viewing the Alameda, the city's main park, through his telescope from the roof of either the convent of Santa Isabel or the Palace of Guardiola, both now destroyed. Created in 1592, the Alameda underwent extensive renovation in the eighteenth century as public parks became increasingly associated with the idea of progress. Rendered as a *veduta*, the scene highlights this important public space and its surrounding buildings but also the racially mixed couple. The Spanish male is situated literally in a position of superiority—atop a roof—while his albino wife and *salta atrás* child turn their backs to the city and face him. The term *salta atrás* (literally, "jump-backward") derives from the belief that while Indian blood could be "purified" or made "white" after three successive generations of mixing with Spaniards, African blood would revert to blackness. Thus the child in this painting is black, although his parents are light-skinned (albinos were largely thought to descend from Africans).

Depictions of the Alameda were fairly common in New Spain in the second half of the eighteenth-century, but not so in *casta* paintings. The selection of this subject may be related in part to the patron who commissioned the set. By the second half of the eighteenth century, a number of colonial officials closely aligned with the Bourbon policies launched by Carlos III and Carlos IV promoted the development of the city and established cabinets of natural history, a sign of modernity; some of their cabinets included *casta* paintings and images of the Alameda. This painting demonstrates the rich variation that the *casta* pictorial genre acquired in the second half of the eighteenth century.

Ilona Katzew

VI-64 Attributed to Andrés López[†]

(Mexican, c. 1740–1811)

Don Matías de Gálvez y Gallardo, Vice-Protector of the Academy of San Carlos

c. 1790–91

Oil on canvas

89 × 61 inches (226 × 155 cm)

Museo Nacional del Virreinato/CONACULTA, INAH, Tepotzotlán, Mexico

PUBLISHED: *Pintura novohispana* 1992–96, vol. 3, part 2, cat. no. PI/0744, p. 190, ill.; Velázquez Guadarrama 1999, cat. no. 49, pp. 246–50, ill.; Pierce et al. 2004, cat. no. 49

EXHIBITED: Mexico City 1999 *Pintura;* Denver 2004, cat. no. 49

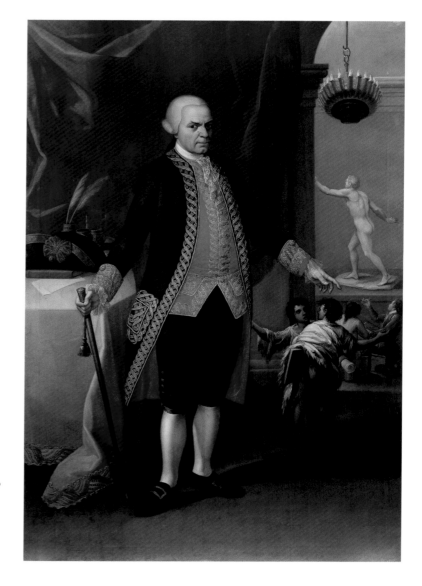

MATÍAS DE GÁLVEZ, the brother of José de Gálvez, "universal minister" of the Indies, was viceroy of New Spain for only a year, from 1783 until his death in 1784. In spite of the brevity of his mandate, much was accomplished under his administration. One of his most important achievements stemmed from his determined support for the Academy of San Carlos, which was founded in 1781 but began to function regularly only in 1783. Of Gálvez there exist two portraits: a half-length depiction showing him with his baton and his coat of arms, and this full-length portrait, which is identical in terms of the subject's posture and features, since generally only one official portrait was made, from which all others were copied. The half-length portrait is signed, so it can be assumed that this full-length one is also by Andrés López, who has managed to capture the character of his subject. Certain allusions in the full-length portrait to the Academy of San Carlos show how much importance the viceroy must have given to his patronage of the institution.

Just a few years after the Academy of San Fernando was founded in Madrid in 1752, the painters of New Spain drew up a petition for a similar academy in Mexico. The petition was not taken into consideration until 1781, when through private initiative, negotiations began for the establishment of such an institution. The statutes of the new academy not only provided for teaching methods—as illustrated in the background of the portrait, where a teacher and his pupil are engaged in copying a classical work—but also established nighttime hours so that artisans of all social classes could receive instruction, as alluded to here by the two poorly dressed boys carrying their learning material (a panel and a roll of paper) under their arms. The great importance of education during the period of the Enlightenment is underlined by how the viceroy himself is depicted gesturing not only toward these children, but to all the labors of the Academy. The portrait shows extremely careful draftsmanship and richness of detail, especially in the viceroy's attire with its fine embroidery in calligraphic style, as well as the clear, vivid colors that reveal the proximity of Andrés López to the neoclassical movement.

Juana Gutiérrez Haces

vi-65 The Reverend Mother María Antonia de Rivera

Mexico

c. 1757

Oil on canvas

49 × 31⅝ inches (124.5 × 80.3 cm)

Inscribed along bottom: *La Rª. Madre Maria Antonia de Rivera, Religiosa de la Sagᵈᵃ. Compª./de Maria SSᵐᵃ. comunmente llamada de la Enseñanza. Resibio el habi-/to de edad de diezynueve años, el dia 9. de Noviembre de 1755, y Professo/el dia 12. de diziembᵉ. de 57. en el Sagᵈᵒ. Convᵗo. de N.S. del Pilar de la Ciuᵈ.d Mex co./En Manos dl ylustrisᵐᵒ. Sʳ. Dʳ. ᴰⁿ. Manuel Anᵒ. Rojo dl Río y Bieyra digniᵐᵒ. Arsovᵖᵒ. dla Ciud.d Man.;* split at lower left and lower right: *Fue electa Priora en-/24 de Marzo de 1791./Relecta e la misma fha. y/mes dl año d 94. Fallecio/el día Miercoles 12/d Marzo d 1806*

Philadelphia Museum of Art, The Dr. Robert H. Lamborn Collection, 1903-920

PROVENANCE: Dr. Robert H. Lamborn; bequeathed to the Academy of Natural Sciences, Philadelphia; Pennsylvania Museum and School of Industrial Arts (now the Philadelphia Museum of Art), 1903 (via Miss Helen Taylor, Lowndes Taylor, and Col. Charles B. Lamborn)

PUBLISHED: Philadelphia Museum of Art 1994, p. 309; Philadelphia Museum of Art 1995, p. 351

EXHIBITED: Dallas 1937; Columbus 1947; New York 1947; Washington 1948; Villanova 1955; Austin 1958; Philadelphia 1966; Montreal 1967; New Orleans 1968; Philadelphia 1968; Philadelphia 1980

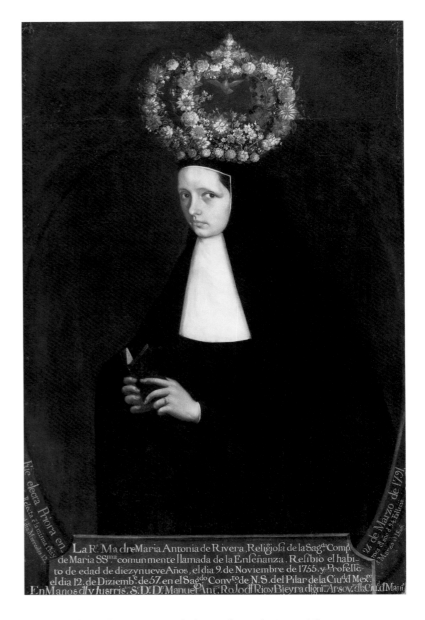

THERE ARE FEW KNOWN WORKS depicting crowned novices, or *monjas coronadas*, of the Society of Mary. The ideological developments of the eighteenth century, most notably the Enlightenment, explain the rise to prominence of this order, which was founded in New Spain by the Reverend Mother María Ignacia de Azlor y Echevers.

This painting portrays the young Sister María Antonia Ribera on the day she entered the novitiate at the Convent of Nuestra Señora del Pilar at the age of 19. The taking of vows was a tremendously solemn rite that was considered to be perpetual and everlasting and that symbolized a mystical wedding with Jesus. The lavishness of the event was meant to stir the emotions of those attending and was marked by a profusion of gilt *retablos* (altarpieces) covered in flowers and images, carved silverwork, and sumptuous liturgical vestments. Musical accompaniment was provided by a choir of nuns and various instruments. Amid the intoxicating wafts of incense stood the young novitiate decked in her crown of flowers.

Here Sister María Antonia is dressed in the order's traditional habit, which is entirely black except for the blindingly white wimple or veil, which extends to the chest. The striking novice's crown is created from a range of colorful flowers set in a metal support, with the image of a dove

extending from the center, symbolizing the Holy Spirit. The novice carries a small book, which would traditionally contain the rules of the order. In this case, however, it may be seen as an allusion to the importance the Marian Order gave to the instruction of novices.

The cartouche on the painting is quite interesting, since it seems that other information about the sister was added at the time of her death. A legend appearing at the bottom center of the painting mentions various important dates in the life of Sister María Antonia, such as her entrance into the novitiate in 1755 and her profession, two years later, on December 12, 1757, at the Convent of Nuestra Señora del Pilar in Mexico City. However, along the right and left edges of the work, other important dates have been inserted: she was elected Prioress on March 24, 1791, and she died on Wednesday, March 12, 1806; this information could not have been included by the unknown painter who created this work. This skillfully rendered and highly suggestive portrait of the young Sister María Antonia seems to stare back at us mysteriously, transporting us to another moment in history, quite distant in time.

Alma Montero

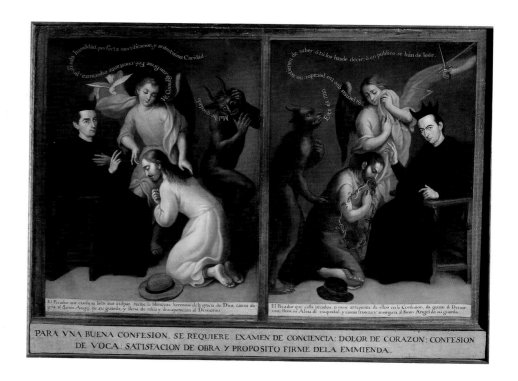

VI-66 José de Alcíbar[†]

(Mexican, 1725/1730–1803)

Conditions for a Good Confession

After 1771

Oil on canvas

59 × 87⅜ inches (150 × 222 cm)

Inscribed below the two scenes: *PARA VNA BUENA CONFESION, SE REQUIERE EXAMEN DE CONCIENCIA . . . ;* below the scene on the left: *El Pecador que confiesa bien sus culpas, recibe la blancura hermosa de la gracia de Dios, . . . ;* issuing from the mouth of the guardian angel: *Vé. Comulga con firme Feé, constante esperanza, profunda humildad, perfecta mortificación, y ardentisima Caridad;* issuing from the mouth of the devil, *Mal he quedado;* below the scene on the right: *El Pecador que calla pecados, o no se arrepiente de ellos en la Confesion, da gusto al Demonio, llena su Alma de iniquidad, y causa tristeza y amargura al Santo Angel de su guarda;* issuing from the mouth of the devil: *Este es mio;* issuing from the mouth of the guardian angel: *Si piensas que tus pecados no se tienen de saber: o tú los has de decir, o en publico se han de leer.*

Pinacoteca, Church of San Felipe Nerí/CONACULTA, DGSMPC, Mexico City

PROVENANCE: Antigua Casa Profesa, Mexico City

PUBLISHED: Cué 1994, cat. no. 70, pp. 268–69; Tovar de Teresa 1995, p. 173, cat. no. 168

EXHIBITED: Mexico City 1994 *Juegos,* cat. no. 70

THIS MORALIZING, TWO-PART PICTURE contrasts the dispositions and states of two sinners. Both men kneel before the same confessor—most probably a portrait—but the one on the left has made a good confession and received the sacrament of Penance worthily, while the one on the right has committed a sacrilege by concealing his sins. In both scenes there is a devil and a guardian angel, and the divine makes itself present through symbols. The angel gazes lovingly at the good sinner, who is clothed in a white robe, and touches him on the shoulder, while the Holy Spirit in the form of a dove flies toward him; the devil turns away to escape, holding his head in distress. With a complacent look, the priest blesses the penitent. At the right, it is the angel who draws back in tears, while the devil claims the sinner with his touch. At the upper right, an arm brandishes a sword, symbolizing the wrath of God, and lightning zigzags downward to strike. Vermin, representing lies, come out of the bad sinner's mouth, and, unrepentant, he retains his worldly clothes. Only the priest might be able to save him. The cleric looks outward sternly, in order to include in the lesson the sinners who are viewing the picture. Gesturing with his left hand toward the example before him, he raises his right to protect the sinner from the lightning bolt, giving him another opportunity to repent and save himself. Although the division of the painting, its iconography, and the accompanying inscriptions in Spanish all clearly distinguish the good sinner from the bad, the full message is given by the painter's handling of the figure of the priest, who offers the possibility of salvation as long as there is still time for repentance.

The painting is one of several didactic pictures still at the former Jesuit house in Mexico City (the Profesa), taken over in 1771 by the Oratorians, who used it for spiritual retreats for men. Although Tovar de Teresa considers that the canvas is "probably" by Miguel Cabrera (1695–1768), it is more likely to have been painted by José de Alcíbar, who executed a number of works for the Oratory. The particular incisiveness of the portrait of the priest and the less than subtle handling of the drapery and clothing are qualities more akin to the work of Alcíbar.

Clara Bargellini

VI-67 *Folding Screen with Pastoral Scenes*

Mexico City
Mid-eighteenth century
Oil on canvases supported on wooden frames with a gold-leaf and
gesso-embossed border
76¾ × 192¹⁵⁄₁₆ × 1⁹⁄₁₆ inches (195 × 490 × 4 cm)
Museo Franz Mayer, Mexico City

PROVENANCE: Sra. Eugenia Souza de Martín del Campo, Mexico City;
acquired by the Museo Franz Mayer in 2003

PUBLISHED: Castelló Yturbide and Martínez del Río de Redo 1970, p. 101;
Grandeur of Viceregal Mexico 2002, cat. no. 9, pp. 98–102

EXHIBITED: Houston, Delaware, and San Diego 2002, cat. no. 9

IN NEW SPAIN FREESTANDING FOLDING SCREENS, or *biombos*, were
an indispensable element in domestic interiors. Colonial archival records
such as testaments, death inventories, and dowries often identify them as
biombos de cama, or folding screens used to reinforce intimacy surround-
ing the bed, and as *rodastrados* or *rodaestrados*. This latter term refers to the
way folding screens delineated the space surrounding the *estrado*, or dais,
a raised platform in the *salón del estrado*, or sitting room, of both Spanish
and New Spanish residences. Moreover, the use of *biombos* in New Spain
was not limited to those of higher socioeconomic means; the utilitarian
nature of the folding screen was recognized across social levels, and colo-
nial inventories reveal that screens covered with inexpensive, unpainted
textiles—often identified as *biombos ordinarios*—could be found in almost
any household.

 This charming eighteenth-century ten-panel folding screen illus-
trates three couples situated within the landscape of the southern environs
of Mexico City. The frame is adorned with an intricate gold border in
imitation of *guadamecí*, a Spanish tradition of leatherwork practiced pri-
marily in the city of Córdoba, and displays a common feature of New

Spanish folding screens that involves the application of a gilt border used to enhance the oil on the surface of the canvas.

The primary difference between folding screens of the seventeenth and eighteenth centuries is the scale of the human figure in relation to their setting. Seventeenth century *biombos*, as seen in the example by Juan Correa (cat. VI-16), are dominated by multitudes of figures, usually engaged in a variety of activities. In the eighteenth century there is a shift from small-scale to nearly life-size figures that dominate the composition. In this example, human activity is relegated to the foreground, with the couples presented in three distinct social groups. The arrangement of these couples, constructed as a progression of social hierarchy, calls to mind a series of horizontal canvases that illustrate the *castas* on a single compartmentalized surface.

At left, the physicality of the elegantly garbed Spanish or Creole couple speaks of the decorum associated with the courting rituals of their class. The seated woman points to her male counterpart, perhaps highlighting his importance within this social setting, while the canopy of red drapery strategically placed above their heads—a standard convention of

portraits of the period—isolates the couple within the composition. The country mansion that serves as their backdrop, and the luxurious blue and white ceramic vase filled with local flowers, accentuates their status and social hierarchy. The mestizo couple occupying the center panels of the folding screen engages in conversation while strolling through a lush countryside. The stylishly dressed woman, adorned in pearls and gold jewelry, has stopped to enjoy a cigarette that she carries in a smart decorative box; in eighteenth-century New Spain, smoking thin cigarettes rolled in rice paper was considered an elegant pastime.

The closeness of the couple at right is at odds with their counterparts on the leftmost panels. Of special note is the unusual placement of the male figure, who is clothed in an all-encompassing cloak. The mulatto couple, identified not by physiognomy but by the female figure, who is depicted in clothing worn exclusively by women of this caste, is located in front of a humble dwelling topped by a thatched roof. The placement of the two outermost couples, both positioned in front of specific architectural structures, highlights the progression of the strict social hierarchy of New Spanish society within this verdant landscape.

Sofia Sanabrais

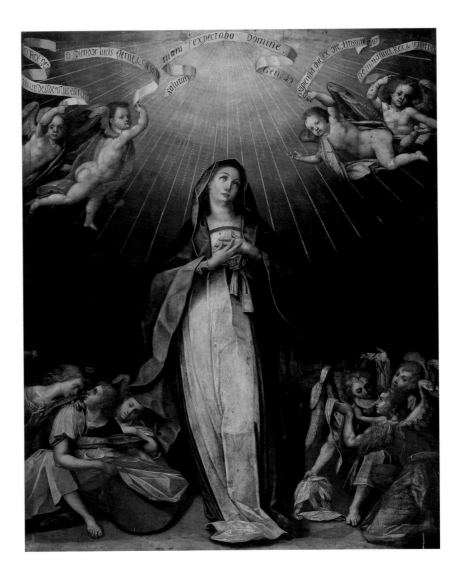

VI-68 Bernardo Bitti[†]

(Italian, active Peru, 1548–1610)

Our Lady of the Expectation

c. 1575–76
Oil on canvas
125⅛ × 100 inches (318 × 254 cm)
Church of San Pedro, Lima, Peru

THE PAINTING SHOWS THE PREGNANT Virgin known as Our Lady of the Expectation, or in the Spanish tradition as *Nuestra Señora de la O* (Our Lady of the O). The "O" corresponds to the chant uttered by clerics after vespers on December 18 in anticipation of the birth of Christ. The devotion had a long history in Spain but did not receive official recognition until 1573, when Pope Gregory XIII Boncompagni (r. 1572–1585) allowed it to be celebrated as a major feast in Toledo, Spain. The pope was also an enthusiastic supporter of the Jesuit missions, and it was during his papacy that Bitti, then in Rome, joined a delegation for Peru. His painting is probably the first image of the subject in the Americas. He shows the Virgin standing among angels who are preparing Jesus's crib and swaddling.

The picture was part of a series of paintings of Marian themes, all by Bitti, in the Jesuit collegiate church of San Pablo y San Pedro in Lima, Peru. Built under the direction of Gerónimo Ruíz Portillo, who arrived in Lima in 1568, it was consecrated on New Year's Day 1576. This church, now known as San Pedro, was rebuilt between 1634 and 1638, and in 1660–61 Bitti's paintings were dispersed to new locations in it. *Our Lady of Expectation* appears to have been originally on a side altar, and pendant to the *Virgin of Candlemas*, celebrating another Marian feast in the liturgical calendar (February 2), whereas the *Coronation of the Virgin* (August 15) was on the high altar. The pictures were part of

large altarpieces, which included sculpture executed by the Andalusian Jesuit Pedro de Vargas according to Bitti's design, of which only a guardian angel survives.

Bitti started the project soon after his arrival in the New World on May 31, 1575. One chronicle relates how difficult it was to find basic art supplies like canvas, but despite these hardships, in this first commission Bitti established the style that he would disseminate throughout the Andes. Although that style, and, especially, its shimmering drapery with characteristically sharp folds, has been related to the art of contemporary Roman artists like Scipione Pulzone and Giuseppe Valeriano, their work for the Jesuit headquarters in Rome actually dates to the decade after Bitti's departure for Peru. The roots of Bitti's manner can be found in his native Marches and, in particular, the painting of Simone De Magistris (1538–after 1611). Marchigian painters were also much influenced by the Dominican friar Giovanni Andrea Gilio's dialogue *Degli errori dei pittori* (*On the errors of painters;* 1564), published in Bitti's native Camerino during the critical time of the artist's formation. Gilio famously condemned the aberrant iconography of Michelangelo's *Last Judgment* in the Sistine Chapel and, in step with reforms then being discussed at the Council of Trent, urged painters to be faithful to the truth of their subjects. Much of the spirit of Bitti's art is rooted in these same concerns.

Carl Brandon Strehlke

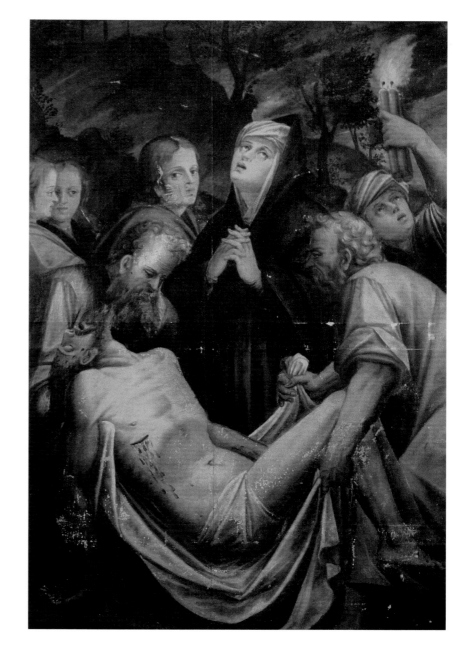

VI-69 Angelino Medoro[†]

(Italian, c. 1567–c. 1631; active South America, 1586–1624)

Descent from the Cross

1598
Oil on canvas
84⅝ × 48⁵⁄₁₆ inches (215 × 138 cm)
Metropolitan Cathedral of Santiago, Chapel of the Ruiz Mancipe
Family, Tunja, Colombia

PUBLISHED: *Documentos* 1935, p. 86; Giraldo Jaramillo 1948,
p. 38; Mesa and Gisbert 1962, pp. 28–29, 40; Arenado 1977,
p. 104; Estabridis Cardenas 1989; Mateus Cortés 1989;
Dictionary of Art 1996, p. 37

ON JULY 29, 1598, THE CAPTAIN Antonio Ruiz Mancipe paid
Angelino Medoro 400 pesos for several paintings and other decoration
for the family burial chapel in the Tunja (Colombia) cathedral, founded
in 1569 by Ruiz Mancipe's father, Don Pedro Ruiz García. Of Medoro's
paintings only this picture and its companion, *Christ in the Garden of
Gethsemane*, survive. The chapel included a choir, sacristy, and a superb
coffered ceiling, decorated by Juan de Rojas, the last of which survives.
The chapel's magnificence was celebrated in *Elegías de varones ilustres
de Indias* (1589–1601), an important account of people and events in New
Granada by Juan de Castellanos (1522–1607), a Spanish adventurer who
later became a curate in Tunja. In canto eighteen, Castellanos proudly
described the chapels in the cathedral, saying that there certainly could
be nothing richer in Toledo or Seville. He eruditely wrote that artists as
capable as the ancient Greeks Phedias, Kimon of Kleonai, and Polykleitos
embellished the cathedral with paintings and sculpture. Castellanos singled
out Antonio Ruiz Mancipe's "precious donations" (*preciosos dones*) to his

family chapel saying that the ensemble resembled a "gold pinecone"
(*piña de oro*).

The composition of the *Descent from the Cross* suggests that
Medoro was aware of the Italian artist Giorgio Vasari's painting of the
same subject (now Casa di Vasari, Arezzo, Italy) executed in the 1530s
for Cardinal Ippolito de' Medici. Both pictures similarly focus on the
bent and naked body of Christ in the foreground. Vasari based his paint-
ing on a famous composition by Rosso Fiorentino in Borgo Sansepolcro.
Medoro could have known the Vasari, which was in Rome during his
youth. But whatever Medoro's inspiration, it cannot be proved that he
was directly inspired by a European source, as is the case for many artists
in the New World. Medoro's particular compositional strategy voids the
scene of much of its narrative content in favor of a concentrated meditation
on the dead Christ. This must have been a particular concern of both the
patron and artist, who conceived the painting specifically for a burial
chapel.

Carl Brandon Strehlke

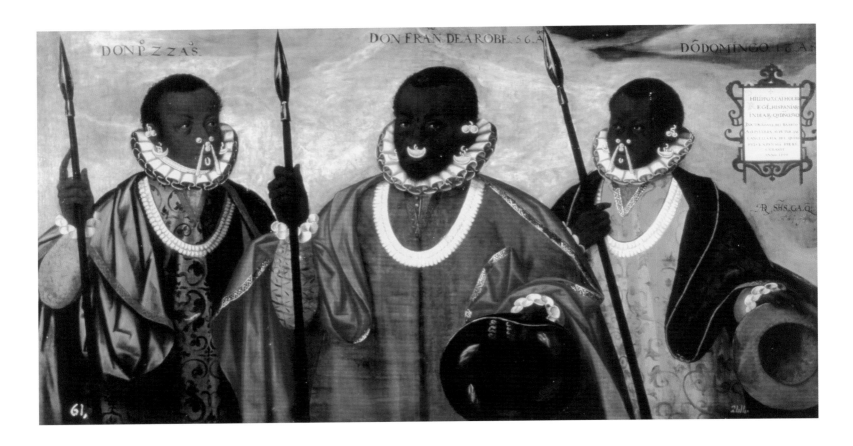

VI-70 Andrés Sánchez Gallque[†]

(Andean, active late sixteenth–early seventeenth century)

Don Francisco de la Robe and His Sons Pedro and Domingo

1599
Oil on canvas
36¼ × 68⅞ inches (92 × 175 cm)
Museo Nacional del Prado, Madrid, P04778. Deposited in the Museo de América, Madrid

PROVENANCE: Alcázar, Madrid; Royal Palace, Madrid

PUBLISHED: Százdi 1986–87, pp. 93–142; *Siglos de oro* 1999, cat. no. 11, pp. 170–73; Lane 2002, pp. xi–xii; *Retratos* 2004, cat. no. 9, pp. 114–15

EXHIBITED: Madrid 1999 *Siglos de oro*, cat. no. 11; San Antonio, Washington, and New York 2004, cat. no. 9

THIS REMARKABLE PAINTING is the oldest known dated and signed portrait from South America. Commissioned by Juan de Barrio, a judge in the court (*audiencia*) of Quito, the portrait depicts three gentlemen: Don (Sir) Francisco de la Robe, age 56; Don Pedro, age 22; and Don Domingo, age 18. All were residents of the coastal province of Emeraldas of present-day Ecuador and were painted while visiting Quito. The group portrait was executed by the native artist Andrés Sánchez Gallque and when completed was sent by Juan de Barrio as a gift for the Spanish king, Felipe III. It remained in the royal collection in the Palace of Madrid and is recorded in the 1747 inventory of paintings owned by Felipe V and Isabel Farnesio. At this time, however, it was described as a portrait of three "Negros Indios." This is, in fact, correct, as the three gentlemen are mulattos, or descendants of African and Native Indians. Don Francisco was the leader of a community of escaped slaves who had married into the local community of natives, and he became their leader as well. The portrait commemorates the peaceful accord reached by Barrio with Don Francisco and his community. Barrio's numerous letters to the Spanish king demonstrate his desire to know whether the monarch had received and enjoyed the painting. Indeed, Sánchez Gallque created a very original and powerful portrait. He depicts the three men pressed close to the foreground at a little less than three-quarters length. Don Francisco stands slightly before his sons, who turn to look at their father and leader. He in turn looks out into the viewer's space. The rich clothes in which the three are dressed are a combination of Spanish and Andean cloth and form, and their faces are decorated with beautiful gold ornaments that were worn by the Indians of the coast. They hold their hats in their hands as a gesture of respect to the king and steel-tip spears in indication of their sworn allegiance to the defense of the Ecuadorian coast against the English and Dutch pirates.

Thomas B. F. Cummins

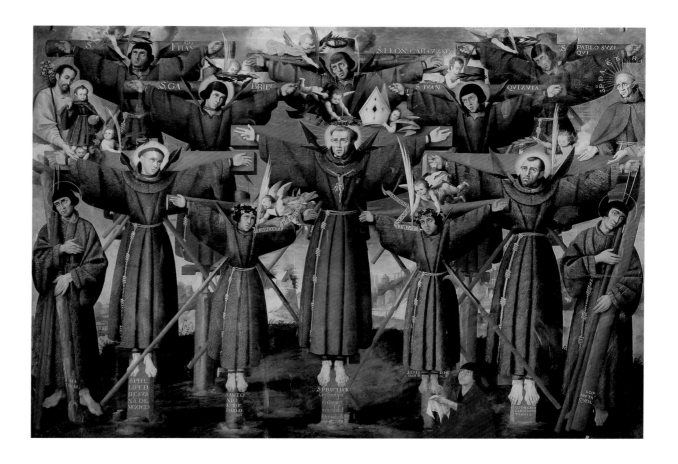

VI-71 Lázaro Pardo de Lago

(Peruvian, active Cuzco, 1630–1669)

Franciscan Martyrs of Japan

1630
Oil on canvas
118⅛ × 196⅞ inches (300 × 500 cm)
Convento Franciscano de La Recoleta, Cuzco, Peru

PUBLISHED: Mesa and Gisbert 1982, vol. 1, p. 72, pl. 4; vol. 2, fig. 34; Sebastián 1990, pp. 307–8, figs. 189–90; Schenone 1992, vol. 2, p. 586; Pastor de la Torre and Tord 1999, pp. 55–56; Mujica Pinilla 2002 "Art e identidad," pp. 10–13, fig. 6

THIS IS THE FIRST OF TWO great canvases that recreate, with serene drama, the martyrdom of a group of Franciscan missionaries—Spaniards as well as Japanese converts to the faith—in Nagasaki on February 5, 1597. Commissioned by the Franciscan monastery of La Recoleta in Cuzco, the painting's completion formed part of the celebrations that the Franciscan community of Peru organized in 1630, on learning of the collective beatification of the martyred monks three years earlier in Rome. The commission fell to a young painter named Lázaro Pardo de Lago, a contemporary of Diego Quispe Tito and Juan Espinosa de los Monteros. Pardo's novel, naturalistic style conformed to the aesthetic preferences of the order, and the commission resulted in two spirited compositions on which Pardo imprinted his signature with evident pride, an unusual gesture in the Andean context of the period.

Based on contemporary European engravings, the painting unites twelve of the twenty-three protagonists of the tragic event. Far from occurring by chance, the number twelve arose out of the recurrent apostolic symbolism among the missionary orders. The figures are arranged in three rows and as many ascending planes. They are shown crucified and pierced with lances in imitation of the sacrifice of Christ. At the same time, they are receiving immediate divine recompense for their suffering: a group of angels has come down to encircle their heads with laurel leaves and present them with palm leaves. Saint Joseph and the Christ Child—the latter dressed as a Franciscan monk in a clear gesture of identification with the martyrs—witness the scene from the upper edges of the picture, along with San Pedro de Alcántara, another member of the order who had just been canonized in 1629. At the center is the bishop Pedro Bautista, head of the mission, with the emblem of Christ Crucified on his breast. To his right is Felipe de Jesús, a Mexican Creole whose presence conferred singular importance on the painting from the Spanish-American perspective.

The impact of the work is not due solely to the nature of the subject matter, but also to its pictorial treatment, characterized by meticulous descriptive detail and exceptionally diaphanous colors, which imbue the painting with a certain strange realism that smacks of the medieval, particularly in the strong individualism revealed by the heads of some of the martyrs. Significantly, the Asian figures—"Oriental Indians"—are represented here with the characteristic hairstyle and features of people of mixed race or Christianized Indians, in accordance with the artistic conventions of the day, as in the drawings of Felipe Guamán Poma de Ayala. This includes the child at the foot of one of the crosses, who is holding a white cloth, attempting to alleviate the suffering of the sacrificed monks.

Luis Eduardo Wuffarden

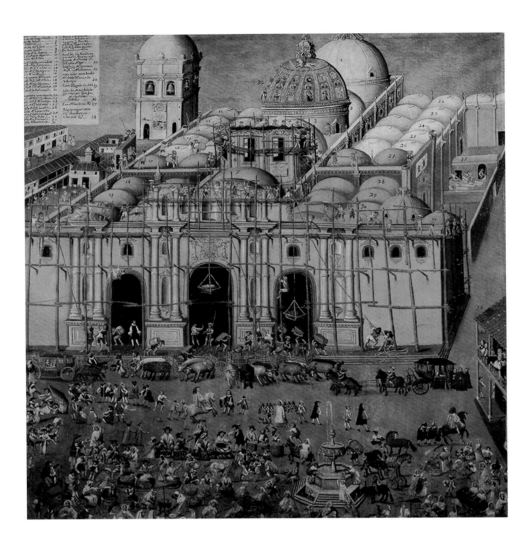

VI-72 Antonio Ramírez Montúfar

(Guatemalan, active second half of the seventeenth century)

The Construction of the Cathedral of Santiago de los Caballeros, Guatemala

1678
Oil on canvas
61¹³⁄₁₆ × 65 inches (157 × 165 cm)
Private collection

PUBLISHED: Amerlinck 1981; *Siglos de oro* 1999, cat. no. 7, pp. 163–66; Navascués Palacio 2000, pp. 2, 123; *Quetzal* 2002, p. 126

EXHIBITED: Madrid 1999 *Siglos de oro*, cat. no. 7

ANTONIO RAMÍREZ MONTÚFAR, who has been described as both a "master painter" and a "black slave," was commissioned in 1678 to paint several large canvases recording the construction and appearance of the grand cathedral of the city of Santiago de los Caballeros in Guatemala. That city, which is now called Antigua, was so devastated by a series of earthquakes that its institutions were moved to Guatemala City after a particularly violent upheaval in 1773. The paintings were intended to be sent to New Spain and to the Council of the Indies in Seville.

The building of this cathedral was begun in 1669 but moved along slowly, with the collapse of a vault along the way, until José de Porras, the mestizo *maestro menor* on the project, was allowed to take over in 1672. Here we see the amazing progress achieved over six years.

The artist took seriously his task to document the construction of the cathedral by giving us a bird's eye view of the whole and by labeling individual vaults with numbers correlated to the dedications of each chapel on the list at upper left. As well, he has identified the college and seminary pictured just beneath the list and a civil palace at the lower right from which the gentry can watch the ongoing construction as well as the goings-on in the plaza. Ramírez Montúfar clearly relished recording the varied population of the city. Among the workers on the cathedral, we can make out the difference between the stonecutters (Spaniards or Creoles) and the Indians hauling materials. Nearly half of the painting is dedicated to the bustle of life in the plaza: the bishop in his carriage; Indians selling their wares; gentlemen on horseback; white, brown, and black faces; and a great variety of costumes—all reminiscent of, but earlier than, the series of *casta* paintings created in Mexico in the following century (cats. VI-49–VI-62).

Suzanne Stratton-Pruitt

VI-73 *The Parish of Saint Sebastian*

(from the series *Corpus Christi de Santa Ana*)

Cuzco, Peru (circle of Basilio de Santa Cruz Pumacallao)
c. 1675–80
Oil on canvas
86¼ × 87³⁄₁₆ inches (219.1 × 221.5 cm)
Museo de Arte Religioso, Palacio Arzobispal, Cuzco, Peru

PROVENANCE: Parish Church of Santa Ana, Cuzco, Peru

PUBLISHED: Cossío del Pomar 1928, p. 175; Mariátegui Oliva 1954, p. 28,
pl. 7; Ugarte Eléspuru and Sarmiento 1973, pp. 126–27; Harten and
Schmidt 1976–77, vol. 1, pl. 2; Gisbert 1980, pp. 82–84, 94–95; Bernales
Ballesteros 1981, pp. 277–92; Mesa and Gisbert 1982, vol. 1, pp. 177–80,
pls. 25–27, vol. 2, fig. 238; Gisbert 1983, pp. 145–89; Sebastián 1990,
p. 278, figs. 174–75; Wuffarden 1996 "Pia Cuzco," pp. 96–100; Wuffarden
1996 "Piadoso Cuzco," pp. 83–88; Wuffarden and Bernales Ballesteros
1996, pp. 83–84, 128–29, figs. 12–13; Gisbert and Mesa 1997, pp. 308–9,
fig. 232; Dean 2002, pp. 70, 90, 123–24, figs. 12, 31; Mujica Pinilla 2002,
"Arte e identidad," p. 30, fig. 26; *Perú indígena* 2004, cat. no. 198, p. 214;
Majluf 2005, pp. 328–29

EXHIBITED: Rome 1996, pp. 66–67; Seville and Monaco 1996, pp. 83–84,
128–29, figs. 12–13; Barcelona, Madrid, and Washington 2004, cat. no. 198

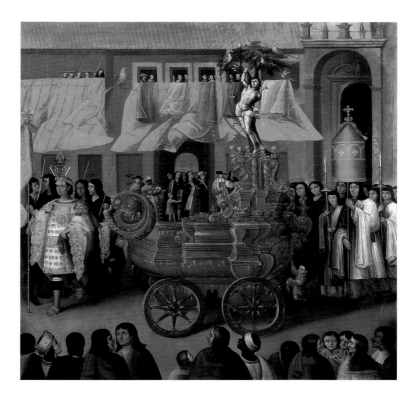

BY THE LAST QUARTER OF THE SEVENTEENTH CENTURY, the
public image of Inca nobility had begun to gain popularity in Cuzco
through works like this one, which shows the native chiefs of the parish
of Saint Sebastian participating as a group in the Corpus Christi proces-
sion. The scene is part of a celebrated series of canvases dedicated to the
religious festival during the time of its most splendid manifestation in the
city, under the episcopal leadership of Manuel de Mollinedo y Angulo
(1673–99). Behind the appearance of a realistic and detailed depiction of
the event is a broad iconographic program devised by those in the arch-
bishop's intellectual circle: an idealized recreation of the festival that omits
any reference to the continual chaos and conflicts over protocol related
to the procession. On the contrary, the various groups are presented as a
harmonious microcosm of Cuzco society marching in step to pay homage
to the Eucharist and, at the same time, demonstrate their loyalty to the
imperial dynasty of the Habsburg House of Austria, the principal champi-
ons of Catholicism.

This idea of order is echoed by the unchanging compositional
scheme of the canvases, which depict four of the city's indigenous parishes
or *reducciones* (settlements of indigenous converts to Christianity). The
canvases all feature a baroque carriage at the center carrying the patron
saint—in this case, Saint Sebastian—and preceded by a group of dignitar-
ies in full march, with the second lieutenant or standard-bearer prominent
among them in Inca costume. His bright garments combine indigenous
and European elements, such as ancestral *cumbi* weaving and Flanders

lace, in stark contrast with the somber Spanish style of his companions'
clothing. His headdress includes the *mascapaycha*, or imperial tassel, in
red wool, as well as combined elements of Inca and colonial heraldry: the
rainbow held up by two mythical birds called *corequenque*. In the context
of the religious procession, this regalia honored the proud desire for a
public display of local identity, while also satisfying the baroque taste for
a ceremony that incorporated the exotic and the "other" as an integral—
and therefore Christianized—part of the festival.

As is well known, the procession depicted in this painting did not
actually take place. Instead, it was copied from one of José Caudí's prints
illustrating J. B. Valda's connection with the *Solemnes fiestas* (Solemn
festivals) in honor of the Immaculate Conception, which were celebrated
in Valencia in 1662. This pictorial artifice serves to situate Saint Sebastian
in a luxurious triumphal carriage in the form of a fantasy ship. His effigy
creates the illusion of a living presence, capable of engaging in a direct
relationship with his devoted local followers. From an ethnic standpoint,
this identification is reinforced by the *guacamayos*, birds emblematic of
Inca aristocracy, which are perched on or flitting about a tree that sym-
bolizes martyrdom, their colorful plumage adorning the pedestal of the
saint's effigy. The ensemble shapes a paradoxical "cosmopolitan" image
of Cuzco—in large measure fictitious—in which this ancient capital of
Tawantinsuyo is placed among the ranks of the great urban centers of the
Hispanic empire and within the Christian universe.

Luis Eduardo Wuffarden

VI-74 *Asiel Timor Dei*

La Paz, Bolivia
Before 1728
Oil on canvas with decorative gilding
63³⁄₁₆ × 43½ inches (160.5 × 110.5 cm)
Inscribed at upper right: *ASIEL TIMOR DEI*
Museo Nacional de Arte, La Paz, Bolivia

PROVENANCE: Acquired from the Villamil de Rada Collection by the Museo Tiahuanacu, La Paz, Bolivia; transferred to the Museo Nacional de Arte, La Paz, Bolivia

PUBLISHED: Davidson 1971, p. 57; Gisbert 1980, pp. 86–88; Herzberg 1986, pp. 63–75; Mujica Pinilla 1992, pp. 29–33; *Retorno* 1996, p. 238, fig. 19

EXHIBITED: New York 1986, pp. 63–75; Paris 1996, p. 238, fig. 19

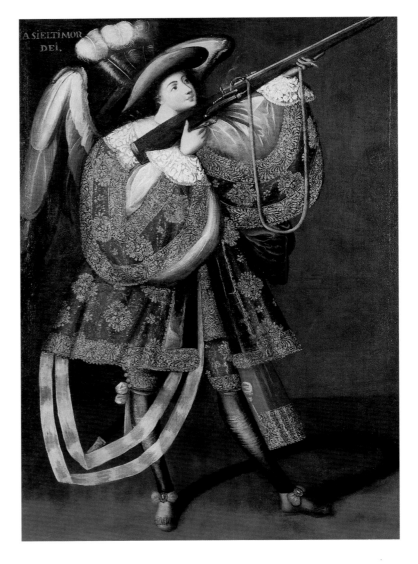

THIS ARCHANGEL, Asiel Timor Dei (Asiel, Fear of God), corresponds to those in series of harquebusier angels from the region of the Collao in the present-day Puno province in southern Peru and the La Paz department in northeastern Bolivia (see cats. VI-75, VI-76). Such angels are to be found in Cuzco in extensive series, and also in the villages around Lake Titicaca. These military angels, under the command of the archangel Michael, derive from the biblical tradition according to which some of the angels refused to worship Christ when they learned that he was to be incarnated as a human, whereupon God ordered their expulsion from Paradise. The angels from the Andes wear clothing corresponding to that of seventeenth-century Spanish and Flemish militiamen. They are depicted with harquebuses (matchlock guns), spears, and swords in poses corresponding to military exercises of the period, in particular those depicted in Jacob de Gheyn's *The Exercise of Arms*, published in 1607 and translated into various languages. The prints illustrating Jacob de Gheyn's work are the source for the poses of these angels.

Their presence in indigenous villages in South America can be accounted for by a tradition deriving from the apocryphal Book of Henoc, which calls them by the same names and states that the angels control the course of the stars and other celestial phenomena. In Andean villages and towns with large indigenous populations—for example, Cuzco and Potosí—church authorities made efforts to replace the cult of stars with that of angels. Such series were painted from 1690 onward and were extremely popular in the first half of the eighteenth century. The most renowned are those painted for the village of Calamarca (La Paz, Bolivia), which are still intact.

Teresa Gisbert de Mesa

VI-75 Master of Calamarca

(Bolivian, active c. 1700–1750)

The Angel Barachiel

First half of the eighteenth century

Oil on canvas

64⁹⁄₁₆ × 45¼ inches (164 × 115 cm)

Church of Calamarca, Bolivia

PUBLISHED: Gisbert 1980, pp. 86–88; Sebastián 1990, pp. 196–98; Mujica Pinilla 1992, pp. 29–33; Mesa and Gisbert 1996, pp. 38–51; *Retorno* 1996, p. 228, fig. 6; Schenone 1998 *Salvando*, pp. 7–20; Gisbert 1999, pp. 126–28

EXHIBITED: Paris 1996, p. 228, fig. 6

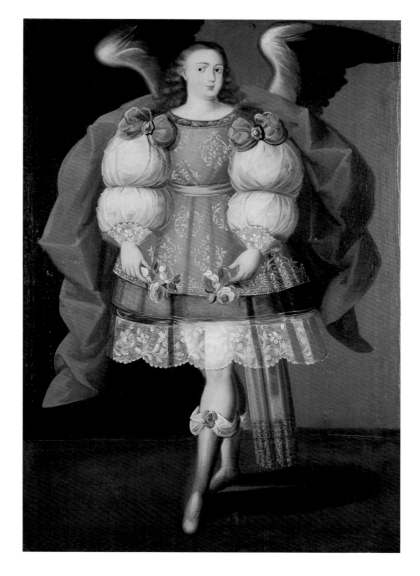

THIS WORK BELONGS TO THE SERIES of angels from the church of Calamarca, an Amerindian village in the district of La Paz, Bolivia (see cat. VI-76). It is the largest group of paintings of angels known from Latin America and consists of two series. The first comprises harquebusier angels, each one with its name by its feet. The second is made up of angels in female dress and Roman military boots, a costume that conforms to their asexual condition. All these figures have ample capes billowing like clouds, and each is identifiable by his attributes. Barachiel is recognizable by the flowers he holds (the name means "blessings of God"). This angel is one of the seven angels of Palermo, a city that especially venerated Michael, Jehudiel, Sealtiel, Uriel, Gabriel (bearing a torch), Raphael (depicted as the guardian angel), and Barachiel. This series of archangels was first depicted in 1516 in a fresco in Palermo's "Church of the Seven Angels." The Spaniards encouraged devotion to these seven, despite the fact that the Catholic Church only recognized three: Michael, Gabriel, and Raphael. The names and characters of the Palermo angels were revealed to the visionary Amadeus of Portugal (c. 1431–1482), and their devotion was promoted by Antonio del Duca. The church of Santa Maria degli Angeli in Rome was built over the Diocletian baths and dedicated to the archangels. There is an engraving by Jerome (Hieronymous) Wierix (1553–1619)

depicting the Palermo angels that was copied on various occasions by painters in the Andes region.

The iconography developed in the Andes shows Barachiel as a warrior angel, as he is described by the Augustinian friar Fernando de Valverde in his poem on Copacabana (Lima, 1641). In this work, Barachiel is portrayed as the angel who defeated the sun and wind on the shores of Lake Titicaca. According to Gustav Davidson's *Dictionary of Angels* (1971), Barachiel is the angel who commands thunder and lightening.

The present work forms part of a series that is stylistically close to the work of the painter Leonardo Flores from La Paz (active in 1684). Flores worked in the towns and villages around Lake Titicaca. A characteristic feature of his work is his manner of painting voluminous cloaks like clouds. This Barachiel has a large and billowing red cloak and is posed almost in the manner of a ballet dancer. While the painting is stylistically indebted to Flores, it was probably painted in the eighteenth century.

Teresa Gisbert de Mesa

VI-76 Master of Calamarca

(Bolivian, active c. 1700–1750)

Angel with Wheat Stalks

First half of the eighteenth century
Oil on canvas
63½ × 43 inches (161.3 × 109.2 cm)
Church of Calamarca, Bolivia

PUBLISHED: *Retorno* 1996, p. 226, fig. 3; Schenone 1998 *Salvando*, pp. 7–20

EXHIBITED: Paris 1996, p. 226, fig. 3

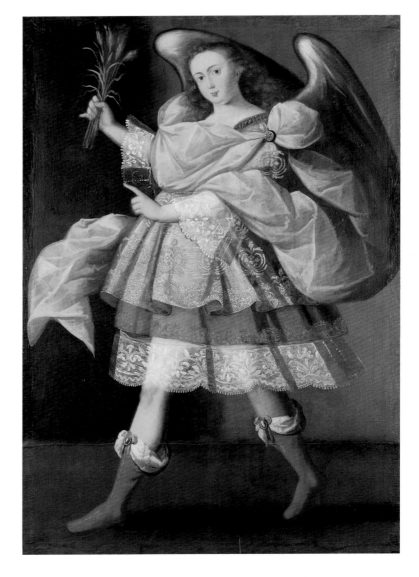

THIS ANGEL IS ONE OF A SERIES in the church at Calamarca in the Bolivian Altiplano (see cat. VI-75). The angel wears a short tunic derived from sixteenth- and seventeenth-century female dress, classical Roman boots, and a voluminous cape that recalls the style of the painter Leonardo Flores from La Paz (active in 1684), though the work probably dates from the first half of the eighteenth century. The angel holds a bunch of wheat stalks, which very probably refer to the Eucharist, although some authors have considered them symbols of hope. This symbolism and the manner in which the angel is depicted indicate that he is ranked among the celestial hierarchy of the virtues, according to the writings of Pseudo-Dionysus the Areopagite. This author wrote a treatise on angels, dividing them into nine celestial hierarchies, ranging from those nearest to God, such as seraphim, to those close to humanity, including simple ones such as guardian angels. The nine orders classified by Pseudo-Dionysus are seraphim, cherubim, thrones, dominations, powers, principates, virtues, archangels, and angels.

This angel and others in the painted series fall into the category of virtues. The Calamarca series includes several of this type: one holding a column, a symbol of strength according to Ripa; another unsheathing a sword, a symbol of justice. Other angels from the same series are easily identifiable as Gabriel, holding lilies; Barachiel, with bunches of roses (cat. VI-75); Uriel, brandishing a sword; and Raphael, with a fish.

The bunch of wheat stalks seen here is also found with other angels in the series, including the harquebusiers. It can thus be considered an established iconography. A painting of one of the harquebusier archangels in the Museo de Bellas Artes in Salamanca, Spain, thought to be from Cuzco, has the wheat at its feet. There is also a similar figure in the Poli collection in Lima.

Teresa Gisbert de Mesa

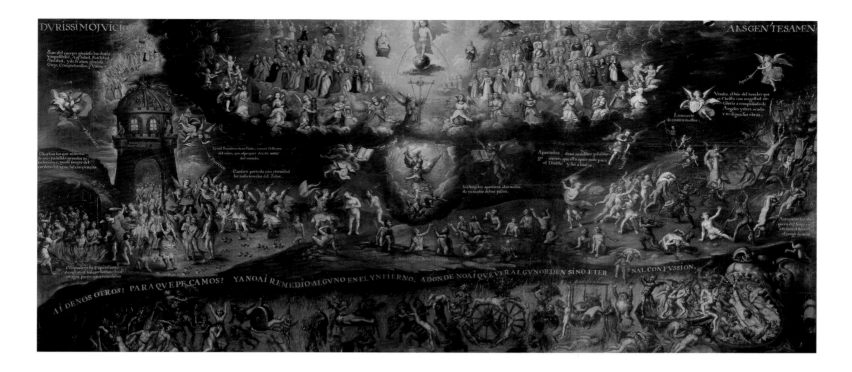

VI-77 Diego Quispe Tito

(Peruvian, 1611–1681)

The Last Judgment

1675
Oil on canvas
59 1/16 × 192 1/8 inches (150 × 488 cm)
Convento de San Francisco, Cuzco, Peru

PUBLISHED: Mesa and Gisbert 1977, pp. 77–110; Mesa and Gisbert 1982, pp. 150–53; Stastny 1994, pp. 13–15; Gisbert 2004 "Sur Andino," pp. 37–48

IN HIS ILLUSTRATED LETTER written about 1613 to the Spanish king Felipe III, the indigenous chronicler Felipe Guamán Poma de Ayala recommends that if His Majesty desires those teaching Christian doctrine in Peru to be successful in their catechism, the parishes of Indians should be equipped with pictorial representations of Heaven, Hell, and the Last Judgment to familiarize the Indians with the Christian theology. There is documentary evidence that since at least 1600, parishes of Indians in the southern Andes possessed paintings of the Last Things. Although it practically disappeared in Europe after 1630, this apocalyptic iconographic tradition survived in Peru until the nineteenth century, as the famous frescoes of 1802 attributed to Tadeo Escalante in the church of Huaro in Cuzco attest.

The iconography of the Last Things—a complement to the eschatological discourse of Advent sermons—derived from the late Middle Ages in Europe and from a long line of Flemish mannerist and baroque engravers. Particularly influential were the depictions of Hell and the Last Judgment by Johan Wierix included in the book of Ignatian meditations *Imágenes de la historia evangélica* (*Images of Evangelical History;* 1593) by Jerónimo Nadal (d. 1584). These European compositions were modified in their Andean versions, however, in order to transform the indigenous population into the new protagonist of the Christian history of salvations.

The *Last Judgment* of the indigenous painter Diego Quispe Tito belongs to the Franciscan catechetic tradition. Its graphic source is an early seventeenth-century engraving by Matthäus Merian (d. 1650), from which it takes its scrolling and composition. The canvas is entitled "The Very Harsh Judgment of the Peoples, Amen." A triumphant Christ appears in the center of the canvas with the world at his feet. He is flanked by the Virgin Mary and Saint John the Baptist, and underneath him Saint Francis of Assisi—as a second Christ—is carrying the cross of Golgotha accompanied by angels holding the instruments of the Passion. The archangel Michael, a demon vanquished at his feet, has descended to earth to weigh the souls in a scale while an angel and a demon read from the Book of Life the good and evil works performed by each. The archangel Uriel, with his fiery sword, separates the sinners from the just.

On the right is the fortified tower of the Gate of Heaven, with Saints Peter and Paul behind its ramparts, and angels accompanying the elect into heaven. Near the entrance some grilles have been opened to free the souls from Purgatory; a Roman Catholic pope, a cardinal, a friar, and an Inca can be identified among them. On the left is the Gate of Hell, where a demon is seated comfortably as he listens to another devil reading out the sentences passed against a condemned Spaniard or *criollo*. A long scroll separates the earth from the underworld: "Woe is us! Why did we sin? There is no help in Hell. Where no order is to be seen, but rather eternal confusion." In line with medieval iconography, not only are the punishments typified in accordance with their corresponding vices, but among the damned souls who burn in a cauldron of fire about to be swallowed up by Leviathan are a cardinal, a king, and an Inca. Divine justice, as Guamán Poma reminded the king of Spain, is the same for all.

Ramón Mujica Pinilla

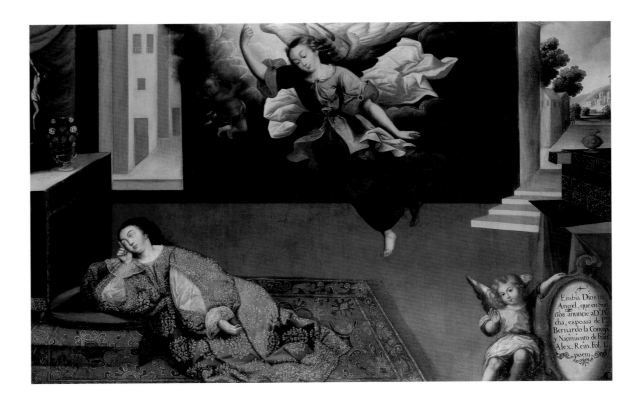

VI-78 Workshop of Basilio de Santa Cruz Pumacallao

Attributed to Juan Zapaca Inga

(active Cuzco, 1661–1700)

Annunciation of the Birth of Saint Francis to Doña Pica (from the series *The Life of Saint Francis of Assisi*)

c. 1680–84

Oil on canvas

74¹³⁄₁₆ × 113⅜ inches (190 × 288 cm)

Inscribed on tablet at lower right: *Embía Dios un/Angel que en sue-/ños anuncie a Dᵃ Pi-/cha, espossa de Pᵒ/Bernardo de la Concep.ᵒⁿ/y Nacimiento de Fran.ᶜᵒ/Alex. Rein. Fol 1./poem*

Museo de San Francisco, Santiago, Chile

PUBLISHED: Benavides 1953, pp. 67–96; Pereira Salas 1965, pp. 66, 371, fig. 25; *Álbum de las pinturas* 1971, pp. 7, 50; Sebastián López 1985, pp. 311–52; Mebold 1987, pp. 232–33; Mateo Gómez 1990, pp. 38–41, fig. 8; Schenone 1992, vol. 1, p. 337; *Barroco hispanoamericano en Chile* 2002, pp. 32–33

EXHIBITED: Castelló de la Plana 2002, pp. 32–33

Between 1668 and 1684 the city of Cuzco presented an important series of canvases on the life of the founder saint to the Franciscan monastery of Santiago de Chile. This image is the second of those forty-eight works. In more than one aspect, the compositions in these canvases resemble an ensemble executed by Basilio de Santa Cruz and his atelier for the main cloister of the same religious order in Cuzco, which garnered effusive praise from the viceroy, the Count of Elmos, upon its completion in 1668. This constituted decisive recognition for Santa Cruz, who subsequently became the favorite painter of the upper echelons of the government. At the same time, it helped launch the first surge of works exported from Cuzco workshops. In the following months, copies and variations on the Franciscan series were dispatched to points as distant as La Paz, Bolivia; Umachiri, Peru; and Santiago de Chile.

This suggests that these new versions were completed on commission by painters in Santa Cruz's circle who had probably collaborated on the Cuzco series, namely Pedro Nolasco and Juan Zapaca Inga, whose signatures appear on two of the Santiago paintings. A significant number of works are attributed to Zapaca—a proud member of the Inca aristocracy, as was Santa Cruz—including this painting. The image depicts Doña Pica, wife of Bernardone and future mother of the saint, asleep before the altar of a domestic *oratorio*, while an angel appears above her to announce the birth of Francis, pointing skyward with an index finger in a gesture reminiscent of the archangel Gabriel. Significantly, the evangelical passages of the Annunciation of Mary and Joseph's Dream are combined here in a single scene, with the evident aim of emphasizing Francis's role as *imitator Christi*, or "second Christ on Earth," which was frequently invoked in the Franciscan hagiography of the day.

In keeping with the iconographic tradition instituted by Santa Cruz, the artist clothes the figures according to contemporary Spanish fashion, presenting them in a domestic interior typical of daily life in the viceroyalty. Singular details include the Spanish desk with its small, half-open drawer on the right side of the picture. However, in contrast to the European style of composition that served as his model, Zapaca's use of perspective is freer, as he creates a unique poetic narrative with the idealized softness of the faces and the curving folds of the angel's cape.

Luis Eduardo Wuffarden

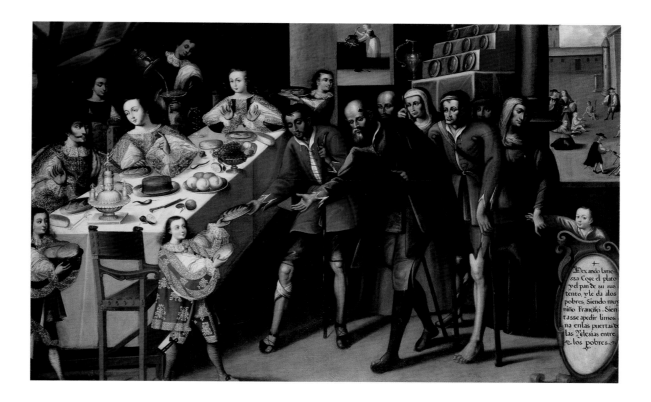

VI-79 Workshop of Basilio de Santa Cruz Pumacallao

Attributed to Juan Zapaca Inga

(active Cuzco, 1661–1700)

A Young Saint Francis Distributes Bread to the Poor (from the series *The Life of Saint Francis of Assisi*)

c. 1680–84
Oil on canvas
74⁷⁄₁₆ × 113¾ inches (189.1 × 288.9 cm)
Inscribed on tablet at lower right: *Dexando la messa coge el plato y el pan de sustento y le da a los pobres. Siendo muy niño Francisci [sic]. Siéntasse a pedir limosna en las puertas de las Yglesias entre los pobres*
Museo de San Francisco, Santiago, Chile

PUBLISHED: Pereira Salas 1965, p. 67; *Álbum de las pinturas* 1971, pp. 7, 20–21, 50; Mesa and Gisbert 1982, vol. 1, p. 123; Cruz de Amenábar 1984, pp. 29, 33, 58; Rojas Abrigo 1985; Sebastián López 1985; Mebold 1987, pp. 236–37; Schenone 1992, vol. 1, p. 340; *Barroco hispanoamericano en Chile* 2002, pp. 40–41

EXHIBITED: Castelló de la Plana 2002, pp. 40–41

THERE IS NO DOUBT THAT THIS PAINTING of a well-known episode from the childhood of Saint Francis corresponds to Juan Zapaca Inga's style. The fifth in a series, the image shows the future saint demonstrating his early affinity with the poor in his native city. There are actually three scenes occurring simultaneously, and although one portrays a differ-ent occasion—the distribution of alms in the doorway of a church—it is indeed related to the theme of the child's Christian charity as an indisputable herald of his saintly vocation. The central event takes place in the dining room of the family home, before a grand table covered with various dishes and a luxurious silver service. These details doubtless allude to the wealth and opulent life of the merchant Bernardone, Francis's father. Separating himself from the pleasures offered by his social status, and to his family's astonishment, young Francis sets himself to distributing bread among the group of cripples and mendicants who have, surprisingly, entered the room, creating an atmosphere of marked social contrast.

The dramatic intensity of this picture—much greater than in other versions of the subject—is supported by the strong contrast between the light emanating from the table of the rich on the painting's left side and the shadowy aspect of the group of beggars and cripples on the right. While the former have softened features and an artificial elegance, the latter display unusually realistic individual character traits. The contrast is accentuated by the deliberate way in which Zapaca has exaggerated the lines of perspective to create a sense of separate worlds. Francis, standing between the two groups of people, is the central focus of the composition, despite his small stature, and the only symbolic link.

The anachronistic setting of the story places the viewer before what could be the interior of a contemporary aristocratic Creole mansion and face-to-face with a group of beggars who may have been typical characters on the picaresque streets of Cuzco. For his part, Saint Francis is dressed in a festive costume reminiscent of those worn by harquebusier archangels of the period. It is significant that the tiny angel usually depicted next to the tablet in such paintings has here been replaced by the son of one of the indigent women. All this adds to the immediacy of the Franciscan message concerning the needy, which bestowed a decidedly didactic and moralizing function on this type of painting vis-à-vis colonial society.

Luis Eduardo Wuffarden

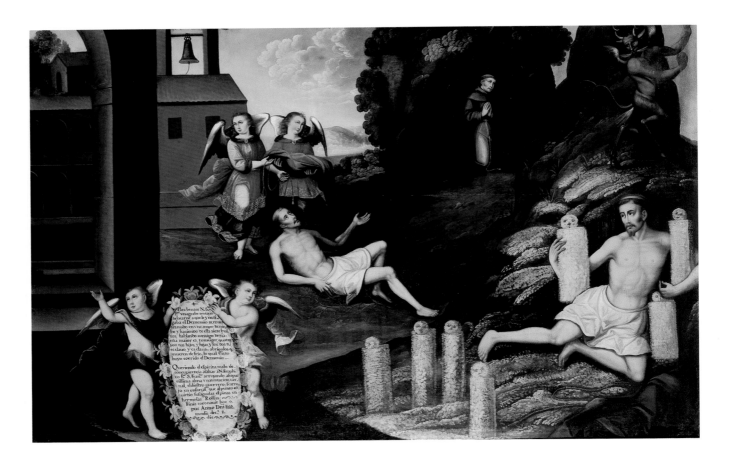

VI-80 Workshop of Basilio de Santa Cruz Pumacallao

(active Cuzco, 1661–1700)

Temptations of the Flesh (from the series *The Life of Saint Francis of Assisi*)

c. 1680–84
Oil on canvas
74⁷⁄₁₆ × 117⁹⁄₁₆ inches (189.1 × 298.7 cm)
Inscribed on cartouche held by angels: *Para vencer Nuestro Padre san Francisco una grave tentación de la carne a que le instigaba el demonio . . . Finis coronavit hoc opus Anno Domini 1668 mensis Dec. 8*
Museo de San Francisco, Santiago, Chile

PUBLISHED: Sebastián 1985; Mebold 1987, pp. 228–29; *Barroco hispano-americano en Chile* 2002, cat. no. 33, pp. 104–5

EXHIBITED: Castelló de la Plana 2002, cat. no. 33

IT WAS DURING THE BAROQUE PERIOD—and above all in Spanish America rather than in Spain itself—that the genre of large-scale historical paintings of the founders of the religious orders flourished. The fifty-four canvases of the life of Saint Francis of Assisi in Santiago de Chile constitute the largest collection produced by the painting workshop of Basilio de Santa Cruz Pumacallao in Cuzco. An initial series of forty-four paintings of the life of Saint Francis, executed for the Franciscan monas-

tery in Cuzco, was completed by the workshop around 1666, and was based on the same graphic source—the *Seraphici Francisci Admiranda Historia* of Philippe and Cornelius Galle (1578; Antwerp)—as the second, Chilean series. Whether this series in Chile was originally painted there or in Peru has been subject to debate, but the similarities between the two collections clearly indicate that both were produced in Cuzco. The chronology is firmly established by the inscription in the decorative scroll of *Temptations of the Flesh*, which states that the work was finished on December 8, 1668. This date refers to the first thirty-five paintings of the series, as no. 36 bears a different signature—that of the painter Pedro Lolasco (or Nolasco)—while no. 45, depicting the funerary rites of the saint, is signed by Juan Zapata Inga and dated 1684. Documentary evidence confirms that these two indigenous painters were working in Cuzco at that date.

Although Saint Francis was a mystic who contemplated God in the sanctuary of the natural world, he nevertheless struggled against the temptations of the flesh, as the narrative scenes on this canvas depict. In the upper part Saint Francis is praying when the Tempter appears, exhaling fire. Fleeing temptation, the saint takes off his clothes and throws himself onto a bramble patch while two angels hold the habit that he honors by the mortification of his flesh. In the foreground Saint Francis converses with the seven snow figures who represent worldly existence and the obligations that will distract him from a life of contemplation devoted exclusively to God.

Ramón Mujica Pinilla

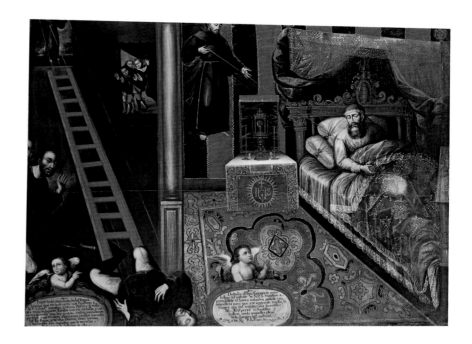

VI-8I Workshop of Basilio de Santa Cruz Pumacallao

(active Cuzco, 1661–1700)

The Miracle of the Wounds (from the series *The Life of Saint Francis of Assisi*)

c. 1680–84
Oil on canvas
75⁹⁄₁₆ × 98⁷⁄₁₆ inches (191.9 × 250 cm)
Inscribed in cartouche at bottom left: *Incrédulo al prodigio de las llagas llevaba mal un indevoto que pintaran a Nuestro Padre San Francisco con ellas . . .* ; in cartouche at bottom center: *Dudaba el Papa Gregorio IX la llaga del costado de Nuestro Padre San Francisco . . .*
Museo de San Francisco, Santiago, Chile

PUBLISHED: Mebold 1987, pp. 265–66; Schenone 1992, p. 395; *Barroco hispanoamericano en Chile* 2002, pp. 146–47

EXHIBITED: Castelló de la Plana 2002, pp. 146–47

IN THIS CANVAS TWO ANGELS HOLD cartouches that describe the miraculous episodes transmitted by the medieval hagiography of Saint Francis of Assisi (d. 1226). The first inscription tells the story of the miracle of the wounds, in which an "undevout" man could not suffer to see Saint Francis painted with them and scratched them out with a knife, only to find that they appeared again. One day, having scraped at the wounds, five streams of blood spurted from them so forcefully that he was knocked to the ground. In a version of the same subject in the Franciscan monastery in Cuzco, an angry Saint Francis himself directs the stream of blood from his side to knock the man to the ground. This iconography raises questions about the very nature of sacred art. It is through a visual representation of himself that the saint is able to break miraculously into the visionary universe of the devout man. The miracle of the wounds tells us much about the neo-Platonic theology of the icon and the fundamental role played by religious images in the late Middle Ages and during the Spanish Counter Reformation.

In the episode described in the second cartouche a visionary dream takes on reality. Pope Gregory IX doubted the existence of the wound in the side of Saint Francis, so the saint appeared to him in his dreams and asked for a small vial so that he could give proof by collecting in it the blood that issued from his side. The Pope awoke and found the vial full of blood. The details of this story were recounted in Saint Bonaventure's *Legenda Major* (1:2) and in the *Considerations on the Stigmata* (V). In the canvas Pope Gregory IX is shown in his private chambers holding in his hand the vial containing the blood from Saint Francis, who is visualized floating in the room. It is thus suggested that the oneiric experience of the pope was a real event: when he awakes he holds in his hand the actual blood Saint Francis gave him in his dream.

It is not surprising that Saint Francis's contemporaries cast doubt on the miracle of the stigmata, for he was the first saint in the history of Christianity to receive them. His mysterious wounds appeared only two years before his death, and after the disappearance of his famous vision of Christ as a crucified seraph, which left him transfigured. Throughout the seventeenth century this portent was interpreted by the Franciscan friars in Peru as an apocalyptic, messianic sign of the Third and Final Age of the Holy Spirit foretold by the Calabrian abbot Joachim of Fiore (d. 1202). As suggested by the inscription on this painting, the miracle of the wounds converted Saint Francis into a "second Christ," and the presence of Saint John the Evangelist, Saint Bonaventure, and even Joachim of Fiore points to the prophetic and redemptive function that Saint Francis and his order would perform in the Christian history of salvation.

Ramón Mujica Pinilla

VI-82 Conquest and "Reducción" of the Indians of the Paraca and Pantasma Mountains in Guatemala

Central America or Mexico

c. 1680–1700

Oil on canvas

63 × 86⅝ inches (160 × 220 cm)

Inscribed in cartouche at upper left: *PONEME IUXTAE, ET CUIUS SUIS MANUS PUGNET CONTRA ME. CONQUISTA Y REDUCCIÓN DE los Indios Infieles de las Montañas de Paraca y Pantasma/en la Sta Provincia del Nombre de Jesús de Guatemala jurisdición de/Nicaragua por el Pe Predor Apostco y comisso issro por su Mad. frai/Xptobal de Miranda Ximénes Religioso de N.P.S. Franco hijo de la Sta/Prova de Castilla desde el año de 1679 hasta el de 168–. Siendo Prese de la/Audiencia de Guatemala el Licdo D. Ope de Sierra Ossorio Goveror y Cap. General/el qual fomentó con cathólico zelo dichas reduciones;* below: *A Pueblo de Pantasma donde habitaban los Indios antiguamente./B Pueblo de Paraca enemigo de el de Pantasma q[ue] co[n] hechisos se mataban./C Río de la Pantasma por donde se entra a la reducción de los Apasimas i los demás./D Rio de Camarones y Canoas de Yndios./E Río de Coa por donde se va avya camino de Boali y Guamblan./F Río de Vocay donde vajan los Yndios Panamacas Motucas y Barucas./G Mar del Norte y Río de la Ciudad Vieja por donde entra el Ynglés a la nueva Segovia guiados por los Yndios Guanaes./H Montaña de Vocay donde havitan los Yndios Carives q[u]e están por reducir./Y Vayles superticiosos q[ue] hacen los Yndios en el qual matan uno dellos y se lo comen./J Bautismo de los Yndios con toda solemnidad y regozijo./*[Over the church]: *EXURGE DOMINE, IUDICA CAUSAM TUAM./K Peines listones Machetes hachas y otras cosas para reduzirlos./L Trages f[...] que usan los Yndios antes de reduzirse a Nra Sta fee católica./M Redución de Yndios/N Pueblo nuevo y convto de St Po de Alcántara donde viven los Yndios ya christianos el [...]/Comissario*

Museo del Prado, Madrid. Deposited in the Museo de América, Madrid

PROVENANCE: Palace of the Buen Retiro, Madrid, 1701–3 (inv. no. 604); The Royal Collection, London; Museo del Prado, Madrid

PUBLISHED: Kagan 1998, pp. 216–20; *Siglos de oro* 1999, cat. no. 14; Rubial and Suárez Molina 2000, ill. 8, p. 68; *Quetzal* 2002, cat. no. 194

EXHIBITED: Madrid 1999 *Siglos de oro*, cat. no. 14; Madrid 2002 Centro, cat. no. 194

THIS WORK DESCRIBES THE *REDUCCIONES*, or missions, of the Pantasma and Paraca Indians in a remote area of present-day Nicaragua that formerly belonged to the department of Nueva Segovia in the Kingdom of Guatemala. Described in the chronicle of Friar Francisco Vásquez (published posthumously in 1714), the Pantasma and Paraca missions belonged to the Franciscan province of the Santísimo Nombre de Jesús of Guatemala. Founded in 1675 by Friar Pedro de Lagares, it enjoyed a period of greater splendor—marked by more baptisms—in 1679 under his followers. It is to that period that we must ascribe this painting, as the inscription refers to Friar Cristóbal de Miranda Jiménez's leadership beginning in 1679.

The painting is by an unidentified artist, possibly from Guatemala City or even Mexico City, and it is more than likely that the artist never saw the isolated region he was asked to depict. Rather, the painting was constructed from written and oral instructions using a combination of pictorial sources that would transmit the desired message to its intended audience. The Indians dancing in a circle in the upper part, the nearby boiling pot with an arm and leg jutting out in a clear allusion to cannibalism, the hunt of the deer in the distant background, and the oversized family of Indians in the lower left are recurrent images that belong to the repertoire Europe compiled to imagine, invent, and pictorialize America, a tradition that began with the discovery of the New World.

Although a fabricated image, the painting aspires to be seen as a viable document through the inclusion of an extensive key in the upper left corner that identifies the multiple scenes set into the composition. With this combination of text and image, the viewer is invited to read, look, and finally conclude that the mission is successful yet fragile, for it suffered the problems common to many mission areas of Spanish America. The composition formulates its message in terms of pointed juxtapositions organized around the dividing river in the middle. This is the boundary that separates the "Christianized" Indians coming to the church in the lower half of the composition from the "barbarian" Indians on the farther shore. This juxtaposition is underscored by the dress of the Christianized Indians, which contrasts with the nudity and darker skin color of the non-Christianized Indians, who are adorned with bone necklaces. Even animals are used to differentiate the two worlds: snakes and wild beasts versus domesticated animals. Finally, the cannibalistic rituals of the non-Christians contrast with the performance of the two most important sacraments in the mission context: baptism (in front of the church) and confession (to one side of the church).

The disparity between these two worlds augments the impression that the mission is successful and that dutiful Christians can be created from cannibals. In fact the first two letters of the key (A and B) designate

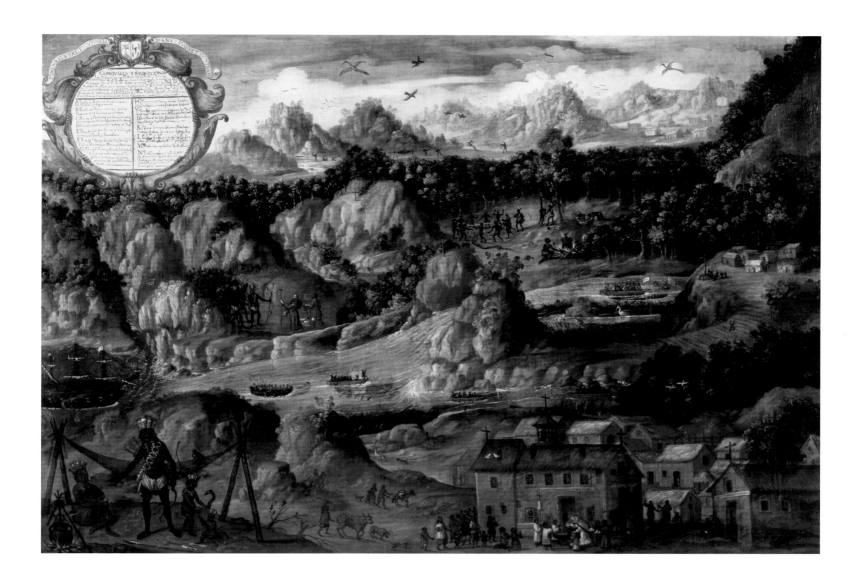

the areas where the Pantasma and Paraca Indians lived before they were "reduced." However, the message of the painting moves beyond the celebration of Franciscan zeal to underscore that in order to be truly successful the missions need royal and military protection. One of the most meaningful passages is found in the boats carrying English pirates and their Indian allies, the Guanaes (letter G). The threat of pirates on the coasts of Central America was an enormous problem for the Spanish crown, and it seems that the Franciscans, who likely commissioned the painting, added this detail quite deliberately. Through it, they make visible that which could most cause anxiety to the crown, revealing that the painting was probably intended for the viceregal and, ultimately, royal government. The plea for greater military as well as economic support for the missions is recurrent in many contemporary documents relating to this area, and this work seems to be the visual corollary to such accounts.

While off by a digit, the number painted in white in the lower right-hand corner, 605, is probably meant to correspond to painting 604 in the royal inventories of 1701–3 taken after Carlos II's death. Referring to the Palace of the Buen Retiro in Madrid, the inventory identifies 604 as "Otra de Dos Varas y tercia de largo y Vara y media de alto de la Conquista y reduccion de los Yndios," a title very similar to that in the inscription on the painting. This identification makes it possible to confirm an *ante quem*

date for this work. In addition, Marías's hypothesis that the painting entered the Royal Collection as a gift to Carlos II when the Captain General of Guatemala, Lope de Osorio, returned to Spain in 1681 becomes more probable. The painting's inscription pointedly flatters Osorio's support of the mission in such a way that it makes him an accomplice to the Franciscan effort and transforms him into an ambassador for their cause at the court in Madrid. In fact, an even more likely possibility is that the work was sent to him a bit later, as Osorio became a member of the Consejo Real de Indias between 1684 and 1702, a post from which he could continue to exert influence in solving the problems of the Franciscan missionaries in this territory.

Luisa Elena Alcalá

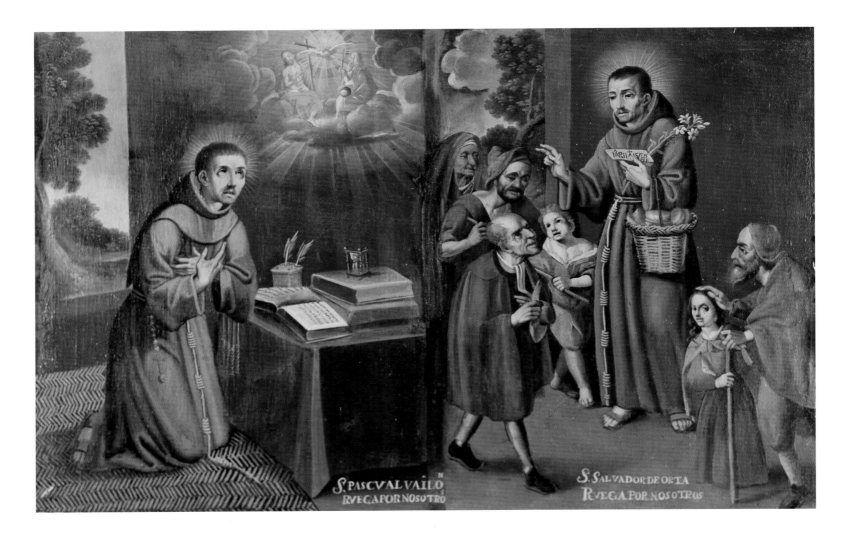

VI-83 Melchor Pérez Holguín†

(Bolivian, c. 1665–after 1732)

Saint Paschal Baylon, Pray for Us; Saint Salvador of Horta, Pray for Us

c. 1720
Oil on canvas
85 × 130 inches (109 × 156 cm)
Inscribed at bottom: *S. Pascual Bailó Ruega por nosotros; S. Salvador de Orta Ruega por nosotros*
Museo Santa Teresa, Potosí, Bolivia

In this unique composition, Holguín brings together two little-known saints who were particularly noted for their humility and charity. Saint Salvador of Horta (1520–1567) was born of a poor family in a town near Gerona, Spain. His calling to a life of austerity led him to join the Franciscan order as a lay brother. The many miracles he evidently brought about caused him considerable persecution by his own brothers (for whom he served for many years as cook), though he spent his last years in peace-

ful exile in Cagliari, Sardinia, where his sepulchre in the church of Santa Rosalia is still credited with miracles. His cult was authorized in 1606 and confirmed in 1711, though he was not canonized until 1938. Saint Paschal Baylon (1540–1592), a Spaniard who also became a Franciscan lay brother, was similarly noted for both his miracles and his austerity, spending most of his life as a humble doorkeeper. He was canonized in 1690.

Holguín's composition brings these two humble, kindly sixteenth-century lay brothers together with the poor and halt who turned to them for succor. It is tempting to read in the small figure of an elderly man, hat in hand, at the center of the composition a self-portrait of the artist. Evidently alone among South American artists during the colonial period, Holguín included his own image in several of his paintings. He appears front and center in the *Last Judgment* (1708; Church of San Lorenzo, Potosí) and in the *Entry of Viceroy Diego Rubio Morcillo de Auñón into Potosí* (1716; Museo de América, Madrid), and perhaps is the figure being pulled from the fires of Hell by an angel in the painting of *Santa María de Cervello* in the Cathedral Museum, Sucre. If Holguín has included his self-portrait as an aging man in *San Paschal Baylon . . .*, we can tentatively date this painting to around 1720, since we know no more of his work after 1724. In any case, the theme and the empathetic treatment of the figures exemplify the humanity with which Melchor Pérez Holguín imbued his art.

Suzanne Stratton-Pruitt

VI-84 Melchor Pérez Holguín†

(Bolivian, c. 1665–after 1732)

Pietà

c. 1720
Oil on canvas
42 11/16 × 30⅜ inches (109 × 77 cm)
Collection of Roberta and Richard Huber

PROVENANCE: Alandia collection, La Paz, Bolivia; purchased at auction house of Proarte, Rio de Janeiro, April 1977

PUBLISHED: Mesa and Gisbert 1956, p. 118, fig. 72; Mesa and Gisbert 1977, p. 180, fig. 194; Querejazu and Ferrer 1997, cat. no. 8, pl. 8; *Colores en los Andes* 2003, p. 31

EXHIBITED: New York 1997, cat. no. 8, pl. 8; New York 2005

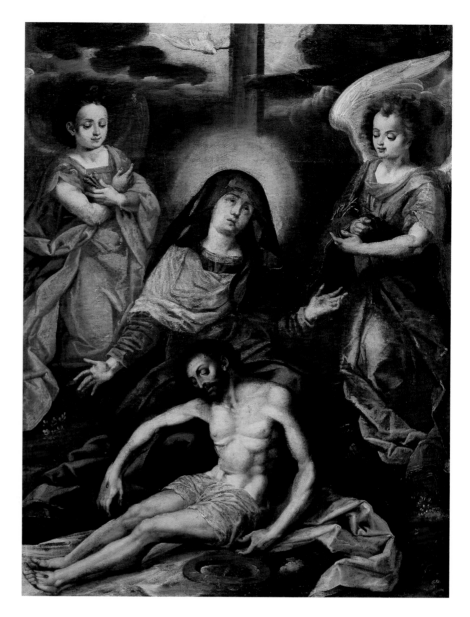

HOLGUÍN PAINTED SEVERAL VERSIONS of the Pietà, the representation of the Virgin Mary holding the body of her dead son in her lap that is traditionally called by its Italian name. Another version by the artist, in the Museo Charcas in Sucre, is based on a composition by Anthony van Dyck, and this painting in the Huber collection is also undoubtedly based on a Flemish prototype.

The Holguín expert José de Mesa, in a letter of 1997, judged the Huber painting to be a "variant or replica" of the one he and his wife, Teresa Gisbert, had published in their first book on Holguín in 1956. Mesa noted that the inscription on the reverse of the painting is "antigua" and thus a validation of his consideration that the painting is indeed by Holguín. However, a comparison of the present work with the old photographs of the painting reproduced in both of their books on the artist (1956 and 1977) suggests that it is the very same one they published, not a variant or replica. Holguín was a prolific artist with a busy workshop, and there are indeed a number of "variants and replicas" of some of his best-loved subjects, but these always vary a bit, one from the other. From the Mesas, then, we know that in the 1950s the Huber painting belonged

to "señor Alandia," who is not otherwise identified, whence it wended its way to an auction house in Brazil two decades later.

In the Museo de Arte Hispanoamericano "Isaac Fernández Blanco" in Buenos Aires is a painting of the Pietà on a panel measuring 109 by 77 centimeters, almost exactly the dimensions of the Huber painting. The authors of the catalogue of an exhibition focused on the materials of paintings from the Viceroyalty of Peru suggest that the painting is of Flemish origin because of the way the wood panel is assembled and because of the use of a particular pigment. If the painting is Flemish, as the authors there suggest, Holguín might have created the Huber painting as a replica, for the works are a match not only in composition but also in palette. However, the style of painting does not correspond to Flemish painting from the late sixteenth to early seventeenth century, as suggested. It is possible that the painting in Buenos Aires is instead an eighteenth-century copy of Holguín's painting, created when the artist's work remained immensely popular throughout South America.

Suzanne Stratton-Pruitt

VI-85 Melchor Pérez Holguín[†]

(Bolivian, c. 1665–after 1732)

The Virgin of Bethlehem

c. 1710–20

Oil and gold on canvas

30 × 23 inches (76 × 58 cm)

Museo Nacional de Arte, La Paz, Bolivia

PUBLISHED: Mesa and Gisbert 1977, pp. 169–70, fig. 181; Gisbert et al. 1994; *Retorno* 1996, cat. no. 43, p. 259, fig. 43

EXHIBITED: Houston and Dallas 1994; Paris 1996, cat. no. 43

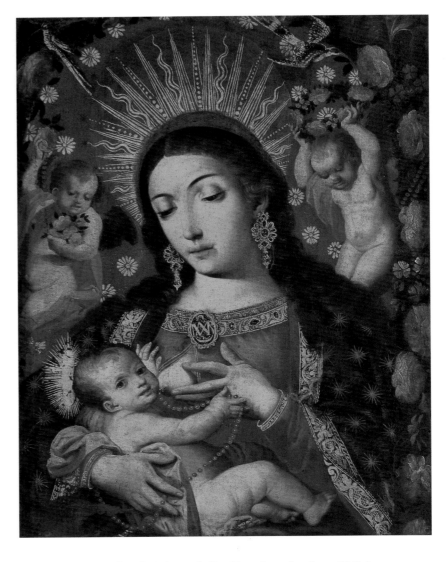

THE *VIRGEN DE BELÉN* (Virgin of Bethlehem) and the *Virgen de la Leche* (Virgin of the Milk) are two names for the same iconographical type in Spanish and Latin American paintings. In Latin America, the more commonly used title is *Virgin of Bethlehem*. Although the subject was popular in Italian art, it is more likely that Holguín's source of inspiration was a painting by one of the Flemish artists, such as Marten de Vos, whose work was well known throughout the Americas. More specifically, Holguín's *Virgin of Bethlehem* may reflect the work of a Flemish "Romanist," for the generously rounded forms of the body of the Child are more suggestive of the infants in Italian Renaissance painting than the long, slender bodies of the Infant Christ in Netherlandish painting prior to the influence of Italy on northern European artists. Many Flemish paintings reached South America through the port of Seville, where the Romanist style was the leading style in the late sixteenth century.

Holguín was an artist capable of creating a wide range of moods. His portraits of ascetics, as in the *Death of Saint Peter Nolasco* (Museo Casa de Murillo, La Paz), are notable for the sunken eyes and cheeks of these self-denying saints, and are painted in largely monochromatic hues of gray and brown. His paintings of the flagellation of Christ (as in the Museo de la Casa de Moneda, Potosí) and the beheading of Saint John the Baptist (of which there are examples in the monastery of San Francisco

in Potosí and in the Museo de San Francisco, Santiago, Chile) are more than sufficiently gory to get the idea across to the viewer. In his paintings of the Virgin Mary, in both narrative scenes and devotional images such as this one, she is always perfectly lovely.

The Virgin is shown full-length in Holguín's remarkable *Virgin of Tiobamba* (private collection, La Paz) and the *Virgin of Laidon* (Museum of Indian Arts and Culture, Santa Fe, New Mexico), which are hieratic figures, paintings representing particular cult images. By contrast, this *Virgin of Bethlehem* in the Museo Nacional de Arte is an intimate devotional image made for private contemplation. While Holguín was undoubtedly very familiar with paintings from Cuzco, which were widely disseminated and stylistically influential in Alto Perú, his work is usually quite distinct from that style. In this painting, however, he adopts to fine effect several elements common to paintings from Cuzco: the floral framing device (borrowed, again, from Flemish painting), and, unique in Holguín's oeuvre, the added gold *brocateado* (brocade) in the haloes, the lace trim on the Virgin's mantle and at her neckline (where a brooch bears a rubric with the letters *MARIA*), and her elaborate earrings. And yet the shapes of the putti and of the Christ Child, and the serene features of both the infant and his mother, are inimitably in the unique style of Melchor Pérez Holguín.

Suzanne Stratton-Pruitt

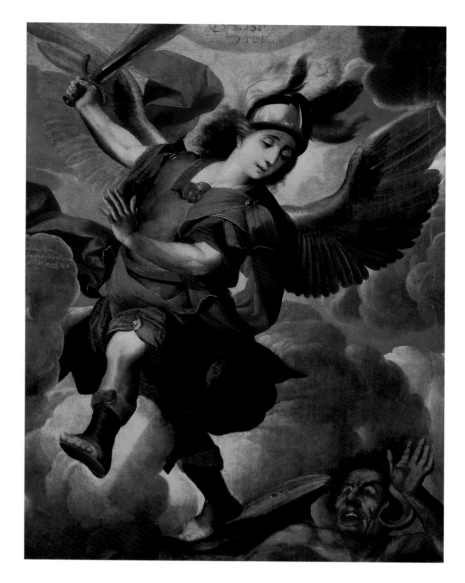

VI-86 Melchor Pérez Holguín†

(Bolivian, c. 1665–after 1732)

Saint Michael Archangel

1708

Oil on canvas

50⅜ × 40⅛ inches (128 × 102 cm)

Inscribed at center left: *Melchor Peres Holguin me fecit en Potosi ano de 1708*

Museo Nacional de Arte, La Paz, Bolivia

PUBLISHED: Mesa and Gisbert 1977, p. 161, fig. 172

FEW SUBJECTS IN ART WERE MORE POPULAR throughout viceregal Latin America than angels, as seen in this book in a painting of 1616 by the Mexican artist Luis Juárez (cat. VI-11), in a Brazilian sculpture by Manuel de Velasco (cat. V-5), and in other works as well. Saint Michael Archangel was a particular favorite. He is here pictured as described in the Apocalypse of Saint John (also known as the Book of Revelation) 12:7–9:

> And there was a great battle in heaven, Michael and his angels fought with the dragon, and the dragon fought and his angels: And they prevailed not, neither was their place found any more in heaven. And that great dragon was cast out, that old serpent, who is called the devil and Satan, who seduceth the whole world; and he was cast unto the earth, and his angels were thrown down with him.

For the theologian Pedro de Ribadeneira, writing in the late sixteenth century, Michael was the Captain of the Holy Angels, the defender of the church, intercessor for mankind, Prince of the Celestial Court who receives the souls of the elect in heaven. For the faithful, Michael was a protector and willing listener. According to Ribadeneira:

He does not neglect those who pray to him, nor reject those who confide in him, nor distance himself from those who love him, for he defends the humble, encourages the pure, embraces the innocent, guards our lives, guides us along the way, and takes us home [*a nuestra patria*], where Jesus Christ our Lord, the true husband of the Church, reigns with the Father and Holy Spirit in the centuries of the centuries.

In two versions of the composition (another, also signed by the artist, was in a private collection in Buenos Aires in 1956), Holguín envisions Michael as defying the enemy with ease and aplomb, his serene expression a contrast to the fluttering of green and red draperies, the swirl of turbulent clouds, and the fiery sword about to dispatch the horned devil at lower right.

Suzanne Stratton-Pruitt

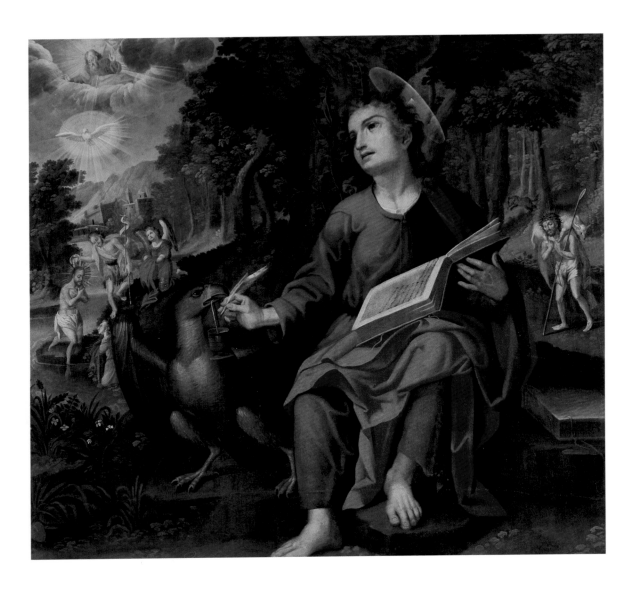

VI-87 Melchor Pérez Holguín[†]

(Bolivian, c. 1665–after 1732)

Saint John the Evangelist

1724
Oil on canvas
48¹³⁄₁₆ × 54⁵⁄₁₆ inches (124 × 138 cm)
Museo de la Casa Nacional de Moneda, Fundación Cultural BCB, Potosí, Bolivia

PROVENANCE: Convento de San Francisco, Potosí, Bolivia

PUBLISHED: Mesa and Gisbert 1977, pp. 200–204, figs. 213, 216–17; Schenone 1992, vol. 1, pp. 527–32

THIS PAINTING OF SAINT JOHN is from the series of the Evangelists painted by Holguín for the Monastery of San Francisco in Potosí (cats. VI-88–VI-90). Here we see the saint next to his traditional symbol, the eagle; by their side is the chalice that recalls Saint John's martyrdom. According to tradition, John was boiled in oil in Rome during the reign of the Emperor Domitian. He did not die, however, and was subsequently accused of sorcery and exiled to the island of Patmos, where he wrote the book of the Apocalypse (or Revelation). He then returned to Ephesus, the city where he had lived before going to Rome, and died there sometime after 1732.

In the landscape to the left, the artist has depicted the Baptism of Christ, the episode that opens the Gospel of Saint John, as the text omits any account of Christ's childhood.

Although the composition is based on a print by Johan Wierix (1549–c. 1618), Holguín varies some details: While the Flemish printmaker included the Devil watching the Baptism, Holguín replaces this figure with an angel. The facial features of his Evangelist are also more delineated. On the right, Holguín has added a walking figure bearing a staff and carrying a lamb across his shoulders. This may represent Christ or the Good Shepherd, or perhaps Saint John the Baptist, who is often shown with a lamb and a staff.

The artist used brilliant colors to depict a tree-filled valley with flowers and streams, creating a contrast with the arid appearance of Potosí, which is located at more than 13,000 feet (4,000 meters) above sea level.

Teresa Gisbert de Mesa

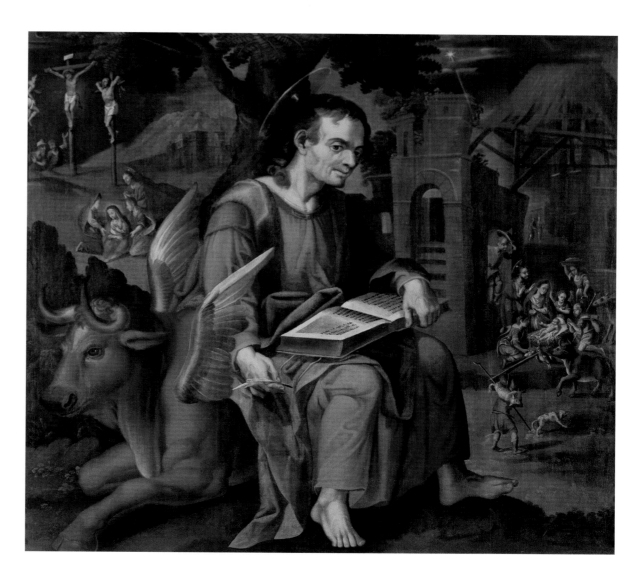

VI-88　Melchor Pérez Holguín[†]

(Bolivian, c. 1665–after 1732)

Saint Luke the Evangelist

1724
Oil on canvas
48¹³⁄₁₆ × 54⁵⁄₁₆ inches (124 × 138 cm)
Museo de la Casa Nacional de Moneda, Fundación Cultural BCB,
Potosí, Bolivia

PROVENANCE: Convento de San Francisco, Potosí, Bolivia

PUBLISHED: Mesa and Gisbert 1977, pp. 200–204, fig. 214

THIS PAINTING OF SAINT LUKE THE EVANGELIST, based on an engraving by Johan Wierix (1549–c. 1618), shows the saint writing in a book that rests on his knees. He is seated next to a winged bull, his symbol. The animal is depicted realistically apart from the wings, which refer to the famous vision of the prophet Ezekiel. The representation adheres closely to that of Maarten de Vos as reproduced by Wierix in his engrav-

ings, and was perhaps inspired by the Jesuits, with whom the Wierix family of artists was associated.

As in the representations of Saint John and Saint Matthew in this series (cats. VI-87, VI-90), the Evangelist is shown seated beneath a tree in a landscape. Also included are other scenes referring to his gospel. The Gospel of Saint Luke includes the greatest number of details of the childhood of Christ, so this composition includes a reference to his birth, with the Nativity depicted in a poor hut among Roman ruins. The painter has added a shepherd who advances toward the entrance to Bethlehem. On the left is the Crucifixion with Mary as the Virgin of Sorrows seated with Saint John and the other two Marys.

Like Saint Mark (cat. VI-89), Saint Luke was not one of the Apostles. Converted by Saint Paul, Luke was Paul's companion in the mission of spreading Christianity, accompanying him to Rome.

Holguín's figure varies little from the original print, although the saint's anatomy is characteristic of Holguín's style, with the body relatively small in relation to the head.

Teresa Gisbert de Mesa

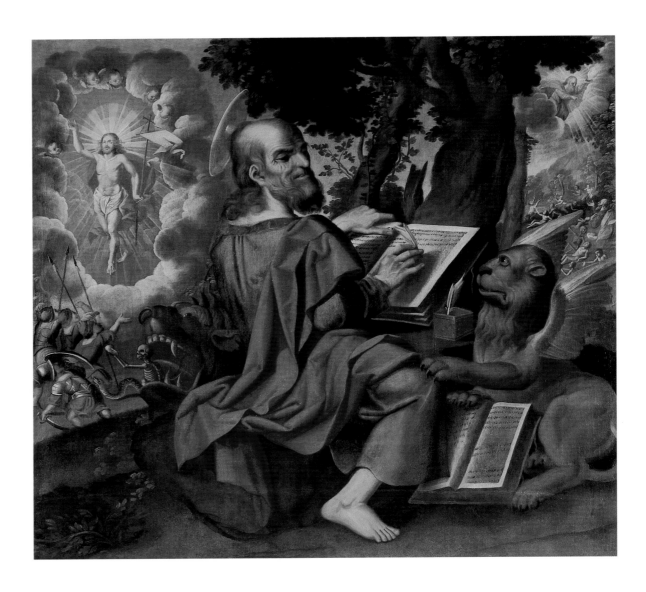

VI-89 Melchor Pérez Holguín†

(Bolivian, c. 1665–after 1732)

Saint Mark the Evangelist

1724
Oil on canvas
48¹³⁄₁₆ × 54⁵⁄₁₆ inches (124 × 138 cm)
Museo de la Casa Nacional de Moneda, Fundación Cultural BCB, Potosí, Bolivia

PROVENANCE: Convento de San Francisco, Potosí, Bolivia

PUBLISHED: Mesa and Gisbert 1977, pp. 200–204, fig. 211

THIS PAINTING AND THAT OF THE OTHER Evangelists, also in the exhibition (cats. VI-87, VI-88, VI-90), are from a series of the Four Evangelists that Holguín based on engravings by Johan Wierix (1549–c. 1618) of drawings by Maarten de Vos (1532–1603). However, Holguín completely altered the appearance of Wierix's Evangelist in order to conform to his own style. He gave him the same face and appearance as in other series of Evangelists that he painted, almost all of them half-length. Besides the series now in the Museo de la Casa Nacional de Moneda represented here, Holguín produced only one other of full-length Evangelists (now in the Museo Nacional de Arte, La Paz), also based on engravings by Wierix, although with numerous modifications. In the present *Saint Mark* the saint is depicted as a bald and bearded old man rather than with the abundant hair seen in Wierix's print.

In all of Holguín's representations of the subject, the Evangelists are depicted with their traditional symbols in a colorful landscape that includes scenes from each saint's life and mission. Saint Mark is shown with the winged lion, and the figure is located next to a tree. In the background, to the left, is the Resurrection of Christ and, on the right, the Resurrection of the Dead and their ascent to heaven. Next to the tree, just to the left of Saint Mark, we see the mouth of the devil Leviathan symbolizing Hell.

Teresa Gisbert de Mesa

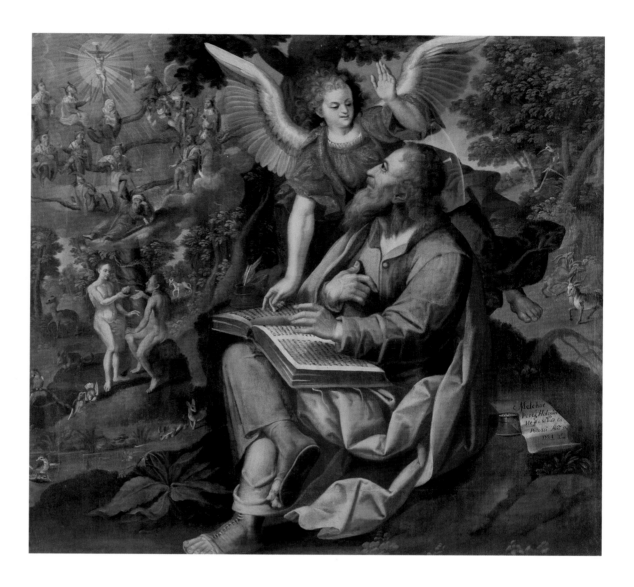

VI-90 Melchor Pérez Holguín[†]

(Bolivian, c. 1665–after 1732)

Saint Matthew the Evangelist

1724
Oil on canvas
48¹³⁄₁₆ × 54⁵⁄₁₆ inches (124 × 138 cm)
Signed and dated on fictive sheet of parchment at right: *Melchor Peres Holguin Me ffasiebat, en Potosí, Año 1724*
Museo de la Casa Nacional de Moneda, Fundación Cultural BCB, Potosí, Bolivia

PROVENANCE: Convento de San Francisco, Potosí, Bolivia

PUBLISHED: Mesa and Gisbert 1977, pp. 200–204, fig. 212

IN 1724 MELCHOR PÉREZ HOLGUIN painted a series of the Four Evangelists for the Monastery of San Francisco in Potosí (see cats. VI-87–VI-89). These compositions have landscape backgrounds in which the artist located episodes corresponding to each Evangelist. Each is also accompanied by his respective symbol, conforming to the words of the

prophet Ezekiel, who saw God on a chariot of fire with its wheels supported by four winged beasts: a lion, a bull, an eagle, and a man (the latter was considered to be an angel in Christian iconography). The present series is based on a group of engravings by Johan Wierix, the renowned Flemish printmaker (1549–c. 1618), who in turn based his engravings on compositions by Maarten de Vos (1532–1603).

Holguín reproduced the composition of the print, but the figure of Saint Matthew is very much in his own style, with highly pronounced features, deep-set eyes, and prominent cheekbones. The angel hovers above him. The palette is rich, and the figures in the background are lightly defined with deft brushstrokes. The canvas is signed on a piece of parchment that states that Holguín made the work in Potosí in 1724. In the landscape we see Adam and Eve still in Paradise, at the moment when Eve gives the apple to Adam. Holguín has added a pair of amorous doves, which do not appear in the print and which refer to the relation between Adam and Eve, from whom was generated the Tree of Jesse, the genealogy of Christ described in detail in the Gospel of Saint Matthew. The Tree of Jesse culminates in the Crucifixion. On the opposite side, above the trees in the landscape, Holguín has added a bird, which is highly characteristic of painting from the Andes region, and a deer drinking at a stream, which may refer to the life-giving waters of the Gospel.

Teresa Gisbert de Mesa

VI-91 Nuptials of Martín de Loyola with the Ñusta Beatriz and of Don Juan de Borja with Doña Lorenza Ñusta de Loyola

Cuzco, Peru

c. 1680

Oil on canvas

107½ × 179⅛ inches (273.1 × 455 cm)

Inscribed in cartouche: *D. Martin de Loyola Governador de Chile sobrino de N.P. S. Ignacio Hijo de su hermano mayor D. Beltran de Loyola caso con Doña Beatriz Ñusta Heredera y Princesa del Perú como Hija de D. Diego Ynga su ultimo Rey. Por haver muerto sin hijos su hermano D. Phelipe Inga de D. Martin y De Da. Beatriz nacio Dña Lorenza Ñusta de Loyola que paso a España por orden de Nros Reyes Catolicos y la casaron en Madrid con el Exmo S. D. Juan de Borja hijo de S. Francisco de Borja y embajador del Sr. Rey Felipe 2° a Alemania y Portugal. Con este matrimonio emparentaron entre si y con la Real Casa de los Reyes Yngas del Perú las dos Casas de Loyola y Borja cuya sucesión esta oy en los Exmo Srs. Marqueses de Alcañices Grandes de Primera Clase.*

Church of the Company of Jesus, Cuzco, Peru

PUBLISHED: Gisbert 1994, pp. 153–57; Timberlake 1999, pp. 563–98; Stastny 2001, pp. 230–32; García Sáiz 2002, pp. 206–16; O'Phelan Godoy 2003, pp. 100–103; Mujica Pinilla 2004, pp. 105–6; *Perú indígena* 2004, cat. no. 157, p. 198; Wuffarden 2005 "Renacimiento," pp. 189–201

EXHIBITED: Barcelona, Madrid, and Washington 2004, cat. no. 157

IN ICONOGRAPHICAL TERMS, this painting by an unknown artist expresses as no other the theocratic and politico-religious agenda of the Compañía de Jesús in viceregal Peru. The persons and the events depicted are all real, but they have been intentionally "fictionalized" by bringing together political, religious, and cultural figures that belong to different times and places. The painting commemorates two marriages of convenience arranged by the Company of Jesus with the aim of uniting the blood and genealogies of the Inca dynasty with those of the Jesuits. A long inscription in the cartouche identifies the figures in the painting.

On the left is Captain Martín de Loyola, nephew of Saint Ignatius of Loyola, founder of the Company of Jesus, in the act of being espoused to the Ñusta (Princess) Beatriz Clara Coya, a direct descendant of the Inca Huayna Capac and holder of the rights of succession to the Tawantinsuyo, the ancient empire of the Sun. The painting suggests that this marriage ceremony, which took place around 1572, was celebrated in the central plaza of Cuzco in the presence and with the approval of the Inca royal family. The members of the Inca royal family, depicted on a raised platform before the Jesuit church of the Transfiguration, wear their traditional costumes with the imperial insignia—parasols, feathers, emblematic bird, and heraldic crests—in order to legitimize a marriage in which the Inca queen Beatriz represented the richest and most powerful war booty that Spanish Catholicism (embodied in the Jesuits) had won from the Inca empire. According to the inscription, the second marriage ceremony, on the right, represents that of Ana María Lorenza de Loyola, the daughter of the Ñusta Beatriz and Martín de Loyola, to Count Juan Enríquez de Borja y Almanza, grandson of Saint Francis Borgia (that is, Borja), another eminent Jesuit saint. This wedding was celebrated by the bishop of Madrid in 1611, as shown in the scene behind the second couple. Recent research has questioned the historical truth of these fictionalized family ties between the wedding consorts and the Jesuit saints: Martín de Loyola was not, in fact, the son of the brother of Saint Ignatius, but rather the grandson of his elder brother; and Ana María Lorenza did not marry Juan de Borja, the son of the saint, but his great-grandson Don Juan Henríquez de Borja, the Marquis of Alcañices.

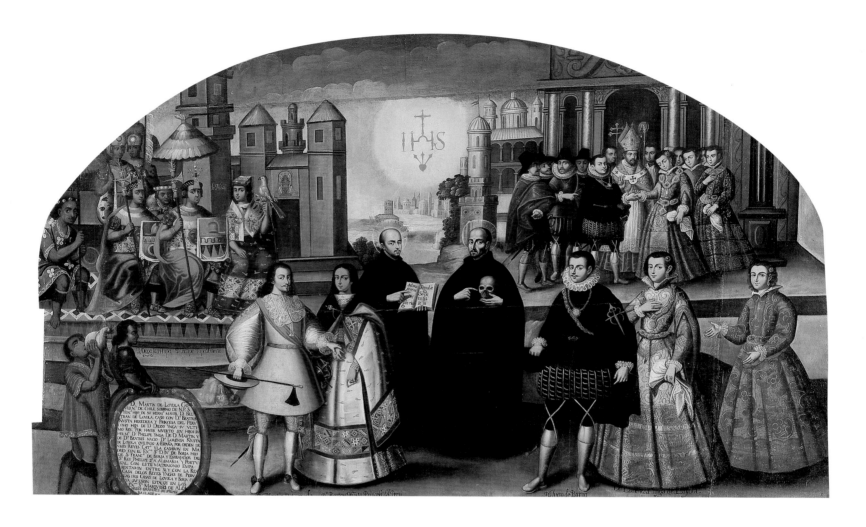

Whatever the historical facts, two details enhance the programmatic message of the canvas: In the center of the composition are Saint Ignatius of Loyola, with the book of the Constitutions of his rule open at the words *Ad majorem Dei gloriam* (To the greater glory of God), and Saint Francis Borgia holding a skull, to which he points with his finger, an allusion to the *Spiritual Exercises* of Saint Ignatius. The solar disk in the firmament—an ancient symbol of the empire of the Incas—now bears the letters *IHS*, the initials of the name of Jesus, a distinctive sign of the Jesuit order and their mission of Christianization.

Several copies of this painting were made to be exhibited publicly at certain privileged locations: the cathedral of Cuzco, the Jesuit churches in the same city and in Arequipa, the Franciscan establishment of Our Lady of Copacabana for noble Indians in Lima, and elsewhere. During specific festivities every year these marriage ceremonies were dramatized in "live" performances in the forecourt of the Jesuit church in Cuzco. In 1741, however, according to the chronicler Diego de Esquivel y Navia, the city of Cuzco censured the tradition and discontinued it, describing

it as "puerile." Nonetheless, when Friar Francisco del Castillo Andraca y Tamayo (d. 1720), better known as the "blind man of the Mercedarian monastery" in Lima, wrote his *Loa a la Conquista del Perú* (*In Praise of the Conquest of Peru*) for the festivities organized by the Indians to celebrate the coronation of the Catholic monarch Fernando VI, he did not hesitate to describe the marriage between Martín de Loyola and the Ñusta Beatriz as the greatest symbol of the political identity of the viceroyalty, an expression of the inseparable union of the bloodlines of the kingdoms of Peru and Spain.

Ramón Mujica Pinilla

Dolores, ansias sin cuento Aqueste horrible tormento, Hogueras, hornos, bol Canes, A tu gusto amargas yeles,
Bolcanes, garfios, cadenas, Con la gran pena de daño, Bronses, yerros abrasa dos, De vívoras y dragones,
Aunque son crueles penas No Seran penas de un año, Todos son Fuegos pintados, Sapos, Sierpes y escorpiones,
No son el mayor tormento Siglos duraran Sin cuento Con las llamas Infernales, Te daran verdugos crueles,
No ver à Dios ni un momento Sin alivio de un momento Los torpes y Sensuales, Side pensar lo te dueles,
Esta esla pena sin par; Eternamente he de estàr, A qui rabiando han de estar, Como lo pod ras pasar,
Yen aquesta obscura Carcel Yen el fuego deeste Ynfierno Yen à que este horrible Fuego Pue Con Fuego del ynfierno
sin Dios, y Sin fin penar. Para Siempre he de rabiar. Para Siempre han de penar, Por Fuersa lo has de tragar.

VI-92 A Condemned Man in Hell

Cuzco, Peru

Eighteenth century

Oil on canvas

59¹⁄₁₆ × 48¹⁄₁₆ inches (150 × 122 cm)

Inscribed on band: *Ay de mi, que ardiendo quedo, ay que pude y ya no puedo, hay que por siempre he de arder, ay que a Dios nunca he de ver;* along bottom: *Dolores, ansias sin cuento Aqueste horrible tormento, hogueras, hornos, volcanes, a tu gusto, amargas yeles. Bolcanes, garfios, cadenas [. . .] Por fuerza lo has de tragar*

Convento de la Merced, Cuzco, Peru

PUBLISHED: Mesa and Gisbert 1982, vol. 2, no. 543; Mujica Pinilla 2002 "Arte," pp. 244–45

FROM THE END OF THE SIXTEENTH CENTURY, when those teaching Catholic doctrine to the Indians discovered the powerful role of figurative art as a tool for evangelization, the iconography of Hell became a powerful weapon in encouraging morality and combating vice and sin. It became common for preachers of the various orders to use paintings as visual supports for their sermons. According to the chronicler of the city of Cuzco, Diego de Esquivel y Navia (d. 1779), the Spanish Augustinian priest Elías de la Eternidad, who arrived in Peru in 1630, used the terrifying iconography of damned souls as a rhetorical device for describing "the dreadfulness of Hell's eternal sufferings, and as he spoke he would hang from his pulpit a painting depicting a condemned soul burning in scorching flames." Esquivel y Navia describes how in 1739 four Spanish Franciscan missionaries arrived in Cuzco after having preached for nine years in various cities in Peru. The principal preacher was Friar José de San Antonio, who preached "dramatized sermons" in several churches in Cuzco. When it was his turn to preach for four days in the Mercedarian church, he showed the faithful a canvas depicting a damned soul burning in hell, an iconography that corresponds to this eighteenth-century painting conserved in the Convento de la Merced in Cuzco.

The same iconography was to be found in New Spain, and in fact the common iconographical source for the sufferings of Hell were some engravings published in 1719 in Puebla, Mexico, as part of a work entitled *El infierno abierto: al christiano para que no caiga en el . . . (Hell Opened*

Up: to the Christian so that he may not fall into it . . .) by the celebrated Italian Jesuit Pablo Señeri (1624–1694). As could also have been seen in the image of Hell in the Casa de Ejercicios (House of Spiritual Exercises), which was established in Lima in 1753 by the Company of Jesus, each "punishment" of Hell could be employed as one stage of a program of spiritual "meditations": the "punishment of imprisonment" was depicted as a burning soul bound in chains; the "worm of conscience" was visualized as a condemned soul with an iron fetter around his neck being bitten on the chest by a serpent; the "punishment of Hell" was a damned soul with his hair standing on end and a dragon wrapped around his body while a second dragon prepares to swallow him, and so on.

Ramón Mujica Pinilla

ESTE LIENZO DEL PATROSINO DE MI S.ᵣ S. IOSEPH, LOMANDO HASER EL D. D. BERNARDO LOPES ED SAGVES ANO DE 1737

VI-93 Gaspar Miguel de Berrío†

(Bolivian, 1706–c. 1762)

The Patronage of Saint Joseph

1737
Oil on canvas
77³/₁₆ × 99⁷/₁₆ inches (196.1 × 252.6 cm)
Inscribed in cartouche at bottom center: *SVB VMBRA ILLIVS QVEM DESÍDERAVERAM SEDI. Gaspar Berrio me fecit.*; along bottom: *ESTE LIENZO DEL PATROSINO DE MI S.ʳ S.ⁿ IOSEPH, LOMANDO HASER EL D.ʳ D.ⁿ BERNARDO LOPES ED SAGVES AÑO DE 1737*
Museo de la Casa Nacional de Moneda, Fundación Cultural BCB, Potosí, Bolivia

PROVENANCE: Convent of Santa Mónica

PUBLISHED: Mesa and Gisbert 1977, pp. 232–34, figs. 255, 256, 259; Querejazu and Ferrer 1997, p. 47, fig. 12

EXHIBITED: New York 1997, p. 47, fig. 12

THE MOST IMPORTANT WORK by Gaspar Miguel de Berrío, an artist from Potosí, this signed canvas from 1737 was formerly in the convent of Santa Mónica and is now in the Casa de Moneda in that city. The canvas, commissioned by Bernardo López de Sagues, is a glorification of Saint Joseph, whose cult was promoted by Saint Teresa of Ávila. In the manner of medieval Virgins of Mercy, it shows Saint Joseph enfolding various saints in his cloak. The lower part of the painting thus represents the

terrestrial realm, where we can see the Four Evangelists, the Four Latin Doctors of the Church (Saints Gregory, Jerome, Ambrose, and Augustine), and the founders of the religious orders. This part of the painting is executed in the style of Melchor Pérez Holguín, a master who was active when Berrío was a very young man and who undoubtedly influenced his work. Above Joseph's cloak are choirs of angels with musical instruments widely used in South America, such as the guitar, violin, harp, and organ. Above an inscription referring to the "house of the Lord" (*casa del señor*) is a cloud of glory with the Trinity in the center, represented by three identical anthropomorphic figures. Flanking them are Mary and Saint John the Baptist, the Virgin's parents, and two archangels, Michael and Gabriel. Instead of the customary stem of lilies, Gabriel holds a ring, symbol of the matrimony of Mary and Joseph. This part of the painting has the traditional decorative gilding found in Cuzco painting.

Gilding may have been used by painters from this region to depict the heavens and scenes from the celestial realm. This would explain the difference between the lower, ungilded part of the painting and the upper part with its splendid gilding. The painting is brilliantly executed with bright, pure colors, while the precise drawing recalls fifteenth-century Flemish art.

Berrío's composition was notably successful in its day, and the artist painted another version, signed and dated 1744, which is now in the Museo de Bellas Artes de Santiago de Chile. Variations from the Potosí version include four angels instead of the two seen here, and a lack of gilding. There is another composition of this subject by Berrío in the Museo Charcas in Sucre.

Teresa Gisbert de Mesa

VI-94, VI-95 João Francisco Muzzi

(Brazilian, active Rio de Janeiro, second half of the eighteenth century)

Fire at the Retreat of Nossa Senhora do Parto and *Reconstruction of the Retreat of Nossa Senhora do Parto*

c. 1789

Oil on canvas

Each, 44½ × 54⁵⁄₁₆ inches (113 × 138 cm)

Inscribed on verso: *Muzzi inventou e delineou*

Museus Castro Maya/IPHAN, MINC, Rio de Janeiro, Brazil

PROVENANCE: Collection of Ricardo Espírito Santo, Lisbon; acquired by Raimundo Ottoni de Castro Maia in 1942

PUBLISHED: Levy 1942, p. 74; Reis 1944, pp. 59–60; Ferrez 1965, pp. 46–47; Valladares 1978, figs. 397–404; Lemos et al. 1983, pp. 88–89; Pestana 1996, pp. 107–13; Trindade 1998, pp. 260–61; Sullivan 2001, cat. nos. 133–34

EXHIBITED: São Paulo 1998, pp. 260–61; New York 2001, cat. nos. 133–34

THE EPISODES DEPICTED IN THESE PAINTINGS are identified by inscriptions on the backs, which were covered when the paintings were relined but which had been photographed. They read, respectively: "Fatal and rapid fire that reduced to ashes, August 23, 1789, the church, its images, and the whole retreat of Nossa Senhora do Parto; only the miraculous image of Our Lady was saved, unharmed, from the fire" and "Fortunate and prompt rebuilding of the church and retreat of Nossa Senhora do Parto initiated August 25, 1789, and finished December 8 of the same year." These captions can also be found in a set of copies of these paintings, which used to be displayed in the church of Nossa Senhora do Parto. The copies, which are oval instead of rectangular, are signed by Leandro Joaquim while the originals are both inscribed "Muzzi invented and delineated."

The reconstruction of the retreat in a mere three months was exceptionally prompt. It must be kept in mind, however, that the capital of Brazil had been transferred from Salvador to Rio de Janeiro in 1763. Consequently, the city went through many transformations and improvements in the second half of the eighteenth century. João Francisco Muzzi and Leandro Joaquim were two of the painters of the period who produced visual records of these transformations. For example, the Passeio Público (a French-inspired, boulevard-like public park) was designed by the celebrated Mestre Valentim and inaugurated in 1785. Its scattered pavilions

were decorated with paintings by Leandro Joaquim depicting a number of the most prominent buildings and monuments of the city. Muzzi's paintings also produced visual records of the transformations the city was undergoing.

As these two paintings show, the Retreat of Nossa Senhora do Parto (Our Lady of the Delivery) was an edifice of considerable size. It had been built in 1742 to give shelter to women in need of support, particularly single mothers who repented of their less-than-virtuous past. Some of them can be seen in the first painting, throwing belongings out the windows and running away from the burning building, while soldiers and firefighters use their engines to try, in vain, to put out the flames. The city's general climate promoting reconstruction, as well as the retreat's social function—certainly furthered by the miraculous rescue of the image of the Virgin—no doubt contributed to the personal involvement of the viceroy D. Luís de Vasconcelos e Sousa, a resident of Rio. He is depicted in white wig, red jacket, and black pants, commanding the operations in the first painting, and again—thwarted in the attempt at salvage but not in his industriousness—discussing the project for the new building in the second. The architect presenting the new project is Mestre Valentim, a man of many talents. Behind him, construction materials are already in orderly stacks, and groups of workers are ready to engage in their tasks of reconstruction.

It is fitting that Muzzi recorded this event. Very little is known about him. His name suggests an Italian origin, and he has been said to have been a disciple of José de Oliveira Rosa, the first painter known to have been born in Rio. Muzzi designed sets for the theater and made botanical drawings for the viceroy, so his relationship to D. Luís had already been established when the burning of the retreat took place. It is very likely that it was the viceroy himself who commissioned the paintings—the only ones by Muzzi known today—which were designed to celebrate not only a construction work of public utility attached to the viceroy's initiative but also one that testified to his capacity for prompt intervention. As a form of celebration once the new building was finished, a procession piously walked the streets of Rio, bringing the image of the Virgin back to its church from the Franciscan convent where it had been kept in the interim.

It is also likely that the viceroy commissioned the oval copies from Leandro Joaquim so that these could be left in Rio while the originals traveled to Portugal with him after his tenure was completed. This would explain the fact that they were acquired from a Portuguese collector before they made their way back to Brazil.

Nuno Senos

VI-96 *The Divine Shepherdess*

Quito, Ecuador
c. 1780
Oil on canvas
61⅛ × 38¼ inches (155.3 × 97.2 cm)
Signed at lower right: *Jph Antt° mef*
Collection of Marilynn and Carl Thoma

PROVENANCE: Sotheby's, New York, Latin American Art auction,
May 18–19, 1993; Collection of Frederick and Jan Mayer, Denver,
Colorado; Valery Taylor Gallery, New York, 1997

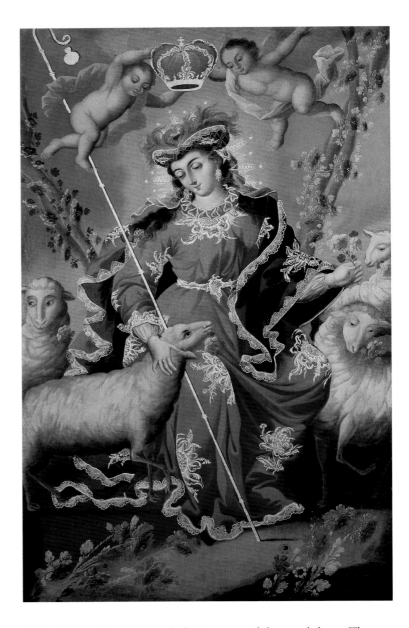

IT IS SAID THAT THE VIRGIN dressed as a shepherdess appeared to the
Capuchin monk Isidore of Seville in 1703. He commissioned a painting
of the subject from Alonso Miguel de Tovar (1678–1758), to whom he
dictated precise iconographical details: the Virgin Mary was to be shown
in the center of the composition, seated on a rock under a tree. She was
to wear a red gown, a blue mantle, a hat appropriate to a shepherdess,
and have her crook nearby. She should be pictured feeding roses to sheep.
In the distance is a sheep chased by a wolf. When the sheep utters the
words "Ave Maria" (expressed through a banderole emerging from its
mouth), the archangel Michael appears from the heavens with his shield
and spear to kill the satanic creature. There are many versions of this
subject in Spanish colonial art: the cult spread rapidly, and sculptures,
paintings, engravings, and medals offering the image of *La Divina Pastora*
proliferated.

In this painting the sheep dutifully hold sprigs of roses in their
mouths, as Isidore dictated, "symbolic of the Hail Mary with which they
venerate her," but the anecdotal details are not included. Mary appears as
a sophisticated porcelain doll, elaborately dressed in brilliant red and blue
with a plumed hat, her tunic and mantle embroidered in gold and edged

with gold lace. Her flock is a balletic quartet of sloe-eyed sheep. The
artist's skill is shown to good effect in the brushy treatment of the flowers
and his masterly treatment of the gold *brocateado*, which he has forced
to follow the shapes created by the folds in the Virgin's garments.

This painting reflects the rococo palette and delicacy of brushwork
introduced to the Quito school by Bernardo Rodríguez and Manuel de
Samaniego in the late eighteenth century. Although the author of the
painting has not been identified, he was probably active in one of the
prolific Quito workshops that produced paintings and sculptures not only
for the Spanish and Creole elite of that city but for collectors in Lima and
Santiago de Chile, and, closer to home, for Pasto, Popayán, Cali, and
Santa Fe de Antioquia (present-day Colombia).

Suzanne Stratton-Pruitt

VI-97 *The Virgin Mary and the Rich Mountain of Potosí*

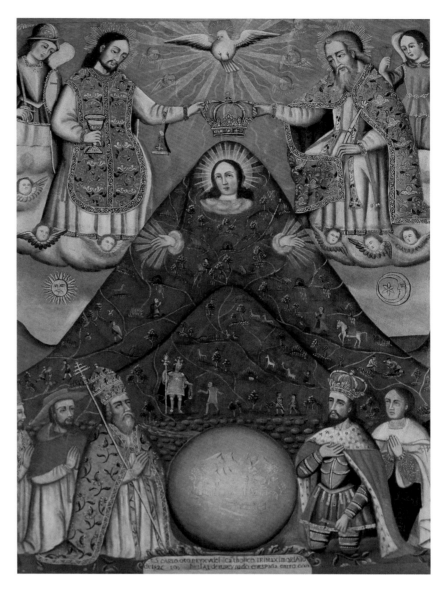

Potosí, Bolivia

c. 1740

Oil on canvas

68⅞ × 53⅛ inches (175 × 135 cm)

Inscribed at the lower center: S.S. ATD. Qto. REY XV DEL CATHOLICO Y.E. MAXIMO DEL AÑO DE 1520 . . . AL DE SU REYNADO EN ESPAÑA ENTRO CON . . .

Museo de la Casa Nacional de Moneda, Fundación Cultural BCB, Potosí, Bolivia

PROVENANCE: Casa de Moneda, Potosí, Bolivia

PUBLISHED: Gisbert 1994, pp. 17–22, ill., and fig. 2; Ramos Gavilán 1988, pp. 154, 184; Vandenbroeck and Zegher 1991, p. 145; *Bride* 1992, p. 145; Kagan 2000, pp. 195–98, fig. 6.37; Phipps et al. 2004, cat. no. 80; Stratton-Pruitt 2006

EXHIBITED: Antwerp 1992, p. 145; New York 2004, cat. no. 80

THE IMAGE OF THE VIRGIN of the Rich Mountain, the "Cerro Rico" of Potosí is found in several versions, most notably this one and another in the Museo Nacional de Arte in La Paz. At the foot of the mountain in this version are the Emperor Charles V (r. 1519–1596), Pope Paul III (r. 1534–1549), a cardinal, a bishop, and a member of the order of Alcántara. Scattered over the surface of the mountain are details telling the story of the discovery of silver on the mountain by a *ladino* (Spanish speaking) Andean named Gualpa while chasing after his escaping llamas.

Literary sources have led to two interpretations of the composition. Alonso Ramos Gavilán, in his *Historia del célebre Santuario de Nuestra Señora de Copacabana* (1621) states that just as the sun sends its rays down to earth to benefit humanity, so God sent Mary. Hence, the identification of the Virgin with the Earth, and by extension with mountains. In a letter of 1559 by the Jesuit Arriaga, he says that the Indians worshipped the Cerro Rico of Potosí: "From time immemorial [the Indians] have held a strange devotion [for the mountain], going there to make their offerings and sacrifices and consulting the devil over their doubts." This may suggest an identification of the Virgin, Queen of Heaven (as she is depicted in this painting) with the Pachamama, a universal, female goddess of the Incas.

Other literary sources suggest a quite different reading of the painting. Two later chroniclers (Luis Capoche and Bartolomé Arzáns de Orsúa y Vela) reported that the Inca Huayna Capac had ordered his army to mine the silver from the mountain, but they were dramatically stopped by a great voice threatening them not to touch the silver, as it properly belonged to other masters. When the silver mountain was discovered in 1547, it was mined by the Spanish, the masters for whom the silver was supposedly intended all along. Thus, the silver deposits found in Peru are linked in this painting with the Spanish Monarchy's apostolic (Pope Paul III) and missionary (Charles V) ideals. The painting, in this reading, is a historical allegory of Divine Providence intervening to preserve the Cerro's riches for the Spaniards, to whom Gualpa reported his discovery despite arguments from the *curaca* Chaqui Catari, who advised him instead to tell the Incas.

Teresa Gisbert de Mesa

VI-98 Luis Niño[†]

(Bolivian, active Potosí, c. 1730s)

The Virgin of the Rosary with Saint Dominic and Saint Francis of Assisi

c. 1737
Oil on canvas
37¹³⁄₁₆ × 29¹⁵⁄₁₆ inches (96 × 76 cm)
Museo de la Casa Nacional de Moneda, Fundación Cultural
BCB, Potosí, Bolivia

PUBLISHED: Querejazu and Ferrer 1997, fig. 11; Querejazu
1999, pp. 7–16

EXHIBITED: New York 1997, fig. 11

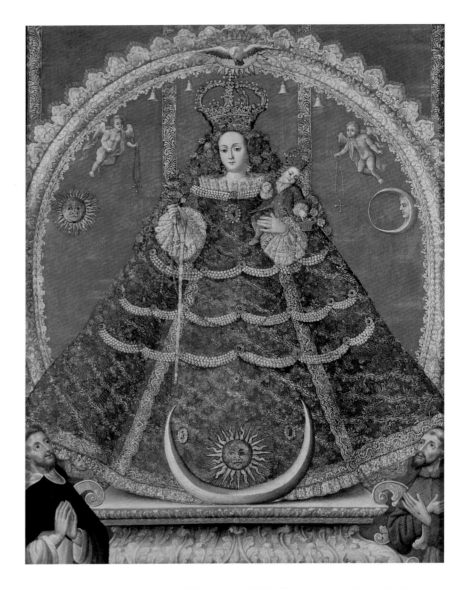

THIS PAINTING IS BY THE INDIGENOUS ARTIST Luis Niño, who worked in Potosí around 1737. It depicts the sculptured image of Our Lady of the Rosary that the Spanish Crown sent to the church of Santo Domingo in Potosí in the sixteenth century, and which also provided the model for Francisco Tito Yupanqui's *Virgin of Copacabana* (1583). The painting is characteristic of the style of Niño, a Potosí artist who also painted the *Virgin of Sabaya* now in the same museum. On that signed work, Niño states that he is a "sculptor, painter, and goldsmith."

This canvas deploys a style notably different from that of Melchor Pérez Holguín, as it pays great emphasis to minute detail. Niño reproduces an idealized image, dressed in seventeenth-century fashion, on a silver base and with a silver arch, both elements possibly made by the artist himself. Like the two versions of the Virgin of Sabaya also painted by Niño, the head of this Virgin of the Rosary is adorned with flowers. At the base of the image are Saints Dominic and Francis, founders of two closely associated religious orders established in the Middle Ages. The Dominicans focused on theological teaching and the Franciscans on giving assistance to the poor. Two small, nude angels at the level of the Virgin's head can be seen in almost all of Niño's paintings, such as the *Virgin of the Victory of Málaga* (Denver Art Museum) and the *Virgin of the Rosary* (Museo del Bellas Artes, Lima), as well as in the present work.

Luis Niño worked for the sizable indigenous population in Potosí, and we know that he painted for those of Carangas (Oruro) and probably for other groups of *mitayos*. For this reason his art responds to a different aesthetic than that found in the work of Holguín, an artist trained under the precepts of the Sevillian school. Niño made frequent use of decorative gilding, although the Virgin in this painting does not have it. He worked in a precisely detailed and decorative style, comparable to that of the late work of his contemporary Gaspar Miguel de Berrío.

The sun and the moon—symbols of the Immaculate Virgin—appear twice in this painting, to either side of the Virgin and beneath her feet, perhaps a nod to the beliefs of indigenous worshippers.

Teresa Gisbert de Mesa

VI-99 Our Lady of the Rosary of Pomata

Cuzco, Peru
c. 1680–1710
Oil on canvas
83⁷⁄₁₆ × 58⅛₁₆ inches (211.9 × 147.5 cm)
Inscribed at bottom center, on a tablet: *NVESTRA SE/ÑORA DL ROSA/RIO DE POMATA ¡OJO! FALTA LE "E" QUE ESTÁ SOBRE PUESTA EN LA D. ESO NO ES POSIBLE PARA MI, PERO SI PARA USTEDES*
Convento de Santa Clara, Huamanga (Ayacucho), Peru

PUBLISHED: Mujica Pinilla et al. 2003, vol. 2, p. vi; *Perú indígena* 2004, cat. no. 216, p. 223

EXHIBITED: Barcelona, Madrid, and Washington 2004, cat. no. 216

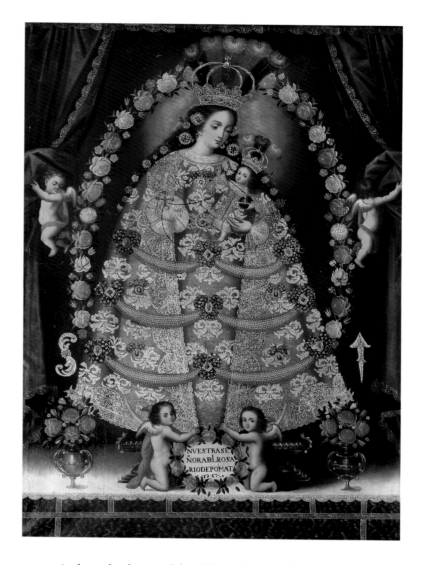

"DIVINE TRICKS," or statue paintings of religious images, were among the most effective means of spreading religious devotion in the Andes region. Thanks to an iconographic ambivalence that juxtaposed realistic elements with those that appeared to be supernatural, the genre helped underline the miracle-working powers of sacred images. From this tradition flowed an abundance of canvases on the theme of the Virgin of the Rosary of Pomata, an effigy carried by Dominican missionaries in 1595 to the *doctrina* (Indian community converted to Christianity) of the same name, located on the Collao plateau. The propagation of the worship of this effigy formed part of an intensive campaign of religious instruction undertaken by the order among the Aymara people of the area. In subsequent years, news of the miracles worked by the Virgin among the miners and merchants traveling the "silver road" spread through the entire Andes region, and the multitude of devotees demanded "true portraits" that would allow them to invoke her protection at a distance. By 1681 Friar Juan Meléndez, chronicler of the Dominican order, was making reference to the countless wonders "that, upon her invocation and presence, with her measures and her image, have been wrought" (vol. 1, p. 620).

By then, the iconographic canons of this Virgin were fully established, as can be seen in this remarkable Cuzco painting—possibly dating from the end of the seventeenth century—which can be attributed to one of the indigenous masters of the day. Among its generic attributes, the most obvious is the rosary, but in this case we also see, to the left of the Virgin, the "talking symbol" in the shape of an S and, to the right, a *clavo*, or spike (*esclavo*, or slave), the latter a semantic allusion to being a slave of Mary as professed by the members of certain religious brotherhoods like that of the Rosary. The artist used the same gilding to suggest the richness of lace and brocade on the Virgin's triangular mantle. The abundance of roses—in the garland, around the tablet, and on the altar—not only alludes to the mysteries of the rosary, in keeping with European tradition, but may also be a reference to the recent canonization of Saint Rose of Lima in 1671. That event was perceived as a political triumph for Creole society as a whole, which thereby sought to exalt its merits as a completely evangelized realm while at the same time highlighting its distinctness in relation to the Old World.

This purely local significance was reinforced by a specific attribute that made the Virgin of Pomata easily distinguishable from other, similar religious devotions: the colored feathers she and the Baby Jesus always wore on their crowns. Although European exegetical tradition, embraced by the preachers of Cuzco at the time, associated the figure of Mary with the ostrich and its plumage, the great red, white, and green plumes used here to symbolize the three theological virtues—faith, hope, and charity—seem to have come from the *zuri*, a mythical bird of pre-Hispanic origins. This lends a certain indigenous look to the Virgin, which nonetheless was never questioned by church authorities. In fact, the painting's presence in the Huamanga convent of the order of Santa Clara attests to the appreciation the communities of nuns had for these types of images, and may also explain the traditional bond between the Dominican and Franciscan orders.

Luis Eduardo Wuffarden

VI-100 Gregorio Vásquez de Arce y Ceballos[†]

(Colombian, 1638–1711)

Saint Thomas of Aquinas with Heretics Underfoot

c. 1680–90
Oil on canvas
51⅝ × 38⅝ inches (131 × 98 cm)
Inscribed on banner held by putti: *Pangeling . . . vaglo . . . riosi corporis misterium sanguinas que presiosi quem in mundi preti . . . VM*; above heretic's head: *PELAGIO*; on heretic's book: *CALVINO*
Navas Collection, Bogotá, Colombia

PROVENANCE: Church of Santo Domingo, Bogotá; Pedro Navas Pardo, Bogotá; Navas S., Bogotá

PUBLISHED: Groot 1859; Pizano Restrepo 1926/1985, pp. 180–82, no. 134; Mendoza Varela 1966, p. 25

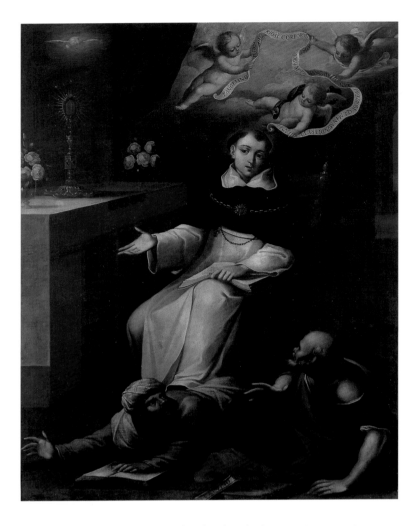

THE SACRAMENT OF THE EUCHARIST was the subject of the Thirteenth Session of the Council of Trent (1545/63). Its canons affirmed that it is "heretical to deny" the Venerable Sacrament and established the celebration of the feast of Corpus Christi as a "triumph over heresy." The Spanish Habsburg monarchs considered themselves ordained defenders, against the Protestants, of the belief that the actual body and blood of Christ were present in the bread and wine of the Eucharist, and missionaries in the Americas championed Communion as the triumph of Christianity and the Crown over the pagan religions of the New World.

In Vásquez's painting, Saint Thomas of Aquinas (1225–1274), the Dominican philosopher and theologian, appears as a vanquisher of heresy and defender of the Eucharist. Aquinas is represented conventionally in the black-and-white habit of his order and with a rosary and his characteristic tonsure. The book in his lap and the golden sun above are both emblematic of his position as a teacher of doctrine. The subject of Aquinas defeating the heretics is inspired by the fourth book of his *Summa Contra Gentiles* (1259–64), in which he refuted those who questioned the miracle of the Eucharist and adopted the term "transubstantiation." The turbaned, scholarly figure beneath Aquinas's foot, whose fingers trace an open book, is traditionally identified as the Muslim philosopher Averroes (also called Ibn Rushd; 1126–1198), whose commentaries on Aristotle had led many Medieval "unbelievers" to heretically question the Eucharist and other Church doctrines.

The gold monstrance on the altar beside Aquinas is suggestive of the many exquisite *custodias* (monstrances for Eucharistic wafers) in viceregal New Granada—including such masterpieces as the bejeweled "La Preciosa" by Nicolá de Burgos y Aguilera (c. 1736; cat. III-18) and "La Lechuga" by José de Galaz (1707; cat. III-17). Costly monstrances, the special importance of the Corpus Christi festival (above all, in Cuzco), and the popular iconography in painting of the defense and triumph of the Eucharist (by figures such as the Spanish king and Saints Rose of Lima, Thomas of Aquinas, and Francis of Borgia) testify to the widespread devotion to the Eucharist in viceregal South America, Mexico, and the Caribbean.

Vásquez's painting employs a subtle and metaphorical chiaroscuro, in which divine light radiates from heavenly angels, the Holy Spirit, the Host, and Aquinas himself to overpower the heretics who emerge out of literal and spiritual darkness.

Alicia Lubowski

VI-101 Gregorio Vásquez de Arce y Ceballos[†]

(Colombian, 1638–1711)

Saint Dominic with the Banner of the Order

c. 1680–90
Oil on canvas
52¾ × 40¹⁵⁄₁₆ inches (134 × 104 cm)
Inscribed under the saint's feet: *Mundum calcans sub pedibus etc* [*manus misit ad fortia*]; at left: *Frma Preuis catuli Pauper fulsit Dominic;* around the saint's head: *Fulque in choro* VILGINUM *un doctor veritatis;* in background: *Peste fugat heretica;* right side: *Ter libellus in flamma mis ter exibit illes, penit*
Navas Collection, Bogotá, Colombia

PROVENANCE: Church of Santo Domingo, Bogotá; Pedro Navas Pardo, Bogotá; Navas S., Bogotá

PUBLISHED: Mendoza Varela 1966, pl. 28; Pizano Restrepo 1926/1985, p. 182, no. 137, p. 246

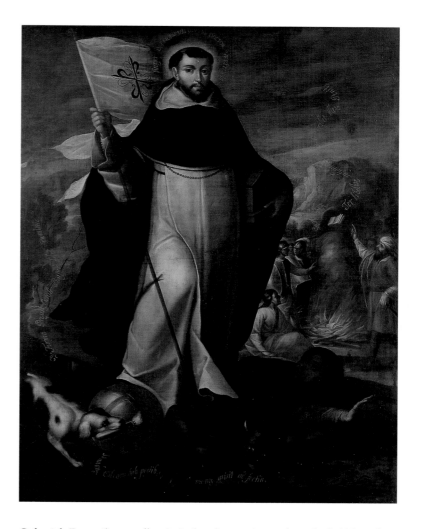

DURING THE DECADE OF THE 1680S, Gregorio Vásquez de Arce y Ceballos produced more than thirty large-scale paintings to decorate the great church and monastery of the Dominican order in Santa Fé de Bogotá (his contract was eventually cancelled when one of his disciples offered to produce works at a lower price). Founded in 1577 and completed in 1630 thanks to the initiative of Friar Alberto Pedrero, Santo Domingo was the oldest monastery in the city. Following devastation caused by a fire of 1761 and the earthquake of 1785, the monastery was reconstructed in a neoclassical style in 1817 by Friar Domingo de Petrés. The Dominican church and monastery were completely demolished between 1939 and 1940, but the original church's facade and cupola can be seen in the background of Vásquez's painting *Abbot Joachim of Fiore Delivering the Portraits of Saint Francis and Saint Dominic* (cat. VI-102).

Vásquez portrays Saint Dominic of Guzman (c. 1170–1221), the founder of the Dominican Order, the Order of Preachers, combating a number of heresies while armed with the Dominican standard, a rosary, and a replica of the Church. Dominic created the order with the intent of fighting heresy and spreading the light of the Faith throughout the world, the latter symbolized in the painting by the globe and the former by the burning torch in the mouth of the dog, which represents the order; the star on the saint's forehead represents the *Lumen Ecclesiae* (light of the church). Dominic is closely associated with the foundation of the Inquisition in 1233 by Pope Gregory IX (1170–1241), and the Dominicans were especially active in the work of that institution.

Gutiérrez portrayed Saint Dominic in several drawn studies of heads (Museo de Arte Colonial, Bogotá) and paintings—including, for Bogotá's Dominican monastery, the episode of *Saint Dominic's Investiture by the Virgin* (1690), *Saint John the Evangelist and Saint Dominic* (1680; private collection), and *The Birth of Saint Dominic* (1684; Museo de Arte

Colonial, Bogotá), as well as in isolated portraits, such as the half-length images for the chapel of Sagrario, Bogotá, and the church of Saint Francis, Bogotá. Gutiérrez also depicted the founding saints of the Franciscan, Agustinian, and Jesuit orders, including a *Saint Ignatius with the Red Banner of the Jesuit Order* (1686; church of San Ignacio, Bogotá).

Under Dominic's feet lies a vanquished devil and a woman personifying carnal sin. In the background, the artist depicts the expulsion of the heresy of the thirteenth-century Cathari (the pure ones), known as the Albigenses in southern France, as their libelous tenets burn in flames. Pope Innocent III (1198–1216) ordered a great crusade against the Cathari (begun in 1209 by the King of France), and fierce measures were taken to persecute the sect. Members of the Cathari were massacred by crusaders, as in the violent fall of the city of Béziers, France (July 22, 1209), and sentenced to death under the Inquisition. Dominic was active during the Albigensian war, purportedly merciful in his routing out of heresy, and is credited with safeguarding the victory of the orthodox Church. In the context of New Granada, the founding saint's fight against heresy would resonate with the Dominican Order's proselytizing of the native indigenous populations.

Alicia Lubowski

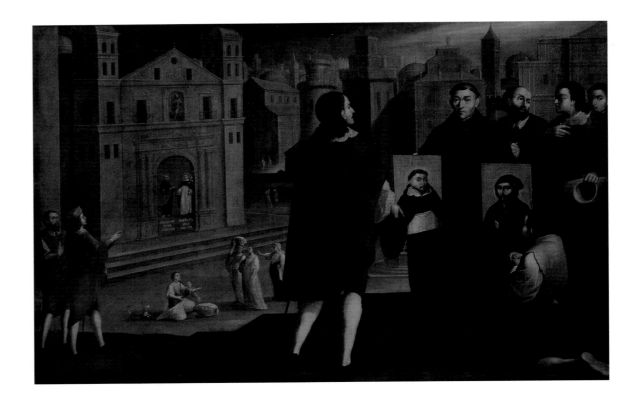

VI-102 Gregorio Vásquez de Arce y Ceballos[†]

(Colombian, 1638–1711)

Abbot Joachim of Fiore Delivering the Portraits of Saint Francis and Saint Dominic

c. 1680
Oil on canvas
81⅞ × 124 inches (208 × 315 cm)
Museo de Arte Colonial/Ministerio de Cultura, Bogotá, Colombia

PROVENANCE: Convento de Santo Domingo, Bogotá; following the government decreed secularization of 1861, this building and its collections became part of the National Museum; reorganized in 1942 under the Museo de Arte Colonial de Bogotá

PUBLISHED: Groot 1859; Pizano Restrepo 1926/85; Gil Tovar 1980; *America, Bride of the Sun* 1991, cat. no. 68, p. 293; *Arte y fe* 1992, cat. no. 26; Schenone 1992, vol. 1, pp. 264, 336–37; Fajardo de Rueda 1994, pp. 618–19; Mujica Pinilla 2002 "Arte," pp. 226–27; Fajardo de Rueda 2004, pp. 236–58

EXHIBITED: Bogotá 1886, cat. no. 20; Antwerp 1992, cat. no. 68; Bogotá 1992, cat. no. 26

THIS PAINTING IS A WORK by Gregorio Vásquez, the most important painter of the colonial period in New Granada (Colombia). His models, as is the case with all colonial artists, were generally derived from the European engravings that reproduced some of the most renowned baroque paintings of the Catholic courts. This particular work depicts the Calabrian prophetic mystic Joachim of Fiore (c. 1130–1202), whose apocalyptic writings were widely disseminated throughout Latin America during the first centuries of conquest and colonization. "Giacomism" is closely linked to the series of lives written by Joachim of Fiore about Saint Francis and Saint Dominic. The writer states that "two angelic figures would soon appear to found the order of monks of the final days." Thus, the followers of these two saints during the thirteenth and fourteenth centuries in Europe, and somewhat later in Latin America, viewed them as the spiritual founders of the order.

This work was probably part of a series dealing with the life of Saint Dominic, for which Gregorio Vásquez was commissioned by a religious order in 1680. The cycle of paintings was unfortunately never completed, and only a few canvases are preserved to this day. These include the first in the series, *Saint John the Evangelist Predicts the Coming of Saint Dominic*, which portrays Saint John at Patmos during a vision of the winged Saint Dominic floating, enveloped in a red halo.

With regard to this painting of Joachim of Fiore, the Argentine art historian Héctor H. Schenone believes that the composition was taken from a print. The scene takes place in an open square, probably in Venice, with the facade of a church at the left. On the right side is a group of men centered around a Benedictine monk (identified by the traditional black cowl and habit) who holds two portraits of the "anticipated ones" (since they had not yet been born)—Saint Dominic and Saint Francis—before they are hung on the doors of the sacristy at San Marco. One of the men has fallen to his feet in veneration of the images.

This work was previously known as "The Painter Vásquez Delivering the Portraits of Saint Francis and Saint Dominic to the Augustinians," a name given to the painting sometime in the nineteenth century, without any justifiable basis.

Marta Fajardo de Rueda

VI-103 Juan Pedro López[†]

(Venezuelan, 1724–1787)

Frame by Domingo Gutiérrez

(Venezuelan, born Canary Islands, 1709–1793)

Virgin of the Immaculate Conception

c. 1765–70

Oil on canvas; gilded cedar frame

61 × 39¾ inches (155 × 101 cm)

Banco Mercantil, Caracas, Venezuela

PROVENANCE: Charles Röhl, Caracas; Charles Rojas Röhl, Caracas; Henrique Röhl MacDermott, Caracas; Arnold Zingg, Caracas

PUBLISHED: Duarte 1977, pl. 32; Duarte 1996, pp. 161, 267

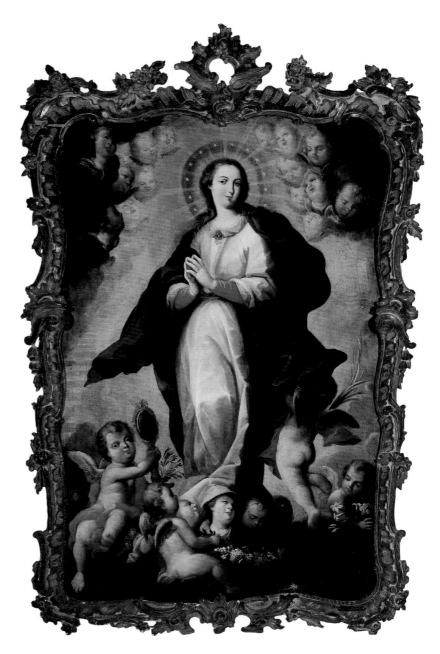

ECONOMIC AND SOCIAL UPHEAVAL on the Canary Islands in the late seventeenth century sparked the emigration of a large contingent of islanders to the Spanish territories of South America. This human tide continued through most of the next century. The Caribbean was one of the final destinations of the migratory current, and places like Cuba, Santo Domingo, and Venezuela accepted a good number of Canary Islanders. Domingo Gutiérrez, a native of La Laguna, on the island of Tenerife, emigrated to the American continent in the early decades of the eighteenth century. He settled in Caracas, where he married in 1730 and became widely renowned as a master cabinetmaker. He won numerous commissions to create work for churches, convents and monasteries, and private residences before his death in 1793. Gutiérrez introduced the formal repertoire of rococo to Venezuela, breaking with the strict dictates of Spanish baroque that had been the dominant style until that time.

Toward the middle of the century, the carver established a fruitful and lasting collaborative relationship with the painter, sculptor, and gilder Juan Pedro López when he was just beginning his career. The collaboration lasted until the death of the painter in 1787. A significant number of Gutiérrez's pieces were gilded and polychromed by López. Other of Gutiérrez's works include paintings by López, as does the altarpiece of the Orden Tercera in the church of San Francisco, Caracas. In addition, many of Juan Pedro López's most important paintings are graced by Gutiérrez frames, such as this work painted between 1765 and 1770. The sophisticated frame perfectly complements and, to a degree, completes the painting. The barely symmetrical, gentle undulation of the inner contour of the frame softens the rigidity of its rectilinear border and echoes the movement of clouds, cherubs, and the draped folds of the Virgin's cloak, lending a graceful dynamism to the pictorial composition. A delicate decoration of fretwork and carved rocaille with foliage, floral motifs, and cabochons adorns the outer edge of the frame and serves as a transitional element from the flat surface of the wall where the painting hangs.

Jorge F. Rivas P.

VI-104 Attributed to Cristóbal Lozano

(Peruvian, d. 1776)

Doña Rosa María Salazar y Gabiño, Countess of Monteblanco and Montemar

c. 1765–70
Oil on canvas
37¾ × 29¾ inches (96 × 75.5 cm)
Inscribed on the reverse: *La Sra. D.a Rosa Salazar y Gavino,*
Condesa de Monte Blanco
Collection of Roberta and Richard Huber

PROVENANCE: Simois Gestion de Arte, Madrid

PUBLISHED: Bailey 2005, p. 344, pl. 206

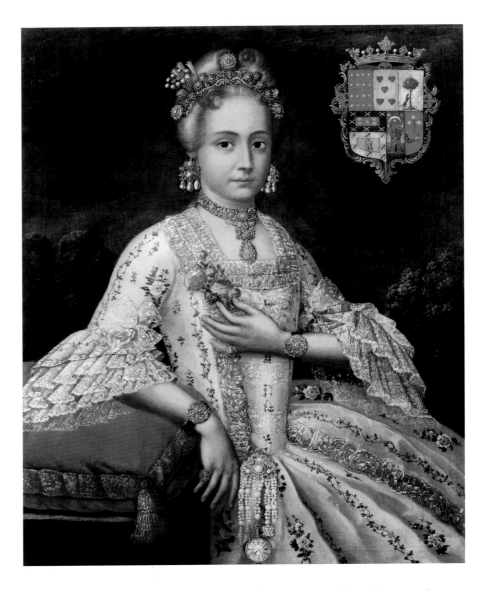

DOÑA ROSA MARÍA SALAZAR Y GABIÑO, the Countess of Monteblanco and Montemar, is here presented in the costume of the upper echelons of Lima society: a corseted gown of rose-colored silk, embroidered throughout with flowering-vine patterns. The floral motif is continued in the nosegay she pinches between her left thumb and forefinger. It is a delicate gesture and one that speaks of her sophistication and social standing. Her powdered hair is held in place by a series of pins and an elaborate tiara adorned with pearls and precious stones. Her jewelry also includes earrings, bracelets, rings, and a pocket-watch ornamented with gold charms of a griffin and a fish. Timepieces have often been mistakenly identified in colonial portraiture as *mementi mori*. As in most portraiture of viceregal Latin America, the countess's watch, of a type manufactured in England during the 1760s, is employed here primarily as a reminder of the sitter's wealth and social status.

Doña Rosa (Chincha 1749–Lima 1810) was the daughter of the first Count of Monteblanco, a wealthy colonial official from Burgos who became mayor of Lima in 1747 and was named a knight of the Order of Santiago in 1753 by Fernando VI. The countess's marriage to Don Fernando Carrillo de Albornoz y Bravo de Lagunas, the sixth Count of Montemar (1727–1814), which joined two of Lima's wealthiest families, would have been one of the most celebrated unions in eighteenth-century Lima. The coat of arms in the picture contains a conflation of both the Monteblanco and Montemar insignias, suggesting that the painting was commissioned around the time of the marriage, likely in commemoration of the event itself.

Unusual in viceregal-era portraiture, the picture's landscape setting reflects the French-inspired artistic taste of the Bourbon court in Madrid and its transferal to the New World. Most contemporaneous works elsewhere in the Spanish colonial world, such as those by Miguel de Herrera the Younger (active 1775–78) in Mexico (for example, *Portrait of a Lady*, Museo Franz Mayer, Mexico), depict female sitters in similar sumptuous attire but eschew this type of outdoor setting. In fact, the picture more closely resembles continental examples or contemporary out-of-doors portraits by such painters as the Puerto Rican José Campeche (1751–1809), who had direct knowledge of the work of Spanish court painter Luis Paret y Alcázar (1746–1799). The character of this portrait may be linked to the countess's and her husband's familiarity with European trends through the count's family picture collection. The most extensive in Lima, the Bravo de Lagunas collection included works not only by Cristóbal Lozano and continental Spaniards but also French, Flemish, Italian, and English masters.

Michael A. Brown

VI-105 Joaquín Gutiérrez[†]

(Colombian, c. 1715–c. 1805)

Viceroy José Solís Folch de Cardona

After 1770

Oil on canvas

59¹³⁄₁₆ × 43¹¹⁄₁₆ inches (152 × 111 cm)

Inscribed in cartouche at bottom: *Reinando la Mag.^d Cathol.^ca del S.^r D.^n Fernando VI. y del S.^r D.^n Carlos III./El Ex.^mo S.^r D.^n Joseph Solis Folch de Cardona, Mariscal de Campo de los R.^s Exercitos, Comendador de Ademus, y/ Castelfavi en la R.^l orden de Monteza, primer Theniente de la tercera campañia de las R.^s Guardias de Crops. Tomò poses/sion de los Empleos de Virrey, Gov.^or y Cap^n Gen.^l de las Prov.^as de este N.^vo R.^no con sus agregadas y de la Presidencia de la R.^l/Aud. de S.^da Fè en 24 Noviembre de 1753. haziendo su juramento en manos del Ex^mo S.^r Virrey Pizarro su ante/cessor por especial R.^l Concession de SM. y en 24 de Febrero de 1761, le succedio en los referidos cargos el Ex.^mo S.^r D.^n Pe/dro Mesia de la Žerda, haviendo governado 7. años y 3. meses, y alos 4. dias se hizo Religioso de S.^n. Fran.^co en el Convento de esta Ciu.^d/donde Murio en 27 de Abril de 1770 Durante su Gov.^no se finalizo la fabrica del Camellon, y la del Puente de Boza, y asus Expenzas/se Extendio el Hospital de S.^r Juan de Dios de S^ta Fe*

Museo de Arte Colonial/Ministerio de Cultura, Bogotá, Colombia

PUBLISHED: Giraldo Jaramillo 1948, p. 85, pl. 10; Giraldo Jaramillo 1956, p. 48; Ospina 2000, p. 203

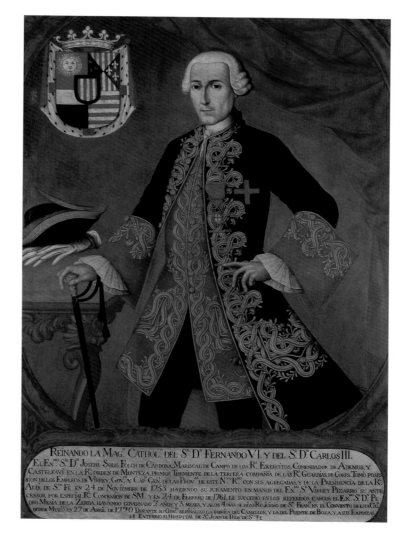

SIGNED WORKS BY JOAQUÍN GUTIÉRREZ include portraits of the marquises of San Jorge de Bogotá (cats. VI-106, VI-107) and of Jorge Miguel Lozano de Peralta y Varaes and his wife María Thadea González Manrique del Frago Bonis (1775). Various other portraits of the viceroys of New Granada have been attributed to the artist on the basis of style, and he is thus referred to as the "painter of Viceroys." Since the inscription on this portrait mentions the sitter's death date, it is probable that it was, like a number of the others, painted posthumously.

José Solís Folch de Cardona, marquis of Castelnuevo and count of Saldueña, was born in Madrid to an important Spanish family—his brother was Bishop of Córdoba and later Archbishop of Seville—and he was as well a boyhood friend of King Fernando VI, who appointed him viceroy of the New Kingdom of Granada in 1753. Folch de Cardona served with distinction until 1761, when he joined the Franciscan order. He died in 1770.

All viceroys, like all bishops and archbishops, were appointed from Spain by the Madrid court. In 1700 the French Bourbon dynasty ascended to the Spanish throne, replacing the last of the Spanish Habsburgs. Philip of Anjou became Felipe V of Spain and was the father of Fernando VI, who appointed Folch de Cardona to his post in Bogotá, and whose reign was followed by that of his brother Carlos III (r. 1759–88). This explains the distinctively French dress seen in this and other eighteenth-century

Spanish American portraits of viceroys. Joaquín Gutiérrez was no doubt favored as a portraitist on account of his lovingly detailed treatment of—as in this painting—the gilt metal thread embroidery, the Flemish lace of the sleeve ruffles and at the neck, the three-cornered hat and fine Spanish leather gloves on the table.

Marta Fajardo de Rueda and Suzanne Stratton-Pruitt

VI-106 Joaquín Gutiérrez[†]

(Colombian, c. 1715–c. 1805)

Don Jorge Miguel Lozano de Peralta, Marquis of San Jorge

1775
57 1/16 × 41 3/4 inches (145 × 106 cm)
Oil on canvas
Inscribed along bottom: *EL SEÑOR D.[N] JORGE MIGUEL LOZANO DE PERALTA, Y VARAES,/MALDONADO DE MENDOZA, Y OLAYA, I.[E] MARQUES DE S.[N] JORGE DE/BOGOTÁ VIII. POSEEDOR DEL MAYORASGO DE ESTE NOMBRE; HA SERVIDO LOS/EMPLEOS DE SARGENTO MAYOR, ALFERES R.[L] Y OTROS VARIOS DE REPUB-LICA EN ESTA/CORTE DE S.[TA] FE SU PATRIA;* signed at lower right: *Joaquín Gutiérrez año 1775*
Museo de Arte Colonial/Ministerio de Cultura, Bogotá, Colombia

PROVENANCE: Pablo Pizano, Bogotá

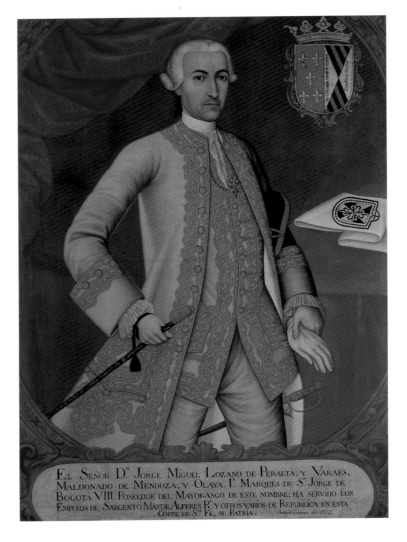

DON JORGE MIGUEL LOZANO DE PERALTA (b. Santa Fé de Bogotá, December 13, 1731) was the first to hold the title of Marquis of San Jorge. He owned a prosperous *mayorazgo* (entailed estate) by this same name (inherited as the Dehesa de Bogotá or El Novillero) and further increased his wealth through merchant activity. Among the marquis's numerous other high-ranking offices, the portrait inscription registers his various military titles. Gutiérrez's pendant portraits commemorate the marriage of the marquis to his first wife, María Tadea González Manrique (cat. VI-107), around 1775.

Balanced between firmness and elegant repose, Gutiérrez's marquis stands authoritatively with legs wide apart and with his right hand confidently grasping a ceremonial staff adorned with a tassel; a tricorn hat rests in the crook of his left elbow, a flaccid glove dangling from his hand. A ceremonial sword with a golden hilt is visible at his side; like the baton, it establishes his privilege to command and his aristocratic office. The shield is cut into two parts, representing the houses of Maldonado and Mendoza. The marquis wears a delicate rosary around his neck, conveying the message that he is a good Christian. A white sash with the black-and-white shield of Calatrava, Spain's oldest religious military order, lies folded on the desk; the marquis donned this sash of the Major of the Rosary (*Mayor del Rosario*) in November 1742. The marquis's French-style waistcoat and vest are lavishly embroidered along the buttonholes, pockets, and cuffs. At the end of the eighteenth century the taste for expensive fabrics

embroidered with silver or gold thread had supplanted the fashion for brocade fabrics, as worn mid-century by Don Juan Joachín Gutiérrez Altamirano Velasco in a portrait by the New Spanish painter Miguel Cabrera (1695–1768) (c. 1752; Brooklyn Museum of Art, New York). The marquis's smooth porcelain skin, painted with small, fine brushstrokes, and the gold-embroidered fabric of his attire approximate the lacquer-like *encarnación* (flesh tones) and colored layers and *estofado* (gilding) of New Granada statuary. His short, powdered wig, with its tight curl at the temples and the tidy black ribbon at the nape of the neck, reflects the taste for modest wigs at century's end. The gleaming white fabric (paler than the marquis's complexion) and the intricate gold embroidery, coat of arms, and picture frame are a tour de force of Gutiérrez's calligraphic and decorative style.

The same formal posture and attributes, as well as the accoutrements of drawn curtain, heraldic shield, desk, and biographical text, appear in Gutiérrez's portraits of New Granada's viceroys (at least twelve are attributed to him). These ultimately derived from images of the Spanish king, such as those by the Spanish court artists Antonis Mor (1512/1516–c. 1576) and Diego Velázquez (1599–1660). Viceroys and other dignitaries in the Americas, governing on behalf of the Spanish monarch, adopted the king's persona in their own portraiture.

Alicia Lubowski

VI-107 Joaquín Gutiérrez[†]

(Colombian, c. 1715–c. 1805)

Doña María Tadea González Manrique del Frago Bonis, Marchioness of San Jorge

1775

57 1/16 × 41 3/4 inches (145 × 106 cm)

Oil on canvas

Inscribed along bottom: LA SEÑORA D.^A MARIA THADEA GONZALES MANRIQUE/DEL FRAGO BONIS, NATURAL DEL PUERTO DE S.^TA MARIA,/I.^A MARQUESA DE S.^N JORGE DE BOGOTA; signed at lower right: Joaquín Gutiérrez fecit año 1775

Museo de Arte Colonial/Ministerio de Cultura, Bogotá, Colombia

PROVENANCE: Pablo Pizano, Bogotá, Colombia

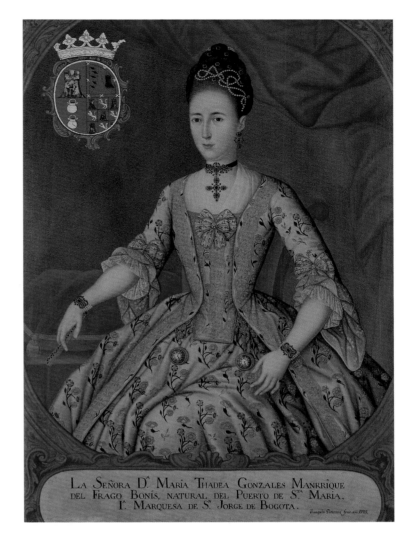

LA SEÑORA D.^A MARÍA THADEA GONZALES MANRRIQUE DEL FRAGO BONÍS, NATURAL DEL PUERTO DE S.^TA MARÍA, I.^A MARQUESA DE S.^R JORGE DE BOGOTA.

THIS PORTRAIT OF THE MARCHIONESS OF SAN JORGE, daughter of the president of the Real Audiencia of Santa Fé de Bogotá, Don Francisco González Manrique, and Doña Rosa del Frago y Bonis, emphasizes her eminent social status as a member of a family of great wealth and noble stature. As in other viceregal portraits, a coat of arms and biographical cartouche provide evidence of her elite ancestry and titles. Her posture, symbolic trappings, and architectural setting are derived from the conventions of Spanish Habsburg court portraiture and serve to further showcase her nobility and affluence.

The marchioness's floral-patterned dress, embroidered with gold thread and festooned with lace and ribbons, reflects a taste for French fashion and culture in New Granada, initiated by the political transformation at the start of the eighteenth century, when the French Bourbon monarch Philip V ascended the Spanish throne. The marchioness is bedecked with a profusion of pearls, gold, and precious gems. A strand of pearls and jeweled pins are artfully threaded through her elaborate hairstyle, while a cross pendant, which dangles on a black ribbon around her neck, is repeated in the design of her matching earrings. Multistrand pearl bracelets adorn each wrist, and she wears a ring on the little finger of her left hand, and in her right holds a gilt fan, tightly closed as befits the etiquette of a refined lady. The marchioness's costly accessories are outdone by her ostentatious display of not just a single but two watches, carefully synchronized and registering a decorous afternoon hour.

Although rich brocade garments and floral silks manufactured in China were standard wear for eighteenth-century Latin American elites, Gutiérrez's painstaking attention to the floral patterning of the marchioness's dress is reminiscent of the blooms in New Granadan mural decoration and the motifs of barniz de Pasto (Pasto lacquer) trunks and vargueños (writing desks). Gutiérrez's precise rendering of the flower pattern suggests his training as a miniaturist. Indeed, the Bogotá native Pablo Antonio García del Campo (1744–1814), who was trained by Gutiérrez, was appointed the first official painter to New Granada's Royal Botanical Expedition, directed by the Spanish botanist José Celestino Mutis (1732–1808). While Gutiérrez himself was not a member of the team of more than thirty draftsmen who worked on the expedition over a period of some twenty years, he did realize a botanical plate at Mutis's request.

Alicia Lubowski

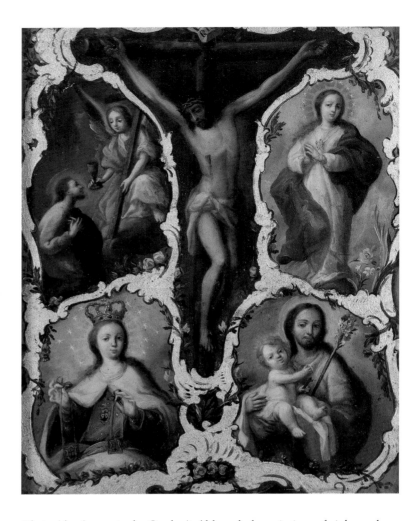

VI-108 Juan Pedro López[†]

(Venezuelan, 1724–1787)

Christ Crucified, with the Agony in the Garden; the Virgin of the Carmen; the Immaculate Conception; and Saint Joseph with the Christ Child

c. 1775–80

Oil on copper; original frame in sgraffitoed and gilded cedar; original glass
9³⁄₁₆ × 7³⁄₁₆ inches (23.3 × 18.3 cm)
Private collection

PROVENANCE: Alberto Rodríguez Santana, Caracas

PUBLISHED: Duarte 1996, pp. 216, 279

THE PACE OF EVERYDAY LIFE in Latin America during the colonial period was governed by the canonical hours of prayer and fixed holidays stipulated by the church. Religion's permanent hold on the lives of the common people may seem strange to today's secular society. The omnipresent power of the Catholic Church, however, its precepts and doctrine, constituted a basic fact of life throughout the existence of any resident of the New World. Even in moments of greatest intimacy and devotion, in the most private places in the home, it was essential to possess a suitable image before which prayers could be offered to God. These small, private devotional images constituted one of the most significant categories within the market for religious painting, and nearly all workshops maintained a regular production of works of this type. In many cases, clients would commission the master to create a painting with a specific theme in accordance with their devotional preference. This could involve the image of a saint or one of the many Marian images; in other cases, they were scenes of the life of Christ or the Virgin. In some instances, a written legend would be included, generally a prayer or an indulgence. Sometimes the same painting depicted various themes, as does this small piece by Juan Pedro López.

This work actually comprises five different pictures separated by a border of thin gold-leaf rocaille. The fact that the themes are only marginally related suggests that this may have been a special commission. In the center is the Crucifixion, and on either side of it are two distinct Marian images (the Virgin of the Carmen and the Immaculate Conception), a saint (Saint Joseph with the Christ Child), and a scene from the life of

Christ (the Agony in the Garden). Although the paintings of eighteenth-century New Spain frequently included small narrative scenes within a larger work—very common in depictions of the Virgin of Guadalupe—this compositional model was unusual in Venezuelan painting and was seldom used by Juan Pedro López. The most important works in which he employed this compositional scheme include the Mysteries of the Rosary series painted in 1781 for the church of the Convent of San Jacinto and the great painting entitled *Our Lady of the Rosary between Saint Dominic and Saint Rose of Lima Surrounded by the Fifteen Mysteries of the Rosary*, probably from the same period. Each of the small images in this piece was painted in accordance with the formulas established by the artist during the previous decade. Christ's pale and deathly silhouette against a dark background contrasts with the luminosity and joyful rococo colors of the four other scenes, which are miniature versions of well-known pieces by the master. It is quite possible that the frame, a simple sgraffitoed and gilded molding, is López's work as well.

Jorge F. Rivas P.

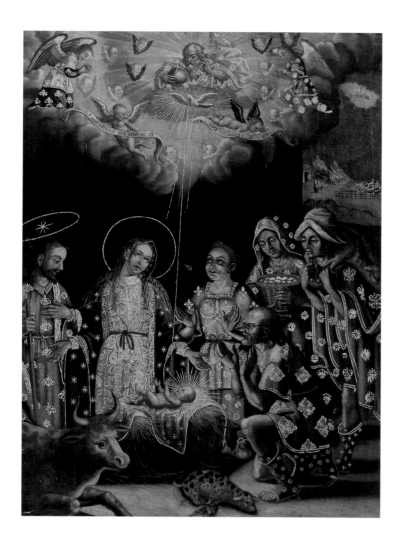

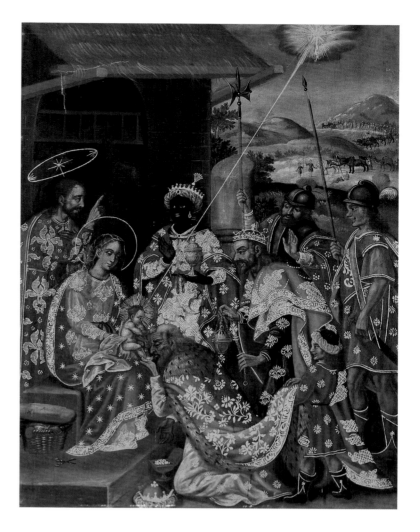

VI-109, VI-110 Gaspar Miguel de Berrío[†]
(Bolivian, 1706–c. 1762)

Adoration of the Shepherds and Adoration of the Magi

Eighteenth century
Oil on canvas
Each 33¹⁄₁₆ × 24 inches (84 × 61 cm)
Museo Nacional de Arte, La Paz, Bolivia

PUBLISHED: Mesa and Gisbert 1977, pp. 232–34, figs. 255–56, 259; *Retorno* 1996, pp. 258–59, figs. 44, 45; Querejazu and Ferrer 1997, p. 48, fig. 12

EXHIBITED: Paris 1996, figs. 44, 45; New York 1997, fig. 12

THESE PENDANT PAINTINGS were created by Gaspar Miguel de Berrío, whose figure style can be closely associated with that of Melchor Pérez Holguín, a leading baroque painter in Potosí. The two paintings have decorative gilding in the Cuzco manner, which was typical also of eighteenth-century Potosí painters, who were working for a large indigenous clientele as well as for Creole and Spanish patrons.

The *Adoration of the Shepherds* is crowned by a heavenly vista whose lightness is characteristic of Berrío's treatment of celestial scenes, with its typical red cherubim, their heads resting on their wings. Two nude angels in the foreground bear banderoles with the phrases *Gloria in Excelsis Deo* and *Et in terra pax omnibus*, or "Glory to God in the heavens" and "Peace on earth to all." In the background and seen through a window are the shepherds who watch their flocks and listen to the angel's message announcing the coming of the Messiah.

The *Adoration of the Magi* depicts the Epiphany, when the Christ Child was acknowledged as the Savior by the Gentiles. They are represented by Melchior, Caspar, and Balthazar, in turn symbolizing Europe, Asia, and Africa, the three continents known in the Middle Ages when this iconography was developed. In the background is a retinue with elephants, camels, and horses that accompanies the kings and again represents the three continents. Representations of this subject in which one of the Magi is depicted as an Inca are known in the towns and villages around Lake Titicaca.

Teresa Gisbert de Mesa

VI-III The Christ Child Wearing the Imperial Inca Crown and Catholic Priestly Robes

Peru
Eighteenth century
Oil on canvas
33⅞ × 29½ inches (86 × 75 cm)
Private collection

PUBLISHED: Mujica Pinilla 2002 "Arte e identidad," pp. 48–51; Mujica Pinilla 2003, pp. 290–92; Cummins 2004, p. 12; Mujica Pinilla 2004, pp. 102–4; *Perú indígena* 2004, cat. no. 159; Estenssoro Fuchs 2005, pp. 137–41

EXHIBITED: Barcelona, Madrid, and Washington 2004, cat. no. 159

WITH THE EXCEPTION OF A CANVAS that is now lost, which once belonged to the Augustinian nuns of Potosí and was last seen in Argentina in the 1950s, this is the only known painting from viceregal Peru that shows the Christ Child attired as an Inca king or, more precisely, as *rex et sacerdos*, both Inca king and Catholic priest. In fact, it is a dressed-statue painting, that is, a "realistic portrait" of a clothed sculpture that faithfully reproduces and recreates the altar and physical setting of the Christ Child in a church in the southern Andes. The figure rests on a baroque pedestal between glass vases containing flowers, and the curtains of the retable have been drawn aside to leave the figure—from which a subtle otherworldly aura emanates—exposed for public worship.

The iconographical details show that the figure is meant to portray Jesus as Savior of the World. He is represented as a universal Christian monarch blessing with his right hand the orb of the world that he holds in his left. His attire is clearly a transcultural hybrid. He wears the cape and gilded tunic of a bishop, from under which the white linen of his alb can be glimpsed, reaching halfway down his leg. But the figure also wears sandals with puma heads and a prominent neo-Inca headpiece, decorated with both pre-Hispanic and European heraldic devices. It has tiny *kantutas*, or Inca flowers, a central black-and-white feather from the *corequenque* (the mythical falcon used by Inca royalty as a dynastic symbol), and a scarlet tassel hanging down over the forehead. These are juxtaposed with the circular ramparts, scepters, and diminutive rainbow at the top of the headpiece, a direct reference to the Inca fortress of Sacsayhuaman, which was incorporated as a central device into the coat of arms granted to the city of Cuzco by the emperor Carlos V on July 19, 1540.

Almost from the founding of the Jesuit church in Cuzco by Jerónimo Ruiz de Portillo (d. 1592) there existed in an adjacent chapel a confraternity of Indians dedicated to the worship of the name of Jesus, fostered by the Jesuits in more than a hundred of the surrounding villages. The first reference to a Christ Child attired in "Inca garb" and carried in procession comes precisely from this confraternity in Cuzco. It is difficult to say whether the Jesuits were seeking by this cult to confer on the Inca Christ Child the emblematic prestige of the ancient idol known as the *Punchao*, or Lord of the Day, which had been worshipped in the Temple of the Sun in Cuzco. According to an anonymous Jesuit chronicler, the *Punchao* was represented as a golden boy with sunrays issuing from his head, dressed in an Inca *uncu* and flanked by a pair of felines, his emblems. In the eighteenth century, the paraliturgical garments used to attire the devotional figures of the Christ Child—which until recently had been taken for the clothing of noble indigenous children—combined Christian symbols, such as the heart of Jesus and the orb of the world, with the symbolic felines of the *Punchao* and Inca geometrical designs (*tocapu*) bearing pre-Hispanic dynastic and heraldic significance.

When the bishop of Cuzco Manuel de Mollinedo y Angulo discovered figures of the Inca Christ Child in the churches of San Jerónimo, Andahuaylillas, and Cayca during an ecclesiastical tour of his diocese, he forbade them to be attired in the royal insignia of the Incas. There is no doubt that this iconography possessed a symbolic ambivalence with deep political resonances: Was it simply the Christ Child dressed as an Inca, or was it the long-awaited Messianic Inca, whose return had been foretold by Saint Rose of Lima, according to popular prophetic traditions in the eighteenth-century Andes, and who was to put an end to Spanish rule and restore the Tawantinsuyo? On the death of Diego Túpac Amaru—the youngest son of Túpac Amaru II, who led the great indigenous uprising in the Andes in 1781—the priest of the *doctrina* of Pampamarca buried him in a bishop's tunic with a royal *mascaypacha*, an Inca headdress with a scarlet fringe covering the forehead. These were the same two emblems displayed by the Inca Christ Child, which codified the claims of the native nobility to an indigenous priesthood and the restoration of rights and privileges lost as a result of the reforms carried out under the Bourbons. If representations of the Inca Christ Child are scarce, this is probably because they were destroyed in 1781 during the iconoclastic campaign of the *visitador* Joseph Antonio de Arreche, which, following the execution of Túpac Amaru, was intended to eliminate all traces of cultural and artistic expressions that evoked the Inca past.

Ramón Mujica Pinilla

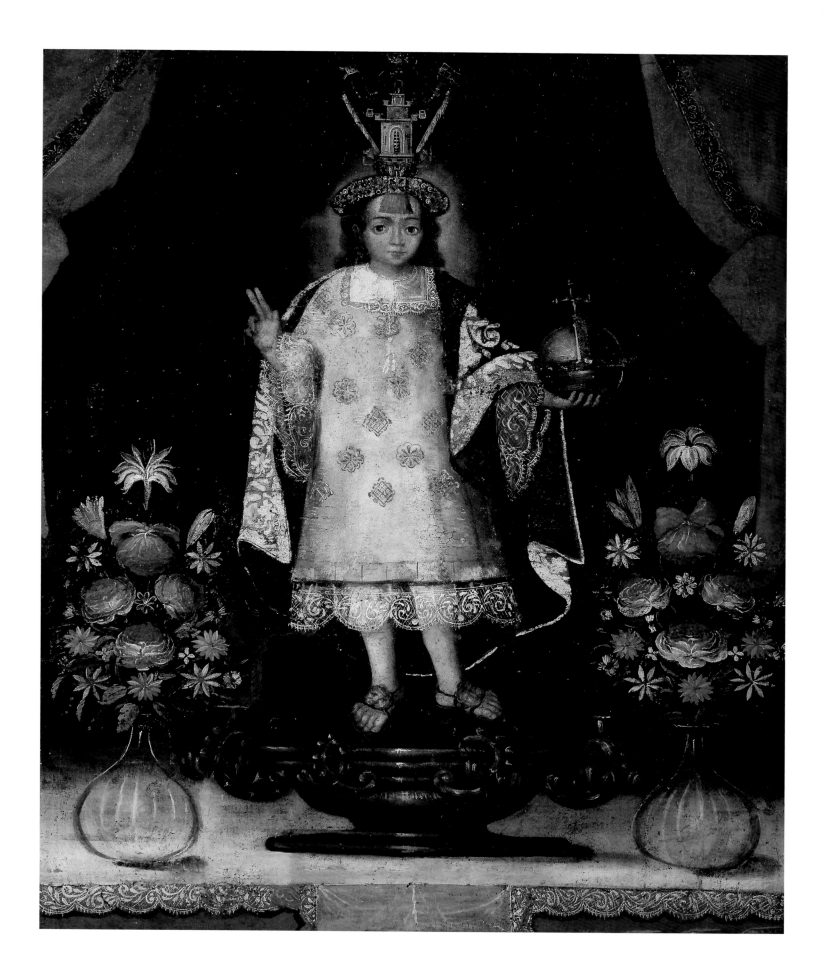

VI-112 José Joaquín Bermejo

(Peruvian, c. 1760–1792)

Don José Antonio Manso de Velasco, Count of Superunda, Viceroy of Peru

c. 1761–66

Oil on canvas

79⁹⁄₁₆ × 54¾ inches (202 × 139 cm)

Inscribed on tablet at lower right: *EL E. Sr. Dn./José A. Manso/de Velasco, Cond/de Superunda, Caba/llero del Orden de S.tia/go, Teniente General de los Rs. Ex./de S.M. Gentil hombre de Ca-/mara. Con entrada y de su Real/Consejo, Virrey Gobernador y Cn./General de los Reinos del Peru, Re-/establecedor de la Ciudad de Lima y/Precidio del Callao que se arruinaron/por el terremoto del año de 1746. Ree-/dificador de la Sta. Yglesia Cathe-/dral Metropolitana y primada/ de las Indias Occidenta-/les Zelosísimo Aumen-/tador del Rl. Erario Dig-/no de eterna memoria/por su piedad*

Instituto Nacional de Cultura, Museo Nacional de Arqueología, Antropología e Historia del Perú, Lima, Peru

PROVENANCE: Palacio de los Virreyes, Lima; Biblioteca Nacional, Lima; Palacio de la Exposición, Lima; Museo de Historia Nacional, Lima; Palacio de Gobierno, Lima

PUBLISHED: *Exposición nacional 1893*, cat. no. 35, p. 7; Gutiérrez de Quintanilla 1916, part 1, p. 33; Durand 1982, p. 4; Estabridis 2003, p. 142, fig. 5

EXHIBITED: Lima 1892, cat. no. 35

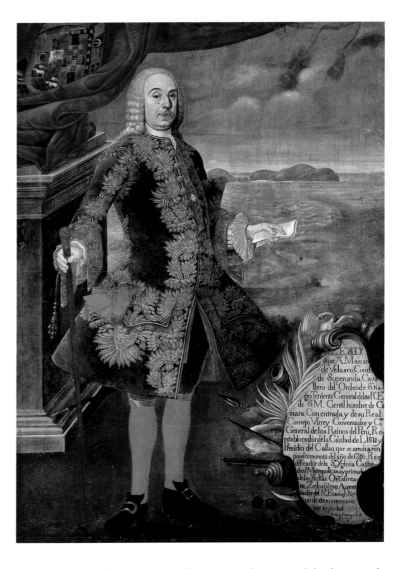

BORN IN TRUJILLO, possibly of mixed race, José Joaquín Bermejo belongs to the second generation of great portraitists active in the capital of the viceroyalty in the second half of the eighteenth century. While it has not been proved that he was in the strictest sense a student of Cristóbal Lozano (1776), the influence of this artist—crucial for the eighteenth-century rebirth of the Lima school of painting—is evident in much of Bermejo's work. This can be deduced not only from the marked stylistic similarities between the two, but also from the various occasions on which Bermejo copied the master's compositions. This is the case with this portrait of the viceroy, the Count of Superunda, which is based on a famous painting Lozano executed in 1758 for the cathedral of Lima immortalizing the decisive role played by the governor during the reconstruction of that building after the devastating earthquake of 1746.

This new version must have been commissioned a few years later for the gallery of the governors of Peru, possibly when Superunda had already left to return to Spain. Whether for this reason or because the earlier work was considered unsurpassable, the young Bermejo did not create this image "from life"; instead, he adhered exactly to Lozano's innovative iconographic model, itself inspired by the new portraiture of the Bourbon court. The main difference lies in the landscape in the background, which does not depict the main square of Lima but rather the Bay of Callao and San Lorenzo Island. The intent was to underline Manso de

Velasco's role in the resurgence of the port settlement and the fortress of Callao following their complete demolition by the great tidal wave that followed the earthquake, an involvement that earned him the title Count of *Superunda* (on top of the wave), bestowed on him by King Carlos III in 1751. This honorific is symbolically reflected in the figure of a white swan swimming on top of the curling wave that crowns the rococo tablet.

In copying this fine work commissioned by the highest official circles, young Bermejo launched a successful career, confirmed in 1777 when he was hired to join the team that was to decorate the palace of the viceroys. There, Bermejo would paint a series of "Chinese landscapes" for the study of the viceroy's wife and would begin working with Julián Jayo. Later, the two artists jointly executed a series of canvases on the life of San Pedro Nolasco (1786), found in the Convento de La Merced, which constituted the most ambitious local pictorial undertaking of its day. Ten years later, Bermejo's career as an artist reached a culminating moment when the viceroy Gil de Taboada y Lemos named him *Maestro mayor del arte de la pintura* (Principal Master of the Art of Painting) in charge of the city's royal commissions.

Luis Eduardo Wuffarden

VI-113 *The Child Virgin at the Spinning Wheel*

Cuzco, Peru

c. 1680–1710

Oil on canvas

49⅝ × 31¾ inches (126 × 80.6 cm)

Museo Pedro de Osma, Lima, Peru

PUBLISHED: Mesa and Gisbert 1982, vol. 1, p. 305; *America, Bride of the Sun* 1991, pp. 468–69; Gradowska et al. 1992, cat. no. 24, pp. 124–25; *Siglos de oro* 1999, cat. no. 104, pp. 344–46; Gjurinovic Canevaro 2004, pp. 82–83; *Perú indígena* 2004, cat. no. 214, p. 222

EXHIBITED: Antwerp 1992, pp. 468–69; Caracas 1992, cat. no. 24; Madrid 1999 *Siglos de oro*, cat. no. 104; Barcelona, Madrid, and Washington 2004, cat. no. 214

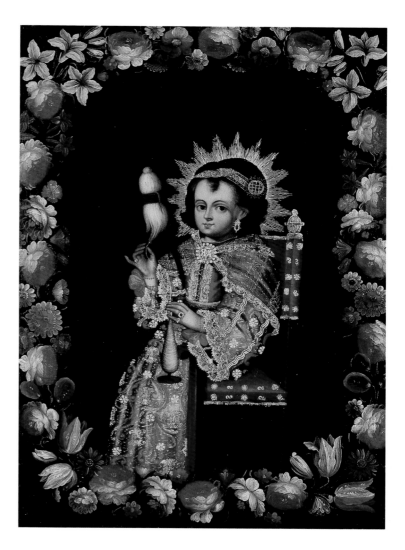

THROUGH "PIOUS IMAGES"—often executed with a fine preciosity, as in this case—the indigenous painters of Cuzco achieved a creative reworking of Andalusian models of devout painting that introduced much-loved themes on the family life of Christ and the Virgin. This image deals with a legendary event from Mary's childhood, absent from official gospel, that depicts the future mother of Jesus seated at a spinning wheel, directing her gaze at the viewer. In all probability, the anecdote was based on the proto-Gospel of James, which narrated the episode related to the great veil intended for the temple of the Lord, in the making of which the future mother of Christ would have participated actively, together with other maidens from the House of David, "spinning the purple and scarlet."

Juan de Roelas may have been the first Spanish artist to take up this theme from the Gothic period, turning the spinning Virgin, always portrayed as an adult, into a child. Later on, at the very peak of Murillo-style sentimental piety, the Sevillian artist Pedro Núñez de Villavicencio separated young Mary from her old domestic environment and enriched her appearance, adorning her with the headdress and jewels that the Cuzco painters also adopted, and which have been interpreted by some authors—in our opinion, without a solid basis—as an expression of syncretism that sought to present the sacred figure as an evocation of the *ñustas*, or imperial Inca princesses. Nevertheless, all the elements of her attire were already present in her Spanish predecessors, and, in principle, it would be a mistake to interpret them as the pre-Columbian Andean *lliclla* or *tupu* (ornamental brooch) being given a contemporary recreation within the cultural climate of the "Inca Renaissance."

This type of image, intended for subjective contemplation, was aimed as much at domestic worship as at cloistered nunneries where textile manufacture was a regular part of the nuns' daily activities. The spinning child Virgin was generally paired with *El Niño Jesús de la espina* (Christ Child of the Thorn), another theme in Andalusian painting, taken in this case from Francisco de Zurbarán–style images. Seated on "friars" chairs, both figures received similar ornamental treatment—a floral garland framing the central figure, as well as fine applications of gilding to enhance their garments—and were placed so that they were looking at each other. While the Christ Child, tenderly and with minimal pathos, foreshadowed his redemptive sacrifice, the Spinning Child Virgin, significantly displaying a wedding ring on her left hand, offered her exemplary industriousness as a model of virtue to be imitated, strictly wedded to prayer and the contemplative spirit characteristic of communal religious life.

Luis Eduardo Wuffarden

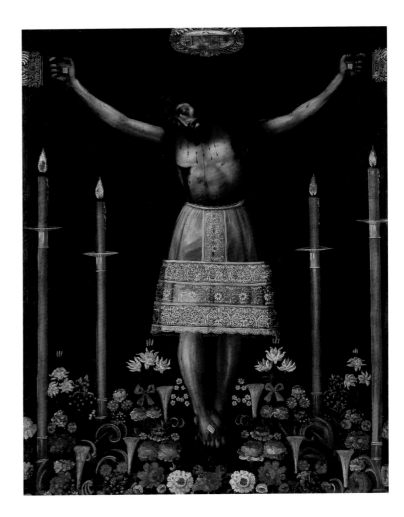

VI-114　*Lord of the Earthquakes*

Cuzco, Peru
c. 1730–60
Oil on canvas
66⅛ × 50⅜ inches (168 × 128 cm)
Banco de Crédito del Perú (Casa Goyeneche), Lima, Peru

PUBLISHED: *Pintura en el virreinato del Perú* 1989, pp. 385–86; *Siglos de oro* 1999, cat. no. 109, pp. 354–56; *Perú indígena* 2004, cat. no. 242, p. 233

EXHIBITED: Madrid 1999 *Siglos de oro*, cat. no. 109; Barcelona, Madrid, and Washington 2004, cat. no. 242

IN THE SAME VEIN as the sacred "statue paintings," this painting, which occupied an important chapel in the cathedral of Cuzco from the sixteenth century, depicts the Lord of the Earthquakes, one of the oldest and most venerated sculptured Christ figures in the Andes. In accordance with the long-standing tradition discussed by historian Diego de Esquivel y Navia, the sculpture was presented as a gift from King Carlos V to the largest church in this city, where—in the words of Esquivel y Navia (1980, p. 97)—"it is placed . . . with much worship and many visitors, as their sole refuge and asylum, not only during earthquakes, but also in times of plague, drought and other tribulations." Its enormous popularity was consolidated after the terrifying earthquake of March 1650, when, in the absence of Bishop Ocón, dean Vasco de Contreras y Valverde arranged for the Christ to be taken out in a solemn procession through the streets of the city, among the ruins and unburied bodies, with the aim of appeasing the divine wrath. The same must have happened seventy years later in 1720, when the great plague dramatically decimated the population of Cuzco.

All these events contributed to the image being much copied, through votive canvases like this one, which took into account its ties to the history of the Inca capital since its Christianization. Modern studies have dismissed the legend of its Spanish origins, showing instead that this is an early "mestizo" sculpture, perhaps created in the 1570s, which melds old Spanish iconographic tradition—specifically that of the famous Christ of Burgos—with a local adaptation of the medieval technique of primed canvas that manages to incorporate the leather of the Andean Camelidae. In fact, the primitive, hieratic aspect of the sculpture, which imbues it

with an expressionist character, harmonizes with the triumphal style of the indigenous painters and the aesthetic expectations of a large, devout public.

In order to invoke his imposing presence, the canvases on the theme of the Lord of the Earthquakes conform to certain patterns of representation that were firmly established by the middle of the eighteenth century, when this painting was created. The image emerges from a dark background, whether in the half-light of its chapel or while being held aloft during a procession, with the Cloth of Purity depicted as a lace skirt placed over it by the faithful. There is a marked pathos in Christ's weakened body and tilted head, which show the traces of his suffering. But the status of the painting as a devout image is emphasized by the candles that surround the figure, and by the diversity of local flowers—principally the red *ñucchu*, symbolically associated with the blood of the Passion of Christ—that adorn the base of the image and the altar table. This is the manner in which the worship of the Lord of the Earthquakes was spread, at a time when the figure was becoming an emblem of identity for the Cuzco region.

Luis Eduardo Wuffarden

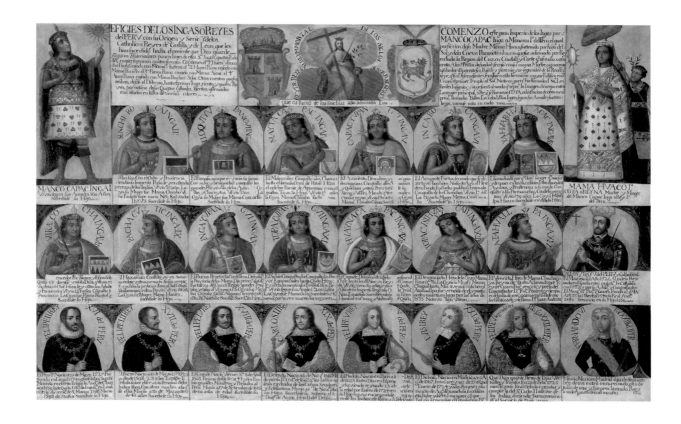

VI-115 *Effigies of the Incas or Kings of Peru*

Lima(?), Peru

c. 1725

Oil on canvas

63¾ × 99³⁄₁₆ inches (161.9 × 251.9 cm)

Inscribed at upper left: *EFIGIES DE LOS INGAS O REYES/del PERV . . .*

Convent of Our Lady of Copacabana, Lima, Peru

PUBLISHED: Gisbert 1980, pp. 128–35, fig. 118; Mesa and Gisbert 1982, vol. 1, p. 284; vol. 2, fig. 503; Stastny 1982, pp. 46–48; Anders 1984, cat. no. 14.3, pp. 12–13, 402; Buntinx and Wuffarden 1991, pp. 151–210; Mujica Pinilla 2002 "Arte e identidad," pp. 30–33, fig. 28; Estenssoro Fuchs 2003, pp. 498–505; *Perú indígena* 2004, cat. no. 158, p. 198; Wuffarden 2005 "Descendencia," pp. 232–44, fig. 56

EXHIBITED: Lima 1942; Loosdorf, Essen, and Schaffhausen 1983, cat. no. 14.3; Barcelona, Madrid, and Washington 2004, cat. no. 158

THE ICONOGRAPHIC CHART of the Incas and kings of Peru, devised by the cleric and historian Alonso de la Cueva about 1725, gave rise to widely distributed prints and to paintings like this one, perhaps the oldest and best known to have survived. It represents the uninterrupted line of succession of Peruvian monarchs from Manco Cápac to Felipe V (here with the subsequent addition of Fernando VI), arranged in three rows of portraits, each with their biographical legends, as if there had been a continuous dynasty free of conflict. Its presence in the Nuestra Señora de Copacabana community house for lay sisters in Lima—intended as a shelter for the poor daughters of the indigenous nobility—is highly significant.

Both the inclusion of the Spanish monarchs and the protective presence of Christ enthroned in the uppermost section bestow an orthodox and official appearance on the work. Shown as "King of Kings," holding both the sword and the olive branch, Jesus presides over the composition and validates the sense of colonial dominance of the old empire, presenting the Spanish monarch as a natural colophon of the Inca dynasty. At the top are the shields of Tawantinsuyo and Spain, with images of the founders of the empire, Manco Cápac and Mama Huaco, who alone are shown in full. By commissioning such paintings, the indigenous aristocracy attempted to proclaim their long-standing loyalty to Spain and to record the rights bestowed on them as heirs of the Incas through their treaty with the Crown, whose provisions were repeatedly violated by the colonial authorities.

Those rights included participation in ecclesiastical life, to which the indigenous population had no access; the native aristocracy aspired to secure for their offspring the comfortable status enjoyed by clerics. Nevertheless, the initiation of the process of canonization of Nicolás Ayllón (1632–1677), an Indian tailor from Chiclayo who lived in Lima, led to a series of such royal decrees during the reign of Charles II. Among other things, the decrees, which were legalized in 1725, allowed the indigenous aristocracy to fulfill Inquisitorial duties. From this flowed the need to stress the continuity between Habsburgs and Bourbons, and to link Carlos II and Felipe V visually. In addition to their similar gestures and attire in the painting, they are the only monarchs holding folded papers, which they offer to the viewer. These are royal letters in favor of the indigenous people, which constituted the central aim of this ingenious iconographic campaign, with which the Inca Renaissance reached a culminating moment.

Luis Eduardo Wuffarden

VI-116 *Virgin of Cocharcas*

Cuzco, Peru
Eighteenth century
Oil on canvas
74 × 56⅞ inches (188 × 144.5 cm)
Private collection

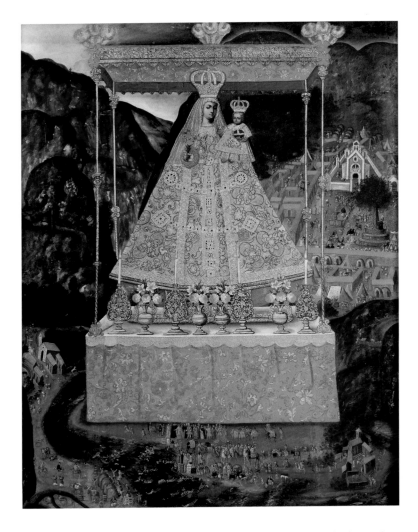

THE SANCTUARY OF THE VIRGIN OF COCHARCAS is one of the oldest and most famous in South America. It is situated in a small Indian village between Cuzco and Ayacucho, on a flowery plateau at the foot of towering mountains and along the banks of the Río Pampas. According to Fernando Montesinos's *Annals of Peru* (1642), toward the end of the sixteenth century an indigenous noble by the name of Sebastián Quimichi, a descendant of a *curaca* (Indian regional leader) from Cajamarca, had an accident that left his hand maimed. Unable to find a remedy and useless to his family, he fled to Cuzco, where he heard that in El Collao, in Copacabana, the Virgin had a sanctuary where she worked miracles. Halfway through his pilgrimage, the Virgin had already cured his hand. On his arrival in Copacabana he decided to bring back to his native village a copy of the sculpture, which had been carved around 1582 by an Indian named Francisco Tito Yupanqui. According to Montesinos, it was thanks to the intervention of a relative of the Incas that Quimichi acquired a copy from Tito Yupanqui himself. He then begged the prior of the sanctuary of Copacabana to grant authorization for "both images to be together for just one night," under the veils and on the same retable. By the following morning a miracle had occurred: the two images were as like as two drops of water. The Virgin was transported over mountains and precipices on the shoulders of devout Indians to the accompaniment of canticles of praise. Wherever the image passed, roses, *alalíes*, and pinks sprouted on the path.

In the month of September 1598, the sculpture arrived and was placed on the principal altar of the Virgin's first sanctuary in Cocharcas, and a confraternity was established to take charge of her cult. At first, paintings were executed of all the miracles performed by the Virgin from her new sanctuary, so that they could be made known to the faithful, but "today there are so many," writes Montesinos, "that this is no longer done." In 1623 the church was rebuilt, and the image, unusually, was carried in procession through the crowds of Indians who had arrived from various Andean villages to celebrate her. In 1690 two new church towers were concluded, complete with six bells. In 1730 the chapel was rebuilt and the ornamentation of the church enhanced.

The popularity and prestige of the Virgin of Cocharcas increased in the eighteenth century. Altars were dedicated to her in Lima and Cuzco, and her influence reached as far as Bolivia and Chile. The devotion to this image acquired such social and religious importance that in 1777 the cantor of the cathedral of Lima, Don Francisco de Santiago Concha,

who had been sent to Cocharcas by the viceroy Amat, asked the king of Spain to designate him patron of the sanctuary, since it had been at his expense that the Virgin's chapel was decorated. He also suggested that in his absence the office could be performed by his brother, a judge of the *Audiencia* of Lima, and, later on, by his successors in the post. On June 4, 1796, however, the Council of the Indies refused the request on the grounds that Francisco de la Encarnación Simpul, the legal representative of the Indians, had filed a suit alleging that his principals, the heirs of Sebastián Alonso, founder of the *conventillo* in Cocharcas, had a right to this patronage.

Some sections of the canvas—restored in chestnut color—have been lost, and with them many details appearing in other canvases from the same period and with the same subject matter. Nonetheless, the high pictorial quality of this work can still be appreciated. With the skill of a miniaturist, the anonymous artist has distorted scale, perspective, and the size of the figures as an archaizing visual device to emphasize the supernatural beauty of the Virgin of Cocharcas and the rugged mountain landscape surrounding her sanctuary, in contrast with the tiny dimensions of the pilgrims who cross rocky precipices and descend to celebrate the festival of the Virgin. Both Mother and Son are crowned and are placed beneath a lavish canopy decorated with the white ostrich feathers that during the viceregal period replaced the parasol used in Inca times as a sign of nobility.

Ramón Mujica Pinilla

VI-117 *Christ Carrying the Cross,* called *Lord of the Fall*

Cuzco, Peru
c. 1720–50
Oil on canvas
51¹⁵⁄₁₆ × 39 inches (132 × 99 cm)
Museo de Arte de Lima, Peru, V-2-0-71

PUBLISHED: Museo de Arte de Lima 1992, p. 111, fig. 53

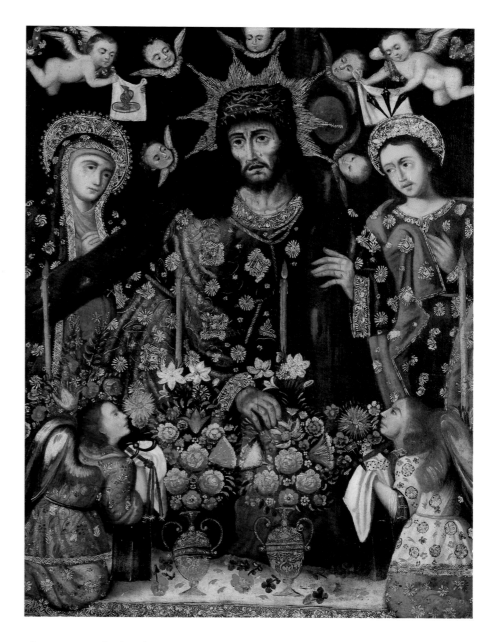

ALTHOUGH AT FIRST GLANCE this painting could be interpreted as a passage from the Passion of Christ, it is actually a "true portrait" of a formal sculptural image depicting a Nazarene or Christ carrying the cross. This can be surmised from the altar table visible at the bottom, as well as from the candles and flowers that surround the central figure. Absent a legend or title, it is reasonable to suppose that the painting is of the famous sculpture venerated for a long period of time in one of the lateral chapels of the church of San Francisco in Cuzco. Mesa and Gisbert record two examples of this type of painting in Cuzco itself: one in the Nazarenas community house for lay sisters, dated to 1713, and the second in the Lechuga collection. The latter work bears the signature of Juan Flores Sevilla.

Just as in the above-mentioned works, this painting depicts Christ during one of his falls along the road to Calvary. He is resting his right hand on a rock for support, while his left is holding up the cross. Unlike the other two images, however, his face is not turned toward heaven but rather toward the viewer. He is accompanied by Our Lady of Sorrows and by a weeping Saint John the Baptist, although it is not possible to establish whether these are meant to represent true miraculous apparitions or statues placed here to add to the scene of the processional "floats" of Easter. The angels bearing white cloths with Passion symbols, kneeling before Christ or flying in the upper part of the painting, appear to be heavenly visions.

These kinds of ambiguities in pictorial representation are characteristic of so-called divine tricks, a genre that aimed to recreate altar images with maximum realistic effect, while also imbuing them with the intense supernatural weight that flowed from the abundant accounts of miracles. Additionally, the image's capacity to move the viewer is underlined here by the accumulation of characters and ornamental elements that saturate the entire surface of the picture—including the copious gilding—and by the gloomy darkness of the background. The whole creates a stifling, oppressive atmosphere, in keeping with the Passion theme embodied by the sacred effigy that served as a model for the artist.

Luis Eduardo Wuffarden

VI-118 Antonio Salas

(Ecuadorian, 1780–1860)

Simón Bolívar

1829
Oil on canvas
23¼ × 18½ inches (59 × 47 cm)
Inscribed along bottom: *El Libertador Simón Bolívar en 1829*
Collection of Oswaldo Viteri, Quito, Ecuador

PUBLISHED: Ades et al. 1989 (Spanish), p. 7

EXHIBITED: London, Stockholm, and Madrid 1989

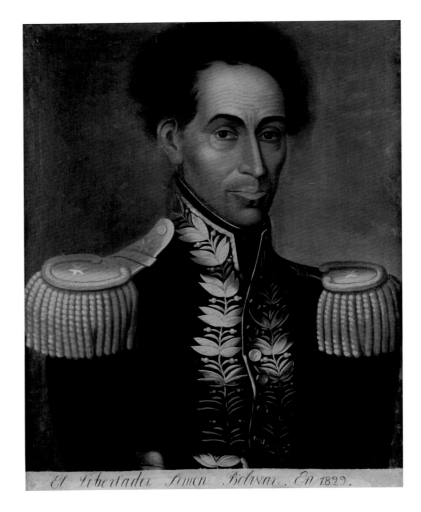

El Libertador Simon Bolivar. En 1829.

A NUMBER OF WORKS OF ART produced in Latin America during the period following the independence of the Spanish colonies served to glorify and memorialize the heroic deeds of patriots as well as the victorious battles of local troops over the royal army. Such works were instrumental in the construction and consolidation of national identities in the former colonies. In Ecuador, a number of portraits celebrated individual heroes and military officers who had participated in the wars against Spain. Antonio Salas, to whom this work is attributed, was commissioned to paint a series of such portraits. These large pictures depict life-size images of heroic men dressed in military regalia, standing on platforms with inscriptions that identify them by name.

Simón Bolívar led the independence movement of a large portion of South America. He also envisioned the political unity of Latin America, a dream that he saw partially fulfilled in the short-lived unification of what are now Venezuela, Colombia, and Ecuador under what was called Gran Colombia. Internal antagonisms and conflicting interests, however, led to the failure of this project and to the eventual dissolution of the new republic in 1830.

Early portraits of Simón Bolívar depict him with a moustache and curly hair falling about his face, following an engraving by A. Leclerc from 1819. Colombian artists José María Espinosa and José Gil de Castro produced the best-known portraits of this hero of independence, in which he is depicted with an ample forehead and deeply staring eyes. In Ecuador, Antonio Salas and his son Rafael produced a number of portraits of Simón Bolívar done in a similar manner.

In this example, Bolívar wears a military suit adorned with the insignia of his rank. An inscription at the bottom is dated 1829, a year before Gran Colombia was dissolved, and identifies him as "the Liberator Simón Bolívar." Bolívar had moved to Bogotá, Colombia, in 1828, so the artist did not work from a live model. He did, however, manage to depict with utmost precision the subject's individual features while also capturing his emotional state. The turning torso of the bust-length portrait, painted against a dark background, seems to project beyond the picture frame. Bolívar's gaze, charged with psychological intensity, engages the spectator in a silent dialogue, and his fatigued and preoccupied expression references the tense political climate that marked this historical moment.

Carmen Fernández-Salvador

VI-119 José Campeche[†]

(Puerto Rican, 1751–1809)

The Rescue of Ramón Power

c. 1790

Oil on panel

16⅞ × 12¼ inches (42.9 × 31.1 cm)

Inscribed along bottom: *Naufragio de que, por la intercession de Nrã Srã de Belen, se librò Dⁿ Ramon Power al querer saltar en la Costa de Cantabria./ Fragate la Esperanza en una Lancha que en el Puerto de Castro saliò socorrerla de una furiosa tempestad. Jose Campeche la pin.*

Collection of the Archbishop's Palace, San Juan, Puerto Rico

PROVENANCE: Chapel of Belén, church of San José, San Juan, Puerto Rico

PUBLISHED: Balsa de la Vega 1891, pp. 26–28; *La ilustración puertorriqueña* 1892, pp. 6–7; Infiesta 1895, p. 87; Newmann Gandía 1896–99, vol. 1, p. 346; Fernández Juncos 1914, p. 72; Coll y Toste 1914–24, vol. 3, pp. 218, 309; Blanco 1932 "Campeche III," no. 14, p. 25; Tapia y Rivera 1862/1946, p. 28; Ortiz Jiménez 1951, pp. 36, 195; Tobar 1963, pp. 48, 52, 175; Gaya Nuño 1965, pp. 5–7; Carreras and Rivera Chevremont 1969, no. 105; Delgado Mercado 1969, p. 19; Dávila 1971, cat. no. 15, pp. 52–53; Ruiz de la Mata 1971, p. 12; Gaya Nuño 1972, p. 36; González García 1972, no. 13, p. 126; Delgado Mercado 1976, p. 36; Gaya Nuño 1980, p. 21; Benítez 1986, p. 23; Rodríguez Juliá 1986, pp. 137–42; Taylor et al. 1988, cat. no. 16, pp. 150–51; *Los tesoros* 2000, p. 287

EXHIBITED: San Juan 1854; San Juan 1863, cat. no. 31; Santurce 1893; Río Piedras 1948, cat. no. 12; Río Piedras 1951, cat. no. 13; San Juan 1959, cat. no. 2; San Juan 1971, cat. no. 15; Ponce, New York, and San Juan 1988, cat. no. 16; San Juan 2000, col. pl. p. 287

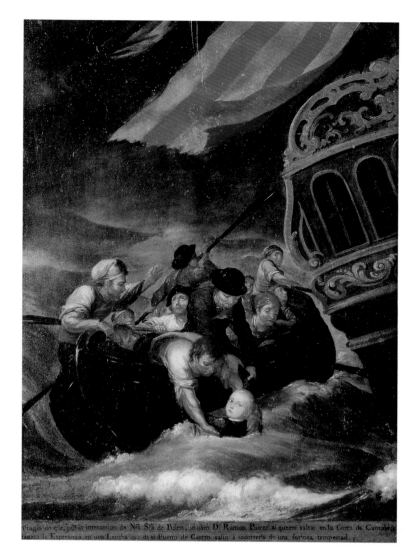

THIS SMALL PAINTING ON A WOOD PANEL is an *ex-voto*, a votive offering given to express the fulfillment of a vow or in gratitude for a blessing (the Latin term *ex voto suscepto* means "from the vow made"). These can be found in a variety of forms throughout the Catholic world, as small silver objects, plaques, paintings—even crutches, abandoned thanks to the intercession of a saint.

Ramón Power y Giralt (1775–1813) is said to have been among the first native-born Puerto Ricans to call himself a "Puerto Rican." In 1788, at the age of thirteen, he was sent to Bilbao, Spain, for schooling, and at the age of seventeen he began his study of naval sciences in Spain. When he graduated he entered the Spanish Navy, eventually rising to the rank of Admiral. His career was particularly notable for his defense of Santo Domingo against French forces in 1808–9. Power was elected in 1810 to go to Cádiz to represent Puerto Rico at the Spanish *Cortes* (senate and congress) in Cádiz, where he died of yellow fever in 1813.

The incident recorded in this painting, considering the age of the boy, could not have occurred much before 1788–89, so the ex-voto can reasonably be dated to about 1790. According to the inscription, Ramón Power was traveling on a frigate that was hit by a furious storm in the Bay of Biscay. A launch set out from the port of Castro Urdiales to assist those on board the frigate. When the boy jumped toward the launch, he misjudged and fell into the sea. His parents, who attributed his rescue to the intervention of the Virgin of Bethlehem, commissioned José Campeche to create the ex-voto, which they gave to the chapel dedicated to that cult (Virgen de Belén) in the church of San José in San Juan. The exciting story must have captured the artist's attention and imagination, for he employed much looser brushwork and a far more animated composition than in his more sedate and orderly religious paintings and portraits of the same period.

Suzanne Stratton-Pruitt

VI-120 José Campeche[†]

(Puerto Rican, 1751–1809)

Governor Don Miguel Antonio de Ustáriz

c. 1792
Oil on panel
25 × 17 inches (62 × 43 cm)
Instituto de Cultura Puertorriqueña, San Juan, Puerto Rico

PROVENANCE: Tadea de Araúz Martínez de Arizala (Ustáriz's widow),
Madrid; Señora Ustáriz de Suelves, Marquesa de Tamarit; Sra. Suelves
de Balcells; José, Ignacio, and Dolores Balcells Suelves, Tarragona; José
Agramunt, Barcelona, 1958; Manuel Pareja Flamen; Instituto de Cultura
Puertorriqueña, San Juan, Puerto Rico, 1961

PUBLISHED: Milicua 1958, pp. 143–44; *El Mundo* 1960, n.p.; Torres Ramírez
1961, p. 19; Gaya Nuño 1965, no. 11, pp. 4, 9–10; Torres Ramírez 1968,
p. 63; Dávila 1971, cat. no. 5, pp. 30–31; Ruiz de la Mata 1971, p. 12; Fer-
nández Méndez and Cárdenas Ruiz 1972, pp. 63, 70, 77; Gaya Nuño 1972,
pp. 33, 40; Traba 1972 "Campeche," p. 47; *Art Heritage of Puerto Rico*
1973, pp. 46, 61; Delgado Mercado 1976, pp. 12, 24; Castro 1980, pp. 361,
365; Rigau Pérez 1982, pp. 390–95; Benítez 1985, n.p.; Dávila 1985 *Expo-
sición*, cat. no. 1, pp. 13–14, 33; Dávila 1985 "Renacer," pp. 1, 8–10; Tió
1985, p. 2; González Lamela 1986, p. 809; Guiness 1986, n.p.; Rodríguez
Juliá 1986, pp. 13–24; Taylor et al. 1988, cat. no. 22, pp. 163–65, col. pl. 8;
Los tesoros 2000, p. 35, fig. 2; Vidal 2000, pp. 36, 44, 244, fig. 25

EXHIBITED: San Juan 1962, cat. no. 3; San Juan 1971, cat. no. 5; New York
1973; San Juan 1985, cat. no. 1; San Juan 1987; Ponce, New York, and
San Juan 1988, cat. no. 22; San Juan 2000

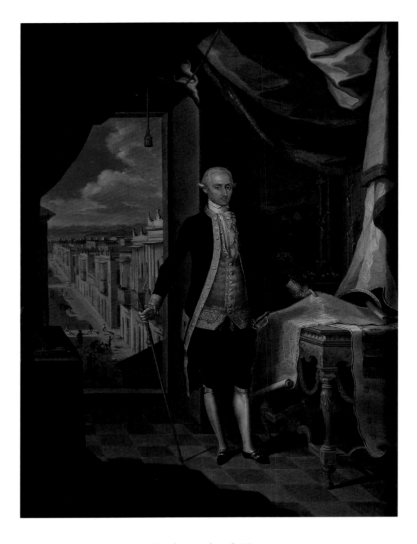

THE MOST ABUNDANT SUBJECTS in José Campeche's oeuvre are
religious, but he is most widely recognized for his portraits of contempo-
rary *puertorriqueños* and *puertorriqueñas*, the latter shown luxuriously
dressed in French style, wearing high wigs garnished with hats bearing
flowers, plumes, and furbelows befitting the prosperous society of San
Juan. He also painted gentlemen in elegant dress and opulent settings,
as in this small portrait of the governor Don Miguel de Ustáriz. As in the
Peruvian portrait of the viceroy Count of Superunda also in this exhibition
(cat. VI-112), the social position of the sitter is indicated by a number of
iconographical elements.

Ustáriz is pictured in a sumptuous room, framed by a generous
swag of drapery. Rococo boiserie on the wall behind him frames a paint-
ing of a (surely European) landscape, and a dainty gilded table next to
the governor bears a plan of San Juan, clearly labeled. Behind Ustáriz we
see an unobstructed view of the city—unobstructed because the balcony
has been conveniently omitted to facilitate our noticing the streets being
paved, a civic undertaking begun during this governor's term of office.
Ustáriz clearly wished to be pictured as a man of the Enlightenment,
a progressive governor of Puerto Rico.

The man himself is posed quite formally and painted with careful
attention to the details of his stylish clothes, and the furnishings of the room
are correctly, even painstakingly, rendered. However, as our eye moves
through the open door, tropical light and a fresh atmosphere pull our gaze
to the sea. Lively genrelike details abound. The workmen shift sand and
push wheelbarrows, watched by spectators from windows and balconies,
giving the viewer a sense of life in San Juan in the late eighteenth century.

Suzanne Stratton-Pruitt

VI-121 José Campeche[†]

(Puerto Rican, 1751–1809)

Governor Don Ramón de Castro

1800

Oil on canvas

90 × 65 inches (228.6 × 165.1 cm)

Inscribed on plinth at lower right: *DE FORTI DULCEDO;* and a bit lower:
*EL S. D. RAMON DE CASTRO, GUTIERREZ/TORRE, SALAMANCA,
CARDENAS, BOCANEGRA, PARDO Y AGUILAR/HUJO LEGITIMO Y
SUCCESOR INMEDIATO/DEL SR. MARQUES DE LORCA;/BARON
DE S. PEDRO, SEÑOR . . .*

Museo de San Juan, Puerto Rico

PROVENANCE: Chapter Room, San Juan City Hall, September 1, 1800–
c. 1898; Manuel Fernández Juncos; Biblioteca Insular; Biblioteca Carne-
gie, Puerta de Tierra, 1932; Acisclo Marxuach, c. 1936–37; Museo de
Arte e Historia de San Juan (now Museo de San Juan), 1980

PUBLISHED: Balsa de la Vega 1891, p. 41; Infiesta 1895, p. 87; Infiesta 1897,
p. 68; Newmann Gandía 1897, p. 283; Brau 1904, pp. 217–18; Fernández
Juncos 1914, pp. 76–77; Coll y Toste 1914–27, vol. 3, p. 308; vol. 6,
p. 316; vol. 8, p. 173; vol. 13, p. 201; Blanco 1932 "Campeche II," no. 1;
Tapia 1862/1946, no. 9, pp. 17, 27; Zapatero 1964, p. 412; Gaya Nuño
1965, no. 23, pp. 5–9; Blanco 1968, pl. 5; Córdova 1831/1968, pp. 15–16;
Delgado Mercado 1969, p. 21; Dávila 1971, cat. no. 11, pp. 42–43; Gaya
Nuño 1972, p. 207; Traba 1972 "Campeche," p. 49; Gaya Nuño 1980,
pp. 20–23; Dávila 1986, pp. 20–22; González Lamela 1986, p. 10; Guiness
1986, n.p.; Rodríguez Juliá 1986, pp. 24–34; Taylor et al. 1988, p. 28, cat.
no. 36, pp. 192–95, pl. 16; *Los tesoros* 2000, p. 264; Vidal 2000, pp. 32–33,
39–40, 224

EXHIBITED: Santurce 1893; San Juan 1971, cat. no. 11; Ponce, New York,
and San Juan 1988, cat. no. 36; San Juan 2000, p. 264

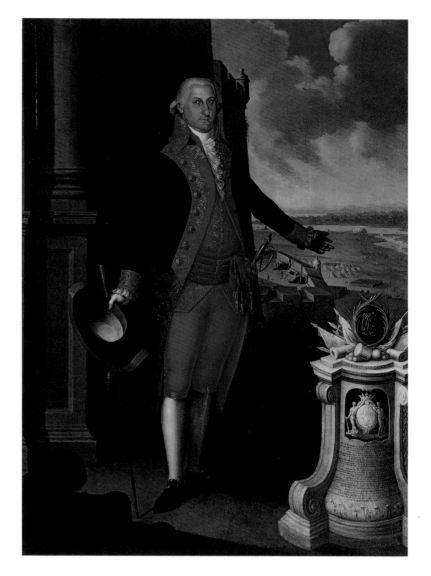

ONE OF ONLY TWO LIFE-SIZE PORTRAITS by Campeche, this work
was commissioned by the city hall of San Juan to commemorate the suc-
cessful defense of the city against English aggression through the military
leadership of the governor Don Ramón de Castro (Burgos 1751–1811
Cádiz). Like the portraits of the viceroys of New Spain (cat. VI-120) and
the viceroy of Peru (cat. VI-112), this painting represents more than the
likeness of the man. Ramón de Castro is accompanied by iconographical
details that include the family coat of arms and a neoclassical plinth on
which his many titles and achievements are detailed.

In the background is a crenellated wall with the barrel of a canon
pointing outward, and the tents of the infantry, largely composed of Puerto
Ricans, who fought under Ramón de Castro's command. The landscape
contains some particular landmarks, such as the wall of the castle of San
Cristóbal immediately behind the governor and the plain called the Puerta
de Tierra, on which the tents are set up, but these elements are arranged
in an artful, rather than strictly accurate, composition.

The pose of the sitter appears to have been based on an engraving
after a portrait by Francisco de Goya (1746–1828). Goya painted a portrait
of General José Urrutia (1798; Museo del Prado, Madrid), which was en-
graved by Blas Amattler so that the sitter could give copies to friends and
family. It is very likely that Ramón de Castro received a copy of one of

these engravings, which he in turn gave to Campeche to use as a composi-
tional model when the city fathers of San Juan commissioned his portrait.

Campeche also received personal commissions from this governor:
a portrait of his daughters (1797; Museo de Arte de Puerto Rico, San Juan)
and, very likely, one of his wife (see cat. VI-122).

Suzanne Stratton-Pruitt

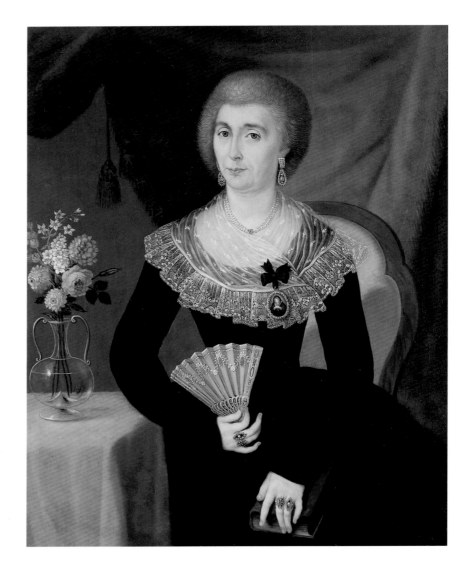

VI-122 José Campeche[†]

(Puerto Rican, 1751–1809)

Portrait of a Woman in Mourning

c. 1807
Oil on canvas
39 × 30⅝ inches (99.1 × 77.9 cm)
Collection of Marilynn and Carl Thoma

JOSÉ CAMPECHE WAS ADEPT at absorbing the Rococo elements of the style of his teacher, Luis Paret y Alcázar, and soon proved equally open to the more subdued tonalities of neoclassicism, as evinced in his portrait of *The Daughters of Governor Don Ramón de Castro* (1797; Museo de Arte de Puerto Rico, San Juan) and this portrait of a woman in mourning dress.

Osiris Delgado Mercado, the highly regarding scholar of Campeche's oeuvre, has attributed this portrait to Campeche on the basis of style, scientific analysis of the pigments, and the simple fact that no other Caribbean painter of the time could have created such a fine, emotionally nuanced portrait.

Delgado has further postulated the identity of the sitter. Ramón de Castro (see cat. VI-121) was married to María Teresa Tobía y Bazán in the Spanish city of Burgos in 1789, when she was around sixteen years of age. Four years later, Ramón de Castro was named Captain General, Intendant, and Governor of Puerto Rico, and not long afterward was named Brigadier. The couple had two daughters, María de Guadalupe Josefa (born in 1793) and María del Carmen Rafaela (born in 1795), whom Campeche painted in 1797. Seven years later, in 1804, the girls died of yellow fever. Ramón de Castro lost his position as governor the same year, and the couple retired to the town of Guaynabo until they were able to return to Spain in 1808. Based on the sitter's apparent age and the age of María Teresa Tobía y Bazán, Delgado suggests that this portrait represents

the wife of the former governor, mother of the two lost girls. The mourning dress would reflect the deaths of her daughters only three years earlier. The pendant representing the Virgin of Sorrows pinned to her lace collar is another symbol of mourning, as are the rings on either hand. Since Campeche painted portraits of the governor and the daughters, it makes sense that he would also have turned his hand to recording the wife and mother. The subdued, gray-blue tones in the portrait underscore the contemplative mood of the sitter.

Suzanne Stratton-Pruitt

VI-123 José Campeche[†]

(Puerto Rican, 1751–1809)

The Child Juan Pantaleón Avilés

1808

Oil on canvas

27¼ × 19¼ inches (69 × 49 cm)

Inscribed at bottom: *Juan Pantaleón hijo legitimo de Luis de Avilés y de Martina de Luna Alvarado vecinos labradores de la Villa de/Coamo esta isla de San Juan Baut.a de Puerto Rico. Nació el dia 2 de Julio de 1806, y conducido por sus padres a esta Capital,/le confirió el Sacramento de la Confirmació el 6 de Abril de 1808 el Illmo. Sr. Obispo Diocesano D.D. Juan Alexo de Arismendi/por cuya orden se hizo esta copia cogida del natural/José Campeche*

Instituto de Cultura Puertorriqueña, San Juan, Puerto Rico

PROVENANCE: Manuel Fernández Juncos; Junhghanns Collection

PUBLISHED: Blanco 1932 "Campeche II," no. 13; Dávila 1960, p. 49; Gaya Nuño 1965, no. 50, pp. 6, 11; Dávila 1971, cat. no. 13, pp. 46–47; Gaya Nuño 1972, p. 40; González García 1972, no. 10, pp. 118–19; Traba 1972 "Campeche," p. 49; Rigau Pérez 1982, p. 390; Benítez 1985, p. 19; Dávila 1985 "Conciencia," p. 10; Dávila 1985 *Exposición*, cat. no. 2, pp. 1, 15–16; González 1985, p. 40; Rigau Pérez 1985, pp. 326–33; González Lamela 1986, p. 11; Rodríguez Juliá 1986, pp. 117–24; Taylor et al. 1988, pp. 210–11, pl. 18; *Los tesoros* 2000, p. 133

EXHIBITED: Río Piedras 1948, cat. no. 5; San Juan 1959, cat. no. 27; San Juan 1971, cat. no. 13; San Juan 1985, cat. no. 2; San Juan 1987; Ponce, New York, and San Juan 1988, cat. no. 44; San Juan 2000, p. 133

THIS POIGNANT PORTRAIT, painted eighteen months before Campeche's death, is his last masterpiece. It was commissioned by Bishop Arizmendi, who had performed the sacrament of Confirmation on the malformed boy who is the painting's subject.

Artists had long recorded images of such anomalous beings (the Spanish painter Jusepe de Ribera had famously painted a bearded woman with her husband and baby in the seventeenth century), but following the Enlightenment, such individuals no longer were considered merely wonders of nature and curiosities, but rather invited scientific study. In the Puerto Rico of Campeche's day, this interest in a child such as Juan Pantaleón Avilés was shared by the military surgeon Dr. Francisco Oller and the garrison doctor, Tomás Prieto. A Franciscan friar who was also a competent sculptor created a wax portrait of a deformed child, which he encouraged Bishop Juan Alejo de Arizmendi to send to the Royal College of Surgeons of San Carlos in Madrid. It is probable that a similar scientific curiosity was behind the bishop's commission of this portrait.

Campeche was not a medical illustrator, however, and the resulting painting is a work of great beauty. The artist's delicate rendering of the face (beautiful despite a sad expression), the fluid brushwork in the soft linens offset by crisply detailed lace, the color brought to the canvas by setting the subject in a landscape—all these painterly devices are used by the artist to elevate his work beyond the mere depiction of a clinical case.

The subject of the painting may have been determined by Enlightenment rationalism, but Campeche's brush brought to it a deeply moving reminder of the humanity of all of us.

Suzanne Stratton-Pruitt

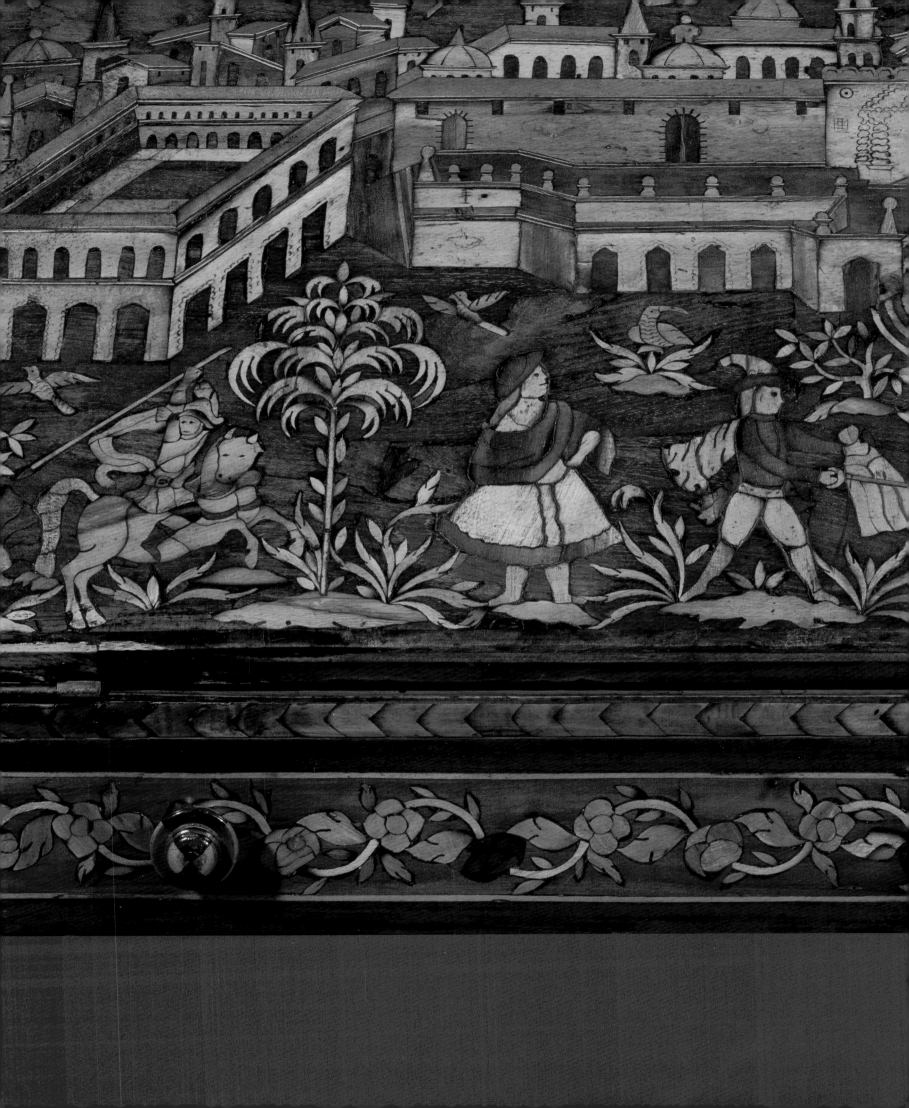

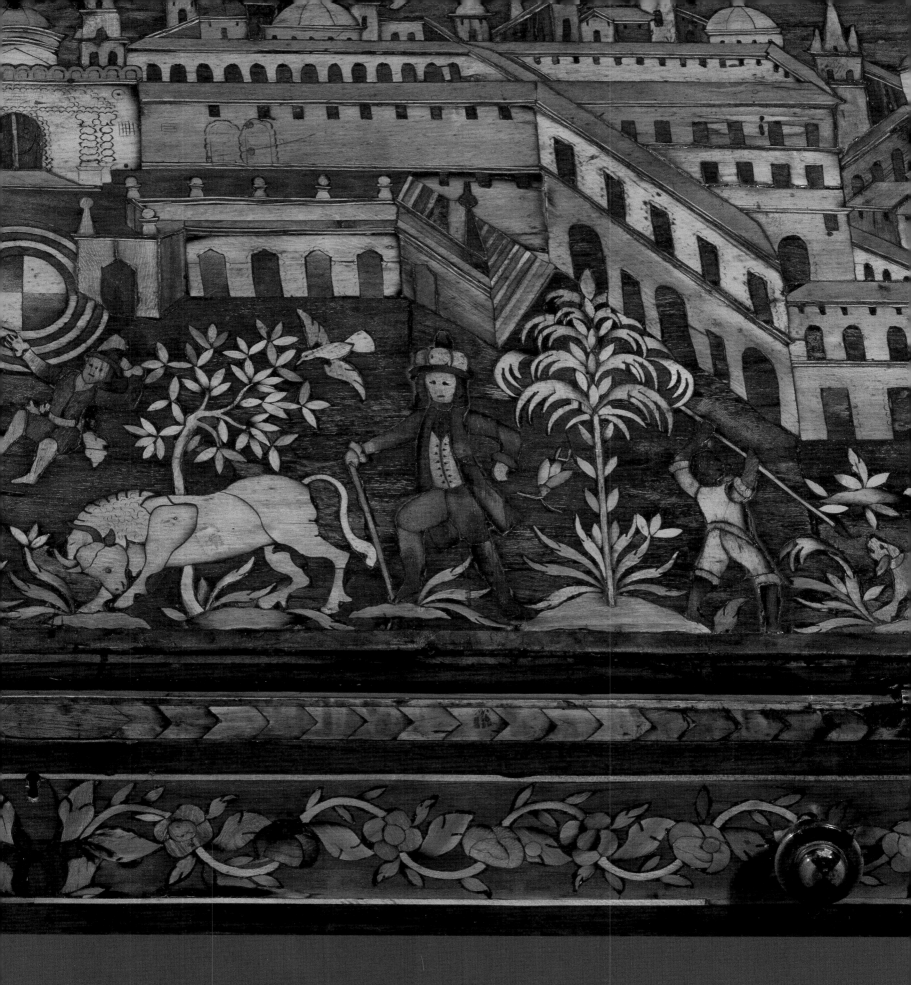

Furniture

Observations on the Origin, Development, and Manufacture of Latin American Furniture

Jorge F. Rivas P.

FIG. VII-1

Tiana, Peru, Inca period, 1450–1533. Wood, 4¾ × 15⅜ × 10 inches (12 × 39 × 25.5 cm). Banco Central de Reserva del Perú, Lima

FIG. VII-2

Bench, Ye'Kuana culture, Venezuela, c. 1950. Pendare wood, 10¼ × 8½ × 31 inches (26 × 21.6 × 78.7 cm). Collection of Patricia Phelps de Cisneros

Europeans described the magnificent cities they encountered in the New World with great admiration. Their detailed texts reveal the practices and customs of the natives, the sumptuous finery of princes and priests, and the ostentatious wealth evident in palaces and temples. However, the first chroniclers of the Indies were surprised and astonished at the dearth of furniture in such opulent surroundings. Indeed, there are very few examples of furniture among the people of pre-Columbian America, and those pieces—usually small seats and sometimes tables placed on straw mats or woven blankets—were primarily reserved for the highest levels of society. The most notable were the seats used by civil or religious authorities; these items were symbols of power and status[1] and frequently utilized in association with religious rituals, as is still the case in many of the tribes that populate regions of the Amazon today.[2]

The pre-Columbian repertoire of materials and techniques was relatively limited; thus, furnishings usually consisted of pieces worked from a solid block of stone, wood, or, in rare instances, metal,[3] and include the Inca *tiana* (fig. VII-1) and the small wooden seats common in Caribbean areas, similar to those still fashioned by certain tribes in the Amazon (fig. VII-2).

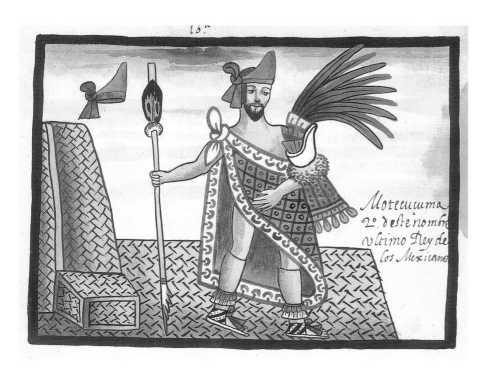

FIG. VII-3
Moctezuma, from the Tovar manuscript, 1583–87.
Paint on paper. John Carter Brown Library,
Providence, Rhode Island

FIG. VII-4
Hammock, from P. Labat, *Nieuwe Reizen Naar de
Franse Eiladen van America* (Amsterdam: Balthasar
Lakeman, 1725). Engraving. Biblioteca Nacional,
Caracas

Another example of a typical furnishing in pre-Columbian America is one that was realized with basketry. Images of these seats appear frequently in the ancient Mexican codices[4] (fig. VII-3). And although we cannot technically classify textiles as furniture, hammocks and floor mats often served as the only furnishings in pre-Columbian dwellings (fig. VII-4).

In general, all of these household articles differed completely in character, use, and manufacture from their European equivalents. Because of the paucity of precedents, the European tradition of joinery and furniture making was introduced with great homogeneity throughout Latin America. The native artisans did not resist learning new methods for making furniture and, at first, rigorously followed the technical and formal conventions of the Iberian Peninsula.[5] Nonetheless, once the practice of the trade was established in the New World, the new materials, tools, artisans, settlements, and social structures significantly altered the various types of furniture and their manufacture, which ultimately resulted in an original style of furniture.

The conquest of Latin America, attempts to convert indigenous people to Catholicism, and the development of vast territories presented an unprecedented challenge to European authorities and the church. The abundant natural resources of the newly discovered land financed the Europeans' monumental enterprise and created favorable conditions for the development of industrial arts in the European mode. From the beginning of the conquest, European artisans established themselves in the new settlements and began producing household goods and furniture. In many cases, joiners came to Latin America as part of a ship's crew, and their maintenance and repair of the boats they sailed on was indispensable during the long crossing from Europe. As a result, joinery was one of the first trades to be practiced in the Indies; the construction and outfitting of temples, dwellings, and public buildings in the newly founded towns demanded the labor of master craftsmen. The joiners followed European methods, standards, and customs; guilds were established and modeled on those of Spain and Portugal. For example, the municipality of Lima regulated the master joiners' trade from its first ordinances in 1549, and this was done in Mexico in 1548.

European furniture was logistically difficult to import, expensive, and vulnerable to tropical wood-eating insects. These factors, from very early on, stimulated the development of workshops capable of meeting local demand. Indigenous workers, whose recognized skill with their hands allowed them to learn the trade quickly, were frequently employed in these workshops and placed under the guidance of master craftsmen who were educated and trained in Europe.[6] This workshop model was used to teach other European industrial arts in Latin America.

A large portion of the furniture produced in these workshops was initially intended for use by the church and the highest levels of society—illustrious Europeans whose numbers grew through the addition of wealthy Creoles (Europeans born in America). Nevertheless, the market soon demanded simple, utilitarian pieces for all levels of society.

FIG. VII-5
Ture, Venezuela, Caracas, 1800. Spanish cedar, leather,
iron, 30¾ × 20⅞ × 29½ inches (78 × 53 × 75 cm).
Private collection

European furniture, its uses and manufacturing techniques,
were a novelty for the natives, who, in certain cases, adapted these
techniques to produce their own traditional pieces. One example
of this phenomenon is the *ture* (fig. VII-5). This small inclined seat,
which later gave rise to the *butaque*,[7] is an adaptation of the ceremonial
benches of Caribbean cultures. Unlike the ritual seats carved from a
solid block of wood, the *ture* was constructed using several different
materials. Strips of wood were fastened by scarf joints[8] to create the
ture's frame; animal hide was stretched taut over the frame and secured
with iron studs. The construction of a piece of furniture with these
characteristics would have been impossible without knowledge of
European techniques.

In order to explain the development of furniture making in Latin
America, it is necessary to consider the technical aspects of woodwork-
ing prior to the arrival of the Europeans. Although pre-Columbian
woodworking skills were limited, technical advances in the two most
highly developed societies—the Aztec Empire in Mexico and the Tawantinsuyo cultures of
the Andean region—were superior to those of other Latin American cultures. Cutting tools
used by indigenous people ordinarily consisted of a smooth blade that was usually made of
stone; copper[9] was occasionally used, and, despite iron's abundance, it was never used to make
tools.[10] The absence of instruments capable of making precise cuts in wood usually limited
production to solid pieces that were made with primitive tools and the use of fire.[11] As a result,
the assortment of scarf joints or fitted joints essential in constructing complex pieces was never
developed.

The two different levels of woodworking skill were obvious to the writers of the period.
"El Inca" Garcilaso de la Vega (1539–1616), who, when referring to carpentry in the chapter
in his *Comentarios reales de los Incas* of 1609 devoted to "the few instruments that the Indians
had available for practicing their craft," observed:

> Joiners in these lands were not very accomplished, because before the arrival of the
> Europeans they lacked for tools; and of those used by the craftsmen from across the
> seas, craftsmen in Peru had only the hatchet and the adze, and they were of copper.
> They did not know the saw, or the auger, or the plane, or any other instrument for
> the trade of joinery, and thus did not know how to make arches or doors beyond cut-
> ting and preparing wood for buildings. To fashion their hatchets and adzes, and the
> few hoes they produced, they turned to silver workers rather than smiths, because
> their only metalwork was in copper and brass. They had no
> nails, and what wood they used in their buildings was bound
> with rope made of esparto grass and not nailed.[12]

FIG. VII-6
Follower of Miguel Cábrera (Mexican, 1695–
1768), *The Five Pannonian Masons as Woodcarvers*,
c. 1740–80. Oil on canvas, 36¾ × 48¼ inches
(93.3 × 122.6 cm). Figge Art Museum, Davenport,
Iowa. Museum Purchase, Friends of Art Permanent
Endowment

Garcilaso de la Vega precisely summarizes the techniques of pre-
Columbian Latin America, and he also points out the important changes
that came with the influence of European technology in the years following
the conquest.[13] The Europeans introduced nails and iron tools (fig. VII-6);
saws and other serrated devices; scarf joints and wood joints.[14] European
furniture and its method of construction clearly amazed the native observ-
ers of the post-conquest period. The extraordinary attention to detail of
Felipe Guamán Poma de Ayala's (1534–1615) furniture sketches in his 1615
Nueva corónica y buen gobierno[15] cannot be considered fortuitous. This
manuscript was actually an unintentional catalogue of seventeenth-century
Latin American woodworking. Joints, nails, wood pegs, door locks, chest

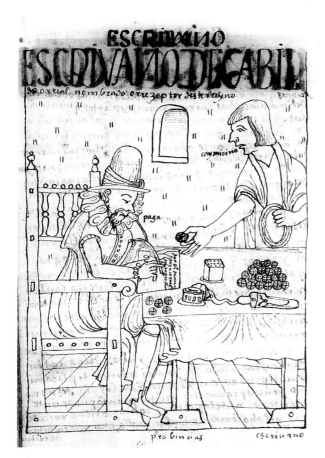

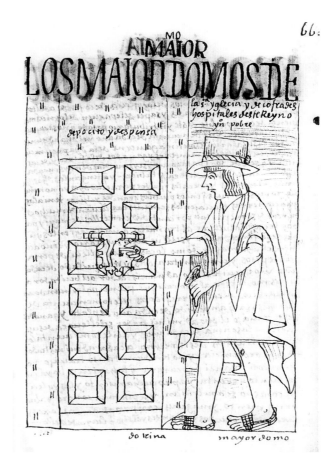

FIG. VII-7

Felipe Guamán Poma de Ayala (Andean, 1534–1615), *El notario del cabildo recibe cohecho de un indio tributario* (The royal administrator's notary receives a payoff from a tributary Indian), from *El primer nueva corónica y buen gobierno*, 1615. Ink on paper, book: 5¾ × 8 inches (14.5 × 20.5 cm). Det Kongelige Bibliotek, Copenhagen

FIG. VII-8

Felipe Guamán Poma de Ayala (Andean, 1534–1615), *El mayordomo de la iglesia, de cofradías y de hospitales de este reino* (The chief attendant of the church, confraternities, and hospitals of the kingdom), from *El primer nueva corónica y buen gobierno*, 1615. Ink on paper, book: 5¾ × 8 inches (14.5 × 20.5 cm). Det Kongelige Bibliotek, Copenhagen

locks, upholstery studs, and countless other particulars are all meticulously represented in the furniture drawings. These details obviously captured Guamán Poma de Ayala's attention and inspired him to reproduce them in his illustrations (figs. VII-7, VII-8).

In many of the newly conquered lands, the workshops benefited from the abundance of raw materials; the territories were extraordinarily rich in wood and many other plant species whose useful properties and potential value were noted by the Europeans.[16] The harvesting of vast areas of forest, and trade in those products, constituted an important segment of the local economy; furthermore, the use of Latin American wood had a considerable impact on the development of European furniture making.[17] In these new workshops, other materials were frequently used to embellish the wood of special pieces—a practice common both in Europe and in pre-Columbian Latin America. Furniture was inlaid with mother-of-pearl, tortoiseshell, horn, bone, ivory, or a precious metal. In other instances, pieces were gilded, plated, or painted; and, in certain regions, techniques similar to those used in Asian lacquering were employed.

By the second half of the sixteenth century, the influence of Asia and Europe on Latin America is evident. The establishment of safe routes permitted commercial exchange between Asia and Europe. This extraordinary convergence of cultures significantly affected the development of the industrial arts. The goods, and indeed the artisans, of Asia that passed through (and in many cases remained) in the Indies left a distinctive mark on local furniture and its manufacture. In certain cases, Latin American artisans adapted the European version of Asian motifs to create their own style. In the midst of this confluence of ideas, forms, and techniques—from three culturally diverse continents—new traditions emerged in Latin America. Skilled artisans fashioned pieces based on a highly individual reinterpretation of the European repertoire, which resulted in furniture that was frequently and admirably a combination of the techniques and decorative motifs of America, Europe, and Asia. These pieces can be considered some of the first works of a globalized world.

NOTES

1. It is not by chance that the chronicler Felipe Guamán Poma de Ayala, in his *Nueva corónica y buen gobierno* of 1615, chose an item of furniture (a *tiana*— an Incan seat) as one of the elements of his coat of arms. This piece was one of the symbols of Incan nobility and was adopted by Guamán Poma de Ayala to demonstrate, in post-conquest society, his aristocratic origins. See Boone and Cummins 1992, pp. 91–148.

2. In many Latin American cultures the use of these seats is tied to religious worship. In some cases, the benches are viewed as a vehicle for communication with the beyond. The Amazonian Ye'Kuana have a myth that the shamans of antiquity flew, seated on their benches, to the world of the gods. Delgado 2004, p. 102.

3. "The Inca ordinarily sat upon a seat of solid gold called a *tiana*: it was approximately eleven inches in height, without armrests or back, and with a concave depression in the seat. The *tiana* was placed upon a large square block of gold." Vega 1609/1985, vol. 2, p. 10.

4. For variants of this type of chair and its development in Mexico, see Carrillo y Gariel 1957, pp. 7–10.

5. The long Moorish domination of the Iberian Peninsula profoundly influenced the style and technique of furniture making; therefore, its form and construction differ notably from the rest of Europe. These characteristics would be reproduced later in Latin America. See Toussaint 1946.

6. The majority of the carpenters who settled in Latin America came from Spain and Portugal. However, a significant number of artisans came from other regions of Europe—in many instances, they were religious missionaries who established workshops for manufacturing furniture. Examples of this kind of establishment are the workshops of the Jesuit missions in Paraguay, which were directed by German artisans. See Academia Nacional de Bellas Artes 1983, pp. 233–35.

7. See Röhl 1946, pp. 97–104; Möller 1962, pp. 172–81.

8. To make a scarf joint, two pieces of wood are tapered or notched to correspond to each other. These ends are then overlapped and secured by lapping. The increased amount of surface area that has contact with the other piece makes an especially strong and flexible connection.

9. The use of this metal significantly improved the cutting capacity of tools, and it was influential in the development of the manual trades. Majluf et al. 2001, p. 64.

10. The Incas called this mineral *quillay*; they even mined iron ore, but they never developed a process for separating the metal from the raw ore. Vega 1609/1985, vol. 1, p. 118.

11. In many aboriginal cultures of Latin America, fire or burning coals were used to fell trees, to cut the wood into lengths, and to effect the rough dressing of the pieces. Delgado 2004.

12. Vega 1609/1985, vol. 1, pp. 118–19.

13. In this paragraph, Garcilaso de la Vega refers specifically to the practice of joinery in Peru. However, it is important to specify that throughout the American territory techniques used in carpentry did not differ greatly from those described in the *Comentarios reales*, with the probable exception of the use of metal tools that occurred in a few cultures.

14. Toothed saws, as well as scarf joints and fitted wood joints, have been known and in ordinary use in Europe for thousands of years. (The western tradition of furniture making started in Egypt during the Early Dynasty [3050–2086 B.C.] and spread to ancient Greece and Rome.) Killen 1994, pp. 19–27.

15. Guamán Poma de Ayala 1615/1980.

16. Many ancient chroniclers were interested in the enormous riches of American flora, and their properties. See Sahagún 1981, pp. 28–31; and Vega 1609/1985, vol. 1, pp. 110–11.

17. Wood from the Indies was used as early as the construction and furnishing of the Escorial, which was completed in 1584 and located on the outskirts of Madrid. Importing precious wood from Latin America was greatly in vogue during the eighteenth century, and certain species such as mahogany (*Swietenia macrophylla*) were thought to be indispensable for decorating elegant furniture. Aguiló Alonso 2001, pp. 11–14; Edwards 1996, pp. 74–81.

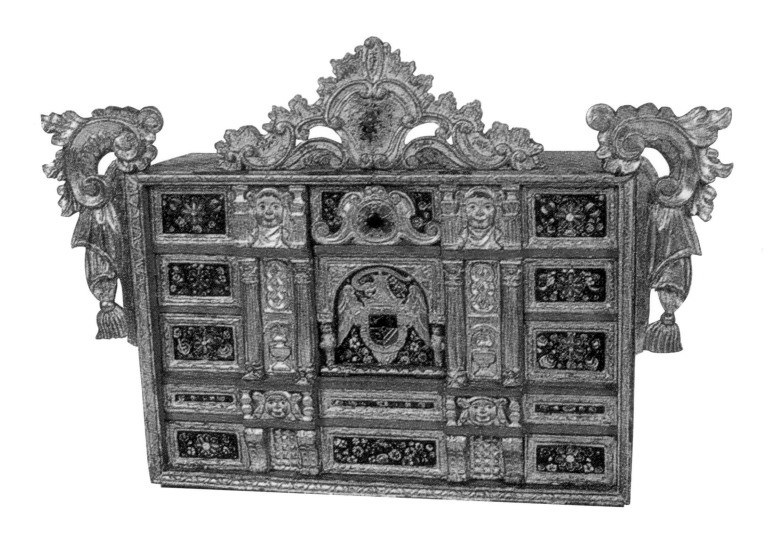

VII-1 *Writing desk*

Bogotá, Colombia
Seventeenth century
Polychromed and gilded wood
42⅛ × 30¹¹⁄₁₆ × 12⅜ inches (107 × 78 × 31.5 cm)
Seminario Mayor de San José, Bogotá, Colombia

IN HOUSES THROUGHOUT LATIN AMERICA in the colonial era, it was customary to designate the largest room, which was generally at the front of the house with a view of the street, as the drawing room. Here, the owners attended to matters of protocol, received important visitors, and held receptions on the occasion of significant events. This room's furnishings were certainly the most luxurious in the house. No expense was spared in creating a suitable atmosphere, since the room's adornments reflected the social status and wealth of the owner. Writing desks stood out among the furnishings in the drawing room. These sumptuous pieces, decorated with marquetry or richly carved and gilded, contained numerous small drawers—and very often, a secret compartment for storing valuable objects, jewels, or important documents. The desks were supported on low tables called *bufetes* (writing desks), and were often placed in the room in pairs.

This outstanding piece from New Granada, luxuriantly polychromed and gilded, is modeled in relief, in which the artist has adapted the characteristic architectural motifs of Andean altarpieces. The main body of the desk is divided vertically into three unequal areas by a pair of double pilasters supported on corbels. The spaces between each pilaster pair are adorned with masks and other motifs carved in relief. In the wider, central area, there is a series of four small drawers with relief carvings. The largest of these drawers bears a noble coat of arms beneath an arch. On top of this is another drawer decorated with a pediment. Each of the lateral areas contains a column of five drawers of various sizes, also all with decorated fronts and gilded borders. The ensemble is framed by a symmetrical crest of rocaille that has been carved, pierced with fretwork, and gilded, with an oval cabochon at its center.

Jorge F. Rivas P.

VII-2 *Bed*

Peru
Seventeenth century
Gilded wood
85¹⁄₁₆ × 66⁹⁄₁₆ × 96¹⁄₁₆ inches (216.1 × 169.1 × 244 cm)
Museo de Arte de Lima, Peru, Donation of Rosa Prado Garland

ONE OF THE MOST OUTSTANDING characteristics of Peruvian furniture from the end of the seventeenth century and the first half of the eighteenth is the intricately carved decorations that completely cover the surface of each piece. This elaborate gilded bed is a typical example of the ornate Cuzco style: the posts, pillars, balusters, knobs, stretchers, and head- and footboards have been delicately sculpted in their entirety. The repertoire of motifs is extensive and includes volutes with leaf motifs, rosettes in various styles, acanthus leaves, scales, feathers, serrated edges, knobs shaped like pomegranates or pineapples, pearls, and cabochons. The eminently

architectural nature of the composition recalls the grilles used to enclose chapels along the sides of many Cuzco churches.

The Spanish custom of the ceremonial bed became fashionable in the American colonies as well. The most luxurious bed in the house was placed in an alcove adjacent to the main room, and was used solely on solemn occasions such as the birth of a new family member or a wake for a deceased individual. This type of bed was rare, and only the wealthiest families could afford its exorbitant price. However, it was not only the furniture that was expensive; in many cases, the value of counterpanes, bedskirts, and draperies—fashioned from rich silks ornamented with gold and silver ribbons, embroidery, and lace—more than surpassed the cost of the cabinetmaker's work. A canopy was suspended over the bed, with its own draperies to match the counterpane and bedskirts. The bed was supported on a carpeted wooden platform. Generally, there were few beds in a house, and these were intended for the exclusive use of the family. Servants and slaves usually slept on straw mats or on the bare floor.

Jorge F. Rivas P.

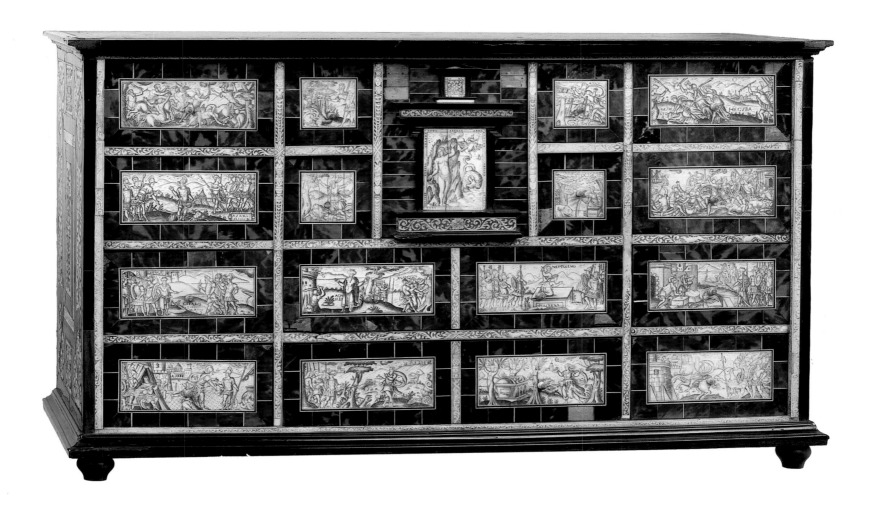

VII-3 *Desk*

Peru
Seventeenth century
Wood, tortoiseshell, and ivory
35¹³⁄₁₆ × 48¹⁄₁₆ × 14¹⁵⁄₁₆ inches (91 × 122 × 38 cm)
Museo de Arte de Lima, Peru, Donation of the Prado Family

ATELIERS IN THE VICEROYALTY OF PERU enjoyed a well-deserved reputation for the quality of their inlay work. The production of furniture decorated with this technique from the Mudejar tradition achieved a remarkable level of development; a few such pieces were exported to Europe as well as other Spanish dominions in the Americas.

The luxurious finish of inlay work proved ideal for decorating desks due to their importance among domestic furnishings. Artisans used a variety of materials. One preferred combination consisted of thin sheets of tortoiseshell applied over previously gilded wood with bone or ivory inlays. Ornamental motifs covered an enormous range, from simple geometric forms taken from Spain's Islamic tradition to minutely detailed patterns inspired by architecture. The latter were often embellished with tiny paintings or, failing these, sheets of ivory sgraffitoed and tinted to resemble engravings.

The themes represented in desks generally included religious scenes or secular motifs taken from classical literature, such as the *Moralized Ovid* (*Ovidio Moralizado*) seen here. This translation of the *Metamorphoses* of Ovid, the Roman poet of the Augustinian era, was hugely popular as a source for the mythological themes used in this period, doubtless due to the prevailing taste for emblematic treatises. In addition to their decorative character, these complex images with moral and allegorical content, sgraffitoed onto ivory plates and tinted black to make the drawing stand out, were eminently didactic in nature. The front of each of the seventeen tiny drawers on the desk bears one of these sheets, framed in alternating strips of tortoiseshell and ivory to imitate the rough texture of stone. The engraving on the central drawer, *Perseus Freeing Andromeda*, has been placed inside a panel made to resemble a door. Over this is another, smaller sgraffitoed sheet with a pediment that functions as a crest. The dividers between the images are thin strips of sgraffitoed and tinted ivory.

Jorge F. Rivas P.

VII-4 *Armoire*

Peru
Seventeenth century
Wood, ivory, and hardwood veneers, some parts gilt
(metal keyhole plates are a later addition)
94½ × 59⅞ × 24 inches (240 × 152 × 61 cm)
Banco de Crédito del Perú (Casa Goyeneche), Lima

THE DESIGN OF THIS PIECE, which consists of two carcasses separated by a row of three drawers in the center, may have been inspired by armoires from the Low Countries. This configuration was often used in Peru in the seventeenth century and the first half of the eighteenth.

The entire surface of the armoire was decorated using complex inlays of grotesquery in sgraffitoed ivory and exotic woods. Ridged frames, gilded moldings, and architectural elements enclose the areas of inlay work. The upper cornice, adorned with geometric motifs, may be a repair from a later date.

The use of grotesquery for ornamentation was widespread throughout Latin America, particularly in the Andes region. Countless building facades and interiors, works in silver, textiles, and of course an infinite number of furnishings were adorned with this capricious combination of foliate and spiral motifs interlaced with an assortment of monsters and fantastic figures. Various creatures, sirens, chimeras, and tritons were interspersed with motifs of leaves and fruits of the earth. While thoroughly inspired by European sources, South American grotesquery in reality

constituted an original decorative mode, as it resulted from the combination, transformation, and synthesis of ornamental models of diverse origin. The main sources of this type of ornamentation were Roman frescoes from the Renaissance in their later variations, arabesque and tracery designs of Moorish origin, some Flemish patterns and embellishments, and certain indigenous elements from the decorative traditions of indigenous Americans.

Inlay work was the ideal medium for transferring grotesquery to furniture making. The rich expressiveness of this decorative technique made it ideally suited to the purpose. Peruvian cabinetmakers used inlay work to adorn many of their pieces and, in addition to wood, they used other valuable materials like tortoiseshell, bone, ivory, mother-of-pearl and, in some cases, precious metals. Inlays were used in all kinds of furniture, particularly everyday pieces such as desks and their *bufetes* (the small tables on which the former were supported), paper storage cabinets, boxes, trunks, coffers, and lecterns.

Jorge F. Rivas P.

VII-5 *Pair of framed mirrors*

Mexico

Seventeenth century

Wood frame inlaid with tortoiseshell, imitation tortoiseshell, and bone; mirrored glass

27½ × 22½ inches (70 × 58 cm)

Museo Franz Mayer, Mexico City, 18-383/00495-01/CEE-0002; 18-384/ 00496-02/CEE-0003

EXHIBITED: Monterrey 1997

THE USE OF FRAMED MIRRORS as decorative objects in a room can be dated back to the mid-sixteenth century, by which time the fabrication of mirrors greater than four inches (10 cm) in diameter had become more common. The mirror, considered a "luxury" item, was protected by a frame expressing the style of the period.

 These two mirrors of antique glass (with recent repairs) are in wood frames veneered with plates of tortoiseshell and fillets of bone in geometric patterns, and plant motifs in the four corners done in *sgraffito* on bone.

The patterns are reminiscent of those used in Mudejar art in Spain during the thirteenth to the sixteenth centuries.

 Although clearly Spanish in style, mirrors of this type were also used as decorative objects in the sumptuous interiors of the palaces of New Spain. It is difficult to be certain about the provenance of these mirrors, since the same method of manufacture and the ornamental elements and materials had already been used on the old continent. Still, the combination of elements lends the mirrors an air that clearly evokes New Spain.

 The application of tortoiseshell and bone—with the occasional use of *sgraffito*—was a common technique in the Spanish colonies for luxury items such as boxes, sewing cabinets, trunks, and mirrors. A great number of mirrors are recorded in inventories from this period. The provenance of some has been stated, while others are merely described. Some mirrors of this type, with similar ornamental motifs and their origins established, have survived to this day, so that the New World origin ascribed to this pair of mirrors may well be correct.

Teresa Calero Martínez de Irujo

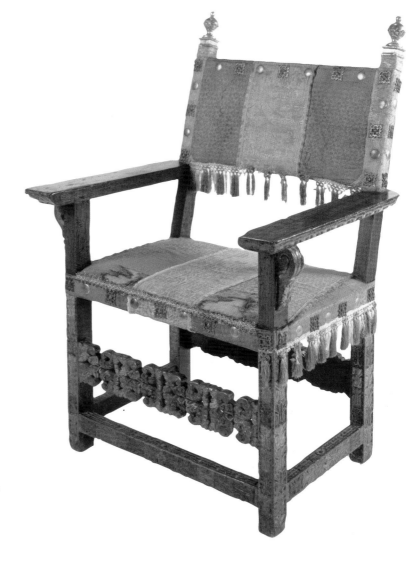

VII-6　Attributed to Antonio Mateo de los Reyes[†]

(Venezuelan, active 1725–66)

Armchair

c. 1740
Polychromed and gilded cedar
42⅛ × 30⁵⁄₁₆ × 22¹⁄₁₆ inches (107 × 77 × 56 cm)
Collection of Patricia Phelps de Cisneros

PROVENANCE: Don Antonio Pacheco y Tovar, the first count of San Javier, Caracas; Manuel Santaella, Caracas; Mercedes Santaella de Henning, Caracas

PUBLISHED: Duarte and Irazábal 1966, p. 88; Duarte 2004, p. 155

ONE REMARKABLE CHARACTERISTIC of the development of cabinet-making on the new continent was the persistent use of the traditional formal repertoire of Spanish baroque furniture until well into the eighteenth century, despite the changes in taste brought about by the accession of the House of Bourbon to the Spanish throne in 1700.

Throughout Spanish America during much of the eighteenth century, not only did furniture continue to be manufactured in the old way, but customs like the use of drawing rooms continued to enjoy enormous popularity despite having fallen into disuse in Spain by the beginning of the century. This clinging to old habits and styles—and by extension to all that the Habsburg dynasty in Spain had stood for—could perhaps be interpreted, not as an anachronism, but rather as a subtle way of legitimizing the new titles and fortunes acquired by the aristocracy of the Indies, thereby building a bridge to the past.

This chair, datable to circa 1740, sat in the Caracas home of Don Antonio Pacheco y Tovar, who was awarded the title of count of San Javier in 1731. The majority of the furnishings in the house, one of the most significant and luxurious in the city at the time, may have been commissioned circa 1727, the year of the count's marriage to Doña Teresa Mijares

de Solórzano y Tovar. The count probably acquired this chair—which dates slightly later—after he received his title, in order to enrich the decor of his house in keeping with his new rank.

In making the chair, the master followed, with slight modifications, the lines used in chairs of this type in Spain since the sixteenth century. Still, there are definitive Spanish American features in the decoration of the piece: its entire surface, particularly the fretwork crosspieces, has been minutely carved with stylized volutes and plant motifs, and the carvings themselves have an ostentatious polychromed and gilded finish.

Jorge F. Rivas P.

VII-7 *Armchair*

Mexico
Second half of the eighteenth century
Carved, incised, turned, gilded, and polychromed wood;
with velvet and bronze
47 × 33⅜ × 21 inches (119 × 77 × 53 cm)
Museo Franz Mayer, Mexico City, 3-032/06220-01/CSD-0071

PUBLISHED: *Artes industriales* 1982; Aguilera et al. 1985, no. 79,
p. 64; *Mexico* 1990, cat. no. 207, p. 443; *Viceregal Mexico* 2002,
cat. no. 43, p. 170

EXHIBITED: New York, San Antonio, and Los Angeles 1990, cat.
no. 207; Houston, Delaware, and San Diego 2002, cat. no. 43

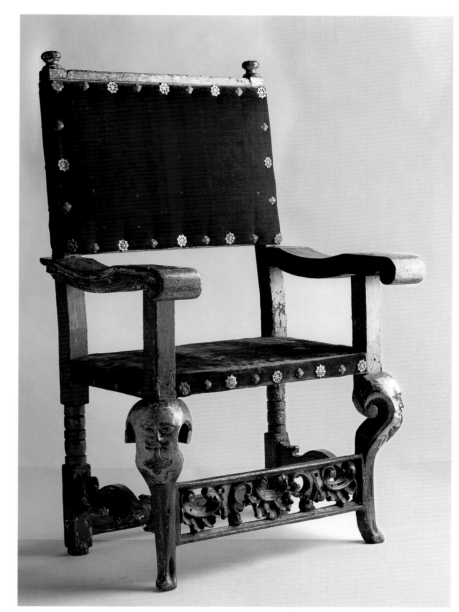

THIS ARMCHAIR HAS A RECTANGULAR BACK upholstered in red velvet, with bronze decorative studs; the arms have slight curves ending in volutes. The rear uprights are straight at the top, while below they are shaped into appliquéd round lozenges, which continue down into square feet. In front, the cabriole legs have gargoyles at the knee and end in duck feet. The crosspieces at the sides bear rocaille ornamentation, while the front one is carved with maritime motifs. All three show remnants of gilding, though the rear crosspiece is plain. The entire surface shows remnants of polychromy. The upholstery and studs were added subsequently.

Furniture in New Spain is the product of diverse stylistic influences that were combined to create a harmony of form. This chair shows Spanish antecedents in its structure, and European Renaissance decorative elements such as the gargoyles (inspired by Italian grotesqueries). The gilded rocaille on the front crosspiece is peculiar to the artistic style known as rococo, and the use of the cabriole leg is an ornamental element that originated in Asia.

The techniques are also diverse, since the entire surface is carved, with incising on the frame. The still-visible polychromy and gilding were important decorative features, and the gargoyles were made using a similar process to that employed in Tlaxcala mask-making. That region could be the provenance of this chair, since there is a register of similar armchairs in the San Nicolás Panotla parish church in the state of Tlaxcala.

This combination of technical and ornamental features lends this chair a clearly New Spanish character.

Teresa Calero Martínez de Irujo

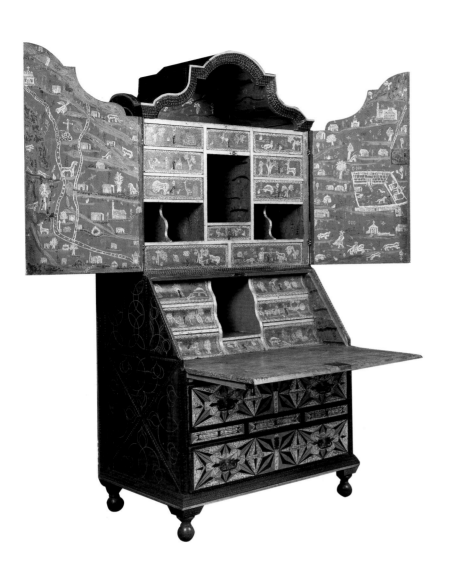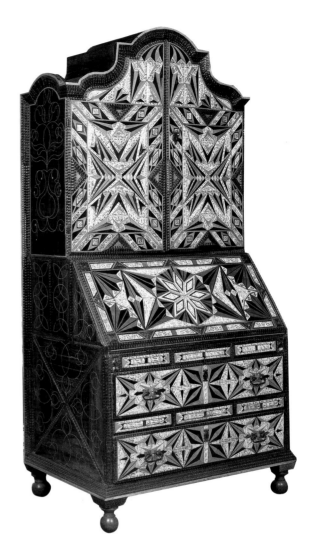

VII-8 *Writing desk*

Puebla, Mexico
Second half of the eighteenth century
Carved wood, inlayed contrasting woods, painted and incised bone and ivory,
New Spain *maque* lacquer, gold paint, metal hardware and hinges
82¹¹⁄₁₆ × 53¹⁵⁄₁₆ × 24 inches (222 × 105 × 65 cm)
Museo José Luis Bello y González, Puebla, Mexico

THIS PIECE OF FURNITURE, designed for writing and storing papers, has a hinged lid that opens up and is lowered to expose a flat surface for writing. Two doors with a mixtilineal upper profile enclose the chest of drawers inside the upper part of the desk. There is no doubt that this piece is part of a group of similar furnishings from the same workshop. Companion pieces to this writing desk include a writing desk in the Museo Franz Mayer (inv. no. 02761 GEB-004), a wardrobe in the same museum (inv. no. CAD 0012), and a privately owned writing desk with chest of drawers. Similarities in decoration can be seen on another armoire in the Museo Franz Mayer (inv. no. B-03905155 CAD-0012). All, with their beautiful marquetry of contrasting woods and incised bone and ivory

motifs, were clearly influenced by the decorative repertoire of Mudéjar art, in, for example, the eight-pointed stars in geometric patterns and the other figures arranged at various angles across the surface. Richly molded undulating forms mark the main profiles of the desk and its mixtilineal pediment. Also noteworthy is the fact that on the inside of these pieces—with the exception of the wardrobe—the artisans applied New Spanish lacquer called *maque*, or paint that mimicked lacquer (referred to in period documents as "imitation Chinese"). Although the Manila Galleons brought a multitude of Chinese and Japanese lacquered pieces to New Spain, the decorative motifs on the New Spanish pieces, which include animals, houses, and other edifices of a western character, are far from being traditional chinoiserie. The motifs also draw on indigenous maps of the viceregal era, and the traditional pagodas, bridges, willows, and other motifs of Asian origin or influence have been replaced by the buildings and vegetation of "the land."

Gustavo Curiel

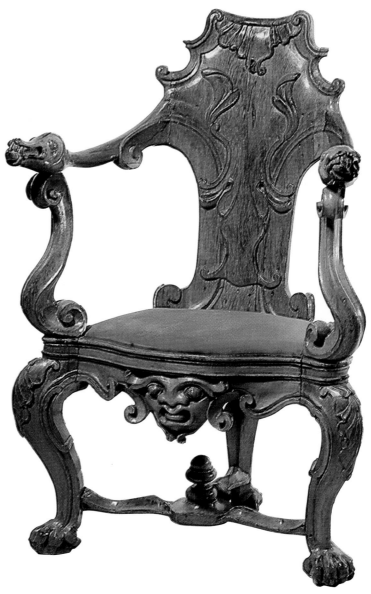

VII-9 *Armchair*

Bahia, Brazil
Eighteenth century
Jacaranda, with leather and metal
45⅜ × 29⅝ × 19¾ inches (115 × 75 × 50 cm)
Museu de Arte Sacra da Universidade Federal da Bahia, Brazil

LATIN AMERICA PROVED TO BE fertile ground for the development of the rococo style, and in the eighteenth century this formal repertoire spread across the length and breadth of the continent. Local variants of the style sprang up in almost every corner of the territory. In Brazil, one of the key periods of development of cabinetmaking as a trade corresponded with the peak of the rococo. The inventiveness and creativity of Brazilian master cabinetmakers includes incomparable examples such as this chair, whose originality of design, coupled with the excellence of its execution, bears witness to the lofty heights achieved in South American cabinetmaking during the eighteenth century.

The decorative elements on the chair, which, oddly, has only three legs, include American fauna. The most prominent of these are a feline effigy at the base of the reverse side of the seat back and two serpent heads, each with a ball between its fangs, serving as ornaments for the arms of the chair. Rocaille with volutes and leaf motifs adorns the rest of the piece, while a grotesque mask with Negroid features appears on the front of the seat. Each of the three cabriole legs ends in a claw-and-ball foot; an acanthus leaf on the knees accentuates the curvature of the legs.

The origins of this type of decoration must be sought among the motifs of grotesquery in the baroque tradition that was so widely embraced throughout the Americas, in which masks, animals, and all kinds of fantastic creatures were intermingled with leaf motifs and volutes. The public taste for "nature fantasy" gained fresh impetus in the second half of the eighteenth century; anticlassicism in the arts of the period found in elements of nature the perfect means of expressing the spirit of the era. This time, though, the capriciousness of nature was the model, with the controlled contrasts of baroque left behind. Now, as in this chair, it was novelty and spontaneity in the use of natural elements that set the tone.

Jorge F. Rivas P.

VII-10 *Desk resting on* bufete

Lima, Peru
Eighteenth century
Wood, tortoiseshell, and mother-of-pearl
94½ × 72¹⁄₁₆ × 24 inches (240 × 183 × 61 cm)
Museo Pedro de Osma, Lima, Peru

THE UPPER STRATA OF COLONIAL Latin American society possessed a limitless appetite for luxury and ostentation. Enormous sums of money were spent on sumptuous goods produced locally or imported from almost anywhere in the known world. Merchandise from Europe and Asia competed with products made in the Indies.

In the homes of those who prided themselves on possessing some sort of fortune, it was de rigueur to flaunt that wealth in front of strangers as well as friends. Household furnishings were considered of primary importance, and special attention was paid to the selection of furniture and other objects designed to adorn the main rooms. Luxury furniture—with desks chief among them—was indispensable when it came time to decorate the salon of some affluent Spanish American. Few items were as effective as desks such as this one in displaying the wealth of the owner.

Inlay work was one of the most frequently used decorative techniques in creating this type of furniture. Inlays were usually designed with valuable materials like bone, ivory, mother-of-pearl, ebony, or tortoiseshell. The use of costly raw materials significantly raised the price of the piece; in many cases, the piece was further embellished with the addition of locks, keyholes, drawer pulls, and corner bands in brass, gold-plated iron, or, better yet, silver.

This striking desk, consisting of two carcasses sitting on a matching *bufete* (small table), is an example of the mastery achieved by Peruvian ateliers in the manufacture of luxury furniture. The decoration of the piece, decidedly in a seventeenth-century Korean Chosŏn style, has been made with tortoiseshell inlays in a technique commonly known as *enconchado* (shell inlay). The dark, lustrous tortoiseshell background sets off the complex mother-of-pearl pattern of flowers, leaves, arabesques, and garlands that are interlaced in intricate geometric designs of a somewhat Asian Mudéjar flavor.

The two carcasses of the desk, each with five faces and numerous drawers and tiny doors, possess an obviously architectural character. The vertices are accentuated with small, turned Solomonic columns finished with pear-shaped ornaments. The upper edge of each section ends in a fretwork rail, and on the front of each of the carcasses is a small religious painting, framed and under glass. The desk sits on a *bufete* held up by five arches that rest on turned double Solomonic columns and ball feet. The *bufete* is bedecked with inlays much like the rest of the desk, except for the table top, which is decorated in a much simpler manner using only a variety of woods.

This outstanding ensemble is an extraordinary combination of the formal Hispano-Flemish repertoire characteristic of Peruvian cabinet-making and decorative techniques from Asia.

Jorge F. Rivas P.

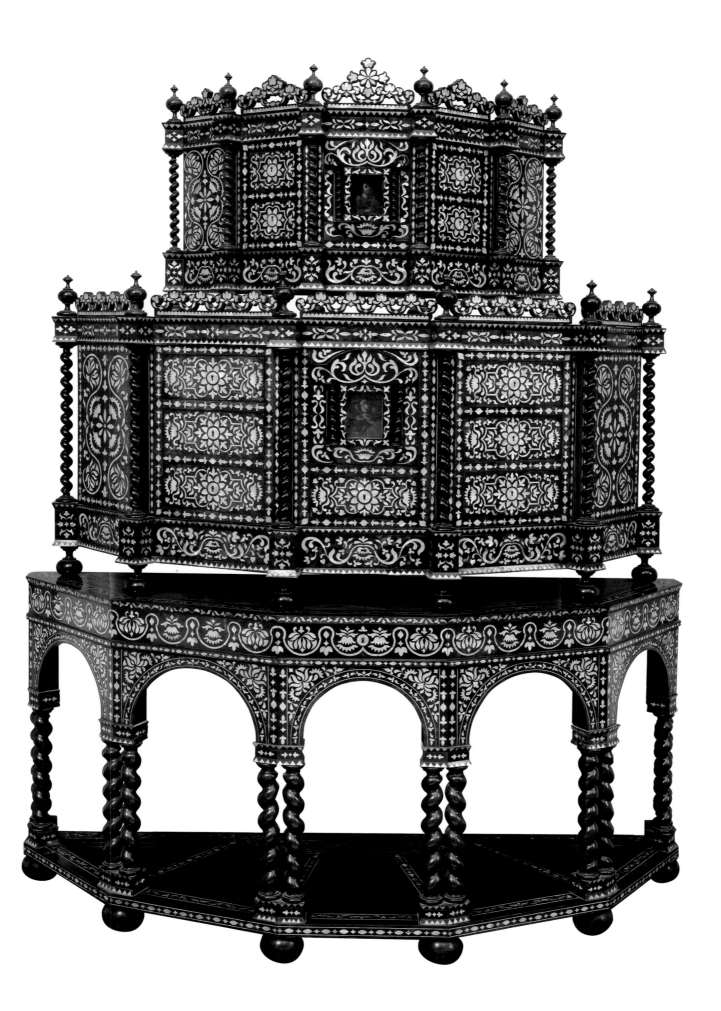

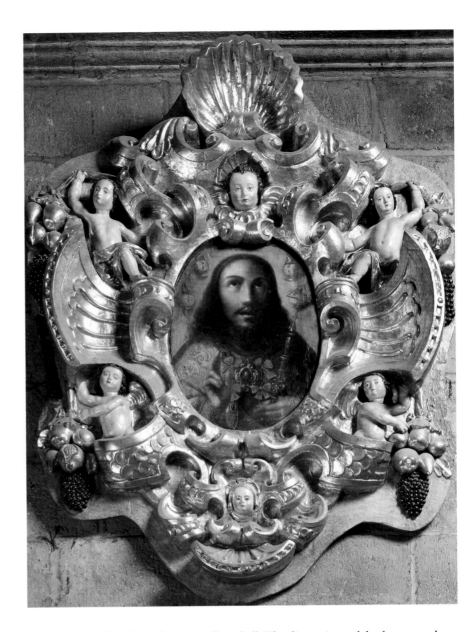

VII-11 *Frame with painting of Christ*

Cuzco, Peru
Eighteenth century
Polychromed and gilded wood
35¹³⁄₁₆ × 27¹⁵⁄₁₆ inches (91 × 71 cm)
Church of San Sebastián, Cuzco, Peru

DURING THE COLONIAL PERIOD in Latin America, picture frames constituted an important ornamental element in interior decoration. Not only did the frames make the paintings inside them stand out, they also functioned as a transitional element between the image and the wall on which the painting was placed. In many cases, frames were part of the overall plan for the decoration of a building's interior and were designed to match the rest of an ensemble. Ornamental motifs in frames were often selected to suit the theme of the painting they were to contain, so that in frames for religious paintings one might find angels and cherubs; it was also common to use symbols of the Passion of Christ, attributes of saints, or Marian symbols. At times the frame became so important that it more than surpassed the dimensions, quality, and value of the painting within.

This sumptuous polychromed and gilded frame, clearly inspired by rococo, is characteristic of cabinetmaking in Cuzco in the eighteenth century. The frame's design follows a rigorous bilateral symmetry. The central oval holding the painting is surrounded by thick, elaborate, and irregular rocaille, carved with volutes and shells. Cherub busts are poised at the four corners, and in their hands are bunches of fruit that hang over the sides of the frame. The upper and lower edges of the piece each end

in a cherub head and a scallop shell. The dimensions of the frame amply overshadow the size of the image of Christ.

Thanks to the ostentatious frame, this relatively small painting, which hangs at the top of a pillar in one of the lateral naves of the church of San Sebastián, stands out against the dark stone wall. The church, located on the outskirts of Cuzco, was rebuilt and enlarged in the second half of the seventeenth century by Bishop Manuel Mollinedo y Angulo after the terrible earthquake of 1650 that destroyed much of the region. The reconstruction of the church lasted until the following century.

Jorge F. Rivas P.

VII-12 *Wardrobe*

Mexico City
Second half of the eighteenth century
Wood
165⅜ × 60¼ × 28⅜ inches (420 × 153 × 72 cm)
Museo Regional de Querétaro/CONACULTA, INAH, Mexico

PROVENANCE: Sacristy of the church of San Felipe Neri in Mexico City

PUBLISHED: Aguilera et al. 1985, pp. 44–46, 174, ill. p. 184; *México eterno* 1999, p. 85

EXHIBITED: Mexico City 1999 *Eterno*

SPECIALISTS HAVE CATALOGUED this monumentally proportioned wardrobe as an armoire. Judging by its shape, it is more wardrobe than armoire. The latter was a piece of secular furniture originally used to store arms in an armory or a home. This piece of furniture comes from the sacristy of the Oratory of San Felipe Neri in Mexico City. Rich liturgical vestments such as pluvials, maniples, dalmatics, and chasubles were placed inside this wardrobe. It also housed the altar linens and other cloths—many of them embroidered with threads of braided silk and precious metals—that were essential to religious ritual. From a formal perspective, the wardrobe is a hybrid of various ornamental repertoires. Elements of French rococo combine with shapes and techniques from New Spanish baroque. Perhaps the most surprising is the enormous pediment crown, an elaborate circle framed by beautiful branches of laurel leaves. These elements were drawn from French classicism, the period of Louis XVI to be precise. These are not neoclassical motifs, as has been stated, but elements that were quite contemporary in their day and the product of enlightened French ideas. The floral branches suspended from the top of the wardrobe were also drawn from the ornamental treatises of this French imperial style, as was the ring that completes the contours of the pediment crown. The scallop shells on the doors, sides, and pediment crown are closer in decorative language to New Spanish baroque. Another innovation is that the piece was neither gilded nor polychromed in accordance with baroque tastes. The piece glows with the natural color of the wood, a technique that was modern in its day. There are similarities between the carving and formal ornamental qualities of this piece and the monumental door of the Canal family palace in San Miguel el Grande, Guanajuato. The same can be said for the porthole windows of that secular building and the circular pediment crown of the wardrobe, which are similar in more than one aspect.

Gustavo Curiel

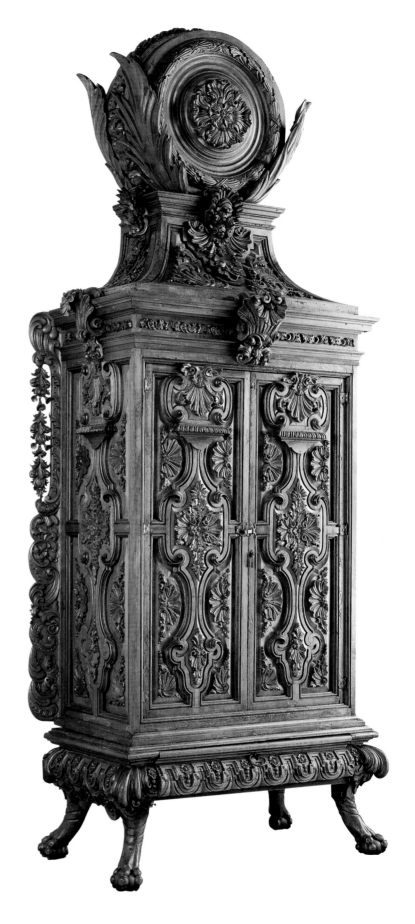

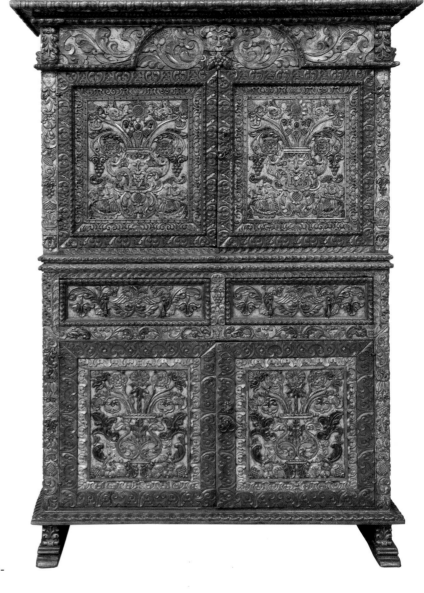

VII-13 *Armoire*

Cuzco, Peru
Eighteenth century
Polychromed wood, iron drawer pulls and hinges
78⅜ × 54¾ × 33 inches (199 × 139 × 84 cm)
Private collection

THE SPANISH CONQUEST OF PERU left an indelible stamp on the decorative arts. The traditional ornamental patterns used by pre-Columbian cultures were soon replaced by those of European derivation. During this process of substitution and adaptation, the complex decorative patterns of the Incas—in many cases based on a square or rectangular screen—gave way to the no less complicated European ornamentation of grotesquery. But native artisans did not simply copy imported patterns and motifs; instead, they transformed and recreated the designs of the Old World in a completely new way, imbuing them with a uniquely original character.

The tangled structure of grotesquery, with its foliage and volutes, strange animals, sirens, masks, and other monstrous creatures, presented the talented Peruvian artisans with a vast arena for artistic expression, one less subject to the control and oversight of Spanish authorities than the representation of religious images in painting or sculpture. In this way, many themes of Andean culture were incorporated into the grotesquery designs; aboriginal flora and fauna often appeared, along with elements of the local iconography. Grotesquery was applied to every conceivable surface, from architectural facades and interiors to small silver objects; not even furniture escaped this aesthetic tendency.

This imposing armoire was built in accordance with formal Cuzco patterns: two cases with doors separated in the middle by a row of drawers.

The piece is supported on molded brackets, and a wide molding tops the upper edge. In this case, the carved and polychromed grotesquery that completely covers the piece is the outstanding design element, and it is rigorously symmetrical. The front is divided into six areas framed with carved molding that matches the doors and drawers. The two identical upper areas have a mask at the center, from which two others arise at the sides. These are ornamented with foliage, flowers, and fruit, including pomegranates, grapes, and cocoa-bean pods. At the sides are a pair of *vizcachas* (burrowing rodents), while two lovely guitar-strumming sirens grace the upper edge. A two-headed eagle sits in the center of each drawer, flanked by a pair of masks and foliage. The lower panels, also identical, bear a jug of flowers at the center, accompanied by a pair of masks and some pomegranates. The fascias are decorated with leaf motifs, volutes, shells, masks, flowers, and fruit, the last-named including grapes, pomegranates, and custard apples. Along the upper edge, a large mask framed by volutes and leaf motifs completes the ornamentation of the piece. The sides are divided into fourteen small panels whose decoration repeats the motifs on the front.

Jorge F. Rivas P.

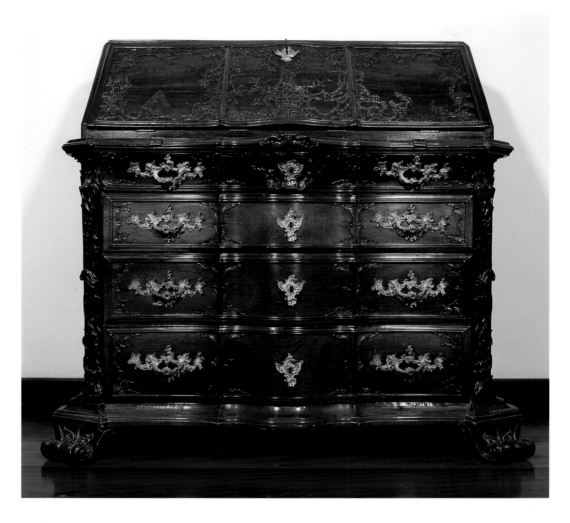

VII-14 *Desk*

Brazil
Second half of the eighteenth century
Jacaranda, with gilded bronze
54¾ × 61½ × 32⅞ inches (139 × 156 × 83.5 cm)
Private collection

BY THE TURN OF THE EIGHTEENTH CENTURY, the Portuguese crown understood full well the strategic importance of Brazil—its most prosperous and lucrative territorial possession overseas—and it became obvious to the Portuguese elite that any potential expansion of the kingdom should center on Spanish America instead of its other colonies in Asia or Africa.

From that moment on, commercial trade across the Atlantic grew remarkably. England and Portugal embarked on a long and prosperous relationship around the middle of the century that further boosted trade between the two kingdoms. The trade agreement that had been signed in 1654, followed by the marriage of Charles II of England and Catarina of Braganza, daughter of King João IV of Portugal, laid the foundations for a close alliance that would benefit both nations for well over a century. This explains, in part, the enormous English influence in Portuguese-Brazilian furniture, particularly during the eighteenth century.

This impressive desk combines formal elements of Portuguese and English rococo in a local variation characteristic of the kingdom of João I (1750–77), adapted to the requirements of Brazilian taste. The piece is made of Bahia jacaranda (*Dalbergia nigra*), an exceptionally hard, heavy rare wood, and is composed of two clearly distinguished parts separated by a wide mixtilineal frame. The upper part has an inclined drop-down cover that opens to serve as a writing surface, while the lower one consists of a chest of four drawers with curved fronts. The desk rests on four inverted corbel legs carved with volutes beneath the mixtilineal molding at the lower edge of the desk.

Perhaps the most outstanding element in this item of furniture is the extraordinarily carved decoration of the finest rocaille that covers almost the entire piece and complements its sinuous forms. Embellishing the desk are handles and keyholes of gilded bronze that reiterate the ornamental motifs in the carving.

Jorge F. Rivas P.

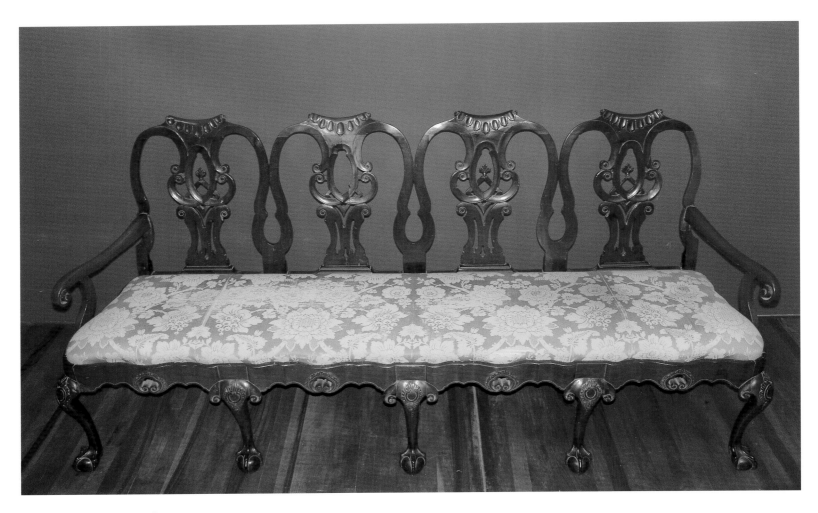

VII-15 *Bench*

Mexico
Second half of the eighteenth century
Mahogany, upholstery stretched over a frame
39⅜ × 82¹¹⁄₁₆ × 22¹⁄₁₆ inches (100 × 210 × 56 cm)
Fundación John Boulton, Caracas, Venezuela

PROVENANCE: The Aguerrevere Pacanins family, Caracas; Arístides Rojas, Caracas

PUBLISHED: Duarte and Irazábal 1966, p. 85

DURING THE SEVENTEENTH AND eighteenth centuries, the Viceroyalty of New Spain maintained close trade relations with the other Spanish colonies in Latin America. Veracruz was the main Caribbean seaport, from which a huge shipping fleet ferried agricultural products, raw materials, and various manufactured goods to and from Central America, the Antilles, and other, more distant locations in the region, such as Cartagena de Indias, Maracaibo, and Caracas. Thanks to this intensive trade, much furniture produced in Mexico was exported to other Caribbean territories, where it was very favorably received.

This bench is part of an ensemble of Mexican furniture that was acquired by a well-to-do Creole, in the eighteenth century, to adorn his Caracas residence (other pieces belonging to the same collection are known), probably in exchange for a shipment of fine cocoa, which was the principal export of the Captaincy General of Venezuela at the time.

The bench is finely carved from solid mahogany, and draws on several elements of the formal Anglo-Dutch repertoire of the mid-eighteenth century. In particular, the piece bears some resemblance to the furniture of Thomas Chippendale, whose book *Gentleman and Cabinet Maker's Director*, first published in 1754, enjoyed an extraordinarily wide distribution. Considering that the Caribbean trade was not limited to Spanish territories, but included the English, French, Danish, and Dutch colonies—often through contraband trade—it is not hard to imagine that either the Chippendale book or some piece of furniture from these places might have come into the hands of a master carpenter in New Spain. Regardless of the means by which the Northern European formal repertoire made its way to Latin America, the style was transformed and combined with other elements of diverse origins to create an original formal language, as can be seen in this fine piece of furniture.

Jorge F. Rivas P.

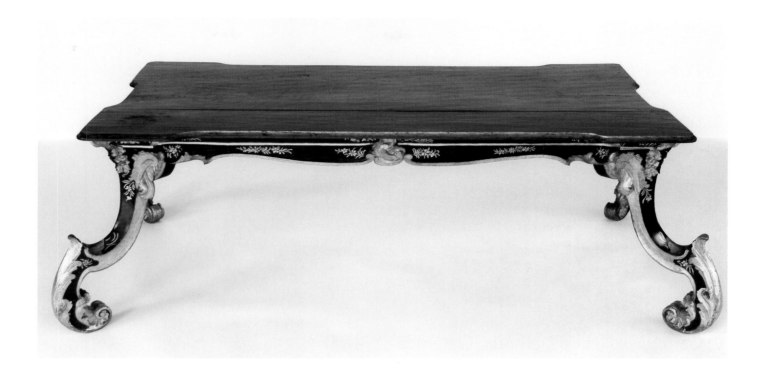

VII-16 Francisco José Cardozo[†]

(Venezuelan, active 1768–1820)

Painting and gilding possibly by Miguel Antonio Mogollones

(Venezuelan, active 1738–1803)

Casket table

For the funeral masses of the Religious Brotherhood of San Pedro
of the Cathedral of Caracas
1769
Polychromed and gilded wood
30⅝ × 80⅜ × 38⅝ inches (78 × 204 × 98 cm)
Collection of Herrera Guevara Family, Caracas

PROVENANCE: Religious Brotherhood of San Pedro of the Cathedral of
Caracas; Luis Felipe Guevara, Caracas

PUBLISHED: Duarte and Irazábal 1966, p. 123; Duarte and Gasparini 1989,
p. 88; Duarte 2004, p. 73

DURING THE HISPANIC PERIOD, the religious brotherhoods were one
of the most significant institutions within the complex system of worship
instituted by the Catholic Church. Usually set up under a patron saint
or some other Christian dedication, these groups of devotees—who paid
membership fees to belong to them—dedicated their revenue to good
works and to defraying their maintenance costs. Matters related to reli-
gious observance were regarded as of primary importance, particularly

everything to do with the death and interment of the members of the
fraternity. The faithful who belonged to a particular brotherhood—and
whose membership fees were current—had the right, at the moment of
their death, to a funeral mass, interment, and a novena period with all
due honors of the brotherhood they belonged to in life.

The various brotherhoods in a way reflected the social structure
of the colony; some attracted well-off Creoles and wealthy merchants,
others drew those of mixed race, while still others appealed to the slave
population.

For artisans, these associations constituted some of their most
important clients, and the execution of continual construction projects
and improvements to chapels or altarpieces required the cooperation of
the most famous craftsmen. In 1769, when the members of the Religious
Brotherhood of San Pedro—one of the oldest, wealthiest, and most presti-
gious in Caracas—commissioned Cardozo to make a piece of furniture
destined for a rite as important as the casket table for funeral masses, they
no doubt had in mind the illustrious career of the master woodworker.

Catholic religious ceremonies often required special furniture for
specific liturgical activities, such as this example. The table, crafted in a
fine rococo style, served as a support for the casket, and the table itself
rested on four sinuous curved and reverse-curved legs that project boldly
out beyond the vertices. The table skirts continue the undulating move-
ment of the legs on their underside and in the elegant mixtilineal curve of
their lower edge. Discrete rocaille carvings accent and highlight the edges
of the skirts, the vertices of the table, the modulation of the curves, and
the ends of the legs. The gilding on the carvings stands out over the black
varnish of the background of the case. The severity of the varnish is atten-
uated by a delicate ornamentation of diminutive flowers and foliage in gold.

Jorge F. Rivas P.

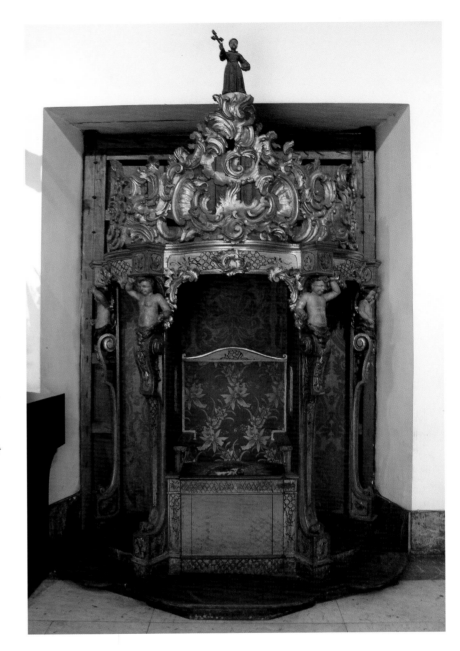

VII-17 Carved by Domingo Gutiérrez[†]

(Venezuelan, 1709–1793)

Painted and gilded by Juan Pedro López[†]

(Venezuelan, 1724–1787)

Confessional

1773
Polychromed and gilded cedar
106¼ × 96⅛ × 96⅛ inches (270 × 244 × 244 cm)
Church of San Francisco, Caracas, Venezuela

PUBLISHED: Duarte 1977, pl. 6; Duarte 1996, pp. 161, 267

THE PRIEST JUAN FÉLIX XEREZ de Aristeguieta y Bolívar (1732–1785) was undoubtedly one of the greatest patrons of the arts in the city of Caracas in the eighteenth century. He held a master of arts degree and a doctorate in theology, and used his considerable personal wealth to finance a number of works in churches, monasteries, and brotherhoods. In 1773, the priest commissioned master carver Domingo Gutiérrez to create this confessional destined for the church of San Francisco in Caracas. He contracted Juan Pedro López, another well-known artist in the city and frequent collaborator with Gutiérrez, to paint and gild the confessional.

The influence of various European schools of architecture is evident in the design of this piece, one of the artist's best; with extraordinary skill, he melded elements of Roman mannerism with those of German and Spanish rococo. The carver was quite probably inspired by European engravings of architecture, a great number of which were in circulation throughout Latin America and which served as guides for artisans. Even so, this is no mere combination and adaptation of architectural themes to the exigencies of a project; in the case of this confessional, these themes

were but a point of departure, transformed and reworked by Gutiérrez through his own language of sculpture in order to create a unique and original work.

The confessional was designed as a small polygonal edifice. It rests on a podium whose curved steps project outward on each side. The material bulk of the carcass is reduced by its having three compartments, a larger one in the center with its seat for the priest and two lateral stalls for the faithful. These areas are separated by thin uprights that end in cherub torsos supported by volutes: Atlas-like figures who in turn support a cornice with three curved sections. The whole is crowned by an elaborately carved rocaille crest with fretwork, at whose highest point a small sculpture of the figure of Saint Francis completes the piece.

The entirety was polychromed and gilded by Juan Pedro López. The inside was painted to imitate crimson damask, while the outside is sky blue with cobalt blue ornamentation. The moldings and carved ornaments were gilded and the sculptures polychromed.

Jorge F. Rivas P.

VII-18 Attributed to Pedro Carmona

(Brazilian, active 1771–80)

Armchair

c. 1777
Jacaranda, with damask upholstery
66½ × 35 × 26½ inches (169 × 89 × 67.5 cm)
Catedral Metropolitana, Buenos Aires

PUBLISHED: Academia Nacional de Bellas Artes 1983, pp. 210–11; *Buenos Aires* 1998, pp. 105–6

EXHIBITED: Buenos Aires 1948, no. 296; Buenos Aires 1964, no. 127

MUCH OF THE FURNITURE PRODUCED in the Viceroyalty of the Río de la Plata possesses substantially different characteristics from that of the rest of Spanish America. Certainly one of its key differences is the marked influence of the Luso-Portuguese repertoire during the eighteenth century. There are a number of contributing factors: for one thing, documents show that Portuguese and Brazilian carpenters had been active in the city since the beginning of the seventeenth century. The proximity of the Portuguese colony and the need for skilled labor doubtless constituted a powerful incentive for the establishment of these artisans of wood. In addition, the city's status during much of the colonial period as a "dry port" (i.e., a port with rigorous controls and prohibitions regarding the entry and exit of cargo) often facilitated contraband trade with Brazil. Moreover, the illegal trade was abetted by the port's distance from Lima, its administrative capital until the creation of the Viceroyalty of the Río de la Plata in 1776. It was extremely costly to bring furniture from the other side of the Andes to Buenos Aires, and the distance allowed for a certain laxity on the part of local authorities in the application of restrictions and controls over contraband goods.

This armchair is probably one of the most beautiful pieces manufactured in the last quarter of the eighteenth century in Buenos Aires. The extraordinary quality and detail of its intricately carved decorative features, as well as its fine design and craftsmanship are evidence of the mastery achieved by the port city's cabinetmakers. The formal repertoire of this chair observes the outlines of Luso-Brazilian furniture from the reign of José I (1714–1777). The chair's tall, sinuously curved back is crowned with a richly carved crest, featuring a great plume at the center surrounded by rocaille with scallops, garlands, and volutes. The curved arms, ending in a large volute, emerge from the mouths of a pair of bearded grotesque

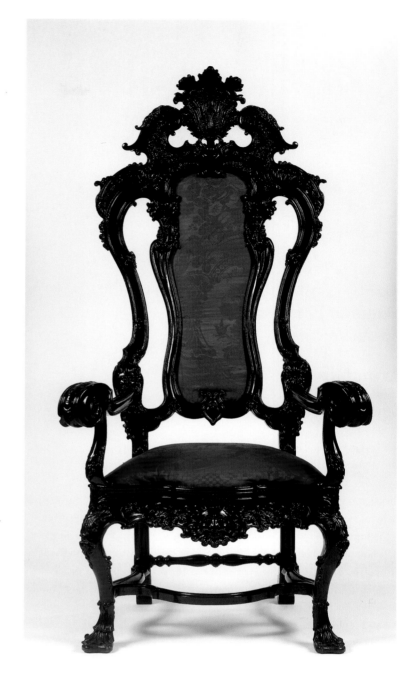

masks and rest on posts in reverse curve. The central sash of the chair back and its seat are upholstered. The front cabriole legs are decorated with ascending rocaille and leaf ornaments that also encompass the curved front of the seat. At the center of the seat is a radiant mustached mask. The feet are linked by stretchers in reverse curve, while a turned stretcher joins the rear feet.

Jorge F. Rivas P.

VII-19 Attributed to O Aleijadinho (Antônio Francisco Lisboa)[†]

(Brazilian, c. 1738–1814)

Armchair

c. 1778–83
Wood
82¹¹⁄₁₆ × 39⅜ × 22⅛ inches (210 × 100 × 56 cm)
Museu Arquidiocesano de Arte Sacra, Mariana, Minas Gerais, Brazil

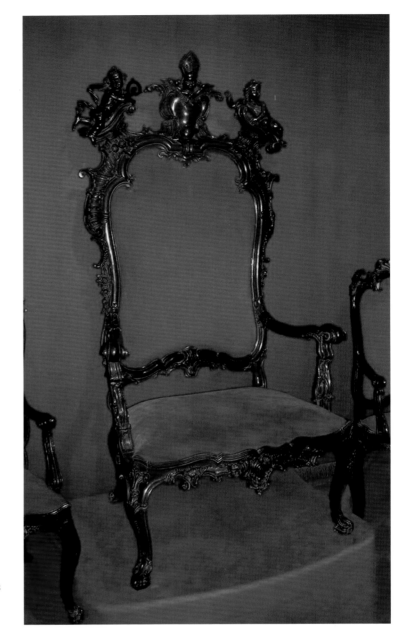

THE EXCEPTIONAL ARCHITECTURAL AND sculptural concepts behind the works of Antônio Francisco Lisboa, better known as "O Aleijadinho" —the little cripple—no doubt reflect his family origins. Born the illegitimate son of Portuguese architect and master builder Manuel Francisco Lisboa and a black slave, he started out as an apprentice in the atelier of his father and an uncle, Antônio Francisco Pombal, one of the most famous carvers in his birthplace of Vila Rica (present-day Ouro Prêto). An architect and sculptor, he made forays into other art forms, including furniture making, as evidenced by this armchair, which was created as the seat of honor in a church.

The chair is of imposing size because it was conceived to project the dignity and magnificence of church hierarchy. This was achieved through ingenious manipulation of the chair's scale and proportions. A design plan in which a simple object like an armchair is transformed into a creative exercise of symbolic importance speaks to the artist's own view of the arts. "O Aleijadinho" saw the architecture, furniture, sculpture, and other ornament of buildings and other environments as interdependent, fitting within a specific context as part of a complex, detailed plan.

In this armchair, the artist used French rococo features, a significant choice since Brazilian tastes of the day tended to favor Portuguese rococo with a marked English influence. Lisboa possibly had access to European books and engravings with images of this type of furniture, and he did not hesitate to adapt the style to his own needs. New World artisans commonly drew inspiration from book illustrations and prints. In addition, such images were often used to show prospective clients the various types of furniture that could be commissioned.

This armchair, with its gently curving cabriole legs, is ornamented with elegant rocaille in shell and plant motifs. The high back ends in an open pediment with volutes. Each outer edge of the pediment supports a cherub in flight, while at the center is a cabochon surrounded by rocaille and crowned by the bust of another cherub wearing a miter.

Jorge F. Rivas P.

VII-20 Attributed to Serafín Antonio Almeida[†]

(Venezuelan, 1752–1822)

Easy chair (butaca)

c. 1800
Solid, hard, veined wood with veneers of hard, veined wood and carreto wood inlays over a cedar base; seat and back upholstered in cloth over a frame
40³⁄₁₆ × 32½ × 17¹¹⁄₁₆ inches (102 × 82.5 × 45 cm)
Private collection

PROVENANCE: Luis Rodríguez Santana, Caracas

PUBLISHED: Duarte 1999, p. 38

EXHIBITED: Caracas 1999

THE BUTACA, A TYPE THAT ORIGINATED in the Americas, is meant for relaxing, and its use was confined to the most intimate spaces in the home, private rooms where the rigid etiquette of the eighteenth century could be set aside, and where it became acceptable to adopt a relaxed posture when seated.

The first references to this type of easy chair in Venezuela date from the seventeenth century. The unique form of the piece, with its high back and slightly backward tilted seat, is derived from the *ture*, a small chair with an inclined back that was often used by the pre-Columbian inhabitants of the Caribbean. The name *butaca* comes from the word *putaca*, which means "chair" in the language of the Cumanagoto people native to the northeast coast of Venezuela. The word *butaca* is commonly used today in Spanish to designate a wide chair with arms and a backward tilted back. This type of chair was enormously popular during the colonial period, and its use spread throughout the Caribbean and New Spain.

Venezuelan cabinetmakers built these chairs based on a local model, using the formal and technical repertoire of European furniture making. Of particular note is the use of characteristic elements taken from English and Dutch furniture of the second half of the eighteenth century. This piece, made in Caracas about 1800, is a clear example of the great refinement and originality achieved by Caracas masters toward the end of the century. A variety of building techniques are combined in this chair: the delicate front legs end in claw-and-ball feet, and the arms and their supports, together with the upper edge of the back, were carved from solid wood. The rest of the piece is covered with hard, veined wood veneer and decorated with very fine strips and delicate garlands inlaid with carreto wood. The decorative inlaid elements are similar to those used by Serafín Antonio Almeida in the pulpits of the Caracas cathedral presbytery in 1803.

Jorge F. Rivas P.

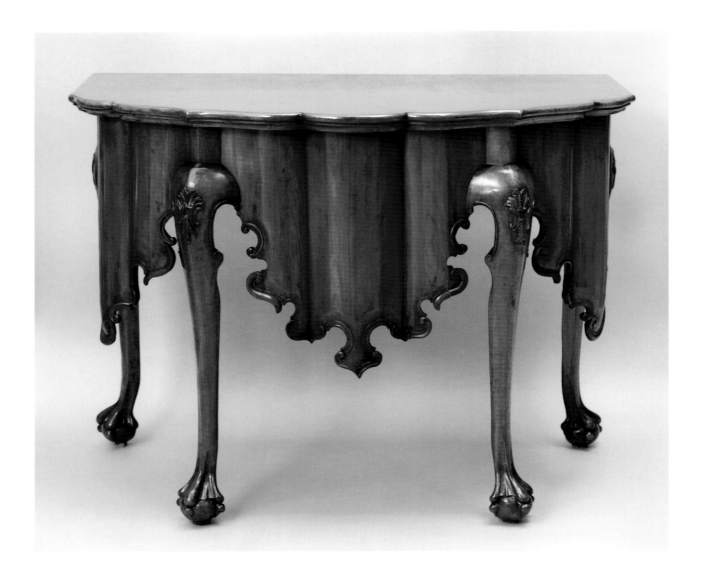

VII-21 *Auxiliary table*

Brazil
Second half of the eighteenth century
Wood
33 × 44 × 27½ inches (84 × 112 × 70 cm)
Private collection

DURING THE SEVENTEENTH AND eighteenth centuries, there was a more-or-less constant flow of Portuguese colonists into Brazil. At certain times, there was a great increase in immigration, particularly during the reign of João V, from 1707 until his death in 1750. This large contingent of immigrants included numerous master carpenters eager to try their luck in South America. These craftsmen launched one of the most important artisanal traditions on the entire American continent.

By the eighteenth century, the practice of carpentry as a trade was firmly established in Brazil and followed Portuguese habits and customs. The trade employed both Portuguese and Creole artisans.

The furniture produced in Brazil in the second half of the century already had a style of its own. Local variations on the rococo style were developed in the most important manufacturing centers, based on formal elements of varied origin. The formal and technical foundation of Brazilian furniture certainly came from the Portuguese repertoire of the period, which in turn was profoundly influenced by English and Dutch rococo furniture. But in Latin America, the evolution of the rococo style took a different course from that on the European continent, as was most evident in the application of ornamentation and the plastic treatment of surfaces. European ornamental forms and motifs were assimilated and recreated in a completely original way. In some cases, they were mixed with Asian themes or indigenous elements.

The most outstanding characteristic of this auxiliary table is its exaggerated, sinuous skirt, with its scalloped edge carved in a delicate rocaille with an Asian flavor. To some degree, this complex design mirrors the curves of the table's surface. The skirt extends almost halfway down the height of the piece and constitutes the dominant element in the table's composition. The wood used to make the skirt has been handled in such a way that its structure is hidden. The four cabriole legs, ending in claw-and-ball feet, seem to emerge from the lower edge of the skirt as if they were an extension of it. The molded edge of the table top echoes the curving line of the skirt.

Jorge F. Rivas P.

VII-22 *Armoire*

Mexico
Second half of the eighteenth century
Carved and coffered wood with polychromy (imitation *maque*,
or sumac lacquer); iron fittings
74¹³⁄₁₆ × 43⅝ × 21⅝ inches (190 × 110 × 55 cm)
Museo Franz Mayer, Mexico City, AD-154/09111/CED-0013

PUBLISHED: Martínez del Río de Redo 1969, p. 19

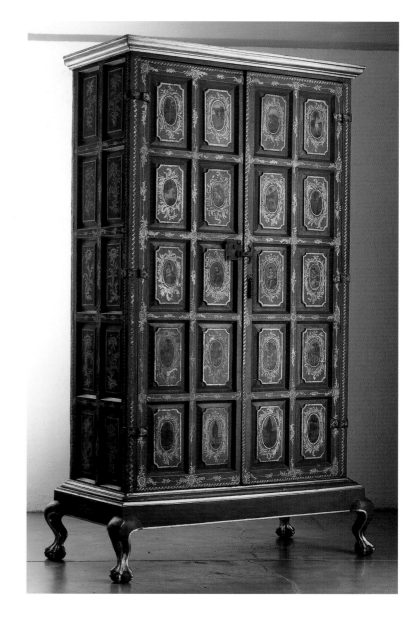

THIS TWO-DOOR ARMOIRE WITH PANELS along the front and sides
has a red polychromed exterior featuring gold motifs arranged in five
bands of four panels on the front. In the first two panels are representa-
tions of animals; the second also includes medallions inset with mytho-
logical figures, most notably Erato, Apollo, Clio, and Terpsichore. The
third panel once again features animal motifs, and the fourth is decorated
with various species of trees. The piece rests on a red base with cabriolet
feet and is crowned by gold molding in the form of a dove's breast. The
interior is painted yellow.

This armoire clearly reflects a fusion of Eastern and Western influ-
ences, in what would best be described as Queen Anne style, a genre
that developed in England during the early eighteenth century and was
influenced by that country's trade with the East. Queen Anne furnishings,
marked by the incorporation of lacquer ornamentation with gold details,
might be called the first universal style. While initially evolved from
Chinese prototypes, it was in English works that the style gained world-
wide recognition and popularity.

It is uncertain when the first examples of such furniture arrived
in the Americas, nor do we know what route these household objects
might have taken to reach New Spain. It is likely that such pieces origi-
nally appeared as a result of the Treaty of Utrecht (1713), whereby Spain
granted certain concessions to Great Britain, allowing the entry of one
British ship each year bearing merchandise for the Spanish colonies.
Piracy and contraband in the Caribbean from the sixteenth through
the eighteenth centuries also would have had a palpable impact on the
economies of the region as a result of the significant underground trade
that developed.

By the mid-eighteenth century the influence of the Queen Anne
style, along with other manifestations of English taste, was undeniable.
So much is evidenced in the examples of actual pieces produced in New
Spain that have survived to the present day, or in renderings of such items
in local genre paintings; inventories also cite specific English or English-
derived pieces. From these sources, it is clear that the Queen Anne style
was prominent in the tastes of New Spain during this period.

Teresa Calero Martínez de Irujo

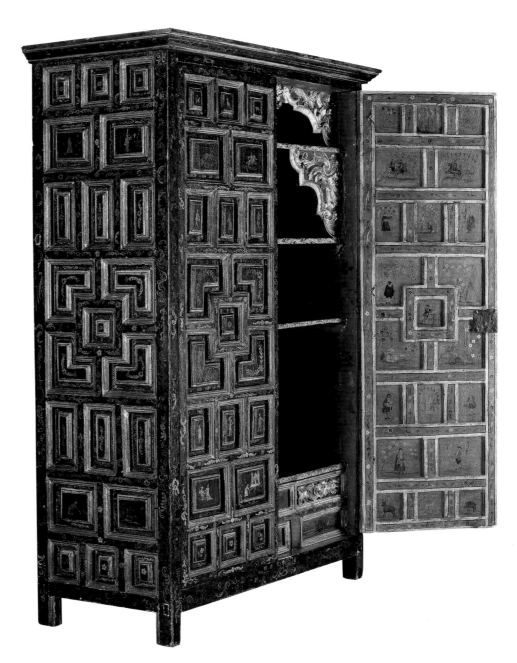

VII-23 *Wardrobe*

Mexico
Second half of the eighteenth century
Carved and coffered wood with polychromy (imitation
maque) and iron
77 × 46 × 22 inches (196 × 117 × 56 cm)
Museo Franz Mayer, Mexico City, D-059/01341/
CAD-0005

PUBLISHED: *Mayer* 1984, ills. pp. 164–65; *Mexico*
1990, cat. no. 211, pp. 448–49; Lechuga et al. 1997,
ills. pp. 42–43

EXHIBITED: New York, San Antonio, and Los Angeles
1990, cat. no. 211; Mexico City 1997 *Lacas*

THE EXTERIOR OF THIS TWO-DOOR WARDROBE, with panels across
the front and sides, is polychromed in black and dark green, with gilded
Chinese motifs. The insides of the doors are painted red and gilt, and
decorated with folkloric scenes of a clearly New Spanish nature. Inside
the wardrobe, its underlying structure visible and painted with a red
background and floral decorations, are three shelves; the upper two have
moldings in the corners with rocaille ornamentation painted in red and
gilt. In the lower part there are two rows of three short drawers each. The
wardrobe rests on a square base with legs, and there is a molding of a half
dove's breast in the upper part.

Chinoiserie is a decorative style that reached its zenith in the eigh-
teenth century, based on the extensive Asian trade and its great quantity
of merchandise. These pieces, so distinctive in technique and decora-
tion, attracted the interest of Europeans, who attempted from the begin-
ning to emulate the objects and their ornamental repertoire. New Spain
was just as attracted to this fashion, which held sway through much of
the eighteenth century, and the colony had a direct connection to the
Philippines, China, and Japan via the Manila Galleon (see the essay
by Gauvin Bailey in this volume), although the source for its immersion
in things Chinese was Spain.

As with much of the production in New Spain, this wardrobe is a
meld of foreign techniques and ornamentation. The use of a dark back-
ground with gilded Chinese motifs is infused by the chinoiserie brought
over from a Europe in search of the exotic. By contrast, the interior,
with its red background and folk images, demonstrates how chinoiserie
became mixed with local tastes, since the painted scenes show day-to-day
activities in which the subjects are dressed in apparel known to be New
Spanish, and which in some cases convey a barely perceptible narrative,
probably of a moralistic nature. In the same way, the eighteenth-century
tradition of lacquered furniture was appropriated and the technique com-
bined with pre-Hispanic techniques. One of these was *maque*, a kind of
shellac in use prior to the arrival of the Spanish, which was taken up again
with the arrival of the European fashion to which this wardrobe alludes.

Teresa Calero Martínez de Irujo

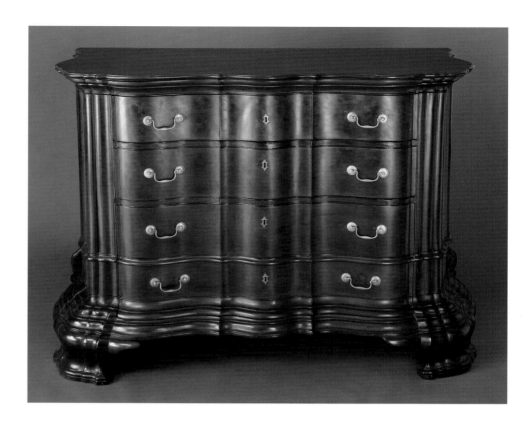

VII-24 *Chest of drawers for a sacristy*

Havana
Second half of the eighteenth century
Mahogany and cedar, with brass drawer pulls and keyholes from
later restoration
45¼ × 63¾ × 31⅛ inches (115 × 162 × 79 cm)
Collection of Patricia Phelps de Cisneros

PROVENANCE: Church of La Victoria, Venezuela; Leopoldo García
Quintero, Caracas; Martín Feo and Valentina García Galindo, Caracas;
Valentina Feo García, Caracas; Axel Stein, Caracas

AFTER MEXICO CITY AND LIMA, Havana was the most important city
among the overseas Spanish territories. This port city was the hub of the
crown's transcontinental trade, and it maintained its supremacy for more
than two hundred years. The economy of Cuba, apart from trade and port-
related activities, was based on the cultivation of certain agricultural goods
like tobacco and sugar cane, as well as on the exploitation of the various
natural resources of the island, including the famous Cuban mahogany
(*Swietenia mahogani*), one of the most valuable species of timber-yielding
wood in Spanish America.

The activities of the port and the availability of fine woods secured
important opportunities for master carpenters. From the earliest date,
there were ateliers in Havana devoted to the manufacture of furniture.

As early as the seventeenth century, references to Cuban furniture
appeared in many inventories of goods in Spanish American capitals, which
is a sign of the popularity of pieces from Havana throughout the continent.
Certainly, one of the elements that made these furnishings so attractive
to Spanish American clients, apart from design considerations, was their

resistance to xylophages—a pest that could, in a matter of months, com-
pletely destroy pieces imported from Europe. Cuban furniture, usually
made from mahogany and American cedar (*Cedrela odorata*), was resistant
to these insect attacks.

Cuban cabinetmakers of the second half of the eighteenth century
incorporated numerous Dutch and English rococo elements into their
furniture. This openness to decorative forms and motifs that differed from
traditional Spanish ones doubtless had to do with important changes in
locally popular patterns and to the steadily growing trade with Northern
European countries. It is particularly worth noting that the British occupa-
tion of the island, between August 1762 and February 1763, despite its
brevity, had enormous political, economic, and social repercussions for
the island; to a certain degree, furniture design from this period reflects
these changes.

This impressive sacristy chest of drawers, made in Cuba and sent
to Venezuela during the eighteenth century, is a classic example of Cuban
furniture of the period. The dimensions and elaborate nature of the chest
of drawers undoubtedly made it the most important piece in the sacristy of
the small church of La Victoria. The four enormous drawers on the front
with their respective locks were used to keep valuable ecclesiastical vest-
ments and sacred altar ornaments. The chest of drawers is supported on
a dynamic and very elaborately worked serpentine molding that imposes
its undulating rhythm on the entire piece. The upper molding, which
follows the sinuous curves of the piece, hides a slim secret compartment.
The edge of the table surface describes the piece's complex scheme of
mixtilineal curves.

Jorge F. Rivas P.

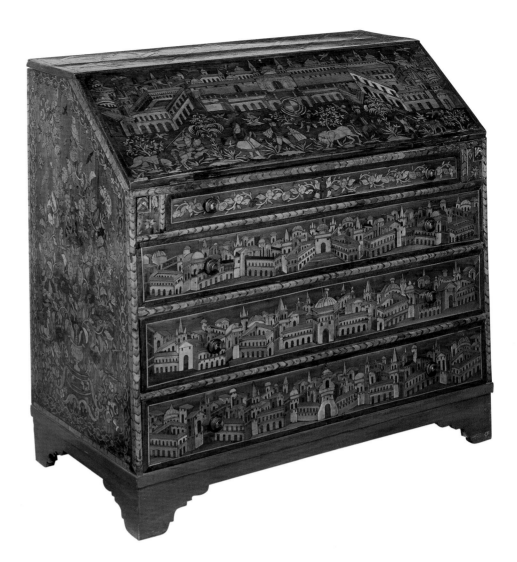

VII-25 *Desk*

Ecuador
Late eighteenth–early nineteenth century
Wood with hardwood marquetry; feet added as part of a later restoration
43⁵⁄₁₆ × 42½ × 24 inches (110 × 108 × 61 cm)
Museo Franz Mayer, Mexico City

THE TRADITIONAL IMAGERY and motifs employed by the ancient cultures of the Andes for the adornment of household or utilitarian objects were heavily symbolic in nature. The use of these elements continued for a long time after the conquest, albeit outside the original context of the Inca Empire and often divested of their original meaning. Over the course of three centuries following the arrival of the Spaniards, pre-Columbian–type local traditions continued to evolve, fusing with European and Asian elements until a new decorative repertoire emerged.

While this piece of furniture bears little resemblance to its model—a variation on an English-style desk from the latter half of the eighteenth century—its intact marquetry does point to a newly formulated Andean decorative tradition. The minutely detailed surface of the desk contains many elements utterly unique to the new continent, specifically in the renderings of native flora and fauna. While it is quite common to find eighteenth-century furniture manufactured in the Quito *Audiencia* decorated with inlaid work or marquetry, this is generally limited to small pieces, not large ones such as this.

On first examination, the decoration recalls the marquetry produced in southern Germany, or perhaps the Netherlands. A more detailed analysis, however, reveals that the desk contains many elements that are irrefutably South American in origin. The exterior of the fold-down writing surface of the desk is particularly striking given its large dimensions, and is decorated with a bullfighting scene; the landscape in the background includes a view of the church of San Francisco in Quito. The interior reveals a hunting scene in the midst of a tropical forest, with Indians bearing lances. Amid palms, flowers, and other dense foliage are images of jaguars, bears, deer, *viscachas*, birds, and insects. These motifs are repeated on the seven small drawers of the dovecote.

The three lower drawers on the front of the desk, which are somewhat larger in size, are decorated with scenes of different cities, while the smaller upper drawer is adorned with a simple garland of flowers. Large vases with flowers, birds, and insects embellish the sides. The narrow upper surface is divided by checker work, with each square bearing some distinct plant, insect, or animal, many of which are indigenous to the region, such as monkeys, *viscachas*, hummingbirds, toucans, parrots, herons, beetles, moths, and butterflies. For the Inca, butterflies and other flying insects were symbolic of death and the soul. This type of decoration, employing flora or fauna organized within a geometric grid, is similar to the woven motifs found on *uncus*—traditional Inca tunics worn by men—from the sixteenth and seventeenth centuries.

Jorge F. Rivas P.

VII-26 Attributed to Francisco José Cardozo[†]

(Venezuelan, 1768–1818)

Fleuron

Last quarter of the eighteenth century
Gilded cedar, iron hook
17¾ × 47¼ × 47¼ inches (45 × 120 × 120 cm)
Collection of Patricia Phelps de Cisneros

PROVENANCE: Arnold Zingg, Caracas

PUBLISHED: Rivas 2000, p. 24

IN THE HOMES OF PROMINENT Latin American families, special attention was paid to illuminating halls or other rooms where visitors were received and banquets or receptions held, which could last well into the night. Numerous mirrors were placed about the room to augment the faint candlelight. Reflective materials such as glass, mirror fragments, and metals such as gold, silver, or brass were frequently used to illuminate details on furniture, decorative objects, and architectural features.

A chandelier used to hang from this fleuron, which is shaped like a five-pointed star, and at each end there is a medallion with fine lattice fretwork. The entire surface has been carved in an exuberant leaf-motif rocaille in three diminishing levels; the whole ends in a pineapple-shaped bulb that holds the iron hook for hanging the lamp. The piece was carved from cedar and its entire surface gilded and burnished.

It is easy to imagine the magnificent appearance of the room—perhaps opened up for a grand festive occasion—which originally contained this piece. Someone looking up would have seen, suspended in the half-light of a high ceiling, this glittering, gilded fleuron, its resplendent carved features appearing like tongues of flame thanks to the light cast by the candles on a chandelier hanging just beneath it.

In colonial Latin America, the establishment of family dynasties in the manual trades was common. The custom, inherited from European ateliers, could continue through several generations of the same family. In this way, trade secrets could be preserved, the availability of financial reserves necessary for the completion of commissions could be secured, and access to important clientele—the church, the various religious fraternities, wealthy individuals, and the assorted religious orders—could be assured.

The Cardozo family of Caracas is an example of this practice; members of this family plied their trade as carpenters from the beginning of the eighteenth century until well into the nineteenth. The first in the dynasty was the cabinetmaker Antonio José Cardozo, active between 1738 and 1784, who was succeeded in the trade by two of his ten sons: José Ramón and Francisco José. Both brothers obtained important commissions for the cathedral as well as for other churches and religious institutions in the city, but the more prominent of the two was Francisco José, the creator of this piece.

Jorge F. Rivas P.

Chronology

Alicia Lubowski and Anne D. Pushkal

c. 1–600
Moche civilization of Peru's north coast produces ceramics, fine metalwork, sophisticated irrigation, and pyramids

c. 1–700
Nazca civilization on south coast of Peru creates huge figures stretching hundreds of feet across the earth

c. 300–1000
Tiwanaku (Bolivia) occupied by five successive cultures

c. 325–925
Maya culture (Mexico and Central America) with large cities, monumental architecture, and flourishing art, literature, astronomy, and mathematics at its peak

c. 400–750
Teotihuacán culture (central Mexico). At its zenith (c. 450–600) this city of 100,000 exerted military, cultural, and economic dominance over hundreds of square miles.

711–59
Umayyad dynasty conquers Iberia, beginning eight centuries of Islamic presence in the peninsula. The Christian Reconquest begins almost immediately, lasting until 1492.

731
Temple of the Giant Jaguar built on the Maya site of Tikal (Guatemala)

800–1200
Late Classic Maya culture continues at Chichén Itzá in Yucatán (Mexico)

c. 1000
Norse voyagers reach North America via Iceland and Greenland

1100
Cuzco (Peru) probably founded

1200
Muslims expelled from Portugal; in Spain they are restricted to the emirate of Granada

1325
On an island in Lake Texcoco the Mexica people (Aztecs) found Tenochtitlán, capital of the Aztec empire and the future Mexico City

c. 1350
Rapid Inca expansion commences in Andean South America

1393
Castilian expansion begins with exploration of Canaries

early 1400s
First caravels—light, fast, maneuverable ships that lend themselves to exploration—built in Iberian peninsula

1415
Prince Henrique (Henry) "the Navigator" begins his patronage of the Portuguese Age of Exploration

1420s
Portuguese settle Madeira, their first colony in the Atlantic, initiating experiments in sugar growing and plantation slavery

Groundwork for Aztec imperial expansion laid with Triple Alliance of Tenochtitlán with Texcoco and Tlacopan

c. 1438–1533
Inca imperial expansion under Pachacuti, continuing under Tupac Yupanqui and Huayna Capac

1444
Portuguese ships reach Cape Verde, westernmost point of Africa

1460s
Portuguese settle Azores in earnest, using captain-donatary system of colonization later used in Brazil

1469
Marriage of Fernando of Aragon and Isabela of Castile unites kingdoms and marks the start of modern Spain

1477–90
Fernando and Isabela introduce Inquisition to enforce religious orthodoxy in the wake of the Reconquest

1479
Treaty of Alcáçovas secures Castile's rights to the Canaries and Portugal's to the Azores, Cape Verdes, and Madeira

1487
Great Temple in Tenochtitlán (Mexico) dedicated

Quito (Ecuador) comes under Inca rule

1488
Bartolomeu Dias sails around southern Africa, whetting Portuguese ambitions for direct trade with Asia

1492
Christopher Columbus, sponsored by Fernando and Isabela, sails west from Spain to reach Asia but instead reaches the Bahamas, exploring it and other islands (which he believes are part of the "Indies") (fig. 1)

Fernando and Isabela defeat the Nasrids of Granada, the last Islamic kingdom in the Iberian peninsula. Jews are ordered to convert or be expelled; most leave.

Spanish humanist Antonio de Nebrija publishes the first grammar of Castilian Spanish and presents it to Isabela, remarking that "language was always the companion of empire"

1493
Pope Alexander VI grants Fernando and Isabela sovereignty over Columbus's discoveries and obliges them to convert the inhabitants to Christianity

1493–96
On his second voyage, Columbus settles La Isabela (Dominican Republic) on Hispaniola, introducing Spanish crops and animals and, unwittingly, European epidemic disease

1494
The Treaty of Tordesillas divides the non-Christian world between Spain and Portugal (at c. 50° W), excluding other countries from trade with and colonization of the Indies

1495
Manuel I "the Fortunate" accedes to Portuguese throne

1496
Santo Domingo (Dominican Republic) is the first permanent European city in the Americas, founded on Hispaniola

1497
Jews expelled from Portugal

1497–99
Vasco da Gama leads first Portuguese voyage around Africa to India, returning with silks and spices. With his second voyage, in 1502, the Portuguese set up fortified trading posts to dominate the lucrative Indian Ocean trade.

FIG. 1 Frontispiece with the crest of Christopher Columbus, from the "Book of Privileges" (Seville, 1502). Museo Navale di Pegli, Genoa, Italy

Fernando and Isabela gave Columbus the "Book of Privileges" as a reward for his 1492 voyage. This is one of four copies he commissioned to evidence his royal contract.

FIG. 2 Machu Picchu, Peru, 1460–70; built for Pachacuti Inca Yupanqui

The Incas created this small, ceremonial mountaintop city surrounded by agricultural terraces and watered by natural springs.

FIG. 3 *Six Fruits*, from Francisco López de Gómara, *Historia de las Indias* (Zaragoza, Spain: Miguel de Capila, 1554). Woodcut. John Carter Brown Library, Providence, Rhode Island

This illustration reflects the sustained European interest in American flora and fauna.

FIG. 4 San Felipe del Morro ("El Morro"), San Juan, Puerto Rico; begun 1539

1498
On his third voyage, Columbus sights South American coast and Orinoco River

1499
On Hispaniola, Columbus assigns natives to Spaniards for whom they are forced to work

1499–1500
Alonso de Ojeda, Amerigo Vespucci, and Juan de la Cosa explore north Brazilian coast and sight the mouth of the Amazon

c. 1500
Incas build Machu Picchu (Peru) (fig. 2)

In *The Garden of Earthly Delights* (Prado, Madrid), Hieronymus Bosch represents exotic fauna and naked people; he may have been influenced by reports of European voyages to Asia and the Americas

1500
While sailing for India, Pedro Alvares Cabral is blown off course to Brazil and claims it for Portugal

Spanish explorer Juan de la Cosa draws a world map that will become the standard

Columbus is removed as governor of Hispaniola and sent to Castile in chains

1501–2
Portuguese explore east coast of South America with Amerigo Vespucci as chronicler, who soon publishes the widely influential *Novus mundus* (1503), in which he concludes the new lands are an independent continent and not part of India

1501–8
The pope gives the Spanish Crown the "royal patronage," the responsibility to evangelize the inhabitants and the right to administer the church in the Americas

1502
Manuel I of Portugal licenses export of brazilwood, initiating exploitation of Brazil's natural resources

Moctezuma II elected ruler of the Mexica (Aztecs) in Mexico

1502–4
Columbus's fourth and final voyage, to east coast of Central America. He brings a few cocoa beans back to Spain, but it is not until Hernán Cortes that their commercial possibilities are recognized (fig. 3).

1502–9
Royal Spanish administration of Hispaniola begins with governor Nicolás de Ovando, who arrives with some 2,500 settlers and orders the founding of towns. He assigns the settlers *encomiendas*, grants of the right to tribute and labor from groups of Amerindians; the colonists in turn are to ensure their instruction in Christianity and "civilized" (i.e., European) ways.

1503
The first sugar mill is built on Hispaniola

Casa de la Contratación (House of Trade) established in Seville to control the American trade

1504
Felipe I accedes to Spanish throne

French reach Brazilian coast

1505–15
Portuguese viceroys lead founding of Portuguese commercial empire in Asia through conquest, alliances with Asian rulers, and development of industries and fortified trading posts

1506
Fernando of Aragon rules Spain as regent for Juana of Castile

1507
German cartographer Martin Waldseemüller names the new continents "America" after Amerigo Vespucci

1508
Juan Ponce de León captures Puerto Rico (fig. 4)

1509
Juan de Esquivel conquers Jamaica

María de Toledo, wife of Columbus's son Diego, arrives on Hispaniola, the first Spanish noblewoman in the Americas

1510
The Alcázar (fortress) built in Santo Domingo (Dominican Republic)

Portuguese acquire Goa (India)

1510–11
Diego de Velázquez conquers Cuba (fig. 5)

1511
Audiencia (high court with judicial, administrative, and legislative responsibilities) established at Santo Domingo, the first in America

Santa María de la Antigua de Darién (Panama) founded, the first Spanish town on the American mainland

Dominican friar Antonio de Montesinos excoriates the colonists for their treatment of Caribbean natives, beginning Dominican leadership of dissent against the exploitation of Amerindians

1512
Laws of Burgos aim to regulate Spanish treatment of Amerindians by trying to convert them into Christian Spanish subjects gathered into towns to work for the Spanish, learn the Catholic faith, receive the sacraments, and engage in "civilized" behavior such as wearing European-style clothes and farming

Cathedral of Santo Domingo constructed on Hispaniola, the first episcopal see in America

1513
Vasco Núñez de Balboa crosses the Isthmus of Panama and sights the Pacific

Juan Ponce de León claims Florida for Spain

FIG. 6 Baptismal font, Mexico, after 1550. *Tezontle* stone. Convent of Zinacantepec, Mexico

This early baptismal font is carved with both Christian and native Mexican symbols.

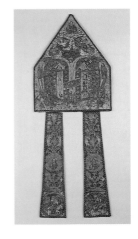

FIG. 7 Bishop's miter, Michoacán, Mexico, c. 1559–66. Feathers on maguey paper (*amatl*), 12½ × 16⅛ inches (31.7 × 41.5 cm). Hispanic Society of America, New York

After European contact, the pre-Hispanic art form of featherwork found new expression in Christian images and vestments.

1514
Juan López de Palacios Rubios drafts the *Requerimiento* for the Spanish Crown, which is ordered read to Amerindians before battle to inform them that if they refuse to submit, the Spanish will wage "legal" war and enslave them

1516
Thomas More writes *Utopia*, which will inspire Franciscan missionaries and others in New Spain to attempt to create a utopia in the New World

Spanish Crown names the Dominican friar Bartolomé de las Casas "Protector of the Indians"

Carlos I accedes to Spanish throne, beginning two centuries of uninterrupted Habsburg rule; elected Holy Roman Emperor Carlos V in 1519

1517
Martin Luther posts his 95 theses in Wittenberg, igniting the Protestant Reformation

1518
Spanish Crown authorizes importation of slaves from Africa as substitute for Amerindian labor

1519
Hernán Cortés lands in the Yucatán (Mexico); first Spanish contact with Aztec emissaries. He explores Mexican coast and founds Veracruz; from there he marches inland to Tenochtitlán, the Aztec capital.

City of Panama founded

1519–22
Portuguese mariner Fernão Magalhães (Ferdinand Magellan) circumnavigates the globe

1520s
French corsairs and other pirates begin activity in the Caribbean

Franciscan enterprise to Christianize the Otomís, Nahuas, and Matlatzincas of the Toluca Valley (sierra west of Mexico City) (fig. 6)

1520
Cortés and his followers routed from Tenochtitlán with heavy losses in the *Noche triste* (Sorrowful Night); Moctezuma II, a prisoner of the Spanish, is killed. The Spanish are spared from pursuit by the decimation of the Aztecs by European epidemic diseases (see fig. 37).

Albrecht Dürer expresses admiration for Aztec artifacts at the court of Carlos V: "For I have seen therein wonders of art and have marveled at the subtle *ingenia* of people in far-off lands. And I know not how to express what I have experienced thereby" (fig. 7).

1521
Although ruler Cuauhtemoc mounts a fierce defense, Cortés and his Amerindian allies take Tenochtitlán, conquering the Aztec empire. Its territories are renamed New Spain.

João III accedes to Portuguese throne

1521–29
Spain's war with France reduces shipping to Caribbean

1522
Pope charges the mendicant orders with converting the Amerindians to Christianity

The *flota*, or convoy, system of annual trade fleets initiated, and all trade ships to the Americas obliged to gather in Seville and cross together

1523
The first three Franciscan missionaries reach New Spain and begin converting the indigenous population

1523–24
Plan of Mexico City laid out over the site of Tenochtitlán, the former Aztec capital

1524
Twelve Franciscan friars, their number chosen in emulation of the Twelve Apostles, arrive in New Spain to begin formal evangelization of the Amerindians

Pedro de Alvarado defeats K'iché Maya leader Tecúm Uman in Guatemala and sets out to conquer the rest of Central America

Carlos V establishes Council of the Indies, key institution in centralizing control of Spanish America

1525
Cortés hangs Cuauhtemoc, ending the independent Aztec succession

San Salvador (El Salvador) founded

1526
Dominican order arrives in New Spain

Franciscans open seminary college of Santa Cruz de Tlatelolco near Mexico City to train noble Aztec boys for priesthood

c. 1527
Flemish Franciscan friar Pedro de Gante (Peeter van der Moere of Ghent) founds the school of San José de Belén de los Naturales (Mexico) to instruct noble indigenous youths in European arts, crafts, and music.

1527–32
Civil war between the Inca Atahualpa and his half-brother Huascar in Peru

1528
Audiencia of Mexico established

1529
Treaty of Zaragoza moves Tordesillas line dividing Spanish and Portuguese territories into the Pacific

1529–70
Construction of the monumental Franciscan mission church at Huejotzingo (Mexico)

1530s
Spanish weavers introduce treadle looms in Mexico and later to the Andes and other parts of the Americas, allowing production of longer and wider cloth, and completely reorganizing clothmaking

João III of Portugal grants 12 hereditary captaincies in Brazil, which donees must colonize, administer, develop, and defend at their own expense

c. 1530
First silver ore strikes in New Spain

1530
Guild of gold- and silversmiths founded in Antigua (Guatemala)

1531
Native Mexican Juan Diego Cuauhtlatoatzin sees the Virgin of Guadalupe on the hill of Tepeyac (see fig. 36)

Puebla de los Angeles (Mexico) founded by Franciscan friars

FIG. 8 Church of Santo Domingo, Coricancha, Cuzco, Peru, seventeenth century

This church rests on the Inca foundation of the Coricancha (Temple of the Sun). Among the finest Inca stonework is the curved wall beneath its west end.

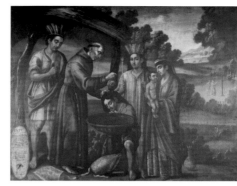

FIG. 9 Antonio Astudillo (Ecuadorian), *Jodoco Ricke Baptizing Indians*, 1785/1798. Museo Fray Pedro Gocial, church of San Francisco, Quito

FIG. 10 *Don Antonio de Mendoza*, sixteenth century. Museo de América, Madrid

Mendoza governed as the first viceroy of New Spain from 1535 to 1550 and as viceroy of Peru from 1551 until his death in 1552.

1531–36
Francisco Pizarro conquers the Inca Empire (South America), reaching Cuzco (Peru) in 1533 (fig. 8)

1531–55
Wars of religion between Protestants and Catholics in Germany

1532
First sugar mills built in Brazil, which would become the world's leading producer over the next century

1533
Augustinian order arrives in New Spain

Francisco Pizarro executes the Inca Atahualpa despite payment of a fabulous ransom

1534
Quito (Ecuador) founded upon the ruins of an Inca capital (fig. 9)

mid-1530s
First printing press in the Americas set up in Mexico City; oldest extant book is a Nahuatl-Spanish catechism of 1539. Printing presses arrived in Lima in 1583; Puebla in 1640, and Santiago de Guatemala in 1660; in Brazil no press operated until the Portuguese court arrives in 1808.

1535
New Spain, first viceroyalty in the Americas, founded with the arrival of Viceroy Don Antonio de Mendoza (fig. 10)

City of Lima (Peru) founded by Francisco Pizarro

Gonzalo Fernández de Oviedo y Valdés's *La historia general de las Indias* published in Seville

1535–39
Austrian Nikolaus Federmann in the service of Austrian banking house Welser explores what is now Venezuela and Colombia searching for El Dorado

c. 1535–c. 1585
Mural decoration of mission churches flourishes in New Spain (figs. 11 and 12)

1536
Manco Capac Inca leads unsuccessful rebellion against the Spanish in Peru, laying siege to Cuzco and attacking Lima before retreating to Vilcabamba, where he and his successors maintained an independent Inca government until 1572 (fig. 13)

Alvar Núñez Cabeza de Vaca, Estevan "the Moor," and two others reach Mexico City seven years after being shipwrecked in Texas. Their accounts began rumors of the Seven Cities of Cíbola. The search for these mythical cities of gold drove much early Spanish exploration of the Southwest.

College of Santa Cruz established in Mexico City to educate elite indigenous young men in Latin and the liberal arts

Church of San Francisco in Quito established

1536–37
Gonzalo Jiménez de Quesada reaches Quito (Ecuador) and Bogotá (Colombia)

1537
Sebastiano Serlio publishes in Venice the first installment of his architectural manual *Regole generali di architettura*. This and other books on the subject begin to circulate in the Americas, influencing the practice of architecture.

Pope Paul III rules that Amerindians are "truly men," capable of becoming Christians, which establishes the moral obligation of Christian rulers to instruct them in the faith

Asunción (Paraguay) founded

1538
Battle of Las Salinas (Peru) and execution of Pizarro rival Diego de Almagro

Probable first shipment of African slaves to Brazil to replace indigenous labor in developing sugar industry

First Audiencia of Panama established at City of Panama

Santa Fé de Bogotá (Colombia) founded

c. 1538–65
Production of corn-pith religious sculpture flourishes under Bishop Vasco de Quiroga in Michoacán (Mexico)

1539
Hernando de Soto explores North America (present-day Florida, Georgia, Tennessee, Alabama, Mississippi, and Arkansas, USA) in search of the Seven Cities of Cíbola

The Franciscans arrive in New Mexico and spread to Arizona (present-day USA), where they try to evangelize the Apaches

1540
Cortés leaves Mexico for Spain, never to return

Ignatius of Loyola founds Order of the Society of Jesus (Jesuits)

Augustinian missionaries found college for Amerindian youths at Tripetío (Mexico); it offers instruction in painting by Spanish artists

1540–42
Francisco de Orellana leads first European expedition to sail down the Amazon, for Spain

Francisco Vásquez de Coronado travels in search of the Seven Cities of Cíbola from New Spain into Arizona, New Mexico, Texas, Oklahoma, and Kansas (present-day USA), greatly expanding Spain's land claims.

1541
Francisco Pizarro assassinated by supporters of Diego de Almagro. Infighting among conquistadors and repeated challenges to royal authority keep Peru in civil war until the 1550s.

Santiago de Chile founded

See of Lima (Peru) created

1541–42
Amerindians rebel against Spaniards in Mixtón War in New Galicia (Mexico)

1542
Viceroyalty of Peru created, the second in Spanish America; Audiencia of Lima established

Spanish Crown issues New Laws to curtail colonists' power and protect indigenous people by curbing *encomienda*, abolishing their enslavement, and reforming government. Attempts at enforcement spark vehement protest from colonists; key provisions are quickly revoked or amended.

FIG. 11 Attributed to Juan Gerson (Mexican), *Heavenly Jerusalem* (Apocalypse 21:10). Oil on fig-tree paper (*amate*), after 1562. Choir vault, church of Saint Francis of Assisi, Monastery, Tecamachalco, Puebla, Mexico

FIG. 12 *Combat between a Tiger-Warrior and Native*, second half of the sixteenth century. Fresco, detail. Monastery, Ixmiquilpan, Hidalgo, Mexico

This nave decoration is remarkable for its use of color and its presentation of native imagery, here a battle between the Chichimecs and the Otomí.

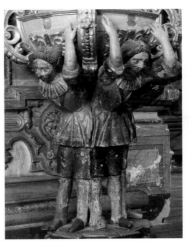

FIG. 13 Pulpit, 1570. Polychromed wood. Church of San Francisco, Quito, Ecuador

This pulpit in the largest church in Quito represents the Catholic victory over the Protestants John Calvin and Martin Luther.

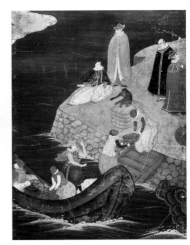

FIG. 14 *Unloading of Merchandise*, from *The Arrival of Portuguese in Japan*, Japan, 1594–1618. Screen. Museo Soares Dos Reis, Porto, Portugal

Juan Rodríguez Cabrillo expedition reaches Alta California (present-day USA)

Santiago de Guatemala (present-day Antigua), third colonial capital of Guatemala, founded

1543
Merchant guild of Seville receives royal charter for monopoly over legal trade with the Indies, which it maintains until new guilds are established in Mexico City in 1594 and Lima in 1613

The first Portuguese arrive in Japan (fig. 14)

1544
Audiencia of Guatemala established

First viceroy of Peru, Blasco Núñez Vela, arrives in Lima and attempts to enact the New Laws; Peruvian colonists rebel violently, beheading the viceroy in 1546

mid-1540s
Major epidemics decimate indigenous populations in New Spain and Central America

1545
Silver ore discovered at Potosí (Bolivia); mining begins shortly after. The *Cerro Rico* (Rich Hill) of Potosí produces nearly half of all Spanish American silver in the next century (figs. 15 and 16).

The cornstalk-paste sculpture *Christ of Ixmiquilpan* donated to Santa Teresa, the first Carmelite convent in New Spain (Mexico)

1545–63
Pope Paul III convokes the Council of Trent to reform church abuses, clarify Catholic dogma, and stem the spread of Protestantism (see fig. 13)

1546
Great silver deposits discovered at Zacatecas (Mexico)

1547
The first grammar of Nahuatl, a Mexican language, produced by Franciscan friar Andrés de Olmos

1548
Audiencia of Nueva Galicia established at Guadalajara (Mexico)

1548–49
Portuguese Crown purchases captaincy of Bahia and appoints Tomé de Sousa governor general of Brazil; he founds Salvador, Bahia, as capital and sets up royal administration. With him are six Jesuits, the first in America; intensive evangelization of native Brazilians begins.

1548–50
Lawyer Pedro de la Gasca, who governs Peru as president of the Audiencia of Lima, defeats and executes the rebel Gonzalo Pizarro (1548), ends warfare among Spanish factions, and establishes royal rule

1549
Audiencia of Santa Fé de Bogotá (Colombia) established

Francis Xavier, the "Apostle of the Indies," founds the first Jesuit mission in Japan

Spanish Crown bans personal service by Amerindians to *encomenderos* (Spaniards who hold grants of *encomienda*), beginning shift to Crown-organized forced labor

Carpenters' guild founded in Lima (Peru)

1550s
Forced resettlement of Native Americans introduced to facilitate evangelization and organization of their labor in central Mexico; *repartimiento* form of compulsory labor begun in New Spain

1550s–c. 1575
Bernal Díaz del Castillo, a member of Cortés's expedition, writes *Historia verdadera de la conquista de la Nueva España* (first published 1634)

1550
Silver ore strike at Guanajuato (Mexico); the region became the principal source of silver in Spanish America after 1740

1550–51
Bartolomé de las Casas and Juan Ginés de Sepúlveda debate in Valladolid, Spain, with Las Casas defending the Amerindians' capacity to become Christian Spanish subjects, and Sepúlveda justifying their conquest and "natural" inferiority

1550–59
With Spain at war, shipping to the Indies is reduced as French privateering surges

1551
See of Brazil created

House of the Tower of Garcia d'Ávila (near Salvador, Brazil) begun

The Royal and Pontifical University of Mexico in Mexico City founded. The first university in the Americas, it was modeled on the University of Salamanca.

Flemish Franciscan friar Joost de Rijcke founds a school in Quito (Ecuador) to instruct Amerindians, mestizos, and orphaned Spaniards in reading and writing, art, music, crafts, and trades; the Flemish friar Pieter Gosseal is the first painting instructor

1552
Bartolomé de las Casas's *Brevíssima relación de la destruyción de las Indias* published in Seville; although written to provoke Spanish reforms, Spain's European enemies used it to promote the Black Legend of Spanish cruelty and advance their own claims in the Americas

FIG. 15 Potosí, Bolivia

FIG. 16 *Macuquinas* (coins), Mexico and Bolivia, 1556–1621. Silver. Museo Numismático, Banco Central de Ecuador

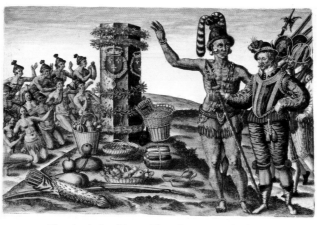

FIG. 17 Theodor de Bry (Franco-Flemish, 1528–1598), after Jacques Le Moyne de Morgues (French, 1533–1588), *René Goulaine de Laudonnière and the Indian Chief Athore Visit Ribaut's Column*, from *Brevis narratio eorum quae in Florida, Americae Provincia Gallis acciderunt* . . . (Frankfurt: J. Wecheli, 1591), 1564. Engraving. Service Historique de la Marine, Vincennes, France

Le Moyne was commissioned to document the Indians of Florida, the first major ethnographic study of the indigenous inhabitants of North America.

mid-1550s

Mercury amalgamation (*patio*) process of silver refining introduced in Mexico, dramatically increasing mining yields as well as worker mortality

1555

French capture and briefly occupy Havana (Cuba) (see fig. 35)

1556

Felipe II accedes to Spanish throne; he promotes Renaissance style during his reign

1557

Sebastião I accedes to Portuguese throne

Guild of painters and gilders established in New Spain to limit the competition from native artists and control their productions. Guilds of carpenters and sculptors followed in 1568 and 1589, respectively.

1557–72

Mem de Sá becomes governor-general of Brazil, bringing the colony under control and defeating Tupinamba, Caete, and Tupinkin indigenous groups

1558

Elizabeth I accedes to English throne; English attacks on Spanish shipping in the Caribbean become frequent

Franciscan missionary and Nahuatl linguist Friar Bernardino de Sahagún ordered to document Nahuatl customs to aid in their conversion to Christianity. For the next 32 years he and his Nahuatl assistants compile the *Historia general de las cosas de Nueva España (Florentine Codex)*, an extensive manuscript with drawings and parallel texts in Nahuatl and Spanish now in the Biblioteca Medicea Laurenziana, Florence.

1559

Audiencia of Charcas established at La Plata (Bolivia)

1560s

Jesuits in Brazil resettle Amerindians into missions (reductions)

With discovery of major mercury deposit in Huancavelica (Peru), American silver refining no longer solely dependent on unreliable shipments from Europe

Taki Onqoy (Dancing Sickness) millenarian movement sweeps Peruvian Indians; those affected believe the Andean gods will expel the Spanish

1560

First grammar of the Andean language Quechua produced by Dominican friar Domingo de Santo Tomás, who also reports conditions in Peru to Bartolomé de las Casas

Facade of mission church at Acolman (Mexico) completed

Captaincy-general of Guatemala established and separated from the viceregal Audiencia of Mexico

1562

Cathedral of Mérida (Mexico) constructed

Nahua painter Juan Gerson, named after the fifteenth-century religious reformer, paints the vault at the Franciscan mission church of Tecamachalco (Mexico) with scenes of the Apocalypse and Last Judgment; Gerson draws on prints after Albrecht Dürer

1562–65

Smallpox and secondary viral infections sweep Brazil, devastating indigenous population

1563

Audiencia of Quito (Ecuador) established

1564

Andrés de la Concha finishes the altarpiece at the Dominican monastery of San Juan Bautista, Coixtlahuaca (Mexico)

1565

Spanish capture and begin settlement of Philippines

Rio de Janeiro (Brazil) founded

Saint Augustine (Florida) founded (fig. 17)

Audiencia of Chile established

1566

Protestant Netherlands begin revolt against Spanish rule

1567

Santiago de León de Caracas (Venezuela) founded

1568

First Jesuits in Spanish America reach Lima (Peru)

Construction begins on Il Gesù in Rome; the mother church of the Society of Jesus, it is the model for many Jesuit churches worldwide

1568–1615

French occupy northern Maranhão (Brazil)

1569

Alonso de Ercilla y Zúñiga pens the epic poem *La Araucana* about the Spanish conquest of Chile

1569–81

Francisco de Toledo's tenure as viceroy of Peru is marked by reform of government and mining, resettlement of indigenous communities, and compulsory labor drafts (*mita*)

1570s

Campaign against native religion in the Andes. Although some missionaries regretted the destruction of native achievements, many set about rooting out heresy and eradicating native sacred objects (fig. 18).

Paradise Garden murals painted at the Augustinian monastery of Malinalco (Mexico)

Itinerant altarpiece makers begin activity in New Spain

1570

The Amerindians of Brazil declared free by Sebastião I of Portugal; in practice their enslavement continues

1570–71

Tribunals of the Inquisition set up in Lima (1570) and Mexico City (1571) to enforce religious conformity. Art inspectors are among its functionaries.

1571

Introduction of mercury amalgamation process of silver refining in Viceroyalty of Peru radically increases yields from ore

Spanish naval victory over Ottoman Turks at Lepanto

c. 1571–1815

The Manila Galleon sails between Manila and Acapulco (Mexico), trading American silver for Asian luxury goods (figs. 19 and 20)

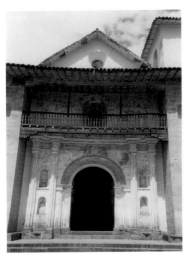

FIG. 18 Church of San Pedro, Andahuay-
lillas, Peru, after 1574; wooden porch and
murals, early seventeenth century

FIG. 19 *The Good
Shepherd*, Goa, South
India, or the Philippines,
1700s. Ivory and painted
wood, height 6¾ inches
(17.1 cm). Denver Art
Museum, Gift of Olive
Bigelow, 1971 (1971.481)

Here Christ as the Good
Shepherd appears in a pose
reminiscent of the Buddha,
which is commonly found
in small sculptures from the
Portuguese colony of Goa
(India).

FIG. 20 Tureen with cover, China, 1770–80. Hard-paste porce-
lain decorated in enamel colors and gilt, height 11⁵⁄₁₆ inches (28.1 cm),
diameter 11¹³⁄₁₆ inches (30 cm). The Metropolitan Museum of Art, New
York, Helena Woolworth McCann Collection, Gift of Winfield Founda-
tion, 1951 (51.86.28a,b)

The tureen was part of a service commissioned by José de Gálvez,
Marqués de Sonora, royal inspector of New Spain, and bears his arms.

1572
English privateer Francis Drake raids Panama, captur-
ing gold and other treasure (fig. 21)

Inca stronghold at Espíritu Pampa (Peru) built with
Inca masonry and imitation Spanish roof tiles

Viceroy Francisco de Toledo commissions portraits
of Inca rulers for Felipe II, which are used to assert
connection between Inca and Spanish rule

Viceroy Francisco de Toledo orders the construction
of the first royal mint in Potosí (Bolivia)

before 1573
The potter's wheel, tin- and lead-based glazes, and
updraft kilns, introduced to Mexico City by primarily
Sevillian potters around 1550, reach Puebla (Mexico),
which becomes a center of ceramic production

1573
Córdoba (Argentina) founded on the trade route
between Peru and Buenos Aires

Claudio de Arciniega begins work on the cathedral
of Mexico City, which is consecrated in 1667 and
completed in 1817

Royal Ordinances for New Discovery and Settlement
state that all new towns in Spanish America must adopt
grid-plan layout with a central plaza

c. 1573–c. 1583
In New Spain, mission parishes administered by the
religious orders are handed over to parish priests who
answer directly to the bishop

c. 1574
Mural with portraits of renowned Augustinians
painted in their monastery in Actopan, Hidalgo
(Mexico)

1574
Ordinance of Patronage codifies Spanish Crown's
church patronage in the Indies

Execution of the last Inca ruler, Tupac Amaru, and
his family

1575
Convent of Santa Catalina in Arequipa (Peru) founded

1576
Italian Jesuit painter Bernardo Bitti brings Roman
mannerism to the Jesuit church of San Pedro in Lima,
the Jesuit missions in the Lake Titicaca region, La Paz,
Potosí, and La Plata

1577
Friar Francisco Dias becomes the director of works for
the Jesuit college in Salvador (Brazil). He also initiates
construction of the Jesuit colleges of Rio de Janeiro
(1585), Olinda (1592), and Santos (1598).

1577–80
Francis Drake, commissioned by Elizabeth I of
England, circumnavigates the globe in a lucrative
privateering voyage, sacking Spanish cities and
capturing Spanish treasure in South America

1578
Walter Raleigh and Sir Humphrey Gilbert harass
Spanish shipping in the Caribbean

Death of Sebastião I, last of the Aviz dynasty of
Portugal. After the two-year regency of Cardinal
Henrique, Felipe II of Spain accedes to Portuguese
throne as Felipe I of Portugal in 1580.

Jean de Léry's *Histoire d'un voyage fait en la terre du
Brésil*, one of the earliest and most influential firsthand
accounts of the Tupinamba, published at La Rochelle
(France)

1579
Francis Drake reaches New Albion (Alta California)

Diego Valadés, first mestizo Franciscan friar in Amer-
ica, publishes *Rhetórica christiana* in Perugia (Italy)

Birth of Martín de Porres, later America's first mulatto
saint, in Lima

Church of São Francisco in Salvador (Brazil)
constructed

1580
Brazil leads the world in sugar production

Buenos Aires (Argentina) refounded

French philosopher Michel de Montaigne's essay
"Of Cannibals" reflects upon native Brazilians

1580–1635
Lope de Vega, prolific Spanish dramatist, active

1580–1640
Spanish monarchs rule both Spain and Portugal

1581
Protestant Netherlands throws off Spanish rule

Felipe II commissions Italian military engineer Battista
Antonelli and his son to repair Spain's Caribbean forts

Monastery of San Francisco in Quito (Ecuador) com-
pleted by Benito de Morales or Alonso de Aguilar

Monastery of São Bento da Bahia (Brazil) founded

1582
Gregorian calendar replaces the Julian throughout
the Christian world

Audiencia of Manila (Philippines) established

1583
Archbishop Toribio de Mogrovejo opens Third Coun-
cil of Lima, delineating plans for the evangelization of
Peru. Its proceedings become the first book printed in
the viceroyalty.

1584
Gutierre Fernández Hidalgo, the leading composer
in sixteenth-century South America, arrives in Bogotá
(Colombia) from Quito (figs. 22, 23, and 24)

1584–88
Altarpiece at Huejotzingo (near Puebla, Mexico),
commissioned by Indian officials of the town and
constructed by Simón Pereyns and Pedro de Requena

FIG. 21 Jacobus Houbraken (Dutch, 1698–1780), *Sir Francis Drake*, c. 1743–51. Engraving. British Library, London

The English Drake was commander of the second ship to circumnavigate the world (1577–80) and probably the first European to sail into San Francisco Bay.

FIG. 22 Clavicord, Ecuador, seventeenth century. Wood and bone, 22 × 35⁵⁄₁₆ inches (56 × 90 cm). Museo Pedro Traversari, Casa de la Cultura Ecuatoriana, Quito, Ecuador

FIG. 23 Chitarra Battente, Italy, eighteenth century. Silver and ebony incrustations, 34¾ × 11½ inches (88.4 × 29 cm). Museo Pedro Traversari, Casa de la Cultura Ecuatoriana, Quito, Ecuador

FIG. 24 Choir Book for Holy Week, eighteenth century. Pages: parchment; cover: wood and leather; page: 17⁵⁄₁₆ × 11⁷⁄₁₆ inches (44 × 29 cm). Museo Fray Pedro Gocial, church of San Francisco, Quito, Ecuador

1586
Order of the Brothers of the Virgin of Carmen established in Salvador (Brazil)

1588
English navy defeats the Spanish Armada, marking the start of Spain's naval decline and threatening silver shipments to Spain

1589
García Hurtado de Mendoza y Manrique, Marqués de Cañete, becomes viceroy of Peru. With him comes Italian-born painter Matteo da Lecce, who had worked on a restoration of the Sistine Chapel and brought Albrecht Dürer engravings to America.

1590s
Labor drafts of Amerindians introduced in Colombia's eastern highlands

Non-Spanish European incursions into the Caribbean increase

1591
Portuguese Inquisition begins in Brazil

1592
Mexico City's Alameda, the first park in the city, established by the viceroy

1595
Caracas's main church built (elevated to cathedral in 1637)

1596
Inquisition holds a great auto-da-fé in Mexico City, publicly punishing and executing heretics

late 1590s
First Dutch settlers arrive on Guiana coast of northeastern South America

1598
Construction begins at the fort of Reis Magos in Natal (Brazil)

Felipe III of Spain (Felipe II of Portugal) accedes to Spanish and Portuguese thrones

Juan de Oñate establishes the first Spanish colony in New Mexico at San Juan de los Caballeros (near present-day San Juan Pueblo, USA). The first Spanish missions are established among the Pueblo people that same year.

Italian painter Angelino Medoro executes the *Agony in the Garden* and the *Descent from the Cross* for the cathedral of Tunja (Colombia)

Florentine painter Bartolommeo Carducci becomes a court painter in Spain; with fellow Florentines Orazio Borgianni and Angelo Nardi, he brings the Tuscan reform style from which seventeenth-century Spanish naturalism derives

1599
Andrés Sánchez Gallque paints the "mulattos of Esmeraldas," *Don Francisco de la Robe and His Sons Pedro and Domingo* in Quito (Ecuador) to send to Spain to commemorate a peace with the Esmeraldas Afro-Indian community two years earlier

Saint James (Santiago) reputed to have appeared to aid the Spanish in their battle with the Acoma people at Acoma Pueblo, New Mexico (USA)

late 16th century
Saint John Writing the Book of the Apocalypse by Marteen de Vos, perhaps the most influential Flemish artist in early colonial Latin America, is in Mexico

c. 1600
Bands based in São Paulo begin ranging far into Brazil's interior to take slaves, prospect for minerals, and explore

Sevillian painter Alonso Vázquez spends five years in Mexico City, helping spread the Sevillian Romanist style in Mexico

1600
São Paulo (Brazil) has a population of 2,000

1603
Viceregal palace in Lima completed

1604
Treaty of London between Spain and England establishes "effective occupation" as principle of colonial possession

Portuguese Crown establishes the India Council to oversee the administration of its empire

1605–15
Miguel de Cervantes publishes *Don Quixote de la Mancha*

1606
Spanish Crown permits sale of almost all local government offices

First *relação* (high court with administrative, advisory, and judicial functions) established at Salvador (Brazil)

1606–c. 1630
Silver boom at Oruro (Bolivia)

1607
Jamestown, Virginia (USA), founded, the first long-term English settlement in North America

1609
Jesuit-run missions (reductions) established among Guaraní and other Amerindians. Beginning in Paraguay and eventually reaching Argentina, Bolivia, and Brazil, these self-sustaining, prosperous "Jesuit Republics" excluded Europeans and protected large numbers of the native population from slavery and forced labor, drawing colonists' enmity.

Moriscos (converts to Christianity from Islam) expelled from Spain

Expatriate Peruvian mestizo historian Garcilaso de la Vega's ("El Inca") *Commentarios reales de los Incas*, in which he defends the reputation of his Inca ancestors, is published in Lisbon

1609–21
Truce between Spain and the Dutch

c. 1610
Three-roller cane mill introduced into Brazil, increasing efficiency of sugar production

1610

Tribunal of the Inquisition authorized for Cartagena, New Granada (Colombia)

Santa Fe established as the capital of New Mexico (USA)

1610–80

Era of Franciscan mission building in New Mexico (USA); initial wall and hide paintings were eventually replaced by altar screens and altarpieces

1611

William Shakespeare writes *The Tempest*, possibly influenced by accounts by survivors of shipwreck in the Bermuda islands, as well as Montaigne's "Of Cannibals"

1613

Juan de Santa Cruz Pachakuti Yamqui writes *Relacion de antigüedades deste Reyno del Perú*

Turks invade Hungary

1613–20

Hasekura Tsunenaga is the first Japanese political envoy to the Americas. Diplomatic contact between Mexico and the East fosters a taste for Asian luxury goods.

1614

Jesuits expelled from Japan

1615

Portuguese drive French from Brazil

Spanish Franciscan friar Juan de Torquemada publishes *Los veynte y un libros rituales y monarchia yndiana*, which describes indigenous society (fig. 25)

Felipe Guamán Poma de Ayala writes *El primer nueva corónica y buen gobierno* (fig. 26)

1616

Belém (Brazil) founded; becomes gateway to the Amazon

Sir Walter Raleigh leads expedition to Guiana in search of El Dorado

1618–48

Thirty Years' War, a complex series of European conflicts that started as a struggle between Protestants and Catholics

1620s

Many non-Spanish European settlements founded in Caribbean and North America

1620–21

English pilgrims establish the New Plymouth Colony in Massachusetts (USA)

1620–80

Piracy flourishes in the Caribbean and breeds mistrust between Spain and other European powers, hindering legitimate trade

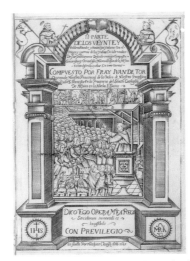

FIG. 25 *Spanish Missionary Instructing Native Americans*, title page from Juan de Torquemada, [*Monarquía Indiana*] IIa parte de los veynte y vn libros rituales y monarchia yndiana . . . (Seville: Matthias Clauijo, 1615). Engraving. John Carter Brown Library, Providence, Rhode Island

In his social and religious history of Mexico, the Franciscan Torquemada expresses an apocalyptic view of the coming of Christianity to the Mexicans and characterizes Mexico City as a new Jerusalem and Rome.

1621

Felipe IV of Spain (Felipe III of Portugal) accedes to Spanish and Portuguese thrones

War between Spanish and the Dutch resumes

State of Maranhão (Brazil) founded

First Brazilian law to forbid mulattos, blacks, and Amerindians from becoming silversmiths. Such laws were reiterated several times in the eighteenth century, to little effect.

Dutch West India Company settles Surinam and disrupts Spanish shipping in Caribbean

1622–43

Count Olivares (the "Count Duke") serves as chief minister of Spain

1623

Jesuits establish the University of Córdoba (Argentina)

1624

Viceroy of New Spain feuds with archbishop and *audiencia* officials; the ensuing riots drive him from his palace

1624–25

Salvador da Bahia (Brazil) captured and sacked by the Dutch, who surrender and depart in 1625

1624–55

England declares war on Spain and gains important footholds in the Caribbean, seizing Saint Kitt's in 1624, Barbados in 1627, and Jamaica in 1655

1625–50

Nadir of native population size in New Spain; free wage labor largely supplants forced labor

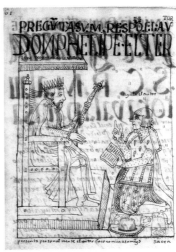

FIG. 26 Felipe Guamán Poma de Ayala (Andean, 1534–1615), *The Author Ayala Presents His Corónica to Philip III, King of Spain*, from *El primer nueva corónica y buen gobierno*, 1615. Ink on paper, book: 5¾ × 8 inches (14.5 × 20.5 cm). Det Kongelige Bibliotek, Copenhagen

In his copiously illustrated chronicle, Guamán Poma de Ayala spoke out about colonial abuses and defended his fellow native Andeans.

1626

Inquisition established in New Mexico (USA)

Portuguese Franciscan friar Alonso de Benavides brings the Spanish sculpture *Our Lady of the Assumption* to New Mexico; later known as *La Conquistadora* for her intercession in the Spanish reoccupation of Santa Fe in 1692 after the Pueblos revolt in 1680

1627

Beatification of the Franciscan Felipe de Jesús, martyred in Japan, who becomes first Mexican-born saint

France's Cardinal Richelieu signs treaty with Spain

1628

Dutch Captain Piet Heyn deals Spain's treasury a major blow by capturing six million pesos in silver from the Spanish fleet off Cuba

Pope Urban VIII prohibits iconography of the trifacial Trinity for fear it promotes misunderstanding of the unity of God. In practice it was widely permitted in Spanish America.

Peter Paul Rubens ships 20 Eucharistic tapestries to the convent of the Descalzas Reales in Madrid. These and other Rubens compositions disseminated in prints and paintings on copper were widely influential in the Americas.

1629

Contract for caravans to supply missions in New Mexico (USA) with tools, cloth, pottery, and church furnishings, including images that would become models for *santos*

1629–44

Franciscans construct the mission of San Esteban Rey at Acoma, New Mexico (USA), by combining utopian Renaissance models from central Mexico with local materials and techniques

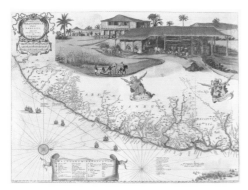

FIG. 27 Joan Blaeu (Dutch, 1576–1673), *Pernambuco, Brazil: A Dutch West Indian Company Outpost*, from Joan Blaeu, *Atlas maior . . .* (Amsterdam: Joan Blaeu, 1662), pl. following p. 243. Hand-colored engraving. John Carter Brown Library, Providence, Rhode Island

Blaeu's map includes images based on the drawings of the Dutch painter Frans Post, one of the first European-trained artists to paint in the Americas.

FIG. 28 *Allegory of the Wealth of the New World*, title page from Willem Piso and Georg Marcgraf, *Historia naturalis Brasiliae* (Leiden and Amsterdam: Franciscum Hackium & Lud. Elzevirium, 1648). John Carter Brown Library, Providence, Rhode Island

The images of the indigenous inhabitants are based on the ethnographic paintings of Albert Eckhout, the first European portrayals of racial mixture in the Americas.

FIG. 29 Frans Post (Dutch, c. 1612–1680), *Brazilian Landscape with Anteater*, 1649. Oil on canvas, 20⅞ × 27⁵⁄₁₆ inches (53 × 69.4 cm). Alte Pinakothek, Munich

While in Brazil in the service of Count Johan Maurits van Nassau-Siegen, Post painted landscapes, flora, and fauna that he would continue to draw upon after his return to Europe.

1630
Fort of San Felipe de Barajas (Colombia) commissioned by Pedro Zapata de Mendoza

1630–54
Dutch capture of Recife, Pernambuco, begins their occupation of northeastern Brazil (fig. 27)

1631
Spanish Crown prohibits trade between New Spain and Peru, partly because vigorous trade on this route diverted an alarming flow of silver to Asia

1633
Vicente Carducho's *Diálogos de la pintura* published in Spain

Poet Gregório de Matos is born in Salvador (Brazil); best known for his burlesque poems satirizing colonial society

1634
Dutch seize Curaçao

1635
French seize Martinique and Guadeloupe

Brazilian sculptor Friar Agostinho da Jesus works for the monastery of São Bento in São Paulo; discards Renaissance rigidity for a looser baroque style

1635–59
Bourbon-Habsburg (Franco-Spanish) War. It ends in a standoff when both powers declare bankruptcy.

1636
Friar Agostinho da Piedade sculpts *Our Lady of Montserrate* (Museu de Arte Sacra da Universidade Federal da Bahia), the patroness of Iberian Benedictines. In 1653, he sculpts another for the abbey in São Paulo.

1637
Calderón de la Barca's *La vida es sueño* first performed in Madrid

1637–39
Pedro Teixeira expedition explores the Amazon and extends Brazil's boundary far westward

1637–44
As governor of Dutch Brazil, Count Johan Maurits van Nassau-Siegen sponsors scientists and artists, among them Albert Eckhout and Frans Post (figs. 28 and 29; see also fig. 27)

1638
New Mexican textiles exported to Mexico

1639
Flemish silversmith Rodrigo Lorenzo is living in Santa Fe, New Mexico (USA)

1639–59
As bishop of Puebla (Mexico), Juan de Palafox y Mendoza patronizes the construction of the cathedral, brings the Antwerp-born artist Diego de Borgraf to the city, and amasses a library of 5,000 books

late 1630s–40s
Francisco de Zurbarán and his workshop ship paintings to the Americas

1640s
Paulistas in search of Indian slaves raid Jesuit reductions in Brazil, which strive to offer their residents protection, religious instruction, and training in crafts, art, music, and agriculture

c. 1640
Large-scale sugar planting begins in the non-Spanish Caribbean islands, assisted after 1654 by the arrival of Dutch planters and technicians from Brazil

1640
Portugal revolts against Spanish rule and gains independence

after 1640
The Solomonic style of baroque architecture, derived from the dynamic, spiraling columns of Gianlorenzo Bernini's baroque baldachin in Saint Peter's in Rome, develops in New Spain

1641
Jesuits arm 4,000 Guaraní to repel Paulista slave hunters

1642
Portuguese Crown creates Overseas Council, which oversees Brazilian affairs

1643
Five-year-old Louis XIV accedes to French throne

1646
Census records more than 35,000 Africans and over 116,000 persons of African descent in New Spain

1648
Peace of Westphalia ends Thirty Years' War and recognizes Dutch independence

Priest Miguel Sánchez publishes *Imagen de la Virgen María* in Mexico, helping to spread the devotion to Our Lady of Guadalupe

1649
Cathedral of Puebla (Mexico) completed

Portuguese Crown charters General Brazil Trading Company to monopolize trade in key foodstuffs, limit ports open to transatlantic trade, and defend Portuguese shipping to Brazil (abolished 1720)

Luis Laso de la Vega publishes an account of the apparition of the Virgin of Guadalupe in Nahuatl to inform native Mexicans of the miracle

Artist and Inquisition inspector Francisco Pacheco's influential treatise *El arte de la pintura* (Seville) draws on the Council of Trent's guidelines for religious orthodoxy in art

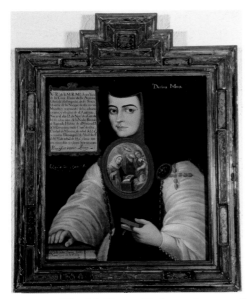

FIG. 30 Miguel de Herrera (Mexican, active 1732–78), *Sister Junana Inés de la Cruz*, 1732. Oil on canvas, 25³⁄₁₆ × 21¼ inches (64 × 54 cm). Banco Nacional de Mexico (Banamex), Mexico City

The inscription on this posthumous portrait—*Décima Musa* (Tenth Muse)—refers to the Mexican nun as a poet.

FIG. 31 N. Guérard the Younger (French, first half of eighteenth century), *Llamas Working at a Silver Mine in the Andes*, from Amédée François Frézier, *Relation du voyage de la mer du Sud aux côtes du Chili, du Pérou, et du Brésil . . .* (Paris, 1717). Engraving. John Carter Brown Library, Providence, Rhode Island

1650
Cuzco (Peru) destroyed in an earthquake. The cult of Christ of the Earthquakes emerges soon after.

1651
Poet, nun, and intellectual Sister Juana Inés de la Cruz, whose fame would extend to the entire Hispanic world, born in Mexico City (fig. 30)

1653
Portuguese author, orator, diplomat, court figure, and Jesuit missionary António Vieira leads a campaign against Indian slavery in Brazil's Maranhão and Pará districts

Viceroy Luis Enriquez de Guzman establishes the Talavera Poblana potters guild in Puebla (Mexico)

1654
Treaty of Taborda signed; the Dutch withdraw from Brazil

1655
The Crown gives Jesuits authority over indigenous villages in the Maranhão and Pará regions (Brazil)

English seize Jamaica from Spain

1656
Alfonso VI accedes to Portuguese throne

Felipe IV's court painter Diego de Velázquez y Silva paints *Las Meninas* (Prado, Madrid), which includes a ceramic vessel from Tonalá, Jalisco (Mexico)

1657
Gregorio Vásquez de Arce y Ceballos of Santa Fé de Bogotá (Colombia) executes his first signed and dated painting, *The Holy Family* (Monasterio Nuevo de Monjas de Santa Clara, Tunja)

1657–74
New church of San Francisco constructed in Lima (Peru) following the earthquake

1660s
English settle the mouth of Belize River to log hardwoods

c. 1660–80
Series of harquebusier angels (angels with guns) completed for the church of Calamarca (Bolivia), the most complete and possibly earliest such series in the Andes. The series is attributed to the Master of Calamarca.

1661
Pope supports the doctrine of the Immaculate Conception of the Virgin Mary

1664–74
Juan de Medino builds the cathedral of Caracas (Venezuela)

1665
Carlos II accedes to Spanish throne

French colonization of Saint Domingue (Haiti) begins with arrival of governor to Tortuga

1666–88
André Félibien des Araux publishes *Entretiens sur les vies et sur les ouvrages des plus excellens peintres anciens et modernes* in Paris

1667
Dutch exchange New York for English-held Surinam in Treaty of Breda

1668
Alfonso VI of Portugal succeeded by Pedro II as regent

Treaty of Aix-la-Chapelle between France and Spain

The Jesuit church of La Compañía completed in Cuzco (Peru) following the 1650 earthquake

With the Treaty of Lisbon, Spain recognizes Portuguese independence

1668–84
Quechua artist Basilio de Santa Cruz Pumacallao and his workshop execute 54 paintings on the life of Saint Francis commissioned by the monastery in Santiago (Chile)

1670s
Mexican mining production surpasses that of Peru (fig. 31)

1670
Italian master Melchiorre Caffa's sculpture *Saint Rose of Lima* is shipped from Rome to Santo Domingo in Lima. The American-born saint's iconography proliferates throughout Spanish America and Europe.

With Treaty of Madrid, Spain and England agree to suppress attacks against each other in Caribbean; Spain recognizes legitimacy of English colonies in Caribbean

1671
Canonization of Saint Rose of Lima, the first American saint

1672
Giovanni Pietro Bellori publishes *Le vite de' pittori, scultori et architetti moderni* in Rome

Mexican-born Carlos de Sigüenza y Góngora accepts the chair of mathematics and astrology at the university of Mexico

1673–99
As bishop, Manuel de Mollinedo y Angulo brings to Cuzco an impressive European art collection with works by El Greco and others, and initiates the construction and decoration of most of the churches in his diocese, patronizing luminaries of Andean painting such as Diego Quispe Tito and Basilio de Santa Cruz Pumacallao

1674–80s
Series of 16 paintings documents the magnificent Corpus Christi celebrations of Cuzco (Peru)

c. 1675–82
Spanish painter Bartolomé Esteban Murillo's career is at its height

1677
First nuns' convent founded in Salvador (Brazil)

1679
Beatification of Toribio de Mogrovejo, archbishop of Lima

Frans Post's 30 Brazilian landscape paintings are given to Louis XIV of France; later copied for the popular Gobelins tapestry series *Les anciennes Indes*

1680s

Portuguese found the colony of Sacramento across from Buenos Aires to ensure access to Río de la Plata and conduct contraband trade with Spanish possessions

Piracy disrupts Spanish shipping along American Pacific coast

c. 1680

Melchor Pérez Holguín, the greatest painter of the school of Potosí of his era, begins his artistic activity

1680–83

Pueblo revolt temporarily drives the Spanish from New Mexico (USA)

1681

Diego Quispe Tito paints his Zodiac series in Cuzco cathedral (Peru)

1682

Death of Baltasar de Echave Rioja, the third and last member of the Echave family artistic dynasty in New Spain

1683

Spain declares war on France

Pedro II accedes to Portuguese throne

1684–91

Juan Correa and Cristóbal de Villapando decorate the sacristy of the Mexico City cathedral

1685

Order of the Discalced Carmelites arrives to complete the convent of Santa Teresa in Salvador (Brazil)

1685–86

Juan Correa paints his *Assumption of the Virgin* in the Mexico City cathedral

1686–1737

Church of São Francisco constructed in Salvador, Bahia (Brazil); sugar barons of Salvador, then the largest port in South America, finance its decoration

1687

Sir Hans Sloane, the Irish naturalist and physician, begins his botanical collection on a visit to Jamaica

Major earthquake in Lima

Spanish Crown begins selling *audiencia* positions, which allows many Creoles access to office

1688

Native artisans of Cuzco (Peru) separate from Spanish masters of the painting guild to establish their own workshops. Andean centers lose contact with European artistic canons and develop the "Cuzco School" of painting, characterized by gold patterning, indigenous motifs, and planar design.

Cristóbal de Villalpando paints the high baroque, illusionistic ceiling painting *Glorification of the Virgin* in the cathedral of Puebla (Mexico)

1688–89

Juan Tomás Tuyru Tupac builds the church of San Pedro in Cuzco

1690s

Major gold deposits discovered in Minas Gerais, boosting the Brazilian economy and hastening settlement of the interior

c. 1690

The German friar Ricardo do Pilar paints the rectangular panel of the *Lord of the Martyrs* for the altar of the sacristy in the monastery of São Bento in Rio de Janeiro (Brazil). He is responsible for the execution of the ceiling of the main chapel and several other paintings for the monastery.

1690

First Franciscan missionaries sent from Querétaro (Mexico) to Texas

The elaborate Rosary Chapel, decorated in gold leaf, is completed in the monastery of Santo Domingo in Puebla (Mexico)

First mural painting in Brazil executed in the small chapel of Nossa Senhora das Mercês in the church of Santa Teresa (Salvador)

1692

Indian and *casta* (mixed-race) rioters burn the viceregal palace of Mexico City during tumult sparked by a maize shortage

1694

Viceroyalty of Brazil founded

1695

Cristóbal de Villalpando paints his bird's-eye view of the Plaza Mayor of Mexico City (collection of James Methuen Campbell, Corsham Court, Bath, England)

1695–1709

The new basilica of Guadalupe (Mexico City) is constructed in a Renaissance style

1696

Palmares (Brazil), one of the largest fortified settlements of escaped black slaves and their descendants, is destroyed after almost a century of independence

1697

Treaty of Ryswyck cedes Saint Domingue to France after French buccaneers capture Cartagena (Colombia)

The Itzás, the last independent lowland Maya, defeated by Spaniards at their stronghold of Tayasal in Lake Petén Itzá (Guatemala)

1698

Head of the French Academy Charles Le Brun publishes *Conference sur l'expression generale et particulière* in Amsterdam

late 17th century

Religious figures and relief plaques executed in Huamanga stone, a translucent white stone, reminiscent of ivory, that is found in Ayacucho (Peru) and was used for pre-Columbian carvings

1700s

Casta painting depicting racial mixtures popularized in New Spain

Portraits of crowned nuns flourish in New Spain and Peru

1700

Death of Carlos II, last of the Spanish Habsburgs, sets off the War of the Spanish Succession

1700–55

Brazilian trade brings prosperity to Portugal; Spanish economy begins to revive

1700–75

English, Dutch, and Chinese influence on Venezuelan furniture transforms the primarily Spanish furniture tradition of the previous 200 years. Rococo style is introduced beginning in 1750, followed by neoclassical in 1775.

1701

Felipe V of Spain accedes to Spanish throne

Germanic rococo style brought to Portuguese court, whence it moves on to Brazil

1703

With Methuen Treaty, Portuguese agree to trade oil, wine, and Brazilian bullion to Britain for manufactured goods

Parián (or Chinese community/marketplace) district founded in Mexico City; Asian Indians, Chinese, Japanese and Filipinos have been present in Spanish America since the late sixteenth century

1705

Manuel Botelho de Oliveira's *Música do Parnaso* is the first book by a Brazilian-born poet to be published

1706

João V accedes to Portuguese throne

Albuquerque, New Mexico (USA) founded

1708–9

In Brazil, Paulistas fight War of the Outsiders against Portuguese newcomers over gold-mine ownership

French painter Charles Belleville reaches Salvador (Brazil)

1709

Captaincies of São Paulo and Minas de Ouro created in Brazil

c. 1710

Zacatecas (Mexico) silver production surpasses that of Potosí (Bolivia)

1711

Rio de Janeiro captured by French

1713

Peace of Utrecht ends War of the Spanish Succession. Spain loses European territories, the Bourbon Felipe V secures throne, and the British gain rights to supply Spanish America with slaves and to engage in limited legal trade.

FIG. 32 Basilica of Nuestra Señora del Pilar, Buenos Aires, Argentina, 1732

FIG. 33 Bernardo de Legarda (1700–1773), *Winged Immaculate Conception (Virgin of Quito)*, c. 1734. Poly-chromed wood, 28¾ × 9⅞ × 12⁹⁄₁₆ inches (73 × 24 × 32 cm). Banco Central, Quito, Ecuador

The cult statue is housed in the church of the convent of San Francisco, Quito.

FIG. 34 Chest depicting the French geodesic expedition to the equator, 1735–44 (detail of the lid), Quito, Ecuador. Cedar, height 20½ inches (52 cm), width 51³⁄₁₆ inches (130 cm), depth 20½ inches (52 cm). Viteri Reyes Collection, Quito, Ecuador

1714
Spain's Felipe V creates Ministry of the Indies

1715
Palace of the Torre-Tagle completed in Lima (Peru) in a Sevillian baroque style with strong Mudejar influence

1716
Melchor Pérez Holguín paints *The Entry of Viceroy Archbishop Morcillo into Potosí* (Bolivia) (Museo de América, Madrid); political and religious processions were important venues of artistic, literary, and musical activity

1717
Casa de la Contratación moved from Seville to Cádiz; reforms in Council of the Indies remove its control over Indies trade

Mexican artist Juan Correa's *Our Lady of the Angels of Porciúncula* (now in the village church, Pecos) installed in the fourth mission church at Pecos (New Mexico), which was completed in this year

Viceroyalty of New Granada (Colombia, Ecuador, Venezuela, Panama) created

1718
England declares war on Spain

1718–20
Epidemic disease reduces Peru's population to lowest point of colonial era

1718–37
Spanish artist Jerónimo de Balbás's Altar of the Kings in Mexico City's cathedral establishes the style known as the Mexican Estípite Baroque

1719
France declares war on Spain

Oaxaca-born Miguel Cabrera, best-known painter in New Spain in the eighteenth century, comes to Mexico City

First examiners of silversmiths appointed in Salvador (Brazil)

1720s
Diamonds discovered in Minas Gerais (Brazil); Captaincy of Minas Gerais created

Central European Jesuit artists and craftsmen arrive in Santiago and the mission of Calera de Tango, bringing the Bavarian rococo style to Chile. The mission work-shop ends with the expulsion of the Jesuits in 1767.

1720
Gold mines established at Matto Grosso (Brazil)

Brief revolt against the governor in Minas Gerais (Brazil)

The title "governor-general" of Brazil is replaced with "viceroy"

1720–22
Spain occupies Texas

1723
Louis XV of France, champion of rococo style, attains majority

1724
In Spain, Felipe V abdicates, Luis I ascends and dies, and Felipe V returns to throne

Brazilian Academy of the Forgotten founded at Salva-dor, first of several Brazilian intellectual academies of the eighteenth century

Antonio Palomino publishes *El museo pictórico y escala óptica*

1726
Portuguese woodworker Manuel de Brito executes the carving for the main chapel of the church of the Third Order of Saint Francis of Penance in Rio de Janeiro and introduces the Dom João V style to Brazil

1727
Coffee growing introduced into Brazil

Jesuit reduction church of San Ignacio Miní (Argen-tina) constructed

Spain declares war on France and England and besieges English-controlled Gibraltar

1728
Guipúzcoa (or Caracas) Company formed in Spain and given right to monopolize trade with Venezuela, especially cacao exports; Venezuelan growers resist

1729
Treaty of Seville between France, Spain, and England

Poet and dramatist Cláudio Manuel da Costa born in Minas Gerais (Brazil)

1731–47
Giovanni Battista Primoli constructs the Jesuit reduc-tion church of São Miguel (Brazil)

1732
Master painter Caetano da Costa Coelho introduces illusionistic ceiling painting to Brazil in the main chapel of the church of the Third Order of Saint Francis of Penance in Rio de Janeiro

The Franciscan Recolect friars build the basilica of Our Lady of Pilar, which houses six German baroque-style altars, the central one gilded with Peruvian silver (fig. 32)

1733
Chico-Rei, an African ruler who arrived in Brazil as a slave after 1700, commissions church of Santa Efigénia dos Pretos in Ouro Prêto, which is finished in 1780

before 1734
The Jesuit mission church of Santa María de Loreto de Achao Chiloé (Chile) constructed

FIG. 35 Thomas Doesburgh (Dutch, active c. 1714), *Havana*, from Carel Allard, *Orbis habitabilis oppida et vestitus* (Amsterdam, c. 1700). Engraving, 8½ × 10¾ inches (21.4 × 27.3 cm). The New York Public Library, I. N. Phelps Stokes Collection, Miriam and Ira D. Wallach Division of Art, Prints and Photographs

Allard's pictorial atlas features one hundred cities around the world, including Havana, a critical point in the Spanish empire's trade networks.

FIG. 36 Luis de Mena (Mexican), *Our Lady of Guadalupe*, c. 1750. Oil on canvas, 47¼ × 40¹⁵⁄₁₆ inches (120 × 104 cm). Museo de América, Madrid

The images of human races and indigenous fruits and vegetables in this painting respond to the eighteenth-century interest in classifying the natural world.

c. 1734
Bernardo de Legarda and his workshop create the *Virgin of Quito* for the church of San Francisco. It is the oldest extant example of the winged Virgin of the Apocalypse and the only winged Virgin in Spanish American art (fig. 33).

1735
Sculptor and woodworker Francisco Xavier de Brito contracts to carve the transept arch of the main chapel of the church of the Third Order of Saint Francis of Penance in Rio de Janeiro (Brazil)

Carl Linnaeus's *Systema Naturae*, his classification of plants, published in Leiden (Holland)

1735–44
Charles-Marie de la Condamine, French naturalist and mathematician, takes part in the expedition to Ecuador to measure a meridian arc at the equator in an attempt to document the earth's precise shape (fig. 34)

1735–67
Swiss Jesuit mathematician Martin Schmid, who is active in Bolivia, links the proportions of Jesuit churches in Chiquitos to musical harmonies

1736
José Fernandes de Pinto Alpoim designs the Palace of Governors in Vila Rica (Brazil)

1736–43
The Italian Lorenzo Boturini Benaducci visits Mexico, learns Nahuatl, and collects 106 indigenous manuscripts

1737
Painter Manuel da Cunha is born a slave in Rio de Janeiro. After being freed, he studies painting in Portugal and returns to Rio de Janeiro, where he works as an artist and instructor.

1739
Viceroyalty of New Granada re-established

British Admiral Vernon captures Portobello (Panama)

Uprising at Oruro (Bolivia) opposing tax increases

1739–41
War of Jenkins's Ear between Spain and England ends English *asiento* (monopoly contract to supply slaves to Spanish America) and increases English privateering in the Caribbean

1740
Spanish Crown charters Havana Company to control exports of tobacco, hides, and sugar from Cuba (fig. 35)

Restrictions of fleet system for Spanish South America loosened with licensing of register ships, which could sail more frequently

1740–48
War of the Austrian Succession involves most of Europe; among the conflicts, France and Spain align against England

1741
Probable founding of first guild of painters and *encarnadores* (painters specializing in flesh tones) in Quito (Ecuador), followed in 1742 by evidence of a guild of sculptors and gilders

1742
Juan Santos Atahualpa's uprising begins in Peruvian Andes

1743
José del Campillo y Cossio's treatise *Nueva sistema de gobierno económico para la América* influences Crown policy by advocating opening trade, lessening church power and wealth, reforming government, and suppressing American manufacturing to increase Spanish profits

1744
Captaincy of Goiás (Brazil) created

c. 1745
Valentim da Fonseca e Silva (Mestre Valentim) born in Vila do Príncipe, Diamantina, Minas Gerais (Brazil) (d. 1813); he is considered the most important sculptor in colonial Brazil prior to Aleijadinho

1746
The Virgin of Guadalupe proclaimed patroness of New Spain and protectress of Mexico City (fig. 36)

Fernando VI accedes to Spanish throne

1746–48
Tiles painted in Portugal by Bartolomeu Antunes de Jesús, including scenes influenced by Flemish engravings, are placed in the convent of São Francisco in Salvador (Brazil)

1748
Last sailing of the *galeones* division of the Spanish fleet to Isthmus of Panama; Spanish fleet system disintegrating

Captaincy of Mato Grosso (Brazil) created

1749
Fernando VI decrees all parishes under mendicant control be transferred to the secular clergy

1749–68
Lorenzo Rodríguez rebuilds the sacristy of the cathedral in Mexico City, a prototype of the Estípite Baroque style

c. 1750
New Mexican (USA) artists begin to produce sculptures and altar screens using local woods

1750
José I accedes to Portuguese throne

Spanish Crown ends sale of *audiencia* appointments in effort to centralize governance of colonies

The Treaty of Madrid abandons the Treaty of Tordesillas and transfers an area containing seven Jesuit missions from Spain to Portuguese Brazil

Commercial Treaty with England ends its *asiento* to provide slaves to Spanish dominions

Miguel Cabrera paints posthumous portrait of Sister Juana Inés de la Cruz

1750–54
Gold mining peaks in colonial Brazil

1751
Miguel Cabrera leads a team to examine the cult image of the Virgin of Guadalupe and verify its miraculous nature

1752
Relaçao (administrative high court) of Rio de Janeiro established, the second in Brazil, because of the importance of nearby mining

Royal Academy in Madrid founded

1754
Miguel Cabrera's and José de Ibarra's attempt to found a fine-art academy in Mexico City fails

1755
Earthquake devastates Lisbon

Royal minister Sebastião José de Carvalho e Melo (Marquis of Pombal after 1770) begins his program to strengthen Portugal by reforming, expanding, and controlling the Brazilian economy, centralizing government, and reducing church power

1756
Portuguese Feliciano Mendes begins the construction of the sanctuary of Bom Jesus do Matosinhos (Brazil), inspired by examples in Portugal

Miguel Cabrera publishes *Maravilla americana*, an account of the Virgin of Guadalupe

1756–63
Seven Years' War between England and France (after 1762 Spain enters) ends with Spain losing Florida to England and gaining Louisiana from France. The first standing Spanish armies are stationed in the Americas, and local militias are expanded. The conflict disrupts Caribbean sugar production, benefiting the Brazilian industry.

1759
Pernambuco and Paraiba Company created (Brazil)

After acceding to Spanish throne, Carlos III initiates the most extensive Bourbon reforms

Voltaire's philosophical novel *Candide* echoes the tale of the misfortunes of an African prince originally told in the 1668 novel *Ooronoko* by English author Aphra Behn; both texts are critical of slavery

1759–60
Marquis of Pombal expels the Jesuits from Portugal, Brazil, and Portugal's Asian territories

c. 1760
German Jesuit Georg Lanz carves the pulpit in the church of La Merced in Santiago (Chile)

1760
Antônio Francisco Lisboa, called O Aleijadinho, executes his important early carving in the church of Our Lady of Good Success, Matriz de Caeté (Brazil)

Carlos III declares the Virgin Mary of the Immaculate Conception the patron saint of Spain and all Spanish possessions

Spanish botanist José Celestino Mutis begins his scientific study of the flora of Nueva Granada (Colombia) that eventually results in over 5,000 color and monochrome plates and fosters a Colombian school of botanical illustrators and herborists

1761
Treaty of El Pardo annuls the Treaty of Madrid

1762
Havana and Manila captured by British (see fig. 35)

Giambattista Tiepolo paints frescoes in the Royal Palace in Madrid; one shows a European ship being loaded with American treasures, while two Amerindians prostrate themselves before it

FIG. 37 J. L. Delignon (French, 1755–1804), after J. M. Moreau the Younger (French, 1741–1814), *The Spaniards Take Moctezuma Prisoner in the City of Mexico*, from Guillaume-Thomas Raynal, *Histoire philosophique et politique* . . . (Geneva: Jean-Leonard Pellet, 1780), vol. 2, book 6 of text, p. 33. Engraving. John Carter Brown Library, Providence, Rhode Island

1762–71
Governor's palace at Belém do Pará constructed, the largest public structure in Brazil

1763
Peace of Paris ends the Seven Years' War; Spain cedes Florida to British in exchange for Havana and Manila

Viceregal capital of Brazil transferred from Salvador, Bahia, to Rio de Janeiro, reflecting the ascendancy of mining over sugar production

1764
First Spanish American ports opened to single ship trade

Spain establishes Captaincy General of Cuba, encompassing Cuba, Santo Domingo, Puerto Rico, and Louisiana territories

1764–65
Painter José Joaquim da Rocha (1737–1807) works in Salvador (Brazil), painting and gilding the Recolhimento de Santa Casa da Misericórdia

1764–90
System of intendants, peninsular administrators who answer directly to the Crown rather than to the viceroy, established in most Spanish colonies to centralize regional authority; Creole influence in government diminished

1765
Portugal ends its fleet system of trade with Brazil, allowing licensed ships to sail individually

Cádiz's monopoly of Spanish trade with Americas ends as direct trade opened to nine Spanish ports

Protests in Quito against growing fiscal pressure induced by Bourbon tax reforms

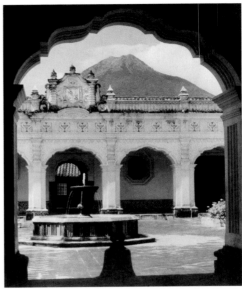

FIG. 38 Architect unknown, with contributions by José Ramírez (brick mason) and Manuel de Santa Cruz (carpenter). Cloister (with Volcán de Agua in the background), Antigua Universidad de San Carlos, Guatemala; begun c. 1763 (major rebuilding c. 1809). American Philosophical Society, Philadelphia

1765–71
Reforming royal minister José de Gálvez makes tour of inspection of New Spain (see fig. 20)

1766
King José I of Portugal orders all silversmith workshops of Brazil closed and destroyed

1767
Carlos III expels the Jesuits from Spain and its empire, outraging their Creole families and associates. Crown confiscates and begins to sell the Society's vast assets, including its religious art.

1768–82
Franciscan mission church of San José y San Miguel de Aguayo, the "Queen of the Missions," is constructed in San Antonio, Texas

1769
Under orders from José de Gálvez, Captain Gaspar de Portolá leads the "Sacred Expedition" of missionaries, artisans, and soldiers to Alta California. Expedition member Friar Junipero Serra founds nine Franciscan missions by 1784.

Antonio Pérez de Aguilar paints *The Painter's Cupboard* (Museo Nacional de Arte, Mexico City), the only known surviving Mexican still life from the mid-eighteenth century

c. 1769–79
The theater of Manuel Luís Ferreira is built in Rio de Janeiro; Leandro Joaquim participates as painter and set designer

1770
Guillaume-Thomas Raynal publishes *L'Histoire philosophique et politique des établissements et du commerce*

des Européens dans les deux Indes in Amsterdam, a text critical of slavery and of the Spanish (fig. 37)

1771

Venezuelan sculptor, painter, and gilder Juan Pedro López paints the *Virgin of the Immaculate Conception* for the Caracas cathedral

State of Maranhão (Brazil) dissolved

1773

Pope Clement XIV suppresses the Jesuits worldwide

Earthquake destroys much of Santiago de Guatemala; capital moved to Guatemala City in 1776 (fig. 38)

Filipino sculptor Esteban Sampzon is recorded as living at Santo Domingo in Buenos Aires (Argentina)

1774

Spain permits intercolonial trade between South America and the rest of Spanish America

1775–83

War of Independence (USA)

1776

Church of San José de Gracia completed at Trampas, New Mexico (USA). Departing from the utopian mission church layout of the sixteenth century, it shows the influence from seventeenth-century baroque architecture.

Viceroyalty of the Río de la Plata (Argentina, Paraguay, Uruguay, Bolivia) created

Last *flota* sails to New Spain as the fleet system ends

1776–87

Spain's José de Gálvez serves as Secretary of State for the Indies

1777

María I accedes to Portuguese throne

Portuguese Crown dismisses Marquis of Pombal

Treaty of San Ildefonso redraws Portuguese-Spanish frontier in South America, fixes Brazil's southern boundaries, and confirms Spain's possession of the Banda Oriental and Portugal's of the Amazon Basin

Captaincy-General of Venezuela established

General Inspector José Antonio de Areche arrives in Peru

José Antonio de Alzate y Ramírez publishes *Memoria sobre la naturaleza, cultivo y beneficio de la grana*, about cochineal, a dyestuff, found in Mexico and Peru. Like Guatemalan indigo, it proved a lucrative American export from the sixteenth century on.

1778

New regulation allows 24 Spanish-American ports to trade with each other and any port in Spanish realms. In the next dozen years, the volume of trade (including of art) between Spain and America quadruples.

Spanish engraver Jerónimo Antonio Gil is issued a royal order to create a school of engraving in Mexico City

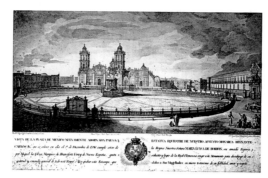

FIG. 39 José Joaquín Fabregat (Spanish, 1748–1807), after Rafael Ximeno y Planes (Spanish, 1759–1825), *View of the Plaza Mayor of Mexico City*, 1797. Engraving, 13⅜ × 26 inches (34 × 66 cm). Benson Latin American Library, University of Texas at Austin

1779–83

Spain and England at war; siege of Gibraltar

1780

Bureau (*Junta de Policía*) formed to oversee architectural activity in Mexico City

1780–81

Exiled Jesuit Francisco Javier Clavijero's *Historia antigua de México* published

1780–83

Tupac Amaru II (José Gabriel Condorcanqui, Marques de Oropesa), a descendant of the Inca royal family, leads armed nativist rebellion in Peru and Upper Peru (Bolivia). After his execution in 1781 the movement continues two more years.

after 1780

In the wake of Tupac Amaru II's rising, Spaniards destroy many Inca portraits as subversive symbols of royalty

1781

Rafael Landívar, Guatemalan Jesuit poet, produces his masterpiece, *Rusticatio Mexicana*

In *comunero* revolt, thousands march on Bogotá (Colombia) against tax and price increases

Siege of La Paz (Bolivia) by Tupac Katari, continuing rebellion begun by Tupac Amaru II

Present-day Los Angeles (USA) founded by 44 settlers

1783

Great Britain recognizes independence of the USA

Florida returned to Spain

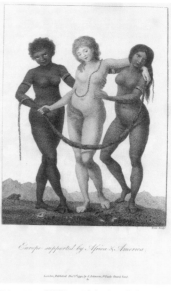

FIG. 40 William Blake (English, 1757–1827), *Europe Supported by Africa and America*, from John Gabriel Stedman, *Narrative, of a Five Years' Expedition, against the Revolted Negroes of Surinam . . .* (London: J. Johnson & J. Edwards, 1796), pl. 80. Engraving. John Carter Brown Library, Providence, Rhode Island

c. 1783–86

Main altar of the church of the monastery of São Bento in Olinda (Brazil) constructed, attributed to Friar José de Santo Antônio Ferreira Villaça, a Portuguese Benedictine

1784

Audiencia of Cuzco (Bolivia) established

1785

The Royal Academy of San Carlos of New Spain (Mexico) opens under the directorship of the Spanish engraver and medalist Jerónimo Antonio Gil. The academy was influential in ushering in the neoclassical style, marking the end of the Mexican baroque (fig. 39).

1787

José Joaquín Fabregat appointed director of engraving of the Royal Academy of San Carlos (see fig. 39)

Audiencia of Caracas (Venezuela) established

1788

First hortensia and fuchsia imported to Europe from Peru

Royal Academy of San Carlos awards first scholarship to an Amerindian, José Mariano de la Águila, *cacique* and governor of Santiago Tlatelolco and San Juan de la Penitencia

Carlos IV accedes to Spanish throne

1789

Inconfidência Mineira, a conspiracy to establish an independent Brazil in Ouro Prêto, is exposed and one of its leaders—"Tiradentes"—captured and executed

George Washington becomes first president of the USA

FIG. 41
O Aleijadinho (Antônio Francisco Lisboa) (Brazilian, c. 1738–1814), *The Twelve Old Testament Prophets*, 1800–1803. Soapstone. Sanctuary of Bom Jesus de Matosinhos, Congonhas do Campo, Minas Gerais, Brazil

FIG. 42 Doors to the convent of Las Conceptas, Cuenca, Ecuador, founded 1599

FIG. 43 Nuns of the convent of Las Conceptas, Cuenca, Ecuador, *Crèche*, eighteenth to twentieth century. Tin, thread, beading, and other materials ("nun's work" [*trabajo de monjas*]). Convent of Las Conceptas, Cuenca, Ecuador

c. 1789–90
Puerto Rican painter José Campeche paints the portrait of *Don Miguel de Ustáriz, Governor and Captain General* (Instituto de Cultura Puertorriqueña, San Juan)

1789–94
French Revolution; Spanish involvement in European wars leads to more foreign trade for its colonies

Spanish naval officer Alejandro Malaspina leads a five-year scientific and geographical expedition to the Spanish colonies in the Pacific to report on them to the Crown and to collect natural science specimens

1790s
Societies to promote economic progress established in many Spanish American cities

Antonio de León y Gama publishes a study of the two Aztec carvings discovered under Mexico City's central plaza—the calendar stone and the statue of the deity Coatlicue

1790
Casa de Contratación closed; Spain terminates all ministries of the Indies and divides their responsibilities among ministries of foreign affairs, justice, war, and finance

José Antonio de Páez, *caudillo* (political strongman) in Venezuela, born

1790–93
Sculpture of *São Pedro de Alcântara*, attributed to Manoel Inácio da Costa, placed in the convent of São Francisco, Salvador (Brazil)

1791
Violent slave revolt in French Saint Domingue (Haiti) destroys the richest sugar colony in the Caribbean, which benefits other sugar-producing regions of the Caribbean and Brazil

Louis XVI of France executed

1793–95
Spanish Crown establishes eight additional merchant guilds throughout the Americas to control expanded trade

1795
Peace of Basel between France and Spain

The Scot John Gabriel Stedman's *Narrative, of a Five Years' Expedition, against the Revolted Negroes of Surinam* exposes the Dutch atrocities used to put down a slave rebellion (fig. 40)

1796–99
Aleijadinho carves the figures of the Stations of the Cross (later painted by Manoel da Costa Athayde, 1808–19) at the pilgrimage church of Bom Jesus de Matosinhos in Congonhas do Campo (Brazil)

1796–1803
Spanish architect and sculptor Manuel Tolsá executes an equestrian statue of Carlos IV for Mexico City's main square. When Tolsá arrived in Mexico in 1791 as director of sculpture at the Royal Academy of San Carlos, he brought a collection of plaster casts of European sculpture for instruction.

1797–1813
Mexico City's School of Mines, the most important example of neoclassical architecture in New Spain, is constructed

1798
Altar screen in chapel of San Miguel, Santa Fe, uses the first solomonic columns in New Mexican art

"Revolt of the Tailors," an attempt to overthrow Portuguese rule in Salvador (Brazil), is suppressed

1798–1809
Spanish Crown disentails and auctions off church lands, and seizes the church's cash funds (*obras pias*), damaging colonial economy and ruining many Creoles who had relied on them for credit

1799
Painters Bernardo Rodríguez and Manuel Samaniego and sculptor Manuel Chili (Caspicara) restore and decorate the cathedral of Quito

1799–1804
Alexander von Humboldt leads a scientific expedition to South America. The publication of his 30-volume account of his voyage (1805–34) sparks travel and exploration of the continent.

1799–1816
Dom João of Portugal becomes regent as a result of the illness of his mother, María I

1800
Population of Los Angeles (USA) numbers 315

Juan Augustín Ceán Bermudez's biographical dictionary of Spanish artists published in Madrid

1800–1803
Aleijadinho carves his series of 12 Old Testament prophets at the pilgrimage church of Bom Jesus de Matosinhos in Congonhas do Campo (Brazil) (fig. 41)

after 1800
Gaspar Sangurima, José Miguel Vélez, and others contribute to the flowering of sculpture in Cuenca (Ecuador), which, during the republican period, surpasses Quito as an artistic center (figs. 42 and 43)

1802
Painter José Teófilo de Jesús returns from Lisbon to Bahia

1803
With 130,000 residents, Mexico City is the most populous in the Americas

In the Louisiana Purchase, Napoleon sells the United States a tract of land stretching from the Gulf of Mexico to the Pacific Northwest

1804
French colony of Saint Domingue becomes Haiti after a violent uprising, the only slave revolt to result in political independence (fig. 44)

1805
Britain defeats the combined French and Spanish fleet at Trafalgar

The neoclassical building of the royal mint is inaugurated in Santiago (Chile) by Italian architect Joaquín Toesca y Ricci

1805–10
Neoclassicism becomes the official style of the Viceroyalty of Peru, brought by the activity of the Spanish architect and designer Matías Maestro

FIG. 44 Anne-Louis Girodet-Trioson (French, 1767–1824), *Jean-Baptiste Belley, Deputy of Santo Domingo*, 1797. Oil on canvas, 62³⁄₁₆ × 43¹¹⁄₁₆ inches (158 × 111 cm). Chateaux de Versailles et de Trianon, Versailles, France

Belley (1747–1805) was a representative to the convention in Paris that abolished slavery in the French colonies on February 4, 1794.

FIG. 45 Arturo Michelena (Venezuelan, 1863–1898), *Portrait of Simón Bolívar*, 1859. Oil on canvas. Museo Bolívariano, Caracas, Venezuela

Bolívar was immortalized in American and European nineteenth-century portraiture as *El Libertador* (The Liberator) and the "George Washington of South America" for his military victories.

FIG. 46 Royal porcelain factory, Sèvres, France (established 1740); decorated by Jean-Charles Develly (French, 1783–1849). Vase: *The Cultivation of Cocoa*, 1827. Hard-paste porcelain, height 12¼ inches (31.2 cm). Musée national de céramique, Sèvres, France

The border of this service recalls Aztec ornament.

1806
Francisco de Miranda attempts unsuccessful rebellion against Spanish rule in Venezuela

1806–7
Britain invades Buenos Aires (Argentina): Spanish viceroy flees inland to Córdoba, and Creole inhabitants drive British out. Crown authority thereafter compromised.

1807
Under Napoleon, France and Spain invade Portugal; Portuguese royal family flees to Brazil with British assistance

1807–8
French begin occupation of Iberian Peninsula

1808
Carlos IV of Spain abdicates. Fernando VII accedes, abdicates, and is exiled by Napoleon, who places his brother Joseph on the Spanish throne. Juntas of resistance form in Spain and later in the Americas; Central Junta convenes to rule in monarch's absence.

Portuguese royal family and its court, numbering in the thousands, reach Rio de Janeiro, where they remain until 1821

João VI opens Brazilian ports to world trade and lifts restrictions on manufacturing

João VI establishes Brazil's first printing press

Audiencia of Mexico deposes the viceroy of New Spain

1809
Royalist uprisings in Buenos Aires and Quito

1809–10
Spain's grip on its American possessions falters as South American independence movement begins in Chuquisaca (Bolivia) and rebellions and turmoil flare throughout the Americas

1810
Self-government declared in Caracas, Santiago de Chile, and Buenos Aires; the viceroy deposed in New Granada

Soldier-statesman Simón Bolívar travels to London to seek support for Caracas junta and emerges as a major figure in South American politics (fig. 45)

Venezuela is producing half the world's cacao, a source of wealth for Simón Bolívar's military campaigns (fig. 46)

General and Extraordinary Cortes (representative assembly) convenes in Cádiz (Spain) to replace Central Junta and govern in place of exiled Fernando VII

Treaty of Navigation and Commerce gives Britain commercial dominance over Brazil

1810–11
With the *Grito de Dolores* (Cry of Dolores), Mexican priest Miguel Hidalgo calls people to revolt against Spanish rule

1811
Venezuela and Paraguay declare independence

French expelled from Portugal

1812
Royalists regain control in Quito (Ecuador)

Wellington enters Madrid; liberal Spanish constitutional monarchy declared by the Cortes in Cádiz

1813
French expelled from Spain

Independence declared in Bogotá (Colombia)

Rebel priest José María Morelos leads capture of the port of Acapulco (Mexico)

1814
Fernando VII restored to Spanish throne, abrogates Constitution of 1812, annuls acts of all American juntas

Mexicans draw up first constitution at Apatzingán; Uruguay declares independence

1815
Audiencia of Puerto Rico established to secure control of the island

Commander Pablo Morillo, *"El Pacificador,"* begins reconquest of northern South America for Spain

Napoleon Bonaparte's final defeat at Waterloo; Second Peace of Paris

Simón Bolívar issues his "Jamaica Letter," a seminal text of the Latin American independence movement

1816
The regent Dom João accedes to Portuguese throne as João VI

Independence declared by United Provinces of South America (Argentina, Bolivia, Paraguay, Uruguay)

1816–31
French artistic mission, led by Joachim Lebreton, serves the exiled Portuguese court. Painter Jean Baptiste Debret, architect Auguste Henri Victor Grandjean de Montigny, and landscape painter Nicolas Antoine Taunay appointed to inaugural posts in the Royal Academy of Fine Arts, founded this year by João VI; French style established in Brazil.

1817
Independence leader José de San Martín crosses the Andes and, with Bernardo O'Higgins, wins the battle of Chacabuco, beginning the end of Spanish rule in Chile (fig. 47)

Manuel Tolsá designs a neoclassical central dome for the cathedral of Mexico City

FIG. 47 After José Gil de Castro (Peruvian, 1785–1841), *José de San Martín*, c. 1850. Oil on canvas. Ibero-Amerikanisches Institut, Staatliche Museen zu Berlin

The portrait commemorates the South American general who led Argentinian troops during their battle for independence from Spain.

FIG. 48 Jean Baptiste Debret (French, 1768–1848), *Acclamation of Dom Pedro, First Emperor of Brazil, in Camp St. Anne in Rio de Janeiro on October 12, 1822*, from *Voyage pittoresque et historique au Bresil* (Paris: Fermin Didot Frères, 1834–39). Bibliothèque nationale de France, Paris

Jean Baptiste Debret (French, 1768–1848) paints his *Disembarkation of Princess Leopoldina* (Museu Nacional de Belas Artes, Rio de Janeiro) to commemorate arrival of Princess Leopoldina of Austria, future empress of Brazil, in Rio de Janeiro

1818
Land granted in Brazil to Swiss and German settlers; the following year they construct their settlement at Nova Friburgo in an Alpine style

1819
Simón Bolívar and Francisco de Paulo Santander win the Battle of Boyacá (Colombia)

1819–21
With the Adams-Oñis Treaty, Spain cedes Florida to the USA, which drops claims to Texas

1819–30
Gran Colombia (roughly Colombia, Panama, Venezuela, Ecuador) declared an independent nation, with Bolívar as its president; effective independence of Colombia

1820s
Venezuelan poet, diplomat, and intellectual Andrés Bello founds the important serials *La biblioteca americana o miscelánea de literatura* (1823) and *El repertorio americano* (1826–27) in London

1820
In Spain, Riego military revolt against Fernando VII restores the liberal Constitution of 1812. In Portugal, constitutional monarchy declared after a military revolt.

1821
Agustín de Iturbide issues the Plan of Iguala; Mexican independence follows. Independence of Central America (Guatemala, El Salvador, Nicaragua, Honduras, Costa Rica) declared.

Colorful patriot and Dominican friar Servando Teresa de Mier escapes Mexican prison to Philadelphia (USA), where he publishes *Memoria político-instructiva* advocating an independent republican government for Mexico

San Martín enters Lima; Peruvian independence declared

Brazil annexes Uruguay

João VI returns from Brazil to Portugal

German painter Johan Moritz Rugendas arrives in Brazil with the Langsdorff expedition

1822
Central America annexes itself to the Mexican Empire

João VI's son Pedro proclaims Brazilian independence and is crowned Emperor Pedro I (fig. 48)

1823
Fernando VII restored as absolute monarch of Spain

Iturbide overthrown as emperor in Mexico; Central America breaks away to form the United Provinces of Central America (later the Federal Republic); it splits into individual countries by 1838

The USA issues the Monroe Doctrine, which states that it will oppose any new settlements or interference in the Americas by European powers

1825
Argentina and Brazil go to war over Uruguay

Bolivia declares independence

1826
Andrés Bello publishes his masterpiece, *Silva a la agricultura de la zona tórrida*, in London, one of the best-known poems of Spanish American literature

Imperial Academy of Fine Arts founded in Rio de Janeiro

After acceding to Portuguese throne, Pedro IV (Pedro I of Brazil) promulgates a liberal constitution and then abdicates; Maria II accedes

1827–28
Treaty between Britain and Brazil ends slave imports into Brazil (ineffective before 1851) and grants Britain commercial advantage

1828
Uruguay's effective independence

Biographies of Artists

Friar Agostinho da Piedade
(Portugal c. 1580–1661 Salvador, Brazil)

Born in Portugal, Friar Agostinho da Piedade arrived in Brazil at a young age. He entered the Benedictine monastic order in Salvador, where his presence has been documented from 1619 to the year of his death, 1661. A chronicler from this order wrote a biography of Agostinho da Piedade sometime around 1700. The work describes the Portuguese monk as a highly virtuous man with a special devotion to the Virgin Mary. Curiously, no specific mention is made of his activities as a sculptor, which have only been identified in recent times as a result of the discovery of three terracotta images, all bearing the artist's name and two the date of execution, an exceptional find among works from Brazil's colonial period.

The first terracotta work, in terms of chronological order, is an imposing sculpture of Our Lady of Montserrat, which is presently in the collection of the Museum of Religious Art at the Federal University of Bahia in Salvador. A long inscription on the back of the sculpture reveals the artist's name, the year it was executed (1636), and the name of the person who commissioned it. The second work, a devoutly introspective image of Saint Anne teaching the virgin, dates from 1642, and is also part of the same collection. Finally, there is a sculpture of the Christ Child seated atop an image of a heart. This work, which is from the collection of the Benedictine Monastery in Olinda (Pernambuco), is undated.

These three documented works have provided a reference for other attributions, which include a beautiful image of Saint Monica, presently at the Museum of the Brazilian National Institute of Historic and Artistic Heritage in Salvador, and a series of reliquary busts created for the Benedictine order of Salvador.

We have no record of any works by this sculptor after 1642. According to the Benedictine chronicler, he abandoned his artistic career by "order of his superiors" so that he could devote his efforts to various administrative tasks, most notably as chaplain for the Grace Church in Salvador. Friar Agostinho da Piedade continued to exert a considerable influence, particularly among the disciples who assisted him in his workshop, the most noteworthy of which was Friar Agostinho de Jesus, who has left an important body of work at the Benedictine Monastery in São Paulo and at various churches in the coastal region of this Brazilian state.

Myriam A. Ribeiro de Oliveira

José de Alcíbar
(active Mexico, 1751–1803)

Although his reputation is now somewhat eclipsed by that of his teacher, Miguel Cabrera, José de Alcíbar ranks as one of the most accomplished artists in New Spain during the second half of the eighteenth century. Over the course of his long career, he participated in the most important artistic events of the era, including the examination and copying of the original cloth of the sacred image of the Virgin of Guadalupe (1751–52) and the publication of those findings in 1756. He also joined colleagues in founding a short-lived art academy in 1753–54 in Mexico City as well as in establishing the Royal Academy of San Carlos in 1781–83, where he served as a faculty member and director into the early 1800s. A prolific artist with a large workshop, Alcíbar left an oeuvre that documents the transition from the late baroque to neoclassicism.

Donna Pierce

O Aleijadinho (Antônio Francisco Lisboa)
(Vila Rica [now Ouro Prêto], Minas Gerais, Brazil c. 1738–1814 Vila Rica, Minas Gerais)

Antônio Francisco Lisboa, known as "O Aleijadinho" (The Little Cripple), was the son of a renowned architect and engineer, Manoel Francisco Lisboa, and an African slave. O Aleijadinho received his training at the local studios and workshops of Portuguese artists, who, like his father, had immigrated to Brazil during the early eighteenth century. O Aleijadinho died in his birthplace of Vila Rica in 1814 and was interred in the altar of Our Lady of Boa Morte, in the main church at Antônio Dias.

A man of vast talents, O Aleijadinho was commissioned to design some of the most important projects of the time, including the church of Saint Francis of Assisi of São João del Rei, in Ouro Prêto. He was also an immensely gifted decorative artist, creating facades and sculptures in the French and German rococo styles that prevailed during this period. His most important work of religious sculpture is the series of scenes depicting the Passion and Death of Christ, which he created for the chapels lining the road to the Sanctuary of Congonhas do Campo in Ouro Prêto. Comprising a total of sixty-four life-size scenes, this massive work includes the Last Supper, the Garden of Gethsemane, Jesus Condemned, the Scourging, the Crowning with Thorns, the Road to Calvary, and the Crucifixion. Executed between 1796 and 1799, in collaboration with a number of assistants, each piece is characteristic of the artist's late career, carried on despite the crippling deterioration of a debilitating disease. O Aleijadinho's sculptures were typically adorned in draped garments with vividly defined pleating, and hair and beards were devised to serve deliberate ornamental effects, often including sinuously cascading locks. Powerful facial expressions were intended to impart a wide range of emotions.

In addition to the works created in Congonhas, only the Carmelite images of Saint Simon Stock and Saint John of the Cross at the Church of the Ordem Terceira do Carmo de Sabará, as well as an articulated image of Saint George at the Museu da Inconfidência, have been documented as works by this artist. All other works have been attributed to him on the basis of a characteristic style, which, owing to a number of peculiarities, can often be easily identified. The greatest difficulty lies in distinguishing O Aleijadinho's pieces from those of his assistants or followers, who continued to create derivative works well into the nineteenth century.

Myriam A. Ribeiro de Oliveira

Serafín Antonio Almeida
(Guatire, Venezuela 1752–1822 Caracas, Venezuela)

Serafín Antonio Almeida was born in 1752 in the town of Guatire, located on the outskirts of Caracas. He was the son of Alberto Almeida and Juana Dionisia Casares Guevas. On December 8, 1779, he married María Rosa Agustina Guevara in the Caracas cathedral, and the union is recorded in the Register of Mixed Race and Slave Marriages. Little is known of the master's life and training. His name appears in the Caracas census from 1781 onward. In the town census of 1797, he is described as a carpenter of mixed race and retired from the militia. In 1798 the Caracas cathedral's ecclesiastic council decided to retire the master José Ramón Cardozo from the work being carried out on the choir loft, and the following year designated Almeida as the master responsible for the project. Almeida completed the choir loft and various pieces of furniture for the cathedral, all crafted in a neoclassical marquetry style, with many of the ornamental motifs reminiscent of English furniture from the end of the eighteenth century. The use of this type of marquetry was without precedent in the history of master carpenters in Venezuela, and it remains a mystery where and from whom Almeida learned his trade. The cabinetmaker remained active as a carpenter during the first two decades of the nineteenth century. His atelier produced the best examples in Caracas of neoclassical furniture made with exotic-wood marquetry.

Almeida was imprisoned on July 13, 1816, during the war of independence from Spain, on order of the Permanent War Council: a copy of a Caracas reprint of *The Rights of Man* had been found in the house of his lover, María Bárbara Peñaloza. The accused defended themselves by claiming to have found the prohibited book on the street during the patriots' flight from the city. The prosecutor found no grounds for proceeding with a trial and the suspects were freed on October 7 of the same year.

Serafín Antonio Almeida died intestate in Caracas on February 12, 1822, at the age of 69.

Jorge F. Rivas P.

The Arellanos
(active Mexico, late seventeenth–eighteenth century)

Various paintings produced in the Viceroyalty of New Spain are signed with the family name Arellano, preceded in only a few cases by the first name Manuel, which belongs to an artist whose activity can be dated by paintings and documents within the period 1691 to 1722. It remains in doubt whether the rest of the works are to be attributed to this painter or to another. Two other Arellanos, Antonio and José, were identified by Manuel Toussaint, but he cast doubt on the very existence of the latter. Due to the repeated use of the surname and the different pictorial personalities to which it might be attached, scholars have spoken of "the Arellanos" as if the term referred to a family. In the museum of Antequera in Spain there is a series of Mexican paintings that includes works by Juan Correa and three canvases signed "El mudo Arellano" (Arellano the Mute), who may be supposed to be one of the painters designated by Toussaint. In 1778 Juan de Viera wrote his *Brief and Compendious Account of Mexico City, Court and Head of All Southern America*, which includes an inventory of "ancient" and "modern" artists, and makes mention of a certain "Mute D. José." If he could be identified with "Arellano the Mute," this would confirm the existence of a José de Arellano. Nevertheless, the only figure who can be identified clearly is Manuel de Arellano, who is known from archival sources to have belonged to the guild of painters and gilders, and to have divided his activities between painting and the making of altarpieces. The existence of certain cityscapes, such as the nighttime view of *The Plaza Mayor on Christmas Eve 1720* and the *Conveyance of the Image and Inauguration of the Sanctuary of Guadalupe* (cat. VI-19), suggests a painter who specialized in this type of picture. In the cartouche designated by the letter "A" on the latter, Joaquín Berchez has attempted to read the words: "a good man named J. a.," and suggests that it refers to a self-portrait of the artist. If "Arellano the Mute" is indeed to be identified with the "Mute Don José" mentioned by Viera, then he might also be the author of this work. Nothing about these painters, however, can be affirmed with certainty. In his book on the Spanish painter Juan de Arellano (1614–1676), who specialized in the depiction of flowers, Alfonso Pérez Sánchez alludes to the family of artists from New Spain and their possible relation to his subject.

Juana Gutiérrez Haces

Manuel de Arellano
(active Mexico, c. 1691–1722)

Several members of the Arellano family were active as painters in New Spain during the transition from the seventeenth to the eighteenth century. Although most of their signed works bear only the surname Arellano, two painters have been identified from documents: Antonio, the father, and Manuel, his son. In addition, several paintings are signed "the mute Arellano," and a certain José de Arellano, whom some scholars have conjectured may belong to the family dynasty, has yet to be documented in connection with any known painting. The relationship of these latter to Antonio and Manuel is still unclear. Manuel de Arellano was active from around 1691 until at least 1722. He is identified in documents as a "Master Painter" and contracted apprentices in 1703 and 1717. Several important and innovative paintings with the distinctive Arellano signature have recently been attributed to Manuel, including the *Rendering of a Mulatto* (cat. VI-47).

Donna Pierce

Gaspar Miguel de Berrío
(Potosí, Bolivia 1706–c. 1762 Potosí [?], Bolivia)

Gaspar Miguel de Berrío was a Creole born in Potosí in 1706. He is recorded as working between 1735 and 1762, mainly in the village of Puna, near his birthplace. A large number of his works are signed. The date of his death is unknown, but his last known signed canvas dates from 1762.

Berrío's early work reveals the influence of Melchor Pérez Holguín, whom he must have known in Potosí. He gradually moved away from the latter's style as he established his own, which, with its emphasis on gilding and highly idealized figures, was characteristic of indigenous painters and of the Cuzco school.

The first known work by the artist is a *Saint Eustace*, dated 1735. Following this are two canvases for the church of the Belén at Potosí (now lost), which dated to between 1736 and 1737 and depicted scenes from the childhood of Christ. Berrío's painting of *Saint Joseph with Other Saints* in the Museo de la Casa Nacional de Moneda in Potosí can be considered his masterpiece. The painting is structured on two planes, an earthly plane and a gilded, terrestrial one. In the former are the saints, painted in the style of Holguín. This work was so successful that Berrío painted various replicas, such as the one in the Museo de Bellas Artes, Santiago de Chile, signed and dated 1744.

Another important work by Berrío is the *Saint Nicholas of Bari*, a particularly popular saint in Potosí as he was the patron of childbirths, which were risky and dangerous in a city located more than 13,500 feet (4,000 meters) above sea level. This canvas is in the Moneda Museum, which also houses his portrait of Charles III. Finally, the Museo Charcas in Sucre has a *View of Potosí* painted in 1758. It shows the city at the foot of the mountain and with the lakes and artificial river that the Spanish created for use in mining.

The last known painting by the artist depicts *Saint John Nepomuk*. Signed and dated in Potosí in 1762, it is now in the Museo de Arte Hispanoamericano Isaac Fernández Blanco, Buenos Aires.

Teresa Gisbert

Bernardo Bitti (Alosio Bernardo Democrito Giovanni Bitti)
(Camerino, The Marches, Italy 1548–1610 Lima, Peru)

Born in Camerino in the Marches in 1548, Bernardo Bitti would have been familiar with the work of Lorenzo Lotto and Federico Barocci as well as the writings of Giovanni Andrea Gilio, who argued for a pure painting style in line with the new thinking about religious art that came out of the Council of Trent. At age 20 he entered the Jesuit order, and three years later, in 1572, the Jesuit Diego de Bracamonte wrote from Peru to the General of the order, Everardo Mercurián, requesting Bitti's services and calling him a "marvelous painter" (*maravilloso pintor*). As Bracamonte had been in Peru since the mid-1560s, Bitti must already have created a reputation for himself. Bracamonte, one of the first Jesuits in the New World and a man deeply concerned with education, was acutely aware of the power of paintings on the native populations, writing, according to an anonymous chronicler in 1600, that "exterior things do much for the Indians, specially paintings, in such a way that by those works of art they esteem and have a concept of the spiritual things." Bitti joined the expedition in Rome and left for Peru from Sanlúcar de Barrameda, Spain, in October 1574, arriving at the port of Callao in May 1575. He spent his entire career working for churches of the Jesuit order in present-day Peru and Bolivia, leaving his principal canvases in Lima, Cuzco, Chuquisaca (now Sucre, Bolivia), Arequipa, and Huamanga (now Ayacucho, Peru). Judging from the varying quality of his work, Bitti must have had a large workshop. However, his only well-documented collaborator was Pedro de Vargas, who worked with him in Lima and Cuzco on the sculptures that adorned the large altarpieces, or retablos, that constituted the principal decoration of the Jesuit churches. Subject to the caprices of time, none of Bitti's altarpieces have survived intact. The artist died in Lima in 1610.

Carl Brandon Strehlke

Miguel Cabrera
(Antequera [now Oaxaca] 1695–1768 Mexico City)

In his day, Miguel Cabrera was one of the most popular artists in New Spain, and he assumed mythical proportions following his death in 1768. Although he seems to have worked especially for the Colegiata de Guadalupe and had close connections with the Jesuits, he divided his time and the labors of his workshop among all the religious orders and members of the ruling class in New Spain. His style, which combines gentle draftsmanship with the refined atmosphere of the rococo, so marked his disciples and contemporaries that it is possible to speak of a school of Cabrera in the second half of the eighteenth century. He was one of the group of painters selected to perform a direct inspection of the image of the Virgin of Guadalupe in 1751, as a result of which he wrote his book *Maravilla americana* (*American Marvel*; 1756), with its blend of enlightened science, faith, and devotion. In 1752 he performed another inspection of the image and made three copies, one of which was sent to Pope Benedict XIV as part of the negotiations to have Our Lady of Guadalupe proclaimed patron of New Spain. The legendary account of the Pope's remarks on the beauty of Cabrera's copy of the image

made the painter famous. Of special note are the paintings he did for the Jesuit college in Tepozotlán and the allegorical medallions of the Virgin that were formerly in the convento of Santo Domingo and are now in the cathedral in Mexico City. His paintings of *castas*, although they follow previously established models, have become paradigms of the genre, owing particularly to their combination of idealized human types and everyday naturalism. Cabrera painted both canvases and frescoes, and he is responsible for the design of the altarpieces in the church at Tepozotlán. A cartouche that accompanies his portrait of the Archbishop Rubio y Salinas reveals that Cabrera held the position of "painter to the chamber" of the prelate, the first appointment of its kind known in New Spain.

Juana Gutiérrez Haces

José Campeche
(San Juan, Puerto Rico 1751–1809 San Juan, Puerto Rico)

On December 23, 1751, José Campeche was born in San Juan to Tomás de Rivafrecha Campeche, a freed slave born in Puerto Rico who worked as a gilder, decorator, and painter as well as a musician at the cathedral, and to María Josefa Jordán Marqués, a native of the Canary Islands. Along with his brothers, Miguel and Ignacio, José was trained in his father's studio, but he also studied at the Dominican convent in San Juan and became a member of the Third Order of that house. His career began modestly with small commissions, for example, to paint royal coats of arms for mail ships (1765). In 1772 he painted the posthumous portrait of a friar and several portraits of bishops of San Juan. His *Saint Joseph and the Christ Child* of that year is his earliest surviving painting (Museo de América, Madrid).

In 1775 a painter from Spain arrived in Puerto Rico who would exercise immense influence on Campeche, an influence that would make the artist outstanding among his contemporaries in Latin America. Luis Paret y Alcázar (1746–1799), a court painter of great refinement and delicacy, was exiled to Puerto Rico by the Council of Castile, having been accused of assisting Don Luis de Borbón, brother of King Charles III, in his love affairs. Paret, who had studied at the Academia de San Fernando in Madrid and spent 1763–66 in Rome, brought a very high style with him to the Caribbean island of Puerto Rico, and Campeche was his avid follower until Paret was allowed to return to Spain four years later. Suddenly, then, as a result of this quirk of fate, there was in Puerto Rico a native-born, mestizo painter who was a master, and who continued to mature as an artist long after Paret's departure.

Campeche's first masterpiece may be *Lady on Horseback*, signed and dated 1785 (Museo de Arte de Ponce, Puerto Rico), a very small painting on panel that is delicious in its refinement of brushwork and rococo palette. Campeche went on to paint many religious subjects and a number of portraits that record—with careful attention to details of furnishings and clothing—Puerto Rican society in the late eighteenth and early nineteenth centuries. José Campeche died on November 7, 1809, in the house he had lived in since birth, having never left his native island.

Suzanne Stratton-Pruitt

Francisco José Cardozo
(born Caracas, Venezuela; active Caracas, 1768–1818)

Francisco José Cardozo was born in Caracas to cabinetmaker Antonio José Cardozo and Manuela Antonia Solórzano. He married María Alejandra Reyes Gresnier in the same city, and had two daughters with her: María de la Merced Elena and Juana Josefa del Rosario. Like many other artisans at that time, Cardozo came from a mixed-race background.

He spent his career as cabinetmaker in his native city, where he received commissions for the cathedral and other important churches. The first document that mentions his name is dated July 20, 1768, when he was entrusted with decorating the door to the burial vault in the chapel of San Pedro in the Caracas cathedral. During his early years as a master carpenter, he was hired to repair and build furniture. Among the altarpieces that he created in later years, these stand out: the Santo Sepulcro of Caracas cathedral in 1791, the Santísima Trinidad for the chapel of the Venerable Orden Tercera de San Francisco in 1798, and the principal altarpiece of the parish church of Nuestra Señora de Altagracia in 1817. In 1789 he collaborated with cabinetmakers Domingo José Antonio Gutiérrez and Antonio José Limardo in the construction of the catafalque for King Charles III's funeral, an expensive piece that was subsequently decorated by master painter Antonio José Landaeta. Cardozo drew up his will in Caracas on September 15, 1818. His name is mentioned for the last time in the newspaper *Gaceta de Caracas* on August 16, 1820.

Jorge F. Rivas P.

Caspicara (Manuel Chili)
(Quito, Ecuador 1723–1796 Quito, Ecuador)

The indigenous sculptor Manuel Chili, known as "El Caspicara" for his pockmarked face, was active in Quito, Ecuador, during the second half of the eighteenth century. Caspicara stands out among the few known sculptors associated with the *Escuela Quiteña* (Quito School), a contemporary term that describes the painting and sculpture produced by workshops of predominantly indigenous and mestizo artists throughout the seventeenth and eighteenth centuries in the Audiencia of Quito. The Escuela Quiteña is generally considered the greatest artistic achievement of Ecuador's colonial era. An undated sculpture of the *Christ Child Sleeping* with the artist's name carved into the reverse is Caspicara's only known signed work; however, his distinctive style and technique has led Ecuadorian art historians to generate a large corpus of works attributed to the sculptor.

Caspicara is known for the high degree of realism in his works, his delicate treatment of human proportions, and the intense emotionality and theatricality of his carvings. Unlike many Quiteño sculptors before him, Caspicara is renowned for his mastery of the proportions of the human body. Although colonial religious conservativeness deterred the depiction of the nude or partially nude body, Caspicara treated this theme frequently, often in the form of the Resurrected or Crucified Christ. In addition, his work is marked by his realistic treatment of flesh tones, often with a highly polished patina influenced by Asian porcelain statuettes. Caspicara's artistic influences were diverse, and he drew inspiration from secular works in both technique and subject matter. In addition, he frequently introduced Italian models into his work.

The majority of Caspicara's commissions came from the religious orders and religious confraternities in Quito and other cities in present-day Ecuador and Colombia. Caspicara's artistic range appears to have been wide: large- and small-scale works, sculptures in the round, dressed sculptures, and relief sculptures have all been attributed to the artist. While Caspicara's preferred medium was wood, a few marble sculptures have also been attributed to him. His most important works are today preserved in Quito. These include the *Four Virtues*, a group of *Angels* and the *Holy Shroud* in the cathedral, the *Apostles* series in the church of San Francisco, and sculptures of the *Virgin of Carmen* and *Saint Joseph* in the Franciscan museum. In addition, several works attributed to Caspicara were exported to present-day Colombia during the colonial period, and are today located in Bogotá and Medellín.

Andrea Lepage

Juan Correa
(Mexico City c. 1646–1716 Mexico)

Juan Correa was born to a mixed-race family. His grandfather came from Albacete in Spain, and his grandmother, Juana María, was from Cádiz. One child from this marriage, also named Juan Correa, was a distinguished surgeon and barber, renowned for having performed the first dissection in Mexico. He was the father of Juan Correa the painter (active 1731–60), who was the third to bear the same name. The artist married Úrsula de Moya, and they had four children: Diego, a master painter and his father's principal assistant; Francisco, who joined a religious order in Manila; Felipa, who married; and Miguel, a journeyman painter when Juan Correa died in 1716.

A register of Juan Correa's works boasts close to 400 entries. He executed a number of works for the cathedral of Mexico City, including an *Assumption* for the sacristy (1689) and a *Coronation of the Virgin* (1689), an *Entry into Jerusalem* (1691), and a *Vision of the Apocalypse* (since destroyed). Some of Correa's works made their way to Spain, where there is a group of ten paintings on the Life of the Virgin in the Museo Municipal in Antequera and a *Virgin of Guadalupe* (1704) in the church of San Nicolás in Seville. Among his secular works are screens, including one with representations of the four continents and of the *Meeting Between Cortés and Moctezuma* (Banco Nacional de México, Mexico City). Correa is thought to have been the teacher of the artists Juan Rodríguez Juárez and José de Ibarra, among others.

Elisa Vargaslugo

Nicolás Correa
(Mexico c. 1670/75–?)

Nicolás Correa was a member of one of the most active families of painters in Mexico City during the late seventeenth and early eighteenth centuries. The son of Tomasa Gómez and José Correa, a noted gilder and painter, he was also the nephew of Juan Correa, the most renowned artist in the family. Nicolás is not widely known because there are few paintings bearing his signature that have survived to this day. All of these signed works date from the 1690s, although documentation

points to activity as late as 1723 in works evidently commissioned by the cathedral of Mexico City. Despite the small number of paintings attributed to him, Nicolás Correa is significant because he is one of only two artists primarily known as painters to have executed several paintings in the *enconchado* technique exclusive to colonial Mexico, as well as in oil on canvas or wood. The other painter is Antonio de Santander, the whereabouts of whose only attributed work in this medium, the *Virgin of Balvanera*, is presently unknown.

Nicolás Correa's earliest known work is a painting of Saint Rose of Lima, now in the collection of the Museo Nacional de Arte in Mexico City. This oil on canvas, signed and dated 1691, shows a mature, relaxed style and is the work of a painter immersed in the traditions of late seventeenth-century Mexico. Correa appears to have embarked on the new technique of *enconchado* by 1693, when he produced a signed piece using this technique, *The Wedding at Cana* (cat. 1-13). In 1694 the artist created his own singular version of the *Holy Family* (private collection), which portrays an enthroned Mary and Saint Anne straddling the Christ Child and flanked by Joseph and Saint Joachim in the interior of a what appears to be a basilica. The last work the artist executed in *enconchado*, its present whereabouts unknown, depicts Christ on the Road to Calvary and might have formed part of a series on the Life of Christ, given its similarity to an anonymous group of twenty-four paintings on wood presently in the collection of the Museo de América, Madrid.

The repertoire of works signed by Nicolás Correa ends in 1696 with an oil panel representing the Miracle of the Loaves and Fishes. Here various elements—most evident in the organization of the composition and in the treatment of subjects—recall the artist's works in *enconchado*.

María Concepción García Sáiz

Baltasar de Echave Ibía (or de León)
(Mexico City c. 1585/c. 1604–1644 Mexico City)

Baltasar de Echave Ibía was a Mexican painter active in the second quarter of the seventeenth century. Manuel Toussaint's research has now established that there were three rather than two painters with the name Echave, resolving previous confusion. Toussaint proposed that these three artists be known by their surnames of Orio, Ibía, and Rioja.

Until recently, it was thought that Echave Ibía was born in 1585 and was the son of the famous painter of Basque origin, Echave Orio. However, it cannot be ruled out that he was the son and not the brother of the painter Manuel de Echave, son of Echave Orio. If this were the case, he would have been born around 1604, the date when Manuel married Jerónima de León. Further information is required to clarify this issue and to establish the family relations between these individuals. What is certain is that Echave Ibía married Ana de Rioja in 1623 and was the father of five children, among them the painter Baltasar de Echave Rioja.

Echave Ibía is an interesting artist, weaker and less solemn but more expressive than Echave Orio (his father or grandfather). This allows us to distinguish his work, which has a looser and less detailed finish. While some of his paintings were executed on large canvases, Echave Ibía primarily favored small-format works on copper panels, undoubtedly influenced by works of the Flemish school that were arriving in the New World in

large quantities in this period. The Flemish influence would also explain Echave Ibía's preference for including landscape backgrounds, executed in various shades of blue in his religious paintings. This preference led to Toussaint's nickname for the artist, *el Echave de los azules*. The artist died in 1644.

Rogelio Ruiz Gomar

Baltasar de Echave Rioja
(Mexico City 1632–1682 Mexico City)

The painter Baltasar de Echave Rioja, son of the Mexican painter Baltasar de Echave Ibía and of Ana de Rioja, was active in the second half of the seventeenth century. He was born in Mexico City in 1632 and died there in 1682 at the age of 50. He was the last of the brilliant dynasty of painters in New Spain known as "los Echave," begun by his grandfather (or possibly great-grandfather) Baltasar de Echave Orio.

Echave de Rioja must have begun his training with his father, but as the latter died in 1644, when Echave Rioja was just 12, he presumably continued his studies with another artist. As is the case for José Juárez and Pedro Ramírez, it has been suggested that Echave Rioja may have been a student of the Sevillian artist Sebastian López de Arteaga, who arrived in Mexico around 1640. It seems more likely, however, that he completed his studies in the studio of José Juárez, as he is known to have been present in that workshop, possibly as a pupil. He has been considered the last important representative of tenebrist painting in New Spain, but in fact, with the exception of two or three works, his painting is generally characterized by a taste for uniform lighting and the use of brilliant color.

Aside from a certain weakness in the drawing and the construction of his figures, Echave Rioja was able to imbue his compositions with a convincingly dramatic tone, with expressive faces and gestures. His style appears to herald the final stage of seventeenth-century painting in New Spain, in particular the work of the famed Cristóbal de Villalpando, recently suggested to have been his pupil.

Echave Rioja's first known work is an *Adoration of the Magi* (1659; Denver Art Museum), and *The Washing of the Feet* and *The Last Supper* are his last known compositions (1680; Izucar, State of Morelos, Mexico). A member of the first generation to be commissioned with the production of large-scale canvases for the walls of sacristies, chapels, choirs, and cloisters, Echave Rioja is known to be the author of the enormous paintings that decorate the sacristy of the cathedral of Puebla (1657). He may also have been responsible for various arch-topped compositions in a number of chapels in the cathedral of Mexico City.

Rogelio Ruiz Gomar

Domingo Gutiérrez
(La Laguna, Tenerife, Canary Islands 1709–1793 Caracas, Venezuela)

Domingo Gutiérrez was born in La Laguna on Tenerife, one of the Canary Islands. His parents were Juan Gutiérrez and María Francisca Curvelo. He came to the American continent early in the eighteenth century and settled in Caracas, where in 1730 he married Clara Josefa Leal, a woman born in Santa Cruz de Tenerife. They had eight children. Documents show that he was active as a carpenter as of 1732. Undoubtedly the most

distinguished master carpenter of his time, he counted among his clientele the local aristocracy, the city council, and the cathedral, as well as other churches and monasteries in the city. His creative output ranged from furniture to the most important altarpiece made in Caracas in the eighteenth century, the altarpiece for the Venerable Orden Tercera de San Francisco, which was built between 1765 and 1767. The exorbitant price of this piece caused a protracted lawsuit between the cabinetmaker and the minister of the Orden Tercera, which was later settled out of court. The artist Juan Pedro López, with whom the master maintained a close collaboration throughout his entire life, provided the gilding and paintings that completed the piece.

Domingo Gutiérrez breathed new life into Venezuela's formal repertoire by introducing the language of rococo to local cabinetmaking. His extraordinary carving skills, coupled with his talent as a designer, set him above his contemporaries. Subsequent generations of cabinetmakers were influenced by his style, and the imprint of his work is evident in the production of such masters as Francisco José Cardozo, José Rafael Chacón, and Eugenio Juan Guzmán, among others. Gutiérrez died in Caracas in April 1793.

Jorge F. Rivas P.

Joaquín Gutiérrez
(Santa Fé de Bogotá, Colombia c. 1715–c. 1805 Popayán [?], Colombia)

Joaquín Gutiérrez lived and worked in Santa Fé de Bogotá, producing portraits, miniatures, and religious paintings. Although the precise dates of his birth and death are unknown, his activity over the greater part of the century can be traced through his few signed works and his role as appraiser (*tasador*) of the property of the viceroy Solís Folch de Cardona (1716–1762), who was named to the position in 1753.

Following the reestablishment of the Viceroyalty of New Granada in 1739 (first created in 1717), the capital city experienced increasing prosperity and urbanization. A new clientele of high-ranking colonial governors and the upper social classes, along with church officials, began to commission portraiture. Although Gutiérrez was active as a religious painter and miniaturist, he stands out first and foremost as a portraitist who captured the luxurious apparel and poised elegance of New Granada's dignitaries and high society. His work is marked by a rather archaic style of flat planes of color inside a closed outline that departs from the freer brushwork of New Granada's seventeenth-century painters. Gutiérrez is considered the principal forerunner of the French rococo artistic movement in New Granada. Rococo elements are evident in his highly decorative style, his introduction of a warmer palette, and his secular themes.

Gutiérrez studied in the workshop of Nicolás Banderas, a pupil or follower of Gregorio Vásquez de Arce y Ceballos. No extant works are known from the workshop of Banderas, who was also the teacher of the Bogotá painter Bernabé de Posadas. The direct imitation of Vásquez's compositions and characteristic types is apparent in some of the close to eighty religious works attributed to Gutiérrez, such as his *Virgin and Child* (Museo de Arte Colonial, Bogotá). Gutiérrez supplants the seventeenth-century master's strong chiaroscuro in favor of a more two-dimensional approach and vibrant colors, as in his *Holy Family with Saint John the Baptist*

and *Saint Augustin* (Museo del Chicó, Sociedad de Mejoras y Ornato, Bogotá) or *Saint Theresa as Good Shepherdess* (Carmelite private collection). A painting of Saint Joseph and the Christ Child attributed to Gutiérrez (private collection) is nearly an exact copy of a Vásquez drawing of the Christ Child (Museo de Arte Colonial, Bogotá), suggesting that Gutiérrez might have worked directly from Vásquez's compositions on occasion. Gutiérrez also portrayed Doña Juana Nepomucena María Hilaria de Jesús Lozano de Peralta y Varaes (c. 1775) and the historian José Manuel Groot as a child (1809; private collection).

A contract dated February 1, 1750, documents Gutiérrez's first commission, a series of twenty-six paintings for the church of San Juan de Dios in Bogotá, of which six still exist. This series devoted to the life of the church's name saint (Saint John of God) was commissioned by Friar Juan Antonio Guzmán. In this same decade, Gutiérrez produced a few portraits of university doctoral candidates. A variation of *donante* (donor) portraiture, this subject matter seems to have been particular to New Granada. Commissioned to mark the successful defense of a thesis, such paintings represent the scholar alongside his patron saint, who has guided his education, and include a summary of the subject of his thesis. An example of this portrait type is Gutiérrez's portrayal of the laureate Francisco Antonio Moreno, a graduate of what is now the Javeriana University, Bogotá (1752; Museo de Arte Colonial, Bogotá).

Gutiérrez's portraits of the marquises of San Jorge are the only signed and dated works by this painter, who portrayed at least twelve of New Granada's viceroys and is often labeled "the painter of the viceroys." His pendant portraits of the *Marquises of San Jorge* (1775; Museo de Arte Colonial, Bogotá) and the series of New Granadan viceroys (c. 1780; Museo de Arte Colonial, Bogotá) show the artist as an accomplished portraitist of Santa Fé high society. At the end of the 1780s, Gutiérrez moved to Popayán with his wife, Doña Josefa Illera.

Alicia Lubowski

Melchor Pérez Holguín
(Cochabamba, Bolivia c. 1665–after 1732 Potosí, Bolivia)

Melchor Pérez Holguín was born in Cochabamba around 1665 and died after 1732. In 1693 he found work in Potosí and went on to become the most highly regarded painter of his day throughout the Audiencia of Charcas. His style shows a characteristic treatment of the figures, with accentuated facial features. Holguín painted saints, mystics, and ascetics who reflected the prevailing baroque spirituality of the time. His art was widely imitated by painters such as Gaspar Miguel de Berrío, Nicolás Ecoz, and Joaquín Carabal, who also worked in Potosí.

In his early years Holguín painted saints such as Pedro de Alcántara, famous for his penitence, and Juan de Dios, who established a network of hospitals and was considered an example of Christian charity. His palette was relatively monochromatic then, but around the end of the century it became brighter. At this time Holguín painted a large composition of the *Last Judgement* in the church of San Lorenzo in Potosí, which included scenes of the Glory and of Hell. For the same

church he also painted an allegorical composition, *The Ship of the Church*. Both works are now in the Museo de San Francisco in Potosí. In 1710 he sent works to the Merced in Chuquisaca (present-day Sucre).

Holguín signed a large number of his works and included his own portrait in some of them, most famously in *The Entry of the Viceroy Diego Morcillo Rubio de Auñón into Potosí* (Museo de América, Madrid), painted in 1716. That canvas, which includes women with their female slaves watching the procession from balconies, and Andeans and mestizos talking in the street, provides a record of contemporary customs. In the upper part are two views of the Plaza Mayor, one of a nighttime masquerade procession. Along with other groups of costumed figures the procession includes Spanish monarchs, Incas, and Ethiopians preceded by their king. Later, Holguín painted more than one set of the Four Evangelists, of which the best is dated 1724. Inspired by prints of the Flemish engraver Johan Wierix (1549–c. 1618), which were in turn based on drawings by Maarten de Vos (1532–1603), these are now in the Museo de la Casa Nacional de Moneda, Potosí (cats. VI-87–VI-90). Also notable are the Evangelists in the Museo Nacional de Arte, La Paz. Holguín also painted scenes from the childhood of Christ, such as the *Rest on the Flight into Egypt* (Museo Nacional de Arte, La Paz).

Holguín's art was extremely influential, and his works continued to be copied into the nineteenth century. He is referred to in documents with the nickname of the "Golden Brush" (*Brocha de Oro*).

Teresa Gisbert

José Juárez
(Mexico City 1617–1661 Mexico City)

José Juárez is considered the most important representative of Mexican baroque painting and among the best, if not the best, of all the painters born in Mexico during the viceregal period. Son of the renowned painter Luis Juárez and of Elena Jáuregui (or López de Vergara), Juárez was born in Mexico City, where he was baptized on July 9, 1617. In 1641 he married Isabel de Contreras, with whom he had five children, three daughters and two sons. His second son was born after the artist's death, when his other son was just 7. The exact date of Juárez's death is not known, but it must have been shortly after the signing of his will on December 22, 1661.

Juárez probably trained in his father's studio, but he soon abandoned the pleasing, somewhat archaic manner acquired there and adopted a more austere and modern style. This was the result of the influence of art arriving from Spain, and can be compared with the vigorous manner of Francisco de Zurbarán and his circle, with its more solidly modeled volumes, realistic figures and drapery, and greater emphasis on light and shade.

While it has been said that Juárez and other important painters of the time, such as Pedro Ramírez and Baltasar de Echave Rioja, were pupils of the Sevillian painter Sebastián López de Arteaga, who arrived in Mexico around 1640, by this point Juárez was already head of the studio inherited from his father. It would appear that Juárez was the teacher of a number of artists of the following generation, including Ramírez and Echave Rioja as well as Antonio Rodríguez, the latter his son-in-law.

Juárez's extant output is relatively small but of notably high quality. An artist of undoubted talent and ability, he was able to combine the influence of local tradition with echoes of Zurbarán and Peter Paul Rubens. In addition to the religious works for which he is known, he painted some portraits. These include depictions of members of the family of a viceroy, the Count of Baños, which the viceroy took with him on his return to Spain without having paid for them, resulting in a lawsuit initiated by Juárez's widow.

Rogelio Ruiz Gomar

Pedro Laboria
(Sanlúcar de Barrameda, Spain c. 1700–after 1764 Santa Fé de Bogotá [?], Colombia)

Pedro Laboria was born sometime around 1700 in Sanlúcar de Barrameda, Spain. In 1729 he was commissioned by the Jesuits of Bogotá to create an image of Saint Joachim, and in 1738 he traveled to that city, where he remained for many years.

In 1739 the Society of Jesus (the Jesuits) in Bogotá hired Laboria to create a sculpture of the dying Saint Francis Xavier. The signed and dated piece adorns the city's church of San Ignacio. Laboria later began work for the same church on a sculpture entitled *The Rapture of Saint Ignatius*, which is considered the most important work of baroque sculpture in Colombia, and from which we get much of our information on this artist. The piece is signed "Petrus Laboria in urbe / S. Lucae Barrameda / natus Faciebat Santa Fidei / Anno MDCCXLIX" (Pedro Laboria, born in Sanlúcar de Barrameda, created this work in Santa Fé [Bogotá] in 1749). Laboria also completed an image of Saint Francis Borgia as well as a series of angels for this same church.

In 1740 Judge José Quintana paid the artist 355 gold pesos for an image of Saint Barbara for the church bearing that saint's name in Bogotá. For the church of San Juan de Dios (Saint John of God), Laboria created a series of sculptures of Saint Francis of Paula, Saint Teresa, and Saint Brigid. In 1746 he was commissioned by the Carmelite order to create a sculpture of Saint Joachim and the child Mary. He also executed an image of Saint Joachim and Saint Anne for the Dominicans in Bogotá. Other noted works by Laboria include *Saint Joseph and the Christ Child* and *Saint John Nepomucene*, part of the collection at the cathedral in Santa Fé de Bogotá, and *Saint Anthony with the Christ Child*, which adorned the church of San Ignacio in Tunja.

It is not known whether Laboria established a family in Bogotá, and there is no indication that he left any workshop or followers. The exact date of his death is also unknown. It is possible that the artist returned to Spain, since there is mention there of a sculptor named Pedro Laboria. An image of *La Virgen del Patrocinio* (Our Lady of Perpetual Succor), executed in 1764 for the parish church of San Antonio de Padua, is attributed to this artist.

Laboria is considered one of the major baroque artists of New Granada. His work is truly exceptional for its great physical beauty, intense dynamism, expression of disparate emotions, and the extraordinary sense of spiritual strength that is evoked in each of his representations. Semimatte finishes are characteristic in the artist's treatment of faces and hands, which are enhanced by the masterful use of polychromy on attire and drapery.

Marta Fajardo de Rueda

The Lagartos

Luis Lagarto (Andalusia, Spain 1556–after 1619
Mexico City)

Luis de la Vega Lagarto (Mexico City 1586–after 1631)

Andrés Lagarto (Mexico City 1589–1666/67)

Francisco Lagarto (Mexico City 1591–after 1638)

The earliest mentions we have of Luis Lagarto in Mexico City are all from the year 1586: in March, identified as "painter," he was a witness for Juan Salcedo de Espinoza, a carpenter at the cathedral; in May he rented a shop; in August his son Luis was born; in September he was named by the viceroy Marqués de Villamanrique as examiner of all who would teach reading and writing in New Spain. In the case involving Salcedo, Lagarto declared himself to be 30 years old. By 1592, Luis and his wife Ana de Paz had five more children, and from 1592 to 1594 a series of documents associates Lagarto and the carpenter Salcedo with the preparation of the Corpus Christi festivities in Mexico City. In 1600 Lagarto was contracted for the decoration of the initials of choir books for the cathedral of Puebla, a task he finished in 1611, when he indicated his intention of returning to Mexico City, where he was living in 1612. While in Puebla, in 1603, he illuminated a book of emblems, and in 1606 he received payment as a composer of songs for the cathedral choir. His dated, independent paintings on vellum are all from a ten-year period, between 1609 and 1619.

A net of probabilities has been woven around these dates and facts to create a fuller story. Guillermo Tovar de Teresa suggests that Luis was the son of Juan Lagarto de Castro, "teacher of writing and counting" in Granada, and of a woman from Seville whose last name was Nuñez de la Vega. Furthermore, he may have been a pupil of Lázaro de Velasco, son of the Italian painter Iacopo Fiorentino (1476–1534), who arrived in Granada in 1520. Lázaro was illuminator of the choir books of the Granada cathedral between 1550 and 1583. Tovar also, and correctly, associates the work of Luis Lagarto with illuminated books in Seville. Luis may have traveled to New Spain with the viceroy Villamanrique. Certainly, he was at the Mexico City cathedral during the 1580s, and some of the illuminated capitals of one choir book preserved there are attributable to him. Recent research seems to indicate that Lagarto also decorated initials in the choir books of the cathedral of Oaxaca.

Three of Luis Lagarto's sons were illuminators and must have learned their trade from their father: Luis de la Vega Lagarto, Andrés, and Francisco. Luis married Leonor Rangel, with whom he had at least seven children, born between 1617 and 1626. A signed *Immaculate Conception* is dated 1631, and Tovar attributes to him a miniature of 1637. The earliest works by Andrés, whose godfather was Diego de Aguilera, master architect of the Mexico City cathedral, are dated 1620 in Puebla. In 1638 he was living in Mexico City, where in 1649 he was contracted for a now lost altarpiece. Francisco is known to have made ten maps in 1637.

Clara Bargellini

Bernardo de Legarda

(Quito, Ecuador, end of the seventeenth century–
1773 Quito, Ecuador)

The Ecuadorian artist Bernardo de Legarda, a pupil of José Olmos, operated a workshop in Quito across from the Franciscan monastery for which he did much of his work. In addition to creating carved wooden sculptures and paintings, he also worked as a goldsmith and silversmith and as a printer and gunsmith. The first documentation of his artistic activity is from 1731, when he made initial retouches to an image of Saint Luke. In 1734 he carved the image of the *Virgen Apocalíptica* (Virgin of the Apocalypse)—the famous "Virgin of Quito"—and from 1734 to 1737 he worked on the lateral altarpieces in the chapel of the Sagrario in the church of El Sagrario in Quito. During these years he was also commissioned with the carving and assemblage of the main altarpiece at the church of La Merced. He returned to El Sagrario between 1742 and 1746 to install new stained glass windows in the chapel of the Santísimo (the Most Holy One). In 1745 he collaborated in the work at the chapel of Nuestra Señora del Rosario (Our Lady of the Rosary), and between 1745 and 1748 he carved the altarpiece at the church of La Merced. Bernardo was commissioned in 1769 to work on the gilding of the altarpiece at the Jesuit church. Years later he created the screen for El Sagrario. In 1770 he was commissioned by the Augustinians to work on a project similar to the one he completed at El Sagrario, which he was never able to complete. He died in Quito in 1773.

Adriana Pacheco Bustillo

Andrés López

(Mexican, c. 1740–1811)

The Mexican painter Andrés López began his lengthy career in 1763, the date of his first known work—a *Virgin of the Dawn* in La Profesa, Mexico City—and concluded in 1811, the year of his death. His sizable output consists mostly of religious paintings, as well as some portraits and allegorical works.

López seems to have belonged to a family of painters, as he is believed to have been the son of Carlos Clemente López, who worked around the middle of the eighteenth century, and brother of Cristóbal López. With the latter he painted a number of enormous but rather indifferent paintings on the Passion of Christ in the church at Aguascalientes, Mexico.

López was involved in the foundation of the Academia de San Carlos (1783–85) along with other painters from the Viceroyalty of New Spain, such as José de Alcíbar, Rafael Joaquín Gutiérrez, and Juan de Sáenz Mariano Vázquez. In particular, he worked with Antonio Jerónimo Gil on the correction of pupils' work. López's name headed the census of artists with studios in Mexico City at this date. He is recorded as living in the city, with a workshop on calle de Las Moras.

Along with a number of the above-mentioned artists, López was asked by Dr. Ignacio de Bartolache to examine the original and widely venerated image of the Virgin of Guadalupe, and to endorse the short text written by Bartolache on the work (*Manifiesto satisfactorio y opúsculo Guadalupino*). In addition, he was commissioned to execute a copy of the image using the same materials and techniques as the original in order to observe whether it resisted aging in the same manner.

This did not prove to be the case, however, as the work deteriorated in a short space of time.

Among López's extensive oeuvre are the two large canvases on either side of the high altar of the church in the convent of La Enseñanza, Mexico City, the paintings in the sacristy of the chapel of Loreto in the church of the Oratorio in San Miguel de Allende, and a small painting of *The Ages of Man* and three delicate works on copper panels in the Museo Nacional del Virreinato in Tepotzotlán, Mexico.

Rogelio Ruiz Gomar

Juan Pedro López

(Caracas, Venezuela 1724–1787 Caracas, Venezuela)

Juan Pedro López was born in Caracas on July 23, 1724, a legitimate son of José Antonio López González and María Domínguez, both natives of Tacoronte, Tenerife, in the Canary Islands. In 1750 he married Juana Antonia de la Cruz Delgado, also from Tacoronte, in the Caracas cathedral. The couple had twelve children.

No documents have come to light regarding the painter's training, but it is quite possible that he became an apprentice at an early age in the workshop of one of the Canary Island masters who were established in the city at the time, perhaps working under Domingo Baupte Arvelo y Castro, active in Caracas between 1737 and 1747, or Nicolás González de Abreu, active in the same city between 1746 and 1760. The painter maintained close ties with the Canary Islands immigrant community throughout his life, as evidenced by his lengthy collaboration with the cabinetmaker Domingo Gutiérrez.

In addition to working as a painter, López was a sculptor and gilder. His professional career began in the 1750s and lasted virtually until his death in August of 1787. Juan Pedro López is considered the most important Venezuelan painter of the second half of the eighteenth century. The quality of his work and his vast creative output are testaments to his stature. He maintained a significant client list over the course of his career, receiving important commissions to create works for the cathedral as well as other churches and religious institutions in the city.

Imbued with the joyfulness of rococo and charged with soft, luminous tonalities, López's paintings evolved from the rigid, repetitive, and formulaic expression of his early works as a professional painter into the greater spontaneity and looser paint handling of his mature works. Like most Latin American painters of the colonial period, López often drew his inspiration and compositional models from Flemish and Italian engravings. The influence of certain New Spanish masters, particularly Miguel Cabrera, whose work was present in numerous churches and private collections in eighteenth-century Caracas, is also evident in his work. Records list some two hundred works attributed to Juan Pedro López.

Jorge F. Rivas P.

Sebastián López de Arteaga

(Seville, Spain 1610–1652 Mexico City)

Sebastián López de Arteaga was born in Seville on March 15, 1610, son of a father of the same name and of Inés de los Reyes. His brother, Bartolomé, was an engraver, which suggests a family ambience of artistic activities, but nothing is known of Sebastián's specific

training. He was examined as a painter on April 19, 1630. In 1638 he was in Cádiz, and he is thought to have arrived in New Spain in 1640. By 1642 he was working in Mexico City, where he had been contracted to execute thirteen paintings of the Prometheus myth for an archway constructed to celebrate the entry of the viceroy García Sarmiento de Sotomayor y Luna, Count of Salvatierra.

López de Arteaga was evidently close to those wielding power in Mexico City, since in 1643 he executed a painting of the *Crucifixion* (Museo de la Basílica de Guadalupe, Mexico City) that he signed as "notary of the Holy Office." He used the same formula in signing his famous *Incredulity of Saint Thomas* (Museo Nacional de Arte, Mexico City). His use of the title "inventor" as well in these two works indicates his desire to affirm his status as a learned painter. Another dated work is the 1650 *Stigmatization of Saint Francis* (Museo de la Basílica de Guadalupe, Mexico City). In addition to a handful of other religious compositions, a portrait of Francisco Manso y Zúñiga, archbishop of Mexico City, has been preserved, and there is documentary evidence of other portraits. On June 13, 1652, feeling himself in danger of death from wounds received in a quarrel, López de Arteaga drew up his will. His wife, Juana, and a painter by the name of Francisco Honorio were to be his executors; his heirs were two daughters, Feliciana and Dorotea. By December he was dead.

In the past, López de Arteaga was considered to have been a disciple of Zurbarán, but Rogelio Ruiz Gomar has pointed to the fact that the two were contemporaries, and that López de Arteaga's known paintings also display familiarity with the idioms of Juan de Roelas, Francisco de Herrera the Elder, and the young Diego Velázquez and Alonso Cano. Strong chiaroscuro appears in few of López de Arteaga's paintings, most of which are characterized by softer lighting and more nuanced coloring. The differences, though always discussed with respect to stylistic influences, should also be evaluated in iconographic terms.

Clara Bargellini

Alonso López de Herrera
(Valladolid, Spain c. 1580–1675 Zacatecas, Mexico)

Alonso López de Herrera was a Spanish painter who moved to Mexico, working there for much of the seventeenth century. Until recently it was thought that he was from Mexico City, but the document of the profession of faith he made upon entering the Order of Saint Dominic in Mexico in 1624 states that he was born in Valladolid, Spain, around 1580. It also states that he was the son of Alonso de Herrera and María de Cárdenas. López de Herrera's father may have been the Spanish painter of that name active in the area of Palencia and Segovia in the late sixteenth and early seventeenth centuries, with whom he may have trained before moving to Mexico.

It is not known when the artist arrived in New Spain, but it must have been before 1609, when he is recorded as working in the church of Santo Domingo. There he signed the magnificent portrait of *Archbishop Friar García Guerra* (Museo Nacional del Virreinato, Tepotzotlán, Mexico).

After his wife died, López de Herrera entered the Order of Saint Dominic, and while still a novice he was commissioned by the order to execute the paintings for the high altar of the church of their monastery. This altarpiece was lost in the nineteenth century, but it may have included the paintings on wooden panels of *The Assumption of the Virgin* and *The Resurrection of Christ* (Museo Nacional de Arte, Mexico City), as well as the recently restored *Ascension*.

Known since his own time as "the divine Herrera," López de Herrera's output is relatively small, but it reveals an artist of great technical mastery with a personal style, evident in the high quality of his drawing, particularly in the correct manner of depicting hands and in the wealth of detail.

After a period spent with the Dominican Order in Mexico City, López de Herrera seems to have moved to Puebla. From the mid-century, however, he is recorded in the monastery at Zacatecas, where he died in 1675.

Rogelio Ruiz Gomar

Joaquím Machado de Castro
(Coimbra, Portugal 1731–1822 Lisbon, Portugal)

A native of Coimbra, Portugal, Joaquím Machado de Castro was the son of organist and sculptor Manuel Machado Teixeira. He later relocated to Lisbon, where he worked under Nicolau Pinto, a sculptor of saintly images, and in the workshop of José de Almeida. In 1756 he became the main assistant to the sculptor Alessandro Giusti in the works commissioned for the monastery of Mafra, which completed his period of apprenticeship.

His most important creations include the equestrian statue of King Joseph I (1771)—the crowning feature of the Marquis de Pombal's reconstruction of Lisbon—as well as all of the statuary at the Basílica da Estrela and a series of royal tombs for Mariana of Austria, Mariana Vitória, and Afonso IV and his wife Beatrice. While Machado de Castro's religious works (in polychromed wood and terracotta) are less significant, we do know that he sculpted an image of Our Lady of the Incarnation for the church of the same name, and that he revived the Portuguese predilection for sentimental and narrative pieces, such as the Nativity scenes he created in terracotta. Machado de Castro always worked from his atelier, thus forming a steady circle of disciples and followers. As a result, a large body of work has been attributed to him.

Myriam A. Ribeiro de Oliveira

Antonio Mateo de los Reyes
(born Caracas [?], Venezuela; active 1725–1766 Caracas, Venezuela)

The date of birth of Antonio Mateo de los Reyes is not known, although he was very likely born in Caracas, the city of origin of his parents, Santiago de los Reyes and Isabel de Liendo, who were both white. The first known documentary reference to him dates to 1725. He married María Feliciana Blanco de Acosta, with whom he had six children. Mateo de los Reyes enjoyed a brilliant career as a carpenter, achieving great renown. In 1756 the city council appointed him inspector of weights and measures and chief master carpenter, to replace inspector and master builder Ventura Balcázar, who had died. The artist's most important extant work is the lecturer's desk in the chapel of Santa Rosa de Lima, a building that formed part of the Seminary and

the University of Caracas. He often collaborated with gilder Pedro Juan Álvarez Carneiro, who gilded many of the pieces that he carved. Mateo de los Reyes drew up his will on January 15, 1766, and passed away several days later in Caracas.

Jorge F. Rivas P.

Angelino Medoro
(Rome, Italy c. 1567–c. 1631 Seville, Spain)

Angelino Medoro was born in Rome around 1567, and was just 19 years old when he left for New Granada in 1586. Nothing is known of his training or work before his departure for the Americas. His first dated work, the 1588 *Annunciation* in the church of Santa Clara in Tunja, shows a firm grounding in the Italian mannerist style. In several of his signatures on paintings he identifies himself as Roman, indicating both his birthplace and his artistic allegiances. This may have lent him a certain cache among his clientele in the New World and attracted apprentices to his studio, for which there exist records. The apprentices were of indigenous origin, like Pedro Loayza from Cuzco, and of European descent, such as Luis de Riaño, son of a Spanish captain.

Besides spending time in Tunja, Medoro was active in Santa Fé de Bogotá, Cali, Lima, and Quito. Perhaps his most famous work is a portrait of Saint Rose of Lima (canonized in 1671) that was painted immediately after her death in 1617 and was much copied. In 1588 Medoro married Lucía Pimental, the illegitimate daughter of Alonso Gutiérrez Pimental, an important government official who in 1600 became commander of Santa Fé de Bogotá. His father-in-law's connections probably gave Medoro access to important patrons throughout the New World. After his wife's death in 1609 while in Lima, Medoro married a Creole woman, María de Valeto, and later, in 1620, he married María Mesta Pareja, who returned to Spain with him in 1624. Medoro continued to work as a painter there. In 1627, in order to operate as an artist in Seville, he had to undergo an examination by the guild of painters. The examination board had four members, headed by the young Alonso Cano, who had received his own license only the year before. It also included the painter Francisco Varela. Medoro's will lists considerable property—including three slaves—in both the Americas and Spain, indicating the financial success of his time in the New World.

Carl Brandon Strehlke

Juan de Miranda
(born Mexico City [?]; died c. 1714)

Juan de Miranda was a Mexican painter active in the late seventeenth and early eighteenth centuries. Little information regarding him survives other than the facts set out in his own will, dated October 12, 1714. This states that he was born in Mexico City; that he was the natural son of Antonio de Miranda and Nicolasa Ramírez; that he had two brothers, José and Ventura de Miranda, the latter possibly the artist who executed a work in a chapel of the Mexico City cathedral; that he married María de Mendoza on April 2, 1689; that his wife did not bring any dowry but only her household items and clothes; that at that time he had no money whatsoever; and that he had no children within the marriage or outside it. Finally, we know that in

1697, 1698, 1702, and 1711 he was involved in the valuation of paintings for estates. Juan de Miranda must have died shortly after his will was written and signed.

Notable among this artist's few extant works is his first known portrait, depicting *Sister Juana Inés de la Cruz;* the "Apostle" series now in the Museo Nacional de las Intervenciones (previously the Museo de Churubusco), Mexico City; and the series of angels with emblems of the Passion in the Jesuit church in the city of Pátzcuaro (Michoacán State, Mexico). These works reveal the influence of Juan Correa and Cristóbal de Villalpando, although they lack the quality of these artists' paintings.

Rogelio Ruiz Gomar

Juan Patricio Morlete Ruiz
(San Miguel de Grande, Mexico 1713–c. 1772)

Juan Patricio Morlete Ruiz was born in San Miguel de Grande (present-day San Miguel de Allende) in 1713. He was registered on his baptismal certificate as a mestizo, like his parents, and with the name of Juan alone. Other documents, as well as signatures on paintings, show that he also used the names Juan Patricio and Juan Gil Patricio. He married María Careaga and had a large number of children. He was probably a disciple of José de Ibarra, and he belonged to the same generation as Miguel Cabrera and Antonio Vallejo. In 1772 he drew up his testament, but it is not certain that he actually died in that year. In 1751 he took part, along with José de Ibarra, Francisco Antonio Vallejo, José de Alcíbar, Manuel de Osorio, José Ventura Arnáez, and Miguel Cabrera, in the inspection of the miraculous *ayate* bearing the image of the Virgin of Guadalupe. Their opinions were set out in Cabrera's treatise *American Marvel.*

The new influences that were reaching New Spain at the time are clearly seen in Morlete's work. His style varies from one painting to another, making him a typical artist in transition who on some occasions followed traces of the baroque and on others employed neoclassical elements. Some of his works were in fact copied from French engravings, rather than the Flemish and Italian ones that traditionally circulated among artists in New Spain. These works of French influence include the series of views of French ports taken from the prints of Claude-Joseph Vernet (1714–1789), to which Morlete added a view of the Plaza del Volador in Mexico City and another of the Plaza Mayor (La Valeta palace, Malta). It is perhaps the transitional times that gave his work its uneven quality, as he moved from the precise lines and brilliant coloring of one style to the looser brushwork in the series of paintings of *castas* that have recently come to light in Spain. A keen and accurate portraitist, Morlete Ruiz produced noteworthy portraits of two viceroys, the Marquis of las Amarillas and the Marquis of Croix, which offer a hint of the prestige he enjoyed among his contemporaries.

Juana Gutiérrez Haces

Luis Niño
(active Potosí, Bolivia, c. 1730s)

The *Historia de la villa imperial de Potosí,* written by Bartolomé Arzáns de Orsúa y Vela, was continued after 1736 by his son, Diego. Writing in 1737 of the painter Luis Niño, Diego noted: "At the time of writing, Luis Niño lives in this Town where he was born, a sagacious Indian, second Zeuxis, Apelles, or Timantes, who, it should be noted, paints and sculpts brilliantly when inspired. Various works by his hand in silver, wood, and on canvas have been taken to Europe, Lima, and Buenos Aires to the general approval, and at the present time he is working for the Archbishop of La Plata [present-day Sucre]." This indicates that Luis Niño was a painter, sculptor, and silversmith who was so highly regarded in his own time that he was compared with the ancient Greeks. This comparison was generally applied only to the major artists who came to South America from Europe, such as Mateo Pérez de Alesio.

No other documentary information is available on this artist, although there are various securely attributed works, such as the *Virgin of Sabaya* (Museo de la Casa Nacional de Moneda, Potosí), which is signed, and an autograph replica in the Recoleta at Sucre. Other paintings are considered to be by his hand, including the *Virgin of the Victoria de Málaga* in the Denver Art Museum (Colorado), the *Virgin of the Rosary* in the Museo de Arte, Lima, another *Virgin of the Rosary* in the Museo de la Moneda, and a small Virgin with various titles (Carmen, Rosario, Copacabana, Merced, etc.) in the Museo de Arte Hispanoamericano Isaac Fernández Blanco, Buenos Aires. All these works reveal drawing and gilding of great precision, characteristic of this artist's style.

A reference by Arzáns y Vela indicates a connection between the indigenous Luis Niño and the architectural decoration of the facade of San Lorenzo Potosí. The historian states that both the facade decoration and the *Virgin of Sabaya* were commissioned by the Indians of Carangas. The Virgin was their patron and the church of San Lorenzo their parish church. From this we can infer that Luis Niño was involved with the famous facade in Potosí. We know that he created wooden architectural structures: he executed a surviving, signed altarpiece for the Merced in Sucre. The treatment of the decoration of this altarpiece is comparable to that of the facade of San Lorenzo.

Teresa Gisbert

José de Páez
(Mexico City 1727–1790)

José de Páez was born in Mexico City in 1727. His father was a schoolmaster but is mentioned in certain documents alongside the names of painters, which suggests that he had some connection with the painters' guild. This may be why his son took up the art. José de Páez's manner exemplifies the features that created a stylistic school around the middle of the eighteenth century in New Spain. His human figures tend to be rendered in relaxed postures and with gentle countenances, whether the context is secular or religious, though they are not lacking in dramatic quality when demanded by the subject. Unlike the painters of the seventeenth century, however, Páez was able to temper the dramatic force of the high baroque with a new tenderness. In coloring, reds and blues predominate; although Páez and his contemporaries were indeed magnificent colorists, it would seem that all the colors work around these two axes. José de Páez showed equal skill in the execution of large-scale works, such as the series of the life of San Francisco Solano (now in Zapopan), and of miniatures, such as his nuns' shields. This important genre consisted of small round paintings on sheets of metal or paper that were placed on the front and center of nuns' habits; they depicted the particular devotions of the bearer and, most importantly, indicated the new name she had assumed upon entering the convent. Páez took great pains with these highly meticulous paintings and revealed a strong compositional sense, managing in some cases to display a multitude of holy figures within a very small compass. In some of his paintings and series, he depicted the daily life of New Spain with a wealth of details.

Juana Gutiérrez Haces

Andrés Sánchez Gallque
(Andean, active Quito, Ecuador, late sixteenth–early seventeenth century)

Andrés Sánchez Gallque was a native Andean painter who lived and worked in Quito in the late sixteenth and early seventeenth centuries. The precise dates of his birth and death are not known. He is presumed to have been trained in Quito as a painter by the Dominican friar Pedro Bedón, who in turn had studied with Bernardo Bitti, an Italian mannerist brought to Lima by the Jesuits. The identification with Bedón is based in part on the fact that Andrés Sánchez Gallque's name was one of the very first to be inscribed in the book of the Confraternity of the Rosary, an important religious society of the church of Santo Domingo in Quito that was founded by Bedón. This confraternity records the names of several other Andean painters, including Alonso Chacha, Antonio Ñaupa, and Francisco Vilcacho. In addition to these native artists, the confraternity listed Spaniards and Africans as well as other Indians as members.

Sánchez Gallque was one of the better known artists in Quito. He was certainly one of the artists commissioned in 1598 by the *cabildo* (city council) of Quito to decorate the funeral monument for Felipe II, on which were placed paintings of the cities of the district. The artist is best known for his signed and dated portrait of *Don Francisco de la Robe and His Sons Pedro and Domingo* (cat. VI-70), which was sent to Felipe III in 1599. He is credited with a series of portraits of the Spanish kings and queens that forms part of the collection of the great monastery of San Francisco in Quito. This monastery has a painting of Christ at the Column that is also attributed to Sánchez Gallque, an attribution based on the work's similarity to a signed painting of the same subject found in Bolivia. The fact that Andrés Sánchez Gallque signed at least two of his paintings is highly unusual in the Viceroyalty of Peru and attests to the high regard in which he was held during the early colonial period.

Thomas B. F. Cummins

Gregorio Vásquez de Arce y Ceballos
(Santa Fé de Bogotá, Colombia 1638–1711 Santa Fé de Bogotá, Colombia)

Gregorio Vásquez de Arce y Ceballos's religious paintings were commissioned by churches, monasteries, and private individuals in and around Bogotá. More than five hundred oil paintings and just over one hundred drawings (Museo de Arte Colonial, Bogotá) by Vásquez are now known. Vásquez's series of more than fifty paintings for Bogotá's chapel of the Sagrario

(1660–1700), commissioned by Gabriel Gómez de Sandoval, as well as his paintings for the parish church of Monguí (1671), the Colegio de Nuestra Señora del Rosario, Bogotá (1698–99), and for the religious orders of Santo Domingo, San Francisco, and San Ignacio count among his most important projects. Vásquez executed portraits of the founders and members of these religious orders as well as subjects from the lives of Christ, the Virgin, and the saints.

Vásquez has been celebrated by modern Colombians as the best painter of viceregal New Granada and was praised by the renowned French art critic and writer Louis Gillet (1876–1943). His talent was recognized in the nineteenth century by the German scientist Alexander von Humboldt (1769–1859), who visited the territory in 1801, and by the distinguished writer, artist, and historian José Manuel Groot (1800–1878) in the first art monograph published in Colombia. Vásquez enjoyed tremendous favor during his lifetime, working primarily as a painter of religious themes for Santa Fé de Bogotá's clergy and monastic orders. He is recognized today for his significant influence on New Granadan painting and as a masterful draftsman with a close affinity to the seventeenth-century school of Seville — in particular its exponents Bartolomé Esteban Murillo (1617–1682) and Francisco de Zurbarán (1598–1664), whose workshop exported paintings directly to Spanish America in a thriving trade. Vásquez's drawings show an economy of line and a contour that creates a sense of volume without the use of shading. They are recognizable in some instances as preparatory sketches for his finished paintings and as studies in which he refined foreshortenings, anatomical parts, portrait heads, and figural groups.

The resemblance of Vásquez's oil paintings to the tenebrism of Andalusian baroque art and to the sweet spirituality of Murillo is so strong that earlier scholars, such as Alberto Urdaneta, inferred that the artist must have traveled to Spain. Others suggested a personal contact with Murillo's son, Gabriel, who in 1678 left for New Granada and held the office of district governor (corregidor) of Ubaque. In addition to emulating Sevillian masters, Vásquez's compositions interpret other Spanish and Italian Renaissance and baroque models, which would have been available through the circulation of prints. As Roberto Pizano Restrepo has documented, Vásquez copied prints of subjects by Murillo (Holy Family, Vision of Saint Anthony), Guido Reni (Virgin of the Angels), Jusepe de Ribera (Apostles), Peter Paul Rubens (Flight into Egypt), Sassoferrato (Virgin in Contemplation), Tintoretto (Christ Washing the Feet of His Disciples), Paolo Veronese (Annunciation), and Zurbarán (Virgin of the Immaculate Conception, Christ Child with Thorn). Vásquez's two majestic Virgins after Reni are particularly stunning (1693, Museo del Seminario, Bogotá; 1670, parish church of Tenjo).

Vásquez also assimilated European pictorial models and technical rigor during his apprenticeship in the Santa Fé workshop of the important Figueroa family of painters, under the instruction of Baltasar de Vargas Figueroa (d. 1667). Baltasar, whose solid and weighty figures are absent in the work of Vásquez, introduced European baroque traces to the stylistic aesthetic of New Granadan religious painting. The precocious Vásquez is said to have been expelled from the workshop in 1658 for having retouched the eyes of a painting of Saint Roch by his master (church of Santa Bárbara,

Bogotá) and to have opened his own workshop the following year. In his oil paintings, Vásquez incorporated the use of elastic gum, elemi resin, and clay, materials adopted by New Granada's criollos from earlier indigenous artistic practices.

Alicia Lubowski

Pedro de Vargas
(Montilla, Andalusia, Spain 1553–after 1597)

Born in Montilla outside of Cordoba in 1553, Pedro de Vargas seems to have traveled to the New World with his family at an early age. He was certainly in Lima by 1568, and was a soldier before joining the Jesuit order on August 6, 1575, at the age of 21. By that time he was known as a painter and gilder of talent, and it has been suggested that he was trained by Juan de Illescas, another Cordoban painter working in Lima. It is also likely that he had some connection with the architect Juan Ruiz, also of Andalusian origin, who built the Compañia in Cuzco, because the design of the large full-wall altarpieces was as much the responsibility of the architect as that of the painters and sculptors who executed the individual parts. Though designated as a painter in documents, Vargas seems to have worked largely as a sculptor and gilder, as he explained in 1585 when writing of his collaboration with Bernardo Bitti in Lima and Cuzco. Vargas received permission to leave the Jesuit Order in 1597. His other works and death date and place are not known.

Carl Brandon Strehlke

Cristóbal de Villalpando
(Mexico City c. 1649–1714 Mexico City)

Born, by his own account, in Mexico City around 1649, Cristóbal de Villalpando was an active member of society in New Spain, first as an ensign and later as a captain, probably of the guild militias. He was married twice and had many children, among whom it is likely that the painter Carlos de Villalpando is to be numbered. Villalpando was celebrated in his time and had the honor on various occasions of being appointed overseer (veedor) of the painters' guild. He probably began his career alongside the painter Baltasar de Echave Rioja, thus continuing the long tradition of this workshop in the artistic life of New Spain. In his youth Villalpando performed important work for the cathedral of Puebla, including a large painting of the Transfiguration and, later, a depiction of the Assumption of the Virgin on the inside of the dome. Chosen by the cathedral chapter in Mexico City to paint the walls of the sacristy, he produced several of his masterpieces. In The Church Militant and the Church Triumphant, The Triumph of Religion, The Virgin of the Apocalypse, and The Apparition of Saint Michael Archangel, the influence of Peter Paul Rubens is evident in the vivid coloring, the robust human forms, and the dynamism of the compositions. Villalpando did not by any means copy, however, but worked rather as one who had learned his lessons well and was able to combine what he had learned with his local tradition. In later years he would move away from the influence of Rubens and paint with greater measure, creating stylized figures of distinctive elegance. Making generous use of a rich and abundant palette, he employed rough blots or smudges in certain works and careful, meticulous brushwork in

others. In short, he adapted his technical means to the subject matter, the support, and probably even to the patron of the work at hand. In his final years he made progress in his study of light and moved away from the uniform luminosity of the large-scale scenes in the sacristy of the Mexico City cathedral toward the use of greater contrast, with artificial light sources that add a dramatic tone absent in his earlier work. He was probably the owner of a large workshop with various followers, and he exercised a deep influence on the painting of New Spain. Villalpando died in Mexico City in 1714.

Juana Gutiérrez Haces

Sources Cited

Academia Nacional de Bellas Artes 1982
Academia Nacional de Bellas Artes, Buenos Aires. *Historia general del arte en la Argentina*, vol. 1. Buenos Aires: Academia Nacional de Bellas Artes, 1982.

Academia Nacional de Bellas Artes 1983
Academia Nacional de Bellas Artes, Buenos Aires. *Historia general del arte en la Argentina*, vol. 2. Buenos Aires: Academia Nacional de Bellas Artes, 1983.

Actas Antiguas **1911**
Actas Antiguas de Cabildo, vols. 43–47 (January 1, 1706–December 22, 1713). Reprinted Mexico City: G. Oropeza Velasco, 1911.

Ades et al. 1989
Ades, Dawn, et al. *Art in Latin America: The Modern Era, 1820–1980*. New Haven: Yale University Press, 1989.

Ades et al. 1989 [Spanish]
Ades, Dawn, et al. *Arte en Iberoamérica, 1820–1980*. Madrid: Ministerio de Cultura, Centro de Arte Reina Sofía, Centro Nacional de Exposiciones, 1989.

Aguilar et al. 2000
Aguilar, Nelson, et al. *Arte barroca: mostra do redescobrimento*. Exh. cat. São Paulo: Fundação Bienal de São Paulo / Associação Brasil 500 Anos Artes Visuais, 2000.

Aguilera et al. 1985
Aguilera, Carmen, et al. *El mueble mexicano: historia, evolución e influencias*. Mexico City: Fomento Cultural Banamex, 1985.

Aguilera Rojas and Moreno Rexach 1973
Aguilera Rojas, Javier, and Luis J. Moreno Rexach. *Urbanismo español en América*. Madrid: Editora Nacional, 1973.

Aguiló Alonso 2001
Aguiló Alonso, María Paz. *Orden y decoro, Felipe II y el amueblamiento del Escorial*. Madrid: Sociedad Estatal para la Conmemoración de los Centenarios de Felipe II y Carlos V, 2001.

Ajofrín 1763/1958
Ajofrín, Francisco de. *Diario del viaje que por orden de la sagrada congregación de propaganda fide hizo a la América septentrional en el siglo XVIII*. 1763; ed. Vicente Castañeda y Alcocer and P. Buenaventura de Carrocera, 2 vols. Madrid: Archivo Documental Español, Real Academia de la Historia, 1958.

Alarcón Cedillo and Alonso Lutteroth 1993
Alarcón Cedillo, Roberto, and Armida Alonso Lutteroth. *Tecnología de la obra de arte en la época colonial*. Mexico City: Universidad Iberoamericana, 1993.

Alberro 1997
Alberro, Solange. "Remedios y Guadalupe. De la unión a la discordia." In *Manifestaciones religiosas* 1997, pp. 315–29.

Álbum de las pinturas **1971**
Álbum de las pinturas que representan el nacimiento, vida, milagros, santidad y último trance de Nuestro Seráfico Padre San Francisco, ejecutadas hace tres siglos para la Orden Franciscana de Santiago de Chile y en cuyo convento se halla. Zurich: Moulinette, 1971.

Alcalá 1997
Alcalá, Luisa Elena. "¿Pues para qué son los papeles . . . ? Imágenes y devociones en los siglos XVII y XVIII." *Tiempos de América* 1 (1997), pp. 43–56.

Alcalá 1998 "Jesuits"
Alcalá, Luisa Elena. "The Jesuits and the Visual Arts in New Spain, 1670–1767." Ph.D. diss., New York University, 1998.

Alcalá 1998 "Profesión"
Alcalá, Luisa Elena. "'. . . Fue necesario hacernos más que pintores': Pervivencias y transformaciones de la profesión pictórica en Hispanoamérica." In *Las sociedades ibéricas y el mar a finales del siglo XVI*, pp. 85–104. Exh. cat. Lisbon: Exposición Mundial de Lisboa; Pabellón de España, 1998.

Alcalá 1999
Alcalá, Luisa Elena. "Imagen e historia: la representación del milagro en la pintura colonial." In *Siglos de oro* 1999, pp. 107–25.

Alcalá Subastas 2004
Alcalá Subastas, Madrid. October 6–7, 2004.

Alcocer 1942
Alcocer, Luis Jerónimo. "Relación sumaria del estado presente de la Isla Española en las Indias Occidentales [1650]." In Rodríguez Demorizi 1942.

Alfaro et al. 1994
Alfaro, Alfonso, et al. "El retrato novohispano." *Artes de México* 25 (1994).

Almeida 1993
Almeida, Fernando Moitinho de. *Inventário de marcas de pratas portuguesas e brasileiras: século XV a 1887*. Lisbon: IN-CM, 1993.

Alonso de Rodríguez 1980
Alonso de Rodríguez, Josefina. *El arte de la platería en la Capitanía General de Guatemala*, vol. 1. Guatemala City: Universidad de San Carlos de Guatemala, 1980.

Alva 1634/1999
Alva, Don Bartolomé de. *A Guide to Confession Large and Small in the Mexican Language*. 1634; ed. Barry D. Sell and John Frederick Schwaller with Lu Anne Homza. Norman: University of Oklahoma Press, 1999.

Alvarez Arévalo 1990
Alvarez Arévalo, Miguel. *Iconografía aplicada a la escultura colonial de Guatemala, Colección Arte guatemalteco*, vol. 1. Guatemala City: Fondo Editorial "La Luz," 1990.

Alvarez Martínez 1993
Alvarez Martínez, Félix. *El Galeón de Acapulco: el viaje de la Misericordia de Dios*. Mexico City: Ediciones Polifemo, 1993.

Alves 1962
Alves, Marieta. *Mestres ourives de ouro e prata na Bahia*. Salvador: Museu do Estado da Bahia, 1962.

America, Bride of the Sun **1991**
Vandenbroek, Paul, with M. Catherine de Zegher. *America, Bride of the Sun: 500 Years Latin America and the Low Countries*. Exh. Cat. Ghent, Belgium: Imschoot; Brussels: Ministry of the Flemish Community, Administration of External Relations, 1991.

Americas Society 1992
Americas Society. *Barroco de la Nueva Granada: Colonial Art from Colombia and Ecuador*. New York: Americas Society, 1992.

Amerlinck 1981
Amerlinck, María Concepción. *Las catedrales de Santiago de los Caballeros de Guatemala*. Mexico City: Universidad Nacional Autónoma de México, 1981.

Anawalt 1981
Anawalt, Patricia Rieff. *Indian Clothing before Cortés: Mesoamerican Costumes from the Codices*. Norman: University of Oklahoma Press, 1981.

Anchisi de Rodríguez 1997
Anchisi de Rodríguez, Coralia. "Elaboración de imaginería en los talleres de la Guatemala colonial." In Paiz de Serra 1997.

Anders 1984
Anders, Ferdinand, with Dr. Kauffmann Doig. *Peru durch die Jahrtausende: Kunst und Kultur im Lande der Inka*. Exh. cat. Recklinghausen, Germany: A. Bongers, 1984.

Anders et al. 1971
Anders, Ferdinand, et al. *Tesoros de México: arte plumario y de mosáico*. Artes de México 137. Mexico City: Artes de México, 1971.

Anderson 1956
Anderson, Lawrence. *El arte de la platería en México*. Mexico City: Porrúa, 1956.

Andrade 1974
Andrade, Carmen. *La Pinacoteca Virreinal*. Mexico City: Secretaría de Educación Pública, 1974.

Andrade 1978
Andrade, Rodrigo Melo Franco de. "A pintura colonial em Minas Gerais." *Revista do patrimônio histórico e artístico nacional* (Rio de Janeiro) 18 (1978), pp. 11–47.

Angel Casas 2000
Angel Casas, Clara Inés. *Rostros metálicos: máscaras, mascarillas, o mascarones de las esculturas policromadas de los siglos XVII y XVIII*. Exh. cat. Bogotá: Museo de Arte Colonial, 2000.

Ángeles Jiménez 1994
Ángeles Jiménez, Pedro. "La destrucción de la misión de San Sabá y martirio de los padres Fray Alonso Giraldo de Terreros y Fray José de Santiesteban: una historia, una pintura." *Memoria* (Museo Nacional de Arte, Mexico City) 5 (1993–94), pp. 4–33.

Ángeles Jiménez 2004
Ángeles Jiménez, Pedro. "Apeles y tlacuilos: Marcos Griego y la pintura cristiano-indígena del siglo XVI en la Nueva España." In Gutiérrez Arriola and Maquívar 2004, pp. 115–33.

Anglería 1530/1989
Anglería, Pedro Mártir de. *Décadas de Nuevo Mundo.* 1530; Madrid: Ediciones Polifemo, 1989.

Angulo Iñiguez 1925
Angulo Iñiguez, Diego. *La orfebrería en Sevilla.* Seville: Tip. M. Cardona, 1925.

Angulo Iñiguez 1935
Angulo Iñiguez, Diego. "Dos Menas en Méjico: esculturas sevillanas en América." *Archivo Español de Arte* (Madrid) 11 (1935).

Angulo Iñiguez 1946
Angulo Iñiguez, Diego. *La cerámica de Puebla* (Méjico). Madrid: Blass, 1946.

Angulo Iñiguez 1947
Angulo Iñiguez, Diego. *El gótico y el renacimiento en las Antilla: arquitectura, escultura, pintura, azulejos, orfebrería.* Seville, 1947.

Angulo Iñiguez 1950
Angulo Iñiguez, Diego. "Orfebrería de Guatemala en el Museo Victoria y Alberto, de Londres." *Archivo Español de Arte* (Madrid) 92 (1950).

Angulo Iñiguez et al. 1945–56
Angulo Iñiguez, Diego, et al. *Historia del arte hispano-americano.* 3 vols. Barcelona and Buenos Aires: Salvat, 1945–56.

Anonymous 1873
"Noticia histórica de la procesión del Santo Cristo de Burgos que salia en la antigüedad, el día Jueves Santo, del convento grande de San Agustín de esta ciudad, y de la erección de su famosa cofradía." In Odriozola 1863–77, vol. 4 [1873].

"Antecedentes" 1989
"Antecedentes: la tradición universal de la cuadrícula." In CEHOPU 1989, pp. 85–102.

Araújo 1997
Araújo, Emanoel, ed. *Arte e religiosidade no Brasil: heranças africanas.* Exh. cat. São Paulo: Pinacoteca do Estado de São Paulo, 1997.

Araújo 1998
Araújo, Emanoel, ed. *A Mão afro-brasileira: significado da contribução artística e histórica.* Exh. cat. São Paulo: Técnica Nacional de Engenharia, 1998.

Araújo 2001
Araújo, Emanoel. "Exhibiting Afro-Brazilian Art." In Sullivan 2001, pp. 312–25.

Araujo Suárez et al. 1989
Araujo Suárez, Rolando, et al. *Esculturas de papel amate y caña de maíz.* Mexico City: Museo Franz Mayer, 1989.

Arbeláez Camacho and Gil Tovar 1968
Arbeláez Camacho, Carlos, and Francisco Gil Tovar. *El arte colonial en Colombia: arquitectura, escultura, pintura, mobilario, orfebrería.* Bogotá: Ediciones Sol y Luna, 1968.

Arenado 1977
Arenado, Fuensanta. "Nuevos datos sobre el pintor Angelino Medoro (Roma, 1567–Sevilla, 1633)." *Archivo hispalense: revista histórica, literaria y artística* (Seville) 60, no. 184 (1977), pp. 103–12.

Armella de Aspe and Meade de Angulo 1989
Armella de Aspe, Virginia, and Mercedes Meade de Angulo. *Tesoros de la Pinacoteca Virreinal.* Mexico City: Multibanco Mercantil de México, 1989.

Armella de Aspe and Meade de Angulo 1993
Armella de Aspe, Virginia, and Mercedes Meade de Angulo. *Tesoros de la Pinacoteca Virreinal,* 2d ed. Mexico City: Fomento Cultural Banamex, 1993.

Armella de Aspe et al. 1988
Armella de Aspe, Virginia, et al. *La Historia de México a través de la Indumentaria.* Mexico City: Inbursa, 1988.

Arricivita 1792
Arricivita, Juan Domingo. *Crónica seráfica y apostólica del Colegio de Propaganda Fide de la Santa Cruz de Querétaro en la Nueva España, dedicada al santísimo patriarca el señor San Joseph: segunda parte.* Mexico City: F. de Zúñiga y Ontiveros, 1792.

Art Heritage of Puerto Rico 1973
El Museo del Barrio, New York; The Metropolitan Museum of Art, New York. *The Art Heritage of Puerto Rico: Pre-Columbian to Present.* Exh. cat. New York: Metropolitan Museum of Art, 1973.

Arte barroca 2000
Arte barroca: mostra do redescobrimento. Exh. cat. São Paulo: Fundação Bienal de São Paulo / Associação Brasil 500 Anos Artes Visuais, 2000.

Arte efímero 1983
El arte efímero en el mundo hispánico. Estudios de arte y estética 17. Mexico City: Instituto de Investigaciones Estéticas, UNAM, 1983.

Arte in Brasile 2004
Palazzo Reale, Milan. *Arte in Brasile dal XVI al XIX secolo: la collezione Beatriz e Mário Pimenta Camargo.* Exh. cat. Milan: Silvana, 2004.

Arte religioso 1992
Museo Nacional de Arte Decorativo, Buenos Aires. *Arte religioso en Buenos Aires: siglos XVII, XVIII, XIX y XX.* Exh. cat. Buenos Aires: Museo Nacional de Arte Decorativo, 1992.

Arte y fe 1992
Rodríguez Ossa, José María, and Rodrigo Buenahora Santos, eds. *Arte y fe, 1575–1992: colección de la Orden de San Agustín.* Exh. cat. Bogotá: Museo Nacional de Colombia. 1992.

Arte y mística 1994
Arte y mística del barroco. Exh. cat. Mexico City: Consejo Nacional para la Cultura y las Artes; Gobierno del Distrito Federal, 1994.

Artes industriales 1982
Las artes industriales en la Nueva España [Manuel Romero de Terreros y Vinet]. Ed. María Teresa Cervantes de Conde and Carlota Romero de Terreros de Prévoisin. 2d ed. Mexico City: Banco Nacional de México; Fomento Cultural Banamex, 1982.

Arzáns de Orsúa y Vela 1736/1965
Arzáns de Orsuá y Vela, Bartolomé de. *Historia de la Villa Imperial de Potosí.* Ed. Lewis Hanke and Gunnar Mendoza. 1736; Providence, R.I.: Brown University Press, 1965.

Ashelford 1996
Ashelford, Jane. *The Art of Dress: Clothes and Society, 1500–1914.* London: National Trust, 1996.

Atl et al. 1924
Atl, Dr., et al. *Iglesias de México.* 6 vols. Mexico City: Secretaría de Hacienda, 1924–27.

Aulnoy 1892
Aulnoy, Madame d'. *Relación que hizo de su viaje por España en 1679.* Madrid: Tipografía Franco-Española, 1892.

Avila [attr.] 1923
Anonymous [attributed to Francisco de Avila]. "Festividades del tiempo heroico del Cuzco." In *Inca,* ed. Carlos A. Romero, vol. 1 (1923), pp. 447–54.

Avila 1984
Avila, Affonso. *Iniciação ao barroco mineiro.* São Paulo: Nobel, 1984.

Aztec Empire 2004
The Aztec Empire. Exh. cat. New York: Guggenheim Museum Publications, 2004.

Aztecs 2002
Aztecs. Exh. cat. London: Royal Academy of Arts, 2002.

Báez-Macías 1970
Báez-Macías, Eduardo. *El arcángel San Miguel: su patrocinio, la ermita en el santo desierto de Cuajimalpa y el santuario de Tlaxcala.* Mexico City: Universidad Nacional Autónoma de México, 1979.

Bailey 1997
Bailey, Gauvin Alexander. "A Mughal Princess in Baroque New Spain: Catarina de San Juan (1606–88), the China Poblana," *Anales del Instituto de Investigaciones Estéticas* (Mexico City) 19 (1997), pp. 37–86.

Bailey 1999
Bailey, Gauvin Alexander. *Art on the Jesuit Missions in Asia and Latin America, 1542–1773.* Toronto: University of Toronto Press, 1999.

Bailey 2005
Bailey, Gauvin Alexander. *Art of Colonial Latin America.* London: Phaidon, 2005.

Balbuena 1963
Balbuena, Bernardo de. *Grandeza Mexicana, y fragmentos del Siglo de Oro y El Bernardo.* Mexico City: Universidad Nacional Autónoma de México, 1963.

Balsa de la Vega 1891
Balsa de la Vega, Rafael. "José Campeche: estudio crítico de sus obras." *Revista Puertorriqueña* 5 (1891), pp. 17–44.

Bandelier 1910
Bandelier, Adolph F. *The Islands of Titicaca and Koati.* New York: The Hispanic Society of America, 1910.

Bantel and Burke 1979
Bantel, Linda, and Marcus B. Burke. *Spain and New Spain: Mexican Colonial Arts in Their European Context.* Exh. cat. Corpus Christi, Tex.: Art Museum of South Texas, 1979.

Baquedano 1993
Baquedano, Elizabeth. "Aspects of Death Symbolism in Aztec Tlaltecuhtli." In *46th International Congress of Americanists, Amsterdam, 1988.* Bonn: Estudios Americanistas, 1993.

Barahona Quintana 1999
Barahona Quintana, Nuria. "La iconografía de San Ignacio de Loyola en la Nueva España." Master's thesis, Universidad Nacional Autónoma de México, Mexico City, 1999.

Barata 1998
Barata, Mário. "A escultura da origem negra no Brasil."
In Araújo 1998, pp. 183–92.

Barba 1640
Barba, Álvaro Alonso. *Arte de los metales*. Madrid:
Imprenta del Reyno, 1640.

Barber 1908
Barber, Edwin Atlee. *The Maiolica of Mexico*. Art Hand-
book of the Pennsylvania Museum and School of Indus-
trial Art. Philadelphia: Pennsylvania Museum and School
of Industrial Art, 1908.

Barber 1915
Barber, Edwin Atlee. *Mexican Maiolica in the Collection of
the Hispanic Society of America*. New York: The Hispanic
Society of America, 1915.

Barbieri and Gori 2000
Barbieri, Sergio, and Iris Gori. *Patrimonio artístico nacio-
nal, inventario de bienes muebles: iglesia y convento de San
Francisco de Córdoba*. Córdoba: Academia Nacional de
Bellas Artes, Gobierno de la Provincia de Córdoba, 2000.

Barbosa and Machado 1988
Barbosa, Marcos, and Arnaldo Machado. *Arte sacra
brasileira*. Rio de Janeiro: Colorama, 1988.

Bardi 1979
Bardi, Pietro Maria. *Arte da prata no Brasil*. Rio de Janeiro:
Banco Sudameris Brasil, 1979.

Bardi et al. 1982
Bardi, Pietro M., et al. *Arte no Brasil*. São Paulo: Victor
Civita, 1982.

Bardi et al. 1986
Bardi, Pietro Maria, et al. *Beneditinos em Olinda: 400
Anos*. São Paulo: Sanbra—Sociedade Algodoeira do
Nordeste Brasileiro, 1986.

Bargalló 1955
Bargalló, Modesto. *La minería y la metalurgia en la América
española durante la época colonial*. Mexico City: Fondo de
Cultura Económica, 1955.

Bargellini 1986
Bargellini, Clara. "Escultura y retablos del siglo XVIII."
In *Historia del arte mexicano*, vol. 8, *Arte colonial IV*, ed.
Juan Salvat and José Luis Rosas. 2d ed. Mexico City:
Salvat Mexicana de Ediciones, 1986.

Bargellini 1993
Bargellini, Clara. *El retablo de la Virgen de los Dolores*.
Mexico City: Fundación Cultural Televisa, 1993.

Bargellini 1994 "Coleccionismo"
Bargellini, Clara. "El coleccionismo estadounidense."
In *México en el mundo de las colecciones de arte*, vol. 4.
Mexico City: Azabache, 1994.

Bargellini 1994 "Jesús"
Bargellini, Clara. "Jesús consolado por los ángeles."
In *Arte y mística* 1994.

Bargellini 1997
Bargellini, Clara. "La colección de pintura colonial de
Robert Lamborn en el Philadelphia Museum of Art."
In *Patrocinio, colección, y circulación de las artes*, ed.
Gustavo Curiel. Mexico City: Universidad Nacional
Autónoma de México, 1997.

Bargellini 1999 "Copper"
Bargellini, Clara. "Painting on Copper in Spanish
America." In *Copper* 1999, pp. 31–44.

Bargellini 1999 "Villalpando"
Bargellini, Clara. "Cristóbal de Villalpando at the Cathe-
dral of Puebla." In *Struggle for Synthesis: a obra de arte total
nos séculos XVII e XVIII—The Total Work of Art in the
Seventeenth and Eighteenth Centuries (Proceedings of the
International Conference, Braga 1996)*, pp. 129–36. Lisbon:
Instituto Portugues do Patrimónió Arquitectónico, 1999.

Bargellini 2002
Bargellini, Clara. "El ochavo: Kunstkammer Americana."
In *El mundo de las catedrales novohispanas*. Puebla: Insti-
tuto de Ciencias Sociales y Humanidades, Benemérita
Universidad Autónoma de Puebla, 2002.

Bargellini 2004
Bargellini, Clara. "Originality and Invention in the Paint-
ing of New Spain." In Pierce et al. 2004.

Bargellini 2005
Bargellini, Clara. "Los retablos del siglo XVI y principios
del siglo XVII." In *Retablos de la Ciudad de México, Siglos
XVI al XX*. Mexico City: Asociación del Patrimonio
Artístic Mexicano, 2005.

Barnadas et al. 2002
Barnadas, Josep M., et al. *Diccionario histórico de Bolivia*,
2 vols. Sucre, Bolivia: Grupo de Estudios Históricos, 2002.

Barrio Lorenzot 1920
Barrio Lorenzot, [Juan] Francisco del. *El trabajo en México
durante la época colonial: ordenanzas de gremios de la
Nueva España . . .* Mexico City: Secretaría de Gobernación,
1920[–21].

Barroco hispanoamericano en Chile 2002
Museo de Bellas Artes de Castelló, Castelló de la Plana.
*Barroco hispanoamericano en Chile: vida de San Francisco
de Asís, según la serie que representa su nacimiento, vida,
milagros, santidad y último trance, pintada en el siglo XVII
para el Convento Franciscano de Santiago de Chile y ex-
puesta en el Museo de San Francisco del citado convento*.
Exh. cat. Madrid: Corporación Cultural 3C Para el Arte,
2002.

Barroco y fuentes 2004
Barroco y fuentes de la diversidad cultural. La Paz, Bolivia:
Viceministerio de Cultura, Union Latina, and UNESCO
[Memoria del II Encuentro Internacional], 2004.

Barthel 1971
Barthel, Thomas S. "Viracochas Prunkgewand." *Tribus*
(Stuttgart) 20 (November 1971), pp. 63–124.

Bauer 1998
Bauer, Brian S. *The Sacred Landscape of the Inca: The
Cusco Ceque System*. Austin: University of Texas Press,
1998.

Bayón and Marx 1989
Bayón, Damián, and Murillo Marx. *Historia del arte
colonial sudamericano: Sudamérica Hispana y el Brasil*.
Barcelona: Ediciones Polígrafa, 1989.

Bayón and Marx 1992
Bayón, Damián, and Murillo Marx. *History of South
American Colonial Art and Architecture: Spanish South
America and Brazil*. New York: Rizzoli, 1992.

Bayón et al. 1989
Bayón, Damián, et al. *History of South American Colonial
Art and Architecture*. Barcelona: Ediciones Polígrafa, 1989.

Bazant 1964
Bazant, Jan. "Evolution of the Textile Industry of Puebla
1544–1845." *Comparative Studies in Society and History* 7
(1964), pp. 56–69.

Bazin 1956–58
Bazin, Germain. *L'architecture religieuse baroque au Brésil /
A arquitectura religiosa barroca no Brasil*. 2 vols. Paris:
Librairie Plon; São Paulo: Museu de Arte, 1956–58.

Bazin 1963
Bazin, Germain. *Aleijadinho et la sculpture baroque au
Brésil*. Paris: Le Temps, 1963.

Bazin 1972
Bazin, Germain. *O Aleijadinho e a escultura barrôca no
Brasil*. Trans. Marisa Murray. São Paulo: Record, 1972.

Benavente and Martínez 1964
Benavente, Teófilo, and Alejandro Martínez. *El escultor de
la colonia D. Tomás Tuiro Túpac Inca, sargento mayor de
los nobles ingas*. Cuzco: Corporación de Reconstrucción y
Fomento del Cuzco, 1964.

Benavides 1953
Benavides, Alfredo. "Las pinturas coloniales del templo
de San Francisco." *Boletín de la Academia Chilena de la
Historia* 49 (1953), pp. 67–96.

Bencard 2002
Bencard, Mogens. "Why Denmark? The Gift of Johan
Maurits to Frederick III." In Berlowicz et al. 2002.

Benevolo 1975
Benevolo, Leonardo. *Corso di disegno*, vol. 4. Rome:
Laterza, 1975.

Benítez 1983
Benítez, Marimar, ed. *Francisco Oller: un realista del
impresionismo / Francisco Oller: A Realist-Impressionist*.
Exh. cat. Ponce, Puerto Rico: Museo de Arte de Ponce,
1983.

Benítez 1985
Benítez, Marimar. "La obra de Campeche en el I.C.P."
El Reportero (San Juan, Puerto Rico), September 21, 1985.

Bennassar 2000
Bennassar, Bartolomé. "The Minas Gerais: A High Point
of Miscenegation." *Diogenes* 48 (2000), pp. 37–44.

Bérchez 1989
Bérchez, Joaquín. "Tolsá en la arquitectura española de
su tiempo." In Gimeno Tolsá, *Fabregat: trayectoria artística
en España, siglo XVIII*. Exh. cat. Valencia, Spain, and
Mexico City: Generalitat Valenciana, Comissió per el
Ve Centenari del Descobriment d'America, 1989.

Bercht et al. 1989
Bercht, Fatima, et al. *House of Miracles: Votive Sculpture
from Northeastern Brazil*. Exh. cat. New York: Americas
Society, 1989.

Bercht et al. 1998
Bercht, Fatima, et al., eds. *Taíno: Pre-Columbian Art and
Culture from the Caribbean*. New York: Monacelli Press,
1998.

Berdan 1987
Berdan, Francis F. "Cotton in Aztec Mexico: Production,
Distribution, and Uses." *Mexican Studies* 3 (1987),
pp. 235–65.

Berger 1998
Berger, Uta. *Mexican Painted Manuscripts in the United
Kingdom*. London: British Museum, 1998.

Berlin 1952
Berlin, Heinrich. *Historia de la imaginería colonial en
Guatemala*. Guatemala City: Editorial del Ministerio
de Educación Pública, 1952.

Berlin 1958
Berlin, Heinrich. "The High Altar of Huejotzingo."
The Americas 15, no. 1 (1958), pp. 63–73.

Berlin-Neubart 1974
Berlin-Neubart, Henrich. *Kirche und Kloster von Santo
Domingo in de Stadt Mexico*. Stockholm: Almqvist and
Wiksell, 1974.

Berlowicz et al. 2002
Berlowicz, Barbara, et al. *Albert Eckhout volta ao Brasil, 1644–2002: simposio internacional de especialistas.* Recife, Brazil: Instituto Ricardo Brennand, 2002.

Bernales 1987
Bernales, Jorge. *Historia del arte hispanoamericano*, vol. 2, *Siglos XVI a XVIII.* Madrid: Alhambra, 1987.

Bernales Ballesteros 1974
Bernales Ballesteros, Jorge. "Escultura montañesina en el virreinato del Perú." *Archivo Hispalense* 57 (1974), pp. 95–120.

Bernales Ballesteros 1981
Bernales Ballesteros, Jorge. "El Corpus Christi: fiesta barroca en Cuzco." In *Primeras jornadas* 1981, pp. 277–92.

Bernales Ballesteros 1999
Bernales Ballesteros, Jorge. "La escultura en Lima siglos XVI–XVIII." In *Escultura en el Perú*, ed. José Antonio de Lavalle. Lima: Banco de Crédito del Perú, 1999.

Bernardini 2002
Bernardini, Maria Grazia. "El ciclo della Passione de Cristo: gli artisti." In *L'Oratorio del Gonfalone a Roma: il ciclo cinquecentesco della Passione di Cristo*, pp. 95–98. Milan: Silvana Editoriale, 2002.

Bernd 1999
Bernd, Beatriz. "Memoria pictórica de la fiesta barroca en la Nueva España." In *Pinceles* 1999.

Bernis 2001
Bernis, Carmen. *El traje y los tipos sociales en El Quijote.* Madrid: Ediciones El Viso, 2001.

Beurdeley and Beurdeley 1971
Beurdeley, Cécile, and Michel Beurdeley. *Giuseppe Castiglione: A Jesuit Painter at the Court of the Chinese Emperors.* Rutland, Vt.: Tuttle, 1971.

Bitti 1972
Catálogo de la Exposición de esculturas de Bernardo Bitti. Museo Historico Regional del Cuzco, June 22–30, 1972.

Blanco 1932 "Campeche II"
Blanco, Enrique Tomás. "Campeche II, su vida." *Alma Latina* (San Juan, Puerto Rico) 22 (1932), pp. 24–29.

Blanco 1932 "Campeche III"
Blanco, Enrique Tomás. "Campeche III, su obra." *Alma Latina* (San Juan, Puerto Rico) 23 (1932), pp. 19–27.

Blum 1997
Blum, Dilys E. *The Fine Art of Textiles: The Collections of the Philadelphia Museum of Art.* Philadelphia: Philadelphia Museum of Art, 1997.

Bochart de Moreno 1995
Bochart de Moreno, Christiana. "Beyond the Obraje: Handicraft Production in Quito toward the End of the Colonial Period." *The Americas* 52 (1995), pp. 1–24.

Boime 1990
Boime, Albert. *The Art of Exclusion: Representing Blacks in the Nineteenth Century.* Washington, D.C.: Smithsonian Institution Press, 1990.

Bomchil and Carreño 1987
Bomchil, Sara, and Virginia Carreño. *El mueble colonial de las Américas y su circunstancia histórica.* Buenos Aires: Editorial Sudamericana, 1987.

Bonavit 1944
Bonavit, J. "La escultura en caña." *Anales del Museo Michoacano* (Mexico City) 3 (1944).

Bonta de la Pezuela 2000
Bonta de la Pezuela, Maria. "Porcelana china de exportación para el mercado novohispano." Master's thesis,

Universidad Nacional Autónoma de México, Mexico City, 2000.

Boogaart et al. 1979
Boogaart, E. van den, et al., eds. *Johan Maurits van Nassau-Siegen, 1604–1679: A Humanist Prince in Europe and Brazil.* The Hague: Johan Maurits van Nassau Stichting, 1979.

Boone 1998
Boone, Elizabeth Hill. "Pictorial Documents and Visual Thinking in Postconquest Mexico." In *Native Traditions in the Postconquest World: A Symposium at Dumbarton Oaks, 2d through 4th October, 1992*, ed. Elizabeth Hill Boone and Tom Cummins, pp. 149–99. Washington, D.C.: Dumbarton Oaks, 1998.

Boone and Cummins 1992
Boone, Elizabeth Hill, and Tom Cummins, eds. *Native Traditions in the Postconquest World.* Washington, D.C.: Dumbarton Oaks Research Library and Collection, 1992.

Borah 1943
Borah, Woodrow. *Silk Raising in Colonial Mexico.* Berkeley and Los Angeles: University of California Press, 1943.

Borah 1954
Borah, Woodrow. *Early Colonial Trade and Navigation between Mexico and Peru.* Berkeley and Los Angeles: University of California Press, 1954.

Borah 1982
Borah, Woodrow. "The Spanish and Indian Law: New Spain." In *The Inca and Aztec States, 1400–1800: Anthropology and History*, ed. George A. Collier et al., pp. 265–88. New York: Academic Press, 1982.

Borah 1991
Borah, Woodrow. "Yet Another Look at the Techialoyan Codices." In *Land and Politics in the Valley of Mexico: A Two Thousand Year Perspective*, ed. H. R. Harvey, pp. 209–21. Albuquerque: University of New Mexico Press, 1991.

Boxer 1957
Boxer, C. R. *The Dutch in Brazil, 1624–1654.* Oxford: Clarendon Press, 1957.

Boxer 1993
Boxer, C. R. *The Christian Century in Japan, 1549–1650.* Reprinted Lisbon: Carcanet, 1993.

Boxer 1995
Boxer, C. R. *The Golden Age of Brazil.* Reprinted Lisbon: Carcanet, 1995.

Boyd-Bowman 1973
Boyd-Bowman, Peter. "Spanish and European Textiles in Sixteenth Century Mexico." *The Americas* 29 (1973), pp. 334–58.

Brading 1993
Brading, D. A. *The First America: The Spanish Monarchy, Creole Patriots, and the Liberal State, 1492–1867.* Cambridge: Cambridge University Press, 1993.

Brading 2001
Brading, D. A. *Mexican Phoenix: Our Lady of Guadalupe; Image and Tradition Across Five Centuries.* Cambridge: Cambridge University Press, 2001.

Bradley and Cahill 2000
Bradley, Peter T, and David Cahill. *Habsburg Peru: Images, Imagination, and Memory.* Liverpool, England: Liverpool University Press, 2000.

Brajniko 1951
Brajniko, Eugène Miller. "Traces de l'art oriental sur l'art brésilien du début du XVIII^ème siecle." *Revista da Universidade Federal de Minas Gerais* 9 (1951), pp. 56–79.

Brancante 1950
Brancante, Eldino da Fonseca. *O Brasil e a louça da India.* São Paulo: Olímpica Editôra, 1950.

Brau 1904
Brau, Salvador. *Historia de Puerto Rico.* New York: D. Appleton and Co., 1904.

Brésil baroque 1999
Brésil baroque: entre ciel et terre. Exh. cat. Paris: Union Latine, 1999.

Breve catálogo 1997
Breve catálogo del Museo de Arte Colonial. Quito: Fundación Amigos del Museo Nacional de Arte Colonial; Casa de la Cultura Ecuatoriana "Benjamin Carrion," 1997.

Brown 1997
Brown, Jonathan. "Cristóbal de Villalpando y la pintura barroca española." In Gutiérrez Haces et al. 1997, pp. 23–28.

Brown 1999
Brown, Jonathan. "La antigua monarquía española como área cultural." In *Siglos de oro* 1999, pp. 19–25.

Brown 2004
Brown, Jonathan. "Spanish Painting and New Spanish Painting, 1550–1700." In Pierce et al. 2004, pp. 17–23.

Buenos Aires 1998
Patrimonio Artístico Nacional, inventario de bienes muebles: ciudad de Buenos Aires I. Buenos Aires: Academia Nacional de Bellas Artes, Fondo Nacional de las Artes, 1998.

Bullock 1824
Bullock, William W. *Six Months' Residence and Travels in Mexico; Containing Remarks on the Present State of New Spain, Its Natural Productions, State of Society, Trade, Agriculture, and Antiquities, Etc.* London: John Murray, 1824.

Buntinx and Wuffarden 1991
Buntinx, Gustavo, and Luis Eduardo Wuffarden. "Incas y reyes españoles en la pintura colonial peruana: la estela de Garcilaso." *Márgenes* 8 (1991), pp. 151–210.

Burke 1979
Burke, Marcus B. "Mexican Colonial Painting in Its European Context." In Bantel and Burke 1979, pp. 15–60.

Burke 1990
Marcus Burke. "Baltasar de Echave Ibía." In *Mexico* 1990.

Burke 1992
Burke, Marcus B. *Pintura y escultura en Nueva España: el barroco.* Mexico City: Grupo Azabache, 1992.

Burke 1998
Burke, Marcus B. *Treasures of Mexican Colonial Art: The Davenport Museum of Art Collection.* Santa Fe: Museum of New Mexico Press for the Davenport Museum of Art, 1998.

Burke 2001
Burke, Marcus B. "On the Spanish Origins of Mexican Retablos." In *Art and Faith in Mexico: The Nineteenth-Century Retablo Tradition*, ed. Elizabeth Zarua et al., pp. 39–45. Exh. cat. Las Cruces: New Mexico State University, 2001.

Buser 1976
Buser, Thomas. "Jerome Nadal and Early Jesuit Art in Rome." *Art Bulletin* 58 (1976), pp. 424–33.

Buvelot 2004
Buvelot, Quentin, ed. *Albert Eckhout: A Dutch Artist in Brazil.* The Hague: Mauritshuis, 2004.

Cabildos de Quito 1934
Libro primero de Cabildos de Quito. Ed. José Rumazo González. 2 vols. Quito: C. Briz Sánchez, 1934.

Cadenas y Vicent 1985
Cadenas y Vicent, Vicente de. *Hacienda de Carlos V al fallecer en Yuste.* Madrid: Instituto Salazar y Castro [CSIC], 1985.

Caiger-Smith 1973
Caiger-Smith, Alan. *Tin-Glazed Pottery in Europe and the Islamic World: The Tradition of 1,000 Years in Maiolica, Faience, and Delftware.* London: Faber & Faber, 1973.

Calderón de la Barca 1843
Calderón de la Barca, Frances ("Fanny"). *Life in Mexico during a Residence of Two Years in That Country.* 2 vols. Boston: C. C. Little and J. Brown, 1843.

Calmotti 2003
Calmotti Crevanti, Franca. "La actividad del Hermano Adalberto Marterer en las misiones de Mojos." In *Investigaciones historicas sobre el Oriente Boliviano*, ed. Ingrid Steinbach de Loza and Franca Calmotti Crevanti, pp. 29–52. Santa Cruz de la Sierra, Bolivia: Facultad de Comunicación Social y Humanidades, 2003.

Calouste Gulbenkian Museum 2001
Calouste Gulbenkian Museum. *Exotica: The Portuguese Discoveries and the Renaissance Kunstkamme.* Lisbon: Calouste Gulbenkian Foundation, 2001.

Calvo 1992
Calvo, Thomas. "Los japoneses en Guadalajara durante el seiscientos mexicano." In *Sociedad y costumbres*, ed. José María Muriá and Jaime Olveda. Guadalajara: Instituto Nacional de Antropología e Historia, 1991.

Camargo-Moro 1995
Camargo-Moro, Fernanda de. "Macau e o Brasil / Um diálogo antigo a ser aprofundado."*Revista de Macau* 22 (1995), pp. 51–58.

Camille 1989
Camille, Michael. *The Gothic Idol: Ideology and Image-making in Medieval Art.* New York: Cambridge University Press, 1989.

Camman 1964
Camman, Schuyler. "Chinese Influence in Colonial Peruvian Tapestries." *Textile Museum Journal* 1 (1964), pp. 21–34.

Canabrava 1944
Canabrava, Alice Piffer. *O comércio português no Rio da Prata, 1580–1640.* São Paulo, 1944.

Cañizares-Esguerra 2001
Cañizares-Esguerra, Jorge. *How to Write the History of the New World: Histories, Epistemologies, and Identities in the Eighteenth-Century World.* Stanford, Calif.: Stanford University Press, 2001.

Canons and Decrees 1990
The Canons and Decrees of the Council of Trent. Trans. H. J. Schroeder. Rockford, Ill.: Tan, 1978.

Carletti 1594/1976
Carletti, Francesco. *Razonamientos de mi viaje alrededor del mundo (1594–1606).* Trans. Francisca Perujo. Mexico City: Universidad Nacional Autónoma de México, 1976.

Carneiro 1942
Carneiro, Newton da Silva. "A louça da companhia das Indias no Brasil." *Estudios Brasileiros* 5 (1942), pp. 151–77.

Carrera 2003
Carrera, Magali M. *Imagining Identity in New Spain: Race, Lineage, and the Colonial Body in Portraiture and Casta Paintings.* Austin: University of Texas Press, 2003.

Carrera Stampa 1954
Carrera Stampa, Manuel. *Los gremios mexicanos: la organización gremial en Nueva España, 1521–1861.* Mexico City: E.D.I.A.P.A.S.A., 1954.

Carreras and Rivera Chevremont 1969
Carreras, Carlos N., and José Rivera Chevremont. "Inventario de las obras pictóricas más importantes que se conservan en edificios públicos de San Juan de Puerto Rico, 1942." *Boletín de la Academia de Artes y Ciencias de Puerto Rico* 2 (1969), pp. 191–97.

Carrillo y Gariel 1949
Carrillo y Gariel, Abelardo. "El Cristo de Mexicaltzingo: técnica de las esculturas en caña." *Boletín del Instituto Nacional de Antropología e Historia* (Mexico City) (1949), pp. 14–19.

Carrillo y Gariel 1957
Carrillo y Gariel, Abelardo. *Evolución del mueble en México.* Mexico City: Instituto Nacional de Antropología e Historia, 1957.

Carrillo y Gariel 1966
Carrillo y Gariel, Abelardo. *El pintor Miguel Cabrera.* Mexico City: Instituto Nacional de Antropología e Historia, 1966.

Carvalho 1999
Carvalho, Anna Maria Fausto Monteiro de. *Mestre Valentim.* São Paulo: Cosac & Naify Edições, 1999.

Castedo 1969
Castedo, Leopoldo. *A History of Latin American Art and Architecture, from Pre-Columbian Times to the Present.* Trans. and ed. Phyllis Freeman. New York: Praeger, 1969.

Castelló Yturbide 1972
Castelló Yturbide, Teresa. "Maque o laca." *Artes de México* 153 (1972).

Castelló Yturbide 1980 "Cuadros"
Castello Yturbide, Teresa. "Los cuadros de mestizaje y sus pintores." In Antonio Pompa y Pompa et al., *De la historia: homenaje a Jorge Gurría Lacroix*, pp. 30–45. Mexico City: Universidad Nacional Autónoma de México, 1980.

Castelló Yturbide 1980 *Maque*
Castelló Yturbide, Teresa. *El arte del maque en México.* Exh. cat. Mexico City: Fomento Cultural Banamex, 1980.

Castelló Yturbide 1990
Castelló Yturbide, Teresa. "La indumentaria de las castas del mestizaje." *Artes de México* 8 (1990), pp. 73–78.

Castelló Yturbide 1993
Castelló Yturbide, Teresa. *El arte plumario en México.* Mexico City: Fomento Cultural Banamex, 1993.

Castelló Yturbide and Martínez del Río de Redo 1970
Castelló Yturbide, Teresa, and Marita Martínez del Río de Redo. *Biombos mexicanos.* Mexico City: Instituto Nacional de Antropología e Historia, 1970.

Castro 1980
Castro, María de los Angeles. *Arquitectura en San Juan de Puerto Rico (siglo XIX).* Río Piedras, Puerto Rico: Editorial Universitaria, 1980.

Castro Morales 1982
Castro Morales, Efraín. "Los Ramírez, una familia de artistas novohispanos del siglo XVII." *Boletín de monumentos históricos* 8 (1982).

Catálogo de pasajeros
Catálogo de pasajeros a Indias durante los siglos XVI, XVII y XVIII. Vols. 1–3, ed. Cristóbal Bermúdez Plata. Seville: Imprenta editorial de la Gavidia, 1940–46. Vols. 4–7, ed. Luis Romero Iruela and María del Carmen Galbis Díez. Madrid: Ministerio de Cultura, Dirección General de Bellas Artes, 1980–86.

Catálogo nacional 1988
Catálogo nacional de monumentos históricos muebles, Catedral de Puebla. 2 vols. Mexico City: Gobierno del Estado de Puebla, Instituto Nacional de Antropología e Historia, 1988.

Catedral de México 1986
Catedral de México. Mexico City: Secretaría de Desarrollo Urbano y Ecología, Fomento Cultural Banamex, 1986.

Catedral de Santo Domingo 1984
López Rodríguez, Nicolás de Jesús, et al. *La Catedral de Santo Domingo: basílica metropolitana primada de América; eje cultural del V centenario.* Santo Domingo: Gustavo Moré Guaschino, 1984.

Cazenave-Tapie 2003
Cazenave-Tapie, Christiane. "La producción artística en la Casa Profesa." In *Ad maiorem Dei gloriam: la Compañía de Jesús promotora del arte.* Mexico City: Universidad Iberoamericana, 2003.

CEHOPU 1989
Centro de Estudios Históricos de Obras Públicas y Urbanismo (CEHOPU). *La ciudad hispanoamericana: el sueño de un orden.* Madrid: CEHOPU, Ministerio de Obras Públicas y Urbanismo, 1989.

Cervantes 1939
Cervantes, Enrique A. *Loza blanca y azulejo de Puebla.* Mexico City: privately printed, 1939.

Chacón Torres 1973
Chacón Torres, Mario. *Arte virreinal en Potosí: fuentes para su historia.* Seville: Escuela de Estudios Hispanoamericanos, 1973.

Charlot 1962
Charlot, Jean. *Mexican Art and the Academy of San Carlos, 1785–1915.* Austin: University of Texas Press, 1962.

Christian 1981 *Apparitions*
Christian, William A., Jr. *Apparitions in Late Medieval and Renaissance Spain.* Princeton, N.J.: Princeton University Press, 1981.

Christian 1981 *Local*
Christian, William A., Jr. *Local Religion in Sixteenth-Century Spain.* Princeton, N.J.: Princeton University Press, 1981.

Ciancas and Meyer 1994
Ciancas, María E., and Bárbara Meyer. *La pintura de retrato colonial (siglos XVI–XVIII): catálogo del Museo Nacional de Historia.* Mexico City: Museo Nacional de Historia, 1994.

Cieza de León 1553/1986
Cieza de León, Pedro. *Crónica del Perú.* 1553; Lima: Pontificia Universidad Católica del Perú, 1986.

Cipriano 1927
Cipriano de Utrera, Fray. *Santo Domingo: dilucidaciones históricas.* 2 vols. Santo Domingo: Impr. de "Dios y Patria," 1927.

Circa 1492 1991
Levenson, Jay A. *Circa 1492: Art in the Age of Exploration.* Exh. cat. Washington, D.C.: National Gallery of Art, 1991.

Cisneros 1621/1999
Cisneros, Luis de. *Historia de el principio y origen, progresos, venidas a México, y milagros de la Santa Imagen de Nuestra Señora de los Remedios.* 1621; ed. Francisco Miranda. Mexico City: El Colegio de Michoacán, 1999.

Cleary and Connolly 2005
Cleary, Joe, and Claire Connolly, eds. *The Cambridge Companion to Modern Irish Culture.* Cambridge: Cambridge University Press, 2005.

Cline 1972
Cline, Howard F. "The *Relaciones Geográficas* of the Spanish Indies, 1577–1648." In Cline 1972–75, vol. 12.

Cline 1972–75
Cline, Howard F., ed. *Handbook of Middle American Indians*, vols. 12–15, *Guide to Ethnohistorical Sources.* Austin: University of Texas Press, 1972–75.

Cobo 1653/1890–95
Cobo, Bernabé. *Historia del Nuevo Mundo.* 4 vols. 1653; Seville: Rasco, 1890–95.

Codex Huejotzingo 1531/1974
Codex Huejotzingo. "The Harkness 1531 Huejotzingo Codex." In *The Harkness Collection in the Library of Congress: Manuscripts Concerning Mexico; A Guide,* trans. J. Benedict Warren, pp. 50–209. Washington, D.C.: Library of Congress, 1974.

Codex Huejotzingo 1531/1995
Huexotzinco Codex = Códice de Huexotzinco. [A Full-Color Facsimile of the Harkness 1531 Huexotzinco Codex.] Mexico City: Ediciones Multiarte; Washington, D.C.: Library of Congress, 1995.

Coelho 1998
Coelho, Beatriz. "Demônio ou Rei Branco?" *Boletim do CEIB* (Center for Studies on Brazilian Imagery) 2, no. 6 (1998), pp. 1–2.

Colecção Camargo 1991
Colecção Beatriz e Mário Pimenta Camargo. Exh. cat. Lisbon: Fundação Calouste Gulbenkian, 1991.

Coll y Toste 1914–27
Coll y Toste, Cayetano, ed. *Boletín histórico de Puerto Rico.* 14 vols. San Juan, Puerto Rico: Tipología Cantero, Fernández y Co., 1914–27.

Colores en los Andes 2003
Museo de Arte Hispanoamericano "Isaac Fernández Blanco," Buenos Aires. *Colores en los Andes: hacer, saber y poder.* Buenos Aires: Museo de Arte Hispanoamericano "Isaac Fernández Blanco," 2003.

Copper 1999
Copper as Canvas: Two Centuries of Masterpiece Paintings on Copper, 1575–1775. Exh. cat. Oxford: Oxford University Press, 1999.

Córdova 1831/1968
Córdova, Pedro Tomás de. *Memorias geográficas, históricas, económicas y estadísticas de la isla de Puerto Rico.* 6 vols. 2d ed. San Juan, Puerto Rico: Institute de Cultura Puertorriqueña, 1968.

Cornejo Bouroncle 1960
Cornejo Bouroncle, Jorge. *Derroteros de arte cuzqueño: datos para una historia del arte en el Perú.* Cuzco: Ediciones Inca, 1960.

Corona 1982
La Corona y las expediciones científica a América en el siglo XVIII. Exh. cat. Madrid: Instituto de Cooperación Iberoamericana, 1982.

Cortés 1986
Cortés, Hernán. *Letters from Mexico.* Trans. and ed. Anthony Pagden. Rev. ed. New Haven and London: Yale University Press, 1986.

Cortés 1993
Cortés, Hernán. *Cartas de relación.* Ed. Angel Delgado Gómez. Madrid: Castalia, 1993.

Cortés Alonso 1565/1973
Cortés Alonso, Vicenta, ed. *Pintura del gobernador, alcaldes y regidores de México: "Códice Osuna"* [1565]. 2 vols. Madrid: Ministerio de Educación y Ciencia, Dirección General de Archivos y Bibliotecas, 1973–76.

Cortina 1989
Cortina, Leonor. "Polvos azules de Oriente." *La Talavera de Puebla.* Artes de México 3. Mexico City: Artes de México, 1989.

Cortina Portilla 1986
Cortina Portilla, Manuel. *Algo sobre la plata en México en el siglo XVIII.* Mexico City: Grupo CONSA, 1986.

Cossío del Pomar 1928
Cossío del Pomar, Felipe. *Pintura colonial (escuela cuzqueña).* Cuzco, Peru: H. G. Rozas; Paris: Crété, 1928.

Couto 1872/1995
Couto, José Bernardo. *Diálogo sobre la história de la pintura en México.* 1872. With an essay by Juana Gutiérrez Haces and notes by Rogelio Ruiz Gomar. Mexico City: Consejo Nacional para la Cultura y las Artes, 1995.

Crawford 1916
Crawford, M. D. C. *Peruvian Fabrics.* New York: The Trustees of the American Museum of Natural History, 1916.

Cruz de Amenábar 1984
Cruz de Amenábar, Isabel. *Arte: lo mejor en la historia de la pintura y escultura en Chile.* Santiago, Chile: Editorial Antártica, 1984.

Cruz de Amenábar 1996
Cruz de Amenábar, Isabel. *El traje: transformaciones de una segunda piel.* Santiago: Ediciones Universidad Católica de Chile, 1996.

Cruz de Amenábar 2000
Cruz de Amenábar, Isabel. "El traje barroco en el Virreinato del Peru, 1650–1800: una metáfora del cuerpo." In *Emblemata áurea: la emblemática en el arte y la literatura del Siglo de Oro,* ed. Rafael Zafra and José Javier Azanza, pp. 111–26. Madrid: Akal, 2000.

Cruz Valdovinos 1992
Cruz Valdovinos, José Manuel. *Cinco siglos de platería sevillana.* Exh. cat. Seville: Ayuntamiento de Sevilla, 1992.

Cruz Valdovinos 2000
Cruz Valdovinos, José Manuel. *Platería en la Fundación Lázaro Galdiano.* Madrid: Fundación Lázaro Galdiano, 2000.

Cruz Valdovinos and Escalera Ureña 1993
Cruz Valdovinos, José Manuel, and Andrés Escalera Ureña. *La platería de la Catedral de Santo Domingo, primada de América.* Ed. Eugenio Pérez Montás. [Madrid]: Tabapress, 1993.

Cuadriello 1999 "Origen"
Cuadriello, Jaime. "El origen del reino y la configuración de su empresa: episodios y alegorías de triunfo y fundación." In *Pinceles* 1999, pp. 50–107.

Cuadriello 1999 "Reino"
Cuadriello, Jaime. "El reino y la construcción del pasado: los cuadros de historia." In *Siglos de oro* 1999, pp. 77–88.

Cuadriello 1999 "Tierra"
Cuadriello, Jaime. "Tierra de prodigios: la ventura como destino." In *Pinceles* 1999.

Cuadriello 2004 *Glorias*
Cuadriello, Jaime. *Las glorias de la República de Tlaxcala o la conciencia como imagen sublime.* Mexico City: Instituto de Investigaciones Estéticas, Universidad Nacional Autónoma de México, 2004.

Cuadriello 2004 "Moctezuma"
Cuadriello, Jaime. "Moctezuma a través de los siglos." In *El Imperio sublevado: monarquía y naciones en España e Hispanoamérica,* ed. Víctor Mínguez and Manuel Chist, pp. 95–122. Madrid: Consejo Superior de Investigaciones Científicas, 2004.

Cué 1994
Cué, Ana Laura. *Juegos de ingenio y agudeza: la pintura emblemática de la Nueva España,* pp. 133–49. Mexico City: Banamex-Accival, 1994.

Cummins 1995 "Lies"
Cummins, Thomas. "From Lies to Truth: Colonial Ekphrasis and the Act of Crosscultural Translation." In *Reframing the Renaissance: Visual Culture in Europe and Latin America, 1450–1650,* ed. Claire Farago, pp. 152–74. New Haven, Conn.: Yale University Press, 1995.

Cummins 1995 "Madonna"
Cummins, Tom. "The Madonna and the Horse: Becoming Colonial in New Spain and Peru." In *Native Artists and Patrons in Colonial Latin America* [= Phoebus 7 (1995)], ed. Emily Umberger and Tom Cummins, pp. 52–83. Tempe: College of Fine Arts, Arizona State University, 1995.

Cummins 1996
Cummins, Tom. "A Tale of Two Cities: Cuzco, Lima, and the Construction of Colonial Representation." In Fane 1996, pp. 157–70.

Cummins 2002
Cummins, Thomas B. F. *Toasts with the Inca: Andean Abstraction and Colonial Images on Quero Vessels.* Ann Arbor: University of Michigan Press, 2002.

Cummins 2003 "Imitación"
Cummins, Thomas. "Imitación e invención en el barroco peruano." In Mujica Pinilla et al. 2003, pp. 30–59.

Cummins 2004
Cummins, Thomas B. F. "Silver Threads and Golden Needles: The Inca, the Spanish, and the Sacred World of Humanity." In Phipps et al. 2004, pp. 2–15.

Cummins et al. 2005
Cummins, Thomas, et al. *Los incas, reyes del Perú.* Colección Arte y Tesoros del Perú. Lima: Banco de Crédito, 2005.

Curcio-Nagy 1996
Curcio-Nagy, Linda A. "Native Icon to City Protectress to Royal Patroness: Ritual, Political Symbolism, and the Virgin of Remedies." *The Americas* 52 (1996), pp. 367–91.

Curiel 1994
Curiel, Gustavo. "El ajuar doméstico del tornaviaje." In *México en el mundo de las colecciones de arte: Nueva España 1,* pp. 166–67. Mexico City: Azabache, 1994.

Curiel 1999
Curiel, Gustavo. "Los biombos novohispanos: escenografías de poder y transculturación en el ámbito doméstico." In *Viento detenido* 1999, pp. 24–32.

Dalton Palomo and Loera y Chávez 1997
Dalton Palomo, Margarita, and Verónica Loera y Chávez, eds. *Historia del arte de Oaxaca,* vol. 2, *Colonia y siglo XIX.* Oaxaca: Instituto Oaxaqueña de la Culturas, 1997.

Danes 1942
Danes, Gibson. "Baltasar de Echave Ibía: Some Critical Notes on the Stylistic Character of His Art." *Anales del Instituto de Investigaciones Estéticas* (Mexico City) 9 (1942), pp. 22–26.

Davidson 1971
Davidson, Gustav. *A Dictionary of Angels, Including the Fallen Angels.* New York: Free Press, Collier-Macmillan, 1971.

Dávila 1960
Dávila, Arturo V. "Notas sobre el arte sacro en el pontificado del ilustrísimo señor de Arizmendi (1803–1814)." *Revista del Instituto de Cultura Puertorriqueña* 9 (1960), p. 49.

Dávila 1971
Dávila, Arturo V. *José Campeche, 1751–1809*. San Juan, Puerto Rico: Instituto de Cultura Puertorriqueña, 1971.

Dávila 1973
Dávila, Arturo V. "The Early Painting Tradition of Puerto Rico." In *Art Heritage of Puerto Rico* 1973, pp. 32–33.

Dávila 1985 "Conciencia"
Dávila, Arturo V. "José Campeche: conciencia de lo puertorriqueño." *El Nuevo Día* (San Juan, Puerto Rico), January 20, 1985.

Dávila 1985 *Exposición*
Dávila, Arturo V. *Exposición de oleos de José Campeche*. Exh. cat. San Juan, Puerto Rico: Instituto de Cultura Puertorriqueña, 1985.

Dávila 1985 "Renacer"
Dávila, Arturo V. "El Renacer de Campeche." *El Nuevo Día* (San Juan, Puerto Rico), October 6, 1985.

Dávila 1986
Dávila, Arturo V. "El asedio de los ingleses en 1797." *El Nuevo Día* (San Juan, Puerto Rico), May 11, 1986, pp. 20–22.

Dean 1996
Dean, Carolyn. "The Renewal of Old World Images and the Creation of Colonial Peruvian Visual Culture." In Fane 1996, pp. 171–82.

Dean 1999
Dean, Carolyn. *Inka Bodies and the Body of Christ: Corpus Christi in Colonial Cuzco, Peru*. Durham, N.C.: Duke University Press, 1999.

Dean 2002
Dean, Carolyn. *Los cuerpos de los incas y el cuerpo de Cristo: el Corpus Christi en el Cuzco colonial*. Trans. Javier Flores Espinoza. Lima: Universidad Nacional Mayor de San Marcos, 2002. Originally published as *Inka Bodies and the Body of Christ: Corpus Christi in Colonial Cuzco, Peru* (Durham, N.C.: Duke University Press, 1999).

Debret 1834–39
Debret, Jean Baptiste. *Voyage pittoresque et historique au Brésil*. Paris: Didot Frères, 1834–39.

Delgado 1998
Delgado, Osiris. "Francisco Oller y Cestero: The Shaping of the Puerto Rican Cultural Identity." In Hermandad de Artistas Gráficos de Puerto Rico 1998, pp. 50–53.

Delgado 2004
Delgado, Lelia. *Vida indígena en el Orinoco*. Caracas: Fundación Cisneros/Editorial Planeta, 2004.

Delgado Mercado 1969
Delgado Mercado, Osiris. *Sinópsis histórica de los artes plásticas en Puerto Rico*. San Juan, Puerto Rico: Instituto de Cultura Puertorriqueña, 1969.

Dellepiane 1917
Dellepiane, Antonio. *La Tarja de Potosí*. Buenos Aires: Coni, 1917.

Desroches et al. 1996
Desroches, Jean-Paul, et al., eds. *Treasures of the San Diego*. New York: Elf Aquitaine International Foundation, 1996.

Díaz de la Vega 1782
Díaz de la Vega, José Mariano. "Memorias piadosas de la nación yndiana recogidas de varios Autores por el P. F. Joseph Díaz de la Vega Predicador grāl è Hijo de la Prov.a del Santo Evangelio de Mexico" (1782), Real Academia de la Historia, Madrid, Col. Boturini, MS 9/4886.

Díaz del Castillo 1956
Díaz del Castillo, Bernal. *The Discovery and Conquest of Mexico, 1517–1521*. Ed. Genaro García. Trans. A. P. Maudslay. New York: Farrar, Straus and Cudahy, 1956.

Díaz del Castillo 1963
Díaz del Castillo, Bernal. *The Conquest of New Spain*. Trans. J. M. Cohen. Harmondsworth, U.K.: Penguin, 1963.

Díaz del Castillo 1983
Díaz del Castillo, Bernal. *Historia verdadera de la conquista de la Nueva España*. Ed. Carmelo Sáenz de Santa María. Madrid: CSIC, 1983.

Dibble 1981
Dibble, Charles E. *Codex en Cruz*. Salt Lake City: University of Utah Press, 1981.

Dictionary of Art 1996
The Dictionary of Art. Ed. Jane Turner. 34 vols. New York: Grove's Dictionaries, 1996.

Diez Barroso 1921
Diez Barroso, Francisco. *El arte en Nueva España*. Mexico City: F. Diez Barroso, 1921.

Disselhoff and Linné 1961
Disselhoff, Hans Dietrich, and Sigvald Linné. *The Art of Ancient America: Civilizations of Central and South America*. Trans. Ann E. Keep. New York: Crown Publishers, 1961.

Divino pastor 2001
El divino pastor: la creación de María Guadalupe en el taller Celestial. Ed. Jaime Cuadriello. Exh. cat. Mexico City: Museo de la Basílica de Guadalupe, 2002.

Documentos 1935
Documentos para la historia del arte en Andalucía, vol. 8, *Pintores y doradores*. Ed. Antonio Muro Orégon. Seville: Facultad de Filosofía y Letras, 1935.

Donkin 1977
Donkin, R. A. "Spanish Red: An Ethnogeographical Study of Cochineal and the Opuntia Cactus." *Transactions of the American Philosophical Society* 67 (1977), pp. 1–84.

Duarte 1977
Duarte, Carlos F. *Domingo Gutiérrez: el maestro del rococó en Venezuela*. Caracas: Ediciones Equinoccio, Universidad Simón Bolívar, 1977.

Duarte 1996
Duarte, Carlos F. *Juan Pedro López: maestro de pintor y dorador, 1724–1787*. Caracas: Galería de Arte Nacional, Fundación Polar, 1996.

Duarte 1998
Duarte, Carlos F. *Catálogo de obras artísticas mexicanas en Venezuela: período hispánico*. Mexico City: Universidad Nacional Autónoma de México, 1998.

Duarte 1999
Duarte, Carlos F. *Un asiento venezolano llamado butaca*. Caracas: Centro de Arte La Estancia, Acción Cultural PDVSA, 1999.

Duarte 2004
Duarte, Carlos F. *Grandes maestros carpinteros del período hispánico venezolano*. Caracas: Cantv, 2004.

Duarte and Gasparini 1989
Duarte, Carlos F., and Graziano Gasparini. *Historia de la Catedral de Caracas*. Caracas: Armitano, 1989.

Duarte and Irazábal 1966
Duarte, Carlos F., and Fernando Irazábal. *Muebles venezolanos: siglos XVI, XVII y XVIII*. Caracas: Grupo Editor Cuatro, 1966.

Dujovne 1972
Dujovne, Marta. *La conquista de México por Miguel Gonzales*. Buenos Aires: Asociación Amigos del Museo Nacional de Bellas Artes de Buenos Aires, 1972.

Dujovne 1984
Dujovne, Marta. *Las pinturas con incrustaciones de concha nácar*. Mexico City: Universidad Nacional Autónoma de México, 1984.

Duncan 1986
Duncan, Barbara. "Statue Paintings of the Virgin." In *Gloria in Excelsis: The Virgin and Angels in Viceregal Painting of Peru and Bolivia*. Exh. cat. New York: Center for Inter-American Relations, 1986.

Duque Gómez 1990
Duque Gómez, Luis. "Oro y esmeraldas en el culto religioso de indios y españoles." In *Oribes* 1990, pp. 34–42.

Durán 1967
Durán, Diego. *Historia de las Indias de Nueva España e islas de la Tierra Firme*, vol. 2. Mexico City: Porrúa, 1967.

Durand 1982
Durand, José, ed. *Gaceta de Lima de 1756 a 1762 de Superunda a Amat*. 2 vols. Lima: Academia Nacional de la Historia, 1982.

Dürer 1520/1937
Dürer, Albrecht. *Journal de voyage dans les Pay-Bas* (1520). Ed. J. A. Goris and G. Martier. Brussels: Éditions de la Connaissance, 1937.

Dusenberry 1947
Dusenberry, William H. "Woolen Manufacture in Sixteenth-Century New Spain." *The Americas* 4 (1947), pp. 223–34.

Edgerton 2001
Edgerton, Samuel Y. *Theaters of Conversion: Religious Architecture and Indian Artisans in Colonial Mexico*. Albuquerque: University of New Mexico Press, 2001.

Edwards 1996
Edwards, Clive D. *Eighteenth-Century Furniture*. New York: Manchester University Press, 1996.

Eguiara y Eguren 1755/1986
Eguiara y Eguren, Juan José. *Biblioteca mexicana* (1755). Ed. Ernesto de la Torre Villar. Mexico City: Universidad Nacional Autónoma de México, 1986.

El arte en el Perú 2001
Museo de Arte de Lima. *El arte en el Perú: obras de arte en la colección del Museo de Arte de Lima*. Lima: Museo de Arte de Lima, 2001.

El Maque 1972
El Maque: lacas de Michoacán, Guerrero y Chiapas. Artes de México (Mexico City) 19, no. 153. Mexico City: Artes de México, 1972.

El Mundo 1960
"Cuadro representa construcción de calle colonial de San Juan." *El Mundo* (San Juan, Puerto Rico), August 15, 1960.

Entre el infierno y la gloria 2003
Entre el infierno y la gloria. Restauración de dos lienzos monumentales "El Infierno" y "La Gloria." Templo de Carabuco. La Paz, Bolivia: Viceministerio de Desarrollo Económico, 2003.

Escalante 1997
Escalante, Pablo. "El patrocinio del arte indocristiano en el siglo XVI: la iniciativa de las autoridades indígenas en Tlaxcala y Cuauhtinchan." In *Patrocinio, colección, y circulación de las artes*, ed. Gustavo Curiel, pp. 215–35. Mexico City: Universidad Nacional Autónoma de México, 1997.

Escamilla González, 2000
Escamilla González, Iván. "El siglo de oro vindicado: Carlos de Sigüenza y Góngora, El Conde de Galve y el tumulto de 1692." In *Carlos de Sigüenza y Góngora: Homenaje 1700–2000*, ed. Alicia Mayer. Mexico City: Instituto de Investigaciones Históricas, Universidad Nacional Autónoma de México, 2000–2002.

Escobosa de Rangel 1993
Escobosa de Rangel, Magdalena. *La Casa de los Azulejos: reseña histórica del palacio de los condes del Valle de Orizaba.* Reprinted Mexico City: San Angel Ediciones, 1993.

Escudero de Terán 1992
Escudero de Terán, Ximena. *América y España en la escultura colonial quiteña: historia de un sincretismo.* Quito: Ediciones del Banco de los Andes, 1992.

España 2003
España y América: un océano de negocios, 1503–2003. Exh. cat. Seville: Real Alcázar and Casa de la Provincia, 2003.

Esquivel y Navia 1980
Esquivel y Navia, Diego de. *Noticias cronológicas de la gran ciudad del Cusco.* 2 vols. Lima: Fundación Augusto N. Wiese, Banco Wiese, 1980.

Estabridis 2003
Estabridis, Ricardo. "El retrato del siglo XVIII en Lima como símbolo de poder." In Mujica Pinilla et al. 2003, pp. 136–71.

Estabridis Cárdenas 1989
Estabridis Cárdenas, Ricardo. "Influencia italiana en la pintura virreinal." In *Pintura en el virreinato del Perú* 1989.

Estabridis Cárdenas 2004
Estabridis Cárdenas, Ricardo. "La fiesta y el arte del siglo XVIII en la Ciudad de los Reyes." In *Perú indígena* 2004, pp. 119–24.

Estella Marcos 1989
Estella Marcos, Margarita. "Tráfico artístico entre Filipinas y España, vía Acapulco." In *El Extremo Oriente Ibérico*, ed. Francisco de Solano. Madrid: Agencia Española de Cooperación Internacional in collaboration with Centro de Estudios Históricos, Departamento de Historia de América, CSIC, 1989.

Estella Marcos 1990
Estella Marcos, Margarita. *Juan Bautista Vázquez el Viejo en Castilla y América.* Madrid: Consejo Superior de Investigaciones Científicas, 1990.

Estenssoro Fuchs 2003
Estenssoro Fuchs, Juan Carlos. *Del paganismo a la santidad: la incorporación de los indios del Perú al catolicismo, 1532–1750.* Lima: Instituto Francés de Estudios Andinos, 2003.

Estenssoro Fuchs 2005
Estenssoro Fuchs, Juan Carlos. "Construyendo la memoria: la figura del inca y el reino del Perú, de la conquista a Túpac Amaru II." In Cummins et al. 2005.

Esteras Martín 1987
Esteras Martín, Cristina. "Aproximaciones a la platería virreinal hispanoamericana." In *Pintura, escultura, y artes útiles en Iberoamérica, 1500–1825*, ed. Ramón Gutiérrez, pp. 377–403. Madrid: Cátedra, 1987.

Esteras Martín 1989
Esteras Martín, Cristina. "Platería virreinal novohispana, siglos XVI–XIX." In *El arte de la platería novohispana, 500 años.* Mexico City: Centro Cultural/Arte Contemporáneo, 1989–1990.

Esteras Martín 1991
Esteras Martín, Cristina. "Orfebrería americana en Andalucía." In *Gran enciclopedia de España y América: los Andaluces y América.* Madrid: Espasa Calpe-Argantonio, 1991.

Esteras Martín 1992 *Marcas*
Esteras Martín, Cristina. *Marcas de platería hispanoamericana, siglos XVI–XX.* Madrid: Tuero Ediciones, 1992.

Esteras Martín 1992 *Mayer*
Esteras Martín, Cristina. *La platería del Museo Franz Mayer: obras escogidas, siglos XVI–XIX.* Mexico City: Museo Franz Mayer, 1992.

Esteras Martín 1992 "Miguel"
Esteras Martín, Cristina. "Miguel Guerra, platero de Guatemala (1773–1802)." *Cuadernos de Arte Colonial* (Museo de América, Madrid) 8 (1992).

Esteras Martín 1993 *Arequipa*
Esteras Martín, Cristina. *Arequipa y el arte de la platería: siglos XVI–XX.* Madrid: Ediciones Tuero, 1993.

Esteras Martín 1993 "Platería mexicana"
Esteras Martín, Cristina. "La platería mexicana en España: arte, devoción, y triunfo social." *Artes de México* 22 (1993–94).

Esteras Martín 1994 "Peruvian"
Esteras Martín, Cristina. "A Peruvian Monstrance of 1649." *Metropolitan Museum Journal* 29 (1994), pp. 71–76.

Esteras Martín 1994 "Plata"
Esteras Martín, Cristina. "Plata labrada mexicana en España: del Renacimiento al Neoclasicismo." In *México en el mundo de las colecciones de arte: Nueva España 2.* Mexico City: Azabache, 1994.

Esteras Martín 1994 *Platería*
Esteras Martín, Cristina. *La platería en el Reino de Guatemala, siglos XVI–XIX.* Guatemala City: Fundación Albergue Hermano Pedro, 1994.

Esteras Martín 1997 *Marcas*
Esteras Martín, Cristina. *Las marcas de platería hispanoamericana: siglos XVI–XX.* Madrid: Ediciones Tuero, 1992.

Esteras Martín 1997 "Orfebrería (Peru)"
Esteras Martín, Cristina. "La orfebrería barroca en Perú y Bolivia." In Gutiérrez 1997, pp. 167–77.

Esteras Martín 1997 "Orfebrería (Río)"
Esteras Martín, Cristina. "La orfebrería barroca en el Río de la Plata, Paraguay, y Chile." In Gutiérrez 1997.

Esteras Martín 1997 *Peru*
Esteras Martín, Cristina. *Platería del Perú virreinal, 1535–1825.* Madrid: BBV; Lima: Banco Continental, 1997.

Esteras Martín 1999
Esteras Martín, Cristina. "El oro y la plata americanos, del valor económico a la expresión artística." In *El oro y la plata de las Indias en la época de los Austrias.* Madrid: Fundación ICO, 1999.

Esteras Martín 2000 *Fisa*
Esteras Martín, Cristina. *La platería de la Colección Várez Fisa: obras escogidas, siglos XV–XVIII.* Madrid: Tf. Editores, 2000.

Esteras Martín 2000 "Platería"
Esteras Martín, Cristina. "La platería hispanoamericana: arte y tradición cultural." In *Historia del arte iberoamericano*, ed. Ramón Gutiérrez and Rodrigo Gutiérrez Viñuales. Barcelona: Lunwerg, 2000.

Esteras Martín 2004 "Acculturation"
Esteras Martín, Cristina. "Acculturation and Innovation in Peruvian Viceregal Silverwork." In Phipps et al. 2004, pp. 59–71.

Esteras Martín 2004 "Altar"
Esteras Martín, Cristina. "Altar frontal." In Phipps et al. 2004.

Esteras Martín 2004 "Bernegales"
Esteras Martín, Cristina. "Sobre bernegales mexicanos del siglo XVI." In *Estudios de platería, San Eloy 2004*, ed. Jesús Rivas Carmona, pp. 150–53. Murcia: Universidad de Murcia, 2004.

Esteras Martín 2005
Esteras Martín, Cristina. *La colección Alorda-Derkens: platería de los siglos XIV–XVII (obras escogidas).* Barcelona and London: AD Alorda Derksen, 2005.

Estrada de Gerlero 1986
Estrada de Gerlero, Elena I. "Sacristía." In *Catedral de México* 1986, pp. 377–409.

Estrada de Gerlero 1994 "Castas"
Estrada de Gerlero, Elena I. "Las pinturas de castas, imágenes de una sociedad variopinta." In *México en el mundo de las colecciones de arte*, vols. 3–4, *Nueva España*, vol. 2, pp. 79–85. Mexico City: Grupo Azabache, 1994.

Estrada de Gerlero 1994 "Plumaria"
Estrada de Gerlero, Elena I. "La plumaria: expresión artística por excelencia." In *México en el mundo de las colecciones de arte*, vols. 3–4, *Nueva España*, vol. 1, pp. 73–117. Mexico City: El Gobierno de la República, 1994.

Estrada de Gerlero 1995
Estrada de Gerlero, Elena I. "Las reformas borbónicas y las pinturas de castas novohispanas." In *El arte y la vida cotidiana*, pp. 217–52. XVI Coloquio Internacional de Historia del Arte. Mexico City: Instituto de Investigaciones Estéticas, UNAM, 1995.

Exposición de óleos de José Campeche 1985
Instituto de Cultura Puertorriqueña and the Fundación Nacional de las Artes, San Juan. *Exposición de óleos de José Campeche en la Sala Central del Arsenal en San Juan.* Exh. cat. San Juan: Instituto de Cultura Puertorriqueña, 1985.

Exposición Histórico-Americana 1893
Catálogo general de la Exposición Histórico-Americana de Madrid, 1892. 2 vols. Exh. cat. Madrid: Est. Tip. "Sucesores de Rivadeneyra," 1893.

Exposición nacional 1893
Exposición nacional: objetos exhibidos en las secciones de Bellas Artes, Minería e Industrial. Lima: Imprenta de El Comercio por J.R. Sánchez, 1893.

Fagiolo 1975
Fagiolo, Marcello. "La fondazione delle città latino-americane: gli archetipi della Giustizia e della Fede." *Psicon* 5 (1975), pp. 34–58.

Fajardo de Rueda 1992
Fajardo de Rueda, Marta. *Santa Bárbara: conjuro de las tormentas.* Exh. cat. Bogotá: Banco de la República, 1992.

Fajardo de Rueda 1994
Fajardo de Rueda, Marta. "Gregorio Vásquez de Arce y Ceballos." In *Gran Enciclopedia de Colombia*, pp. 618–19. Bogotá: Círculo de Lectores, Printer Colombiana, 1994.

Fajardo de Rueda 1999
Fajardo de Rueda, Marta. *El arte colonial neogranadina: a la luz del estudio iconográfico e iconológico.* Bogotá: Convenio Andrés Bello, 1999.

Fajardo de Rueda 2004
Fajardo de Rueda, Marta. "Milenarismo y arte: la presencia del pensamiento de Joaquín di Fiore en la Nueva Granada." *Revista Palimpsesto* (Universidad Nacional de Colombia, Bogotá).

Falkenburg et al. 1999
Falkenburg, Reindert, et al., ed. *Kunst voor de markt, 1500–1700 / Art for the Market, 1500–1700.* Nederlands

kunsthistorish jaarboek 50. Zwolle, Netherlands: Waanders, 1999.

Fane 1996
Fane, Diane, ed. *Converging Cultures: Art and Identity in Spanish America.* Exh. cat. New York: Brooklyn Museum in association with Harry N. Abrams, 1996.

Feest and Kann 1986
Feest, Christian, and Peter Kann. *Gold und Macht: Spanien in der Neuen Welt; eine Austellung anlässlich des 500. Jahrestages der Entdeckung Amerikas.* Exh. cat. Vienna: Kremayr and Scheriau, 1986.

Fernández 1943
Fernández, Justino. "Rubens y José Juárez." *Anales del Instituto de Investigaciones Estéticas* 3 (1943), pp. 51–57.

Fernández 1988
Fernández, Miguel Ángel. *Historia de los museos de México.* Mexico City: Promotora de Comercialización Directa, 1988.

Fernández de Piedrahita 1688
Fernández de Piedrahita, Lucas. *Historia general de las conquistas del Nuevo Reyno de Granada.* Antwerp, Belgium: J. B. Verdussen, 1688.

Fernández Gracia 2002
Fernández Gracia, Ricardo. *Arte, devoción y política: la promoción de las artes en torno a Sor María de Ágreda.* Soria, Spain: Diputación Provincial de Soria, 2002.

Fernández Jaramillo 1968
Fernández Jaramillo, Germán. *Arte religioso en la Nueva Granada.* Bogotá: Ediciones Sol y Luna, 1968.

Fernández Juncos 1914
Fernández Juncos, Manuel. "José Campeche, pintor puertorriqueño." *Revista de las Antillas* (San Juan, Puerto Rico) 2, no. 4 (1914), pp. 69–79.

Fernández Méndez and Cárdenas Ruiz 1972
Fernández Méndez, Eugenio, and Manuel Cárdenas Ruiz. "José Campeche en la pintura americana del siglo XVIII." *La Torre* (Universidad de Puerto Rico, Río Piedras) 20, nos. 77–78 (1972), pp. 53–80.

Ferrez 1965
Ferrez, Gilberto. *A muito leal e heróica cidade de São Sebastião do Rio de Janeiro.* Paris: Marcel Mouillot, 1965.

Fisher 1981
Fisher, John. "Imperial 'Free Trade' and the Hispanic Economy, 1778–1796." *Journal of Latin American Studies* 13 (1981), pp. 21–56.

Fleming 1982
Fleming, John V. *From Bonaventure to Bellini: An Essay in Franciscan Exegesis.* Princeton, N.J.: Princeton University Press, 1982.

Flexor 1999
Flexor, Maria Helena Ochi. "Nouvel aperçu sur la sculpture brésilienne." In *Brésil baroque* 1999.

Florencia 1692
Florencia, Francisco de. *Narracion de la marabillosa aparicion que hizo San Miguel a Diego Lazaro de San Francisco . . .* Seville: Imprenta de las Siete Revueltas, 1692.

Florencia 1685/1745
Florencia, Francisco de. *La milagrosa invencion de un Thesoro Escondido . . . 1685.* Seville: Imprenta de las Siete Revueltas, 1745.

Flores Ochoa et al. 1993
Flores Ochoa, Jorge A., et al. *Pintura mural en el sur andino.* Lima: Banco de Crédito del Perú, 1993.

Flores Ochoa, et al. 1998
Flores Ochoa, Jorge, et al. *Qeros: arte inka en vasos ceremoniales.* Lima: Banco de Crédito, 1998.

Fonseca 1995
Fonseca, Sonia Maria. "Orientalismos no Barroco em Minas Gerais e a circularidade cultural entre o Oriente e o Ocidente." *Revista de Cultura* (Macau) 22 (1995), pp. 109–16.

Franceschi 1988
Franceschi, Humberto M. *O ofício da prata no Brasil: Rio de Janeiro.* Rio de Janeiro: Studio HMF, 1988.

Frézier 1717
Frézier, Amédée François. *A Voyage to the South-Sea and along the Coasts of Chili and Peru in the Years 1712, 1713, and 1714.* London: Jonah Bowyer, 1717.

Fricciones 2000
Fricciones: versiones del sur. Exh. cat. Madrid: Museo Nacional Centro de Arte Reina Sofía, 2000.

Friedemann 1985
Friedemann, Nina S. de. "El barniz de Pasto: arte y rito milenario." *Lámpara* 23 (1985), pp. 15–18.

Frota 1982
Frota, Lélia Coelho. *Ataíde: vida e obra de Manuel da Costa Ataíde.* Rio de Janeiro: Nova Frontier, 1982.

Frota 1989
Frota, Lélia Coelho. "The Ex-Voto of Northeastern Brazil: Its Antecedents and Contemporary Expression." In Bercht et al. 1989.

Fulcanelli 1973
Fulcanelli (pseud.). *El misterio de las catedrales.* Trans. J. Ferrer Aleu. Barcelona: Plaza y Janés, 1973.

Gage 1648/1958
Gage, Thomas. *Travels in the New World* (1648). Ed. J. Eric S. Thompson. Norman: University of Oklahoma Press, 1958.

Galdiano 2002
Obras maestras de la Colección Lázaro Galdiano. Exh. cat. Madrid: Fundación Santander Central Hispano, 2002–2003.

García Fernández 1989
García Fernández, José Luís. "Trazas urbanas hispano-americanas y sus antecedentes." In CEHOPU 1989, pp. 213–21.

García Sáiz 1978
García Sáiz, María Concepción. "Pinturas costumbristas del mexicano Miguel Cabrera." *GOYA* (Madrid) 142 (1978), pp. 186–93.

García Sáiz 1980
García Sáiz, María Concepción. *La pintura colonial en el Museo de América,* vol. I, *La escuela mexicana.* Madrid: Ministerio de Cultura, 1980.

García Sáiz 1985
García Sáiz, María Concepción. "La imagen del mestizaje." In *El Mestizaje americano: octubre–diciembre 1985,* pp. 45–55. Exh. cat. Madrid: Museo de América, [1985].

García Sáiz 1989
García Sáiz, María Concepción. *Las castas mexicanas: un género pictórico americano.* Milan: Olivetti, 1989.

García Sáiz 1991
García Sáiz, María Concepción. "The Contribution of Colonial Painting to the Spread of the Image of America." In *America, Bride of the Sun,* pp. 171–78.

García Sáiz 1992
García Sáiz, María Concepción. "El desarrollo de las artes figurativas en la América hispana." In *Influencias artísticas entre España y América,* ed. José E. García Melero. Madrid: Mapfre, 1992.

García Sáiz 1994
García Sáiz, Maria Concepción. "La conquista de México por Hernán Cortés: una iconografía al servicio de los intereses encontrados de criollos y peninsulare." In *Actas del Congreso Internacional: Llerena Extremadura y América,* pp. 213–222. Llerena, Spain: Ayuntamiento, 1994.

García Sáiz 1996
García Sáiz, María Concepción. "The Artistic Development of Casta Painting." In *New World Orders: Casta Painting and Colonial Latin America,* pp. 30–41. Exh. cat. New York: Americas Society Art Gallery, 1996.

García Sáiz 1998
García Sáiz, Concepción. "La interpretación de los modelos europeos en las artes de tradición indígena." In *Felipe II y el arte de su tiempo,* pp. 293–303. Madrid: Fundación Argentaria; Mexico City: UNAM Ediciones; Madrid: Visor, 1998.

Garcia Sáiz 2002
Garcia Sáiz, María Concepción. "Una contribución andina al barroco iberoamericano." In Mujica Pinilla et al. 2002, pp. 201–17.

García Sáiz 2003
García Sáiz, María Concepción. "Mexican Ceramics in Spain." In *Cerámica y Cultura: The Story of Spanish and Mexican Mayólica,* ed. Robin Farwell Gavin et al.; trans. Kenny Fitzgerald. Albuquerque: University of New Mexico Press, 2003.

García Sáiz 2004
García Sáiz, María Concepción. *Un arte nuevo para un Nuevo Mundo: la colección virreinal del Museo de América en Bogotá.* Madrid: Museo de América, 2004.

García Sáiz and Albert de Leon 1991
García Sáiz, María Concepción, and María Angeles Albert de Leon. "La cerámica de Tonalá en las colecciones europeas." In Alberto Ruy-Sánchez et al., *Tonalá, sol de barro.* Mexico City: Banco Cremi, 1991.

García Sáiz and Albert de Leon 1998
García Sáiz, María Concepción, and María Angeles Albert de Leon. "Exotismo y belleza de una cerámica." *Artes de Mexico* n.s. 14 (Winter 1991), pp. 34–49, 83–85. 2d ed. *Cerámica de Tonalá* (1998).

García Sáiz and Barrio Moya 1987
García Sáiz, María Concepción, and José Luis Barrio Moya. "Presencia de cerámica colonial mexicana en España." *Anales del Instituto de Investigaciones Estéticas* (UNAM) 58 (1987).

García Sáiz and Gutiérrez Haces 2004
García Sáiz, María Concepción, and Juana Gutiérrez Haces, eds. *Tradición, estilo o escuela en la pintura Ibero-americana, siglos XVI–XVIII.* Mexico City: Universidad Nacional Autónoma de México, 2004.

García Sanz y Sánchez Hernández 1999
García Sanz, Ana, and María Leticia Sánchez Hernández. *Conventos de las Descalzas Reales y de la Encarnación: dos clausuras de Madrid.* Madrid: Editorial Patrimonio Nacional, 1999.

Gaya Nuño 1965
Gaya Nuño, Juan A. "José Campeche: el colega de Goya en Puerto Rico." *Goya* 67 (1965), pp. 3–11.

Gaya Nuño 1972
Gaya Nuño, Juan A. "Precisiones en torno de José Campeche." *La Torre* (Universidad de Puerto Rico, Río Piedras) 22, nos. 77–78 (1972), pp. 29–42.

Gaya Nuño 1980
Gaya Nuño, Juan A. "La pintura en Puerto Rico durante el siglo XVIII." *Revista del Museo de Antropología, Historia y Arte de la Universidad de Puerto Rico* 2 (1980), pp. 14–26.

Gemelli Carreri 1699/1927
Gemelli Carreri, Giovanni Francesco. *Viaje a la Nueva España* (1699–1700). Trans. José Maria de Agreda y Sanchez. Mexico City: Sociedad de bibliófilos mexicanos, 1927.

Gerbi 1993
Gerbi, Antonello. *La disputa del Nuevo Mundo: historia de una polémica, 1750–1900.* Mexico City: Fondo de Cultura Económica, 1993.

Gerlero 1994
Gerlero, Elena Isabel Estrada de. "'Pavana' en un biombo de las adias." In Vargaslugo and Guadalupe Victoria 1994, pt. 2, pp. 491–522.

Gerlero 1996
Gerlero, Elena Isabel Estrada de. "La representación de los indios gentiles en las pinturas de castas novohispanas." In Katzew et al. 1996, pp. 124–31.

Gerlero et al. 1992
Gerlero, Elena Isabel Estrada de, et al. *El retrato civil en Nueva España.* Mexico City: Museo de San Carlos, CONACULTA, INBA, 1992.

Gibson 1952
Gibson, Charles. *Tlaxcala in the Sixteenth Century.* Stanford, Calif.: Stanford University Press, 1952.

Gibson 1960
Gibson, Charles. "The Aztec Aristocracy in Colonial Mexico." *Comparative Studies in Society and History* 2 (1960), pp. 169–96.

Gibson 1964
Gibson, Charles. *Aztecs under Spanish Rule: A History of the Indians of the Valley of Mexico, 1519–1810.* Stanford, Calif.: Stanford University Press, 1964.

Gil Tovar 1980
Gil Tovar, Francisco. *La obra de Gregorio Vásquez.* Bogotá: Carlos Valencia Editores; Museo de Arte Moderno, 1980.

Gil Tovar 1986
Gil Tovar, Francisco. "Orfebrería, platería y bordado." In *Historia del arte colombiano*, vol. 4. Bogotá: Salvat, 1986.

Giraldo Jaramillo 1948
Giraldo Jaramillo, Gabriel. *La pintura en Colombia.* Mexico City: Fondo de Cultura Económica, 1948.

Gisbert 1980
Gisbert, Teresa. *Iconografía y mitos indígenas en el arte.* La Paz: Gisbert y Cía, 1980.

Gisbert 1983
Gisbert, Teresa. "La fiesta y la alegoría en el virreinato peruano." In *Arte efímero* 1983, pp. 145–89.

Gisbert 1992
Gisbert, Teresa. "The Artistic World of Felipe Guamán Poma." In *Guaman Poma de Ayala: The Colonial Art of an Andean Author.* New York: Americas Society, 1992.

Gisbert 1994
Gisbert, Teresa. *Iconografía y mitos indígenas en el arte.* La Paz: Editorial Gisbert y Cia, 1994.

Gisbert 1999
Gisbert, Teresa. *El paraíso de los pájaros parlantes: la imagen del otro en la cultura andina.* La Paz: Plural Editores, Universidad de Nuestra Señora de la Paz, 1999.

Gisbert 2001
Gisbert, Teresa. *El paraíso de los pájaros parlantes: la imagen del otro en la cultura andina.* 2d ed. La Paz: Plural Editores, 2001.

Gisbert 2002
Teresa Gisbert. "La identidad étnica de los artistas del Virreinato del Perú." In Mujica Pinilla et al. 2002, pp. 99–143.

Gisbert 2003
Gisbert, Teresa. "Del Cusco a Potosí: la religiosidad del Sur Andino." In Mujica Pinilla et al. 2003, pp. 64–70.

Gisbert 2004 *Iconografía*
Gisbert, Teresa. *Iconografía y mitos indígenas en el arte.* 3d ed. La Paz: Editorial Gisbert y Cia, 2004.

Gisbert 2004 *"Sur Andino"*
Gisbert, Teresa. "El cielo y el infierno en el mundo virreinal del Sur Andino." In *Barroco y fuentes* 2004.

Gisbert and Mesa 1997
Gisbert, Teresa, and José de Mesa. *Arquitectura andina, 1530–1830.* 2d ed. La Paz: Embajade de España, 1997.

Gisbert et al. 1987
Gisbert, Teresa, et al. *Arte textil y mundo andino.* La Paz: Gisbert y Cía, 1987.

Gisbert et al. 1994
Gisbert, Teresa, et al. *Bolivian Masterpieces: Colonial Painting.* Exh. cat. La Paz: Secretariat of Culture, 1994.

Gjurinovic Canevaro 2004
Gjurinovic Canevaro, Pedro. *Museo Pedro de Osma.* New ed. Lima: Fundación Pedro y Angélica de Osma Gildemeister, 2004.

Glass and Robertson 1975
Glass, John B., and Donald Robertson, "A Census of Native Middle American Pictorial Manuscripts." In *Handbook of Middle American Indians*, vol. 14, *Guide to Ethnohistorical Sources, Part 3*, ed. Robert Wauchope, pp. 214–17, census no. 350. Austin: University of Texas Press, 1975.

Gloria in Excelsis 1986
Duncan, Barbara, et al., eds. *Gloria in Excelsis: The Virgin and Angels in Viceregal Painting of Peru and Bolivia.* Exh. cat. New York: Center for Inter-American Relations, 1986.

Gonzalbo Aizpuru 1990
Gonzalbo Aizpuru, Pilar. *Historia de la educación en la Epoca Colonial: la educación de los criollos y la vida urbana.* Mexico City: Colegio de México, Centro de Estudios Históricos, 1990.

González 1985
González, Rubén. "La noche oscura del niño Aviles, la subversion de la historia." *Revista del Instituto de Cultura Puertorriqueña* 89 (1985), pp. 39–44.

González García 1972
González García, Sebastián. "Catálogo parcial de obras de José Campeche y Jordán, 1751–1809." *La Torre* (Universidad de Puerto Rico, Río Piedras) 22, nos. 77–78 (1972), pp. 85–204.

González Lamela 1986
González Lamela, María del Pilar. "José Campeche y Jordán (1751–1809): primer retratista puertorriqueño." *Revista Oriente* (Humacao, Puerto Rico) 2, no. 3 (1986), pp. 7–36.

González Leyva 1992
González Leyva, Alejandra. "La devoción del Rosario en la Nueva España: historia, cofradías, advocaciones, obras de arte, 1538–1640," Master's thesis, Universidad Nacional Autónoma de México, Mexico City, 1992.

González Moreno 1959
González Moreno, Joaquín. *Iconografía guadalupana*, vol. I. Mexico City: Jus, 1959.

González Pozo 1994
González Pozo, Alberto. "Catedral de Puebla." In *Catedrales de México.* Mexico City: CVS, 1994.

González Suárez 1971
González Suárez, Federico. *Historia general de la República del Ecuador.* 3 vols. Quito: Casa de la Cultura Ecuatoriana, 1969–70 [1971].

Goode and Schneider 1994
Goode, Judith, and Jo Anne Schneider. *Reshaping Ethnic and Racial Relations in Philadelphia: Immigrants in a Divided City.* Philadelphia: Temple University Press, 1994.

Grabski 1990
Grabski, Jozef, ed. *Opus Sacrum.* Exh. cat. Warsaw: Royal Castle, 1990.

Grâce baroque 1999
La Grâce baroque: chefs-d'oeuvre de l'École de Quito. Nantes: Musée du Château des ducs de Bretagne; Paris: Union Latine, 1999.

Gradowska et al. 1992
Gradowska, Anna, et al. *Magna Mater: el sincretismo hispanoamericano en algunas imágenes marianas.* Caracas: Museo de Bellas Artes, 1992.

Grandeur of Viceregal Mexico 2002
Rivero Borrell M., Héctor, et al. *The Grandeur of Viceregal Mexico: Treasures from the Museo Franz Mayer.* Exh. cat. Houston: Museum of Fine Arts, 2002.

Greer 2003
Greer, Allan. "Iroquois Virgin: The Story of Catherine Tekakwitha in New France and New Spain." In *Colonial Saints: Discovering the Holy in the Americas, 1500–1800*, ed. Allan Greer and Jodi Blinkoff, pp. 235–50. New York and London: Routledge, 2003.

Griffiths 1996
Griffiths, Nicholas. *The Cross and the Serpent: Religious Repression and Resurgence in Colonial Peru.* Norman: University of Oklahoma Press, 1996.

Groot 1859
Groot, José Manuel. *Noticia biográfica de Gregorio Vásquez i Ceballos, pintor granadino del siglo XVII, . . .* Bogotá: Francisco Torres Amaya, 1859. Originally published in the Bogotá periodical *El Catolicismo* 359–66 (March 1, 1859–April 19, 1859).

Gruzinski 1992
Gruzinski, Serge. *Painting the Conquest: The Mexican Indians and the European Renaissance.* Trans. Deke Dusinberre. Paris: Flammarion, 1992.

Gruzinski 1995
Gruzinski, Serge. *La guerra de las imagines: de Cristóbal Colón a "Blade Runner" (1492–2019).* Mexico City: Fondo de Cultura Económica, 1995.

Guamán Poma de Ayala 1615/1980 *Nueva*
Guamán Poma de Ayala, Felipe. *Nueva corónica y buen gobierno.* 2 vols. 1615; facsimile. Caracas: Biblioteca Ayacucho, 1980.

Guamán Poma de Ayala 1615/1980 *Primer*
Guamán Poma de Ayala, Felipe. *El primer nueva corónica y buen gobierno.* 1615; ed. John V. Murra and Rolena

Adorno; trans. Jorge L. Urioste. 3 vols. Mexico City: Siglo Veintiuno, 1980.

Guamán Poma de Ayala 1615/1993
Guamán Poma de Ayala, Felipe. *Nueva corónica y buen gobierno.* 1615; ed. Franklin Pease; trans. Jan Szemiński. Mexico City: Fondo de Cultura Económica, 1993.

Guarda 2002
Guarda, Gabriel, ed. *Barroco hispanoamericano en Chile: vida de San Francisco de Asís, segun la serie que representa su nacimiento, vida, milagros, santidad y último trance, pintada en el siglo XVII para el Convento Franciscano de Santiago de Chile y expuesta en el Museo de San Francisco del citado convento.* Exh. cat. Madrid: Corporación Cultural 3C Para el Arte, 2002.

Guevara 1560/1788
Guevara, Felipe de. *Comentarios de la pintura . . . se publican por la primera vez con un discurso preliminar y algunas notas de Don Antonio Ponz, quien ofrece su trabajo al Excelentisimo Señor Conde de Florida-Blanca, protector de las nobles artes* (1560). Madrid: Don Geronimo Ortega, Hijos de Ibarra y Compañia, 1788.

Guiness 1986
Guiness, Gerald. "Campeche." *The San Juan Star* (San Juan, Puerto Rico), November 16, 1986.

Gutiérrez 1983
Gutiérrez, Ramón. *Arquitectura y urbanismo en Iberoamérica.* Madrid: Ediciones Cátedra, 1983.

Gutiérrez 1995 "Circuitos"
Gutiérrez, Ramón. "Los circuitos de la obra de arte: artistas, mecenas, comitentes, usuarios y comerciantes." In Gutiérrez 1995 *Pintura.*

Gutiérrez 1995 "Escultura"
Gutiérrez, Ramón. "La escultura en Centroamérica y el Caribe." In Gutiérrez 1995 *Pintura.*

Gutiérrez 1995 *Pintura*
Gutiérrez, Ramón, ed. *Pintura, escultura y artes útiles en Iberoamérica, 1500–1825.* Madrid: Ediciones Cátedra, 1995.

Gutiérrez 1995 "Utilitarias"
Gutiérrez, Ramón. "Artes utilitarias en el virreinato de Perú." In Gutiérrez 1995 *Pintura.*

Gutiérrez 1997
Gutiérrez, Ramón, ed. *Barroco iberoameriano de los Andes a las Pampas.* Barcelona: Lunwerg, 1997.

Gutierrez and Avila 1999
Gutierrez, Angela, and Cristina Avila. *Museu do Oratório: coleção Angela Gutierrez.* Belo Horizonte, Brazil: Instituto Cultural Flávio Gutierrez, 1999.

Gutiérrez and Gutiérrez Viñuelas 2000
Gutiérrez, Ramón, and Rodrigo Gutiérrez Viñuelas. *Historia del arte iberoamericano.* Barcelona: Lunwerg, 2000.

Gutiérrez Arriola and Maquívar 2004
Gutiérrez Arriola, Cecilia, and María del Consuelo Maquívar, eds. *De arquitectura, pintura y otras artes: homenaje a Elisa Vargaslugo.* Mexico City: Universidad Nacional Autónoma de México, 2004.

Gutiérrez de Medina 1947
Gutiérrez de Medina, Cristóbal de. *Viaje del Virrey Marqués de Villena.* Mexico City: Imprenta Universitaria, 1947.

Gutiérrez de Quintanilla 1916
Gutiérrez de Quintanilla, Emilio. *Catálogo de las secciones colonia i república i de la Galería Nacional de Pinturas del Museo de Historia Nacional.* Lima: Imprenta L. Ramos, 1916.

Gutiérrez Haces 1995
Gutiérrez Haces, Juana. "Escultura novohispana." In *Pintura, escultura y artes útiles en Iberoamérica, 1500–1825,* ed. Ramón Gutiérrez. Madrid: Ediciones Cátedra, 1995.

Gutiérrez Haces 2005
Gutiérrez Haces, Juana. "The Painter Cristóbal de Villalpando: His Life and Legacy." In *Exploring New World Imagery.* Exh. cat. Denver: Denver Art Museum, 2005.

Gutiérrez Haces et al. 1997
Gutiérrez Haces, Juana, et al. *Cristóbal de Villalpando, ca. 1649–1714: catálogo razonado.* Mexico City: Instituto de Investigaciones Estéticas: Fomento Cultural Banamex: Consejo Nacional para la Cultura y las Artes, 1997.

Gutiérrez Reyes and Celaya Méndez 1991
Gutiérrez Reyes, Judith, and Lucía Celaya Méndez. *Catálogo de la biblioteca de noviciado de los dieguinos de San José de Tacubaya.* Mexico City: Instituto Nacional de Antropología e Historia, 1991.

Gutiérrez Solana 1983
Gutiérrez Solana, Nelly. *Objetos ceremoniales en piedra de la cultura mexica.* Mexico City: Universidad Nacional Autónoma de México, 1983.

Hammer and D'Andrea 1978
Hammer, Olga, and Jeanne D'Andrea, eds. *Treasures of Mexico from the Mexican National Museums / Tesoros de México de los museos nacionales mexicanos: An Exhibition Presented by the Armand Hammer Foundation.* Exh. cat. Los Angeles: Los Angeles County Museum of Art, 1978.

Hampe Martínez 1996
Hampe Martínez, Teodoro. *Cultura barroca y extirpación de idolatrías: la biblioteca de Francisco de Avila (1648).* Cuzco: Centro de Estudios Regionales Andinos, Bartolomé de las Casas, 1996.

Hardoy 1975
Hardoy, Jorge E. "La forma de las ciudades coloniales en Hispanoamérica." *Psicon* 5 (1975), pp. 8–33.

Harten and Schmidt 1976–77
Harten, Jürgen, and Katharina Schmidt, eds. *Barocke Malerei aus den Anden: Gemälde des 17. und 18. Jahrhunderts aus Bolivien, Ecuador, Kolumbien und Peru; eine Austellung unter der Schirmherrschaft des Bundesministers des Äusseren Herrn Hans-Dietrich Genscher.* 2 vols. Düsseldorf: Städtische Kunsthalle, 1976–77.

Hecht 1994
Hecht, Johanna. "New Identities for Some Old Hispanic Silver." *Metropolitan Museum Journal* 29 (1994), pp. 77–88.

Heikamp 1972
Heikamp, Detlef. *Mexico and the Medici.* Florence: Edam, 1972.

Heredia Moreno 1991
Heredia Moreno, Maria del Carmen. "Las ordenanzas de plateros limeños del año 1633." *Archivo español de arte* 256 (1991).

Heredia Moreno 1992
Heredia Moreno, Maria del Carmen. "Ordenanzas de la platería limeña del año 1778." *Laboratorio de arte* 5, no. 10 (1992).

Herkenhoff 1999
Herkenhoff, Paulo, ed. *O Brasil e os Holandeses, 1630–1654.* Rio de Janeiro: GMT Editores, 1999.

Hermandad de Artistas Gráficos de Puerto Rico 1998
Hermandad de Artistas Gráficos de Puerto Rico. *Puerto Rico: arte e identidad.* San Juan: Editorial de la Universidad de Puerto Rico, 1998.

Hernández Díaz 1965
Hernández Díaz, José. "Martínez Montañés en Lima." *Anales de la Universidad Hispalense* 25 (1965), pp. 99–108.

Herzberg 1986
Herzberg, Julia P. "Angels with Guns: Image and Interpretation." In *Gloria in Excelsis* 1986, pp. 63–75.

Hibbard 1969
Hibbard, Howard. "Guido Reni's Painting of the Immaculate Conception." *The Metropolitan Museum of Art Bulletin* 28 (1969–70), pp. 18–32.

Hispanic Society 1938
The Hispanic Society of America, Museum and Library Collections. Hispanic Notes & Monographs, Catalogue Series. New York: The Hispanic Society of America, 1938.

Hispanic Society 2004
The Hispanic Society of America: A Centennial Celebration. New York: The Hispanic Society of America, [2004].

Historia del arte colombiano 1977
Historia del arte colombiano. 7 vols. Bogotá: Salvat Editores Colombiana, 1977.

Hong Kong Museum of Art 1995
Hong Kong Museum of Art. *Heaven's Embroidered Cloths: One Thousand Years of Chinese Textiles.* Hong Kong: Urban Council of Hong Kong, 1995.

Honour 1975
Honour, Hugh. *The New Golden Land: European Images of America from the Discoveries to the Present Time.* New York: Pantheon, 1975.

Honour 1989
Honour, Hugh. *The Image of the Black in Western Art,* vol. 4, *From the American Revolution to World War I,* pt. 1, *Slaves and Liberators.* Houston: Menil Foundation, 1989.

Hoogerwerff 1944
Hoogerwerff, G. J. "'Vultus trifrons': emblema diabolico; immagine improba della Santísima Trinità." In *Rendiconti della Pontificia Accademia Romana di Archeologia* 19. Anno Académico 1942–43. Rome: Tipografía Poliglotta Vaticana, 1944.

Horkheimer and Doig 1965
Horkheimer, Hans, and Federico Kauffmann Doig. *La cultura incaica.* Lima: Peruano Suiza, 1965.

Hospicio de los Venerables et al. 2000
Hospicio de los Venerables et al. *El Galeón de Manila.* Exh. cat. Madrid: Aldeasa, 2000.

Huerta Carrillo 1991
Huerta Carrillo, Alejandro. *Análisis de la técnica y materiales de dos colecciones de pinturas enconchadas.* Mexico City: Instituto Nacional de Antropología e Historia, 1991.

Huertas 1995
Huertas, Juan Miguel. *El tesoro de la catedral de Santafé de Bogotá.* Bogotá: Amazonas, 1995.

Humboldt 1994
Humboldt, Alexander von. *La ruta de Humboldt: Colombia y Venezuela.* Ed. Benjamín Villegas. Bogotá: Villegas Editores, 1994.

Humphrey 1997
Humphrey, Carol. *Samplers.* Fitzwilliam Museum Handbooks. Cambridge: Cambridge University Press, 1997.

Ibáñez 1913–23
Ibáñez, Pedro María. *Crónicas de Bogotá.* 4 vols. Bogotá, 1913–23.

Icaza 1969
Icaza, Francisco A. de. *Diccionario autobiográfico de conquistadores y pobladores de Nueva España: sacado de los textos originales.* 2 vols. Guadalajara: Edmundo Aviña Levy, 1969.

Iconología y sociedad 1987
International Congress of Americanists. *Iconología y sociedad: arte colonial hispanoamericano.* XLIV Congreso Internacional de Americanistas. Mexico City: Universidad Nacional Autónoma de México, Instituto de Investigaciones Estéticas, 1987.

Iglesia 1992
La iglesia en América: evangelización y cultura. Exh. cat. Seville: Vatican Pavilion, 1992.

Imagen de México 1984
Fundación Santillana, Santillana del Mar. *Imagen de México.* Exh. cat. Santillana del Mar, Spain: Fundación Santillana, 1984.

Imágenes de los naturales 2005
Imágenes de los naturales en el arte de la Nueva España, siglo XVI al XVIII. Mexico: Fomento Cultural Banamex, 2005.

Imágenes guadalupanas 1987
Imágenes guadalupanas. Exh. cat. Mexico City: Centro Cultural de Arte Contemporáneo, 1987.

INAH 1967
Instituto Nacional de Anthropologia e Historia (INAH). *Viceroyal Period National Museum, Tepotzolan: Official Guide.* Mexico City: Instituto Nacional de Antropologia e Historia, 1967.

Infiesta 1895
Infiesta, Alejandro. *La exposición de Puerto Rico: memoria redactada, según acuerdo de la Junta del Centenario.* Puerto Rico: Impr. del "Boletín Mercantil," 1895.

Infiesta 1897
Infiesta, Alejandro, comp. *Lealtad y heroísmo de la isla de Puerto-Rico.* Puerto-Rico: Impr. de A. Lynn é hijos de Pérez-Moris, 1897.

Inventario de bienes muebles 1998
Patrimonio artístico nacional: inventario de bienes muebles; ciudad de Buenos Aires. Buenos Aires: Academia Nacional de Bellas Artes; Fondo Nacional de las Artes, 1998.

Iriarte 1993
Iriarte, Isabel. "Las túnicas incas en la pintura colonial." In *Mito y simbolismo en los Andes: la figura y la palabra.* Cuzco: Centro de Estudios Regionales Andinos "Bartolomé de Las Casas," 1993.

Israel 1989
Israel, Jonathan I. *Dutch Primacy in World Trade, 1585–1740.* Oxford: Clarendon Press, 1989.

Jamieson 2004
Jamieson, Ross W. "Bolts of Cloth and Sherds of Pottery: Impressions of Caste in the Material Culture of the Seventeenth-Century Audiencia of Quito." *The Americas* 60 (2004), pp. 431–46.

Jansen 1955
Jansen, Bonifácio, O.S.B. "Livro do dasto da sacristia do mosteiro de São Bento de Olinda: 1756–1802." *Revista do património artístico e histórico nacional* 12 (1955), pp. 233–385.

Jantz 1976
Jantz, Harold. "Images of America in the German Renaissance." In *First Images of America: The Impact of the New World on the Old,* ed. Fredi Chiappelli et al., pp. 91–106. Berkeley and Los Angeles: University of California Press, 1976.

Jenkins 1967
Jenkins, Katharine D. "Lacquer." In *Handbook of Middle American Indians,* ed. Robert Wauchope, vol. 6, pp. 125–37. Austin: University of Texas Press, 1967.

"Jerarquía celeste" 1990
"Jerarquía celeste." In *Obras completas del Pseudo Dionisio Areopagita,* ed. Teodoro H. Martín-Lunas. Madrid: Biblioteca de Autores Cristianos, 1990.

Jiménez Codinach 1997
Jiménez Codinach, Estela Guadalupe. *México: su tiempo de nacer, 1750–1821.* Exh. cat. Mexico City: Fomento Cultural Banamex, 1997.

Joris de Zavala 1994
Joris de Zavala, Huguette. "Un paravent peint en Nouvelle-Espagne par Juan Correa d'après Charles Le Brun." In Vargaslugo and Guadalupe Victoria 1994, pt. 2, pp. 523–37.

Jornadas Culturales Mexicano-Filipinas 1997
Jornadas Culturales Mexicano-Filipinas. *El Galeón de Manila: un mar de historias.* Mexico City: JGH Editores, 1997.

Jose 1990
Jose, Regalado Trota. *Images of Faith: Religious Ivory Carvings from the Philippines.* Pasadena, Calif.: Pacific Asia Museum, 1990.

Jose and Villegas 2004
Jose, Regalado Trota, and Ramon N. Villegas. *Power, Faith, Image: Philippine Art in Ivory from the Sixteenth to the Nineteenth Century.* Manila: Ayala Foundation, 2004.

José Juárez 2002
José Juárez: recursos y discursos del arte de pintar. Exh. cat. Mexico City: D.R. Patronato del Museo Nacional de Arte, A.C. / Instituto Nacional de Bellas Artes, 2002.

José Campeche 1971
José Campeche, 1751–1809. San Juan de Puerto Rico: Instituto de Cultura Puertorriqueña, 1971.

Joyería española 1998
La joyería española de Felipe II a Alfonso XIII en los museos estatales. Exh. cat. Madrid: Neria, 1998.

Juan and Ulloa 1748/1964
Juan, Jorge, and Antonio de Ulloa. *A Voyage to South America* (1748). The John Adams translation, abridged with intro. by Irving A. Leonard. New York: Knopf, 1964.

Juan and Ulloa 1826/1918
Juan, Jorge, and Antonio de Ulloa. *Noticias secretas de América (siglo XVIII)* (1826). 2 vols. Madrid: Editorial América, 1918.

Juárez Burgos and Luyando Lares 1986
Juárez Burgos, Antonio, and Adalberto Luyando Lares. *La Catedral de Puebla.* Mexico City: Benemérita Universidad de Puebla, 1986.

Junquera y Mato 1999
Junquera y Mato, Juan José. "Zurbarán y América." In Pérez Sánchez 1999, pp. 147–60.

Kagan 1998
Kagan, Richard L., with Fernando Marías. *Imágenes urbanas del mundo hispánico, 1493–1780.* Madrid: El Viso, 1998.

Kagan 2000
Kagan, Richard L., with the collaboration of Fernando Marías. *Urban Images of the Hispanic World, 1493–1793.* New Haven and London: Yale University Press, 2000.

Katzew 1996
Katzew, Ilona. "Casta Painting: Identity and Social Stratification in Colonial Mexico." In *New World Orders: Casta Painting and Colonial Latin America,* pp. 8–29. Exh. cat. New York: Americas Society Art Gallery, 1996.

Katzew 2004
Katzew, Ilona. *Casta Painting: Images of Race in Eighteenth-Century Mexico.* New Haven and London: Yale University Press, 2004.

Katzew 2004 Race
Ilona Katzew. *Inventing Race: Casta Painting and Eighteenth-Century Mexico.* Exh. cat. Los Angeles: Los Angeles County Museum of Art, 2004.

Katzew 2006
Katzew, Ilona. *Una visión de México del siglo de las luces: la codificación de Joaquín Antonio de Basarás.* Mexico City: Landucci, 2006.

Katzew et al. 1996
Katzew, Ilona, et al. *New World Orders: Casta Painting and Colonial Latin America.* Exh. cat. New York: Americas Society Art Gallery, 1996.

Kaufmann 2004
Kaufmann, Thomas DaCosta. *Toward a Geography of Art.* Chicago and London: University of Chicago Press, 2004.

Kelemen 1971
Kelemen, Pál. *Peruvian Colonial Painting: A Special Exhibition; The Collection of the Stern Fund and Mr. and Mrs. Arthur Q. Davis with an Additional Selection from the Brooklyn Museum.* New York: Brooklyn Museum, 1971.

Kennedy and Fajardo de Rueda 1992
Kennedy, Alexandra, and Marta Fajardo de Rueda. *Barroco de la Nueva Granada: Colonial Art from Colombia and Ecuador.* Exh. cat. New York: Americas Society, 1992.

Kennedy 1993
Kennedy Troya, Alexandra. "La esquiva presencia indígena en el arte colonial quiteño." *Procesos: Revista Ecuatoriana de Historia* (Quito) 4 (1993), pp. 87–101.

Kennedy 1995
Kennedy, Alexandra. "La escultura en el virreinato de Nueva Granada y la audiencia de Quito." In Gutiérrez 1995 *Pintura.*

Kennedy 2002 "Barroco de Quito"
Kennedy, Alexandra. "Algunas consideraciones sobre el arte barroco de Quito y la interrupción 'ilustrada' (siglos XVII y XVIII)." In Kennedy 2002 *Quito.*

Kennedy 2002 "Exportación"
Kennedy, Alexandra. "Arte y artistas quiteños de exportación." In Kennedy 2002 *Quito.*

Kennedy 2002 "Mujeres"
Kennedy, Alexandra. "Mujeres en los claustros: artistas, mecenas y coleccionistas." In Kennedy 2002 *Quito.*

Kennedy 2002 Quito
Kennedy, Alexandra, ed. *Arte de la Real Audiencia de Quito, siglos XVII–XIX: patronos, corporaciones y comunidades.* Hondarribia, Spain: Nerea, 2002.

Killen 1994
Killen, Geoffrey. *Egyptian Woodworking and Furniture.* London: Shire Egyptology, 1994.

Kimura 1997
Kimura, Uemon. *Date Masamune genkæroku.* Ed. Koikawa Yuriko. Tokyo: Shin Jinbutsu æraisha, 1997.

Kinder Carr 2004
Kinder Carr, Carolyn. "Mirror Image: Portraiture in Latin America and the United States." In *Retratos 2004,* pp. 20–29.

Kinkead 1984
Kinkead, Duncan T. "Juan de Luzón and Sevillian Painting Trade with the New World in the Second Half of the Seventeenth Century." *Art Bulletin* 66 (1984), pp. 303–10.

Klein 1976
Klein, Cecilia. *The Face of the Earth: Frontality in Two-Dimensional Mesoamerican Art.* New York: Garland, 1976.

Klor de Alva 1996
Klor de Alva, J. Jorge. "*Mestizaje* from New Spain to Aztlán: On the Control and Classification of Collective Identities." In Katzew 1996.

Knauth 1972
Knauth, Lothar. *Confrontación transpacífica: el Japón y el nuevo mundo hispánico, 1542–1639.* Mexico City: Universidad Nacional Autónoma de México, 1972.

Kohl 1982
Kohl, Karl-Heinz. *Mythen der Neuen Welt: Zur Entdeckungsgeschichte Lateinamerikas.* Exh. cat. Berlin: Frölich & Kaufmann, 1982.

Kubler 1948
Kubler, George. *Mexican Architecture of the Sixteenth Century.* 2 vols. New Haven, Conn.: Yale University Press, 1948.

Kubler 1962 *Art and Architecture*
Kubler, George. *The Art and Architecture of Ancient America: The Mexican, Maya, and Andean Peoples.* Baltimore: Penguin, 1962.

Kubler 1962 *Shape*
Kubler, George. *The Shape of Time: Remarks on the History of Things.* New Haven, Conn.: Yale University Press, 1962.

Kubler and Soria 1959
Kubler, George, and Martin Soria. *Art and Architecture in Spain and Portugal and Their American Dominions, 1500 to 1800.* Baltimore, Md.: Penguin Books, 1959.

Kuwayama 1997
George Kuwayama. *Chinese Ceramics in Colonial Mexico.* Exh. cat. Los Angeles: Los Angeles County Museum of Art, 1997.

Kuwayama 2000
"Cerámica china en el Perú colonial." *Iconos* 3 (2000–2001).

L'Art colombien 1975
L'Art colombien à travers les siècles. Exh. cat. Paris: Petit Palais, 1975.

La Force 1964
La Force, J. Clayburn. "Royal Textile Factories in Spain, 1700–1800." *The Journal of Economic History* 24 (1964).

La ilustración puertorriqueña 1892
"En defensa." *La ilustración puertorriqueña* 1, no. 10 (1892), pp. 6–7.

Lacas mexicanas 1997
Lechuga, Ruth, et al. *Lacas mexicanas.* Exh. cat. Mexico City: Museo Franz Mayer; Artes de México, 1997.

Ladd 1976
Ladd, Doris M. *The Mexican Nobility at Independence, 1780–1826.* Austin: Institute of Latin American Studies, University of Texas, 1976.

Lafaye 1976
Lafaye, Jacques. *Quetzalcóatl and Guadalupe: The Formation of the Mexican National Consciousness, 1531–1813.* Chicago: University of Chicago Press, 1976.

Lane 2002
Lane, Kris. *Quito 1599: City and Colony in Transition.* Albuquerque: University of New Mexico Press, 2002.

Lapa 1968
Lapa, José Roberto do Amaral. *A Bahia e a Carreira da Índia.* São Paulo: Cia. Ed. Nacional, 1968.

Lara 2004
Lara, Jaime. *City, Temple, Stage: Eschatological Architecture and Liturgical Theatrics in New Spain.* Notre Dame, Ind.: University of Notre Dame Press, 2004.

Larsen 1962
Larsen, Erik. *Franz Post, interprète du Brésil.* Amsterdam: Colibris Editora, 1962.

Lasso de la Vega 1649/1998
Lasso de la Vega, Luis. *The Story of Guadalupe: Luis Laso de la Vega's Huei tlamahuiçoltica of 1649.* Ed. and trans. Lisa Sousa et al. Stanford, Calif.: Stanford University Press, 1998.

Leal 1993
Juan de Valdés Leal y el arte sevillano del Barroco. Mexico City: Centro Cultural de Arte Contemporáneo–Fundación Cultural Televisa, 1993.

Lechuga et al. 1997
Lechuga, Ruth, et al. *Lacas mexicanas.* Mexico City: Museo Franz Mayer; Artes de México, 1997.

Lee 1948
Lee, Raymond L. "Cochineal Production and Trade in New Spain to 1600." *The Americas* 4 (1948), pp. 449–73.

Lee 1951
Lee, Raymond L. "American Cochineal in European Commerce, 1526–1625." *The Journal of Modern History* 23 (1951), pp. 205–24.

Leite, J. R. T. 1999
Leite, José Roberto Teixeira. *A China no Brasil: influências, marcas, ecos e sobrevivências chinesas na sociedade e na arte brasileira.* São Paulo: Unicamp, 1999.

Leite, S. 1953
Leite, Serafim. *Artes e ofícios dos jesuítas no Brasil, 1549–1760.* Lisbon: Edições Brotéria, 1953.

Lemos 1999
Lemos, Carlos A. C. *A imaginária paulista.* São Paulo: Pinacoteca do Estado, 1999.

Lemos et al. 1983
Lemos, Carlos A. C., et al. *The Art of Brazil.* New York: Icon, 1983.

Lemos et al. 1983 *Museu*
Lemos, Carlos A. C., et al. *O Museu de Arte Sacra de São Paulo.* Ed. Antonio de Oliveira Godinho. São Paulo: Banco Safra, 1983.

Lenaghan 2000
Lenaghan, Patrick, ed. *The Hispanic Society of America: Tesoros.* New York: The Hispanic Society of America, 2000.

Levey 1983
Levey, Santina M. *Lace: A History.* London: Victoria & Albert Museum with W. S. Maney & Son, 1983.

Levy 1942
Levy, Hannah. "A pintura colonial do Rio de Janeiro." *Revista do serviço do patrimônio histórico e artístico nacional* 6 (1942).

Liedtke 1984
Liedtke, Walter A. *Flemish Paintings in the Metropolitan Museum of Art.* 2 vols. New York: Metropolitan Museum of Art, 1984.

Lister and Lister 1982
Lister, Florence C., and Robert H. Lister. *Sixteenth Century Majolica Pottery in the Valley of Mexico.* Tucson: University of Arizona Press, 1982.

Litto Lecanda 1999
Litto Lecanda, Lilia del. *El revestimento de lo sagrado: la obra del bordador Marcus Maestre en Tepotzotlán.* Mexico City: Instituto Nacional de Antropología e Historia, 1999.

Lluberes 1975
Lluberes, Pedro. "El damero y su evolución en el mundo occidental." *Boletín del Centro de Investigaciones Históricas y Estéticas, Caracas* 21 (1975), pp. 9–66.

Loayzaga 1745/1750
Loayzaga, Manuel. *Historia de la Milagrosissima Imagen de N.ra S.ra de Occotlan que se venera extramuros de la ciudad de Tlaxcala* (1745). Mexico City: Reimpreso por la viuda de D. Joseph Hogal, 1750.

Locke 1999
Locke, Adrian. "From Ice to Icon: El Señor de Qoyllur Rit'i as Symbol of Native Andean Catholic Worship." *Arara* 2 (1999). http://www2.essex.ac.uk/arthistory/arara/issue_two/paper1.html.

Locke 2001
Locke, Adrian K. "Catholic Icons and Society in Colonial Peru: The Peruvian Earthquake Christs of Lima and Cusco, and other Comparative Cults." Ph.D. diss., University of Essex, Colchester, 2001.

Lockhart 1992
Lockhart, James. *The Nahuas after the Conquest: A Social and Cultural History of the Indians of Central Mexico, Sixteenth through Eighteenth Centuries.* Stanford, Calif.: Stanford University Press, 1992.

Lockhart et al. 2006
Lockhart, James, et al., eds. and trans. *Annals of His Time: Don Domingo de San Antón Muñón Chimalpahin Quauhtlehuanitzin.* Stanford, Calif.: Stanford University Press, 2006.

Lohmann 1997
Lohmann, Guillermo. "La minería y la metalurgia de la plata en el Virreinato del Perú." In Esteras Martín 1997 *Peru.*

López 2003
López, María del Pilar. "El oratorio: espacio doméstico en la casa urbana en Santa Fé durante los siglos XVII y XVIII." *Ensayos: Historia y Teoría del Arte* 8 (2003), pp. 157–226.

López-Baralt 1992
López-Baralt, Mercedes, ed. *Guaman Poma de Ayala: The Colonial Art of an Andean Author.* New York: Americas Society, 1992.

López Cervantes 1976
López Cervantes, Gonzalo. *Cerámica colonial en la Ciudad de México.* Mexico City: Instituto Nacional de Antropología e Historia, 1976.

López Pérez 1997–98
López Pérez, María del Pilar. "Los enseres de la casa en Santafé de Bogotá siglos XVII y XVIII en el Nuevo Reino de Granada." *Ensayos: Instituto de Investigaciones Estéticas* 3 (1997–98), pp. 131–69.

López Sarrelangue 1957
López Sarrelangue, Delfina E. *Una villa mexicana en el siglo XVIII.* Mexico City: Universidad Nacional Autónoma de México, 1957.

Lorenzo Macías 2005
Lorenzo Macías, José María. "El arquitecto ensamblador Mateo de Pinos." *Anales del Instituto de Investigaciones Estéticas* 37 (2005), pp. 113–67.

Los tesoros 2000
Los tesoros de la pintura puertorriqueña / Treasures of Puerto Rican Painting. Ed. Carmen T. Ruiz de Fischler and Mercedes Trelles; trans. Anne Jones. Exh. cat. San Juan: Museo de Arte de Puerto Rico, 2000.

Lothrop 1979
Lothrop, S. K. *Treasures of Ancient America: Pre-Columbian Art from Mexico to Peru.* Geneva: Skira; New York: Rizzoli, 1979.

Lothrop et al. 1957
Lothrop, Samuel K., et al. *Pre-Columbian Art: Robert Woods Bliss Collection.* New York: Phaidon, 1957.

Luft 1972
Luft, E. "Las imágenes de caña de maíz de Michoacán." *Artes de México* (Mexico City) 153 (1972).

Luján Muñoz 1997
Luján Muñoz, Luis. "Santiago de Guatemala y Puebla de los Angeles: sus relaciones culturales." In Paiz de Serra 1997.

Luján Muñoz and Alvarez Arévalo 1993
Luján Muñoz, Luis, and Miguel Alvarez Arévalo. *Imagenes d'oro.* Guatemala City: Corporación G&T, 1993.

Luján Muñoz and Alvarez Arévalo 2002
Luján Muñoz, Luis, and Miguel Alvarez Arévalo. *Imágenes de oro.* 2d ed., Galeria Guatemala II. Guatemala City: Fundación G&T Continental, 2002.

Lutteroth 1988
Lutteroth, Armida Alonso. "El dibujo y la trama." In *Tepotzolán: la vida, y la obra en la Nueva España.* Mexico City: Sociedad de Amigos del Museo Nacional de Virreinato; Bancomer, 1988.

Luyando Lares and Juárez Burgos 1986
Luyando Lares, Adalberto, and Antonio Juárez Burgos. *La Catedral de Puebla.* Mexico City: Benemérita Universidad de Puebla, 1986.

MacCormack 1984
MacCormack, Sabine. "From the Sun of the Inca to the Virgin of Copacabana." *Representations* 8 (1984), pp. 30–60.

MacCormack 1990
MacCormack, Sabine. "Loca Sancta: The Organization of Sacred Topography in Late Antiquity." In *The Blessings of Pilgrimage*, ed. Robert Ousterhout, pp. 1–40. Urbana: University of Illinois Press, 1990.

MacCormack 2004
MacCormack, Sabine. "Religion and Society in Inca and Spanish Peru." In Phipps et al. 2004, pp. 101–13.

Magalotti 1943
Magalotti, Lorenzo. *Lettere odorose, 1693–1705.* Ed. Enrico Falqui. Milan: Valentino Bompiani, 1943.

Magia 1995
Magia, mentiras y maravillas de las Indias. Exh. cat. [Huelva], Spain: Diputación Provincial de Huelva; Madrid, Museo de América, Ministerio de Cultura, Dirección General de Bellas Artes y de Conservación y Restauración de Bienes Culturales, 1995.

Majluf 2005
Majluf, Natalia, ed. *Los Incas, reyes del Perú.* Lima: Banco de Crédito, 2005.

Majluf and Wuffarden 1998
Majluf, Natalia, and Luis Eduardo Wuffarden. *La piedra de Huamanga: lo sagrado y lo profano.* Lima: Banco de Crédito del Perú, Museo de Arte de Lima, and Prom Perú, 1998.

Majluf et al. 2001
Majluf, Natalia, et al. *Art in Peru: Works from the Collection of the Museo de Arte de Lima.* Lima: Museo de Arte de Lima, 2001.

Majluf et al. 2001 [Spanish]
Majluf, Natalia, et al. *El arte en el Perú: obras en la colección del Museo de Arte de Lima.* Lima: Museo de Arte de Lima, 2001.

Mâle 1932
Mâle, Émile. *L'art religieux après le Concile de Trente: Étude sur l'iconographie de la fin du XVIe siècle, du XVIIe, du XVIIIe siècle; Italie, France, Espagne, Flandres.* Paris: Librairie Armand Colin, 1932.

Manifestaciones religiosas 1997
Manifestaciones religiosas en el mundo colonial americano. Mexico City: INAH, COMDUMEX, UIA, 1997.

Mann and Mann 2002
Mann, Graciela, and Hans Mann. *The 12 Prophets of Antonio Francisco Lisboa "O Aleijadinho."* Austin: University of Texas Press, 1967.

Manrique 1971
Manrique, Jorge Alberto. "Reflexiones sobre el manierismo en México." *Anales del Instituto de Investigaciones Estéticas* 10 (1971), pp. 21–42.

Manrique 1976
Manrique, Jorge Alberto. "Manierismo en Nueva España: Letras y Artes." *Anales del Instituto de Investigaciones Estéticas* 15 (1976), pp. 107–16.

Manrique et al. 1992
Manrique, Jorge Alberto, et al. *La colección pictórica del Banco Nacional de México.* Mexico City: Fomento Cultural Banamex, 1992.

Maquívar 1994
Maquívar, María del Consuelo, ed. *El arte en tiempos de Juan Correa.* Mexico City: Museo Nacional del Virreinato, Instituto Nacional de Antropología e Historia, 1994.

Maquívar 1999
Maquívar, María del Consuelo. *El imaginero novohispano y su obra.* Mexico City: Instituto Nacional de Antropología e Historia, 1999.

Maravilla Americana 1989
Maravilla Americana: variantes de la iconografía guadalupana, siglos XVII–XIX. Exh. cat. Mexico City: Museo de la Basílica de Guadalupe, 1989.

Marchi and Van Miegroet 1999
Marchi, Neil de, and Hans J. Van Miegroet, "Exploring Markets for Netherlandish Paintings in Spain and Nueva España." In Falkenburg et al. 1999, pp. 81–111.

Marco Dorta 1973
Marco Dorta, Enrique. *Arte en América y Filipinas.* Madrid: Editorial Plus-Ultra, 1973.

Mariátegui Oliva 1954
Mariátegui Oliva, Ricardo. *Pintura cuzqueña del siglo XVII: los maravillosos lienzos del Corpus existentes en la Iglesia de Santa Ana del Cuzco.* Lima: Alma Máter, 1954.

Marino 1998
Marino, João. "Notas sobre a prata e a mineração no Brasil." In *Universo mágico* 1998, pp. 273–338.

Marques dos Santos 1940
Marques dos Santos, Francisco. "A ourivesaria no Brasil antigo." *Estudos Brasileiros* 4 (1940).

Marroqui 1900/1963
Marroqui, José María. *La ciudad de México* (1900). 3 vols. Mexico City: Jesús Medina Editor, 1963.

Martínez de la Torre and Cabello Carro 1997
Martínez de la Torre, Cruz, and Paz Cabello Carro. *Museo de América, Madrid.* Zaragoza, Spain: IberCaja, 1997.

Martínez del Río de Redo 1969
Martínez del Río de Redo, Marita. "La influencia oriental en el mueble Mexicano." In *El mueble mexicano*, pp. 15–25. Mexico City: Artes de México, 1969.

Martínez del Río de Redo 1987
Martínez del Río de Redo, María Josefa. "Iconología humanista en un biombo del siglo XVII." In *Iconología y sociedad* 1987, pp. 127–38.

Martínez del Río de Redo 1994 "Biombos"
Martínez del Río de Redo, Marita. "Los biombos en el ámbito doméstico: sus programas moralizadores y didácticos." In *Juegos de ingenio y agudeza: la pintura emblemática de la Nueva España*, pp. 133–49. Mexico City, Museo Nacional de Arte, 1994.

Martínez del Río de Redo 1994 "Dos biombos"
Martínez del Río de Redo, María Josefa. "Dos biombos." In Vargaslugo and Guadalupe Victoria 1994, pt. 2, pp. 393–408.

Martínez del Río de Redo 1994 "Encuentro"
Martínez del Río de Redo, María Josefa. "El Encuentro en la literatura de los siglos XVI y XVII." In Vargaslugo and Guadalupe Victoria 1994, pt. 2, pp. 539–62.

Martínez del Río de Redo 1994 "Tema profano"
Martínez del Río de Redo, María Josefa. "Dos biombos con tema profano." In Vargaslugo and Guadalupe Victoria 1994, pt. 2, pp. 453–67.

Martínez del Río de Redo 1994 "Temas"
Martínez del Río de Redo, María Josefa. "Temas humanistas en un biombo." In Maquívar 1994, pp. 150–62.

Martínez del Río de Redo and Castelló Yturbide 1978
Martínez del Río de Redo, Marita, and Teresa Castelló Yturbide. "Art in the Viceregal Period." In Hammer and D'Andrea 1978.

Mason 1961
Mason, F. Van Wyck. *Manila Galleon.* Boston: Little Brown, 1961.

Mateo Gómez 1990
Mateo Gómez, Isabel. "Aspectos religiosos, sociales y culturales en la iconografía de las ordenes religiosas en Hispano América." In *Relaciones artísticas* 1990, pp. 33–71.

Mateos 1944
Mateos, F., ed. *Historia general de la Compañía de Jesús en la provincia del Perú, crónica anónima de 1600 que trata del establecimiento y misiones de la Compañía de Jesús en los países de habla española en la América meridional.* 2 vols. Madrid: Consejo Superior de Investigaciones Científicas, Instituto Gonzalo Fernández de Oviedo, 1944.

Mateus Cortés 1989
Mateus Cortes, Gustavo. *Tunja: el arte de los siglos XVI, XVII, XVIII.* Bogotá: Litografía Arco, 1989.

Mathes 1973
Mathes, Michael. *Sebastián Vizcaíno y la expansión española en el Océano Pacífico, 1580–1630.* Mexico City: Universidad Nacional Autónoma de México, 1973.

Matilla 1991
Matilla, José Manuel. *La estampa en el libro barroco: Juan de Courbes*. Madrid: Calcografía, 1991.

Matos Moctezuma 1999
Matos Moctezuma, Eduardo. *Estudios Mexicas*, vol. 1, book 2, *Obras*. Mexico City: El Colegio Nacional, 1999.

Matos Moctezuma and Solís Olguín 2002
Matos Moctezuma, Eduardo, and Felipe Solís Olguín. *Aztecs*. Exh. cat. London: Royal Academy of Arts, 2002.

Mauquoy-Hendrickx 1978
Mauquoy-Hendrickx, Marie. *Les estampes des Wierix: conservées au Cabinet des Estampes de la Bibliothèque Royale Albert Ier*, vol. 1, *Ancien Testament, Nouveau Testament, Dieu le Père, le Christ, le Saint-Esprit, les Anges et la Vierge*. Brussels: Bibliothèque Royale Albert Ier, 1978.

Mayer 1984
Franz Mayer: una colección. Mexico City: Bancreser, 1984.

Mayer-Thurman 1975
Mayer-Thurman, Christa C. *Raiment for the Lord's Service: A Thousand Years of Western Vestments*. Exh. cat. Chicago: The Art Institute of Chicago, 1975.

Maza 1940
Maza, Francisco de la. "José Luis Rodríguez Alconedo." *Anales del Instituto de Investigaciones Estéticas* 6 (1940).

Maza 1963
Maza, Francisco de la. "Pintura barroca mexicana (Cristóbal de Villalpando)." *Archivo español de arte* 36 (1963).

Maza 1964
Maza, Francisco de la. *El pintor Cristóbal de Villalpando*. Mexico City: Instituto Nacional de Antropología e Historia, 1964.

Maza 1968
Maza, Francisco de la. *La mitología clásica en el arte colonial*. Mexico City: Universidad Autónoma de México, 1968.

Maza 1971 *Pintor*
Maza, Francisco de la. *El pintor Martín de Vos en México*. Mexico City: Universidad Nacional Autónoma de México, 1971.

Maza 1971 "Santiago"
Maza, Francisco de la. "¡Santiago y a ellos!" (1950). In *Páginas de arte y de historia*, pp. 120–22. Mexico City: Instituto Nacional de Antropología e Historia, 1971.

Maza 1981
Maza, Francisco de la. *El guadalupanismo mexicano*. Mexico City: Fondo de Cultura Económica, 1981.

McAndrew 1965
McAndrew, John. *The Open-Air Churches of Sixteenth-Century Mexico: Atrios, Posas, Open Chapels, and Other Studies*. Cambridge, Mass.: Harvard University Press, 1965.

McQuade 1999 "Renaissance"
McQuade, Margaret Connors. "Talavera Poblana, the Renaissance of a Mexican Ceramic Tradition." *Magazine Antiques* 156 (1999).

McQuade 1999 *Talavera*
McQuade, Margaret Connors. *Talavera Poblana: Four Centuries of a Mexican Ceramic Tradition*. Exh. cat. New York: Americas Society Art Gallery, 1999.

McQuade 2005
McQuade, Margaret Connors. "Loza Poblana: The Emergence of a Mexican Ceramic Tradition." Ph.D. diss., City University of New York Graduate Center, 2005.

Meave 1791
Meave, Joaquín Alejo de. "Memoria sobre la pintura del Pueblo de Olinalan, de la Jurisdiccion de Tlapan." *Gazeta de literatura de México* 2, no. 22 (1791), pp. 173–78.

Mebold 1987
Mebold K, Luis. *Catálogo de pintura colonial en Chile: obras en monasterios de religiosas de antigua fundación*. Santiago: Ediciones Universidad Católica de Chile, 1987.

Medina González 1997
Medina González, Isabel. "¿Maque prehispánico? Una antigua discusión." In *Lacas mexicanas*. Exh. cat. Mexico City: Museo Franz Mayer; Artes de México, 1997.

Mena 1997
Mena, Claudio. "Originalidad de la escultura quiteña." *Revista del Banco Central del Ecuador*, vol. 2 (1997), pp. 51–63.

Méndez Casal 1926
Méndez Casal, Antonio. "Pintura Mejicana: un cuadro perdido de José Juárez." *Arte Español* 8, no. 3 (1926–27), pp. 118–20.

Méndez Reyes 2004
Méndez Reyes, Salvador. *Las élites criollas de México y Chile ante la Independencia*. Mexico City: Centro de Estudios sobre la Independencia de México, 2004.

Mendieta 1596/1971
Mendieta, Gerónimo de. *Historia eclesiástica indiana: obra escrita a fines del siglo XVI (1596)*. 2d ed. Mexico City: Porrúa, 1971.

Mendieta 1870/1945
Mendieta, Fray Gerónimo de. *Historia eclesiástica indiana*. Mexico City: Antigua Librería, 1870; Mexico City: Editorial Salvador Chávez Hayhoe, 1945.

Mendoza Varela 1966
Mendoza Varela, Eduardo. *Dos siglos de pintura colonial colombiana*. Bogotá: Ediciones Sol y Luna, 1966.

Menezes 1989
Menezes, Ivo Porto de. *Mestre Atayde*. Rio de Janeiro: Spala Editora, 1989.

Merlo Juárez et al. 1991
Merlo Juárez, Eduardo, et al. *La basílica catedral de la Puebla de los Ángeles, Puebla*. Puebla, Mexico: Litografía Alai, 1991.

Mesa 1981
Mesa, José de. *Museo de la Catedral de La Paz*. La Paz: Instituto de Estudios Bolivianos, Universidad Mayor de San Andrés, 1981.

Mesa 1992
Mesa, José de. "The Flemish Influence in Andean Art." In *America, Bride of the Sun: 500 Years Latin America and the Low Countries*. Antwerp: Royal Museum of Fine Arts, 1992.

Mesa and Gisbert 1956
Mesa, José de, and Teresa Gisbert. *Holguín y la pintura altoperuana del Virreinato*. La Paz: Instituto de Investigaciones Artísticas, 1956.

Mesa and Gisbert 1962
Mesa, José de, and Teresa Gisbert. *Historia de la pintura cuzqueña*. Buenos Aires: Instituto de Arte Americano e Investigaciones Estéticas, 1962.

Mesa and Gisbert 1965
Mesa, José de, and Teresa Gisbert. "El pintor Angelino Medoro y su obra en Sud América." *Annales del Instituto de Arte Americano e Investigaciones Esteticas* (Buenos Aires) 18 (1965), pp. 23–47.

Mesa and Gisbert 1970
Mesa, José de, and Teresa Gisbert. "Martín de Vos en América." *Anales del Instituto de Arte Americano e Investigaciones Estéticas* 23 (1970), pp. 36–48.

Mesa and Gisbert 1972
Mesa, José de, and Teresa Gisbert. *Escultura virreinal en Bolivia*. La Paz: Ediciones Academia Nacional de Ciencias, 1972.

Mesa and Gisbert 1974
Mesa, José de, and Teresa Gisbert. *Bitti un pintor manierista en sudamérica*. Cuadernos de Arte y Arqueología 4. La Paz: División de Extensión Universitaria, Instituto de Estudios Bolivianos, Universidad Mayor de San Andrés, 1974.

Mesa and Gisbert 1977
Mesa, José de, and Teresa Gisbert. *Holguín y la pintura virreinal en Bolivia*. 2d ed. La Paz: Librería Editorial Juventud, 1977.

Mesa and Gisbert 1982
Mesa, José de, and Teresa Gisbert. *Historia de la pintura cuzqueña*. 2 vols. Lima: Fundación Augusto N. Wiese, 1982.

Mesa and Gisbert 1991
Mesa, José de, and Teresa Gisbert. *El arte de la platería en la Audiencia de Charcas*. La Paz: Municipalidad de La Paz, Oficialia Mayor de Cultura, 1991.

Mesa and Gisbert 1992
Mesa, José de, and Teresa Gisbert. *Sucre, Bolivia*. Santa Fé de Bogotá, Colombia: Mayr & Cabal; Quito: Ediciones Libri Mundi, Enrique Grosse-Luemern, 1992.

Mesa and Gisbert 1992 *Monumentos*
Mesa, José de, and Teresa Gisbert. *Monumentos de Bolivia*. 3d ed. rev. La Paz: Embajada de España en Bolivia, 1992.

Mesa and Gisbert 1995
Mesa, José de, and Teresa Gisbert. *Escultura policroma virreinal*. Exh. cat. La Paz: El Museo de Arte Sagrado de la Catedral de La Paz, 1995.

Mesa and Gisbert 1996
Mesa, José de, and Teresa Gisbert. "Ángeles y arcángeles." In *Retorno 1996*, pp. 38–51.

Mesa and Gisbert 2002
Mesa, José de, and Teresa Gisbert. *Monumentos de Bolivia*. 4th ed. La Paz: Editorial Gisbert, 2002.

Mesa and Gisbert 2005
Mesa, José de, and Teresa Gisbert. *El manierismo en los Andes: memoria del III Encuentro Internacional sobre el Barroco*. La Paz: Unión Latina, 2005.

Mexicaans Zilver 1993
Mexicaans Zilver / Mexican Silver. Exh. cat. Brussels: Foundation Europalia International, 1993.

Mexico 1990
Mexico: Splendors of Thirty Centuries. Exh. cat. New York: The Metropolitan Museum of Art; Boston, Mass.; Bulfinch Press, 1990.

México colonial 1989
México colonial: salas de exposiciones. Exh. cat. Alicante, Spain: Caja de Ahorros del Mediterráneo, 1989.

México en el mundo 1994
México en el mundo de las colecciones de arte: Nueva España I. 7 vols. Mexico City: Grupo Azabache, 1994.

México eterno 1999
México eterno: arte y permanencia. Exh. cat. Mexico City: Consejo Nacional para la Cultura y las Artes, Instituto Nacional de Antropología e Historia, Instituto Nacional de Bellas Artes, Espejo de Obsidiana, 1999.

Michaelis de Vasconcelos 1905
Michaelis de Vasconcelos, Carolina. "Algunas palavras a respeito de púcaros de Portugal." *Bulletin hispanique* 7 (1905), pp. 140–96.

Milicua 1958
Milicua, José. "Un retrato de Campeche." *Archivo español de arte* 122 (1958), pp. 143–44.

Mills 1997
Mills, Kenneth. *Idolatry and Its Enemies: Colonial Andean Religion and Extirpation, 1640–1750.* Princeton, N.J.: Princeton University Press, 1997.

Miño Grijalva 1993
Miño Grijalva, Manuel. *La manufactura colonial: la consiticion tecnica del obraje.* Mexico City: El Colegio de México, 1993.

MMA Bulletin 1957
Metropolitan Museum of Art Bulletin 16 (October 1957).

Moacir Maia 1987
Moacir Maia, Pedro, ed. *O Museu de arte sacra da Universidade Federal da Bahia.* São Paulo: Banco Safra, 1987.

Moffitt 1984
Moffitt, John F. "El Sagrario Metropolitano, Wendel Dietterlin, and the Estípite: Observations on Mannerism and Neo-Plateresque Architectural Style in 18th Century Mexican Ecclesiastical Façades." *Boletín del Seminario de Estudios de Arte y Arqueología Valladolid* 50 (1984), pp. 325–49.

Moissén 1967
Moissén, Xavier. "Murillo en México: la Virgen de Belén." *Boletín del Instituto de Antropología e Historia* 28 (1967), pp. 11–18.

Möller 1962
Möller, Carlos Manuel. *Páginas coloniales.* Caracas: Ediciones de la Associación Venezolana Amigos del Arte Colonial, 1962.

Montero Alarcón 1999
Montero Alarcón, Alma. *Monjas Coronadas.* Mexico City: Consejo Nacional para la Cultura y las Artes, 1999.

Monterrosa Prado 1997
Monterrosa Prado, Mariano. "La colección de pintura y su profundo sentido humano." In Rivero Torres 1997, pp. 130–49.

Montesinos 1642/1906
Montesinos, Fernando. *Anales del Perú.* Published by Víctor M. Maurtua. 2 vols. Madrid: Imp. de Gabriel L. y del Horno, 1906.

Montgomery 1970
Montgomery, Florence M. *Printed Textiles: English and American Cottons and Linens, 1700–1850.* New York: Viking Press, 1970.

Mora-Osejo 1977
Mora-Osejo, Luis Eduardo. "El barniz de Pasto." *Caldasia* 11 (1977), pp. 5–31.

Moreno Villa 1942
Moreno Villa, José. *La escultura colonial mexicana.* Mexico City: El Colegio de México, 1942.

Moreno Villa 1986
Moreno Villa, José. *La escultura colonial mexicana.* Mexico City: Fondo de Cultura Económica, 1986.

Morison 1963
Morison, Samuel Elliot, ed., trans. *Journals and Other Documents on the Life and Voyages of Christopher Columbus.* New York: Heritage Press, 1963.

Mostra medicea 1939
Palazzo Medici Riccardi, Florence. *Mostra medicea.* Florence: Casa Editrice Marzocco, 1939.

Motolinía 1541/1951
Motolinía, Toribio de Benavente. *Motolinía's History of the Indians of New Spain.* Ed. and trans. Francis Borgia Steck. Washington, D.C.: Academy of American Franciscan History, 1951.

Motolinía 1541/1969
Motolinía, Toribio de Benavente. *Historia de los indios de la Nueva España.* 1541; Mexico City: Porrúa, 1969.

Motolinía 1541/1985
Motolinía, Toribio de Benavente. *Historia de los Indios de la Nueva España.* Ed. Georges Baudot. Madrid: Castalia, 1985.

Motolinía c. 1555/1971
Motolinía, Toribio de Benavente. *Memoriales, o libro de las cosas de la Nueva España y de los naturales de ella . . .* [c. 1555] 2d ed., ed. and trans. Edmundo O'Gorman. Mexico City: Universidad Nacional Autónoma de México, 1971.

Moura 1997
Moura, Carlos Eugênio Marcondes de. "Religiosidade Africana no Brasil." In Araújo 1997, unpaginated.

Moyssén 1966
Moyssén, Xavier. "El San Sebastián de Xochimilco." *Boletín del Instituto Nacional de Antropología e Historia* 24 (1966), pp. 4–7.

Moyssén 1979
Moyssén, Xavier. "La Alameda de México en 1775." *Boletín de monumentos históricos* (Mexico City) 2 (1979), pp. 47–56.

Moyssén 1990
Moyssén, Xavier. "Escultura en pasta y piedra." In *Imaginería virreinal: memorias de un seminario*, ed. Gustavo Curiel, pp. 21–24. Mexico City: Instituto de Investigaciones Estéticas, Universidad Nacional Autónoma de México, 1990.

Mues Orts et al. 2001
Mues Orts, Paula, et al. *El divino pintor: la creación de María de Guadalupe en el taller celestial.* Mexico City: Museo de la Basílica de Guadalupe, 2001.

Muestra 1984
Muestra de cultura precolombina y colonial. Cáceres, Spain: Institución Cultural "El Brocense," 1984.

Mugaburu 1975
[Mugaburu, Josephe and Francisco]. *Chronicle of Colonial Lima: The Diary of Josephe and Francisco Mugaburu, 1640–1697.* Trans. and ed. Robert Ryal Miller. Norman: University of Oklahoma Press, 1975.

Mujica Pinilla 1992
Mujica Pinilla, Ramón. *Ángeles apócrifos en la América virreinal.* Lima: Fondo de Cultura Económica, Instituto de Estudios Tradicionales, 1992.

Mujica Pinilla 2001
Mujica Pinilla, Ramón. *Rosa limensis: mística, política e iconografía en torno a la patrona de América.* Lima: Fondo de Cultura Económica, 2001.

Mujica Pinilla 2002 "Arte"
Mujica Pinilla, Ramón. "El arte y los sermones." In Mujica Pinilla et al. 2002, pp. 222–312.

Mujica Pinilla 2002 "Arte e identidad"
Mujica Pinilla, Ramón. "Arte e identidad: las raíces culturales del barroco peruano." In Mujica Pinilla et al. 2002, pp. 1–57.

Mujica Pinilla 2003
Mujica Pinilla, Ramón. "Identidades alegóricas: lecturas iconográficas del barroco al neoclásico." In Mujica Pinilla et al. 2003, pp. 258–335.

Mujica Pinilla 2004
Mujica Pinilla, Ramón. "El 'Niño Jesús Inca' y los Jesuitas en el Cusco virreinal." In *Perú indígena* 2004, pp. 102–6.

Mujica Pinilla et al. 2002
Mujica Pinilla, Ramón, et al. *El barroco peruano*, vol. 1. Lima: Banco de Crédito, 2002.

Mujica Pinilla et al. 2003
Mujica Pinilla, Ramón, et al. *El barroco peruano*, vol. 2. Lima: Banco de Crédito, 2003.

Mullen 1995
Mullen, Robert. *The Architecture and Sculpture of Oaxaca, 1530s–1980s.* Tempe: Center for Latin American Studies, Arizona State University, 1995.

Muriel et al. 1987
Muriel, Josefina, et al. *Los vascos en México y su colegio de las Viscaínas.* Mexico City: Universidad Nacional Autónoma de México, 1987.

Murillo 1925
Murillo, Gerardo (Dr. Atl). *Iglesias de México*, vol. 3, *Tipos Ultra-Barrocos, Valle de Mexico.* Mexico City: Secretaría de Hacienda, 1925.

Murúa 1590–1600
Murúa, Martín de. *Historia del origen y genealogía real de los reyes Incas del Perú, 1590–1600.* MS. Collection of Mr. Sean Galvin, Ireland.

Murúa 1613
Murúa, Martín de. *Historia general del Perú.* 1613. MS Ludwig XIII 16. J. Paul Getty Museum, Los Angeles.

Museo de Arte Colonial 2000
Museo de Arte Colonial. *Esculturas de la colonia: colección de obras.* 2d ed. Bogotá: Museo de Arte Colonial, 2000.

Museo de Arte de Lima 1992
Museo de Arte de Lima. *Museo de Arte de Lima: 100 obras maestras.* Lima: Asociación Museo de Arte de Lima; Banco Latino, 1992.

Museo de Historia Mexicana 1998
Museo de Historia Mexicana. *Los galeones de la plata: México, corazón del comercio interoceánico, 1565–1815.* Mexico City: Consejo Nacional para la Cultura y las Artes, 1998.

Museo Histórico de Acapulco, Fuerte de San Diego, 2002
Museo Histórico de Acapulco, Fuerte de San Diego. *Porcelana de la Compañía de Indias para México.* Mexico City: Conaculta, 2002.

Museo Histórico Nacional 1985
Museo Histórico Nacional, Rio de Janeiro. *A Carreira das Indias e o gosto do Oriente.* Rio de Janeiro: Secretaria de Estado da Cultura, 1985.

Museo Histórico Nacional 1993
Museo Histórico Nacional, Rio de Janeiro. *Arte do Marfim.* Rio de Janeiro: Ministério da Cultura, 1993.

Museo Histórico Nacional 2002
Museo Histórico Nacional, Rio de Janeiro. *A sagração do Marfim.* Rio de Janeiro: Secretaria de Estado da Cultura, 2002.

Museo Nacional de Historia 1988
Museo Nacional de Historia. *El Galeón de Acapulco.* Mexico City: INAH, 1988.

Museo Nacional del Banco Central del Ecuador 2000
Museo Nacional del Banco Central del Ecuador. *La gracia barroca*. Quito: Banco Central del Ecuador, 2000.

Museo Nacional del Banco Central del Ecuador 2001
Museo Nacional del Banco Central del Ecuador. *Sala de Arte Colonial*. Quito: Banco Central del Ecuador, 2001.

Museo Pedro de Osma 2004
Museo Pedro de Osma. Lima: Fundación Pedro y Angélica de Osma Gildemeister, 2004.

Museo Querétaro 1986
"Las colecciones de pintura." In *Museo Regional de Querétaro: 50 años*, pp. 168–69. Mexico City: Gobierno del Estado de Querétaro, Dirección de Patrimonio Cultural, 1986.

Museo Soumaya 1999
Museo Soumaya. *Viento detenido: mitologías e historias en el arte del biombo*. Mexico City: Artes Gráficas Panorama, 1999.

Museu de São Roque 1996
Museu de São Roque. *A Herança de Rauluchantim*. Lisbon: Comissão Nacional para as Comemorações dos Descobrimentos Portugueses, 1996.

Navarrete Prieto 1998
Navarrete Prieto, Benito. *Zurbarán y su obrador: pinturas para el Nuevo Mundo*. Exh. cat. Valencia, Spain: Generalitat Valenciana, 1998.

Navarrete Prieto 1999
Navarrete Prieto, Benito. "El ideario volante: la estampa como medio de difusión y transmisión de formas en el barroco virreinal." In *Viento detenido* 1999, pp. 40–41.

Navarrete Prieto 1999 "Mecánica"
Navarrete Prieto, Benito. "La mecánica de trabajo en el obrador de Zurbarán." In Pérez Sánchez 1999, pp. 115–46.

Navarrete Prieto 1999 *Zurbarán*
Navarrete Prieto, Benito. *Zurbarán y su obrador: pinturas para el nuevo mundo*. Mexico City: Museo Nacional de San Carlos, 1999.

Navarro 1991
Navarro, José Gabriel. *La pintura en el Ecuador del XVI al XIX*. Quito: Dinediciones, 1991.

Navascués Palacio 2000
Navascués Palacio, Pedro. *Las catedrales del Nuevo Mundo*. Madrid: Ediciones El Viso, 2000.

Newman and Derrick 2002
Newman, Richard, and Michele Derrick. "Painted Qero Cups from the Inka and Colonial Periods in Peru: An Analytical Study of Pigments and Media." In *Materials Issues in Art and Archaeology VI: Symposium Held November 26–30, 2001, Boston, Massachusetts, USA*, ed. Pamela B. Vandiver et al., pp. 291–302. Warrendale, Pa.: Materials Research Society, 2002.

Newmann Gandía 1896
Newmann Gandía, Eduardo. "José Campeche genial pintor puertorriqueño 1752 [sic]–1809." In Newmann Gandía 1896–99, pp. 335–55.

Newmann Gandía 1896–99
Newmann Gandía, Eduardo. *Benefactores y hombres notables de Puerto Rico: bocetos biográficos-críticos, con un estudio sobre nuestros gobernadores generales*. 2 vols. Ponce, Puerto Rico: Tipografía La Libertad, 1896–99.

Newmann Gandía 1897
Newmann Gandía, Eduardo. *Gloriosa epopeya: sitio de los iglesias de 1797 con datos hasta ahora no publicados*. Ponce, Puerto Rico: Imprenta La Libertad, 1897.

Obras maestras 1990
Obras maestras del arte colonial: exposición homenaje a Manuel Toussaint. Exh. cat. Mexico City: Instituto de Investigaciones Estéticas, Universidad Nacional Autónoma de México, Museo Nacional de Arte, 1990.

Obregón 1967
Obregón, Gonzalo. "La platería en el Museo Nacional de Historia." *Artes de México* 92–93 (1967).

Odriozola 1863–77
Odriozola, Manuel de, ed. *Collección de documentos literarios del Perú*. 11 vols. Lima: Imprenta del Estado, 1863–77.

Oliveira 1989
Oliveira, Myriam Ribeiro de. "La escultura colonial brasileña." In Damián Bayón and Murillo Marx, *Historia del arte colonial Sudamericano*, pp. 365–90. Barcelona: Editorial Polígrafa, 1989.

Oliveira 1995
Oliveira, Myriam Ribeiro de. "La pintura y la escultura en Brasil." In Gutiérrez 1995 *Pintura*, pp. 294–96.

Oliveira 2000
Oliveira, Myriam Andrade Ribeiro de. "The Religious Image in Brazil." In Aguilar et al. 2000.

Oliveira 2001
Oliveira, Myriam Andrade Ribeiro de. "Sant'Ana na imaginária sacra brasileira." In *O livro de Sant'Ana: coleção Angela Gutierrez*, ed. Angela Gutierrez, pp. 8–19. Belo Horizonte, Minas Gerais, Brazil: Instituto Cultural Flávio Gutierrez, 2001.

Oliveira 2002
Oliveira, Myriam Andrade Ribeiro de. *Aleijadinho: passos e profetas*. Belo Horizonte, Brazil: Editora Itatiaia Limitada, 2002.

Oliveira et al. 2002
Oliveira, Myriam Andrade Ribeiro de, et al. *O Aleijadinho e sua oficina: catálogo das esculturas devocionais*. São Paulo: Capivara, 2002.

Oman 1968
Oman, Charles. *The Golden Age of Hispanic Silver, 1400–1665*. London: Her Majesty's Stationery Office, 1968.

O'Neill and Dominguez 2001
O'Neill, Charles E., and Joaquín M.a Dominguez. *Diccionario histórico de la Compañía de Jesús*, vol. 1. Rome: Archivum Historicum Societatis Iesu, 2001.

O'Phelan 1988
O'Phelan, Scarlett. *Un siglo de rebeliones anticoloniales: Perú y Bolivia, 1700–1783*. Cuzco: Centro de Estudios Regionales Andinos "Bartolomé de Las Casas," 1988.

O'Phelan Godoy 2003
O'Phelan Godoy, Scarlett. "El vestido como identidad étnica e indicador social de una cultura material." In Mujica Pinilla et al. 2003, pp. 100–134.

Oratorio Filipense 1995
El Oratorio Filipense en Guanajuato. 200 años y los precursores jesuitas. Mexico City: Gobierno del Estado de Guanajuato, 1995.

Orfebrería 1986
Orfebrería hispanoamericana, siglos XVI–XIX. Exh. cat. Madrid: Museo de América, 1986.

Orfebrería 1995
La orfebrería hispanoamericana en Andalucía occidental. Exh. cat. Seville: Fundación El Monte, 1995.

Oribes 1990
Oribes y plateros en la Nueva Granada. Exh. cat. Bogotá: Museo de Arte Religioso del Banco de la República, 1990.

Oro y plata 1999
El oro y la plata de las Indias en la época de los Austrias. Exh. cat. Madrid: Fundación ICO, 1999.

Ortega Ricaurte 1965
Ortega Ricaurte, Carmen. *Diccionario de artistas en Colombia*. Bogotá: Tercer Mundo, 1965.

Ortega Ricaurte 1979
Ortega Ricaurte, Carmen. *Diccionario de artistas en Colombia*. 2d ed. Bogotá: Plaza & Janes, 1979.

Ortiz Crespo 2001
Ortiz Crespo, Alfonso. "La casa quiteña." In *La casa meridional: correspondencias*, ed. Nicolás Ramírez Moreno and José Rodríguez Galadi, pp. 139–209. Seville: Junta de Andalucía, Consejería de Obras Públicas y Transportes, 2001.

Ortiz Crespo 2004
Ortiz Crespo, Alfonso. *Origen, traza, acomodo y crecimiento de la ciudad de Quito*. Quito: Fondo de Salvamento del Patrimonio Cultural, 2004.

Ortiz Crespo and Terán Najas 1993
Ortiz Crespo, Alfonso, and Rosemarie Terán Najas. "Las reducciones de indios y la vida en policía en la zona andina de la Real Audiencia de Quito." In *Pueblos de Indios: otro urbanismo en la región andina*, ed. Ramón Gutiérrez, pp. 205–61. Quito: Ediciones Abya-Yala, 1993.

Ortiz Jiménez 1951
Ortiz Jiménez, Juan. "Campeche artists y artesano." *Puerto Rico Ilustrado*, December 19, 1951.

Ortiz Vaquero 1987
Ortiz Vaquero, Manuel. "Procesión de la Virgen de Guadalupe en el siglo XVIII." In *Imágenes guadalupanas, cuatro siglos*, pp. 32–36. Exh. cat. Mexico City: Centro Cultural de Arte Contemporáneo—Fundación Cultural Televisa, 1987.

Osorio Romero 1993
Osorio Romero, Ignacio. *La luz imaginaria: epistolariode Atanasio Kircher con los novohispanos*. Mexico City: Universidad Nacional Autónoma de México, 1993.

Ospina 2000
Ospina, William. *Mestizo America: The Country of the Future*. Bogotá: Villegas Editores, 2000.

Pacheco 1649/1990
Pacheco, Francisco. *Arte de la pintura* (1649). Edición, introducción y notas de Bonaventura Bassegoda i Hugas. Madrid: Ediciones Cátedra, 1990.

Pacheco 2001
Pacheco, Francisco. *Arte de la pintura*. 2d ed., ed. Bonaventura Bassegoda i Hugas. Madrid: Ediciones Cátedra, 2001.

Pagden 1986
Pagden, Anthony. *The Fall of Natural Man: The American Indian and the Origins of Comparative Ethnography*. Cambridge: Cambridge University Press, 1986.

Pagden 1987
Pagden, Anthony. "Identity Formation in Spanish America." In *Colonial Identity in the Atlantic World, 1500–1800*, ed. Nicholas Canny and Anthony Pagden, pp. 51–93. Princeton, N.J.: Princeton University Press, 1987.

Pagden 1992
Pagden, Anthony. *The Fall of Natural Man: The American Indian and the Origins of Comparative Ethnology*. Cambridge: Cambridge University Press, 1992.

Paiz de Serra 1997
Paiz de Serra, Isabel, ed. *Teoxché: Madera de Dios—imaginería colonial guatemalteca*. Exh. cat. Mexico City:

Embajada de Guatemala en México / Museo Franz Mayer, 1997.

Palafox y Mendoza 1642/1762
Palafox y Mendoza, Juan de. "De la naturaleza del indio" (c. 1642). In *Obras del ilustrisimo, excelentisimo, y venerable siervo de Dios, don Juan de Palafox y Mendoza . . .* Madrid: Imprenta de Don Gabriel Ramírez, 1762.

Palesati and Lepri 1999
Palesati, Antonio, and Nicoletta Lepri. *Matteo da Leccia: manierista toscano, dall'Europa al Perù.* Pomarance, Italy: Pro Pomarance, 1999.

Palm 1946/1948
Palm, Erwin Walter. "A Descendant of the Arfe Family in Spanish America: Manuel de Arfe and the Monstrance of the Cathedral of Santo Domingo." *Gazette des Beaux Arts* 34 (1946); 36 (1948).

Palm 1950 *Arte*
Palm, Erwin Walter. *Arte colonial en Santo Domingo, siglos XVI–XVIII.* Publicaciones de la Universidad de Santo Domingo 76. Exh. cat. Ciudad Trujillo, Pol Hnos., 1950.

Palm 1950 "Treasure"
Palm, Erwin Walter. "The Treasure of the Cathedral of Santo Domingo." *Art Quarterly* 13 (1950).

Palma 1952
Palma, Ricardo. *Tradiciones peruanas completas.* Ed. Edith Palma. Madrid: Aguilar Ediciones, 1952.

Palmer 1987
Palmer, Gabrielle G. *Sculpture in the Kingdom of Quito.* Albuquerque: University of New Mexico Press, 1987.

Palmer and Pierce 1992
Palmer, Gabrielle, and Donna Pierce. *Cambios: The Spirit of Transformation in Spanish Colonial Art.* Exh. cat. Santa Barbara, Calif.: Santa Barbara Museum of Art, 1992.

Pamplona 1970
Pamplona, German de. *Iconografía de la Santísima Trinidad en el arte medieval español.* Madrid: Consejo Superior de Investigaciones Científicas, 1970.

Panofsky 1943
Panofsky, Erwin. *Albrecht Dürer.* 2 vols. Princeton, N.J.: Princeton University Press, 1943.

Paredes 1784
Paredes, Antonio. *Carta edificante . . . la vida exemplar de la Hermana Salvadora de los Santos, India Otomí . . .* Mexico City: Imprenta Nueva Madrileña de los Herederos del Lic. D. Joseph de Jaùregui, 1784.

Parker Brienen 2001
Parker Brienen, Rebecca. "Albert Eckhout and Frans Post, Two Dutch Artists in Colonial Brazil." In Sullivan 2001, pp. 62–74.

Parry 1990
Parry, J. H. *The Spanish Seaborne Empire.* Berkeley and Los Angeles: University of California Press, 1990.

Pasinski 2002
Pasinski, Tony. *Informe sobre la cerámica de importación, siglos XVI al XVIII,* vol. 2. Antigua, Guatemala: Escritos San Sebastian, 2002.

Pastor de la Torre and Tord 1999
Pastor de la Torre, Celso, and Luis Enrique Tord. *Perú: fe y arte en el Virreynato.* Córdoba, Argentina: CajaSur, 1999.

Patiño 1993
Patiño, Victor Manuel. *Historia de la cultura material en la América equinoccial,* vol. 8, *Trabajo y ergología.* Bogotá: Instituto Caro y Cuero, 1993.

Paz 1976
Paz, Octavio. "Foreword: The Flight of Quetzalcóatl." In Jacques Lafaye, *Quetzalcóatl and Guadalupe: The Formation of Mexican National Consciousness, 1531–1813,* trans. Benjamin Keen. Chicago: University of Chicago Press, 1976.

Paz 1988
Paz, Octavio. *Sor Juana: Her Life and Her World.* Trans. Margaret Sayers Peden. Cambridge, Mass.: Harvard University Press, 1988.

Pereira Salas 1965
Pereira Salas, Eugenio. *Historia del arte en el Reino de Chile.* Santiago: Ediciones de la Universidad de Chile, 1965.

Pérez Carrillo 1989
Pérez Carrillo, Sonia. "La tradición indígena en las artes coloniales." In *México colonial: salas de exposiciones.* Exh. cat. Alicante, Spain: Caja de Ahorros del Mediterráneo, 1989.

Pérez Carillo 1990
Pérez Carillo, Sonia. *La laca mexicana: desarrollo de un oficio artesanal en el Virreinato de la Nueva España durante el siglo XVIII.* Madrid: Alianza Editorial, 1990.

Pérez Carillo and Rodríguez de Tembleque 1997
Pérez Carillo, Sonia, and Carmen Rodríguez de Tembleque. "Influencias orientales y europeas." In *Lacas mexicanas* 1997.

Pérez Morera 2003
Pérez Morera, Jesús. "Platería peruana en Canarias." *Noticias del Museo Canario* 9 (2003).

Pérez Sánchez 1998
Pérez Sánchez, Alfonso E. *Juan de Arellano, 1614–1676.* Madrid: Caja Madrid, 1998.

Pérez Sánchez 1999
Pérez Sánchez, Alonso E., ed. *Zurbarán ante su centenario, 1598–1998.* Valladolid, Spain: Universidad de Valladolid, 1999.

Perú indígena 2004
López Guzmán, Rafael, ed. *Perú indígena y virreinal.* Exh. cat. Madrid: SEACEX (Sociedad Estatal para la Acción Cultural Exterior), 2004.

Pestana 1996
Pestana, Til Costa. "O quadro sobre a reconstrução do recolhimento e Igreja de Nossa Senhora do Parto—João Francisco Muzi." *Barroco* (Minas Gerais) 17 (1996), pp. 107–13.

Peterson 1993
Peterson, Jeanette Favrot. *The Paradise Garden Murals of Malinalco: Utopia and Empire in Sixteenth-Century Mexico.* Austin: University of Texas Press, 1993.

Pettazzoni 1946
Pettazzoni, Raffaele. "The Pagan Origins of the Three-Headed Representation of the Christian Trinity." *Journal of the Warburg and Courtauld Institutes* 9 (1946), pp. 135–51.

Phelan 1969
Phelan, John L. "Panlatinismo, la intervención francesa en México y el origen de la idea de latinoamerica." *Latino América anuario / estudios latinoamericanos* 2 (1969), pp. 119–41.

Philadelphia Museum of Art 1994
Philadelphia Museum of Art. *Paintings from Europe and the Americas in the Philadelphia Museum of Art: A Concise Catalogue.* Philadelphia: Philadelphia Museum of Art, 1994.

Philadelphia Museum of Art 1995
Philadelphia Museum of Art. *Philadelphia Museum of Art: Handbook of the Collections.* Philadelphia: Philadelphia Museum of Art, 1995.

Phipps 1996
Phipps, Elena J. "Textiles as Cultural Memory: Andean Garments in the Colonial Period." In Fane 1996.

Phipps 2004 "Cumbi"
Phipps, Elena. "Cumbi to Tapestry: Collection, Innovation, and Transformation of the Colonial Andean Tapestry Tradition." In Phipps et al. 2004, pp. 73–99.

Phipps 2004 "Garments"
Phipps, Elena. "Garments and Identity in the Colonial Andes." In Phipps et al. 2004, pp. 17–39.

Phipps et al. 2004
Phipps, Elena, et al. *The Colonial Andes: Tapestries and Silverwork, 1530–1830.* Exh. cat. New York: Metropolitan Museum of Art; New Haven and London: Yale University Press, 2004.

Phipps et al. 2004 "Conservation"
Phipps, Elena J., et al. "Conservation and Technical Study of a Colonial Andean Tapestry." *Met Objectives* 5, no. 2 (Spring), pp. 1–6.

Pierce et al. 2004
Donna Pierce, et al. *Painting a New World: Mexican Art and Life, 1521–1821.* Exh. cat. Denver: Denver Art Museum, 2004.

Pillsbury 2002
Pillsbury, Joanne. "Inka unku: Strategy and Design in Colonial Peru." *Cleveland Studies in the History of Art* 7 (2002), pp. 68–103.

Pinceles 1999
Los pinceles de la historia: el origen del reino de la Nueva España, 1680–1750. Exh. cat. Mexico City: Instituto Nacional de Bellas Artes, 1999.

Pinceles 2000
Los pinceles de la historia: de la patria criolla a la nación mexicana, 1750–1860. Exh. cat. Mexico City: Museo Nacional de Arte; UNAM, Instituto de Investigaciones Estéticas, 2000.

Pintura en el Virreinato del Perú 1989
Nieri Galindo, Luis, ed. *Pintura en el Virreinato del Perú: el libro de arte del centenario.* 2d ed. Lima: Banco de Crédito del Perú, 1989.

Pintura novohispana 1992–96
Alarcón Cedillo, Roberto M., et al. *Pintura novohispana: Museo Nacional del Virreinato, Tepotzotlán,* vol. 2., *Siglos XVIII, XIX, and XX, primera parte.* Tepotzotlán, Mexico: Asociación de Amigos del Museo Nacional del Virreinato, 1992–96.

Pizano Restrepo 1926/1985
Pizano Restrepo, Roberto. *Gregorio Vázqvez de Arce y Ceballoz, pintor de la ciudad de Santa Fe de Bogotá, . . . la narración de sv vida y el recvento de svs obras . . .* Paris: C. Bloch, 1926; 2d corrected and expanded ed., Bogotá: Editorial Siglo Dieciseis, 1985.

Plá 1999
Plá, Josefina. *El barroco hispano guaraní.* Asunción, Paraguay: Editorial del Centenario, 1975.

Platería 1974
Platería virreynal. Lima: Banco de Crédito del Perú, 1974.

Platería mexicana 1989
El arte de la platería mexicana, 500 Años. Exh. cat. Mexico City: Centro Cultural/Arte Contemporáneo, 1989.

Plattner 1960
Plattner, Felix Alfred. *Deutsche Meister des Barock in Südamerika im 17. und 18. Jahrhundert.* Freiburg: Herder, 1960.

PMA Handbook 1999
Philadelphia Museum of Art. *Philadelphia Museum of Art: Handbook of the Collections.* 1995; reprinted Philadelphia: Philadelphia Museum of Art, 1999.

Poole 1981
Poole, Stafford. "Church Law on the Ordination of the Indians and Castas in New Spain," *Hispanic Historical American Review* 61 (1981), pp. 637–50.

Poole 1995
Poole, Stafford. *Our Lady of Guadalupe: The Origins and Sources of a Mexican National Symbol, 1531–1797.* Tucson: University of Arizona Press, 1995.

Popkin 1989
Popkin, Richard H. "The Rise and Fall of the Jewish Indian Theory." In *Menasseh Ben Israel and His World*, ed. Yosef Kaplan et al., pp. 63–82. Leiden, The Netherlands: E. J. Brill, 1989.

Posner 1971
Posner, Donald. *Annibale Carracci: A Study in the Reform of Italian Painting around 1590.* 2 vols. London: Phaidon, 1971.

Powell 1992
Powell, Jean D. "Coloured Glazes on Silver-Gilded Surfaces." In *Conservation of the Iberian and Latin American Cultural Heritage: Preprints of the Contributions to the IIC Madrid Congress, 9–12 September 1992*, ed. H. W. M. Hodges et al., pp. 116–18. London: International Institute for Conservation of Historic and Artistic Works, 1992.

Pratt 1992
Pratt, Mary Louise. *Imperial Eyes: Travel Writing and Transculturation.* New York: Routledge, 1992.

Prieto 1968
Prieto, Carlos. *La minería en el Nuevo Mundo.* Madrid: Revista de Occidente, 1968.

Primeras jornadas 1981
Primeras jornadas de Andalucía y América: 1a Rábida. 2 vols. Huelva, Spain: Instituto de Estudios Onubenses, Universidad de la Rábida, 1981.

Privilegio sagrado 2005
Reta, Martha, et al. *Un privilegio sagrado: la concepción de María Inmaculada; celebración del dogma en México.* Zacatecas: Museo de la Basílica de Guadalupe, Basílica de Santa Maria de Guadalupe, 2005.

Querejazu 1995
Querejazu, Pedro. "La escultura en el virreinato de Perú y la Audiencia de Charcas." In Gutiérrez 1995 *Pintura*.

Querejazu 1997
Querejazu, Pedro. "Un mundo de madera en el Cerro de la Plata: la escultura y arquitectura en madera en Potosí." In Querejazu and Ferrer 1997.

Querejazu 1999
Querejazu, Pedro. "Luis Niño, el famoso desconocido." *Revista de la Fundación Cultural del Banco Central de Bolivia* 3, no. 7 (1999), pp. 7–16.

Querejazu and Ferrer 1997
Querejazu, Pedro, and Elizabeth Ferrer. *Potosí: Colonial Treasures and the Bolivian City of Silver.* Exh. cat. New York: Americas Society Art Gallery in association with Fundación BHN, La Paz, 1997.

Quetzal 2002
El país del Quetzal: Guatemala maya e hispana. Exh. cat. Madrid: Centro Cultural de la Villa de Madrid, 2002.

Ramos Gavilán 1621/1988
Ramos Gavilán, Alonso. *Historia del célebre Santuario de Nuestra Señora de Copacabana* (1621). Ed. Ignacio Prado Pastor. Lima: Ignacio Prado Pastor, 1988.

Ramos Sosa 2004
Ramos Sosa, Rafael. "La grandeza de lo que hay dentro: escultura y artes de la madera." In Guillermo Lohmann Villena et al., *La Basílica Catedral de Lima*, pp. 127–31. Lima: Banco de Crédito, 2004.

Rea 1643/1882
Rea, Alonso de la. *Crónica de la Órden de N. Seráfico P. S. Francisco, Provincia de San Pedro y San Pablo de Mechoacán en la Nueva España.* 1643; Mexico City: J. R. Barbedillo, 1882.

Reis 1944
Reis, José Maria dos, Jr. *História da pintura no Brasil.* São Paulo: Leia, 1944.

Relaciones artísticas 1990
Relaciones artísticas entre España y América. Madrid: Consejo Superior de Investigaciones Científicas; Centro de Estudios Históricos, Departamento de Ha. del Arte "Diego Velásquez," 1990.

Restrepo Posada 1952
Restrepo Posada, José. "Ilmo. Antonio Claudio de Quiñones." *Hojas de Cultura popular colombiana* 20 (1952), unpaginated.

Restrepo Uribe 2001
Restrepo Uribe, Fernando. "Joaquín Gutiérrez el 'pintor de los virreyes': expresión del estilo rococó en la Nueva Granada." *Revista credencial historia*, edition 138 (2001 web page of the Biblioteca Luis Ángel Arango del Banco de la República de Colombia). http://www.lablaa.org/blaavirtual/revistas/credencial/junio2001/joaquin.htm.

Reta 2005
Reta, Martha. "El ingenio humano a favor de la Inmaculada: la defensa teológica del Misterio." In *Privilegio sagrado* 2005.

Retorno 1996
El retorno de los ángeles: barroco de las cumbres en Bolivia / Le retour des anges: baroque des cimes en Bolivie. Exh. cat. Santo Domingo: Union Latine, 1996.

Retratos 2004
Benson, Elizabeth P., et al. *Retratos: 2,000 Years of Latin American Portraits.* Exh. cat. New Haven, Conn.: Yale University Press, 2004.

Reyes-Valerio 1978
Reyes-Valerio, Constantino. *Arte indocristiano: escultura del siglo XVI en México.* Mexico: Instituto Nacional de Antropología e Historia, 1978.

Reyes-Valerio 1986
Reyes-Valerio, Constantino. "El arte indocristiano o tequitqui." In *Historia del arte mexicano*, vol. 5, *Arte colonial*, pp. 706–25. 2d ed., ed. Juan Salvat and José Luis Rosas. Mexico City: Secretaría de Educación Pública, 1986.

Reyes-Valerio 2000
Reyes-Valerio, Constantino. *Arte indocristiano.* Mexico City: Instituto Nacional de Antropología e Historia, 2000.

Ribera 1985
Ribera, Adolfo Luis. "Platería." In *Historia general del arte en la Argentina*, vol. 4. Buenos Aires: Academia Nacional de Bellas Artes, 1985.

Ribera and Schenone 1948
Ribera, Adolfo Luis, and Héctor H. Schenone. *El arte de la imaginería en el Río de la Plata.* Buenos Aires: Universidad de Buenos Aires, 1948.

Ribera and Schenone 1981
Ribera, Adolfo Luis, and Héctor H. Schenone. *Platería sudamericana de los siglos XVII–XIX.* Munich: Hirmer, 1981.

Ricard 1947
Ricard, Robert. *La conquista espiritual de México: ensayo sobre el apostolado y los métodos misioneros de las órdenes mendicantes en la Nueva España de 1523–24 a 1572.* Trans. Ángel María Garibay K. Mexico City: Editorial Jus, 1947.

Ricard 1966
Ricard, Robert. *The Spiritual Conquest of Mexico: An Essay on the Apostolate and the Evangelizing Methods of the Mendicant Orders in New Spain, 1523–1572.* Trans. Lesley Byrd Simpson. Berkeley and Los Angeles: University of California Press, 1966.

Rico Cervantes 1987
Rico Cervantes, Araceli. "El biombo, una mirada que se esconde: los biombos de la colección Franz Mayer." *Boletín del Museo Franz Mayer* 21 (1987).

Rigau Pérez 1982
Rigau Pérez, José Gabriel. "El ojo clínico de José Campeche confirmado por documentos medicos de la época." *Boletín de la Asociación Médica de Puerto Rico* 77, no. 8 (1985), pp. 326–33.

Rivas 2000
Rivas, Jorge. *Arte del período hispánico venezolano en la Hacienda Carabobo.* Caracas: Colección Patricia Phelps de Cisneros, 2000.

Rivero Lake forthcoming
Rivero Lake, Rodrigo. *El arte namban en el México virreinal.* Madrid: Ediciones Turner, forthcoming.

Rivero Torres 1997
Rivero Torres, José Manuel, ed. *San Francisco: un convento y un museo surcando el tiempo.* Querétaro, Mexico: Amigos del Museo Regional de Querétaro, 1997.

Robertson 1959
Robertson, Donald. *Mexican Manuscript Painting of the Early Colonial Period: The Metropolitan Schools.* New Haven, Conn.: Yale University Press, 1959.

Robertson 1975
Robertson, Donald. "Techialoyan Manuscripts and Paintings, with a Catalog." In Cline 1972, vol. 14, pp. 253–80.

Rocha et al. 1982
Rocha, Paulo, et al. *400 años do Mosteiro de São Bento da Bahia.* Salvador: Mosteiro de São Bento and Construtora Norberto Odebrecht, 1982.

Rodríguez 1980
Rodríguez, Santiago. "Iglesia de Santo Domingo de México." In *Monografías de arte sacro.* Mexico City: Comisión de Arte Sacro, 1980.

Rodríguez Demorizi 1942
Rodríguez Demorizi, Emilio. *Relaciones históricas de Santo Domingo.* Archivo General de la Nación 14, no. 2. 3 vols. Ciudad Trujillo, Dominican Republic: R. D. Editora Montalvo, 1942.

Rodríguez Docampo 1650/1994
Rodríguez Docampo, Diego. "Descripción y relación del estado eclesiástico del Obispado de San Francisco de Quito (1650)." In *Relaciones histórico-geográficas de la Audiencia de Quito: siglos XVI–XIX*, ed. Pilar Ponce Leiva, vol. 2, pp. 207–322. Quito: Marka / Ediciones Abya-Yala, 1994.

Rodríguez G. de Ceballos 1999
Rodríguez G. de Ceballos, Alfonso. "Usos y funciones de la imagen religiosa en los virreinatos americanos." In *Siglos de oro* 1999.

Rodríguez García and Castilla Soto 1998
Rodríguez García, Justina, and Josefina Castilla Soto. *Diccionario de términos de historia de España: edad moderna*. Barcelona: Editorial Ariel, 1998.

Rodríguez Juliá 1986
Rodríguez Juliá, Edgardo. *Campeche o los diablejos de la melancholia*. San Juan, Puerto Rico: Editorial Cultural and Instituto de Cultura Puertorriqueña, 1986.

Röhl 1946
Röhl, Juan. *Historias viejas y cuentos nuevos*. Caracas: Élite, 1946.

Roig 1984
Roig, Arturo Andrés. *El humanismo ecuatoriano de la segunda mitad del siglo XVIII*. 2 vols. Quito: Banco Central del Ecuador / Corporación Editora Nacional, 1984.

Rojas Abrigo 1985
Rojas Abrigo, Alicia. "El Barroco en las pinturas de la serie de la vida de San Francisco de Asís de Santiago." In *Barroco europeo y americano, 1981–1983*. Valparaíso: Ediciones Universitarias de Valparaíso, 1985.

Rojas-Mix 1978
Rojas-Mix, Miguel A. *La plaza mayor: el urbanismo, instrumento de dominio colonial*. Barcelona: Muchnik Editores, 1978.

Rosa 1980
Rosa, Mercedes. *A prata da casa: um estudo sobre a ourivesaria no Museu Carlos Costa Pinto*. Salvador, Brazil: Conselho Federal da Cultura, 1980.

Rowe 1979
Rowe, John H. "Standardization in Inca Tapestry Tunics." In *The Junius B. Bird Pre-Columbian Textile Conference, May 19th and 20th, 1973*. Washington D.C.: The Textile Museum & Dumbarton Oaks, Trustees for Harvard University, 1979.

Rowe and Rowe 1996
Rowe, Ann Pollard, and John H. Rowe. "Inca Tunics." In *Andean Art at Dumbarton Oaks*, ed. Elizabeth Hill Boone. Washington, D.C.: Dumbarton Oaks Research Library and Collection, 1996.

Rubial García 1995
Rubial García, Antonio. "Introduction" to *Zodíaco Mariano*. By Francisco de Florencia and Juan Antonio de Oviedo. 1755; Mexico City: Consejo Nacional para la Cultura y las Artes, 1995.

Rubial García 1997
Rubial García, Antonio. "Los santos milagreros y malogrados de la Nueva España." In *Manifestaciones religiosas* 1997.

Rubial García 2005
Rubial García, Antonio. "Santiago y la cruz de piedra: la mítica y milagrosa fundación de Querétaro, ¿una elaboración del Siglo de las Luces?" In *Creencias y prácticas religiosas en Querétaro*, ed. Juan Ricardo Jiménez Gómez, pp. 25–58. Mexico: Universidad Autónoma de Querétaro, 2005.

Rubial García and Suárez Molina 1999
Rubial García, Antonio, and María Teresa Suárez Molina. "La construcción de una iglesia Indiana: las imágenes de su edad dorada." In *Pinceles* 1999.

Rubial García and Suárez Molina 2000
Rubial García, Antonio, and María Teresa Suárez Molina. "Mártires y predicadores: la conquista de las fronteras y su representación plástica." In *Pinceles* 2000, pp. 50–71.

Rubio 1982
Rubio, Fray Vicente. *La custodia de la catedral dominicana es la obra más valiosa del arte colonial*. Suplemento El Caribe, Santo Domingo, 19-6-1982.

Rueda González and Leal de Castillo 2002
Rueda González, Armando, and María del Rosario Leal de Castillo. *Arte y naturaleza en la colonia*. Exh. cat. Bogotá: Museo de Arte Colonial; Ministerio de Cultura; Universidad Nacional de Colombia; 2002.

Ruiz de Fischler and Trelles 2000
Ruiz de Fischler, Carmen T., and Mercedes Trelles, eds. *Los tesoros de la pintura puertorriqueña*. San Juan, Puerto Rico: Museo de Arte de Puerto Rico, 2000.

Ruiz de la Mata 1971
Ruiz de la Mata, Beatriz. "José Campeche." *The San Juan Star* (San Juan, Puerto Rico), April 25, 1971.

Ruiz Gomar 1976
Ruiz Gomar Campos, Jose Rogelio. "Un panorama y dos ejemplos de la pintura mexicana en el paso del siglo XVI al XVII." Master's thesis, Universidad Nacional Autónoma de México, Mexico City, 1976.

Ruiz Gomar 1987
Ruiz Gomar, Rogelio. *El pintor Luis Juárez: su vida y su obra*. Mexico City: Universidad Nacional Autónoma de México, 1987.

Ruiz Gomar 1990
Ruiz Gomar, Rogelio. "El gremio de escultores y entalladores en la Nueva España." In *Imaginería virreinal: memorias de un seminario*, ed. Gustavo Curiel, pp. 27–44. Mexico City: Instituto de Investigaciones Estéticas, Universidad Nacional Autónoma de México, 1990.

Ruiz Gomar 1991
Ruiz Gomar, Rogelio. "El gremio y la cofradía de pintores en la Nueva España." In Vargaslugo and Guadalupe Victoria 1991, pp. 203–22.

Ruiz Gomar 1994
Ruiz Gomar, Rogelio. "Nuevo enfoque y nuevas noticias en torno a 'los Echave.'" In Gutiérrez Arriola and Maquívar 2004, pp. 183–207.

Ruiz Gomar 1998
Ruiz Gomar, Rogelio. "La presencia de Rubens en la pintura colonial mexicana." In *Rubens y su siglo*, pp. 47–53. Mexico City: Instituto Nacional de Bellas Artes, 1998.

Ruiz Gomar 2004 "Expressions"
Ruiz Gomar, Rogelio. "Unique Expressions: Painting in New Spain." In Pierce et al. 2004, pp. 55–57.

Ruiz Gomar 2004 "San Pablo"
Ruiz Gomar, Rogelio. "San Pablo y San Antonio ermitaños." In Ruiz Gomar et al. 2004, pp. 235–42.

Ruiz Gomar et al. 2004
Ruiz Gomar, Rogelio, et al. *Catálogo comentado del acervo del Museo Nacional de Arte*, vol. 2, *Nueva España*, vol. 2. Mexico City: Museo Nacional de Arte; Universidad Nacional Autónoma de México, 2004.

Sahagún 1961
Sahagún, Bernardino de. *Florentine Codex: General History of the Things of New Spain*, pt. 11, book 10, *The People*. Trans. Arthur J. O. Anderson and Charles E. Dibble. Santa Fe, N.M.: School of American Research, 1961.

Sahagún 1979
Sahagún, Bernardino de. *Historia general de las cosas de Nueva España (Códice florentino)*. Mexico City: Secretaría de Gobernación, Archivo General de la Nación, 1979.

Sahagún 1981
Sahagún, Bernardino de. *El México antiguo*. Caracas: Biblioteca Ayacucho, 1981.

Sahagún 2001
Sahagún, Bernardino de. *Historia general de las cosas de Nueva España (Códice florentino)*. Facsimile edition, Mexico City: Editorial Aldus, 2001.

Sallnow 1987
Sallnow, Michael J. *Pilgrims of the Andes: Regional Cults in Cusco*. Washington, D.C.: Smithsonian Institution Press, 1987.

Salomon and Urioste 1991
Salomon, Frank, and George L. Urioste, trans. *The Huarochirí Manuscript: A Testament of Ancient and Colonial Andean Religion*. Austin: University of Texas Press, 1991.

Salvador Lara 1992
Salvador Lara, Jorge. *Quito*. Colección ciudades de Iberoamérica 5. Madrid: Editorial MAPFRE, 1992.

Salvando 1998
Salvando alas y halos: pintura colonial restaurada. Buenos Aires: Museo Nacional de Bellas Artes, 1998.

Salvucci 1987
Salvucci, Richard J. *Textiles and Capitalism in Mexico: An Economic History of the Obrajes, 1539–1840*. Princeton, N.J.: Princeton University Press, 1987.

Samayoa Guevara 1962
Samayoa Guevara, Héctor Humberto. *Los gremios de artesanos en la ciudad de Guatemala, 1524–1821*. Guatemala: Editorial Universitaria, 1962.

San Francisco de Asís 1978
San Francisco de Asís: escritos, biografías, documentos de la época. Ed. José Antonio Guerra. Madrid: Biblioteca de Autores Cristianos, 1978.

Sanabrais 2005
Sanabrais, Sofía. "The Influence of Murillo in New Spain." *Burlington Magazine* 147 (2005), pp. 327–30.

Sánchez 1648
Sánchez, Miguel. *Imagen de la Virgen Maria, madre de Dios de Guadalupe: milagrosamente aparecida en la ciudad de Mexico; celebrada en su historia, con la profecia del capitulo doce del Apocalipsis*. Mexico City: Imprenta de la Viuda de Bernardo Calderón, 1648.

Sánchez Cantón 1956–59
Sánchez Cantón, F. J., ed. *Inventarios reales bienes muebles que pertenecieron a Felipe II* (1599). 2 vols. Madrid: Real Academia de la Historia, 1956–59.

Sanchiz Ruiz 2000
Sanchiz Ruiz, Javier. "La familia Fagoaga. Apuntes genealógicos." In *Estudios de historia novohispana*, vol. 23, pp. 129–67. Mexico City: Universidad Nacional Autónoma de México, Instituto de Investigaciones Estéticas, 2000.

Santa Gertrudis 1722
Santa Gertrudis, Francisco Xavier de. *La cruz de piedra, imán de la devoción venerada en el Colegio de misioneros apostólicos de la ciudad de Santiago de Querétaro . . .* Mexico City: Francisco Ortega y Bonilla, 1722.

Santa Gertrudis 1956
Santa Gertrudis, Juan de. *Maravillas de la naturaleza*. 2 vols. Bogotá: Empresa Nacional de Publicaciones, 1956.

Santiago Cruz 1960
Santiago Cruz, Francisco. *Las artes y los gremios en la Nueva España.* Mexico City: Editorial Jus, 1960.

Santiago de la Vorágine 1982
Santiago de la Vorágine. *La leyenda dorada.* 2 vols. Madrid: Alianza Forma, 1982.

Santisteban 1992
Santisteban, Miguel de. *Mil leguas por América: de Lima a Caracas, 1740–1741.* Ed. David J. Robinson. Bogotá: Banco de la República, 1992.

Santos Filho 2003
Santos Filho, Olinto Rodrigues dos. "A capela da fazenda da Jaguara e o mestre Aleijadinho." *Revista Imagem Brasiliera* 2 (2003).

Sanz 1999
Sanz, María Jesús. "Las primitivas marcas en la platería sevillana: reflexiones sobre su significado." *Laboratorio de arte* (Seville) 12 (1999).

Sanz Serrano 1975
Sanz Serrano, María Jesús. "Las jarras bautismales del Museo Lázaro Galdiano." *Goya* (Madrid) 129 (1975), pp. 149–55.

Sayer 1985
Sayer, Chloë. *Mexican Costume.* London: British Museum Publications, 1985.

Schávelzon 1982
Schávelzon, Daniel, ed. *Representaciones de arquitectura en la arqueología de América: Mesoamérica.* 2 vols. Mexico City: Universidad Nacional Autónoma de México, 1982 and 1984.

Schávelzon 1993
Schávelzon, Daniel. "La representación iconográfica de los poblados indígenas de la región andina de Sudamérica." In *Pueblos de indios: otro urbanismo en la región andina,* ed. Ramón Gutiérrez, pp. 109–56. Quito: Biblioteca Abya-Yala, 1993.

Schenone 1989
Schenone, Héctor H. *Salvando alas y halos: pintura colonial restaurada.* Exh. cat. Buenos Aires: Fundación Tarea, 1989.

Schenone 1992
Schenone, Héctor H. *Iconografía del arte colonial,* vols. 1–2, *Los santos.* Buenos Aires: Fundación Tarea, 1992.

Schenone 1998 *Iconografía*
Schenone, Héctor H. *Iconografía del arte colonial,* vol. 3, *Jesucristo.* Buenos Aires: Fundación Tarea, 1998.

Schenone 1998 *Salvando*
Schenone, Héctor H. *Salvando alas y halos.* Buenos Aires: Ediciones Tarea, 1998.

Schmidt 1995
Schmidt, Gary D. *The Iconography of the Mouth of Hell: Eighth-Century Britain to the Fifteenth Century.* Selingsgrove, Pa.: Susquehanna University Press; Cranbury, N.J.: Associated University Presses, 1995.

Schreffler forthcoming
Schreffler, Michael. *The Art of Allegiance: Visual Culture and Imperial Power in Baroque New Spain.* University Park: Pennsylvania State University Press, forthcoming.

Schroeder 1941
Schroeder, H. J. *Canons and Decrees of the Council of Trent.* St. Louis, Mo., and London: B. Herder Book Co., 1941.

Schroeder 1991
Schroeder, Susan. *Chimalpahin and the Kingdoms of Chalco.* Tucson: University of Arizona Press, 1991.

Schurz 1939
Schurz, William Lytle. *The Manila Galleon.* New York: E. P. Dutton, 1939.

Schurz 1959
Schurz, William Lytle. *The Manila Galleon.* New York: Historical Conservation Society, 1959.

Sebastián 1985
Sebastián, Santiago. "El ciclo iconográfico franciscano de Santiago de Chile." *Boletín de la Académica Chilena de la Historia* 95 (1985).

Sebastián 1990
Sebastián, Santiago. *El barroco iberoamericano: mensaje iconográfico.* Madrid: Encuentro Ediciones, 1990.

Sebastián 1992
Sebastián, Santiago. *Iconografía y iconología del arte novohispano.* Mexico City: Grupo Azabache, 1992.

Sebastián 2004
Sebastián, Santiago. "European Models in the Art of the Viceroyalty of New Granada." In *Retratos* 2004, pp. 13–38.

Sebastián López 1985
Sebastián López, Santiago. "El ciclo iconográfico franciscano de Santiago de Chile." *Boletín de la Academia Chilena de la Historia* 95 (1985), pp. 311–52.

Sebastián López et al. 1992
Sebastián López, Santiago, et al. *Arte iberoamericano desde la colonización a la independencia.* 4th ed. Summa artis 28–29. Madrid: Espasa-Calpe, 1992.

Seed 1993
Seed, Patricia. "'Are These Not Also Men?' The Indians' Humanity and Capacity for Spanish Civilisation." *Journal of Latin American Studies* 24, pt. 3 (1993), pp. 629–52.

Sepúlveda y Herrera 1978
Sepúlveda y Herrera, María Teresa. *Maque.* Mexico: Instituto Nacional de Antropología e Historia, 1978.

Serrano 1964
Serrano, Luis G. *La traza original con que fue construida la Catedral de México.* Mexico City: Escuela Nacional de Arquitectura, Universidad Nacional Autónoma de México, 1964.

Serrano Cabrera 1985
Serrano Cabrera, Manuel. "Informe de los trabajos de conservación y restauración de un biombo de la colección del Banco Nacional de México." In Vargaslugo and Guadalupe Victoria 1985, pt. 2, pp. 409–19.

Serrera 1988
Serrera, Juan Miguel. "Zurbarán y América." In *Zurbarán,* pp. 63–83. Madrid: Ministerio de Cultura, Banco Bilbao Vizcaya, 1988.

Serrera 1991
Serrera, Juan Miguel. *Alonso Vázquez en México.* Mexico City: Pinacoteca Virreinal de San Diego-INBA, 1991.

Serrera 1995
Serrera, Juan Miguel. "La defensa novohispana de la ingenuidad de la pintura." *Academia* 81 (1995), pp. 277–88.

Seseña 1991
Seseña, Natacha. "El búcaro de *Las Meninas.*" In *Velázquez y el arte de su tiempo.* V Jornadas de Arte del Departamento de Arte "Diego Velázquez" del Centro de Estudios Históricos del C.S.I.C. Madrid: Editorial Alpuerto, 1991.

Sharborough 1975
Sharborough, Stephen. "El ciclo de los pastores." *History of Religions at UCLA* 3 (1975), pp. 7–11.

Shulsky 1995
Shulsky, Linda Rosenfeld. "The 'Fountain' Ewers: An Explanation for the Motif." *Bulletin of the Museum of Far Eastern Antiquities* (Stockholm) 67 (1995), pp. 51–78.

Shulsky 1998
Shulsky, Linda R. "Chinese Porcelain in Spanish Colonial Sites in the Southern Part of North America and the Caribbean." *Transactions of the Oriental Ceramic Society* 63 (1998–99), pp. 83–98.

Shulsky 2001
Shulsky, Linda R. "A Chinese Porcelain Bowl Found in Concepción de la Vega." *Oriental Art* 47 (2001), pp. 61–65.

Shulsky 2002
Shulsky, Linda R. "Chinese Porcelain at Old Mobile." *Historical Archaeology* 36 (2002), pp. 97–104.

Sigaut 2002
Sigaut, Nelly. *José Juárez: recursos y discursos del arte de pintar.* Exh. cat. Mexico City: Museo Nacional de Arte, 2002.

Siglos de oro 1999
Los siglos de oro en los virreinatos de América 1550–1700. Exh. cat. Madrid: Sociedad Estatal para la Conmemoración de los Centenarios de Felipe II y Carlos V, 1999.

Silva Santisteban 1989
Silva Santisteban, Fernando. "Prefectos Betlemitas por Joseph de Páez." In *Pintura en el Virreinato del Perú,* pp. 314–19. Lima: Banco de Crédito del Perú, 1989.

Silva-Nigra 1942
Silva-Nigra, Clemente da, O.S.B. "A prataria seiscentista do Mosteiro de São Bento do Rio de Janeiro." *Revista do Serviço do Patrimônio Histórico e Artístico Nacional* 6 (1942).

Silva-Nigra 1971
Silva-Nigra, Clemente da, O.S.B. *Os dois escultores: Frei Agostinho da Piedade, Frei Agostinho de Jesus, e o arquiteto Frei Macário de São João.* Salvador, Brazil: Universidade Federal da Bahia, 1971.

Silva-Nigra 1972
Silva-Nigra, Clemente da, O.S.B. *Convento de Santa Teresa, Museu de Arte Sacra da Universidade Federal da Bahia.* Rio de Janeiro: Livraria Agir, 1972.

Simón 1953
Simón, Pedro. *Noticias historiales de las conquistas de Tierra Firme en las Indias Occidentales.* Ed. Manuel José Forero. 9 vols. Bogotá: Ministerio de Educación Nacional, Ediciones de la Revista Bolivar, 1953.

Siracusano 2005
Siracusano, Gabriela. *El poder de los colores.* Buenos Aires: Fondo de Cultura Económica, 2005.

Smith 1959
Smith, Robert S. "Indigo Production and Trade in Colonial Guatemala." *Hispanic American Historical Review* 39 (1959), pp. 181–211.

Smith 1963
Smith, Mary Elizabeth. "The Codex Colombino: A Document of the South Coast of Oaxaca." *Tlalocan* 4 (1963), pp. 276–88.

Smith 1966
Smith, Mary Elizabeth. "Las glosas del Códice Colombino / The Glosses of the Codex Colombino." In *Interpretación*

del *Códice Colombino / Interpretation of the Codex Colombino*, ed. Alfonso Caso, pp. 51–84, 151–76, 179–89. Mexico City: Sociedad Mexicana de Antropología, 1966.

Smith 1972
Smith, Robert C. *Frei José de Santo António Ferreira Vilaça, escultor beneditino do século XVIII.* 2 vols. Lisboa: Fundação Calouste Gulbenkian, 1972.

Smith 2000
Robert C. Smith, 1912–1975: a investigação na história de arte / Research in History of Art. Lisbon: Fundação Calouste Gulbenkian, 2000.

Smith and Parmenter 1991
Smith, Mary Elizabeth, and Ross Parmenter. *The Codex Tulane.* New Orleans: Middle American Research Institute, Tulane University, 1991.

Smith and Wilder 1948
Smith, Robert C., and Elizabeth Wilder. *A Guide to the Art of Latin America.* Washington, D.C.: Library of Congress, 1948.

Sobrino Figueroa 1998
Sobrino Figueroa, María de los Ángeles. "Grabados y grabadores novohispanos en la colección del Museo Soumaya." *Memoria* (Mexico City) 7 (1988), pp. 109–16.

Sodi Pallares 1969
Sodi Pallares, Ernesto. *Pinacoteca Virreinal de San Diego.* Mexico City: Populibros La Prensa, 1969.

Soria 1952
Soria, Martín S. "Una nota sobre pintura colonial y estampas europeas." *Anales del Instituto de Arte Americano e Investigaciones Estéticas* 5 (1952), pp. 43–49.

Soria 1956
Soria, Martín S. *La pintura del siglo XVI en Sudamérica.* Buenos Aires: Instituto de Arte Americano e Investigaciones Estéticas, 1956.

Sotheby's 2005
Sotheby's, New York. *Latin American Art.* Sale, May 20–24, 2005.

Sousa-Leão 1973
Sousa-Leão, Joaquim de. *Frans Post, 1612–1680.* Amsterdam: A. L. van Gendt, 1973.

Stafford 1997
Stafford, C. M. *Our Lady of Guadalupe: The Origins and Sources of a Mexican National Symbol, 1531–1797.* Tucson: University of Arizona Press, 1997.

Stastny 1969
Stastny, Francisco. "Mateo Perez de Alesio y la pintura del siglo XVI." *Anales del Instituto de Arte Americano e Investigaciones Estéticas* (Buenos Aires) 22 (1969).

Stastny 1982
Stastny, Francisco. "Iconografía, pensamiento y sociedad en el Cusco virreinal." *Cielo Abierto* 21 (1982), pp. 41–55.

Stastny 1984
Stastny, Francisco. "La universidad como claustro, vergel y árbol de la ciencia: una invención iconográfica en la Universidad del Cusco." *Antropológica* 2 (1985), pp. 105–67.

Stastny 1994
Stastny, Francisco. *Síntomas medievales en el "Barroco Americano."* Documento de Trabajo 63. Lima: Instituto de Estudios Peruanos, 1994.

Stastny 2001
Stastny, Francisco. "De la confesión al matrimonio: ejercicios en la representación de correlaciones con incas coloniales." *Revista del Museo Nacional* 49 (2001).

Steele 1982
Steele, Arthur R. *Flores para el rey: la expedición de Ruiz y Pavón y la Flora del Perú (1777–1788).* Barcelona: Ediciones del Serbal, 1982.

Stone-Miller et al. 1992
Stone-Miller, Rebecca, et al. *To Weave for the Sun: Andean Textiles in the Museum of Fine Arts, Boston.* Boston: Museum of Fine Arts, 1992.

Stratton 1989
Stratton, Suzanne. *La Inmaculada Concepción en el arte español.* Madrid: Fundación Universitaria Española, 1989.

Stratton 1994
Stratton, Suzanne L. *The Immaculate Conception in Spanish Art.* Cambridge: Cambridge University Press, 1994.

Sullivan 1996
Sullivan, Edward J. "European Painting and the Art of the New World Colonies." In Fane 1996, pp. 28–41.

Sullivan 2001
Sullivan, Edward J., ed. *Brazil: Body and Soul.* Exh. cat. New York: Solomon R. Guggenheim Museum and Harry N. Abrams, 2001.

Suntory Museum of Art 1990
Suntory Museum of Art. *Date Masamune to Rœma shisetsu Hasekura Tsunenaga.* Tokyo: Santorī Bijutsukan, 1990.

Százdi 1986–87
Százdi, Adan. "El Transfondo de un cuadro: 'Los Mulatos de Esmeradas' de Andrés Sánchez Galque." *Cuadernos prehispánicos* (Valladolid, Spain) 12 (1986–87), pp. 93–142.

Talavera poblana 1979
Talavera poblana: Pinacoteca Marqués del Jaral del Berrio, Fomento Cultural Banamex. Exh. cat. Mexico City: Fomento Cultural Banamex, 1979.

Tapia 1862/1946
Tapia y Rivera, Alejandro. *Vida del pintor puertorriqueño José Campeche, y Noticia histórica de Ramón Power.* 2d ed. San Juan, Puerto Rico: Imprenta Venezuela, 1946.

Taullard 1941
Taullard, A. *Platería sudamericana.* Buenos Aires: Peuser, 1941.

Taullard 1944
Taullard, A. *El mueble colonial sudamericano.* Buenos Aires: Peuser, 1944.

Taylor 1987
Taylor, William B. "The Virgin of Guadalupe in New Spain: An Inquiry into the Social History of Marian Devotion." *American Ethnologist* 14 (1987), pp. 9–33.

Taylor 1996
Taylor, William B. *Magistrates of the Sacred: Priests and Parishioners in Eighteenth-Century Mexico.* Stanford, Calif.: Stanford University Press, 1996.

Taylor et al. 1988
Taylor, René, et al. *José Campeche y su tiempo / José Campeche and His Time.* Exh. cat. Ponce, Puerto Rico: Museo de Arte de Ponce, 1988.

Taylor et al. 1998
Taylor, Dicey, et al. "Epilogue: The Beaded Zemi in the Pigorini Museum." In Bercht et al. 1998, pp. 158–69.

Tepotzolán 2003
Museo Nacional del Virreinato, Tepotzolán. *Tepotzolán: la vida y la obra en la Nueva España.* 2d ed., rev. Mexico City: Asociación de Amigos Museo Nacional del Virreinato, 2003.

Thompson 1983
Thompson, Robert Farris. *Flash of the Spirit: African and Afro-American Art and Philosophy.* New York: Vintage Books, 1983.

Thompson 1993 "Countenance"
Thompson, Robert Farris. "Divine Countenance: Art and Altars of the Black Atlantic World." In Phyllis Galembo et al., *Divine Inspiration: From Benin to Bahia*, pp. 1–17. Albuquerque: University of New Mexico Press, 1993.

Thompson 1993 *Face*
Thompson, Robert Farris. *Face of the Gods: Art and Altars of Africa and the African Americas.* New York: Museum for African Art; Munich: Prestel, 1993.

Thomson 1992
Thomson, J. K. J. *A Distinctive Industrialization: Cotton in Barcelona, 1728–1832.* Cambridge: Cambridge University Press, 1992.

Tiempos de Correa 1994
El arte en tiempos de Juan Correa. Mexico City: Museo Nacional del Virreinato, Instituto Nacional de Antropología e Historia, 1994.

Timberlake 1999
Timberlake, Marie. "The Painted Colonial Image: Jesuit and Andean Fabrication of History in Matrimonio Garcia de Loyola con Ñusta Beatriz." *Journal of Medieval and Early Modern Studies* 29, no. 3 (Fall), pp. 563–98.

Tió 1985
Tió, Teresa. "Campeche." *El Mundo* (San Juan, Puerto Rico), October 3, 1985.

Tiscareño 1910
Tiscareño, F. A. *Nuestra Señora del Refugio, patrona de las misiones del colegio apostólico de Nuestra Señora de Guadalupe de Zacatecas.* Zacatecas, Mexico: Tall. de Nazario Espinosa, 1910.

Tobar 1963
Tobar, Emilio. *La iglesia de San José: Templo de Museo del Pueblo Puertorriqueño.* San Juan, Puerto Rico: Imprenta La Milagrosa, 1963.

Tord 1977
Tord, Luis Enrique. *Crónicas del Cuzco.* 2d ed. [Lima]: Delfos Ediciones, 1977.

Tord 2003
Tord, Luis Enrique. "El barroco en Arequipa y el Valle del Colca." In Mujica Pinilla et al. 2003, pp. 173–256.

Tormo y Monzó 1917–47
Tormo y Monzó, Elías. *En las Descalzas Reales de Madrid, estudios históricos, iconográficas y artísticos.* 4 vols. Madrid: Blass y cía, 1917–47.

Torquemada 1615/1975
Torquemada, Juan de. *Monarquía indiana.* 1615; ed. Miguel León-Portilla. 7 vols. Mexico City: Universidad Nacional Autónoma de México, Instituto de Investigaciones Históricas, 1975–83.

Torquemada 1723/1986
Torquemada, Juan de. *Monarquía indiana.* 3 vols. 2d ed. 1723; facsimile, Mexico City: Porrúa, 1986.

Torre 1981
Torre, Ernesto de la. *Asia and Colonial Latin America.* Mexico City: Colegio de México, 1981.

Torre Revello 1932
Torre Revello, José. *El gremio de plateros en las Indias occidentales.* Buenos Aires: La Universidad, 1932.

Torres 1657/1974
Torres, Bernardo de. *Crónica Agustina.* Ed. Ignacio Prado Pastor. Lima: Ignacio Prado Pastor, 1974.

Torres Balbás 1968
Torres Balbás, Leopoldo. "La Edad Media." In *Resumen histórico del urbanismo en España,* ed. Antonio García y Bellido et al. 2d ed. rev. Madrid: Instituto de Administración Local, 1968.

Torres Ramírez 1961
Torres Ramírez, Bibiano. "Sucesos acaecidos en la proclamación de Carlos IV en Puerto Rico." *Revista del Instituto de Cultura Puertorriqueña* (San Juan, Puerto Rico) 12 (1961), pp. 17–19.

Torres Ramírez 1968
Torres Ramírez, Bibiano. *La isla de Puerto Rico (1765–1800).* San Juan, Puerto Rico: Instituto de Cultura Puertorriqueña, 1968.

Toussaint 1946
Toussaint, Manuel. *El arte mudéjar en América.* Mexico City: Editorial Porrúa, 1946.

Toussaint 1948 *Arte*
Toussaint, Manuel. *Arte colonial en México.* Mexico City: Universidad Nacional Autónoma de México, Instituto de Investigaciones Estéticas, 1948.

Toussaint 1948 *Catedral*
Toussaint, Manuel. *La catedral de Mexico y el Sagario Metropolitano, su historia, su tesore, su arte.* Mexico City: Universidad Nacional Autónoma de México, Instituto de Investigaciones Estéticas, 1948.

Toussaint 1965
Toussaint, Manuel. *Pintura colonial en México.* Mexico City: Universidad Nacional Autónoma de México, Instituto de Investigaciones Estéticas, 1965.

Toussaint 1967
Toussaint, Manuel. *Colonial Art in Mexico.* Ed. and trans. Elizabeth Wilder Wiesmann. Austin: University of Texas Press, 1967. Originally published as *Arte colonial en México* (Mexico City: Universidad Nacional Autónoma de México, 1949).

Toussaint 1974
Toussaint, Manuel. *Arte colonial en México.* 3d ed. Mexico City: Universidad Nacional Autónoma de México, Instituto de Investigaciones Estéticas, 1974.

Toussaint 1982
Toussaint, Manuel. *Pintura colonial en México.* 2d ed. Mexico City: Universidad Autónoma de México, 1982.

Toussaint 1983
Toussaint, Manuel. *Arte colonial en México.* 4th ed. Mexico City: Universidad Nacional Autónoma de México, Instituto de Investigaciones Estéticas, 1983.

Toussaint 1990
Toussaint, Manuel. *Pintura colonial en México.* 3d ed. Mexico City: Universidad Nacional Autónoma de México, Instituto de Investigaciones Estéticas, 1990.

Toussaint 1992
Toussaint, Manuel. *La Catedral de México y el sagrario metropolitano: su historia, su tesoro, su arte.* 3d ed., reprint; Mexico City: Porrúa, 1992.

Tovar de Teresa 1979
Tovar de Teresa, Guillermo. *Pintura y escultura del renacimiento en México.* Mexico City: Instituto Nacional de Antropología e Historia, 1979.

Tovar de Teresa 1984
Tovar de Teresa, Guillermo. "Consideraciones sobre retablos, gremios y artífices de la Nueva España en los siglos XVII y XVIII." *Historia mexicana* 132–33 [34] (1984), pp. 5–40.

Tovar de Teresa 1988
Tovar de Teresa, Guillermo. *Un rescate de la fantasía: el arte de los Lagarto, iluminadores novohispanos de los siglos XVI y XVII.* Mexico City and Madrid: El Equilibrista and Turner Libros, 1988.

Tovar de Teresa 1990 "Concha"
Tovar de Teresa, Guillermo. "Los artistas y las pinturas de incrustaciones de concha nácar en México." In *La concha nácar en México,* pp. 106–34. Mexico City: GUTSA, 1990.

Tovar de Teresa 1990 "Convento"
Tovar de Teresa, Guillermo. "El convento de Santo Domingo y su capilla del Rosario." In *Programa del Sexto Festival del Centro Histórico de la Ciudad de México,* 1990, pp. 46–48.

Tovar de Teresa 1990 "Estípite"
Tovar de Teresa, Guillermo. "El estípite barroco: su orígen español y su difusión novohispana." In *Estudios sobre arquitectura iberoamericana,* ed. Ramón Gutiérrez, pp. 103–23. Seville: Junta de Andalucía, 1990.

Tovar de Teresa 1991
Tovar de Teresa, Guillermo. *La ciudad de los palacios: crónica de un patrimonio perdido,* vol. 2. Mexico City: Fundación Cultural Televisa / Vuelta / Espejo de Obsidiana, 1991.

Tovar de Teresa 1992
Tovar de Teresa, Guillermo. *Pintura y escultura en Nueva España (1557–1640).* Mexico City: Grupo Azabache, 1992.

Tovar de Teresa 1995
Tovar de Teresa, Guillermo. *Miguel Cabrera: pintor de cámara de la reina celestial.* Mexico City: InverMéxico, 1995.

Tovar de Teresa et al. 1992
Tovar de Teresa, Guillermo, et al. *La utopía mexicana del siglo XVI: lo bello, lo verdadero, y lo bueno.* Mexico City: Grupo Azabache, 1992.

Tovar de Teresa et al. 1995
Tovar de Teresa, Guillermo, et al. *Repertorio de Artistas en México.* 3 vols. Mexico City: Grupo Financiero Bancomer, 1995.

Traba 1972 "Campeche"
Traba, Marta. "El ojo alerta de Campeche." *La Torre* (Universidad de Puerto Rico, Río Piedras) 22 (1972), pp. 43–51.

Traba 1972 *Rebelión*
Traba, Marta. *La rebelión de los santos / The Rebellion of the Santos.* San Juan, Puerto Rico: Ediciones Puerto, 1972.

Tribe 1996
Tribe, Tania Costa. "The Mulatto as Artist and Image in Colonial Brazil." *Oxford Art Journal* 19 (1996), pp. 67–79.

Trindade 1998
Trindade, Jaelson Britan. "A corporação e as artes plásticas: o pintor, de artesão a artista." In *Universo mágico* 1998.

Trusted 1996
Trusted, Marjorie. *Spanish Sculpture: Catalogue of the Post-Medieval Sculpture in Wood, Terracotta, Alabaster, Marble, Stone, Lead, and Jet in the Victoria and Albert Museum.* London: Victoria and Albert Museum, 1996.

Tudela 1967
Tudela, J. "Cristos 'tarascos' en España." *Revista de Indias* (Madrid) 107–8 (1967), pp. 137–41.

Turmo 1955
Turmo, Isabel. *Bordados y bordadores sevillanos (siglos XVI a XVIII).* Seville: Laboratorio de Art, Universidad de Sevilla, 1955.

Ugarte Eléspuru and Sarmiento 1973
Ugarte Eléspuru, Juan Manuel, and Ernesto Sarmiento. *Pintura virreynal.* Lima: Banco de Crédito, 1973.

Universo mágico 1998
Galeria de Arte do SESI, São Paulo. *O universo mágico do barroco brasileiro.* Exh. cat. São Paulo: SESI, 1998.

Urruela de Quezada 1997
Urruela de Quezada, Ana María, ed. *The Treasure of La Merced: Art and History.* Miami: Trade Litho, 1997.

Urtassum 1724
Urtassum, Juan de. *La gracia triunfante en la vida de Catharina Tegakovita India Iroquesa, y en las de otras, assi de su nacion, como de esta Nueva España . . .* Mexico City: Imprenta de Joseph Bernardo de Hogal, 1724.

Uztáriz 1751
Uztáriz, Gerónimo de. *The Theory and Practice of Commerce and Maritime Affairs. Written originally in Spanish, by Don Geronymo de Uztariz . . .* London: J. & J. Rivington, 1751.

Valadés 1579
Valadés, Diego. *Rhetorica Christiana: ad concionandi et orandi vsvm accommodata . . .* Perugia: Petrumiacobum Petrutium, 1579.

Valladares 1952
Valladares, José Gisella. "Ourivesaria." In *As artes plásticas no Brasil,* ed. Rodrigo Mello Franco de Andrade, vol. 1, pp. 203–63. Rio de Janeiro, 1952.

Valladares 1978
Valladares, Clarival do Prado. *Rio barroco.* Rio de Janeiro: Bloch, 1978.

Valladares 1990
Valladares, Clarival do Prado. *Nordeste histórico e monumental,* vol. 4. Salvador, Brazil: Odebrecht, 1990.

Valle-Arizpe 1941
Valle-Arizpe, Artemio de. *Notas de platería.* Mexico City: Polis, 1941.

Vandenbroeck and Zegher 1991
Vandenbroeck, Paul, and M. Catherine de Zegher, eds. *America, Bride of the Sun: 500 Years Latin America and Low Countries.* Exh. cat. Gent, Belgium: Imschoot; Brussels: Ministry of the Flemish Community, 1991.

Vargas 1965
Vargas, José María. *Biografía de Fray Pedro Bedón, O.P.* Quito: Editorial Santo Domingo, 1965.

Vargas 1975
Vargas, José María. *Manuel Samaniego y su tratado de pintura.* Quito: Editorial Santo Domingo, 1975.

Vargas 1977
Vargas, José María, ed. *Arte colonial de Ecuador: siglos XVI–XVII.* Quito: Salvat Editores 1977.

Vargas 1982
Vargas, José María. *La economía política del Ecuador durante la colonia.* Quito: Banco Central del Ecuador / Corporación Editora Nacional, [1982].

Vargas Murcia 2003
Vargas Murcia, Laura Liliana. *Retablo tríptico de la Inmaculada.* Bogotá: Panamericana Formas e Impresos, 2003.

Vargas Ugarte 1931
Vargas Ugarte, Rubén. *Historia del culto de María en Hispanoamérica y de sus imágenes y santuarios más celebrados.* Lima: Imprenta "La Providencia," 1931.

Vargas Ugarte 1956
Vargas Ugarte S. J., Rubén. *La iglesia de San Pedro de Lima*. Lima: Hernando Vega Centeno, 1956.

Vargas Ugarte 1963
Vargas Ugarte S. J., Rubén. *Los jesuítas del Perú y el arte*. Lima: Librería e Impr. Gil, Talleres Iberia Offset, 1963.

Vargaslugo 1976
Vargaslugo, Elisa. "Proceso iconológico del culto a Santa Rosa de Lima." In *Actes du XLIIe Congrès International des Américanistes*, vol. 10. Paris: Société des Américanistes, 1976.

Vargaslugo 1993
Vargaslugo, Elisa. "Un maestro y su influencia: comentarios acerca de los pintores Valdés Leal, Juan Correa, y Cristóbal de Villalpando." In *Leal 1993*, pp. 125–27.

Vargaslugo 1994
Vargaslugo, Elisa. "La pintura de enconchados." In *México en el mundo de las colecciones de arte*, vol. 4. Mexico City: El Gobierno de la República, 1994.

Vargaslugo 2005
Vargaslugo, Elisa. "Imágenes de la conquista en el arte del siglo XVII en la Nueva España: dos visiones." In *Imágenes de los naturales en el arte de la Nueva España, siglos XVI al XVIII*, pp. 94–123. Mexico City: Fomento Cultural Banamex, 2005.

Vargaslugo and Guadalupe Victoria 1985–94
Vargaslugo, Elisa, and José Guadalupe Victoria. *Juan Correa: su vida y su obra*, vol. 2, *Catálogo*, 1985; vol. 3, *Cuerpo de documentos*, 1991; vol. 4, *Repertorio pictórico*, 1994 (2 pts.). Mexico City: Universidad Nacional Autónoma de México, Instituto de Investigaciones Estéticas, 1985–94.

Vargaslugo et al. 2000
Vargaslugo, Elisa, et al. *Parábola novohispana: Cristo en el arte virreinal*. Exh. cat. Mexico City: Fomento Cultural Banamex, 2000.

Vega 1600/1948
Vega, Antonio de. "Historia o e narración de las cosas sucedidas en este colegio del Cuzco destos Reynos del Perú desde su fundación hasta hoy Primero de Noviembre día de Todos Santos año de 1600." In *Historia del Colegio y Universidad de San Ignacio de Loyala de la ciudad del Cuzco*. Lima: Publicaciones del Instituto de Investigaciones Históricas, 1948.

Vega 1609
Vega, Garcilaso de la. *Primera parte de los Comentarios Reales de los Incas*. Lisbon: Oficina de Pedro Crasbeeck, 1609.

Vega 1609/1966
Vega, Garcilaso de la. *Royal Commentaries of the Incas, and General History of Peru* (1609). Trans. Harold V. Livermore. Austin: University of Texas Press, 1966.

Vega 1609/1985
Vega, Garcilaso de la. *Comentarios reales de los Incas*. 2 vols. 1609; facsimile, Caracas: Biblioteca Ayacucho, 1985.

Velarde Estrada 1999
Velarde Estrada, Mónica López. "Las cuatro partes del mundo: alegorías continentales; contenidos memoriosos." In *Viento detenido 1999*, pp. 177–92.

Velásquez Chávez 1986
Velásquez Chávez, Agustín. *La pintura colonial en Hidalgo en tres siglos de pintura colonial mexicana: con nuevos datos sobre pinturas en los estados de Aguascalientes, Durango, Guanajuato, Hidalgo, Jalisco, México, Michoacán, Morelos, Nayarit, Oaxaca, Puebla, Querétaro, San Luis Potosí, Sonora, Tlaxcala, Zacatecas y la Ciudad de México*. Pachuca de Soto, Mexico: Gobierno del Estado de Hidalgo, 1986.

Velázquez Guadarrama 1999
Velázquez Guadarrama, Angélica. "Pervivencias novohispanas y tránsito a la modernidad." In Gustavo Curiel et al., *Pintura y vida cotidiana en México, 1650–1950*. Mexico City: Fomento Cultural Banamex, CONACULTA, 1999.

Vergara 1999
Vergara, Alexander. *Rubens and His Spanish Patrons*. Cambridge: Cambridge University Press, 1999.

Vermeylen 1999
Vermeylen, Filip. "Exporting Art across the Globe: The Antwerp Art Market in the Sixteenth Century." In Falkenburg et al. 1999.

Viceregal Mexico 2002
The Grandeur of Viceregal Mexico: Treasures from the Museo Franz Mayer. Exh. cat. Houston: The Museum of Fine Arts; Mexico City: Museo Franz Mayer, 2002.

Victoria 1994
Victoria, José Guadalupe. *Un pintor de su tiempo: Baltasar de Echave Orio*. Mexico City: Universidad Nacional Autónoma de México, 1994.

Vidal 1994
Vidal, Teodoro. *Los Espada: escultores sangermeños*. San Juan, Puerto Rico: Ediciones Alba, 1994.

Vidal 1998
Vidal, Teodoro. "The Art of Folk Imagery: A Puerto Rican Tradition." In Hermandad de Artistas Gráficos de Puerto Rico 1998.

Vidal 2000
Vidal, Teodoro. *Cuatro puertorriqueñas por Campeche*. San Juan, Puerto Rico: Ediciones Alba, 2000.

Vidal 2004
Vidal, Teodoro. "José Campeche: Portrait Painter of an Epoch." In *Retratos 2004*, pp. 102–13.

Viento detenido 1999
Viento detenido: mitologías e historias en el arte del biombo. Colección de biombos de los siglos XVII al XIX del Museo Soumaya. Mexico City: Asociación Carso, 1999.

Villagran 1996
Villagran, Alfredo. *La Santa Cruz de los Milagros: epopeya evangelizadora desde Santiago de Querétaro; exposición temporal*. Querétaro: Museo Regional de Querétaro, 1996.

Villalobos 1607
Villalobos, Arias de. "En alabanza y encomio de la obra y de su autor." In Baltasar de Echave, *Discursos de la antigüedad de la lengua cantabra bascongada*. Mexico City: Henrico Martínez, 1607.

Villanueva 1985
Villanueva, Margaret A. "From Calpixqui to Corregidor: Appropriation of Women's Cotton Textile Production in Early Colonial Mexico." *Latin American Perspectives* 12 (1985), pp. 17–40.

Wadsworth Atheneum 1951
Wadsworth Atheneum, Hartford, Conn. *2000 Years of Tapestry Weaving: A Loan Exhibition*. Exh. cat. [Hartford, 1951?].

Wake 1995
Wake, Eleanor J. "Framing the Sacred: Native Interpretations of Christianity in Early Colonial Mexico." Ph.D. diss., University of Essex, Colchester, 1995.

Wardwell 1973
Wardwell, Anne. "Love's a Good Musician." *The Bulletin of the Cleveland Museum of Art* 10 (December 1973), pp. 283–91.

Webster 2004
Webster, Susan Verdi. "Shameless Beauty and Worldly Splendor: On the Spanish Practice of Adorning the Virgin." In *The Miraculous Image in the Late Middle Ages and Renaissance: Papers from a Conference Held at the Accademia de Danimarca in Collaboration with the Bibliotheca Hertziana*, ed. Erik Thunø and Gerhard Wolf. Rome: "L'Erma" di Bretschneider, 2004.

Weibel 1939
Weibel, Adele C. "'Creolerie': A Peruvian Tapestry of the Spanish Colonial Period." *Art Quarterly* 2 (1939), pp. 197–206.

Weismann 1950
Weismann, Elizabeth Wilder. *Mexico in Sculpture, 1521–1821*. Cambridge, Mass.: Harvard University Press, 1950.

Welles and McKim-Smith 2004
Welles, Marcia L., and Gridley McKim-Smith. "The Object in Question." Paper delivered at the annual meeting of the Renaissance Society of America, New York, April 1, 2004.

Wethey 1949
Wethey, Harold E. *Colonial Architecture and Sculpture in Peru*. Cambridge, Mass.: Harvard University Press, 1949.

Wethey 1961
Wethey, Harold E. *Arquitectura virreinal en Bolivia*. Ed. and trans. José de Mesa and Teresa Gisbert. La Paz: Instituto de Investigaciones Artísticas, Facultad de Arquitectura, Universidad Mayor de San Andrés, 1960 [1961].

Whistler 2001
Whistler, Catherine. "Art and Devotion in Seventeenth- and Eighteenth-Century Brazil." In Whistler et al., *Opulence and Devotion: Brazilian Baroque Art*. Exh. cat. Oxford: BrasilConnects / Ashmolean Museum, 2001.

Whistler 2001
Whistler, Catherine. *Opulence and Devotion: Brazilian Baroque Art*. Exh. cat. Oxford: Ashmolean Museum, 2001.

Whitehead and Boeseman 1989
Whitehead, P. J. P., and M. Boeseman. *A Portrait of Dutch 17th Century Brazil: Animals, Plants, and People by the Artists of Johan Maurits of Nassau*. Amsterdam: North-Holland Pub., 1989.

Wind 1968
Wind, Edgar. *Pagan Mysteries in the Renaissance*. London: Faber and Faber, 1968.

Wood 1989
Wood, Stephanie. "Don Diego García de Mendoza Moctezuma: A Techialoyan Mastermind?" *Estudios de cultura nahuatl* 19 (1989), pp. 245–68.

World Furniture 1965
Ash, Douglas, et al. *World Furniture: An Illustrated History*. Ed. Helena Hayward. London: Hamlyn, 1965.

Wuffarden 1996 "Retablos"
Wuffarden, Luis Eduardo. "Retablos e imágenes en San Pedro de Lima." In *Redescubramos Lima: Iglesia de San Pedro*. Ed. Fondo Pro-Recuperación del Patrimonio Cultural de la Nación. Lima: Banco de Crédito del Perú, 1996.

Wuffarden 1996a
Wuffarden, Luis Eduardo. "Pia Cusco: il corpus di Sant Anna." *FMR* 118 (1996), pp. 96–100.

Wuffarden 1996b
Wuffarden, Luis Eduardo. "Piadoso Cuzco: el corpus de Santa Ana." *FMR* 32 (1996), pp. 83–88.

Wuffarden 1999
Wuffarden, Luis Eduardo. "Los lienzos del virrey Amat y la pintura limeña del siglo XVIII." In *Los cuadros de mestizaje del virrey Amat*, pp. 49–65. Lima: Museo de Arte de Lima, 1999.

Wuffarden 2004 "Catedral"
Wuffarden, Luis Eduardo. "La Catedral de Lima y el 'triunfo de la pintura.'" In *La Basílica Catedral de Lima*. Lima: Banco de Crédito del Perú, 2004.

Wuffarden 2004 "Escuelas"
Wuffarden, Luis Eduardo. "Las escuelas pictóricas virreinales." In *Perú indígena* 2004, pp. 88–95.

Wuffarden 2005 "Descendencia"
Wuffarden, Luis Eduardo. "La descendencia real incaica en el virreinato." In Majluf 2005, pp. 232–44.

Wuffarden 2005 "Renacimiento"
Wuffarden, Luis Eduardo. "La descendencia real y el 'renacimiento inca' en el virreinato." In Cummins et al. 2005, pp. 189–201.

Wuffarden and Bernales Ballesteros 1996
Wuffarden, Luis Eduardo, and Jorge Bernales Ballesteros. *La procesión del Corpus Domini en el Cuzco / La procession du Corpus Domini à Cuzco*. Seville: Unión Latina-Fundación El Monte; Monaco: Maison de l'Amerique Latine de Monaco, 1996.

Wuffarden and Guivobich Pérez 1992
Wuffarden, Luis Eduardo, and Pedro Guivobich Pérez. "El clérigo Juan López de Vozmediano, comitente de Martínez Montañés en Lima." *Archivo Español de Arte* 65 (1992), pp. 94–102.

Zapatero 1964
Zapatero, Juan Manuel. *La guerrra del Caribe en el siglo XVIII*. San Juan, Puerto Rico: Instituto de Cultura Puertorriqueña, 1964.

Zarua and Lovell 2001
Zarua, Elizabeth Netto Calil, and Charles Muir Lovell, eds. *Art and Faith in Mexico: The Nineteenth-Century Retablo Tradition*. Exh. cat. Las Cruces: New Mexico State University, 2001.

Zawisza 1972
Zawisza, Leszek M. "Fundación de las ciudades hispanoamericanas." *Boletín del Centro de Investigaciones Históricas y Estéticas, Caracas* 13 (1972), pp. 88–128.

Zea de Uribe et al. 1976
Zea de Uribe, Gloria, et al. *El arte colombiano a través de los siglos*. Barcelona: Museo Maritimo-Reales Atarazanas, 1976.

Zimmern 1943–44
Zimmern, Nathalie H. "The Tapestries of Colonial Peru." *Brooklyn Museum Journal* 1943–44.

Zodíaco Mariano 2004
Zodíaco Mariano, 250 años de la declaración pontificia de María de Guadalupe como patrona de México. Ed. Jaime Cuadriello. Exh. cat. Mexico City: Museo de la Basílica de Guadalupe, 2004.

Exhibitions Cited

Alicante and Murcia 1989
Alicante, Spain, Caja de Ahorros del Mediterráneo; Murcia, Spain. *México colonial: salas de exposiciones* (1989).

Antwerp 1992
Antwerp, Koninklijk Museum voor Schone Kunsten (Royal Museum of Fine Arts). *America, Bride of the Sun: 500 Years Latin America and the Low Countries* (1992). Catalogue by Paul Vandenbroeck in collaboration with M. Catherine de Zegher.

Austin 1958
Austin, Texas Fine Arts Association. Exhibition (1958).

Barcelona, Madrid, and Washington 2004
Barcelona, Museu Nacional d'Art de Catalunya; Madrid, Biblioteca Nacional; Washington, D.C., National Geographic Museum at Explorers Hall. *Perú indígena y virreinal (Native and Viceregal Peru)* (2004–5). Catalogue edited by Rafael López Guzmán.

Berlin 1982
Berlin, Martin-Gropius-Bau. *Mythen der Neuen Welt: Zur Entdeckungsgeschichte Lateinamerikas* (1982). Catalogue edited by Karl-Heinz Kohl.

Bogotá 1886
Bogotá, Escuela de Bellas Artes. *Primera Exposición Anual* (1886). Organized under the direction of School's Chancellor, General Alberto Urdaneta.

Bogotá 1968
Bogotá, Biblioteca Luis Ángel Arango. *Arte religioso en la Nueva Granada* (1968). Catalogue by German Fernández Jaramillo.

Bogotá 1981
Bogotá, Museo Nacional de Colombia. *Muestra del barroco en Colombia* (1981).

Bogotá 1990
Bogotá, Museo de Arte Religioso del Banco de la República. *Oribes y plateros en la Nueva Granada* (1990).

Bogotá 1992
Bogotá, Museo Nacional de Colombia. *Arte y fe, 1575–1992* (1992). Catalogue edited by José María Rodríquez Ossa and Rodrigo Buenahora Santos.

Bogotá 1992 *Santa Barbara*
Bogotá, Museo de Arte Religioso. *Santa Bárbara: conjuro de las tormentas* (1992). Catalogue by Marta Fajardo de Rueda.

Bogotá 2001
Bogotá, Museo de Arte Colonial. *Arte y naturaleza en la colonial* (2001). Catalogue by Armando Rueda González and María del Rosario Leal de Castillo (2002).

Bogotá 2004
Bogotá, Museo de Arte Colonial. *Un arte nuevo para un Nuevo Mundo: la colección virreinal del Museo de América en Bogotá* (2004–5). Catalogue by María Concepción García Sáiz.

Bogotá 2005
Bogotá, Museo de Arte Colonial. *El oficio del pintor: nuevas miradas sobre la obra de Gregorio Vásquez de Arce y Ceballos* (2005). Catalogue forthcoming.

Brooklyn, Austin, and New Orleans 1971
New York, Brooklyn Museum; Austin, Texas, University Art Museum; New Orleans, Isaac Delgado Museum of Art. *Peruvian Colonial Painting: A Special Exhibition; The Collection of the Stern Fund and Mr. and Mrs. Arthur Q. Davis with an Additional Selection from the Brooklyn Museum.* Catalogue by Pál Kelemen.

Brooklyn, Phoenix, and Los Angeles 1996
New York, Brooklyn Museum; Phoenix Art Museum; Los Angeles County Museum of Art. *Converging Cultures: Art and Identity in Spanish America* (1996–97). Catalogue edited by Diana Fane.

Buenos Aires 1948
Buenos Aires, Academia Nacional de Bellas Artes. *Exposición de historia y arte religiosos* (1948).

Buenos Aires 1964
Buenos Aires, Centro de Artes Visuales, Instituto Di Tella. *El arte después de la conquista* (1964).

Buenos Aires 1989
Buenos Aires, Museo Nacional de Belles Artes. *Salvando alas y halos: pintura colonial restaurada* (1989). Catalogue by Héctor Schenone.

Buenos Aires 1992
Buenos Aires, Museo Nacional de Arte Decorativo. *Arte religioso en Buenos Aires* (1992).

Cáceres 1984
Cáceres, Spain, Institución Cultural "El Brocense." *Muestra de cultura precolombina y colonial* (1984–85). Catalogue.

Cádiz 1982
Cádiz, Spain, Palacio de la Diputación Provincial. *La Corona y las expediciones científicas espanolas a América en el siglo XVIII* (1982).

Caracas 1992
Caracas, Museo de Bellas Artes. *Magna Mater: el sincretismo hispanoamericano en algunas imágenes marianas* (1992–93). Catalogue by Anna Gradowska et al.

Caracas 1999
Caracas, Centro de Arte La Estancia, Acción Cultural PDVSA. *Un asiento venezolano llamado butaca* (1999).

Castelló de la Plana 2002
Castelló de la Plana, Spain, Museo de Belles Artes de Castelló. *Barroco hispanoamericano en Chile: vida de San Francisco de Asís* (2002). Catalogue edited by Gabriel Guarda.

Chicago 1975
The Art Institute of Chicago. *Raiment for the Lord's Service: A Thousand Years of Western Vestments* (1975–76). Catalogue by Christa C. Mayer-Thurman.

Columbus 1947
Columbus, Ohio, Columbus Gallery of Fine Arts. *Colonial Exhibition* (1947).

Columbus 1957
Columbus, Ohio State University, Museum of the Ohio Historical Society. Exhibition (1957).

Córdoba 1994
Córdoba, Argentina, Museo Histórico Provincial Marqués de Sobre Monte. *Obras de arte del convento de San Francisco* (1994).

Cuzco 1972
Cuzco, Museo Historico Regional del Cuzco. *Exposición de esculturas de Bernardo Bitti* (1972).

Dallas 1937
Dallas, Pan American Palace. *Greater Texas and Pan-American Exposition* (1937).

Denver 2004
Denver Art Museum. *Painting a New World: Mexican Art and Life, 1521–1821* (2004). Catalogue by Donna Pierce et al.

Florence 1939
Florence, Palazzo Medici Riccardi. *Mostra medicea* (1939). Catalogue by Casa Editrice Marzocco, Florence.

Ghent 1993
Ghent, Belgium, Museum voor Sierkunst. *Mexicaans Zilver / Mexican Silver* (1993).

Hartford and Baltimore 1951
Hartford, Conn., Wadsworth Atheneum; Baltimore Museum of Art. *2000 Years of Tapestry Weaving: A Loan Exhibition* (1951–52).

Houston and Dallas 1994
Houston, Menil Museum and Allen Center; Dallas, Meadows Museum. *Masterpieces of Bolivian Colonial Art* and *Angels of the Andes* (1994–95). Catalogue by Teresa Gisbert et al.

Houston, Delaware, and San Diego 2002
Houston, Museum of Fine Arts; Winterthur, Delaware, The Henry Francis du Pont Winterthur Museum; The San Diego Museum of Art. *The Grandeur of Viceregal Mexico: Treasures from the Museo Franz Mayer / La grandeza del México virreinal: tesoros del Museo Franz Mayer* (2002–3). Catalogue by Héctor Rivero Borrell M. et al.

Lima 1892
Lima, Palacio de la Exposición. *Exposición nacional de 1892* (1892). Catalogue by Imprenta del Estado.

Lima 1942
Lima, Sociedad Entre Nous. *Exposición de muebles y objetos de arte virreynales con ocasión del IV Centenario de Pizarro y el Descubrimiento del Amazonas* (1942). Catalogue by Sociedad Entre Nous.

Lisbon 1991
Lisbon, Fundação Calouste Gulbenkian. *Colecção Beatriz e Mário Pimenta Camargo* (1991).

London 2002
London, Royal Academy of Arts. *Aztecs* (2002–3). Catalogue by Eduardo Matos Moctezuma and Felipe Solís Olguín.

London, Stockholm, and Madrid 1989
London, Hayward Gallery; Stockholm, National Museum; Madrid, Palacio de Velásquez. *Arte en Iberoamérica, 1820–1980* (1989–90). Catalogue by Dawn Ades.

Loosdorf, Essen, and Schaffhausen 1983
Loosdorf bei Melk, Austria, Scloss Schallaburg; Essen, Germany, Villa Hügel; Schaffhausen, Switzerland, Museum zu Allerheiligen. *Peru durch die Jahrtausende: Kunst und Kultur im Lande der Inka* (1983–84). Catalogue by Ferdinand Anders, with the assistance of Dr. Kauffmann Doig.

Los Angeles 2004
Los Angeles County Museum of Art. *Inventing Race: Casta Painting and Eighteenth-Century Mexico* (2004). Catalogue by Ilona Katzew.

Madrid 1892
Madrid. *Exposición Histórico-Americana de Madrid, 1892.* Catalogue (1893).

Madrid 1984
Madrid, Ayuntamiento de Madrid, Sala de Exposiciones del Centro Cultural de la Villa de Madrid. *Malaspina y su entorno* (1984).

Madrid 1985
Madrid, Museo de América. *Mestizaje americano* (1985).

Madrid 1986
Madrid, Museo de América. *Orfebrería hispanoamericana, siglos XVI–XIX* (1986).

Madrid 1998
Madrid, Museo Arqueológico Nacional. *La joyería española de Felipe II a Alfonso XIII en los museos estatales* (1998).

Madrid 1999 *Oro y plata*
Madrid, Fundación ICO. *El oro y la plata de las Indias en la época de los Austrias* (1999).

Madrid 1999 *Siglos de oro*
Madrid, Museo de América. *Los siglos de oro en los virreinatos de América, 1550–1700* (1999–2000). Catalogue edited by Joaquín Bérchez.

Madrid 2000
Madrid, Museo Nacional Centro de Arte Reina Sofía. *Fricciones: versiones del sur* (2000–2001).

Madrid 2002 *Centro*
Madrid, Centro Cultural de la Villa de Madrid. *El país del Quetzal: Guatemala maya e hispana* (2002).

Madrid 2002 *Fundación*
Madrid, Fundación Santander Central Hispano. *Obras maestras de la Colección Lázaro Galdiano* (2002–3).

Madrid and Lima 1997
Madrid, Banco Bilbao Vizcaya, Sala de Madrid; Lima, Museo de Arte de Lima. *Platería del Perú virreinal, 1535–1825* (1997). Catalogue by Cristina Esteras Martín.

Mexico City 1980
Mexico City, Pinacoteca Marqués del Jaral de Berrio. *El arte del maque en México* (1980–81). Catalogue by Fomento Cultural Banamex.

Mexico City 1984
Mexico City, Palacio de Iturbide. *Biombos mexicanos* (1984).

Mexico City 1985
Mexico City, Palacio de Iturbide. *El mueble mexicano: historia, evolución e influencias* (1985). Catalogue by Carmen Aguilara et al.

Mexico City 1987
Mexico City, Palacio de Iturbide, Banco Nacional de México. *Biombos mexicanos, asiaticos y europeos siglos XVII–XX* (1987).

Mexico City 1989
Mexico City, Centro Cultural Arte Contemporáneo. *El arte de la platería mexicana, 500 Años* (1989–90).

Mexico City 1990
Mexico City, Museo Nacional de Arte. *Obras maestras del arte colonial: exposición homenaje a Manuel Toussaint* (1990).

Mexico City 1991 *Festival*
Mexico City, Museo Franz Mayer. *Programa del décimo Festival del Centro Histórico* (1991).

Mexico City 1991 *Franz Mayer*
Mexico City, Museo Franz Mayer. *Obras maestras de la colección de plata del Museo Franz Mayer* (1991).

Mexico City 1991 *Retrato civil*
Mexico City, Museo de San Carlos. *El retrato civil en la Nueva España* (1991–92).

Mexico City 1992
Mexico City, Museo Nacional del Virreinato. *Juan Correa: su obra y su tiempo* (1992).

Mexico City 1993
Mexico City, Centro Cultural Arte Contemporáneo. *Juan de Valdés Leal y el arte sevillano del barroco* (1993).

Mexico City 1994 *Barroco*
Mexico City, Colegio de San Ildefonso, Universidad Nacional Autónoma de México. *Arte y mística del barroco* (1994).

Mexico City 1994 *Juegos*
Mexico City, Museo Nacional de Arte. *Juegos de ingenio y agudeza: la pintura emblemática de la Nueva España* (1994–95). Catalogue by Ana Laura Cué.

Mexico City 1997 *Lacas*
Mexico City, Museo Franz Mayer. *Lacas mexicanas* (1997). Catalogue by Ruth Lechuga et al.

Mexico City 1997 *México*
Mexico City, Fomento Cultural Banamex. *México: su tiempo de nacer, 1750–1821* (1997). Catalogue by Estela Guadalupe Jiménez Codinach.

Mexico City 1999 *Eterno*
Mexico City, Palacio de Bellas Artes. *México eterno: arte y permanencia* (1999).

Mexico City 1999 *Pinceles*
Mexico City, Museo Nacional de Arte. *Los pinceles de la historia: el origen del reino de la Nueva España, 1680–1750* (1999).

Mexico City 1999 *Pintura*
Mexico City, Fomento Cultural Banamex. *Pintura y vida cotidiana en México, 1650–1950* (1999). Catalogue by Gustavo Curiel et al.

Mexico City 2000
Mexico City, Fomento Cultural Banamex. *Parábola novohispana: Cristo en el arte virreinal* (2000). Catalogue by Elisa Vargaslugo et al.

Mexico City 2000 *Pinceles*
Mexico City, Museo Nacional de Arte. *Los pinceles de la historia: de la patria criolla a la nación mexicana, 1750–1860.*

Mexico City 2002
Mexico City, Museo Nacional de Arte. *José Juárez: recursos y discursos del arte de pintar* (2002).

Mexico City 2003
Mexico City, Instituto Nacional de Antropología e Historia, Consejo Nacional para la Cultura y las Artes, Museo Nacional del Virreinato. *Monjas coronadas: vida conventual femenina en Hispanoamérica* (2003).

Mexico City 2004
Mexico City, Museo de la Basílica de Guadalupe and Museo Soumaya. *Zodiaco Mariano: 250 años de la declaración pontificia de María de Guadalupe como patrono de México* (2004–5). Catalogue edited by Jaime Cuadriello.

Mexico City 2006
Mexico City, Universidad Nacional Autónoma de México / Banco Nacional de México. *Imágenes del indio en el arte de la Nueva España* (2006).

Mexico City and Madrid 1997
Mexico City, Fomento Cultural Banamex; Madrid, Academia de San Fernando. *Cristóbal de Villalpando, ca. 1649–1714* (1997–98). Catalogue by Gutiérrez Haces et al.

Mexico City and Zacatecas 2005
Mexico City, Museo de la Basílica de Guadalupe; Zacatecas, Museo de Guadalupe. *Un privilegio sagrado: la concepción de María Inmaculada; celebración del dogma en México* (2005). Catalogue by Martha Reta et al.

Milan 2004
Milan, Palazzo Reale. *Arte in Brasile dal XVI al XIX secolo: la collezzione Beatriz e Mário Pimenta Camargo* (2004).

Monterrey 1997
Monterrey, Mexico, Museo de Vidrio. *El espejo en México* (1997).

Monterrey, San Antonio, and Mexico City 1989
Monterrey, Mexico, Museo de Monterrey; San Antonio, Texas, Museo de Arte de San Antonio; Mexico City, Museo Franz Mayer. *Las castas mexicanas: un género pictórico americano* (1989–90).

Montreal 1967
Montreal, Montreal Museum of Fine Arts. *The Painter and the New World* (1967).

Nantes and Paris 1999
Nantes, France, Musée du Château des ducs de Bretagne; Paris, Maison de l'Amérique latine. *La Grâce baroque: chefs-d'oeuvre de l'École de Quito* (1999–2000). Catalogue.

New Orleans 1884
New Orleans. *World's Industrial and Cotton Centennial Exposition* (1884–85).

New Orleans 1968
New Orleans, Isaac Delgado Museum of Art. *The Art of Ancient and Modern Latin America in United States Collections* (1968).

New York 1940
New York, Museum of Modern Art. *Twenty Centuries of Mexican Art* (1940). Catalogue by the Museum of Modern Art, New York, in collaboration with the Mexican government.

New York 1947
New York, M. Knoedler & Co. *Latin-American Exhibition* (1947).

New York 1973
New York, El Museo del Barrio and The Metropolitan Museum of Art. *The Art Heritage of Puerto Rico: Pre-Columbian to Present* (1973).

New York 1986
New York, Center for Inter-American Relations. *Gloria in Excelsis: The Virgin and Angels in Viceregal Painting of Peru and Bolivia* (1986). Catalogue edited by Barbara Duncan et al.

New York 1992
New York, Americas Society. *Barroco de la Nueva Granada: Colonial Art from Colombia and Ecuador* (1992). Catalogue by Alexandra Kennedy and Marta Fajardo de Rueda.

New York 1996
New York, Americas Society Art Gallery. *New World Orders: Casta Painting and Colonial Latin America* (1996). Catalogue by Ilona Katzew et al.

New York 1997
New York, Americas Society Art Gallery. *Potosí: Colonial Treasures and the Bolivian City of Silver* (1997). Catalogue by Pedro Querejazu and Elizabeth Ferrer.

New York 1999
New York, Americas Society Art Gallery. *Talavera Poblana: Four Centuries of a Mexican Ceramic Tradition* (1999). Catalogue by Margaret Connors McQuade.

New York 2001
New York, Guggenheim Museum. *Brazil: Body and Soul* (2001). Catalogue edited by Edward Sullivan.

New York 2004 *Andes*
New York, The Metropolitan Museum of Art. *The Colonial Andes: Tapestries and Silverwork, 1530–1830* (2004). Catalogue edited by Elena Phipps et al.

New York 2004 *Aztec*
New York, Solomon R. Guggenheim Museum. *The Aztec Empire* (2004–5).

New York 2005 *Geography*
New York, Americas Society Art Gallery. *Beyond Geography: Forty Years of Visual Arts at the Americas Society* (2005).

New York 2005 sale
Sotheby's, New York. *Latin American Art*, sale, May 20–24, 2005.

New York, Austin, and Miami 1985
New York, Center for Inter-American Relations; Austin, Archer M. Huntington Art Gallery, University of Texas; Miami, Center for the Fine Arts. *Gloria in Excelsis: The Virgin and Angels in Viceregal Painting of Peru and Bolivia* (1985–86). Catalogue edited by Barbara Duncan et al.

New York, San Antonio, and Los Angeles 1990
New York, The Metropolitan Museum of Art; San Antonio, San Antonio Museum of Art; Los Angeles County Museum of Art. *Mexico: Splendors of Thirty Centuries* (1990–91). Catalogue introduction by Octavio Paz.

Oxford 2001
Oxford, Ashmolean Museum. *Opulence and Devotion: Brazilian Baroque Art* (2001–2). Catalogue by Catherine Whistler.

Palos de la Frontera 1995
Palos de la Frontera (Huelva), Spain, Foro Iberoamericano de La Rábida. *Magia, mentiras y maravillas de las Indias* (1995–96). Catalogue by Carmen Alborch Bataller et al.

Paris 1975
Paris, Musée du Petit Palais. *L'Art colombien à travers les siècles* (1975–76). Catalogue by S. Monzon et al.

Paris 1999
Paris, Union Latine, Petit Palais, Musée des Beaux-Arts de la Ville de Paris. *Brésil baroque: entre ciel et terre* (1999–2000).

Paris, Madrid, and Barcelona 1975
Paris, Petit Palais; Madrid, Palacio Velázquez; Barcelona, Reales Atarazanas. *El arte colombiano a través de los siglos* (1975–76). Catalogue by Gloria Zea de Uribe et al.

Paris, Santillana del Mar, and Madrid 1996
Paris, Chapelle de la Sorbonne; Santillana del Mar, Spain, Fundación Santillana; Madrid, Real Academia de Bellas Artes de San Fernando. *El retorno de los ángeles: barroco de las cumbres en Bolivia / Le retour des anges: baroque des cimes en Bolivie* (1996). Catalogue by Union Latine.

Philadelphia 1966
Philadelphia, St. Joseph's College. Exhibition (1966).

Philadelphia 1968
Philadelphia Museum of Art. Mexican Art Exhibition (1968).

Philadelphia 1980
Philadelphia Museum of Art. *Mexican Art from the Collections* (1980).

Phoenix, Kansas City, and The Hague 1998
Phoenix Art Museum; Kansas City, Nelson-Atkins Museum of Art; The Hague, Royal Cabinet of Paintings Mauritshuis. *Copper as Canvas: Two Centuries of Masterpiece Paintings on Copper, 1575–1775* (1998–99).

Ponce, New York, and San Juan 1988
Ponce, Puerto Rico, Museo de Arte de Ponce; New York, The Metropolitan Museum of Art; San Juan, Puerto Rico, Instituto de Cultura Puertorriqueña. *José Campeche y su tiempo / José Campeche and His Time* (1988–89). Catalogue by René Taylor, with Lydia A. Quigley and Marimar Benítez.

Río Piedras 1948
Río Piedras (San Juan), Universidad de Puerto Rico, Sala de Exposiciones. *José Campeche* (1948).

Río Piedras 1951
Río Piedras (San Juan), Universidad de Puerto Rico. *Exposición conmemorativa del II centenario del nacimiento de José Campeche* (1951).

Rome 1996
Rome, Instituto Italo Latino-Americano. *La processione del Corpus Domini nel Cusco* (1996). Rome: Instituto Italo Latino-Americano, 1996.

Salvador 1961
Salvador, Brazil, Museu de Arte Sacra da Universidade Federal da Bahia. *Exposição tricentenária retrospectiva da obra de Frei Agostinho da Piedade* (1961).

San Antonio, Washington, and New York 2004
Texas, San Antonio Museum of Art; Washington, D.C., National Portrait Gallery, Smithsonian Institution; New York, El Museo del Barrio. *Retratos: 2,000 Years of Latin American Portraits* (2004). Catalogue by Elizabeth P. Benson et al.

San Juan 1854
San Juan, Puerto Rico. *Primera feria exposición de Puerto Rico* (1854).

San Juan 1863
San Juan, Puerto Rico. Real Sociedad Económica de Amigos del País (RSEAP). *Corona poética dedicada al maestro José Campeche* (1863).

San Juan 1959
San Juan, Puerto Rico, Instituto de Cultura Puertorriqueña. *Campeche y su taller* (1959).

San Juan 1962
San Juan, Puerto Rico, Instituto de Cultura Puertorriqueña. *Dos siglos de pintura puertorriqueña* (1962).

San Juan 1971
San Juan, Puerto Rico, Instituto de Cultura Puertorriqueña. *José Campeche, 1751–1809* (1971). Catalogue by the Instituto de Cultura Puertorriqueña.

San Juan 1985
San Juan, Puerto Rico, Sala Central del Arsenal. *Exposición de óleos de José Campeche en la Sala Central del Arsenal en San Juan* (1985). Catalogue by the Instituto de Cultura Puertorriqueña and the Fundación Nacional de las Artes.

San Juan 1987
San Juan, Puerto Rico, Instituto de Cultura Puertorriqueña. *Maestros de la pintura puertorriqueña: segunda mitad del siglo XVIII al primer tercio del siglo XIX* (1987).

San Juan 2000
San Juan, Puerto Rico, Museo de Arte de Puerto Rico. *Los tesoros de la pintura puertorriqueña* (2000–2001). Catalogue edited by Carmen T. Ruiz de Fischler and Mercedes Trelles.

Santa Barbara 1992
Santa Barbara, Calif., Santa Barbara Museum of Art. *Cambios: The Spirit of Transformation in Spanish Colonial Art* (1992). Catalogue by Gabrielle Palmer and Donna Pierce.

Santillana del Mar 1984
Santillana del Mar, Spain, Fundación Santillana. *Imagen de México* (1984).

Santo Domingo 1950
Santo Domingo, Universidad de Santo Domingo. *Arte colonial en Santo Domingo, siglos XVI–XVIII* (1950). Catalogue by Erwin Walter Palm.

Santurce 1893
Santurce (San Juan), Puerto Rico, Palacio de Santurce. *La exposición de Puerto Rico* (1893). Catalogue by Alejandro Infiesta (1895).

São Paulo 1998
São Paulo, Galeria de Arte do SESI. *O universo mágico do barroco brasileiro* (1998). Catalogue by Emanoel Araújo and Orlandino Seitas Fernandes.

São Paulo 2000
São Paulo, Parque Ibirapuera. *Arte barroca: mostra do redescobrimento* (2000). Catalogue by Nelson Aguilar et al.

Seville 1982
Seville, Pabellón Mudéjar de la Plaza de América. *La hacienda de los Borbones en España y América* (1982).

Seville 1992 *Iglesia*
Seville, Vatican Pavilion. *La iglesia en América: evangelización y cultura* (1992).

Seville 1992 *Platería*
Seville, Real Monasterio de San Clemente. *Cinco siglos de platería sevillana* (1992). Catalogue by José Manuel Cruz Valdovinos.

Seville 1995
Seville, Fundación El Monte. *La orfebrería hispanoamericana en Andalucía occidental* (1995).

Seville 2003
Seville, Real Alcázar and Casa de la Provincia. *España y América: un océano de negocios, 1503–2003* (2003–4).

Seville and Monaco 1996
Seville, Real Monasterio de San Clemente; Monaco: Maison de L'Amerique Latine de Monaco. *La procesión del Corpus Domini en el Cuzco / La procession du Corpus Domini à Cuzco* (1996). Catalogue by Luis Eduardo Wuffarden and Jorge Bernales Ballesteros.

Tucson 1966
Tucson, Ariz., Tucson Art Center. *Spanish Colonial Art of Latin America* (1966).

Vienna, Budapest, and Cologne 1986
Vienna, Künstlerhaus; Budapest, Nationalgalerie; Cologne, Josef-Haubrich-Kunsthalle. *Gold und Macht: Spanien in der Neuen Welt* (1986–87). Catalogue edited by Christian Feest and Peter Kann.

Villanova 1955
Villanova, Pennsylvania, Villanova University Library. Exhibition (1955).

Warsaw 1990
Warsaw, Royal Castle. *Opus Sacrum* (1990). Catalogue edited by Jozef Grabski.

Washington 1948
Washington, D.C., Pan American Union. *Exhibition of Latin-American Religious Paintings* (1948).

Washington 1961
Washington, D.C., The Textile Museum. *Peruvian Spanish Colonial Textiles* (1961).

Washington 1991
Washington, D.C., National Gallery of Art. *Circa 1492: Art in the Age of Exploration* (1991–92). Catalogue edited by Jay A. Levenson.

Washington, New York, Los Angeles, and Monterrey 1978
Washington, D.C., National Museum of Natural History, Hirshhorn Museum and Sculpture Garden, Smithsonian Institution; New York, M. Knoedler & Co., Hammer Galleries; Los Angeles County Museum of Art; Mexico, Museo de Monterrey. *Treasures of Mexico from the Mexican National Museums* (1978). Catalogue edited by Olga Hammer and Jeanne D'Andrea.

Acknowledgments

This exhibition has enjoyed a long period of gestation during which it has been immeasurably enriched by the scholarly advice, practical assistance, and enthusiasm of many people, including Barbara B. Aronson, as well as Dawn Ades, Monseñor Lorenzo Albacede, Barbara Anderson, Jaime and Pamela Aparicio, Yona Backer, Elizabeth C. Baez, Estrellita Brodsky, Jonathan Brown, Beatriz Cáceres-Péfour, Father Joseph Chorpenning O.S.F.A., Arturo Cuéllar, Carol Damian, Arthur Dunkelman, Samuel Edgerton, Juan Carlos Estenssoro, Diana Fane, Nancy Farriss, María Judith Feliciano, Matthew Feliz, Rosa María Fort Brescia, Jill Furst, John Gray, Johanna Hecht, Renata Holod, Richard Kagan, Edward L. Keenan, Ana María and John Keene, Michael Komanecky, Johnny Lee, Mark Leithauser, Jay Levenson, Manuel Lombera, Annabelle and Alberto Mariaca, Deborah Marrow, Adele Nelson, Gabriel Pérez-Barreiro, Elena Phipps, Silvia Pontual, Rodrigo Rivero Lake, Conchita Romero, Natasha Ruiz-Gómez, Scott Schaefer, Jon Seydl, Héctor Tajonar, Anita Tapia, Valery Taylor Brown, Dodge Thompson, Peter Tjabbes, Susana Torruela Leval, Carmen and Joseph Unanue, Ximena Varela, Regina Weinberg, Julián Zugazagoitia, and the late Robert Glynn and Gaillard F. Ravenel. We sincerely thank them all for their contributions to the success of this exhibition.

We have been very fortunate in the generosity of lenders and in the friends who often interceded on our behalf during the process of securing loans. In Argentina, in Buenos Aires, we thank Mauro Herlitzka, Héctor Schenone, and Ricardo González for their hospitality and good advice; Jorge Luis Cometti, Director, and Patricio López Méndez, Curator, Museo de Arte Hispano-americano Isaac Fernández Blanco, for generous access to their collection; Rafael Ayerza Achaval, Archicofradía del Santísimo Sacramento de la Catedral Metropolitana; Prebendary Jorge Junor of the Iglesia Catedral Metropolitana de la Santísima Trinidad; José Pérez Gollán, Director, Museo Histórico Regional; and Fray Julio César Bunader, Ministro Provincial, Provincia Franciscana de la Asunción de la Ssma. Virgen del Río de la Plata. In Córdoba, we are grateful to Sergio Barbieri and to Father Manuel Andrada, Superior del Convento de San Francisco.

In Bolivia, in La Paz, we thank Edgar Arandia, Vice Minister of Culture; Dr. Alberto K. Bailey Gutiérrez, Executive Secretary, Fundación Cultural del Banco Central de Bolivia; Teresa Villegas de Aneiva, Director, Museo Nacional de Arte; José Bozo Jivaja, Jefe Unidad de Museos Municipales; Inés Aramayo Suárez, Advisor, Oficialía Mayor de Culturas, Gobierno Municipal de La Paz; Monseñor Edmundo Abastoflor Montero, Museo de Arte Sacra de la Catedral de La Paz; President Gonzalo Sánchez de Lozada; and Beatriz Bedoya. We are grateful for the efforts on our behalf of Monseñor Toribio Porco Ticona, Bishop Prelate of Corocoro. In Potosí, we again thank Dr. Alberto Bailey Gutiérrez for loans from the Museo de la Casa Nacional de Moneda, and Sor Carmen Alvarez Segura, Directora del Convento y Museo de Santa Teresa. In Sucre, we thank Fray Antonio Bussone, Superior del Convento La Recoleta; Ana María Chumacero de Tames, Director, Museo de Charcas; and Blanca Thorrez Martínez. In Santa Cruz de la Sierra, we thank Monseñor Sergio Gualberti, Auxiliary Bishop of the Archdiocese of Santa Cruz and Moderator of the Basílica Menor de San Lorenzo Mártir; Father Raúl Arrázola, Rector of the Basílica Menor de San Lorenzo Mártir; Anita Suárez de Terceros, Director of the Museo de Arte Sacro; and Anahí Antelo.

In Brazil, in the state of Bahia, we thank Abbot Dom Emanuel d'Able do Amaral and Dom Ivan da Silva Andrade, Mosteiro de São Bento da Bahia; Neomar de Almeida Filho, Rector of the Federal University of Bahia; Francisco de Assis Portugal Guimarães, Director of the Museu de Arte Sacra of the Federal University of Bahia; Gilberto Pedreira de Freitas Sá; Maria Mercedes de Oliveira Rosa, Director, and Bárbara Carvalho dos Santos, Assistant Director, Museu Carlos Costa Pinto; and Monsenhor Ademar Dantas dos Santos, Archdiocese of São Salvador da Bahia. In the state of Minas Gerais, we are grateful to Antonio Fernando, IPHAN, Belo Horizante; Leonardo Barreto de Oliveira, Regional Director—13ª Superintendência Regional do IPHAN; Deacon Agostinho Barroso de Oliveira, Museu Arquidiocesano de Arte Sacra de Mariana and Museu do Aleijadinho; Alexandre Sales Pimenta, Director, Museu do Ouro de Sabará; and Ademar Dantas dos Santos, Museu Arquidiocesano de Arte Sacra. In the state of Pernambuco, we thank Frederico Faria Neves Almeida, Regional Director, Superintendente Regional—5ª Superintendência Regional do IPHAN; and Abbot Bernardo Alves de Silva, Mosteiro de São Bento de Olinda. Special thanks go to Pérside Omena, GRIFO, Diagnostics and Preservation of Cultural Goods. In Rio de Janeiro, thanks are owed to Vera de Alencar, Director, Museus Castro Maya. In São Paulo, we are

grateful to Marcelo Mattos Araujo, Director, Pinacoteca do Estado de São Paulo; Ladi Biezus; Beatriz Pimenta Camargo; Domingos and Adriana Giobbi; Luiz S. Hossaka, Chief Curator, MASP (Museu de Arte de São Paulo Assis Chateaubriand); Professor Cláudio Lembo, Governor of São Paulo; D. Renéa de Castilho Lembo, Presidente do Grupo de Orientação, and Angelo Ponzoni Neto, Arquiteto Responsável pelo Acervo Artístico e Cultural do Palácio do Governo; James Kung Wei Li; Mari Marino, Director, Museu de Arte Sacra de São Paulo; and Ricardo Von Brusy. We also wish to thank Edemar Cid Ferreira, Angela Gutierrez, and Silva Souza Aranha.

In Chile, in Santiago, we are grateful to Carlos Alberto Cruz; Rosa Puga Domínguez, Director of the Museo Colonial de San Fancisco; Prior Rogelio Wouters, Convento de San Francisco; and Ricardo Claro Valdez.

In Colombia, in Bogotá, thanks go to Elvira Cuervo de Jaramillo, Minister of Culture; Darío Jaramillo Agudelo, Cultural Affairs Director, Banco de la República; Monseñor Pedro Rubiano Saenz, Catedral Primada de Colombia; Constanza Toquica Clavijo, Director, Museo de Arte Colonial; Pedro Miguel Navas and Pablo Navas; Olga Pizano and Clemencia Pizano; Father Alejandro Díaz García, Rector, Seminario Mayor de San José; Father Edison Sahamuel, Palacio Arzobispal, Bogotá; and Beatriz Eugenia Del Castillo Restrepo, Dirección de Patrimonio, Ministerio de Cultura de Colombia. In Tunja, we thank Archbishop Luis Augusto Castro Quiroga and Monseñor José Ramón Páez.

In the Dominican Republic, in Santo Domingo, we extend our gratitude to Cardinal Nicolás de Jesús López Rodríguez, Archbishop of Santo Domingo; and Esteban Prieto Vicioso, Director, Oficina de la Obra y Museos de la Catedral de Santo Domingo.

In Ecuador, in Cuenca, we thank Alexandra Kennedy Troya for her hospitality. In Quito, we are grateful to Iván Armendariz, Director Nacional, Instituto Nacional de Patrimonio Cultural del Ecuador; Friar José Tapia Chamorro O. de M., Superior Provincial, Curia Provincial de la Orden de la B.V. María de la Merced; Dr. Marco Antonio Rodríguez, President, and Carlos Yáñez, Director, Colonial Museum, Casa de la Cultura Ecuatoriana Benjamín Carrión; J. Fernando Moncayo, Director Cultural, Museo Nacional del Banco Central de Ecuador; Oswaldo Viteri; Manuel Corrales, S.J., Rector, Pontificia Universidad Católica del Ecuador; José María Jaramillo Breilh, Director, Museo Jacinto Jijón y Caamaño, Pontificia Universidad Católica del Ecuador; Rvdo. Padre Fray Walter Heras, Presidente del Consejo Gubernativo de Bienes de la Orden Franciscan en el Ecuador; Father John Castro, Director, Museo Franciscano "Fray Pedro Gocial" (Convento Máximo de San Francisco); Diego Santander, Director Ejecutivo-Técnico, Fundación Iglesia de la Compañía; Alfonso Ortiz Crespo; and Judy de Bustamante.

In England, in Cambridge, we owe thanks to Duncan Robinson, Director, The Fitzwilliam Museum. In London, we thank Mark Jones, Director, Victoria and Albert Museum; and Mary Anne Stevens, Acting Secretary, Norman Rosenthal, Exhibitions Secretary, and Adrian Locke, Exhibitions Curator, Royal Academy of Art.

In Guatemala, in Guatemala City, we are grateful to Manuel Salazar Tezaguic, Minister of Culture and Sports; Enrique Matheu, First Vice Minister of Culture and Sports; Monseñor Rodolfo Cardinal Quezada Toruño, Archbishop of Santiago de Guatemala; Ana María Urruela de Quezada, Archbishopric of Santiago de Guatemala; Coralia Inchisi de Rodríguez, Museo Popol Vuh, Universidad Francisco Marroquín; Susana Campins, Director, Museo Vigua; Edgar and Jorge Castillo; Guillermo Fortín Gualarte and Javier Fortín; Father Bernardino Rodríguez, Church of Santo Domingo; Father Pedro Medina, Museo Fray Francisco Vázquez, Templo de San Francisco; and Sofía Paredes-Maury. In Amatitlán, we thank Father Hipólito Chow.

In Italy, in Florence, our gratitude goes to Ornella Casazza, Curator, Museo degli Argenti, Palazzo Pitti; and Moreno Bucci.

In Mexico, in Guanajuato, we thank Father Miguel Antonio Juárez Pérez, Prefect of the Oratorio de San Felipe Neri, Templo de la Compañia. In Mexico City, many thanks are owed to Salvador Rueda Smithers, Director, Museo Nacional de Historia, Castillo de Chapultepec; Canon Luis Avila Blancas, Director, Pinacoteca de la Casa de La Profesa, dependency of the Templo de San Felipe Neri; José Ortiz Izquierdo, Director, Communications and Public Affairs, Banco Nacional de México; Alberto Sarmiento, Deputy Director of Contents, Banco Nacional de México; Cándida Fernández de Calderón, Fomento Cultural Banamex; María del Refugio Cárdenas, Manager of the Banamex Art Collection; Emilio Azcárraga Jean, Chairman, Fundación Televisa; Claudio X. González Guajardo, President, Fundación Televisa; Mauricio Maillé, Coordinator of Visual Arts, Fundación Televisa; Diana Mogollón González, Manager of Visual Arts, Fundación Televisa; Cardinal Norberto Rivera Carrera, Canon Rubén Avila Enríquez, and Jorge Armando Ruiz Castellanos, Catedral Metropolitana; Mercedes Iturbe; Daniel Liebsohn; Mercedes Martínez Lámbarri, Coordinadora de Fomento Cultural, Colegio de San Ignacio de Loyola Vizcaínas; Miguel Sánchez Navarro Redo, Presidente del Patronato del Fideicomiso Cultural Franz Mayer; Héctor Rivero Borrell M., Director General, Museo Franz Mayer; Roxana Velázquez Martínez del Campo, Director, Museo Nacional de Arte; Felipe Solís Olguín, Director, Museo Nacional de Antropología; Soumaya Slim de Romero, Director, and Mónica López Velarde Estrada, Curator, Museo Soumaya; Monseñor Rogelio Esquivel, Episcopal Bishop, and Prebendary Alejandro Rodríguez Cadillo, San Bernardino de Siena (Xochimilco); and Father Raúl Vázquez and Baldomero Villicaña Avila, Parish Church of Santiago Apóstol. In Puebla, our thanks go to Archbishop Rosendo Huesca Pacheco and Canon Antonino López Sánchez, Sacristán Mayor of the Cathedral of Puebla; Delia Domínguez Cuanalo, Director,

Museo de Arte José Luis Bello y González; Moisés Rosas, Director, Museo Amparo; and Víctor Hugo Valencia Valera, Centro INAH, Puebla. In Querétaro, we thank Araceli Ardón Martínez, Director, Museo de Arte de Querétaro; and Rosa María Estela Reyes García, Director, Museo Regional de Querétaro. In Tepotzotlán, thanks are owed to Miguel E. Fernández Félix, Director, and Víctor Hugo González, Vice-Director, Museo Nacional del Virreinato. In Monterrey, we are grateful to Doña Lydia Sada de González, Tomás González Sada, and Pablo González Sada.

This exhibition would not have been possible without the full support in Mexico of Sari Bermúdez, President of the Consejo Nacional para la Cultura y las Artes (CONACULTA); Saúl Juárez Vega, Director General of the Instituto Nacional de Bellas Artes (INBA); and Luciano Cedillo Álvarez, Director General of the Instituto Nacional de Antropología e Historia (INAH). At CONACULTA, we have benefited from the interest and assistance of Alberto Fierro Garza, Director General de Asuntos Internacionales; and Carlos Enríquez Verdura, Director de Promoción y Difusión Cultural Internacional. The works of art from churches and religious houses were loaned through the auspices of Xavier Cortés Rocha, Director General de Sitios y Monumentos del Patrimonio Cultural (CONACULTA). We also thank Gabriela Eugenia López, Coordinadora Nacional de Artes Plásticas, and Denise Muñoz, Directora de Asuntos Internacionales, both of INBA. We owe special thanks to Miguel Angel Fernández and José Enrique Ortiz Lanz, Coordinador Nacional de Museos y Exposiciones of INAH, and to Ivonne Morales for her adept coordination of the loans.

In Peru, in Arequipa, we are grateful to Monsignor José Rivera Martínez, Vicar General, and Luis Sardón Cánepa, Director of Cultural Property, Archbishopric of Arequipa. In Cuzco, we thank Father César Quiroga Luna, Comendador del Convento de La Merced, Templo y Convento de La Merced; Father Jorge Chacón Mendoza, Templo de San Sebastián; Father Jorge Beneito Mora, Templo de la Compañía de Jesús; Father Alejandro Repulles Benito, S.J., Superior de la Orden Jesuita, Templo de la Compañía de Jesús; Elías Carreño, Director, Museo Histórico Regional (Instituto Nacional de Cultura); David Ugarte Vega Centeno, Regional Director of Instituto Nacional Cultura; Edwin González, General Manager, Hotel Libertador; and Luis Castañeda Tirado and Luis Castañeda Luna, Vice President and Executive Director of Salvemos Iglesias. In Lima, we extend our thanks to Alvaro Carulla, Gerente del Area de Imagen y Relaciones Institucionales, and Luis Nieri G., Asesor Institucional, Banco de Crédito del Perú; Mr. and Mrs. Juan Fernando Belmont; Vivian and Jaime Liébana; Mother Superior Emilia Díaz Monge, Concepcionistas Franciscanas de Copacabana; José Luis Fernández-Castañeda, S.J., Church of San Pedro; Mrs. Mónica Taurel de Menacho; Pedro Gjurinovic Canevaro, Director, and Carmen de Osma de Santa Cruz and Oscar de Osma, Museo Pedro de Osma; Reverend Father Miguel Díez Medina, Provincial of the Order of the Augus-

tinians; Carlos R. del Aguila Chávez, Director, Museo Nacional de Arqueología, Antropología e Historia del Perú; Juan Carlos Verme, President, and Natalia Majluf Brahim, Director, Museo de Arte de Lima; Isabel Larco de Alvarez-Calderón; Andrés Alvarez Calderón; Mrs. Dionisio Romero; Leonel and Silvia d'Erteano; and Ana María and Gonzalo Aliaga, the late Isabel de Aguirre, and Eli de Romero. Arrangements for the loans were adroitly handled by the Instituto Nacional de Cultura. We are grateful to Luis Guillermo Lumbreras Salcedo, Director, Bertha Vargas, Head of the Office of Regional Coordination, and Jaime Mariazza Foy, Director, National Register of Patrimony.

In Puerto Rico, in Ponce, we thank Luis E. Martínez Margarida, Director, and Cheryl Hartup, Chief Curator, Museo de Arte de Ponce. In San Juan, we owe thanks to Archbishop Roberto González Nieves, Palacio Arzobispal; José Luis Vega, Executive Director, Instituto de Cultura Puertorriqueña; Laura Vélez, Museo de San Juan; and Elisa de Jesús.

In Spain, in Barcelona, thanks go to Mr. Manuel Alorda and Núria Poch, Curator of the Alorda-Derksen Collection. In Madrid, we are grateful to Miguel Zugaza, Director, Museo Nacional del Prado; Yago Pico de Coaña de Valicourt, President, and José Antonio Bordallo Huidobro, Director, Patrimonio Nacional; Miguel Osorio Nicolás-Correa, Adrián Zunzunegui, and Paloma Botín; Leticia Arbeteta, Director, and Carmen Espinosa, Chief Conservator, Fundación Lázaro Galdiano; Mr. and Mrs. Wagner de García; Mrs. Eunice Regioli; José Luis Várez-Fisa; and Paz Cabello Carro, Director, Museo de América. In Seville, we thank Don Francisco Ortiz Gómes, President of the Cabildo, Francisco Navarro Ruiz, Delegado Ejecutivo de Administración, and Teresa Laguna, Cathedral of Seville. In Telde, Gran Canaria, thanks go to Francisco Cases Andreu, Bishop of the Canaries, and Don José Lavandera, Dean of the Cathedral, Gran Canaria.

In the United States, we thank the following: in Paradise Valley, Arizona, Stephen and Ardie Evans; in Northridge, California, Mrs. Elisabeth Waldo-Dentzel; in Denver, Colorado, Lewis Sharp, Director, Timothy Standring, Deputy Director of Collections and Programs, and Donna Pierce, Frederick and Jan Mayer Curator of Spanish Colonial Art, Denver Art Museum; and Jan and Frederick Mayer and Ann Daley, Curator, Collection of Jan and Frederick Mayer; in Hartford, Connecticut, Willard Holmes, Director, and Eric Zafran, Curator of European Painting and Sculpture, Wadsworth Atheneum Museum of Art; in Kenilworth, Illinois, Carl and Marilynn Thoma; in New York City, Ellen Futter, President, American Museum of Natural History; Mitchell Codding, Director, Marcus B. Burke, Curator of Paintings and Drawings, and Margaret E. Connors McQuade, Curator of Ceramics, Furniture, and Glass, The Hispanic Society of America; Roberta and Richard Huber; and Philippe de Montebello, Director, The Metropolitan Museum of Art; in Brooklyn, New York, Arnold Lehman, Director, and Charles Desmarais, Deputy Director for

Art, The Brooklyn Museum of Art; in Philadelphia, Miguel Angel Corzo, President, The University of the Arts; Richard M. Leventhal, The Williams Director of the University of Pennsylvania Museum of Archaeology and Anthropology; His Eminence Cardinal Justin Rigali, Archbishop of Philadelphia; and Enrique Ruíz-Sánchez, Consul of Mexico; in Dallas, Texas, Marc Roglan, Director, The Meadows Museum, Southern Methodist University; in San Antonio, Texas, Marion Oettinger, Jr., Director, San Antonio Museum of Art; and Esther and Marc Siegfried; and in Washington, D.C., Edward L. Keenan, Director, and Gudrun Buehl, Curator and Museum Director, Dumbarton Oaks Research Library and Collection.

In Venezuela, in Caracas, we are grateful to José Manuel Rodríguez, President, Juan Carlos León, and Lilia Vierma, Anthropologist and Manager of Control, Instituto de Patrimonio Cultural; Patricia Phelps de Cisneros, Rafael Romero, Director, and Jorge Rivas, Curator of Colonial Art, Colección Cisneros; Marisa Rodríguez de Legorburu; María Teresa Boulton, Director, Fundación John Boulton; Tahía Rivero, Curator, Banco Mercantil; Father Epifanio Labrador, S.J., Church of San Francisco; Gustavo Merino F. and Alberto Hernández, Fundapatrimonio; and Carlos F. Duarte, Museo de Arte Colonial de Caracas/Quinot de Anauco.

We want to thank our colleagues at our respective institutions. In Philadelphia we are grateful to Ruth Abrahams, Larry Berger, Richard Bonk, Elie-Anne Chevrier, Sahar Coston, Charles Croce, Peter Dunn, Tara Eckert, Corinne Filipek, Zoe Kahr, Ann Kessler, Norman Keyes, Carolyn Macuga, Betty J. Marmon, Bethany Morris, Kelly M. O'Brien, Bill Ristine, Cynthia Rodríguez, Jack Schlechter, Suzette Sherman, Andrew Slavinskas, Jeffrey Snyder, Erin Soper, Shari Stoltz, William Valerio, Jennifer Vanim, Mary Grace Wahl, Jason Wierzbicki, and Maia Wind. We appreciate the work of the Latino Outreach Committee: Carmen A. Adames, Yolanda Alcorta, Cynthia Alvarez, Emilio Buitrago, Nancie Burkett, Ted Burkett, Aurora Camacho de Schmidt, Luz Cárdenas Virilli, Andreina Castillo, Anamaria Cobo de Paci, Héctor Contreras, Rev. Luis Cortés, Jr., Miguel Angel Corzo, Carlos De los Ramos, Isabel DeBeary, Maria Del Pico Taylor, Nelson Díaz, Roberto Díaz, Joseph Dominguez, Monica Dominguez Torres, Carmen Febo-San Miguel, Josue Figueroa, Joan Friedman, Joseph Gonzales, Wilmarie Gonzalez, Juan Gutierrez, Joseph Hare, Elba Hevia y Vaca, Yolanda Jimenez Colón, Cheryl McClenney-Brooker, Mia Mendoza, Damalier J. Molina, Ana Cecilia Montalbán, Giovanni Morante, Mike Muñoz, Doris Nogueira-Rogers, Monica Orozco, Benjamin Ramirez, Teresa Rauscher, Pedro J. Rivera, Jesse Rodriguez, Nilda I. Ruiz, Guillermo Salas, Natalia Salgado, Marta Sánchez, Roberto Santiago, Marla K. Shoemaker, Suzana Silva, Ricardo Stoeckicht, Kenneth I. Trujillo, and Thomas A. Warnock.

In Mexico City, we thank María Claudia Barragán Arellano, Félix Barranco Hernández, Ernesto Bejarano Villegas, Rubí Blasi Toledo, Alejandro Camalich Guerrero, Ery Cámara Thiam,

José de Jesús Castillo Bravo, José Antonio Castro Maldonado, Magaly Cruces Arteaga, Sergio David Espinosa Navarro, Ilya Elka Franco Espinosa de los Monteros, Erasmo Isaac Hernández Hernández, Gerardo Hernández Hernández, Luis Miguel León Cornejo, Lilia Millán López, Rosa María López Montaño, Marcela Madrid Orozco, Ana Luz Mejía Guerra, Enrique Melgarejo Oropeza, Eduardo Morales Torres, Guillermo Pérez Martínez, Anabel Rendón Treviño, Hugo Torres Víctor, and Monika Iwona Zukowska Kielska. Our gratitude is also extended to the Antiguo Colegio de San Ildefonso's Board of Trustees.

In Los Angeles we are grateful to the organizing curator at the Los Angeles County Museum of Art, Ilona Katzew. Also assisting with the project were Janelle Aieta, Victoria Behner, Nola Butler, Jan Cromartie, Tom Frick, Joe Fronek, Mark Gilberg, Laura Hardy, Jeff Haskin, John Hirx, Bernard Kester, Megan Knox, Irene Martín, Amy McFarland, Catherine McLean, Don Menvig, Sarah Miller, Renée Montgomery, Bruce Robertson, Michael Ruff, Sofía Sanabrais, William Stahl, Toby Tannenbaum, and Glenn Thompson.

Photography Credits

Frontispiece photograph © Michel Zabé, assistant Enrique Macias Martinez; fig. A-1 photograph by Judy de Bustamante; fig. C-1 photograph by Manuel Aguilar; fig. C-5 courtesy Tulane University, New Orleans, photograph by Ross Parmenter; figs. D-1, D-11, D-12 photographs by Alfonso Ortiz Crespo; figs. E-11, E-12 photographs by Fernando Chaves; fig. E-14 photograph by John Betancourt; fig. F-8 photograph © 2006 Museum of Fine Arts Boston; fig. H-1 photograph by Sergio Barbieri; fig. I-4 photograph by Gonzalo de Serna; cat. I-12 University of Pennsylvania Museum Photo Archives; cat. I-21 photograph © Mark Morosse; cat. I-24 photograph © Rodrigo Benavides; cat. I-26 photograph © Michel Zabé; cat. I-27 photograph by Judy de Bustamante; cats. I-28–I-30 photographs by Graydon Wood; cat. I-32 photograph by Lynn Rosenthal; cat. I-33 photograph © Michel Zabé; cat. I-34 photograph by Lynn Rosenthal; fig. II-5 photograph by Graydon Wood; fig. II-6 photograph by Lynn Rosenthal; fig. II-8 photograph by Major Dache M. Reeves; cat. II-2 photograph by Justin Kerr; cat. II-3 photograph © Amnh D. Finnin; cat. II-4 photograph © 2001 The Metropolitan Museum of Art; cats. II-5–II-7 photographs © Michel Zabé; cat. II-8 photograph © Museum Associates/LACMA; cat. II-9 photograph by Judy de Bustamante; cat. II-10 photograph by Gustavo Sosa Pinilla; cat. II-11 photograph © Fitzwilliam Museum, University of Cambridge; cat. II-12 photograph by Graydon Wood; fig. III-2 photograph courtesy Cristina Esteras Martín; figs. III-3, III-4a, b photographs by Alberto Otero Herranz; fig. III-6 photograph courtesy Cristina Esteras Martín; cat. III-4 photograph © Museum Associates/LACMA; cat. III-6 photograph © Michel Zabé; cat. III-7 Arenas Fotografía Artística, S.C.; cats. III-9, III-10 photographs © Michel Zabé; cat. III-20 photograph by Javier Hinojosa; cat. III-21 photograph © 1992 The Metropolitan Museum of Art; cats. III-23, III-26–III-28 photographs by Daniel Giannoni; cat. III-33 photograph by Jaime Cisneros; cats. III-34–III-36 photographs by Alberto Otero Herranz; cat. III-37 photograph by Gustavo Sosa Pinilla; cat. IV-1 photograph by Adenor Gondim; cat. IV-2 photograph by Rômulo Fialdini; cats. IV-3, IV-4 photographs by Adenor Gondim; cats. IV-5, IV-6 photographs by Rômulo Fialdini; cat. IV-7 photograph by Adenor Gondim; cat. IV-8 photograph by Saulo Kainuma; fig. V-5 photograph by Walter Gutiérrez; fig. V-7 photograph by Christoph Hirtz; fig. V-8 photograph by Fernando Chaves; figs. V-11, V-12 Sacredsites.com; cats. V-1, V-2, V-4–V-8 photographs © Michel Zabé; cats. V-9–V-16, V-18 photographs by Rodrigo Castillo; cat. V-23 photograph by Judy de Bustamante; cat. V-24 photograph by Christoph Hirtz; cats. V-25–V-27, V-29 photographs by Judy de Bustamante; cats. V-31–V-38 photographs by Daniel Giannoni; cats. V-42, V-44 photographs by Rômulo Fialdini; cat. V-46 photograph by RCS Arte Digital; cat. V-47 photograph by Elpidio Suassuna; cat. V-48 photograph by Adenor Gondim; cat. V-51 photograph by Fernando Chaves; cats. V-53, V-54 photographs by Jaime Cisneros;

fig. VI-7 photograph by Will Brown; fig. VI-10 photograph by Daniel Giannoni; fig. VI-11 photograph by Luis Díaz Reynoto; fig. VI-12 photograph by Luis de Anda; fig. VI-14 photograph by Adenor Gondim; cat. VI-1 photograph © Michel Zabé; cat. VI-2 photograph by Graydon Wood; cats. VI-4, VI-7, VI-11, VI-13–VI-18 photographs © Michel Zabé; cat. VI-19 photograph by Alberto Otero Herranz; cats. VI-20, VI-21, VI-24, VI-26–VI-30 photographs © Michel Zabé; cat. VI-32 photograph © James O. Milmoe, 1996; cats. VI-34–VI-38 photographs © Michel Zabé; cat. VI-39 photograph by Javier Hinojosa; cat. VI-41 photograph © Michel Zabé; cat. VI-43 photograph by Graydon Wood; cats. VI-44, VI-45 photographs © Michel Zabé; cat. VI-46 photograph © Museum Associates/LACMA; cat. VI-48 photograph © James O. Milmoe, 1996; cats. VI-49, VI-51–VI-54 photographs © Michel Zabé; cat. VI-64 photograph © Michel Zabé; cat. VI-65 photograph by Graydon Wood; cats. VI-66, VI-67 photographs © Michel Zabé; cat. VI-68 photograph by Daniel Giannoni; cat. VI-70 photographic Archive, Museo Nacional del Prado, Madrid; cats. VI-71, VI-73 photographs by Daniel Giannoni; cats. VI-74–VI-76 photographs by Jaime Cisneros; cat. VI-77 photograph by Daniel Giannoni; cats. VI-78–VI-81 photographs by Peter Hochhausler; cat. VI-82 photographic Archive, Museo Nacional del Prado, Madrid; cats. VI-83, VI-85–VI-90 photographs by Jaime Cisneros; cats. VI-91, VI-92 photographs by Daniel Giannoni; cats. VI-93, VI-97, VI-98 photographs by Jaime Cisneros; cat. VI-99 photograph by Daniel Giannoni; cats. VI-100, VI-101 photographs by Camilo Monsalve; cat. VI-103 photograph by Reinaldo Armas and Charlie Riera; cat. VI-108 photograph by Carlos Germán Rojas; cats. VI-109, VI-110 photographs by Jaime Cisneros; cats. VI-111–VI-117 photographs by Daniel Giannoni; fig. VII-1 photograph by Wilfredo Loayza; cats. VII-2–VII-4 photographs by Daniel Giannoni; cats. VII-5, VII-7, VII-8 photographs © Michel Zabé; cats. VII-10, VII-11 photographs by Daniel Giannoni; cat. VII-12 photograph © Michel Zabé; cat. VII-13 photograph by Daniel Giannoni; cat. VII-14 photograph by Adenor Gondim; cats. VII-15–VII-17 photographs by Carlos Germán Rojas; cat. VII-18 photograph by Gustavo Sosa Pinilla; cat. VII-20 photograph by Carlos Germán Rojas; cat. VII-21 photograph by Fernando Chaves; cats. VII-22, VII-23 photographs © Michel Zabé; cat. VII-24 photograph © Mark Morosse; cat. VII-25 photograph © Michel Zabé; fig. 1 Scala/Art Resource, NY; figs. 2, 4, 5 DDB Photography; figs. 6, 8 photographs by Anne D. Pushkal; fig. 9 photograph by Judy de Bustamante; fig. 10 Scala/Art Resource, NY; figs. 11, 12 Gilles Mermet/Art Resource, NY; fig. 13 photograph by Judy de Bustamante; fig. 14 Giraudon/Art Resource, NY; fig. 15 photograph by Anne D. Pushkal; fig. 16 photograph by Judy de Bustamante; fig. 17 Giraudon/Art Resource, NY; fig. 20 photograph © 2003 The Metropolitan Museum of Art; fig. 21 HIP/Art Resource, NY; figs. 22–24 photographs by Judy de Bustamante; fig. 29 Scala/Art Resource,

NY; fig. 32 photograph by Barbara B. Aronson; figs. 33, 34 photographs by Judy de Bustamante; fig. 36 Scala/Art Resource, NY; fig. 44 Réunion des Musées Nationaux/Art Resource, NY; fig. 45 Giraudon/Art Resource, NY; fig. 46 Réunion des Musées Nationaux/Art Resource, NY; fig. 47 Bildarchiv Preussischer Kulturbesitz/Art Resource, NY; fig. 48 Snark/Art Resource, NY